THE MARINE WORLD

A Natural History of Ocean Life

THE MARINE WORLD

A Natural History of Ocean Life

FRANCES DIPPER

Illustrated by
Marc Dando

To Georgina
- FD

To Riley
- MD

To children and grandchildren everywhere
Long may they marvel at this vital, vast and vulnerable realm

Published in 2016 by
Wild Nature Press
Winson House, Church Road
Plympton St. Maurice, Plymouth PL7 1NH

Copyright © 2016 text Frances Dipper
Copyright © 2016 illustrations Marc Dando
Copyright © 2016 photographs as named and listed on page 527

The right of Frances Dipper to be identified as the author of this work has
been asserted by her in accordance with the Copyright, Designs and Patents Act 1988.

All rights reserved. No parts of this publication may be reproduced, stored in a retrieval system
or transmitted, in any form or by any means, electronic, mechanical, photocopying, recording
or otherwise, without the prior permission of the publishers.

A CIP catalogue record for this book is available from the British Library.

ISBN 978-0-9573946-2-9

Designed by Julie Dando
Printed and bound in Slovenia on behalf of Latitude Press
10 9 8 7 6 5 4 3 2 1

www.wildnaturepress.com

Contents

Foreword *by Mark Carwardine* — 8

Introduction — 9

PART I: THE PHYSICAL OCEAN — 11

Ocean Research — 12
- Going down — 13
- From the surface — 14
- Satellites — 15

The Marine Environment — 16
- Light — 18
- Salinity — 20
- Density and viscosity — 22
- Water pressure — 23
- Dissolved gases and acidity — 24
- Sea temperature — 26
- Ocean currents — 28
- Tides — 30
- Waves — 32
- The main divisions of the marine environment — 34

PART II: THE LIVING OCEAN — 39

Environments and Ecosystems — 40
- Open water (pelagic environments) — 49
- Seabed (benthic environments) — 68
- Sea shore (intertidal) — 82
- Sublittoral — 92
- Deep seabed — 109

PART III: MARINE LIFE — 115

Ocean Life — 116
- Distribution of ocean life — 117
- Past ocean life: marine fossils — 118
- Classification — 120

Bacteria and Archaea — 126

Marine Plants and Chromists — 128
- Seaweeds (macroalgae) — 130
- Marine microalgae — 149
- Marine flowering plants — 157

Marine Fungi — 168
- Lichens — 169

Protozoa — 172

Microanimals — 174
- Comb jellies — 174
- Arrow worms — 176
- Water bears — 177
- Gastrotrichs — 178
- Goblet worms — 179
- Rotifers — 180

Placozoans	181
Cycliophorans	181
Sponges	**182**
Cnidarians	**188**
Hydroids	191
Jellyfish	195
Soft corals and sea fans (Octocorals)	200
Stony corals and anemones (Hexacorals)	205
Annelid Worms	**210**
Polychaetes	211
Oligochaetes	216
Leeches	217
Other Worms	**218**
Flatworms	218
Ribbon worms	220
Nematodes	222
Peanut worms	223
Spoon worms	224
Cephalorhyncha	225
Phoronids	226
Xenacoelomorpha	227
Molluscs	**228**
Gastropods	230
Bivalves	238
Cephalopods	246
Chitons	252
Minor molluscs	254
Brachiopods	**256**
Arthropods	**258**
Horseshoe crabs and sea spiders	262
Crustaceans	264
Bryozoans	**284**
Echinoderms	**288**
Starfish	290
Brittlestars	294
Sea urchins	296
Sea cucumbers	300
Featherstars	302
Hemichordates	**304**
Chordates	**306**
Non-vertebrate chordates	307
Marine Fishes	**314**
Jawless fishes	320
Cartilaginous fishes	326
Ray-finned fishes	358
Lobe-finned fishes	400
Marine Reptiles	**402**
Crocodiles	405
Sea turtles	407

Sea snakes	412
Marine Iguana	415
Marine Mammals *by Robert Irving*	**416**
Whales and dolphins	420
Dugong and manatees	439
Seals and Walrus	444
Marine otters	454
Polar Bear	456
Marine Birds *by Marianne Taylor*	**458**
Seabirds	464
Waders	478
Marine wildfowl	485
Other marine birds	490
Interrelationships	**492**
Defence, attack and camouflage	492
Symbiosis	498
Marine Protected Areas	**502**
Ocean sanctuaries	504
Marine reserves	506
Marine parks	510

Appendices — 514

Appendix I	Organisations and recording schemes	515
Appendix II	Metric and imperial measurements and SI units	518
Appendix III	Prefixes and suffixes	519

References — 521

Acknowledgements — 526

Image credits — 527

Index — 529

Foreword

At last! This is the book we've all been waiting for. A one-size-fits-all comprehensive guide to the vast and wide-ranging wonders of the marine world. It's been a long time coming, but here it is – with bells on.

All you could possibly want to know about everything from El Niño to elasmobranchs and waves to whales is crammed into Frances Dipper's irresistible book. What an outstanding achievement. How do marine organisms make their own light? What is an upwelling? Where does the European Eel go on migration? What is the difference between a spring tide and a neap tide? How do you identify different species of sea turtle? When did Steller's Sea Cow become extinct? These and a squillion other questions are answered, with the help of wonderful diagrams, maps, charts, drawings, paintings and photographs, in a way that makes sense to everyone from curious naturalists to top-level policy makers.

The ultimate guide to everything marine, *The Marine World* is authoritative, though not too scientific; easy to read, though not dumbed down; and comprehensive, though far from overwhelming.

Like many people, I am happiest when I'm near the sea. It doesn't matter whether I am strolling along a beach, bobbing about in a boat, swimming, snorkelling or diving, the sea is where I feel most at home. It fires the imagination, tugs at the heart strings, and clears the mind. And, quite simply, it is good for the soul.

It is also fundamental to life on earth. It is our life support system. As the great oceanographer Sylvia Earle once commented, "We need to respect the oceans and take care of them as if our lives depended on it. Because they do."

Yet we are not taking care of them. Far from it. At best, we are guilty of neglect. At worst, we treat them with utter contempt.

Human impact has now reached every corner of the marine world. Global fish populations are collapsing, thanks to unsustainable fishing: there are too many boats chasing too few fish. Tens of millions of whales, dolphins, porpoises, albatrosses, turtles, sharks and other marine creatures – so-called non-target 'bycatch' – are drowning in fishing gear every year. We're treating the oceans as bottomless dumping grounds for everything from oil and industrial waste to untreated sewage and plastics. We still allow the barbaric practice of commercial whaling (can you believe Japan, Norway and Iceland are still hunting whales?). Marine habitats are being destroyed and disturbed by coastal development, heavy shipping, mangrove clearance for shrimp production, deep-sea trawling, and so on. And we're making a shocking amount of underwater noise with oil and gas exploration, military sonar, and many other human activities.

To cap it all, the effects of climate change could ultimately trump all these other threats. A simple rise in sea temperature, for example, is likely to alter migrations, expand or contract breeding and feeding ranges, change the timings of seasonal cycles, influence reproductive success, and increase susceptibility to disease.

To describe what we're doing as frightening is a gross understatement.

If we are going to mitigate our negative impact on the world's oceans, we need more people who are moved to help – and that comes with an understanding of their beauty and fragility. Knowledge is power. So, as you dip into *The Marine World*, I sincerely hope that it will inspire you to stand up and be counted as an advocate of ocean conservation.

There is still time to turn things around. But not a lot.

Mark Carwardine
Zoologist and conservationist

INTRODUCTION

The Marine World occupies more than two thirds of our planet and yet is largely hidden from our view beneath an ever restless ocean surface. Elucidating the natural history of the myriad plants, animals and other organisms that live their lives away from our gaze is, however, vital to our own survival. Our species and terrestrial life as we know it could not exist without the ocean and the marine life it contains. The more we learn, the more we are coming to understand just how dependent our lives are on a healthy and biodiverse marine environment. Biodiversity is the key word here and it is the life within our oceans with which this book is mainly concerned.

The ocean provides us with both food and water, since rainfall comes largely through evaporation of saltwater and subsequent freshwater precipitation over land. The photosynthetic, floating phytoplankton in the ocean produces at least 50% of the oxygen in the air we breathe. We extract oil and gas from within the seabed deep beneath the ocean, aggregates and minerals from the seabed, useful chemicals from a wide variety of marine organisms and even salt itself from seawater. We also use the ocean as a dumping ground for our waste, both purposefully and inadvertently. Overexploitation and wasteful or damaging fishing methods are now global problems and rarely out of the news, and the list of species now considered endangered grows ever longer. Knowing just what lives in the ocean, and where and how it does so, is essential to mitigate such problems and for effective management and conservation of the resources on which we depend, but also it is and has been since early times, a source of interest and fascination in its own right.

The Census of Marine Life (see p.12) estimates that around 250,000 marine species are currently known, but predicted estimates of the total number of marine organisms that may exist run to over 2 million (see p.116). This book provides an accessible introduction to this astonishing diversity, from the more familiar marine fish, mammals and other large animals, to the many small and often obscure marine invertebrates, and to seaweeds and other photosynthetic organisms. The ocean has an influence that extends far beyond the high water mark and this book similarly extends to cover familiar maritime organisms and ecosystems including mangroves, sand dunes, saltmarshes and the strandline. With its

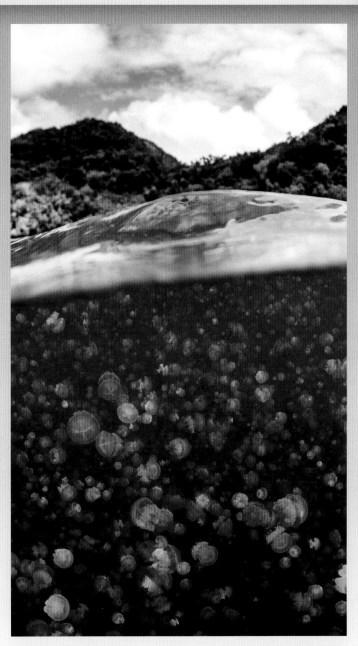

Huge numbers of *Mastigias* jellyfish thrive naturally in enclosed marine lakes in Palau (see p.76). However, the question of whether the increasingly large and numerous swarms of jellyfish seen in the open ocean in recent years are normal, or are the result of imbalances caused by human use of the oceans, can only be answered if the natural history of these animals is fully understood.

wealth of photographs and illustrations, and plainly written but detailed text, the book is ideal for naturalists, divers, seafarers and the general reader, as well as providing a useful and scientific resource for students. The author hopes that it will encourage all those who visit, study, use or simply enjoy the ocean, to recognise, record and photograph what they see, and equally to question the ways in which they see the ocean's resources being used and managed.

HOW TO USE THIS BOOK

The book is divided into three main sections. The first and shortest is an introduction to **THE PHYSICAL OCEAN** and provides a brief overview of the physical environment within which marine organisms live. It includes the main factors, such as tides, currents, salinity and temperature that influence how and where marine life exists in the oceans. The second section on **THE LIVING OCEAN** describes the main environments and ecosystems within which marine organisms live, from seashore and maritime habitats, to deep sediments and hydrothermal vents.

The third section on **MARINE LIFE** occupies most of the book. Within this, each main section covers one (or sometimes several) of the known marine phyla, the large taxonomic groups into which life is divided by scientists. Reptiles, fishes, marine birds and marine mammals all belong to the same phylum (Chordata) but each has its own section because they are large and important groups. Readers can dip into the Marine Life section (or indeed the whole book) at any point. Each marine life section has an illustrated **introduction** to the phylum concerned that should answer the basic question of 'what is'...a sea squirt, a mollusc etc. or, 'what marine reptiles, birds, mammals are there?' This is followed by a Linnaean-style **classification** that can be ignored by those who prefer to move straight on to natural history aspects, but which will give students and others a basic grounding in how the organisms within that phylum are related. **Distribution** tells where in the world and ocean the reader might look to find each type of organism. Current knowledge on the natural history of each type of organism follows in sections on **structure**, **biology** and **ecology**. Finally, an assessment of the ways and extent to which humans have exploited the group in question and how we are seeking to protect it, is given in a section entitled **Uses, threats, status and management**. Photographs illustrating worldwide examples from each phylum follow, along with more detailed information on the features that unite the organisms within each classification unit.

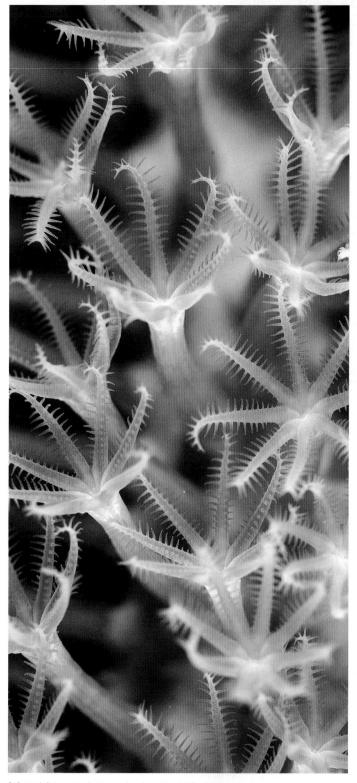

Soft coral, *Briareum asbestinum*, showing extended feeding polyps.

THE PHYSICAL OCEAN

OCEAN RESEARCH

Ocean research has never been more important than it is today. Without detailed knowledge of how the ocean works and the interrelationships of life within it, we cannot hope to tackle major threats such as ocean warming, ocean acidification and overfishing. Even if this were not the case, our natural curiosity and desire to explore and to see for ourselves has drawn us into the ocean from early times. Today tens of thousands of scuba divers explore shipwrecks and coral reefs, play with seals and swim with fish every year. Ocean research is no longer the exclusive province of marine scientists. The enthusiasm and recording skills of an army of amateur divers, snorkellers, sailors and beach visitors can be harnessed to provide a wealth of data on the status and well-being of our ocean life. Divers can watch and record the behaviour and interactions of marine life in shallow water, but with the deep ocean this is difficult, dangerous and expensive. However the draw of 'seeing for ourselves' has led to the development of manned research submersibles that can reach the deepest part of the ocean and is now being followed by the exciting development of 'personal submarines'. As an alternative, remote technology can provide high quality photographs, films and samples but can be equally challenging to deploy and use in very deep water.

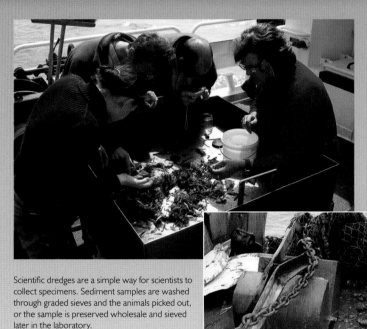

Scientific dredges are a simple way for scientists to collect specimens. Sediment samples are washed through graded sieves and the animals picked out, or the sample is preserved wholesale and sieved later in the laboratory.

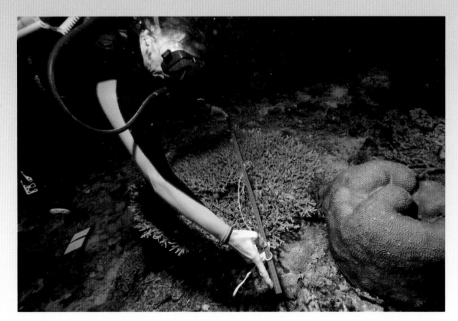

The five-year expedition of HMS Challenger from 1872 to 1876 circumnavigated the globe and provided the first overview of the whole ocean and the marine life in it. Nearly 130 years later, the World Ocean Census of Marine Life began a ten-year programme (2000–2010) to look at all life in the ocean from bacteria to whales, from the surface to the greatest depths and from the Arctic to the Antarctic. This time instead of a single ship the project eventually involved around 2,700 scientists from more than 80 nations, who took part in 540 expeditions and follow-up laboratory work, at a cost of $US 650 million (www.coml.org). More than 2,500 scientific papers have already been published as a result of this amazing global effort and the final count of the new species discovered is likely to be around 6,000. Nevertheless, a huge amount still remains to be discovered about marine life in the ocean.

Diving can provide a cheap and effective way of monitoring the state of coral reefs and other habitats in local areas. Here the author is measuring a staghorn coral plate. Data is recorded on a simple writing board.

GOING DOWN

DIVING

In spite of our distant watery ancestry we are not well equipped to explore the oceans. We rapidly lose heat in water, we can hold our breath for a few minutes at most, our eyes cannot focus underwater and our legs and arms make inefficient propulsive units. In spite of this, thousands of scientists all over the world venture into the ocean using SCUBA equipment (Self-contained Underwater Breathing Apparatus) and are able to observe, photograph, film, survey and collect marine life. However, their numbers are far exceeded by so-called 'amateur' and recreational divers. Many recreational divers are keen naturalists and contribute huge amounts of data to various organised recording schemes, some of which are described in Appendix 1.

Diving provides first-hand observations of marine life but has the disadvantage that the depth and the length of time that a diver can spend underwater are both severely limited by the need to avoid decompression sickness. 'The bends', as this is often called, is avoided by diving mammals through inbuilt physiological adaptations described further on p.419.

SUBMERSIBLES

Even within the research community, opportunities to dive in a submersible are rare, but the rewards of a successful dive are great. The discovery of giant tube worms clustered around 'smoking' chimneys at a hydrothermal vent site (p.112) in 1977 must rank as one of the most exciting of all moments in marine biology. This dive was in *Alvin*, which since it was commissioned in 1964 has been a mainstay of the world's submersible fleet. *Alvin* is depth-rated to 4,450m, which puts much of the deep seabed within its reach, but when Neil Armstrong stood on the moon in 1969 only one successful mission had ever been made to the deepest part of the ocean, the Marianas Trench. This notable achievement was secured by Don Walsh and Jaques Piccard in 1960, in the bathyscape *Trieste*. With tiny portholes, little manoeuvrability and poor lighting, they were only able to confirm that marine life existed at these depths, but could not make any identifications. In March 2012 the film director James Cameron successfully piloted the one-man submersible *Deepsea Challenger* to the bottom of that same trench, reaching 10,898m.

Research submersibles maintain an internal pressure of one atmosphere, the same as that on the surface, and so apart from being extremely cramped, do not greatly affect the physiology of the divers in them. The development of acrylic viewing domes strong enough to withstand the tremendous pressures at these depths, now allows scientists a good view and the opportunity for top quality photography. Many submersibles also have the capability to collect samples using robotic arms.

Vehicle	Type	Depth capability	Year of first operation
Johnson Sea-Link 1/2	DSV 2 person	800m	1971/1975
Alvin	DSV 3 person	4,450m	1964
MIR 1 and MIR 2	DSV 2 person	6,000m	1987
Shinkai 6500	DSV 3 person	6,500m	1987
Nautile	DSV 3 person	6,000m	1985
Jialong	DSV 3 person	7,500m	2010
Deepsea Challenger	DSV 1 person	11,000m	2012
Nereus	Hybrid AUV-ROV	11,000m	2009

In-service deepwater research vehicles and their capabilities. DSV: Deep Submergence Vehicle. ROV: Remote Oceanographic Vehicle. AUV: Autonomous Underwater Vehicle.

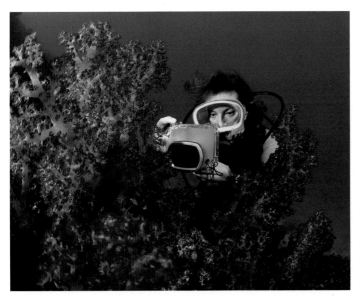

The ready availability of digital cameras and underwater housings has revolutionised underwater photography in recent years. Whilst not all species can be identified from photographs, many can and recreational divers now contribute large numbers of valuable records.

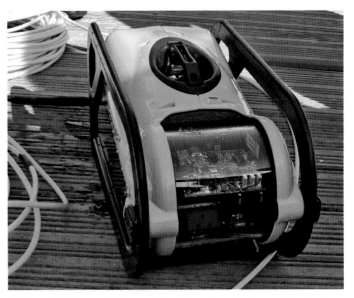

Small portable ROVs are useful for surveying in shallow water and can be used from the shore and from small boats.

FROM THE SURFACE

DEPTH AND SEABED MEASUREMENT

The original way in which depth was measured in the ocean was to use a weighted line, deployed from a ship with the length of line measured by an onboard meter or by hand. Taking such 'soundings' from the deep ocean was extremely laborious, but navigation charts covering remote parts of the ocean still carry some of these original depth measurements. Today sophisticated side scan and multi scan sonar devices, linked to computers, can provide sufficient detail of both depth and type of seabed to produce complex 3D images. These techniques can be used to map entire seamounts and other features in the deep ocean, or on a much simpler scale, to survey and map bottom types and habitats such as coral reefs and kelp forests in shallow water. Small, hand-held depth sounders carried by divers can detect seabed features around them but below their operational limits.

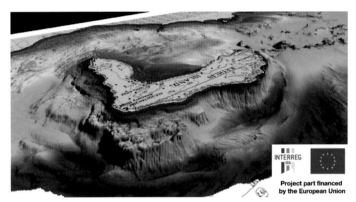

Multibeam echosounder technology allows scientists to make detailed maps of underwater bathymetry, in this case of Rathlin Island in Northern Ireland. Courtesy of the Joint Irish Bathymetric Survey (JIBS), an EU-funded Interreg-IIIA seabed mapping project led by the Irish Marine Institute and the UK Maritime and Coastguard Agency.

BIOLOGICAL SAMPLING

With the possible exception of hand collecting by divers, sampling the seabed always results in some collateral damage to species and disturbance of the seabed (as does any type of bottom fishing on a much larger scale). Animals and seaweeds collected by divers will be in good condition and divers are particularly ingenious in devising custom-made containers to protect their specimens. In shallow, rocky areas divers are the only effective option for collecting specimens. In deep water collections can be made from ROVs and DSVs but trying to manoeuvre a robotic arm to collect small and delicate organisms is very difficult and many such species are known only from photographs.

Sediments are generally easier to sample from the surface than is rock, and dredges and trawls have been used since the 1800s to bring up seabed animals. In the mid 1800s marine biologist Michael Sars succeeded in dredging up animals from around 450 fathoms (823m) depth thus disproving an early theory put forward by Manx-born Edward Forbes, that no life existed below 300 fathoms (549m).

Scientific trawls, grabs and dredges come in all shapes and sizes and can be qualitative or quantitative, deployed from small boats or large oceanographic ships. Deep sediments can only be sampled from large ships with the necessary equipment to handle many metres of cable. At the other end of the scale, divers can just push a coring tube into the sediment, cap it off and take it back up to the surface. Something as simple as a known length of plastic drainpipe with a metal bar through the top to

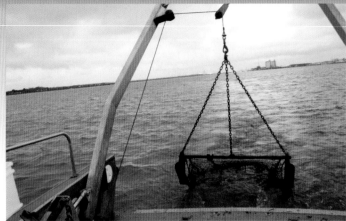

Benthic trawls such as this at the Southampton Oceanography Centre, UK, are used by scientists to find out what is living on seabed sediments.

provide grip, can be very effective. A plastic crate with compartments allows several corers to be stored and used along a transect line.

Mobile animals such as crustaceans, starfish, sea cucumbers and bottom-living fish are still sampled simply by towing trawl nets over the seabed. However, this is extremely difficult in water several thousand metres deep. The chances of a successful trawl are greatly increased by prior mapping of the seabed using sonar and by feedback from instruments attached directly to the trawl itself. Even so, such 'blind' sampling could be likened to dangling a net from a helicopter to catch insects in a forest. The use of baited traps is less damaging but only samples the animals in a small area. Nevertheless, many bizarre new species, especially crustaceans, have been found in this way. Baited traps combined with remote cameras capture images of the animals in their natural habitat, before they are hauled unceremoniously to the surface. Extreme bait in the form of whale carcasses (collected opportunistically) towed out to sea and dropped into deep water provide fascinating insights into which animals benefit from such a food bonanza (see p.111).

An unsophisticated sampler used by divers to suck up sediment through a mesh bag that retains any animals present. Compressed air from a normal diving cylinder generates an air lift in the coring tube.

SATELLITES

It was not until the end of the 18th century that the problem of calculating longitude out at sea was solved and before then many ships hit the rocks due to uncertain navigation. Today GPS (Global Positioning System) can pinpoint our whereabouts to just a few metres and ocean navigation is extremely accurate. The system depends on satellites placed in different orbits in space whose signals are detected by GPS units such as mobile phones or car navigation units. GPS is now an essential tool for many disciplines and is widely used in marine surveys and monitoring. Remote sensing through satellites is also responsible for much of our modern knowledge about how the ocean works and the marine life within it.

Satellite tag type	Use and function
PAT Pop-up Archival Tag or PSAT Pop-up Satellite Archival Tag	Animals that rarely come to the surface or are rarely caught. Releases after set time, transmits at surface within battery limits. Retains full data in case tag is retrieved.
SPOT Smart Position or Temperature Transmitting Tag	Air-breathing seals, cetaceans, turtles and fish that often swim near the surface (e.g. Blue and Mako sharks). Data sent when device antenna breaks the surface.
SRDL Satellite Relay Data Logger	Large air-breathing animals such as elephant seals, turtles, sea lions. Similar to SPOT but can compress, store and send more data including oceanographic data from integrated CTD (conductivity, temperature and depth) devices.

Commonly used satellite tags. The type of tag selected for a particular study will depend on the target animal and the questions being asked.

REMOTE SENSING

Remote sensing is a science in itself and is a way of obtaining information about objects or areas without ever going near them. Satellites can now measure many ocean parameters and scientists can present the resultant data on a global scale. Changing patterns of warm and cold ocean currents such as those that occur during an 'El Niño' event (p.17) can be tracked in this way, as can seasonal changes and geographical variations in phytoplankton concentration and hence primary productivity. Coastlines, islands and estuaries can be mapped along with their covering vegetation. However, the accuracy of remotely sensed ocean data is not yet on a par with direct measurement for all parameters.

Satellite data can be collected both passively and actively. Passive sensors measure various wavelengths of electromagnetic radiation emanating from the ocean (or land). Colour scanners measure ocean radiance which is the light that is radiated back after sunlight hits and partially penetrates the ocean, plus light generated by organisms in the ocean. This is the first stage in a set of complex calculations to link measured radiance to the concentration of photosynthetic pigments in the ocean. This ultimately provides an estimate of primary productivity. In contrast, active data collection involves a satellite sending out a signal in the form of electromagnetic waves, such as microwaves, which travel to the ocean surface and their reflection is then measured. In this respect it can be thought of as a kind of aerial echo sounding. Satellite altimetry measures the time taken for a radar signal to pass from the satellite to the sea surface and back again and is used to measure wave heights.

Whilst satellites collect data from above the ocean, ocean observatories collect it from below. This relatively new concept allows scientists to collect water samples and conduct remote experiments without setting foot in a ship. Power and fibre optic cables connect permanent or semi-permanent equipment deployed on the seabed hundreds of metres below the surface, to bases on land.

SATELLITE TAGGING

Many ocean animals make regular migrations, sometimes ocean-wide, in their search for food and to reach mating and breeding areas. Knowing where such animals travel is essential for the success of local and international conservation efforts and management of fisheries. A great deal of information has and can be collected using simple archival tags that collect and store pressure (to give depth), temperature and ambient light data (which provides an estimate of where the animal has been between release and capture point). Such devices rely on the animal being re-caught sometime after it has been tagged and is mainly used for species that are regularly fished for food or sport, such as tuna and bill-fishes. Archival tags are robust and cheap but provide limited data (always assuming the tag is returned by the finder). In contrast, satellite tags not only collect data but transmit it to researchers in real time via satellites. Satellite tags are basically radio transmitters and can be programmed to collect data on a variety of parameters such as location, temperature, depth and swimming speed at pre-defined intervals. Modern tags can store large quantities of data. Individual Whale Sharks, White Sharks, salmon sharks, mako sharks, Leatherback Turtles, seals, Blue Tuna and others continue to be tracked through various institutions and organisations around the world.

Commercially available satellite tags work through the Argos system. The transmitter (satellite tag) sends signals to polar orbiting satellites (850km above the Earth) at periodic intervals, at times when the tag is at the surface. The satellites collect and store the data and relay it back to earth in real-time where it is picked up by antennae placed around the globe. These in turn send the data to two Argos processing centres (in France and the USA). The information is then made available to the user.

The data provided by satellite tags is invaluable but the tags themselves are expensive and so is the necessary satellite time. Tags cannot always be retrieved except from animals such as elephant seals that regularly return to the same beaches. As well as providing essential data, satellite tagging programmes can be educational and often involve the general public who can follow individual animals in real time via dedicated websites.

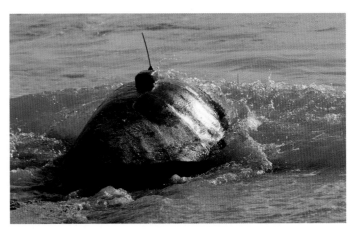

A Loggerhead Turtle (*Caretta caretta*) with a satellite tag glued onto its shell.

THE MARINE ENVIRONMENT

This section takes an outline look at the physical and chemical nature of the ocean and some of the ways in which this affects the marine life living there. Some understanding of this is useful in order to fully appreciate the way of life, distribution, migrations and other ecological aspects of marine organisms. For those who want to delve further, much more detailed information will be found in any good modern oceanography text.

The major oceans and seas of the world are shown below and whilst all the oceans are connected, each has its own particular physical characteristics which may impose constraints on its inhabitants. This is reflected in the species composition of the plankton, nekton and benthos found in each region. A partial exception may be the deep ocean where conditions are very similar throughout the world. The cold water coral *Lophelia pertusa* for example, is found in all the major ocean basins. In contrast, deepwater hydrothermal vents (p.112) support different communities of animals in the Atlantic Ocean than in the Pacific Ocean, possibly because these hotspots are so isolated from each other, which makes it difficult for species to disperse between them.

Of the physical and chemical constraints within the marine environment, light, temperature and availability of gases (especially oxygen and carbon dioxide) are factors that are equally as important to organisms on land as they are to those in the ocean. Pressure, salinity, density and viscosity have a much greater effect on aquatic organisms than on those living in air, whilst tides only directly affect marine organisms. Currents and waves have direct effects on aquatic organisms rather as wind does on land organisms, but they also have indirect effects. Currents, wind, temperature and air pressure all interact to create and modify climate and weather. So physical conditions in the ocean cannot be considered in isolation and the climate we experience on land is greatly affected by what happens at sea.

In the Arctic and Antarctic Oceans winter brings an extensive cover of sea ice which effectively isolates water from air. Even when a screaming blizzard rages above, the water below remains calm and the temperature stable. However, light penetration is severely reduced. The recent earlier and more extensive breakup of sea ice as a result of global warming is already affecting the distribution and abundance of polar marine life.

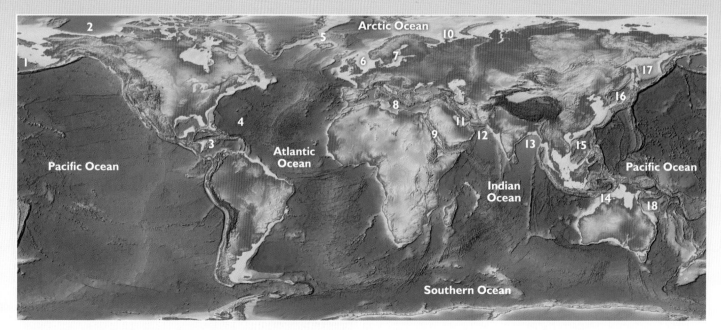

Major oceans and seas of the world. 1. Bering Sea; 2. Beaufort Sea; 3. Caribbean Sea; 4. Sargasso Sea; 5. Greenland Sea; 6. North Sea; 7. Baltic Sea; 8. Mediterranean Sea; 9. Red Sea; 10. Barents Sea; 11. Arabian Gulf; 12. Arabian Sea; 13. Bay of Bengal; 14. Timor Sea; 15. South China Sea; 16. Sea of Japan; 17. Sea of Okhotsk; 18. Coral Sea.

	Area (km²)	Average depth (m)	Max depth (m)	Max depth site
OCEANS				
Pacific	161,760,000	4,080	10,803	Mariana Trench
Atlantic	85,133,000	3,646	8,486	Puerto Rico Trench
Indian	70,560,000	3,741	7,906	Sunda (Java) Trench
Arctic	15,558,000	1,205	5,567	Eurasia Basin
Southern (Antarctic)	21,960,000	3,270	7,075	Sandwich Trench
SEAS				**Notes**
North (Greater)	750,000	95	700	Skagerrak
Baltic	386,000	55	449	Off Gotland
Mediterranean (inc. Black and Asov Seas)	2,967,000	1,480	5,139	Off Cape Matapan
Caribbean	2,750,000	2,200	7,685	Cayman Trench
Red	450,000	500	2,500	Central Trough
South China	3,700,00	1,419	5,016	West of Luzon, DK

Not surprisingly, ocean statistics vary according to their source. Area varies according to the exact ocean boundaries used by the calculating agency. In this table area and depths for oceans and for the Mediterranean are from the NOAA National Geophysical Data Centre (Eakins and Sharman 2010). Data for other seas are from various sources that do not refer to specific surveys and may be less reliable.

EL NIÑO

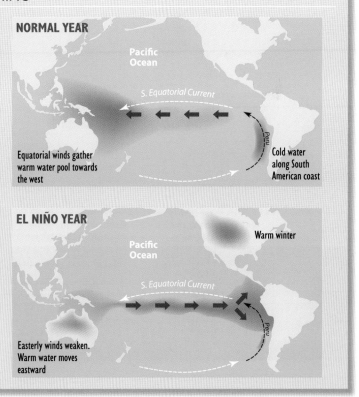

The close link between ocean conditions and climate is well illustrated by a phenomenon in the Pacific Ocean generally known just as El Niño but part of a much wider complex global weather pattern called the El Niño-Southern Oscillation (ENSO). During an El Niño event, the southeast trade winds which normally blow from east to west drawn across the ocean by low pressure systems in the West Pacific, weaken or even reverse as the low pressure systems themselves fail to develop normally. This allows a wedge of warm surface water, normally found in the western Pacific to extend eastwards right across to the west coast of South America.

In a strong El Niño year the effects can be dramatic. During the 1997–98 El Niño event, warm water reached the coast of Peru towards Christmas time (El Niño means 'Christ child' or 'little boy'). The warm water effectively blocked the cold upwelling currents that usually bring nutrients to the surface here at this time of year, allowing rich plankton populations to develop. Without the plankton the enormous shoals of anchoveta that are the basis of the fishing industry here failed to materialise with huge repercussions for the people and other animals dependent on them. At the same time the reversals in air pressure systems caused unseasonal heavy rainfall and disastrous flooding in Peru and conversely drought in northern Australia. Increased water temperatures both in the Pacific and Indian Oceans also caused widespread coral bleaching (p.27). In 1998 and 2004 large tracts of coral reef around the Maldives and the Chagos Islands in the Indian Ocean bleached and died due to elevated water temperatures brought about by a severe El Niño event.

Diagrammatic representation of warm surface water flow in a normal year and during an El Niño event. The most recent El Niño, classified as moderate, was 2009–10 (as at 2014).

THE MARINE ENVIRONMENT

LIGHT

Living on land we take light for granted. We can stand on top of a mountain or hill and view the landscape laid out below us stretching away for many miles. In the ocean, even in the clearest tropical waters, a diver would not expect to see for more than about 30m horizontally. This is primarily because seawater absorbs light to a much greater degree than air does. Additionally much of the sunlight striking the surface of the ocean never gets any further as it is reflected back into the atmosphere. The amount reflected depends on the angle at which the light rays strike the surface and this depends on time of day, season and latitude. The total daily radiation will therefore vary just as it does on land, with a fairly constant level at the Equator and greater seasonal variations as latitude increases towards the Poles, but the total radiation will always be considerably less than that available on land.

Sunlight is made up of different wavelengths of light, perceived by us as different colours and beautifully displayed in a rainbow formed when raindrops act as a prism and split the light. Red has the longest wavelength of visible light and colours at this end of the spectrum are absorbed by water first. Only 1% of red light penetrates to 10m depth even in the clearest water. Blue light penetrates the furthest even though violet has a slightly shorter wavelength. Therefore as a diver goes deeper he will see less and less colour until everything appears blue or very dark. This was confirmed by the author when she was bitten by a moray eel and trailed blue blood. The green colour of coastal waters results from the rich blooms of plankton and also sediment runoff from land.

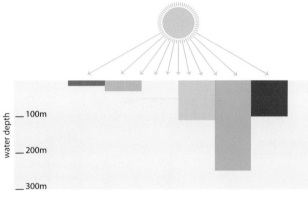

Colour	Approximate wavelength interval (nm)	Approximate maximum water depth penetration (m)
Red	700–635	15
Orange	635–590	30
Yellow	590–560	50
Green	560–490	110
Blue	490–450	250+
Violet	450–400	100

Although a rainbow is traditionally described as having seven colours, most scientists do not recognise indigo as a separate wavelength division but include it with violet.

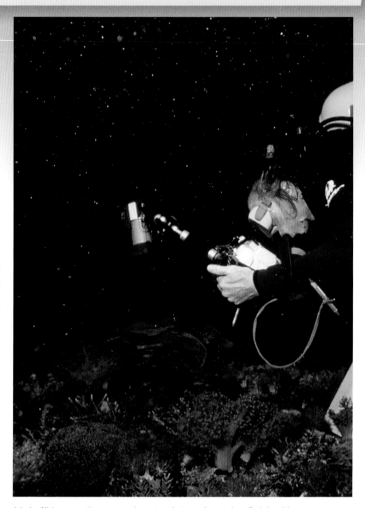

A lack of light means that most underwater photographs require a flash but this causes problems of backscatter from particles in the water.

The maximum depth to which any light penetrates depends on the amount of suspended material in the water including sediment and plankton. Particles in the water absorb, scatter and reflect light. Underwater photographers must adjust the angle and distance of their flashgun to minimise this effect. Below about 200m in the clearest waters, there is still enough light for vision but not enough for photosynthesis and by 1,000m even animals with specially adapted eyes far more visually sensitive than ours cannot detect any sunlight. There is light however in the form of bioluminescent organisms (p.66).

Light penetration can be measured using a simple device called a 'secchi disc'. This is a white disc 30cm in diameter that is lowered into the water to find the depth at which it just disappears. Results are usually expressed as the extinction coefficient determined from the empirical relationship $k = 1.45/d$ where d is the deepest depth at which the disc can be seen. Accurate measurements of the extinction coefficient use sophisticated electronic devices that project a beam of light into the water and measure the amount of light that bounces back.

Light is essential to life in the ocean just as it is on land. The difference is that only a tiny fraction of the ocean is within the euphotic zone where sufficient light penetrates to sustain photosynthesis and so allow plant growth and reproduction. Seaweeds and seagrasses, rooted to the seabed, can only live down to about 150m depth and usually considerably shallower, especially if the water is turbid as it often is in coastal areas. On a seamount off the Bahamas there are seaweeds growing at 268m depth but this is exceptional (Littler et al. 1985). In general red seaweeds (Rhodophyta) are able to live at deeper depths than green or brown seaweeds by virtue of additional photosynthetic pigments that make best use of the low levels of prevailing blue light. The biomass of seaweeds is nowhere near enough to sustain ocean ecosystems and the majority of photosynthetic organisms in the ocean are not fixed seaweeds but drifting microscopic phytoplankton (p.51). These can live over the entire ocean but they too are restricted to the euphotic zone in the top 200m or so of water.

LIGHT CAMOUFLAGE

Red flowers, insects, cars and matador's capes are easily seen on land and stand out from the crowd. In contrast a bright red soldierfish (above) living at depths where there is light but no red light, is well camouflaged as it will appear very dark or black. In the deep bathypelagic zone where no natural light penetrates, deep-water shrimps tend to be dark red because this colour will not reflect blue bioluminescent light produced by many predators. In the sunlit epipelagic zones this colour would be an invitation to dine and most shrimps and other drifting pelagic animals are more or less transparent and so effectively invisible to predators.

For us with our air-adapted eyes, confusion can arise. Divers are prone to telling 'fishermen's tales' exaggerating the size of the fish they have seen. Due to the refractive properties of water, a diver will perceive an object such as fish as being about a third bigger than it truly is. We are also blind to the ultraviolet and even polarised light that some animals including squid can see.

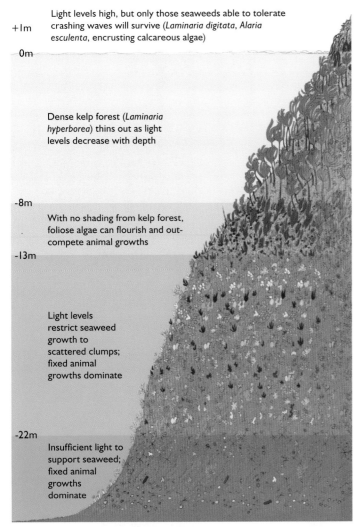

Zonation on a typical rocky coastline exposed to moderate wave action in the UK. Zonation on the shore largely reflects the ability of organisms to withstand exposure to air and to waves, but in the sublittoral decreasing light penetration controls the balance between seaweed and animal dominated zones (see also p.41).

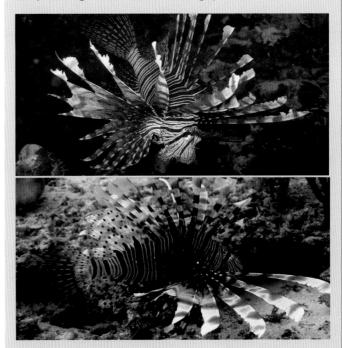

Lionfish (Pterois volitans) above with flashlight light, and below natural.

SALINITY

Anyone with any connection at all to the sea knows that seawater is too salty for humans to drink. Just how salty it is, is termed the salinity, a measure of the total concentration of inorganic dissolved substances it contains. Over 85% by weight of the salt is sodium chloride (see below). The average salt content of seawater in the open ocean is about 35 grams salt per kilogram of seawater usually written as 35‰ (thirty five parts per thousand) or as a percentage 3.5%.

Solutes in average seawater (3.5%)	Concentration in ‰	% of total salts
Chloride (Cl_2)	19.3	55
Sodium (Na^+)	10.7	30.6
Sulphate (SO_4^{2-})	2.7	7.7
Magnesium (Mg^{2+})	1.3	3.7
Calcium (Ca^{2+})	0.41	1.2
Potassium (K^+)	0.38	1.0
Bicarbonate (HCO_3)	0.14	0.4

The major constituents of seawater (after Stow 2004).

Instruments that measure salinity mostly measure conductivity and although salinity is often still quoted in parts per thousand, oceanographers worldwide have adopted a system devised in 1978 called the Practical Salinity Scale (PSS). This is the conductivity ratio of a seawater sample to an internationally accepted standard KCl (potassium chloride) solution. This equates fairly closely but not exactly with parts per thousand and as it is a ratio it has no units. Parts per thousand are used below as this system is probably familiar to more people.

The salinity of most open ocean water varies at different latitudes within the range 34–37‰ as a result of climatic conditions. Higher salinities are found at latitudes with low rainfall and high evaporation due to high air temperatures. These conditions are found in the Sargasso Sea in the North Atlantic and off the east coast of Brazil where average salinities are around 37‰. At high latitude in the Arctic the surface salinity is lower than average due to heavy rainfall, high land drainage and melting ice, and varies between about 28 and 33‰.

Enclosed areas show greater variations from the average. The Baltic Sea is shallow and almost entirely enclosed and is the largest area of brackish water in the world. The low salinity of between 29‰ near the entrance and 5‰ in the north is due to a high input of freshwater from rivers and land drainage, and little exchange of saltwater with the North Sea. The extremely high temperatures and low rainfall of the Persian Gulf and Red Sea result in surface salinities that sometimes exceed 40‰.

Regardless of the surface salinity, that of the deep ocean below about 1,000m remains stable at 34.5–35‰.

The majority of marine organisms are adapted to living in full strength seawater and can only live within a narrow range of salinities. These stenohaline species will die if the salinity drops below about 30‰. Aquatic animals are liable to lose or gain water and ions (salts) through diffusion and osmosis. Osmosis (p.318) is the tendency of water to move from a solution with low salt concentration (such as the body fluids of a marine teleost fish) to one of high salt concentration (such as seawater). Any deviation from the normal concentration of salts in tissues and body fluids of animals can prove stressful or fatal.

LOCH OBISARY

A halocline occurs where the salinity changes relatively rapidly at a certain depth. In the wilds of the Outer Hebrides in Scotland, divers can experience a halocline (and thermocline) at first hand in Loch Obisary, a sheltered sea loch and a National Nature Reserve. Around 3m down the clear peat-coloured water swirls where saltwater mingles with fresh, like water added to whisky, but by 4m it clears again. Saltwater pours into the loch through a single narrow entrance only at extreme high tides and as saltwater is heavier than freshwater it sinks to the bottom. Freshwater flows into the loch from the surrounding boggy land. Measurements show a salinity of around 14‰ in the first 4m increasing to 28‰ below this. The edges of the loch support essentially freshwater plants and invertebrates whilst marine seasquirts, starfish and seaweeds cover the loch floor (Mitchell et al. 1980).

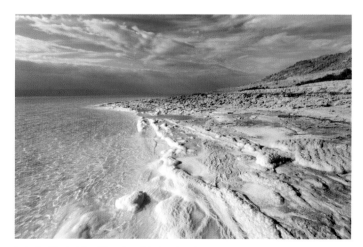

In the land-locked Dead Sea, the salinity is so high that salt is deposited along the shoreline. Some tide pools along hot desert coasts can also become extremely salty through evaporation.

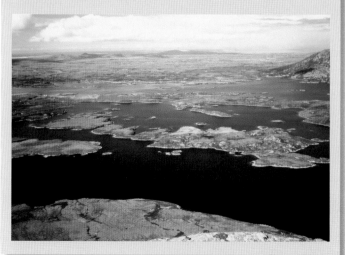

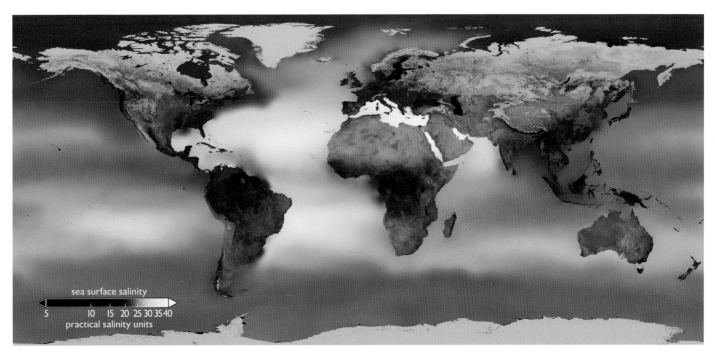

Approximate average ocean salinities worldwide.

Most marine invertebrates have blood that in terms of salt content is very similar in overall concentration and composition to seawater. So whilst the majority are unable to change this, they do not have a problem as long as they remain in full-strength seawater. However, those living in the brackish water of estuaries and similar areas will gain water by osmosis and lose ions by diffusion. To combat this, such invertebrates tend to be more 'waterproof' with less permeable skin than their close relatives in the open sea. However, their main defence is simply that they can tolerate dilution because they have developed physiological mechanisms to protect their cells from damage. Such species are called euryhaline and include Blue Mussels *Mytilus edulis* which are found in water with salinities ranging from 35‰ to 5‰, though they only attain a very small size in the very low salinities (see below). They and other bivalves can also close their shell if the salinity changes abruptly as the tide flows in or out, and this gives time for them to adjust.

A large volume of research exists into the numbers and distribution of euryhaline species in estuaries, some examples of which are given in Little 2000. These studies show a significantly lower number of species living in brackish areas compared to similar fully marine habitats nearby. However, those that do live there have less competition and whilst biodiversity may be lower, biomass is often high. The tiny NE Atlantic snail *Hydrobia ulvae* on which shelduck and other marine birds feed, has been found on estuarine mudflats at densities of many thousands per square metre. Salinity also appears to affect size. Mussels *Mytilus* spp. and cockles *Cerastoderma* spp. in the Baltic get progressively smaller as salinity decreases away from the entrance into the North Sea. However, other factors such as food supply probably also play a part.

In contrast to most marine invertebrates, fish and other marine vertebrates can osmoregulate, that is maintain their blood concentrations at ideal levels. Their blood salt concentrations are much less than seawater, equivalent to between a quarter and a half its strength. So, marine fish will tend to lose water through osmosis and replace it by drinking seawater. Normal salt and water balance in all vertebrates is carried out by the kidneys but fish and other marine vertebrates need additional physiological adaptations to get rid of the extra salts that they ingest. Marine bony fish pump salt out through specialised cells in their gills whilst sharks and other elasmobranchs retain urea in the blood such that their body fluids are almost isosmotic with seawater (p.318). Andromadous fish, such as salmon and eels that migrate from seawater to freshwater, face particular challenges. Marine reptiles and birds have special salt glands for excreting salt (pp.403 and 462).

Humans have none of these adaptations and cannot drink seawater. Our kidneys can only produce relatively dilute urine with less salt in it than seawater. So, to get rid of the excess salt a person would need to pass more water in the form of urine than they had drunk in the first place, and so would gradually dehydrate.

Desalination plants in arid areas such as coral atoll islands may change the salinity regime in a local area unless the outlets, which release high salinity water, are carefully positioned.

DENSITY AND VISCOSITY

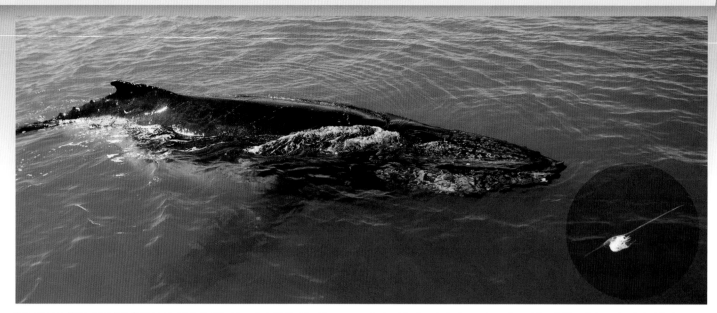

Seawater provides support both for the immense bulk of the Humpback Whale (*Megaptera novaeangliae*) and the tiny plantonic zoea larva of a crab (inset). The whale must swim but the larva floats easily thanks to its expanded shape, totally different from its bottom-living adult form.

The density of seawater depends on its temperature and salinity. An increase in salinity or a decrease in temperature will make saltwater denser and heavier and it will sink. So, water at the bottom of the ocean will always be cold, saline and dense. The slow, large scale circulation of water between the surface and deep water and between oceans, sometimes called the 'global conveyor belt' (p.29) is largely dependent on the rising and sinking of seawater caused by processes that change its density. A vital aspect of this is the formation and sinking of large amounts of cold and salty water in the Arctic and Antarctic fringes. Water carried by surface currents towards these regions is cooled and becomes more saline through ice formation.

The density of seawater has a direct effect on marine organisms through the support it provides. Convenience apart, it should be very much easier to learn to swim in the sea than in freshwater. Highly saline water such as that found in the Dead Sea is so dense a person can float and even read a newspaper without buoyancy aids or swimming. This is an extreme and very little can survive in this hypersaline water but normal seawater is sufficiently dense to support the Blue Whale (*Balaenoptera musculus*), the largest animal in the world. No dinosaur ever reached this size and without the support of seawater no animal ever could. Scuba divers will notice the effects of density in the greater amount of weight they will need when diving in seawater than in freshwater.

Seaweeds also benefit. Giant Kelp (*Macrocystis pyrifera*) grows up to 45m long, reaching up from the seabed to the sunlit surface waters, yet its stem is less than the thickness of a human wrist. In contrast a rainforest tree of similar height needs a trunk several metres in girth to hold it upright. The kelp can therefore divert much more of its energy to growth and reproduction, and can grow at a rate of about 36cm a day. It may also have air bladders to help it remain upright.

At the microscopic level, the small size of plankton, especially phytoplankton, reduces its sinking speed. A small plankton animal such as a copepod experiences water in a very different way to us. For them, seawater is a much more viscous environment than it is to a larger animal such as a fish or person, perhaps equivalent to something like treacle. Their tiny size means that viscous flow dominates the interaction between them (or any small particle) and the surrounding fluid, whilst inertia is unimportant. The relative importance of inertial forces to viscous forces is often expressed as a dimensionless number called Reynold's number. So the very small size of plankton helps prevent them sinking without having to expend energy on swimming. However, many plant and animal plankton species also have features such as spines that increase their surface area and hence friction through the water.

The seaweeds in this tidal pool can continue photosynthesis buoyed up by the water. Those on the rocks above have limited ability to do so whilst the tide is out.

THE PHYSICAL OCEAN

WATER PRESSURE

Water is a very heavy material and as such it exerts a pressure on any object submerged in it. Pressure is usually measured in water as 'bars' (Appendix II). One bar is roughly equivalent to the atmospheric pressure at sea level. Underwater the pressure increases by approximately one bar for every 10m depth (actually 1 bar every 10.19716m). So, for example, the pressure at the surface is 1 bar, at 30m depth it is 4 bars, at 300m it is 31 bars and at 3,000m it is 301 bars. An easy way to calculate the pressure at any depth is to move the decimal point one place to the left (i.e. divide by 10) and add one e.g.

Depth: 3048.00m
Pressure: 304.80 +1 = 305.8 bars

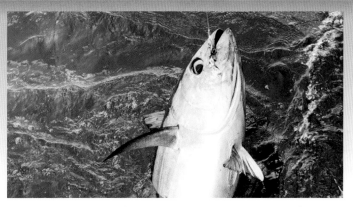

This Bluefin Tuna (*Thunnus thynnus*) caught in shallow water, would probably survive if released. Fish hauled up from deep water rarely do, as a result of the sudden decrease in pressure.

Fish and other animals live even in the deepest parts of the ocean, where pressures are immense. Deepsea animals are not crushed by the pressure because, like most living creatures, they consist primarily of water and their tissues are therefore incompressible by water. However, any animals with air- or gas-filled spaces will be affected by pressure. This includes air-breathing marine mammals, birds and reptiles as well as those bony fish and cephalopods that use gas-filled structures to provide buoyancy.

The air in the lungs of a diving mammal such as a whale will be compressed as the animal dives deeper and pressure increases. This is because pressure and volume are inversely proportional to one another (Boyle's law). This means that if the pressure doubles, the volume of a fixed amount of gas is halved. So, if a whale dives to 10m depth (2 bar pressure) the volume of air in its lungs will be halved. When it reaches 30m depth (4 bars pressure) the volume of air in its lungs will be a quarter of that at the surface. It will be obvious from this that if, for instance, a Sperm Whale dives to 1,000m its lungs will effectively collapse. In humans a collapsed lung is a serious condition but diving mammals have physiological and morphological adaptations to overcome this and other pressure-induced problems such as 'the Bends' (p.419). A scuba diver breathing compressed air risks burst or damaged lungs if he holds his breath when surfacing and a burst ear drum if he does not equalise the pressure between inner and outer ear, particularly whilst descending.

The relationship between gas volume and pressure is important for bony fish with a gas-filled swimbladder (p.360). The swimbladder provides buoyancy and allows the fish to hover without expending much energy. However, if the fish significantly changes its depth it must adjust the amount of gas in order to remain neutrally buoyant. This is especially important in fish that regularly make vertical migrations to and from the surface. Deepwater fish can easily swim within a large vertical range because pressure changes at depth are proportionally smaller per metre than near the surface. A fish swimming from 500m to 1,000m only experiences a doubling of pressure from 51 to 101 bars whereas one swimming from 0m to 100m experiences a ten-fold increase from 1 bar to 11 bars. Fish caught at depth and hauled rapidly to the surface may even have their gut protruding from their mouth because their swimbladder has expanded with the reduction in pressure and displaced the gut.

In very deep water, such as in oceanic trenches, the pressure is so high that it can inhibit the normal functioning of proteins. Deepsea animals have evolved various ways around this including proteins that can function effectively under high pressure. However, other pressure-sensitive proteins in deepsea animals appear to be protected by high levels of nitrogenous compounds such as trimethylamine N-oxide (TMAO) which act as protein stabilisers. For example, levels of TMAO are higher in deepsea skates than in their shallow-water counterparts (Yancey 2005).

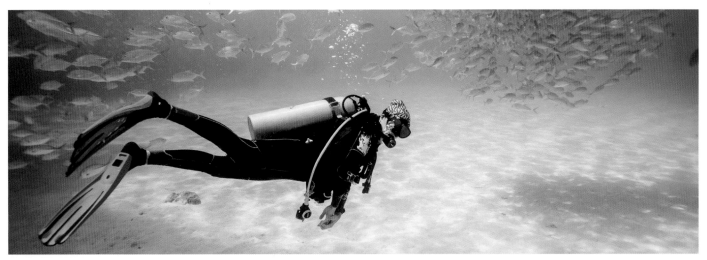

Both diver and fish hover effortlessly, adjusting their buoyancy to suit the depth (pressure) by moving gas in and out of a swimbladder in the fish and a buoyancy control device (BCD) worn by the diver.

DISSOLVED GASES AND ACIDITY (pH)

The most abundant gases in the ocean are the same as those in air, namely nitrogen, oxygen and carbon dioxide, but they are not found in the same proportions (see table). Notably there are much higher levels of carbon dioxide in the ocean. Oxygen and carbon dioxide are used or produced by living organisms in respiration and photosynthesis, and levels vary accordingly. Oxygen levels are highest in the top 100m or so, where it is absorbed from the air and produced by photosynthetic organisms. Levels decrease steadily below this as it is used in respiration and in the bacterial decomposition of dead remains. Interestingly, the lowest levels are not found in the deep ocean but at around 700–1000m depth and there is a slight increase below this. Such oxygen minimum layers are present in most of the world's oceans. These layers are by no means devoid of life but pelagic animals living there must have special respiratory adaptations that allow them to make full use of what little oxygen is present.

Exactly why oxygen minimum layers exist is complex and results from a number of processes. Organic debris may collect and decay at these levels as a result of changes in water density, so using up oxygen. Below this there are fewer animals and less organic matter, so less oxygen is used up. Oxygen reaches the depths through gradual sinking of surface water and deep ocean currents.

Carbon dioxide levels are lowest in the surface 100m because, although it is absorbed into the water from the air, it is used up by photosynthetic organisms at a faster rate than it is produced by respiration. Below the photosynthetic zone, carbon dioxide is continually produced by respiration and decomposition.

Dissolved carbon dioxide plays an extremely important part in maintaining the pH of the ocean. Carbon dioxide reacts with water to form carbonic acid, and the dissociation of this acid into its constituent ions forms a buffering system that prevents sudden changes in pH. The average pH or acidity of seawater is about 7.8 with a range between 7.5 and 8.5. It is therefore very slightly basic (alkaline) as pure water has a pH of 7 and is neutral. Values from 1 to 6.99 are acidic and values from 7.01 to 14 are alkaline. What is actually being measured on this scale is, in very simple terms, the concentration of hydrogen ions:

- Carbon dioxide reacts with water to form carbonic acid:

 $CO_2 + H_2O \rightleftharpoons H_2CO_3$ (carbonic acid)

- In solution in seawater the carbonic acid partially dissociates into ions:

 $H_2CO_3 \rightleftharpoons HCO_3^- + H^+$ then $HCO_3^- \rightleftharpoons CO_3^{2-} + 2H^+$

 (HCO_3^- is the hydrogen carbonate ion; CO_3^{2-} is the carbonate ion)

- If acid is added which increases the number of H^+ ions present then the reaction will shift to use up the excess ions and maintain the pH.

Levels of oxygen and other dissolved gases also vary with latitude because gases are more soluble in cold water than in warm water. About twice as much oxygen (8ml/l) can dissolve in cold Arctic water at 0°C than in tropical water at 30°C (4.3ml/l). An increase in pressure also increases the solubility of gases, an attribute well understood by manufacturers of fizzy drinks and by divers. A diver will absorb increasing amounts of nitrogen into the bloodstream the deeper he goes and the longer he stays. A calculated rate of ascent (using a dive computer or tables) will prevent bubbles forming in his blood, as happens to carbonated (pressurised) drinks when the lid is taken off.

Gas	Atmosphere (% by volume)	Ocean surface water (% by volume) at 20°C & salinity 36‰	Whole ocean (% by volume)	Max. solubility in ocean surface water at 0°C ml/l
Nitrogen (N_2)	78.08	48	11	14.0
Oxygen (O_2)	20.99	36	6	8.0
Carbon dioxide (CO_2)	0.03	15	83	0.47
Other	0.90	1		

Typical percentage of gases in air and ocean (various sources).

In sheltered estuaries and sea lochs, wave action is minimal and little oxygen can penetrate the mud, resulting in smelly black sub-surface layers.

Factors increasing solubility of gases	Factors increasing O_2 and decreasing CO_2	Factors increasing CO_2 and decreasing O_2
Turbulence from waves and currents	Photosynthesis	Respiration
A drop in temperature		Decomposition
A drop in salinity		
An increase in pressure		

Factors affecting the solubility and concentration of gases in the ocean.

OCEAN ACIDIFICATION

Since the beginning of the Industrial Revolution 250 years ago, the level of CO_2 in the atmosphere has risen steadily; it stood at just over 390ppm in 2012 and is expected to exceed 500ppm by 2050 to 2100. Accurate measurements have been made by NOAA at the Mauna Loa Observatory, Hawaii since 1958 when the level was just over 310ppm. Much of this additional CO_2, produced from burning fossil fuels and from land use changes (such as peat extraction), is absorbed into the ocean where it forms carbonic acid. This has led to an average increase in seawater acidity of about 30% and it is predicted to rise much higher if levels of atmospheric CO_2 continue to increase. As a reduction in temperature increases the solubility of gases in seawater, cold polar water in the Arctic and Antarctic Oceans absorbs more carbon dioxide than warmer regions. It is in these areas that ocean acidification is most obvious and increases in acidification continue to be measured in polar regions. Deep ocean water is naturally more acidic because CO_2 is more soluble at low temperatures and high pressures. Below 4,000–5,000m calcium carbonate dissolves as quickly as it arrives (carbonate compensation depth) and organisms with calcium carbonate skeletons cannot survive. This also results in a lack of 'calcareous oozes' – sea floor sediments made of calcium carbonate principally in the form of foraminiferan shells – below this depth.

Innumerable marine organisms including molluscs, corals, echinoderms, calcareous algae and foraminifera have shells or skeletons made of calcium carbonate and are adapted to living within the normal slightly basic (alkaline) seawater pH range. On land the effects of so-called 'acid rain' on our own urban environment can easily be seen in the erosion of statues and buildings made of limestone. Acids chemically attack and break down calcium carbonate.

A multitude of experiments exposing key shelled organisms to the levels of dissolved CO_2 predicted for future decades have shown serious erosion of their shells, effects on their ability to build and maintain their shells in the first place, and on survival rates of their larvae (e.g. in polar planktonic organisms: Comeau et al. 2009; Orr et al. 2005). In the field Moy et al. (2009) have demonstrated reduced calcification in modern Southern Ocean foraminifera (p.154) compared to fossil species preserved in sediments. Studies of corals in the Great Barrier Reef, Australia, have shown reductions in their rate of calcification which is likely to be a response both to ocean acidification and to ocean warming (De'Ath et al. 2009).

Ocean acidification is now recognised worldwide as a significant threat to many key species and groups of calcifying organisms, with the potential to alter foodwebs, affect whole ecosystems and reduce biodiversity (Royal Society 2005).

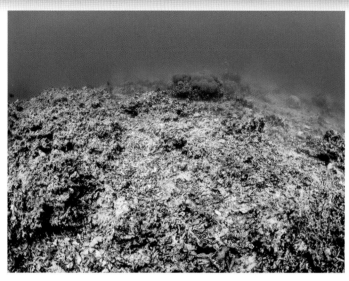

Ocean acidification is yet another factor that may affect the survival of coral reefs although it was not the cause of the devastation shown here.

DEAD ZONES

The deep ocean in open water generally receives sufficient oxygen to support life (plenty of it), but deep-water basins in semi-enclosed seas can be completely devoid of oxygen. This is usually a result of the topography and local climate. The Black Sea has very little water exchange with the Mediterranean and many freshwater rivers feed into it. Lighter low salinity water warmed by summer temperatures forms a layer over higher salinity cooler water beneath. The sharp density gradient caused by the salinity and temperature differences isolates the water below about 100–150m. Decaying organic matter sinking down from above uses up all the oxygen and the whole system is almost devoid of life. Dead zones are also found in the eastern Mediterranean and the Gulf of California and there is concern that increasing ocean temperature is leading to an increase in the extent of such zones. Temporary and seasonal dead zones can result from massive algal blooms, often known as 'red tides' in nutrient-enriched coastal water warmed by the sun. As the plankton dies and decomposes it uses up the available oxygen, killing both fish and invertebrates. The incidence and extent of dead zones worldwide appears to have increased since the 1970s, when they were first observed. Over 400 such zones were counted in 2008 (Diaz and Rosenberg, 2008). Fertiliser carried in the outflow from the Mississippi river is probably the cause of a dead zone covering over 22,000 sq km in the Gulf of Mexico.

The deep parts of the Black Sea form the world's largest marine system devoid of oxygen.

SEA TEMPERATURE

Water temperature affects almost every aspect of the marine environment including the density of seawater (p.22), which in turn drives the vital deepwater circulation of the ocean (p.29), and it also affects the solubility of gases such as oxygen and carbon dioxide (p.24). Water temperature plays a significant part in modifying the climate of coastal land masses. Water has a high heat carrying capacity and around the UK, for instance, the surrounding ocean acts like a warm blanket especially in winter. This is also why hot water bottles are so effective. Ocean currents carry huge amounts of heat energy around the world. For example, the Gulf Stream flowing across to the UK from subtropical areas around the Gulf of Mexico results in relatively warm winters in London as compared to Moscow at a similar latitude (see below).

City	Latitude	Average temperature (°C) Dec–Feb (BBC)
UK		3.7°C
London, UK	51° 32' N	2.7°C
Birmingham, UK	52° 25' N	2.3°C
Berlin, Germany	52° 20' N	-2.3°C
Moscow, Russia	55° 45' N	-13.3°C

Average winter temperatures in two cities in the UK compared to mainland European cities at a similar latitude.

The high specific heat capacity (SHC) of seawater, and the large volume and surface area of the ocean mean that ocean water heats up and cools down slowly resulting in stable ocean temperatures. Consequently, most marine organisms are adapted to live and thrive within a relatively narrow temperature band. On a daily basis the average temperature fluctuation is generally less than 2°C within a 24-hour period. The exception to this is in the intertidal region where organisms may experience large temperate (and also salinity and pH) fluctuations every time the tide goes in and out. On the United Arab Emirates coast of the Arabian Gulf, for example, the surface water in summer averages around 28°C but temperatures on the shore can reach 45°C.

	Temp. °C	Date recorded	Place recorded
LAND: coldest	-89.2	21 July 1983	Vostock, Antarctica
LAND: hottest	57.8	13 Sept. 1922	El Azizia, Libya
LAND: range	147		
OCEAN surface: coldest	-2		Arctic and Antarctic
OCEAN surface: warmest	36		Arabian Gulf
OCEAN: range	38		

Temperature extremes and ranges on land and in the ocean.

Ghost crabs survive temperatures exceeding 35°C on this beach in Oman by retreating into deep burrows when the tide is out.

Intertidal plants and animals are adapted physiologically to cope with these extremes, but compared to land even this variation is relatively small. With the exception of the water adjacent to hydrothermal vents, the temperature range within the ocean is far less than that on land.

BIOGEOGRAPHICAL DISTRIBUTION

Although many factors affect the distribution of marine species, water temperature is perhaps the most important single factor in determining their biogeographical distribution. This is often obvious even on a relatively local scale. For example, the red seaweed *Odonthalia dentata* is a cold-adapted species common around Norway but in and around the UK is restricted to Scotland and the northern parts of England and Northern Ireland. In contrast, Peacock's Tail (*Padina pavonica*) only occurs along the southern coasts of England and Ireland but is abundant throughout the Mediterranean.

Around the UK a number of fish species are recognised as summer visitors from the warmer waters further south. For example, in most years the Atlantic Pomphret or Ray's Bream (*Brama brama*) is an occasional visitor to British waters. However, in warmer years large numbers sweep north moving up to Scotland and Norway and down into the North Sea. The detailed movements of this migratory oceanic species appear to be dependent on water temperature. In autumn and winter dead fish are often found along the shores of East Anglia, trapped and weakened by cold water during their return south.

SPECIFIC HEAT CAPACITY (SHC)

The SHC of a substance is a measure of the energy (joules) required to raise the temperature of one gram of it by 1°C. Seawater has a very high SHC (3.93) which means it can absorb (and later release) large amounts of heat energy with only a small change in its temperature. For comparison, olive oil has a SHC of 1.97. When water is heated, for example by solar energy from the sun, the heat energy is mostly used to break hydrogen bonds between water molecules. Only a small part is used to increase the agitation or vibration of the molecules, detected as a rise in temperature.

Biogeographical zone	Average temperature	Area	Example species (fish)
Polar (south)	-1.9°C to +2.0°C	Southern Ocean	Blackfin Icefish (*Chaenocephalus aceratus*)
Polar (north)	-1.9°C to +5.0°C	Arctic waters	Arctic Charr (*Salvelinus alpinus*) (anadromous)
Cold temperate (south)	2.0°C to 10.0°C	Southern hemisphere	Patagonian Toothfish (*Dissotichus eleginoides*)
Cold temperate (north)	5.0°C to 10.0°C	Northern hemisphere	Atlantic Cod (*Gadus morhua*)
Warm temperate	10.0°C to 15°C	Both hemispheres	Big-belly Seahorse (*Hippocampus abdominalis*)
Subtropical	15.0°C to 25°C	Both hemispheres	Queen Angelfish (*Holacanthus ciliaris*)
Tropical	25°C or greater	Both hemispheres	Lionfish (*Pterois volitans*)

Major biogeographical ocean zones.

Whilst some marine species are able to extend their range on a seasonal basis, the test of a true range extension is when the animal breeds further north or south than it has ever done previously. Most species can only reproduce within a much narrower temperature band than the adult can withstand. The Grey Triggerfish (*Balistes capriscus*) has a wide distribution across the North Atlantic, mostly south of the British Isles. It is a regular summer visitor to southern Britain and has been observed by divers for many years. In recent years divers have reported seeing fish in the English Channel in early spring and there are also some reports of young fish – too small to have swum there – which suggests this species may now be breeding in British waters. There are now considerable data documenting seasonal and year-round changes in distribution of marine species linked to the increasing water temperatures associated with global warming.

Animals living in habitats with extreme temperatures, such as the coastal waters of the Arctic and Antarctic and around hydrothermal vents, have evolved special adaptations. The Blackfin Icefish (*Chaenocephalus aceratus*) has a natural antifreeze protein in its blood which prevents freezing in Antarctic waters that can reach -2°C. The mechanism has been explored in Arctic fish where the protein appears to slow down bond formation between water molecules, so preventing ice crystal formation (Ebbinghaus et al. 2010). The Blackfin Icefish also has no red blood cells which might impede the flow of blood under such low temperatures, but can absorb extra oxygen from these naturally oxygen-rich waters through its skin. In contrast, the aptly named Pompeii Worm (*Alvinella pompejana*) lives in tubes on hydrothermal vent chimneys where, as long as they keep their heads facing out into cooler water, they can survive temperatures up to about 80°C. A thick covering of bacteria may help to insulate them from the heat – some bacteria are known to be able to withstand extremely high temperatures.

Benthic, sessile animals that cannot move are particularly susceptible to unusual increases in water temperature. Reef-building stony corals, for example, can suffer severe bleaching. Under stress the corals eject the coloured symbiotic zooxanthellae from their cells with the result that their white skeleton shows through and they appear 'bleached'. The corals can survive for some time but ultimately die of starvation as they rely on their zooxanthellae for a large part of their nutrition. In the long term they cannot catch sufficient food to sustain their growth and reproduction.

On the global scale animal and plant distributions are often described in terms of wide biogeographical zones based on average surface ocean temperatures. Various classifications and subdivisions are in use but the principal zones are shown in the table above.

THERMOCLINES

Whilst surface ocean temperatures worldwide can vary by more than 30°C from the coldest to the warmest, the temperature of the deep ocean everywhere remains remarkably constant at about 4°C. Thus, warm tropical and temperate ocean areas have a layered structure where lighter warmer water floats above cold, dense water. Rather than a gradual decrease in temperature there is a relatively sharp transition from warm to cold between about 200m and 1,000m depth. This permanent layer of rapid temperature change is called a thermocline. In cold, rough polar seas there is no thermocline and very little variation in temperature between surface and deep water.

In mid latitudes (e.g. North Atlantic around Europe and the USA) a temporary summer thermocline often develops in the first 100m of water as the sun warms the surface layers. This disappears in autumn with the onslaught of stormy weather, and the consequent water mixing brings deeper nutrients within reach of the phytoplankton in the surface layers, resulting in a plankton bloom. This is smaller than the spring plankton bloom that results from increasing temperatures. Once the summer thermocline has developed, the plankton above it gradually uses up the available nutrients.

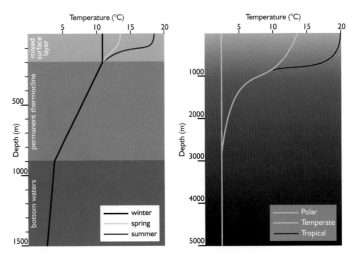

Typical ocean temperature profiles. Left: a generalised temperature profile for temperate latitudes. Right: profiles for the open oceans in different regions.

SEA TEMPERATURE

OCEAN CURRENTS

Water in the ocean is constantly on the move both within ocean basins and throughout the global ocean. If this were not the case then there would be little life in the ocean, especially in the deeps and even the amount and distribution of life on land would be different. Ocean currents carry plankton, the ocean's essential primary producers and the basis of ocean food webs (p.46); they transport warmth from tropical areas towards the poles; they bring nutrients up from the depths and they provide a free ride for migrating fish, sharks, turtles and whales. Strong local currents resulting from tidal movements are described on pp.30–31.

SURFACE CURRENTS

Ocean travellers are likely to be most aware of surface currents. Just as jet stream winds high in the atmosphere can significantly reduce or increase journey time for airline passengers, so can ocean currents for cruise liners, freight ships and pleasure craft. The main driving force behind surface currents is the wind and in turn the pattern of prevailing global winds results from the combined effects of solar heat and the Earth's rotation. Although wind provides the engine that drives surface currents, the water is not simply dragged with the wind but, instead, the current direction is also influenced by the Earth's rotation – the Coriolis Effect – and pressure differences created as water piles up into 'mounds' within the gyres (see below). The sea surface about 1,000km off eastern North America is about 1m higher than at the North American and African coasts (actually higher, not just as a result of wave height).

CORIOLIS AND EKMAN SPIRAL

If you were able to observe a cut-away view of the movement of one of the great ocean currents, you would not see a linear forward rush like a river but instead a spiralling flow pattern of the different water layers called the Ekman Spiral and a net movement of water at right angles to the wind direction (Ekman Transport). The drag effect of the wind lessens with depth and so the lower water layers in the current move more slowly and are increasingly deflected by the Coriolis Effect.

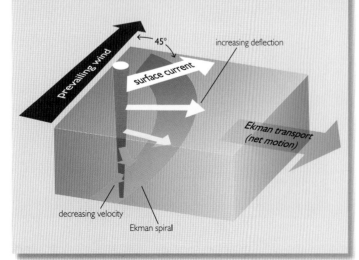

After mating in the western North Atlantic many female Blue Sharks (*Prionace glauca*) ride the Gulf Stream as they migrate eastward to have their pups in traditional areas off southern Europe. They make the return journey with the help of major current systems such as the southward flowing Canary current and westward flowing North Equatorial current.

The end result is a system of *gyres* which are large scale circular water movements in each of the main ocean basins. The gyres in the North Atlantic, North Pacific and Indian Oceans run clockwise whilst the gyres in the South Atlantic and South Pacific run anti-clockwise. Each gyre is made up of several differently named currents and is asymmetric with much stronger, narrower currents running along the western side of the North Atlantic and of the North Pacific as the well-known Gulf Stream and Kuroshio currents respectively. This is not so obvious in the Indian Ocean which experiences seasonal variation associated with the monsoon. In the Southern Ocean, westerly winds drive water continuously clockwise around the Antarctic between latitudes 45° and 60° south, as the Antarctic Circumpolar Current or West Wind Drift. The surface currents shown opposite are well-known but their actual position, width and strength varies considerably. Diagrams and pilot charts used by shipping are based on averages of data collected over considerable time periods. Many records, especially early ones, come from ships which log their calculated and actual positions. Modern fixed current meters and drift buoys collect data and transfer it via satellites.

Within the main ocean gyres there are calm areas with very little surface water circulation. Perhaps the best known of these is in the Sargasso Sea in the North Atlantic near Bermuda. Here it is so calm that a live community of Sargassum seaweed floats permanently (p.61).

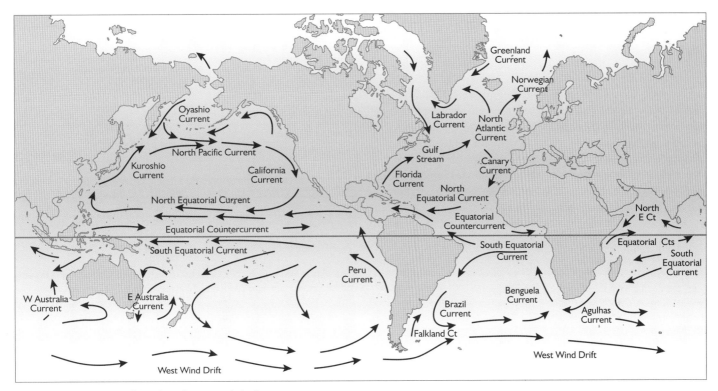

Names and average directions of the major surface currents in the Oceans.

SUBSURFACE CURRENTS

Ocean circulation is not restricted to surface currents and there is a continuous deep, slow movement of water throughout and between ocean basins. This is obviously not driven directly by wind and results instead from the rising and sinking of water masses with different densities. The density of seawater (p.22) in turn depends on its temperature and salinity. This massive deep-water circulation, known as the Global Thermohaline Conveyor Belt or often just the Global Conveyor, is extremely slow and cannot be measured by conventional means. Instead it is inferred from collecting seawater samples from the deep oceans and analysing their chemical composition to find their probable origin. It should not be thought of as a current as such but as water movement associated with a balancing of temperature and salinity between different areas and depths. High air temperatures in the tropics result in a net gain of heat into surface water with heat being transferred down to around 1,000m. This warm surface and intermediate water is slowly drawn towards the North Atlantic which experiences a net loss of heat to the atmosphere. Warm water moves from the Pacific and Indian Oceans into the South Atlantic and then into the North Atlantic.

Very cold winter temperatures in the northern North Atlantic cool the water, thus increasing its density and creating a mass of water which sinks (downwelling) and moves south through the deep Atlantic. Similarly dense, cold water forms and sinks in the Antarctic and the whole mass flows past and around Antarctica at depth and then moves north into the Pacific and Indian Oceans. Antarctic bottom water can be detected well into the northern part of the North Pacific. Diffuse upwelling (p.52) draws water up to mix with surface waters in the Indian and Pacific Oceans. The upper layers of warm surface water from the Pacific are usually shown moving west past Indonesia and northern Australia but this is certainly an over-simplification. Data suggest that the Global Conveyor may take around 1,000 years to circle between the oceans.

During the 1990s considerable data on ocean temperature, salinity and currents was collected as part of a worldwide collaborative research project. The World Ocean Circulation experiment (WOCE) developed new data collection methods and deployed thousands of subsurface floats, surface drifters, moored current meter arrays and other techniques (Siedler et al. 2001, WOCE 2003). Today Autonomous Underwater Vehicles (AUVs) are being developed that will be able to roam the oceans on a long term basis and collect much more data. Data collectors attached to elephant seals which can dive to depths of at least 1,800m with data recovery via satellite are yielding results.

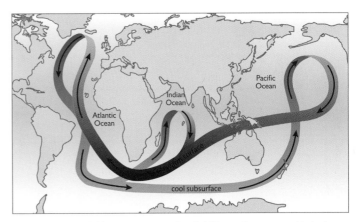

The 'global conveyor belt' current system couples wind driven surface currents with density driven deeper currents. The immensely slow flow patterns are still not fully understood.

TIDES

Anyone who wants to walk, explore, research, fish or sail around any coast in the world needs to know and understand tides, or risk inconvenience at the least and drowning at worst. Tides are the daily rise and fall in sea level that result from the gravitational pull of the moon with some influence from the sun. The gravitational pull of the moon causes the ocean to bulge towards it resulting in high tides. As the Earth spins on its axis different parts of the ocean pass under the influence of the moon and so, as the Earth takes 24 hours to rotate, this ought to result in one high tide per day. However, most parts of the world experience two high tides a day (semidiurnal). This is because the Earth's spin creates a centrifugal or inertial force resulting in a second bulge of water on the side facing away from the moon.

Place	Mean spring tidal range metres	Tidal frequency
Mediterranean	<0.3	No appreciable tide
Fremantle, W Australia	0.8	Diurnal
Galveston Bay, Texas	0.5	Diurnal
Portland, UK	2	Double low
Boston, USA	3	Semidiurnal
St Malo, France	10.7	Semidiurnal
Avonmouth, Bristol Channel, UK	12.2	Semidiurnal
Bay of Fundy, Minas Basin, Canada	16	Semidiurnal

Examples of tidal range and frequency around the world.

Although a semidiurnal pattern of tides is the most common, it is not the only one. Land masses interact with the tidal bulges and local topography can also modify tides. In a few parts of the world such as the Gulf of Mexico, and parts of SE Asia and SW Australia, there is only one high and one low tide a day (diurnal). In many areas with semidiurnal tides the heights of the two high tides and two low tides in any one day are very unequal (mixed semidiurnal). There are also local anomalies such as the double low tide at Portland in southern England where low tide is followed by a slight rise and subsequent dip before moving towards high tide.

The tidal range is the difference in height between high and low tide and this varies greatly in different parts of the world (see table above). There is also variation in the tidal range on a monthly basis as a result of the movement of the moon around the Earth and the sun's weaker gravitational pull. Twice a month – at the times of the new and full moons – the Earth, Moon and Sun are aligned. This alignment results in a stronger gravitational pull and therefore in increased tidal ranges, with higher than normal high tides and lower than normal low tides. This effect peaks some 1–2 days following the new and full moons (not reflected in the simplified diagram below). These tides are known as spring tides. With the moon and sun at right angles to the Earth (first- and last-quarter moon) the gravitational pull of the sun partly cancels that of the moon resulting in smaller tidal ranges known as neap tides. The sun has its greatest influence when it is directly over the Equator at the spring and autumn equinoxes, resulting in the highest and lowest spring tides of the year.

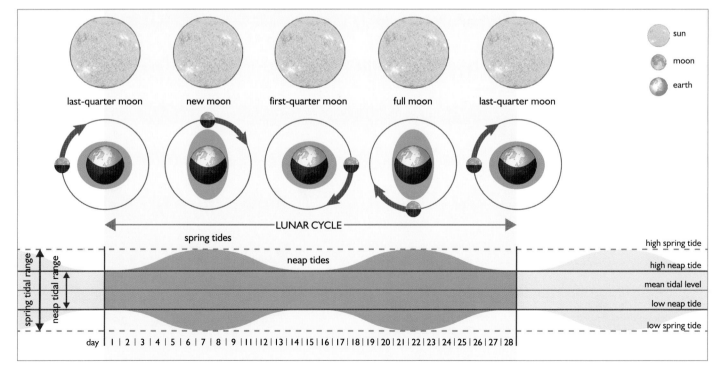

The lunar cycle and mean shore tidal ranges.

THE PHYSICAL OCEAN

A male California Grunion (*Leuresthes tenuis*) wraps himself around an egg-laying female and deposits his sperm. As the tide retreats the fish go with it leaving the eggs to hatch at the next high spring tide.

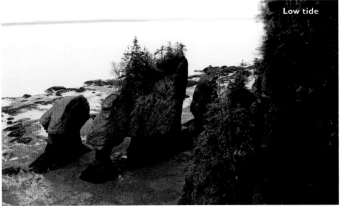

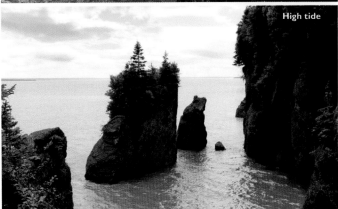

The Hopewell or Flowerpot rocks, New Brunswick are found in the upper reaches of the Bay of Fundy, Canada. This region experiences an extreme vertical tidal range of 16m, the highest in the world.

The timing and heights of high and low water around the world can be predicted, and are published yearly in the UK by the Hydrographic Office as Admiralty Tide Tables. Local tide tables are often produced for coastal towns and various web-based predictions are also available. However, the precise timing and heights can be influenced by local conditions. On 31 January 1953, tides of 2–2.5m higher than those predicted broke sea defences and caused extensive flooding and loss of life along the coasts of south-east England and Holland. This resulted from a deep atmospheric low pressure system over the North Sea pulling the water higher, and storm force winds pushing water down the coast and funnelling it into the narrow Channel between England and Holland.

Animals and plants living on the shore in intertidal regions are heavily influenced by the tides. Those living high on the shore will be exposed to the air for much longer periods than those low on the shore, which results in an often distinct zonation of plants and animals (p.86). Most shore animals exhibit semidiurnal patterns of activity as they are active when the tide is in and quiescent when it is not. In addition, the lunar cycle appears to control reproduction in a number of animals including certain fish, worms and corals. The California Grunion (*Leuresthes tenuis*) times its spawning to commence at night, shortly after a full moon, to coincide with high spring tides. This allows these small fish to their lay their eggs en masse high up on sandy shores, out of the reach of predators. The eggs hatch at the next high spring tide.

Whilst the tidal cycle affects shore animals in particular, tidal currents affect organisms living in the sublittoral below the shore. As the tide rises and falls it does so as a result of water moving horizontally as tidal currents. These currents may be very weak but can also be extremely strong where water is funnelled through narrow channels, around headlands and promontories and over and around submerged pinnacles and other obstructions. Although strong tidal currents can cause problems for mobile animals it is a distinct advantage to many sessile (fixed) animals. Tidal channels, such as the Menai Straits that run between the island of Anglesey and mainland Wales (UK), support very rich communities of anemones, hydroids, sponges, bryozoans and other filter-feeders that capture plankton brought to them by water currents. Famous tidal races include the Gulf of Corryvreckan in the western Isles, Scotland (12 knots), Saltstraumen on the north-west coast of Norway (22 knots) and Skookumchuck Narrows in British Columbia, Canada (15 knots). Scuba divers wanting to explore the rich marine life in such areas must wait for 'slack tide' when the current is at its minimum, usually near high or low tide as water movement slows and reverses direction.

The Severn Estuary in south-west Britain is famous for its 'tidal bore' a wave of water that forms as high spring tides surge up the estuary. The narrowing banks and upward shelving estuary force the water upwards forming a fast moving wave much appreciated by surfers. Strong tidal races such as the one in the entrance to Strangford Lough in Northern Ireland are good locations for tidal energy turbines, a technology currently (2015) in its infancy but expected to contribute an increasing amount of renewable energy within Europe and other areas.

Surfers riding the incoming tidal bore on the Severn Estuary, UK.

WAVES

Whilst storm waves out at sea can be a frightening and dangerous experience for anyone in a small boat, it is at the coast and shore that waves have their greatest impact on marine life. They also sculpt and shape the coastline, eroding cliffs, piling up shingle and moving sand. With the exception of tsunamis, waves are generated by wind usually far out to sea. Major storms can generate waves strong enough to cross an entire ocean. Wave size largely depends on the wind strength and duration plus the distance over which it is blowing (known as the 'fetch'). A storm blowing across the vast expanse of the Southern Ocean will generate much larger waves than one of similar strength in the relatively small Mediterranean Sea. Seafarers measure the severity of sea conditions using the Beaufort Wind Scale. This is a visual assessment of the type and height of waves that is easy to use and understand.

A wave travelling across the ocean surface might appear to be a quantity of water moving from one place to another. Instead it is actually the transfer of energy from one point to the next. If the water molecules were visible they would be seen moving in approximate circles within the wave down to a depth of about half the wavelength – the distance between wave crests (see graphic below). Anything floating on the surface such as a seabird, boat or flotsam will rise up and down but only move fractionally forward as each wave passes under it. The water moves in smaller and smaller circles with increasing depth until movement ceases altogether. This is very apparent to scuba divers who, within the depth of a few metres, can move from tossing uncomfortably at the surface to peace and tranquillity below.

It is only when sea waves approach land that the full force of the latent energy contained in them becomes apparent. As the water shallows, the 'bottom' of the waves where the water is still circling contacts the seabed and the resultant frictional drag slows them down, the wavelength decreases and the wave crests get closer together. The wave height increases rapidly until it becomes unstable and breaks, either over-spilling relatively gently or, on steep shores crashing down all at once. The same thing happens with a tsunami except on a much larger scale. The cause of a tsunami is generally an underwater earthquake or landslide which sets off a series of waves rather like giant ripples. Out at sea these may pass unnoticed but as they approach land at speeds up to 500mph (805kph) they pile up into a wall of water that can devastate coastal areas. Fringing habitats such as coral reefs and mangrove forests can be destroyed but in the process provide considerable protection to inland areas.

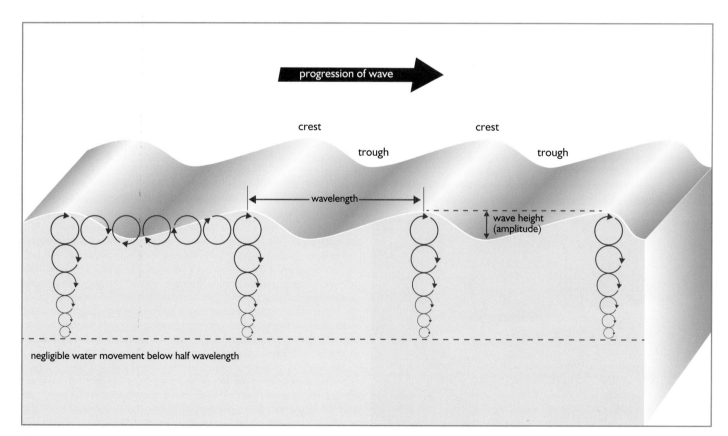

Diagrammatic representation of water movement within and between waves. Wave velocity (the speed at which a wave travels) can be calculated by dividing the wavelength by the wave period (the time interval between successive waves).

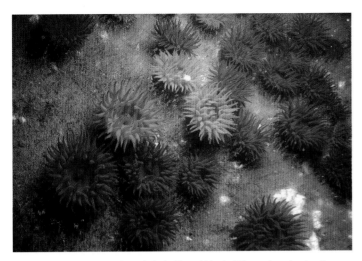

The walls of this wave exposed cave in Sark, Channel Islands, UK are coloured red and brown by Beadlet Anemones (Actinia equina) which flourish on the rich plankton brought in by the waves.

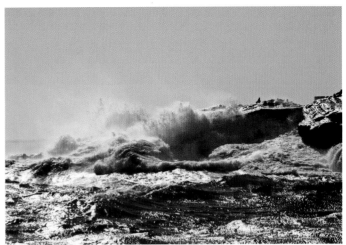

Pounding heavy surf along the desert coastline of Namibia. This area is dubbed the 'skeleton coast' due to the number of beached shipwrecks, but the well-oxygenated water provides rich fish-pickings for fur seals.

WAVE EFFECTS

In rocky intertidal areas, wave exposure is often the most important variable determining which species can be found on a particular shore. Some organisms can withstand frequent pounding by waves and even thrive under such a regime. Others would be torn to shreds or quickly dislodged. On a perfectly windless day with calm seas, it is still possible to tell how wave exposed a shore is by looking at the species present at different levels on the shore. In the UK an extremely exposed rocky shore will be dominated by barnacles and mussels, cemented firmly to the substratum with only small patches of low-growing seaweeds. *Alaria*, a tough narrow-bladed kelp species, predominates in the sublittoral fringe. Wave splash and blown spray encourage the growth of salt-tolerant lichens many metres above the high tide mark. In contrast, a very sheltered shore will be covered with brown fucoid seaweeds (p.144) arranged in zones according to how long they can survive out of water. A forest of large kelp plants fills the sublittoral fringe zone. Ballantine (1961) developed a biologically-defined exposure scale to allow comparison between rocky shores throughout the UK.

Where waves surge through steep-sided gullies, in and out of caves and along steep cliff walls in shallow water, they can mimic the effect of strong tidal currents. The abundant supply of food and oxygen brought by waves on exposed coasts results in rich growths of sessile animals that are able to hang on tightly. There is little grazing pressure from sea urchins which are swept off the walls. Around the exposed coasts of the St Kilda archipelago, some 65km (40 miles) west of Scotland's Outer Hebrides, colourful walls of Jewel Anemones (*Corynactis viridis*), Dead Men's Fingers (*Alcyonium glomeratum*), sponges and hydroids are a common sight.

Barnacles and mussels cover the rocks at St Agnes, Cornwall, a typical exposed rocky shore in the UK.

Extensive mats of the large brown seaweed *Ascophyllum nodosum* grow on wave-sheltered shores in Strangford Lough, Northern Ireland.

THE MAIN DIVISIONS OF THE MARINE ENVIRONMENT

An understanding of the main topographical features of the ocean floor and how they are formed helps to explain the distribution and structure of the main habitats and ecosystems found in the ocean and described under Environments and Ecosystems (p.40). The ocean is a three-dimensional environment with marine organisms living throughout the water column as well as on and in the seabed. Life can be found from the intertidal to the deepest depths, but well-lit, wave exposed coastal and surface waters are obviously a very different place to live than the cold, dark slow-moving waters of the abyssal depths. Pressure, temperature, light regimes and food supply all change with increasing depth. This results in corresponding changes in the types of marine organisms inhabiting these regions – in fact a zonation of ocean life within a number of different environments. Therefore on a global ocean scale, the ocean environment and its marine life can be divided into various regions.

The most obvious split is between the ocean water and the ocean bottom, termed respectively the Pelagic Division and the Benthic Division. Pelagic organisms live, drift and swim throughout the whole body of water that makes up the oceans and seas, whilst benthic organisms live on or burrow into the seabed.

The **Pelagic Division** is conventionally subdivided both horizontally and vertically. The shallow water over the continental shelf is subject to quite wide variations in water movement, temperature and chemical composition and is termed the **Neritic Province**, whilst the more stable waters of the **Oceanic Province** extends out beyond this point. Four major depth zones are usually recognised:

- The **Epipelagic** or Sunlit Zone, from the surface to about 200m, at which depth there is only about 1% of the light at the surface. Not surprisingly this zone teems with phytoplankton since these depend on the light for photosynthesis. Organisms living within this zone experience both diurnal (night and day) and seasonal variations in light and temperature. Many epipelagic animals make vertical (diel) migrations down to the relative safety of the lower levels during the day.
- The **Mesopelagic** or Twilight Zone, from 200 to 1,000m, where very little light penetrates and other variables such as temperature are more stable. Mesopelagic fish often have very large eyes to make maximum use of what little light there is. An oxygen-minimum layer often occurs between about 700–1,000m depth (p.24). In contrast, levels of nutrients, especially nitrates and phosphates, gradually increase with depth in this zone with a maximum between 500 to 1,500m depth. In the epipelagic zone, nutrients are quickly used up by plants, replenished by mixing and upwelling.
- The **Bathypelagic** or Dark Zone, from 1,000 to 4,000m, where virtually no light penetrates and the temperature is a frigid 2–4°C. Bioluminescent organisms including fish, crustaceans and jellyfish are common here. Food is in short supply and animals must either eat each other or try to catch detritus raining down from above. For most animals it is too far to make feeding migrations into the upper zones.
- The **Abyssopelagic Zone** below 4,000m, where only a few highly adapted pelagic animals can survive the dark, cold, enormous pressures and dearth of food. Sometimes a further distinction is made between this zone and the **Hadal Zone** in both the pelagic and benthic divisions. The hadal zone occurs within ocean trenches from about 6,000m to the deepest depths around 11,000m.

The **Benthic Division** includes the entire sea bottom and the seashore whatever it consists of – rock, sand or glutinous mud. Five zones are usually recognised:

- The **Littoral Zone** or Intertidal Zone, which includes everything above the lowest spring tide level up to the highest spring tide level and slightly beyond to where wave splash reaches. Seashore animals and plants are adapted to withstand extremes of salinity, temperature and exposure to air.
- The **Sublittoral Zone,** which extends out from the bottom of the littoral zone to the edge of the continental shelf at around 200m depth or where oceanic islands drop away into the depths, is characterised by an abundance of marine life including rich growths of seaweeds.
- The **Bathybenthic Zone** extending down the continental slope from 200 to 4,000m. Whilst plants are mostly absent, rocky areas support fascinating communities of fixed animals including crinoids (sea lilies), sponges and coldwater coral reefs (e.g. *Lophelia pertusa*).
- The **Abyssobenthic Zone** which extends out from the foot of the continental slope at 3,000m to 4,000m, down to the deepest depths. Most of this zone consists of extremely flat, muddy abyssal plains (p.110) that fill the immense spaces out to the lower slopes of mid ocean ridges and to the edges of ocean trenches. Abyssal plains occupy almost two thirds of the ocean floor. The sea floor within ocean trenches is also part of the hadal zone (see abyssopelagic zone).

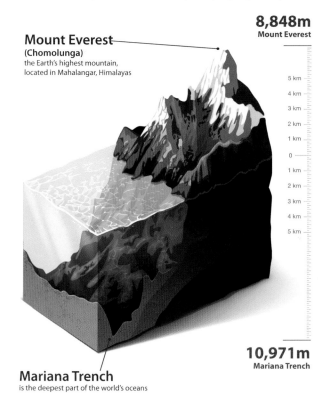

Diagrammatic cross-section showing the highest and deepest points on Earth.

THE PHYSICAL OCEAN

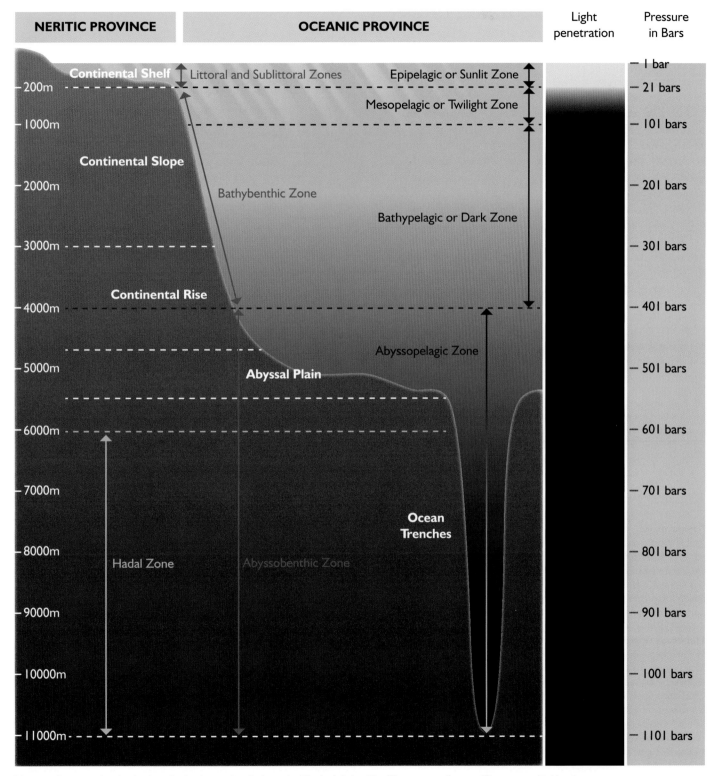

Diagrammatic cross-section showing the major depth zones described opposite. The depth limits of the different zones will vary at different geographical locations.

THE MAIN DIVISIONS OF THE MARINE ENVIRONMENT

OCEAN TOPOGRAPHY

Satellite photographs of the Earth can show us mountains, plains, rivers, lakes and forests. We can see for ourselves the immense range of topography and physical features found on land and it is unlikely that there remains any major feature as yet undiscovered. Although we now know that the ocean floor is equally if not more varied, we cannot see this but must rely instead on depth soundings to build up a visual picture. Mapping of the ocean floor using these techniques is still very much an ongoing process and new seamounts, for example – the equivalent of huge mountains on land – are still being found. Originally, depth soundings were laboriously taken by dropping a weighted line over the side of a ship – the voyage of the *Discovery* in 1872 to 1876 collected an amazing 492 deep sea soundings helping to map the edges of continental shelves and the mid-ocean ridges. The expedition also discovered the Challenger Deep, the deepest known place in the ocean. The invention of sonar in the early 20th century revolutionised the process and recent surveys during the multi-national ten-year 'Ocean Census' project have provided a wealth of new data using cutting edge sonar technology.

The major topographical features of the ocean are described below and shown in the map opposite.

Continental shelf Around each continent and major islands such as Borneo and Iceland, the seabed shelves away gradually forming a coastal ledge usually down to about 200m but varying from 20m to 500m. The seaward limit of this ledge is called the continental edge or shelf break. From here the continental slope falls away at a steeper gradient until it reaches the floor of the ocean basins. The width of the shelf varies around the different land masses, ranging from less than a kilometre to 1,500km. Some of the broadest areas are around the British Isles which lies on the north-western European Shelf and includes the North Sea, under Hudson Bay in Canada, and Atlantic Patagonia where the shelf extends out to the Falkland Islands.

The shallow, well lit, nutrient-rich waters over the continental shelf are extremely rich in marine life and we extract around 99% of the fish and other living resources we eat and use from this relatively small area of the ocean.

Abyssal plains As sediment falls down the continental slope it gradually accumulates at its base and so the slope gradient lessens. This area, the continental rise, merges into the flat sea floor of the abyssal plains. These vast, almost featureless areas of accumulated mud stretch right across the ocean basins, only broken by mid-ocean ridges, and occasional seamounts and abyssal hills. Once considered to be almost barren, this immense habitat is now thought to support more species per square metre than tropical rainforest – albeit most of these are bacteria and other micro-organisms.

Mid-ocean ridges A vast system of linked mountain chains, that dwarf anything found on land, runs for 28,000 miles through all the major ocean basins including the Arctic. Whilst the ridges run almost down the centre of the Atlantic and Indian Oceans dividing each into two basins, the Pacific Ocean ridge is skewed to the east. These underwater mountain ranges rise at least 3,000m above the flat abyssal plains but rarely come within striking distance of the surface. A major exception is Iceland where the northerly section of the mid-Atlantic ridge, known as the Reykjanes Ridge, reaches the surface. Some oceanic islands are the peaks of especially high submarine mountains that rise to the surface from the ridges. Well known examples are the Azores in the North Atlantic and Ascension Island and Tristan da Cunha in the middle of the South Atlantic.

Date	Ship and equipment	Deepest depth record	
	Indirect measurements	metres	original units
1875	HMS *Challenger*, line soundings	8,184	4,475 fathoms
1951	HMS *Challenger* (named after original one); echo soundings	10,900	5,960 fathoms
1984	Japanese survey ship *Takungo*; multibeam echosounder	10,924	35,842 feet
2009	Research vessel *Kilo Moana* (mother ship of ROV *Nereus*); Simrad EM120 multibeam sonar system for deep water	10,971	10,971m
	Direct measurements	metres	original units
1960	Bathyscape *Trieste*	10,916	35,814 feet
1995	ROV *Kaiko*	10,911	
2009	HROV *Nereus*	10,902	35,768 feet
2012	*Deepsea Challenger*	10,898	35,756 feet

Depth records from within the Challenger Deep in the Mariana Trench.

The mid-ocean ridges are volcanically active and mark the boundaries between the Earth's tectonic plates (see Box opposite). Here molten magma pushes up from beneath the seabed, spreading out sideways and gradually cooling to form new sea floor. As more magma wells up, the newly formed sea floor is pushed away from the ridge widening the Atlantic Ocean by 1–2cm a year and building up the submerged mountain ranges, acting rather like a long sinuous volcano. The cool mountain flanks of the ridges provide a sediment-free habitat but few animals live here as there is little in the way of food. In contrast, along the volcanically active tops of the ridges (which of course are many miles wide) hydrothermal vent communities flourish, forming oases of rich marine life (p.112).

Ocean trenches These are the deepest parts of the ocean floor found at depths greater than 6,000m, mostly around the Pacific rim and equivalent perhaps to water-gouged gorges and canyons on land. The deepest of all is the Mariana Trench near Guam in the western North Pacific (see table above). Ocean trenches are, however, formed not by the action of water but by volcanic processes. They are subduction zones where an oceanic tectonic plate meets a continental plate and slides down beneath it. The extreme conditions in the depths of a trench restrict the type and number of animals that can live there, but nevertheless macrofauna do exist, even at the deepest depths. The first two people to descend to these depths, Jaques Piccard and Donald Walsh in the bathyscape *Trieste*, described a small flatfish-like animal on

Species	Maximum depth	Details	Trench
Notoliparis kermadecensis	7,560m	Photographed 2009	Kermadec, New Zealand
Pseudoliparis amblystomopsis	7,703m	Filmed 2008 First caught 1955	Japan trench Kuril-Kamchatka trench

The two species of fish filmed by the Hadeep project.

THE PHYSICAL OCEAN

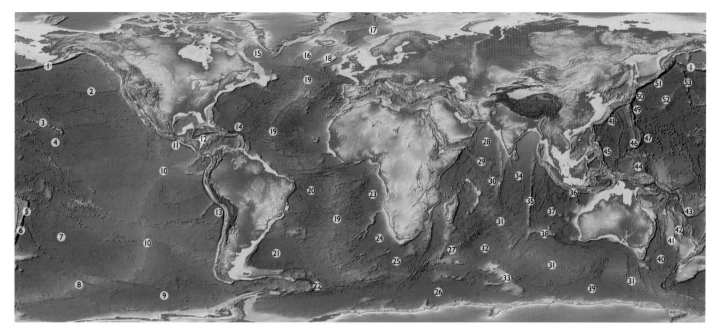

Map showing the location of major topographical features of the ocean.

1. Aleutian Trench
2. Northeast Pacific Basin
3. Hawaiian Ridge
4. Central Pacific Basin
5. Tonga Trench
6. Kermadec Trench
7. Southwest Pacific Basin
8. Pacific Antarctic Ridge
9. Bellingshausen Basin
10. East Pacific Rise
11. Middle America Trench
12. Cayman Trench
13. Peru–Chile Trench
14. Perto Rico Trench
15. Labrador Basin
16. Reykjanes Ridge
17. Norwegian Basin
18. Rockall Plateau
19. Mid Atlantic Ridge
20. Brazil Basin
21. Argentine Basin
22. South Sandwich Trench
23. Angola Basin
24. Cape Basin
25. Agulhas Basin
26. Weddell Sea Basin
27. Southwest Indian Ridge
28. Arabian Basin
29. Carlsberg Ridge
30. Central Indian Ridge
31. Southeast Indian Ridge
32. Crozet Basin
33. Kergelen Plateau
34. Mid Indian Ocean Basin
35. Ninetyeast Ridge
36. Sunda Trench
37. Wharton Basin
38. Broken ridge
39. Australian–Antarctic Basin
40. Tasman Basin
41. Lord Howe Rise
42. New Caledonia Trough
43. South New Hebrides Trench
44. Manus Trench
45. Philippine Trench
46. Challenger Deep
47. Mariana Trench
48. Nansei–Shoto Basin
49. Izu–Ogasawara Trench
50. Japan Trench
51. Kuril–Kamchatka Trench
52. Northwest Pacific Basin
53. Emperor Seamount Chain

PLATE TECTONICS

The way in which new sea floor is formed and spreads out from the mid-ocean ridges and the way in which continents move and split away from each other over millions of years (continental drift) are both explained by plate tectonics. The outer crust of the Earth (the so-called lithosphere) is cracked rather like an eggshell, into about 20 'tectonic plates'. These effectively float on a dense underlying layer called the asthenosphere that consists mostly of molten rock and is very dense. Most plates consist both of continental crust (including dry land) and adjacent oceanic crust but some, including the massive Pacific plate, carry only oceanic crust (ocean floor). The approximate outlines of the tectonic plates are shown below and of course coincide with the ocean ridges. As the rigid, cool tectonic plates slide over the asthenosphere, they carry continents and ocean basins with them. The driving force behind the plate movements is a complex flow of thermal energy deep within the mantle that has yet to be fully explained. This fascinating process explains many of the Earth's geological features including mountain ranges on land, mid-ocean ridges, ocean trenches, the 'ring of fire' volcanoes around the Pacific Rim, and island chains.

the seabed. Fifty years later the film director James Cameron reached the seabed in *Deepsea Challenger* but did not report seeing any macrofauna. In 2007 to 2009 the Hadeep project filmed and photographed two species of fish (see table opposite) between 7,000 to 8,000m attracting them to their camera-laden ROVs with bait traps (Jamieson *et al.* 2009). These fish have so far been found only in specific trenches in a narrow depth range suggesting they may be endemic in the same way that some land animals are on islands. Other deep sea fish are also found in ocean trenches but are more widespread, both in terms of distribution and depth. This includes the (so far) deepest recorded fish *Abyssobrotula galatheae*, trawled up (dead on arrival) from a depth of 8,370m in the Puerto Rico trench.

Seamounts, abyssal hills and guyots The flat monotony of the abyssal plains is broken by the tops of underwater mountains emerging from the mud. Those rising less than 1,000m above the surrounding mud are called abyssal hills, and anything taller than this is a seamount. Extrapolation from the data available suggests there are at least 100,000 sizeable seamounts (and many more smaller ones) with over half these found in the seismically more active Pacific Ocean, which is not surprising since they are mainly volcanic in origin. Many seamounts are tall enough to reach up into the epipelagic zone and are extremely rich in marine life (p.62), a fact that has not gone unnoticed by fishermen. Of the 400 or so that have so far been sampled by scientists, many show signs of fishing damage. Some seamounts reach right to the surface and form oceanic islands such as Christmas Island in the Indian Ocean. Guyots are flat-topped seamounts that once rose above the surface but now lie well below it. When still above water their summits were eroded by waves and covered by coral reefs. Riding on tectonic plates they are carried away from the volcanically active 'hot spots' where they originally formed, into deeper water. Their sheer weight can depress the oceanic crust and rising sea levels help submerge them during geological periods of land ice melting.

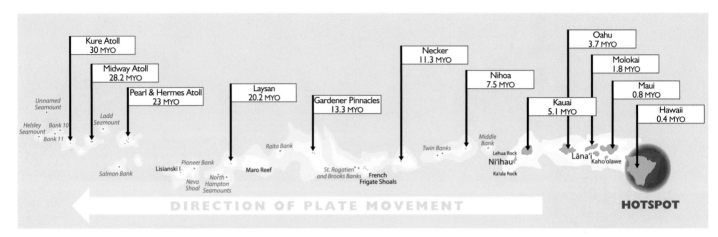

The island of Hawaii owes its existence to a geologic 'hot spot', a volcanically active area in the underlying mantle of the Pacific tectonic plate. Hawaii was formed as molten magma broke through the plate here and built up into an undersea volcano that eventually reached the surface. It is currently highly volcanically active but, like the other islands formed over this hotspot, it will eventually be carried away to the northwest by tectonic movement of the Pacific plate. Visitors 10,000 years from now might then see another island added to the chain. MYO = Million Years Old.

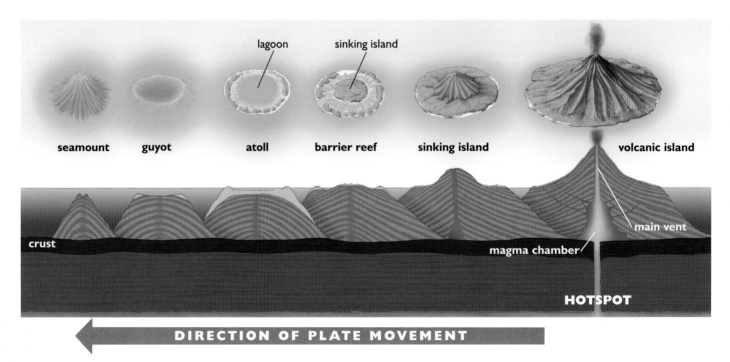

A volcanic island formed over a hotspot gradually becomes dormant as it is carried away by tectonic plate movement. As the dome collapses and the ocean crust beneath it cools and shrinks, the island subsides. When it drops below the surface it is known as a seamount or guyot. Other seamounts never reach the surface.

ENVIRONMENTS AND ECOSYSTEMS

The ocean provides an immense three-dimensional living space. Some estimates suggest that 99% of all available living space on Earth is in the ocean. Since two-thirds of the planet is ocean and living space is available throughout the water column as well as on the seabed, this is probably a reasonable assumption. This ocean living space is just as complex as that on land with a huge variety of habitats from still, cold deepsea mud to exposed rocky shores with crashing waves. Organisms that live under such contrasting conditions will obviously have very different adaptations and ways of life. The physical habitat may be the main driver as to what lives where but the biological habitat can be equally as important. The two together, the non-living and living, make up the environment of an organism.

For example, marram grass is one of the few plants that can establish and grow in shifting coastal sand but once it has, then a complex sand dune ecosystem can develop. An ecosystem includes the various populations and communities of animals, plants and micro-organisms that all live in the same geographical area. At one level an estuary is an ecosystem but so is the whole pelagic water column, and even the whole ocean.

This chapter provides an introduction to the main habitats, environments and ecosystems found in the ocean, what organisms live there and how they do so, and what you might expect to see when you visit a saltmarsh, dive a coral reef or snorkel from a yacht becalmed in the Sargasso Sea. Living on or in the seabed is a very different way of life to drifting and swimming in the open ocean and these two great 'ocean realms' are covered in separate sub-chapters. However, many marine organisms move effortlessly between the two at different stages of their life cycle, and ecosystems throughout the ocean interconnect through complex food webs.

Sargassum seaweed community.

Zonation

If you have ever walked, climbed and scrambled your way to the top of a mountain you will have noticed how the vegetation changes during your ascent. The base of Mount Kinabalu, the highest mountain in SE Asia, is shrouded by thick rainforest with tall trees and lush undergrowth. After a few hours climb the trees have shrunk, orchids are replaced by hanging veils of lichen and insect-eating pitcher plants. Right at the top, vegetation is sparse and concentrated in cracks and crevices in the rock. This dramatic zonation is driven principally by a temperature gradient from 30°C at the base to 0°C at the top.

A similar journey, but this time downwards, from the edge of the ocean to the abyssal plain below would encompass almost the same temperature gradient if started in the tropics. However, in the ocean, light rather than temperature provides the strong environmental gradient which results in different vertical life zones. Light decreases in both quantity and quality with depth (see pp.18–19). This will obviously affect the growth of seaweeds, seagrass, corals and phytoplankton, all of which rely on photosynthesis and need light to grow. However, it will also affect any animal that relies on vision to hunt for food, find a mate and go about its daily business. On land daylight predictably follows night but in the ocean there is permanent darkness below about 1,000m depth and bright light to less than 100m.

Apart from the seashore (of which more later) the sublittoral zone (p.34) along a moderately exposed, temperate rocky coastline is one of the best places to see a clear zonation as depth increases and light levels consequently decrease. Wading in from a rocky shoreline along the west coast of Great Britain, a scuba diver will first swim over or through a dense kelp forest (p.99). The large brown seaweeds that form the structure of this forest need high light levels in order to make enough food to grow to their full potential. If the water is clear, dense kelp forest might extend to 15m or so, but below this the kelp plants start to thin out and a diver will be swimming through a 'kelp park'. The rock between the kelp is not bare but covered by smaller seaweeds, especially red species adapted to thrive at low light intensities. These seaweeds

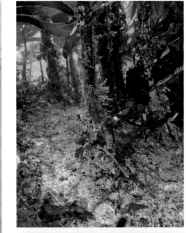

Dense forests of kelp *Laminaria hyperborea* occur in the upper infralittoral zone on rocky substrata around much of Great Britain and Ireland.

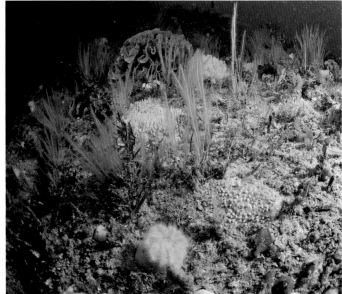

A rich upper circalittoral community of bryozoans and sponges in the Isles of Scilly, UK.

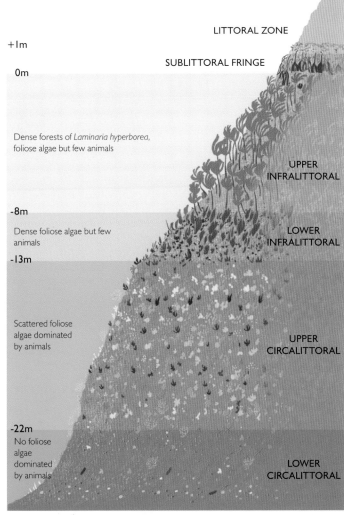

A typical sublittoral profile off a moderately exposed rocky coastline in the UK.

flourish where the kelp canopy diminishes and more light reaches the seabed. However, as the light reduces further with increasing depth, they too start to reduce in number and their place is taken by sessile (fixed) plant-like animals (p.44) such as bryozoans and hydroids. This animal-dominated part of the sublittoral region is known as the circalittoral zone whilst the seaweed-dominated zone above is the infralittoral. The beginning of the circalittoral is about as far as a scuba diver can go, but swap to a submersible and it would soon become evident that even though the animals growing on the rocks do not need light, they too decrease in number with increasing depth, and patches of bare rock soon become evident. Most sessile animals feed by catching or filtering out plankton and organic debris from the water and the availability of their food decreases dramatically with depth. This follows because phytoplankton can only grow in the upper sunlit layers and the rain of dead material from it and the zooplankton that feeds on it lessens as it is consumed on the way down.

On the seashore there is generally plenty of light but vertical zonation is almost universally apparent if you look carefully enough. Walk down a rocky seashore and distinct horizontal bands of dominant species such as seaweeds and barnacles will often be evident. Dig for bivalve molluscs and worms on a sediment shore and you will find different species at the top and the bottom of the shore. This is hardly surprising since the intertidal zone is alternately an essentially terrestrial and then a marine habitat. At low tide, rocky seashore organisms are subjected to extremes of temperature, drying winds, diluting rainfall and difficulties in obtaining oxygen and in feeding. Those at high shore levels must be tough enough to endure these conditions for many hours. Living low on the shore is easier but there is far more competition for space and food, and there are more predators.

Animals living buried in a sandy seashore may fare better because sediment retains water and reduces temperature changes. Dig a hole in the sand half way down a shore and it will slowly fill with water. Sand too hot to walk on barefoot is cool only a few centimetres down. At high shore levels, a much deeper burrow is necessary to stay cool and wet than is needed lower on the shore. Most animals living in intertidal sand and mud can only feed when the tide is in, a short time for those living near the high water mark.

Zonation is not obvious on all shores and exactly where a particular animal or seaweed lives is not controlled simply by their physiological ability to withstand exposure to air, important as this is. Many rocky seashore animals as well as seaweeds, live fixed to rocks and competition for space is paramount. Grazing and predation also play their part as do mechanisms by which larvae 'choose' where to settle. Chemical cues from adults already happily living at a particular shore level, encourage preferential settlement in some species, space allowing. Slow moving periwinkles and other mobile animals can settle and then move to their optimal living quarters by innate responses to moisture, gravity and light.

Searching a rocky seashore such as this one in Cornwall, UK, from the top to the bottom at low tide will reveal many more species than a much longer horizontal walk at one shore level.

Within major and obvious zones there may also be subtle sub-zones. A wide zone of barnacles on the upper shore is easy to see, but recognising that more than one species is involved is more difficult. Barnacles are not the easiest things to identify. A careful look at a rocky shore in Scotland will often show a zone of the barnacle *Chthamalus montagui* right at the top of the shore between high water neap (HWN) and high water spring (HWS) tide levels. Below this, a second barnacle *Semibalanus balanoides* predominates but decreases in numbers as you move further down the shore. *Chthamalus* can stand dry conditions better than *Semibalanus* but grows more slowly and is out-competed where conditions are more favourable lower down. Lower down on the shore increasing numbers of Dogwhelks (*Nucella lapillus*) which eat barnacles, limits the abundance of *Semibalanus*. The dogwhelks cannot survive high up the shore where it is dry. However *C. montagui* does not do well where wave exposure is high and under these conditions, another species *Chthalamus stellatus* may predominate. Latitude also modifies the barnacles' distribution.

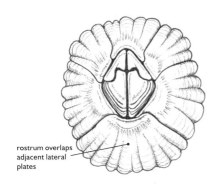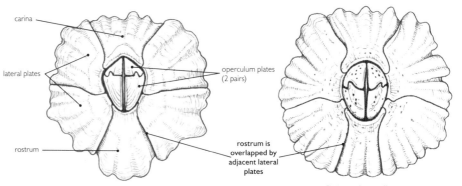

Semibalanus balanoides
operculum plates form diamond-shape

Chthamalus montagui
operculum plates form an angular kite-shape

Chthamalus stellatus
operculum plates form oval or rounded kite-shape

When closed, barnacles can be identified by the shape of the opening (operculum) and of the sutures (joints) between the two pairs of operculum plates.

Ways of life

Marine organisms can usefully be grouped according to their general way of life rather than the specific habitat or ecosystem in which they are found. The first and most obvious split is between organisms that float or swim in the water column and those that live in or on the seabed. Plankton are those organisms that live a life suspended in and supported by the water with very little ability to control where they go, whilst nekton can swim purposely through the water. Together they are described as pelagic organisms and they live within the pelagic division of the ocean. Organisms living on and in the seabed are termed benthos and live within the benthic division (p.34). Fish, cephalopods and crustaceans that swim near to the seabed and mostly depend on it for food are termed demersal. Cod (*Gadus morhua*) and flatfish are both demersal fish but flatfish are also benthic as they spend most of the time lying on the seabed. Cod never do this but live fairly near to the seabed and so are benthopelagic fish. Whilst all these names may sound esoteric, they are very relevant to fishermen who need to know the way of life of their target fish in order to deploy the correct type of fishing gear.

Benthic organisms that live on the surface of the seabed whether rock, wreck, reef or sediment are termed the epibenthos (epifauna, epiflora) whilst animals that burrow into sediment are the infauna.

Some benthic seaweeds and sessile (fixed) animals (see plant-like animals below) specialise in living (non-parasitically) on other plants or animals and are described as epiphytes and epizoophytes respectively. In practice this way of life is usually termed epiphytic whatever the combination of being lived on and living on. Sponges and other sessile animals often grow on and over each other and the hard shell of a mussel is simply another piece of rock to a settling barnacle. There are however, many examples of seaweeds and sessile animals that always or almost always live epiphytically.

Molluscs such as piddocks (Pholadidae) bore into soft rock such as chalk, riddling it with their burrows and weakening it.

Some animals construct burrows by boring into rock, wood and shell during their larval or young stages and remaining permanently entombed as adults. Such boring animals are effectively specialised infauna. Shipworms (p.244), which are highly modified bivalve molluscs and gribbles (p.275) which are specialised crustaceans, cause considerable damage to wooden ships and pilings. Boring sponges such as *Cliona celata* (p.187) riddle calcareous rocks and shells with an extensive network of tissue lying in chemically excavated tunnels. The recently discovered bone-eating *Osedax* worm (p.111) specialises in boring into the bones of whale carcasses in the deep ocean.

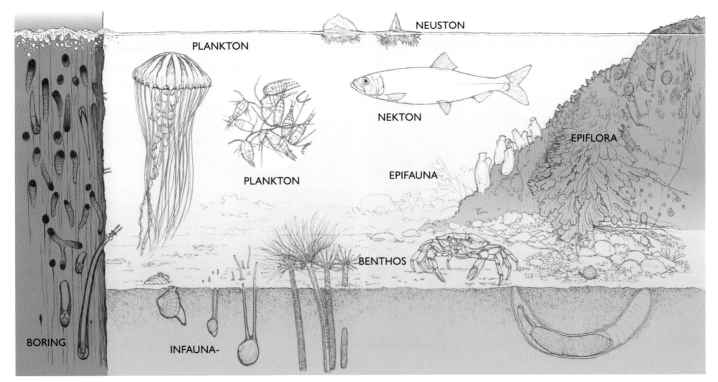

Ways of life of marine organisms.

Plant-like animals

When early Victorian naturalists first found and collected corals and anemones from rock pools and seafans and sponges dredged from the depths, they considered that these colourful but unmoving organisms must be plants. As their animal nature became apparent they were dubbed zoophytes or animal-plants. Even today children learn from observation that animals must move around to find their food whilst plants stay in one place and use sunshine to make their own food. Excluding the complex world of microorganisms, terrestrial animals do move around in search of good grazing, prey, detritus or carrion. They also go in search of mates. Some range for many miles whilst others find what they need close by, but either way most animals would starve if they stayed in the same place for any length of time and were not brought food.

In contrast, many marine animals are sessile, which in this context means permanently fixed and not able to move about. Familiar examples are barnacles, mussels and sponges. Less familiar are the many colonial animals found in the ocean including corals, hydroids, and bryozoans. Sessile animals must find food and reproduce without ever moving from one spot. This would be hard to achieve on land but in the three-dimensional ocean it is relatively easy. The water is full of drifting plankton, detritus, dissolved organic material and swimming animals. Water currents and waves move this vast food supply from place to place and effectively bring breakfast, lunch and dinner to sessile animals, provided they have settled in an appropriate place and depth. Marine invertebrates have evolved a wealth of different mechanisms for collecting and extracting food from the water.

Drop a stick into a flowing river and it may be carried for miles downstream. The same principle applies to sessile animals which release sexual products or larvae directly into the sea. Fertilisation can occur either in the water column as sperm and eggs mix or released sperm can be carried to female or hermaphrodite individuals. Larvae drifting in the plankton are dispersed by water currents and can settle and colonise new areas, if they are not caught and eaten first. This method of reproduction and dispersal is also widely used by many slow-moving mobile bottom-living (benthic) animals such as crabs and sea cucumbers.

Some individual non-colonial sessile animals improve their egg fertilisation chances

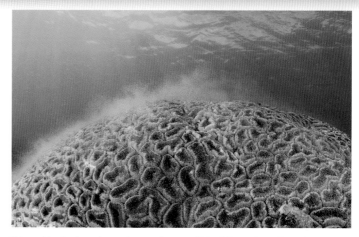

This coral is releasing packages of eggs and sperm which will float to the surface before bursting and mingling with those from other corals that are spawning at the same time (see also p.207).

by living close enough together to mate. Barnacle larvae settle preferentially on rocks where there are already other barnacles, often in the spaces left where adults have died and fallen off. A highly extensible penis means neighbours can fertilise one another even though they cannot move (see photo p.279). An ingenious adaptation to ensure successful breeding is found in barnacles that live attached to whales, turtles and other wandering animals where they cannot grow in aggregations. Some barnacle larvae settle on *in situ* adults, which are either hermaphrodite or female depending on species, and remain there as dwarf or 'apertural' males ready to fertilise their host. Sessile and colonial animals also occur in freshwater but this lifestyle is far less common than it is in the marine environment. Freshwater lacks the quantity of minerals and nutrients available in the ocean and which support a wide variety of planktonic organisms. The latter in turn provide food for sessile animals.

Rich populations of sessile animals such as these bryozoans and tube worms (*Sabella penicillus*) growing off the Norfolk coast, UK, are found where strong water currents bring plenty of plankton food.

The Ruffled Lettuce Sea Slug (*Elysia crispata*) can crawl in search of its food and is not a sessile animal. However, it not only looks like a plant but 'steals' the chloroplasts of its seaweed food and uses them to manufacture food for itself like a plant. Other species of *Elysia* share this ability.

SESSILE MARINE PHYLA

Examples of phyla and classes where all or the majority of species are sessile 'plant-like' animals.

Sponges (Porifera) (p.182)

Tube sponges on a coral reef.

Hydroids (Cnidaria: Hydrozoa) (p.191)

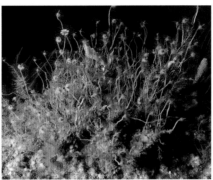

Hydroids (*Tubularia indivisa*) covering a rocky reef.

Soft corals, seafans and stony corals (Cnidaria: Anthozoa) (p.200)

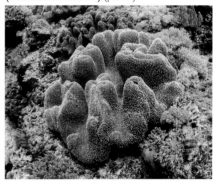

Soft corals can cover large areas of tropical reef.

Tube worms (Annelida: Polychaeta: Sedentaria) (p.215)

Cluster of tube worms in Grand Cayman.

Phoronids (Phoronida) (p.226)

Although tiny, phoronids can cover large areas of rock.

Bivalve molluscs (Mollusca: Bivalvia) (p.238)

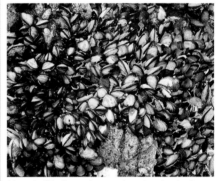

Mussels (*Mytilus* sp.) grow in extensive beds on rocky shores worldwide.

Barnacles (Arthropoda: Cirripedia) (p.278)

Leaf barnacles (*Pollicipes polymerus*) grow densely on shores in the NE Pacific.

Bryozoans (Bryozoa) (p.284)

Bryozoans form extensive turfs on shaded areas of rocky reefs.

Sea squirts (Chordata: Tunicata) (p.307)

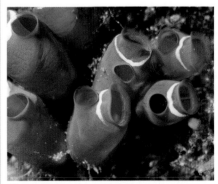

Clumps of colourful sea squirts are common on coral reefs.

Food chains and webs

The habitats, ecosystems and species described below and throughout this book do not exist in isolation from one another. With the exception of deepsea hydrothermal vent communities and 'cold seep' communities where energy is derived from chemical sources (p.112), even the deepest animal communities are ultimately dependent on the productive surface waters. There may be many intermediate stages, but a sea cucumber feeding on detritus on the abyssal plain 4,000m down would have nothing to eat if it were not for tiny single-celled phytoplankton at the surface busy making their own food via photosynthesis.

Phytoplankton (p.51) are autotrophic primary producers, that is they can manufacture organic food from inorganic material. The grass in a field does the same. The phytoplankton is grazed by tiny zooplankton (p.52), herbivores such as protozoans and copepods, which are therefore called primary consumers. Rabbits grazing grass in a field are the equivalent primary consumers. Carnivorous zooplankton such as arrow worms (Chaetognatha) that feed on the herbivorous species are called secondary consumers and so is the fox that eats a rabbit. Small fish that eat the arrow worms and the wolf that eats the fox are tertiary consumers and so on. At each stage, when an animal eats a plant or another animal, another trophic (consumer) level is added to the 'food chain'. The number of trophic levels varies within different ecosystems and parts of the ocean but rarely exceeds six. This is because there is an energy 'loss' at each step along the food chain as the animals' metabolism uses up energy.

This is one reason why it is more efficient to farm herbivorous or planktivorous fish or shellfish such as Milkfish (*Chanos chanos*) low down in the food chain, rather than carnivorous species such as salmon near the top of the chain. However, there are of course many other considerations such as taste, convention and ease of rearing. Food chains in nutrient-rich waters where primary productivity is high can support short food chains with only a few trophic levels and a high end biomass of fish, mammals or seabirds. A well-known example is found off the Peruvian coast of South America where upwelling currents (p.52) supply sufficient nutrients to allow relatively large phytoplankton, such as colonial diatoms, to grow. These are large enough to be eaten

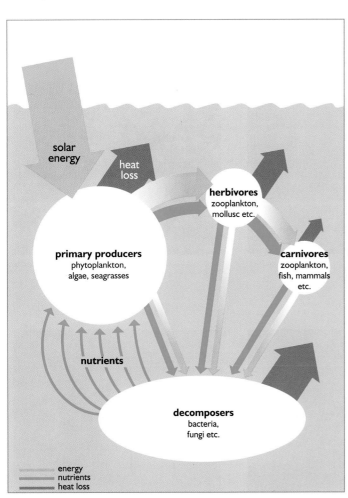

A simple representation of energy flow and trophic levels in the marine ecosystem.

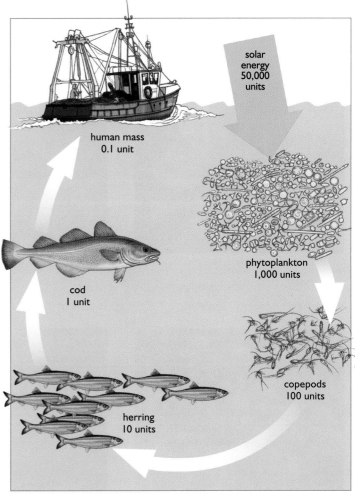

It takes 1,000 units of phytoplankton mass to make one unit of Atlantic Cod (*Gadus morhua*) and 0.1 unit of human mass. In simple terms, a feeding population must of necessity be smaller in total biomass than the one it is feeding on.

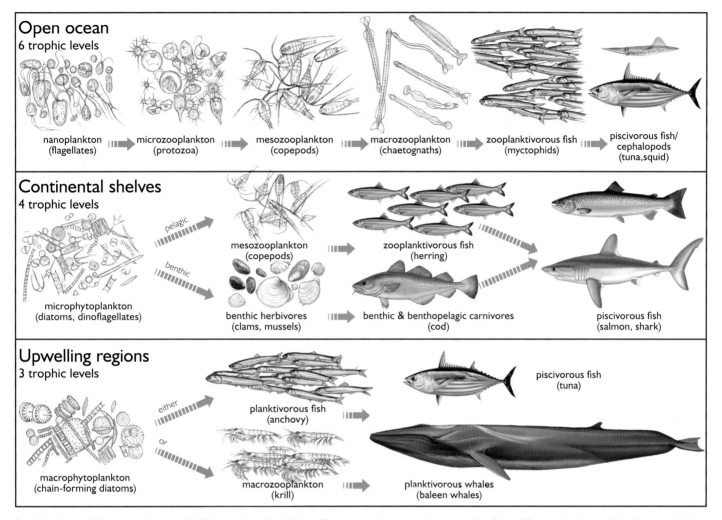

Food chains in three different marine habitats with differing numbers of trophic levels. The organisms shown are only representatives of many different species that could be utilised at each level. (based on Lalli and Parsons 1993).

directly by small planktivorous fish especially anchoveta, which occur in huge numbers and are in turn eaten by tuna (and people). This is a very efficient system but one that is subject to dramatic 'crashes' when the upwelling currents fail due to climatic fluctuations (see El Niño p.17). In contrast, the open ocean far from land has few nutrients and especially lacks iron which limits phytoplankton productivity. This leads to longer food chains with more trophic levels, consequent loss of energy along the way and so smaller numbers of top level predators. A system with more trophic levels and a greater biodiversity of species is more resilient to change.

Most marine animals feed on a variety of organisms and what they eat may come from several different trophic levels. Simple food chains are rare in the ocean and organisms actually live and feed within complex food webs. Within a food web there will be species that eat only one or a few types of organisms but also omnivores that eat a wide range. Others specialise in eating dead material and detritus. A single species may feed in very different ways and on different organisms in its larval and adult phases. A sessile bryozoan living on the seabed makes a direct link between the benthic food web and the pelagic food web because it filters plankton from the water above it. All this means that it is extremely difficult to work out the intricacies and energy transfers within a particular food web.

Sandeels form an important part of the diet of Atlantic Puffins (*Fratercula arctica*) and a decline in the breeding success of Atlantic Puffins in some parts of Great Britain has been attributed to a lack of sandeels in some areas at critical times.

FOOD CHAINS AND WEBS

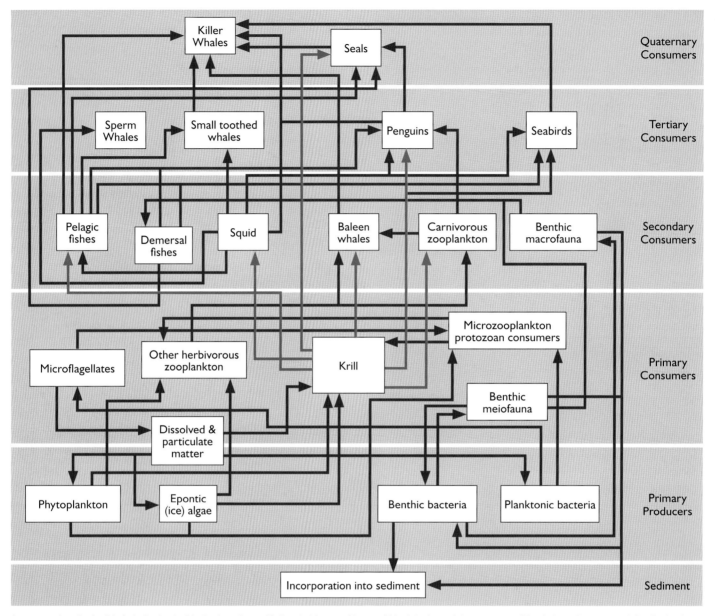

A representation of major links in the food web of the Southern Ocean. Biodiversity is in general lower at higher latitudes, and the extreme conditions in Antarctic waters results in a food web at a level of complexity that can be more easily unravelled. Even then, by no means all the links are shown here.

It is, however, important to do so in order to understand the impacts of fishing and other human activities. Krill (*Euphausia superba*) is a vital food resource within the Southern Ocean food web. In these nutrient rich waters it directly links baleen whales, Crabeater Seals and Adélie Penguins all of which feed primarily on it, with the phytoplankton and ice algae on which it itself feeds. It is also eaten by many other animals at different levels within the food web. The removal of this one animal would have dire consequences for the Southern Ocean food web.

The addition of an alien species into a food web can also have devastating consequences. A comb jelly (Ctenophora) *Mnemiopsis* accidentally introduced into the Black Sea in the 1980s caused a huge decline in fisheries because it fed voraciously on fish eggs and larvae and increased dramatically in numbers in the absence of its own predators (see also p.175).

Bacterial activity in the ocean is immensely important just as it is on land and is closely linked with food webs. Bacteria and Archaea (p.126) and protozoans (p.172) are microscopic but vital recyclers of organic material. Bacteria decompose particulate material in the water column including dead remains of plankton, nekton, faeces, moulted skin from crustaceans, mucus and other secretions and plant fragments. They are also able to absorb and use dissolved organic matter (DOM). Protozoans, dinoflagellates (p.152), foraminiferans (p.154) and other nanoplankton (p.50) consume the bacteria and are in turn eaten by larger zooplankton thus returning 'lost' nutrients to the food web.

OPEN WATER (PELAGIC ENVIRONMENTS)

Open water is the realm of drifting and swimming organisms, plankton and nekton respectively. The pelagic environment in which they live is immense and includes the whole water column from the surface to the deepest parts of the ocean. In comparison the benthic environment (p.68), encompassing the entire seafloor, provides only a fraction of the available living space. As a place to live, the sunlit surface waters and the deepsea are totally different, with contrasting physical attributes. Similarly, inshore waters differ from offshore. This is reflected in the types of plankton and nekton that live in the different zones defined by depth and distance from land. In this section plankton and nekton are described first, then the different pelagic environments, from the surface and the upper sunlit (epipelagic) to the dark deep (bathypelagic) zones. The main divisions of the entire marine environment, their physical attributes and depths are defined on pp.34–35.

Many small pelagic fishes live and move in dense shoals as a protection against predators in open water.

PLANKTON

Plankton comprises the myriad organisms that live a hidden, drifting existence suspended in the water column. They might be described as the vagrants and gypsies of the ocean, wandering with no fixed abode. Most plankton is small, at most a few centimetres long and usually much less, and even those that can swim are not powerful enough to combat ocean currents, turbulence and waves. Almost all marine phyla are represented in the plankton even if only for part of their life cycle, and whilst a powerful microscope is needed to see them alive, specialist photography is now revealing them in all their glory in publications such as Kirby (2010). Plankton is often described as the grass of the sea because the photosynthetic element of it, the phyto- plankton, underpins almost all life in the oceans. Single-celled plants, plant-like chrom- ists (p.128) and cyanobacteria are the primary producers of the ocean. Feeding on them and on each other are tiny animals, the zooplankton ranging from single-celled protozoa (p.172) to glowing comb jellies (p.174) and larval fish. The distinction between phytoplankton and zooplankton is frequently blurred because some, such as some dinoflagellates, that ingest and eat other plankton also have chloroplasts, either their own or obtained from their food, and so can photosynthesise. Although normally photosynthetic, prymnesiophytes (p.155) are occasionally found in large numbers well below the photosynthetic zone. Some very large jellyfish and the huge tubular colonies of pyrosome tunicates (p.309) which can reach 10m long, are also usually considered part of the plankton because they are weak swimmers. However, some strong swimming jellyfish might be considered to be nekton (see p.59).

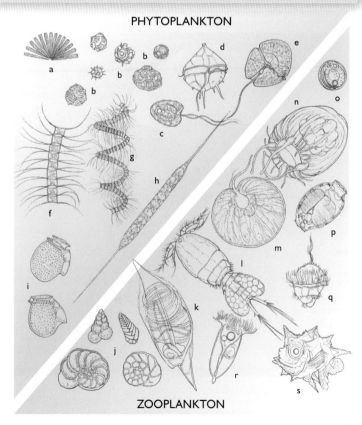

Typical representatives of phytoplankton and zooplankton. Dinoflagellates appear on both sides of the divide because many are photosynthetic and some (such as *Noctiluca*) are carnivorous. **PHYTOPLANKTON Diatoms**: (p.149) (a) *Licmophora splendida*, (f) *Chaetoceros* sp., (g) *Chaetoceros curvisetus*, (h) *Rhizosolenia setigera*. **Prymnesiophytes:** (p.155) (b) various spp., (c) *Hymenomonas roseola*. **Dinoflagellates:** (p.152) (d) *Gymnodinium breve*, (e) *Gymnodinium* sp., (i) *Dinophysis* sp. **ZOOPLANKTON Foraminiferans:** (p.154) (j) various spp. **Tunicates:** (p.309) (k) salp, (p) doliolid *Doliolum denticulatum*. **Other zooplankton:** (l) copepod (p.280) *Halicyclops magnceps*, (m) dinoflagellate *Noctiluca* sp., (n) jellyfish, (o) fish egg, (q) polychaete trocophore larva, (r) ciliate; (s) fish larva *Ranzania leavis*.

Sizing and collecting plankton

With few exceptions plankton can only be successfully studied by catching it and observing it in the laboratory. Plankton nets are designed with various mesh sizes to catch particular size classes of plankton. There is no point in clogging up a net with tiny phytoplankton if all you want to study are the larger zooplankton such as arrow worms (Chaetognatha). There are many designs of plankton nets but most consist essentially of a cone-shaped net, held open at the wide end and with a container at the narrow end to collect the concentrated plankton. Most plankton sampling is done from scientific research boats (of all sizes) with the net towed at slow speed. However, it is perfectly possible to collect plankton using a home made net pulled along either by wading through the water or from a rowing boat, or even a two-person canoe. Ladies tights with the feet cut off, a jam jar as a collector, held open with wire and towed with string can be remarkably effective. This will collect animals large enough to be seen with a hand lens or a simple low-power microscope.

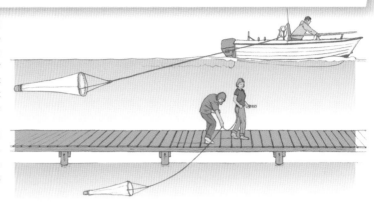

Plankton nets come in a wide variety of sizes from simple hand-held to self-closing models deployed from ships.

Size designation	Size range	Examples
Megaplankton	>20mm	Jellyfish, salps
Macroplankton	2–20mm	Comb jellies, arrow worms, euphausid shrimps
Mesoplankton	200μm–2mm	Copepods, larvaceans
Microplankton	20–200μm	Phytoplankton, rotifers, foraminiferans
Nanoplankton	2–20μm	Small flagellates, small diatoms
Picoplankton	<0.2–2μm	Bacteria, cyanobacteria

Size groups of plankton.

By their very nature jellyfish, salps, siphonophores and other gelatinous plankton are damaged when they are caught in nets. To overcome this problem marine biologists sometimes go 'bluewater diving' to collect and to observe and film these animals in their natural habitat. Within an aquarium such animals may not behave naturally since they would never normally meet any hard surfaces let alone glass walls. This is one of the reasons that aquariums find it hard to maintain jellyfish successfully. Tubular tank designs in which the water constantly rotates help prevent contact and aquarium jellyfish displays are now much commoner. Bluewater divers collect animals directly into wide-mouthed jars which are then stored in nets clipped onto a line. The divers themselves are also clipped onto safety ropes or trapezes which are attached to a surface cover boat. Working out in mid ocean in clear blue water perhaps thousands of metres above the seafloor can be disorientating and diver safety is paramount.

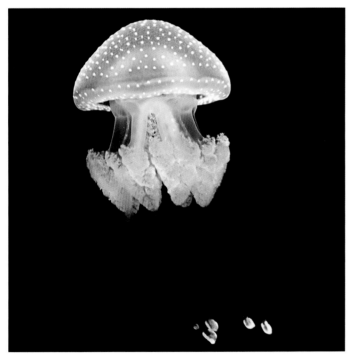

A large jellyfish such as this Spotted Jellyfish (*Phyllorhiza punctata*) might be considered either as part of the megaplankton or as part of the nekton (p.59) depending on its swimming abilities. As a juvenile it would anyway be unable to swim strongly and would be part of the plankton.

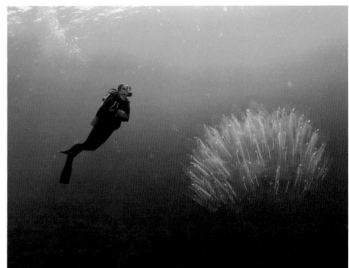

Any diver can contribute to plankton research by taking photographs of plankton that drift past them whilst they are making 'safety stops' at various levels at the end of a dive.

Marine phytoplankton

Phytoplankton comprises all those planktonic organisms capable of photosynthesis, the vast majority of which are unicellular and too small to see with the naked eye. The term 'unicellular algae' or 'unicellular plants' is often used to encompass phytoplankton but microalgae, considered as 'true' plants (Kingdom Plantae), make up only a small part of the phytoplankton. Chromists (Kingdom Chromista) and cyanobacteria (Kingdom Bacteria) make up the rest. Diatoms (p.149) are the dominant phytoplankton in many parts of the ocean, especially in temperate and high latitudes whilst dinoflagellates (p.152) and prymnesiophytes (p.155) are also important. Which groups flourish in different parts of the ocean depends partly on the availability of various chemicals, such as silica, which are incorporated into the cell walls and shells of phytoplankton.

The productivity of different parts of the ocean depends on how much phytoplankton is present. Areas rich in phytoplankton will support more zooplankton and ultimately more fish and so richer fisheries. Plankton production varies considerably with latitude and seasonally, due to varying climatic and oceanographic conditions. Phytoplankton will obviously grow better in places and at times where there is plenty of light and nutrients and in warm conditions, as is the case for plants on land. Water of course is never in short supply. In tropical waters, there is plenty of light the whole year round, but nutrients are often in short supply especially far from any coastal input from rivers and runoff. The sun heats up the upper part of the water column and a stable thermocline develops (p.27), effectively cutting off any nutrient supply from the seabed. This leads to generally low productivity except in areas of upwelling (p.52). In cold Arctic and Antarctic regions, a long-term thermocline rarely develops, storms stir the water and nutrients are plentiful. Light however, is lacking except during the short summer months, when massive plankton blooms occur. Plankton productivity is highest overall in temperate regions but shows a distinct seasonality.

During warm summer conditions a thermocline cuts off the nutrient supply and phytoplankton decline. Autumn and spring storms and cooler weather break up the thermocline releasing nutrients and leading to plankton blooms.

In warm coastal waters and with sufficient nutrients phytoplankton can 'bloom' naturally, causing the sea to turn green (see also 'red tides' p.153).

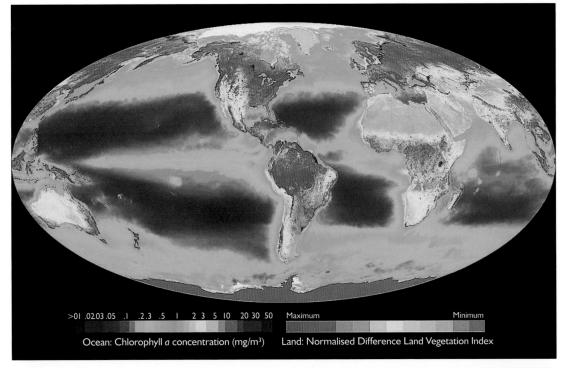

A satellite data composite image from the Sea-viewing Wide Field-of-view Sensor (SeaWiFS) Project for the year September 1997 to August 1998. It indicates the magnitude and distribution of oceanic global primary production (mg/m3 chlorophyll a), which is a reflection of the amount of phytoplankton present. Terrestrial primary production is also shown (Normalized Difference Vegetation Index).

Upwelling and nutrients

In some areas of the ocean, nutrients are brought to the surface by upwelling water currents and productivity in these areas is therefore increased. Upwelling is simply water coming to the surface from deeper depths and bringing nutrients with it. The nutrients replace those used up by phytoplankton in the surface layers and thus fuel continued phytoplankton growth. The physical oceanographic processes by which upwelling occurs are, however, quite complex and involve wind, the Coriolis effect and Ekman transport (p.28) the interplay of which results in several different types of upwelling.

Significant coastal upwelling (shown on the map on p.51) occurs along the west coasts of South America (Peru and Chile), North America (Oregon), Africa (Mauritania and Namibia) and Arabia, driven by prevailing offshore winds pushing surface water away from the coast, which is then replaced with water drawn from deeper levels (down to 100–200m) up into coastal currents. Equatorial upwelling occurs in a broad band stretching along the equator from the Americas across the Pacific and from Africa across to South America. This is caused by divergences, areas where adjacent surface currents move in opposite directions. These mid-ocean upwelling areas increase the productivity of adjacent tropical areas. Polar upwelling, caused by violent winter storms, increases the intensity of the spring plankton blooms that result as the dark winter days give way to sunlit spring ones.

The place and extent of upwelling currents are sometimes obvious from huge aggregations of seabirds and cetaceans that gather to feed on the abundant small fish that are sustained by blooms of phytoplankton and consequent explosions of zooplankton.

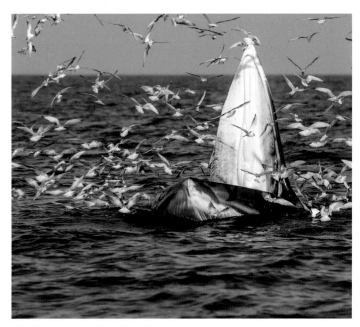

Areas of tropical upwelling support large numbers of small schooling fish on which Bryde's Whales (*Balaenoptera edeni*) feed. Seabirds take advantage of the feast as the whale lunges upwards, pushing the fish shoals towards the surface.

Marine zooplankton

Many small animals such as comb jellies (Ctenophora) (p.174) and arrow worms (Chaetognatha) (p.176) spend their whole lives as permanent members of the plankton and are termed holoplankton. However, the zooplankton also includes the eggs and larvae of bottom-living benthic animals and of free-swimming nektonic animals. These are termed temporary plankton or meroplankton. The free-floating spores of seaweeds and other benthic algae are also part of the meroplankton. One of the great detective stories of early marine biologists was to match up which planktonic larvae belonged to which adult and this process continues to this day, complicated by the fact that many benthic animals such as crabs go through several completely different larval phases. A terrestrial caterpillar lives in a different habitat and feeds on different foods from the adult butterfly, so it is not surprising that the two phases look and behave entirely differently. Likewise a larval lobster living in the plankton faces a different set of environmental conditions to the adult, and behaves and is shaped accordingly. Various adaptations for flotation, defence against predators and for feeding, has resulted in a wide variety of strange and sometimes alien-like body forms. Evolutionary relationships between different marine phyla can often be elucidated by reference to their larval stages. For example, the trochophore larva of gastropods is remarkably similar to that of polychaete worms.

Almost any plankton haul taken anywhere in the ocean is likely to contain copepods (Copepoda) and probably euphausid shrimps (Euphausiacea) as well. These, along with a miscellany of other tiny crustaceans are the numerically dominant members of the permanent holoplankton and are a vital component in the open ocean food web. Even humans are now exploiting them in the form of krill (p.271) from the Southern Ocean. These herbivores graze on phytoplankton and in their turn are preyed upon by carnivorous holoplankton including comb jellies (Ctenophora), arrow worms (Chaetognatha), medusae (Cnidaria), hyperiid amphipods and pteropods (Mollusca). If we could scale everything up by many orders of magnitude, we would see action amongst the holoplankton every bit as dramatic as watching a killer whale eating a seal.

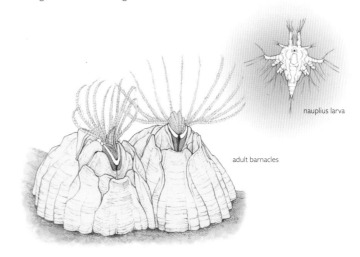

Early naturalists understandably thought that barnacles, with their hard encasing shells, were molluscs. It was only when the connection between the nauplius larva and the adult barnacle was made that it was realised that they are crustaceans.

MACROFAUNAL HOLOPLANKTON TAXA

Holoplankton are those organisms that spend their entire life cycle as part of the drifting plankton. Some examples of holozooplankton (animals) are shown here.

Arrow worms (Chaetognatha) (p.176)

Parasagitta elegans

All arrow worms are planktonic except for one genus. *Parasagitta elegans* is a typical boreal arrow worm and is the dominant species in continental shelf waters of the Arctic and subarctic. It is an important link in the food chain between the copepods that it eats and the small fish that eat it.

Comb jellies (Ctenophora) (p.174)

Bolinopsis infundibulum

Almost all comb jellies are planktonic. This large (up to 15cm) but delicate species is common and can be very abundant in the North Atlantic and Mediterranean. It feeds by engulfing its prey using lobes that surround the mouth and are nearly as long as the rest of its body.

Jellyfish (Cnidaria: Scyphozoa) (p.195)

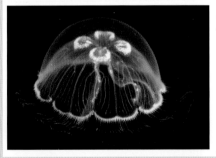

Moon Jellyfish *Aurelia aurita*

All true jellyfish are planktonic as 'adults'. However, some species, including the Moon Jellyfish, do have a tiny and transient fixed polyp stage. In this respect such species are not truly holoplankton but are usually considered as such because almost all their life is spent in the plankton. This is perhaps the most common of all jellyfish and is found worldwide.

Polychaete worms (Annelida: Polychaeta) (p.211)

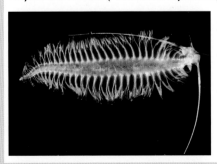

Tomopteris sp.

With a flattened body just a few centimetres long, this genus of worms is well-suited to a floating existence in surface and near-surface waters. Long feelers help the worms to detect food. Only a few polychaete worms live permanently like this in the plankton, but many others have planktonic larvae.

Copepods (Arthropoda: Copepoda) (p.280)

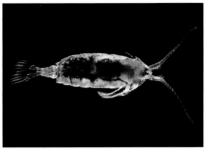

Anomalocera patersoni

Copepods are tiny but vitally important crustaceans, the majority of which are planktonic and form an important lower link in the open ocean food chain. Just the size of a grain of rice, they are as important in the ocean food web as rice is to us on land. This N Atlantic species, amongst many others, is fed on by Atlantic Mackerel (*Scomber scombrus*).

Euphausid shrimps (Arthropoda: Euphausiacea) (p.270)

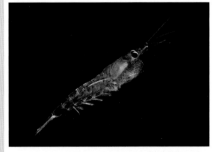

Northern Krill
Meganyctiphanes norvegica

This is the North Atlantic equivalent of Antarctic Krill and fulfils a similar function as a food source for fish, cetaceans and seabirds. Euphausids are all planktonic and are a vital food resource for many vertebrate predators.

Gastropod molluscs (Mollusca: Gastropoda) (p.230)

Limacina helicina

This small sea snail up to 1.5cm long feeds on small zooplankton and can be very abundant in Arctic waters. It floats and swims by means of two large flaps (parapodia) derived from the foot and its shell is very light. Few other molluscs live permanently in the plankton but many have planktonic larvae.

Tunicates (Chordata: Tunicata) (p.307)

Salpa thompsoni

Two of the four tunicate classes, Appendicularia and Thaliacea are planktonic. Salps, such as the one shown here, are a very common group of planktonic tunicates. They float through the ocean looking like small, bobbing barrels up to about a centimetre long. Some species occur in clumps or long chains of individuals.

MEROZOOPLANKTON (LARVAE)

The larval types of major phyla are shown here. The number of different larval stages varies widely between taxa, sometimes even between closely related species, and only common types are illustrated here. Some species have benthic larvae which are not included here. Larvae can be long-lived (planktotrophic) in which case they must feed, or short-lived (lecithotrophic), metamorphosing before their yolk supply is used up.

Sponges (Porifera)

Parenchymula larva
Several types but all are basically a solid ball of cells with an outer covering of cells equipped with flagella for swimming.

Cnidarians (Cnidaria)

Planula larva
Found in all classes of Cnidaria except box jellyfish (Cubozoa). Planulae of stalked jellyfish (Staurozoa) do not swim. Some hydroids have an actinula larva.

Polychaete worms (Annelida: Polychaeta)

Trochophore larva
Trochophores swim using a girdle of cilia (prototroch) around the widest part of the body. They feed from an early stage.

Molluscs (Mollusca)

Chitons, some gastropods and some bivalves have a trochophore as the first, short larval stage. This develops into a veliger larva, the typical larva of most molluscs.

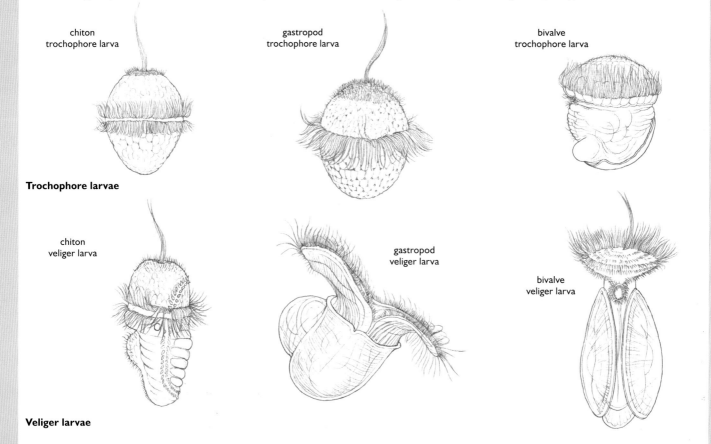

Crustaceans (Crustacea)
The diversity of crustaceans is reflected in the variety of their larvae and the various stages they go through but all have typical jointed limbs.

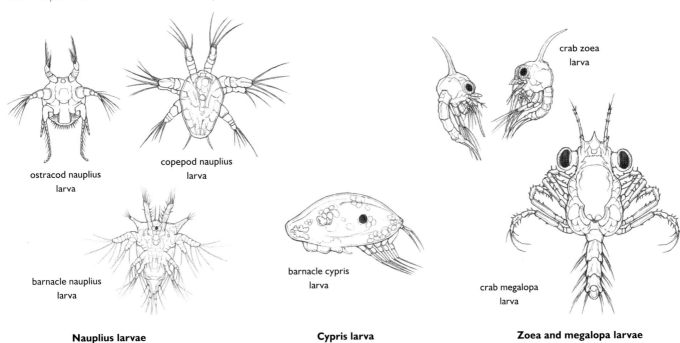

Nauplius larvae — ostracod nauplius larva, copepod nauplius larva, barnacle nauplius larva

Cypris larva — barnacle cypris larva

Zoea and megalopa larvae — crab zoea larva, crab megalopa larva

Echinoderms (Echinodermata)
Echinoderm larval types are fundamentally different from those of polychaetes and molluscs, reflecting their separate evolutionary branches. Whilst the basic early larva (dipleura) is quite similar in echinoderms, each class then develops through its own later variants.

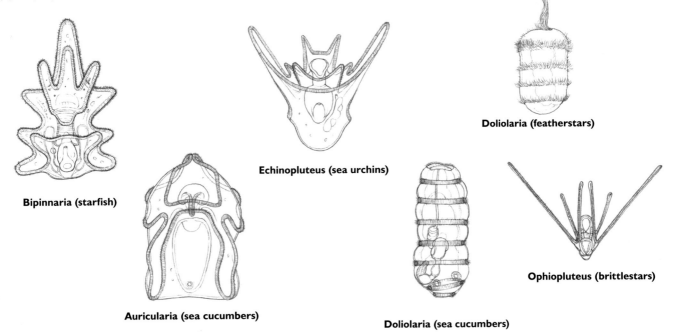

Bipinnaria (starfish)

Echinopluteus (sea urchins)

Doliolaria (featherstars)

Auricularia (sea cucumbers)

Doliolaria (sea cucumbers)

Ophiopluteus (brittlestars)

Bryozoans (Bryozoa)

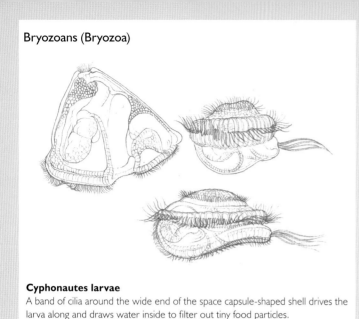

Cyphonautes larvae
A band of cilia around the wide end of the space capsule-shaped shell drives the larva along and draws water inside to filter out tiny food particles.

Sea squirts (Tunicata)

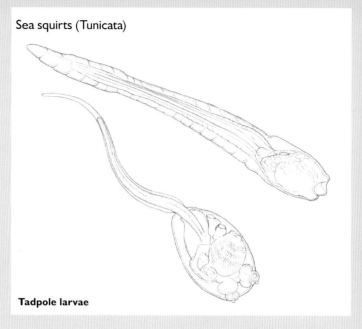

Tadpole larvae

Plankton and climate change

Regular and repeat sampling of plankton populations over a period of time can provide useful data on the general health of the oceans, changes in established current strength, and extent and the effects of global warming. The species makeup of plankton populations varies geographically, sometimes on a very local scale and also seasonally. In the UK a Continuous Plankton Recorder survey (CPR) has taken place in the North Atlantic almost every year since its inception in 1931 and continues today, currently under the aegis of the Sir Alister Hardy Foundation for Ocean Science (SAHFOS). The survey uses an instrument that can be towed by normal commercial ships such as ferries and cargo ships at minimal cost as they go about their business.

These long term datasets are now showing up changes in the abundance and distribution of plankton that are coincident with observed changes in sea surface temperature. Global sea surface temperatures are about 1°C higher than they were 140 years ago and the rate of increase has accelerated in the past 25 years or so. In the NE Atlantic certain copepod species such as *Corycaeus anglicus*, that prefer warm southern water, have extended their range northwards by about 1,200km during the period from 1960–2005 (Kirby 2010). Other species that live in cold water have retreated further north. Shifts in plankton distribution affect the whole marine food web. A reduction in breeding success of Atlantic Puffins (*Fratercula arctica*) around Great Britain has been attributed to a lack of sandeels, a vital part of their diet. There is evidence that sandeels are moving further north following their copepod prey. Other factors may also be involved in puffin decline but it is certain that, as plankton populations shift, then there will be consequent shifts further up the food chain.

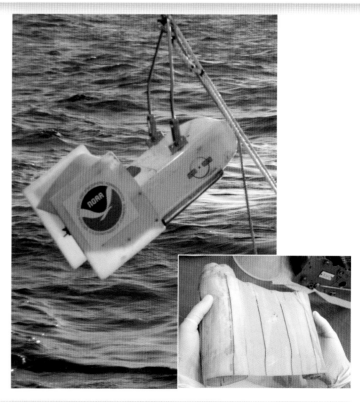

A continuous plankton recorder used by NOAA (National Oceanic and Atmospheric Administration) to provide ongoing data on plankton communities in the North Pacific. The plankton collects on a roll of silk mesh (inset).

NEKTON

If you eat a herring, you are eating nekton and if you go whale-watching then you are watching nekton. In contrast to planktonic organisms which float freely at the whim of waves and currents, nektonic animals are in charge of their own destiny. Nekton comprises the more powerful swimming animals found in the pelagic environment, which essentially means vertebrates and cephalopods. Fish, whales, dolphins, seals, turtles, some sea snakes and squid are all nektonic animals. Of these, fish make up by far the largest number. Seabirds such as albatrosses that spend their whole lives out at sea are sometimes included as nekton and could therefore be described as surface nekton. However, the term nekton is more usually restricted to animals swimming in the ocean. Nektonic fish and squid make up a majority of the world's fisheries. Many of these live in large shoals for protection which makes them easier to find and catch, especially those living near the surface in the epipelagic region.

All but the strongest swimmers are occasionally caught out and washed ashore like this stranded Sunfish (*Mola mola*). Sometimes nektonic animals are carried far outside their normal distribution by storms and strong currents.

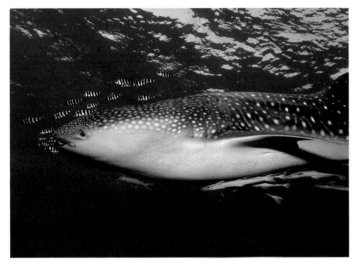

Out in the wide open ocean the little Pilotfish (*Naucrates ductor*) associates with the Whale Shark (*Rhincodon typus*) and other large nektonic fish and turtles. By swimming next to the shark's head it can 'slipstream' and save energy.

such as Sailfish (*Istiophorus platypterus*) and even giant squid (*Architeuthis dux*) start life as planktonic eggs and larvae drifting at the mercy of ocean currents, but later become nektonic. Their body shape as a larva or juvenile and as an adult may be very different to suit a drifting versus an active swimming lifestyle. However, many of the sleekest and most powerful species have a remarkably similar body shape and design in spite of belonging to totally different vertebrate classes. A typical tuna, dolphin and shark are all streamlined for efficient swimming with an approximately torpedo-shaped body, powerful tail and slim, curved pectoral fins/flippers. Even birds and pinnipeds that hunt fish underwater, such as penguins and the sealions assume pretty much the same shape whilst swimming in search of their prey. Two hundred million years ago, similarly-shaped giant marine reptiles known as ichthyosaurs roamed the oceans.

Not all pelagic animals can be clearly defined as either nekton or plankton. A purist definition of plankton might include only those animals that are so small that the viscosity of the water limits their ability to move within it. However, whilst euphausid shrimps (Euphausiacea) such as Antarctic Krill (*Euphausia superba*) grow up to about 5cm long and can swim, they are limited in their ability to control where they go and are usually considered as large plankton. The same applies to jellyfish which are mostly weak swimmers though as they outgrow their planktonic stage, some become large and powerful enough to swim wherever they want to. *Chironex fleckeri*, the most notorious of all box jellyfish, can swim at speeds of over a knot and has eyes and a nervous system capable of directing it from one place to another, and as an adult is certainly classed as nektonic. Nomura's Jellyfish (*Nemopilema nomurai*), found in the China Sea and Yellow Sea, is much bigger and can grow to 2m across the bell and a weight of around 200kg. Several other jellyfish can certainly reach this size but these huge animals are not strong swimmers and should probably still be classed as plankton.

Nektonic animals may be able to swim wherever they want to go (within limits) but many still drift with water currents using them to their advantage to travel long distances whilst on migration (see below). Large and powerful nektonic animals

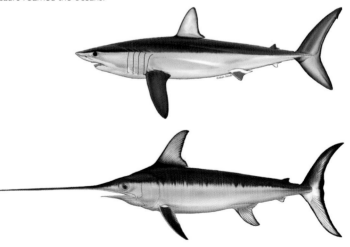

There is a remarkable similarity in general shape, tail shape and positioning of the other fins between the Shortfin Mako (*Isurus oxyrinchus*) (above) and Swordfish (*Xiphias gladius*) (below). This is a result of convergent evolution, driven by the similar lifestyles of these very different animals.

OPEN WATER

Migration

With the ability to live in open water and to swim actively from one point to another, nektonic animals are in an excellent position to undertake extensive migrations. Many sharks, ray-finned (bony) fish, cetaceans and of course seabirds, have been tagged, ringed and tracked, and shown to make ocean-wide journeys. Migration is usually seasonal and often to and from annual breeding and feeding grounds. Whilst requiring a lot of energy and exposing the migrants to some considerable risks from weather and predators, such journeys allow these animals to make the best use of different areas for specific purposes. A breeding area safe from predators and with temperature and an environment suitable for rearing young, is the driving force behind many migrations. Some whales and birds undertake such migrations without feeding and so must first build up sufficient fat reserves for the journey. Going with prevailing currents minimises energy expenditure, but may necessitate a longer circular journey. Migratory fish such as the Blue Shark (*Prionace glauca*) make use of ocean gyres in this way. Counter currents often run in different or opposite directions near the surface and at depth, especially along coastlines. By adjusting their travel depth fish can take advantage of this, rather like aeroplanes saving time (and fuel) flying high with the jet stream.

Not all marine animal migrations involve vast distances or very precise routes and times. Neither need the whole population of a particular species be involved. Green Turtles (*Chelonia mydas*) wander far and wide and there are major breeding sites throughout the tropics and subtropics. However, once mature, individual turtles

The ability of salmon to find their way back from the ocean to the river where they were hatched is legendary.

migrate many hundreds or even thousands of miles to lay their eggs at the site where they themselves were hatched (p.408). The spawning grounds of many ray-finned fishes with floating eggs and larvae are often inshore in areas of high plankton productivity. This applies even to offshore oceanic species, many of which migrate inshore to spawn. The newly hatched young then have access to a plentiful food supply and in many cases the larvae drift into protected nursery areas such as bays and estuaries. When they reach a certain size the young fish migrate further offshore to join the adult populations. Blue Whale (*Balaenoptera musculus*) and Humpback Whale (*Megaptera novaeangliae*) need enormous quantities of food and are amongst a number that migrate to polar regions, especially around Antarctica, to feed on spring and summer blooms of krill (Euphasiacea). They move to more clement but food-poor tropical and subtropical waters in the winter and survive on their body fat reserves. This is also where their calves are born.

The ways by which migrating animals find their way is the subject of many books and there is still a huge amount to be learnt, not least in the ocean. Whilst some aspects are innate, such as night time hatchling turtles heading towards light, many marine animals have developed sophisticated means of navigation. That some can detect and use the Earth's magnetic field has been shown experimentally in birds, sharks, ray-finned fishes and turtles. This works both underwater and above it. Astronomical clues from sun, moon and stars are another important means for air-breathing marine vertebrates that must anyway surface to breathe. Salmon are renowned for their ability to 'imprint' chemical cues at birth and return to the rivers where they hatched. Current flow and water temperature provide other clues.

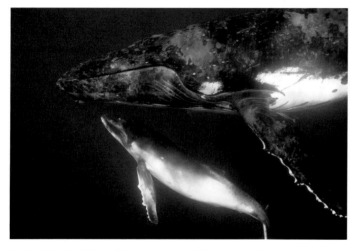

In winter, Humpback Whales (*Megaptera novaeangliae*) journey to low latitude warm waters such as around Hawaii, to give birth.

Species	Route and distances (round trip)
Blue Shark (*Prionace glauca*)	Trans-Atlantic (p.338)
Albacore (*Thunnus alalunga*)	Trans-Atlantic and trans-Pacific
South African Pilchard (*Sardinops sagax*)	May to July 'sardine run' with seasonal cold current north along E coast of South Africa
European Eel (*Anguilla anguilla*)	Europe to Sargasso Sea (p.376); 3,000 km
Grey Whale (*Eschrichtius robustus*)	Arctic summer feeding; Baja California winter mating and calving; 18,000 km
Arctic Tern (*Sterna paradisaea*)	Arctic summer breeding; Southern Ocean winter feeding (southern summer); 70,000 km (p.463)

Migration routes of some marine animals.

INVERTEBRATE NEKTON

Most nektonic animals are vertebrates but a few groups of invertebrates are good enough swimmers to be classed as nekton and examples of these are illustrated here.

Jellyfish (Cnidaria: Scyphozoa) (p.195)

The majority of jellyfish are relatively small, weak swimmers and are treated as large plankton, but some species are big or powerful enough to behave more like nektonic animals. The well-known Box Jellyfish (*Chironex fleckeri*) illustrated on p.199 is a good example which, whilst only medium in size, is a powerful and directional swimmer.

Cyanea capillata

Features With a bell that often reaches 1m across and occasional giants that reach 2m, this jellyfish is much bigger than many nektonic fishes. Contractions of its large bell propel it along in a slow, ponderous fashion but it drifts with the currents just as small plankton animals do. It appears to catch its prey (including small fish and other jellyfish) by chance encounter with its long tentacles rather than by purposeful swimming.
Size 1m across bell.

Crustaceans (Arthropoda: Crustacea) (p.264)

Most crustaceans are benthic animals such as decapod crabs that live on and in the seabed or tiny planktonic animals such as copepods. Shrimp-like animals such as mysids (Mycidacea) and Euphausids (Euphausiacea) grow up to a few centimetres long and can occur in vast swarms, and are usually considered as plankton rather than nekton. Just a few decapod crustaceans live a truly pelagic existence and are large enough to be considered as nekton.

Red Tuna Crab *Pleuroncodes planipes*

Features Tuna crabs are a species of squat lobster, most of which are benthic and live tucked away in rocky crevices. In contrast this species spends the first one or two years of life swimming, both horizontally and vertically and is large enough to be considered as nekton. However, the crabs also drift and are periodically washed ashore in huge numbers along the Californian coast, and can also be seen swarming at the surface. Larger and older adults live in deeper water on the seabed.
Size Up to 13cm.

Cephalopods (Mollusca: Cephalopoda) (p.246)

Most cephalopods are nektonic animals, squid indisputably so, and even the smallest species swim well by ejecting water forcibly from their siphon. Cuttlefish are more sedate but swim in a similar way. Octopuses spend most of their time on the seabed and are benthic with the exception of about 50 species in the suborder Cirrata (order Octopoda).

Dumbo octopus *Grimpoteuthis* spp.

Features Named for their ear-like fins situated just behind their eyes, dumbo octopus live in deep water below about 3,000m. They swim by slow graceful up and down movements of their fins rather than by jet propulsion. A wide web between the arms combined with their fin movements means they can hover effortlessly above the seabed looking for small animals to eat. Little is known of the 17 or so species, which is not surprising given their deepsea habitat.
Size Up to 1.8m, usually smaller.

THE SURFACE

Organisms living at the very surface of the ocean are exposed to environmental extremes in the same way that intertidal species are. Heavy rain can temporarily dilute surface layers, something taken advantage of by the truly pelagic sea snake *Pelamis platurus* (p.453) which will drink at such times (p.464). Strong sun and powerful ultraviolet light present further challenges whilst storm waves can disperse and damage floating animals. The latter, plus cold temperatures, may be the reason why there are more surface-living, pelagic animals in tropical regions than in temperate, and few if any in polar regions. Surface-living animals are also exposed to predation from above (by birds and turtles) and below (by fish and predatory invertebrates).

Surface living

Most people have seen or heard of pond skaters or water striders (Gerridae) which, together with a few spiders, can walk on water. These insects are able to support their weight on the water surface using the surface tension. Sailfin lizards (*Hydrosaurus* spp.) can sprint to safety running over the surface of rainforest pools for several metres before sinking and swimming the rest of the way. The ocean surface is rarely still enough for either of these tricks but there are a few organisms that spend their lives floating on the surface and these are collectively known as marine neuston. Sea skaters (*Halobates* spp.) are insects belonging to the same family as pond skaters and are commonly found in coastal habitats. Around five species are truly pelagic, living out at sea, feeding on plankton and laying their eggs on floating seaweed and other debris. Theirs is a precarious existence because they cannot survive underwater and their wingless state means they cannot fly away.

Also held by surface tension are films of bacteria and a look at surface scum under a powerful microscope will reveal a concentration of bacteria and micro-organisms. The scum contains organic material on which the bacteria feed and they in turn are eaten by micro-organisms such as Protozoa (p.172). Nowadays such samples are also likely to reveal tiny particles and pellets of plastic, which may provide a home for bacteria but are a real problem for fish and birds that mistake them for plankton.

Were a sailing boat to be considered as part of the ocean surface ecosystem then it would technically be part, not of the neuston but of another ecological grouping, the pleuston. The boat floats on the surface with its sails, spars and part of the hull projecting up into the air and the rest of the hull and its keel lying beneath the water.

Tiny blue-grey insects floating on the surface of rock pools and saltmarsh pools around the world are likely to be *Anurida maritima*. These small wingless relatives of true insects (p.284) are collembolans or springtails (Collembola), an abundant and widespread group of mostly terrestrial species. Unlike *Halobates* (see text left), they cannot live out at sea and are restricted to intertidal habitats.

Many drifting animals follow this lifestyle, a well-known example being the Portuguese Man-of-War (*Physalia physalis*) (p.220). A gas-filled float projecting above the water surface acts as a sail whilst the long trailing tentacles below act as a stabilising keel as well as capturing food.

To these animals, drifting over long distances is an advantage as it increases their feeding opportunities. In contrast the nudibranch mollusc *Glaucus atlanticus*, which feeds on *Physalia* and *Velella*, needs to be able to float to find its prey but once it has, it does not want to be blown away by the wind. Instead of a float or sail it has a flattened body and projecting finger-like cerata that allow it to float upside down, held just underwater by the surface tension. It also holds air in its stomach, one reason that it floats upside down. As it eats its victim, *Glaucus* stores the stinging nematocysts it ingests in special sacs at the tips of its cerata. This provides it with second-hand protection from predators and in spite of its small size (3cm) it can inflict a painful sting on bathers. Another ingenious method for floating at the surface is demonstrated by *Janthina*, a genus of marine gastropod snails often called violet snails, which produces a float by 'blowing bubbles'. The bubbles are actually formed from mucus secreted by the foot with air incorporated into it. This forms a stable raft onto which the snail clings. This species is also predatory and feeds mainly on *Velella*.

Neuston and pleuston both describe organisms that live on and just below the ocean surface and in practice the distinction between them is subtle and the organisms are exposed to essentially the same physical conditions. Neuston is carried along mostly by waves and currents whilst pleuston takes advantage of the wind.

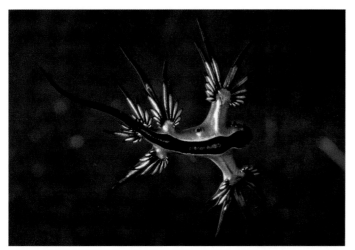

The blue colour of the pelagic nudibranch *Glaucus atlanticus* and many other pleustonic animals is an effective camouflage in clear blue water and may also provide protection from strong ultra-violet light.

Some other animals breach the interface between air and water but are not considered to be part of the neuston or pleuston since they are not restricted to a floating existence. Flying fish (Exocoetidae) (p.413) propel themselves up out of the water and into the air to escape from predators but are essentially nektonic animals (p.57). Many seabird species spend almost their whole lives out at sea. The sea surface is their home and here they sleep, preen and even mate in between feeding forays, only coming ashore for any length of time during the breeding season. Some of these seabirds known as skimmers (p.475) are specifically adapted to feed on the accumulation of neuston at the water surface, which also includes buoyant eggs of fish such as anchovy.

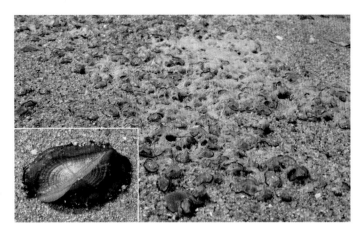

Mass strandings of the By-the-wind Sailor (*Velella velella*) are a regular occurrence, carried ashore by strong winds acting on the stiff sail-like extension of their float. The sail is oriented obliquely to the left or right of the long axis of the float and the animal drifts at 45° to the prevailing wind. This ensures a wide dispersal but also prevents all individuals in an area from stranding during a storm.

Floating communities

Drifting logs, coconut palm branches and nuts and nowadays a variety of rubbish can all develop their own mini-communities around and on them. Seaweed and algae spores and fragments and goose barnacle (p.305) larvae settle and grow on large logs and, in their turn, attract crustaceans, worms and fish. Seabirds resting on the logs add nutrients from their droppings, which help the seaweeds to flourish. Some fish associate with drifting debris, including the Unicorn Leatherjacket (*Aluterus monoceros*) and Oceanic Pufferfish (*Lagocephalus lagocephalus*), and consequently are distributed almost globally. These temporary habitats eventually get washed ashore or break up and sink, but an enduring floating community exists in the Sargasso Sea. This area, roughly south and east of Bermuda, is delimited not by physical coastlines but by the swirling, ocean currents that make up the North Atlantic gyre. The relatively still waters and warmth within this part of the gyre allows a floating forest of *Sargassum* seaweed to grow, buoyed up by gas bladders.

A wide variety of invertebrates including cnidarians, worms, crustaceans, molluscs, echinoderms and bryozoans are associated with the seaweed, along with over 100 species of fish though many of these are temporary visitors. Whilst many of them are

Species
Sargassum Anemone (*Anemonia sargassensis*)
Platyhelminth (*Hoploplana grubei*)
Sargassum Crab (*Planes minutes*)
Shrimp (*Latreutes fucorum*)
Amphipod (*Sunampithoe pelagica*)
Amphipod (*Biancolina brassicacephala*)
Sargassum Snail (*Litiopa melanostoma*)
Sargassum Slug (*Scyllea pelagica*)
Sargassum Pipefish (*Syngnathus pelagicus*)
Sargassum Anglerfish (*Histrio histrio*)

Species endemic to the floating *Sargassum* community in the Sargasso Sea.

benthic species whose larvae have settled amongst the seaweed and epiphytic species of barnacles, bryozoans and algae, all of which are also found in other habitats, there are also species that are endemic and found nowhere else. The seaweed provides a home to small and young open water fish and there is some evidence that hatchling Loggerhead Turtles may spend at least part of their vulnerable first year there. Commercially important fish such as Blue Marlin and Bluefin Tuna use the area as feeding grounds. Large, dense rafts of *Sargassum* are used by seabirds including shearwaters and tropicbirds, as safe roosts and foraging areas.

The floating *Sargassum* seaweed is made up of two main species *S. natans* and to a much lesser extent, *S. fluitans*. Neither of these two brown seaweeds ever live as attached forms. The seaweed provides the structural habitat for the other members of the community just as kelp does in a kelp forest (p.99). However, whilst it is always there, the amount and distribution of the seaweed varies from small patches to large rafts and long windblown lines. Gower and King (2008) used satellite images to track the movements of floating *Sargassum* seaweed and concluded that it grows strongly in the Gulf of Mexico in spring each year, is moved out on ocean currents and into the Atlantic in July, ending up NE of the Bahamas by February of the next year. Their data suggests that most of the *Sargassum* in the Sargasso Sea has a lifespan of only about a year. Continuing work is showing up additional patterns but a substantial input of *Sargassum* from outside the relatively nutrient-poor Sargasso Sea area certainly makes sense.

The Sargassum Frogfish (*Histrio histrio*) is camouflaged by its colour and skin flaps to resemble the sargassum weed amongst which it lives. Many of the other endemic animals are similarly camouflaged.

THE SUNLIT (EPIPELAGIC) ZONE

The epipelagic zone (p.34) extends from immediately below the surface down to about 200m depth. The definition is really one of light rather than an absolute depth, since in turbid coastal areas darkness will prevail at a shallower depth than it will out in clear oceanic water. The relatively shallow waters lying above the continental shelf (p.36) around each continent and major islands fall almost entirely within this zone. These coastal epipelagic waters are not only well-lit but also nutrient-rich and provide ideal conditions for phytoplankton (p.51) to flourish. Consequently they also teem with zooplankton, fish and other marine life. Out in mid-ocean, a lack of nutrients restricts phytoplankton growth and consequently the abundance of fish and other animals ultimately dependent on its productivity. The number of different species of epipelagic fishes and squid living out in the true open ocean is much smaller than in coastal waters. Commercial pelagic fisheries are therefore concentrated over continental shelf waters, and it is within these waters that nations declare their exclusive economic zones.

Adaptations

Living in a well-lit environment makes hunting much easier for visual predators but life much more difficult for prey species. With nowhere to hide, camouflage becomes all important. Many of the small planktonic invertebrates that thrive in this zone have bodies that are almost transparent. See-though jellyfish, salps (tunicates) and small crustaceans are common and many fish larvae are also virtually transparent, only their gut contents giving them away. Similar species living in the dark mesopelagic and bathypelagic zones would derive no benefit from being transparent and most jellyfish and shrimps living there are dark in colour. With their mineral skeleton, dense musculature and relatively large size, fish and other vertebrates are rarely transparent.

If you have ever wondered why most of the pelagic fish we eat, such as herring, sprat, and mackerel, have dark backs, pale bellies and live in shoals, then it is for the same reason, i.e. camouflage. Having a dark back and a pale underside makes it more difficult to be seen from above and below respectively, a system called counter-illumination. Predators use the same ploy both to hide from their own predators and to approach their prey unseen. Look up at a shark in an aquarium and you will see that most will have a pale belly. Living in vast shoals provides protection from predators (see p.317).

Driving a noisy motorboat through clear waters sometimes results in a 'rain' of small fish which flow up, out and back into the water in a silvery stream. Epipelagic fishes living near the surface use this behaviour to confuse their predators by disappearing briefly into thin air. To the fish, boat vibrations suggest an immense predator coming their way. Flying fish (p.386) and flying squid (p.247) take this to extremes and can glide for many metres above the ocean surface.

Pelagic organisms at any depth face the problem of maintaining their position in the water column without expending undue energy. Living in the top few hundred metres of water provides a particular challenge to diving mammals and birds, and to fish with gas-filled swim bladders. Changes in pressure (p.23) will affect lungs and swim bladders (p.360) alike, with the greatest relative changes being in the first ten metres where pressure doubles and gas volume therefore halves. Diving mammals have special adaptations to overcome this (p.419). Coming up fast from depth to escape a predator or on the end of a fishing line can cause a fish's swim bladder to expand and push the gut out through the mouth. Catch a shark or a benthic fish with no swim bladder and this does not happen. Nor does it happen in herrings and related fish, where the swim bladder connects with the gut and gas can be released more easily.

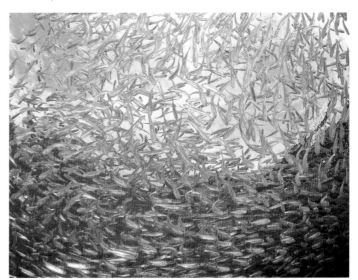

Small fish in open water often associate with large jellyfish. They will similarly gather around inanimate objects but stinging jellyfish provide better protection. The juveniles of some fishes specifically associate with particular jellyfish.

Seen from below, these silvery, semi-transparent young fish merge with the background and are more difficult for a predator to spot.

THE TWILIGHT (MESOPELAGIC) ZONE

Between the obviously sunlit epipelagic zone and the obviously dark bathypelagic zone is a region where, whilst it might seem pretty dark to us, detectable light still remains. This is the mesopelagic zone (p.34), extending from around 200m to 1,000m depth. At anything from 200m to 800m we cannot see any surface light at all but fish are far more sensitive and can detect light to between 700m and 1,300m. Animals living in this region can still be herbivores because they can move up into the phytoplankton-rich epipelagic zone to feed. Many do this on a regular basis, a phenomenon called diel migration and described below. However, most mesopelagic animals are carnivores and feed on each other or eat the rain of dead material that descends from above and is still plentiful in this zone. The commonest fishes found in this region are lanternfish (Myctophiformes) and dragonfishes (Stomiiformes).

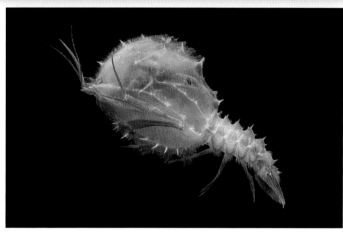

The larvae of many deepwater benthic (bottom-living) crustaceans, such as this *Stereomastis* sp., live as plankton in the mesopelagic zone. At these depths their red colour renders them effectively invisible.

Adaptations

Animals living in the lower levels of the mesopelagic zone may have to contend with abnormally low oxygen levels. Oxygen levels are at their lowest between about 700m and 1,000m in many parts of the ocean. This oxygen minimum layer (see p.24) results from a complex interaction of physical and biological processes including an accumulation of particulate detritus. Bacteria and zooplankton feed on this and can be abundant along with fish and shrimp that have evolved physiological adaptations to cope with low oxygen levels.

Mesopelagic shrimps and prawns living below about 500m are almost universally red, a colour that does not show up in the dim blue-green light that penetrates to these depths. Hatchet fish (Sternoptychidae) and lanternfish (Myctophidae) have silvery sides and scales that reflect surface light, and also have bioluminescent light organs on their bellies. This acts as an effective camouflage. Many mesopelagic fishes have large eyes with pigments that are most sensitive to wavelengths around 470nm, seen by us as blue. Bioluminescent light (p.66) produced by many mesopelagic and bathypelagic fishes and squid is also essentially blue. The strange elongated tubular eyes of the Barrel-eye (*Opisthoprotus soleatus*) increases its sensitivity to light and its binocular vision.

In contrast to most bathypelagic fishes which do not have swim bladders, many mesopelagic fishes do. Perhaps the main reason is that many species migrate vertically each day (see below) and so need to be able to adjust their buoyancy.

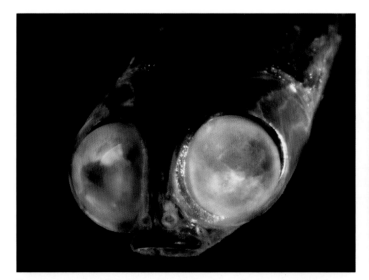

The eyes of many mesopelagic fishes are large and may have a diameter as much as half or more of the head length. This is a species of pencil smelt, *Xenophthalmichthys danae*.

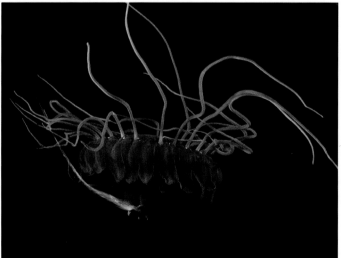

Like many other mesopelagic jellyfish, *Atolla manubrium* is predominantly red, a colour that does not show up in deep, poorly-lit water.

Diel Vertical Migration (DVM)

Most truly bathypelagic animals living below the 1,000m mark spend their lives within a relatively narrow depth range and rely on the meagre resources available to them. This, however, is not true for a great many mesopelagic (p.34) animals living in the so-called twilight zone between about 200 and 1,000m depth. Whilst it would already appear to us to be completely dark even by 200m depth, many marine animals have a much greater light sensitivity and can distinguish night from day to at least 1,000m in clear waters. Using this ability and others, huge numbers of animals from siphonophores to fish and shrimp, migrate up towards the surface as darkness falls, and migrate back down again at dawn. This mass movement, known as diel vertical migration, shows up on echosounders as 'false bottoms' known as deep scattering layers (DSLs) which change position over 24 hours.

Finding out the details of each species migration in terms of scale, timing, depth and seasonality is very difficult and involves complex sampling strategies. For this reason the record of which species do what, where and how is very incomplete. Over the years some general patterns have emerged. Bathypelagic species rarely undertake DVM for obvious reasons but a great many of the planktonic and nektonic animals living above 1,000m in the mesopelagic and epipelagic zones do so. Whether every individual does so every night is another question. Some estimates suggest as many as 40–50% of animals within these two zones may migrate in some areas, with the important exception of polar regions where the phenomenon is rarely observed. Again this is not surprising because at these latitudes it can be perpetually night or day for months on end. Unsurprisingly the vertical distance travelled is proportional to size. A tiny copepod 2mm long might travel up to the surface from 20m down, whilst the 5cm long shrimp *Systellaspis debilis* is known to cover at least 500m.

The most likely and most widely accepted explanation for DVM is as a response to food availability and avoidance of predators. There is a great deal more food (biomass) available in surface layers of the ocean than in deeper layers. Herbivorous species such as copepods, must spend time near the surface because that is where their food, phytoplankton, is found. Phytoplankton needs high light levels for efficient photosynthesis and is most abundant in the brightly lit region near to the surface. Copepods will therefore concentrate in these upper layers to graze on them. However, if they were to stay there during daylight then visual predators such as shrimp and small fish would be able to feast on this concentration of their prey. By swimming down to deeper levels and dispersing, predation pressures are reduced. The same applies to the shrimp and small fish whose larger predators may follow them up. This is a simplistic view of what is obviously a very complex phenomenon.

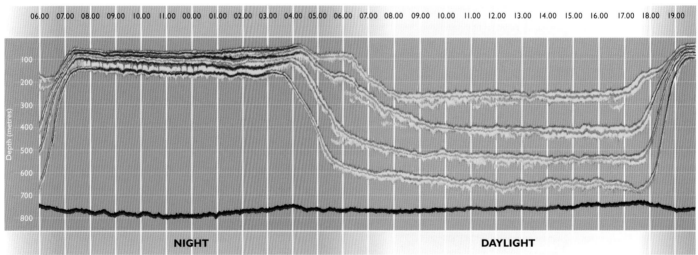

Hypothetical sonar trace over a 24-hour period showing the diurnal vertical migration of plankton and nekton.

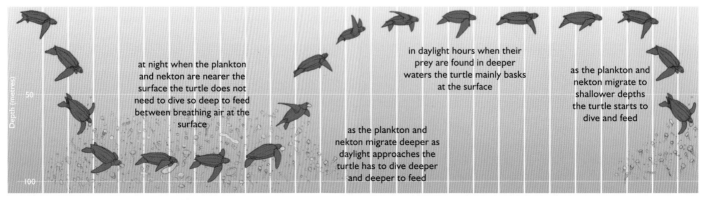

The diurnal feeding cycle of a Leatherback Turtle (*Caretta caretta*).

THE DARK (BATHYPELAGIC) ZONES

As air-breathing, warm-blooded, terrestrial mammals, it seems to us almost impossible that anything could live in a pitch dark cold environment with no physical boundaries. The nearest we are ever likely to get to this might be in a sensory deprivation tank, floating in (admittedly warm) water with all light and sound shut out. However, whilst the cold (2–4°C) and the pressure are realities, animals living in this environment have plenty of sensory input. Scientists and film makers lucky enough to enter this region in a submersible would see a fantastic array of bioluminescent light (see below), a major means of communication for mesopelagic and bathypelagic animals. Bathypelagic (and mesopelagic) animals are very difficult to capture and study intact because their bodies are not designed to contact hard surfaces. They are easily damaged by the mechanical collecting arms of submersibles and unless placed directly into pressurised containers can disintegrate on the way to the surface. Bathypelagic planktonic animals include coronate jellyfish (Coronatae) (p.227), comb jellies (Ctenophora) and siphonophores (Siphonophora). Anglerfishes (Lophiformes) especially of the family Oneirodidae are the commonest fishes at these depths with flabby whalefishes (Cetomimidae) not far behind. Unsurprisingly, the number and diversity of bathypelagic fishes is lower than that of mesopelagic fishes which in turn are much less diverse and abundant than epipelagic species.

Adaptations

The immense pressure experienced by bathypelagic fishes and other animals living at these depths does not create the problems it would for air-breathing creatures like us. We have all sorts of internal air spaces including lungs, sinuses and inner ears that would be instantly crushed. Many ray-finned fishes have gas-filled swim bladders to help them adjust their buoyancy but it is physiologically difficult to secrete gas from the blood-stream into a swim bladder under high pressure. Most bathypelagic fishes do not have swim bladders. However, very high pressure does affect cellular chemistry especially protein function. Some bathypelagic fishes have been shown to have proteins that are less sensitive to high pressure than those of their shallow-water relatives.

Food is scarce in the deep ocean and it is important for animals that live in this region to minimise their energy use. Life here is in the slow lane and many predatory fish and cephalopods have weak musculature, relying on skill and deception to capture their prey, rather than speed. Smaller muscles and a reduced skeleton in the case of ray-finned fishes means less weight and less energy expenditure to maintain position in the water column. A strong skeleton, whether external or internal, is not needed in a world that lacks any physical barriers. This is perhaps one reason for the abundance of jellyfish and other gelatinous zooplankton including siphonophores, comb jellies and salps. These animals have a very high water content which reduces their overall density to something close to seawater so that they sink only very slowly. Some bathypelagic fish, including viperfish (*Chauliodus*) and deepsea smelt (*Bathylagus*), have a gelatinous layer under the skin which helps to prevent sinking.

With their slow lifestyle many bathypelagic fish can survive for long periods without food. However, when they do manage to eat, they do so in true Roman style filling their highly distensible stomachs to capacity and then slowly digesting their gargantuan meals. Some species of deepsea eels (Saccopharyngiformes p.375) can eat fish larger than themselves and in the manner of large pythons on land, can loosen or dislocate their jaws when swallowing their prey and distort their bodies to accommodate it.

As important as it is to find enough food, avoiding being eaten is also essential. The prevalent colour of animals living in water beyond the reach of any surface illumination is dark brown or black and perhaps surprisingly, dark red. The only light available is blue bioluminescence which is not reflected by any of these colours and red appears black. Red jellyfish and red shrimps are common but, interestingly fish do not seem to have taken up this option. Some fish and the Blood Belly Comb Jelly (*Lampocteis cruentiventer*) have dark stomachs which are thought to hide bioluminescent prey and so prevent attracting larger predators.

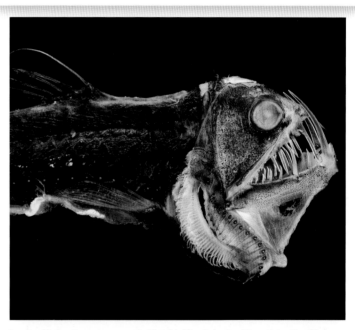

In spite of its ferocious appearance, the Viperfish (*Chauliodus sloani*) is small, less than 30cm or so, as are most bathypelagic ray-finned fishes.

In the immensity and darkness of the bathypelagic region, reproduction is always going to be a difficult process. Bathypelagic fishes have evolved innovative ways of finding a mate with which to spawn. In several families of deepsea anglerfishes the males are tiny dwarfs, only one or two centimetres long, with females ten times their size. The males, whole existence revolves around finding a female and attaching himself firmly to her, either temporarily or permanently with a parasitic connection. To this end the males have an extremely well developed sense of smell, and muscles adapted to swimming marathons. Some have enlarged eyes to enable them to home in on bioluminescent clues from the female. Flabby whalefishes (Cetomimidae) also have small males (Nelson 2006) as do bristlemouths (Gonostomatidae). Of course, all this is inferred from captured specimens as it is difficult enough to film or photograph bathypelagic animals in their natural habitat let alone observe such behaviour.

Bioluminescence

Even as they haul up their catch from the pitch dark depths at night, Japanese squid fishermen can see exactly how full their nets are. Their prize, the Firefly Squid (*Watasenia scintillans*), glows with an eerie blue light emitted from hundreds of light-producing organs called photophores. Firefly Squid spend most of their time in darkness because during daylight they live at depths of around 400–500m, only coming to the surface to feed at night. However, whilst most bioluminescent marine organisms are found in the perpetual dark of the deep ocean, bioluminescence is also exhibited by some surface-living plankton. A scuba diver in shallow water on a warm, still night can create a spectacular light show of pin-prick bioluminescence just by waving his arms about. This and the glowing wake left by moving boats are mainly caused by disturbance of certain dinoflagellates (p.152) such as *Noctiluca*. Bioluminescence is found in a wide range of marine taxa in at least 11 phyla, but in very few terrestrial (or freshwater) groups, the best known being fireflies and glow worms, which are both beetles (Coleoptera). This is admirably illustrated in a recent review of bioluminescence by Haddock et al. (2010). It is most prevalent in planktonic and nektonic organisms and its incidence increases with depth (and therefore darkness).

Taxon	Examples
Bacteria	*Vibrio fischeri*
Chromista: Dinoflagellata (dinoflagellates)	*Noctiluca scintillans*, *Protoperidinium* spp.
Cnidaria: Hydrozoa (hydroid medusae)	*Aequorea forskalea*, *Aegina citrea*
Cnidaria: Siphonophora	*Erenna* sp.
Cnidaria: Scyphozoa (jellyfish)	*Atolla* spp., *Pelagica noctiluca*
Ctenophora (comb jellies)	*Beroe cucumis*, *Mnemiopsis leidyi*
Chaetognatha (arrow worms)	*Sagitta elegans*
Crustacea: Amphipoda (amphipods)	*Scina crassiformis*
Crustacea: Copepoda (copepods)	*Gaussia princeps*
Crustacea: Euphausida (krill)	*Euphausia* spp.
Crustacea: Decapoda	*Parapandalus* spp.
Annelida: Polychaeta (polychaete worms)	*Chaetopterus variopedatus*, *Tomopteris* sp.
Mollusca: Bivalvia (bivalve shells)	*Pholas dactylus*
Mollusca: Cephalopoda (squid, octopus, cuttlefish)	*Watasenia scintillans*, *Vampyroteuthis infernalis*
Mollusca: Ostracoda (ostracods)	*Vargula hilgendorfi*
Echinodermata: Asterozoa (brittlestars and starfish)	*Ophiopsila californica*, *Plutonaster notatus*
Echinodermata: Holothuroidea (sea cucumbers)	*Enypniastes eximia*
Tunicata: Thaliacea and Appendicularia	*Pyrosoma atlanticum*, *Oikopleura dioica*
Elasmobranchii (sharks)	*Isistius brasiliensis*
Actinopterygii (ray-finned fishes)	*Myctophum punctatum*

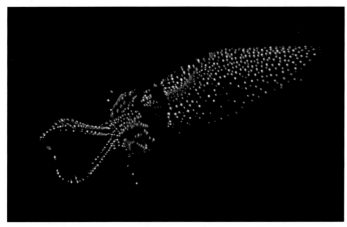

The Firefly Squid (*Watasenia scintillans*) exhibits an impressive array of bioluminescence. Whilst only a handful of gastropods and one bivalve mollusc (*Pholas dactylus*) exhibit bioluminescence, it is common in cephalopods.

Examples of bioluminescent marine organisms. Bioluminescence is found in at least 11 marine phyla. In terrestrial species it is restricted to a few insects and some fungi, and is virtually absent in freshwater organisms.

Light production

Most bioluminescent organisms make their own light from chemical reactions within specialised cells called photocytes, but some play host to bioluminescent bacteria which do the work for them. The latter method is used in several groups of fish such as the Flashlight Fish (*Photoblepharon palpebratus*) which houses the bacteria within specialised pits under the eyes, and anglerfishes (Lophiiformes) where the bacteria are within the fishing lures. Once they reach a threshold density, such bacteria glow continuously and the light can only be turned off if the host animal covers them up with another part of its body such as a skin flap. In all other bioluminescent organisms light is produced intermittently, as and when needed in response to a mechanical, chemical or electrical stimulus.

Blooms of dinoflagellates often form in calm tropical bays, especially where there is an influx of nutrients. At night bioluminescent species colour the waves with a blue glow as the water movement activates them.

Perhaps surprisingly, the basic energy (light) releasing chemical reaction is the same in many different bioluminescent groups (including terrestrial ones). The reaction involves the oxidation of a molecule imaginatively called a luciferin and is controlled by an enzyme called luciferase. The resultant oxyluciferin releases light photons as it changes back from its high energy oxidised state to a low energy state. The light is a cold light because very little of the energy is released as heat. Some organisms use a photoprotein instead of a simple luciferase. These have everything including luciferin and oxygen already bound together as one unit, and the light-producing reaction is initiated when the photoprotein binds with another factor, often calcium or magnesium (Ca^{2+} or Mg^{2+}) ions. Analysis of the chemical structure of luciferin, luciferase and photoprotein from many different organisms has shown that there are many different luciferases and photoproteins each one specific to a particular and sometimes quite small taxonomic group. In contrast just four different luciferins have so far been identified and are used by almost all bioluminescent marine organisms. Of these four, coelenterazine is used in nine different phyla including cnidarians (previously known as coelenterates). Luciferin is present in many organisms, both bioluminescent and non-bioluminescent, species and so can be obtained from the diet, thus explaining how a single type can be shared by disparate phyla. Based on the number of known chemicals and mechanisms involved, Haddock et al. (2010) calculate that bioluminescence has evolved independently at least 40 times.

Photophores

The light-producing photophores in different organisms vary from single, scattered photocyte cells to complex photophores found in fish and cephalopods. The latter may have lenses to concentrate and direct the light, reflectors and pigment screens and even colour filters. Light from photophores deep within tissues can even be channelled to the outside via 'light pipes' using reflectors. In the building industry, light is brought into rooms that have no external windows in a similar way.

Functions of bioluminescence

Ascertaining the ways in which organisms use bioluminescence in their natural habitat is difficult, but as well as direct observation and experimentation, much can be inferred from the structure and position of photophores. The most obvious uses are in defence and offence, and in communication between individuals of the same species. Put simply nobody wants to get eaten but everyone wants to eat and reproduce. The light is rarely used simply as a means to see the way as we would use a torch at night.

Mechanisms used by marine and terrestrial non-bioluminescent animals to deter an approaching predator (see p.492) are largely mirrored in the bioluminescent world. A predator about to engulf its prey is likely to be startled and deflected by a sudden flash of light, just as a snake might when suddenly faced with the two apparent 'eyes' on the backside of a four-eyed frog (*Eupemphix nattereri*). Released bioluminescent particles, mucus or fluid should be equally as effective as the 'ink' released by many squid and octopuses. This smokescreen technique is used by animals as small as copepods and as large as the Vampire Squid (*Vampyroteuthis infernalis*). Camouflage is widely used throughout the animal kingdom as an effective way to avoid predation. Many open water fishes are counter-shaded with dark backs and pale bellies to minimise their visibility from both above and below. Counter-illumination has the equivalent where photophores on the lower underside give out sufficient light to match dim surface light, thus avoiding a sharp silhouette. Many mid-water predatory fishes hunt by looking upwards for silhouetted prey. Counter-illumination is common amongst ray-finned fishes and also found in cephalopods and planktonic crustaceans.

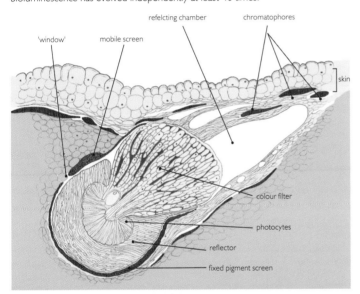

Longitudinal section through a photophore in the deepsea squid *Histioteuthis*. Fish and cephalopods with well-developed bioluminescent capabilities have correspondingly well-developed eyes. In contrast many non-bioluminescent deepsea species living at the same depths have very small eyes.

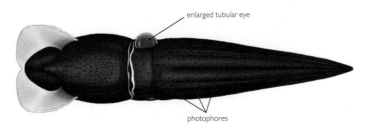

Histioteuthis has one large, tubular eye directed vertically upwards and is thought to detect silhouettes during daylight. The other eye has a normal shape and orientation.

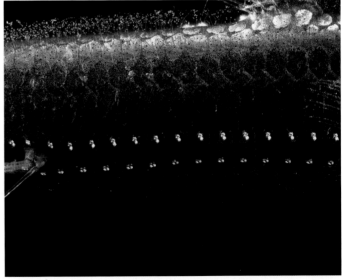

A close-up view of the ventral photophores in a Viperfish (*Chauliodus sloani*).

SEABED (BENTHIC ENVIRONMENTS)

The seabed or seafloor begins at the high tide mark and ends at the deepest point in the ocean. As a place to live it presents very different challenges to open water pelagic environments that are populated by free-floating and swimming organisms. It provides a wide variety of diverse habitats from shallow intertidal rock to deepsea muddy sediments. It is these bottom-living (benthic) environments and the organisms that live there that are described here. Sea cliffs and sand dunes fringing the coastline are technically not benthic environments as they lie above the high tide mark, but are included here under coastal habitats.

The most productive benthic habitats are those found beneath the relatively shallow water that extends out from the shore to the edge of the continental shelf (p.36). The shore and the sublittoral zone that follows are supplied with nutrients both from rich coastal phytoplankton populations and from the terrestrial input from rivers, streams and land runoff. This is sometimes too much of a good thing when it is supplemented by nutrients in runoff from farmland and sewage inputs. Blooms of toxic phytoplankton can result which can kill benthic animals as well as fish. Benthic environments far out to sea and lying beneath deep water have a much more limited nutrient input. The richness and diversity of benthic communities is closely linked to the primary productivity of phytoplankton living in the pelagic environment above them. Benthic animals rely directly or indirectly on plankton as a food source. Phytoplankton needs light, so well-lit, nutrient rich inshore waters support the richest communities of benthic animals. These areas also support rich growths of seaweeds and seagrasses which also require light and nutrients.

COASTAL HABITATS

Strictly speaking coastal habitats such as sea cliffs are not benthic habitats because they are mostly above high tide mark. However, the ocean is a moving, dynamic force and trying to define just where ocean ends and land begins is not an exact art. We can measure and predict the normal high tide mark for any time and any place in the world but the influence of the ocean extends well inland of that point. Salt spray affects coastal vegetation as does the warming effect of being near the sea. Shoreline environments above the high tide mark include sea cliffs and sand dunes which support specialised communities of terrestrial but salt-tolerant animals and plants. A visit to a sea cliff and a geologically similar inland cliff in the same area and at the same altitude would show up very different species. Tidal estuaries bring marine habitats well inland and are often fringed with saltmarsh or mangrove communities. These develop below the high tide mark but also extend well above it. Estuaries, saltmarsh and mangrove are therefore included here as coastal habitats, along with sea cliffs and sand dunes.

Sea cliffs

Cliffs are one of the most dramatic and inspiring of all coastal landscapes, with their abrupt transition from land to ocean. Examples are found on the fringes around all the oceans, but the Kalaupapa Cliffs on Molokai in the Hawaiian Islands are cited as the highest in the world at 1,010m. Whilst cliffs and stacks are a draw to adventurous climbers and some television presenters, most people would settle for a pair of binoculars and perhaps a boat trip to study the wildlife. Seabirds, lichens and some specialised flowering plants have all conquered the not inconsiderable problems associated with using such a vertical habitat. The advantage is freedom from most predators, grazers and human interference, though cliff-nesting seabirds and their eggs were heavily targeted for food in the 19th century (and in some parts of the

The cliffs of Moher in County Clare, Ireland are a draw for tourists and seabirds alike. Rising up to 214m high and stretching for 8km, they support upwards of 30,000 seabirds in the breeding season.

The layered chalk cliffs at Hunstanton, on the East Anglia coast of UK are famous for their unusual geology but are too low and unstable to support much wildlife.

world still are). The annual seabird collection practiced in the inhospitable Faroe Islands used to provide an essential protein source, albeit at great risk to the collectors' lives.

The geology of sea cliffs around the world varies hugely and has a major influence on the wildlife they support. Many, such as the famous white chalk cliffs of Dover in the UK, were once part of the seabed themselves whilst others were unceremoniously dumped as piles of glacial debris during the last ice age and are especially prone to crumble. Exposures of granite bedrock at the coast make excellent seabird cliffs as they are very stable and have plenty of ledges. Their often considerable height creates updraughts of air that assist takeoff for large birds such as gannets.

As anyone with an 'artificial cliff', such as a garden wall or old chimney, knows plants will take root almost anywhere. However, the problems for plants growing on sea cliffs are substantial. To grow here, plants must be able to survive a lack of water, salt exposure, little soil and few nutrients. Add hot sun or ice in some localities and most flowering plants would not stand a chance. Apart from the verticality of cliffs, plants face similar problems growing on shingle banks and at the tops of rocky shores. However, on the plus side, maritime climate is often more temperate, grazing animals cannot reach the plants, and seabird droppings, rich in nutrients, appear

The tiny island of Bass Rock in Scotland is home to the largest breeding colony of Northern Gannet (*Sula bassana*) in the world.

seasonally (although these can burn vegetation when fresh). With the exception of a physiology able to tolerate salt, many adaptations found in coastal plants are shared by similarly water-deprived desert and arid region plants of the world.

Sea cliffs, offshore stacks and entire cliff-clad islands are important breeding areas for seabirds worldwide. Many therefore have protected status and are a great draw for wildlife tourists. Aside from oil spills, the main threats to seabird colonies in such areas come from introduced island pests such as rats and potentially from increased storm frequency and ferocity resulting from global warming.

XEROPHYTES

Coastal plants living on cliffs, shingle and sand have the overriding problem of obtaining and conserving water just as desert plants do. Plants that live in such habitats are called xerophytes and have morphological and physiological adaptations to help them survive. Water loss is reduced though modifications of leaves and stems which may be reduced in size, clumped together, hairy or have a thick cuticle and a waxy covering. Plants such as marram can roll their leaves up in dry weather, whilst thrift grows as dense low clumps. Fleshy stems and leaves are found in Sea Sandwort (*Honkenya peploides*), as well as many others, and store water much as a cactus does. Root systems are usually extensive and long tap roots and rhizomes also serve for water storage and anchorage.

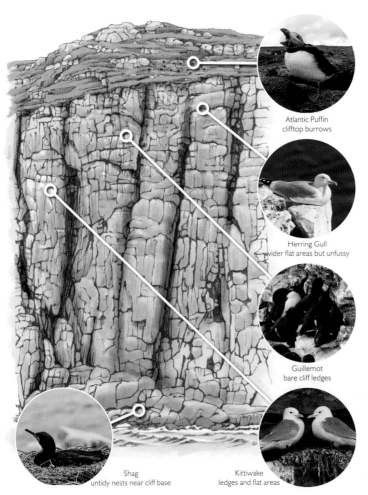

Atlantic Puffin
clifftop burrows

Herring Gull
wider flat areas but unfussy

Guillemot
bare cliff ledges

Shag
untidy nests near cliff base

Kittiwake
ledges and flat areas

Preferred levels of different seabirds on a hypothetical cliff face in the UK. Zonation helps to avoid competition for space between species but the actual zonation often depends on the type and availability of nesting places.

The Oysterplant (*Mertensia maritima*) thrives in shingle and gravel areas along coastlines in northern parts of the North Atlantic.

MARITIME CLIFF AND SHINGLE FLOWERS

Coastal clifftop paths worldwide can be rewarding places to search for maritime flowers. Both clifftops and ledges frequently have enough soil and nutrients to support a rich community of those flowering plants that can withstand strong, salt-laden winds. Vertical cliffs and shifting shingle are more challenging habitats but some xerophytic plants do manage to colonise them.

Thrift *Armeria maritima*

Features This plant is equally at home on clifftops, saltmarshes, gravelly tundra and on stable sand or shingle beaches in the northern hemisphere. In all these habitats, freshwater is scarce and the substratum and air are salt-laden. It also grows inland in mountain grasslands. On clifftops this perennial grows as small rounded mounds which, along with its tufts of very narrow, fleshy leaves helps to reduce water loss. Its alternative name of Sea Pink aptly describes its pink pom-pom flower heads.
Size Flower stems up to 30cm tall.

Sea Squill *Drimia maritima*

Features The elegant flower spikes of Sea Squill emerge in late summer and autumn on dry, rocky clifftops and hillsides in coastal areas around the Mediterranean. By this time the rosette of broad leaves has died down and only the flower spike and top of the large onion-like bulb from which it grows are visible. The plant is poisonous to most grazing animals, rodents and humans, and so remains common even where notoriously unfussy goats are feeding. It grows for some distance inland but within the maritime zone.
Size Bulb up to 20cm diameter; flower spike up to 1.5m tall.

Hottentot Fig or Pigface *Carpobrotus edulis*

Features Although native to South Africa, the daisy-like flowers and keeled, fleshy leaves of this colourful plant can be found on cliffs, coastal heaths and dunes in sunny parts of the world from Europe to the USA, New Zealand and Australia. A low creeping habit allows it to spread quickly and avoid dislodgement by wind and it has become an invasive pest in some countries. However, there are many similar species in this showy genus, some native outside S Africa such as *C. glaucescens* in eastern Australia.
Size Flowers 8–10cm diameter.

Yellow Horned Poppy *Glaucium flavum*

Features This poppy, with its extraordinarily long seed capsules (up to 30cm), is frequently the only plant found growing in the tough environment of coastal shingle banks and flats. It also grows well on higher level sand flats and sand dunes. It is a northern hemisphere plant, native to Europe, western Asia and N Africa and has been introduced to the USA. A low rosette of leaves overwinters the first year and shoots and flowers appear in the second. All parts of this plant are poisonous.
Size Stems up to 90cm long.

Rock Samphire *Crithmum maritimum*

Features Rock Samphire has an amazing ability to cling onto even the smallest of ledges and cracks in cliff faces. However it is equally happy on the dry upper parts of shores amongst rocks and stones such as seen here in southern Greece. It has roots up to a metre long that penetrate deep into rocky crevices. The fleshy leaves are edible and are often collected and pickled throughout its coastal distribution from Great Britain to N Africa and the Mediterranean.
Size Up to 30cm tall.

Sea Kale *Crambe maritima*

Features As its name suggests sea kale is edible, at least when it is young. This tough, salt-tolerant plant has a deep tap root which anchors it in shingle and allows it access to freshwater that has percolated through the shingle. It is a long-lived perennial with crinkled waxy leaves and white flowers. The seeds resemble small peas in individual round pods, and they can float and survive in seawater which provides one method of dispersal. It grows best on stable shingle flats on European coasts including the Mediterranean, but is now scarce in some areas.
Size Up to 75cm tall and 100cm across.

Coastal sand dunes

Coastal sand dunes fringe and protect shorelines in many parts of the world. Sometimes these are the seaward fringes of desert areas, exemplified by the remote and beautiful coast of Namibia. Most are true maritime sand dune systems derived from sand blown inshore off sandy beaches and flats. Many of these back attractive and accessible shores and are extensively used for recreation. From the wildlife point of view, sand dunes are a difficult habitat but stable dune systems support a diverse range of plants, invertebrates, reptiles and even amphibians.

A coastal dune system will only build up if certain conditions are met. The first and most obvious is a good supply of sand, carried inshore by currents and deposited on the beach where it can dry at low tide. Where the sand supply is plentiful then extensive sand dune systems can develop, provided the second condition is met, that of prevalent onshore winds to blow the sand inland and build up the dunes. Sometimes that is all that happens and the sand dunes remain as a shifting, impoverished habitat. The largest and highest dune in Europe is the Dune du Pilat in Arcachon Bay, France which extends for 3km and is around 110m high. This, however, is more an enormous mobile pile of sand than a dune ecosystem. The huge dunes on Moreton Island off Brisbane in Australia are similarly bare, but provide endless entertainment for thrill-seeking 'sand boarders'. However, in temperate regions of the world, vegetation often stabilises the sand and a complex ecosystem of plants and animals develops. Dune systems back long stretches of coastline in Europe and the USA.

Coastal sand dunes are inhospitable places for plants and animals to live and anything that does grow there must be able to survive a lack of freshwater, strong, salty winds, drifting sand and, at least on young dunes, a lack of nutrients. With their extensive root and rhizome systems, grasses such as marram (p.72) make effective dune stabilisers. They and other salt-tolerant flowering plants as well as shoreline debris, can also initiate dune formation. If you have ever sat on a sandy beach surrounded by your belongings and with a wind blowing, then you will soon see why. The sand strikes your towel and the particles collect on the leeward side. Tough pioneer plants growing along the strandline act in a similar way to trap sand, but can also grow upwards and encourage further sand deposition. Such early and often ephemeral dunes are sometimes called embryo dunes. Once a dune has reached a certain height and some stability, the vegetation cover increases which results in better water retention and an increase in nutrients and humus. The further inland the dune, the greater the variety and extent of the vegetation cover. This 'succession' can ultimately lead to shrub and woodland on the landward part of the system. The full succession is rarely seen in Europe where roads, houses, golf courses and other developments halt the march of the dunes.

Coastal sand dune systems are a fragile habitat that is easily damaged and there can be major impacts from uncontrolled recreational use. Trampling, horse riding and off-road driving can kill vegetation and lead to 'blow-outs', as the wind erodes the exposed sand away and can destroy large areas of dunes. Duck-board paths leading through dune systems to the beach and replanting and restoration programmes help minimise such damage. Stable dune systems the world over have been converted into golf courses or as sites for holiday caravan parks, with obvious loss of habitat and wildlife.

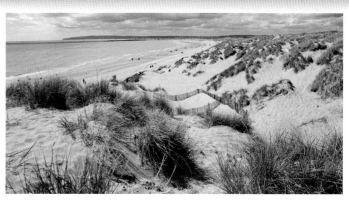

The ancient and extensive dune system at Camber Sands, on the south coast of UK is an important wildlife area as well as a popular recreational site. Careful management is necessary to provide for both.

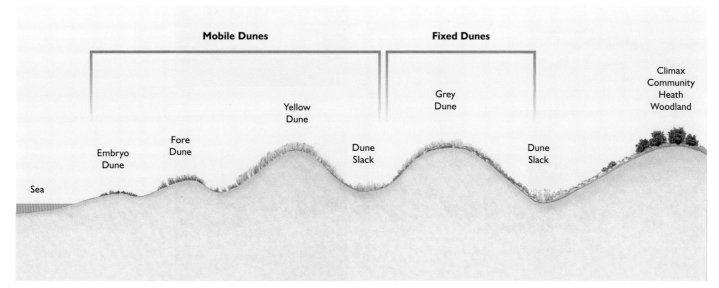

A cross-section through a hypothetical sand dune system showing the stages of dune development and vegetation succession typically seen in the UK.

MARRAM GRASS

Sand dunes in Europe and North America owe their continued existence to marram grass (*Ammophila arenaria* and *A. brevilgulata*) a genus of plants with an extraordinary ability to live and thrive in mobile sand. Marram is now used far outside its native range to stabilise coastal sand dunes. It spreads by means of amazingly long, under-sand rhizomes which send up new stems and leaves at each node. The tussocks of grass are stimulated to grow as sand builds up around them. It will not grow without new sand and so gradually dies out on dunes further inland. Roots can reach 10m down to water trapped at the base of dunes. It has a thick cuticle and stomata on the underside of the leaves sunk into pits to prevent water loss. In dry, sunny weather the strap-shaped leaves curl into a tube but flatten out when humidity is high. Surprisingly, marram grass can only tolerate salt spray not inundation, which is why it does not take over from pioneers such as Sand Couch (*Elytrigia juncea*) until a dune has reached about 1m high and rain has washed out the salt.

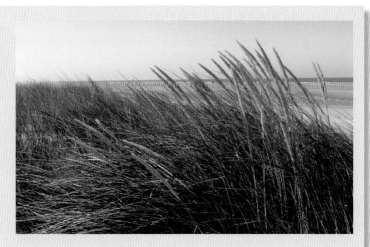

SAND DUNES AND PLANTS

The type, extent and height of coastal sand dunes varies geographically around the world and is mainly dependent on topography, wind regime, sand supply and stabilising vegetation. A wide range of different plants are found in this habitat but Marram Grass (see above) is especially important worldwide. Various other perennial, grasses such as Lyme Grass (*Leymus arenarius*) and Sand Couch Grass (*Elytrigia juncea*) in Europe; American Dune Grass (*Leymus mollis*) in USA and Canada; and Silvery Sand Grass (*Spinifex sericeus*) in New Zealand and Australia, are important dune grasses.

Embryo dunes

Low accumulations of sand on the seaward side of dune systems, such as this one on South Padre Island, Texas, USA, are often called embryo dunes. Plants growing here and on the strandline must be able to tolerate inundation at high tides and during storms and rarely cover more than about 20% of the dune. Such mini dunes often come and go seasonally as they are liable to be washed away in winter storms.

Grey Dune

Beyond the influence of wind-blown sand, pioneering grasses such as marram fail to thrive. Their dead remains provide humus along with droppings from rabbits and other grazing animals. Other less salt-tolerant plants are able to establish and the dunes become more stable and are often referred to as semi-fixed. The dunes shown here are at Winterton, UK, are acidic (no shell sand), providing ideal conditions for lichens and mosses, Fescue Grass (*Festuca rubra*) and Sand Sedge (*Carex arenaria*).

Yellow Dune

Yellow or white dunes are so called because there is usually extensive bare sand between the colonising grasses such as marram or *Spinifex*. They are also known as mobile dunes and as fore dunes because they can shift with the wind and because of their position. With their deep roots, extensive runners and ability to trap and grow up through sand, such grasses thrive here where other plants would be buried.

Coastal dune heath

Well established, fixed dunes some distance back from the sea may develop a climax vegetation of shrubs, bushes and even woodland. Exactly what grows will depend on geographic locality and the age of the dune system. The low, coastal heath vegetation shown here is on the south coast of Tasmania. The dunes formed in the last ice age when sea levels were much lower and strong SW winds deposited sand from what is now the seabed.

Prickly Saltwort *Salsola kali*

Features This summer annual grows along the strandline in northern Europe where it may initiate the formation of embryo sand dunes. It has succulent, spine-tipped, hairy leaves that store and retain water and feel decidedly prickly. Whilst usually low and prostrate in form, it can form small bushes and there are several varieties. Using genetic data some authorities classify this species as *Kali turgida*. Dogs and people scuffing and treading on it mean that it is now rare on heavily used beaches.

Size Up to 40 cm long.

Vipers Bugloss *Echium vulgare*

Features This strangely named, biennial plant often grows on sand dunes and sandy coastal soils but can also be found in similar dry and disturbed habitats inland. The plant is covered in hairs and bristles which help to reduce the drying effects of wind. Whilst native to southern Europe it has been widely introduced elsewhere including USA and Australasia where it can be invasive. The flowers and fruits supposedly resemble a snake's head ('Vipers') whilst 'bugloss' derives from the Greek for ox-tongue, reflecting the rough, bristly feel of the plant.

Size Up to 1m tall.

Sea Bindweed *Calystegia soldanella*

Features The trailing stems and large, trumpet-shaped leaves of Sea Bindweed can be found on sandy shorelines and sand dunes in temperate areas of both the northern and southern hemispheres. This photograph is from Wales, UK but it could equally as well have been taken in New Zealand or Australia. Its prostrate stems spread out rapidly and take root wherever they can. Water is obtained and conserved by deep fleshy roots and the glossy leaves help prevent water loss.

Size Flowers up to 10cm long.

Sea Holly *Eryngium maritimum*

Features With its spiky, grey-green leaves and mauve-blue flowers, Sea Holly is very attractive, and collection has led to its decline in some areas. It grows in sand and shingle well above the high tide mark and is found in dune systems along most NE Atlantic coasts, the Mediterranean and North Africa. It has a 1m long tap root and wax covered leaves close to the stem whose reflective colour helps keep them cool. In winter the plant shrivels but often remains in a dry state which protects new emerging shoots.

Size Up to 60cm tall.

Sea Oats *Uniola paniculata*

Features The swaying seed heads of this grass are a common sight on fore dunes on Atlantic coasts of southern USA, Mexico and in the Caribbean. Like other dune grasses it has long roots and extensive rhizomes that help stabilise the dunes. The roots are colonised by micorrhizal fungi, a symbiotic relationship that helps the plants to grow in nutrient-poor sand. The attractive seed heads are sometimes picked for decoration but the plant is protected in some states.

Size Flower stems up to 2m tall.

Sea Daffodil *Pancratium maritimum*

Features The large white flowers of sea daffodil push up through the sand at the top of beaches and the lower edges of sand dunes in Greece and other Mediterranean countries. Its distribution also extends to Portugal and the Canary Islands and there is a small but persistent colony in Cornwall, UK. The leaves appear early and die back in the hot summer months, leaving the flowers looking strangely artificial. The deeply buried bulb stores food and water but cannot tolerate sea water immersion.

Size Flowers up to about 50cm tall.

Estuaries

Estuaries represent some of the most remote and wildlife-rich areas in the world. They are also the sites of some of the world's largest and most vibrant cities and many are heavily industrialised. These semi-enclosed coastal areas form where rivers meet the sea, and the mixing of fresh and salt water creates brackish conditions. Their sheltered nature and the huge input of river-borne silt and sediment means that estuaries are extremely muddy places. For us the mud means treacherous walking and lost wellington boots but for birds and fish it means food in the form of abundant worms and other invertebrates. Similar muddy, food-rich environments with extensive mudflats, saltmarsh (p.77) or mangrove swamps (p.80) can also form in bays, inlets and gulfs fed with freshwater from land runoff and small streams. Where large, high volume river systems empty into the ocean, offshore deltas of mud and sand build up creating a mixed world of land and water, fresh and salt.

Physical conditions

An estuary provides a sheltered, organic-rich environment for marine animals with fewer large predators than are found in the open ocean. However, it also presents a challenge in terms of constant fluctuations in the salinity and temperature of the water. Walk the length of a temperate estuary and the visible fringing, mudflat vegetation will change from saltmarsh to freshwater marsh as you move upstream and the influence of saltwater lessens. Dig and sieve the sediment along the same route and there will be similar changes in animal life. However, as well as horizontal gradients in salinity, there are usually vertical changes within the water column as well. Freshwater is lighter than saltwater and depending on the shape and structure of the estuary and the strength of the river flow, the incoming tidal water and outgoing freshwater will mix in different ways. In some estuaries the water is well mixed for much of its length for much of the time, whilst in others there is a distinct but shifting halocline (p.20), with a relatively sudden change in salinity which can range from nearly fresh in the surface layers to nearly full strength seawater near the bottom.

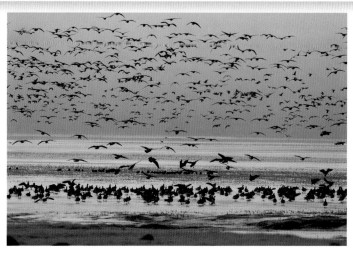

Estuaries such as the Solway Firth, in SW Scotland, are important winter feeding grounds for migratory waterfowl. These Barnacle Geese (*Branta leucopsis*) breed in Svalbard, an Arctic archipelago in Norway.

Salinity tolerances

Living in an environment in which salinity and temperate changes with the tidal cycle as well as seasonally, restricts the species that can live in estuaries. In general, estuaries support fewer marine species than equivalent fully marine habitats along the coast. However, those species that can adapt to the conditions can take full advantage of the rich food supply and lack of competition, and often occur in very large numbers. Walking over an estuarine mudflat along the Atlantic coast of Europe a single footprint could cover hundreds of tiny Spire Shells (*Hydrobia ulva*), busy feeding on diatoms, fragments of green seaweed and bacteria. A Common Shelduck (*Tadorna tadorna*) (p.488) sifting the water along the water's edge will be scooping up equally as many.

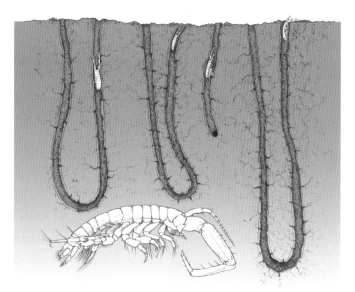

The tiny amphipod *Corophium volutator* can tolerate salinities ranging from almost fully marine to almost fresh. A section of intertidal estuarine mud shows its tightly packed U-shaped burrows with several thousand per square metre.

The Horned Wrack (*Fucus ceranoides*) is characteristic of estuaries in north-west Europe but is also found along the open coast where freshwater streams run over the shore or there is runoff from cliffs.

Hydrobia is a euryhaline species that is physiologically adapted to cope with wide variations in salinity. Such species can be found both inside and outside estuaries but often occur in higher numbers inside, where there is less competition. The Shore Crab (*Carcinus maenas*), Edible or Blue Mussel (*Mytilus edulis*), Common Periwinkle (*Littorina littorea*), Flounder (*Pleuronectes flesus*) and green seaweed *Ulva* are all euryhaline species common on shores in NW European estuaries. In contrast the isopod crustacean *Sphaeroma rugicauda* is only ever found in estuaries whilst its equivalent marine relative *Sphaeroma serratum* takes its place in fully saline water.

Estuarine fish

Relatively few estuarine fishes are truly residential, spending their whole lives there. Some gobies (Gobiidae) belong to this group and are one of the few fish families that can be found in estuaries around the world at any time of the year. Some fishes live and breed in estuaries but in temperate and cold climates they may leave to overwinter in deeper water where temperatures are more stable, just as many other coastal species do. However, the majority of fishes found in a typical estuary will be juveniles that later leave. Many fish species spawn in shallow water along the coastline and their eggs or larvae are then carried into estuaries on the rising tide. As the larvae of benthic species develop, they move down to the estuary floor where they can exploit the rich food supply. Many estuaries therefore act as nursery grounds for maturing fish that subsequently head out to sea and remain there as breeding adults. Fish that can tolerate variable salinity enter estuaries seasonally as adults, to take advantage of increased food supplies. In summer, blooms of phytoplankton lead to a build up of zooplankton such as copepods and mysid shrimps. This seasonal abundance attracts in great shoals of anchovies and sprats to feed and they in turn provide food for terns, other diving birds and predatory fish such as sea bass.

Estuaries also support migrant species that are on their way between rivers and the ocean. These migratory species only spend enough time in the estuary to allow them to adapt to the changing salinity before moving on. Lampreys (Petromyzontidae), shads (*Alosa* spp.), salmon (Salmonidae) and sturgeons (Acipenseridae) all make renowned journeys from the ocean and up into rivers to spawn (anadromous species). Freshwater eels (Anguillidae) make the reverse journey (catadromous species) to breed in the Atlantic Ocean, but the adults die after spawning and only the juvenile elvers return. These migrations are exploited by people and animals

Fish ladders provide a passageway around river dams for anadromous fish that enter from estuaries.

alike. There are fisheries in estuaries for *Anguilla* eel elvers and salmon on both sides of the North Atlantic, and for sturgeon in parts of northern Europe.

American Shad (*Alosa sapidissima*) once formed an important seasonal fishery in Chesapeake Bay on east coast USA, but overfishing, pollution and river dams have drastically reduced their numbers. Brown Bears in Alaska rely on successful upriver runs of salmon and the uneaten remains of the fish they catch add vital nutrients to the surrounding forests.

Human impact

The huge importance of estuaries in terms of marine and coastal wildlife is reflected in the number of conservation areas found within them, ranging from local nature reserves to international designations. Clean estuaries are wonderful places to watch wildlife, sail, walk and fish. However, their current and historical role as a focus for large populations of people means that inevitably many suffer from pollution. This is a particular problem because soft muddy sediments accumulate pollutants, anoxic areas develop and the sheltered conditions curtail re-oxygenation. Shellfish in particular can accumulate toxins and clean water is essential for productive oyster and mussel beds. Caged fish aquaculture can add to the problem. Estuarine fisheries can have a disproportionate effect on particular species if they are not effectively managed because many of the fish are juveniles or subadults that have not yet reproduced.

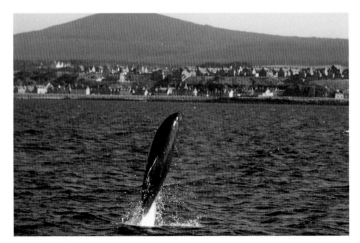

The Moray Firth, an estuary on the east coast of Scotland, is home to the most northerly resident pod of Common Bottlenose Dolphins (*Tursiops truncatus*) which take advantage of the abundant fish found there. This estuary is an important nursery for Herring (*Clupea harengus*).

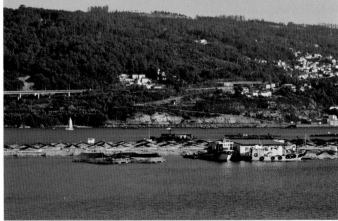

Estuarine wildlife, people and aquaculture can coexist. These are mussel rafts in an estuary in Galicia, Spain.

Saline lagoons

Tucked away behind banks of shingle and sand that run parallel to the coast in parts of Western Europe, are what look at first sight like freshwater lakes or ponds. However, in many cases they are actually small oases of marine or at least brackish life. These saline lagoons are isolated from the nearby ocean to varying degrees by barriers of sand and less often, shingle. In spite of the barrier they remain salty even in those with no apparent connection to the sea. Some of the famous 'Broads', freshwater lakes derived from old peat diggings, in the East Anglia region in UK, have parts where the water is brackish, in spite of being some distance from the coast. Salt water percolates through the permeable gravel, sand and glacial deposits that separate sea from lake, although in this case the saltiness is barely noticeable. Other saline lagoons have a direct connection to the sea and vary from fully saline to almost fresh, depending on the degree of water exchange. Saline lagoons are essentially ephemeral habitats usually lasting for fewer than a thousand years, and for the smaller ones, considerably less. As the soft coastline shifts and changes, the barriers separating lagoons from the sea may be breached or swept away, and in some instances small lagoons have been known to disappear overnight in one great storm.

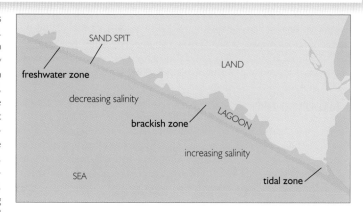

Saline lagoons formed behind shingle and sand spits often run parallel to the coast and usually have a single entrance. This results in a progressive decrease in salinity along the length.

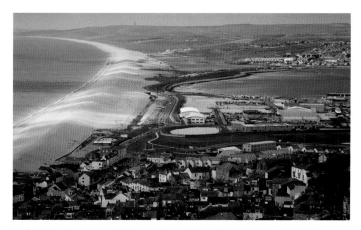

At 13km long, Fleet Lagoon is the largest saline lagoon in England. It is separated from the sea by the pebble barrier of Chesil Beach and has only one entrance at the eastern end.

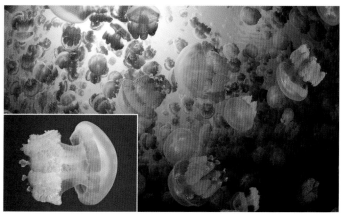

Mastigias jellyfish in Palau's marine lakes have fewer spots and shorter mouth tentacles than *Mastigias papua* from which they may have evolved.

Many of the animals found in saline lagoons are those same species that thrive in estuaries and can cope with variable salinities. However, with little exchange of water and a preponderance of very soft, sometimes anoxic sediments species diversity is usually low. A few species are found only in saline lagoons and are never found either in nearby estuaries or in adjacent marine habitats. Endemic species usually evolve in areas cut off from neighbouring similar habitats, but the short lifespan of saline lagoons does not encourage this trait. Freshwater species of plants that can cope with slightly brackish water often form a fringe around lagoons, making them look even more like lakes. It can therefore come as a surprise to find anemones and bryozoans attached to rocks and cockles and clams in the mud.

Marine lakes are another fascinating result of coastal change, this time resulting from the rise and fall of sea levels over many thousands of years. The island country of Palau in the western Pacific Ocean is underlain by limestone riddled with caves, holes and channels, and home to many beautiful lakes. The most famous is known as 'jellyfish lake' and has provided thousands of tourists with the unforgettable experience of swimming through a dense mass of pulsating jellyfish whilst surrounded by lush tropical forest. The lake and others are connected to the distant sea by fissures in the limestone, itself the remains of an ancient coral reef. The *Mastigias* jellyfish populations found in these lakes differ both from each other and from the Golden Jellyfish (*Mastigias papua*) found in the adjacent ocean and are thought to represent different subspecies (Dawson 2005). Geographical isolation and a long time frame certainly provide ideal conditions for new species or subspecies to evolve.

Species	Distribution
Starlet Sea Anemone (*Nematostella vectensis*)	Lagoons in England and North America
Ivell's Anemone (*Edwardsia ivelli*)	One lagoon in southern England
Hydroid (*Pachycordyle navis*)	One lagoon in southern England. Baltic, Germany, Netherlands
Lagoon Sand Shrimp (*Gamarus insensibilis*)	Lagoons in southern England. Atlantic coast of Europe to Mediterranean and Black Sea
Tentacled Lagoon Worm (*Alkmaria romijni*)	Lagoons and some estuaries in England. Netherlands to Denmark, Baltic

Animal species restricted to saline lagoons and brackish pools in England but occurring more widely in brackish habitats elsewhere.

Saltmarsh and mangrove

Low-lying, soft sediment coastlines in many parts of the world are fringed by saltmarshes in temperate and arctic regions, and mangroves in tropical regions. These salty coastal and intertidal ecosystems are often considered as 'marine swamp' wastelands, but in fact they are surprisingly beautiful and productive places with a wealth of wildlife. They also provide vital ecosystem services such as coastal protection and act as nurseries for commercial fish species. Temperate saltmarshes are productive all year round and so are havens for coastal birds in winter. The plants that dominate and form the structure of saltmarshes and mangrove forests are terrestrial plants that have adapted to withstand partial immersion in saltwater (halophytes). The detailed structure and biology of mangrove plants and the adaptations that help them to survive in brackish and fully saline water are described in the section of the book on Marine Plants (p.162).

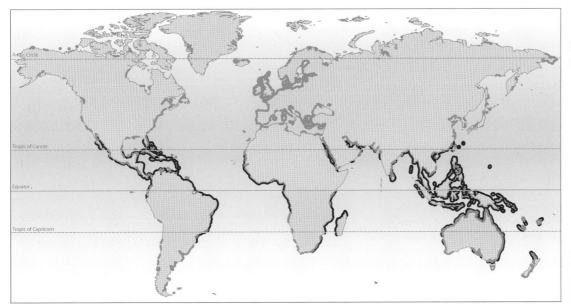

Global distribution of mangroves and saltmarshes. Mangrove distribution from Spalding et al. (2010), saltmarsh distribution from various sources.

Saltmarsh

Saltmarsh develops on soft mud flats in coastal areas sheltered from wave action. This type of habitat is most prevalent in estuaries which is where the majority of saltmarshes are found. However areas of saltmarsh are also present in deltas, sea lochs and fjords and in bays and behind shingle spits along open coasts. The vegetation is dominated by grasses, shrubs and herbaceous flowering plants most of which are found only in this habitat or very similar ones such as saline lagoons. The dominant saltmarsh plants vary with geographical location so whilst it is easy to recognise a saltmarsh whether you are in North America or Australia, the species present will be different. Most well-developed saltmarshes also show a clear zonation in their vegetation from the low-lying seaward edges covered with water on every tide, to the higher levels on the landward side that are only inundated on the highest spring tides.

New saltmarshes develop through a series of successive stages that involves colonisation by saltmarsh plants and accumulation of silt. The first colonists of new intertidal mud deposits are tough pioneers such as glasswort (*Salicornia* spp.) and cord grass (*Spartina* spp.). These arrive as floating seeds and uprooted plant fragments from other saltmarsh areas. Once established, the root systems and stems of these plants reduce water flow such that silt is dropped around them and mud levels build up. Pioneer plants can withstand saltwater immersion for long periods and are tolerant of waterlogged soil. If sufficient silt builds up, then other less tolerant, but often more vigorous plants will become established and may out-compete the initial colonisers. The end result is a zonation of saltmarsh plants, with the least salt-tolerant plants found at the highest levels where they are rarely if ever covered. The initial pioneers do not disappear completely but competition from other plants means they take a lower profile. The banks of saltmarsh creeks provide further opportunities for pioneer colonisation where the edges slump down through erosion.

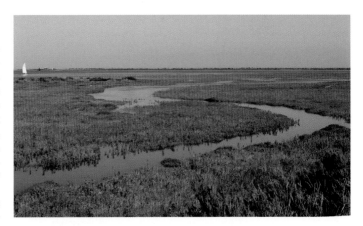

Like an intricate system of blood vessels, a network of creeks carries saltwater, mud and nutrients to every part of these saltmarshes in Norfolk, England. Walking across such areas is both difficult and can be dangerous on an incoming tide. As the tide comes in, water spills out from the creeks and floods across the marsh.

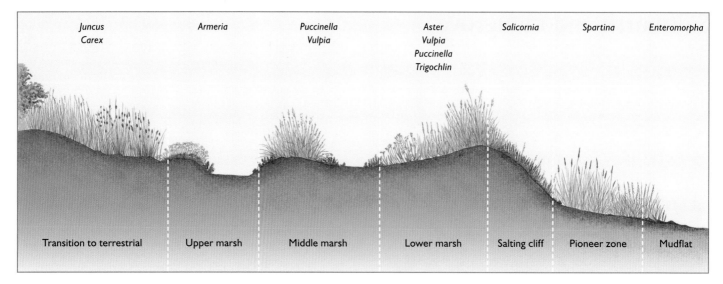

A typical northern European saltmarsh in sectional view showing main plant zonation.

Whilst saltmarshes around the world support a wide variety of plants, cord grass (*Spartina*) is the quintessential saltmarsh plant in the northern hemisphere. In North America it dominates entire marshes along the Atlantic and Gulf of Mexico coasts. *Spartina*-dominated marshes are also common in northern Europe. Zonation is still apparent in such marshes but defined mainly by different species and growth forms of *Spartina*. With extensive rhizome and root systems and the ability to spread both by seed and fragmentation, *Spartina* can quickly colonise and take over large areas. In addition it exhibits a wide range of adaptations (see table below) which allow it to survive a range of tidal regimes. It has a high requirement for nitrogen, is intolerant of grazing and is sparse in upper marsh areas.

The most obvious animals that use saltmarshes as feeding and resting grounds are birds. Brent Geese (*Branta bernicla*) nest in the Arctic but overwinter on estuarine saltmarshes in Great Britain and northern Europe where they graze on eelgrass (*Zostera*), algae such as *Ulva* spp. and saltmarsh grass *Puccinellia*. Other wildfowl with

SPARTINA INVASION

Spartina is able to hybridise readily and such hybrids have caused problems in both Europe and North America. *S. alterniflora* accidentally introduced to Great Britain (England) from the east coast of North America in the late 18th century, crossed with the native *S. maritima* and produced a sterile F1 hybrid *Spartina* x *townsendii* which spread rapidly. This hybrid then gave rise to *S. anglica* a new fertile allopolyploid species, by chromosome doubling. *S. anglica* is now the main *Spartina* species found in British saltmarshes. Monocultures of *S. anglica* are of less value to wildlife than the species-diverse native saltmarshes and in a twist of fate, this species is now a serious invasive species in parts of North America (and Asia and Australasia), where it was introduced to stabilise coastlines. In Great Britain some sort of balance seems to have been achieved.

Adaptation	Function
Salt glands	Salt removal: specialised cells near leaf surface actively excrete sodium ions
Shedding leaves	Salt removal: salt transported to leaves which are then shed especially in autumn
Succulence	Salt tolerance: high water content dilutes salt load
Thick cuticle and stomata in grooves or pits	Water conservation
Aerenchymal tissue	Oxygen supply: tissue perforated by hollow tubes conducts air into roots that are surrounded by anoxic mud, from stems which absorb it from the atmosphere
Additional supporting tissue (sclerenchyma)	Strength: helps prevent damage from strong tidal flow
Additional photosynthetic pathways	Food supply: when submerged in turbid saltwater, allows photosynthesis to continue with reduced availability of light, CO_2 and water

Adaptations of halophytic saltmarsh plants.

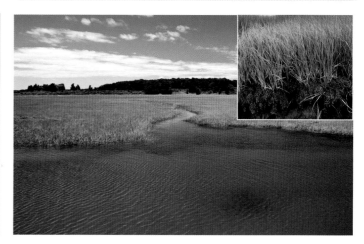

Spectacular saltmarshes dominated by cord grass *Spartina* form a wilderness covering hundreds to thousands of acres along the coasts of south-eastern USA. *S. alterniflora* predominates on the low marsh with *S. patens* taking over on the high marsh.

Sea-lavender (*Limonium* spp.) and other mid and upper saltmarsh flowering plants provide nectar for flying insects. Along the East Anglia coast of the UK, sea lavenders provide an important fuel stop for Painted Lady butterflies (*Cynthia cardui*) that have migrated in from south-west Europe and Africa.

Glassworts or samphires (*Salicornia* spp.) can tolerate many hours of saltwater immersion each day. They are therefore pioneer saltmarsh species and are abundant at the seaward edge of saltmarshes and along the edges of creeks and saltpans. Glassworts store water in their succulent, jointed stems and have tiny scale-like leaves and minute flowers. The edible green summer shoots often turn red in autumn.

similar habits include Grelag Geese (*Anser anser*) and Wigeon (*Anas penelope*). The majority of invertebrates found in saltmarshes are marine worms, small crustaceans and molluscs that feed on detritus. Saltmarsh plants such as *Spartina* are tough and resistant to grazing but produce a mass of leaf detritus that is partially broken down by bacteria and fungi. The hydrobiid snails (Hydrobiidae) graze on bacterial and algal films and are themselves eaten by Common Shelduck (*Tadorna tadorna*). Saltmarsh creeks provide a safe habitat for small and juvenile fishes such as Flounder (*Platichthys flesus*), Common Eel (*Anguilla anguilla*) and Three-spined Stickleback (*Gasterosteus aculeatus*) in the NE Atlantic, and Mummichog (*Fundulus heteroclitus*) in North American saltmarshes. These species are typically found in estuaries and can withstand fluctuations in temperature and salinity.

Saltmarsh forms a living and dynamic defence for low-lying coastlines. As waves hit the coastline their energy is dissipated along the extensive system of creeks that meander through a marsh. Water is soaked up and held in the creeks, sediment and vegetation. The global extent of saltmarsh has decreased considerably since around the 16th century through both small and large-scale reclamation of coastal areas for farming, port construction, industry and in recent years for recreational boat marinas. In low-lying coastal areas around southern parts of the North Sea, many seawalls were built in the past as coastal marshes were drained and land reclaimed. These same sea walls prevent saltmarsh on their seaward side from extending further inland as they have done for millennia in response to increased storms and rising sea levels. The resultant decreased extent of saltmarsh provides less protection and sea walls need to be built up at great expense, to prevent flooding.

Some sea walls protecting low-lying land behind saltmarshes, are now being experimentally breached, and the sea allowed back in so that new saltmarsh can develop. Although some once reclaimed land is lost, this sea defence strategy, known as 'managed retreat' is succeeding at least on a small scale in estuaries along the SE coast of Great Britain and is a great deal cheaper than building and repairing high sea walls.

American Horseshoe Crab (*Limulus polyphemus*) in a saltmarsh creek, Cape Cod, Massachusetts, USA.

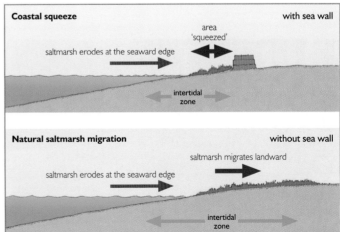

The effects of rising sea level on saltmarshes. Above: with a seawall – the saltmarsh is prevented from migrating landward and is gradually eroded away. Below: without a seawall – the seaward edge of the saltmarsh is eroded but the higher water levels allow the marshland to extend inland.

Mangrove forests

Tropical mangrove forests grow in deltas and along the edges of sheltered estuaries where they often line the banks for some distance upriver. These are similar to the sheltered habitats in which temperate saltmarshes develop. In these areas salinity is reduced and variable, but mangrove forests also grow in fully saline conditions along sheltered coastlines, in bays and in shallow sandy channels between islands. With very few exceptions, mangrove plants are trees and a mature mangrove forest exhibits a true forest structure with tall canopy trees and lower stature trees, bushes and saplings beneath. However, there are also many mangrove forests where the trees are low and shrubby and the vegetation looks more like wet scrubland. Mangrove trees are common, scattered along sandy tropical shores, but true forests currently only cover about 152,000 square kilometres worldwide (Spalding et al. 2010). Much of this occurs as relatively small patches of forest that mirror the locations of suitable estuarine habitat, but forest clearance has also exacerbated its patchiness. Large undivided expanses of mangrove forest are found along remote coastlines with extensive and complex river delta systems, including the Sundarbans (Bangladesh and west Bengal in India), the Niger Delta, northern Brazil and the southern part of Indonesian West Papua (Spalding et al. 2010).

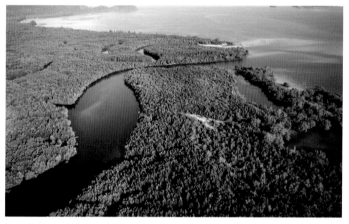

Tropical river estuaries are often surrounded by dense mangrove forests from some distance upriver down to the open sea and along the abutting coast. The dense canopy resembles that of a terrestrial tropical rainforest.

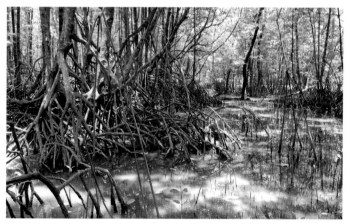

The forest floor beneath a mangrove forest is filled by prop roots and aerial roots and is flooded with each high tide.

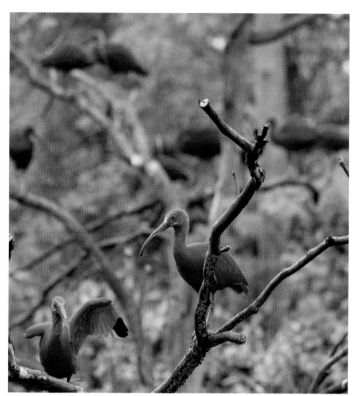

Large numbers of Scarlet Ibis (*Eudocimus ruber*) are a spectacular sight roosting in mangrove swamps on Trinidad and other Caribbean islands.

Mangrove forests are highly productive and provide food and a home to a wide variety of terrestrial and marine animals. Whether the tide is in or out, the forest canopy provides roosting and nesting sites for birds, many of which are waders that feed on the forest floor at low tide and in adjacent exposed mudflats. Most mangrove birds are not exclusively dependent on the mangrove habitat, but there are rich pickings for insect eaters such as the Mangrove Robin (*Peneonanthe pulverulenta*), nectar-containing flowers for a variety of honeyeaters, and berries and fruit which also attract fruit bats and monkeys. Mangrove leaves are tough with a high cellulose content and contain unpalatable tannins. Proboscis monkeys (*Nasalis larvatus*), endemic to Borneo, are one of very few large herbivores that can eat and digest them. Few predators roam the forest floor beneath the canopy because even at low tide mud and thickets of prop and aerial roots impede their progress. This does not stop Estuarine Crocodiles (*Crocodylus porosus*) or tree-climbing Mangrove Monitor Lizards (*Varanus indicus*).

The muddy floor of intertidal mangrove forests is rich in detritus and organic matter and is home to a wide variety of invertebrate animals that either crawl around on the surface or live buried in the sediment (or both). Colourful claw-waving male fiddler crabs (*Uca* spp.), intent on attracting females, emerge at low tide and are amongst the most numerous and conspicuous. However, they are extremely shy and disappear down their burrows at the slightest hint of danger. Mud lobsters (*Thalassina* spp.) appear much less often and usually the only sign of them are large conical mounds of mud balls up to 1m high excavated from their burrows. The feeding and burrowing activities of all these crustaceans brings buried nutrients up within reach of shallow mangrove roots. In upper tidal regions they build up the mud level and provide elevated habitat for mangrove ferns (*Acrostichum* spp.). Mud whelks (*Terebralia* spp.) gather under mangrove trees to eat fallen leaves, acting much as earthworms do on

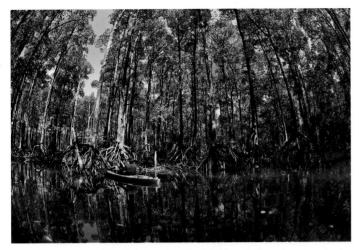

Canoeing and snorkelling into a mangrove channel at high tide are both excellent ways of seeing mangrove plants and animals close up.

Periopthalamus species are so well adapted to life out of water that they cannot survive long periods underwater.

Mangroves make an ideal home for fish, providing them with abundant food and shelter. The juveniles of many species use the mangrove habitat as a nursery where they feed on plankton and small invertebrates in relative safety. As they grow larger, a proportion moves out to populate habitats further offshore, including coral reefs. Many adult fish live permanently amongst the mangroves feeding on detritus and algae or preying on smaller fish and crustaceans. Kingfishers are also adept at catching small fish so the mangrove root habitat is by no means predator-free but large predators such as adult sharks and barracuda are certainly excluded. Mangroves also act as a nursery for penaeid prawns. The larvae and juveniles live within mangrove, seagrass and seaweed habitats feeding on detritus and small invertebrates, moving offshore as they grow and mature.

Mangrove forests and their associated estuarine channels and lagoons are a vital resource to the people of the 123 countries in which they are found, and are widely exploited for timber and for a variety of fisheries including shrimps, crabs, oysters and finfish. Many species of shrimps caught in offshore fisheries thrive because their young benefit from the high productivity of adjacent mangrove systems. Mangroves also help to protect coastlines from the effects of storm surges and tsunamis, and play a larger role in sequestering carbon dioxide, thus helping to slow global warming, than their visible extent might suggest. This is because much of their biomass is hidden underground in massive root systems. In spite of their importance, estimates suggest that about a quarter of the original mangrove habitat has been lost. This is mainly through conversion to aquaculture (mainly prawn ponds), agriculture and urbanisation. The rate of loss is several times greater than the overall loss of global forests (Spalding *et al.* 2010). Many of the remaining mangrove forests have been degraded by oil pollution, sewage pollution (often from tourist developments) and excessive timber extraction. Coastal development in areas with an expanding tourist industry such as the Red Sea and small island resorts such as Tioman in Malaysia, often clashes with conservation efforts. Sea level rise poses a future threat and like saltmarsh 'squeeze' (p.79), the forests may be prevented from spreading inland by hard engineering constructed to protect people and their property. However, the importance of mangrove forests is increasingly being recognised by governments through protective legislation, restoration and re-planting projects. Spalding *et al.* (2010) estimate that around 25% of all remaining mangrove forest lie within protected areas but this by no means always ensures effective protection.

land to recycle this important source of nutrients. Sesarmid crabs (Sesarmidae) perform the same function. Dead mangrove wood is partially broken down by shipworms (*Teredo* spp.) whose burrows open up the wood and so initiate decay. Predatory Mangrove Murex (*Nequetia capucina*) snails search out and eat the shipworms.

The tangle of prop roots found in forests dominated by *Rhizophora* and other prop-rooted mangroves, provides an extensive habitat, colonised by oysters (*Crassostrea* spp.), mangrove mussels, encrusting sponges, tunicates and barnacles, all of which filter plankton and organic materials from the water. These communities cannot withstand exposure to air for any length of time and so are only found along the seaward edges of mangrove forests and along deep channels and in tide-excavated pools.

Prop roots also allow mangrove periwinkles (*Littoraria* spp.), which live on the lower branches of the trees, to escape upwards as the tide comes in. They feed by scraping off films of slimy algae and bacteria on the mangroves and are adapted to live out of water in damp places. Somewhat unexpectedly, small mud skippers, a type of fish related to gobies, also climb up mangrove trees. Not all mud skippers do this but

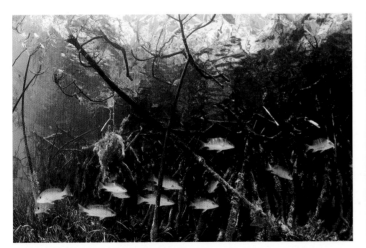

In the Caribbean there are extensive areas of mangroves in lagoons and bays that are permanently inundated with water. Many fish forage on adjacent seagrass beds and coral reefs but return to the safety of the mangroves at night.

Wooden boardwalks in some mangrove forests are now attracting tourists interested in wildlife and photography. This benefits the local economy and encourages conservation of the forests.

SEA SHORE (INTERTIDAL)

Every time the tide goes out, sea becomes land and as it returns, land becomes sea. This fringe of land and sea extending between the lowest of low tides and the highest of high tides is variously called the seashore, intertidal zone and littoral zone. Whatever we call it, it is undoubtedly a harsh place for anything to live, exposed as it is to powerful storms, rain and snow, drying sun and wind. When the tide retreats mobile animals living there must either follow it down or find some place and means to survive until the water returns. However, for those species which do manage to establish themselves on the shore, there is less competition for space and food, and the tide brings a regular input of organic matter, plankton and oxygen. For us it is a window into the marine world, albeit a sleepy one, where we see the animals at their least active. A low spring tide gives us longer to explore but for the residents it means a longer wait until conditions return to what is optimal for them. The extent of shore exposed at low tide varies greatly around the world with maximum tidal ranges varying from less than 1m to more than 15m (see p.30).

Intertidal areas experience the greatest daily and seasonal fluctuations in environmental conditions of any marine habitat. Organisms living on sea shores where low tide falls at or near noon will experience the widest daily variations. On a really hot summer's day in the UK, limpets, barnacles and seaweeds might be exposed to air temperature up to 27°C only to be cooled almost instantly to around 16°C as the tide returns. Within pools, salinity, pH and oxygen levels fluctuate widely.

By crowding together in damp crevices whilst the tide is out, periwinkles (Littorinidae) and dogwhelks (Muricidae) keep water loss to a minimum. This especially applies to gastropod species that do not have an operculum to block up their shell entrance, though both the species shown do have one.

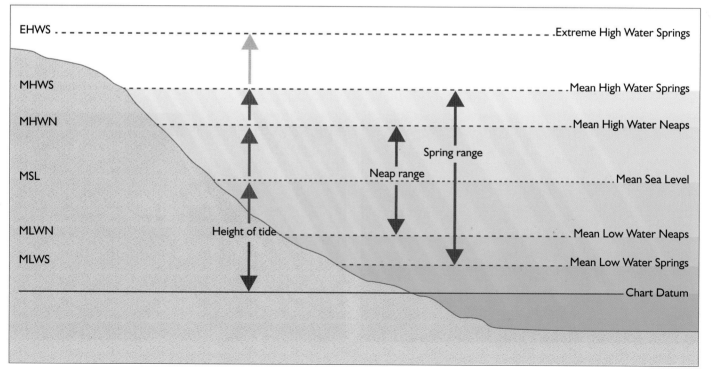

Diagram showing tidal levels and datums.

ENVIRONMENTS AND ECOSYSTEMS

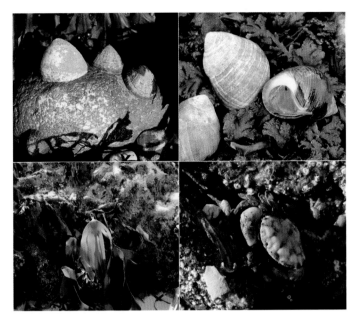

The lack of water itself is a major problem, reducing the ability to absorb oxygen through gills and other surfaces. In addition, few intertidal animals can feed with the tide out. Many of the adaptations seen in intertidal organisms are designed to retain water either through structural or behavioural means or both. Seaweeds are covered in slippery mucus, not to make it difficult for us to walk over them but to retain moisture. Molluscs such as limpets, abalone and chitons have a powerful foot with which to clamp firmly to the rocks, retaining water beneath whilst many snail-like gastropod molluscs plug up their shell entrances. Sediment-living animals burrow down deeper below the surface.

These same adaptations will also help prevent animals from being dislodged by waves as the tide returns. Those same waves help some animals to ride easily up the shore from deeper water as they come in with the tide to feed. Seashore seaweeds often have especially strong holdfasts to keep them firmly attached to rocks. Others are carried to new areas of the shore still attached to stones and small rocks. Some seaweeds grow as low crusts during winter periods when storms are common, and only grow erect fronds in the calm of summer.

Intertidal animals and seaweeds employ a variety of ways to retain moisture when the tide is out. Top left: limpets clamp down onto the rock. Top right: periwinkles close their shell opening with an operculum. Bottom left: seaweeds coat their fronds with mucilage. Bottom right: crabs hide in damp crevices and under rocks.

Strandline

By its very nature the strandline is an ephemeral habitat and a moveable feast for scavenging animals. It is also a rich hunting ground for naturalists and even for those looking for treasure. Ambergris, that strange and valuable material regurgitated by whales, floats and is sometimes washed up onto the strandline. Sadly the strandline is also the place where myriad discarded items wash up as beach litter, with plastic topping the bill. In 2014 the Marine Conservation Society in the UK recorded an average of 2,457 items of litter per kilometre during their nationwide beach weekend cleanup.

In temperate areas, the bulk of natural material on the strandline consists of seaweed, especially following winter storms. Kelp (p.99) sheds its fronds as winter approaches, annual seaweeds die off and storm waves tear perennial seaweeds from subtidal rocks. This rotting mass is rapidly consumed and broken down by scavengers and decomposers. Lift a patch of strandline seaweed and a host of beach-hopping amphipods (p.272) will spring off in all directions. These small crustaceans are major consumers of rotting seaweed. Kelp flies, such as *Coleopa frigida*, lay their eggs in seaweed debris thrown high up on the shore where their larvae hatch and feed on

As spring tides give way to neaps and tides get smaller, successive tide levels are marked by parallel lines of debris, seen here in Sardinia, Italy. As well as seaweed and dead animal remains, jellyfish and other pelagic animals are often stranded alive.

Some tourist beaches are cleaned to remove unsightly and sometimes smelly strandline material but whilst this may be necessary on urban beaches, it reduces the food source available to many invertebrates and birds.

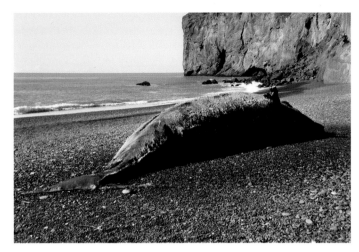

The bloated corpses of whales and dolphins are occasionally washed ashore and whilst these can cause problems near habitation, they also provide opportunities for scientists to collect useful data and take samples for DNA and pollutant analysis.

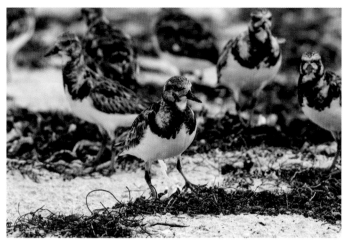

Ruddy Turnstones (*Arenaria interpres*) make good use of the strandline, searching under stones and seaweed for invertebrates. Strandline material removed for amenity purposes, reduces their food supply.

it with minimal risk of immersion. Breakdown products from seaweed also enter the food chain as dissolved organic matter (DOM).

Strandline material can provide useful clues as to what is living buried in the beach and further offshore. Mollusc shells are the most obvious and abundant and collecting empty seashells from the beach is a popular hobby. Cast-off crab shells, empty egg cases of sharks, rays, whelks and other gastropod molluscs plus the ubiquitous cuttlefish 'bone' (p.248) are all common finds on shores worldwide.

The strandline is a major source of food for many bird species, especially those inveterate scavengers, gulls, and shores well-endowed with organic debris make for good birdwatching the world over. Turnstones (*Arenaria* spp.), as their name implies, expertly flip over pebbles and strandline debris with their beaks in search of small invertebrates. Even terrestrial birds such as crows will join in, pecking at dead fish and crab corpses. Whilst dead fish washed up on the seashore have often come from fishing discards, they are sometimes the result of weather or climate dependent phenomena and can provide useful indications of change. Atlantic Pomphret or Ray's Bream (*Brama brama*) (p.396) are often cast up on the coast of Norfolk, UK in autumn and early winter. Some years see large numbers of these occasional visitors swept up around Scotland and down into the North Sea, trapped and killed by cold water before they can return south.

Dead strandline seaweed is sometimes collected and used by island people to provide a rich fertiliser for gardens and crops. It also provides natural humus for salt-tolerant coastal plants such as Shrubby Seablite (*Suaeda vera*) and such plants can look almost unnatural as they often grow in rows along the lines of old strandlines, where seeds deposited by high spring tides grow and thrive. Coconuts cast up on the strandline of tropical shores will sprout and grow after months in the sea. A few seeds such as the sea bean can drift across an entire ocean and still remain viable. Sea Beans (*Entada gigas*) and Nickar Nuts (*Caesalpinia bonduc*) are long-distance drift seeds and are regularly washed up along the west coasts of Great Britain and Ireland having originated in the tropical Americas. Many are still viable but do not survive in cold climates. Such finds provide clues to the direction of ocean currents, acting as drift markers, as do occasional lost cargoes of plastic bath toys and shoes.

Sea Beans (*Entada gigas*) drift onto European shores from the tropics and can remain afloat for many years. However, they are also imported and sold in curio shops and some beach finds could simply be lost mementoes.

Goose barnacles will attach to anything floating in the ocean such as this bottle, found cast up along the coastline of Victoria in Australia.

Rocky shores

Searching for small fish and crabs in a rock pool as a child has started many people along the road to becoming a marine biologist, or at the very least has fostered a lifelong interest in natural history. Rocky shores are one of the richest of all intertidal habitats and make excellent outdoor classrooms. This is especially so in temperate regions with moderate climates where rocky shores exhibit a high biodiversity. Seaweeds grow well, attached to stable rock along with barnacles and other sessile animals. Anemones and limpets also need to cling on and find plenty of secure sites.

Rocky shores exist where waves erode the coastline and carry away loose material exposing the bedrock beneath. These same waves oxygenate the water and bring with them copious supplies of plankton for filter feeders. Seaweeds provide food for grazing molluscs and shelter for many other invertebrates.

Whilst rocky shores in general provide a better and more varied living for intertidal organisms than sediment shores do, some rocky shores are better than others in this respect. A rugged shore with numerous ledges, cracks, crevices and pools provides more shelter and a much greater variety of micro-habitats than a smooth platform of rock. Just looking at a geological map will give a clue as to the richness of rocky shores in a region. A coastline of strata tilted across the shore erodes to a varied shore, whilst horizontal strata often produce flat, stepped platforms.

Exactly what lives on a rocky shore within a particular geographical region is greatly affected by wave exposure. Dramatic and extensive rocky shores fringe coastlines exposed to strong waves. The tremendous power of waves can be seen easily along a coastline in the aftermath of a storm with rocks, debris and sand flung up onto roads and esplanades. The undertow of strong waves can easily drag a person out to sea and equally will pull against seaweeds and animals attached to rocks. A visit to an exposed and a sheltered rocky shore with similar geology only a few miles apart will be two very different experiences. Along the Scottish west coast,

A rocky shore of bedrock and boulders on the north coast of Cornwall, UK. Rocky shores exist where waves have eroded soft material and carried it away leaving only hard, stable rock.

rocky shores exposed to the full force of the Atlantic are dominated by barnacles, mussels and limpets which have a low profile and can cling on tightly. However, move a short distance into the shelter of a sea loch and similar shores will be covered in dense growths of brown fucoid seaweeds (Fucaceae). Seaweeds increase the biodiversity of a shore by providing food and shelter.

Geology can have both direct and indirect effects on the fauna and flora of a rocky

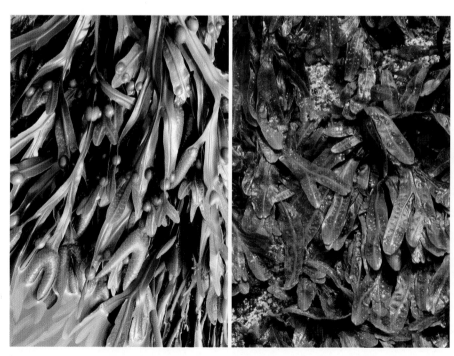

Bladder Wrack (*Fucus vesiculosus*) (left) has paired gas-filled bladders which help to keep it upright in the water. On very wave-exposed coasts a short bladderless form known as *Fucus vesiculosus* var. *linearis* grows (right).

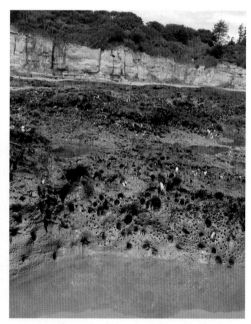

Piddocks (*Pholas dactylus*) bore into soft rocks such as chalk and mudrock which can be riddled with their burrows. Whilst this makes the rock more likely to break up, empty burrows provide homes for many small mobile animals.

Heavy grazing pressure by these limpets has prevented seaweed growth except on their own shells.

shore, unchecked by grazing. It took ten years for equilibrium to return. Predators can also influence the makeup of seashore communities. Along the north eastern coast of USA, the Ochre Seastar (*Pisaster ochraceus*) is a voracious predator of mussels. Unlike many other starfish it is able to withstand desiccation and can continue feeding at low tide.

Rocky shore zones

Rocky shores worldwide may exhibit a distinct vertical zonation with different species dominating at different shore levels. The causes of zonation both on the shore and in deeper water are discussed further on pp. 19 and 41. The best place to see rocky shore zonation is on an extensive, moderately exposed shore in temperate latitudes. In contrast, hot sun and a small tidal range limit biodiversity and zonation on Mediterranean shores.

Temperate and cold temperate rocky shores worldwide exhibit a similar general pattern of zonation. Standing just above the high tide mark with the tide in and a strong wind blowing, you are likely to be soaked by wind-blown spray. This is the supralittoral, splash or spray zone, the first of three main zones. Only covered on high spring tides, this zone also extends well above this level on exposed shores. As a transitional area between land and sea, this is a harsh place to live, populated by only a few terrestrial species that can withstand salt spray and some particularly tough marine animals. These include gastropod snails, isopod crustaceans, lichens and a few flowering plants (see sea cliffs p.68). In the NE Atlantic, searching in crevices for the tiny snail *Melarhaphe neritoides* will give an indication of shore exposure. This species can be found several metres above high water mark on very exposed shores and at mean high water mark on more sheltered shores.

The eulittoral or midlittoral zone encompasses the major part of the shore between high and low water. In many parts of the world the key organisms covering the rocks are barnacles, tube worms (polychaetes), mussels, rock oysters and various types of seaweeds. Barnacles are particularly good at withstanding desiccation and can predominate even on hot tropical rocky shores and at the top of temperate and cold shores. In the latter two areas, brown seaweeds predominate on the middle and lower shore, particularly on sheltered coasts.

shore. Hard rock such as granite is stable and provides a strong purchase for large seaweeds, but weathers slowly and provides fewer micro-habitats than a softer rock such as sandstone. Chalk erodes rapidly and provides plenty of hiding places but large seaweeds may be swept away if it cracks up under pressure from waves. However, chalk's very softness makes it a good place to look for burrowing animals that specialise in boring into rocks. In polar areas ice scour has a major influence and, along with low temperatures, may prevent almost anything from growing during part or all of the year.

Whilst wave action and geology largely determine how much seaweed there is on a rocky seashore, grazing limpets, ormers and periwinkles also have a significant effect. In the aftermath of the SS *Torrey Canyon* oil spill, which polluted beaches in Cornwall, UK in 1967, dispersants used to treat the oil killed large numbers of limpets. Once the oil was gone, fast-growing green seaweed swamped parts of the

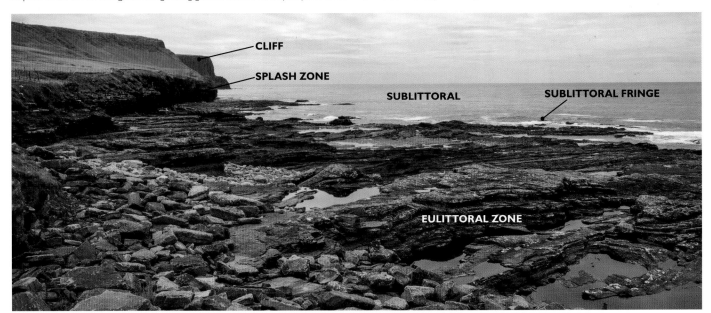

An extensive NE Atlantic rocky shore in County Clare, Ireland.

Species	Tide level	Features	Photo
Channel Wrack (*Pelvetia caniculata*)	Top of upper shore	Inrolled fronds conserve moisture	
Spiraled Wrack (*Fucus spiralis*)	Upper shore below *Pelvetia*	Twisted fronds conserve moisture	
Bladder Wrack (*Fucus vesiculosus*)	Middle shore	Bladders improve photosynthesis when tide is in	
Serrated Wrack (*Fucus serratus*)	Mid to lower shore	Flat fronds conserve moisture poorly	

Distribution pattern (zonation) of fucoid seaweeds (Fucaceae) on a typical moderately exposed to sheltered rocky shore in the British Isles.

A low spring tide and a calm sea are necessary for a visit to the lowest part of the shore, known as the sublittoral fringe. This affords a glimpse of what lies below in the permanently covered sublittoral zone, but seaweeds and animals unique to this zone will also be found. Such species are able to tolerate short bouts of breaking waves or baking sun. In the NE Atlantic the sublittoral fringe is often dominated by kelp, but a different species to that found deeper in the sublittoral. Crusts of coralline algae are common worldwide whilst UV-tolerant corals emerge on tropical shores. In Tasmania and temperate Australia a band of fist-sized sea squirts *Pyura stolonifera* is often present.

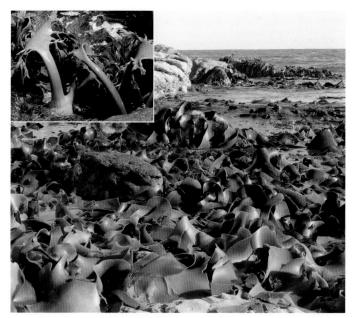

Bull Kelp (*Durvillaea potatorum*) grows as a kelp forest in the sublittoral fringe in temperate Australia and New Zealand. It has an extremely strong holdfast and flexible stipes (stems) that bend but do not break when the kelp is exposed on low tides.

Boulder shores

Rocky shores made up entirely or mainly of boulders lack the variety of habitats found on bedrock shores, but can still be very productive, provided the boulders are stable. Small boulders on exposed coasts are likely to be rolled during storms and such shores are generally low in species diversity. A shore of large boulders in moderately sheltered conditions, but exposed to strong tidal currents, makes an ideal home for a wide variety of intertidal animals. However, most of them will only be found by turning boulders over (and of course turning them back again). Provided there is underlying sediment or uneven rock then there will be space and trapped moisture for animals to live. Waves and water currents replenish food and oxygen supplies as the tide returns.

Whilst the upper surfaces of these boulders in the Isles of Scilly, UK are dominated by brown seaweeds, the under surfaces support rich growths of encrusting sponges, bryozoans, sea squirts and barnacles.

Some animals are specifically adapted to living in this confined environment. NE Atlantic porcelain crabs (Porcellanidae) have thin bodies and flattened claws to allow them to crawl underneath rocks and even hang on upside down. One of these small, circular crabs picked up and placed in the palm of your hand will immediately scuttle to the edge and disappear underneath. Turn your hand over and it will repeat the performance. Lifting boulders will often also reveal small fish including eels, blennies and gobies that can survive in damp places out of water for some hours.

The Broad-clawed Porcelain Crab (*Porcellana platycheles*) rarely needs to emerge from under the boulders where it lives because it feeds mainly by filtering food particles from the water. It uses its flattened claws for protection and possibly to feed on dead animal matter.

Rock pools and crevices

One of the drawbacks of visiting a rocky seashore at low tide is that the residents are mostly inactive and not going about their normal business. This can be overcome to some degree by snorkelling over the seashore at high tide. However, an easier solution is to look at the organisms living in permanent rock pools, which provide a natural aquarium view. Here life can go on almost undisturbed whilst the tide is out. Rock pools provide a permanent home for some organisms and a temporary refuge for others when the tide retreats. Seaweeds and animals such as anemones and gastropod molluscs, can survive at much higher levels on shores where there are plenty of rock pools. In this way they can maintain a higher population and greater reproductive potential.

Many shallow water sublittoral fish exploit feeding opportunities on the shore by swimming up with the incoming tide and retreating as the tide falls. Some of these are occasionally stranded in rock pools but there are many fish that live only or mostly in the intertidal region and for them rock pools are essential for survival. The Shanny (*Blennius pholis*) is perhaps the commonest resident in rock pools around Great Britain and maintains a territory, one very good reason for returning any netted fish back to its home pool. Shannies are expert at fast flips and wriggles, a necessity to escape being caught by roaming gulls and waders and one reason they are so difficult to net. To survive, shore fishes must have great escape capabilities or must be well camouflaged. Certain families of fishes share these abilities and rock pool fishes the world over tend to belong to a limited number of such families. Search a rock pool in Europe, America, South Africa or Australia and you will find blennies (Blennidae), gobies (Gobiidae), pipefishes (Syngnathidae) and clingfishes (Gobiesocidae) as the main pool residents.

Living in a rock pool is by no means easy because of wide fluctuations in temperature, salinity and oxygen availability. In sunny climates exposure to UV light is also a problem. Nevertheless for those organisms that are physiologically adapted, there is less competition and in general fewer predators. Large rock pools and those nearest to low water mark have the most stable conditions and will support more species. However, even the smallest and highest rock pools are favoured by some species. The Giant Goby (*Gobius cobitis*) is found in high level pools from the south of England to the Mediterranean. It seems counter-intuitive that this large goby, which grows up to 27cm long, should live in tiny brackish pools,

A rock pool on a moderately exposed shore in Cornwall, UK. Delicate red seaweeds, anemones and many mobile animals thrive in the pool whilst only hardy barnacles survive on the rock around it.

but here it has little competition for its food supply of green algae, small crustaceans and even insects.

Bright green juveniles of Ballan Wrasse (*Labrus bergylta*) are common in rock pools around Great Britain in spring and summer whereas adults of this long-lived species are very rarely encountered there. The same applies to other normally sublittoral fishes including Thick-lipped Grey Mullet (*Chelon labrosus*), Lumpsucker (*Cyclopterus lumpus*) and Saithe (*Pollachius virens*). Rock pools provide a protected environment for the vulnerable juveniles of these species which move into deeper water as they grow larger.

The Rock Goby (*Gobius paganellus*) is a common rock pool resident in northern Europe. It survives even in very small pools as long as there is plenty of seaweed cover.

Vertical rock faces provide shade and can support soft sponges and delicate seaweeds outside of rock pools, whilst only barnacles and limpets live on adjacent horizontal rock exposed to the sun.

Sediment shores

As the tide retreats in The Wash estuary off the east coast of Britain, an immense, flat and apparently lifeless expanse of mud and sand is revealed. On the other side of the world along Australia's east coast, beautiful long stretches of sandy beach appear and are rapidly colonised by sun-seeking holiday makers. In neither situation is there much marine life in evidence. Seaweeds require hard surfaces for attachment and so are certainly in short supply and without them and with no rocky crevices and pools, there are few places for animals to hide from predators and to shelter from the elements. The incoming tide brings food and fresh oxygen but also flatfish and others looking for a good meal. So the animals on a sediment shore spend all or most of their lives buried beneath the surface in permanent or temporary chambers and burrows. Living beneath the surface also protects them from fluctuations in temperature, and those that can do so will burrow deeper during cold winter weather or migrate offshore into deeper water.

Walking from the top to the bottom of a sediment shore at low tide it will quickly become apparent that the sand at higher levels is much drier and generally coarser than that near the low tide mark. There are also few signs of life near the top, apart from holiday makers. Worm casts, tracks and trails are much more abundant in mid and low shore areas. Digging and sieving sand at different shore levels will show smaller numbers and fewer species of animals at high levels than there are lower down. In the NE Atlantic a search right at the top of a sandy shore will uncover numerous burrowing amphipods (p.272). These are sand hoppers (*Talitrus saltator*) which lives buried in sand above the high tide mark. They emerge under cover of darkness when the tide is ebbing and move down the shore and along the strandline, feeding on seaweed detritus. Adapted to breathe air, they will drown if submerged and return to a level above the previous high tide as dawn breaks.

Living in and moving through sediment requires specialist adaptations. Bivalve molluscs and polychaete worms are particularly suited to this way of life and from around mid-tide level it is these animals that will usually turn up in the sieve. However, a good dig and sieve on a productive shore will also reveal a variety of other animals including amphipods, crabs, starfish, sea urchins, ribbon worms (Nemertea), peanut worms (Sipuncula) and the occasional fish. These too have their preferred zones with some occurring over a wide part of the shore and others restricted to the upper or lower levels. Lugworms leave familiar squiggly piles of faeces on sediment shores all

On a sunny summer day on east coast England, the top of the shore has dried out nicely for the beach hut owners, whilst the bottom remains wet and supports a rich community of hidden worms and bivalve molluscs.

round Great Britain. However, a careful look will show that at upper and mid-shore levels, the casts have an accompanying circular feeding depression (p.213) whilst low on the shore this is not always the case. The casts without a depression are made by the Black Lug (*Arenicola defodiens*) whilst the ones with are produced by a second species the Blow Lug (*Arenicola marina*). Black Lugs are not always present and seem to prefer more exposed shores. As with rocky shores, the zonation of burrowing species is influenced by several factors but the length of time they remain submerged is particularly important. Most burrowing species are filter feeders or deposit feeders and reach up into the clean water above the sediment surface using siphons (bivalve molluscs) or tentacles (tube worms), and so can only obtain food and oxygen when the tide is in. Those living further up the shore have less time to feed than those lower down. In general errant polychaete worms that can move from place to place are more common at higher shore levels than sedentary bivalve molluscs.

Freezing temperatures during winter night-time low tides sometimes causes mass mortalities of razor shells, cockles and other bivalves. Conversely, midday low tides can cause heat stress to animals inhabiting sediment shores in hot climates.

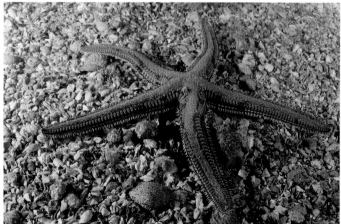

With arms reinforced with skeletal plates, burrowing starfish (*Astropecten* spp.) can push through the sediment in search of prey. Large predators are relatively rare in sediment as hunting through sand and mud is difficult and energy-consuming.

Meiofauna

Whilst worms and molluscs are obvious, a significant and important part of the fauna of a sediment shore is too small to be seen with the naked eye. Put a sample of seashore sand under a microscope and it will be evident that the grains are irregular in shape and size. As a result the sand grains do not fit closely together like a jigsaw, but instead there are water-filled spaces between them. To microscopic animals this provides a habitat equivalent to a jumble of boulders with plenty of available living space. The animals that live interstitially between sediment grains are called the meiofauna and comprise representatives from the majority of marine animal phyla.

Some meiofaunal animals live in habitats other than sediment and the technical definition is one of size. Meiofauna will pass through a 0.5mm sieve but will be retained by a mesh size of 0.063mm. This miniature world includes peaceful grazers and filter feeders as well as fearsome predators. It forms a vibrant community in its own right, but the meiofauna also provides a vital early link in the food web of sediment communities as a whole. Many species are permanent residents whilst others are the young or larval stages of burrowing or surface-living macroscopic animals. Exactly what you might find in a particular sediment sample will depend largely on the size of the sediment grains which in turn influences available living space, organic material, oxygen availability and stability of the habitat.

Sand and mud shores

Exactly which species of macrofauna you will find in a particular sediment shore is also determined largely by particle size and hence type of sediment, apart of course from the obvious differences imposed by geographical location and climate. A shore of clean coarse sand on a wave-exposed coast provides a very different habitat from fine mud in a sheltered bay.

Whilst it may be well-oxygenated, coarse sand is generally too mobile to allow construction of stable burrows and water drains from it quickly. It contains little in the way of organic matter which is washed out and the large grains also provide less surface area for attachment of bacteria and other micro-organisms. Mud on the other hand may be good for burrow construction and often contains plenty of organic material, but is anoxic (lacks oxygen) and can clog up gills because it can remain in suspension when the tide is in. Fine sand somewhere between these two extremes usually supports the greatest biodiversity. However, very fine mud deposited in estuaries may actually have a higher biomass but this is composed of just a few specialist species (p.74). Sediment shores in general have a lower biodiversity and abundance of species than equivalent rocky shores in the same area, as they offer far less choice of micro-habitat.

Phylum	Meiobenthic representatives	Example
Gnathostomulida	All species	
Cephalorhycha	Two classes (Kinorhyncha and Loricifera)	
Gastrotricha	Most species	
Nematoda	Many species	
Annelida	Several polychaete families ('archiannelids')	
Tardigrada	Most marine species	
Arthropoda	Most harpacticoid copepods (Harpacticoida)	
Arthropoda	All species of amphipods in suborder Ingolfiellidea	
Arthropoda	Some marine mites (Acarina)	
Arthropoda	All species of subclass Mystacocarida	

Important permanent meiobenthic animal groups.

On a fine sand shore the upper 5–15cm or so are well-oxygenated and yellow in colour. A worm cast, brought up from below this depth where the sand is anoxic (lacks oxygen), is blackened by iron sulphides produced when hydrogen sulphide reacts with iron. The hydrogen sulphide is a by-product from anaerobic bacteria able to thrive without oxygen.

READING THE SIGNS

With a little practice, the hidden residents on a sediment shore can be found from the clues they leave behind. Some are obvious such as the faecal piles left by lugworms (*Arenicola*) or the tufted tops of Sand Mason Worm (*Lanice conchilega*) tubes, whilst others are more subtle. A sudden strong jet of water often indicates a razor shell (Solenacea) that has detected the vibrations from your feet and pulled rapidly down into its burrow leaving behind a 'keyhole' in the sand. A star-shaped pattern of grooves in muddy sand shows where a deposit-feeding bivalve mollusc has suctioned up organic debris using its siphons (e.g. *Scrobicularia* p.267) or it may simply be a brittlestar or burrowing starfish buried just below the surface. Predatory gastropod molluscs including cone shells (Conidae) and shelled sea slugs such as *Acteon tornatilis* leave meandering trails in wet surface sediment as they search out their victims.

Tracks and trails left on a sandy island beach in Borneo when the tide is out, indicate the numerous comings and goings of scavenging ghost crabs and hermit crabs, as well as seabirds and land animals.

Ecological aspects

Visit a sediment shore at low tide almost anywhere in the world with a pair of binoculars and their importance as feeding grounds for wading birds will soon become apparent. The fortunes of many waders are intimately connected with the abundance of their main prey species. In The Wash estuary, UK, numbers of Oystercatcher (*Haematopus ostralegus*) have been correlated with the abundance of cockles. A poor seasonal settlement of cockles and over-harvesting both lead to a decline in numbers as the birds go in search of other foraging areas.

On a tropical mudflat it is not only birds that can be found feeding but also mudskippers, small blenny-like fish that emerge from burrows at low tide to feed on algae. They can survive with just the occasional gillful of water. Fiddler crabs (*Uca*) do much the same. On South African sandy shores dead fish are eaten by specialist scavenging gastropod molluscs that are drawn to carrion by smell and clean up much as hyaenas do on African plains. Called plough snails (*Bullia*), they use their large, fleshy foot to surf up the shore on an incoming tide. They will also eat stranded jellyfish and so help to clear beaches following a storm.

Sandy shores are important nesting areas for sea turtles and birds such as terns (Sternidae) which lay their eggs above the high tide mark. Some marine animals including horseshore crabs (p.262) and small fish called grunions (p.31), swim up the shore with a high spring tide and bury their eggs near the top. Here they can develop in relative safety, hatching on the following high spring tide.

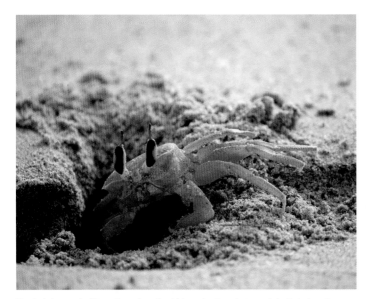

Tropical ghost crabs (*Ocypode* spp.) can live high up the shore but remain in their damp burrows during the heat of the day. With their large stalked eyes they can spot predators when they are still far distant.

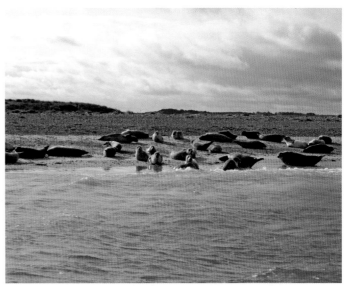

Remote sand banks exposed at low tide on the Norfolk coast, UK, provide a welcome resting place for Grey Seals (*Halichoerus grypus*) and Harbour Seals (*Phoca vitulina*), which also give birth in such areas.

SUBLITTORAL

The sublittoral is the area of seabed extending out from the lower part of the shore to the edge of the continental shelf (p.34). It is therefore permanently submerged except for the sublittoral fringe between the low water neap and low water spring tide marks (p.30). The lowest spring tides in a year fall in March and September at the equinoxes and expose the full extent of the sublittoral fringe. This is the time to visit the seashore to see the exposed edges of kelp forests, of coral reefs and seagrass beds, or just vast expanses of sediment. Sublittoral habitats beyond the fringe are the realm of scuba divers, accessible nowadays to anyone willing to invest time and money in training and equipment.

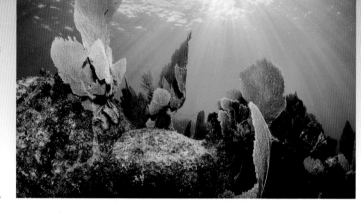

Seafans sway gently in the shallow sublittoral regions of a Caribbean island.

Rocky reefs and wrecks

Steep cliffs and rocky crags on land are relatively barren as there is little or no soil to support plants and therefore no associated animals. Underwater it is the exact opposite and rocky surfaces are generally covered in a profusion of marine life. With their requirement for light, seaweeds are restricted to shallow water but sessile and sedentary animals such as anemones, sponges, bryozoans, sea squirts and mussels thrive on much deeper reefs throughout the sublittoral zone. Rocky reefs and cliff faces that rise well above surrounding sediment provide elevated living space for such animals, where they are exposed to the water currents that carry their plankton food. Such currents (or waves in shallow water) also carry away settling sediments and prevent the animals from being smothered.

Favourable living space is at a premium in productive sublittoral waters and any new hard surfaces are colonised quickly. Most sessile animals produce planktonic eggs and larvae which disperse, often over a wide area. Finding a suitable space to settle is often difficult as clean surfaces only becomes available when existing growths die or are torn away by storms. Exactly what settles to fill such spaces will depend on many different factors including chance. However, many larvae increase their likelihood of finding suitable attachment sites by using chemical clues. Intertidal barnacles such as *Semibalanus balanoides* are attracted to sites where there are already other barnacles. Under very crowded conditions, these barnacles grow much taller than usual and therefore are exposed to a greater drag force from wave action. Clumps of old barnacles break away and are replaced by settling larvae. Some larvae are able to delay metamorphosis whilst they explore the seabed looking for a suitable attachment site.

A shipwreck often results in tragic loss of life and of valuable cargo but to a drifting larva ready to settle, it is simply a welcome piece of new real estate. If the wreck lies on a sediment seabed then it immediately provides a habitat for species that would otherwise be unable to live there. Shipwrecks always attract fish, which use them to shelter from currents and predators and hunt in their vicinity in the same way as they do on a rocky reef. It is surprising just how quickly fish move into a new shipwreck. The author observed large groupers (*Ephinephelus tauvina*) and angelfish (*Pomacanthus maculosus*) on a wreck in the Arabian Gulf within a few days of it sinking, even though it lay on sand and with no rocky reefs for miles around (Dipper 1991).

This attraction to solid objects, sometimes termed thigmotrophism, is well documented in fishes and is exploited by fishermen who deploy FADs (Fish Aggregating Devices) to gather together open water fish.

A shipwreck situated adjacent to or on a rocky or coral reef provides an opportunity to compare the marine communities in the two habitats. Most observations suggest that shipwrecks develop and at least initially maintain slightly different communities to those on natural rock nearby. Wrecks sunk purposely to form artificial reefs to attract fish or for recreational diving purposes make useful experiments. The Royal Navy frigate HMS *Scylla* was scuttled in 2004 near Plymouth, UK, for the

Exactly what lives on a rocky reef depends on numerous factors. This reef off the East Anglia coast, UK, is made of soft chalk and so has numerous holes and crevices and is a perfect habitat for crabs and lobsters. Seaweeds dominate the top of the reef whilst sessile animals grow on shaded vertical surfaces.

Plumose Anemones (*Metridium senile*) are commonly found on the tops of shipwrecks as well as rocks (as here in Puget Sound, USA), held up into the current. These large anemones use large and highly extensible 'catch tentacles' to sting and discourage anemones of their own or another species that settle nearby. Once large enough, an individual produces new anemones from around its base (p.235) and these clones are not attacked.

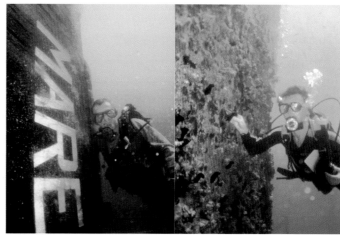

The stern of the cargo vessel *Mare*. Left: one month after sinking; Right: fifteen months after sinking.

latter purpose, and scientists and volunteers have studied the growth of marine life on and around it ever since.

As well as shipwrecks, almost any hard object placed in the sea will act as an 'artificial reef' and such reefs are incidentally created when new harbours, breakwaters and, in recent years, offshore wind turbines are built. However, purpose-designed artificial reefs are increasingly being deployed. The usual aim is to increase the catch of fish and crustaceans both in artisanal and commercial fisheries. Whilst floating and moored FADs collect pelagic fish together in one place making them easier to catch, they do not increase productivity and have led to local declines in fish populations in some areas. This is in direct contrast to well-researched and properly constructed artificial reefs which are designed to increase the habitat and food supply available to resident species and encourage them to reproduce and spawn on-site. The use of artificial reefs in fisheries management is now widespread but their effectiveness is not always clearly documented. A useful reference is provided by Bortone *et al.* (2011) based on the 10th International Conference on Artificial Reefs. Modern modular artificial reefs are increasingly being used to mitigate damage to coral reefs and other damaged habitats. Successful designs have also been produced to increase numbers of habitat-limited groups such as lobsters and octopuses in an area.

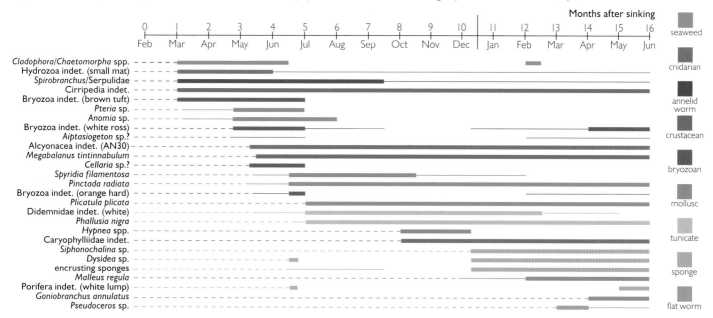

Succession of species on the wreck of the cargo vessel *Mare* in the Arabian Gulf documented from 1–16 months after sinking. Fast-growing seaweeds, barnacles and serpulid tubeworms settled first. Whilst some of these persisted, others were replaced by slower-growing, long-lived species such as the Pearl Oyster (*Pinctada radiata*). The 'experiment' came to an end after two years when the wreck was cut up and sold for scrap.

Coral reefs

Coral reefs are arguably the most vibrant, productive and biodiverse of all marine ecosystems. Developed to various degrees around at least a third of tropical coastlines, many have now been destroyed, damaged or degraded by human activities. Coral reefs are both a biological and a geological phenomenon and many were first discovered and mapped when ships ran aground and were wrecked on them in centuries past. Corals themselves have fascinated naturalists since the early 18th century and the bleached white skeletons of early specimens dredged from the seabed, can still be found in many museums. However, our understanding of coral reefs as living ecosystems only started to develop with the advent of scuba diving in the mid 20th century and from early films by pioneers such as Hans and Lotte Hass and Jacques Cousteau.

Coral reefs are complex limestone structures made up of many different components, but are built primarily from colonies of stony scleractinian corals (Scleractinia). Many thousands of tiny individual, but interconnected polyps make up each living colony and are responsible for secreting the massive calcium carbonate skeleton beneath a thin veneer of living tissue. The detailed structure and biology of corals is described on pp.233–236 in the cnidarians section of this book. Coral reefs vary hugely in their component corals, but all reef-building corals are hermatypic, which means they have a symbiotic relationship with various species of photosynthetic unicellular algae or cyanobacteria, collectively called zooxanthellae (p.234). These are the means whereby the corals obtain sufficient energy to build their skeletons in relatively nutrient-poor tropical waters. Coral reefs are dynamic structures that are continually being built up and eroded away. Coral growth adds material to the reef whilst calcareous algae, sand and coral debris bind and strengthen it. Destructive agents include wave erosion and bioerosion resulting from the feeding and burrowing activities of reef animals (see below).

Coral reefs occur in shallow, warm waters around tropical and subtropical coasts between latitudes of about 30°N and 30°S. Right on these limits are Lord Howe Island off SE Australia with the world's most southerly coral reef and the southern coast of Honshu, Japan with the most northerly (highest latitude) reefs (Veron, 2000). Coral flourishes best at steady temperatures between 25°C and 30°C, conditions generally found near the equator. Reefs in cooler water such as those at Lord

Coral reefs teeming with life contrast markedly with the hot arid desert coastlines that they fringe in the Red Sea. With little silt and freshwater input from rivers, reefs thrive in the clear water of this region.

Howe Island look very different with a mixture of coral and algal (seaweed) communities. It is only in tropical waters that slow-growing coral communities can outcompete algal communities.

As temperature is so important in coral reef formation, it is not surprising that reef distribution is affected by major surface currents. The cold north-flowing Benguela current running up the SW coast of Africa limits coral growth along the coastlines of Namibia and Angola. These dry desert coastlines also lack the suitable hard substratum which corals need to settle and grow. In contrast coral communities are able to grow in Bermuda because of warm water carried north from the Caribbean by the Gulf Stream. Tropical coastlines along the east coast of South America do not support as much in the way of coral reefs as might be expected, due mainly to large outflows of turbid freshwater from great rivers such as the Amazon. However the paucity of reefs in the eastern Atlantic in general and their absence in the Mediterranean results mainly from their geological history.

Map (based on Spalding et al. 2001) showing approximate world distribution of coral reefs. The most recent estimate of cover (made over 10 years ago) is 284,300km² of coral reef worldwide which is less than 1.2% of the area covered by the world's continental shelves (Spalding et al. 2001). For further detailed regional maps and the most current conservation status of coral reefs for specific areas see Wilkinson (2008).

Reef zones

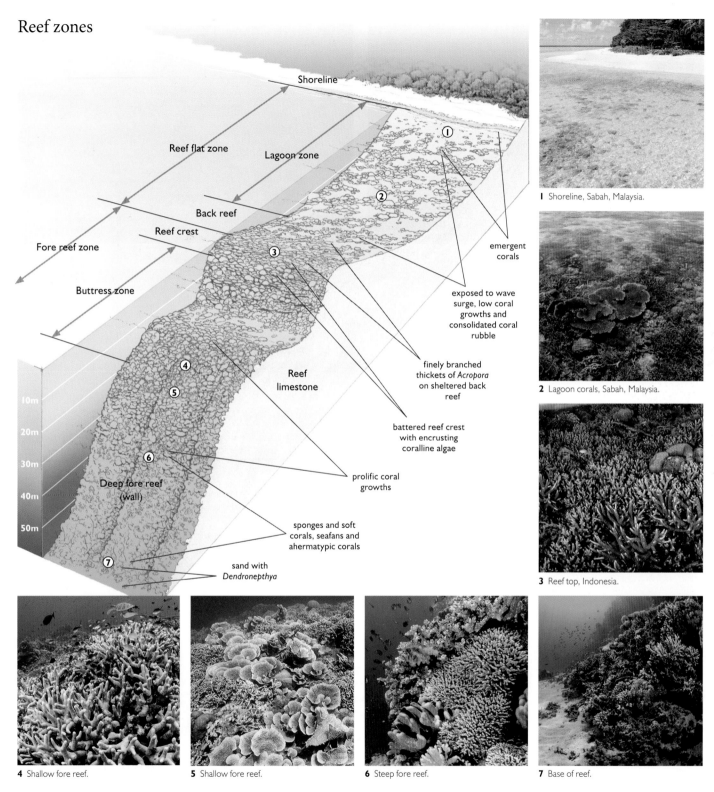

1 Shoreline, Sabah, Malaysia.
2 Lagoon corals, Sabah, Malaysia.
3 Reef top, Indonesia.
4 Shallow fore reef.
5 Shallow fore reef.
6 Steep fore reef.
7 Base of reef.

A cross section through a generalised coral reef showing zones.

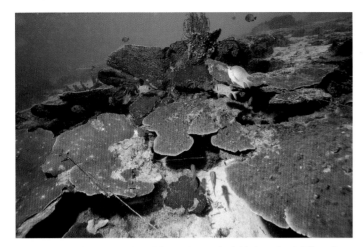

In clear, low latitude waters, coral can thrive on deep, unshaded horizontal reefs. This reef in the Semporna Islands, Sabah (Borneo) is at 40m depth. The majority of the corals are upward-facing plate-like species.

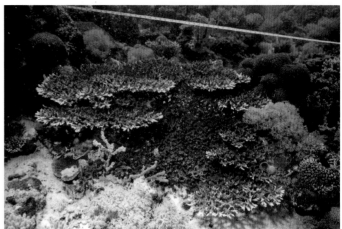

This *Acropora* table in Sabah (Borneo) measured by the author over a period of four years increased in diameter by 50cm, an average growth rate of 12.5cm per year. Many massive corals grow only by a few millimetres a year.

On any particular reef, the depth to which the coral extends is limited to around 50m by decreasing light levels. However, the richest growths are in shallow water from about 2m to 15m depth. Coral extent depends not only on water clarity, but also on aspect and the steepness of the slope, all of which affect light levels. In some areas such as the Great Barrier Reef of Australia, coral-covered reef flats are exposed on low spring tides, but most reefs remain permanently submerged. Whilst they need light, few corals can withstand exposure to air for very long and most, like humans, are susceptible to damage by ultra-violet rays. Some very shallow-water corals contain chemicals that act as a type of sunscreen.

The well-developed zonation patterns shown by many coral reefs are not only related to depth and light but also reflect where and how they have developed. The crest of a reef pounded by waves is a very different habitat to the sheltered back reef on its landward side. Zonation is often most apparent in fringing reefs along a coastline or around an island or coral sand cay. Recreational divers are usually dropped off their boats directly onto the seaward slope, the fore reef or 'drop off', where coral growth and fish life is richest. However for a naturalist, a snorkel or dive on the back reef and in a reef lagoon may be less exciting, but will reveal a wider variety of habitats including seagrass beds and patch reefs, with their associated specialist species. These areas are often fished by local people who wade out at low tide to collect molluscs, sea urchins and seagrass fruits for food.

Reef life and diversity

Coral reefs support incredibly high numbers of different species, easily on a par with tropical rainforest. On a healthy reef, fish are the most obvious and the kaleidoscope of different colours and shapes is what attracts most tourist divers. Worms, crustaceans, molluscs and echinoderms are numerous, but often less obvious, with some notable exceptions including armies of spine-waving *Diadema* sea urchins. Growing amongst the hard corals is a wide variety of soft corals and other cnidarians, sponges and tunicates. As explained below, the high productivity of coral reefs is a result of an efficient nutrient recycling system such that the reef is almost independent of any nutrient input from outside the ecosystem.

The diversity of corals varies between reefs in different geographical areas around the world, with far higher numbers in the Indo-Pacific than in tropical Atlantic regions. Whilst it is difficult to find precise numbers there are around 700 species of hermatypic corals in the Indo-Pacific as compared to around 60 in the Caribbean and West Atlantic.

Within any given area, the diversity of coral species on a particular reef will vary according to conditions. Strong wave action breaks up delicate species and a fringing reef on the lee side of an island may well support a greater variety of species than one on the exposed side. In very sheltered areas such as lagoons with little in the

THE CORAL TRIANGLE

Coral biodiversity is at its greatest in an area of the Central Indo-Pacific dubbed the 'Coral Triangle'. Stretching south from the Philippines, past eastern Borneo to central and eastern Indonesia and Timor Leste, it continues eastwards to Papua New Guinea and the Solomon Islands. Within this 'hotspot' of global ocean biodiversity are about 35% of the world's coral reefs, 75% of all coral species and more than 3,000 species of fish (Wilkinson 2008). Southern Papua has one of the four largest single expanses of mangroves in the world. Living within the triangle are more than 120 million people, the great majority of whom rely on marine resources for their living. Not surprisingly, the majority of coral reefs in this region have therefore suffered degradation, particularly from overfishing and destructive fishing practices including fish bombing using explosives. Conserving the biodiversity of this region both on land and in the ocean is vitally important, both in terms of global biodiversity and for the well-being of the people living there.

Clumps of tough, calcareous algae growing on 'bald' patches in massive coral colonies provide a further foothold for tunicates and hydroids.

way of tidal streams, the silt load in the water may be so high it leads to smothering. However, perhaps surprisingly, coral diversity is often higher where the water is slightly turbid. This is because in very clear, wave-sheltered water, fast-growing branching species of *Acropora* out-compete slower growing species reducing diversity. *Acropora* does not thrive well in turbid waters.

Corals form the structural framework of a coral reef much as trees do in a tropical rainforest. Their three-dimensional shapes provide safe refuges for many species of small reef fish and a permanent home to many mobile invertebrates such as small crabs. Christmas tree worms (*Spirobranchus* spp.) and other tube worms settle in coral crevices and their tubes become encased in rock armour as the coral grows. Cracks, holes and tunnels between and beneath live corals and within the limestone of dead coral rock, provide a further wealth of hiding places. Parrotfish take advantage of this at night and wedge themselves into crevices, secrete a mucus cocoon and remain in safety until morning (see photograph on p.493).

Live corals have various chemical and physical means for preventing other organisms from settling on them but often have dead 'bald' patches where sponges, hydroids, sea squirts and other sessile animals and seaweeds, can attach and grow. Areas of dead coral rock between live colonies are similarly colonised. These sessile animals and seaweeds in turn provide living space and food for grazing invertebrates such as sea slugs.

In an ecosystem such as a seagrass bed it is obvious that the productivity comes from the plants. Animals graze directly on them and detritus from them is recycled through the food chain. In contrast, live coral, protected as it is by its hard skeleton, is rather inaccessible as a food source as are the photosynthetic zooxanthellae hidden within its tissues. Most coral-reef animals feed either on plankton, detritus, encrusting algae, seaweeds and sessile animals or eat each other. Only a few specialists directly eat live coral. Corals, however, provide a very large input of dissolved organic matter (DOM) to the reef ecosystem, exuding some compounds directly but also releasing mucus and waste products. Whilst bacteria absorb and utilise some of this material, recent experimental work has shown that most of the DOM is recycled and retained in the system by sponges, which rapidly filter out and absorb the DOM. This has been demonstrated both in the aquarium and in the wild, using sugars labelled with carbon isotopes. These are quickly absorbed by sponges and appear within gastropod snails and worms within just a few days (de Goeij *et al.* 2013). Sponges themselves are not particularly edible either, but they have a rapid turnover of their filter-feeding cells (choanocytes) which are shed as copious quantities of detritus. This is then consumed by bottom-living worms, molluscs, holothurians and other detritivores which are in turn eaten by fish and other predators. The finding of this so-called 'sponge loop' helps complete the picture of how coral reefs manage to thrive in nutrient-poor tropical waters.

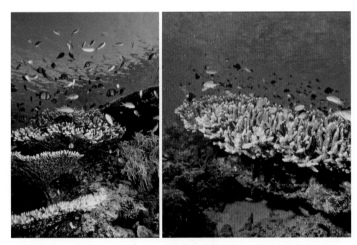

A series of dives undertaken by the author during a 24-hour period off Sipadan Island, Malaysia showed how day-active plankton-picking fish (left) move down close to their coral home at dusk (right), finally retreating between the branches as darkness falls, and only emerging again at daybreak.

Sponges form an integral part of healthy reef ecosystems. Here encrusting species are filling the spaces between live corals in the Caribbean. On a healthy reef, encrusting corals and sponges often compete with one another for space, producing a varied mosaic of many different species.

Species/group	Feeding method and impact
Hawksbill Turtle (*Eretmochelys imbricata*)	Uses strong beak to tear off sponges and soft coral and often takes coral with it.
Long-nosed Butterflyfish (*Forciper flavissimus*)	Picks off individual coral polyps; many other food sources. Minimal impact.
Bumphead Parrotfish (*Bolbometodon muricatum*)	Bites off coral lumps, digests tissues and voids skeleton as fine sand. Also eats encrusting algae. Small impact.
Crown-of-thorns Starfish (*Acanthaster planci*)	Digests tissues externally with gastric juices from everted stomach. Outbreaks can kill large areas of coral.
Drupella cornus (gastropod mollusc)	Uses proboscis to probe for polyps. Population outbreaks uncommon but can cause considerable coral death.
Amakusaplana acroporae (flatworm)	Eats *Acropora* corals. Effect in the wild unknown, kills coral colonies in aquaria.

The edible reef: major coral predators (coralivores).

Status of coral reefs

The litany of deleterious impacts facing the world's coral reefs is long and daunting. It includes a variety of pressures from human populations as well as wider global climatic events. Reefs near major population centres are especially at risk from over-fishing and destructive fishing practices, pollution, increased siltation resulting from de-forestation, coastal development and even tourism. However, there are also many initiatives both local and global working to conserve reefs. The latest (5th) global report produced by the Global Coral Reef Monitoring Network (Wilkinson 2008) estimates that nearly a fifth (19%) of the original extent of coral reefs worldwide has been destroyed. Based on the current state (in 2008) of the remaining reefs they estimate 15% (from the original 100%) are seriously threatened with loss by 2018 to 2028, and 20% are threatened with loss by 2018–2048. The remaining 46% are not immediately threatened by anthropogenic effects (i.e. those caused by man) but this does *not* take into consideration the potentially considerable threat posed by global climate change. Excepting remote island archipelagos such as the Hawaiian Islands, the Red Sea has lost the least percentage of its original reefs (4%) and the neighbouring Gulfs the highest at 70%. The Red Sea of course started out with nearly five times the coral reef area than the Gulf region.

That reefs can and do recover from devastating destruction caused by climatic events has been shown by the recovery of reefs in the western Maldives, Chagos, Lakshadweep Islands (India), and NW Sri Lanka following the 1998 widespread coral bleaching (p.27) caused by a severe El Niño event (p.17). However, recovery is only possible where pressure from human populations is minimal. In spite of significant conservation efforts, many reefs within the heavily populated 'coral triangle' in SE Asia have shown little or no recovery from the same event.

Climate change poses a threat to coral reefs through ocean warming, with consequent increases in severity and extent of coral bleaching, through an increase in the frequency and severity of storms and hurricanes, and through rising sea levels. The increased carbon dioxide levels that are driving climate change also impacts coral reefs directly through the ocean acidification (p.25) that occurs as more carbon dioxide is absorbed into the ocean. The lowered pH reduces the concentration of carbonate ions needed by corals to make their calcium carbonate skeletons. Scientists warn that a level of atmospheric carbon dioxide of around 450ppm may result in an ocean too acidic to support coral reefs. Current levels are around 390ppm (p.25).

The efforts of 372 coral reef specialists from 96 countries gathered the data compiled and presented in the 2008 Status of Coral Reefs of the World report (Wilkinson 2008). However, an increasingly important part is being played by 'Reef Check' (Appendix I) and other initiatives that involve recreational divers and naturalists in repeat surveys that monitor changes in the condition of reefs in different areas.

Date	Event	Reef areas affected
1998	El Niño catastrophic bleaching event	Indian Ocean, Western Pacific, Caribbean
2004	Indian Ocean earthquakes and tsunamis	Sumatra, Indonesia, Thailand, Andaman & Nicobar Islands, Sri Lanka, Maldives
2005	El Niño catastrophic bleaching event	Wider Caribbean
2005	Most severe hurricane season on record	Caribbean, Gulf of Mexico
2005	Disease	Caribbean
1998–2005 (and earlier)	Crown-of-thorns Starfish plagues	Great Barrier Reef Australia
2013	Typhoon Haiyan	Philippines

Major damaging events for coral reefs from 1998 to the present (2014). Each of the earthquakes, tsunamis, hurricanes and typhoons listed also caused devastating loss of life and livelihood to people.

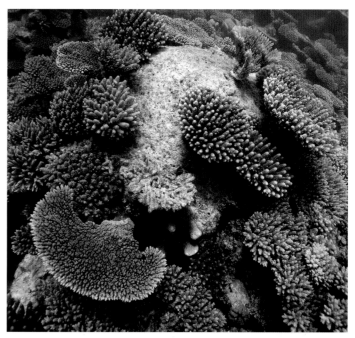

On healthy and otherwise undamaged reefs such as this one in the Maldive Islands, growth of new corals after an El Niño event can be rapid.

Kelp forests

The idea of seaweeds forming a forest is hard to grasp, unless that is, you have swum through a kelp forest off the Californian coast. Here kelp, a type of brown seaweed (macroalgae), grows as tall as any rainforest tree. Kelps belong to the order Laminariales and are described in detail in the Marine Plants and Chromists section (p.156). Tranquil kelp forests fringe cold temperate rocky coastlines in both hemispheres, often starting just below the low water mark. Forests of giant kelp (*Macrocystis* and *Nereocystis*) are prominent along the Pacific coasts of North and South America whilst smaller *Laminaria* species predominate in the northern part of the North Atlantic. Forests of smaller species are sometimes referred to as kelp beds. Like forest trees on land, kelp forms the physical framework for a highly productive and biodiverse ecosystem and like seagrass it is valuable both in an ecological context and economically through its role as a nursery and breeding ground for commercially important fish and invertebrates.

Kelp forests only grow in cool waters ranging from about 5–20°C (see map below) and different species have different temperature tolerances. The most southerly forests are found around sub-Antarctic islands including South Georgia and the South Sandwich Islands, although kelp is also an important component of bottom communities around some parts of Antarctica. The Bull Kelp (*Durvillaea antarctica*) is one of the toughest kelps and can withstand both the cold and the pounding waves found in the Southern Ocean. It is the predominant forest kelp around Australia's Macquarie Island situated half way between the southern tip of New Zealand and Antarctica. Giant Kelp (*Macrocystis pyrifera*) also grows here but not on Heard Island, situated between Madagascar and Antarctica which, whilst on a similar latitude, is below the Antarctic Convergence. This is the encircling meeting point where north-flowing cold Antarctic water meets relatively warmer sub-Antarctic water.

Cold, vigorous waters have a higher nutrient content than warm, placid waters and kelp thrives in nutrient-rich coastal areas, especially in upwelling areas driven by cold currents such as the Benguela, Peru and California currents. Divers are often surprised to find kelp beds, albeit rather small scruffy ones, off Salalah in Oman. Here summer water temperatures can rise well above 20°C but cold upwelling waters allow kelp to grow.

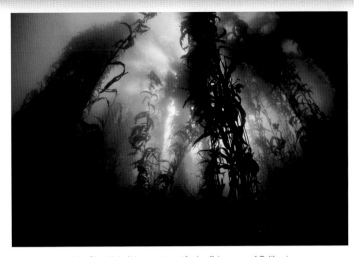

Reaching for the light Giant Kelp (*Macrocystis pyrifera*), off the coast of California, grows upwards until it reaches the surface 30–40m above. In the right conditions this kelp can increase in length by 60cm a day, the fastest rate of any seaweed.

Waves and currents exert considerable drag on large kelp plants and kelp forests need a stable substratum to which they can attach. Consequently the best developed forests are found on solid bedrock and large boulders. There are no substantial kelp forests around the coast of SE England where soft chalk rock predominates, but kelp flourishes along the granitic NE coast of Scotland. Kelp also has a high light requirement and will not grow in turbid waters, even when a suitable substratum is present.

A classic kelp forest has a tiered structure similar to that of a rainforest. The fronds, in the equivalent capacity to leaves, form a dense canopy designed to absorb the maximum amount of available light. At its densest the canopy shades the seabed and restricts the growth of smaller seaweeds and algae on the rocks below. Giant

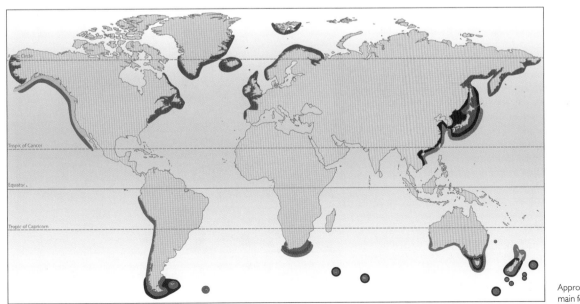

Approximate native distribution of the main forest-forming kelp genera.

SUBLITTORAL

In Great Britain it is possible to walk through a bluebell wood in the morning and swim through a kelp forest off the same coast in the afternoon. There are striking similarities in the structure of the two ecosystems.

Macrocystis fronds reach right to the surface arranged along a flexible stipe (stem) and form a tangled surface mat trailing over the water surface for many metres. Each blade is supported at the base by a gas-filled bladder (p.148). *Laminaria* and other smaller species of kelp form a canopy below the surface and are restricted to relatively shallow water where they can obtain sufficient light. Most have a stipe like a thin tree trunk which holds the frond aloft and incidentally provides a home for epiphytic seaweeds, much as forest trees support orchids and bromeliads. A strong holdfast attaches the kelp to the seabed which is overgrown by an understorey of smaller seaweeds and sessile animal growths. Sea urchins graze this undergrowth, playing a similar role to deer in a rainforest. As light decreases with depth, the kelp forest thins out and becomes a kelp 'park' often with a concomitant increase in red seaweeds no longer restrained by a kelp canopy above them. However, these too fade out with a further increase in depth.

A kelp forest provides food and a wide variety of habitats for an abundance of marine wildlife. Fish, seals and cetaceans swim and hunt gracefully between the stipes and fronds, molluscs and crustaceans crawl over and around the kelp, whilst sessile animals and epiphytic seaweeds attach directly to it. A thick kelp forest on the lower shore and in shallow water dissipates the power of the waves, allowing many small invertebrates to live in the lower energy environment between and within the kelp holdfasts. Kelp holdfasts are large and complex structures (p.130) and a forest of them can turn a smooth and featureless bedrock slab into a miniature undulating landscape of mounds and rough surfaces to which, sponges, hydroids, soft corals and bryozoans can attach. The holdfasts also provide a myriad of cracks and crevices in which mobile animals can hide. Around 90 species have been found in *Durvillaea* holdfasts from Macquarie Island, which lies between New Zealand and Antarctica, including molluscs, crustaceans, worms, brittlestars and sea cucumbers. Analysis of kelp holdfast faunas is a useful tool in monitoring changes in rocky shore and shallow sublittoral ecosystems. Kelp forests provide a temporary refuge for seabirds and mammals such as seals, sea lions and sea otters during violent storms. Even Grey Whales (*Eschrichtius robustus*) have been known to seek shelter in Californian kelp forests.

A range of herbivorous animals, especially sea urchins, limpets and chitons graze directly on live kelp. The Blue-rayed Limpet (*Patella pellucida*) found in European kelp forests, excavates large cavities in stipes and holdfasts, significantly weakening them. However, most of the kelp production is consumed as detritus. Pieces of frond continually break off, fall to the seabed and so come within reach of amphipods, worms and a host of other small invertebrates. Some species such as the Forest Kelp (*Laminaria hyperborea*) are deciduous and drop their fronds in spring as they grow new ones. The shed fronds decay, and release nutrients into the water column and also into sediments when the debris is washed ashore.

KEYSTONE SPECIES

The Sea Otter (*Enhydra lutris*) is a keystone species in Californian kelp forests. A keystone species is one whose removal may lead to ecosystem collapse. Much to the delight of tourists, otters can often be seen lying on their backs amongst the kelp fronds at the surface, busily breaking open and eating sea urchins. This activity is vital for the health of the kelp forest as it keeps urchin numbers in check. Urchins chew into the holdfasts anchoring the kelp which may break off and float away leading to the destruction of the forest (p.324).

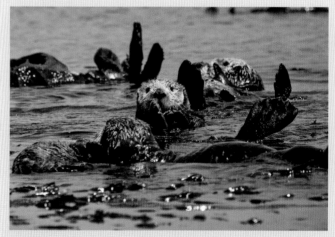

Sea Otters sleep with kelp fronds draped around them to prevent themselves from floating away. The kelp forest provides them with food, shelter and a safe place to rear their young.

Seagrass beds

Seagrass 'meadows' are one of the most widespread of marine, shallow water ecosystems and are found off the coasts of all continents except Antarctica. Dense beds grow in sand and mud in calm, sheltered waters from just below the seashore down to around 5m depth. Some species, such as *Zostera noltii*, cover the lower parts of muddy shores with a dense green swathe and seagrassses can grow at depths down to at least 50m in clear water, but only sparsely. Seagrass beds are extremely valuable both in ecological and economic terms, the latter especially in areas where local and subsistence fishing is the predominant way of life. They are also very beautiful and an excellent hunting ground for anyone keen to see unusual marine creatures such as seahorses and of course dugongs, or sea cows as they are widely known (p.439). The seagrass plants themselves are marine flowering plants and are described in detail in the Marine Plants and Chromists section (p.128).

Most seagrasses grow and spread relatively quickly and a seagrass bed will maintain itself over many years. A stable bed has the capacity to recover relatively rapidly from storm or human-induced damage, given the right conditions. Some *Posidonia* seagrass beds in the Mediterranean cover many kilometres of seabed and are calculated to have been there for hundreds and sometimes thousands of years. Dead material accumulates in the anoxic sediment in a structure called a 'matte' and is preserved in a similar manner to the build up of peat on land. Specialised acoustic technologies, cores and radiocarbon dating show just how old and thick these structures can be. In this way, seagrass beds lock carbon away for extended periods and calculations suggest they are responsible for more than 10% of the carbon that is buried each year in the oceans (Fourqurean et al. 2012). This makes them extremely important in the mitigation of global warming. The continuing widespread degradation and destruction of seagrass beds around the world should therefore concern even those who might otherwise express little interest in them.

Natural grasslands on land usually consist of many different species of grass along with other flowering plants and large numbers of associated invertebrates. Cultivated fields and lawns with only one or a few species of grass generally support a much lower biodiversity of wildlife. Seagrass beds, however, are frequently made up mainly of one or two species and yet they form an extremely biodiverse ecosystem. This results partly from their complex, three-dimensional structure and also from their high productivity and relatively efficient recycling of nutrients. The structure provides a variety of micro-habitats which are exploited by different species. For juvenile fish and shrimps the stems and leaves provide a miniature forest where they can live safely in a relatively predator-free environment and seagrass beds are important nurseries for many commercial fish species.

Sessile and colonial animals such as sea anemones, hydroids, stalked jellyfish, bryozoans and colonial sea squirts settle and grow as epifauna on seagrass leaves, especially the tops where they are in a good position to filter plankton from the water. In turn these provide a food source for sea slugs and sea snails (and presumably an unintentional protein boost for grazing herbivores such as dugongs). Small epiphytic seaweeds also find space on the leaves and all these growths add to the detritus when the

A seagrass meadow in Florida, Gulf of Mexico.

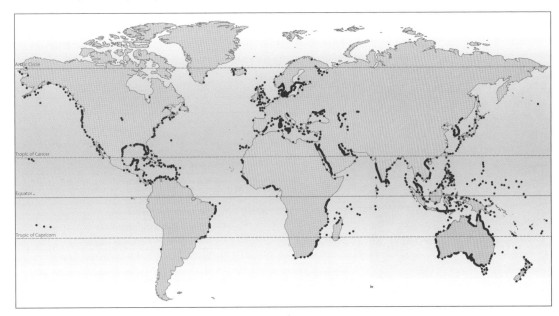

General world distribution of seagrasses. The distribution shown is indicative only of the general geographic areas where seagrasses are found. Modified from Green and Short 2003.

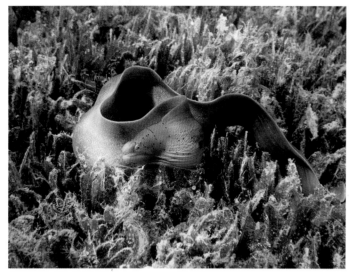

Like a snake in a forest, this moray eel (*Gymnothorax* sp.) slithers easily through a seagrass bed in the western Indian Ocean, searching out crustaceans and unwary fish.

seagrass leaves die or break off. The extensive root and rhizome systems of a dense seagrass bed play a very important role in binding sediments. This in turn provides a stable environment for surface-living molluscs and crustaceans including commercially important scallops, oysters, mussels, conch, shrimp, lobsters and crabs. Such bound sediments are much less prone to erosion during storms and like mangroves, seagrass beds may play a role in mitigating the effects of storms and tsunamis.

Herbivores that feed directly on seagrass, including fish, sea snails and turtles, benefit from the productivity of seagrass communities. Various studies estimating average net primary production in different plant communities indicate that seagrass beds are several times more productive than equivalent seaweed or phytoplankton communities. Dugongs, weighing in at up to 500kg and more, are the largest marine herbivore and each one can eat a considerable quantity of seagrass each day. A herd of over 600 was recorded in the Arabian Gulf in 1986 though this was exceptional even then. Many of the herbivorous fish, including snappers, emperors, rabbitfish, parrotfish and surgeonfish, that graze in seagrass beds, are targeted by commercial and artisanal fisheries.

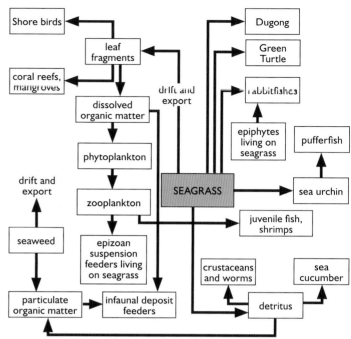

Food web in a Philippine seagrass ecosystem, based on Fortes (1990).

Seagrass leaves are often frayed at the ends and the pieces that drop off provide a continual supply of detritus as do plants that die and decay. This provides a feast for many worms, amphipods, shrimps and other invertebrates and fish that eat decaying plant matter.

In spite of their ability to regenerate, seagrass beds are declining worldwide, mainly due to increased turbidity, increased nutrient levels and mechanical damage to their coastal habitats. This is not surprising given the propensity of the world's population to live along the coasts. Threats to seagrasses are covered in more detail in the Marine Plants and Chromists section (p.160). Artificial grass on land provides recreational areas for people, but perhaps surprisingly there has been some small-scale success in using artificial seagrass to repair and create new beds, but with the primary aim of providing habitat for fish and other marine species.

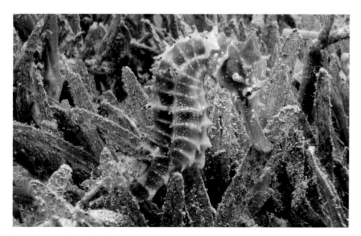

Seagrass is an ideal habitat for seahorses, providing a good tailhold and a plentiful supply of the tiny planktonic crustaceans on which they feed.

Taxonomic group	Species
Seagrasses	*Enhalus acoroides*
Green algae	*Caulerpa lentillifera*
Crustacea	Blue Crab *Portunus pelagicus*
Molluscs	Conch *Strombus* species
	Spider conch *Lambis* species
	Pen shells *Pinna* species
	Cone shells *Conus* species
	Cuttlefish *Sepia phaoronish*
	Squid *Sepiotheuthis leiognathus*
Echinoderms	Sea cucumbers *Holothuria* species
	Sea cucumbers *Stichopus* species
Fish (vertebrate)	Seahorse *Hippocampus* species (medicinal uses)

Edible seaweed and invertebrate species commonly collected from seagrass beds by resident fishermen in the Semporna Islands, Sabah, Borneo (mostly by hand).

Shallow sublittoral sediments

Given the choice, the majority of recreational scuba divers and snorkellers will usually opt to dive on wrecks or reefs, which attract fish and have an abundance of other obviously visible marine life. Swimming over an endless plain of shifting sand is decidedly boring but there is far more to sublittoral sediments than just sand. A relatively short distance out from the shore, waves no longer stir up the bottom except under storm conditions. Instead, the type of sediment is determined by average current speed along with the many factors that govern sediment input. Dive in the mouth of a sea loch with a narrow entrance, and tidal currents will have scoured away all but the coarsest sand. In the inner reaches, fine mud can settle even in shallow water. Different grades of sediment tend to support distinct communities of animals and classic early dredging studies around the UK characterised sediments by their dominant species of infauna. However, this type of work has shown that sublittoral sediment communities are often extremely patchy. This patchiness is a result of many factors including the ways in which pelagic larvae are distributed. For example, local currents may keep larvae near to their origin or distribute them along a coastline. Mobile animals such as burrowing crabs will also disturb the sediment and, at least on a local scale, can affect the settlement and distribution of sedentary fauna such as worms and bivalves. This can be compared with the way in which gardeners can change the abundance and distribution of earthworms by regular digging of a particular patch.

Large physical disturbances such as trawling have been shown to have effects that last for years and can significantly change the composition of the infaunal communities. Defining and recording infaunal communities is both difficult and time-consuming and benthic ecologists need considerable patience and skill to collect, sieve, sort and identify the worms, crustaceans and molluscs that live in sublittoral sediments. In this section only a selection of epibenthic sediment communities with visible epifauna (and in some cases epiflora), that can be seen and surveyed by divers, are described.

Maerl beds

With the exception of seagrass beds sublittoral sediments are not the place to look for extensive plant or seaweed dominated communities. However, one group of calcareous red seaweeds (Corallinaceae) grow as extensive beds over sand and shell gravel. Known collectively as maerl, these hard, calcareous nodules and twig-like growths lie unattached on the seabed and are difficult to recognise as seaweeds. They are described further in the section on red seaweeds (pp. 137 and 139). Maerl beds provide a hard substratum and form the basis for a rich community of attached seaweeds and sessile animals which could not otherwise colonise sediment areas.

Maerl beds will only develop under certain conditions. Maerl thrives in currents (or sometimes waves) that are strong enough to remove any fine cloying silt but not so strong that the maerl is lifted and swept away. In an established maerl bed, a thin layer of living, pink maerl will overlie dead maerl fragments that have built up over many years. This is similar to the way living coral overlies dead coral rock. Maerl grows extremely slowly and will not thrive if it is continuously disturbed and broken by excessive wave action. Some maerl beds are many thousands of years old although the individual life span of a single maerl nodule is relatively short at 50-100 years or so. The dead maerl below the living layer provides a habitat for animals that are otherwise found only in coarse sediments such as mixed shell gravel and sand. This includes bivalve molluscs, anemones and burrowing sea cucumbers such as the NE Atlantic Gravel Sea Cucumber (*Neopentadactyla mixta*).

Maerl beds are found in the NE Atlantic as far north as Iceland and Norway and south to Portugal and the Mediterranean. Around the British Isles they are best developed along the southern and western coasts, especially in the narrow, tide-swept entrances to estuaries and sea lochs. Whilst maerl itself can grow as deep as 40m in clear water, maerl beds typically develop above 20m or so right up to the low tide level.

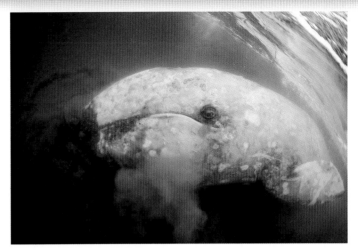

Grey Whales (*Eschrichtius robustus*) forage for small amphipods by ploughing through and sifting sediment with their huge mouths. They leave disturbance trails in the mud that may not fully recover for months.

Because of their fragility maerl beds can be badly damaged by bottom trawling for scallops (Pectinidae) and by the heavy chains and anchors of ships. In the UK the latter is a problem in some large south coast estuaries where the occurrence of maerl beds in the outer reaches coincides with industrial port developments. Commercial extraction of maerl (live and dead) as a conditioner for acidic soils and for other uses can lead to the destruction of entire beds which may never return. Within enclosed bays, sea lochs and estuaries, organic enrichment can cause excessive overgrowth of the beds by other seaweeds. This can cut out so much light that the maerl dies.

A wide variety of seaweeds, invertebrates and fish are associated with this rich maerl bed in Helford Estuary, UK.

With their hard shells, Horse Mussels (*Modiolus modiolus*) show up well on side scan sonar and this technique can be used to ascertain the condition and extent of mussel beds, backed up by photography. Many epibenthic animals grow attached to the shells.

Tube anemones (Ceriantharia) provide a micro-habitat for other animals that can live both on and within the tube in sediment areas.

Epibenthic animal beds and reefs

Away from the shore, the seabed of wave-sheltered areas such as estuaries, sea lochs and enclosed bays is usually composed of soft sediments. However, sometimes marine scientists are surprised when their sampling dredges and grabs come up almost empty. This can indicate that the nature of the sediment has been changed from soft to hard by bivalve molluscs growing over the surface. In the North Atlantic, dense beds of Horse Mussels (*Modiolus modiolus*) cover extensive areas of the seabed in certain inshore areas such around the Isle of Man. These large bivalve molluscs grow up to at least 12cm long and have tough shells that protect them from predation. This means they can live safely on top of or only partially buried in the sediment. Their shells quickly become covered in sessile hydroids, bryozoans, barnacles and sponges giving the impression of a rocky reef. Dredging has broken up many such beds and most are far smaller in extent than they once were. Like most bivalves, Horse Mussels are filter feeders and so thrive best in current-swept areas. In Strangford Lough in Northern Ireland, the beds are thought to be relict populations from perhaps as long ago as the last ice age.

Some species of brittlestars (Ophiuroidea) are found in similar strong current habitats, living in huge beds that can cover many square metres and sometime kilometres of sediment. These small, lightweight animals prevent themselves from being swept away by linking two or three of their arms together, whilst raising their remaining arms up to filter plankton from the water. In contrast to Horse Mussels and maerl (see above) these are mobile animals and they do not provide a habitat for others. In fact the sediment beneath them may be less species-rich than nearby uncovered areas. It is certainly a slightly eerie experience diving over a solid mass of writhing brittlestar arms. Similar beds can occur on rock but are generally less dense and smaller in extent.

With protective tubes made out of calcium carbonate or constructed from sand grains and shell fragments, tube worms are also capable of forming extensive 'reefs', with hundreds to thousands of individuals cemented together. The Organ Pipe Worm (*Serpula vermicularis*) forms calcareous tubes about 0.5cm wide and up to 15cm long. It is found worldwide except in polar regions but so far has only been found forming reefs in a few locations, with the best developed in Loch Creran in Scotland. Clumps of tubeworms up to a metre or more across develop when larvae settle onto individuals already growing on stones and shells. From this nucleus a rounded clump builds up such that each individual can extend its colourful fan of tentacles to filter feed. Large clumps tend to break up but carry on growing and so gradually extend the reef. This hard habitat on an otherwise muddy seabed provides an attachment for sponges, sea squirts and hydroids, resulting in a colourful array of invertebrates. This in turn attracts fish, crustaceans and molluscs, greatly increasing the biodiversity of what is essentially a soft mud habitat. Worm reefs such as this are slow-growing and extremely prone to physical damage and to smothering, both of which can result for seabed trawling for crustaceans such as *Nephrops*.

Clumps of tubeworms (*Serpula vermicularis*) growing on mud in Loch Creran, Scotland.

Infaunal communities

Deep mud covers much of the ocean floor in the form of abyssal plains thousands of metres below the ocean surface. However, mud also covers large areas of the sublittoral region below about 30m offshore and as shallow as 20m in sheltered inlets such as sea lochs (p.106). Out of reach of wave action, this habitat is relatively stable which allows quite complex communities of burrowing animals to develop. These can only be seen and appreciated by using divers or remote cameras to film them. Dredged up buckets of mud and damaged animals are no substitute. It might be a surprise to many people that the Norway Lobster (*Nephrops norvegicus*), widely sold in restaurants as 'scampi', excavates a home tunnel in the mud which it guards fiercely. Given a large tank in a laboratory with plenty of suitable mud, these small lobster-relatives will soon establish territories. The burrows of these and other deep mud-dwelling crustaceans can be as complex as the systems excavated by some land mammals such as meerkats. This was discovered by divers pouring a quick-setting resin down the burrows and then retrieving the casts.

One of the best ways for a diver to explore sediment habitats is on a towed underwater sledge which 'flies' just above the seabed or on a powered underwater scooter. Covering large areas in this way, a diver can identify and count the varied burrows and mounds that are prominently scattered over the surface of the mud. However, matching these to their occupants, collected by dredging, can be more difficult. In some areas dense communities of sea pens (Pennatulacea) (p.200) project up from the mud like miniature trees in a forest, between heaped up mounds of spoil from buried Spoon Worms (Echiura) (p.224). In tropical waters, acorn worms (Hemichordata) (p.304) produce the same lunar landscape effect. Burrowing sea urchins and brittlestars characterise some deep mud areas whilst mud below about 100m in the Arctic may be dominated by tiny foraminiferans (Foraminifera) (p.154), polychaete worms and small bivalve hatchet-shells (*Thyasira* spp.)

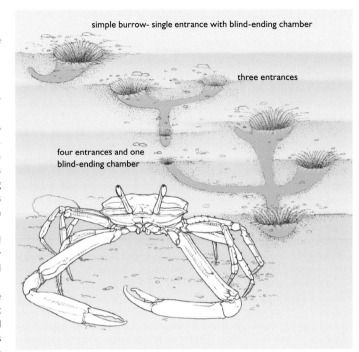

The Angular Crab (*Goniplax rhomboides*) excavates complex burrows in the mud with up to six entrances and various blind-ending chambers. The burrows often interconnect with those of other burrowing crustaceans and fish such as the Red Band Fish (*Cepola macrophthalma*) and various gobies.

Fries's Goby (*Lesuerigobius friesii*) often shares Norway Lobster burrows and it is possible that it may act as a lookout for its host in a similar way to the well-known partnership between tropical gobies and some snapping shrimps (Alpheidae).

Sea pens (Pennatulacea) protruding from soft sediment in Lembeh Strait, Indonesia, provide a stable home for tiny gobies (*Bryaninops yongei*).

Fjords and sea lochs

A fjord (or fiord) is, geologically speaking, a long, narrow and sometimes convoluted inlet from the sea, formed by glacial erosion and subsequent marine flooding. Most are steep-sided and often very deep, and many have a shallow rock sill across the entrance. Norway is famous for its indented coastline studded with numerous beautiful fjords. Iceland and Greenland are also well supplied and on the other side of the world New Zealand has some prime examples. The coastline of Scotland and the outlying island chains of the Western Isles (Hebrides), Orkney and Shetland are also highly indented but in this case the inlets are called sea lochs. Many of these have a glacial origin and are fjords in the true sense of the word, whilst others are marine inlets with non-glacial origins such as rias (drowned river valleys), though these are rare in Scotland. Sea lochs in the Western Isles are (confusingly) often described as fjards (or fiards). Whilst still glacial in origin, they have a much lower relief than fjords and characteristically are shallow with a maze of islands and basins often connected by rapids, and share some characteristics with estuaries.

The enclosed nature of fjords means they are sheltered from wave action and their surrounding steep cliffs restrict the light available. This results in still, cool and dark conditions, similar to those prevalent in the deep ocean, extending up into relatively shallow water around the edges. Communities normally restricted to very deep water can therefore be found well above their normal depth range. One dramatic example is the Deepwater Coral (*Lophelia pertusa*) found within diving depths in some Norwegian fjords. *Lophelia* is a slow-growing coral usually restricted to deep offshore water between about 200–1,000m and found worldwide. It forms massive mounds which, whilst usually smaller, can be up to 30m high and many kilometres long. The mounds are referred to as 'bioherms' in which the main bulk consists of a rock-like material derived from dead coral built up over thousands of years, with the living coral as a skim on the top.

Whilst *Lophelia* is the predominant species and provides the main physical structure of North Atlantic coldwater coral reefs, many soft corals, sponges and tube worms colonise and infill around the living hard coral. *Lophelia* reefs also support a high biodiversity of mobile invertebrates especially crustaceans, molluscs and echinoderms. The abundance and diversity of fish is no match for that found in the warm, productive waters of a tropical coral reef, but nevertheless these reefs provide a habitat and nursery for important commercial species. In the NE Atlantic these include Orange Roughy (*Hoplostethus atlanticus*) and codfishes (Gadidae). It would be difficult for tourists on a cruise in the Norwegian fjords to imagine such a scene not so far below them.

The seabed at the bottom of fjords and sea lochs consists mainly of very soft mud and many have spectacular communities of sea pens (Pennatulacea) and tube anemones (Ceriantharia), along with commercially important burrowing crustaceans such as the Norway Lobster (*Nephrops norvegicus*) that thrive in such sheltered conditions. At these depths, which range from tens to a few hundred metres, there is still plenty of food available in the form of plankton and detritus, which is not the case with the superficially similar sediments of the deep ocean abyssal plains. However, in stark contrast to this, large areas of many fjords are floored with anoxic, black mud in which little but anaerobic bacteria can survive. This is most often the case in deep basins of fjords with reduced water flow. The shallow sills found at the entrances to many fjords, restrict the inflow of well-oxygenated water from the open sea beyond and with little in the way of wave action or deep currents, the water above the seabed stagnates.

Fjords and sea lochs provide a safe sheltered environment for fish farms. Almost all the farmed salmon (*Salmo salar*) produced worldwide originates in such farms in Scotland and Norway. Chemicals used to rid the salmon of crustacean parasites pose a threat to marine life in these enclosed waters. Mussels (*Mytilus edulis*) grown on ropes and rafts in the same areas appear to have little environmental impact.

Trondheimsfjord in Norway is the shallowest known European location for *Lophelia* reefs which occur here at as little as 40m depth where this photograph was taken. Sula Ridge in 300m of water off the west coast of mid-Norway is the location for what is probably the best developed *Lophelia* reef in the NE Atlantic.

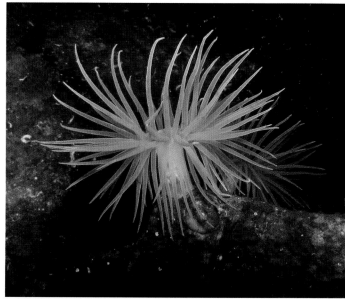

Sea lochs along the west coast of Scotland are home to the Sea Loch Anemone (*Protanthea simplex*) which lives attached to stones, wrecks and even Deepwater Coral (*Lophelia pertusa*). This anemone was first recorded in British inshore waters in 1979 by the author.

Tidal rapids

It is a strange experience to be in a small yacht with the engine at full throttle making no progress at all. Such is the power of tidal rapids or tidal races. Tidal rapids are common at the entrances to fjords and sea lochs where the sides narrow and funnel the water, and where there is commonly an underwater sill obstructing the flow. The many islands and constrictions frequently found in fjords and sea lochs, also create tidal rapids. Side branches within fjords and sea lochs may have their own rocky sills and sometimes prove to support rich and occasionally unique communities. Similar tidal maelstroms occur in many coastal areas where there are narrows and straits. Strong tidal currents are beneficial to sessile and sedentary animals because they bring an increased supply of plankton food as described on p.31. The composition of the rich communities found in tidal rapids varies with depth, seabed type and geographical location. In Great Britain typical growths includes soft corals, anemones, hydroids, sponges, mussels and beds of brittlestars.

Luxuriant growths of seaweeds often grow along the edges of tidal rapids but for large seaweeds such as kelp, there is a trade-off between an increased supply of nutrients and oxygen and the risk of being torn from the rocks. Under these conditions, seaweeds with finely divided fronds tend to flourish as they present less resistance to the water flow. Forest Kelp (*Laminaria hyperborea*) growing in rapids such as those leading into Lough Hyne (see box), tends to have a greater number of divisions in the frond than when it grows in quiet waters. For the same reason, freshwater plants in fast flowing rivers often have broad leaves at the water surface and well divided leaves below.

A mosaic of encrusting bryozoans, tunicates, tube worms and sponges grow on the undersides of boulders in the tideswept narrows of Strangford Lough, Northern Ireland, UK. The abundance and biodiversity of sessile animal growths on the undersides of similar boulders outside the narrows is significantly less.

Fast tidal current flows in moderately shallow water within sheltered locations, are attractive as sites for tidal electricity generators. This technology is still in its infancy but as it develops, potential conflicts with the conservation of the abundant marine life associated with tidal rapids will have to be resolved.

LOUGH HYNE

Lough Hyne in West Cork, Ireland is a small marine lake connected to the North Atlantic by a short stretch of shallow, rocky rapids. It is though to have originated from a freshwater lake, inundated by seawater around 4,000 years ago. The fast-flowing rapids deliver highly oxygenated water twice a day. This, together with warm, sheltered conditions and a wide variety of underwater habitats, has resulted in unique marine communities and a very high biodiversity. Lough Hyne has a long history of marine research and was designated as Ireland's first marine nature reserve in 1981. Snorkelling or diving through the narrows (on an incoming tide) is an exhilarating experience.

Strangford Lough in Northern Ireland, UK was home to the prototype *SeaGen*, the world's first grid-connected underwater tidal electricity generator with a capacity of 1.2 megawatts. Studies so far indicate that it has had a minimal impact on marine wildlife of this internationally important marine nature reserve. Tidal currents run through the eight kilometre-long narrow entrance at up to 8 knots.

Ice communities

Sea ice is a constant, though sometimes seasonal feature of polar marine ecosystems. Arctic ice is an essential hunting ground for polar bears (p.456) and is where their seal prey rests and gives birth. In the Antarctic the ice platform is similarly important for seals and penguins. However, perhaps surprisingly sea ice is also home to a thriving community of micro-organisms and tiny invertebrates that are a vital early link in polar food webs. Unlike the relatively solid block of ice that cools your drink on a warm summer's evening, sea ice is riddled with small channels and cavities and the underside is extremely uneven. This makes it an excellent habitat for micro-organisms, and a wide variety of algae, photosynthetic and non-photosynthetic bacteria and protozoans are associated with sea ice. Sea ice is highly variable in structure depending on the conditions under which it forms and its age and position in the ice pack. During its formation, pockets of salty brine are trapped between the ice crystals. These coalesce as the brine drains away and form channels, some of which are large enough to provide a refuge for amphipods, krill and tiny worms. Experimental work indicates that ice algae (in the Arctic) secrete polysaccharide mucus that not only helps to prevent their freezing, but also maintains brine-filled channels and pores within the ice to improve and extend their habitat (Krembs et al. 2011).

Algae and cyanobacteria from the water column may simply become trapped in winter ice and may survive to be released as it melts in spring. These photosynthetic organisms may then 'kick start' spring phytoplankton blooms. However, it is now known that some algae colonise the ice and actively grow within it and on its underside, utilising it as a sort of upside down seabed and turning it green or brown. This can be seen as a coloured band in ice cores. Ice algae in both the Arctic and Southern Oceans are important as primary producers especially at times and locations when phytoplankton is scarce (Lizotte 2001). This mix of photosynthetic micro-organisms plays a vital role in the Southern Ocean. Krill (*Euphausia superba*) feed on phytoplankton but also graze on sea-ice algae. It is difficult to study organisms under ice, but by using autonomous underwater vehicles equipped with cameras and echolocation, it has been discovered that krill are more abundant under the ice than in open water beyond the ice cover (Brierley et al. 2002). Ice algae may be essential for the maintenance of healthy krill populations. As krill is a keystone species underlying the entire Southern Ocean food web a significant reduction in Antarctic sea ice would have widespread implications.

In the Arctic Ocean the growth of ice algae is limited to summer when thinning of multi-seasonal ice and melting of the snow cover allows sufficient light to penetrate. Stratification of the water column beneath the ice also limits their growth through nutrient availability. Summer blooms of the filamentous diatom *Melosira arctica* can be seen hanging down from the underside of the ice as long strands and clumps, easily visible in areas where the ice is breaking up. At this time the alga is easily dislodged and Boetius et al. (2013), using a submersible, observed large amounts of algal detritus on the seabed 3,000–4,000m below the ice during the record decline of sea ice in the summer of 2012. Increased thinning of Arctic sea ice may lead to increased algal growth and to larger deposits to the seabed as the ice melts, with consequent changes in the seabed ecosystem.

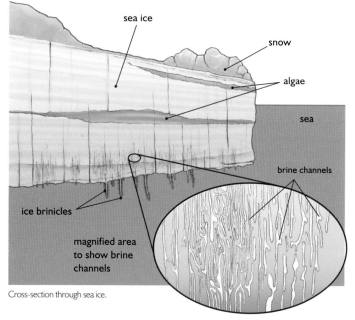

Cross-section through sea ice.

Pancake ice is a stage in the formation of sheet ice that occurs in rough water. With global warming reducing multi-year ice and more open water the proportion of this type of ice is increasing in the Arctic.

Antarctic Krill (*Euphausia superba*) is vitally important to the Southern Ocean ecosystem. Here individuals are feeding on algae that grow on the underside of ice.

DEEP SEABED

The deep ocean floor is one of the least accessible places on Earth and consequently we know far less about the marine communities that live there than we do for shallow water areas. New technology and international efforts such as the Census of Marine Life (p.12) is slowly starting to change this. It is now well understood that the deepsea ecosystem is not disconnected from the surface layers as was once thought. Seasonal changes in phytoplankton production affect the food supply for abyssal animals within weeks and months, not years (see below). Proposals to use the deep ocean as a dumping ground for redundant oil rigs because there is nothing down there to worry about now seem preposterous. In deepsea sediments it has been shown that even the spicules from dead sponges can alter the species composition in the area around them, so an oil rig would most certainly have an effect.

The seabed sloping down from the edge of the continental shelf to the bottom of the continental slope is known as the bathybenthic zone (p.34). Extensive areas of both rocky and sediment habitats are present, providing a variety of habitats for marine life. However, light levels are generally too low to support photosynthesis, even in the shallower regions of this zone, and so the great seaweed dominated communities found in the sublittoral zone are absent. Rocky areas are dominated by attached, sessile animal communities including cold water coral reefs, dense beds of glass sponges (Hexactinellida) and groves of seafans and sea lilies. However these suspension feeders rely on filtering plankton and other organic matter from the water and both the supply and the dispersion of this by surface currents diminishes with depth. The amount of silt covering rocky areas increases as the steepness of the slope decreases and both these factors result in a decline in filter feeders and an increase in deposit feeders such as sea cucumbers.

The Mar-Eco expedition to explore deepsea areas in the mid-Atlantic in 2004, documented animals belonging to all the major groups including many new and undescribed species such as this deepsea stone crab (*Neolithodes* sp.). Boyle (2009) gives an accessible account of this major scientific survey.

The abyssobenthic seabed (p.34) extends out and down from the bottom of the continental slope, normally at between 3,000 to 4,000m and is almost entirely composed of thick sediments. However, mid-ocean ridges (p.36) and seamounts (p.114) provide extensive rocky habitats and create nutrient-rich upwelling currents. This results in much richer communities of suspension feeders than might be found at equivalent depths on continental slopes, at least in upper bathybenthic areas. Startlingly rich communities of animals are found around hydrothermal vents on mid-ocean ridges, but for other reasons (p.112). This zone also includes the seabed right down to the bottom of the deepest ocean trenches.

Tourist submersibles now allow people to see bathybenthic communities down to around 1,000m depth for themselves, especially in clear tropical regions. The descent of James Cameron to the deepest spot on Earth in a one-man submersible (p.13) in 2012 may pave the way for future individual exploration, but the expense and danger involved means that exploration of the deepsea is likely to remain mostly in the realm of remote submersibles and scientific expeditions.

Whilst representatives of most animal phyla can be found in and on the seabed in the bathbenthic and abyssobenthic zones, certain animal groups are actually more biodiverse and abundant in really deep water than they are in the shallow sublittoral zone. Glass sponges (Hexactinellida) can be abundant in this habitat and are rarely found in shallow water. Sea cucumbers (Holothuroidea) are also far more abundant here, especially on abyssal plains, and stalked sea lilies (Crinoidea) are restricted to deepsea habitats. From what little is known of the fauna in deep ocean trenches, many species, both pelagic and benthic, are never found outside the trench environment. Many are also restricted to just one trench or a couple near to each other. However, a great deal remains to be discovered about these extremely difficult to access habitats.

The deepsea sea cucumber *Psychropotes* has a strange sail-like extension of its body. This may help to keep it from sinking into soft mud but studying the behaviour of deepsea macrofauna is extremely difficult.

Abyssal plains

The deep sediments that have accumulated in ocean basins over millions of years are a very different habitat to the sunlit, organically rich sediments found on the relatively shallow continental shelf and described on p.103. There is plenty of living space as abyssal plains cover huge areas (p.36), but organisms living here must be adapted to survive intense cold, perpetual darkness, immense pressure, a very soft muddy sediment habitat and little in the way of food except for each other. Under these conditions it might be expected that species biodiversity would be low, especially given the flat and unvaried nature of the terrain; abyssal plains are the flattest and most uniform regions anywhere on Earth. However this is only true at the macro scale. Remote cameras and sediment samplers that can recover completely undisturbed sediment cores, have shown that the sediment surface at the small scale is anything but smooth. Mounds, depressions, burrows and tracks are created by bottom-living animals such as sea cucumbers, echiuran worms, amphipods and even fish searching for a meal. These relatively large animals are not particularly numerous as each one needs a large area in order to find sufficient food, but their activities greatly increase the variability and dynamism of the seabed. In addition, currents sculpt and move the surface sediment and seasonal rains of dead plankton and organic debris collect in some places and not others (see marine snow p.111), adding temporal variability to the system. Habitat variation leads to increased species diversity.

Finding out just what lives on and in deepsea sediment is both difficult and expensive and only a tiny fraction of the world's abyssal plains has been explored. However, a huge amount of new data was collected by the Census of Marine Life, a ten year international project concluded in 2010. The census included several major expeditions which documented and sampled the marine life of abyssal plains throughout the world's oceans. At least half the organisms collected were new to science and work to describe them continues to this day (see also p.12).

Living on the surface of abyssal mud presents a number of challenges to large, mobile animals. They must have some means to prevent their sinking into the very soft sediment as they move around, and they need to find their food in complete darkness. Sea cucumbers (Holothuroidea) (p.300) have adapted well to this environment and are the most abundant and widespread of the large animals in all abyssal plain areas so far studied. The tube feet in holothurians are generally small and inconspicuous but in many deepsea genera these useful appendages are modified into relatively long 'legs' on which the animals wander around propped up above the sediment surface (see photograph p.301).

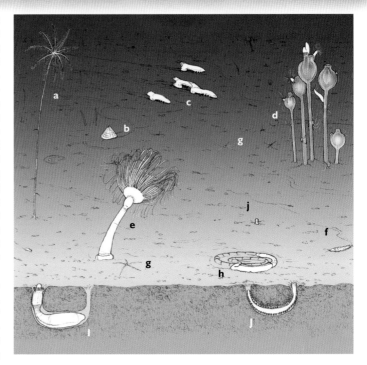

Abyssal plain community: a) long stalked crinoid; b) *Echinocrepis* sp., a sea urchin; c) foraging Sea Pigs, sea cucumbers; d) stalked tunicates, other species are also found attached or climb up these tunicates; e) giant hydroid; f) polychaete worm; g) brittlestars; h) acorn-worm; i) sipunculid; j) burrowing polychaete.

A similar strategy is used by other groups including the well-known and elegant tripod fishes which prop themselves up on elongated fin rays. Some sedentary filter-feeding animals also raise themselves well above the mud surface by means of long stalks. Sea lilies (Crinoidea) (p.328) are an obvious example and thrive in this environment, whilst the very similar but sessile feather stars would soon be smothered and are restricted to shallow rocky habitats.

Almost the only available food source on abyssal plains is detritus from dead plankton and other debris that rains down from the surface layers (see 'Marine snow'). Holothurians are well-placed to take advantage of this as even in shallow water, many species are detritus feeders. Abyssal plain holothurians 'vacuum' the mud surface, cleaning up any available organic material.

Many abyssal plain animals are sedentary, a slow lifestyle well-suited to a food-deficient habitat. In addition to well-known sedentary groups such as sea anemones, sea pens and tube worms, there are others that have taken up a sedentary life but whose shallow-water relatives are active hunters. Starfish fall into the latter category

Unusually for a sea cucumber, *Paelopatides grisea* has a wide, flattened body which prevents it sinking into the sediment when feeding. It swims slowly from one pile of detritus to another by undulations of its body.

Taxon	Feeding mode
Nematode worms (Nematoda)	Carnivores, detritus feeders
Polychaete worms (Annelida)	Carnivores, detritus feeders, mud swallowers
Harpacticoid copepods (Arthropoda)	Bacteria and organic detritus
Bivalve molluscs (Mollusca)	Detritus feeders

Small but numerically dominant abyssal plain infaunal animals.

and some starfish do wander over the abyssal plain in search of buried bivalve molluscs. However, such food is in short supply and so others such as *Freyella elegans* have adapted by becoming suspension feeders. *Freyella* saves energy by staying in one place for long periods of time, spreading its long thin arms up into the water column to intercept food particles carried along in water currents.

The types of animals living within abyssal sediments are similar to those found in shallow sediments and include bivalve molluscs, polychaete worms and crustaceans. The main difference is that the abyssal plain species are almost all very small at less than a centimetre across. They are mostly detritus feeders in contrast to shallow water bivalves which predominantly filter plankton from the water, a resource not available at depth.

Living within the sediment brings its own problems since burrows and tunnels in the fine, soft mud are prone to collapse, and sediment particles can easily clog up gills and are difficult to separate from edible particles. Many polychaetes solve this by simply eating their way through the sediment, digesting any organic matter and voiding the rest.

Marine snow

'Marine snow' is a wonderfully descriptive phrase for the aggregated, dead organic material that rains slowly down through the water column from the productive upper layers. This is the material that allows life to flourish on abyssal plains 3,000m and more below the surface. Most of it originates as the dead remains of plankton sinking slowly down through the water column. However, the tiny individual tests of diatoms or the exoskeletons of copepods would take forever to reach the seabed, even if they were not consumed on the way down or dissolved once below the carbonate compensation depth (p.25). Sinking rates of particles are greatly increased by aggregation, and time lapse photography of the deep seabed as early as the 1980s, showed seasonal deposition linked to phytoplankton blooms (Lampitt 1996). Marine snow is generally considered to constitute aggregates larger than about 0.5mm but sometimes reaches a size that can be seen and collected by divers in shallow water. Composition varies but aggregates commonly contain live, dead and dying phytoplankton, zooplankton moults, crustacean faecal pellets and small inorganic particles. The material is held together by sticky polysaccharides exuded by living phytoplankton and bacteria. It is this that sticks the aggregate particles together when they collide. In some areas, marine snow aggregates consist mainly of the gelatinous houses of larvaceans (Tunicata) (p.309) which are rapidly produced and frequently discarded. Bacteria and other micro-organisms colonise these and other marine snow aggregates and their concentration here makes them available as a food source to grazers such as copepods. These in their turn leave faeces within the aggregates.

With no daily or seasonal changes in light or temperature, the periodic deposition of organic material onto the deepsea bed is the only way for deepsea benthic species to time their growth and reproduction. It had long been assumed that there was no periodicity in their lives, but whilst this may be true for some, it certainly is not for others. Some sea cucumbers and sea urchins have been filmed or photographed crawling slowly around in pairs or wandering the abyssal plain in herds, presumably waiting for the stimulation of an increase in food to start off their spawning.

Deepsea animals are occasionally treated to a food bonanza when the carcass of a whale or other large animal drifts down to the seabed. A large food source such as this landing on the abyssal plain dramatically if temporarily changes the abundance and composition of the biota. First, it attracts numerous scavengers including hagfish, grenadiers (deepsea fishes), sleeper sharks, small lithodid crabs, amphipods and giant isopods, which strip the flesh rapidly from the bones. However, it also creates a new community of animals that would not be present without the carcass. Species of *Osedax*, a genus of polychaetes imaginatively dubbed zombie worms, penetrate into whale bones and extend out feathery red tentacles to absorb oxygen from the water. They cannot consume bone materials directly but rely instead on symbiotic bacteria living within the tissues of their tangled, root-like lower body situated within the bones. The bacteria break down bone lipids and proteins and release nutrients that the worms can utilise. In breaking down lipids, sulphophilic bacteria release sulphides which can be used as an energy source by chemosynthetic bacteria. These in turn provide a food source and sustain a community of clams, mussels and crustaceans in much the same way as happens at hydrothermal vents.

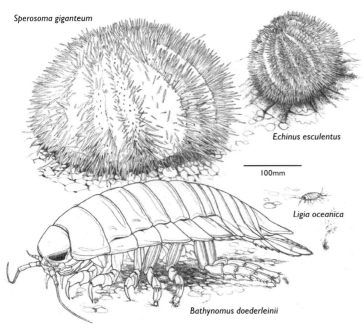

Sperosoma giganteum

Echinus esculentus

100mm

Ligia oceanica

Bathynomus doederleinii

Deepwater benthic animals move, grow and reproduce much more slowly than their close relatives in shallow water, and they live much longer. Most are also much smaller but longevity may be the key to the gigantism regularly observed in the deepsea and in cold environments such as Antarctic waters.

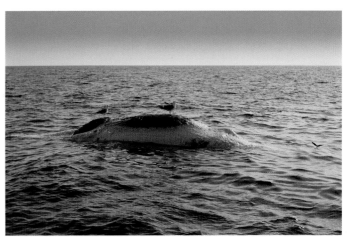

When a whale or other large mammal dies in the open ocean, the carcass will eventually sink to the seabed below. As well as attracting large scavengers, organic matter leaching from a 'whale fall' can trigger a population explosion of abyssal plain animals living in the surrounding sediment, including polychaete worms, bivalve molluscs and small crustaceans.

Hydrothermal vents

The story of the discovery of the rich communities living around hydrothermal vents is not new but is still just as fascinating as when it happened in the 1970s. Hot water spewing out of the seabed 2,000–3,000 metres below the surface is interesting enough but to find dense populations of tubeworms, clams, crustaceans and even fish living in close proximity was totally unexpected. Hydrothermal vents are powered by volcanic activity and so are found along mid-ocean ridges and occasionally at isolated 'hot spots' in the ocean floor. They are formed when water percolates down through cracks in the seabed that open up where new sea floor spreads away along the mid-ocean ridge system. A kilometre or more below the seabed the oceanic crust rock is hot where magma lies relatively close to the surface and the water is heated to anything up to 400°C. This hot pressurised water dissolves sulphur, forming hydrogen sulphide, and metal minerals out of the rocks and, as hot water is buoyant, it starts to rise back up to be released through cracks near the tops of the ridges.

As any tropical diver knows, as he descends away from the warm surface water, it shimmers where it meets colder water below. However, this subtle shimmer is not what scientists on the submersible 'Alvin' saw when the first vents were discovered. Instead great clouds and plumes of black 'smoke' issued from cracks and tall chimneys. The smoke effect is caused when the emerging hot vent water (hydrothermal fluid) meets the surrounding cold (2–3°C) water. Dissolved iron, copper, zinc and other metals react with hydrogen sulphide and precipitate out as metal sulphide particles. At some vents the particles drop down around the plume of water and build up fragile chimneys up to 10m high.

Scalding hot water, a toxic mix of chemicals and little in the way of food finding its way down from the productive waters near the surface, mean that life should not flourish in hydrothermal vent areas. The fact that it does is entirely due to bacteria and archaea which form the basis for a food chain entirely independent from sunlight and the photosynthetic activities of any organisms. Bacteria flourish around the vents

CHEMOSYNTHESIS AND PHOTOSYNTHESIS

Photosynthetic organisms use the energy of sunlight to manufacture organic matter ($C_6H_{12}O_6$) from carbon dioxide (CO_2) and water H_2O. Oxygen (O_2) is released as a by-product. There are several steps involved but a very simple summary of the chemical process is:

$$6CO_2 + 6H_2O \text{ (+ light energy)} = C_6H_{12}O_6 + 6O_2$$

Chemosynthetic sulphur-oxidising bacteria at hydrothermal vent sites oxidise the abundant hydrogen sulphide contained in hydrothermal fluid. Oxygen for this process is available in the seawater. The oxidation releases energy which powers the production of organic matter from carbon dioxide and water as happens in photosynthesis.

Again, the chemistry is complex and multi-stepped, and the true processes are beyond the scope of this book but can be summarised as:

$$H_2S + CO_2 + O_2 + H_2O = CH_2O + H_2SO_4$$

Chemosynthetic bacteria are not restricted to hydrothermal vent sites and can, for example, operate in the anaerobic black sulphide layer found beneath the surface of poorly drained sandy beaches, but the entire hydrothermal vent ecosystem is driven by chemical energy with no direct or indirect input from sunlight.

Some lower temperature vents are known as 'white smokers' because the minerals that precipitate out are pale particles of amorphous silica and calcium sulphate (anhydrite). The dark iron sulphide particles precipitate out whilst the vent water is still below the seabed.

Vent mussels (*Bathymodiolus* spp.) occur in huge numbers at some vent sites in the eastern Pacific. The mussels feed on bacteria which they filter from the water using their gills and digest them in their gut. However, their tissues also contain symbiotic bacteria which manufacture enough food material to supply a large part of the mussels' nutritional requirements.

Vent field name (VN)	Location	Max. depth (m) and temp. (°C)	Visual confirmation	Main species present
Beebe (Piccard)	N Atlantic Ocean, Mid-Cayman Rise	4,960m; no data	2010 (deepest known)	Rimicaris hybisae (shrimp), anemones
Solitaire Field (Roger Plateau)	Indian Ocean, Central Indian Ridge	2,630m; no data	2009	Rich community. Alviniconcha hessleri (gastropod), mussels, Alvinellid worms (Alvinellidae), scaly foot gastropod (undescribed)
Rose Garden Field (includes Clambake vents)	N Pacific Ocean, Galapagos Rift (East Pacific Rise)	2,550m; 220°C	1977 first deepsea vents discovered	Riftia pachyptila (tubeworm), Calyptogena magnifica (giant clam), Bathymodiolus spp. (mussel), Munidopsis susquamosa (squat lobster)
Magic Mountain	N Pacific Ocean, Explorer Ridge	1,850m; 311°C	1984	Riftia pachyptila, gastropods, Alvinellidae, anemones
Columbo	Mediterranean	500m; 224°C	2006	Bacterial mats, tunicates
East Scotia Ridge	Southern Ocean	2,600m; 383°C	2009	Kiwa sp. (yeti crab), stalked barnacles, limpets, gastropod snails

Examples of vent fields and their biological communities found in different oceans (German et al. 1996, Rogers et al. 2012 and the InterRidge Vents Database 2.2 accessed on 21 November 2013.). Based on (limited) species information, vent fields globally seem to be separated into separate biogeographical provinces, though there is not yet agreement on exactly how many. The most recently discovered province is along the East Scotia Ridge.

because they can utilise sulphides as a source of energy through the process of chemosynthesis. At some vent sites thick mats of bacteria cover the rocks. However, the bacteria are not just a food source for vent animals as they also live within the body tissues of many of them in a symbiotic association. Giant polychaete worms, Riftia pachyptila, form clusters of 2m high white tubes around Pacific vents and extend red gill plumes out into the chemical-rich water. Shallow-water tubeworms filter plankton food from the water with similar plumes, but Riftia absorbs hydrogen sulphide and oxygen into its bloodstream and delivers it to its bacterial partners. The bacteria manufacture organic matter that is absorbed directly by the worms, which have no mouth or gut. The majority of vent animals have a greater or lesser association with vent bacteria.

The biodiversity of animal life around hydrothermal vents is relatively low but the biomass can be very high, a situation typical of extreme environments. The same situation is found in estuaries (p.74) where fluctuating salinity and low oxygen levels restrict the species that can live there, but a plentiful supply of food allows large populations of them. Because they are widely separated oases, each vent system supports unique animal communities and the discovery and exploration of new vents almost always results in the discovery of new species. Giant tubeworms (Riftia) and giant clams (Calyptogena) have only been found at Pacific vent sites, never in the Atlantic. North Atlantic vent sites support abundant shrimps.

Within each vent field, animals inhabit different micro-habitats as a result of differing physicochemical conditions, primarily the levels of oxygen, hydrogen sulphide and various forms of iron sulphide (Luther et al. 2001), as well as the temperature. The location and details of the 554 currently documented vent fields (active and inactive) are listed in the InterRidge Vents Databases (www.interridge.org/irvents). The majority have simply been detected as hot plumes and only a few have been visually explored by submersible. By no means all have the right conditions to support rich animal communities and some of those that did when they were discovered in the 1970s may have become inactive since then.

ANTARCTIC YETI

Recent expeditions to explore the East Scotia Ridge off South Georgia in the frigid waters of the Atlantic section of the Southern Ocean have revealed hydrothermal vents with communities unlike any found elsewhere. Vent chimneys were covered in thousands of a new species of 'yeti' crabs (Kiwa n. sp.), along with stalked barnacles, limpets, peltospiroid gastropods and a predatory seastar (Rogers et al. 2012). The underside of the crabs are densely covered with hairs (setae) to which filamentous bacteria are attached. Kiwa puravida, a yeti crab found around cold hydrocarbon seeps off Costa Rica, is believed to 'farm' its bacteria for consumption (Thurber et al. 2011), and the new hydrothermal vent species may do the same. Kiwa hirsuta, the first yeti crab to be discovered, feeds on bacteria it nurtures on its long, hairy claws.

Ventral view of deepsea Yeti crab (Kiwa sp.) from Dragon vent field, Indian Ocean, November 2011.

Seamounts

The deep open ocean, far from land, is a relative desert in terms of productivity but there are unseen oases of life in the form of seamounts, rising towards the surface from the seabed, thousands of metres below. In recent years interest in seamounts has increased as it has become apparent that not only are these isolated underwater mountains rich in marine life, but also that many are being irreparably damaged by commercial trawling activities. Seamounts are found throughout the ocean and in simple terms are extinct volcanoes that rise up from the seabed sometimes reaching upwards for several thousand metres. Beyond that, definitions vary between researchers working in different disciplines. Commonly, only those that rise up to 1,000m or more but still do not break the surface, are considered true seamounts (p.38). However, with greatly improved technologies many much smaller ones have been found, mapped and named. They are found in every ocean basin with the highest numbers in the Pacific Ocean. Numbers can only be estimated and there may be as many as 100,000 that are more than 1,000m high. Many islands, especially in the Pacific and Indian Oceans, are volcanic in origin and are essentially seamounts that grew large enough to break the surface. Subsequent erosion and plate movements have re-submerged many and these flat-topped seamounts are often called guyots (p.38).

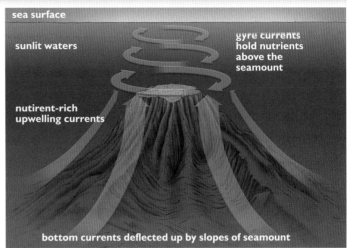

Strong currents deflected up the flanks of some seamounts develop into complex spiral eddies and so-called 'Taylor cones' above them, carrying nutrients up from the depths. These fuel and maintain plankton and thus local pelagic fish populations.

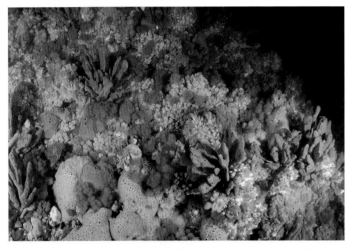

Underwater seamount covered in invertebrate life including sponges, soft corals, ascidians, and barnacles, all of which are filter feeders, Alaska.

The productivity of a seamount stems from its ability to divert cold, nutrient-rich bottom currents upwards. Upwelling currents on large seamounts bring nutrients within reach of phytoplankton within the sunlit layers. Complex rotating currents, set in motion above the seamount, result in a spiralling cylindrical column of water which traps and holds the nutrients and the proliferating plankton. Huge shoals of open-water fish thrive on an abundance of copepods and other zooplankton sustained by the phytoplankton. This abundance draws in large predators including sharks, and seabirds are attracted if the shoals come near enough to the surface. Large schools of adult Scalloped Hammerhead sharks (*Sphyrna lewini*) aggregate around seamounts in some parts of the world, swimming languidly around during the day and dispersing at night to feed.

The abundance of plankton in the water around seamounts also supports rich communities of sessile, filter-feeding animals, especially stony corals (Sceractinia), soft corals and seafans (Octocorallia), black corals (Antipatharia) and sponges. Seamounts provide extensive areas of relatively sediment-free rock for attachment and accelerated water currents carrying organic matter, nutrients and plankton. Exactly what grows where depends on geographical location, depth and the topography of the seamount. The communities on Davidson Seamount in Monterey Bay, about 80km off the Californian coast, have been well-documented using an ROV fitted with cameras and sampling equipment. Dense coral and sponge 'gardens' cover the more elevated areas and are populated with basket stars (*Gorganocephalus* sp.), lithodid crabs and starfish. A total of 168 fish and invertebrate taxa have been identified from this seamount, including new and apparently endemic species, and the coral communities appear to be undamaged and pristine (Clague et al. 2010). The same cannot be said for many other seamounts where scars from trawling are painfully evident.

Some seamounts have high numbers of endemic species, defined as species found on only one isolated seamount or a chain of them. Some seamounts have been found to have 40–50% endemic species but in others the figure is less than 10% (Stocks 2004). Documenting the marine life on remote seamounts in deep water is difficult and expensive and the true degree of endemism is extremely difficult to calculate. Nevertheless, every new seamount explored seems to bring with it new species.

Species	Range and usual depth (m)
Orange Roughy (*Hoplostethus atlanticus*)	Worldwide 400–900m
Alphonsino (*Beryx splendens*)	Worldwide 400–600m
Black Cardinalfish (*Epigonus telescopus*)	Worldwide 300–800m
Oilfish (*Ruvettus pretiosus*)	Circumtropical and temperate 200–400m
Black Scabbardfish (*Aphanopus carbo*)	Atlantic 200–600m
Pelagic Armorhead (*Pseudopentaceros richardsoni*)	Temperate southern hemisphere 0–1,000m
Abyssal Grenadier (*Coryphaenoides armatus*)	Worldwide 300–2,000m
Smooth Oreo Dory (*Pseudocyttus maculatus*)	Southern hemisphere 900–1,100m

Deepwater fish species commonly targeted in seamount fisheries (but also found in other deepwater rocky habitats). These are all slow-growing, long-lived species vulnerable to overfishing and, according to Pitcher (2010), worldwide reported catches are thought to be well under the true catch.

OCEAN LIFE

Whilst the vast expanses of the ocean can be considered as a single ecosystem, it is in reality a whole series of extremely varied and different environments and habitats. The previous section covering the Living Ocean described many of the principal ones and the ways of life of the organisms inhabiting them. In the Marine Life section, which begins here and which forms the bulk of the book, the myriad of different organisms that live in the ocean are described, starting with the smallest, the bacteria, and progressing to mammals which includes the largest animals on earth, the great baleen whales.

One of the most difficult questions you can ask a marine scientist is 'how many species are there in the Ocean?'. Or for that matter 'how many species are there on Earth?'. The true answer to both these questions must remain for the moment an estimate, but is likely to be a very large number because what is obvious, and becomes more so with every new expedition and survey, is the huge diversity of life on Earth in its entirety. The advent of powerful databases is now making it easier to collate information on known scientifically described species and make it accessible to the public. Each database must be painstakingly built up using the huge amounts of published material from diverse sources ranging from the present back to around 250 years ago when taxonomic classification really began. WoRMS (World Register of Marine Species) aims to provide a comprehensive list of names of marine organisms and integrates a large number of global species databases, some with and some without a direct interface, plus many external global species databases. WoRMS currently contains nearly 222,000 accepted extant marine species (WoRMS Editorial Board 2016). A recent estimate using an analysis of patterns in taxonomic groups predicts about 2.2 million marine species and about 8.7 million species in total on Earth (Mora et al. 2011). The World Ocean Census of Marine Life discovered a potential 6,000 new marine species in ten years of concentrated effort (p.12), an amazing achievement. However, if there really are 2.2 million species in the ocean, then that leaves plenty of scope for others to enjoy the excitement of discovering and naming a new species (p.125).

DISTRIBUTION OF OCEAN LIFE

Using huge amounts of technical ingenuity, marine scientists have now recorded and in most cases actually seen marine life at all depths and at all latitudes in the ocean. Even given the fact that it is much easier to document marine life in shallow coastal waters than at great depths, it is obvious that shallow sunlit areas (p.62) support the greatest abundance and the widest variety of organisms (with the possible exception of bacteria and other microorganisms in the deep ocean). It is no coincidence that the vast majority of fishing effort is concentrated over the continental shelf (p.36) which itself makes up only a small percentage of the total ocean habitat. However, there are also certain geographical areas of the ocean where biodiversity is exceptionally high. The so-called 'coral triangle' (p.96) in the Central Indo Pacific supports a far higher concentration of corals, fish and molluscs than equivalent-sized tropical areas anywhere else. There are approximately 600 species of scleractinian (stony) corals within this area compared to about 300 for the Red Sea and about 70 in the Caribbean.

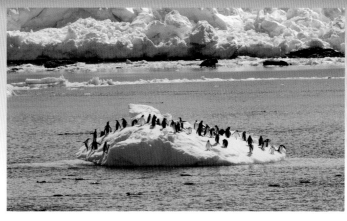

The rich variety of marine life in the Southern Ocean around Antarctica is largely dependent on a single species of krill (p.270), a tiny 5cm long crustacean.

Whilst the diversity of marine life in the coral triangle region is largely a result of the long geological history of the area, 'seasonal hotspots', where marine life is temporarily drawn into an area, can result from a rich food source that appears at a certain time of the year. Ningaloo Reef off Western Australia is a spectacular example. Here synchronous spawning of corals (p.207) fills the water with highly nutritious bundles of eggs and sperm. Large numbers of Whale Sharks (Rhincodon typus) migrate into the area on a regular basis around April to feed on the coral spawn and on the planktonic crustaceans and small fish which are also feeding on it. Top predators such as sharks and seabirds also join the seasonal feast.

The location of strong ocean fronts is often indicated by large aggregations of feeding seabirds. Wherever currents meet or are deflected off continental land masses, areas of upwelling can occur (p.52). High concentrations of phytoplankton and zooplankton result from the nutrient input and provide a food supply for pelagic fish. These in turn draw in larger predatory fish and cetaceans. Thermal fronts form where water masses with different temperatures meet, for example, the Celtic Sea front at the southern entrance to the Irish Sea. In summer, warm stratified water from the deep Celtic Sea meets the cooler tidally mixed water of the Irish Sea. On a calm summer's day, the front can be clearly visible with mist rising from the surface, swirling currents and occasionally Basking Sharks (Cetorhinus maximus) feeding on the plankton. Upwelling water in the vicinity of seamounts (p.114) means that many of these are also 'hotspots' for marine life. Nutrients support high plankton concentrations, not just attracting pelagic life but also fuelling rich growths of soft corals (Anthozoa) and other filter feeders.

Identifying so-called 'biological hotspots', which may vary in size from a single sea loch to an entire area such as the Galapagos Islands, is vital for conservation efforts and for the effective management of fisheries. The area of the coral triangle is subject to extremely high pressures from its human inhabitants, most of which rely almost entirely on the ocean as their source of protein. Balancing the needs of people and wildlife is particularly difficult in this and similar relatively undeveloped regions.

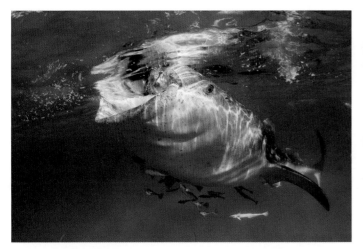

Whale Sharks (Rhincodon typus) need vast quantities of plankton and small fish, and take advantage of fish and coral spawning events where such material is concentrated.

Plankton flourish in the cold, upwelling waters around the Galapagos Islands and provide food for huge shoals of planktivorous fish.

PAST OCEAN LIFE: MARINE FOSSILS

Marine fossils give us a fascinating insight into ancient forms of marine life in the ocean but they also play an extremely important role in allowing scientists to work out the evolutionary history and relationships of organisms. Some marine organisms such as horseshoe crabs (*Limulus* spp.) have an ancient lineage and we know from their fossils that they look much the same today as they did then (see photographs p.262), and for this reason they are sometimes called 'living fossils'. For other marine groups, working out their evolutionary origins through the fossil record is a difficult and painstaking task. However, long before the science of palaeontology began, people were collecting and using fossils without knowing what they were. Fossil sea urchins have been found worldwide at burial sites stretching back to at least 4,000 years ago, placed purposely in graves, perhaps because their five-rayed symmetry resembles stars in the heavens. Fossils were (and perhaps still are) kept as talismans. Bullet-shaped fossil belemnites were once believed to be thrown down to earth during thunderstorms and amongst other uses, were kept to stave off lightening hits.

Marine fossils represent ancient inhabitants of the marine world and are accessible to naturalists and professionals alike along many coastlines. In the UK, Mary Anning is one of the best known early amateur palaeontologists, celebrated for her discoveries of ichthyosaurs and pleisiosaurs (marine reptiles) at Lyme Regis in the early 1800s. Today hundreds of children and adults alike follow in her footsteps each year and join in with the annual Lyme Regis fossil festival. Her findings were highly significant and eventually accepted by the scientific community. Fossils have now become a commercial business around the world with the risk that new and important findings are lost to science. Nevertheless, responsible 'amateur' fossil collecting is hugely rewarding and can and does contribute important finds to palaeontology. Local museums are often the best place to report or confirm a fossil of scientific value.

Marine fossils are commonly found along the coastline where sedimentary rocks such as limestone, shale and clay are exposed as cliffs. However, they can also be found at inland sites such as quarries and in naturally rugged terrain in areas once covered by ancient seas. Where detailed geological maps are available these will provide information on the age and type of rocks and the likelihood of finding marine fossils.

Whilst marine fossils are found all over the world, one site in the Canadian Rockies called the Burgess Shale Formation, is exceptional in the number of soft-bodied invertebrate fossils that are preserved there. The animals were buried by an underwater avalanche of fine mud that preserved them in great detail. The formation dates from the Middle Cambrian, about 505 million years ago, and gives an indication of just how biodiverse the ocean that covered this area was at that time. Many can be recognised as early ancestors of living phyla or classes of animals, whilst others appear to represent unknown evolutionary branches that died out and have no living relatives. Since there are few sites where soft-bodied organisms are preserved so well, it is difficult to know if this fossil hotspot reflects an exceptionally high biodiversity or if similar abundances were widespread. The Messel Pit in Germany provides a similar fossil hotspot for land mammals.

Cretaceous fossils found in Buckinghamshire, UK, have enabled the re-creation of a possible scene from the ancient seas of that time.

COMMON MARINE FOSSILS

Fish, reptiles, molluscs, arthropods, brachiopods, echinoderms and corals all have hard parts that fossilise well, and consequently are better represented in the fossil record than soft-bodied invertebrates.

Phylum MOLLUSCA

Belemnites
CLASS Cephalopoda

Features Like their modern-day relatives, the squid and cuttlefishes (p.246), belemnites had an internal support known as a pen or guard. This was usually cylindrical and made of many thin layers of hard calcite. It is the bullet-shaped guard that is most commonly preserved. The thick head end of the guard had a conical indentation in which was bedded the phramacone, a chambered cone-shaped structure which, by analogy with the cuttlebone in cuttlefishes, helped to regulate buoyancy.
Time scale Triassic to Cretaceous; most prominent in Jurassic.

Ammonites

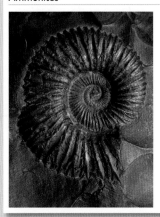

Features Ammonites had a chambered flat-spiralled shell similar to present day nautiloids (Nautiloidea) (p.251). Fossils show complex suture patterns representing the chambers. The head and tentacles extended out from the wide terminal chamber but little is known of the fine detail of their soft parts. Based on models of shells and their present day living counterparts, it is thought that most species could probably swim well, buoyed up by gas secreted into the shell chambers.
Time scale Early Devonian to end of Cretaceous; abundant and diverse in Mesozoic.

Gryphaea
CLASS Bivalvia

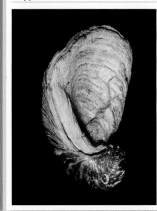

Features *Gryphaea* was a genus of bivalve molluscs with a heavy shell inrolled at the hinged end of the left valve giving it a boat-like shape similar to that of present day Slipper Limpets (*Crepidula fornicata*) (although *Crepidula* are gastropods). The smaller right valve fitted inside the larger valve and is much less commonly found. These fossils are commonly called Devil's Toenails and can often be picked up in ploughed fields in areas that were once under the ocean.
Time scale Lower Triassic to Lower Jurassic.

Phylum ECHINODERMATA

Crinoids
CLASS Crinoidea

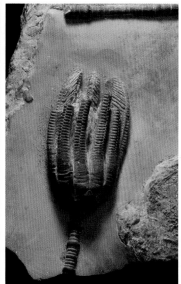

Features Sea lilies are stalked crinoids with many species still living today (p.302). Entire fossil crinoids are rare because the internal skeleton usually falls apart when the animal dies. Small 'star' shaped or circular discs are the individual ossicles of the stem and arms of the animal. Thick beds of these are sometimes found and their remains were abundant enough to form limestone deposits in some areas.
Time scale Ordovician to present; abundant in Palaeozoic.

Phylum ARTHROPODA

Trilobites
CLASS Trilobita

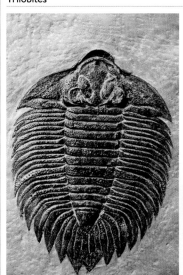

Features Trilobites had a three-part body made up of a large head shield (cephalon), segmented thorax and a small tail shield (pygidium). However, their name comes from the lengthwise division into three lobes, the central one raised slightly above the flanking two. Each segment had limbs but these are not evident on most fossils. Like isopods today, they could roll up into a loose ball presumably for protection.
Time scale Cambrian to Permian.

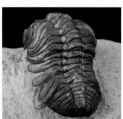

CLASSIFICATION

Whilst not everyone is interested in the details of how taxonomy and classification work, anyone trying to identify a bird, butterfly, fish or even garden plant will need some understanding of the process. Grouping organisms together in a logical and systematic way is essential for our understanding of life on Earth. At some levels this can be easy, for example any living animal with feathers is a bird. However it is often quite difficult. For example, any animal with scales is not necessarily a fish and fish themselves do not constitute one group equivalent to birds, as explained in the section on Marine Fishes (p.314).

The goal of attaining a single unanimously accepted classification of all living (and fossil) organisms that reflects natural evolutionary (phylogenetic) relationships is one that may never be achieved. There has, however, been huge progress since the time when every species had to be either a plant or an animal. We know now that not all animals can move about freely (see 'plant-like animals' p.44) and that some single-celled organisms can photosynthesise like plants but also consume other organisms and organic material (e.g. dinoflagellates p.152). Highly sophisticated analysis of cell structure and molecular techniques for comparing genetic material, are providing new insights into which groups and species might be related to which. This sometimes adds clarity and sometimes totally contradicts well established groupings. Classification will always change as new species are discovered and new techniques and methods of analysis are developed. There will also always be arguments and disagreements between scientists about taxonomic relationships.

It is now well understood that bacteria are different from the rest of life and to this end they are often grouped as Prokaryota and everything else (whether unicellular or multicellular) as Eukaryota (or Eukarya). This book is concerned with eukaryotes with just a brief description of bacteria (p.126) to cover those that have clearly visible manifestations in the ocean. In the late 1970s Dr Carl Woese analysed relationships between different bacteria using RNA analysis and on this basis he determined that prokaryotes were actually not one group but two, known today as Eubacteria and Archaea (Woese and Fox 1977). He considered these to be as different from each other as from eukaryotes and therefore proposed that life should be considered as three domains Eubacteria, Archaea and Eukaryota. This is widely but not universally accepted, but further discussion of prokaryote relationships is beyond the scope of this book.

Excluding domains, the kingdom is the highest level of classification (see Linnaean hierarchy below). Today animals (Animalia), plants (Plantae) and fungi (Fungi) are well-accepted kingdoms of eukaryotes but the classification of all unicellular eukaryotes together in one kingdom (variously Protista, Protoctista) as in Whittaker's five kingdom classification (Whittaker 1969) is no longer acceptable. We now know there are unicellular plants (e.g. *Chlamydomonas*) and fungi (e.g. yeasts) as well as the much better known multicellular ones. However, these are in the minority compared to the many unicellular organisms that do not fit as animals, plants or fungi. A fourth kingdom Protozoa (p.172), once defined simply as animal-like unicellular organisms, is now used for many unicellular eukaryotes with specific cellular characteristics, whether or not they have chloroplasts and photosynthetic abilities. In recent years another kingdom of life was proposed by Cavalier-Smith (2004) called Chromista. He established this kingdom distinct from Plantae and Protozoa 'because of the evidence that chromist chloroplasts were acquired secondarily by enslavement of a red alga, itself a member of kingdom Plantae, and their unique membrane topology' (Cavalier-Smith 2010). Chromista is not universally accepted as a formal kingdom and no doubt this exciting field of taxonomy will continue to change and challenge, but it can be frustrating and difficult to follow for non-specialists. See p.125 for the classification followed in this book.

Chevalier-Smith's six kingdoms of life (summarised in Chevalier-Smith 2004) are listed below. Whilst he groups all bacteria including Archaea together, others consider them to be separate kingdoms:

> Empire PROKARYOTA
> Kingdom Bacteria
> Empire EUKARYOTA
> Kingdom Protozoa
> Kingdom Animalia
> Kingdom Fungi
> Kingdom Plantae
> Kingdom Chromista

CLASSIFICATION SYSTEMS

Linnaeus was the pioneer who initiated the ranked hierarchy of categories (taxa) that is still in use today in traditional classification (Linnaean hierarchy). The many species that have been discovered in the 280 years or so since he published his *Systema Naturae* have necessitated additional ranks and considerable revisions, but the principle remains the same. Species are put into groups that become increasingly smaller, the closer they are related and the more characteristics they share. Using such a system allows us to take considerable 'short cuts' when trying to identify a species. For example, picking up an intact seashell from the shore and noticing that it has two hinged parts to its shell will instantly place it as a bivalve mollusc (class Bivalvia) rather than a gastropod mollusc (class Gastropoda) which has only one part to its shell. However, whilst most seashells will be molluscs, members of the small phylum of brachiopods (Brachiopoda) also have two parts to their shell, and so in this case knowledge of how to distinguish these two phyla is also needed.

LINNAEUS

During his 71 years of life (1707–1778) Carl Linné or Carolus Linnaeus (the latinised form of his name) established the foundations of a classification system that endures to this day. The *Systema Naturae*, his classification of living things, was first published in 1735 as a slim booklet but evolved to become a multi-volume publication. Today he would recognise only small fragments of his original work within the current classification system, but his methodology of hierarchical classification and his binomial nomenclature survives and thrives. He was first and foremost a botanist and initiated many botanical expeditions to bring back unknown plants to Europe from around the world. However, he was also a trained medical doctor, university lecturer and horticulturist. His name lives on in the Linnaean Society of London, founded in 1788 and which holds his library and manuscripts. It remains an active and influential society today.

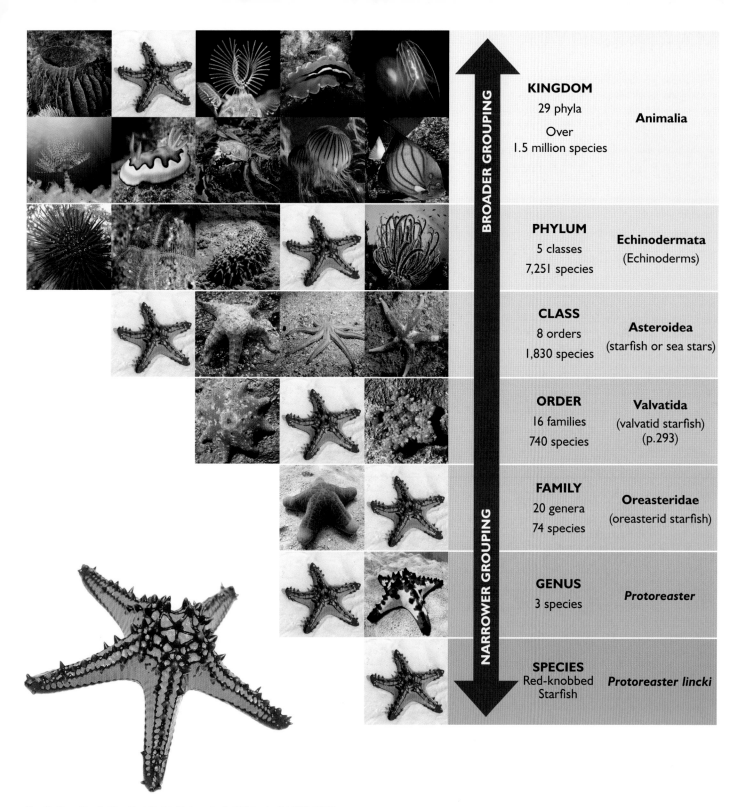

Classification of the Red-knobbed Starfish (*Protoreaster lincki*) following WoRMS (2016).

MARINE PHYLA

Many of the larger marine organisms that most non-specialists will encounter can be relatively easily assigned to their correct phylum with a little experience. For example, with their jointed limbs and external skeleton, crabs, lobsters and shrimps are readily identified as crustaceans (sub-phylum Crustacea). Finding an empty crab shell on the beach and then coming home and finding the empty skin of a spider in the corner of a room would provide a clue that spiders are related to crustaceans. Both belong to the largest phylum in the animal kingdom, the arthropods (Arthropoda).

However, small and microscopic marine organisms are often difficult to categorise and encrusting, soft organisms such as some tunicates and sponges are hard for non-specialists to assign to the correct phylum. The majority of marine phyla are well established but uncertainties remain as to the relationships between some groups. Sometimes two phyla are re-assigned as one, with a new phylum name and the two previous phyla as sub-phyla within it. Conversely sub-phyla or classes are sometimes elevated to phylum status as more information about their structure and phylogeny (evolution) becomes apparent.

KINGDOM/Phylum	Common names and notes
KINGDOM ARCHAEA	(p.126)
KINGDOM BACTERIA	(p.126)
KINGDOM PLANTAE	
Chlorophyta	Green seaweeds and algae (p.141)
Rhodophyta	Red seaweeds and algae (p.135)
Tracheophyta	Vascular plants, angiosperms; seagrasses, mangroves (p.157)
KINGDOM CHROMISTA	
Bigyra	Labrinthulids (not covered here)
Cercozoa	protists (not covered here)
Ciliophora	Ciliates (not covered here)
Cryptophyta	Cryptomonads (not covered here)
Foraminifera	Foraminiferans (p.154)
Haptophyta	Coccolithophores, prymnesiophytes (p.155)
Heliozoa	Sun animicules (not covered here)
Myzozoa	Dinoflagellates (p.152)
Ochrophyta	Brown seaweeds (p.144) and algae, golden-brown algae (p.151)
Oomycota	Water moulds, pseudofungi (not covered here)
Radiozoa	Radiolarians (p.154)
KINGDOM FUNGI	(p.168)
KINGDOM PROTOZOA	(p.172)
Amoebozoa	
Apusozoa	
Choanozoa	
Euglenozoa	
Loukozoa	
Metamonda	
Percolozoa	
KINGDOM ANIMALIA	
Acanthocephala	Parasitic worms (not covered here)
Annelida	Annelid or true worms (p.210)

KINGDOM/Phylum	Common names and notes
Arthropoda	Arthropods (p.258), horseshoe crabs and sea spiders (p.262), crustaceans (p.264)
● Brachiopoda	Brachiopods (p.256)
Bryozoa	Bryozoans (p.284)
Cephalorhyncha	Combines Priapulida, Kinorhyncha, Loricifera and Nematomorpha, considered separate phyla by some authorities (p.225)
Chaetognatha	Arrow worms (p.176)
Chordata	(p.306), tunicates (p.308), cephalochordates or lancelets (p.312), vertebrates (p.314 onwards)
Cnidaria	Cnidarians (p.188)
● Ctenophora	Comb jellies (p.174)
● Cycliophora	Cycliophorans (p.181)
● Dicyemida	Rhombozoa, Mesozoans (parasites; not covered here)
● Echinodermata	Echinoderms (p.288)
● Echiura*	Spoon worms (p.224)
Entoprocta	Goblet worms (p.179)
Gastrotricha	Gastrotrichs (p.178)
Gnathostomulida	Jaw worms (see meiofauna p.90)
● Hemichordata	Hemichordates (p.304)
Mollusca	Molluscs (p.228)
Nematoda	Nematodes, roundworms (p.222)
Nemertea	Ribbon worms (p.220)
Orthonectida	Minute parasitic worms (also mesozoans?) (not covered here)
● Phoronida	Phoronids (p.226)
● Placozoa	Placozoans (p.181)
Platyhelminthes	Flatworms (p.218)
Porifera	Sponges (p.182)
Rotifera	Rotifers (p.180)
● Sipuncula	Peanut worms (p.223)
Tardigrada	Water bears (p.177)
Xenacoelomorpha	Acoel and xenoturbellid flatworms (p.227)

Marine animal, plant, protozoan and chromist phyla (listed alphabetically) taken from World Register of Marine Species (WoRMS Editorial Board 2014). Exclusively marine phyla are indicated with ●.
*Echiura is no longer (as of July 2015) listed in WoRMS as a separate phylum. Molecular evidence suggests both Echiura and Sipuncula may be Annelids.

CLADISTICS

This book uses the traditional Linnaean method of classification but cladistics is a useful additional methodology. It is an excellent research tool that tells us much about the relationships between different groups. However, it is complex and subject to frequent changes and is not as easy to use for most people as the Linnaean system. Cladistics arranges organisms in terms of how they are related to one another and is based on evolutionary theory. The term 'clade' is used to describe a group whose members share a common evolutionary history. A clade therefore comprises a common ancestor and all the descendants (living and extinct) of that ancestor. Within a clade the members share unique characteristics that have arisen during the evolutionary process and which were not present in distant ancestors. The evidence indicates that life on Earth arose only once, so therefore all organisms are related in some way and a clade can be large or small. A phylum is a large clade whilst a genus is a small clade. However, when a detailed cladistic analysis of a particular group of organisms is undertaken, the results cannot always be fitted into the conventional Linnaean hierarchy. A recent cladistic revision of gastropod molluscs by Bouchet and Rochroi (2005) was the first to rely mostly on molecular phylogenetics rather than purely on morphology and has helped greatly to elucidate relationships within this huge taxonomic group. Matching the resultant unranked clades to fit in with conventional rankings is, however, difficult.

The basis of cladistics is that it utilises many different characters (heritable traits) and choosing the right ones for analysis is crucial, whether these are morphological, molecular (DNA and RNA sequencing data) or biochemical. Feathers are a good derived character and clearly a change from having no feathers to having them occurred in the group of theropod dinosaurs from which we now know (from fossil evidence) birds evolved. Computational algorithms are used to produce cladograms of particular groups and can help resolve long-standing disagreements, but knowing which characters will produce a sensible result is difficult. In the past organisms were grouped entirely on their physical characteristics but now genetics and biochemistry play an increasingly important role

Taking the case of reptiles and looking at the Linnaean-style classification of marine tetrapods, shown at the beginning of the section on chordates (p.306), we can see:

Phylum Chordata

Subphylum Vertebrata (vertebrates)

Superclass Gnathostomata (jawed vertebrates)

Superclass Tetrapoda (an informal group of Gnathostomata)

Class Reptilia (reptiles)

 Order Crocodilia (crocodiles)

 Order Squamata (lizards and snakes)

 Order Testudines (turtles)

 Order Spenodontia (tuataras)

We can further see that there are three other classes of Tetrapoda

Class Amphibia (amphibians)

Class Aves (birds)

Class Mammalia (mammals)

We cannot tell from this is what the relationships are between the four classes of tetrapods or between the four orders of reptiles. A cladistical analysis using shared derived traits would show amongst other things that:

 Birds, crocodiles and lizards belong in a clade together (Diapsida)
 Within the Diapsida, birds and crocodiles (and extinct dinosaurs and pterosaurs) belong in a clade together (Archosauria)

The derived trait that defines the Diapsida is the possession of a characteristic pair of skull openings behind the eye sockets. The derived trait that defines the Archosauria is the possession of a specialised ankle joint that greatly improved mobility in their common ancestor.

Museum collections

Museums around the world hold many millions of specimens representing all known living and fossil organisms. These collections are a vital resource for taxonomists and those performing cladistic analyses, but they also have other uses. The Natural History Museum (NHM) in London, UK holds most of the material collected during the scientific voyage of *HMS Challenger* from 1872–1876, which was funded by the British government. Researchers still access this material today, for example in studying ocean acidification (p.25).

When a new species (living or fossil) is described and named, the specimen (or sometimes specimens) on which the description is based is kept for reference and is called a 'type specimen'. Under the current rules of nomenclature (see p.125) a single specimen must be designated the 'holotype' as part of the published species description. Additional listed specimens are termed 'paratypes'. Type specimens are very important and are usually deposited with museums or other established research institutions. Researchers can refer to these specimens for comparison with specimens they themselves have collected from other localities. Most museums now have databases listing the type specimens they hold.

Archaeopteryx lithographica was first described in 1861 from a single fossil feather imprint and this specimen became the type specimen. Several complete skeletons are now in existence and, in a very unusual move, the first one discovered (also in 1861) and now held by the NHM in London, was ruled by the ICZN as the official type specimen of this species (the photograph shown is not this specimen). The original fossil feather may belong to another species.

SPECIES

The concept of how to define a species is a difficult one. The traditional, simplest and most applicable definition is the biological species concept. This defines species as members of a population that in nature can interbreed or exchange genes with one another and produce fertile offspring and which are reproductively isolated from other such populations. There are obvious difficulties with this definition. For example, different species might only be prevented from breeding with each other by geographical isolation. Also whilst most hybrids produced from two different species are infertile, this is not always the case, especially amongst plants. The biological species concept certainly does not work for bacteria which do not undergo sexual reproduction in the normal sense. The 'species problem' is a fascinating one but well beyond the scope of this book.

SPECIES NAMES

Every recognised species is identified by a unique two-part (binomial) scientific name. This is made up of the genus (generic) and species (specific) name. These, like the rest of the names in classification, are most often based on Latin or Greek with the whole name subject to Latin grammar. There is therefore a tendency for scientific names to be called Latin names but this is not strictly correct because most of the words are not actual Latin but are instead Latinised words. When writing a scientific name the convention is that the genus name always begins with a capital letter but the species name begins with a lower case letter, something that many newspapers seem incapable of following. The great advantage of scientific names is that they are understood worldwide by people who speak a multitude of different languages. Although it is not always used, the full scientific name also includes the name of the person who described the species and the year in which they did so. Thus the Atlantic Cod is *Gadus morhua* Linnaeus, 1758.

When the authority name is in brackets, it means that although the species was first described by that person, it has since been moved to a different genus in light of later information on its relationships. The Fin Whale now has the scientific name *Balaenoptera physalus* (Linnaeus 1758) but the original name was *Balaena physalus* Linnaeus, 1758. The Bowhead Whale is *Balaena mysticetus* Linnaeus, 1758 and has not changed.

Scientific names can give a clue to what a species looks like because the specific names in particular, are often descriptive. If a species name ends in 'nigra' you can be pretty sure that the organism is a predominantly black colour, for example the Black Brittlestar *Ophiocomina nigra*. Species are sometimes named after the person who

Dipturus cf. *intermedia*

Dipturus cf. *flossada*

The Common Skate (*Dipturus batis*) (Linnaeus 1758) is now thought to comprise two distinct species with differences in morphology, genetics and life history. Iglésias et al. (2010) argue that it should be resurrected as the Blue Skate (provisionally called *Dipturus* cf. *flossada*) and the Flapper Skate (*Dipturus* cf. *intermedia*).

discovered them or brought them to prominence (these are called 'eponyms'). Hector's Beaked Whale is named *Mesoplodon hectori* after Sir James Hector who was the founding curator of the colonial museum in Wellington, New Zealand. *Rhopalorhychus cinclus* is a small sea spider collected by the author and described and named by Dr Roger Bamber in 2001. *Cinclus* is the genus to which the freshwater birds called Dippers (Cinclidae) belong and the author's name it of course Dipper,

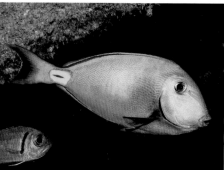
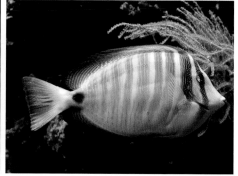

These three fishes are all surgeonfishes (Acanthuridae) characterised by a pair of sharp blades at the base of the tail. Left to right: the Sohal Surgeonfish (*Acanthurus sohal*) and the Monrovian Surgeonfish (*Acanthurus monroviae*) share more characters and are more closely related to each other than they are to the Sailfin Tang (*Zebrasoma velifer*) which is placed in a different genus *Zebrasoma*.

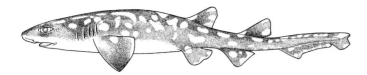

The Jaguar Catshark was discovered by Dr John McCosker and some years later described and named by him and his colleagues as '*Bythaelurus giddingsi* McCosker, Long and Baldwin, 2012'. The specific name honours the underwater photographer Al Giddings who worked with him on films about the Galapagos where the shark was found.

Abbreviation	Definition	Example
sp.	An unspecified or as yet unidentified species within a known genus	*Carcinus* sp. (a species in the crab genus *Carcinus*).
spp.	As above but several species	*Ostrea* spp. (several oysters in the genus *Ostrea*)
cf.	An identification or name not yet confirmed	*Chondrosia* cf. *corticata* (a sponge specimen that is probably this species but needs confirmation
sp. nov.	New species. Follows the new binomial name in the paper describing the species.	*Chromodoris buchananae* sp. nov. (a new sea slug in the genus *Chromodoris*)

thus proving that scientists have a sense of humour. The specific name can also give an indication of the geographical distribution of a species. The Ganges Dolphin *Platanista gangetica* is found only in the River Ganges and associated catchment area in India.

Sometimes there are three parts to a scientific name and the additional third part indicates a subspecies. *Diplecogaster bimaculata bimaculata* (Bonnaterre, 1788) and *Diplecogaster bimaculata pectoralis* Briggs, 1955 are both the same species of Two-spotted Clingfish *Diplecogaster bimaculata* but since its original description by Bonnaterre, Briggs has established that there are two subspecies.

Whilst scientific names are recognised worldwide, there are several reasons why they can and do change with time. For example two different scientists may have described a species and each given it a name but later research shows that the two species are actually the same. Alternatively, it may be found that one species is actually two similar species. This can have important implications for areas such as fisheries management and conservation. There are strict rules to be followed when making such changes, and time and patience are needed to determine the correct name. The Piked Dogfish (*Squalus acanthias*, Linnaeus 1758) has had 17 other scientific names since it was first described by Linnaeus, but the original name remains the correct one as it is the oldest available name.

Some common abbreviations used with binomial names.

NAMING NEW SPECIES

The rules for naming a new species are strict and are governed by the following codes:

 International Code of Zoological Nomenclature (ICZN)
 International Code of Nomenclature for algae, fungi, and plants (ICN)
 International Code of Nomenclature of Bacteria (ICNB)

The ICZN is run by the International Commission on Zoological Nomenclature, the ICN by the International Botanical Congress and the ICNB by the International Committee on Systematics of Prokaryotes. Whilst anyone might be lucky or skilful enough to discover a new species, the process of formally describing and naming one can be long and difficult. Most species are described by specialists who must first do sufficient research to ensure that the species really is a new one and has not been described before.

CLASSIFICATION AND ARRANGEMENT OF SPECIES IN THIS BOOK

The classification given at the beginning of each of the following marine life sections conforms with that used in WoRMS (see p.116), a regularly updated database easily accessible to anyone who uses the World Wide Web. Experts in particular groups may well disagree with aspects of this and there are sometimes alternative ways in which a hierarchy could be expressed. As more taxonomic information becomes available, this book will require updating, and will certainly lag behind the WoRMS database.

For marine fishes, a separate database, the Catalog of Fishes (Eschmeyer 2014) is followed but the two databases are largely in agreement.

The majority of the major sections cover a single phylum such as sponges (Porifera) and Molluscs (Mollusca). However, the vast phylum of the chordates necessitates five separate sections and some of the smaller phyla are grouped together for convenience rather than because they are closely related. In the Marine Plants and Chromists section, the three main types of seaweeds (red, green and brown) are discussed together even though they may belong to different Kingdoms. Non-specialists should find this easier than a purely taxonomic approach.

In the past botanists used the term Division as the equivalent to the zoological term Phylum. Today phylum is becoming the norm because the distinction between plants and animals is no longer considered absolute.

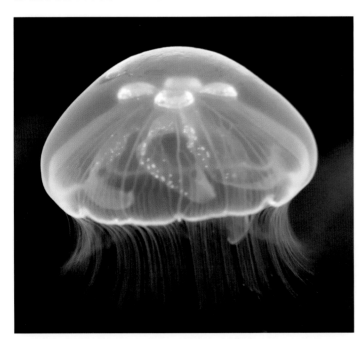

The Common Jellyfish featured on the cover of this book was first described by Linnaeus in 1758 and has the scientific name of *Aurelia aurita* (Linnaeus 1758).

BACTERIA AND ARCHAEA

As we go about our daily business, most of us will not bother to think about micro-organisms such as bacteria unless we become ill. In the marine world, scuba divers are sometimes made painfully aware of bacteria when they get an ear infection or an infected cut from a coral. However, whilst mostly invisible us, marine bacterial colonies occasionally build up into structures or amass in numbers large enough to be seen. Algae-like cyanobacterial colonies appear on seashore rocks, white bacterial mats cover dead organic material, symbiotic species living within animal tissues colour coral polyps and giant clams (*Tridacna* spp.) and, most dramatic of all, mat-forming cyanobacteria build up rock-like structures called stromatolites over thousands of years. Bacteria are even responsible for the gradual deterioration of the Titanic wreck. Long strings of 'rusticles' hanging down from the wreck are a complex mix of bacteria and compounds produced as they break down iron in the ship's structures.

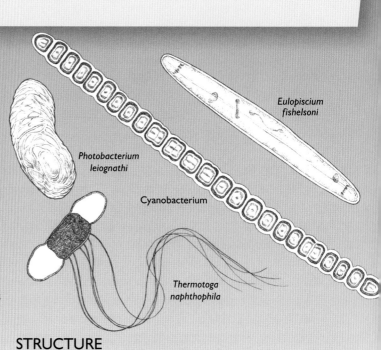

Eulopiscium fishelsoni

Photobacterium leiognathi

Cyanobacterium

Thermotoga naphthophila

DISTRIBUTION

Bacteria are universally present in every known habitat on Earth and without them neither we nor the world as we know it could function. Within the marine environment both Bacteria and Archaea are now known to be far more abundant and diverse than was thought, prior to the development of certain molecular techniques. These techniques allow sea water and other marine samples to be analysed for microbial genetic material without isolating and culturing the organisms. Archea in particular are now known to form a significant part of the microbiota in ocean water worldwide. Originally it was thought that they only inhabited extreme environments where no other life could survive.

CLASSIFICATION

Bacteria and Archaea are considered to be fundamentally different in their cellular organisation from all other life (Eukaryota), and from each other (see p.120). Bacteria, also known as Eubacteria or true bacteria, are grouped into a variable number of major divisions and the Archaea into at least two, the Euryarchaeota and the Crenarchaeota, or sometimes more depending on the authority. However, the concept of a species as it is generally understood (p.124) cannot be applied to Bacteria and Archaea which do not undergo sexual reproduction. Many of the marine forms have never been cultured and are only known from (16S rRNA) gene sequences isolated from collected water samples. Microbiologists must use instead a number of different criteria to differentiate species, including phenotypic (visible structures), genotypic (genetic makeup) and phylogenetic (evolutionary relationships).

STRUCTURE

Bacteria and Archaea are both extremely small unicellular organisms ranging from $0.1\mu m$ to $750\mu m$ in diameter. The cell structure is generally simple and the majority of well-known species do not have their genetic material within a membrane-bound nucleus, nor any other obvious organelles such as mitochondria that are found in eukaryote cells. However, this is not universally the case and some groups of marine bacteria such as the Planctomycetes (often associated with 'marine snow' (p.111) do have such structures. The major differences between Bacteria and Archaea lie in the detailed composition and structure of the cell membrane, along with the ways in which they replicate their DNA and produce proteins; this is well beyond the scope of this book.

With a high power microscope those marine bacteria that have been isolated show a variety of cell shapes of which the main forms are cocci (spherical or ovoid), bacilli (rod-shaped) and spirilla (spiral forms). Some species also live as colonies, either permanently, for example the filaments of some cyanobacteria, or temporarily with the individuals showing some functional differentiation.

BIOLOGY

The fact that Bacteria and Archaea can survive and thrive in most environments including extremely hot, extremely cold and highly acidic places is partly due to the huge variety of sources from which they can derive the energy they need to grow and reproduce. Many species are autotrophs, which simply means they are primary producers and make their own food using carbon dioxide as the sole source of

Colonies of the cyanobacterium *Rivularia bullata* on intertidal rocks in Cornwall, UK. Cyanobacteria used to be called 'blue-green algae'.

Shark Bay in Western Australia has World Heritage status partly because of the extensive stromatolite formations found in Hamelin Pool in the southern part of the bay.

carbon, in much the same way as plants do. Others are heterotrophs and rely on organic material originally produced by autotrophs as their carbon source, just as animals do. Whilst autotrophic organisms, including bacteria, require sunlight for photosynthesis, some bacteria and archaea are chemosynthetic and can use reduced inorganic compounds as an energy source. This means that they are not reliant on the sun's energy either directly or indirectly.

Anyone with a cut or other injury will know how quickly infection can set in and get worse. Bacteria are often to blame and are exhibiting their ability to increase rapidly in numbers by simple cell division into two equal halves. Sexual reproduction does not occur in either Bacteria or Archaea. However, a few bacteria, especially stalked Proteobacteria such as *Caulobacter crescentus*, live fixed to rocks, seaweeds or algae and can bud off smaller daughter cells. The daughter cell has a flagellum and can swim away to colonise other surfaces whilst the original stalked 'mother' cell remains to produce more daughters (Munn 2011).

Ecology

Bacteria and Archaea have functions in the ocean which are just as important and diverse as they are on land. Amongst their many other roles, they are important in the decomposition and recycling of nutrients, and photosynthetic species contribute significantly to primary production. One of the most important in this respect is *Prochlorococcus*, which occurs in very high densities in the upper layers of the ocean in many tropical and warm water areas. It is particularly good at surviving in nutrient-poor waters.

Cyanobacteria are a major component of the biofilms and microbial mats that develop on sediment surfaces and on rocks, and which are grazed by a wide variety of herbivores including fish, chitons and other gastropod molluscs. One highly visible manifestation of this is in stromatolites. Fossil stromatolites are abundant but living marine examples of these rock-like structures are only found in Shark Bay in Australia and in two locations in the Bahamas where they can easily be seen by snorkelling. Stromatolites are built up by mats of filamentous cyanobacteria which trap and bind sediment. Periodically heterotrophic bacteria feed on and decompose some of the material and transform it into hard calcium carbonate crusts. Cut through a stromatolite and these fine layers can be seen easily. However, this might not be such a good idea since a living, one metre high stromatolite may be 2,000 years old, and examples exist that are estimated to be 3,000 years old. Cyanobacteria produce oxygen as a by-product of photosynthesis and stomatolites were responsible for increasing the levels of oxygen in the atmosphere from an estimated 1% in pre-Cambrian times to the 21% we know today. Their success was also their downfall as oxygen-breathing organisms proliferated to take their place.

Bacterial genus or group	Function	Habitat
Azotobacter	Aerobic nitrogen fixer	Sediments in estuaries, seagrass beds, saltmarsh and intertidal
Deltaproteobacteria e.g. *Desulfovibrio* and *Desulfobacter*	Sulphur and sulphate-reducing	Anoxic environments
Photobacterium spp. (Vibrionaceae)	Bioluminescent light-organs in fish	Mostly in deepsea fish
Actinomycetes (phylum) e.g. *Rhodococcus marionascens*	Decomposition and heterotrophic nutrient cycling	Sediments
Vibrio spp. (Vibrionaceae)	Pathogens	Fish, corals, molluscs, crustaceans (and humans)
Epulopiscium spp.	Help breakdown food in the gut	Gut of herbivorous surgeonfishes (Acanthuridae)
Aquifex spp., *Thermotoga* spp. and various Archaea	Carbon fixation (primary production)	Hydrothermal vents
Epsilonproteobacteria, Gammaproteobacteria, Bacteroidetes	Unknown; may be harvested as food by Yeti Crab	Setae (hairs) on legs of Yeti Crab (*Kiwa hirsuta*)
Poribacteria (phylum)	Symbiotic nutritional role	Sponges
Cyanobacteria	Symbiotic	Tissues of corals, clams, ascidians etc.
Halomonas titanicae	Breaks down iron	Titanic shipwreck

Examples of roles played by Bacteria and Archaea in the marine environment.

MARINE PLANTS AND CHROMISTS

The most familiar marine plants are 'seaweeds', those brown, red and green tangles that make walking on a rocky seashore so treacherous and a shallow dive in cold temperate waters so beautiful. Seaweeds are macroscopic marine algae, i.e. they are large enough to be seen with the naked eye, but range in size from less than a centimetre to more than 30m long. Algae (singular alga) is an informal collective term for a huge variety of simple organisms that contain chlorophyll and (usually) make their own food by the process of photosynthesis. Seaweeds are algae but not all algae are seaweeds. Many algae are microscopic organisms that may look and behave quite unlike plants as we generally know them. Our ideas about the relationship between living things has changed markedly in the last 20 years following molecular studies on the DNA of organisms. Whilst green and red seaweeds are generally considered true plants (kingdom Plantae), brown seaweeds are not and they have been separated out into a different kingdom, the Chromista (see below) which have a closer relationship to fungi than other seaweeds. However, to a sea snail grazing on a rocky shore, their separate origins are of no concern and likewise need not affect a naturalist intent on identifying which ones live where and their ecological role. Seagrasses and mangroves, which are also covered in this section, are less widely distributed and are true marine flowering plants.

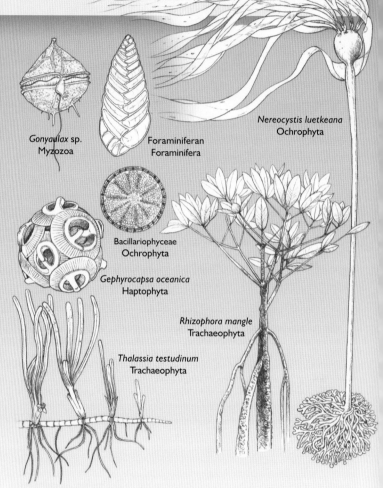

Gonyaulax sp.
Myzozoa

Foraminiferan
Foraminifera

Nereocystis luetkeana
Ochrophyta

Bacillariophyceae
Ochrophyta

Gephyrocapsa oceanica
Haptophyta

Rhizophora mangle
Trachaeophyta

Thalassia testudinum
Trachaeophyta

CLASSIFICATION OF MARINE PLANTS AND CHROMISTS

The classification shown here follows WoRMS (2016). However, a fully agreed classification does not yet exist. In the case of green algae especially, the classification is constantly changing as further work is done. Significant differences in higher classification will be seen by anyone brave enough to make comparisons between different authorities, and the classification shown here will certainly change in the future.

Classically, the equivalent term for a phylum of plants is a division, but since the distinction between 'plant', 'chromist' and 'animal' is blurred, especially amongst microscopic algae, phylum is now often used universally. Classes that are mostly macroscopic seaweeds are indicated with an asterisk*.

CLASSIFICATION OF MARINE CHROMISTS (KINGDOM CHROMISTA)

The kingdom Chromista was established and later modified by Cavalier-Smith (2004) as discussed further in the subsection 'Classification' in the main section of the book on 'Ocean Life' (p.120). It is quite difficult to see why brown seaweeds and tiny organisms such as diatoms and dinoflagellates should be grouped together as their morphology is so different. The features that unite chromists are complex and on the microscopic and physiological scale. What can be said is that they contain an additional type of chlorophyll unique to them, termed 'chlorophyll-c' and that, unlike true plants (including green seaweeds), they do not convert their photosynthetic products into starch for storage. There are also differences in whereabouts within each cell these products are stored.

KINGDOM PLANTAE

DIVISION OR PHYLUM	SUBPHYLUM	CLASS OR SUPERCLASS (SC)	ORDER
Rhodophyta	Eurhodophytina	Florideophyceae* (red seaweeds)	28 orders
		Bangiophyceae* (red seaweeds)	2 orders
	Metarhodophytina	Compsopogonophyceae*	3 orders
	Cyanidophytina	Cyanidophyceae	1 order
	Rhodophytina	Porphyridiophyceae	1 order
		Rhodellophyceae	3 orders
		Stylonematophyceae	2 orders
Chlorophyta		Ulvophyceae* (green seaweeds)	8 orders
		Prasinophyceae (mostly marine flagellates)	3 orders
		Chlorodendrophyceae (mostly marine flagellates)	1 order
		Chlorophyceae (mostly freshwater microalgae)	6 orders
		Trebouxiophyceae (mostly freshwater)	4 orders
		Mamiellophyceae (microalgae, picoplankton)	3 orders
		Nephroselmidophyceae (microscopic, biflagellate)	1 order
		Pedinophyceae (microscopic)	3 orders
Trachaeophyta (vascular plants)		Angiospermae (SC) (flowering plants)	Alismatales (seagrasses)
			Malpighiales (mangroves)
			Myrtales (mangroves)

KINGDOM CHROMISTA

SUBKINGDOM	INFRAKINGDOM	PHYLUM	CLASS
Harosa	Heterokonta	Ochrophyta	Phaeophyceae* (brown seaweeds)
			Bacillariophyceae (diatoms)
			Chrysophyceae (golden-brown algae)
			11–15 other small classes of microalgae
		Bigyra	Labrinthulid microalgae
		Oomycota	Water moulds, pseudofungi
	Rhizaria	Foraminifera (foraminiferans)	3 classes
		Radiozoa (radiolarians)	3 classes
		Cercozoa (protists)	
	Alveolata	Myzozoa	Dinoflagellata (infraphylum) Dinoflagellates
		Ciliophora (ciliates)	
Hacrobia		Haptophyta	Prymnesiophyceae (coccolithophores)
			Pavlovophyceae
		Cryptophyta (cryptomonads)	4 classes
		Helizoa (sun animalcules)	1 class

SEAWEEDS (MACROALGAE)

Take a walk along a rock-covered seashore almost anywhere in the world and you are likely to find at least some seaweed and many temperate shores are smothered in them. Strandlines of sandy beaches are often littered with piles of seaweed thrown up by seasonal storms. In temperate regions dense kelp forests grow just beyond the shoreline, forming a rich habitat for fish and a playground for seals and scuba divers. On land we are used to plants being predominantly green as a result of the photosynthetic pigment chlorophyll contained in their leaves and stems. Seaweeds on the other hand come in three main colours, red, green and brown, with green ones the least common. They all contain chlorophyll but the colour of the red and brown seaweeds is altered by additional photosynthetic pigments, which help to gather and use the restricted wavelengths of light available in the ocean (p.18). The three colour groups of seaweeds are not closely related but have a similar design because they are adapted to live in the same habitats.

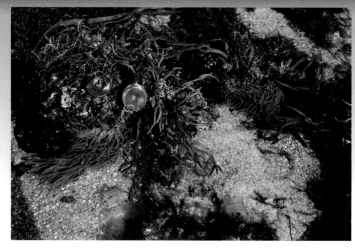

Red, brown and green seaweeds on a shore in the Isles of Scilly, UK.

DISTRIBUTION

Whilst algae can be found in the ocean, in freshwater and even on land, seaweeds are generally only found in the ocean. The largest and most abundant populations grow in temperate and cold waters where there are plenty of nutrients, and even the frigid waters of the Southern Ocean support rich communities. Most need a hard substratum to which to attach and all are restricted to seashores and shallow coastal water where there is sufficient light for photosynthesis. Hot sun and drying winds prevent much growth on seashores in areas such as the Arabian Gulf and Red Sea.

STRUCTURE

Seaweeds are relatively simple organisms, at least in terms of their structure if not their reproduction. Seaweeds do not have roots, stems and leaves, but equivalent terms used are holdfast, stipe and frond, with the latter two together called the thallus. As its name suggests, the holdfast is an attachment device which allows seaweeds to fix themselves firmly to rocks, pebbles, shells and other hard substrata. The stipe holds the plant up in the water column whilst the frond provides the main photosynthetic surface. These structures vary tremendously in different species and

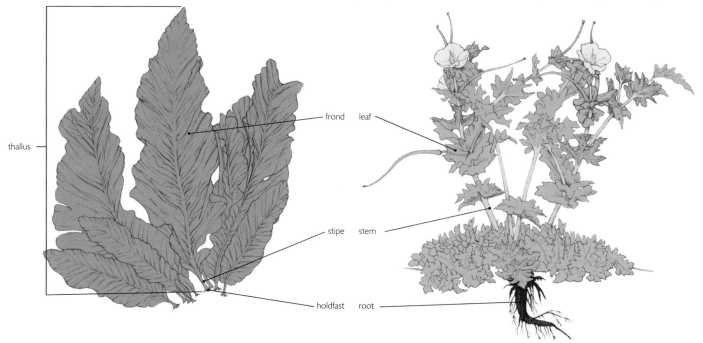

Comparison of the parts of a typical seaweed (left) and flowering plant (right Yellow Horned Poppy *Glaucium flavum*).

MARINE PLANTS AND CHROMISTS

many have additional structures such as air bladders, veins and midribs. Apart from this basic structure, seaweeds come in an amazing variety of shapes and sizes from simple sheets to complex branched forms.

Some species also have different growth forms in different habitats. So, for example, temperate Forest Kelp (*Laminaria hyperborea*) normally has a frond that is divided into long finger-like lobes. This shape allows it to grow quite large but still present little resistance to water movement. In sheltered conditions with minimal wave action, this same species often grows as a large, cape-like form. This gives it a much greater surface frond area for photosynthesis, but this form would be torn to shreds in an open wave-exposed situation.

It would be easy to mistake the intricate, tangled branches of some seaweed holdfasts for roots. However, unlike the root systems of land plants, the holdfast has no function in drawing up water and nutrients. Seaweeds are after all, surrounded by nutrient-laden water and can simply absorb what they need. In fact, the holdfast can be quite small in relation to the overall size of the seaweed and in many is just a simple disc. Clearly something else is needed to provide adequate attachment and that something is glue. Seaweeds produce a powerful adhesive and what is more, one that works in water. Whilst little research has yet been done on the chemical constitution and mode of operation of seaweed glue, there is now increasing interest in the potential it may have for use in surgery because the human body is also a 'wet' environment.

Whilst seaweed holdfasts produce glue, the fronds of many species produce substances designed to do just the opposite and prevent surfaces catching on each other. Seaweeds may seem pretty innocuous and though some contain strong acid, no truly poisonous ones are known, but they are actually responsible for many seaside cuts, bruises and even broken limbs as people walk over boat ramps and rocks made slippery by a covering of weed. Their slipperiness is not there to make life difficult for holiday makers but to allow them to slide easily through the water as they are whipped to and fro by waves and currents. In the tangle of a kelp forest, damage is prevented as the fronds slip past each other like well conditioned strands of hair. Excess mucus produced by intertidal and shallow water species exposed at low tide dissolves at high tide adding organic matter (DOM) to the water which can be absorbed and utilised by seaweeds and by small invertebrate animals. The mucus also helps to prevent intertidal species from drying out.

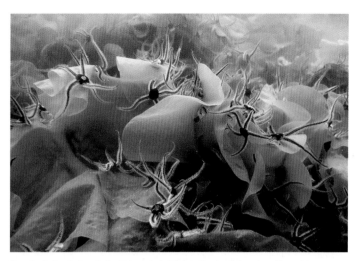

Growing in the shelter of a Scottish sea loch, this kelp (*Laminaria hyperborea*) has wide, undivided fronds which provide a platform for brittlestars and sea snails. Under normal wave conditions on open coasts, the fronds are digitate, that is divided into strap-like lobes (see photograph of *L. digitata* on p.148).

Seawater provides considerable support to objects immersed in it (p.22) and most seaweeds do not need rigid branches and stems to hold up their fronds to the light. However, many bulky brown seaweeds such as kelps (Laminariales) and fucoids (Fucaceae) utilise air bladders or pneumatocysts to hold up their long fronds near to the surface where the light is most intense. Generations of children playing on the seashore, have delighted in 'popping' these little buoyancy devices by walking on them or squeezing them. What they are releasing is mostly oxygen and nitrogen in similar proportions to that found in air plus some carbon dioxide. These gases are readily available, especially oxygen which seaweeds produce as a by product of photosynthesis. What is strange is that the pneumatocysts of some giant kelps, specifically *Nereocystis*, contain up to 10% of carbon monoxide. This was discovered as far back as the 1930s but the reason is still unknown.

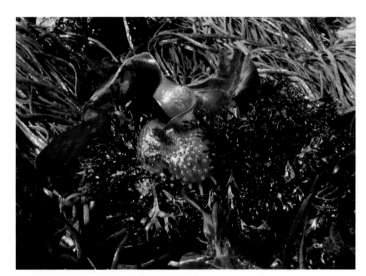

The knobbly, bulbous holdfast of Furbellows (*Saccorhiza polyschides*) kelp is hollow and small crabs and even fish sometimes shelter inside if they can find a way in.

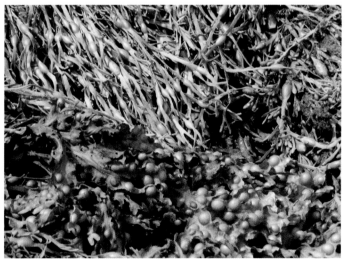

The number and arrangement of bladders can be a useful identification feature for brown seaweeds. Knotted Wrack (*Ascophyllum nodosum*) has single bladders along the midline (top) whilst Bladder Wrack (*Fucus vesiculosus*) has paired bladders (bottom).

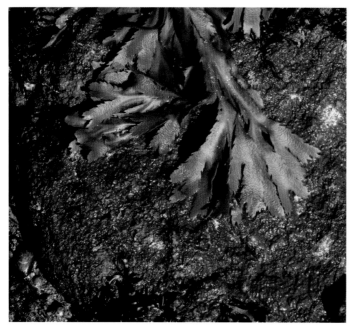 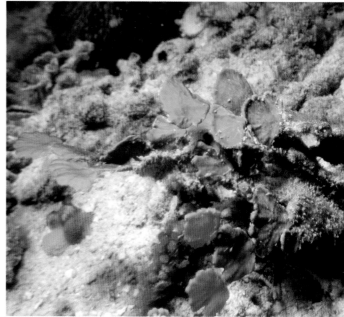

This red calcareous seaweed (Isles of Scilly UK) has calcite deposits in the cell walls making it exceptionally tough. In contrast the bead-like fronds of *Halimeda*, which commonly grows on tropical coral reefs, have aragonite crystals between the cells and are relatively brittle.

Whilst red and green seaweeds do not have bladders, some are hollow and fill with gas especially when they are photosynthesising. Gut Weed *Ulva intestinalis* (formerly *Enteromorpha intestinalis*) is so named because of its tubular shape and propensity for inflation.

Seaweeds tend to be leathery, springy, squishy, slimy or soft but some are hard or brittle and many of these resemble coloured rock or even coral. These calcareous seaweeds are very abundant and important in the marine environment. They fortify coral reefs against the pounding of wave action and in temperate water form the very diverse maerl habitat. Much of the bulk of calcareous seaweeds is made up of calcium carbonate which is deposited as crystals (aragonite or calcite) either inside each cell or in the gaps between cells. Calcareous seaweeds tend to grow rather slowly because the chalky deposits limit the amount of light that can penetrate into the plant. On the other hand they are so tough that few animals will eat them. There are species of calcareous seaweed in the red, green and brown seaweed groups.

The internal structure of most seaweeds is relatively simple with little in the way of separate tissues performing different functions. It is mostly a matter of 'every cell for itself' with each cell needing to absorb the gases and nutrients it needs and produce its own food. The tube-like internal 'xylem' and 'phloem' found in higher plants and used to transport water from the roots and food from the leaves to all parts of the plant, are not found in seaweeds. However, it is fairly obvious that whilst small seaweeds can easily manage without specialised transport tissues, giant kelp with its base in dim, poorly oxygenated water 30–40m down and its photosynthetic fronds near the well-lit and aerated surface, would struggle. Large kelps such as *Laminaria* and *Macrocystis* have a central core of elongate trumpet cells, arranged end to end. Each cell has its two ends perforated like a sieve and experiments in which the fronds are exposed to radioactive carbon dioxide have shown photosynthetic products being transported through the trumpet cells at rates of over 60cm per hour (Mauseth 2009). The trumpet cells are not permanent structures like xylem but can be produced as needed from the surrounding, loosely packed cortex cells.

SEAWEED REPRODUCTION

In temperate regions, looking for seaweeds in winter is a very different experience to searching in summer, quite apart from the weather. Just like land plants, many seaweeds are short-lived annuals and die off as winter sets in. This is not always the case and some seaweeds e.g. calcareous species such as maerl only reproduce in the winter. Others, especially kelps and other large brown seaweeds are long-lived perennials surviving many years but may shed their fronds along with a heavy load of epiphytic growths and grow new clean ones in the spring. Again like land plants, many seaweeds can spread by vegetative means from fragments of the parent plant. In sexual reproduction seaweeds face the same problems as land plants, which is to bring male and female gametes into contact in an efficient manner for fertilisation. Pollen can be carried for miles by wind (making life a misery for hay fever sufferers) or collected and delivered by insects. Underwater currents perform the same task but many seaweeds improve their chances of fertilisation by having sperm that can swim and some, especially brown seaweeds, have eggs that release attractive pheromones, a situation much more familiar in animals. Releasing eggs and sperm in a mass spawning also helps and these events can sometimes be seen as green or milky discoloration of the water.

The reproductive cycle of most seaweeds is quite complex and usually includes both an asexual (sporophyte) phase and a sexual (gametophyte) phase. The appearance and structure of a particular seaweed species in its two phases can be so different that many were originally described and named as different species. Sometimes the gametophyte phase is large and obvious and the sporophyte phase tiny, and sometimes the reverse. Alternatively, in some species the two phases look identical. Seaweeds show a tremendous variation in their life cycles and examples of the various patterns found in red, brown and green seaweeds are described in the relevant sections below. Many seaweeds are able to propagate asexually through fragmentation and non-native species such as *Sargassum muticum* in the UK, have spread widely in this manner.

Knotted Wrack (*Ascophyllum nodosum*) and Bladder Wrack (*F. vesiculosus*) are often found at the same shore levels, but Knotted Wrack only grows at sheltered sites.

DEPTH AND ZONATION

Seaweeds are photosynthetic organisms and so rely on light. Light levels decrease and light quality changes with depth (p.18), and so it is not surprising that the abundance and species of seaweeds changes with increasing depth. The maximum depth at which seaweeds are found varies widely from place to place and is dependent on water clarity. One of the reasons scuba divers like visiting tropical coral reefs is the excellent visibility they encounter. If not distracted by the abundant coral and fish life, a diver might notice seaweeds as deep as 50m, or deeper though this would be beyond the limits of normal recreational diving. In temperate Great Britain, seaweeds are rarely found below about 20–30m. As a (very) rough guide seaweeds will not grow at depths below a point where the irradiance is 0.05–0.1% of that at the surface. In the silt-laden waters of many of the world's great estuaries, this point might be reached within a metre or two of the surface. In clear tropical waters it might be 100m or more. The record so far is held by red encrusting seaweeds growing on a seamount near the Bahamas at 268m (Littler *et al.* 1985).

On the seashore light is not the limiting factor and it is the physical ability of particular species to survive exposure to air that dictates whereabouts each species can live. The varying tolerances of even closely related seaweeds to emersion (exposure to air) can be seen by taking a walk from the top to the bottom of a moderately sheltered rocky shore in temperate North Atlantic areas such as Great Britain and Scandinavia at low tide. Here several species of brown fucoid seaweeds often predominate. Near the high tide level are tufts of the Channelled Wrack (*Pelvetia caniculata*). With its ability to roll its fronds inwards as it dries and trap moisture in the resulting 'channels', it is well suited to survive long periods out of water. At the other extreme near the low water mark is the Serrated Wrack (*Fucus serratus*). It does not like prolonged exposure but neither does it do well below the shoreline. In between, in the middle shore, are species with air bladders, namely the Bladder Wrack (*Fucus vesiculosus*) and the Knotted Wrack (*Ascophyllum nodosum*) which have a much tougher constitution. Overlying any such basic zonation will be biological effects including grazing and competition between species as well as other physical factors including geology and wave exposure. This is obviously an over simplification as other factors such as incline also play a part but the resultant bands are sometimes very obvious. Zonation is discussed further on p.41.

Seaweeds living under ice in the extreme environments encountered in the Arctic and Antarctic, must cope with low light levels (and extreme cold) even at shallow depths. In the winter months, not only does the ice cover reduce the light available, but there are only a few hours of light available anyway each day. Perennial kelp such as *Laminaria solidungula* and fucoid (*Fucus*) species growing in the Arctic mark time during winter and grow fast when the ice melts and daylight increases. However, *L. solidunga* is able to get a head start by beginning its growth spurt towards the end of winter when it is still dark. To do this it uses stored food materials manufactured the previous summer. It is then ready to make maximum use of the short summer months of light. Some Antarctic species are able to do the same. See also 'Ice Communities' on p.108. Such seaweeds also have physiological adaptations (enzymes and cell membrane lipid content) to stop them from freezing and to allow them to grow and metabolise at temperatures far below those normal for other seaweeds.

Ice-scoured seashores do not usually show clear, long-term patterns of seaweed zonation because the seaweeds are scraped away each year by ice movements.

Pigment	Typical max (and peak) absorption of wavelengths (nm)	Seaweed group
chlorophyll a	400–500 (430) and 650–700 (660)	red, green and brown; universal in photosynthetic organisms
chlorophyll b	400–520 (455) and (642)	green
chlorophyll c	425–490 (443) and 620–650 (630)	brown (chromists)
fucoxanthin	450–540 (515)	brown
β-carotene	400–520 (450)	red, green, brown
phycoerythrin	490–570 (550)	red
phycocyanins	550–630 (618)	red
allophycocyanins	650–670 (655)	red

Principal seaweed pigments. Shorter wavelengths are at the green end of the visible spectrum and longer wavelengths at the red end (p.18). Figures are not exact and vary with the techniques used.

PRESSING AND IDENTIFYING SEAWEEDS

Pressing flowers is a hobby enjoyed by many people and is also a vital tool in plant classification and identification. In the 17th century, early botanists set out to explore far flung parts of the world and brought home thousands of unknown plants, all beautifully dried and displayed on paper. Many of these still survive today in museums and collections. Perhaps surprisingly, the same technique can be used for seaweeds which can be prepared as reference specimens collected by diving or from shores. Whilst live material is preferable, seaweed debris cast up on the shore can also be a source of material although site data will be missing. Making such a collection is also an excellent way to improve identification skills, especially as time spent underwater when diving is very limited. Obviously collecting should be done with conservation and local regulations in mind. The technique is best applied to the finer seaweeds as large, perennial seaweeds do not press well and can anyway be relatively easily identified in the field or from photographs.

- Write date, location etc. on a sheet of sketch pad paper (around 180gm) in pencil or indelible ink (museums use acid-free herbarium paper)
- Place paper in white tray and add tap water* to cover
- Float seaweed in water over the paper and spread out using a paintbrush
- Gently tip the tray to drain water away leaving seaweed in position
- Lift paper out and lay onto newspaper
- Cover seaweed with protective disposable nappy liner or stocking material
- Cover with more newspaper and place in plant press or under weights
- Change newspaper (leave liner in place) every day until paper and specimen are dry
- Gently peel away protective liner and store dried specimen away from light

When carefully prepared and stored in the dark, pressed seaweeds will retain their colour for many years. Museums use special acid-free herbarium paper for further protection. The seaweeds shown here are on good quality art paper and are over 30 years old. (Frances Dipper)

* Using saltwater rather than freshwater, maintains the cell structure of specimens for later re-hydration and microscopic examination, but salt residue can attract water and promote mould growth.

Just like land plants, seaweeds branch and grow in a wide variety of ways, and these patterns are used in identification. In a well-pressed seaweed, the branching patterns will be clear, but for identification purposes photographs are also helpful. This is especially the case where it is not practical or desirable to collect and press the whole seaweed. Holdfast shape can be important but can be recorded by a close-up photograph or a note. Dried specimens may also lose their colour and certainly lose their three-dimensional aspect, both of which are captured in a photograph.

Dichotomous (evenly forked) *Dictyota* sp. (Malaysia)

Pectinate (one-sided) branching *Claudea elegans* (Malaysia)

Fan-shaped *Padina* sp. (Malaysia)

Alternate *Cystoclonium purpureum* (UK)

With veins Sea Oak *Phycodrys rubens* (UK)

Reproductive cystocarps *Myriogramme bonnemaisoni* (UK)

Examples of pressed seaweeds showing branching, veins and reproductive structures. (Frances Dipper)

RED SEAWEEDS

Whilst giant brown kelps may be the largest and most obvious seaweeds, red seaweeds (Rhodophyta) outnumber brown and are by far the most numerous of the three groups with an estimated 6,400 species worldwide. Most are quite small, growing up to about 50cm long. The easiest place to look for them is at the bottom of a rocky seashore on a low spring tide. Most red seaweeds are not particularly tough and only a few species (such as Tough Laver *Porphyra umbilicalis*) grow at higher shore levels. A slow dive pushing your way through the tall stipes of a kelp forest will also be productive. Here red seaweeds form an understorey thriving in the dim light under the dense kelp canopy. Like orchids in a rainforest, many species also grow as epiphytes on the kelp stipes. Macroscopic seaweeds make up the majority of the Rhodophyta or red algae, but there are also microscopic species and single-celled species. A few small red algae live in freshwater.

STRUCTURE

Most red seaweeds are relatively small and delicate and there are no 'giants' such as there are amongst the brown seaweeds. However, red seaweeds are very diverse and come in many different shapes and forms from intricately branched bushes to flat sheets, gelatinous lumps and springy clumps. There are also a large number of hard calcareous encrusting species growing as crusts, tufts and unattached nodules (rhodoliths and maerl). Whilst many are obviously red or pink, others can be a brownish-red or even yellowish, and it can sometimes be difficult to distinguish these from fine brown seaweeds.

Red algae including red seaweeds are characterised by their accessory photosynthetic pigments phycoerythrin and phycocyanin which give them their red colour (see table on p.133), masking the green of their chlorophyll. This is the only way to tell them apart visually from green or brown seaweeds. Other distinguishing characteristics are all cellular in detail, including the structure of their plastids which contain accessory pigments arranged in granules called phycobilisomes (chloroplasts are a type of plastid that contains chlorophyll). Floridean starch is stored as a reserve in the cell cytoplasm instead of inside plastids (as in other seaweeds) and is different from starch made and stored by higher plants and green seaweeds and algae.

Red seaweeds are often found in the shelter of larger brown seaweeds such as seen here with Thong Weed (*Himanthalia elongata*) in the Isles of Scilly, UK.

Flagella are never found in red algae but are present in single-celled forms and reproductive cells of some brown and green algae. Red seaweeds are the only algal group to have agar and carageenans in their cell walls, both of which have important industrial uses (p.138).

Pepper Dulse (*Osmundea pinnatifida*) is a red seaweed commonly found on seashores in the Atlantic and Indo-Pacific. However it often appears more yellow or brown than red, especially if 'bleached' from exposure to strong sunlight.

The beautiful colour of Rainbow Weed (*Drachiella spectabilis*) (Ceramiales), a NE Atlantic species, is enhanced by brilliant blue-purple iridescence.

BIOLOGY

Life history

When it comes to reproduction, red seaweeds are masters of diversity with a variety of exceedingly complex life cycles of which only a sample can be given here. Many can also spread by vegetative means from pieces that break off and grow into new individuals. Most red seaweeds reproduce both sexually and asexually and have two phases in their life cycle, the gametophyte and the sporophyte. Sometimes both these phases grow as obvious seaweeds and look the same (e.g. siphon weeds *Polysiphonia* spp.). In others, the two phases can look totally different, usually with one growing as a recognisable seaweed entity and the other as a small or microscopic growth. Working out the life cycle of commercially important species has vastly improved our ability to grow them efficiently in aquaculture. This was certainly the case with *Porphyra*, generally known as 'nori' or 'laver' and described below.

The 'adult' sheet-like blade of *Porphyra* that we see and eat is the gametophyte phase. In complete contrast, the sporophyte phase grows as tiny filaments that typically bore into the calcareous shells of molluscs such as oysters. This is known as the conchocelis phase because until 1949 it was thought to be a separate species (*Conchocelis rosea*). It can sometimes be seen with the naked eye as dark reddish patches on shells. Rocks can quickly become covered in dense growths of *Porphyra* when the 'adult' gametophyte reproduces asexually simply by producing spores that are released, settle and grow into more genetically identical blades. At certain times the gametophyte instead produces male and female sexual cells called spermatia and gametangia respectively, often in different parts of the same seaweed frond. The spermatia (sperm) are released and fertilise the female gametangia still within the seaweed thallus. Each fertilised gametangium divides to form a zygotosporangium which produces and releases zygotospores. These settle on shells and grow into the conchocelis phase. This too can replicate itself with asexual spores. The cycle is completed when the conchocelis phase produces sexual conchospores by the special cell division called meiosis, which halves the number of chromosomes in each cell. Each conchospore then grows and develops to form an 'adult' seaweed.

Fresh oyster shells are often riddled with the conchocelis phase of *Porphyra*, which may show up with a magnifying glass as small red patches.

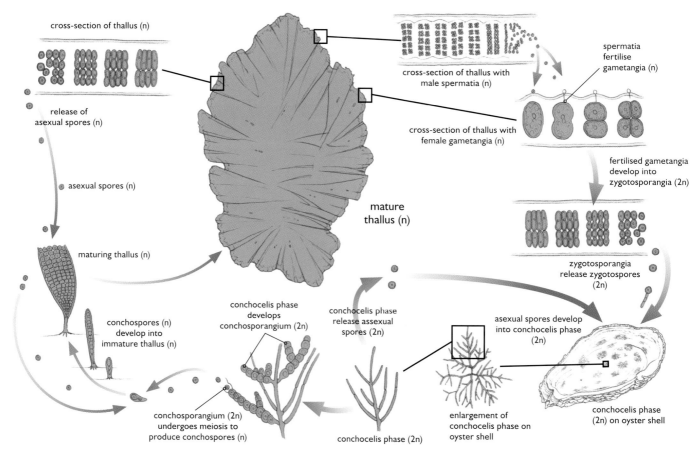

Life cycle of *Porphyra* (Class Bangiophyceae). Haploid cells have one complete set of chromosomes (n) whilst diploid cells have two sets (2n).

The gametophyte and sporophyte phases in siphon weeds (*Polysiphonia* spp.) look identical and can only be told apart by microscopic examination.

Ecology

Seaweeds in general are a vital food resource for herbivorous fishes and a wide range of invertebrates, especially sea urchins, gastropod molluscs and polychaete worms. Rotting seaweed provides a feast for smaller amphipods and copepods and really rotten stuff finally adds to the dissolved organic matter (DOM) found in seawater and absorbed by many organisms. Red seaweeds often form dense undergrowth in shallow sublittoral areas, gradually giving way to sessile (fixed) animal growths in deeper water. Whilst they may shelter small invertebrates, red seaweeds do not generally provide the structural basis for an ecosystem in the way that large brown seaweeds such as kelp do (p.99). However, there are some exceptions, especially amongst calcareous seaweeds. Unlike most seaweeds, species of maerl such as *Phymatolithon calcareum* (p.139) grow as unattached, free-living twiggy or pebble-like nodules. These can cover large areas of sediment and provide a hard, structural framework on an otherwise soft and mobile substratum. Other seaweed species use the maerl to attach to, in turn attracting a wide variety of invertebrates which graze and hunt through the maerl 'forest' (p.103).

Just as you would expect to find different species of wild flowers in a grassland habitat than in a woodland, so too particular red seaweeds occur in different habitats. For example, some low growing filamentous species such as Sand Binder (*Rhodothamniella floridula*) can tolerate sand scour and will grow on boulders and rocks near sandy areas. Unstable habitats such as areas of cobbles and pebbles are a difficult habitat for seaweeds to colonise. However, many temperate red seaweeds are annuals and can settle and grow during the calm of summer, completing their life cycle before winter storms set in and dislodge them. Summer and winter scenes in such habitats can be as different as those of a bluebell wood in spring and winter.

Maerl can be productive even when dead. The beautiful white sands found along the coasts of the Western Isles (Hebrides) off Scotland are largely formed from dead maerl and in turn support a community of calcium-loving flowers termed 'machair'.

Red seaweeds tend to occur as small tufts on coral reefs because they are constantly nibbled by herbivorous fish. In temperate regions there are fewer herbivorous fishes and the nutrient-rich waters promote seaweed growth. *Eucheuma* sp., Malaysia.

Genus	Product	Main uses	Main source and production in tonnes (FAO 2010)
Chondrus, Gigartina	Carageenans. Whole food	Suspensoids in food and drug industry	Wild harvest
Kappaphycus alvarezii	Carageenans	Suspensoids in food and drug industry	Aquaculture 1,875,277
Eucheuma	Carageenans	Suspensoids in food and drug industry	Aquaculture 3,748,000
Gelidium, Gracilaria, Hypnea, Pterocladia	Agar	Thickener in desserts; microbiological plates	Wild harvest and aquaculture
Porphyra	Nori	Food; e.g. laver bread (UK), sushi	Aquaculture, Japan and China 1,636,584
Lithothamnion, Phymatolithon (maerl)	Soil conditioner	Horticulture	Wild harvest by dredging

Some red seaweeds and their uses.

USES, THREATS, STATUS AND MANAGEMENT

Seaweeds are the basis of a worldwide, multi-million dollar industry and red seaweeds play a large part in this as they are the source of agar and carageenan. Alginates, which originate from brown seaweeds, are also important (p.147). Almost every household in developed countries is likely to have at least one seaweed-derived product in their kitchen or bathroom cupboard, and probably several. Seaweed extracts are used as gelling agents and thickeners in a huge variety of foods and pharmaceuticals. Many seaweeds are also eaten directly as food or in vitamin and mineral supplements. Agar makes an ideal growth medium for bacteria and other microbes and is widely used for preparing cultures in microbiological laboratories – an interesting thought considering its use in the food industry.

Many seaweeds are still collected from the wild, but aquaculture production now far exceeds wild harvest for all the major commercial species and this is particularly the case with red seaweeds. One of the most damaging wild collections is dredging for maerl (calcareous seaweeds) which takes place in parts of the NE Atlantic and Mediterranean. Maerl is both delicate and slow-growing, and maerl beds support a wide variety of other seaweeds and animals. Like peat on land, maerl is effectively a non-renewable resource and alternatives are easily available.

Most seaweed aquaculture takes place in the sea and on a large scale this itself can be damaging to the environment unless very carefully sited. In Japan and China, thousands of acres of shallow coastal waters are covered by the suspended nets on which nori (*Porphyra* spp.) is grown. Production in 2010 was 1,636,584 tonnes (FAO 2013). However, small scale seaweed production can actually lead to environmental improvements when local people change from destructive fishing practices (such as netting on coral reefs) to seaweed cultivation.

Cultured seaweeds are often fast growing, vigorous species that can grow from fragments. This is good from the grower's point of view but has the potential for creating problems if species are grown outside their native range. Escapes from aquaculture include *Kappaphycus alvarenzii*, a large vigorous tropical red seaweed native to the Indo-Pacific. This is now causing smothering problems in other parts of the Indian and Pacific Oceans, such as Hawaii.

Six species of red seaweeds are listed as critically endangered in the IUCN Red List but all these appear to be naturally rare and none are exploited species.

Collecting seaweeds from the wild plays an important part in subsistence living and small scale businesses in some countries.

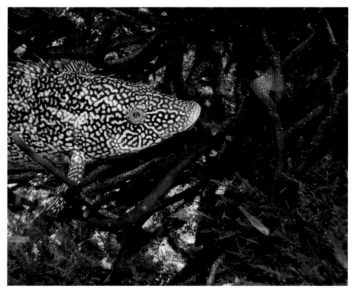

Harpoon Weed (*Asparagopsis armata*) is now widespread in Europe but is thought to have originated from Australia and New Zealand. It was probably brought in as food, but discarded or lost fragments can hook onto other seaweeds and soon grow new branches. Also seen here are green *Codium* seaweed and a male Ballan Wrasse (*Labrus bergylta*).

RED SEAWEED SPECIES: PHYLUM (DIVISION) RHODOPHYTA

The majority of the approximately 6,400 red algae are seaweeds (macroalgae) and are contained in one class, the Floridiophyceae which has 28 orders. The other six classes in this phylum have only around 250 species between them and most are small filamentous species or microscopic unicellular algae, though some Bangiophyceae are obvious seaweeds. It is often features that can only be seen under a microscope which are used to classify red seaweeds, and so field guides usually group them into artificial categories using their growth forms. Examples of Floridiophyceae and Bangiophyceae showing the spectrum of red seaweed shapes are illustrated here.

Class Floridiophyceae

It is not usually possible to tell without a microscope to which class a red seaweed belongs, but as most are in the class Floridiophyceae it is easier to learn which seaweeds do *not* belong to this class. Most species in this class have a life cycle with three phases. This comprises asexually reproducing tetrasporophytes, sexually reproducing gametophytes and a microscopic carposporophyte which lives on the gametophytes and produces diploid spores which develop into tetrasporophytes.

ORDER Plocamiales FAMILY Plocamiaceae

Red Comb Weed *Plocamium lyngbyanum*

Features The huge variety of frond shape and branching in red seaweeds can be daunting for anyone setting out to identify them. They can look very similar when growing en masse but often a hand lens will reveal beautiful details. Red Comb Weed is an excellent beginner species as it has distinctive curved branchlets with smaller brachlets along one side only. It is common in the NE Atlantic but also found as far away as Australia and USA. However, detailed studies have now shown that there are several distinct species in northern Europe. Most non-specialists will know them all as *P. cartilagineum* but *P. lyngbyanum* is the commonest species.

Size Up to about 15cm long.

ORDER Palmariales FAMILY Palmariaceae

Dulse *Palmaria palmata*

Features Dulse is an edible seaweed that commonly grows on rocky seashores and in the sublittoral down to about 20m depth in the northern hemisphere. It typically grows up from a small disc-shaped holdfast that widens into a flat blade. This divides dichotomously into 'fingers', hence its specific name *palmata* referring to a hand. However, shape varies with age and growing conditions. In the UK (at least) it is often abundant growing on the stipes of Forest Kelp (*Laminaria hyperborea*). It has a long history of human use for food but tastes best after drying.

Size Up to 50cm long.

ORDER Corallinales FAMILY Corallinaceae

Coral Weed *Corallina officinalis*

Features This species is one of the prettiest seaweeds found on rocky seashores almost worldwide (though there may be confusion between species), where it grows especially well in rock pools. When it dies (or bleaches in strong sunlight) it loses its pink colour leaving behind a white skeleton of bead-like segments. Flat feather-shaped branches grow up from a basal crust in dense tufts. It provides an excellent habitat for small invertebrates and is little grazed due to its chalky skeleton.

Size Fronds up to about 10cm long; basal crust up to 15cm across.

FAMILY Hapalidiaceae

Maerl *Phymatolithon calcareum*

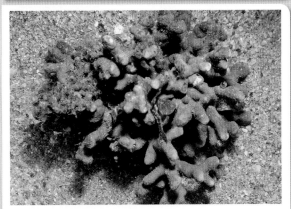

Features 'Maerl' is used as a general name to cover a number of species of free-living calcareous seaweeds which grow as small twigs, nodules or even plate-like growths. *P. calcareum* itself is variable in shape but often forms extensive beds of twiggy growths on gravel or sand around Great Britain, Ireland and southern Europe. Maerl grows best in clear water down to about 20m depth where there is some current. It is a fragile habitat easily damaged by boat anchors, careless divers and especially by dredging.

Size Nodules up to several cm across; branches 2–3mm diameter.

Pink Paint Weeds

Features Look on almost any hard shore or on rocks and coral reefs on any dive and you are likely to see hard, pink crusts in patches or covering large areas. Even living mollusc shells and other seaweeds may have their share of these Corallinaceae crusts. There are many different species worldwide and they are very difficult to identify without expert knowledge and a high powered microscope. Nevertheless they are worth a look as they can transform a boring pebble into a 'hedgehog' and a rock pool into a pink arena.

Size Indeterminate.

ORDER Corallinales
FAMILY Corallinaceae

Solier's Red String Weed *Solieria chordalis*

Features This bright red seaweed is adept at spreading by vegetative means and in summer can quickly cover rocks and cobbles in sheltered areas. It is found on NE Atlantic coasts from Morocco and the western Mediterranean as far north as southern Britain. It was first recorded in Britain in 1976 and most likely crossed the English Channel as small fragments with shipments of oysters or on ballast rock. Southern European seaweeds that do not rely on sexual reproduction have a high potential to move north as the climate warms.

Size Up to 20cm long.

ORDER Gigartinales
FAMILY Solieriaceae

Peyssonnelia spp.

Features *Peyssonnelia* is an example of a genus of encrusting dark red seaweeds. There are several other similar genera and not only are they difficult to tell apart but many look more like discoloured rock or spilt paint than seaweeds. The one shown above is an Indo-Pacific species that grows as encrusting lobes with free edges on deep, shaded areas of coral reefs. Below is a typical encrusting species, *Peyssonnelia atropurpurea*, from the NE Atlantic. This genus is amongst the deepest growing marine algae.

Size Up to about 20cm across.

ORDER Peyssonneliales
FAMILY Peyssonneliaceae

Class Bangiophyceae

This class of red algae of about 180 species includes seaweeds (macroalgae) as well as microalgae. They are mostly very thin sheets or thread-like filaments that are easily visible en masse. Future molecular analysis is likely to show that this is not an entirely natural assemblage of species. The most important genera are *Porphyra* and *Pyropia*, many species of which are edible.

Laver or Nori *Porphyra* spp.

Features There are about 60 species of *Porphyra* found worldwide and some of these are important commercial food species. In the UK *Porphyra* is often seen growing high up on rocky seashores. On the shore and partly dried out it looks black and rather unattractive but spread out in water it forms beautiful translucent sheets only one to a few cells thick. Each one grows up from a small disc-shaped holdfast and a short stipe. Other places to look for it are pontoons, sea walls and launch ramps.

Size Variable from about 2cm to 1m long.

ORDER Bangiales
FAMILY Bangiaceae

GREEN SEAWEEDS

Green seaweeds (Chlorophyta) often grow in abundance under the right conditions but there are only about 1,000 species known worldwide, though taxonomic confusion means there may be more than this. They can appear most unattractive when they cover mud flats or turn launch ramps into slippery skating rinks. However, there are also many beautiful and bizarre species that are well worth looking for. Most rocky seashores will reveal a variety of species, especially in rock pools or hidden under the damp shade of larger brown seaweeds. Shallow dives can also be productive in both temperate and tropical waters, especially on coral reef flats. Macroscopic seaweeds make up only a small proportion of green algae (Chlorophyta). There are also many single-celled and colonial chlorophyte species in the ocean (p.156) but the majority live in freshwater. Some of these are filamentous species such as the familiar blanket weed (*Cladophora* spp.) that clogs up ponds and ditches.

Green seaweeds such as *Cladophora* that are tolerant of freshwater are often found in abundance on seashores where streams, rivers and runoff cross the shore. These short-lived species may disappear as quickly as they appear.

STRUCTURE

Many green seaweeds grow as finely branched tufts or flat sheets but there is also a wide variety of other forms. Tropical species especially seem to have some wonderfully bizarre shapes including calcified discs with or without stalks, chains of beads (*Chaetomorpha*) and rose or cone-like rosettes (*Rhipocephalus phoenix*). One of the most bizarre is the so-called Sailor's Eyeball (*Ventricaria ventricosa*) which grows as individual spherical, fluid-filled balls which can be several centimetres in diameter and are common in the tropics. Each one is actually a single cell and these are the largest known uninucleate (with one nucleus) cells.

The colour of green algae including green seaweeds comes from chlorophyll-a and chlorophyll-b which are present in about the same proportions as they are in 'higher' plants. Other pigments include xanthophylls and beta-Carotene which are also responsible for the wonderful autumn hues of yellow and red in the leaves of deciduous trees. Some of the reproductive spores of green seaweeds have flagella, something that is never found in red seaweeds.

BIOLOGY

Life history

Green seaweeds have complex life histories which have by no means been worked out for all species. Most have an alteration of generations as is common for seaweeds but this is rarely obvious as the two phases either look exactly the same or the gametophyte phase is the seaweed we see and the sporophyte is so small that it is never normally noticed. Sea lettuce (*Ulva* spp.) is an example of a green seaweed genus in which the two phases look exactly the same (isomorphic). When it reaches a certain size and when the water temperature and other conditions are right, the sporophyte phase produces microscopic spores which are released into the water. These spores are produced by meiosis, the same process used to produce eggs and sperm in animals and which results in each spore having half the normal number of chromosomes (called haploid and designated as 'n'). In an animal, eggs and sperm would fuse returning the chromosome number back to normal (called diploid and designated as 2n). The *Ulva* spores, however, swim around for a short time (around an hour) using four flagella and then settle and grow into the gametophyte phase, which looks exactly like the sporophyte but its cells are haploid. The gametophyte produces gametes by normal cell division (mitosis) which have two flagella and which swim around until they meet another and fuse with it, thus producing a diploid zygote with the normal (2n) chromosome number. This grows into a new sporophyte phase. *Ulva* is often found in dense stands covering large areas, a result of having two opportunities in its life cycle to produce lots of new individuals.

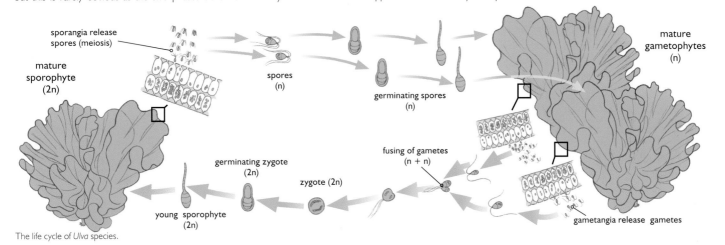

The life cycle of *Ulva* species.

Nestled amongst coral, this Sailor's Eyeball (*Ventricaria ventricosa*) looks more like a marble than a living green seaweed.

USES, THREATS, STATUS AND MANAGEMENT

Unlike red and brown seaweeds, green seaweeds are not widely utilised in the pharmaceutical industry though *Dunaliella salina* is processed on a large scale to extract beta-Carotene. There are a few edible species such as Sea Grapes (*Caulerpa racemosa*) (p.143), which is a common sight in SE Asian fish markets, whilst sea lettuces (*Ulva* spp.), often known as green nori, are widely eaten in Europe and SE Asia.

Some species have very fast growth rates and can thrive in polluted and low salinity water. For this reason they are increasingly being used to help clean up effluents in much the same way that reedbeds are on land. Nutrients and heavy metals can be effectively removed by growing species such as Sea Lettuce (*Ulva lactuca*) in the effluent. The seaweed can then be harvested and either disposed of along with the harmful contaminants or recycled as fertiliser.

Several species of green seaweeds have proved to be highly invasive when accidentally introduced outside their native range. One of the worst offenders is an aquarium strain of the tropical *Caulerpa taxifolia*, a beautiful feathery species. This has spread through parts of the Mediterranean from Monaco where it may have originated from the Oceanographic Museum in the early 1980s. As it contains toxins, it is not eaten by herbivorous fish or invertebrates and its impressive growth has impacted seagrass beds. Presumably herbivores in its Indian Ocean native range are made of sterner stuff or wild strains are more palatable.

Ecology

Green seaweeds are most abundant on the shore and in shallow water, and are also often found in estuaries and other low salinity areas as many species are tolerant of brackish water. Dangling mangrove roots are often festooned with epiphytic green seaweeds, which tolerate the low salinities and cover the roots almost as soon as they grow. Green seaweeds are adept at living on a wide variety of different surfaces, including small shells and pebbles in muddy areas. Some tropical species such as *Udotea* have an expanded holdfast which works like an anchor and allows them to live in sandy areas. Tropical sand and reef flats are also home to a variety of *Caulerpa* species, known as sea grapes, which spread rapidly by vegetative, runner-like extensions. *Caulerpa taxifolia* has invaded and spread rapidly in the Mediterranean by this means and is smothering some areas of seagrass.

With an ability to multiply rapidly using both sexual and asexual means, fine filamentous green seaweeds are often the first to colonise areas of coral killed by bleaching or Crown-of-thorns Starfish. Usually seaweed growth on coral reefs is kept in check by the corals themselves, which out-compete them and secrete protective mucus, and also by grazing fish and sea urchins. Only when something goes wrong do the seaweeds take over. Even native species can cause problems with their rapid growth and can clog up harbours, bays and lagoons when agricultural waste and domestic sewage inputs provide an excess of nutrients. One such outbreak at a tourist resort on a Philippine tropical island was ultimately traced to a break in a sewage pipe, outside the lagoon but where currents swept the nutrient-laden water back into it.

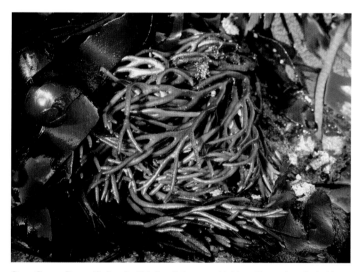

Green Sponge Fingers (*Codium fragile*) is found almost worldwide and is seen here in the Isles of Scilly, UK, but at least one non-native subspecies is invasive in the USA. Massachusetts beaches are sometimes swamped by it when it washes up after storms.

GREEN SEAWEED SPECIES: PHYLUM (DIVISION) CHLOROPHYTA

Seaweeds make up only a small minority of the species within the phylum Chlorophyta. The rest are microscopic and largely single-celled green algae.

Class Ulvophyceae

The majority of macroscopic green seaweeds that most non-specialists will encounter belong in a single class, Ulvophyceae (p.129), with nine orders of which species from four are illustrated. A second class, Trebouxiophyceae (p.129), includes some small macroscopic species such as *Prasiola* but is not described further here. Whilst some genera of green seaweeds are distinctive, others are notoriously difficult to identify and the features that distinguish orders and families often rely on microscopic features, and so are not described here.

Seagrapes *Caulerpa racemosa*

ORDER Bryopsidales FAMILY Caulerpaceae

Features It is easy to see how this seaweed got its common name as it looks just like bunches of tiny grapes. Each 'grape', 2–4mm in diameter, is a branchlet and each bunch arises from a creeping runner which itself often branches. In this way it can intertwine between rocks and corals and can withstand the surf that runs over reef tops, though it is also found in calm sandy reef lagoons. This is the most widespread of several similar species and has a pantropical distribution.
Size Up to about 15cm high.

Cactus Weed *Halimeda* spp.

ORDER Bryopsidales FAMILY Halimedaceae

Features *Halimeda* species are easy to recognise as each is made up of chains of miniature, flat, plate-like segments. The different species, however, are more of a challenge. The segments are brittle and calcified, which explains why they are common on tropical reefs and sediment flats in spite of an abundance of grazing fish and molluscs. Their chalky skeleton makes them unpalatable and when the seaweed dies this hard material contributes to the consolidation of reefs.
Size Varies between species, up to about 25cm high.

Tydemania expeditionis

ORDER Bryopsidales FAMILY Udoteaceae

Features This tropical species commonly grows as tufted chains that can be found draping coral rock or hanging between coral clumps. The author nicknamed it 'Michelin-man' after the advertising figure for Michelin tyres. However, it also occurs in a completely different fan-shaped form. Either form has connecting runners by which it spreads vegetatively. In the clear waters of the Indo Pacific it grows down to 60m depth, unusually deep for a green alga.
Size Tufted form to about 15cm long.

Common Green Branched Weed *Cladophora rupestris*

ORDER Cladophorales FAMILY Cladophoraceae

Features Species of *Cladophora* can be found throughout the world and this genus has many different species. All are made up of thread-like branches in which the cells are arranged in a single row end to end, something that is relatively easy to see with a powerful hand lens. *Cladophora rupestris* forms wiry, dark green tufts on shores in cool Atlantic and polar waters and south into the Mediterranean. Unlike most other species in this genus, it can be readily recognised.
Size Up to about 20cm long (high).

Turtle Weed *Chlorodesmis fastigiata*

Features The brilliant green tussocks of Turtle Weed show up on reef tops and flats in the Indo-Pacific and thrive in exposed shallow water areas, down to about 5m depth. The clumps are firmly attached to rocks or corals by a mat of rhizoids and are made up of fine filaments which move to and fro with the water so that the clumps resemble miniature heads with a mop of green hair. Turtle Weed is left alone by most herbivorous fish as it contains deterrent chemicals.
Size Clumps up to about 8cm high and 30cm diameter.

Sea Lettuce *Ulva stitipata*

ORDER Ulvales FAMILY Ulvaceae

Features Like its namesake, Sea Lettuce forms thin, blade-like sheets with a rather irregular shape and wavy edges. The fronds are only two cell layers thick and yet are remarkably strong. There are actually many different species that are hard to tell apart without looking under a microscope. Tubular species are called gut weeds and were previously known as *Enteromorpha*. Sea Lettuce is common on European shores and in shallow water, and probably has a much wider world distribution.
Size Up to 1m long, usually much smaller.

Mossy Feather Weed *Bryopsis plumosa*

FAMILY Bryopsidaceae

Features The delicate fern-like branches of this seaweed are best appreciated with a hand lens or by collecting and pressing a small piece (see p.134). *B. plumosa* is found in the N Atlantic but other very similar species occur worldwide and there is uncertainty over distribution. However, it is relatively easy to recognise the genus. The fronds grow up from prostrate, runner-like branches.
Size Up to at least 10cm tall.

Mermaid's Wine Glass *Acetabularia* spp.

ORDER Dasycladales FAMILY Polyphsacyaea

Features Only a sharp-eyed diver in a shallow, sheltered reef area will spot this small delicate seaweed, though it will also grow in marine aquariums. Each consists of a slender stalk topped by a flat or concave disc which itself is made up of fused ray-like branches radiating out from the centre. In a manner reminiscent of toadstools, the discs produce spores and disintegrate afterwards. Each stalk has a single nucleus at the base which divides to supply nuclei for the reproductive spores.
Size Up to 8cm high, disc up to 2cm across.

GREEN SEAWEEDS

BROWN SEAWEEDS

Brown seaweeds (Phaeophyceae) will be familiar to many people in the form of the wracks or fucoids that cover temperate rocky shores around the world, and as magnificent kelp forests that dominate the shallow waters. Kelp forests are described further on p.99. In number, browns slightly outdo the green seaweeds with around 1,800–2,000 species. Their sheer bulk is impressive and never more so than when winter storms cast up huge masses on sandy beaches where they are greeted with delight by detritus feeding sand hoppers (Amphipoda) and dismay by tour operators. Kelps and other large brown seaweeds also form the basis for the multi-million dollar alginate industry and are even used whole for (apparently) refreshing seaweed baths. However, there are also many small species and a number of microscopic species belong to this class.

STRUCTURE

The range of shapes and sizes found amongst brown seaweeds is impressive but there are a large number of tough and robust species, which survive well on wave-battered shores. These may be the most obvious but numerically they are far outnumbered by small species including filamentous branched forms, flat fans and even hollow balls and small prickly bushes, as well as encrusting species. The really small species are often difficult to identify and will only be found in specialist identification guides. The brown colour of this group of seaweeds results from accessory photosynthetic pigments, mainly fucoxanthin and chlorophyll-c (p.133). They are not all a true brown colour and many range through olive-brown to almost yellow, especially when exposed to high levels of sunlight.

Kelps (Laminariales) are the largest brown seaweeds and in them the typical seaweed structures of holdfast, stipe and frond are usually obvious. Large heavy kelp plants need a massive holdfast to resist the pull exerted by wave surge and strong currents. This applies especially to giant kelp such as *Nereocystis* and *Macrocystis*, but even smaller species such as *Laminaria*, just a couple of metres tall, are almost impossible to pull off the rocks by hand. Most kelps have a distinct stipe, varying in length from a few centimetres to at least 30m, for example in *Nereocystis*. The fronds are generally flat and wide providing a large surface area for photosynthesis. To this end

Brown fucoid wracks (Fucaceae) cover the shores of the Kola Peninsula in the far northwest of Russia. They are tough enough to withstand even the severe winters found within the Arctic Circle.

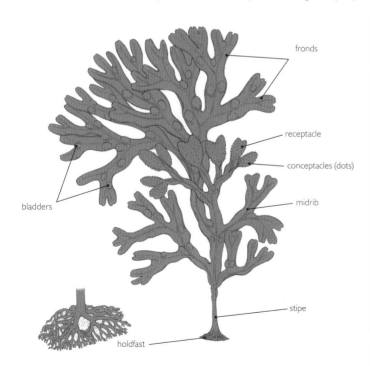

Macroscopic structure of a brown fucoid seaweed *Fucus vesiculosus*.

As well as producing mucus, the Channelled Wrack (*Pelvetia caniculata*) has fronds that can curl inwards to form channels and prevent water loss in its exposed position high on the shore. This species is so well adapted to its shore position that it grows very poorly if submerged for more than half the time.

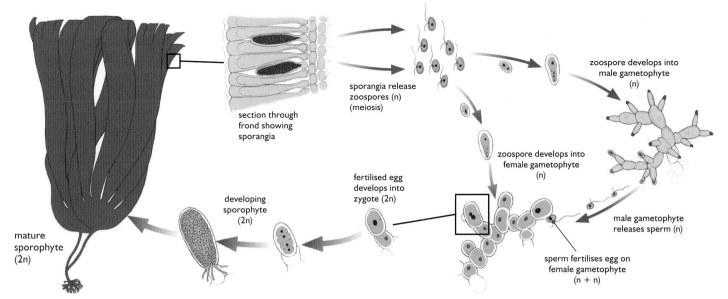

Life cycles of a typical kelp (*Laminaria* sp.).

they need a means of holding their fronds up to the light and, as well as a strong stipe, many have large gas-filled bladders (see Giant Kelp photo p.148).

Wracks are the dominant seaweeds found on temperate and cold temperate shores especially in the northern hemisphere though species are found worldwide. Wrack is a general name familiarly used for the 54 or so fucoid seaweeds (Fucaceae) but also including tough branched species in other families such as Neptune's Necklace (*Hormosira banksii*), abundant on Australian shores, and Upright Wrack (*Bifurcariopsis capensis*) found on the shores around South Africa. Many of these versatile seaweeds occur in different forms according to their habitat (see Ecology below) but in general they are bulky branching species with the largest reaching about 1.5m long.

The tissues of these large kelps and wracks have some internal organisation with an outermost protective layer (meristoderm), an underlying layer of larger cells (cortex) and a central mass of loosely packed cells (medulla). The inner tissues of many wracks contain polysaccharides which help to retain water when the seaweed is exposed to air at low tide.

BIOLOGY

Life history

Brown seaweeds, in common with many red and green seaweeds, have a two phase life history, a haploid gametophyte and a diploid sporophyte, both usually living independent and separate lives (see Life history under Green Seaweeds p.141 for an explanation of haploid and diploid). In kelps and fucoid seaweeds it is the sporophyte phase that we see whilst the gametophyte is microscopic, and in the case of fucoids is retained in special pits on the sporophyte. In other brown seaweeds both phases are macroscopic and easily visible but may have a completely different form and lifestyle. Many encrusting brown seaweeds are the sporophyte phase of upright and foliose species though in others both sporophyte and gametophyte are crusts. As should by now have become obvious, there are few 'rules' for reproduction between or within any of the seaweeds.

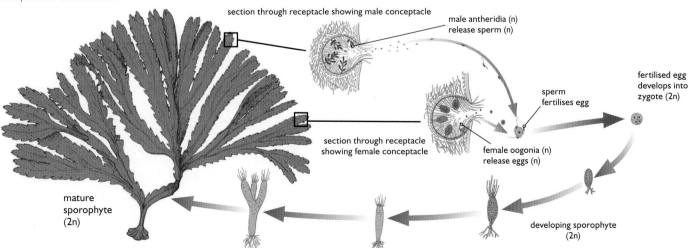

Life cycles of a typical wrack (*Fucus* sp.). Some *Fucus* species have both male and female conceptacles in the same individual, whilst others have them on separate individuals.

BROWN SEAWEEDS

The long, bifurcating, strap-like fronds (left) of Thong Weed (*Himanthalia elongata*) are produced from its stalked button-like fronds (right) only when the seaweeds reproduces. Each individual is either male or female and the gametangia are visible as small dots along the straps.

The Knotted Wrack (*Ascophyllum nodosum*) forms a dense sward on very sheltered rocky shores in the NE Atlantic. Its fronds provide a damp covering beneath which many smaller seaweeds and invertebrate animals find shelter during low tide.

Brown seaweeds such as kelps and wracks invest considerable energy in the growth of their bulky bodies and many species of brown seaweeds are perennials. In *Laminaria hyperborea* a new frond grows at the top of the stipe below the old one in late autumn and the old frond is eventually shed in spring (often along with a considerable load of epiphytic bryozoans and hydroids). The approximate age of perennial species with large stipes can sometimes be estimated by cutting the stipe and counting annual growth rings in much the same way as is done for trees. *L. hyperborea* can live for around 10 years (Sjøtun and Fredriksen 1995) whilst Knotted Wrack (*Ascophyllum nodosum*) survives for at least 30. Not surprisingly, giant kelps such as *Macrocystis* are perennial, living for up to ten years, but the equally large *Nereocystis* is a fast growing annual. Some foliose temperate brown seaweed species seem to disappear in autumn but in fact overwinter as crusts or other low growths.

Ecology

Brown seaweeds are usually the dominant photosynthetic organisms on sheltered or semi-sheltered rocky shores and in shallow coastal water around the world. They are a vital source of food for grazers and detritus feeders, and in some areas are even eaten by domestic animals and deer roaming on the seashore. However, it is the much smaller and more succulent sea grasses and green seaweeds that are grazed by large marine herbivores such as turtles and manatees. This is not surprising because brown seaweeds predominate in temperate regions whilst turtles and manatees prefer warmer waters but brown seaweeds are also tough and less palatable.

Where conditions are right, kelps grow densely and form the structural element of a kelp forest. This important habitat is described in detail on p.99. The size and complex three-dimensional structure of many other types of brown seaweeds means that they too form miniature forests, something easily appreciated by snorkelling over a seaweed-dominated rocky shore at high tide. A forest of Bladder Wrack (*Fucus vesiculosus*) may not be as dramatic as a forest of giant kelp, but is an equally thriving habitat, just on a smaller scale. As the water flows in, these shores come to life and with the seaweeds buoyed up by the water, fish, crabs, shrimps and other animals take full advantage of hunting opportunities whilst gastropod snails graze the seaweeds themselves. Brown seaweeds resist grazing by both physical and chemical means. Many seaweeds use metabolic by-products as deterrent chemicals but Desmarest's Green Weed (*Desmarestia viridis*) and other *Desmarestia* species produce and store sulphuric acid. This appears to have a deterrent effect on grazing sea urchins, and the presence of this seaweed may also protect kelp and other seaweeds in its vicinity. Keeping this seaweed in the same bag or bucket with other seaweeds often results in a slimy mess as the acid attacks the collected material. *Desmarestia* and many other brown seaweeds have long fronds that whip to and fro in response to waves and currents and this too appears to discourage grazing urchins.

A number of large brown seaweeds grow as unattached plants. The classic example is *Sargassum*, some species of which forms extensive floating mats in the western Atlantic. Juvenile Loggerhead Turtles (*Caretta caretta*) originating in Florida use this habitat in the Sargasso Sea, as a safe refuge in which to live and grow before

With its narrow fronds and strong midrib, Dabberlocks (*Alaria esculenta*), here seen lying across *Laminaria digitata*, can withstand strong waves and grows on exposed shores. However, in winter often only the holdfast survives and grows a new frond later.

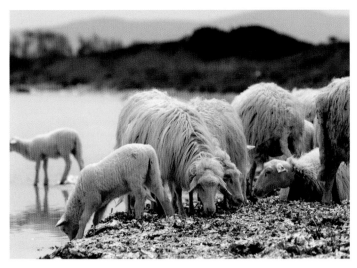
Seaweeds can provide a diet rich in minerals and vitamins for sheep. Wild deer and rabbits will also eat it.

Wakame (*Undaria pinnatifica*) is a popular food in Japan and SE Asia but its importation has led to accidental introductions. This specimen is growing as an alien species on a pontoon in Plymouth, England.

dispersing further. Many other animals are also found in this habitat which is described in more detail on p.61. Small tufts of feathery and filamentous brown seaweeds such as *Sphacelaria* can frequently be found growing as epiphytes on other seaweeds along with bryozoans and hydroids, and it can sometimes be difficult to tell which is which.

USES, THREATS, STATUS AND MANAGEMENT

In temperate regions a good storm will often result in masses of kelp being washed up on the shore where it decays into a slimy, smelly mass. It is this very bulk that makes kelp and other large brown seaweeds easy to harvest in large quantities, something that has been done since early times. They have long been used as a fresh fertiliser and mulch in fields and for livestock feed. Cattle and sheep can still be seen grazing on the foreshore in remote parts of Scotland.

However, their main use today is as food and in the production of alginates. The latter have a wide variety of uses many of which exploit their ability to absorb water quickly and in large quantities. It seems slightly ironic that alginates are used in slimming products as well as in the food industry for thickening delicious soups, drinks and ice cream. One of the most interesting uses is in burn dressings where easy removal is very important. The variety of edible brown seaweeds is smaller than for red seaweeds, but species of *Laminaria* are widely used as food. The Sea Palm (*Postelsia palmaeformis*) which grows on exposed rocky shores along west coast USA, is eaten raw or dried but is now protected in many areas.

Ascophyllum nodosum is the most commonly harvested species in Iceland and Ireland whilst various species of *Laminaria* are collected in France, Ireland, Japan and Korea. Nearly 457,000 tonnes of brown seaweeds were taken from the wild worldwide in 2010 (FAO 2014). The removal of such large, canopy forming species will obviously impact the complex community of fish and invertebrates that live amongst them. To minimise impacts, most harvesting is done in rotation leaving the holdfasts of these perennial species in place to regenerate. However aquaculture production of brown seaweeds far exceeds wild collection and 6,785,193 tonnes were produced in 2010 (FAO 2014). Around 75% of this is Japanese Kelp (*Laminaria japonica*) and most of the remainder is Wakame (*Undaria pinnatifida*). Unlike many red seaweeds, kelp cannot be grown from fragments and the microscopic gametophyte phase must first be grown in land-based facilities and young sporophyte plants produced. These are then grown on, attached to ropes in the sea.

BROWN SEAWEED SPECIES: PHYLUM (DIVISION) OCHROPHYTA

Brown seaweeds make up only one class within this phylum. The other classes are all microscopic organisms of which the diatoms (Bacillariophyceae) and golden-brown algae (Chrysophyceae) are described later.

Class Phaeophyceae

Different authorities vary in the number of orders listed within the Phaeophyceae with about 20 on average, and this uncertainty reflects ongoing research into the classification of brown algae. However, over three quarters of the 1,800 to 2,000 species fall within five orders, examples of four of which are given below. Seaweeds within the order Laminariales are generally known as kelps. Seaweeds within this order vary in size but all are relatively large and bulky and usually have a distinct holdfast, a rod-like stipe and blade-like fronds. The gametophyte stage is microscopic. Seaweeds within the order Fucales vary greatly in shape but most are substantial, bushy branching species. They exhibit apical growth which means they grow outwards from the branch tips. Included are the familiar seashore fucoids and wracks that dominate rocky shores and shallows in many temperate regions. The order Dictyotales consists of species that have relatively thin, flattened or even membranous fronds varying from small discs and funnels to dichotomously branched blades. A close look will show small tufts of hairs on the fronds. They grow from the tips in a similar way to the Fucales. All except two species belong in one family the Dictyotaceae. Species in this order frequently cover large areas as they have ways to resist grazing. The order Scytosiphonales has about 90 species and includes various forms including open flattened blades, but many form closed vesicles or sausage-like tubes.

ORDER Laminariales | FAMILY Laminariaceae

Giant Kelp *Macrocystis pyrifera*

Features If any seaweed has international fame then Giant Kelp is the one. It is the largest seaweed in the ocean and forms magnificent forests off the west coast of N America as well as in cool waters (below 20°C) in the southern hemisphere. Several stipes grow up towards the surface from a large holdfast, each with many fronds branching off it. Each frond is buoyed up by a single large gas-filled bladder and at the surface the fronds lie horizontally absorbing the sunlight.
Size At least 45m long.

Oarweed *Laminaria digitata*

Features With its wide digitate fronds, Oarweed forms a tangled forest in the sublittoral fringe of rocky shores in the N Atlantic. When exposed at low spring tides its smooth flexible stipe bends but does not break. This means it can withstand strong waves and currents, especially as it is not loaded with epiphytes thanks to its slippery texture. Forest Kelp (*L. hyperborea*) which often occurs in deeper water just below the Oarweed zone, has a rigid stem that would snap if tossed about on the shore.
Size Up to 2m long.

ORDER Fucales | FAMILY Fucaceae

Bladder Wrack *Fucus vesiculosus*

Features Whilst there are more than 50 species of *Fucus* found worldwide, the Bladder Wrack, found in the N Atlantic, is one of the easiest to recognise (usually). Each dichotomously branching frond has a distinct midrib with a series of mostly paired bladders either side of it. The tips of the fronds are often swollen to form oval or forked reproductive parts, dotted with conceptacles. The seaweed grows up from a small but strong disc-shaped holdfast.
Size Up to about 1m long.

ORDER Fucales | FAMILY Sargassaceae

Wireweed *Sargassum muticum*

Features Wireweed forms thick bushes of delicate string-like branches that arise alternately. A profusion of small round bladders dot the branches and these, together with oval-shaped side branches resembling little leaves, give an overall impression of a small fruiting plant. *S. muticum* is known in the UK as 'Japweed' because here and in the USA it is an alien invasive species originating from Japan and China. It grows rapidly and can spread by floating fertile branches that break off from the seaweed.
Size Up to 2m long.

ORDER Fucales | FAMILY Sargassaceae

Trumpet Weed *Turbinaria* spp.

Features Many of the seaweeds that occur on coral reefs are heavily grazed by fish and urchins, but the tough, leathery and sometimes sharp-edged fronds of Trumpet Weed survive better than most. Their robustness also means they are able to grow in shallow water on reef tops and near reef crests where wave action and currents are strong. The common name comes from the flared top and tapering shape of the frond blades. Each 'trumpet' has an air bladder embedded in it but this is not obvious.
Size Up to 40cm tall, usually shorter.

Neptune's Necklace *Hormosira banksii*

Features Rocky shore platforms in New Zealand and temperate Australia are often covered by a dense mat of this seaweed. It grows as branching chains of bead-like vesicles connected by thin stalks but is variable in form depending on local conditions. Each bead acts as a reservoir of water, which together with thick mucilage, prevents the seaweed from drying out. The damp fronds also protect many invertebrates that hide beneath it.
Size Up to 30cm long.

ORDER Dictyotales | FAMILY Dictyotaceae

Peacock's Tail *Padina pavonina*

Features The elegant fan to funnel shape of this seaweed gives rise to its common name. The fronds feel crisp due to calcium deposits which act as a deterrent to grazing animals. Concentric bands of prominent hairs on the underside probably also put grazers off. It has a wide distribution and, for example, is found on shores in southern Great Britain and Ireland and on coral reefs in the Indian Ocean. There are however, many different species of *Padina* worldwide.
Size Up to about 10cm across the frond.

ORDER Scytosiphonales | FAMILY Scytosiphonaceae

Oyster Thief *Colpomenia peregrina*

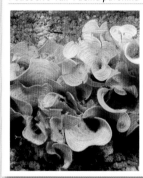

Features Whilst probably originally a Pacific species, this strange seaweed can now be found on shores and in shallow water almost worldwide including Europe, N America, Australia and Japan. It may have spread through imports of oysters and seaweeds as it lives mainly attached to other organisms, but it can also float long distances when its hollow spheres fill with air. Its reputation for floating off with oysters may be exaggerated, but it can float off with shells and stones to which it is fixed.
Size Up to about 10cm across.

MARINE PLANTS AND CHROMISTS

MARINE MICROALGAE

With one or two exceptions, seaweeds are restricted to the margins of the ocean so out in open water, the role of primary production is taken over by tiny floating 'microalgae'. Collectively known as phytoplankton, these single-celled and small colonial photosynthetic organisms form the basis for much of life in the ocean. Blurring the boundary between animals and plants, many of them are classified in the kingdom Chromista to which the brown seaweeds (Phyophyceae) also belong. Most chromists are photosynthetic but differ from true plants in using chlorophyll c (as opposed to chlorophyll a) as their main energy-capturing pigment. This is not found in true plants. Many can also engulf and feed on organic material. Other microalgae are true plants (kingdom Plantae) and are grouped along with the red seaweeds (Rhodophyta) and green seaweeds (Chlorophyta) (see p.129). Whilst the majority of microalgae are free-living some, known as zooxanthellae, live within the tissues of animals such as corals and giant clams and a few are parasitic.

The classification of microalgae has changed greatly over time and continues to do so as cellular and nuclear details become apparent. Whole groups may well be put into different phyla or even kingdoms as knowledge increases.

DISTRIBUTION

As photosynthetic or partially photosynthetic organisms, marine microalgae are mostly found as phytoplankton in the well-lit epipelagic zone (p.34) down to about 200m depth. Others live on the seabed attached to various surfaces and other organisms.

Microalgae are found as symbiotic zooxanthellae in many different organisms. Here an Upside-down Jellyfish (*Cassiopea* sp.) exposes its tentacles, with their contained algae, to the sunlight.

DIATOMS (CHROMISTA, OCHROPHYTA)

Diatoms are the largest group of microalgae, both in terms of species and numbers, with over 8,500 known species. These tiny organisms which range in size from around 15μm to 400μm form a vital part of the phytoplankton, the 'grazing pastures' of the ocean. Although invisible to the naked eye, they affect us every time we take a breath of fresh air. Together with dinoflagellates and other smaller groups of photosynthetic microalgae, they produce a significant part of the oxygen in the air we breathe. Parts of the deep ocean bed consist almost entirely of their silica-rich remains which form a blanket of 'siliceous ooze' built up over millions of years. This forms an almost continuous belt around Antarctica with its northern limit approximating the Antarctic Convergence. The nutrient-rich waters here provide ideal growing conditions for diatoms. Most diatoms live a drifting life in the plankton but some species form visible films over rocks, seaweeds or even slow-moving animals including whales.

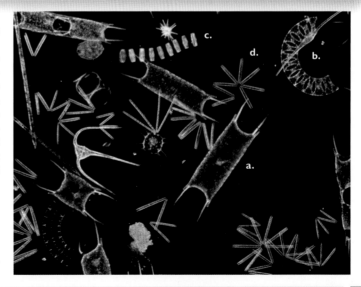

A variety of common diatoms from around the British Isles. (a) *Biddulphia*, (b) *Fragilaria*, (c) *Thalassiothrix*, (d) *Thalassiosira*.

STRUCTURE

The majority of diatoms are unicellular organisms with a single nucleus though many species form chains of loosely connected individuals which can certainly be seen with a relatively low power microscope. The largest known species is the tropical *Ethmodiscus rex* which can grow to 2mm diameter. Although varying greatly in overall shape, all diatoms are enclosed by a distinctive cell wall called the frustule. This consists of two overlapping halves or valves one of which fits in the other like an old fashioned pill box or a petri dish. The 'lid' is called the epitheca and the 'box' is the hypotheca. The frustule is composed mainly of silica (silicon dioxide) and is often ornamented with spines, knobs and perforations which make it stronger.

Shape category	Common genera
Pillbox	*Coscinodiscus, Hyalodiscus, Thalassiosira*
Rod/needle; valve division at right angles to long axis	*Rhizolenia*
Rod/needle; valve division lengthways	*Thalassiothrix, Asterionella*
Filamentous; cylindrical chains or ribbons of individuals	*Guinardia, Fragilaria*
Spiny; with long spines or projections	*Chaetoceros, Biddulphia*

Diatoms can be grouped into four broad shape categories. Whilst most diatoms live singly, there are species in each category which form chains. 'Centric' diatoms are radially symmetrical whilst 'pennate' diatoms are bilaterally symmetrical.

Many diatoms have small perforations in the frustule and strands of cytoplasm extending out through these, along with cell wall spines, help to link chain-forming diatoms together. Some benthic diatoms can glide slowly along probably through the action of these same strands.

BIOLOGY

Diatoms are primarily photosynthetic organisms and contain chlorophylls a and c and fucoxanthin, a carotenoid found in all Chromista (including brown seaweeds; see p.133). In coastal waters where there are high levels of nutrients, they are the major primary producers of the phytoplankton. The spring blooms of plankton that reduce the visibility for scuba divers in temperate regions mostly result from diatoms taking advantage of nutrient upwelling along the continental shelf. Whilst still important in other parts of the ocean, their role in silica-poor waters is taken over by other plankton including the even smaller cyanobacteria. In spite of their relatively heavy silica coating, diatoms float near the sunlit surface by generating oily substances (lipids) within the cell or by increasing their surface area with spines and by forming linked chains. By regulating their lipid content, diatoms can, like dinoflagellates, undertake vertical migrations (p.64).

Diatoms reproduce asexually by splitting into two and can increase rapidly in numbers until vast blooms colour the sea. Try working out how many diatoms can result from one cell dividing three times a day (quite usual) for ten days. However, living within a box makes division into two more difficult for the diatom cell. When it divides into two, each daughter cell receives either the 'lid' (epitheca) or 'box' (hypotheca) valve of the protective frustule. Whichever it is, this is used as the larger epitheca and a new smaller hypotheca is secreted to fit within it. It follows that one of the two daughter cells will be the same size as the original, but the other will be smaller. So over time the size of individuals within a population reduces.

In most species this is halted when a diatom is about a third of the original size at which stage it becomes capable of sexual reproduction if conditions such as light and temperature are conducive. 'Centric' diatoms divide to produce motile sperm and large immobile eggs whilst 'pennate' diatoms just produce amoeba-like gametes of the same size, and not necessarily 'male' or 'female', which fuse together to form a zygote. Either way the gametes are haploid and produced by meiosis. The protective frustule is discarded at some stage during the process and the zygote grows and produces its own new full size one. Instead of growing, zygotes can become resistant

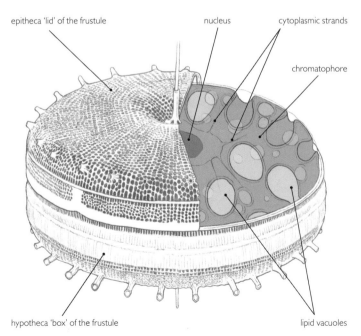

Diagram of a single pillbox-shaped diatom.

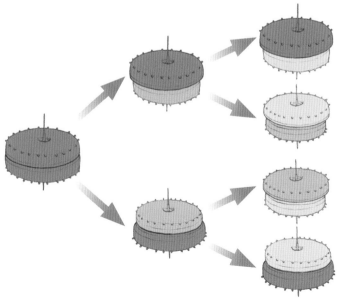

With continued asexual reproduction, the average size of diatoms reduces.

MARINE PLANTS AND CHROMISTS

auxospores better able to survive adverse conditions. In the Antarctic diatom spores can remain in darkness under and within ice during winter and then divide rapidly producing a welcome spring bloom to kick start the food chain as krill feed on them.

Whilst diatoms can form extensive blooms, very few species are toxic and so these do not usually have the same effect as dinoflagellate 'red tides'. However, blooms of *Pseudonitzchia* are an important exception. This genus produces domoic acid which can have adverse neurological effects on people as well as marine mammals and birds. Mass mortalities of sealions and seabirds along the northern Californian coast have been attributed to this. Like many other toxins, domoic acid can accumulate along the food chain and krill grazing on these diatoms can pass their load on to baleen whales and the Crabeater Seal (*Lobodon carcinophaga*), a specialist Antarctic krill feeder.

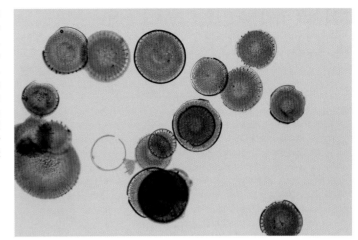

Thick seabed deposits of the remains of diatoms such as this centric species are now found exposed on land as sedimentary rocks. These are mined for 'diatomaceous earth', a powder with a wide variety of uses including the mild abrasive in toothpaste.

GOLDEN-BROWN ALGAE (CHROMISTA, OCHROPHYTA)

Golden-brown algae are a family (Chrysophyceae) of at least 500 microscopic algae that are found both in the ocean and more particularly in freshwater. Their golden colour comes from photosynthetic pigments which include fucoxanthin, also found in the related brown seaweeds (Phaeophyceae). As is the case with many other families of microalgae, there are species that are included or excluded from this family by different authorities and the status quo changes frequently as more research is done. They are included here as a family (Chrysophyceae) within the phylum Ochrophyta, but have also been classified as a chromist order Chrysophyta. As there are many more freshwater species than there are marine species, plankton samples from freshwater would be a good starting point for those interested in searching for them.

STRUCTURE

Golden-brown algae are highly variable in form and apart from their characteristic golden or yellow-brown colour (itself not always very evident) are difficult to recognise. In any case a high power microscope is needed to see them as in size they are classed as nanoplankton (2–20μm) (p.50). Some species live as zooxanthellae within other chromists such as radiolarians.

Uroglena and *Synura* are examples of colonial genera. *Uroglena marina* lives in brackish water as free-swimming ball-like colonies up to 3mm in diameter. The cells are arranged within a gelatinous matrix permeated by threads to which the cells are attached. The colonies are easily disrupted and only found in quiet water.

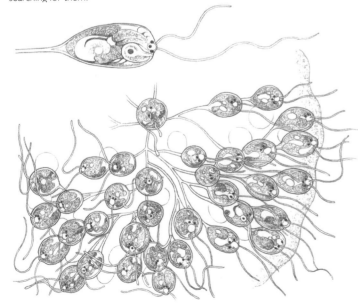

Uroglena sp.

Golden-brown algae colouring a rocky shore pool in Sardinia, Italy.

DINOFLAGELLATES (CHROMISTA, MYZOZOA, DINOFLAGELLATA)

Whilst individually are invisible without a reasonably powerful microscope, blooms of dinoflagellates can result in some highly visible phenomena. Splash along the water's edge on a warm, still night especially in the tropics and you may set off a sparkling phosphorescent display. The performer is *Noctiluca scintillans*, a species that lights up when disturbed, giving away the position of submarines as they surface and providing entertainment to scuba divers. However, dinoflagellates are most commonly seen as 'red tides', potentially harmful blooms of toxic species described below. Whilst primarily found as plankton in coastal (neritic) and oceanic water, some dinoflagellates are benthic and can be found as meiofauna (p.90) living in the water between sand grains. Species of *Symbiodinium* are the prevalent microalgae found living symbiotically in the tissues of corals and other invertebrates. Dinoflagellates are the second largest group of microalgae in the ocean and some are also found in brackish estuaries and in freshwater.

A thecate dinoflagellate *Ceratium longipes*. There are about 80 species of *Ceratium* recognised by the elegant extensions of their cell wall.

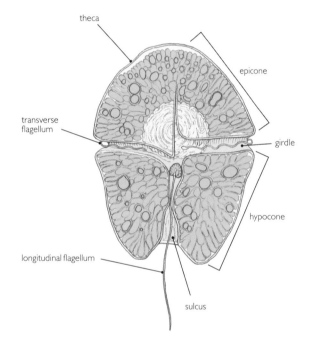

Gymnodinium sanguineum is a simple naked or non-thecate dinoflagellate.

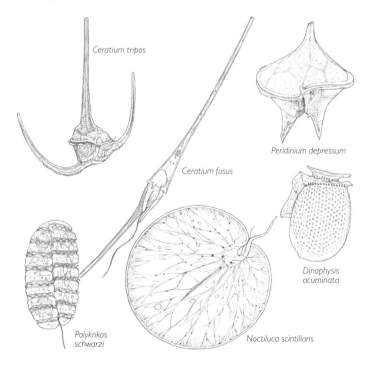

STRUCTURE

Dinoflagellates are single-celled organisms that have a wide range of beautiful shapes but all with the same basic design. They have two flagella with a characteristic arrangement whereby one encircles the cell in an equatorial groove (transverse flagellum) whilst the other trails behind emerging from a longitudinal groove called the sulcus. This arises just behind the origin of the transverse flagellum. The latter acts more like a ribbon whose outer edge undulates whilst the longitudinal flagellum can move to and fro. The result is a reasonably efficient spinning motion (*dinein* is

A variety of N. Atlantic dinoflagellates. In those with a cellulose cell wall the design can be modified by extensions forming spines and other structures that provide buoyancy.

MARINE PLANTS AND CHROMISTS

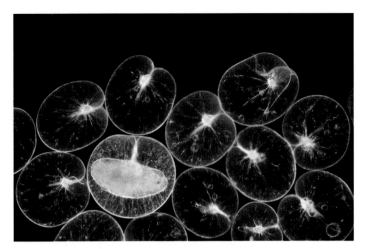

The 'phosphorescent' trail left by a moving boat or diver at night is often caused by bioluminescent light from *Noctiluca scintillans*, a non-thecate dinoflagellate which at up to 2mm is exceptionally large. The bioluminescence is set off when the cell membrane is deformed by moving water or the approach of a predator.

Whilst commonly the cause of 'red tides', dinoflagellates are not the only culprits as some other microalgae also produce toxins. Such blooms are therefore often referred to as HABs or Harmful Algal Blooms, or Toxic Algal Blooms.

Greek for 'to whirl') sufficient to propel these tiny microalgae at least 30m up and down during vertical migrations (see below). So-called 'naked' dinoflagellates are held together only by a thin cell membrane (pellicle) but armoured dinoflagellates have a series of overlapping cellulose plates beneath the membrane, called the theca. This is often drawn out into spines and projections which provide buoyancy for these 'heavier' species. The shape and ornamentation of the theca is important in species identification. Whilst still unicellular, some genera such as *Polykrikos* have several nuclei and the cell looks like a miniature block of flats with (usually) eight sets of flagella. Some species form chains of individuals after dividing.

BIOLOGY

Dinoflagellates as a group are important producers but not all species have the capacity to photosynthesise. Some of the naked species are heterotrophic, that is they eat other organisms mainly bacteria, diatoms and other microalgae including other dinoflagellates. *Protoperidinium* species (of which there are many) engulf their prey by extending a sheet of cytoplasm (called the pallium) around it, digesting it externally and absorbing the resulting soup. Even more surprisingly the prey is first caught by 'fishing' with a long cytoplasmic filament. Many dinoflagellates can both photosynthesise and capture prey, rather like carnivorous plants do on land. Photosynthetic dinoflagellates remain near the surface during the day to maximise their light exposure. With the onset of dusk they sink down to deeper levels where more nutrients are generally available. In areas of upwelling this is not necessary.

Red tides

As dinoflagellates reproduce asexually simply by dividing into two (binary fission), they can increase in numbers very rapidly if conditions are right and this can lead to 'red tides'. Calm sunny conditions and an excess of nutrients provide such conditions, and blooms commonly occur in the vicinity of sewage, or other nutrient-rich discharges and land runoff, but also result from natural enrichment. Whilst red and red-brown blooms are common, yellow or green ones also occur, resulting from variously pigmented species. In some bloom-forming species, toxins within the algae are released as they die or are eaten and can cause large fish kills. 'Red tides' can cause huge problems for fish farms, especially in sheltered sea lochs and fjords. They can also kill algae and invertebrates. Shellfish such as mussels and oysters on the other hand are not generally affected but accumulate toxins as they filter the microalgae from the water. This is one of the causes of paralytic shellfish poisoning in people, which can be very unpleasant and occasionally fatal. The huge mass of dead material following a bloom can also cause oxygen deficiencies when it sinks down to the seabed and decays along with any animals that have been killed.

Sexual reproduction is known to occur in some species and usually involves two haploid individuals fusing together. The resulting diploid zygote often forms a resting 'dinocyst' which can survive inactive on the seabed for months or even years. Dinoflagellates are scarce in winter in cold temperate regions and many species probably spend this time as cysts. Some natural blooms may be caused when storms stir up the seabed stimulating growth of resting cysts. As it becomes active again the dinocyst divides by meiosis so that the resulting individuals are haploid again.

Species	Toxin	Examples
Alexandrium tamarense	Saxitoxin (a neurotoxin)	Humpback Whales died in Cape Cod Bay, USA, from toxins in food chain (1987)
Gonyaulax catenella	Saxitoxin (a neurotoxin)	Frequent occurrences of paralytic shellfish poisoning along Pacific coast N. America
Dinophysis and *Prorocentrum* spp.	Toxin ocadaic acid; diarrhetic shellfish poisoning	Europe and Japan
Karenia brevisulcata	Brevetoxin (a neurotoxin)	Toxic bloom in Wellington Harbour New Zealand killed wide variety of organisms (1998)
Karenia brevis	Brevetoxin (a neurotoxin); shellfish poisoning; respiratory problems from wind blown (aerosol) toxic material	Florida (USA) and Gulf of Mexico

Examples of dinoflagellates capable of causing serious red tides.

FORAMINIFERANS AND RADIOLARIANS (CHROMISTA)

Imagine fine sand grains shaped into beautiful spirals, stars, helmets and any number of other intricate shapes and you will have an idea of the size and form of foraminiferans. These tiny, single-celled marine organisms resemble an amoeba with a shell and are amongst the most abundant of all marine creatures. Their dead shells or tests are so numerous they form thick seabed deposits called globigerina ooze over most of the deep Atlantic and much of the Indian and Pacific Oceans. Fossil species are found in marine sedimentary rocks and even lying loose in large deposits. Living species are mostly benthic, living on and in the seabed, from the seashore right down to the deepest depths. A certain amount of patience is needed to find them but a search through fine, damp beach sand under a microscope or powerful hand lens is usually rewarding. Another productive source is to collect coralline algae, wash them with seawater and search through whatever comes out, or simply look at the algae under a microscope.

There is still no complete agreement on the higher classification of foraminiferans and radiolarians. They are both included here as phyla (Foraminifera and Radiozoa) in the kingdom Chromista and infrakingdom Rhizaria, but Rhizaria is sometimes given kingdom status. Although still referred to as 'protists' they are no longer included with the Protozoa (see p.172). Protist is a useful term for eukaryote organisms that are not plants, animals or fungi.

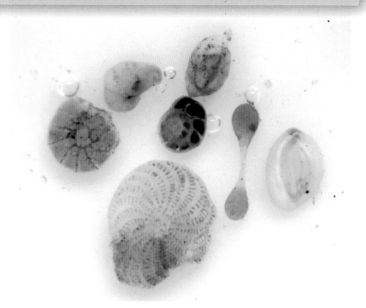

These foraminiferan shells were relatively easily extracted from shell sand in Carnsew pool in the Hayle Estuary, Cornwall, UK.

STRUCTURE

Almost all foraminiferans have a protective shell called a test, which in most species is made from calcium carbonate deposited within an organic matrix. However, deepsea species, living below the carbonate compensation depth where there is effectively no calcite available, use other minerals or have an entirely organic test because calcium carbonate dissolves in water at high pressures. Some species make an external home by sticking grains of sediment together with an organic cement, quite a feat for a single-celled organism. Shell design can be intricate with connected chambers resembling tiny sea shells. The test is riddled with small holes (foramens) out of which the cell extends strands of cytoplasm called pseudopods or pseudopodia. These anastomose (merge), form and reform as a moving net so that the test is barely visible in active, living cells. The cytoplasm itself is characteristically granular and as well as a nucleus (or sometimes many nuclei), may also contain smaller symbiotic algae since foraminifera form associations with a wide range of organisms including dinoflagellates, and red, green and golden-brown algae.

BIOLOGY

Foraminifera, of which there are many thousand species, obtain food by a wide variety of means but in general the pseudopodia flow around and engulf static items such as diatoms and bacteria. Foraminifera living on hard surfaces can spread out a wide net to trap food some distance away, rather like a spider in its web. Some of the larger species are truly predatory and can temporarily strengthen their pseudopodia with extracellular material. This allows them to hold onto copepods and invertebrate larvae. Food intake can be supplemented by direct absorption of dissolved organic matter (DOM) and by food produced by symbiotic algae. The pseudopodial strands also act as 'legs' and 'arms' to move foraminiferan along or anchor it in place and help to build the test.

When it comes to reproduction and life cycle, foraminiferans are very inventive but like many macroscopic algae, most have two alternative generations of haploid 'adults' (gamont) and diploid 'adults' (agamont) which may look similar or dissimilar. The haploid phase releases simple flagellated gametes into the water and when two of these meet they fuse to form a zygote. This grows into the diploid agamont 'adult', which in turn eventually divides by meiosis and produces haploid young through multiple fission.

RADIOLARIA

Radiolarians are essentially the planktonic equivalent of foraminiferans in that they too are single-celled 'protists' but with internal skeletons made from silica. The largest class (Polycystina) are roughly spherical or cone-shaped and many have radiating spines or spicules, hence their name. The structure of the skeleton and the cytoplasm are amazingly complex for a single-celled organism. Radiolarians fossilise well and form thick ooze deposits on the seabed in parts of the tropical Pacific and Indian Oceans.

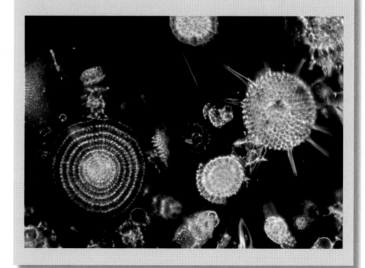

PRYMNESIOPHYTES (CHROMISTA, HAPTOPHYTA)

The prymnesiophytes are generally known as coccolithophores or coccolithophorids, at least to older generations of marine biologists. These unicellular photosynthetic organisms form a very important part of the phytoplankton in spite of their minute size – most are less than 100μm in diameter. Whilst they are generally only seen alive by plankton specialists, they regularly occur in such large numbers that they can colour the water. Herring fishermen used to call this 'white water' and considered it an indication of productive fishing. Seen from the surface such blooms appear milky blue or bright blue in colour, a result of light reflection from the white calcareous plates which adorn the majority of them.

STRUCTURE

Most prymesiophytes are spherical and have an external covering of tiny protective plates called coccoliths made from calcium carbonate. These plates have a finely elaborate sculpture which helps to identify the different species. Coccoliths survive well and make up a significant part of the calcareous 'globigerina' ooze covering parts of the deep ocean floor especially in the tropics. Closer to home, anyone who has walked over the White Cliffs of Dover in southern England has walked on fossilised coccoliths, which are the major constituent of the chalk in this region.

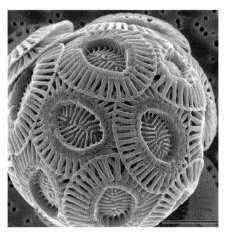

Emiliania huxleyi is one of the best known and abundant of the coccolithophores and forms massive blooms in most years in temperate waters, especially around the coasts of northern Europe and Scandinavia.

In spite of its tiny size *Emiliania huxleyi* can be seen from space when it divides rapidly and produces characteristic blooms that turn the ocean a milky white colour due to the reflective properties of their coccoliths.

that have much lighter non-calcified scales and swim using their flagella. These essentially act as gametes. Prymnesiophytes play an important but complex role in the global carbon cycle and may even have an effect on climate. When constructing their calcium carbonate coccolith plates they release CO_2 but they also fix CO_2 during photosynthesis and sequester it to the seabed when they die.

Contained inside the single cell of a prymesiophyte are two (sometimes one) plastids which manufacture and contain photosynthetic pigments (the chloroplasts found in plants are a type of plastid). Each cell also has two (usually) flagella and close by, a unique flagellum-like structure called a haptonema (hence the name of the class Haptophyta). This is implicated in nutrition and may gather minute food particles that are later engulfed by the cell.

Phaeocystis is a well-known prymesiophyte in which the individuals cluster together and form a floating colony, enclosed within a thick coating of polysaccharide mucilage. Massive blooms of species such as *Phaeocystis globosa* can form under certain climatic and nutrient conditions, which gives the water a slimy consistency, thick enough to clog up aquaculture nets. Fish avoid such blooms if possible, but can be killed if trapped in the vicinity.

BIOLOGY

Many prymesiophytes have a complex life cycle and alternate between normal, diploid individuals with calcified coccoliths and a motile haploid stage with individuals

The mysterious summer foam that appears on some beaches is also the result of prymesiophyte blooms as the individuals secrete a precursor of the gas DMS (dimethyl sulphide). As the bloom dies off, it leaves behind an unpleasant, sulphurous smell.

MICRO-PLANTS (PLANTAE)

Whilst all the major phytoplankton groups discussed above can be grouped together as chromists, there are also microalgae that are true plants (kingdom Plantae). So within the phylum (division) Chlorophyta as well as green macroalgae or seaweeds there are at least seven classes of green microalgae. Two classes, Prasinophyceae and Chlorodendrophyceae, are predominantly found in the ocean whilst the others live mainly in freshwater. Like other microalgae, these micro-plants can only be seen and appreciated with a microscope but whilst normally invisible they can form clearly visible blooms under certain conditions. This will be familiar to anyone with a small pond where the water can suddenly turn a soupy green. The relatively few unicellular red algae known belong to the family Bangiophycidae which also has many macroalgae.

STRUCTURE AND BIOLOGY

Most green microalgae are single-celled, motile flagellates but there are also non-motile forms (which may have a motile phase) and colonial forms. Their morphology, even within a single class, is highly varied and their classification is constantly being updated as further species are subjected to analysis of their genomic material. Two of the better known genera that a naturalist might come across are described below.

Halosphaera (Prasinophyceae) is a common, green microalga that is easily collected with a plankton net as it accumulates near the surface, especially in calm weather. Reaching nearly 1mm in diameter, it is one of the largest species of unicellular green algae. A mature individual resembles a tiny sphere which is a single cell with a nucleus, cytoplasm and numerous chloroplasts. At a certain stage, possibly related to the lunar cycle, the nucleus divides and forms many tiny individuals called swarmers, each equipped with four flagella at the front end. These are released as the original cell disintegrates. Each swarmer can itself divide asexually before losing its flagella and developing into a non-motile individual.

Tetraselmis (Chlorodendrophyceae) is a minute (5–25µm) species that would certainly not normally be apparent if it were not for one species, *Tetraselmis convolutae* which lives symbiotically within a common acoelomate flatworm *Symsagittifera roscoffensis* (p.227), colouring it bright green. Each individual is elliptical or almost spherical with a single chloroplast that takes up most of the cell and an eyespot sensitive to light. Many species swim freely in the plankton using flagella

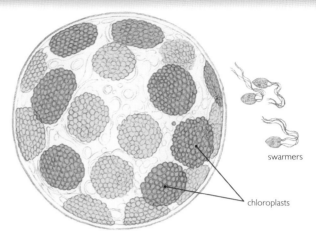

Halosphaera minor. Mature (left), motile phase (right).

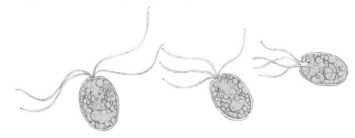

Tetraselmis cordiformis.

(usually four), whilst others can be found on and within sediment. Some can form resting cysts or stages with no flagella. Various species (mostly freshwater) are cultured as food for microanimals such as rotifers (p.180), in turn fed to larger aquarium and experimental animals.

The flatworm *Symsagittifera roscoffensis* packed with *Tetraselmis* can colour sand with green patches. The flatworms benefit from the photosynthetic products produced by the *Tetraselmis*.

MARINE FLOWERING PLANTS

Flowering plants, with their wonderful range of colourful and pollen-laden blooms, are part and parcel of life on land and in the margins of freshwater. However, very few can tolerate any exposure to salt water let alone permanent immersion. Seagrasses are an exception and grow totally submerged in shallow marine environments. Mangroves live up to their waists in salt water whilst saltmarsh plants tolerate temporary or partial immersion during high tides. Seagrass beds, mangrove forests and saltmarshes are all important marine or semi-marine ecosystems and these are covered in the section on Environments and Ecosystems (p.40).

STRUCTURE

Flowering plants, classically known as angiosperms but in recent texts generally classified in a phylum (division) called Magnoliophyta, are a highly diverse group that includes trees, shrubs, 'flowers' and grasses. Their classification is constantly changing as the relationship between species becomes clearer through DNA sequencing and other modern techniques. Their main defining characteristic is, not surprisingly, that they have flowers, sometimes showy ones but also often tiny and inconspicuous depending on which agent is employed for pollen dispersal. Pollen produced in male stamens or anthers is deposited on the female carpel or stigma from where it can grow and fertilise female ovules. Fertilised ovules develop into seeds held within fruits which themselves can be dry, fleshy, hard and almost any size and shape you can imagine. Marine flowering plants, including fully submerged seagrasses, produce flowers and seed-laden fruits just as their land counterparts do and they similarly have a proper root system, stems and leaves.

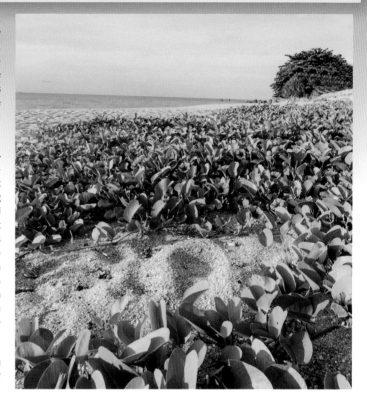

Beach Morning Glory (*Ipmoea pes-caprae*) has salt-tolerant seeds dispersed by ocean currents but cannot survive submersion. It is found on sandy beaches in the tropical Atlantic, Pacific and Indian Oceans.

SEAGRASSES

A summer walk through a meadow of knee-high grasses and flowers is a must for anyone with an interest in plants but swimming over an underwater meadow of seagrass dappled with sunlight can also be a magical experience. Seagrasses form a rich and varied habitat that supports a wide variety of marine organisms, and the ecology of seagrass beds is described in more detail in the section on Environments and Ecosystems (p.101), whilst the plants themselves are described here.

Seagrasses are all monocotyledons, a technical grouping of flowering plants in which the seedlings have only one (rather than two) initial seed-leaves (cotyledons) and which includes true grasses, bamboos and palms. However, seagrasses are not all closely related and are not true grasses. They are united by the fact that they are able to grow fully submerged in marine or estuarine conditions and to this end have evolved a similar morphology to cope with an environment not normally suitable for flowering plants. Some live on the seashore anchored in sand and sandy mud, and can be seen at low tides by walking along sheltered estuaries, harbours and bays. Most seagrasses live completely submerged forming underwater meadows. They are best appreciated by snorkelling or diving.

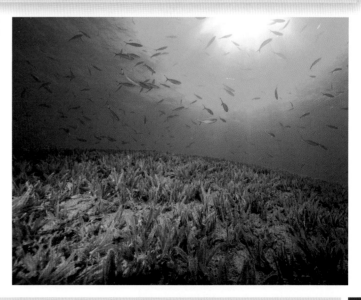

Seagrass beds grow well in the shallow sunlit waters of the tropics, but are also found in temperate regions of the world.

DISTRIBUTION

Seagrasses are found around all the world's continents except Antarctica and grow well in both temperate and tropical waters. Global biodiversity is centred in the area around the Philippines, Papua New Guinea and Indonesia. They grow in soft sediments of sand and mud but a few can also grow on hard surfaces such as old coral rock. Seagrasses have a high light requirement, much more so than most seaweeds, and so they are almost entirely restricted to shallow water. Some species are tolerant of lower salinities and are found in estuaries and tidal lagoons.

STRUCTURE

The majority of seagrasses are relatively easy to recognise as such as they have flattened, elongated, strap-like leaves and really do look superficially like true grasses. However, there are a number of exceptions including the two species of *Syringodium* found in the Indo-Pacific (*Syringodium isoetifolium*) and the Caribbean and Gulf of Mexico (*S. filiforme*), both of which have long leaves which are round in cross-section, rather like those of many freshwater rushes. *Halophila* species are unlike all other seagrass genera and have delicate round, oval or elliptical, stalked leaves with a central vein and side veins much like a miniature tree leaf.

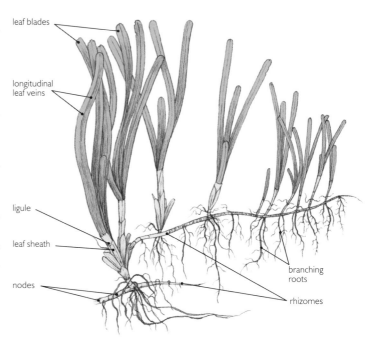

Cymodocea is a typical strap-like seagrass with stems and leaves arising at intervals from a creeping rhizome.

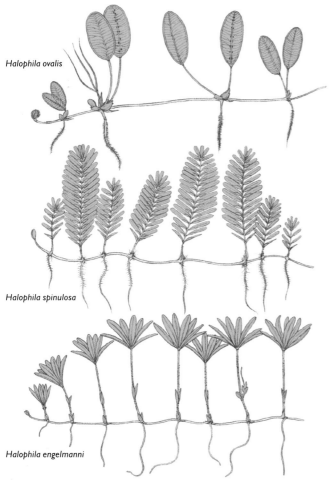

The plants are anchored in the sediment by an extensive root system and spread horizontally by means of long rhizomes, essentially horizontal stems. The roots and rhizomes together help to bind the sediment and anchor the plants firmly so that they can resist water movement. This has similarities with the way Marram Grass (*Ammophila*) binds and spreads through sand dunes (p.72). Vertical stems bearing leaves grow up from the rhizomes, but in *Zostera* leaves arise directly from the horizontal rhizomes, a type of leaf called a prophyllum.

Genus	Number of marine species	General distribution
Enhalus	1	Indo Pacific
Halophila	16 (14)	Tropical and warm temperate
Thalassia	2	Indo Pacific, Gulf of Mexico, Caribbean
Amphibolis	2	South Australia
Cymodocea	4	Indo Pacific, Mediterranean
Halodule	6	Indo Pacific, tropical Atlantic
Syringodium	2	Gulf of Mexico, Caribbean, Indo Pacific
Thalassodendron	2	Indo Pacific, south-west Australia
Posidonia	7 (8)	South Australia, Mediterranean
Zostera	15 (9)	Atlantic, Pacific, Indian Oceans, Mediterranean
Phyllospadix	5	North-east and north-west Pacific
Ruppia	4	Insufficient data

Leaf arrangements in *Halophila*: *H. ovalis* paired leaves on long petioles; *H. spinulosa* two vertical opposing rows on upright stems (distichous); *H. engelmanni* clusters (pseudo-whorls) on the ends of lateral shoots.

Seagrass genera and species from Guiry and Guiry (2014) and from Green and Short (2003) in brackets.

BIOLOGY

Life history

Most seagrasses have separate male and female plants (dioecious) though some genera such as *Zostera*, carry male and female flowers alternately on the same flower spike. In contrast, Neptune's Weed *Posidonia oceanica* and other species in this genus have hermaphrodite flowers with three stamens and a disc-shaped stigma. On land the two major convectors of pollen are insects and wind, neither of which is available to submerged seagrasses. Instead, pollen is carried by currents and waves, a system known as hydrophilous pollination. In some species the pollen floats up to the surface and is carried along to pollinate the female flowers but in many species, including *Zostera marina* and *Posidonia australis*, pollination occurs below the water surface. Some freshwater plants in rivers and streams also use water flow to distribute their pollen. Rather than being round, as the pollen grains in most flowering plants are, seagrass pollen is elongate, a shape which helps water dispersal. Some species do have round pollen but the grains stay together in chains.

As in other flowering plants, fruits and seeds form after fertilisation and are hugely varied in size and shape between the different genera. Delicate *Halophila* species produce seeds less than 0.5mm long whilst those of *Enhalus* are up to 2cm long in fruits large enough (and apparently tasty enough) to be eaten by islanders in the Indo-Pacific region and South Pacific.

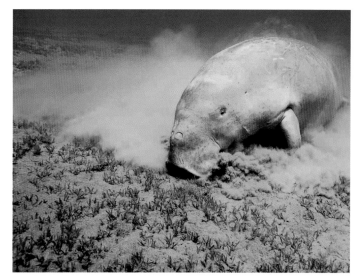

Dugong (*Dugong dugon*) feeding on seagrass in the Red Sea.

Whilst some seagrass seeds float and are dispersed by currents, others sink but can still be pushed tens of metres along the seabed by waves and currents. Broken off but intact flowering shoots can survive for weeks and carry seed to distant places. Animal vectors including fish, turtles and seabirds may also play an important role in seed dispersal. New laboratory research has shown that seeds of *Zostera marina* can survive passage through the guts of various animals that feed in seagrass beds and still germinate successfully (Sumoski and Orth 2012).

Seagrasses can disperse and spread further afield when detached shoots or even whole plants drift away and later re-establish themselves. Dugongs and turtles probably help as they tear up mouthfuls to eat. There is now evidence that at least one seagrass *Posidonia oceanica* can also reproduce asexually by forming plantlets within the flower head as well as producing normal fruits and seeds (Ballesteros et al. 2005). This is called pseudoviviparity where asexually produced plantlets, bulbils or similar structures replace sexual reproductive structures in the flowers.

Ecology

Seagrasses are a vital food resource for tropical Dugongs (*Dugong dugon*) which root out and eat the plants including roots and rhizomes as well as leaves. The species eaten is wide and depends on what is available but smaller, more nutritious species such as *Halophila* and *Halodule* are preferred where there is a choice. Coastal manatees will also eat seagrasses but are not nearly as dependent on them. Turtles graze on seagrass especially Green Turtles (*Chelonia mydas*) which are the only species of sea turtle that is strictly herbivorous when adult. A wide variety of fish, birds and invertebrates include seagrass in their diet (live, decaying or dead) but it is as a habitat and ecosystem that seagrass comes into its own. Seagrass beds (p.101) provide a home for a wide range of fish and invertebrates, and a foothold for epiphytic algae and sessile animals such as hydroids. They are also extremely important to people in terms of fisheries, coastal protection and other roles (see below).

Most seagrasses only thrive in full-strength seawater but some are adapted to the lower salinities found in estuaries and mangrove swamps. In contrast, intertidal species are subject to higher than normal salinities through evaporation when the tide is out. Of the two species of *Zostera* (eelgrass) found in the UK, *Zostera noltii* is smaller with thinner leaves and usually grows intertidally whilst the larger-leaved *Z. marina* is almost entirely sublittoral.

The flowers of *Enhalus* float at the surface on long stalks (peduncles), which retract and coil after fertilisation, pulling the young fruit (inset, right) underwater and into the shelter of the seagrass canopy. The mature fruit (inset, left) is up to 6cm long and covered in soft spines.

USES, THREATS, STATUS AND MANAGEMENT

Seagrass beds worldwide are vitally important, productive ecosystems and indirectly support millions of coastal people through various fisheries. This extends beyond the seagrass beds themselves and into adjacent ecosystems such as coral reefs which benefit from nutrient export. Their ability to bind sediments makes them important in protecting coasts from erosion and the effects of storms and even tsunamis. Currently their importance in ameliorating climate change by locking up carbon is being increasingly recognised. However, seagrass itself now has few large-scale direct uses. It has been (and still is in some areas) used to make bedding for animals, to stuff mattresses, for thatch, mat and basket weaving and as a fertiliser and mulch.

Seagrasses face many threats, both man-made and natural, and seagrass beds around the world are declining in both extent and condition. Seagrass losses accelerated through the latter half of the 20th century and in the single decade between the mid 1980s to the mid 1990s estimates suggest losses of around 12,000 km² worldwide (Short and Wyllie-Echeverria 2000). However, of the 60 or so seagrass species only two *Phyllospadix japonicus* and *Zostera chilensis* are listed as Threatened in the IUCN Red List of threatened species. Both these seagrasses have a very limited range which makes them especially vulnerable and potentially open to extinction.

The most obvious threats to seagrasses are direct destruction by human activities and from natural storms, but indirect human impacts are more widespread and difficult to quantify and control. Anything that drastically reduces seagrass photosynthesis, especially in the long term, is likely to degrade seagrass ecosystems. This includes increased sediment loads resulting in high turbidity and therefore lower light levels and increased nutrients from sources such as sewage, resulting in overgrowth by epiphytic algae and sessile animals. Natural threats include diseases of which the eelgrass (*Zostera*) wasting disease, caused by the slime mould *Labyrinthula zosterae* is one of the best known. In the 1930s this destroyed large swathes of seagrass in the North Atlantic and it remains a threat today.

One of the most effective and practical ways of protecting seagrasses is the inclusion of important beds in effectively managed Marine Protected Areas. The same applies to other species such as corals and kelp that provide the structural framework of an ecosystem. However, it is also important to control anthropogenic effects such as nutrient runoff originating outside such areas.

Mechanical damage and loss from direct effects	Indirect effects
Dredging for development of ports and harbours and shipping channels	Increased sediment loads from river inputs e.g. after logging
Boat damage from anchors and propellers	Nutrient-rich overland runoff from farmland
Aquaculture pond construction	Sewage input
	Toxins from any of the above
	Hydrological changes resulting from sea defences and coastal development

Examples of widespread human threats to seagrass beds.

Seagrass beds can be unwittingly damaged by boat anchors which can lift and undermine the matted base. In Studland Bay, Dorset, UK this is a potential problem as the area is popular with yachts and the seagrass beds are important for the only two seahorse species native to the UK.

SEAGRASS SPECIES: ORDER ALISMATALES

There are about 12 genera and 60 species of seagrasses but the actual number is debatable because some possible candidates live only on the margins of the sea and do not always have all the physical attributes of true seagrasses. Some species of *Ruppia* are accepted as seagrasses because they commonly occur in fully marine water, but *Ruppia* is predominantly a freshwater genus.

Halodule uninervis

FAMILY Cymodoceaceae

Features This is one of only three seagrasses able to tolerate the often high temperatures and salinities found in the Arabian Gulf. It is the only grass-shaped species found in the Gulf (the other two are broad leaf-shaped *Halophila* species) and so is easy to identify there. However, it also has a wide distribution throughout the Indo Pacific region growing in sand and mud and is frequently found in mangrove areas. Each leaf has a well-defined midrib flanked by marginal veins.

Size Leaves up to 15cm long and 0.5cm wide.

Paddle Weed *Halophila ovalis*

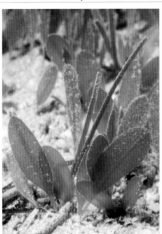

Features The delicate plants of this most ungrass-like of seagrasses grow in calm, warm waters throughout the Indo Pacific region including the Arabian Gulf and the Red Sea. Pairs of oval, veined leaves on long stalks arise from 2mm wide creeping rhizomes with a single root at each node. Whilst usually found in fine sand it can also grow amongst coarse coral rubble. In the Gulf it is eaten with relish by Dugongs.

Size Leaves usually 1–2cm long but up to 7cm.

FAMILY Hydrocharitaceae

Tropical Seagrass *Enhalus acoroides*

Features Found in the Indo Pacific, this is one of the largest and most robust of the seagrasses. It usually grows in scattered clumps and patches that grow up from deeply buried rhizomes in shallow water down to about 4m depth. The leaf bunches are sheathed by the fibrous remains of old decayed leaves and the roots are thick, fleshy and unbranched. It has flowers that extend above the water surface and a large, edible fruit (see photograph on p.159).

Size Leaves up to 2m long and 2cm wide.

FAMILY Hydrocharitaceae

Halophila stipulacea

Features This elegant seagrass is found in the Indian Ocean from the Red Sea and Arabian Gulf to the coast of east Africa and Madagascar. Its introduction into the Mediterranean was probably via the Suez canal. Recent finds in the West Indies (Granada, Dominica and St Lucia) are thought to be accidental introductions. This resilient species is both fast-growing and seeds copiously, giving it the potential to become an invasive species. It can also cope well with physical disturbance and a range of salinities. However, in the Arabian Gulf large areas have been lost to land reclamation.

Size Leaves up to 6cm long and 0.8cm wide.

FAMILY Hydrocharitaceae

Neptune Grass *Posidonia oceanica*

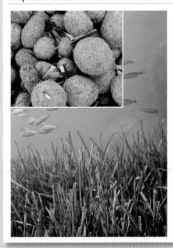

Features If you swim in the Mediterranean, then this is the seagrass you are most likely to see. Endemic to the region, it forms extensive beds and is the most abundant of the four seagrasses found here. Individual plants can live for at least 30 years and the slow-growing rhizomes form thick mats. Meadows of this seagrass are stable over hundreds or even thousands of years, but are declining with pollution and physical damage. Leaves occur in tufts of 6–7 and the (rarely produced) olive-like fruits float. Cast up, palm-sized fibrous balls (inset) are formed from the plants remains by water movements.

Size Leaves up to 1.5m long.

FAMILY Pocidoniaceae

Thalassia hemiprichii

Features This relatively short-bladed seagrass has distinctively curved, almost sickle-shaped leaves, 2–6 per joint. It can cover extensive areas of sand but does not form very dense beds. It is often found growing in mixed beds between taller clumps of *Enhalus*. It is a widespread species around coasts in the Indo Pacific including the Red Sea.

Size Leaves usually up to 40cm long but occasionally more.

Eelgrass *Zostera marina*

Features Eelgrass is widespread throughout the northern hemisphere, especially around northern European coasts, and is the only seagrass found around Iceland. Excluding the Mediterranean, only one other seagrass *Z. noltii* is found in the NE Atlantic. In Europe a wasting disease in the 1930s destroyed many beds with a concurrent decline in Brent Geese which feed on it. The leaves grow at the ends of horizontal rhizomes in bunches of 3–7. Each square metre of seagrass produces thousands of tiny seeds.

Size Leaves usually 30–60cm but up to 1.5m long.

FAMILY Zosteraceae

MANGROVES

Whilst the trees in a forest or woodland will usually survive temporary flooding from freshwater rivers and lakes, they would soon die if inundated with seawater. Yet there are forests that thrive along ocean edges with trees rooted into sediments that are covered by saltwater at every rising tide. Mangrove forests constitute a relatively small group of trees, shrubs, a few ferns and a palm that can tolerate partial immersion in salt water and are normally found nowhere else. They belong to a variety of families that are not necessarily closely related. Most are in families of familiar land plants such as the mahogany family (Meliaceae) whilst a few such as *Sonneratia* (Sonneratiaceae) have their own family or subfamily. So a mangrove is an ecological grouping rather than a taxonomic one. Spalding *et al.* (2010) describe 65 full mangrove species and a number of hybrids, all of which are structurally and physiologically adapted to survive and thrive in varying salinities. Mangrove forests and the animals associated with them are described in Environments and Ecosystems (p.77) whilst the plants themselves are covered here.

DISTRIBUTION

Mangroves are essentially tropical plants, but some species extend into warm temperate areas (see map on p.77). They are broadly divided into Indo Pacific and Atlantic/East Pacific species, with by far the greatest diversity in the former, centred in SE Asia (Indonesia, Malaysia and Papua New Guinea). Mangroves can be found fringing sheltered coastal bays and channels with no associated freshwater inlet, but the majority occur in river estuaries and deltas where river flows dilute the saltwater. The soils they live in range from shallow sandy sediment to soft mud and peat-like deposits. Whilst scattered individual mangrove trees are often found in marginal conditions, most mangroves occur in monospecific or mixed mangrove forests.

Whilst mangrove forests can cover immense areas (see photograph on p.80), small stands and single trees are found along many tropical coastlines such as this one in Madagascar.

The long held belief that mangroves can actively store excess salt in 'sacrificial' leaves which are then dropped is not well supported by scientific evidence. In one study, analysis of leaves in *Rhizophora mangle* showed that old yellow leaves ready to drop contained no more salt than healthy young green ones (Gray *et al.* 2010).

STRUCTURE AND PHYSIOLOGY

As essentially land plants, mangroves must cope first and foremost with the physiological problems of living rooted in waterlogged, anaerobic soil regularly inundated with brackish and salt water. In addition, unlike a stable structured soil on land, soft coastal sediments are moved and sculpted by tidal flows and provide poor stability. Marginal mangrove plants living furthest inland and exposed to the lowest salinities may cope simply through having a slightly higher tolerance to salt than usual. Terrestrial plants growing along major highways where salt is regularly spread to keep the road clear of snow and ice also have this ability. However, the 38 or so mangrove species that predominate in most mangrove forests need more than this and have mechanisms that exclude salt and actively excrete at least some of what does get into the internal tissues. Water and contained solutes are drawn into the roots and up through the stems and leaves. This happens because the leaves lose water through evaporation via small holes called stomata, a process known as transpiration. More water is effectively siphoned up to replace that lost. Once within the mangrove roots, the dissolved salt in the water is kept out of the inner xylem (the water transport system) by the cells which form a protective endoderm (the tissue that lies beneath the surface layer) using an ultrafiltration process. Some mangrove species are better than others at keeping salt out. Less efficient species have a second defence in the form of salt glands in their leaves. *Avicennia* species are well known for their ability to secrete salt via this route. If there has been little rain to wash the salt away then crystals and concentrated droplets of salt water can often be seen on the undersides of the leaves and their saltiness easily tasted (not recommended). *Aegialitis* and *Aegiceras* species share this ability.

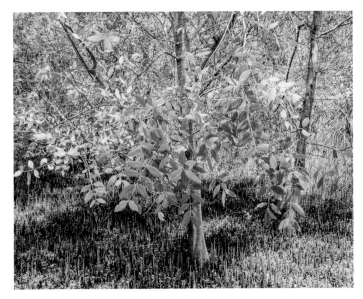
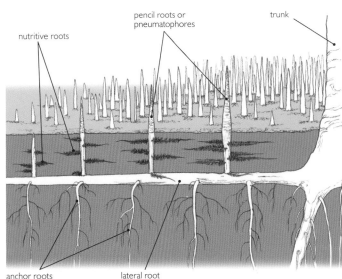

Root structures of the Mangrove Apple (*Sonneratia caseolaris*). Thin pencil or peg-shaped pneumatophores arise vertically from a system of buried, branched lateral roots. Finer nutritive roots extend out from the buried portions of the pneumatophores and from the lateral and anchoring roots.

Walking though a mangrove forest at low tide the most obvious structural adaptation of mangroves quickly becomes apparent. Strangely-shaped aerial roots hanging down from the trees or poking up above the sediment surface make progress slow and difficult. Aerial roots solve the problem of how to supply oxygen to the normal buried root systems. The buried roots cannot absorb it from the surrounding sediment because this is waterlogged and anoxic (oxygen deficient). Aerial roots or pneumatophores are studded with numerous small pores called lenticels through which air can diffuse inwards when the tide is out. The pores are closed when the tide rises again. Around half the material within the root system is aerenchymal tissue, a honeycomb of tubes through which the air can move easily. Its progress down into the buried root system is helped by a build up of negative pressure as, with the lenticels closed, the roots use up oxygen and carbon dioxide diffuses out into the surrounding water. When the tide goes out and the lenticels open again, air is sucked in. Different genera of mangroves can be identified from the shape of their pneumatophores which are given descriptive names such as knee roots (*Bruguiera* spp.), peg roots (*Sonneratia*) and pencil roots (*Avicennia*). Pneumatophores are also found in freshwater swamp trees such as swamp cypresses (*Taxodium* spp.).

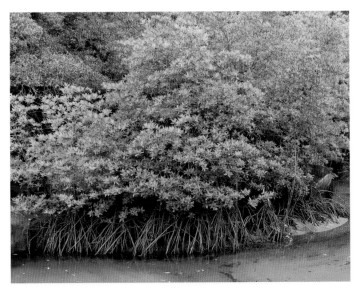
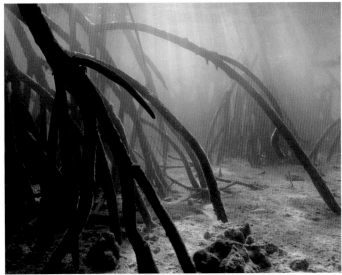

The complex arching aerial roots produced by *Rhizophora* not only carry oxygen down to the buried nutritive roots but also support and stabilise the tree, holding it up in its soft mud habitat. For this reason these roots are often called prop or stilt roots.

BIOLOGY

Life history

Living in a semi-water world, mangroves face the problem of their reproductive efforts going to waste as seeds and fruit float away out to sea. Most mangrove trees have normal flowers pollinated in the usual way by insects, birds or bats and produce fruit with seeds. The fruit eventually drops off the tree if it hasn't been eaten by fruit bats or monkeys and either lands on the mud below if it is low tide, or floats in the water if it is high tide. However, many species have a clever way of increasing the chances of successful establishment of their seedlings through viviparity. The fertilised seed actually germinates whilst still attached to the parent tree and grows through and out of the seed to form a long, sturdy propagule, which is effectively a seedling. This ability is best developed in *Rhizophora*, *Bruguiera*, *Ceriops* and *Kandelia*, all members of the family Rhizophoraceae.

When the propagule is finally released it drops from the tree and either spears directly into the mud below or if the water is too deep for this, it floats off until it gets caught in the shallows where it can establish itself. A muddy walk at low tide through a mangrove forest where any of these species are growing, should show up propagules at various stages of growth, with leaves sprouting from the top and roots from the part buried in the mud. Most propagules only remain floating and viable for a few days and settle fairly close to where they were released, resulting in characteristically dense tangles of mangroves. The propagules of a few species can remain floating and survive for weeks or months. Viviparity also occurs in mangroves from at least four other families and seems to have evolved independently (convergent evolution). *Pelliciera rhizophorae*, a small mangrove tree found on Atlantic and Pacific coasts of Central America, is also viviparous but this is not obvious because whilst the seedling germinates and breaks through the seed coat whilst on the parent tree, it does not emerge from the fruit before this falls. This is known as cryptoviviparity. Whatever the extent, viviparity is obviously an effective adaptation in a habitat of soft mud and swirling tides where fast establishment is essential.

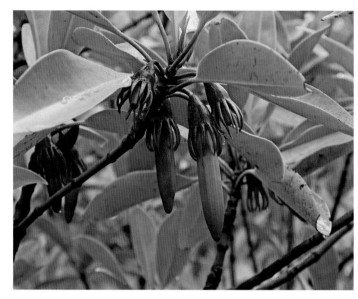

The propagules of *Bruguiera gymnorhiza* have a bright red calyx and can often be seen scattered over the mud beneath the tree. The calyx falls off once the propagule has been released.

Ecology

Mangroves play a dual role as an aerial habitat for terrestrial species and an intertidal habitat for marine and estuarine species. Animals as diverse as crocodiles and sponges live and hunt within mangrove forests and this aspect is described in more detail in the section on Mangrove Forests (p.80). In hot areas such as the Middle East, mangroves provide vital shade, nesting areas and food for wildlife and livestock along exceptionally arid coastlines where few other trees survive. In countries such as Oman and the United Arab Emirates their importance as green places for people is also increasingly being recognised and areas are protected as reserves. In the Arabian (Persian) Gulf and the Red Sea where permanent rivers are rare, mangroves grow in

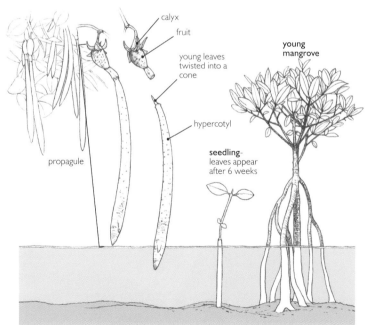

Growth and development of mangrove propagules in Red Mangrove (*Rhizophora mangle*).

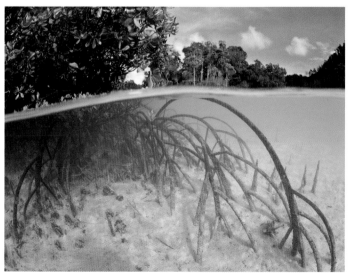

The arching thickets of mangrove prop and aerial roots make excellent nurseries for fish and shrimps because large predators find it hard to swim through them.

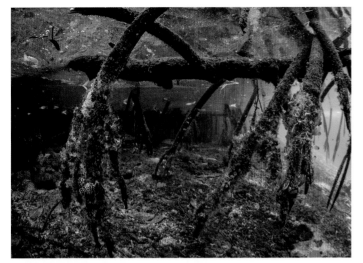

Mangrove prop roots provide a hard substratum on which marine life can settle. Sponges, seasquirts, hydroids, oysters and algae grow on them especially in mangroves growing in fully saline conditions.

USES, THREATS, STATUS AND MANAGEMENT

The ways in which the mangrove forest ecosystem is used and the threats it faces as a consequence, are described in the section on Mangrove Forests (p.80). However, mangrove plants are also used directly for food and for building, and a wide variety of products are made from them by the people living in their vicinity as shown in the table below. Whilst many of these are for local and artisanal use, some products, particularly furniture and carved ornaments made from the wood, are exported.

Mangrove trees have and are being planted in many parts of the world on both small and large scale projects. Some of these plantings are afforestation projects where attempts are made to grow mangroves where there were none before. Others involve restoration of damaged and degraded areas such as returning shrimp ponds and felled areas back to productive forest. Both can benefit local people by increasing the resources available. New areas of mangrove trees are planted for a wide variety of reasons including protection of coastal villages and agricultural land, but all such projects are likely to benefit wildlife as well.

small tidal creeks (khors) and in the complex lagoons and channels found at the mouths of wadis (seasonal rivers).

Mangroves provide food in the form of leaves and fruit for a variety of terrestrial herbivores such as monkeys and fruit bats. Fruit and seed dispersal, especially in those species that are not viviparous, benefits the mangrove but losing leaves to herbivores is detrimental. So some mangrove trees have developed a close and mutually beneficial relationship with various species of ants which build their nest by pulling together and pinning leaves to form a protective ball. The ants in turn will bite and deter browsing animals. This and other complex interactions between mangroves and both terrestrial and marine fauna are described in Cannicci et al. 2008. Whilst this is straying away from the marine world and into the terrestrial realm, it does show how mangroves bridge the two worlds with benefit to both.

Resource	Use
Timber	Construction poles, boat building, fish traps
Fuel wood	Burned directly and made into high quality charcoal
Tannins from bark	Tanning leather; preserving nets and lines
Nypa palm fronds	Traditional roofing
Nypa palm flowers and fruits	Food, sugar, drinks (sap),
Mangrove flowers	Bee-keeping
Mangrove fruits	Food
Leaves, fruits, bark	Traditional medicines

In undeveloped countries many people still live in traditional ways and depend on mangrove forests for their food and living. Shown here are some of the more common uses to which mangrove plants are put, but there are many others.

With their limb-like pectoral fins, mudskippers can crawl out of the water away from their predators as the tide rises.

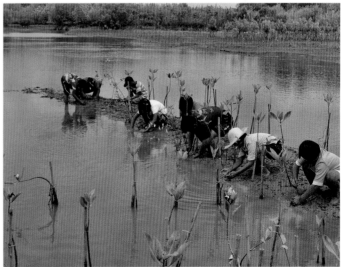

Mangrove seedlings are relatively easy to grow in nurseries for planting out in the wild and will grow well if suitable sites are chosen.

MANGROVE SPECIES

Mangroves are an ecological rather than a taxonomic group and examples can be found in a variety of plant orders and families that are not necessarily closely related. Therefore, examples from the main families which contain mangroves are illustrated here but no further taxonomic information is presented.

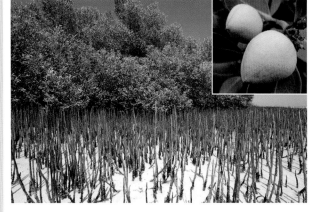

FAMILY Avicenniaceae

White Mangrove *Avicennia marina*

Features At low tide individual trees or untidy bushes can be seen surrounded by a dense thicket of thin conical-shaped pneumatophores (aerial roots) sticking up 10–15cm above the mud. It is extremely variable in its growth form and several subspecies have been described. This is the most widely distributed of all the Indo Pacific mangroves and is the only species that is widespread (if patchy) along the hot desert coastlines of the Red Sea and Arabian Gulf as it can tolerate very high salinities.

Size Mature tree up to about 15m tall.

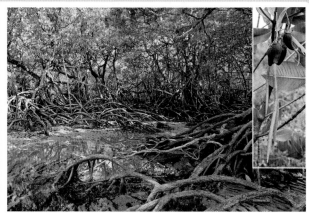

FAMILY Rhizophoraceae

Rhizophora spp.

Features There are six species of *Rhizophora*, all characterised by their extensive and tangled prop roots. These small to large trees have elliptical leaves, usually with pointed tips, and the species are difficult to tell apart without careful reference to the flowers and fruits. Fruits are generally pear-shaped crowned by tough sepals retained from the flower. The seeds germinate whilst on the tree and send out a hypocotyl (young stem) which grows up to 80cm long (depending on the species) before the fruit drops off. *R. mangle* and *R. racemosa* are found in the Atlantic and East Pacific and the others in the Indo Pacific.

Size Mature trees about 6–20m tall.

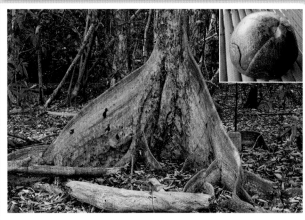

FAMILY Meliaceae

Cannonball Mangrove *Xylocarpus granatum*

Features Deep plank buttresses snake out for some distance around the base of the trunk in a sinuous fashion and are actually the upper parts of roots, flattened sideways to act as pneumatophores. Many other mangroves have trunk buttresses to give support. The only other species in this genus (*X. moluccensis*) does not have plank buttresses. Both trees are found in the Indo Pacific but only *X. granatum* extends across the Indian Ocean to East Africa. The ripe fruit is brown and woody and about the size and shape of a grapefruit or melon – or cannonball.

Size Mature tree 3–8m tall; fruit to 25cm diameter.

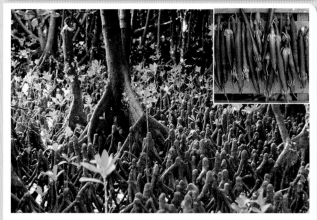

Bruguiera gymnorhiza

Features This mangrove tree is a tall attractive species with loose rosettes of glossy, elliptical leaves, pointed at the ends. The calyx of red sepals surrounding the fruit contrasts against the green foliage. A long, fat cigar-shaped hypocotyl (young stem) grows out from the seed whilst still on the tree. This genus sends up looped roots above the sediment surface which resemble knobbly knees. It is the most widespread of the six species in this genus and extends throughout the Indo Pacific from East Africa to the Pacific Islands.

Size Mature trees up to 15m tall, more in some areas.

FAMILY Rhizophoraceae

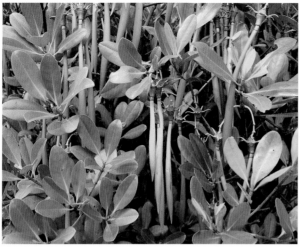

Kandelia candel

Features This small mangrove tree is found in the Indo Pacific but is far less common than *Rhizophora*, which is in the same family. In Singapore and Malaysia it is known as Pisang Pisang. It has no pneumatophores, oblong shiny leaves and small white flowers. The thin propagules grow up to 40cm long and have light green sepals that bend back towards the stem. It is typically found some way up tidal rivers or at the back of coastal mangroves.

Size Up to 7m tall.

FAMILY Sonneratiaceae

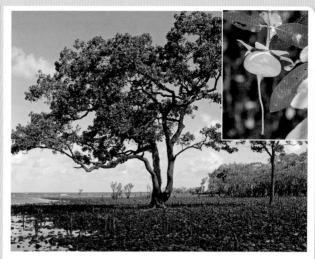

Mangrove Apple *Sonneratia caseolaris*

Features *Sonneratia* species are found throughout the Indo-West Pacific from East Africa to the Pacific Islands. A careful look around the base of these trees will show numerous pencil-like pneumatophores (aerial roots) sticking up through the mud. The leaves of the Mangrove Apple are elliptical but are classically rounded in the widespread *S. alba* and *S. ovata*. Its flower buds have red petals which help to distinguish it from other *Sonneratia* species. Fruits resemble small, slightly squashed apples and are edible.

Size Mature trees up to 20m tall.

FAMILY Arecaceae

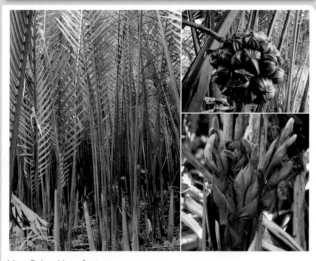

Nipa Palm *Nypa fruticans*

Features This is the only palm considered to be a true mangrove plant and is common along the tidal reaches of rivers from Sri Lanka to the Pacific Islands. Horizontal stems running below the mud surface send up short, hidden erect shoots each of which produces a rosette of feather-like palm fronds (leaves). These are widely used for thatching whilst the seeds of the spherical fruiting head are edible when young. The yellow male flowers are found directly below the female flowers.

Size Fronds up to 9m long.

FAMILY Myrsinaceae

River Mangrove *Aegiceras corniculatum*

Features This common and widespread mangrove is found throughout the Indo Pacific from India to China and Australia, but along with most mangroves, the population is declining mostly due to coastal development. This usually grows as a bushy shrub rather than a tree and is able to tolerate the cooler conditions found at the extremes of its range in SE Australia. The small white flowers are fragrant and the fruit is strongly curved.

Size Usually up to 2m tall, sometimes to 6m.

MARINE FUNGI

Mushrooms, toadstools, moulds and true yeasts are all familiar fungi on land but are not something most people would associate with either the seashore or the ocean. This is hardly surprising since most marine fungi are inconspicuous and do not have the beautiful and sometimes dramatic spore-producing fruiting bodies so familiar in the countryside and in the kitchen. Unseen they may be, but marine fungi play a vital role as decomposers in ocean ecosystems and are found in sediments, detritus, dead wood, spilt oil and many other microhabitats. Some cause diseases in corals, fish and a variety of other animals. In lichens they form a symbiotic relationship with algae creating a dual organism with the ability to survive in extremely harsh environments including the seashore.

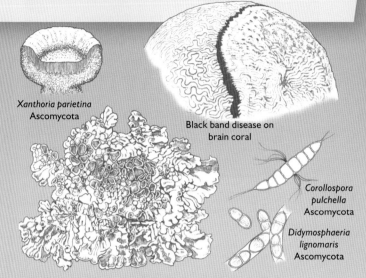

Xanthoria parietina Ascomycota

Black band disease on brain coral

Corollospora pulchella Ascomycota

Didymosphaeria lignomaris Ascomycota

CLASSIFICATION

Fungi were once classified as plants but have long been recognised as a separate kingdom of both multi-cellular and unicellular organisms. Their classification is complex and further information is available in Hibbett *et al.* (2007) who accept seven phyla. Most lichen fungi are from the phylum Ascomycota.

Phylum	Description	Example and notes
Ascomycota	Sac fungi	Includes most lichen fungi
Basidiomycota	Includes majority of mushrooms and toadstools	Mostly on land
Chytridiomycota	Moulds and parasites	*Batrachochytrium dendrobatidis* causing chitridiomycosis in amphibians
Microsporidia	Unicellular parasites infecting animals	*Myospora metanephrops* infecting nephropid lobsters
Zygomycota	Moulds	Black Bread Mould (*Rhizopus stolonifer*)

The five phyla of fungi listed in WoRMS (2016).

STRUCTURE

Fungi are relatively simple organisms and a typical multi-cellular fungus consists of a mass of thin thread-like hyphae, which together are known as the mycelium. The hyphae spread over and penetrate the substratum on which the fungus is living, typically dead plant and animal material, but also living organisms in parasitic and disease-forming species. The hyphae secrete enzymes which externally digest the food material breaking it down into simple molecules that the hyphae can absorb through their cell walls. The fungus mycelium can be quite diffuse and it is only when the fungus develops spore-producing structures that it becomes at all noticeable.

FUNGI IN THE MARINE ENVIRONMENT

Finding marine fungi is not easy but one of the most productive places to look is in decaying wood that has been cast up on the beach. A good hand lens is essential and preferably a microscope to examine collected material. The wood comes both from man-made constructions and from trees and bushes washed away in storms. Although many marine organisms such as shipworms (p.244) bore into and eat wood, fungi are especially important in breaking such tough material down. Marine fungi are common in habitats such as saltmarsh and kelp forests where there is an abundance of dead organic material. Marine fungi are a vital part of the ocean ecosystem and in degrading organic material for their own need they release dissolved organic matter (DOM), an essential food resource for many small and microscopic invertebrates.

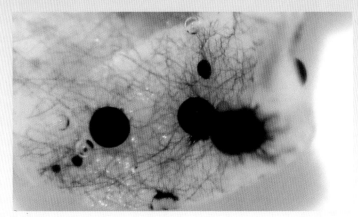

Corollospora maritima is a common marine fungus found worldwide in intertidal habitats. The black blobs are the fruiting bodies and the threads are the hyphae. This sample came from driftwood bored by shipworm. In the tropics *Corollospora* is one of a number of fungi that help to break down debris from coastal mangroves.

LICHENS

Visit a temperate rocky coast exposed to wind-driven salt spray and you may be surprised at just how colourful a landscape you are in. Coastal rocks and cliffs are colonised by lichens that paint the rock in bands of bright orange, green, grey and black. An occasional splash of white is artistically provided by seabird droppings. Lichens are one of very few organisms that can flourish in this extremely hostile environment with little fresh water, no soil and exposed to biting, salt-laden winds.

DISTRIBUTION

Lichens occur on coastal cliffs and rocky seashores worldwide, both above high tide in the splash zone and on the upper shore where they are periodically submerged. They are also a common component of the vegetation on stable sand dunes. Further inland they excel at surviving in harsh, dry habitats from trees and gravestones to park benches and the bare tops of mountains, but they also thrive in damp places.

Lichen-covered coastal rocks in the Isles of Scilly, UK.

STRUCTURE

A lichen consists of a fungus which has an alga or a cyanobacterium (occasionally both) living within its tissues. The association is usually a close one such that the lichen appears as an individual entity and neither partner can live on its own in the wild. The two can be separated and cultured in the laboratory, though this is not easy and in the species where this has been done, both look completely different from the original lichen. It is the fungus name that the lichen carries because every lichen is a unique fungus species, associated with one of a relatively small number of algae and cyanobacteria. There are many thousand lichen fungi but only about 40 known algal and cyanobacterial partners. The same species of alga or cyanobacterium can be utilised by many different lichens, but each lichen uses only one (occasionally two together) chosen species. A lichen is better called a 'lichenised fungus' than a lichen species.

The lichen body or thallus is made up predominantly of the fungus with the alga or cyanobacterium comprising less than 20%. The detailed structure varies according to the type of lichen but the algal or bacterial cells are always near the upper or outer surface layers where they are exposed to light. Most coastal lichens grow as dry, leafy crusts that closely adhere to rocks and are not easily blown or washed away.

SYMBIOSIS OR CAPTIVITY?

Lichens are one of the best-known examples of mutualistic symbiosis (p.498) where two organisms live together to the advantage of both. The fungal partner is provided with energy-rich carbohydrates from its alga or cyanobacterium and so can live on bare rocks and similar places where there is none of the organic matter normally exploited by fungi. To date biochemical studies have not shown up any flow of nutrients from the fungus to the alga or cyanobacterium. In contrast, the zooxanthellae in corals receive nutrients via the coral's waste products. Once 'captured', lichen algae and cyanobacteria are modified such that they lose their cell walls and are prevented from reproducing sexually. Some scientists therefore argue that this is a case of enforced and controlled parasitism. However, like the fungal partner, they do get to live in dry, brightly lit places where they otherwise could not survive, so the case for this being a true symbiosis also stands.

Lichens thrive on these coastal, salt-sprayed rocks on the Antarctic island of Galindez, but cannot tolerate the heat-baked coastal rocks of islands such as Ascension Island in the mid-Atlantic.

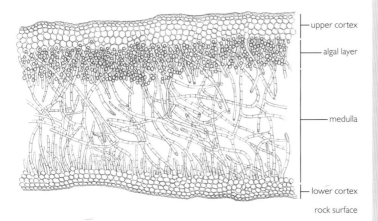

Cross-section through a layered leafy lichen thallus showing the relationship between the fungal hyphae and its contained algae/cyanobacteria.

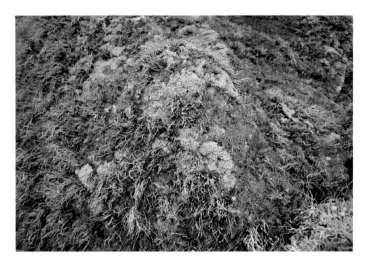

This lichen assemblage in the Isle of Man, a British Crown Dependency in the Irish Sea, is typically found on coastal rocks backing exposed intertidal areas in the NE Atlantic. Three genera predominate: grey-green tufted *Ramalina*, grey *Tephromela* and orange *Xanthoria*.

BIOLOGY

The green algae or cyanobacteria within a lichen photosynthesise and produce carbohydrates in the same way as plants do. These are easily passed on to the fungus because the contained algae or cyanobacteria lose their cell walls. The fungus converts and stores the food as a sugar alcohol called mannitol. Water is absorbed from rain, dew and fog and brings with it dissolved nutrients and minerals. In addition, cyanobacteria can 'fix' atmospheric nitrogen and convert it into ammonium ions (NH_4^+) that the fungus can utilise. Coastal lichens often benefit from nutrients derived from seabird droppings. Lichens are not especially good at retaining moisture but they are excellent at surviving long periods of drought. They can withstand a reduction in water content down to about 15–30% when they will feel crisp and dry to the touch. In this state they are completely inactive but can resume photosynthesis even after several months, as soon as they are wetted again.

Lichens reproduce sexually in the same way as normal ascomycete fungi, by producing spores in special fruiting bodies called ascomata or apothecia. Apothecia can be seen with the naked eye as small cups, discs or blobs but within them are microscopic flask- or sac-shaped asci, each of which usually contains eight spores.

These exposed cliffs edging the Isle of May off the east coast of the UK, are subject to high winds that blow spray right to the top and the lichen zones are wide. On sheltered shores the lichen bands follow one another closely, within a few metres.

The spores are released and dispersed and if they land on a suitable substratum, they will germinate and grow into fungal hyphae. However, the fungus can only develop further if there is a suitable alga or cyanobacterium nearby that they can 'capture'. As the lichen grows, its contained algae or cyanobacteria can divide asexually but are prevented from reproducing sexually.

Whilst sexual reproduction is important to maintain genetic diversity, most lichens also reproduce asexually by producing little bundles of fungal hyphae wrapped round a bunch of their algae or cyanobacteria. These soredia can travel long distances by wind, or are carried by insects, birds and mammals to new locations where they will grow if they land on a suitable surface. Sit down on lichen-covered seaside rocks then move to another spot and you may unwittingly have helped a lichen to find a new place to grow.

Ecology

Coastal lichens vary in their ability to withstand salt water and salt spray and this is the reason behind the coloured bands of lichens so often seen on temperate coastal cliffs. In Europe, the lowest band is formed by the thin, black crusts of the Tar Lichen (*Verrucaria maura*) which looks exactly like an oil stain. This can tolerate brief periods underwater. Above this, out of range of the tides but wetted by wave splash and spray, are the bright orange lichens *Xanthoria* spp. and *Caloplaca* spp. Right at the top above most of the sea spray is a greyish-green zone with a wider variety of lichens including tufts of *Ramalina* spp.

Lichens can transform a barren coastal cliff into a microhabitat where small invertebrates can find shelter and food. They can break down rock material both mechanically and by acid production, and the minerals released, combined with dead remains of lichens and seabird droppings, can produce a thin soil allowing coastal flowering plants to gain a foothold. Seashore and coastal lichens are specialists able to tolerate salty conditions but away from the coast, lichens form the dominant vegetation in some parts of the world, especially the Arctic tundra (where they form the staple diet of reindeer) and in Antarctic maritime rocky habitats.

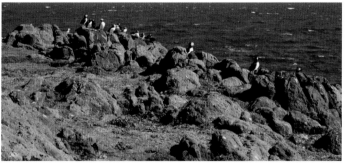

Puffins and other cliff-nesting birds provide nutrients in their droppings which benefit lichens.

USES, THREATS, STATUS AND MANAGEMENT

Lichens have a long and continuing history of human use for a very wide range of purposes from medicine and food to their use as indicators of pollution. It is even possible to navigate by looking at which sides of trees are covered by lichens. A number of coastal lichens in the family Roccellaceae can be used to produce a reddish-purple dye. *Rocella fusiformis* was the basis of a small-scale industry in Scotland in the mid 17th century but their use goes back to biblical times. Lichens have long been used in traditional medicine and today are one of a number of organisms that are being screened as potential sources of medicinal drugs. Lichens are extremely slow-growing and their collection from the wild can be very destructive, so laboratory production would be necessary to take forward any such discoveries.

LICHEN SPECIES: PHYLUM ASCOMYCOTA

Sac fungi as they are commonly known, form this, the largest phylum of fungi, with around 65,000 species. Almost all lichenised fungi belong to this phylum but they are in a minority as most sac fungi do not form lichens. Sac fungi produce sexual spores in structures called asci (single ascus).

Class Eurotiomycetes
A diverse range of fungi with a variety of lifestyles including some lichens, parasites and pathogens.

ORDER Verrucariales | FAMILY Verrucariaceae

Black Tar Lichen *Verrucaria maura*

Features With its striking resemblance to an oil stain, this lichen has often sparked complaints by beach users who assume a spill has washed ashore. This thinly encrusting species can cover quite large areas of rock at and above high tide level especially on exposed coasts. A similar but dark green species *V. mucosa* occurs on rocks below high tide level. Both species are common in the North Atlantic.
Size Variable patches.

Class Lichinomycetes
Lichenised fungi associated with cyanobacteria as the symbiont.

ORDER Lichinales | FAMILY Lichinaceae

Lichina pygmaea

Features This low-growing lichen can easily be mistaken for a patch of miniature seaweed and is usually found at around high tide level on exposed shores in the North Atlantic. A close look with a hand lens will show it is composed of tiny, flattened branching tufts ending in rounded lobes. Small spherical structures at the branch tips are the fruiting bodies. The lichen clumps provide a haven for many small invertebrates that would otherwise have nowhere to hide.
Size Patches up to 1cm tall.

Class Lecanoromycetes
The majority of lichen-forming fungi belong to this class. The few non-lichenised species in the group are thought to have secondarily lost their symbionts.

ORDER Lecanorales | FAMILY Teloschistaceae

Xanthoria parietina

Features The orange pigment (physcion) found in this lichen, provides protection from UV light which would otherwise damage the contained algae. The colour varies from bright orange in sunny spots, to grey in shaded areas. Many different orange lichens grow on coastal rocks around the world and they require some practice to identify correctly. *X. parietina* is found in nitrogen-rich habitats and thrives on cliffs with seabird colonies in Britain, Europe and America.
Size Variable patches. Lobes up to 7mm wide.

ORDER Lecanorales | FAMILY Ramalinaceae

Sea Ivory *Ramalina siliquosa*

Features This shrubby greenish-grey lichen is common near the tops of coastal cliffs and on hard rocks backing exposed shores. It consists of tufts of mostly undivided lobes that grow upright or hang down slightly depending on its situation. When dry it has a crunchy, brittle consistency but in spite of this it is grazed by sheep in some parts of the UK such as the Shetland Islands. This lichen dominates many coastal cliffs in western Europe.
Size Tufts up to 7cm long.

ORDER Lecanorales | FAMILY Tephromelataceae

Black Shields *Tephromela atra*

Features The common name of this encrusting lichen comes from the black disc-like fruiting bodies which are edged with a grey crinkled margin when they are mature. The colour varies from almost white through pale to medium grey, and the texture from smooth to warty. This is one of the most common of the grey seashore lichens in the North Atlantic but can be confused with similar species of *Lecanora* in which genus it was previously included.
Size Patches up to 10cm across.

FAMILY Cladoniaceae

Cladonia uncialis

Features Acidic sand dune systems such as at Winterton-on-Sea in Norfolk, UK where this photograph was taken, often support a dense cover of mosses and lichens on the fixed dunes at the inland end of the system. *Cladonia* is common in these situations where it forms soft clumps of branched, hollow finger-like lobes. The ultimate branches end in pinkish-brown pointed tips. In England, UK, this lichen is most common in coastal habitats but is also widespread inland, especially with heather on heaths. *Cladonia* is the genus that provides winter feed for reindeer and caribou in the Arctic.
Size Clumps up to about 12cm high.

PROTOZOA

In the past unicellular organisms that were not bacteria, were grouped together into a single kingdom as Protista or Protoctista, depending on the classification system and authority. Then for many years the term 'protozoa' was used to mean animal-like unicellular organisms, whilst plant-like ones with chloroplasts were deemed to be 'algae'. This was not at all satisfactory because many unicellular organisms bridge the apparent divide between plants and animals as they are able both to photosynthesise and to engulf food particles. Since then, huge advances in microscopy and in molecular techniques have greatly increased understanding of the relationships between different groups of unicellular and multi-cellular organisms. However, it has not made it any easier to include unicellular eukaryotic organisms in one formal classification of all life. The term 'protist' is now widely used as a useful but informal term to encompass all eukaryotic (i.e. not bacteria or archaea) unicellular organisms. As can be seen in the section on marine plants and chromists (p.128), protists can be found amongst red and green algae in the plant kingdom (Plantae) and in the kingdom Chromista which includes brown seaweeds (macroalgae), and as here, in the Protozoa.

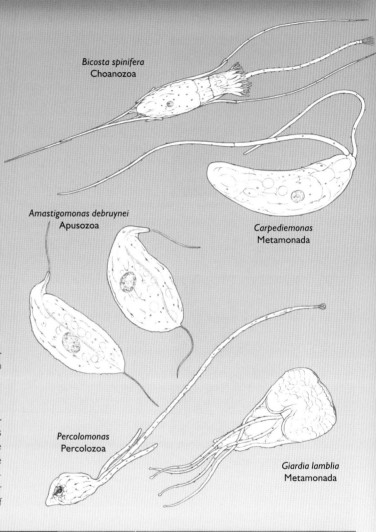

Bicosta spinifera
Choanozoa

Amastigomonas debruynei
Apusozoa

Carpediemonas
Metamonada

Percolomonas
Percolozoa

Giardia lamblia
Metamonada

DISTRIBUTION

Protozoans are almost universally distributed throughout habitats in the ocean, in freshwater and on land. They form an important component of the plankton.

CLASSIFICATION

The kingdom Protozoa is used here to encompass a number of related protist groups that typically ingest their food (heterotrophic) though many can photosynthesize (phototrophic) or do both (myxotrophic). The classification ranks assigned here follow the World Register of Marine Species (WoRMS 2014) but not all are universally accepted as formal taxonomic groups. Protist classification is based on cellular details, molecular studies and biochemical evidence, and is well beyond the scope of this book.

SUBKINGDOM	INFRAKINGDOM	PHYLUM	CLASS
Sarcomastigota		Amoebozoa	7 classes
		Apusozoa	3 classes
		Choanozoa	4 classes
Eozoa	Euglenozoa	Euglenozoa	4 classes
	Excavata	Loukozoa	2 classes
		Metamonada	6 classes
		Percolozoa	4 classes

STRUCTURE

The visible (by microscopy) morphology of protozoans varies greatly between groups and only a few important marine groups are described here. The most familiar are probably amoebas and their relatives. These amoebozoans do not have a fixed shape and are famous for their flowing motion. An outer covering of gel-like protoplasm (ectoplasm) surrounds a more fluid endoplasm inside. The ectoplasm stretches out to form projections or pseudopodia ('false feet') into which the endoplasm flows, moving the amoeba along.

Amoebas feed by surrounding food particles, usually other protists, with their pseudopodia trapping the prey in a fluid-filled vacuole. This method of feeding is known as phagocytosis and is common in protozoans. Amoebas are no means the only protists to use pseudopodia for movement and feeding. Foraminifera (p.154) such as *Polystomella* which are chromists, extend long, filamentous pseudopodia that pick up and ingest food particles.

Choanozoans or choanoflagellates, as they are more often called, are an interesting group of protists found globally in marine and freshwater environments. An individual free-living choanoflagellate has a very similar structure to, and functions in much the same way as, the choanocyte cells that are found in sponges (p.184) and they provide a possible link to multicellular animals. Choanoflagellates have a single long flagellum which beats to draw water in through a collar of tentacle-like projections at the top of the cell, which trap food particles. These are then engulfed into food vacuoles in much the same way as in amoebas.

Euglena viridis is a common protozoan in freshwater but it and many other euglenoids (Euglenoidea) also live in the ocean. Euglenozoans are flagellated protists that move along by lashing one or two flagella (singular is flagellum). In *Euglena* one short and one long flagellum arise from a permanent invagination called the flagellar pocket, at the front end. In the right conditions euglenozoans can form blooms in sheltered shallow coastal water. These conditions include bright sunlight because, as can be seen clearly in *Euglena*, these protists contain chloroplasts and can photosynthesise. However, where there is little light such as in deeper water, their chloroplasts reduce in size and number, and they survive instead by absorbing dissolved organic matter (DOM) from the water. Some species have lost their chloroplasts and with them the ability to photosynthesise.

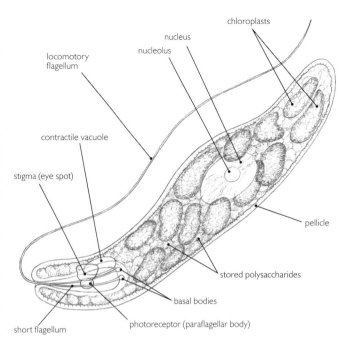

In *Euglena* the bases of the flagella are embedded in a 'paraflagellar body' which along with a red eyespot imparts light sensitivity. Research suggests the paraflagellar body detects the light and the eye spot shades the latter, thus providing directional information. Whilst euglenoids cannot change shape in an amoeboid fashion, they have a flexible cell wall (pellicle) and so can stretch out and contract.

BIOLOGY AND ECOLOGY

As indicated in the examples above, protozoans feed in a variety of ways. All of them have the ability to either take in particulate food or absorb DOM from the water around them. Many can also switch to photosynthesis or do both at the same time. Protozoans are important bacteriovores feeding partly or exclusively on bacteria, making these tiny organisms available to the food chain in larger protist packages. For example whilst amoebae are not usually planktonic themselves, they are found living on and within drifting organic material such as marine snow (p.111). Here their ability to change shape and squeeze into tiny crevices means they are able to prey on the many bacteria that also live there.

Most protozoans reproduce asexually by simple binary fission, dividing into two equal daughter cells. Genetic material is duplicated and split (mitosis) as the nucleus divides, followed by the cytoplasm. Some protozoans such as amoebas can also undergo a type of sexual reproduction called conjugation. This involves the fusion of individuals and an exchange of genetic material. Many protozoans degenerate into resting cysts if conditions such as food supply or temperature are unfavourable. A thickened cell wall protects the organism until conditions allow it to become active again.

Some choanoflagellates such as *Proterospongia* alternate between living as individuals and forming colonies, often enveloped in a gelatinous matrix. In the latter the individuals on the outside show the typical collar-cell anatomy whilst those on the inside are amoeboid. Many sponges also have motile amoeboid cells within the body and the resemblance provides strong evidence for a close relationship between choanoflagellates and animals.

Many marine protozoans live parasitically and whilst some cause disease others are important as part of the gut biota, especially in fish.

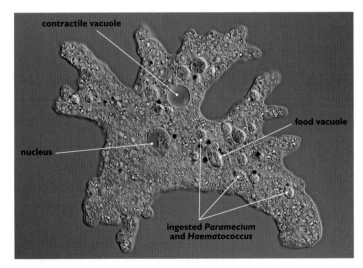

Whilst *Amoeba proteus* has only one nucleus other protozoans may have more than one. A contractile vacuole maintains osmotic equilibrium (water balance). This specimen has ingested a number of ciliates (*Paramecium*) and green algae (*Haematococcus*) which are being digested within food vacuoles. This is a freshwater species much studied in laboratories because of its large size (up to 750μm).

MICROANIMALS

The eight phyla included within this chapter are all small or microscopic multi-cellular animals that are seldom seen by most people. Comb jellies are large and colourful enough to attract the attention of divers but for the rest a targeted search and a strong hand lens or microscope are needed to find and see them. However, in spite of their small size, many of them play important roles within various marine ecosystems and lead fascinating miniature lives. Comb jellies and arrow worms are fearsome predators within the plankton and water bears graze in the miniature world between sand grains.

Pseudosagitta maxima Arrow worm

Cestum veneris Comb jelly (Cestida)

Brachionus plicatilis Rotifer

Barentsia discreta Goblet worm

Echiniscoides sigismundi Water bear

Symbion pandora Cycliophoran

Thaumastoderma ramuliferum Gastrotrich

Trichoplax adhaerens Placozoan

COMB JELLIES

Comb jellies (Ctenophora), or sea gooseberries as they are often called, are one of the most beautiful of all planktonic animals when alive but turn into small blobs of jelly when they wash ashore as they do all round the world. They are often mistaken for jellyfish (Scyphozoa) and were at one time classified as a class of cnidarians (Cnidaria). Their beauty lies in the ripples of iridescence that run down their sides as they swim along beating their comb-like cilia. Divers can appreciate this display whilst doing decompression stops after a dive and some aquaria have special darkened tanks to show them off. They are also bioluminescent and give off bright flashes of greenish light at night.

DISTRIBUTION

Comb jellies are found only in the ocean, mostly near the surface and have a worldwide distribution. The majority swim and drift in open water as part of the plankton but a few specialised genera creep around on the seabed.

CLASSIFICATION

CLASS	ORDER
Tentaculata	Cambojiidae
	Cestida
	Cryptolobiferida
	Ganeshida
	Lobata
	Thalassocalycida
	Cydippida
	Platyctenida
Nuda	Beroida

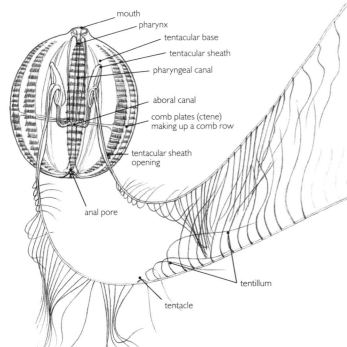

The classic comb jelly *Pleurobrachia* illustrated here belongs to the order Cydippida, considered to be the most primitive group. However, the fossil record of such soft-bodied animals is, not unsurprisingly, sparse. *Pleurobranchia* is a cosmopolitan genus.

STRUCTURE

Whilst a 'classic' comb jelly is round like a gooseberry, others are shaped like oval sausages, double-capped mushrooms or hats with ear flaps. Whilst most are millimetres to a few centimetres long, Venus's Girdle (*Cestum veneris*) has a ribbon-shaped body up to 1.5m long. Like jellyfish, a comb jelly is mostly 'jelly', and consists of a layer of gelatinous material (mesoglea) sandwiched between an outer protective epithelium (ectoderm) and the stomach and digestive canals (endoderm). However, the most obvious feature of comb jellies is the eight bands of cilia that run vertically down the body like the longitudinal lines on a globe. Each band is made up of successive comb plates, short transverse rows of cilia fused at their base like the teeth of a hair comb.

BIOLOGY

Feeding

Comb jellies are voracious predators that catch their prey by trailing out two long, tentacles armed with side branches that hang down like washing on a line. The tentacles are covered with sticky 'lasso' cells or colloblasts that do not sting like the nematocysts of jellyfish, but instead secrete a glue-like material. Fish eggs and larvae, copepods and even other comb jellies all get stuck on the tentacles which then contract, and the mucus-covered food is wiped off on the mouth. Beroids (Beroida) have no tentacles and simply engulf their prey through a wide mouth opening.

Life history

Comb jellies are all hermaphrodite and most release their eggs and sperm into the surrounding water through special pores. Fertilised eggs develop into a cydippid larva which resembles a classic, round sea gooseberry in miniature and later changes to one of the various adult shapes. Most species reproduce only once and then die but some of the creeping species can reproduce asexually from small pieces that break away from the edge of the body.

USE, THREATS, STATUS AND MANAGEMENT

The Sea Walnut (*Mnemiopsis leidyi*), from the west Atlantic was accidentally introduced to the Black Sea in the 1980s, probably via ballast water from ships. This voracious predator rapidly reproduced and had a devastating effect on local fisheries by eating fish eggs and larvae. The subsequent introduction of one of its predators, another comb jelly *Beroe ovata*, has subsequently restored some balance.

Beroe lacks the two 'fishing' tentacles found in almost all comb jellies as do all the species in the class Nuda which contains only one other genus, *Neis*.

Benthic creeping comb jellies lack cilia combs but retain the feeding tentacles, one of which can be seen in the background in this photograph taken off Dubai in the United Arab Emirates.

COMB JELLIES

ARROW WORMS

At up to 12cm long, arrow worms (Chaetognatha) are relatively easy to find and study, especially as they are one of the commonest plankton animals in the ocean. At first glance they could be mistaken for fish larvae as they have fins, a tail, a head and eyes, but in the world of plankton these are voracious predators of fish larvae. Catching them is simple using a hand held plankton net towed behind a small boat. Even an old pair of tights with the feet cut off and replaced by jam jars will work when plankton is abundant.

DISTRIBUTION

Arrow worms spend their entire lives floating, swimming and hunting in open water especially in the upper layers of the ocean where their prey is most abundant. This phylum is one of the very few in which all the species are marine and all (well very nearly all) live in the plankton. They are found worldwide though the various species have specific ecological requirements and so inhabit different open water habitats, coastal or offshore, warm or cold.

CLASSIFICATION

There is only one class of arrow worms, the Sagittoidea, which is divided into two orders, the Aphragmophora and the Phragmophora, distinguished by details of the musculature.

STRUCTURE

Shaped like a torpedo complete with nose cone and stabilising fins, arrow worms are ideally designed to dart through the water after their prey. The head is equipped with a set of curved, grasping spines, two simple eyes that can detect changes of light intensity and a terminal mouth. Behind the head a wider trunk region tapers to a narrower tail, both well supplied with muscles for fast swimming. Head, trunk and tail are divided internally by transverse septa through which the gut and nerves pass.

Species of *Spadella*, the only non-planktonic genus of arrow worms, are easily recognised as arrow worms but attach themselves to hard objects by the undersurface of their tail region.

BIOLOGY

Feeding

When they are not feeding, arrow worms float motionless in the water with the help of their lateral fins, their head spines covered by a hood and their transparent bodies rendering them almost invisible. The approach of a bumbling copepod (p.280), detected by cilia on the body which react to vibrations, spurs them into a swift dart forward and a rapid strike with their grasping head spines. The prey, which also includes hydromedusae, larval fish and other arrow worms, is also held still by rows of small teeth surrounding a depression in which the mouth lies, and is eventually swallowed whole. Large prey is subdued by tetradotoxin, the same lethal neurotoxin found in pufferfish. Arrow worms hunt mainly by night following their prey upwards and returning to deeper water during the day (diel or diurnal migration).

Life history

The partitioning of the body regions allows separation of the two ovaries (in the trunk) from the testes (in the tail) of these hermaphrodite animals. Testis cells are released into the tail body cavity where they develop into sperm and are collected into two seminal vesicles which release them to the outside during spawning. Eggs are fertilised by sperm, usually from another spawning individual, and drawn into the ovaries through two gonoducts, and are released the same way. Fertilised eggs develop directly into juveniles.

Arrow worms are used as 'indicator species' to track the movement of particular bodies of water such as the periodic tongues of water that extend up the west coast of Britain from the bottom outflow leaving the Straits of Gibraltar. Change in the normal distribution of different arrow worm species is currently also providing information on ocean warming. Arrow worms are a vital link in the ocean food chain and changes in their distribution and availability can ultimately affect seabird and mammal populations.

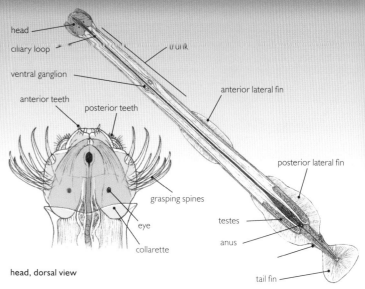

A typical chaetognath *Parasagitta setosa*.

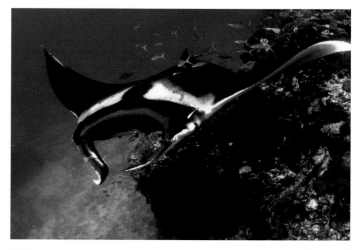

Whilst arrow worms are predators, they themselves help to sustain large plankton-feeders such as manta rays.

WATER BEARS

Pick up a scoop of muddy sand on a beach and you could be holding a bear (or more likely many) in your hands. Admittedly it would be a microscopically small bear less than 1mm long but nevertheless one that scrambles along on clawed legs munching as it goes. To save confusion these animals are probably better referred to as tardigrades (Tardigrada) but this is a much less descriptive name for these charming microcopic animals. Finding them requires a patient search, sorting through beach sediment under a high power microscope. Non-marine species can be found relatively easily in moss or pond debris.

DISTRIBUTION

Tardigrades are an important part of the meiofauna (p.90), living in the spaces between sand grains in shallow marine sediments all round the world. They have also been found scrambling about amongst algae and seaweeds, in deepsea mud and at hydrothermal vent sites. However around 90% of species live on land, albeit in places that are at least seasonally wet, but in habitats as varied as mountain tops, ponds and house gutters.

CLASSIFICATION

CLASS	ORDER
Eutardigrada	Apochela
	Parachela
Heterotardigrada	Arthrotardigrada
	Echiniscoidea
Mesotardigrada (freshwater only)	Thermozodia

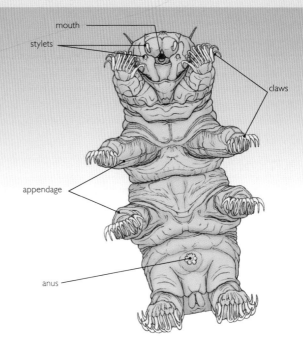

Ventral view of a typical water bear, *Echiniscoides sigismundi*.

STRUCTURE

Tardigrades are called water bears because they have a short plump body and stubby appendages ending in a bunch of claws. However, they have eight rather than four pairs of appendages, no clearly separated head and come in various shades of white, black, red, green and transparent. They are protected from abrasion by thick cuticle plates which sometimes give them the appearance of being segmented. The cuticle ornamentation also helps to distinguish different species. In general, the drier their habitat, or the older the animal, the thicker their cuticle is. Like arthropods they periodically moult as they grow. To find their way around and detect food, they have two simple eye spots at the head end and sensory bristles on the body.

BIOLOGY

Feeding

With sixteen sets of claws, tardigrades are well equipped for scrambling along or wending their way between sand grains. Sand-living, marine species search out bacteria, diatoms, nematodes or rotifers, and attack them using two sharp stylets which they extend out of the mouth to pierce their minute prey. The body or cell contents are sucked up by a muscular pharynx that leads into the gut. This is called suctorial feeding. Many land species feed in the same way on mosses and other plant tissue, piercing the cell walls.

Life history

Most of the tardigrade species that have been investigated have separate males and females,, and produce eggs and sperm from a single gonad within the body. The female moults and then typically uses her shed skin as a convenient container in which to lay her eggs. All the male has to do is fertilise them. The eggs hatch directly into juveniles which have an unusual growth pattern. The juvenile already has all the cells it needs (a condition termed eutelic) and grows simply by enlargement of those cells. Some species reproduce by parthenogenesis where unfertilised eggs laid by the female develop directly into more females.

LIVING DEAD

Ranulph Fiennes, one of today's greatest explorers, would surely envy a tardigrade its ability to survive extreme conditions including freezing and desiccation. Tardigrades have even survived periods in space where they were deprived of oxygen, exposed to radiation and of course sub-zero temperatures. When faced with such conditions tardigrades enter a state of suspended animation called cryptobiosis in which their metabolism drops to an exceedingly low level. The usual challenge for tardigrades is desiccation and they can survive in a dried up state for at least 10 years and withstand temperatures from minus 272°C to plus 150°C. Special chemicals called bioprotectors prevent damage to cell membranes, cell organelles and DNA, as the animal dehydrates and later rehydrates. The disaccharide trehalose is an important bioprotector and acts as a gel-like protective packaging within and between cells. Tardigrades living in the ocean are less likely to meet such conditions.

GASTROTRICHS

Gastrotrichs (Gastrotricha) are one of the smallest multi-cellular (metazoan) animals ranging from less than 0.1mm to 3mm long, so they are only ever going to be found by people who know where to look and who are willing to sort through material under a high power microscope. However, many beautiful photographs of these and other microanimals are available on the internet taken both by scientists and by amateurs interested in photomicrography, for example Gastrotricha World Portal (www.gastrotricha.unimore.it).

DISTRIBUTION

These tiny animals live down on the seabed mostly as part of the meiofauna (p.90) where they are found worldwide in large numbers, creeping between sand grains. Some marine and most freshwater species are found in aquatic debris often as part of the periphyton, a mixture of detritus, microorganisms and microanimals that can be found covering rocks, stones and hard-shelled animals. A few species live a free-swimming existence in the plankton. About half of the known species live in freshwater.

CLASSIFICATION

There are two orders of gastrotrichs, the marine Macrodasyida (with only two freshwater species) and the predominantly freshwater Chaetonotida (about a quarter of which are estuarine or marine).

STRUCTURE

Most marine gastrotrichs are shaped like an elongate computer wrist support with a flattened ventral surface and a convex back. The head and tail end often look similar but in many freshwater species the tail is forked. Under the microscope, gastrotrichs often appear quite hairy and are sometimes called 'hairy-backs' because they have a covering of tiny bristles and scales. However, their most characteristic feature is a

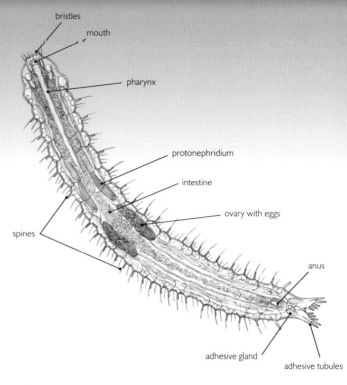

A typical marine gastrotrich.

series of cylindrical, adhesive tubules, often with a row along each side of the body, but sometimes only at the head and tail end (especially in freshwater species). The tubules help the animal to anchor itself in one place. Gastrotrichs find their way around using long, sensory cilia and bristles on the head end.

BIOLOGY

Feeding

Gastrotrichs are miniature underwater cleaners, sucking in bacteria, microalgae, protozoans and organic detritus using a muscular pharynx behind the mouth. Food is digested and absorbed by a simple straight gut. The animals glide along using cilia that cover the ventral surface. More cilia around the mouth also help collect food. Species with adhesive tubules at either end can also loop along like a leech or inch worm, alternately attaching and detaching the tubule groups. Their abundance means they are an important food source for meiofaunal predators.

Life history

A variety of reproductive strategies are employed by gastrotrichs but most marine species are simultaneous or sequential hermaphrodites producing both eggs and sperm. When the eggs are laid they are attached to sand grains and presumably fertilised by sperm shed by the same or another individual. There is no larval stage and the eggs hatch directly into juveniles. In contrast, most freshwater species reproduce asexually by parthenogenesis in which females lay unfertilised eggs that hatch into females.

Marine gastrotrichs might be found amongst the material growing on this bivalve shell (*Spondylus*) and in the sediment below.

GOBLET WORMS

Using the term 'worm' for these tiny, attached animals is misleading as they are not at all worm-like but they are shaped like miniature drinking goblets. They are also called kamptozoans, especially by German and Russian biologists because Kamptozoa is an alternative phylum name. However, the more usual entoprocts (Entoprocta) is what we are calling them here. Since they are usually less than 5mm long and superficially resemble hydroid polyps, they are very easily overlooked. The best place to search is on other fixed animals such as sponges, tunicates and bryozoans. These intriguing little animals may not have a large role to play in the ecology of the oceans but are well worth becoming acquainted with under the microscope.

DISTRIBUTION

Almost all entoprocts live in the ocean, mainly in relatively shallow coastal waters attached to rocks and other hard objects and on other sessile (fixed) animals. *Urnatella gracilis* and *Loxosomatoides sirindhornae* are found in freshwater.

CLASSIFICATION

There are only two orders and three families of entoprocts. Colonial species, which are in a majority, are contained within the order Coloniales whilst solitary species are (unsurprisingly) within the Solitaria.

STRUCTURE

Each individual entoproct has a rounded cup-like body or calyx on top of a long stalk which attaches the animal to its chosen substratum. In colonial species the individuals are linked together by stolons at the stalk base or have a shared branching stem. The calyx is topped by a crown of solid (as opposed to hollow) tentacles covered in cilia. The mouth opening is inside the ring of tentacles and leads into a U-shaped gut exiting at the anus which also lies inside the ring of tentacles on top of a short papilla. This is a key difference from bryozoans, to which these animals were once thought to be closely related, as in the latter group the anus lies outside the tentacle ring. Watching live specimens under a microscope it is possible to see that when the animal is not feeding, the tentacles can be folded down into the space (vestibule) formed by a membrane that joins their bases together.

A clump of sea squirts such as these would be a good place to search for entoprocts.

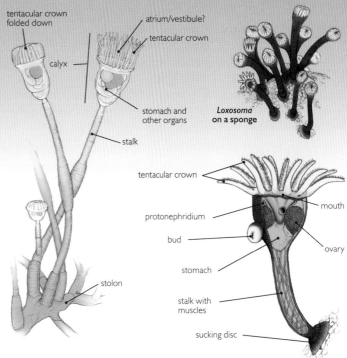

Left: *Barentsia*, a typical colonial goblet worm (see p174 for colony). Right: *Loxosoma*, a typical solitary goblet worm.

BIOLOGY

Feeding

Beating cilia on the tentacles create a current of water that is drawn up through the tentacle ring from below. The cilia are so arranged that water passes in near the base of the tentacle ring bringing food, and out at the top carrying away waste from the anus. Small planktonic animals and organic debris are trapped in mucus on the tentacles and wafted down into the mouth. Colonial species probably do not share ingested nutrients in the way that bryozoans and hydroids do. Colonial species and most solitary species remain in one place as adults but a few solitary ones can move very slowly in a looping fashion, alternatively releasing and attaching themselves by the muscular base of their stalk and by their tentacles. This allows them to find a position where they can benefit from water currents created by their host. Entoprocts are sometimes called 'nodding heads' because contraction of their stalks causes their 'heads' (actually the body) to bend and sway.

Life history

Entoprocts are sequential hermaphrodites meaning they produce both eggs and sperm but not at the same time. Sperm is released but eggs are retained and are fertilised within the body, possibly in the ovaries. They develop into larvae within the vestibule formed by the tentacle ring and once released, the larvae swim and drift, eventually settling down on a suitable substratum. The larva is similar in shape to the trochophore larvae of annelid worms and molluscs. Most entoprocts can also reproduce asexually by budding off new individuals from the stalk or the body wall. These crawl a short distance away before attaching and so a dense community of entoprocts can quickly build up.

ROTIFERS

With most species measuring under 0.5mm long, rotifers (Rotifera) or wheel animals are amongst the smallest of metazoan (multi-celled) animals, but this phylum contains a myriad of remarkably complex forms that have fascinated scientists and naturalists ever since the microscope was invented. They are abundant and easy to find in freshwater ponds and lakes whilst marine species are harder to locate. However, with practise and a good microscope they can be found amongst seaweeds, seagrass, organic debris and sediment samples collected from shores.

DISTRIBUTION

Rotifers have always been considered as a predominantly freshwater phylum but around 20% of the known species are found in brackish and marine environments (Fontaneto et al. 2006). In the ocean there are both planktonic species and ones that are fixed to or creep over and within the seabed. The latter are found mainly in intertidal areas but deepsea sediment-living species are also known. There are also rotifers that live on crustaceans and sea cucumbers, and on land in damp places such as amongst mosses. There are even parasitic species in the gut of earthworms.

CLASSIFICATION

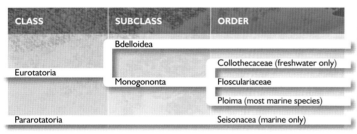

CLASS	SUBCLASS	ORDER
Eurotatoria	Bdelloidea	
	Monogononta	Collothecaceae (freshwater only)
		Flosculariaceae
		Ploima (most marine species)
Pararotatoria		Seisonacea (marine only)

STRUCTURE

Rotifers vary in form according to their way of life, from flask and cup-shaped to miniature sausages and balloons. All but the most specialised are crowned with a ring or rings of cilia called the corona or wheel organ. This multi-purpose structure on the head propels motile species through the water and collects food. Typical bottom-living rotifers have a small head region with a wheel organ, a bigger trunk region which contains the gut, gonads and other body organs, and finally a tapering tail end often

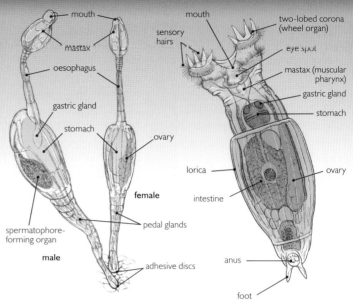

Left: *Seison nebaliae*. Right: *Philodina roseola*.

and slightly confusingly, called the foot. Many bottom-living species attach themselves to a solid object when feeding and detach when they want to move on. This is achieved by two (usually) pointed 'toes' which secrete an adhesive material. Some species remain permanently attached and planktonic species usually lack a foot and toes.

Many species have simple eyes and sensory bristles, often mounted on short antennae on the head or trunk. There is a simple nervous system with a brain and two main nerve cords.

BIOLOGY

Feeding

In the majority of species the cilia of the wheel organ create a water current that draws in microorganisms, microalgae and organic particles which are then directed into the mouth by rows of cilia. The tough outer shells of items such as diatoms are crushed by beautifully ornate, muscle-operated jaws called trophi, in the pharynx behind the mouth. The detailed structure of the trophi varies according to the diet and is used by taxonomists (who presumably have excellent eyesight and access to electron microscopes) to identify different groups and species of rotifers. Some species are predators and can extend their pharangeal jaws out through the mouth to secure their prey.

Life history

Much of the work on reproduction in rotifers has been done on freshwater species which frequently have to withstand dry periods or harsh winter conditions. This may be the reason that many habitually reproduce by parthenogenesis where females simply produce more females from unfertilised eggs, allowing large populations to build up quickly. In those species where males have been identified, they are usually much smaller, may not even feed and can be considered simply as sperm carriers. There is little information available on reproduction of marine rotifers. Those in the subclass Pararotatoria only reproduce sexually and have normal-sized males.

Much of the work done on rotifers has been on freshwater species such as this one.

PLACOZOANS

If you keep live corals and related animals in a marine tropical aquarium then you may also have *Trichoplax adhaerens*, the only recognised species in the phylum Placozoa. However, the easiest place to see one is undoubtedly in a marine laboratory where this tiny creature can be relatively easily cultured. In fact *Trichoplax* was first discovered by a sharp-eyed German zoologist in the late 19th century who noticed tiny flat organisms gliding along the glass walls of his laboratory aquarium in Austria. *Trichoplax* has been found in reef material collected from most warm and tropical areas including the Mediterranean, Caribbean, and Indian and Pacific Oceans. A few populations have been found and studied in the wild (by regular sampling) on tidal mangroves and stony beaches. These diverse populations may eventually be shown to be separate species.

Trichoplax wins the competition for the simplest free-living (i.e. non-parasitic) metazoan (multi-celled) animal. When viewed down a microscope it looks like a flat disc or plate just 2–3mm across and so thin that light shines through its body. As it moves it looks remarkably like a giant version of an amoeba (p.173) but made up of a few thousands of cells instead of a single one, which are arranged in three layers.

Trichoplax has no gut or organs. Instead the whole lower surface acts as a digestive blanket which breaks food down into nutrients externally and then absorbs the products. In the laboratory *Trichoplax* has been observed to draw up parts of the lower surface to form small chambers, effectively creating tiny temporary stomachs. In the wild it probably eats a variety of plant and animal material. It moves by gliding around using the cilia on its lower surface or by stretching out like an amoeba.

Asexual reproduction by binary fission (splitting in two) is the most common method of reproduction in placozoans but a single animal can also break up into several pieces or small hollow buds can be pinched off from the upper surface. These

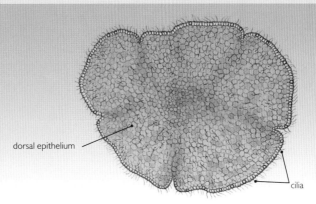

Structure of *Trichoplax adhaerens*.

bud balls later flatten and open up. Periodic sexual reproduction is probably necessary to maintain diversity.

Placozoans were once included in another phylum, the Mesozoa, which currently contains two classes of tiny microanimals, orthonectids (Orthonectida) and rhombozoans (Rhombozoa), of which the best known are dictyemids (Dictyemida). Mesozoans have both a free-living and a parasitic stage in their life history and it is possible that the sexually produced stage of *Trichoplax* might also be parasitic but there is currently no evidence for this.

CYCLIOPHORANS

It is always exciting when a new species is discovered, so imagine how pleased two Danish biologists must have been in 1995 when they found their new species was so different from anything else living that it had to be placed in a new phylum, Cycliophora. Their find, named *Symbion pandora*, was joined by one other species *S. americanus* in 2006 and others are likely to be found now that scientists know that they live attached to the mouthparts of lobsters. *S. pandora* lives on the Norway Lobster (*Nephrops norvegicus*) and *S. americanus* on the American Lobster (*Homarus americanus*). The discovery of these two tiny animals, less than half a millimetre long, may not fire the imagination as much as finding a new species of vertebrate, but it shows how much we still have to learn about the marine world.

Both *Symbion* species have a cocktail shaker-shaped body which is attached to the host by a short stalk ending in an adhesive disc. At the other end is a funnel-shaped mouth ringed by cilia. As the cilia beat they draw food particles into the funnel which leads into a U-shaped gut, with its exit (anus) near the mouth. The food comes from their hosts, leftovers and that's all this feeding stage does, until it comes to reproduction.

For such a tiny animal the life cycle is complex to say the least and must have taken many patient hours of microscopy to elucidate. The feeding stage individual is neither male nor female and can bud off new individuals within its body in a brood chamber. These can be of three types but all are non-feeding. The first type is a 'pandora' larva, which is released but quickly settles and develops into a new feeding-stage individual on the same lobster, so numbers rapidly build up. This is asexual reproduction. Sexual reproduction occurs when the host is about to moult, in which case of course, the feeding stages would be shed along with the lobster's shell. This involves a second

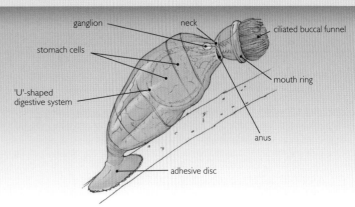

Structure of feeding stage individual of *Symbion pandora*.

larval type, the 'prometheus' larva. This is also released, but quickly attaches to a normal feeding-stage individual and produces from within itself one or two tiny dwarf males which escape to the outside. The third type is a female individual (not a larva) which also escapes from the feeding stage individual. Males find a female and fertilise her, probably as she is leaving the feeding stage. She finds a sheltered spot on the same lobster's mouthparts and turns into a cyst within which a fertilised egg hatches into a 'chordoid' larva. This stage is the one which finally leaves the original host, drifting off to find a new one (Obst and Funch 2003).

SPONGES

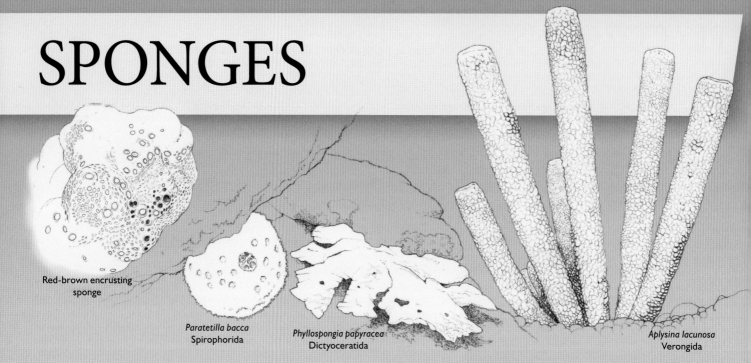

Red-brown encrusting sponge

Paratetilla bacca
Spirophorida

Phyllospongia papyracea
Dictyoceratida

Aplysina lacunosa
Verongida

Sponges (Porifera) are a very ancient group of animals and fossil sponges have been found in Cambrian rocks at least 580 million years old. In human terms the fibrous skeletons of certain species have been used for bathing since Greek and Roman times – and still are today in spite of their synthetic replacements. Even earlier uses have been traced back to the Bronze Age. Sponges are often beautiful and frequently bizarre but are overlooked and unrecognised by most people. This, however, is changing as more scuba divers and snorkellers recognise them as colourful photographic subjects. Scramble down a sea shore on a good spring tide, peer under rocks and overhanging curtains of seaweeds and you might well get your first glimpse of these primitive multicellular animals.

DISTRIBUTION

Sponges are found in all oceans from cold Antarctic waters to the tropics, wherever there are hard surfaces to which they can attach. Whilst they are commonest in shallow waters, especially in tropical areas, sponge communities are also a key component of deep-sea ecosystems. Most of the 8,500 or so species are marine, but a small number (under 200) occur in freshwater.

CLASSIFICATION AND IDENTIFICATION

Sponge classification is problematic and always has been. Once preserved, most lose their colour and shape and early classifications relied almost entirely on differences in skeletal components (see below). With the advent of underwater photography, there began the Herculean task of matching museum specimens, identified from their spicule complement, with their colourful live counterparts. Today sponge identification often still requires microscopic examination, because many sponges can grow in a wide variety of forms. Nevertheless with care, large common species can frequently be identified in the field in spite of numerous erroneously named sponge photographs in popular marine life guides. Traditionally, three classes of sponge have been recognised. Recent molecular analysis has confirmed a fourth class, the Homoscleromorpha, containing two families previously included in the Demospongiae (Gazave et al. 2010, 2012).

CLASS	SUBCLASS	ORDER
Calcarea	Calcaronea	Baerida
		Leucosolenida
		Lithonida
	Calcinea	Clathrinida
		Murrayonida
Demospongiae	Heteroscleromorpha	Clionaida
		Haplosclerida
		Poecilosclerida
		8 other orders
	Keratosa	Dendroceratida
		Dictyoceratida
	Verongimorpha	Chondrillida
		Chondrosiida
		Verongiida
Homoscleromorpha		Homosclerophorida
Hexactinellida	Amphidoscophora	Amphidoscosida
	Hexasterophora	Aulocalycoida
		Hexactinosida
		Lychniscosida
		Lyssacinosida

STRUCTURE

Sponges come in a bewildering variety of shapes, sizes and textures, and whilst some such as the Barrel Sponge (*Xestospongia testudinaria*) are instantly recognisable, many have no precisely defined shape or size. Instead, sponges are often described in broad terms such as encrusting, irregular lumps, branching, tube-shaped and so on. In many sponges, the shape is heavily influenced by substratum, water movement and surrounding habitat.

The body of a sponge is riddled with holes and channels and is essentially made up of an intricate system of water canals connecting small chambers. The chambers are lined by the choanoderm, a layer of specialised flagellated cells called choanocytes which are unique to sponges. As the choanocytes beat their small hair-like flagella, water is drawn into the sponge through small (10–100μm) pores or ostia all over the body, circulates via inward canals to the choanocyte chambers and exits via exhalent canals through larger holes, the oscula (singular osculum). This arrangement means that the flow of water is unidirectional. Some sponges can control the flow of water by varying their flagella beat and by partially closing off the oscula.

The Shredded Carrot Sponge *Amphilectus fucorum*, a common NE Atlantic shallow water sponge, is very variable in shape but with practise can be recognised from a combination of the colour, surface texture, osculum shape and (when collected) from its strong smell. Left: from sheltered site in the Channel Islands, UK. Right: from tide-exposed site in Norfolk, UK.

Spicule skeleton

With very few exceptions it would be most uncomfortable to wash with a sponge. This is because the majority of sponges are riddled with slivers of silica (SiO_2) or calcium carbonate ($CaCO_3$) which provide a supporting skeleton for the sponge tissue. Calcium carbonate is used only by the 650 or so sponges in the class Calcarea. The spicules vary in shape and size from tiny star-shapes to rods several millimetres long, and the spicule complement is species-specific. Most sponges belong to the class Demospongiae and in most of them the spicules are combined with a fibrous material called spongin (similar to collagen) which gives the sponge form and bulk. True bath sponges (such as *Spongia officinalis*) have a skeleton made only from this soft material. Sometimes the spicules can be seen projecting out from a sponge as tufts, or crowns to give it a prickly coating. A significant number of sponges have no spicules at all.

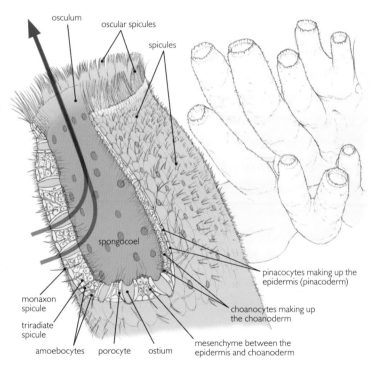

External and internal structure of a simple calcareous sponge *Leucosolenia*.

The outside of a sponge is protected by the pinacoderm, a layer of flattened epithelial cells called pinacoyces, and similar cells (endopinacocytes) line the water channels. The rest of the sponge between the pinacoderm and the water channels and choanocyte-lined chambers is filled with a gelatinous material called the mesohyl. Living within this are amoeba-like mesenchyme cells. This army of mobile working cells move around doing all the jobs performed by tissues and organs in more advanced animals. This includes secreting the skeleton (see below), carrying food and oxygen, storing and digesting food, and removing waste.

Glass sponges (Hexactinellida) have a rather different body plan in which there are few individual cells but instead strands of tissue with many nuclei supported on a complex lattice-like spicule skeleton.

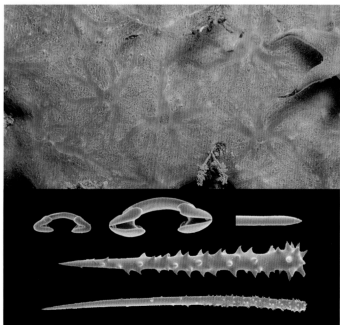

A NE Atlantic encrusting sponge *Hymedesmia peachi* plus a scanning electron microscope photograph of its spicules.

> ## NEW FROM OLD
>
> Some of the mesenchyme cells that move around within the body of a sponge are undifferentiated and can simply turn into whatever specialised cell type is needed at the time. These archaeocytes are described as totipotent and can become gametes, choanocytes, spicule-producing sclerocytes etc. This is one reason sponges are so good at regenerating damaged and missing parts. Taken to extremes, the cells of some sponges are able to re-group and grow into new individuals after the original sponge has been 'sieved' through fine-meshed cloth. Given the right conditions, the dissociated cells stick together in clumps and reorganise themselves into fully functional sponges.

BIOLOGY

Feeding

With very few exceptions sponges are filter feeders. Bacteria, single-celled algae and protozoa are dragged into the sponge with the water current produced by the choanocyte cells. The choanocytes trap food particles in a collar of tiny tentacle-like structures that surround the flagellum. As sponges have no gut or other organs the food is then engulfed by individual cells including the choanocytes. Wandering amoeboid cells (amoebocytes) engulf, digest and transport food (and oxygen) throughout the sponge. They can collect food particles accumulated by the choanocytes or catch them from the water coming in through the ostia. They can also receive food products initially engulfed by the choanocytes or other cells.

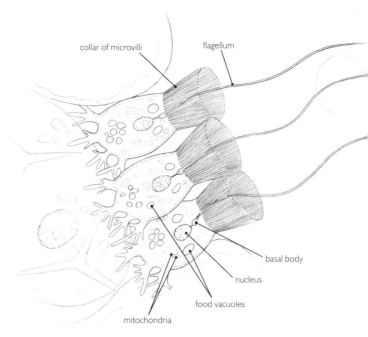

Collar cells or choanocytes of a sponge. Food particles are trapped on the outside of the collar as water is sucked in though the sides of the collar by the beating flagellum and passes out at the top.

Some shallow-water sponges contain symbiotic algae in their cells which provide additional nutrients for the sponge. On the shore, where there is plenty of light, the Breadcrumb Sponge, *Halichondria panicea*, is coloured green by these algae (left). In deeper water this sponge has no algae and is usually cream, yellow or tan coloured (right).

> ## CARNIVOROUS SPONGES
>
> On land some plants living in nutrient-poor habitats trap and digest insects and other small animals, an unusual strategy for a plant to say the least. In the deep sea where plankton is in short supply, some sponges follow a similar strategy and have become carnivorous. They catch small animals, usually crustaceans, by trapping them on protruding spicules, the equivalent perhaps of the sticky insect-catching hairs of a sundew plant (*Drosera* sp.), and digest them externally. Most carnivorous sponges belong to a single family of deep sea sponges, the Cladorhizidae. *Asbestopluma hypogea*, however, lives in shallow-water caves. Anything bumping into its long filaments is trapped by velcro-like spicules. Motile cells move in and cover and engulf tiny pieces of the prey (Vacelet and Duport 2004).

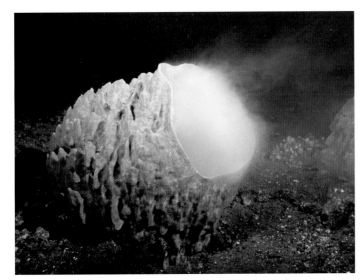

Giant Barrel Sponge (*Xestospongia testudinaria*) spawning in Bali, Indonesia. Sperm is released in a plume with water exiting from the osculum. This widespread Indo-Pacific sponge, is relatively constant in shape and so is easy to recognise.

methods, but is still poor. Many of the sponges making up these dense aggregations are large, slow-growing and long-lived, just as the cold water *Lophelia* coral reefs found in similar areas are. In the NE Atlantic, sponge grounds are found on the shelf plateau near the shelf break, and their distribution is related to the flow paths of the Norwegian Atlantic Current and the Irminger Current (Hogg et al. 2010).

Most sponges need a hard surface for attachment when their larvae settle onto the seabed. However, glass sponges (Hexactinellida) are able to live in soft deep-sea oozes by using a tuft of spicules up to 3m long as anchors. Whilst most sponges remain anchored in one spot after attachment, a few can adjust their position. The 'spiky' look of young ball sponges such as *Tethya seychellensis* is due to thin extensions of the body wall that reach out, attach to solid objects and contract dragging the sponge along at the vast rate of 10–15mm per day. A few sponges bore into calcareous rocks or shells and the holes they leave behind can in turn become miniature homes for other invertebrates. Boring species chemically etch holes and cracks into

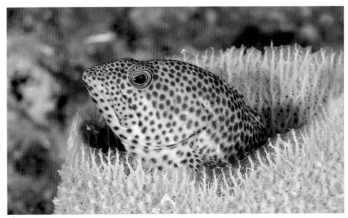

The many channels and holes found in sponges means that they provide ideal real estate for a wide variety of permanent and temporary residents, including bacteria, crustaceans, polychaete worms and molluscs. Here a grouper is hiding in a barrel sponge in the Caribbean.

Life history

Sponges employ a huge variety of reproductive methods which may be one of the reasons they are so successful and have survived for so long. Most species are hermaphrodite with eggs and sperm produced at different times. Sperm is released through an osculum, something that can be seen easily underwater, especially in tube sponges. It is drawn into another sponge with the normal ingoing water stream and the eggs are fertilised internally. The well-protected eggs develop into larvae of various types, commonly a solid ball of cells with an outer layer of flagellated cells. This is released through an osculum and swims for a short time before settling and attaching to something solid. So far this is a fairly familiar story, but the interesting bit is how the sperm get to the eggs. In essence they are captured and ingested by choanocyte cells in the same way as food particles. With the sperm safely onboard protected inside a vesicle, the choanocyte loses its flagellum and collar, moves through the sponge, attaches to an egg, transfers the sperm to it and then goes off to perform other duties. The eggs and sperm themselves are produced from undifferentiated archaeotype cells. Some sponges have separate sexes, some release their eggs for external fertilisation and some deepwater sponges synchronise spawning with annual falls of organic matter that follow seasonal plankton blooms.

Asexual reproduction is equally important. Many sponges can spread via buds and branches which separate off from the parent rather like runners from a grass. Broken and torn fragments can attach and grow, and sponges are famous for their ability to regenerate damaged and missing parts. Some sponges produce gemmules, little packages of undifferentiated cells protected by a coat of spicules. These can survive unfavourable conditions and are produced by all freshwater sponges. Some marine sponges use them as a means of dispersal.

Ecology

Sponges are an important component of many marine ecosystems but in some habitats they are the key component, much as corals are in a coral reef. Deep-sea sponge grounds are one such example and are now known to be reservoirs of high biodiversity, providing a habitat for numerous bottom-living fish and invertebrates including commercial species. Knowledge of the existence, distribution and ecological importance of these grounds is widening with advances in deepwater research

Some sponges use their chemical defences to gain living space. *Chalinula nematifera*, a purple encrusting sponge, has overgrown part of this coral killing it in the process. Corals have their own chemical defences and can usually prevent such invasions.

Mediterranean sponges for sale in a market.

which they grow, flaking off more material in the process. However, sponges produce a wide variety of chemical compounds, the main uses of which are to prevent sponges being eaten and to gain living space. Some of these chemicals may be produced by bacteria living within the sponges and according to McClintock and Baker (2001) sponges produce half of all the natural compounds that can be extracted from marine invertebrates. Hawksbill Turtles (*Eretmochelys imbricata*) and some nudibranchs are amongst the few animals that readily eat sponges.

Research into sponge ecology and distribution continues worldwide. However, with relatively few sponge experts, problems with taxonomy and consequent difficulties in identifying new species, this is no easy task.

USES, THREATS, STATUS AND MANAGEMENT

The harvest of marine sponges (*Spongia officinalis* and *Hippospongia* spp.) from the wild for use in bathing, car washing, cleaning and pottery, reached its peak in the early to mid 1900s. Today the industry is relatively small with total world capture of 352,386kg in 2010 (FAO 2012). In Greece the catch in 2010 was 4,000kg compared to around 100,000kg in 1959. Over-exploitation and disease are largely to blame. Small-scale bath sponge aquaculture on ropes and in nets using *Coscinoderma mathewsii* provides sustainable income for some communities in Micronesia.

A wide variety of sponge species have been screened for biologically active compounds with considerable success. Drugs derived from sponges are used as anti-bacterial agents, anti-inflammatories and in the fight against cancer. However, few have reached the clinical trial stage due to the difficulty and destructiveness of obtaining enough sponge material from the wild. Sea ranching and laboratory culture of sponge cells are helping solve this supply problem (Hadas *et al.* 2005).

Deep-sea sponge grounds are especially susceptible to trawling for deep-sea fish such as Orange Roughy (*Hoplostethus atlanticus*). The slow growth and great age of such sponges and the three-dimensional habitat they provide makes them and associated fauna especially vulnerable. Oil and gas exploration pose a similar threat.

SPONGE SPECIES: PHYLUM PORIFERA

Four classes of living sponges are currently recognised, based primarily on the chemical composition, size and shape categories of their spicules. This means that even with a photograph it is not possible to categorically assign an unknown sponge to a class without laboratory examination. However, 85% of the 8,500 or so described sponges belong to one class Demospongiae and with practice it is possible to pick out those likely to be calcareous sponges (Calcarea) in the field. Assigning unknown sponges to an order within each class is even more difficult for the non-expert. Classes and orders are shown in the classification diagram on p.210.

Calcareous sponges CALCAREA

Sponges in this class are shaped mostly like small (<10cm) vases, branched tubes or cushions and are usually white, fawn or yellow. The spicules are made of calcium carbonate and often include some with a characteristic shape of three (occasionally four) rays extending out from the centre. The majority are found on the shore and in shallow water. There are five accepted orders and around 680 species.

ORDER Clathrinida

Lemon Sponge *Leucetta chagosensis*

Features The vibrant yellow colour of this sponge makes it easy to spot underwater. It grows as individual or clumped sacs and is found on shaded and often steep areas of coral reef in the Indo-Pacific. This photograph was taken on Sipadan Island, Malaysia.
Size Up to about 20cm across.

ORDER Leucosolenida

Grantessa sp.

Features This small urn-shaped sponge is a delicate, attractive species found on coral reefs in the Indo-Pacific region. Densely packed spicules are clearly visible from the outside. It frequently appears in popular guides to Pacific reef invertebrates named as *Pericharax* sp. Museum examination of material collected by the author from Malaysia (Sabah) has identified it as an as yet undescribed species of *Grantessa*.
Size Up to about 5cm tall.

Demosponges DEMOSPONGIAE

Demosponges come in all shapes, colours and sizes. They have spicules made of silica dioxide and almost always a flexible spongin (p.211) skeleton made up of discrete fibres or in a looser arrangement binding the spicules (or both). The spicules are variously shaped, but fall into two distinct size categories, large supporting megasleres and tiny microscleres (<60μm). A few have no spicules but a substantial spongin skeleton, whilst some have no skeleton at all. The latter rely on fibrils of collagen, universally present in this class, to give them form. Twenty-two orders are listed on p.210 but the number of orders will continue to change in the light of current molecular studies and analysis of new collections.

ORDER Verongiida

Stove-pipe Sponge *Aplysina archeri*

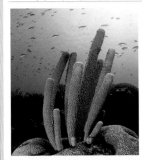

Features Tube and vase-shaped sponges are common on coral reefs. This species has soft, thin-walled tubes whose purple clusters brighten up deeper Caribbean reefs. Single tubes are not uncommon and a close look will show the pale inside colour of the sponge. During spawning it lives up to its name, releasing clouds of smoke-like sperm. It belongs to the order Verongida.
Size Up to 2m high.

ORDER Clionaida

Boring Sponge *Cliona celata*

Features In its massive form this is a conspicuous and easy to recognise NE Atlantic sponge, found from Scandinavia to the Mediterranean. The surface is covered in sieve-like papillae through which water enters the sponge. Exhalent oscula are clustered along ridges. The boring form is much less conspicuous, appearing as scattered papillae and oscula emerging from limestone rock and shells. It is a serious pest of oyster beds in some areas.
Size Up to 100cm across and 50cm high.

ORDER Poecilosclerida

Toxic Rope Sponge *Negombata magnifica*

Features This beautiful Red Sea sponge, previously known as *Latrunculia magnifica*, contains bioactive compounds called latrunculins which are being investigated as potential anti-cancer drugs. It can be successfully grown in sea ranches. These toxic compounds protect the sponge from predation. The sea slug *Chromodoris quadricolor* feeds on the sponge and assimilates the toxins for its own defensive purposes.
Size At least 60cm long

ORDER Haplosclerida

Pink Puffball Sponge *Oceanapia sagittaria*

Features With its thin stalk and delicate powder-puff top, it is difficult to tell that this is a sponge at all. The main body of the sponge is the 'stalk' which is usually buried in a crevice or anchored between corals or amongst coral debris. The lightweight 'powder-puff' top breaks off easily and can bounce along the seabed on water currents until it lodges and grows into another sponge. It is found in the western Pacific.
Size Up to 10cm high.

Glass sponges HEXACTINELLIDA

Glass sponges are commonly tube or vase-shaped, sometimes stalked, usually white and can grow to at least 1m high. The spicules often include hexactines which have six radiating rays made of silica and are often fused together to form a lattice framework which means they cannot retract like most sponges. They are restricted to deepwater between about 500m and 7,000m. There are six accepted orders and about 600 species..

ORDER Lyssacinosida

Yellow Picasso Sponge *Staurocalyptus* sp.

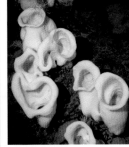

Features This photograph was taken at 1,330m on the Davidson seamount off California, USA using remote technology. This genus of glass sponges are shaped like open potato sacks or vases and have the pale to white colour typical of this sponge class. Two new species in the genus were described in 2013 from deep water in Alaska. Glass sponges grow well in areas where levels of silica, needed for their skeleton, are high, usually below 100m but as shallow as 8m in the Antarctic.
Size Up to about 25cm tall.

HOMOSCLEROMORPHA

The 100 or so sponges in the single order of this class have very small silica spicules or none at all, and they have a unique larva.

ORDER Homosclerophorida

Chicken Liver Sponge *Plakortis lita*

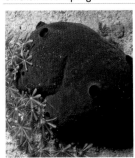

Features Closely resembling its common name, this sponge has a smooth velvety feel and is soft to the touch, a reflection of the lack of large spicules, a characteristic of all sponges in this class. It has the same dark brown colour inside and out. The author has frequently found this sponge near the base of coral slopes in Sabah, Borneo.
Size Lobes around 10–15cm across.

CNIDARIANS

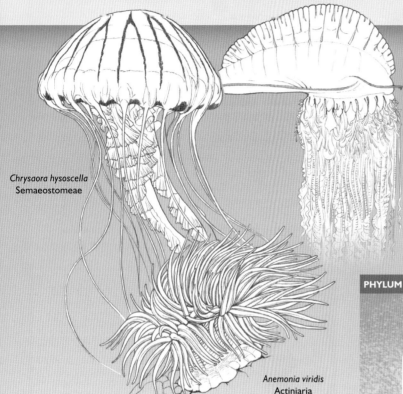

Chrysaora hysoscella
Semaeostomeae

Physalia physalis
Siphonophorae

Anemonia viridis
Actiniaria

The best known members of this colourful and ancient group (Cnidaria) of predominantly marine animals are the reef-building corals and the anemones. Jellyfish are also familiar cnidarians, highlighted for their ability to sting and in some cases even kill humans. Spectacular sea fans and soft corals are much admired by divers and snorkellers, whilst hydroids, often known as sea firs, are often unfairly ignored except by scientists and enthusiasts.

DISTRIBUTION

As with other large and diverse phyla it is difficult to calculate just how many species have been described and documented but there are certainly over 11,000. The majority of these are found in the ocean where the group has adapted to live both on the seabed, from the shore down to the abyssal depths, and also as drifters throughout the open ocean. Only a few hydroids, including the well-known *Hydra* and a number of small hydrozoan jellyfish have successfully colonised freshwater though a number of true jellyfish tolerate brackish conditions.

CLASSIFICATION

Cnidarians are the Coelenterates of old - the phylum was renamed when it was split into two phyla the Cnidaria, described here and the comb jellies Ctenophora (p.208). Five classes are now recognised, including box jellyfish and stalked jellyfish which were previously considered orders within the Class Scyphozoa (Cubomedusae and Stauromedusae respectively). A sixth class, Polypodiozoa is recognised by some authorities but the phylogenetic relationships of the single species *Polypodium hydriforme* in this group, are currently unclear and it may actually be an unusual hydrozoan. This fascinating little animal is parasitic within the eggs of sturgeon and some other freshwater fish and is not considered further here.

PHYLUM	CLASS	SUBCLASS	ORDER
CNIDARIA	Hydrozoa (hydroids)	Hydroidolina	Anthoathecata
			Leptothecata (syn. Thecata)
			Siphonophorae
		Trachylinae	Actinulida
			Limnomedusae
			Narcomedusae
			Trachymedusae
	Scyphozoa (jellyfish)	Coronamedusae	Coronatae
		Discomedusae	Rhizostomeae
			Semaeostomeae
	Cubozoa (box jellyfish)		Carybdeida
			Chirodropida
	Staurozoa (stalked jellyfish)		Stauromedusae
	Anthozoa	Hexacorallia	Actiniaria (sea anemones)
			Scleractinia (stony corals)
			Antipatharia (black and wire corals)
			Ceriantharia (tube anemones)
			Corallimorpharia (mushroom anemones)
			Zoantharia (zoanthids)
		Octocorallia	Alcyonacea (soft corals)
			Heliporacea (blue coral)
			Pennatulacea (sea pens)

STRUCTURE

Cnidarians come in a huge variety of shapes and sizes and in order to see why the giant Lion's Mane Jellyfish (*Cyanea capillata*), staghorn coral (*Acropora* spp.), the beautiful Dahlia Anemone (*Urticina felina*) and the fern-like Stinging Hydroid (*Aglaeophenia cupressina*) are all cnidarians, it is necessary to look closely at their anatomy. The single unique characteristic that is found in all cnidarians and no other phylum is the possession of specialised stinging cells called *cnidae*, more widely known as nematocysts. However nematocysts are not normally visible to the naked eye and although only a few species have a powerful enough sting to affect humans, touching them is probably not a sensible diagnostic test. Luckily the various groups of cnidarians share other characteristics.

The basic cnidarian body comes in two forms with fundamentally the same anatomy. The first is the polyp, a simple often cylindrical sac with a single opening at one end that is encircled by stinging tentacles. The latter are used both for defence and for catching food. Anemones are good examples of solitary polyps and show the structure clearly. However, many cnidarians, including corals and hydroids, are colonial and as such are made up of hundreds, thousands or even millions of tiny, genetically identical polyps all joined together and derived originally by division of a single basal polyp.

The second form is the medusa, typified by true jellyfish. A medusa can be thought of as an upside down polyp that has sagged into a bell or umbrella shape with the mouth and tentacles hanging down instead of facing upwards. This form suits a pelagic lifestyle and medusae drift with the ocean currents or swim by gentle pulsations of the bell. Some groups and species exhibit both body forms at different phases of their life cycle. For jellyfish the medusa is the main and often the only phase but some jellyfish also have a small fixed polyp phase as part of their life cycle (p.225). At the opposite end of the spectrum, the fixed polyp is the main phase for hydroids, but most also include a dispersive medusa phase in their life cycle. Corals and anemones spend their whole lives as polyps.

In both polyp and medusa the opening into the body cavity (coelenteron or gastric cavity) acts as mouth and anus and is surrounded by food-catching tentacles. The old name of Coelenterata for this phylum related to the fact that this body cavity is a digestive cavity – '*coel*' means hollow and '*enteron*' means gut. Whilst other groups such as bryozoans, tube worms and sea cucumbers also have food-collecting tentacles surrounding the mouth, only cnidarians have specialised stinging cells.

Whether polyp or medusa, the body wall is made up of two layers of cells: an outer protective epidermis and an inner digestive gastrodermis separated by a firm jelly-like material called the mesoglea. Both cell layers contain several types of cells specialised for different functions whilst the mesoglea contains few cells and is primarily for structural support. Its thickness and structure vary greatly between the different cnidarian classes.

Both polyp and medusa have a basic radial symmetrical with repeated similar parts arranged around a central body axis. If you were to cut a single anemone vertically through the axis which runs from the mouth (oral end) to the opposite side (aboral end), you would get two equal halves wherever you cut – rather like separating the segments of an orange. This is easy to see in an anemone or jellyfish but in colonial species such as sea fans and corals, the colony itself is not radially symmetrical, only the individual polyps and as a microscope is often needed to see the polyps, this characteristic is not always apparent at first sight.

Stinging cells

The name of the phylum is derived from a Greek word *knide* which means 'nettle', an apt name as anyone who has brushed through a nettle patch will know. Many of the epidermal cells that make up the outer layer covering a polyp's tentacles are stinging cells known as cnidocytes or nematocytes. Each cnidocyte contains a single cnida more commonly known as a nematocyst, a neatly packaged venomous dart in the form of a very thin, spirally coiled, hollow tube inverted into a fluid-filled capsule and closed off by a lid (operculum). Each stinging cell also has a hair-like projecting trigger called a cnidocil, actually a modified cilium. When this is touched or chemically stimulated, the lid of the nematocyst opens and the coiled tube instantaneously everts, stabbing into the victim. This is one of the fastest cellular processes known requiring only about three milliseconds in *Hydra attenuata* (Holstein and Tardent 1984). Not all nematocysts are venomous. Some are designed to snag the surface of the victim and hold onto it. The shape, form and function of nematocysts are species specific and can be used to help identification of difficult groups of cnidarians.

Hydroid medusa and hydoid polyp (*Obelia*).

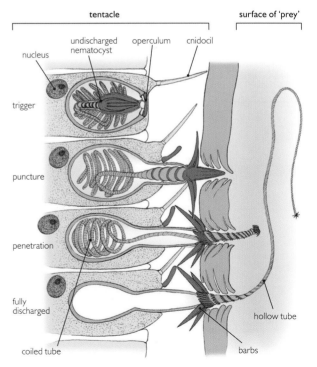

Discharge sequence of a cnidarian's cnidocyte.

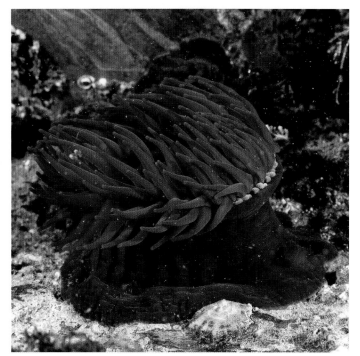

The 'beads' (accrorhagi) of this Beadlet Anemone (*Actinia equina*) show up well in this photograph. They are packed with stinging cells (cnidocytes).

Cnidocytes are not restricted to the tentacles and in some species of jellyfish and anemones, patches can be found all over the body. So picking a jellyfish up by its bell is not always safe. The pretty North Atlantic Beadlet Anemone (*Actinia equina*) has clusters of stinging cells arranged around the top of its column. These appear as bright blue beads, hence its common name, and are known as acrorhagi. They are the reason that these anemones are well-spaced out on the rocky shores and shallows they inhabit. Tentacle contact with a smaller neighbour stimulates the anemone to lean over and sting it with the acrorhagi, forcing the victim to crawl away or drop off the substratum.

Cnidarian venom

Considering the vast number and array of cnidarian species, only a very few are at all harmful to humans. A sting from most is just an annoyance, but some from jellyfish are virulent and a few such as the notorious box jellyfish can be life-threatening, so all jellyfish should be treated with caution. This also applies to hydrozoan 'jellyfish' such as the Portuguese Man-of-War (*Physalia physalis*) and to the hydrozoan fire corals (*Millepora* spp.) (p.192). Large anemones can also impart a significant sting.

Cnidarian venom is complex and often contains a diverse set of bioactive compounds. These include haemolysins, proteins that bind to red blood cells and make them 'leaky' and cardiotoxins that affect the heart in various ways. Some of these compounds may be specific to particular species whilst others may be common to different classes or even the entire phylum. Some compounds in box jellyfish venom have been shown to activate the same pain receptors (TRPV1) that respond to capsaicin in chilli peppers which may explain why many jellyfish stings result in a burning sensation (Cuypers *et al.* 2006).

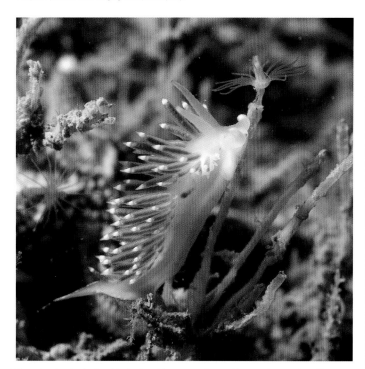

Even after the death of a cnidarian, its cnidocytes can live on. Many seaslugs, such as this aeolid (*Coryphella browni*) eat hydroids, anemones and soft corals and can store undischarged cnidocytes from their prey in their cerata (long processes) on the back, which then serve to protect their new owner.

Scientific name	Common name	Area
VERY DANGEROUS		
*Chironex fleckeri** (Cubozoa)	Box jellyfish, Sea Wasp	NE Australia
Carukia barnesi (Cubozoa)	Irukandji (some other box jellyfish are also called this)	Australia
DANGEROUS		
Potentially all Cubozoan jellyfish	Box jellyfish	Tropical and warm temperate regions
*Physalia physalis** & *P. utriculus* (Hydrozoa)	Portuguese Man-of-War or Blue Bottle	Tropical, subtropical and temperate (in summer) regions
Large specimens of *Cyanea* spp.* (Scyphozoa)	Lion's Mane Jellyfish	Worldwide
PAINFUL (sometimes dangerous)		
Carybdea spp. (Cubozoa)	Jimble, Small box jellyfish, Sea Wasp	Tropical, subtropical and warm temperate regions
*Pelagia noctiluca** (Scyphozoa)	Mauve Stinger	Warm and tropical regions
Millepora spp.*	Fire coral	Tropical regions
Actinodendron spp. (Anthozoa)	Burrowing anemone	Indo-Pacific
ANNOYING (sometimes painful)		
*Aglaophenia cupressina** (Hydrozoa)	Stinging hydroid	Indo-Pacific
Lytocarpus spp.	Stinging hydroid	Indo-Pacific
Broken off cnidarian tentacles	'Sea lice'	Worldwide

Notorious, common or widespread venomous cnidarians. (* = illustrated). Note: people vary in their reaction to jellyfish stings. Medical help should always be sought if a sting from any box jellyfish (Cubozoa) is suspected or if in any doubt.

HYDROIDS

The majority of hydroids (Hydrozoa) are small colonial animals that resemble plant growths and live attached to the seabed or other objects. They have as much beauty, style and colour as corals but just on a smaller scale, and can cover large areas of seabed, forming miniature forests. However, hydrozoans also include some colonies such as the well-known Portuguese Man-of-War (*Physalia* spp.), that float and drift on or near the surface of the ocean. Whether drifting or sessile the polyp is usually the dominant stage in the life history and is what we mostly see, whilst the drifting medusa stage is small and inconspicuous. A few hydroids exist only as medusae but in some cases this has turned out to be because the fixed polyp stage has not yet been identified. Some hydroids have no free medusa stage but have structures that represent vestigial medusae. The polyp and medusa stages of one species may have different scientific names because they were described separately before a link was made between the two.

DISTRIBUTION

Hydroids are a very successful class of cnidarians and can be found in all oceans from the shore to the abyssal depths. Their medusae are largely found in the plankton of the upper ocean layers. Hydroids, perhaps more than any other metazoan animal group, are nearly cosmopolitan in their distribution and many species are found right round the world in similar habitats. If you look closely enough you are likely to find a hydroid in almost every marine habitat in every ocean (Cantero 2004).

STRUCTURE

Although there are a few solitary hydroids with only a single large polyp, the vast majority are colonial. A typical colony consists of many erect branches, along which the polyps are arranged connected together by extensions of the body cavity. The branches are usually joined together at the base by horizontal stolons which also attach the colony to the seabed. There are many different growth forms from feathers and plumes to bushes and threads. In attached species the colony is protected by an inert exoskeleton, the perisarc, made primarily of chitin. Finely branched, delicate species are often surprisingly tough due to the perisarc. In thecate hydroids (order Leptothecata) this expands into a protective cup or hydrotheca around each polyp into which the feeding polyps can withdraw.

As well as the numerous feeding polyps (hydranths) there are specialised reproductive polyps called gonangia (singular gonangium) in which tiny hydromedusae are budded off asexually. These are either released or are vestigial and remain attached. Each hydranth is closed at the top by a mouth surrounded by tentacles, arranged in rings or scattered over the hydranth. The tentacles vary in shape, length and function. Some species also have specific defensive polyps called nematophores. These lack a mouth and have densely packed stinging nematocysts. Obviously the feeding polyps also provide protection and nematophores are usually found on stems and stolons where there are no feeding polyps. All this detail is only usually visible under the microscope as the polyps in most hydroids are less than 1mm long.

At 30–40cm high, *Nemertesia ramosa* is a large hydroid. This branched species flourishes in moderate tidal streams on shallow bedrock in the North Atlantic.

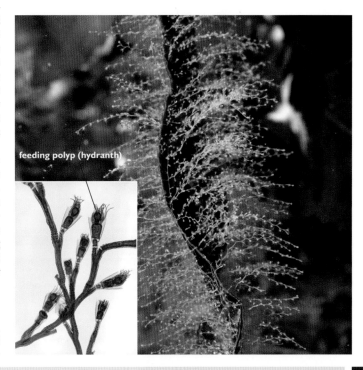

Kelp Fur (*Obelia geniculata*) is a common hydroid that grows on kelp throughout the Atlantic. It is also found in the Indo-Pacific region. The inset photomicrograph shows the detailed structure of part of a colony stained red. See also diagram on p.189.

Most hydroids can easily be recognised as such, but a few initially appear to be something quite different. Hydrocorals such as fire coral (*Millepora*), look like stony corals (Scleractinia) because they build a hard calcareous skeleton. Structurally the skeleton is much simpler than that of a coral and the polyps are typically hydrozoan. Each polyp lies in a cup-like pit in the skeleton and extends out through a tiny pore. The polyps are connected by epidermal tissue on the outside of the skeleton and by branching hollow strands of tissue that ramify through the skeleton. In effect these strands are equivalent to the stems and branches of normal hydroids. Medusae are produced in tiny rounded chambers and also escape through pores.

The stinging polyps of fire coral *Millepora* spp. can be seen as tiny projecting hairs which pack a powerful sting that results in an itchy red rash. Feeding polyps extend out through larger pores. Found on Caribbean and Indo-Pacific reefs *Millepora* species can be massive, branching or encrusting. Most are yellow-brown in colour with pale tips or projections.

Hydromedusae

Hydroid medusae are generally called hydromedusae to distinguish them from true jellyfish medusae and are usually small, (less than 5cm) transparent and delicate. Hydromedusae typically have a velum, which is a muscular girdle-like shelf that extends inwards from the bell edge, sometimes nearly closing the bell entrance. Sudden contractions of the bell force water out through the remaining space so that the hydromedusa swims forward with a kind of jerky jet propulsion. The velum is a useful identification feature as, with few exceptions, true scyphozoan jellyfish do not have one. In other respects they resemble jellyfish medusae (p.223) in having a variable number of tentacles around the bell edge and a mouth on the end of a dangling stalk, the manubrium. However, not all hydromedusae have a manubrium. Four radial canals (sometimes more) are usually visible and lead from the stomach to the edge of the bell where they join a circular ring canal. There is a simple nerve net in the ectoderm on the underside of the bell and a nerve ring around the bell margin. Statocysts (balance organs) are lined around the bell edge between the tentacles. Many hydromedusae also have swellings at the base of the tentacles called tentacular bulbs which are well supplied with sensory cells and are also where nematocysts are produced. The polyp stage also has a simple nerve net. Hydromedusae with a polyp stage are mostly Leptomedusae (order Leptothecata), which are saucer-shaped with gonads attached to the radial canals, or Anthomedusae (order Anthoathecata) which have a tall bell, eye spots at the tentacle bases, gonads attached to the manubrium and no statocysts.

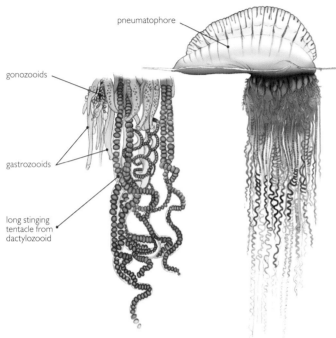

The Portuguese Man-of-War (*Physalia physalis*) is a siphonophore with a gas-filled float from which hang specialised polyps. Tentacles trail for tens of metres and can inflict a severe sting. It is common in the tropics but also found in the Mediterranean and warm temperate seas.

Siphonophores (order Siphonophorae) are often mistaken for jellyfish. Along with a few species from the order Anthoathecata (see below), they lead a pelagic existence. The polyp stage is adapted to allow them to float. So instead of an upright form with the polyps on branches, they have their feeding, reproductive and defensive polyps suspended in various configurations underneath a float. Some also have swimming bells beneath the float which can actively drag the colony along. These are derived from modified, retained asexual medusae that pulsate. Siphonophore colonies vary from the long thin strings of *Apolemia* to the large Cornish pasty-shaped floats and trailing tentacles of *Physalia*.

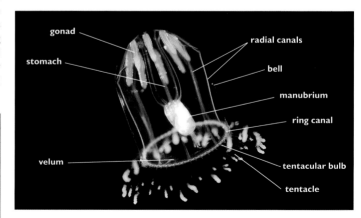

With its transparent body, *Aglantha digitale* (Trachymedusae) demonstrates the typical structure of a hydromedusa. Trachymedusae have no polyp stage.

Hydromedusa (hydroids)	Scyphomedusa (true jellyfish)
Has a velum	Does not have a velum
Gastric cavity simple sac with no septa (partitions)	Gastric cavity has septa
Gonads located on manubrium or radial canals	Gonads located in gastrodermis or on septa
No nematocysts in endoderm	Some nematocysts in endoderm – on gastric filaments
Mesoglea contains no cells	Some cells in mesoglea
Tentacular bulbs	No tentacular bulbs

Structural differences between the medusae of hydroids and true jellyfish.

BIOLOGY

Feeding

Hydroids are generally carnivorous. Each hydranth (feeding polyp) catches minute planktonic animals with its stinging tentacles and then passes them into its mouth. Small species may absorb dissolved organic matter (DOM) directly from the water. All the polyps in a hydroid colony are connected through extensions of the gastrovascular cavity running through stems and stolons. So if one eats, all can eat. Hydromedusae also feed passively simply catching what drifts within reach, but a few such as *Gonionemus*, show active feeding behaviour alternately swimming up and drifting down with tentacles spread wide. In spite of their stinging defences hydroids are the favourite prey of many seaslugs (nudibranchs).

Life history

As in true jellyfish (Scyphozoa), it is the medusa that is the sexual stage and therefore technically the adult even though it may be tiny and the fixed polyp stage large. The general story is that (hydro)medusae produce and release eggs or sperm, in separate individuals. The fertilised egg develops into a ciliated planula larva (p.54) which eventually settles on the seabed and grows into a new hydroid colony. When mature this produces hydromedusae by asexual budding within reproductive polyps (gonangia). There are, however, endless variations with different stages omitted as shown below.

REGENERATION

Turritopsis nutricula is a tiny hydroid with a very unusual ability. It is potentially immortal. Under normal conditions it has the typical hydroid life cycle. However, under stressful conditions, the sexually mature hydromedusae, which normally produce eggs and sperm, revert back to the juvenile polyp stage. The hydromedusa turns itself inside out, attaches to a rock and undergoes a reverse metamorphosis to a fully functional polyp. When conditions improve, the polyp buds off new medusae. This is the equivalent of a butterfly turning back into a caterpillar. Reverse development has also been described in a few other hydroids, jellyfish (Scyphozoa) and Anthozoans (Piraino et al. 2004).

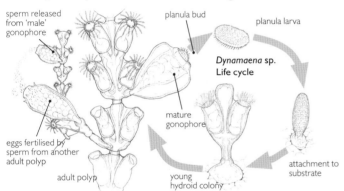

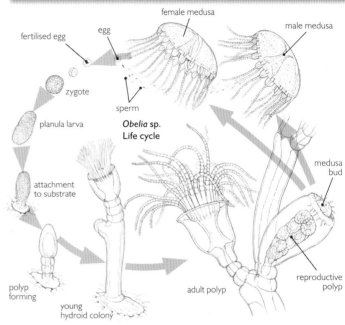

Species	Polyp phase	Free-swimming hydromedusa	Released eggs and sperm	Planktonic planula or actinula	Polyp phase	Free-swimming hydromedusa
Obelia	→	→	→	➤	→	
Hydractinia	→			➤	→	
Liriope		→	→	➤		→
Tubularia	→			➤	→	

Examples of the range of life cycles found in hydroids e.g. no polyp, no free medusa etc. (solid blue = planula; solid orange = actinula).

Ecology

In temperate European regions hydroids often form dense undergrowths in the circalittoral zone (p.92) along with bryozoans and sponges. These miniature forests provide a habitat and food for a wide variety of invertebrates. The richest growths are found in areas of high water movement such as straits and narrows, fuelled by a plentiful supply of water-borne plankton. In the tropics, fire coral *Millepora* spp. forms an important structural element of many shallow-water coral reefs.

Many hydromedusae make diel (24-hourly) vertical migrations, rising towards the surface at night and descending to deep, (up to several hundred metres) dark water during the day where they are relatively safe from visual predators.

USES, THREATS, STATUS AND MANAGEMENT

Hydroids form a significant part of the bio-fouling community the world over and will grow thickly on chains, ships hulls and oil rig legs all of which provide an elevated position in the water column. This has consequent financial implications for their removal. Hydromedusae can cause significant problems if accidentally introduced outside their native range. They can rapidly increase in numbers and out-compete fish larvae for food, especially in confined habitats such as estuaries.

HYDROID SPECIES: CLASS HYDROZOA

There are seven hydroid orders. The largest, the Anthoathecata (= Anthomedusae plus Athecata) are often called 'naked' hydroids because the hydranths (feeding polyps) do not have a protective cup (hydrotheca) into which they can withdraw. As well as typical attached forms this order includes the pelagic velellids and the calcareous fire corals (Milleporidae). The second largest order Leptothecata (= Leptomedusae plus Thecata) have hydranths with a protective hydrotheca. The order Siphonophorae contains only pelagic hydrozoans. Their medusae are retained and function as swimming floats and modified reproductive structures. The remaining minor orders are the Narcomedusae and Trachymedusae which have no polyp stage and inhabit open water; the Limnomedusae with solitary, reduced polyps, with only a few or even no tentacles and the Actinulida, tiny solitary hydroids that live freely between sand grains.

ORDER Anthoathecata

Oaten Pipe Hydroid *Tubularia indivisa*

Features This species has large polyps easily seen underwater. Each polyp has a single stem that arises from a tangle of stolons and has two whorls of tentacles between which are the reproductive structures (gonophores) looking like bunches of tiny grapes. It is common on current exposed rock faces and shipwrecks in the NE Atlantic. *T. larynx* is similar but grows as compact clumps because each stem branches near its base.
Size Up to 15cm tall.

Lace coral *Stylaster* sp.

Features Brightly coloured and often fan-shaped hydrozoans, with the polyps embedded in a hard calcareous matrix of brittle, tapering branches. Polyps extend from pores grouped on the outer edges of the branches. This unidentified species is common on coral reefs in the Indo-Pacific. There are about 85 *Stylaster* species found in all warm seas.
Size Variable, mostly a few centimetres tall.

Blue Buttons *Porpita porpita*

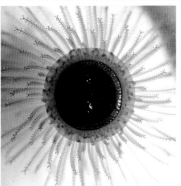

Features These extraordinary little colonies are kept afloat by a horny, chambered, gas-filled central disc, edged with what look like knobbed tentacles of various lengths. These are actually defensive stinging polyps. Reproductive polyps surround a single large feeding polyp on the underside which acts as a mouth for the whole colony. Found worldwide in warm waters, they are often washed up on the beach.
Size 2–8cm diameter.

ORDER Leptothecata

Stinging Hydroid *Aglaophenia cupressina*

Features This pretty feather-like hydroid grows up to 40cm high and is common on coral reefs in the Indo-Pacific. Brushing against the feathery fronds, results in a sharp sting and an itchy raised rash that may persist for up to a week. Gonangia (reproductive polyps) can be seen as small capsules along the side branches. The white stinging hydroid *Lytocarpus philippinus* is similar but less feathery.
Size About 35cm high.

Aequorea sp.

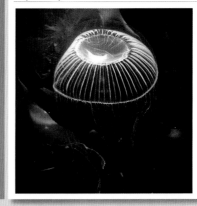

Features Whilst most hydroids have tiny medusae, *Aequorea* is the opposite with a large medusa and a tiny fixed polyp stage, which is only known from a few of the 22 species worldwide. The medusa has numerous radial canals (most hydromedusae have four), and a saucer-shaped disc. *Aequorea* is bioluminescent and its protein aequorin is used in cell research. The discovery of GFP (glowing green fluorescent protein) led to the Nobel prize in 2008.
Size Up to about 20cm diameter.

ORDER Siphonophorae

Physophora hydrostatica

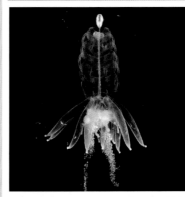

Features This beautiful siphonophore has a small gas-filled float at the top beneath which are several swimming bells that move it along in search of its zooplankton prey. A 'skirt' of finger-shaped dactylozooids heavily armed with nematocysts can give an unpleasant sting. Long clusters of feeding zooids hang beneath this plus long extensible tentacles (not visible here).
Size Up to 12cm plus trailing tentacles.

JELLYFISH

The term 'jellyfish' is widely used to encompass almost any jelly-like floating organism but here the term is used to mean true jellyfish (Scyphozoa) and box jellyfish (Cubozoa). Stalked jellyfish (Staurozoa) are also briefly described but general descriptions talking about 'jellyfish' (as in the next sentence) do not include them. In all jellyfish the medusa is the dominant and sometimes the only phase and in those species that do also have a temporary fixed polyp stage (the scyphistoma), it is usually small and inconspicuous. However, scyphistomae can occur in large numbers and cover extensive areas of rock or wrecks. Jellyfish medusae are well adapted to a pelagic existence and maintain their position up in the water column by rhythmic contractions of their bell-shaped body, using up very little energy in the process. Bell size varies from a couple of centimetres to over a metre.

DISTRIBUTION

True jellyfish are found throughout the ocean from the poles to the tropics and from the surface to the deep ocean but are prevalent in equatorial regions between about 45°N and 30°S. Box jellyfish are commonly found in tropical waters but also extend into temperate areas. Stalked jellyfish are mostly found in intertidal or shallow cold temperate waters in both hemispheres though a few occur in warmer waters. Amazingly, stalked jellyfish have also been found at hydrothermal vent sites on the East Pacific Rise (off the west coast of Central America), sometimes in large numbers (Lutz et al. 1998).

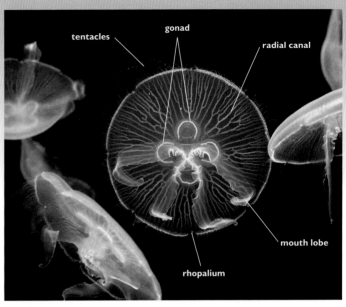

Aurelia aurita, a common and ubiquitous coastal jellyfish, is transparent enough to see most internal structures and has been widely studied. It has a very mild sting.

STRUCTURE

True jellyfish vary in shape from shallow saucers to tall bells with a variable number of peripheral tentacles and come in a surprising variety of colours. As their name suggests, box jellyfish have an almost square bell, usually only a few centimetres high, with tentacles hanging in four clusters from each corner. It is as well to be able to recognise them as even the small ones can inflict a dangerous sting. Small jellyfish can be confused with hydrozoan medusae but the latter are mostly tiny (see p.220 for differences). Some hydromedusae have a high bell shape and can look remarkably like small box jellyfish.

Stalked jellyfish, (not surprisingly) have a stalk by which they attach themselves to seaweed or sometimes to rocks and other objects. These pretty little animals look like a tiny, ornamented hand bell and hang suspended with their eight clusters of short, knobbed tentacles, held on extensions of the bell rim, spread out to catch passing prey.

In contrast to the other classes of cnidarians where the mesoglea is usually a thin filling in a sandwich of ectodermis and gastrodermis, the main bulk of a jellyfish is provided by the mesoglea. This in itself is mostly a non-cellular matrix but it is far from featureless and contains complex fibres and amoeboid cells. It is also riddled with a complex radial system of gastric canals. The mouth opens into the gastric cavity which itself extends into several (usually four) pouches. From each pouch narrow gastric canals radiate out and branches extend right to the edge of the bell. So a jellyfish is really one large diffuse stomach. (But then so are we as our gut is 5–12m long once unravelled). Tentacle-like gastric filaments project into the gastric pouches and secrete enzymes which partly digest the food. In coronate jellyfish (Coronatae) the gastric filaments (and gonads) are located on internal septa dividing the gastric cavity. Beating cilia distribute the food particles which are engulfed by the gastrodermal cells for final digestion. The mouth hangs down below the bell as a short tube, the manubrium which ends in four oral arms or mouth tentacles. The oral arms, which are often very ornate and decorative, have various functions including food capture (they are armed with nematocysts). A ciliated groove along each one helps to transport food into the mouth. In some species larvae are held in pouches in the oral arms for fertilisation or further development.

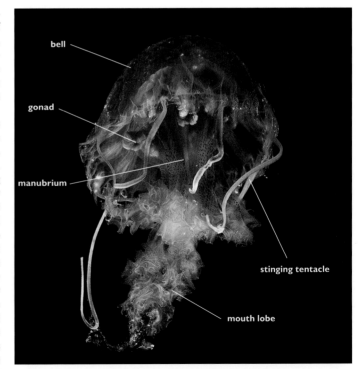

Pelagia noctiluca is a widespread coastal warm water jellyfish (Semastomeae). The red warts are concentrations of nematocysts and its long tentacles can inflict a powerful sting. Bioluminescent mucus produced on the bell surface makes them visible from boats and beaches at night.

Sensory systems

Jellyfish have no brain but they are by no means incapable of sensing and reacting to their environment. They have a simple nervous system consisting of rhopalia (sense organs), a motor nerve net and a diffuse nerve net. The motor nerve net reaches over the muscle sheets under the umbrella and controls the swimming action of the bell. As the muscles contract and the bell closes, water is expelled and provides a simple form of jet propulsion. When the muscles relax the elastic mesoglea springs back and returns the bell to its original 'open' shape. The diffuse nerve net works via an indirect pathway and ultimately controls the individual contractions of the feeding tentacles. Box jellyfish have an especially well developed nervous system with a nerve ring running around the margin of the bell and can control their movements much more precisely. Whilst there is still a lot to be understood about box jellyfish, this ring is thought to help coordinate their more complex visual, swimming and tentacle systems.

Sensory input is provided by the rhopalia (single rhopalium). There are usually eight of these distributed around the edges of the bell though box jellyfish have one in the middle of each of the four 'box' sides. Stalked jellyfish do not have rhopalia which would be of little use considering their sessile way of life. Each rhopalium consists of a simple balance organ the statocyst, simple pigmented eyes (ocelli) that detect light levels and sensory pits that detect food and chemicals. Statocysts in jellyfish (and hydrozoan medusae) contain one or more small solid statoliths. When a jellyfish tilts, these move and trigger nerve impulses via tiny sensitive hairs lining the statocyst. Nerve signals stimulate muscle cells to contract unequally around the bell so that more water is pushed out from one side or the other. Statocysts or similar structures are found in many different groups of animals but it is interesting that the statolith in jellyfish, which are themselves 90% water and live in water, is made of calcium sulphate hemihydrate, a dense hygroscopic biomineral. Ganglia near each rhopalium receive and distribute incoming sensory information and also act as pacemakers to control the rate at which the bell pulses.

The ocelli allow jellyfish to respond to light by moving towards or away from it. Those that feed during the day near the surface move towards brightly lit surface layers. Moon Jellyfish (*Aurelia aurita*) can also navigate using the sun as a directional source allowing them to congregate into vast swarms for breeding (Hamner *et al.* 1994).

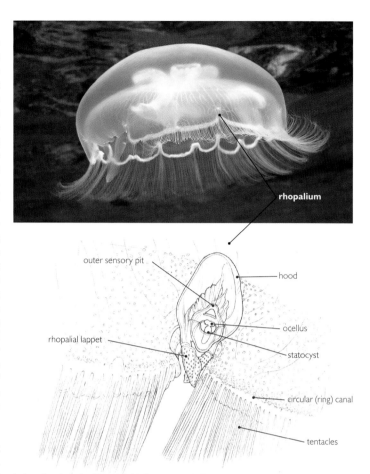

A rhopalium from the Moon Jellyfish (*Aurelia aurita*). These small sense organs are well supplied with nerves and provide information on orientation and light input.

THE EYES HAVE IT

Next time you bump into a box jellyfish, bear in mind it might be your fault and not the jellyfish's. The jellyfish may have seen you with some of its 24 eyes and tried to take avoiding action. In addition to two bilateral pairs of simple eyes (slit eyes and pit eyes) in each rhopalium, box jellyfish have a median pair of remarkably complex eyes with similarities to those of vertebrates. Each of these eyes has a cornea, lens and retina with sensory cells, and experiments and observations have shown that box jellyfish can see and actively avoid objects. They can also react to different colours of light (Gershwin and Dawes 2008). Recent research on *Tripedalia cystophora*, a Caribbean species, also suggests that box jellyfish can use their upper lens eyes to actively find their way around. *Tripedalia* lives amongst the prop roots in mangrove forests and uses a set of lens eyes designed to look up through the water surface to detect the mangrove canopy above it (Garm *et al.* 2011). These eyes constantly look upwards whatever the orientation of the jellyfish. If the jellyfish drifts or is moved outside the mangrove area it will swim back as long as the canopy is still within its visual range.

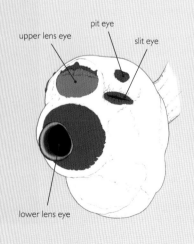
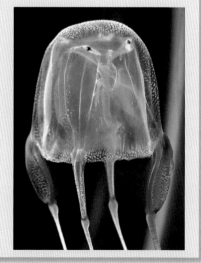

Box jellyfish rhopalium.

BIOLOGY

Feeding

Most jellyfish are predators and use their stinging tentacles to catch and subdue prey. The majority are not fussy and will take anything of an appropriate size that is unfortunate enough to swim or drift into their tentacles. Contraction of the tentacles brings the food up towards the mouth tentacles. From here the prey is passed into the gastric cavity. If the prey is still struggling in spite of the toxins from numerous stings, it can be further subdued and held by internal nematocysts on the gastric filaments. Fish are perhaps the most important item on the jellyfish menu which makes it rather surprising that some juvenile fish choose to live amongst jellyfish tentacles (p.500). Box jellyfish can reach speeds of 2 to 4 knots and appear capable of actively hunting their prey.

A few jellyfish including the ubiquitous *Aurelia*, augment their diet by trapping plankton using sticky mucus on the bell and mouth lobes. The plankton is transported over the bell and down into the mouth by cilia. The pinprick stings from an invisible source experienced by swimmers especially in tropical waters is due in part to sloughed off jellyfish mucus containing stinging cells.

Life history

Most jellyfish have separate sexes. Sexual cells are formed from gastrodermis and the gonads generally lie either in the floor of the gastric cavity or in coronate jellyfish, on the septa. In the Moon Jellyfish (*Aurelia aurita*), the gonads are visible through the translucent bell as four horseshoe-shaped structures, dark blue or purple in males (white when spawning) and (appropriately) pink in females. In most species sperm are shed into the water, exiting through the mouth. The eggs may also be shed at this stage and fertilised externally in the water column or caught up and fertilised in special pits in the oral arms as they exit. Some species retain the eggs inside the gastric cavity where they are fertilised by sperm drawn in from outside. Whichever happens, the fertilised eggs develop into small ciliated planula larvae. The next stage depends on the lifestyle of the jellyfish. In many coastal shallow-water jellyfish the planula larva swims down to the seabed and attaches to rocks or other hard objects. It then develops into a small polyp called a scyphistoma. These are usually found in extensive patches, because the original settled polyp buds off new polyps asexually usually from stolons extending out from its base. At some point, which may be days, months or years later, the polyp undergoes a process called strobilation, actually another form of asexual reproduction. The polyp elongates, re-absorbs its tentacles and develops a series of horizontal constrictions around its column, eventually resembling a fat, segmented worm or more prosaically a stack of coins. The 'coins' are in fact tiny medusae known as ephyrae each one of which is released in turn to drift off and develop into a sexually mature adult over the course of a few months to a couple of years depending on the species. As the medusa and polyp stages of jellyfish are so different, they were often classified as different animals until the connection between the two was worked out. The scyphistomae of *Nausithoe*, a coronate jellyfish, form a branched colony and were originally given the genus name of *Stephanoscypus* which is still widely used. The polyp stage is common in the Indo-Pacific growing on sponges and has surprised sponge researchers with its sting.

Species living away from the coast and in deep water frequently do not have a polyp phase. Instead the free-swimming planula larva develops directly into an ephyra which matures into the adult medusa as it drifts in the water column. Some deepsea species retain the planula larvae and brood them until they are fully developed and released as miniature medusae.

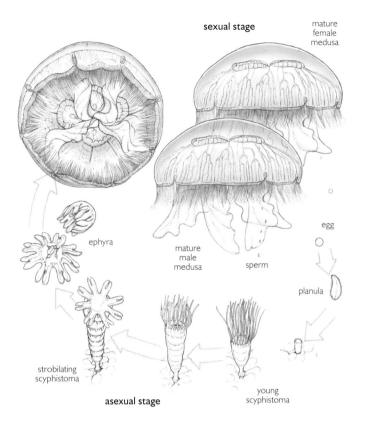

The life cycle of the Moon Jellyfish (*Aurelia aurita*).

The scyphistomae of Moon Jellyfish can cover large ares of shaded rock and could be easily be mistaken for hydroids.

Box jellyfish polyps are tiny (about 1mm high), very simple and do not produce ephyrae. Instead each one buds off new polyps asexually and the polyps metamorphose directly into the medusa stage. Stalked jellyfish can be considered as medusae but ones that remain fixed instead of drifting. Like true jellyfish they release eggs and sperm (from different individuals) and the fertilised eggs develop into planula larvae. These, however, have no cilia and cannot swim but creep around like tiny caterpillars. They asexually bud new planulae which are thought to form cysts in unfavourable conditions sometimes remaining like this for several months before finally becoming minute fixed polyps. These metamorphose directly into the adult form. Stalked jellyfish are common on seaweeds on the shore in summer but can rarely be found in winter. Many are presumably washed away along with the seaweed they are attached to, especially if they are growing on annual red seaweeds.

The sac-like gonads of this stalked jellyfish *Haliclystus octoradiatus* filled with eggs, are visible arranged alongside the gut. Also clearly visible are the knobbed hollow feeding tentacles bunched at the end of each arm and a single large primary tentacle (anchor) on the bell margin between.

Example species	Order	Development phases	Habitat and distribution
Pelagia noctiluca	Semaeostomeae	Medusa only	Oceanic
Aurelia aurita	Semaeostomeae	Polyp and medusa	Coastal
Rhizostoma pulmo	Rhizostomeae	Polyp and medusa	Coastal
Periphylla periphylla	Coronatae	Medusa only	Deepsea

Development in Scyphozoan jellyfish. Within all three scyphozoan orders, species without access to shallow water generally do not have a fixed polyp stage.

USES, THREATS, STATUS AND MANAGEMENT

Jellyfish are exploited as food in some parts of the world, especially southeast Asia where semi-dried jellyfish is a multi-million dollar business. The main commercial species are rhizostome jellyfish, for example *Rhopilema esculentum*. The Cannonball Jellyfish (*Stomolophus meleagris*) is exploited in the USA. Worldwide the commercial catch of jellyfish was about 239,000 tonnes in 2009 (FAO statistics). Jellyfish are a major food source for the Leatherback Turtle and in the UK and elsewhere tracking jellyfish aggregations helps to predict turtles distribution.

Stinging jellyfish can cause losses to the tourist industry when popular bathing beaches are closed as happens in Northern Australia during the box jellyfish season (about November to May). The large Australian *Chironex fleckeri* is known to have caused deaths and other species are suspected to have done so. Jellyfish blooms can cause significant problems as they clog fishing nets and water intakes to power stations as well as fouling beaches. Torness nuclear power station in Scotland has been closed many times due to jellyfish blooms (Gershwin 2013). Blooms occur naturally when currents and winds aggregate them, and when conditions are particularly favourable for growth and reproduction. The frequency and extent of such blooms may be increasing worldwide as a result of overfishing, ocean warming, pollution and other stressors (Gershwin 2013). Overfishing results in less competition for food whilst warming and eutrophication may lower oxygen levels. Jellyfish will tolerate such conditions better than fish.

A noticeboard in Sabah, Borneo warns swimmers that jellyfish are about. Even when no jellyfish can be seen, tiny medusae or bits from broken tentacles can cause irritating pinprick stings to swimmers.

JELLYFISH SPECIES: CLASSES SCYPHOZOA, CUBOZOA AND STAUROZOA

Around 200 species of true jellyfish (Scyphozoa) have been described and are classified into 3 orders. The order Semaestomeae (3 families) includes many of the more familiar jellyfish such as the ubiquitous Moon Jellyfish (*Aurelia aurita*), the giant Lion's Mane Jellyfish *Cyanea* spp. and the Purple Stinger (*Pelagia noctiluca*). The order Rhizostomae (10 families) are mostly found in the warmer waters of the tropics and subtropics. The Coronatae (6 families) are mostly deepsea species some of which have now been filmed. Box jellyfish (Cubozoa) are divided into two orders Carybdeida and Chirodropida with seven families between them and about 37 species. There are only about 50 species of stalked jellyfish (Staurozoa) in one order Stauromedusae (6 families).

CLASS Scyphozoa

ORDER Semaeostomeae

Compass Jellyfish *Chrysaora hysoscella*

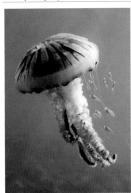

Features Semaeostome jellyfish have bowl-shaped bells with a gently scalloped margin. Four long, frilled mouth lobes extend down from the mouth beneath the bell and the marginal tentacles vary greatly in length and number. *Chrysaora* is translucent with V-shaped, brown radiating lines on the bell and 24 marginal tentacles. The sting is painful but not normally dangerous. Common in the NE Atlantic. Other species in this genus are known as Sea nettles e.g. *C. quinquecirrha* off east coast North America.
Size Bell up to 30cm; tentacles up to 60cm long.

ORDER Coronatae

Crown Jellyfish *Periphylla periphylla*

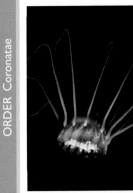

Features Coronate jellyfish have a distinctive two-part bell which is encircled by a groove giving them the appearance of a crown or a flamboyant hat. A deeply scalloped bell edge with vertical grooves running up to the encircling groove adds to the design and most have relatively few tentacles. Most live in the deep sea and are red. *Periphylla* is also bioluminescent. If attacked it gives a remarkable light show in an effort to attract a larger predator to eat its own attacker. It is found in every ocean except the Arctic.
Size Bell up to 35cm high.

ORDER Rhizostomeae

Barrel Jellyfish *Rhizostoma pulmo*

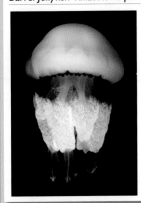

Features Rhizostome jellyfish have thick, firm, bells and a neat appearance because there are no marginal tentacles. Eight fused mouth lobes hang beneath the bell and in most these have free ends armed with nematocysts. The lobes have many tiny mouth openings the size of which restricts their food to small organisms. These lead into a series of canals which disgorge into the gastric cavity. *Rhizostoma* has a dome-shaped, opaque, white bell with a coloured margin. Its sting is variable, stronger when breeding. Mediterranean and temperate North Atlantic.
Size Bell up to 1m; no tentacles.

CLASS Cubozoa

ORDER Chirodropida

Australian Box Jellyfish *Chironex fleckeri*

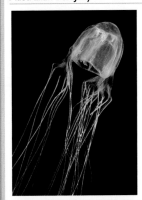

Features *Chironex* is the largest and most dangerous box jelly, with an excruciating sting responsible for at least 77 human deaths since 1884. It is common along shores in NE Australia and extends north to Papua New Guinea, Malaysia and the Philippines. Young medusae are common amongst mangroves and are washed out along coasts by monsoon rains in December or earlier.
Size Bell up to 30cm; tentacles to at least 2m.

Upsidedown Jellyfish *Cassiopea andromeda*

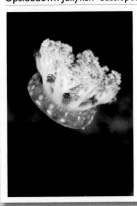

Features *Cassiopea* is an unusual rhizostome jellyfish, usually seen by divers lying upside down on the seabed, pulsing gently with its large, branched mouth arms held up into the water. The mouth arms are edged with numerous tiny bladders containing photosynthetic zooxanthellae (see p.234). The sting is mild but causes an intensely itchy rash. *C. xamachana* which inhabits coastal mangroves and reefs in the Gulf of Mexico and Caribbean may be the same species.
Size Bell up to 30cm; tentacles none.

CLASS Staurozoa

ORDER Stauromedusae

Stalked Jellyfish *Lucernariopsis campanulata*

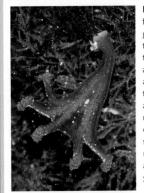

Features Stalked jellyfish vary in shape from the more usual bells to urns and goblets. Species are distinguished by the arrangement of the arms and their tentacle bunches and the presence, or absence of eight modified tentacles called anchors situated one between each of the feeding tentacle clusters. Species such as *Haliclystus* with anchors (p.198), can move in a somersault fashion by bending over to temporarily attach the bell to the substratum. The animal then releases and repositions its stalk. *Lucernariopsis* has no anchors and cannot re-position itself.
Size Up to 5cm high.

SOFT CORALS AND SEA FANS (OCTOCORALS)

Octocorals (Octocorallia) are colonial animals resembling colourful underwater plants which live permanently attached to the seabed. They are amongst the most flamboyant and decorative of all seabed animals. Along with corals and anemones they belong to the cnidarian class Anthozoa and like all anthozoans they have no medusa stage. As well as the familiar soft corals and sea fans (Alcyonacea) there are two other main groups (orders) of octocorals. Sea pens (Pennatulacea) are restricted to soft muddy seabeds and make a visit to such unpromising terrain a real delight. Blue corals (Helioporacea) are a small relict group which, unusually for octocorals, have a hard skeleton and superficially resemble stony corals. Our knowledge and appreciation of octocorals has greatly expanded since the advent of modern scuba diving. Early work was all based on trawled and often mangled specimens, pickled in alcohol and deposited in museums around the world. Classification relied heavily on the shape and form of the microscopic 'sclerites' that form the skeleton. This is still important today but is now also combined with living form and shape. Sea fans are particularly difficult to identify from shape and colour alone, and modern DNA techniques are now helping to sort out the still far from complete taxonomy of this exciting but difficult group.

DISTRIBUTION

Octocorals are found worldwide in all oceans from the intertidal to the abyssal depths. However, by far the greatest biodiversity is found in the shallow waters of the tropical Indo-Pacific, which supports at least 90 genera. In contrast there are less than ten genera within diving depths in the temperate coastal waters of the UK with just a handful more in deeper water.

STRUCTURE

The term 'soft corals' is used to describe the softer octocorals in the order Alcyonacea. These come in a wide range of shapes and sizes from a single polyp (one deepwater species in its own genus) to others with a few tiny polyps connected by stolons, to lumpy masses, umbrellas, fingers and graceful arborescent bushes all with many thousands of polyps. Sea fans on the other hand are generally more rigid and form branching colonies mostly less than a metre tall but with some species over 3m. In some classifications sea fans are given a separate order the Gorgonacea and are often referred to as gorgonians, but there are many intermediate types linking soft corals and sea fans. Many sea fans are genuinely fan-shaped, growing in one plane but there are also whips, tangles and bushes. The polyps are arranged along the branches. 'Classic' sea pens resemble a feather or an old-fashioned quill pen in shape, but there are many variations. Each colony has a central stalk (the 'shaft' of the feather) formed from the single primary or axial polyp. The lower part forms an anchor in sediment whilst the upper part has numerous other polyps along its length and on side branches (the 'plume' of the feather).

The single feature that unites all octocorals is that individual polyps have eight tentacles, each of which has a single row (sometimes more) of small branches one along each side. The technical term is 'pinnate', but they often look like and are described as 'feathery'. Octocoral colonies vary in shape and form according to their way of life and can sometimes vary within a species according to habitat and conditions.

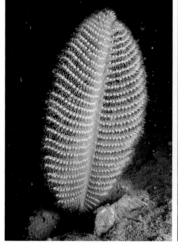
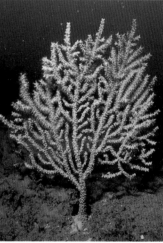

British octocorals. Soft coral *Alcyonium glomeratum* (top); sea pen *Pennatula phosphorea* (left); sea fan *Eunicella verrucosa* (right).

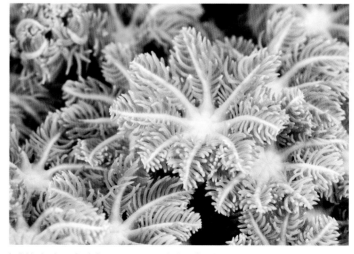

Individual polyps of a shallow-water, zooxanthellate *Clavularia* species.

Skeleton

In the majority of octocorals, the body is given substance and some structure by sclerites, tiny slivers of calcium carbonate embedded in the common body or coenchyme of the colony. These vary in shape, size and colour between species and are important in octocoral classification and identification. Sea fans have additional support and are held up by an internal 'skeleton' that forms the central axis of each branch. This is made primarily from a tough but flexible material similar to horn called gorgonin. Others also have dense sclerites or amorphous calcium carbonate incorporated in their axes. A thin layer of living material (coenenchyme) incorporating the polyps covers the skeleton. The sclerites are embedded in this material. In contrast many soft corals, especially those with few sclerites, rely on hydrostatic pressure to support them rather like a water bed. When the colony is active, water is pumped into a canal system through the mouths of the polyps, the colony expands and the polyps are held up in the water column where they can feed.

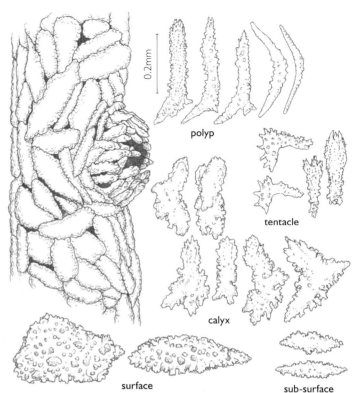

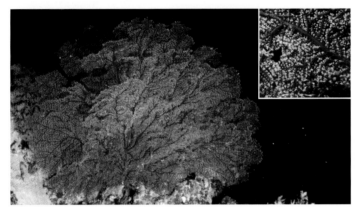

A small piece snipped from this sea fan by the author in the Semporna Islands, Sabah, Borneo, provided sclerites that confirmed it as a species of *Paracis*. The sclerites of this genus are shown redrawn from Fabricius and Alderslade 2001.

BIOLOGY

Feeding

Most octocorals are suspension feeders. With polyps expanded and tentacles held out, a colony forms an efficient collecting 'net'. A 'field' of large sea fans all orientated across the prevailing current to maximise their catchment area, is quite a sight. Octocorals have very small and simple nematocysts incapable of stinging humans and only able to subdue small zooplankton. The feathery tentacles can however, also trap phytoplankton, bacteria and dead organic matter. A few soft corals, such as some *Xenia* species, open and close their tentacles in a pulsating rhythm – a beautiful sight on a shallow, sunlit reef. This may help create a feeding and respiration current but exactly why they pulsate is not known.

Most octocorals have only one type of polyp called the autozooid which captures food and is also involved in sexual reproduction. A few of the larger genera have a second, much smaller type of non-feeding polyp the siphonozooid scattered between the feeding polyps. Their primary function seems to be uptake of water into the colony but they may have other functions and are also useful to biologists in soft coral identification. The genus *Lobophytum* can be distinguished from often similar species of *Sinularia* because unlike the latter, it has numerous siphonozooids. These look like small dots on the colony surface between the larger feeding polyps. Shallow-water octocorals such as *Sarcophyton* and the sea fan *Rumphella* are often a dull greeny-grey colour because they play host to photosynthetic zooxanthellae. These satisfy some of their food requirements though significantly less than the zooxanthellae in stony corals.

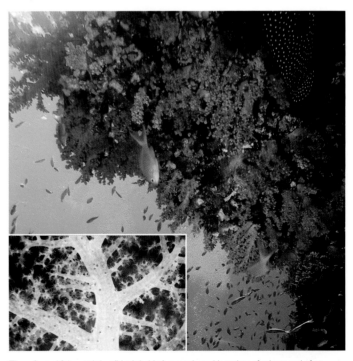

The soft coral *Scleronephthya* (Nephtheidae) comes in a wide variety of colours and often covers steep reefs forming a soft coral 'garden'. When expanded (inset) the supporting sclerites can be seen through the body wall.

Life history

Octocorals have perfected the asexual technique of reproduction and can spread locally using a wide range of runners, fragments, buds and splitting techniques. This allows some species to colonise and spread rapidly over coral reef areas damaged by blast-fishing, storms and other phenomena. It also means that many species are easy to propagate in aquaria. A miniature forest of the seawhip Junceella fragilis can grow up on a reef when the delicate tips break off, attach to the seabed and grow into new individuals.

Sexual reproduction in octocorals follows the familiar cnidarian pattern where the fertilised egg develops into a planktonic planula larva. After drifting for a few days or weeks the larva settles and develops into a founder polyp. The colony develops by division of this original polyp. The majority of octocorals have separate male and female colonies and the gonads develop on mesenteries that hang down like curtains within each polyp. Whilst many species broadcast eggs and sperm into the water, others, including most sea fans (gorgonians), release sperm but retain the eggs which are fertilised in situ and in some species, the resultant larvae are brooded internally.

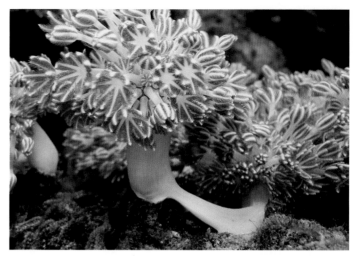

Soft coral colonies are often found in groups as they spread asexually. In this *Xenia* species, a new colony has developed on a stolon extending from the base of the colony and will eventually separate completely from the parent.

Ecology

By their very nature, octocorals do not form reefs in the way that stony corals do. However, under suitable conditions they can dominate large areas of seabed. On coral reefs damaged by fish blasting, soft corals often overgrow dead hard corals and prevent reef regeneration (Wood and Dipper 2008). Some soft corals such as *Sinularia* produce spiculite, a dense base of spicules that can build up over time to form a type of reef on which other animals can grow (Jeng et al. 2011). In contrast to the other octocoral orders, the sea pens (Pennatulacea) are adapted and restricted to living in soft sediment. Recently however, fascinating high quality photos from ROVs have shown deepwater sea pens living attached to rock by a suction cup modified from the stalk base (Williams and Alderslade 2011).

Octocorals themselves are home to a wide variety of small invertebrates and fish, often extremely well camouflaged to resemble their hosts. It takes a really observant diver to spot a pygmy seahorse amongst the branches of a sea fan where it spends its whole life. Brittlestars, sea slugs, allied and spindle cowries, small crabs and shrimps and sea anemones are all know to make their homes on octocorals. Other associates are not so beneficial and fleshy soft corals in particular often have large chunks missing where they have been eaten by molluscs such as egg cowries (Ovulidae).

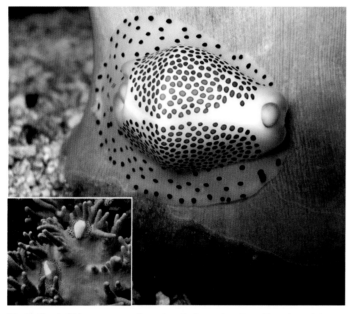

The Egg Cowrie (*Calpurnus verrucosus*), seen here feeding on the soft coral *Sarcophyton*, belongs to a large family of molluscs that feed on anemones and octocorals.

Octocoral species	Inhabiting species	Notes
Primnoid octocoral *Candidella imbricata*	Scale worm *Gorgoniapolynoa caeciliae*	Deepsea
Chrysogorgiid octocoral *Metallogorgia melanotrichos*	Brittlestar *Ophiocreas oedipus*	Atlantic and Pacific
Soft coral *Dendronepthya* spp.	Dendronepthya crab *Holophrys oatesii*	Indo-Pacific
Soft coral *Chironepthya* spp.	Red-faced squat lobster *Galathea* sp.	Eyes resemble retracted polyps
Sea fan *Leptogorgia virgulata*	Barnacle *Conopea galeata* and Atlantic Pearl Oyster *Pteria colymbus*	Western South Atlantic
Sea fan *Melithaea* and other red and yellow sea fans	Shrimp *Hamodactylus* sp.	Indo-Pacific
Sea fans (various)	Allied cowries Ovulidae	Tropical
Sea fans (various)	Spindle cowries Ovulidae	Tropical
Sea fan *Eunicella verrucosa*	Sea slug *Tritonia nilsodhneri*	NE Atlantic
Sea fans *Eunicella verrucosa* and *Swiftia pallida*	Sea Fan Anemone *Amphianthus dohrnii*	NE Atlantic
Sea fan *Muricella*	Pygmy seahorse *Hippocampus bargabanti*	Western central Pacific

Examples of the wide variety of commensal animals that live only and permanently on octocorals.

USES, THREATS, STATUS AND MANAGEMENT

Octocorals (along with sponges and corals) are exploited in the search for bioactive compounds for potential use as drugs and anti-fouling paint because they produce a range of chemicals to protect themselves from grazers and to restrict overgrowth from other sessile species. Live octocorals are collected for the aquarium trade and sea fans for dried souvenirs. Over-collection has caused local extinctions especially of slow-growing, long-lived species. The relentless trade for the spectacular red coral *Corallium* led to the collapse of many populations in the Mediterranean and western Pacific within a few years of their discovery. Unusually for an octocoral it has a hard skeleton which is fashioned into jewellery. *Corallium* has some local protection, but is not yet listed on CITES. Some octocorals are easily grown from fragments and have the potential to be successfully propagated and sustainably sourced. Conversely an unintentional result of deepwater trawling for Orange Roughy (*Hoplostethus atlanticus*) in the NE Atlantic is that it regularly brings up huge sea fans hundreds of years old.

Necklaces (left) fashioned from *Corallium rubrum* (above) and some other corals, can be found for sale in many parts of the world.

SOFT CORAL AND SEA FAN SPECIES: CLASS ANTHOZOA, SUBCLASS OCTOCORALLIA

Soft corals and sea fans can be very difficult to identify to species level, especially underwater, and many can only be identified by microscopic analysis of their sclerites. Therefore, not surprisingly, the classification of octocorals is currently still in a state of flux and diving scientists regularly find new genera and species. *Orangaslia dipperae* was named after the author who discovered it in Sabah, Malaysia (Alderslade 2001). It is accepted that there are at least three orders of octocorals, the main one being the Alcyonacea, soft corals and sea fans (gorgonians). This system, with both the soft corals and sea fans in the same order, was proposed by Bayer (1981) because re-working of museum material and discovery of new species showed intermediates between the several orders previously used in, for example George and George (1979). Further work may yet result in re-division of the Alcyonacea. The Pennatulacea (sea pens) and Helioporacea (blue corals) are distinct orders.

Orange Sea Pen *Ptilosarcus gurneyi*

ORDER Pennatulacea
FAMILY Virgulariidae

Features Any diver swimming across a monotonous sediment plain should be delighted to see this beautiful sea pen. The polyps are held on leaf-like branches on the side facing into the prevailing current to maximize feeding opportunities. If conditions become unfavourable the strong, bulbous stem can retract and pull the animal down into the sediment. Found below 10m depth in sand and mud along the Pacific coast of North America.
Size Up to 50cm high.

Blue Coral *Heliopora coerulea*

ORDER Helioporacea
FAMILY Helioporidae

Features This is the only species of *Heliopora* and with its massive calcium carbonate skeleton it superficially resembles stony coral amongst which it grows as upright bluish or brownish plates or fingers. Broken fragments clearly show the distinctive blue skeleton. It is widespread in shallow water in the Indo-Pacific but is listed as Vulnerable in the IUCN Red List (IUCN 2014).
Size Can reach several metres across.

ORDER Alcyonacea

FAMILY Alcyoniidae

Dead Man's Fingers *Alcyonium digitatum*

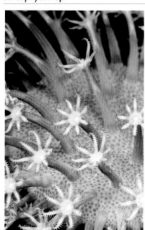

Features Soft corals and sea fans prefer warm waters and this is the only really common soft coral found around the UK. Two other soft coral species and two sea fans also occur here. *A. digitatum* grows as fleshy, lobed, white or orange colonies on sublittoral rocks in the North Atlantic especially in current-swept areas. The polyps can withdraw completely and in the autumn and winter they remain contracted and the colony is inactive. This species grows best where there are strong currents or waves to bring food to it. Can live for at least 25 years.
Size Up to 25cm high.

FAMILY Alcyoniidae

Sarcophyton sp.

Features *Sarcophyton* soft corals tend to look like toadstools as they have a definite stalk topped by a disc-like head which bears the polyps. In older individuals and large species this is usually folded and wavy around the edges. The polyps can completely retract leaving a smooth, leather-like surface with pin-prick spots.
Size Up to 1m diameter.

FAMILY Tubiporidae

Organ Pipe Coral *Tubipora musica*

Features This is an unusual soft coral as it has a skeleton of closely packed red tubes joined together by cross bars. It grows on coral reefs in the Indo-Pacific as rounded clumps, with each tube housing a single polyp. When the tentacles are out, the distinctive skeleton is hidden and it is difficult to distinguish it from other soft corals such as *Clavularia*. The skeleton is made into jewellery and local populations are sometimes over exploited. Small pieces can often be found washed up on tropical shores and retain their beautiful red colour.
Size Colonies to several metres.

FAMILY Nidaliidae

Chironephthya sp.

Features Arborescent octocorals are very common and decorate most Indo-Pacific reefs with their varied colours. They are not easy to identify underwater. *Chironepthya* species are stiff and often brittle unlike the similarly shaped *Dendronepthya* and *Scleronepthya* (photo on p.201). This is because their outer wall is packed with large calcareous spicules which give the colony support. The branches are often a different colour to the polyps as can be seen here and species of *Chironephthya* come in a variety of other bright colours.
Size Varied, up to about 50cm high.

ORDER Alcyonacea

FAMILY Subergorgiidae

Giant Sea Fan *Annella mollis*

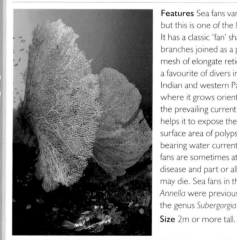

Features Sea fans vary hugely in size but this is one of the largest species. It has a classic 'fan' shape with the branches joined as a pink or orange mesh of elongate reticulations. It is a favourite of divers in the Red Sea, Indian and western Pacific Oceans where it grows orientated across the prevailing current direction. This helps it to expose the maximum surface area of polyps to the food-bearing water currents. These sea fans are sometimes attacked by disease and part or all of the colony may die. Sea fans in the genus *Annella* were previously included in the genus *Subergorgia*.
Size 2m or more tall.

FAMILY Gorgoniidae

Sea plume *Antillogorgia* sp. (previously *Pseudopterogorgia*)

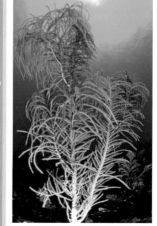

Features This genus of nine species is found on Caribbean reefs, their tall feathery fronds waving gently with the sea swell or streaming out in the currents. This one is probably *A. elisabethae*. *Antillogorgia bipinnata* is relatively stiff with branchlets in opposite pairs whilst the largest species *A. acerosa* looks more like a collection of feather boas. A close look at the branches will often show up a Flamingo Tongue, actually a small commensal mollusc *Cyphoma gibbosum* (p.236). In shallow, sheltered water extensive thickets of Sea plumes may develop.
Size Up to about 2m tall.

STONY CORALS & ANEMONES (HEXACORALS)

Early Victorian naturalists in Britain were fascinated by corals and anemones which they considered to be plants – not surprising since many resemble colourful flowers, ferns and bushes attached to the seabed. In 1860 Philip Henry Gosse, an English naturalist, published *British Sea-anemones and Corals* bringing their vibrant colours to a fascinated public long before the advent of scuba diving and underwater photography. Now, 150 or so years later, corals are one of the best studied of all cnidarians and the reefs they form are the basis of a multi-million dollar tourist industry. Coral reefs as a habitat are described in Environments and Ecosystems (p.94). Anemones live a solitary life as single large polyps, whilst most corals form large colonies with many anemone-like polyps protected by a complex hard exoskeleton. As in all anthozoans, there is no medusa stage. Stony corals and anemones are the two largest and ecologically the most important orders of hexacorallian anthozoans and so are considered in detail here. Tube anemones (cerianthids) and black corals (antipatharians) are also included in the Hexacorallia but are very different from the other hexacorallian orders and may warrant subclass status.

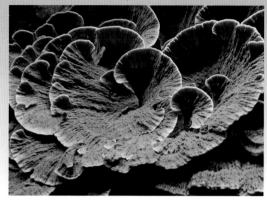

Whilst the skeleton of the hard coral *Montipora* is obvious, the living polyps are all but invisible at less than 1mm across.

DISTRIBUTION

The majority of stony corals and all reef-building (hermatypic) species, are restricted to warm, shallow waters in the tropics mostly between 30°N and 30°S of the Equator (see map on p.94). Within this zone corals are absent from areas along the west coasts of Africa and South America which are bathed by cold ocean currents and wherever substantial rivers bring large amounts of silt into the ocean. Non reef-building (ahermatypic) species have no such restriction and are found in all oceans albeit they are usually small and inconspicuous. On rocky surfaces in the deep ocean, cold-water corals such as *Lophelia* can grow as dense thickets and even form reefs but these are extremely slow-growing and very different from tropical coral reefs. Anemones are found worldwide at all depths.

STRUCTURE

At first sight corals and anemones look very different from each other. However, an anemone and a single coral polyp are structurally very similar although the latter are usually tiny compared to the former. Both have simple unbranched tentacles and these are usually arranged in multiples of six hence the name Hexacorallia. However

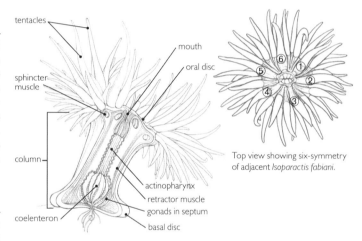

Top view showing six-symmetry of adjacent *Isoparactis fabiani*.

Left: longitudinal section of *Isoparactis fabiani*. Right: disc and tentacles of a hexamerous anemone showing two inner rings of six tentacles. The following rings double up each time (12, 24 etc.). Some anemones have a ten-symmetry. Many are irregular due to asexual splitting.

this fundamental feature is not the way most people will recognise an anemone or a coral. The larger anemones at least are relatively easy to recognise as such without bothering to count the tentacles, in spite of the fact that many of them are rather good at contracting their cylindrical, columnar body down to resemble a blob of jelly. A flat oral disc at the top of the column has a slit-like mouth in the centre surrounded by circlets of tentacles. The arrangement and colour of the disc and tentacles are important for species identification though colour can vary. The base of the anemone forms a sucker-like disc or in the case of burrowing forms expands into a bulb shape that anchors the animal.

In most corals it is difficult to see the polyps at all, let alone count their tentacles and it is their hard skeleton with its thin veneer of living tissue that defines them. Corals come in an amazing variety of shapes and sizes, from tiny solitary cup corals to massive brain corals. Many genera and species have well-defined shapes but others vary under different environmental conditions. The most common growth forms are massive (solid lumps with similar dimensions in all directions), branching, arborescent (tree-like), columnar, plate-like, laminar and encrusting.

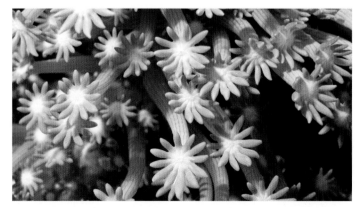

Unusually for hard corals, *Alveopora* has large polyps in which the hexamerous arrangement of twelve tentacles (6 × 2) is clear. The stripes on the column indicate the matching internal mesenteries.

STONY CORALS AND ANEMONES

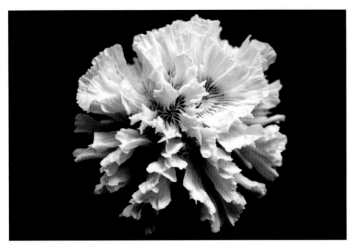

After cleaning and drying coral skeletons can be stored for taxonomic use.

BIOLOGY

Feeding

Anemones catch and eat a wide variety of prey depending on their size and stinging ability. Large anemones can cope with small fish, prawns and even jellyfish and sea urchins. Once inside the gastric cavity, still struggling prey can be further subdued by nematocysts on the edges of the septa before being digested. Digestion within the gastric cavity is only partial and is completed once the material has been taken up by the gastrodermal cells. Coral polyps are in general only capable of catching zooplankton but will also eat any detrital material that comes their way. After capture by coral tentacles, food is mostly carried into the mouth by the action of numerous beating cilia rather than being pushed in as in anemones. Most corals polyps expand and unfurl their tentacles at night when coral-nibbling fish are inactive. This is when the vibrant colours of a coral reef are at their best. Reef-building corals cannot catch enough food to build and maintain their massive skeletons and gain a large part of their nutrition from symbiotic algae in their tissues (see Zooxanthellae below).

Internally (in all anthozoans) the mouth leads into the body cavity (coelenteron) via a short tube called the actinopharynx. The coelenteron is divided into compartments by vertical mesenteries that hang down like curtains but are perforated to allow free circulation of fluids. This gives a large surface area for digestion and respiration. Water for respiration and for inflating the polyp is drawn in by cilia lining one, or sometimes two grooves running down the actinopharynx.

Coral skeletons

The intricate design, beauty and strength of coral skeletons have been known and appreciated for hundreds of years and this has led to their widespread collection for decoration, building and production of lime. The skeleton is entirely external although it may not seem so as the coral flesh is draped closely over every lump, blade and bump. Each polyp has its own little skeleton cup called a corallite into which it can withdraw. The cup is really the top of a tube with vertical plates (septa) that radiate out from the centre and help support the polyp's internal mesenteries. In a few genera the septa join at the centre of the corallite, but in most corals the inner edge of each septum ends in fine projections which form a tangled mass called the columella. The corallites are joined together by horizontal plates and other skeletal elements and all these structures between the corallites are collectively called the coenosteum. Coral skeletons have long been the basis for coral taxonomy and identification and in many cases remain important for identification to species level.

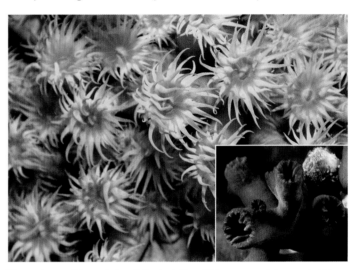

The true beauty of the tropical corals *Dendrophyllia* and *Tubastrea* can only be seen at night when they extend their tentacles. The inset shows retracted polyps during the daytime. These two coral genera form small colonies in shaded areas and have no zooxanthellae (ahermatypic) and they are very difficult to tell apart.

Zooxanthellae

Imagine being able to sit back, relax and have your food manufactured for you inside your own body. This is what many stony corals and a selection of other cnidarians including some anemones, octocorals and jellyfish, are able to do. Reef-building (hermatypic) corals harbour single-celled, photosynthetic dinoflagellates (p.152) called zooxanthellae within their gastrodermal cells. The coral uses the photosynthetic products of the zooxanthellae as an energy source, enabling hermatypic corals to build their massive skeletons. In turn the coral provides a safe, stable environment and the carbon dioxide, nitrogen and phosphorus (from its own waste products) that the zooxanthellae need for photosynthesis. How much of the coral's carbon supply comes from zooxanthellae varies between species and under different light regimes but can be as high as 95%. This relationship has always been considered as a mutually beneficial one, but recent discussions have postulated that the zooxanthellae are enslaved by corals (Wooldridge 2010). This theory suggests they are attracted chemically, captured and 'eaten', then imprisoned within membranes in the gastrodermal cells and their reproduction controlled. Under stress zooxanthellae can die, or be expelled leading to coral bleaching (p.27).

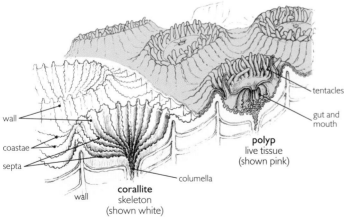

Structure of typical coral polyps showing the relationship between the living polyp and its corallite skeleton.

Life history

Corals and anemones practise both asexual and sexual reproduction. Large clusters of anemones are produced when individuals simply divide longitudinally. Some species, such as the Plumose Anemone (*Metridium senile*) fragment around the basal disc, each fragment subsequently developing into a tiny anemone. Coral polyps naturally divide in order to form a colony but in addition, coral fragments, especially of fast-growing genera such as *Acropora*, can develop into whole new colonies provided they lodge in a stable position. This ability is exploited in 'coral farms' where fragments are collected by divers and cemented onto plates. Once the corals have grown they can be used for regenerating damaged reefs or sold for aquarium use. Methods for the artificial propagation of corals are continually being developed and refined. As a coral colony grows, polyps can either divide into two or more daughter polyps (called intratentacular budding) or new polyps develop from one side of a polyp and grow into the space between other corallites (called extratentacular budding).

In sexual reproduction in corals and anemones (and all hexacorallians), eggs or sperm or both in hermaphrodite species, (which is the usual case in corals) are produced within the mesoglea of the mesenteries within the body cavity. When ripe, these are shed through the mouth and fertilisation occurs externally. The eggs develop into planula larvae which eventually settle and develop into a new anemone or coral polyp. Some anemone and coral species retain and brood their eggs, first drawing sperm in through the mouth. Anemones then release juveniles and corals release advanced planula larvae through the mouth. Fertilised anemone eggs can alternatively settle in brood pits on the outside around the basal disc.

Many reef-building corals practise synchronous spawning to ensure fertilisation. This amazing phenomenon is a great attraction to divers in places such as the Great Barrier Reef of Australia, and also attracts fish and larger predators to what is for them a veritable feast of food. Triggered by rising temperatures, eggs and sperm are released at night in late spring a few days after the full moon. Each species may have slightly different and often very precise timings. Hermaphroditic species package eggs and sperm together for release and eggs are also often supplied with a starter pack of zooxanthellae.

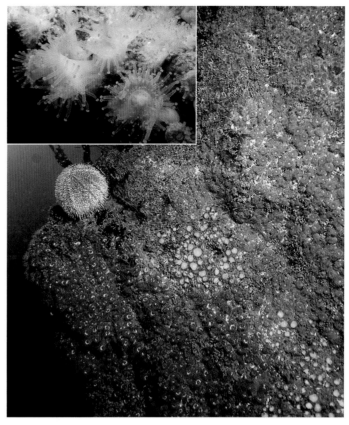

Jewel Anemones *Corynactis viridis* (order Corallimorpharia) divide by longitudinal fission and so form densely packed groups of genetically identical, same-coloured clones.

Ecology

The great majority of corals grow within tropical coral reefs, which form one of the most important and biodiverse ecosystems in the ocean. Whilst almost all stony corals require a hard substratum to attach to, a few species such as *Fungia* live unattached. Corals will fight for their living space using chemical warfare and their stinging tentacles to avoid overgrowth by other corals and sponges. Anemones will do the same and often space themselves out by stinging their neighbours even if they are the same species. Exceptions are genetically identical clones produced by asexual splitting.

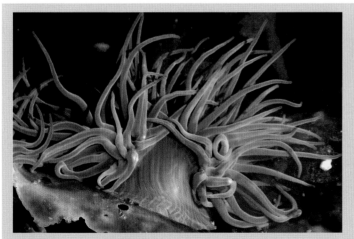 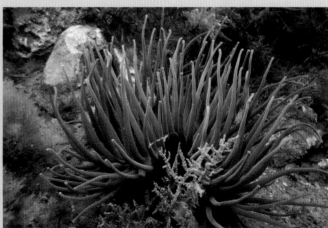

Anemonia viridis (left) in sunlit intertidal pool appearing green due to contained zooxanthellae; (right) on shaded sublittoral rock appearing brown without zooxanthellae.

Anemones live attached to hard objects but some live in soft sediments. Tube anemones (cerianthids) build their own parchment-like tubes. A few anemones are commensals (p.499) and live permanently on hermit crab shells hitching a free ride. Most anemones can move slowly along on their muscular basal disc and some can swim short distances by muscular jerks of their extended column. *Stomphia coccinea* and others in the family Actinostolidae, swim in response to contact with predators such as starfish and nudibranchs. There are no truly pelagic anemones though some drift at certain times after their normal larval phase (Riemann-Zürneck 1998). Perhaps the most unusual habitat so far found for an anemone is for *Anthosactis pearseae* found in a whale carcass in the Pacific Ocean at 3000m (Daly and Gusmao 2007).

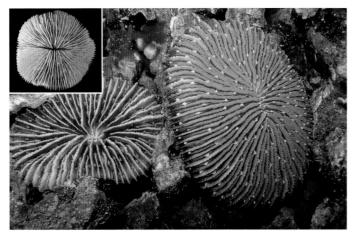

Mushroom corals are solitary free-living single polyp corals. When young they are attached to the seabed by a short stalk, but soon break off. They can right themselves if turned upside down and can even move very slowly from place to place.

USES, THREATS, STATUS AND MANAGEMENT

Coral reefs provide an income and livelihood to millions of people and contribute to the economies of many nations through fishing, export of reef products and tourism. Reefs also provide protection to coastal areas during storms and tsunamis. Corals and anemones are widely collected and traded internationally for use in aquaria, as curios, for jewellery (especially antipatharians) and for pharmaceutical research. Man-made threats to reefs include blast and cyanide fishing, coastal development and land run-off from logging and farming. Corals are also susceptible to coral bleaching with rising sea temperatures resulting from climate change. Increased levels of carbon dioxide are leading to ocean acidification (p.25) which is a serious threat as it interferes with calcification. Outbreaks of Crown-of-Thorns Starfish (*Acanthaster planci*) which eats coral, can be very destructive.

Data on the status of coral reefs around the world is compiled biennially by the Global Coral Reef Monitoring Network (Wilkinson 2008). International trade in stony corals and their products is controlled under Appendix II of CITES (p.517) and an export permit is required. Marine Protected Areas (p.502) provide an important way of protecting coral reefs.

CORAL IDENTIFICATION

Corals vary so much in their shape and growth forms under different conditions that identification even to genus level can be daunting. However, the publication of the three volume *Corals of the World* (Veron 2000) with in situ photographs of live corals as well as details of the cleaned skeleton, now provides a wonderful reference. This is arranged taxonomically and so is not easy for field biologists or diving naturalists to use as a first step. A recent publication, the *Coral Finder Indo Pacific* (Kelley 2012), a waterproof guide designed to be used underwater is a huge step forward. It allows identification to genus level based on field characteristics and with some practice and training can be used with confidence even by complete beginners.

STONY CORAL AND ANEMONE SPECIES: CLASS ANTHOZOA, SUBCLASS HEXACORALLIA

There are currently six orders within the sub-class Hexacorallia of which the stony corals (Scleractinia) and anemones (Actiniaria) are the two largest groups. Corallimorpharians (Corallimorpharia) are closely related to stony corals and are sometimes confusingly called mushroom corals, a name also given to some free-living stony corals. Zoanthids (Zoantharia) are colonial anemones with the individuals joined together to varying degrees. Tube anemones (Ceriantharia) live in soft sediment with the column inside a felt or parchment-like tube of mucus and discharged nematocyst threads, mixed with mud. Black corals (Antipatharia) superficially resemble sea fans and seawhips and grow as bushes, feathery plumes, fans and single whips.

Magnificent Sea Anemone *Heteractis magnifica*

ORDER Actiniaria
FAMILY Stichodactylidae

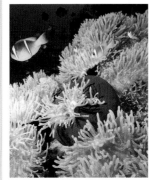

Features Situated in exposed, prominent positions on Indo-Pacific reefs, the column of this striking anemone varies in colour from green to violet often with contrasting tentacles. Whilst it can be found singly, this anemone also occurs in large groups, an impressive sight that results from asexual reproduction. It plays host to 12 different anemonefish.

Size Usually 0.3–0.5m diameter; up to 1m.

Staghorn coral *Acropora* sp.

ORDER Scleractinia
FAMILY Acroporidae

Features *Acropora* is the most diverse and numerous of all stony coral genera with at least 180 species found throughout the Indo-Pacific and Caribbean. It has numerous branches and the most usual growth forms are tables, plates and thickets. The actively growing branch tips are often a paler colour. *Acropora* is the only genus to have an axial corallite – a large corallite at the growing tip of each branch clearly visible in the inset.

Size Indeterminate.

ORDER Scleractinia • FAMILY Faviidae

Brain coral *Diploria* sp.

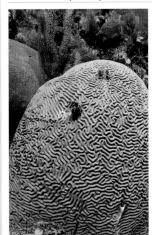

Features Many different genera and species of brain corals are found throughout the tropics. These massive corals tend to grow as rounded colonies and have the polyps arranged in meandering rows that resemble the folds of a brain. *Diploria* is a Caribbean genus common on shallow reefs. Brain corals grow very slowly and large ones can be centuries old. One (of a different species *Colpophyllia natans*) in Tobago is over 5m across and 3m high.
Size Very variable, large.

ORDER Zoanthidea • FAMILY Parazoanthidae

Yellow Cluster Anemone *Parazoanthus axinellae*

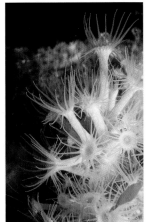

Features Zoanthids are joined together at their bases and differ internally from true anemones in the arrangement of their mesenteries. On coral reefs they will rapidly colonise empty spaces and grow over damaged corals. *P. axinellae* adorns shaded, steep rocky areas at about 5–100m in the NE Atlantic and Mediterranean. Each polyp has a slender column widening out to a disc edged with two circles of tentacles. The inner tentacles are characteristically help upright whilst the outer are held horizontally.
Size Polyps up to 1.5cm tall.

FAMILY Faviidae

Devonshire Cup Coral *Caryophyllia smithii*

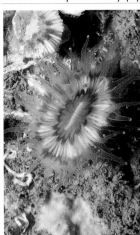

Features This fingernail-sized coral is a typical example of shallow water temperate corals, the majority of which are solitary and consist of a single polyp. At first sight, cup corals can easily be mistaken for anemones but when the knobbed tentacles are contracted the skeleton is obvious. In this close up photograph it can be seen through the covering translucent tissues. This species is highly variable in colour, but usually with a contrasting zigzag pattern ringing the mouth. It occurs from the Mediterranean to mid Norway.
Size Up to 3cm diameter.

ORDER Ceriantharia • FAMILY Cerianthidae

Tube anemone *Cerianthus* sp.

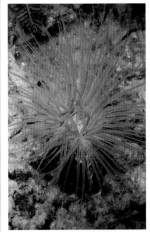

Features Photographing tube anemones is difficult as they instantly withdraw into their tube at the slightest vibration. They have two types of tentacles; short labial tentacles around the mouth (green in the illustrated species) and long, slender marginal tentacles around the disc edge. The larval stage (arachnactis larva) is very different from the planula larva of other hexacorals. *Cerianthus* is a common genus worldwide and the one shown is common in muddy patches on coral reefs in Malaysia.
Size This specimen is about 10cm diameter.

ORDER Corallimorpharia • FAMILY Discosomatidae

Elephant Ear Anemone *Amplexidiscus fenestrafer*

Features Corallimorpharians are disc-shaped with short tentacles that end in small knobs and are mainly tropical. Small fish straying onto the disc of *Amplexidiscus* are likely to end up as dinner. The disc edges fold up around the prey enveloping it in a fish bowl trap. Short stubby tentacles restrain and break up the prey. Most other similar species simply catch plankton and particulate matter. This species adorns reefs in the Indo-Pacific.
Size The largest known corallimorpharian, up to at least 30cm across.

ORDER Antipatharia • FAMILY Antipathidae

Black coral *Antipathes* sp.

Features Black corals are mostly yellow or fawn in colour but have a very solid, black skeleton that often shows through the overlying tissue. It is made of chitin and a non-fibrous scleroprotein, is covered in small spines, and is exceedingly tough but flexible. Most species live below 100m but some such as *Antipathes* can be found on coral reefs. The polyps have six slender, pointed, unbranched tentacles. They are found in all oceans. Longnose Hawkfish (*Oxycirrhites typus*) live amongst the branches of black corals and gorgonians.
Size Variable.

STONY CORALS AND ANEMONES

ANNELID WORMS

Gardeners the world over will be familiar with annelid worms (Annelida) in the form of earthworms that turn over, aerate and fertilise the soil for them. The notorious and much maligned leeches are also annelids but are not generally welcomed by people. However, perhaps surprisingly, the majority of annelids are found in the ocean and belong to a group known as polychaetes or bristleworms. Lugworms and ragworms are polychaetes and are well-known to fishermen who use them as bait. These are classic annelid worms easily recognised as such from their elongate, segmented bodies. Much more of a surprise are worms that look like miniature furry mice, graceful tube-dwelling worms with colourful fans of tentacles, worms that build reefs from sand grains or construct calcareous tubes, and tiny worms that live and feed in the interstitial spaces between sand grains. Almost all marine annelids are considered highly edible by fish, crustaceans and even people and so generally hide away. Search for them under stones, amongst seaweed, by digging and sieving sediment or by learning to recognise the tubes and burrows in which many of them live.

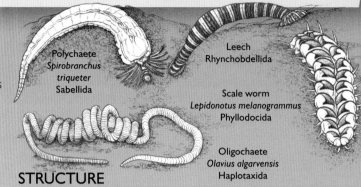

Polychaete
Spirobranchus triqueter
Sabellida

Leech
Rhynchobdellida

Scale worm
Lepidonotus melanogrammus
Phyllodocida

Oligochaete
Olavius algarvensis
Haplotaxida

CLASSIFICATION

The annelid taxon tree is a simplified version of that currently shown on the WoRMS (World Register of Marine Species) website. The higher classification of polychaetes continues to be revised.

STRUCTURE

The many marine invertebrates that are described as 'worms' tend to be long and comparatively thin and annelid worms are no exception. However annelids are the only worms with segmented bodies, which at its most obvious makes them look as though they are made up of a series of thick rings. Although some polychaetes have the body divided into different regions, in most annelids each segment or metamere is externally similar with the exception of the head and tail end and, in oligochaetes and leeches, specialised reproductive regions. Segmentation is also apparent internally, with muscles, nerves, blood vessels and excretory organs repeated in the majority of segments. An annelid worm is effectively a fluid-filled tube with a muscular body wall and internal partitions (septa) at the junction of each segment. A more or less straight gut runs the length of the body from the mouth at the head end to the anus at the tail end, perforating each septum along with longitudinal nerve cords and blood vessels. The fluid-filled body cavity (coelom) acts as a hydrostatic skeleton against which the muscles can work though leeches differ in this respect. To a large extent, annelids respire through their damp skin, one reason that earthworms cannot survive in dry soil. Surface area is often greatly increased in polychaetes by lateral bristle-bearing extensions, the parapods (p.211). Many polychaetes also have external gills on a few or many segments.

CLASS	SUBCLASS	INFRACLASS	ORDER
Polychaeta (bristleworms)	Errantia (Aciculata)		Amphinomida
			Eunicida
			Phyllodocida
	Sedentaria		Sabellida
		Canalipalpata	Spionida
			Terebellida
		Scolecida	
Clitellata	Oligochaeta (earthworms)		Capilloventrida
			Crassiclitellata
			Enchytraeida
			Haplotaxida
			Lumbriculida
	Hirudinea (leeches)	Euhirudinea	Arhynchobdellida
			Rhynchobdellida

POLYCHAETES

Polychaete worms (Polychaeta) are extremely diverse with more than 80 families, each specialised for a particular way of life. Many do not look and behave as we might expect, based on our experience of terrestrial worms. A crawling, centipede-like ragworm (Nereidae) is obviously worm-shaped and segmented, but a diver seeing a beautifully crafted tube topped by a fan of colourful, feathery tentacles could be forgiven for mistaking it for an anemone or even seaweed. Such fan-worms (Sabellida) are amongst the most attractive of all polychaetes but their true nature is hidden until extracted from their tube. Polychaetes are also called bristleworms and Polychaeta means 'many bristles'. Typically, each segment of the body has four bundles of them, two either side.

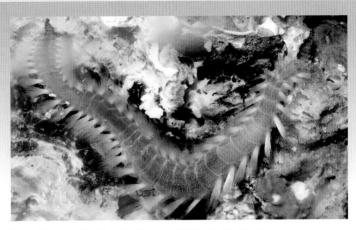

Tropical fireworms (Amphinomidae) have especially long bristle tufts (chaetae) on each segment and are therefore easily recognisable as polychaetes. A brush with them can be a painful experience as the mildly venomous bristles break off and cause intense skin irritation.

DISTRIBUTION

Polychaete worms are almost exclusively aquatic and the vast majority are marine, found throughout the world's oceans, from rock and sediment shores to abyssal depths. A few specialist species live around hot hydrothermal vents (p.112) whilst others thrive in the ice-cold Southern and Arctic Oceans. Whilst most abundant in sediments, there are also many species that inhabit rocky areas and a few such as *Tomopteris* and alciopids (Alciopidae) are free-swimming in the open ocean. There are fewer than 200 species of freshwater polychaetes and only a very few live in moist, semi-terrestrial environments such as soil and litter in mangrove swamps.

STRUCTURE

The body shape and form of polychaete worms varies widely depending on their lifestyle. Active mobile species have a well-developed head equipped with eyes and sense organs whilst sedentary tube-living species often have specialised food-collecting tentacles and large gills. The polychaete head region is made up of two pre-segmental parts, a frontal lobe which typically projects forward above the mouth and is called the prostomium and a ring surrounding the mouth called the peristomium. Active predatory species usually have pairs of eyes and sensory palps and antennae on the prostomium; the peristomium may be fused with one or more anterior segments and bear sensory ('peristomial') cirri only. Some sedentary species have long peristomial tentacles for collecting and manipulating food. In the calcareous tube-living serpulids and 'feather-duster' sabellid fan worms, these tentacles form a feathery funnel-shaped circle or circles around the mouth called the branchial crown. This can be pulled back rapidly and, in serpulids, the tube plugged with an operculum when danger threatens.

On each body segment is a pair of biramous lateral projections called parapodia (a single one is a parapodium or parapod) used in swimming and crawling. These are strengthened internally with chitinous rods and are armed with bunches of protruding bristles called chaetae. Parapodia are well-developed in active swimming and crawling polychaetes such as nereids (Nereidae) and paddleworms (Phyllodocidae) but can be greatly reduced, sometimes to just a few chaetae, in slow burrowers and sedentary tube-dwellers.

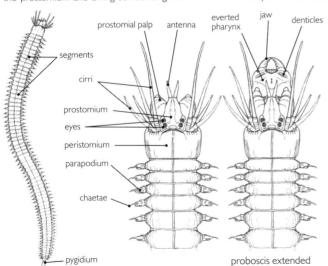
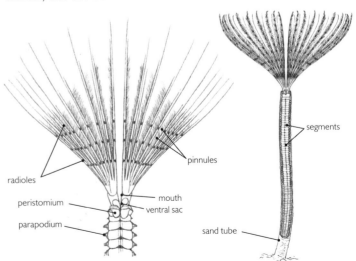

Comparison of two polychaete worms and their feeding parts. Left: the Slender Ragworm (*Neries pelagica*) (an errant species). Right: the Peacock Worm (*Sabella pavonina*) (a sedentary species).

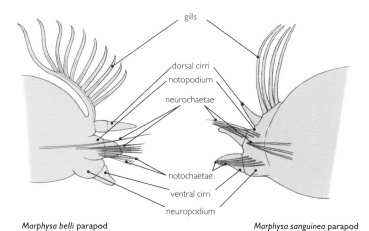

Marphysa belli parapod *Marphysa sanguinea* parapod

Structure of a polychaete (*Marphysa*) parapod.

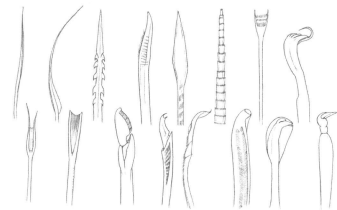

A multitude of bristles is a defining feature of polychaete worms and chaetae come in various forms like the blades on a Swiss army knife. These are put to various uses such as the hooked chaetae (crochets) which anchor burrowing species.

BIOLOGY

Feeding

Picking up a large King Ragworm (*Alitta virens*) is likely to result in a painful nip as this and many other nereids are active predators armed with strong chitinous jaws. These are held on the end of an eversible proboscis which is turned inside out through the mouth and then pulled back in again along with the prey. Not all predatory polychaetes have jaws but many have a pharynx or proboscis specialised for grasping and pulling.

As well as predatory polychaetes there are docile browsing herbivores, scavengers, filter feeders that extract plankton from the water, worms that collect organic deposits from the sediment surface using a multitude of long thin tentacles and burrowers that munch their way through their home of sand and mud digesting the contained organic material.

Life history

Many polychaetes reproduce simply by releasing eggs and sperm into the water, where the eggs are fertilised and develop into drifting, planktonic larvae. There are however many fascinating variations on this theme including copulation, asexual reproduction, egg brooding, hermaphroditism and most noticeable, mass spawning. Water filled with the writhing bodies of thousands of breeding worms is an unforgettable sight especially if they glow in the dark. In Bermuda, swarms of *Odontosyllis enopla* (Syllidae) rise to the surface as darkness falls on a few days following a full moon. Males and females attract each other with green bioluminescent flashes and ripples. Many nereids sacrifice themselves to produce the next generation. As they mature the worms change into a sexual stage called an epitoke whose sole aim in life is to swim up to the surface and release gametes. The rear end of the worm gradually fills up with eggs or sperm as internal changes partially break down segment partitions and thin the body wall. Parapodia and muscles enlarge and strengthen for

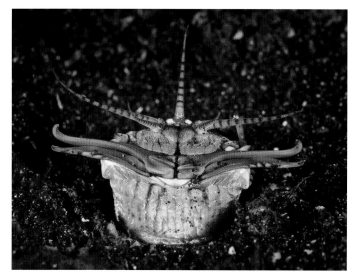

The metre long (or more) Bobbit Worm (*Eunice aphroditois*) is a predatory, warm water polychaete that lurks head up in sediment often near coral reefs. Sensing a passing fish, octopus or crab, it strikes with lightening speed dragging its prey down into its burrow.

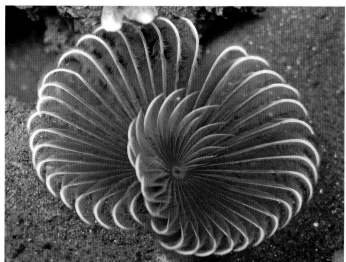

The feathery tentacle crowns of sabellid tube worms (Sabellidae) have a large surface area for trapping plankton and absorbing oxygen. Beating cilia move the food along the tentacles and down into the mouth.

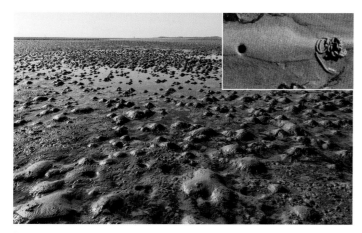

Flat sediment shores can be transformed into a lunar landscape by the activities of lugworms (*Arenicola* spp.). Depressions in the sand mark the head end of the burrow and casts mark the tail end.

epitokes. They make a fine delicacy for local people who scoop them up in nets, jars or even their hands. In this species only the rear end of the worm forms the epitoke, complete with a line of simple eyes, one on each segment, whilst the front end stays in its seabed burrow and eventually regenerates its lost parts.

Eggs of polychaetes released and fertilised in the water, typically develop into trochophore larvae (p.54) which resemble a spinning top with a band of cilia around the widest part. Many molluscs also go through an early trochophore stage indicating the close relationship between annelids and molluscs. Some polychaete species have simple trochophore larvae that never feed whilst others are much more complex with a mouth and digestive system. The larvae eventually either metamorphose into young worms that settle down onto the seabed or the larvae themselves settle and only metamorphose when they find a suitable substratum. In contrast many tube-dwelling polychaetes lay egg capsules or brood their eggs and young. Populations of Lugworms (*Arenicola marina*) on muddy sand shores are maintained and increased because they lay their eggs within their own tubes. These develop directly into young worms which are flushed out and up the shore on incoming tides. The huge and fascinating variety of polychaete reproductive modes is summarised in Wilson (1991).

Ecology

Whilst found in many different habitats, certain polychaete species can attain very high densities living in organically-rich sediment. Their burrowing activities help to aerate the sediment whilst lugworms (*Arenicola* spp.) and other sediment-eating species play a similar role to earthworms in soil. Polychaetes everywhere make great efforts to remain hidden in an attempt to avoid their many predators. Seabirds, fish, crabs, molluscs, anemones and occasionally people are happy to eat them. Pectinariids (Pectinariidae) even drag their cone-shaped tubes of carefully cemented sand grains along with them when they emerge from the sediment to search out new supplies of detritus (see *Lagis koreni* below). However species living in strong protective tubes can afford to be conspicuous as long as they can make an instantaneous withdrawal when danger threatens.

When we talk about 'reefs' it generally conjures up a picture of warm water and corals but a few specialised polychaetes live in colonies and build up substantial reefs made from their carefully constructed protective tubes. The Ross Worm (*Sabellaria spinulosa*) builds a tube of sand grains stuck together with mucus. Individual tubes are

swimming whilst eyes and tentacles at the head end, increase in size and sensitivity. At the surface, the females burst open shedding their eggs and the males release sperm through specialised openings, their final act before they (usually) die. Other species produce epitokes by growing a new rear portion in which the gametes develop. The epitoke develops a basic head and breaks away from the parent. Some species of *Autolytus* (Syllidae) produce several epitokes that develop sequentially in a chain thus combining asexual and sexual reproduction. Swarming and synchronised release of gametes is obviously advantageous, and in many species reproduction is regulated by the lunar cycle, whether it is adults releasing gametes or epitokes bursting open.

The Pacific Palolo Worm (*Palola viridis*) exhibits perhaps the most highly synchronised spawning of any marine animal. Visit Samoa or Vanuatu during neap tides of the last quarter of the moon in October and November, take a torch and wade into the water after dark and you will find yourself in the midst of a writhing mass of worm

A summer search amongst seaweed on a rocky shore in the NE Atlantic will almost always reveal jelly-like egg capsules which belong to paddle worms (Phyllodocidae) such as *Eulalia viridis* (p.215).

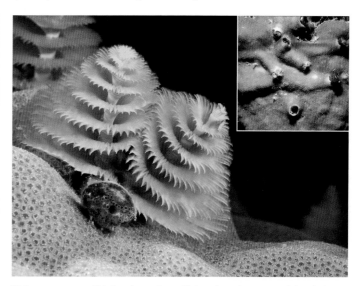

Christmas tree worms (*Spirobranchus* spp.) can withdraw almost instantaneously into their calcareous tubes hidden within coral, as is well-known to divers intent on photographing them. The worms react both to water vibrations and shadows.

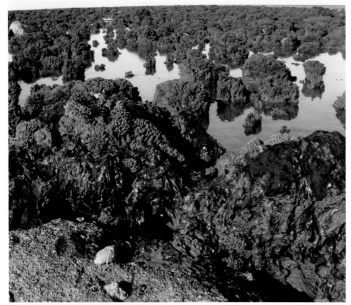

The Honeycomb Worm (*Sabellaria alveolata*) (Sabellariidae) creates coral-like reefs of fused tubes on intertidal boulders in the NE Atlantic and Mediterranean. These are built with fragments of shell sand stirred up by the incoming tide and stuck together with mucus. Across the world in Australia, *Idanthyrus pennatus* builds similar reefs.

only a few centimetres long but in some areas such as the Wash, a large estuary in East Anglia UK, the intertwined tubes create structures up to a metre high. By creating a (relatively) hard substratum in areas of sediment, these reefs greatly increase the biodiversity of the area. Hydroids, anemones, bryozoans and sponges settle and grow on the structure whilst cracks and crevices provide refuge for crustaceans, other worms and fish.

Polychaetes are experts at finding cracks, crevices and holes in which to live and so it is not surprising that some species have taken up permanent residence in the burrows and shells of other animals or even on and within their bodies. Martin and Britayev (1998) list 292 polychaetes from 28 families living in commensal associations with other species. Hosts include examples from almost all the main marine metazoan phyla, but echinoderms are especially popular as are sponges, with their myriad of holes and channels. Such commensal relationships (p.499) are of great benefit to the worms, providing a safe place for them to live and an easy supply of food, but in a few cases may also help the host. The scale worm *Arctonoe vittata* lives with a variety of hosts in the NW Pacific, including the keyhole limpet *Diodora*, feeding on its host's leftovers. The worm has been observed to nip the tubefeet of starfish intent on eating the limpet though whether this is exploratory or intentional is not certain.

USES, THREATS, STATUS AND MANAGEMENT

Polychaetes are not widely eaten in developed countries such as the USA or UK but form an important delicacy in some coastal communities. Perhaps the best known examples are palolo worms (*Palola* spp.) whose collection forms an important cultural event each year in some Pacific island communities. Bait digging is big business in NE European countries and frozen lugworms (*Arenicola* spp.) form a small but important export. Recreational anglers often dig their own bait and the industry is subject to local regulations and bylaws in many countries.

Whilst collection of polychaetes for food or bait may result in local overexploitation, only one polychaete *Mesonerilla prospera*, a small primitive species found only in marine caves in Bermuda, is listed as Critically Endangered in the IUCN Red List of Threatened Species (IUCN 2014).

POLYCHAETE SPECIES: CLASS POLYCHAETA

The polychaetes are divided into two subclasses each containing a number of orders (p.210). Polychaetes are immensely varied and the differences between the orders are often based on characters that are difficult to see without a microscope and even then not obvious to non-specialists. A lot of the variation, especially in head characteristics, comes from adaptations to different habitats and ways of life. However, some orders and even families have characteristics that make them relatively easy to recognise.

Subclass ERRANTIA

This long-established taxon which, consists mainly of free-living polychaetes, went out of vogue in the late 1990s. It has now been revived and is roughly equivalent to Aciculata, used in between times by several authorities (Read and Fauchald 2014).

Order EUNICIDA

Of the seven families in this order of around 1,400 species, the Eunicidae is the largest with around 420 species. The body segments are all very similar and the prostomium is distinct. Armed with strong eversible jaws most are free-living predators or scavengers but some live in tubes or burrows.

Marphysa sanguinea

FAMILY Eunicidae

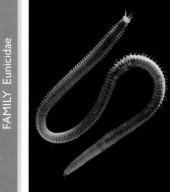

Features This green and blood-red polychaete belongs to the same family (Eunicidae) as the fearsome Bobbit Worm (p.212). Eunicids are predators and scavengers with strong jaws, and several pairs of toothed cutting plates on an eversible proboscis. *Marphysa* is collected for angling bait in some areas but can give a painful bite. Its long body, with as many as 300 or more segments, often breaks up when handled. It seems to be cosmopolitan, found in crevices and sediments round the world in temperate to tropical areas but there may actually be several similar species.

Size Up to 60cm long.

Order PHYLLODOCIDA

Numerically this is the largest polychaete order with 22 families and about 4,580 species. Phyllodocids have a large eversible proboscis armed with jaws, a distinct prostomium (p.211) and are predators and scavengers. They have well-developed parapodia.

Green Paddle Worm *Eulalia clavigera*

FAMILY Phyllodocidae

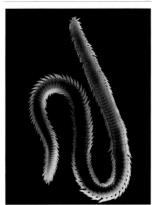

Features Paddle worms are long thin predatory polychaetes that wander freely in search of prey. The top part (cirrus) of each parapod is enlarged into a flattened leaf or paddle shape, hence their name. The species shown is one of at least two bright green species that can be spotted under stones and amongst seaweeds both on the shore and in sublittoral areas of the N Atlantic. *Eulalia viridis* is the other and it is difficult for non-specialists to tell them apart.
Size Up to about 15cm long.

Scale Worm *Harmothoe extenuata*

FAMILY Polynoidae

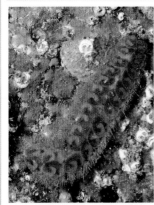

Features Scale worms are broad, flattened worms protected by a covering of scales or elytra each formed by the modified upper lobe of a parapodium (the little 'paddles' found on each segment). They can be found hiding under stones and amongst seaweed on rocky shores and in shallows. This one was found by the photographer under a rock in a rockpool in Cornwall, UK. There are at least 900 species found worldwide but these are not easy worms to identify. With a good hand lens, the number and arrangement of elytra can be counted but these are easily shed.
Size Up to about 5cm long.

Sea Mouse *Aphrodita aculeata*

FAMILY Aphroditidae

Features Not surprisingly many people do not at first recognise this animal as a polychaete worm. Heavily disguised by a thick mat of fine bristle-like chaetae over its back, it definitely resembles a dead mouse when washed up on the shore. In life it glows with iridescent colours from a fringe of fine, silky chaetae around its edge. Beneath this mat are 15 pairs of overlapping scales revealing its close relationship to scale worms (Polynoidae). The worm lives in sublittoral sediment in the NE Atlantic and Mediterranean.
Size Up to 20cm long.

Subclass SEDENTARIA

Polychaetes within this taxon live mostly in tubes or permanent burrows of one sort or another and are deposit feeders or filter feeders. There are two traditional groups Canalipalpata (orders Sabellida, Spionida, Terebellida) and Scolecida (nine families) but these may both be polyphyletic (Zrzavy *et al.* 2009).

Order SABELLIDA

Sabellid and serpulid worms (see also photographs on p.104 and p.212) live in tubes so their body structure is not obvious from the outside. The tubes they inhabit can be hard and calcareous, membranous, or gelatinous and encrusted with mud. When feeding they extend a fan of stiff tentacles which function both as feeding structures and as gills and are often brightly coloured. There are about 1,525 species in seven families.

Spiral Worm *Spirorbis spirorbis*

FAMILY Serpulidae

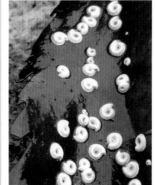

Features The tiny, coiled calcareous tubes of spirorbin worms (subfamily Spirorbinae) are a familiar sight on seaweeds and rocks on shores and in shallow water around the world. There are many different species, all hard to tell apart. *Spirorbis*, whose tubes coil to the left (sinistral), attaches mainly to the brown seaweed *Fucus serratus* on rocky shores in northern temperate waters. At low tide, when most people see them, they are safely shut inside their tubes, but when covered by water they extend a tiny fan of tentacles.
Size Tube about 3mm across.

Order TEREBELLIDA

Many terebellid worms have a characteristic writhing mass of long, highly contractile tentacles on the head region which they use to collect food particles though these are smaller in some of the 12 or so families. Species such as the Sand Mason (*Lanice conchilega*) and Honeycomb Worm (*Sabellaria alveolata*) (p.214) use these to construct intricate tubes from sand grains.

Strawberry Worm *Eupolymnia nebulosa*

FAMILY Terebellidae

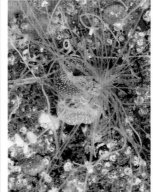

Features This worm clearly shows the 'mop head' of long, mobile tentacles typical of terebellids (Terebellidae). Three pairs of red gills on the segments behind the head appear as finely branched bushes. The front end of the worm is a fat sausage-shape tapering to a thinner posterior portion. The best way to find this worm is to turn over stable rocks and shells embedded in muddy sediment near low tide. In turning the stone, the worm's sandy tube which is attached to the rock, is usually torn open.
Size Up to 15cm long.

Trumpet Worm *Lagis koreni*

FAMILY Pectinariidae

Features Pectinariid worms (Pectinariidae) construct a cone-shaped tube from flat sand grains or shell fragments carefully selected using their mobile tentacles. The worm lives head down in the tube with the open pointed end above the sediment surface which allows water to flow through the tube for respiration. It digs using two comb-shaped bundles of strong spines at the head end. The tube is carried around with the animal and empty tubes are sometimes washed up intact on NE Atlantic shores.

Size Up to 5cm long.

Infraclass SCOLECIDA

The Scolecida currently comprises eight families and about 1,100 species of worms that are mainly unselective deposit feeders that effectively eat sediment.

Blow Lugworm *Arenicola marina*

FAMILY Arenicolidae

Features Lugworms are one of the most familiar of all marine worms. Their presence, hidden in the sand in U-shaped burrows, is given away by squiggly piles (casts) of faeces. A few centimetres away from each pile there is usually a saucer-shaped depression denoting the head end of the tube. The worm itself is fat with bristle-like chaetae at the front end plus bushy red gills in the middle section and a thinner, naked tail region. *A. marina* is found in the N Atlantic along with *A. defodiens*, and a number of similar species occur worldwide.

Size Up to about 20cm long.

OLIGOCHAETES

Searching amongst seaweed and under stones on the seashore, especially near a source of organic pollution such as a sewer pipe, you might be lucky enough to come across what looks like a small earthworm. This is likely to be a marine oligochaete (Oligochaeta). Earthworms are familiar to most people but marine oligochaetes are small and rarely seen, except by biologists willing to sieve quantities of sediment through a fine-mesh. However, home aquarium enthusiasts might be familiar with oligochaetes in the form of freshwater *Tubifex* worms which are sold as live food for fish and terrapins.

DISTRIBUTION

Oligochaetes are primarily terrestrial and freshwater worms. Marine oligochaetes are small and live on and in the seabed worldwide and whilst there are relatively few species, they can sometimes be found in large numbers where there is plenty of organic debris for them to feed on.

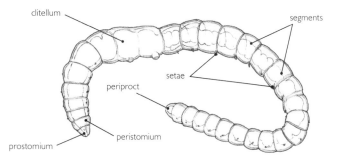

A marine oligochaete.

STRUCTURE

Oligochaete worms have none of the embellishments of polychaetes and entirely lack the projecting parapodia so characteristic of the latter. They generally have a smooth body with only a few chaetae (bristles) in each of the typically four bundles per segment. The chaetae project directly from the body wall (rather than being on parapodia as in polychaetes) but many species have none at all. Whilst some species have simple eye spots, most have neither obvious eyes nor head tentacles and it is sometimes difficult to tell which end is which. The body segments all look very similar with the exception of a saddle-like area of thickened, glandular skin, the clitellum which covers several segments. This is only obvious in sexually mature adults and its secretions play a role in mating and egg protection.

BIOLOGY

All oligochaetes are hermaphrodites and the gonads are restricted to a few segments near the anterior end of the worm with the testes in segments in front of the ovaries. The exact positions of the reproductive segments and of the clitellum are precise and definite for each species, and allow for head to tail copulation, so that the clitellum of one lies opposite the reproductive segments of the other. During the process, sperm is passed between the two individuals and stored for later use. Eggs are laid sometime after the worms have separated. They are caught up in material secreted by the clitellum along with stored sperm and the whole thing shrugged off over the worm's head, as a cocoon or capsule. Fertilised eggs hatch directly into juvenile worms. Not surprisingly the details of this process are known mainly for the larger oligochaete species such as earthworms. Some naidid oligochaetes (Naididae) can reproduce asexually by budding off smaller individuals from the posterior end.

LEECHES

Leeches (Hirudinea) are not universally popular to say the least. They are generally considered blood-sucking pests of people and their domestic animals. However there are relatively few species large enough to bite people and many simply scavenge or eat small invertebrates. Leeches are closely related to oligochaete worms and share their major characteristics and whilst the two groups are sometimes placed in separate classes, they are more usually included as two subclasses in the class Clitellata. People most commonly encounter marine leeches as surprise passengers attached to trawled and netted fish, or on marine turtles and even marine mammals.

DISTRIBUTION

Marine leeches can be found worldwide throughout the ocean, but the majority of species live in freshwater lakes, ponds and ditches, in fact anywhere with slow-moving or still water. They also thrive in the warm, damp conditions of tropical rainforests.

STRUCTURE

Whilst polychaetes and oligochaetes crawl and burrow in typical worm fashion, leeches move from place to place by a series of elegant loops. They achieve this by alternatively attaching and releasing two suckers, one at each end of the body. The sucker at the head end is the smaller of the two, surrounds the mouth and is the means whereby blood-sucking species attach to their host. Leeches vary in overall shape between species but with a muscular and flexible body, each individual can also change from a small blob to a long thin worm as it goes about its business. Many marine leeches can swim in a wriggling fashion and some will flatten their body to do so. With the exception of a small group (Acanthopdellida) that parasitise salmonid fishes (Salmonidae), leeches have no chaetae (bristles) or parapodia.

The segmentation of leeches is not as obvious or complete as it is in polychaetes. It is easy to see the numerous external rings (annuli) around the body but these are secondary and do not correspond to segments. Instead there are several rings to each segment, the number varying between species and even internally there are no septa (partitions). The body itself is almost solid rather than fluid-filled as in most annelid worms. Leeches have a fixed number of segments (29–32), each delineated internally by a nerve ganglion but this is obviously only visible microscopically. The clitellum, a thickened region of glandular skin also found in oligochaetes (see previous page) is only obvious during the reproductive period.

BIOLOGY AND ECOLOGY

In the temperate waters of NW Europe all known species of leeches belong to one family (Piscicolidae) and all British species feed on fish (Hayward and Ryland 1995). Freshwater species in this same region are much more varied with many invertebrate-eating species. Fish-living species also predominate in other areas. Marine leeches either use a variety of different hosts or are restricted entirely or mainly to one species. *Oceanobdella blenni* lives on the Shanny (*Blennius pholis*) (p.395) under the gill covers and behind the pectoral fins. This leech lives and grows on the same individual fish but drops off to lay egg capsules and then dies.

Large, blood-sucking freshwater species such as the Medicinal Leech (*Hirudo medicinalis*) have sharp jaws, bite their host and drop off after feeding. They can store blood in special pouches to last until their next meal. Large marine leeches feeding on relatively easy to find, bottom-living fishes may well do the same. Piscicolid leeches (Piscicolidae) feed using a hypodermic-like, eversible proboscis to penetrate the skin of their host. Leeches find their victims using sense organs on the head and body. Small black dot-like eyes on the head detect light intensity. Leeches also respond to vibrations and chemical cues. This is difficult to observe underwater but it is fascinating to watch a leech in a rainforest rear up on its hind sucker and sway as your footsteps approach.

Leeches are hermaphrodite and like oligochaetes, two individuals intertwine to exchange sperm. Eggs are laid in a cocoon secreted by the clitellum and juveniles hatch directly from them. However, copulation in leeches is often more than a simple deposition of eggs and sperm into a cocoon. Some species have an eversible penis whilst others attach a spermatophore (packet of sperm) to their partner. This injects sperm into the body where fertilisation takes place in the ovaries before the eggs are laid in a cocoon.

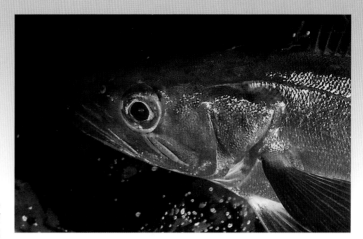

This Hake (*Merluccius merluccius*) has three leeches clinging under its eye. Marine leeches are difficult to identify without microscopic examination and these can only be identified as belonging to the family Piscolidae.

Pontobdella muricata is a large leech which usually feeds on rays and skates, here a Thornback Ray (*Raja clavata*) photographed in the UK. Very similar species of *Pontobdella* parasitise rays the other side of the world in Australia and New Zealand.

OTHER WORMS

Many different and unrelated groups of marine animals are called 'worms' usually because they are vaguely worm-shaped and their scientific name may be long and difficult to pronounce. Ten different phyla are grouped together here for no other reason than convenience. Most worms in these phyla are small with a few notable exceptions but some of the phyla, such as the nematodes are exceptionally widespread and of great ecological importance.

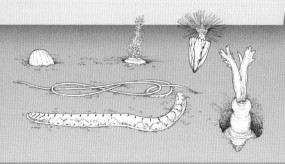

FLATWORMS

Most people would probably be perfectly happy if they never met a flatworm (Platyhelminthes). This is not surprising since this large and diverse group includes the internal parasitic flukes (Trematoda) and tapeworms (Cestoda) both of which can infect humans. However, there are also a large number of free-living flatworms in the ocean. Most are inconspicuous and difficult to find with the exception of the tropical polyclad flatworms. These are often mistaken for seaslugs (nudibranchs) by underwater photographers but with their bright colours they make equally worthy subjects.

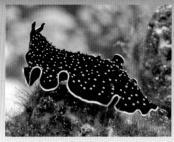

Left: Polyclad flatworm *Thysanozoon* sp. Unlike sea slugs, flatworms have no external gills and whilst their skin may be knobbled with papillae, they do not have the long body projections (cerata) seen in many sea slugs.

CLASSIFICATION

Flatworm classification has changed considerably in the past thirty years and many details remain unresolved. Originally all the hugely diverse free-living flatworms were included in one class, the Turbellaria. Since then several orders within the Turbellaria have been extracted and given higher status (e.g. see acoel flatworms p.227) and this class is no longer accepted as a legitimate grouping (it is paraphyletic). The relationships between many genera remain unresolved as yet and additional work will no doubt result in further revision of the classification. Only a simple outline is shown here.

Right: Nudibranch sea slug *Chromodoris willani*. A ring of gills on its back clearly shows this is a sea slug not a flatworm. Sea slugs have thicker bodies hence the need for gills.

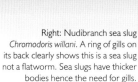

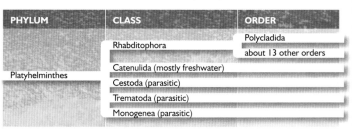

PHYLUM	CLASS	ORDER
Platyhelminthes	Rhabditophora	Polycladida
		about 13 other orders
	Catenulida (mostly freshwater)	
	Cestoda (parasitic)	
	Trematoda (parasitic)	
	Monogenea (parasitic)	

Left: *Dugesia subtentaculata* a freshwater northern European flatworm. The pigment cup eyes give the animal directional information about light.

DISTRIBUTION

Platyhelminth flatworms are found in the ocean, in freshwater and on land. Marine species are found worldwide but it is coral reefs that support the largest and most colourful species. The majority inhabit the seashore and shallow water down to a few hundred metres, but some are found much deeper.

Right: A tropical hammerhead flatworm from Tioman Island, Malaysia. Terrestrial flatworms are typically elongate.

STRUCTURE

Whilst all flatworms are thin and flattened from top to bottom, they vary in shape from the typically 'worm-shaped' land species to the oval and leaf-shaped polyclad marine species. The animals are solid in the sense that they do not have a body cavity, but are generally soft and delicate. The space between the various body organs is filled with connective tissue, the mesenchyme. One opening on the underside near the middle of the body serves as both mouth and anus. Being so thin oxygen can diffuse in all over the body and so there is no need for specific respiratory structures or a circulatory system.

Other structural details, especially the reproductive system and shape of the gut vary and are used in flatworm classification. The following description applies primarily to the leaf-like marine polyclad flatworms. Whilst it is sometimes difficult to see which end is which, polyclads often have a pair of tentacles at the head end and clusters of small, dot-like eyes. More eyes are found along the edges of the body. The gut has many branches that reach to all parts of the body and this is the main defining character of polyclad flatworms. Flatworms are usually hermaphrodite and the reproductive system is surprisingly complicated. Most species have separate genital pores for the male and female parts of the system, which open on the underside behind the mouth.

BIOLOGY

Feeding and movement

Polyclad flatworms are predators and one of the best ways to find them is to search for their favourite and rather unappetising prey of sea squirts (ascidians). Turn over a rock and you may find a colourful polyclad busy sucking out individual zooids of a colonial ascidian using its eversible pharynx like a drinking straw or scoop. Prey is often pre-digested with enzymes.

Mobile prey such as sea snails is enveloped whole and undigested remains are regurgitated. Most marine flatworms find their food by smell using simple sensory cells on the head and body though some can detect vibrations from moving prey. Polyclads either glide smoothly over the seabed propelled by a down of microscopic cilia or swim with graceful undulations of the body.

Life history

Flatworms are hermaphrodite and some have a surprisingly colourful sex life. Many undergo reciprocal mating but in polyclad flatworms this can be a fairly violent affair. Members of the family Pseudocerotidae are known to 'penis fence'. When two individuals meet, they rear up to expose their undersides and each tries to stab the other with a penis often armed with a sharp stylet. The successful combatant pumps sperm across to its partner, and this migrates from the injection site to oviducts or a chamber where the eggs are fertilised. The 'loser' thus becomes the mother and lays thin sheets of sticky eggs onto the seabed. In other flatworm groups, mating involves a more gentle exchange of sperm through the genital pores. The eggs of polyclads either hatch directly into juveniles (which may spend some time in the plankton) or into one of two types of lobed and ciliated larvae (Müller's and Götte's larvae).

Some polyclad flatworms such as this Persian Carpet Flatworm (*Pseudobiceros bedfordi*) (p.220) can swim strongly and do so regularly.

Ecology

Flatworms make a tasty snack for fish and so most marine species are drab and spend their lives hidden away. Some live permanently in the cavities of sessile animals such as sponges, corals and barnacles. In contrast coral reef polyclads are large, colourful and brilliantly patterned with stripes and spots. Fish quickly learn not to eat them as they are laden with toxins. These are probably contained in granular structures called rhabdoids that produce mucus and pack the epidermis along with pigment granules. The Mimic Flatworm (*Pseudoceros imitatus*) closely resembles the seaslug *Phyllidiella pustulosa* which is highly toxic. Predators avoid the flatworm but it is still not known if this rare flatworm is itself also toxic. A few flatworms are planktonic.

USES, THREATS, STATUS AND MANAGEMENT

The deleterious effects of parasitic flatworms are obvious but some marine polyclad species are serious pests of commercial mollusc fisheries. The so-called 'oyster-leech' (*Stylochus* spp.) crawls inside oysters, feeds on the flesh and may kill its victim. Others feed on scallops, mussels, and giant clams.

POLYCLAD FLATWORM SPECIES: ORDER POLYCLADIDA

There are two suborders of polyclad flatworms. Those in the Cotylea have a sucker on the ventral surface near the middle and most have a pair of marginal tentacles on the front edge of the head. Acotylea have no sucker and have nuchal (neck) tentacles set back on the head near the 'brain'. There are families within both suborders that have no tentacles.

Stylochoplana maculata

SUBORDER Acotylea
FAMILY Stylochoplanidae

Features Parts of the digestive and nervous systems can be seen through the semi-transparent body of this unobtrusive flatworm. It was photographed in Norway and its distribution extends south to the western Mediterranean. It can be found by looking under stones on the shore and extends down to at least 40m depth.

Size Up to 1.5cm long.

Candy Striped Flatworm *Prostheceraeus vittatus*

SUBORDER Cotylea
FAMILY Euryleptidae

Features This conspicuous temperate water species can be found crawling over rocks, pier pilings and even sediment in the NE Atlantic from Scandinavia to the western Mediterranean. Other similar *Prostheceraeus* species are found on both coasts of the USA. Each tentacle has a dense cluster of eyes and there are two groups of eyes over the 'brain'.

Size Up to 5cm long.

SUBORDER Cotylea **FAMILY** Pseudocerotidae

Persian Carpet Flatworm *Pseudobiceros bedfordi*

Features Divers frequently encounter this colourful flatworm on coral reefs in the Indo-Pacific. It is a fast crawler and if threatened will swim gracefully to advertise its colour indicating its unpleasant taste. This large species engulfs small gastropods and crustaceans whole. Like other members of this genus it has two penises.
Size Up to 8cm long.

Pseudobiceros sp.

Features This genus contains some of the largest and most colourful polyclad flatworms. There are many different species all of which have a highly ruffled margin, which would be the envy of any dress designer. This helps to separate them from similar *Pseudoceros* species. When threatened they will swim to advertise their unpleasant taste and toxicity.
Size Up to 14cm.

SUBORDER Cotylea **FAMILY** Pseudocerotidae

Pseudobiceros ferrugineus

Features Contrasting edges and stripes in this and other *Pseudobiceros* species act as a warning to predators that they are toxic. The tentacles, as in the very similar *Pseudoceros* species, are simple folds of the front margin. This large tropical genus has many species all of which feed on colonial ascidians.
Size Up to 8cm long.

Tiger Flatworm *Pseudoceros* cf. *dimidiatus*

Features A classic Tiger Flatworm has bold black and yellow longitudinal stripes, hence its common name. However, whilst the black body with an orange margin is constant, the yellow pattern is very variable in this species. The one shown here has not been positively identified hence the 'cf.' which in this context means 'most like'.
Size About 5cm.

RIBBON WORMS

At first sight it may be difficult to raise any enthusiasm for ribbon worms (Nemertea), which mostly resemble long thin strands of slime. However, this would be a shame as these unsegmented worms include many beautifully patterned species as well as possibly the longest animal in the world, the Bootlace Worm (*Lineus longissimus*). Fully stretched out this can be 30–40m long though their elasticity makes it difficult to estimate their true length. This and other similar cylindrical species are often called bootlace worms whilst ribbon worms more aptly describes the slightly flattened species.

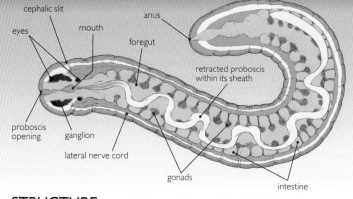

CLASSIFICATION

Other names for this phylum are Nemertina, which is still an accepted name, whilst Nemertinea, Nemertini and Rhynchocoela are generally not accepted. The three subclasses shown here are given order status in some earlier classifications. A fourth subclass Bdellonemertea (in the class Enopla) is recognised in some classifications but included here in the Hoplonemertea as a suborder (Eumonostilifera) of the Monostilifera.

PHYLUM	CLASS	SUBCLASS	ORDER
Nemertea		Paleonemertea	
	Anopla (temporary name)	Heteronemertea	
	Enopla	Hoplonemertea	Monostilifera
			Polystilifera

DISTRIBUTION

Nemertean worms are almost exclusively marine and are found in all oceans, including the Arctic and Southern Oceans, mostly living on the seabed. Just a few dozen occur in freshwater and in damp places on land.

STRUCTURE

The main feature that distinguishes nemerteans from other unsegmented worms is a long tubular proboscis, enclosed in a muscular sheath that lies in its own fluid-filled cavity immediately above the digestive tract. This versatile structure can be turned inside out through a separate opening just above the mouth or through a shared opening. Its main use is to catch food and in some species it is armed with a sharp, calcareous spike called a stylet. This can also act as a weapon to deter predators or as an anchor.

Unless the worm is feeding, it is difficult to tell one end from the other. A careful search for a pair of sensory grooves on either side of the head and numerous simple, dot-like eyes may give the game away. Internally there is a brain of sorts consisting of cerebral ganglia connected around the proboscis sac and two or three large nerve cords connected by a nerve net, running down the body. The gut also runs the length of the body exiting at the anus – a feature not found in flatworms (Platyhelminthes). There is a simple circulatory system, branches of which are closely associated with the branched tubules of an excretory system. The latter open to the outside via two or more pores some distance behind the head.

BIOLOGY

Feeding and movement
They may be long and slimy but nemertean worms are effective if rather unimpressive predators and scavengers. With only limited sensory input they find slow-moving prey such as worms by random searching, smoothing their way with a trail of slime and gliding along using cilia. The proboscis is flexible and can curl around the prey trapping it with sticky secretions before drawing it back towards the mouth. A quick stab with the stylet can help inject neurotoxin produced by the proboscis in some species. Nemerteans, especially scavenging species, may also find their prey using simple chemoreceptors. Hordes of 3m-long Antarctic nemerteans have been filmed homing in on a dead seal (BBC Blue Planet series) along with starfish and other scavengers. *Lineus longissimus* uses its great length to advantage and can absorb dissolved organic matter (DOM) directly through its skin.

Life history
In most species males and females release eggs and sperm into the water from a series of simple gonads situated under the skin along the length of the body, via temporary pores that form in the skin. Fertilised eggs either develop into a ciliated pilidium larva, which looks rather like a bobble hat with ear flaps, or into one of two other planktonic larval types (desor and iwata). In some this dispersive phase is skipped and the eggs develop directly into young worms. A few species increase the chances of fertilisation by pairs or groups of worms encasing themselves inside a mucus cocoon. A few species have internal fertilisation and produce live young (Thiel and Junoy 2006). An ability to regenerate a new head or tail end or both if the worm is pulled apart has led some species to use fragmentation as a means of asexual reproduction.

Ecology
Most nemertean worms live an inconspicuous life tucked away under rocks and seaweeds or partially buried in sediment. There are a few open ocean species that spend their entire lives floating and swimming. A number of small species (in the family Malacobdellidae) have found a niche inside bivalve shells where they hang on by means of a sucker and catch incoming plankton. A variation on this theme is *Carcinonemertes*, a genus of small nemerteans whose larvae settle on crabs and feed on their eggs when these are present. The egg mass provides them with enough food to be able to reproduce and a safe place to live.

USES, THREATS, STATUS AND MANAGEMENT

Nemertean worms are responsible for financial losses in crustacean and mollusc fisheries such as that for the soft-shelled clam *Mya arenaria* along the Atlantic coast of Canada. This fishery is significantly impacted through predation by the nemertean *Cerebratulus lacteus*. Crab fisheries along east coast USA suffer from infestations by the parasitic *Carcinonemertes errans* which consumes a large proportion of its host's eggs. Two flat tapeworm-like species in America and South Africa respectively are collected and sold as fish bait.

Large nemertean worms *Parborlasia corrugatus* and starfish *Odontaster validus* feeding on seal faeces in Antarctic waters.

RIBBON WORM SPECIES: PHYLUM NEMERTEA

Large nemerteans can often be identified from their size and colour patterns but for many, reference to their internal structure is needed to classify them correctly. Three classes are currently recognised: Anopla have separate openings for proboscis and mouth, no stylets (usually) and the brain lies in front of the mouth; Enopla usually have a single shared opening for the mouth and proboscis and most have either one stylet (Monostilifera) or numerous stylets (Polystilifera). They have the brain behind the mouth. Palaeonemertea are primitive nemerteans, considered by some authorities to be an order within the Anopla.

CLASS Anopla

Bootlace Worm *Lineus longissimus*

Features This worm will either be seen as a slowly writhing brown mass under a rock or like a piece of brown string stretched over the seabed. Its slimy body breaks easily if picked up. It is found on the shore and shallow sublittoral in the NE Atlantic. There are over 100 *Lineus* species.
Size Usually 5–15m, up to at least 30m.

CLASS Palaeonemertea

Football Jersey Worm *Tubulanus annulatus*

Features The bright pattern of this flattened worm may serve as a warning to predators that it tastes nasty and may be toxic. This allows it to hunt safely during the day. It is found on the lower shore and shallow sublittoral in the NE Atlantic and NE Pacific.
Size Up to 75cm.

CLASS Enopla ORDER Monostilifera

Nipponnemertes pulcher

Features This colourful orange, brown or pink ribbonworm has a wide N Atlantic distribution from east coast N America to Scandinavia and south to Atlantic coast France. It is most likely to be seen by divers (this photograph was taken in a Norwegian fjord) or in grab samples as it rarely occurs on the shore and extends to around 600m depth.
Size Up to 9cm long.

NEMATODES

You may think you have never seen a nematode (Nematoda) but it is unlikely that you have never come into contact with one since they are found almost everywhere. Millions can be present in a square metre of ocean sediment or soil. They are sometimes called roundworms since their bodies are round in cross section. Nematodes are the causative agent of a number of unpleasant human diseases including elephantiasis and commonly infest our guts in the form of hookworms and the threadworms often present in children. However, there are also many free-living and parasitic marine species.

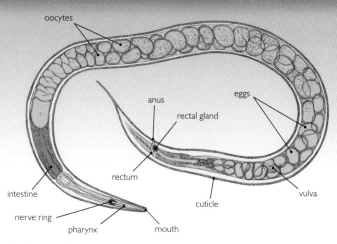

Anoplostoma species

CLASSIFICATION

There are well over 20,000 species of nematodes and the classification of this large phylum remains incomplete. In modern classification, which takes into account DNA analysis, there are two main classes Chromadorea and Enoplea. The majority of free-living marine nematodes are in the Chromadorea.

DISTRIBUTION

Free-living nematodes are found almost everywhere wet or damp from the highest mountains to the deepest lakes and seas. In the ocean they are extremely abundant in sediment, especially shallow areas rich in organic matter. Marine invertebrates and vertebrates are commonly infested with parasitic nematodes and it is not unusual to find them when gutting fish for your dinner. They also infest seaweeds and seagrass, which is not surprising since on land nematodes are significant plant pests.

STRUCTURE

It can be remarkably easy to recognise a nematode worm. Most are a few millimetres to centimetres long, round in cross-section and usually pointed at both ends. A minority of species are much longer and resemble cotton thread and the parasitic *Placentonema gigantissima*, which lives in the placenta of sperm whales, grows to 13m long. There is a head region but a very close look is needed to tell one end from the other. A tough, non-living, layered cuticle made of collagen fibres and other material protects the worm. Nematodes find their way around and detect food using sensory bristles and papillae, photoreceptors and a pair of sensory pits (amphids) at the head end which detect chemicals. Information from these is co-ordinated by a nerve ring and ganglia around the pharynx and (usually) four longitudinal nerve cords. Internally a nematode can be thought of as a gut tube within a body wall tube the two separated by fluid which acts as a hydrostatic skeleton and also distributes oxygen and nutrients.

BIOLOGY

Feeding and movement

Nematodes are equipped with a simple mouth and a muscular pharynx with which they suck in organic matter, bacteria, fungal and algal cells. Larger species hunt small animals including tardigrades (p.177) and rotifers (p.180) and tear open their prey with tiny teeth. Some pierce their prey with a stylet, inject a digestive enzyme and suck it dry. The miniature world still has its tigers. They hunt between sand grains moving in a characteristic sinusoidal fashion forming an S-shape or whipping from side to side forming a C-shape. This results from their having longitudinal but no circular muscles.

Life history

Nematodes may not be attractive to us but they are to one another and both males and females use pheromones for this purpose. Mating nematodes often form a T-shape because the male positions his tail end, where the sperm duct opens, over the female's uterine opening, a ventral slit somewhere near the middle of her body. He uses cuticular spines in the cloaca (the shared opening for the anus and sperm duct), to hold open the slit and pass sperm over. Eggs hatch directly into juvenile worms which moult their cuticle exactly four times as they mature. The eggs are very tough and can survive extremely harsh conditions. Nematodes cannot reproduce asexually though some species can produce offspring without mating (parthenogenesis) and a few are hermaphrodite.

USES, THREATS, STATUS AND MANAGEMENT

On land nematodes cause significant health and pest problems but are also used as biological control for insect pests. In ocean sediments they play a key role in nutrient recycling just as earthworms do in soil. They can also be an important indicator of pollution as they form a significant part of the meiofauna (p.90) living between grains of sediment.

An intertidal sediment nematode (*Actinonema* sp.) from the Gulf of California, Mexico. The male copulatory apparatus is clearly visible.

PEANUT WORMS

The English name of peanut worms (Sipuncula) for this phylum refers to their shape when retracted, though they look more like the unshelled version than a single peanut. This group of unsegmented, worm-like animals are occasionally seen by divers and might be found by anyone searching under rocks and seaweed on the seashore. Small ones only a few millimetres long might be missed but the largest grow to half a metre.

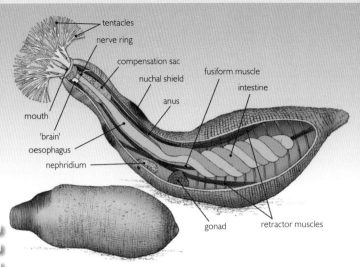

CLASSIFICATION

Whilst traditionally given their own phylum, recent molecular studies suggest peanut worms might be better placed as a sub-group within the annelid worms (Struck et. al. 2011). The 350 or so species are arranged in three orders and six families.

PHYLUM	CLASS	ORDER
Sipuncula	Phascolosomatidea	Aspidosiphonida
		Phascolosomatida
	Sipunculidea	Golfingiida

External view of a sipunculan with introvert retracted (below) and internal view with introvert extended (above).

DISTRIBUTION

Sipunculans are an exclusively marine phylum found in all oceans from the seashore to abyssal depths. Many burrow into bottom sediments and are brought up in dredges but they can also be found in almost any protected hideaway such as seaweed holdfasts, under boulders, within beds of bivalve molluscs such as mussels and in coral reef crevices.

STRUCTURE

Active peanut worms look like half-inflated sausages because their body consists of a fat trunk and a thinner front end, called the introvert that can be completely withdrawn (introverted) within the trunk. Push the uninflated part of a sausage-balloon back inside the inflated part and you have an approximation of how this works.

The mouth at the end of the introvert is often surrounded by a circle of tentacles. It leads into a long coiled gut that voids through the anus towards the front of the trunk region. The gut, gonads and a pair of simple excretory organs (nephridia) are suspended within a fluid-filled body cavity (pseudocoelom). The nephridia help with waste removal, control the volume of body fluid and act as an escape route for eggs and sperm, whose precursors are shed into the body cavity. The mouth tentacles may help absorb oxygen and free-floating cells within the body cavity contain a respiratory pigment (hemerythrin). A ring-shaped 'brain' (cerebral ganglion) surrounds the gut near the mouth and a single ventral nerve cord runs along the body. The only sense organs are simple light-detecting eyes (ocelli) and chemical receptors near the brain plus sensory nerve endings all over the body.

BIOLOGY

Feeding

Like lugworms, burrowing peanut worms eat the sediment around them, digest contained organic matter and void the rest. Hence they are not generally found in very clean sediments. Unlike lugworms they actively (if slowly) burrow through the sediment using the introvert. Some live in more permanent burrows or crevices and collect and ingest food particles using a fan of frilly, ciliated tentacles around the mouth.

Life history

Most peanut worms have separate males and females. Eggs and sperm are released into the water where the eggs are fertilised and subsequently develop into a planktonic ciliated larva called a trochophore (p.54) which settles on the bottom and develops into a juvenile worm. In many species the trochophore develops first into a similar but more elongated larval stage called a pelagosphera. This can survive for many months in the plankton which results in many species having a wide distribution.

USES, THREATS, STATUS AND MANAGEMENT

In some parts of the world including some regions of China, large sipunculans are collected for food.

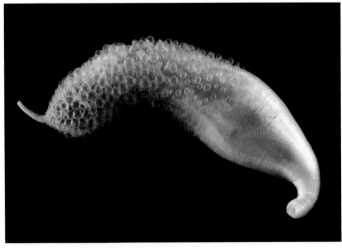

A deepsea species of *Golfingia* (order Golfingiida).

SPOON WORMS

Soft, defenceless spoon worms (Echiura) are occasionally seen by divers who spot the long feeding proboscis searching for food, and it is this proboscis that gives them their alternative English name of tongue worms. Fishermen digging for bait on a muddy beach might also spot one as they are a reasonable size ranging from around 1cm to 50cm long excluding the proboscis. With the proboscis stretched out, some species can reach over 3m long.

CLASSIFICATION

Although represented here as a phylum, DNA analysis suggests that this group is probably allied to annelid worms (Annelida). They have a trochophore larva and early development similar to polychaete annelids and in WoRMS (2015) Echiura are presented as a subclass of the class polychaeta in the phylum Annelida.

PHYLUM	CLASS	ORDER
Echiura	Echiuroidea	Bonellida
		Echiurida

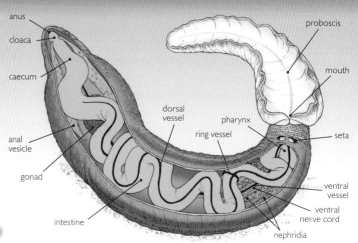

External and internal features of an echiuran worm with a wide ribbon-like proboscis.

DISTRIBUTION

Spoon worms look superficially similar to sipunculid worms and have a similar cosmopolitan distribution. They occur in all oceans, living on and in the seabed. They are perhaps most common burrowing in deep muddy sediments down to abyssal depths, but also live in the shallows under rocks and in almost any hidey hole where they are safe from predators.

STRUCTURE

The characteristic structure defining this worm phylum is the hugely extensible proboscis, often the only part of the worm that can be seen. This amazing structure varies from a classic spoon-shape or forked tongue to a wide, flat ribbon and acts like a long arm stretching out to collect food. A pair of chitin bristles below the mouth, and circles of bristles around the rear end help burrowing forms to dig and maintain their burrows. Internally the mouth leads into a long coiled gut with an anus at the end of the body. The gut and other organs are suspended in the fluid-filled body cavity (pseudocoelum). The proboscis is the most sensitive part of the body and is supplied with a nerve loop from a simple 'brain' near its base from which a ventral nerve cord also runs. Oxygen is absorbed through the skin especially along the proboscis.

BIOLOGY

Feeding

Most spoon worms stay well hidden and simply extend their proboscis to feed, methodically reaching out over the seabed to collect organic debris. This is swept back to the mouth in a ciliated groove on the underside of the proboscis. The proboscis of *Bonellia viridis* can collect food from at least a metre away from its 15cm-long body. A diver touching (gently) the proboscis can find the animal by following it as it contracts.

Some spoon worms with a short proboscis secrete a cone of mucus around the head. The mucus traps food and is then drawn into the burrow by water currents created as the worm contracts and ripples its body. Gobies, pea crabs and scale worms frequently share the burrow and the food. The Californian species *Urechis caupo* is sometimes called the 'Innkeeper Worm' because of these residents.

Life history

The sexes are separate and fertilisation is external. A single ovary or testis releases developing eggs or sperm into the fluid-filled body cavity. From here they are expelled through tiny organs that resemble the excretory nephridia of annelid worms. The eggs develop into planktonic ciliated larvae that eventually settle onto the seabed and grow into juvenile worms. One genus, *Bonellia*, has a much more colourful sex life. Larvae that settle near mature females are attracted to her and chemically influenced to become males. Whilst still tiny, they are taken into the female's body through the exit of her egg-collecting organs and stay there as minute sperm providers. Larvae that settle well away from a female themselves develop into females.

Bonellia viridis is often spotted by divers in the NE Atlantic and Mediterranean as it has a characteristic bright green, forked proboscis. This may be a warning to predators that its skin is toxic. This one has been removed from its hiding hole.

USES, THREATS, STATUS AND MANAGEMENT

Large echiurans are collected and sold as food in Korea and other Far Eastern countries. A species of *Urechis* found in the Yellow Sea off Shandong province in eastern China is becoming very popular where it is served up as 'sea intestines' – it does look like slimy pink sausages.

CEPHALORHYNCHA

This phylum includes four groups of small to microscopic animals that are unlikely to be encountered by anyone not specifically searching for them. For those interested in tiny animals they are worth the effort because many are beautiful, or if not then at least have interesting shapes and lives.

CLASSIFICATION

The four classes within this phylum have each been described as individual phyla and their affinities are still not clear. They will be found under various clades in different publications and future molecular evidence is likely to mean more changes to their classification.

PHYLUM	CLASS	ORDER
Cephalorhyncha	Kinorhyncha (spiny-crown worms)	Cyclorhagia
		Homalorhagida
	Loricifera (girdle-wearers)	Nemaloricida
	Nematomorpha (hair worms)	Nectonematida
	Priapulida (penis worms)	

DISTRIBUTION

Most of these tiny animals are found in marine sediments and considerable effort is needed to sieve or skim them out. Loriciferans attach themselves to clean gravel or sand and live in the spaces between the individual grains. Nematomorphs occur mostly in freshwater and terrestrial habitats and only one genus (*Nectonema*) is found in the ocean – at least as far as is currently known. Adult *Nectonema* swim around in surface waters, but their larvae are parasitic inside crabs.

STRUCTURE AND BIOLOGY

The features that unite these four groups of animals are not obvious and are mostly to do with the possession of a spiny introvert, which is basically a head end that can be completely withdrawn into the body and closed off. All have a protective cuticle made from chitin. Kinorhynchans look like miniature spiny insect grubs but only 1mm long at most. The head has a 'crown' of spines which help anchor the animal as it drags itself along and the body has thirteen partially telescopic segments. They feed by sucking up organic particles and microorganisms. Most species have separate sexes and probably mate but observing this is obviously extremely difficult. Eggs hatch directly into juveniles.

Loriciferans are also tiny, at around half a millimetre long, and were only discovered in 1983 when they were described as a new phylum. They have a rounded, vase-shaped body protected by a six-plated casing of chitin called the lorica. The head with its mouth cone is encircled by a ruff of spines and can be completely withdrawn. In spite of their small size these animals have a gut, simple brain, sense organs and especially in the larva, spines to help crawling. The sexes are separate.

Priapulids have a stout worm-like body up to at least 20cm long though many are tiny. The front end is a bulbous introvert decorated with longitudinal rows of spines with a mouth at its end. The two-part body shape is the reason they are sometimes called penis worms. Mouth and pharynx are lined by spines which are pushed out to capture prey such as other worms. The body is protected by a tough ridged cuticle

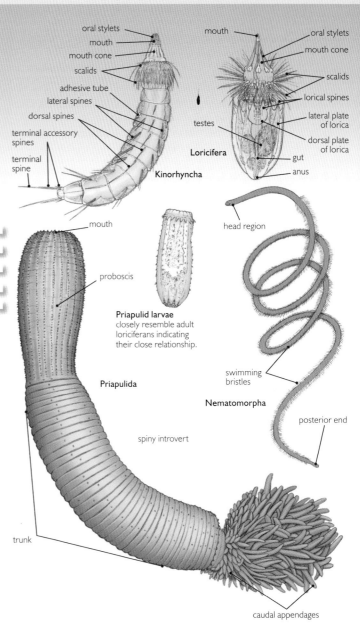

adorned with spines and papillae. Some have a hollow tail stalk covered in vesicles. The sexes are separate, eggs are fertilised externally and the developing larvae live in the sediment.

Nematomorphs are hair-like worms a few millimetres wide and up to a metre in length. Members of the only marine genus, *Nectonema* are around 20cm long. Adults are covered in swimming bristles, live in the water column and do not feed, whilst the larvae of the marine species are parasitic in decapod crustaceans. The sexes are separate and the females lay eggs after mating. It is only in the developing larvae that the spiny introvert which links them to the other three groups, is apparent.

PHORONIDS

In English these diminutive but pretty animals are also known as horseshoe worms because of the horseshoe-shaped ring of tentacles that surrounds the mouth. At first sight they could be mistaken for tiny thin-stalked anemones or fan worms (polychaetes) but a close look will show the characteristic arrangement of the tentacles. In spite of their relatively small size, with the tentacle crown a few millimetres to a couple of centimetres across, they will be spotted by divers who are willing to peer closely at the seabed. In clear waters, they can also be seen by wading over shallow, sheltered sediments in estuaries and bays.

CLASSIFICATION

Whilst now usually placed in their own phylum (Phoronida), the relationship of phoronids to brachiopods and bryozoans is disputed amongst taxonomists and all three groups are sometimes put into one phylum, the Lophophorata. This is based on the fact that they all have a similar feeding apparatus, the lophophore. Only around 17 species in three genera have been described so far.

DISTRIBUTION

Phoronids have a worldwide distribution in all oceans but are most common in temperate and tropical waters. They live attached to rocks and shells, or project out of soft sediments in coastal waters and on the shore. Most species have a very wide geographical distribution or are truly cosmopolitan.

STRUCTURE

The only part of a phoronid that is usually visible is the horseshoe-shaped feeding apparatus or lophophore, which extends out from a rigid tube made of chitin with the cylindrical body inside. The tube is made and repaired by secretion of a sticky liquid that hardens on contact with water. The lophophore consists of an incomplete circle of ciliated tentacles surrounding the mouth. As far as the animal is concerned the more tentacles the better as they not only collect food but also absorb oxygen. So the ends of the 'horseshoe' may curl inwards like a scroll to fit in more tentacles. A simple U-shaped gut exits via the anus adjacent to the mouth but just outside the lophophore. Two simple excretory organs (nephridia) open next to the anus.

BIOLOGY

Feeding

Phoronids live a sedentary life as suspension-feeders collecting phytoplankton and detritus from the water using the lophophore. Food is drawn into the lophophore on a current of water created by the beating of cilia on the tentacles. Food particles detected by a tentacle, are swept towards the mouth by a localised reversal in the direction in which the cilia beat. Particles concentrated at the base of the lophophore are picked up by a ciliated groove and ridge called the epistome and carried to the mouth.

Life history

Phoronid eggs released into the body cavity from the ovary are fertilised there with sperm drawn in through the nephridia. In most species the fertilised eggs are released (via the nephridia) and develop into free-swimming actinotroch larvae. The larvae are propelled along like miniature underwater scooters by a ring of cilia around the anus and can feed using ciliated tentacles. They can survive long journeys which may explain the wide distribution of many species. The larvae undergo a complex and rapid (under

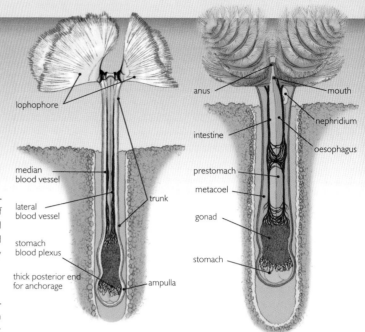

Phoronids in their tubes showing internal structure and lophophore extended to feed above the substratum.

an hour) metamorphosis into the adult form. Some species retain and brood the fertilised eggs within the lophophore and only have a short larval stage. *Phoronis ovalis* is in this category and yet has a wide geographic distribution. This species can reproduce asexually by budding or by a transverse split of the body and can regenerate lost parts when damaged. Perhaps individuals fragmented by predators or storms can drift and grow elsewhere but this is conjecture.

Ecology

Most phoronids are small but they can occur in very high densities and so provide a useful food source for grazing invertebrates. They can escape predation by a rapid withdrawal down their tubes but those that do have their tops eaten can regenerate them. Planktonic phoronid larvae form a significant food source for filter feeders at certain times of the year. *Phoronis australis* lives as a commensal within the tubes of cerianthid anemones and there may be up to 100 phoronids within a single host anemone tube.

Phoronis hippocrepia attached to sublittoral rock, Plymouth UK.

XENACOELOMORPHA

The majority of species in this practically unpronounceable phylum are tiny acoel flatworms, usually only found and recognised if you know what you are looking for. Divers may see the larger species, especially, those associated with corals, whilst others can be found on the shore, colouring patches of sand bright green or orange.

CLASSIFICATION

Acoel flatworms have traditionally been included with other flatworms in the phylum Platyhelminthes (p.218). More recent work elevates them to phylum or subphylum status. Recent molecular studies (Philippe et al. 2011) group the Xenacoelomorpha along with echinoderms, hemichordates and chordates as deuterostomes, phyla with a specific type of embryonic development. Agreement on whether *Xenoturbella* should be grouped with the Acoelomorpha or be in its own phylum (or subphylum as shown here), has not yet been reached.

PHYLUM	SUB-PHYLUM	ORDER
Xenacoelomorpha	Acoelomorpha	Acoela
		Nemertodermatida
	Xenoturbellida	

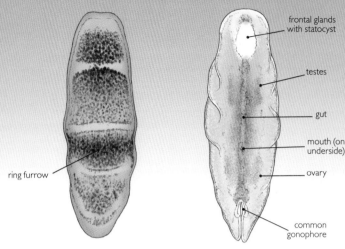

Xenoturbella (left), acoel flatworm (right).

DISTRIBUTION

The majority of acoel flatworms are marine and are most common in cool temperate and arctic waters. They live on and in sediment, under rocks and amongst seaweeds or animal 'turfs'. Those containing symbiotic algae are restricted to shallow water habitats whilst others occur on deep sediments. A few species form dense planktonic swarms in warm oceanic water. Xenoturbellids, of which *Xenoturbella* is the only genus (with two species), occur in soft muddy bottoms in the North Sea.

STRUCTURE

Acoel flatworms are tiny, oval or round worms which have no digestive or body cavities. The mouth on the underside opens into a mass of digestive cells which fill much of the body. These engulf food particles and digest them within vacuoles. They have no circulatory or excretory systems and only a very simple nervous system. Most have balance organs called statocysts which are important in species that move up and down within sediments in response to gravity. *Xenoturbella* looks like a 3cm long blob of opaque jelly that glides slowly over its muddy home using its covering of cilia. It too has very few body organs or systems and only a simple nerve net under the epidermis (skin). This is concentrated under two sensory grooves that run round the body.

BIOLOGY AND ECOLOGY

Feeding

Most species of acoel flatworms feed on detritus and tiny organisms such as diatoms found on the surfaces over which they glide. Others live on animals such as corals and eat the mucus their living home secretes. This is a good source of trapped food material. Many species live as commensals within the body cavity of sea cucumbers and molluscs where they presumably benefit from their hosts' food scraps. *Symsagittifera roscoffensis* (previously *Convoluta roscoffensis*) contains symbiotic algae. During the day these worms, which have light sensitive cells, gather together in their thousands on top of the sediment in which they live so that their symbiotic algae can photosynthesise (see photographs p.156). They quickly disperse and disappear into the sediment if disturbed. It is fascinating to watch patches of green intertidal species 'sunbathing' in shallow pools and rivulets of water. Footsteps cause an almost instantaneous retreat and the green patches magically disappear.

Life history

Sexual reproduction follows a similar pattern to platyhelminth flatworms with reciprocal mating of hermaphroditic individuals followed by the attachment of egg capsules to rocks and other hard substrata. Asexual fragmentation is also common with each piece developing into another individual. Almost nothing is yet known about the life cycle of *Xenoturbella*.

USES, THREATS, STATUS AND MANAGEMENT

Warm water aquaria are prone to outbreaks of acoel flatworms, especially of those that can reproduce asexually. *S. roscoffensis* is widely kept in the laboratory and used in the study of the early development of bilateral animals.

These brown patches on bubble coral (*Plerogyra* sp.) are acoel flatworms *Waminoa* sp. which also infests other corals. It contains photosynthetic zooxanthellae which provide it with nourishment.

MOLLUSCS

Molluscs (Mollusca) are one of the most successful and diverse of all invertebrate groups, ranking alongside the arthropods. Almost everyone in the world must have come across a mollusc at some stage as this phylum includes pests such as slugs and snails (gastropods), delightful seafood including clams and oysters (bivalves), the seashells that strew our beaches and contortionist octopuses and squids (cephalopods). This variety of body form and behaviour allows molluscs to live almost everywhere in the ocean as well as in freshwater and on land. Giant squid, reaching a length of at least 13m and giant clams, with a shell diameter of over a metre, are the stuff of legends and the subject of many imaginative films, but the majority of molluscs are small at under 5cm long.

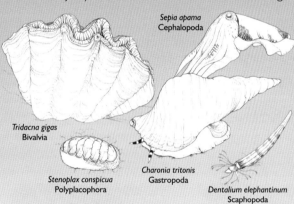

Sepia apama Cephalopoda
Tridacna gigas Bivalvia
Stenoplax conspicua Polyplacophora
Charonia tritonis Gastropoda
Dentalium elephantinum Scaphopoda

CLASSIFICATION

Mollusc classification has undergone numerous recent revisions and updates, especially within the largest class the Gastropoda, and this process is still ongoing. Traditionally the Gastropoda was divided into three subclasses: the Prosobranchia (snails with forward-facing gills), the Opisthobranchia (sea slugs and their relatives) and the Pulmonata (air breathing snails and slugs). The prosobranchs were divided into three main orders Archaeogastropoda, Mesogastropoda and Neogastropoda, but the first two of these in particular do not appear to be natural groups. A recent complete revision has resulted in the groups used here (Bouchet and Rochroi 2005). Their analysis, which involved molecular studies, used clades (p.123) not the Linnaean ranking shown here. Vetigastropoda, Patellogastropoda and Neritimorpha are all primitive gastropods and were originally classified together as the Archaeogastropoda.

CLASS	SUBCLASS	INFRACLASS OR SUPERORDER (SO)	ORDER OR SUPERFAMILY (SF)
Monoplacophora			Tryblidiida
Polyplacophora	Neoloricata		Chitonida
			Lepidopleurida
Caudofoveata			Chaetodermatida
Solenogastres			4 small orders
Gastropoda	Vetigastropoda		Haliotoidea (SF)
			9 other superfamilies
	Patellogastropoda		Patelloidea (SF)
			2 other superfamilies
	Cocculiniformia		Cocculinoidea (SF)
	Neomphalina		Neomphaloidea (SF)
	Neritimorpha		Cycloneritimorpha
	Caenogastropoda		Littorinimorpha
			Neogastropoda
			9 unassigned superfamilies
	Heterobranchia		Nudibranchia
			Cephalaspidea
		Opisthobranchia	Anaspidea
			Gymnosomata
			6 other orders
		Pulmonata	Mostly terrestrial
		Unassigned Heterobranchia	10 superfamilies
Bivalvia	Heterodonta	Archiheterodonta	Carditoida
		Euheterodonta	Veneroida
			Myoida
			2 or 3 other orders
	Pteriomorphia		Mytiloida
			Ostreoida
			Pectinoida
			3 other orders
	Protobranchia		Nuculida
			2 other orders
	Palaeoheterodonta		Mostly freshwater
Scaphopoda			Dentaliida
			Gadilida
Cephalopoda	Coleoidea	Decapodiformes (SO)	Myopsida and Oegopsida
			Sepiida
			Spirulida
		Octopodiformes (SO)	Octopoda
			Vampyromorpha
	Nautiloidea		Nautilida

STRUCTURE

In spite of their wide variation in size and shape, certain basic features are common to nearly all molluscs and can be seen in all eight classes, though sometimes in a highly modified form. Molluscs are unsegmented, bilaterally symmetrical, soft-bodied animals albeit often protected by a hard shell. Most molluscs have a distinct head, a muscular foot and a hump called the visceral mass which contains the major body organs. This arrangement is perhaps most easily seen in a snail or a slug but the various analogous parts can be found even in an oyster or an octopus. A sheet of tissue, the mantle, extends out from the body wall and envelops all or part of the body creating a space between it and the visceral hump. This space, the mantle cavity, is open to the outside and in all except air-breathing molluscs, contains the gills. The mantle is also responsible for secreting the protective, calcareous shell sported by the majority of molluscs.

These lilac-hued Horse Mussel (*Modiolus modiolus*) shells cast up on a beach in Norfolk, UK have partially lost the periostracum that renders the live shells a dull black colour.

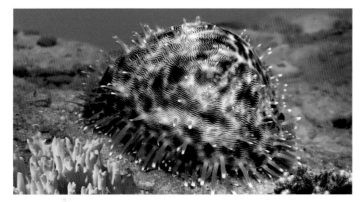

In most molluscs the mantle remains hidden but cowries extend two folds of mantle tissue up over the shell which deposit enamel and protect the shell. The tropical Tiger Cowrie (*Cypraea trigris*) shown here, has numerous papillae on the mantle which may help in respiration. The mantle is instantly withdrawn if a predator (or finger) touches the cowrie.

Shell

An external shell is the feature most people associate with molluscs and the beautiful colours, shapes and textures of mollusc shells have resulted in a multi-million pound collecting industry. However, an external calcareous shell is neither unique to molluscs nor universally adopted by them, but is obviously advantageous as so many do have one. The mollusc shell is very much a protective home into which the animal can withdraw. In most cases it is relatively easily separated from its owner; think of extracting a cooked periwinkle or snail from its shell using a pin. This is in contrast to arthropods where the external skeleton is universal and intimately associated with the soft tissues (see photo p.259). Getting the meat from a crab without any bits of shell is almost impossible.

A mollusc shell is laid down in layers. It consists predominantly of calcium carbonate but it is the way in which this is arranged that gives the shell its amazing strength. Mineral crystals are formed, laid down and held within an organic matrix of proteins (conchiolin) and polysaccharides. The outermost layer is a relatively thin layer of protein called the periostracum, usually black or brown in colour, which helps to protect the shell, particularly at the growing edges. This layer is missing in cowries (see above) and some of their relatives.

Underneath the periostracum are layers of calcite, the stable mineral form of calcium carbonate found in chalk and limestone. Other layers are formed from aragonite which is crystalline calcium carbonate. In some molluscs, famously pearl oysters, the shell is lined with nacre or mother-of-pearl from which pearls are derived (p.242). Nacre consists of layers of hexagonal aragonite plate crystals separated by organic matrix.

Radula

Whilst a shell is a typical but not a unique or universal characteristic of molluscs, a radula is unique to this phylum and is found in the majority of molluscs with the exception of bivalves, whose sedentary filter-feeding lifestyle render it obsolete. This rasping mouth structure resembles a miniature cheese grater and at its own level, is as amazing as the multiple rows of teeth found in sharks. This is the tool that slugs and snails use to create havoc in your vegetable patch. It consists of a ribbon of chitin covered in rows of tiny curved-back teeth and supported on a moveable fleshy base. As the teeth at the front of the radula are worn out they are replaced by new rows from behind. The detailed structure and positioning of the radula varies between the mollusc classes and the shape of the teeth is matched to the diet.

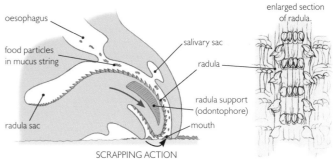

The symmetrical patterns in the photograph are the radula tooth marks left by limpets grazing a film of algae and bacteria on intertidal rocks.

MOLLUSCS

GASTROPODS

Whilst the name of this group may be unfamiliar to many people the animals themselves should certainly not be. These are the slugs and snails of your garden, the periwinkles and whelks served up in seaside cafes, the limpets clinging to rocks on the seashore and the baskets of tropical seashells sold the world over. Gastropods are by far the most numerous and varied class of molluscs and outnumber all the others put together. Gastropod translates roughly as 'belly-foot' and reflects the fact that most of them slither and creep around on a broad, muscular foot. They are, however, hugely diverse and whilst many, perhaps most, are instantly recognisable as gastropods, others are so highly modified it is difficult to tell what sort of animal they are at all.

DISTRIBUTION

By far the greatest diversity of gastropods is found in the ocean, but they also live in almost any type of freshwater and anywhere on land as long as it is damp. There are even a few parasitic species. In the ocean they occur worldwide and from the intertidal to the hadal zone. The majority live in rocky areas, but many creep and burrow through sediments and a few drift with the ocean currents.

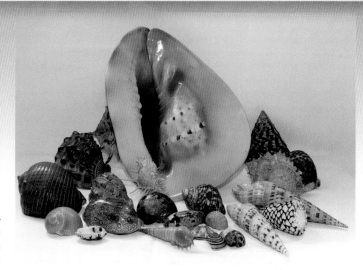

Whilst gastropod shells all have the same basic structure, this collection of tropical gastropods from the Seychelles demonstrates the enormous variations that exist in shell size, colour and ornamentation.

STRUCTURE

A typical gastropod mollusc glides along on a large, flat foot, has a prominent head with eyes and sensory tentacles and carries its visceral mass of body organs on its back covered by the mantle. The one thing they do not all have is a shell, though of course a very large number of them do, including all the familiar sea snails. Sea slugs (Nudibranchia) and their swimming equivalents, sea angels (Gymnosomata) have no shell at all whilst other related groups have a reduced internal shell.

The one-piece, spirally coiled snail shell is familiar to most people as the protective home into which a snail can completely withdraw if danger or desiccation threatens. Whilst highly variable in shape, marine gastropod snail shells all have the same basic design though the typical coil is not always apparent. In most species the shell opening can be effectively sealed by an operculum, a horny or calcareous plate-like 'door' carried on the rear, dorsal side of the foot. Rock-clinging limpets and ormers have no need of an operculum. From the gastropod point of view the spiral shape is ergonomically very efficient in terms of space in which to fit the visceral mass.

In gastropod snails, the mantle cavity containing the gills faces forwards and is situated above and behind the head. As the anus, excretory organs and gonads all empty into the mantle cavity this effectively means that gastropods have their rear end twisted round to face the same way as their head. This process of twisting or torsion of the body through 180° happens during the larval veliger (p.54) stage and is unique to gastropods. The evolutionary advantage of this process is not clear but it does mean the head-foot can be squashed up into the mantle cavity, displacing its contained water, when the animal shuts itself into its shell for protection. The torsion affects the shape and position of the gut and the major nerves serving the body organs. It also results in most cases in a single gill rather than a pair.

In opisthobranch molluscs (Opisthobranchiata) which includes sea slugs (Nudibranchia) the torsion is not so clear or is partially reversed during development. Adult nudibranchs have no shell, and no mantle cavity with its contained gill (ctenidium). However, the larva of all opisthobranchs is a normal gastropod mollusc veliger with a shell and shows various degrees of torsion. During metamorphosis to the adult form, the shell, operculum and velum (larval swimming and feeding organ) are all shed.

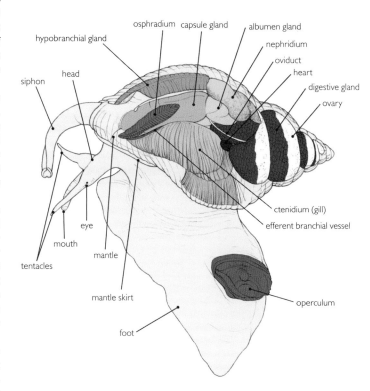

A marine whelk (Buccinidae) showing the approximate positions of the body organs within the shell.

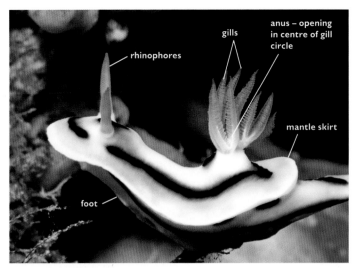 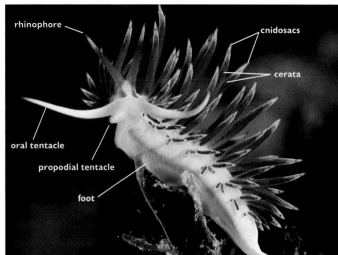

Typical features in a dorid (Doridacea) sea slug (left) and an aeolid (Aeolidida) sea slug (right). The anus in the aeolid opens via a small tubercle on the right side, not visible here.

The animal also flattens, elongates and develops respiratory projections in the form of an external gill plume, long processes on the back called cerata or leaf-like projections along the sides.

Compared to their bivalve relatives, gastropods are pretty active animals, as they need to be able to find the best grazing areas or to hunt down their prey or find a mate. They therefore have well-developed eyes and other sensory structures and a relatively complex nervous system. They may still be 'brainless' but they have a high concentration of nerve ganglia in the head. For most gastropods a chemical sense is more important than sight. Chemical cues from food, predators and mates are detected by the osphradium, a sensory area just below the gill inside the mantle cavity. This is especially large in active predatory species. Predators and scavengers such as cone shells (Conidae) and whelks (Buccinidae) often have a hose-like siphon derived from the mantle, with which they actively draw scent-laden water into the mantle cavity.

BIOLOGY

Feeding

Many marine gastropods, especially the more primitive groups, are herbivores just like their land relatives and graze amongst seaweeds and undergrowth. This includes winkles, limpets, ormers and top-shells which are found mainly on the seashore and in shallow water where there is enough light for plants to survive. They rasp away at films of algae, bacteria and seaweed sporelings coating rocks or graze directly on the fronds and stipes of seaweeds using a well-developed radula (p.229). Employing this same scraping method, keyhole limpets, slit limpets and cowries feed on fixed animal growths including sponges, tunicates and hydroids and so can live in much deeper water. This makes them technically carnivores but there are some much better equipped gastropod predators out there.

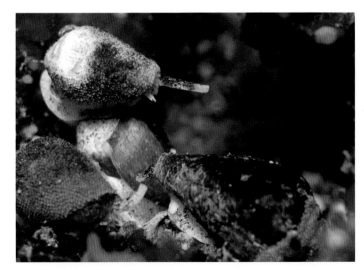

Cone shells detect their prey almost entirely by scent. Water drawn into the mantle cavity by the outstretched siphon, brings chemical cues with it. This California Cone (Conus californicus) is one of a very few cone shells found outside the tropics.

The Blue-rayed Limpet (Patella pellucida) is a true limpet (Patellogastropoda) that lives and feeds exclusively on kelp and fucoid seaweeds in the NE Atlantic. It can weaken kelp stipes by excavating numerous pits, making them liable to break off in storms.

Most whelks and muricids (Muricidae) are predators or scavengers and these include pests such as the American Oyster Drill (*Urosalpinx cinerea*) which feeds primarily on juvenile oysters. These efficient predators use both mechanical and chemical means to get through the shell of their victim. The radula is used to scrape a hole through the shell which is softened by acid secretions from an accessory boring organ on the sole of the foot. Nevertheless, it can take several days to get through to the flesh and Dog Whelks (*Nucella lapillus*) may try first to wedge their proboscis between the shell valves of a mussel or barnacle before it clamps shut.

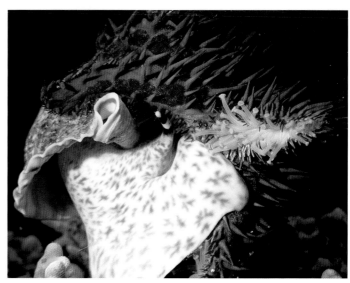

The Triton Shell (*Charonia tritonis*) produces saliva laced with sulphuric acid which it uses to make a hole in sea urchins and other echinoderms. The acid is so strong it can dissolve through 1mm of test in about 10 minutes. This gastropod predator is one of only a few that will attack the coral-eating Crown-of-thorns Starfish (*Acanthaster planci*) as shown here.

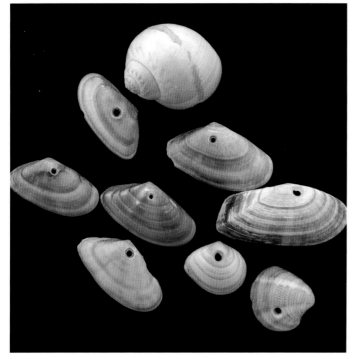

The neat bevelled holes left in these bivalve shells are the work of necklace shells (Naticidae) of which the European *Euspira catena* is shown here (top centre). These predatory gastropods burrow through sand in both tropical and temperate waters feeding on small bivalves

Life history

The majority of snail-like marine gastropods have separate sexes whilst nearly all slug-like species (Opisthobranchia) are hermaphrodite. In both cases mating is the norm and the eggs are laid and attached to the seabed or to other plants and animals. Eggs either hatch directly into crawling juveniles or into an advanced free-swimming and planktonic veliger larva (p.54). In some of the more primitive gastropods the eggs hatch first into a simple trochophore larva (p.54) similar to that of a polychaete worm, which then develops into a veliger. The more advanced gastropods go through the trochophore stage within the egg before it hatches. In some cases eggs and sperm are shed directly into the water and fertilisation is external.

Tropical cone shells (Conidae) take things even further and inject their prey with toxic venom. Whilst most target polychaete worms and other molluscs, some hunt small bottom-living fish at night when the fish are torpid. The cone shell sniffs out its victim drawing scent-laden water into its mantle through its long, hose-like siphon. It then reaches out with its thin proboscis and stabs the prey with a harpoon-like radula tooth, positioned at the end of the proboscis and previously coated with venom from special glands. Once the prey is quiet or dead, it is engulfed by the hugely extensible proboscis and mouth. Some cone shells have been observed to engulf fish before stabbing them, presumably having released some sort of chemical first that drugs the victim. Cone shell venom, which contains as many as 200 different compounds, is extremely toxic to humans and has caused fatalities.

Most gastropods crawl along rather slowly but some sediment-living species such as screw or tower shells (Turitellidae) found in sediments worldwide, hardly move at all and filter-feed in the same way as sedentary bivalves. Food particles are strained out by the ctenidium (gill) in the enlarged mantle cavity and bound up in mucus before being swallowed. The Slipper Limpet (*Crepidula fornicata*) is also a filter feeder and because they settle gregariously in large numbers, they can damage oyster beds by filtering out most of the available food.

Slipper Limpets (*Crepidula fornicata*) live up to their name. Larvae settle preferentially onto other slipper limpets building up a chain of individuals. The smaller, newer individuals are males, those in the middle are changing sex whilst the largest, oldest ones are females. Males near the top extend their long penis down to fertilise the females at the end of the chain. An individual settling on a rock near a female part of a chain will itself develop into a female.

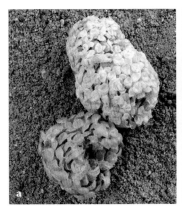 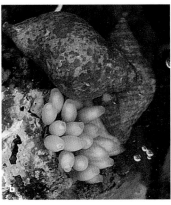 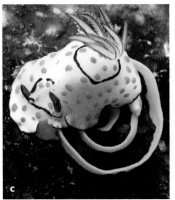 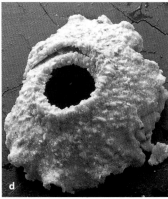

Gastropod eggs vary greatly in shape size and colour and can often be identified to species level. Eggs from (a) whelk *Buccinum undatum*; (b) Dog Whelk *Nucella lapillus*; (c) sea slug *Chromodoris* sp.; (d) necklace shell (Naticidae).

Nudibranchs (true sea slugs) are hermaphrodite and mate in pairs, each exchanging sperm with the other. Both then lay a jelly ribbon of eggs often amongst the hydroids, bryozoa and sponges on which the adults feed. The shape, size and colour of the coiled egg mass is distinctive for each species or genus. The closely related sea hares often form long chains of reciprocally mating individuals.

Ecology

Whilst most marine gastropods are benthic and live on the seabed, a few have taken up a drifting and swimming existence with consequent modifications in their feeding habits. One of the prettiest of these is the Violet Snail (*Janthina janthina*), a cosmopolitan oceanic species that floats at the water surface. It hangs upside down from a float made from mucus-coated air bubbles and preys on floating cnidarians *Velella* and *Porpita* (p.222). However, with no shell or a reduced shell the lightweight opisthobranchs (sea slugs and relatives) are much more suited to a drifting existence and two orders, the sea angels (Gymnosomata) and the sea butterflies (Thecosomata) are entirely planktonic. A pair of wing-like extensions derived from the foot, helps them to drift and swim. Sea butterflies are filter feeders whilst sea angels are carnivorous, with sea butterflies as one of their main prey items.

Grazing gastropods play an important role in maintaining a balance and diversity of seaweeds and other algae in shallow rocky ecosystems. Following the Torrey Canyon oil spill in 1967 in Cornwall, UK, toxic dispersants killed grazing limpets on adjacent rocky shores. This resulted in a rapid overgrowth by some algae and it took ten years for a true balance to be restored.

USES, THREATS, STATUS AND MANAGEMENT

Gastropods are widely utilised as food but not nearly on the same scale as bivalve molluscs (see table on p.242). Abalone (*Haliotis*), various winkles and conchs are the most widely eaten but there are local fisheries for many others. The Queen or Pink Conch (*Lobatus gigas*) (previously *Strombus gigas*) is widely exploited in the tropical West Atlantic both as food and for its beautiful shell. As a result, this species is declining throughout its range in spite of its listing in Appendix II of CITES which controls international trade.

Marine gastropod shells, especially tropical species, are in wide demand for the curio trade. Baskets of tropical shells and trinkets made from them are a common sight for sale all over the world, not just in their country of origin. Only two marine gastropods *Lobatus gigas* and *Haliotis midae* are currently (2014) given some

The Hooded Nudibranch (*Melibe leonina*) hangs on to kelp and seagrass whilst opening and closing the two halves of its large, tentacle-edged oral hood. Small planktonic animals are trapped inside and consumed.

Shells like these can be found for sale in markets and shops all over the world. Whilst trade in a few protected species is controlled, overall there is only patchy regulation of the trade.

protection under the international CITES convention (p.516) and both these are primarily collected for food. However, 14 species of cone shells (*Conus*) are listed in the IUCN Red List of Threatened Species as Critically Endangered or Endangered, along with two *Haliotis* species.

Both gastropod and bivalve molluscs can be affected by pollution. A classic example is that of tributyl tin (TBT), a compound found in some anti-fouling paints. The chemical kills the larval stages of molluscs, especially bivalves but affects some adult gastropods as well. In the UK in the 1980s it caused a partial sex change (imposex) in Dog Whelks (*Nucella lapillus*) rendering them sterile. A worldwide ban on its use was ratified by the International Maritime Organisation in 2007. Whilst our activities cause considerable problems for molluscs, there are a few molluscs that cause problems for people. The Atlantic Oyster Drill (*Urosalpinx cinerea*) is a predatory gastropod that is a serious pest of commercial oyster beds where it drills into young oysters. In tropical waters the sea snail *Drupella cornus* devours live coral polyps and an outbreak can cause significant coral damage. Freshwater gastropod snails act as intermediate vectors for serious human parasites such as blood flukes which cause schistosomiasis (bilharzia) and some marine species similarly infect seabirds and fish, but generally not people.

GASTROPOD SHELL IDENTIFICATION

Most marine gastropods have a shell that coils in a clockwise direction (dextral) when viewed from above. A few species coil in the reverse (sinistral) direction as can the occasional individual from a normally dextral species. Particularly with the larger shells, the general shape and size will usually provide an initial identification down to one or a group of orders or families e.g. cap-shaped (limpets), egg-shaped with a ridged, slit-like aperture (cowries). However, to follow most available keys a familiarity with the nomenclature of the various parts is necessary. Some gastropods also have distinctive colour patterns, spines and other ornamentation.

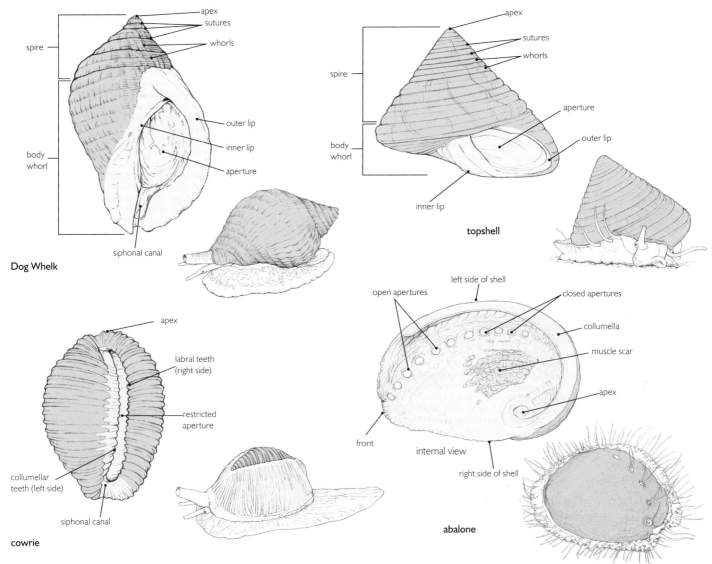

The main features and nomenclature of the various parts in four different gastropod shells. The live animal is also shown.

GASTROPOD SPECIES: CLASS GASTROPODA

Gastropod classification has undergone considerable revision in recent years (see p.228) and is now radically different from that presented in early textbooks and publications such as George and George (1979). Herein, gastropod molluscs are divided into seven subclasses of which five are described and illustrated below. The remaining two (Cocculiniformia and Neomphaloidea) comprise about 100 species of specialised deepsea limpets.

Subclass VETIGASTROPODA

Abalone or ormers, keyhole limpets and topshells are the most familiar of this group of around 3,400 gastropods, and in evolutionary terms are considered the most primitive. Ormers and keyhole limpets have a wide-based 'open' shell and a correspondingly broad, muscular foot with which they clamp down onto rocks in a similar way to true limpets. Their shells have small secondary openings. Topshells are more snail-like and so-named for their pyramidical shell, shaped much like a child's spinning top toy. Vetigastropod shells often have a beautiful mother-of-pearl lining and they share a number of internal features including a two-chambered heart and two gills.

Abalone *Haliotis* sp.

SUPERFAMILY Haliotoidea
FAMILY Haliotidae

Features Abalone or ormer are found worldwide clamped to rocks on the shore and in coastal water. The main body whorl of the shell is large and flattened whilst the other whorls form a tiny spire. Water passes in under the shell but exits through holes along the outer edge. The animal glides along on its foot grazing on algae, finding its way with sensory tentacles on the head and mantle. In New Zealand the endemic Paua (*H. iris*), is used to make coloured mother-of-pearl jewellery.

Size Up to 30cm.

Subclass PATELLOGASTROPODA

Limpets are found on rocky shores the world over and are one of the most familiar of all gastropod molluscs. True limpets in this group, have an open, conical shell with no extra slits or holes and a flat foot powerful enough to clamp to intertidal rocks exposed to pounding waves. Like the vetigastropods described above, they are primitive algal and biofilm grazers and have many rows of teeth in the radula, a two-chambered heart and two gills. There are about 330 species.

Common Limpet *Patella vulgata*

SUPERFAMILY Patelloidea
FAMILY Patellidae

Features True limpets (as opposed to keyhole and slit limpets) have a cone-shaped shell and a wide foot ideally suited to clamping onto rocks. The Common Limpet is the most abundant one found on rocky shores in the NE Atlantic where it grazes on algae. Individuals have a home range of about 1m and return to the same spot as the tide ebbs, wearing a groove in the rock which fits their shell exactly. This allows them to retain water under their shell when the tide is out.

Size Up to 5cm long, 2cm high.

Subclass NERITIMORPHA

Neritimorpha are a small diverse group of terrestrial, coastal and freshwater snails with about 200 marine species. They were originally included in the Archaeogastropoda and have a long fossil history.

Nerite *Nerita* sp.

ORDER Cycloneritimorpha
FAMILY Neritidae

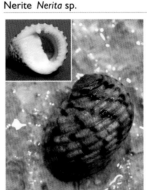

Features Nerites are common on tropical rocky shores and in mangroves and can survive out of water for some time. The thick, heavy shell has a low or flat spire and a distinctive, wide ledge (parietal shield) across the back of the aperture. These tough animals are difficult for crabs to break into because they can close their shell with a thick operculum, fall off their rock and roll away. They graze on algae and even lichens near the top of the shore.

Size Up to 4cm.

Subclass CAENOGASTROPODA

Caenogastropoda are the largest and most diverse order of sea snails with more than 21,500 marine species. They have a single-chambered heart and only one gill. There are two main orders, Neogastropoda with about 12,600 species and Littorinimorpha with about 5,100 species. The Neogastropoda are a well defined and accepted group which includes the familiar whelks, volutes and cone shells. The shell has an obvious groove in the shell aperture rather like the pouring lip of a jug and called the siphonal canal. In life this allows a flexible tube-like siphon to be extended up and out of the shell to draw water into the mantle cavity allowing these mainly predatory and scavenging snails to find their prey. Littorinimorpha includes periwinkles, slipper limpets, cowries, conchs and worm shells but is not a well-defined group. The remaining 4,000 or so species currently classified as caenogastropods do not fit into either of these groups.

Common Whelk *Buccinum undatum*

ORDER Neogastropoda
FAMILY Buccinidae

Features In this photograph a Common Whelk has homed in on a dead razor shell (*Ensis* sp.) and is competing for it with a starfish (*Asterias rubens*). Whelks can detect carrion from many metres away and also potential mates at spawning time. Their keen sense of smell means this North Atlantic edible species is easily caught in baited pots. The horny operculum carried on the foot is also visible and the lower photograph shows the siphonal canal typical of neogastropods.

Size Up to 10cm tall.

Textile Cone *Conus textile*

ORDER Neogastropoda · FAMILY Conidae

Features The beautiful geometrical pattern of this cone shell is very attractive and often tempts people to pick it up. However this Indo-Pacific reef species is one of the most venomous of all cone shells and has caused fatalities. The venom is a complex mixture of compounds and is normally used to subdue its prey of small fish (see p.232). Cone shells are easy to recognise from their characteristic shape and live ones should never be handled without thick gloves as the animal can reach back the length of its shell with its proboscis.

Size Up to 15cm long.

Flamingo Tongue *Cyphoma gibbosum*

ORDER Littorinimorpha · FAMILY Ovulidae

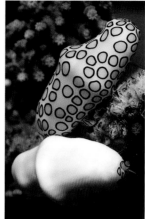

Features The beautiful spotted pattern exhibited by the Flamingo Tongue is the mantle not the shell. Like its cowrie relatives, it envelops the shell with mantle flaps when out and about but can withdraw completely if danger threatens. The whitish shell has a distinct transverse ridge. This predatory gastropod lives on sea fans which provide it both with a home and with food - it consumes the living polyps and tissues of its host. Sharp-eyed divers will spot them on a variety of sea fans and other gorgonians in the Caribbean.

Size Up to 3cm long.

Edible Periwinkle *Littorina littorea*

ORDER Littorinimorpha · FAMILY Littorinidae

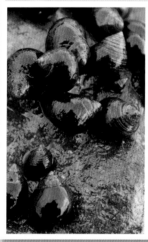

Features Winkles or periwinkles are a common and familiar site on temperate rocky shores. There are many different species but the Edible Periwinkle is one of the largest and the most widely eaten on both sides of the North Atlantic and in the Mediterranean. Their telltale trails can be seen as they glide through silt on rocks in shallow pools or they can be found bunched together in damp crevices where they can withstand many hours out of water by sealing themselves shut with a thin horny operculum. When on the move their pretty black-striped tentacles are often visible.

Size Up to 2cm high.

Worm snail *Thylacodes* sp.

ORDER Littorinimorpha · FAMILY Vermetidae

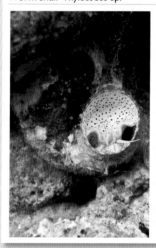

Features Worm snails (Vermetidae) have such a loosely coiled shell that the whorls are separated and they look much more like polychaete tubeworms than gastropods. *Thylacodes* (previously *Serpulorbis*) lives on Indo-Pacific coral reefs cemented permanently to rocks, though juveniles start life as normal motile snails. It feeds by secreting a net of mucus, visible in this photograph, which ensnares drifting planktonic animals and is then pulled back into the animal's mouth. Some species can close the shell aperture with a circular operculum.

Size Shell opening up to about 2cm across.

Eyed Cowrie *Arestorides argus*

ORDER Littorinimorpha · FAMILY Cypraeidae

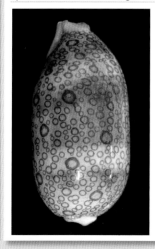

Features Cowries are one of the best known seashells because of their attractive shape and colour and are irresistible to collectors and tourists. The Eyed Cowrie is just one of many beautiful Indo-Pacific species. Young cowries have a short spire but as the animal grows the body whorl envelops the spire and develops its characteristic slit-shaped aperture. When active, cowries extend two mantle flaps up across the back of the shell which protect and repair it and are the reason that cowrie shells are so shiny. This species was previously known as *Cypraea argus*.

Size Up to 9cm long.

Tower Screw Shell *Turritella terebra*

ORDER Unassigned Caenogastropoda · FAMILY Turritellidae

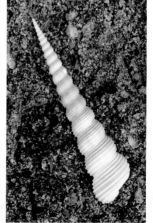

Features Screw shells or turret shells, have an elegant, tapering, tightly coiled shell, with distinct ridges encircling the whorls. They have a round aperture closed with a horny operculum. The Tower Screw Shell is an Indo-Pacific species but other *Turritella* species are found worldwide on muddy sediments. They feed by ploughing along through the sediment surface searching for organic detritus. Species vary in number of whorls and ornamentation. This large species is collected and eaten in the Philippines.

Size Up to 14cm tall.

Subclass HETEROBRANCHIA

Heterobranch gastropods have very different respiratory arrangements to the single or paired, feather-like gills found in the mantle cavity of other gastropods. This subclass includes two well-defined groups, Opisthobranchia commonly referred to as sea slugs and Pulmonata, the mostly terrestrial air breathing snails (not considered further here). Opisthobranchs have a foot with a flattened sole on which they glide along. The head is well equipped with up to four pairs of sensory tentacles. Of these the rhinophores on top of the head can be withdrawn into sheaths. Whilst there are at least ten opisthobranch orders, about 60% of the 3500 or so species are true sea slugs in the order Nudibranchia. Nudibranchs have no shell and no mantle cavity or internal gill, but many are covered in finger-like outgrowths (cerata) or have a circle of external gills. Other opisthobranchs have a shell but it is often very reduced and hidden.

Brown-lined Paper Bubble *Hydatina physis*
ORDER Cephalaspidea | FAMILY Aplustridae

Features When alive and going about their business, bubble shells look like fat sea slugs as their shell is hidden by mantle folds. The shell is thin and light with a large aperture and a sunken spire, but is sufficient to provide some protection. Opisthobranchs have either reduced shells as shown here and below in the Sea Hare or no shell at all as in nudibranchs (true sea slugs). The Brown-lined Paper Bubble is a common Indo-Pacific species that inhabits sand flats in shallow water.

Size Up to 4cm long.

Dorid nudibranch *Hypselodoris iacula*
ORDER Nudibranchia | FAMILY Chromodorididae

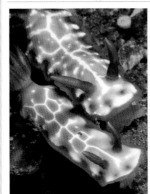

Features Like most tropical nudibranchs this species from the western Pacific Ocean is extremely colourful. The incredible combination of bright colours exhibited by nudibranchs is almost limitless and they are one of the most popular macro-subjects for underwater photographers. Temperate and cold water species can be equally as colourful as tropical ones. *H. iacula* feeds on sponges which contain colour pigments and toxins which are utilised by nudibranchs for their own purposes.

Size Up to 2.5cm.

Sea hare *Aplysia punctata*
ORDER Anaspidea | FAMILY Aplysiidae

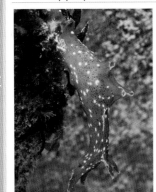

Features Sea hares are named after their large ear-like sensory head tentacles (rhinophores). Two large side flaps from the foot are held up over the back of the animal hiding its visceral hump and reduced shell. The animal can also flap them and swim clumsily away from a predator sometimes also releasing a cloud of dark 'ink' as a smokescreen. Colour varies according to its algal diet. This large NE Atlantic species is widely used in laboratory research in neurobiology and development.

Size Up to 20cm.

Aeolid nudibranch *Cratena peregrina*
ORDER Nudibranchia | FAMILY Facelinidae

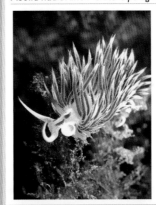

Features This little Mediterranean nudibranch is a typical aeolid (Aeolidida) with numerous projections (cerata) on its back. These act as gills but inside each is a branch of the digestive tract. Aeolids feed mostly on hydroids, this species mostly on *Eudendrium* and are able to transfer the stinging cells of their prey through the digestive system and into the cerata tips (cnidosacs). Here they are used by the nudibranch to deter predators. A true case of successful recycling.

Size Up to 5cm.

Spanish Dancer *Hexabranchus sanguineus*
ORDER Nudibranchia | FAMILY Hexabrachidae

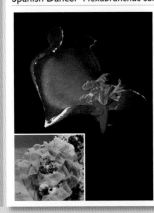

Features The bright red colour and large size of this Indo-Pacific sea slug make it unmistakable. It can also swim in a graceful undulating fashion much to the surprise of many underwater photographers. Like other members of this nudibranch group (Doridacea) it has a circle of branched gills near the posterior end surrounding the anus and two tentacles (rhinophores) on the head. After mating females lay a large ribbon-like coil of eggs (inset) which are also red.

Size Up to 40cm.

Sea Angel *Clione limacina*
ORDER Gymnosomata | FAMILY Clionidae

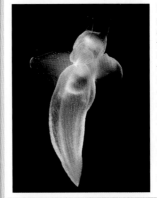

Features Sea Angels are effectively planktonic sea slugs although they are placed in a separate order to the true sea slugs. These charming little animals live near the surface in the open ocean, where they swim by flapping a pair of wing-like fins derived from the foot. They can be seen in some public aquaria. Not so charming is their feeding habit. They eat their shelled relatives (Thecosomata) by shooting out special buccal (throat) tentacles and radular hooks.

Size Usually around 2cm long.

BIVALVES

Mention 'seashells' and the word may well conjure up a vision of a sandy shoreline scattered with clam shells, delicate tellins open like butterfly wings, elongate razor shells and gnarled old oysters. Bivalves are almost synonymous with a seaside walk. They are perhaps the most widely known of all molluscs and have always been closely associated with human coastal settlements. 'Middens' of discarded seashells at least 10,000 years old have been found. Even ardent city dwellers miles from the sea are likely to have come across mussels, cockles and clams in shops, markets and restaurants. Bivalves are the second largest group of molluscs but are still far fewer in numbers than the gastropods.

DISTRIBUTION

Bivalve molluscs are one of two groups of invertebrates that are supremely at home living in bottom sediments (the other being 'worms' of all sorts). Most live in sand or mud throughout the ocean from the seashore to abyssal depths. Others have adapted to live on rocks and other hard substrata where they can occur in huge numbers, and there are even large clams living on hydrothermal vent chimneys in the depths. Bivalves are also found in freshwater but are far less diverse and abundant there than in the ocean.

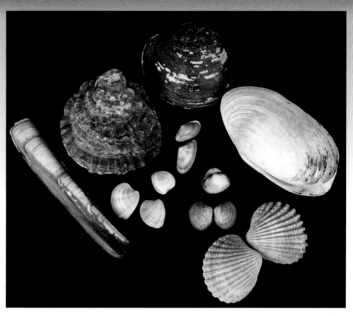

This varied assemblage of bivalve shells was collected from beaches in the UK but similar shells can be found on a walk along almost any strandline in the world.

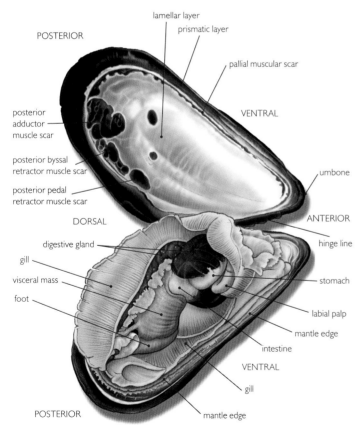

A Common Mussel (*Mytilus edulis*) opened to show the major organs.

STRUCTURE

Although it is not always obvious when picking up shells on the seashore, bivalve molluscs have a hinged shell made up of two separate halves (valves). The hinge design ranges from simple to complex with interlocking teeth and other structures which are useful in identification. In life the two shell valves are also joined together by an elastic ligament adjacent to the hinge. However what holds the shell firmly shut in life, are strong adductor muscles, usually two (anterior and posterior) but in some bivalves, only one. Anyone who has ever tried to open an oyster or scallop to eat it will know just how powerful their single muscle can be.

Inside the shell the visceral mass containing the body organs sits in the widest part near the hinge (dorsal side). It is enclosed by the mantle which hangs down round it as two folds that follow the contours of the shell and also encompass the head, the foot and a large space, the mantle cavity. Then there are the gills. In bivalves these are large and modified for filter feeding as well as respiration. The gill lamellae hang down into the mantle cavity and vary in their shape and complexity between the four subclasses of bivalves. Obviously water needs to circulate over the gills to bring in both food and oxygen. To achieve this, the edges of the mantle folds at the posterior end are fused to form an inhalant and an exhalent siphon (in most species) through which water can pass in and out of the mantle cavity. It is actually quite difficult to grasp the internal anatomy of a bivalve but most people do not worry about that as they swallow down an oyster, gut, gills, heart, gonads and all.

With their sedentary mode of life bivalve molluscs do not need a complex sensory and nervous system. However, the more active species such as scallops have numerous simple eyes capable of detecting shadows such as might be cast by a predator. A diver approaching a giant clam may notice it reacting and partially closing if the diver's shadow falls on it. The clam has numerous basic eyes (ocelli)

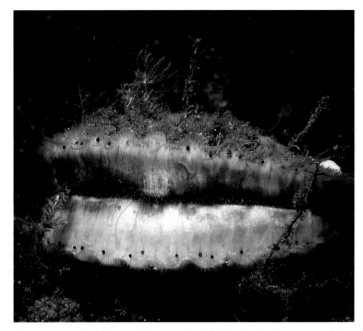

Two rows of eyes along the edges of the mantle help this Queen Scallop (*Chlamys opercularis*) to detect predators and either swim off or close up.

The inhalant siphon of this buried clam in Scotland has a fringe of sensory tentacles which also help to keep out debris. The exhalent siphon is joined to the inhalant suggesting this is a species of *Mya* clam. Most bivalves have completely separate siphons.

scattered all over the mantle. Most bivalves have light and touch sensitive sensory cells around the tops of the siphons and chemosensory cells on the mantle. Active burrowing species such as razor shells have balance organs (statocysts) in the foot.

BIOLOGY

Feeding

Bivalves are the ultimate sifters and sorters amongst invertebrates. Most simply open their shell valves sufficiently to extend their siphons and start filtering the water. This is called suspension feeding. The incoming stream of water brings with it edible plankton and suspended organic matter but also inedible debris and sediment particles. As the water passes through the gills all this material is strained out and retained on the gill surfaces which are covered in cilia. The cilia sort and move the material. Unwanted heavy particles of sediment drop down into the bottom of the mantle cavity whilst the tiny food particles are entangled in mucus. The food-laden mucus stream is carried down to the edges of the gills and then forward towards the mouth. Here the material is picked up by two folds of tissue either side of the mouth. Cilia on these mouth palps do a final sort before the material passes into the mouth. Periodically bivalves 'sneeze' to clear clogged up gills and get rid of accumulated debris (pseudofaeces) in the mantle cavity. The gills contract and the shell valve muscles convulse forcing a jet of water and debris out of the exhalent aperture.

Deposit feeding is an alternative strategy and is used by all tellins (Tellinoidea) and the protobranchs (Protobranchia), which are especially diverse in the deep sea. Species such as the Baltic Tellin (*Macoma balthica*) remain safely buried some distance below the surface but use their long flexible inhalant siphon to 'vacuum' up food particles from the sediment surface above them. However some fish such as the European Dab (*Limanda limanda*), bite off bivalve siphons, especially wriggling worm-like ones. Luckily most bivalves can re-grow their siphons if this happens.

Amazingly a few bivalves, mostly from the order Anomalodesmata, are active

Star-shaped patterns in the sticky mud of Cardiff Bay in Wales, UK, are the feeding marks left by the Peppery Furrow Shell (*Scrobicularia plana*) and a clue to anyone who wants to eat them. However, their sharp taste and muddy habitat means they are not popular.

predators albeit they still stay mostly in one place. *Poromya granulata* is a small clam that lives partly buried in deepwater sediments. It has an enlarged inhalant siphon ending in a cowl-like hood with which it reaches out to trap small (1–2mm) crawling crustaceans. The cowl then inverts and the siphon rapidly retracts so that the food is deposited near the mouth (Morton 1981).

Some examples of bivalve molluscs from the NE Atlantic showing approximate relative burrowing depth and method of feeding. In the intertidal the larger bivalves tend to burrow deeper, not always the case in subtidal areas.

PLANT-LADEN BIVALVES

The Giant Clam (*Tridacna gigas*) is the largest of all bivalve molluscs reaching a shell length of 140cm. Its body is so large that the shell valves cannot completely close (so discounting tales of divers being trapped by it and drowned) and the mantle is always visible. These clams live on and around shallow coral reefs in the Indo-Pacific. Like other bivalves they feed by filtering food from the water using their gills but this is insufficient and like reef-building corals, they utilise zooxanthellae (p.206) to provide extra energy. These specialised dinoflagellates (*Symbiodinum microadriaticum*) live, reproduce and photosynthesise in the mantle tissues, exposed to sunlight as the clam holds its valves apart in a wide gape. Up to half the clam's metabolic requirements are met by these tiny residents, which are also responsible, at least in part, for the glorious colours of the mantle. Primitive eyes (iridiophores) along the margins of the mantle direct light down into the lower layers to allow the zooxanthellae to thrive. They are taken onboard whilst the clam is still in its drifting larval veliger stage (p.54). Many bivalves (Vesicomyidae, Solenyidae and Bathymodiolines) inhabiting cold seeps and hot vents in the deep sea, harbour sulphur and methane oxidising bacteria (see p.112). These provide 100% of their metabolic needs and they do not filter feed.

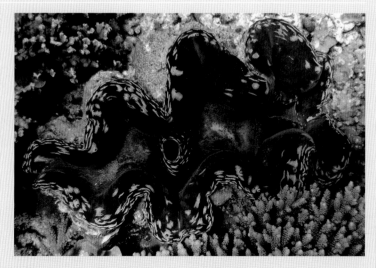

MOLLUSCS

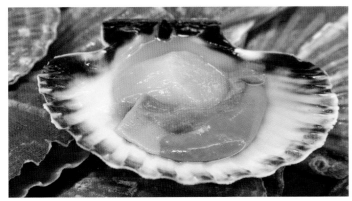
The Great Scallop (*Pecten maximus*) is a functional hermaphrodite. The orange part of the gonad is the ovary and the creamy white part is the testis. The whole gonad and the strong adductor muscle are the edible parts. Other body parts have been removed – see diagram p.238.

Annual rings on this Great Scallop (*Pecten maximus*) shell, indicate an age of about 16 years. The rings become more difficult to read in older, slow-growing shells creating some uncertainty. Maximum life span is about 20 years.

Life history

The majority of bivalves live a sedentary life in one place and therefore, not surprisingly, most of them reproduce by broadcasting their gametes into the water through the exhalent siphon or aperture. Fertilised eggs hatch into trochophore larvae which develop into dispersive, feeding veliger larvae (p.54) before settlement and metamorphosis. Most species have separate sexes though a few are sequential or simultaneous hermaphrodites. European Oysters (*Ostrea edulis*) cannot make up their minds and alternate sexes, starting life as males, becoming females and then continuing to switch sometimes several times a year. In the female stage they retain their eggs in the mantle cavity where they are fertilised by sperm drawn in from the surrounding water. The larvae are released at the veliger stage and so get a head start in life.

The age to which bivalves can live varies from a few months to many years. The Arctic Clam (*Arctica islandica*) regularly reaches 100 years and 200 years is not uncommon. One specimen has been estimated to be 374 years old making it the longest lived animal (excluding colonial animals) known to science (Schöne et al. 2005). Bivalves living in temperate regions grow faster in the warmer months when their plankton food is abundant and this is reflected in the structure of their shells where new material is laid down in annual increments. So in *Arctica* and many other species, it is possible to count annual rings as you can in trees though in *Arctica* this requires sectioning and special preparation of the shell (Butler 2007).

Ecology

Bivalve molluscs, such as oysters and mussels that occur in dense beds, modify the environment and provide a habitat for numerous other species. Beds of the Horse Mussel (*Modiolus modiolus*) can cover large areas but are prone to damage (p.242). Lying partially embedded in the sediment these shells mimic a hard rocky substratum providing a home for a wide array of other animals and seaweeds.

Bivalves can also modify and affect the water column because they filter such vast quantities of water. In harbours and other enclosed waters, attached mussels and clams help to remove bacteria from polluted water. At the same time they can accumulate toxins and can become a source of food poisoning. Accumulated toxins can also be passed up the food chain, as bivalves are a food source for a wide range of marine fish, crustaceans, birds and mammals as well as people. Their hard shells and hidden lifestyle provide considerable protection but they still form a major prey item for marine predators.

The colourful shells of these Horse Mussels (*Modiolus modiolus*) (see p.257) are covered in hydroids and bryozoans which settle on them as larvae and benefit because they are elevated above on an otherwise silty seabed. The single Queen Scallop (*Chlamys opercularis*) on the right has no such growths as it can swim and move from place to place.

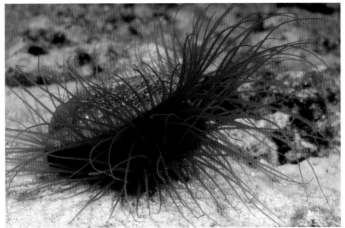
Fire clams or file shells (Limidae) live in cavities in rock or sediment and use byssus threads to line their home. Their flamboyant tentacles help in swimming and deter predators. In the North Atlantic *Limaria hians* can occur in such large numbers that it makes a hidden reef beneath the surface of sand and gravel which provides a substratum for seaweeds to settle and grow.

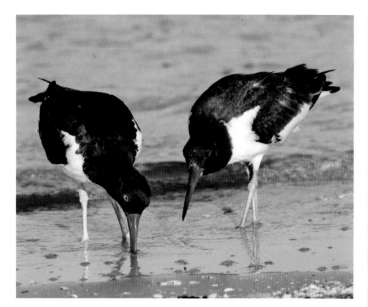

Oystercatchers (*Haematopus* spp.) around the world use their strong bills to open a range of bivalve molluscs. American Oystercatcher (*H. palliatus*).

USES, THREATS, STATUS AND MANAGEMENT

Bivalve molluscs are a vital resource used by people throughout the world for everything from subsistence living to high dining and from valuable pearl jewellery to tourist trinkets and buttons. The range of species eaten is wide but the main groups are oysters, mussels, scallops, clams, cockles and arkshells. In all these groups (counting clams, cockles and arkshells as one group) aquaculture now far exceeds capture production especially with oysters and mussels (see below). Incidental damage from seabed trawling for fish has greatly reduced the extent of beds of Horse Mussel in the Irish Sea and elsewhere in the North Atlantic.

No marine bivalve molluscs are yet listed as endangered in the IUCN Red List of Threatened Species (IUCN 2014) but there are many instances where local stocks are overexploited. An example is the Giant Clam (*Tridacna gigas*) which appears to be locally extinct on the reefs in the Semporna Islands in Sabah (Malaysia), Borneo (pers. obs.).

Species group	Capture production (tonnes)	Aquaculture (tonnes)
Oysters	103,985	4,488,544
Mussels	88,943	1,812,371
Scallops	840,876	1,727,105
Clams, cockles, arkshells	669,169	4,885,179
Abalone, winkles, conch	142,157	383,811
Squid, cuttlefish, octopus	3,652,632	10

World capture production and aquaculture production for molluscs in 2010 (FAO 2012).

There are several bivalve molluscs that cause substantial commercial damage worldwide. Perhaps the best known of these is the so-called shipworm *Teredo navalis* which has a considerable appetite for wood and bores into pilings and wooden ships with gusto. A number of bivalves are able to bore into rocks, usually calcareous rocks or coral rock, but some can damage submerged concrete pilings and structures especially when these have a high content of calcareous aggregate.

A STRING OF PEARLS

Pearl diving was once a lucrative trade in the Arabian Gulf, Oman, the South China Sea and a few other warm Indo-Pacific locations. The pearl oysters were collected from the wild by hand whilst free-diving with just the help of a nose clip, primitive goggles and sometimes a protective shirt and hood. Today almost all pearls come from cultured oysters, the large ones mainly from *Pinctada margaritifera* and *P. maxima*. To produce a pearl it is necessary to irritate an oyster. If a piece of sand gets stuck between the shell surface and mantle, the natural reaction of bivalves is to envelope it in mantle epithelial cells which then secrete concentric layers of shell lining material. In pearl oysters this is the famous, hard and shiny mother-of-pearl but other species can produce dull non-shiny pearls (hence perhaps, the term lacklustre). Even small fish have been found entombed. Today pearl oysters are stimulated to produce pearls by surgical implantation of a nucleus (a bead of mussel shell and mantle tissue) often into the gonad and finished pearls are also removed surgically. Not quite the same romance as finding a natural wild pearl.

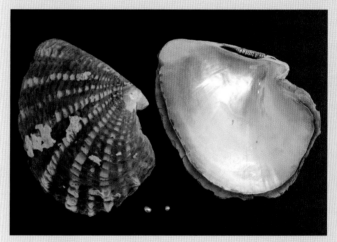

This large Black-lipped Pearl Oyster (*Pinctada margaritifera*) collected by the author whilst diving in Oman in the 1980s, revealed two tiny pearls, two parasitic flatworms and a small commensal crab.

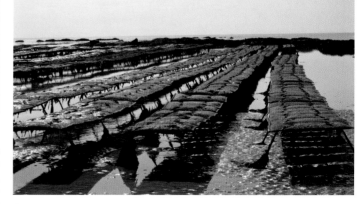

Oysters are widely cultivated in Europe, often on trays near low water mark. This installation is in France.

Juvenile giant clam being raised in a hatchery in the Tun Sakaran Marine Park, Sabah (Malaysia), Borneo. They will be grown on in submerged cages. The aim is to re-populate reefs and to provide an alternative livelihood for resident fishermen and so reduce fishing pressure on the reefs.

BIVALVE SHELL IDENTIFICATION

Identifying bivalve molluscs relies much more on their shells than on features of the live animal. As there are often many similar species in a family, an accurate identification requires practise, a familiarity with a rather large glossary of scientific terms and a good written or online guide to the shells of your region. General shape and size are the first clues though many bivalves are a similar sideways flattened 'clam' shape, a design well suited to a burrowing habit. Details of shell ornamentation, hinge structure and colour pattern come next followed by the various marks on the inside of the shell left by the adductor (shell closing) muscles and mantle attachment points (pallial line).

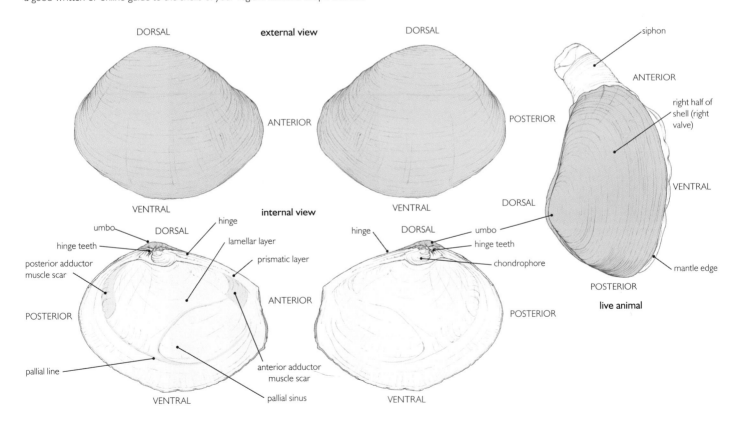

Main features of a bivalve mollusc shell, the Fat Gaper (*Tresus capax*).

BIVALVES

BIVALVE SPECIES: CLASS BIVALVIA

Three of the four subclasses (p.228) of bivalves are described and illustrated here whilst the fourth Palaeoheterodonta is mainly freshwater.

Subclass HETERODONTA

This is the largest subclass of bivalves with about 5,300 marine species in five orders (p.228). Around 60% are currently placed in the Veneroida which includes venus shells and giant clams. Cockles (Carditoida), and piddocks and shipworms (Myoida) are important commercial or nuisance bivalves. Anomalodesmata, which includes many bizarre bivalves with dissimilar shell halves and Lucinoida which, whilst common in some habitats such as seagrass beds, are not commonly encountered by non-experts, are not considered further here. The majority of heterodont bivalves live out their lives buried in sediment and have the mantle edges fused together; many have siphons that can reach to the surface to draw in water. Others live on the surface amongst rocks and coral, bore into rocks and wood or burrow into sediment.

Basket Cockle *Clinocardium nuttallii*

ORDER Carditoida FAMILY Cardiidae

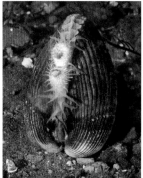

Features Cockles belong to a very large family of commercially important bivalves that are eaten the world over. The two rounded shell valves have prominent ribs that radiate out from the umbones of the shell and which are mirrored on the inside of the shell. Most species live half buried in mud and sand as they have very short siphons. The edible species shown here is from the Pacific coast of N America.

Size Up to 13cm long.

Tellin Shell *Angulus tenuis*

ORDER Veneroida FAMILY Tellinidae

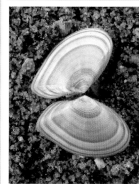

Features Walk along a sand shore almost anywhere in the world and you will probably find scatterings of small colourful shells laid out like butterfly wings. The tellin shell family is large and contains nearly 40 genera. The species shown is a typical and common one found in the NE Atlantic, with a shell that is rounded in front and angular in the rear section. The inside of the shell has a similar coloration to the outside but without the regular concentric bands.

Size Up to about 2.5cm.

Crocus Clam *Tridacna crocea*

Features The Crocus Clam is the smallest of the nine species in the giant clam subfamily (Tridacninae). Unlike the others, it lives buried in coral or rock into which it bores when young using both mechanical and chemical means. It makes a bright splash of colour from vivid blue and green through to crimson, violet and brown on coral reefs in the Indo-Pacific. There is a large space at the base of the shell through which byssus threads hold it in place.

Size Up to 15cm length.

Norway Shipworm *Nototeredo norvagica*

ORDER Myoida FAMILY Teridinidae

Features You are much more likely to see evidence of shipworm activity rather than the animal itself. These strange, highly modified bivalves excavate substantial tunnels in wood which they line with calcareous material. This species is widespread but there are many others. The shell is reduced to two small rough valves at the front end which act like a drill bit as the animal turns them from side to side. The animal can plug the burrow opening with two plates called pallets.

Size Tunnels up to 20cm long.

Rayed Artemis *Dosinia exoleta*

ORDER Veneroida FAMILY Veneridae

Features Venus shells are a large superfamily (Veneroidea) of solid and often pretty shells. Many species are edible including the one shown here; local fishermen rake them from the sand and shell gravel in which they live. This species is beautifully patterned with rays and streaks of pink and brown though the colour fades in dead shells. The razor shell in the background shot up out of the sediment whilst the author was taking this photograph.

Size Up to about 6cm long.

Geoduck *Panopea generosa*

(Order) Euheterodonta unassigned FAMILY Hiatellidae

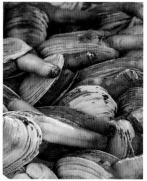

Features The strangely named Geoduck is one of the largest of all burrowing bivalves with siphons up to 1m long. It lives along the west coast of North America and is now widely farmed to satisfy recent demand from Asia. The Chinese name for it translates as 'elephant trunk clam' which suits it well. Buried at least a metre down in muddy sediment, these bivalves have few natural predators and can live for over 100 years. Think about that next time you eat one.

Size Shell up to 20cm long.

Subclass PTERIOMORPHIA

Within the 2,000 or so marine bivalves in this group there are many of economic importance including mussels, oysters and scallops. Most live on top of the seabed (epibenthic) rather than buried in sediment and many attach to hard objects, either cemented on by one valve or fixed by byssus threads. Others lie on the surface of sediment, partially buried or protrude from it. Their shells are often ornamented with 'wings' in the hinge area, ribs or spiny projections. Internally they have a small foot and large complex gills for filter feeding and respiration. The edges of the mantle are not fused to form extensible siphons.

ORDER Mytiloida — FAMILY Mytilidae

Green-lipped Mussel *Perna canalicula*

Features There are many different species of mussels found throughout the world and some of these are of great commercial importance. The Green-lipped Mussel is endemic to New Zealand and lives attached to rocks in shallow water. Unlike the European Mussel (*Mytilus edulis*) it rarely occurs on the shore. It is cultivated on a large scale and as well as being delicious to eat it is widely used in anti-inflammatory supplements for arthritis.

Size Up to 25 cm long.

ORDER Pectinoida — FAMILY Pectinidae

Great Scallop *Pecten maximus*

Features Scallops are one of the few bivalves that live on the surface of sediments. The Great Scallop is well adapted to this way of life, with a curved lower valve which fits snugly in the sand and a flat upper valve that lies flush with the sediment surface. If challenged by a predator such as the Spiny Starfish (*Marthasterias glacialis*) scallops have a most un-bivalve-like habit of swimming away backwards by rapidly opening and closing the shell valves. Other scallops attach to rocks with byssus threads.

Size Up to 15cm length.

FAMILY Spondylidae

Thorny Oyster *Spondylus versicolor (aurantius)*

Features Thorny Oysters are large bivalves, commonly found on coral reefs whose shells are adorned with spines or scales. This allows sessile organisms a good purchase on the shell which is usually heavily overgrown. When they first settle, the shells cement themselves firmly to rocks by the lower valve. Until the animal opens its valves they are almost impossible to spot. Then the colourful mantle, gills and a row of small eyes around the mantle edge show up its bivalve nature.

Size 20cm.

ORDER Ostreoida — FAMILY Ostreidae

Cock's-comb Oyster *Lopha cristagalli*

Features This dramatic bivalve belongs to the same family as the oysters we generally eat such as *Crassostrea* described below. The zigzag edge to the shell makes it easy to identify even when encrusted by sponges and other sessile organisms. Divers often see them attached to the edges of coral rocks and under overhangs on steep reefs in the Indo-Pacific. The author has found them attached to shipwrecks in the Arabian Gulf and they can also survive on rocky shores.

Size Up to 10cm across.

Japanese Oyster *Crassostrea gigas*

Features Native to the Pacific coast of Asia, this is one of the most widely cultivated of all oysters and has been introduced to Europe, North America, Australia and New Zealand. Other names include Pacific Oyster and Portuguese Oyster. In the wild the shells live cemented to hard substrata by the lower valve in shallow, sheltered places such as estuaries. Their chunky, boat-shaped shells have a flattened upper valve and are ridged like geological rock strata. Oysters are traditionally eaten raw.

Size Up to at least 20cm long.

Subclass PROTOBRANCHIA

This is a small group of around 750 ancient bivalves divided into three orders. They have simple leaf-like gills used only for respiration not for filter feeding as in other bivalves. Instead, most collect organic material from the sand with two large mouth palps. The shell hinge has many small regular teeth, an arrangement called taxonodont. Whilst relatively few are intertidal, their small, neat shells are often washed ashore.

ORDER Nuculida — FAMILY Nuculidae

Shining Nut Shell *Nucula nitidosa*

Features There are many different species of nut shells which are difficult to tell apart. All have small, oval or sub-triangular shells. The greenish-brown colour of the one shown is typical of many of the species as is the white inside. The species can be told apart by counting the hinge teeth. It lives in sediment from the lower shore down to at least 90m in the NE Atlantic.

Size Up to 1.3cm long.

CEPHALOPODS

Octopuses, squid, cuttlefish and the enigmatic Nautilus are all cephalopods, a class of highly developed molluscs that includes the largest, most deadly and most intelligent of all marine invertebrates. Their beautiful fluid movements, abrupt colour changes and ability to interact and respond to people make them a favourite of divers and one of the most popular exhibits at public aquariums. Whilst the smallest species is less than 2cm long, giant squid grow to at least 13m (including long stretchy tentacles) and are probably the basis of many legendary sea monsters including the fearsome 'Kraken'.

DISTRIBUTION

Cephalopods have exploited the full range of depths in the ocean from rock pools, where the tiny (and deadly) blue-ringed octopus may lurk, to the vampire squids living (appropriately) in the inky black darkness of the abyssal depths. With a few notable exceptions, octopuses live on the seabed and cuttlefish near to it, whilst the majority of squid roam the water column. There are no freshwater cephalopods.

STRUCTURE

The majority of cephalopods do not have an external shell with the beautiful exception of *Nautilus* and *Allonautilus*, the only two genera in the subclass Nautiloidea. Squid and cuttlefish have an internal shell familiar as the 'pen' in the squid we eat and the 'cuttlebone' in cuttlefish (frequently fed to budgerigars and parrots as a source of calcium). Most octopuses have no shell at all, hence their remarkable ability to squeeze through the tiniest gap when hunting on a reef or escaping from an aquarium.

All cephalopods have a well-developed head equipped with a pair of large, complex eyes and a ring of tentacles at the centre of which is a mouth, armed with a sharp, parrot-like beak. It is those tentacles, or arms, which earn these animals such a fearsome reputation. Octopuses have eight arms with strong suckers that do not have teeth or hooks. Squid and cuttlefish have ten in total, eight short arms with suckers, plus two long tentacles with suckers only at their expanded tips (clubs). Squid suckers are armed with ferocious hooks or a ring of sharp chitonous teeth (sometimes both). Cuttlefish suckers are unarmed except for fine teeth in the two tentacle clubs. Cephalopod eyes can form clear images and are very similar in design (but independently evolved) to those of vertebrates and they have excellent vision.

In cephalopods the body is enclosed by the mantle which is not the delicate structure seen inside the shell of bivalves and gastropods but instead is tough, protective and muscular. It fits around the base of the head like a shirt collar and when relaxed allows water to enter the ventral mantle cavity to bathe the gills. A 'normal' mollusc foot would be of limited use in open water where many cephalopods live and so it has instead become a funnel exiting from the mantle cavity. A sudden contraction of the mantle forces water out of the funnel and propels the animal rapidly backwards. As if that wasn't enough to confuse a predator, cephalopods can also squirt out an inky smokescreen as they go, secreted into the mantle cavity by ink glands. Some deepwater cephalopods squirt luminous ink.

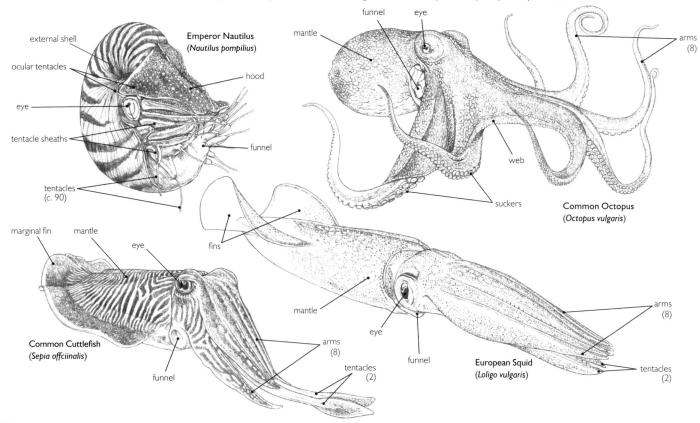

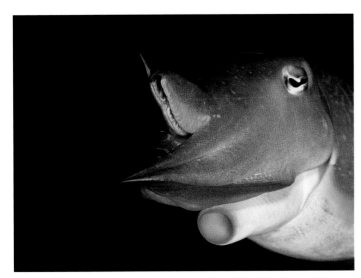

Cephalopods can easily spot a predator with their large eyes and the siphon provides instant backwards escape. When unconcerned and relaxed, cuttlefish and squid use their mantle fins to swim gently forwards.

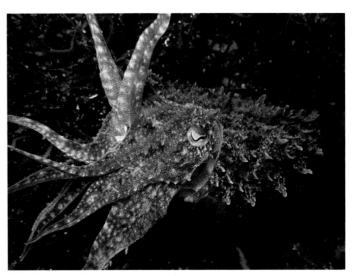

Cuttlefish use posture, along with changes in skin texture and coloration, to communicate with each other and as effective camouflage against predators.

Cephalopods are arguably the most 'intelligent' of all invertebrates and have a highly developed nervous system. They have a large, multi-lobed brain between the eyes which surrounds the oesophagus, a position we, as vertebrates, might find surprising. Even more surprising is the fact that around two thirds of the 500 million or so neurons that an octopus has, are not in the brain but in ganglia distributed along the arms. Amongst other things, this allows for very fine control of each of the suckers on their arms. Many experiments have been carried out to determine the learning capabilities of octopuses and cuttlefishes. Octopuses are the stars and can learn quickly to distinguish between different shapes and colours using either vision or touch and can find their way through a maze. They can remember such 'lessons', which are based on reward and deterrent, for several weeks. This is perhaps not surprising in a predatory animal that must learn to recognise a wide variety of prey but an octopus itself is highly edible and behavioural flexibility is the key to their survival.

The wide-ranging, subtle and instantaneous colour changes shown by cephalopods and developed to the ultimate degree in cuttlefish, are under nervous control. Cephalopod skin contains highly specialised cells, chromatophores, each of which contains an elastic sac of a particular coloured pigment usually yellow, orange, red, brown or black. The chromatophores are arranged in colour layers providing an almost endless palette, rather like the layers and pixels in a computer graphic. Each chromatophore provides only a pinpoint of colour until the pigment sac is stretched out by muscle filaments. By expanding and contracting chromatophores in different layers a huge variety of patterns can be achieved as any diver who has watched an octopus 'disappear' in front of their eyes, will attest. All that from animals that have no colour vision.

Cephalopod behaviour has been widely studied (Hanlon and Messenger 1996) and in recent years has been well-documented using digital underwater video. The cephalopod brain is also well studied and the challenge now is to tie together observed behaviour and neurophysiology.

MASS ESCAPE

Cephalopods are highly edible and consequently have evolved some sophisticated escape mechanisms. Squid living out in open water are particularly liable to become a fish supper but some species have a surprise tactic up their siphon. Using jet propulsion they can reach speeds of at least 40kph, quite sufficient to launch out of the water like a torpedo. As soon as a flying squid is airborne it spreads it tentacles into a fan shape, opens out a pair of mantle-derived fins at the rear end, and embarks on a smooth glide before plunging back into the water up to 50m away. It can top up its glide by blasting retained water from its siphon. A noisy, vibrating boat engine is often enough to turn a school of squid into a flock of silent gliders. Several species of *Ommastrephes* have been observed flying as well as other genera (Maciá et al. 2004). Rapid escape jet propulsion in cephalopods is controlled by different nerve pathways to normal swimming. The mantle muscles are innervated by special giant nerve fibres which, as a result of their greater diameter, can carry impulses at a much faster rate. The sizes and therefore the speed of conduction of these giant fibres varies according to the position along the mantle of the muscles they serve. This arrangement means that the mantle muscles can all receive a signal to contract at the same time.

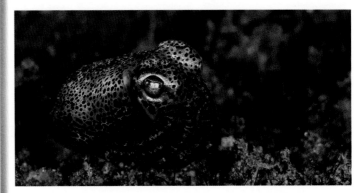

In addition to chromatophores, some cephalopods such as this bobtail squid (*Sepiola* sp.) have an underlying layer of iridiophores which reflect and polarise light through stacks of crystalline plates resulting in green, blue and silver iridescence.

Buoyancy

Unlike squid, cuttlefish can hover effortlessly in the water which allows divers some fascinating head to head encounters with these animals. The cuttlebone allows them to do this without using up precious energy in swimming. This light but rigid, porous structure holds the cuttlefish up in the water like a scuba diver's back-mounted adjustable buoyancy life jacket. Take a careful look next time you come across one on the beach – it has quite a complex structure. The cuttlebone is built up in layers (lamellae) laid down as the animal grows and supported by vertical pillars. The lamellae form a series of sloping chambers filled with gas (nitrogen) at just under atmospheric pressure or with fluid. The cuttlefish can increase or decrease the number of chambers that contain fluid over those filled with gas and so change the density of the cuttlebone. This is done by osmosis through the rear part of the cuttlebone called the siphuncular region, where the tips of the chambers converge and there is a good blood supply.

BIOLOGY

Feeding

Cephalopods are active predators that hunt their prey which is mainly fish and crustaceans. Excellent vision and stealth make them efficient hunters. Two of the ten arms in squid and cuttlefish are long, very mobile, have specially modified, sucker-laden tips and can be shot out to grab their prey. In cuttlefish these two tentacle arms can be retracted into special pits, which is why they sometimes appear to have only eight arms. Once in the grip of the other arms, which have suckers along their whole length, there is no escape. Octopuses can reach out any of their arms to catch their prey but can also pounce on their prey enveloping it in under the umbrella of their webbed arms. The prey is bitten by the sharp jaws and subdued by toxins in the saliva before being torn up and swallowed. Like most molluscs, cephalopods have a radula behind the mouth but in general the food is broken apart mainly by the jaws. Octopuses can also use their highly mobile arms to dismember their prey. Cuttlefish will often mesmerise and distract their prey with shimmering colour changes and by spreading their lower arms out sideways as they inch forward ready to strike.

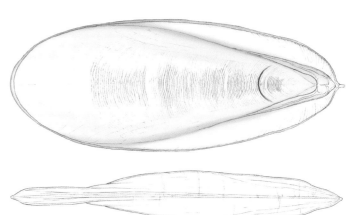

Hard parts of cephalopods: (top) Giant Squid beaks are often found in sperm whale stomachs; (middle) cuttlefish 'bone': structured to provide bodily support and buoyancy; (bottom) squid 'pen': purely structural and squid cannot hover in one place as cuttlefish often do.

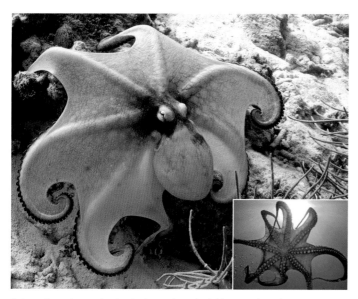

Part crawling and part swimming slowly over the seabed, this octopus is ready to trap any prey it comes across. Octopuses usually retire to a lair to eat what they catch, as evidenced by scattered remains outside. The inset shows the underside of a swimming octopus.

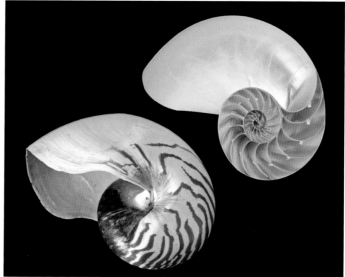

Nautilus occupies only the last and largest of its shell chambers, but maintains a thin strand of mantle tissue, the funiculus, which runs through a porous tube to the innermost chamber of the shell. The gas content of the chambers is controlled via this tissue.

Life history

Cephalopods have separate sexes and with their active lifestyle and ability to communicate they are able to choose their mate and perform elaborate courtship and mating rituals. In most species the male transfers packets of sperm into the mantle cavity of the female using a modified tentacle, the heterocotylus or hectocotylus. The eggs are released from the ovary into the mantle cavity and then laid singly or in clusters. Whilst squid and cuttlefish abandon their eggs, female octopuses guard, clean and fan their eggs assiduously until they hatch and disperse. Cephalopod eggs hatch into juveniles which closely resemble the adults. Life span varies but is generally short and in most cephalopods, the females and often the males as well, die after spawning. Many small species complete their life cycle within a single year.

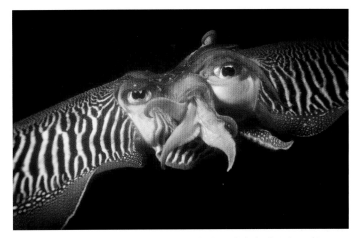

Cuttlefish mate head to head but in this case both animals are displaying the zebra-stripe pattern and are probably males checking one another out for size.

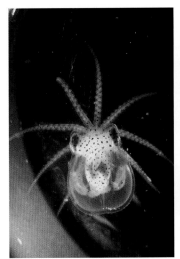

Whilst many octopus eggs hatch into (relatively) large juveniles that can immediately crawl and hunt on the seabed, others hatch into small, planktonic 'paralarvae'. These drift with the plankton and feed on other tiny animals such as crab zoea larvae, whilst they develop. Finally they settle on the seabed and start to hunt like the adults. Elucidating their life histories is helping attempts to rear octopuses in captivity.

Paper Nautilus (*Argonauta*) of which there are several species, are oceanic octopuses that secrete a floating shell within which the female can lay and brood her eggs. The shell is produced from glands in her arms not from the mantle as in the normal mollusc shell. This one was found by the author cast up on a beach in the Arabian Gulf. Some other oceanic cephalopods carry and brood their eggs in their arms.

Many squid aggregate to breed and in a frenzy of spawning, attach their long loose egg masses to rocks, discarded nets, wrecks and any other hard objects. Hundreds of metres of seabed may be covered with a dense mat of egg strings and subsequently the dead bodies of the spent animals. This bonanza attracts fish, sharks, crabs and other predators and scavengers.

Perhaps the most fascinating of all cephalopod rituals are cuttlefish mating displays. Cuttlefish can display a dazzling variety of colour patterns, changing in an instant from one to another depending on their mood. Males can adopt a special aggressive, zebra-striped pattern over their arms and back which provides a way for them to tell a rival male from a potential mating partner. Large males will try to keep other males away from a chosen female and from good egg-laying sites. However where competition for females is fierce, males of some species have been observed to try for a sneaky mating. A small male that would normally have no chance of mating in competition with a large male, will edge in presenting a plain female-style colour on the side facing the male and a zebra-stripe male colour on the side facing the female. Females will anyway often mate with several males and can choose which sperm packets to use to fertilise their eggs.

Ecology

Cephalopods, especially open water squid, are an important and abundant food source utilised by many sharks, bony fish, toothed whales and seals. They themselves are important as predators in coastal habitats worldwide. Huge sucker marks on the skin of sperm whales conjure up visions of gigantic battles between them and Giant Squid (*Architeuthis dux*) though in fact the less well known Colossal Squid (*Mesonychoteuthis hamiltoni*) is more likely to put up a decent fight. Giant Squid are thought to hang head down above the seabed with their long tentacles trailing like a bead curtain to catch fish and smaller squid, possibly including their own species. The Colossal Squid on the other hand has a powerful muscular fin and impressively hooked suckers suggesting an active predatory lifestyle. However, some studies suggest they may not be as active as all that (Rosa and Seibel 2010). Squid beaks (jaws) are regularly found in sperm whale stomachs and some large ones remain unidentified hinting at the possibility of other giant squid species.

It is perhaps not surprising that there are so many myths and legends about giant cephalopods. However there is also a lot of exaggeration over the size and lifestyle of these creatures. Most data comes from dead, beached specimens which are often incomplete. Squid are also very elastic, especially their tentacles and measurements can vary depending on whether the animal is live, dead, fresh or preserved.

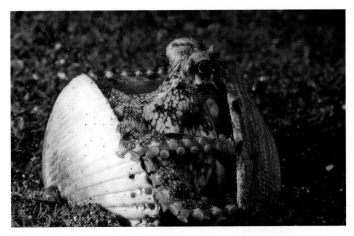

Octopuses are found in both rock and sediment areas and small ones often use shells as a hiding place for themselves and their eggs.

Species	Mantle length (m)	Total length (m)	Weight (kg)	Notes
Giant Squid *Architeuthis dux*	2.25	13	300	Longest squid. 130 specimens measured by Dr Steve O'Shea, New Zealand.
Colossal Squid *Mesonychoteuthis hamiltoni*	2.5	5.4	495	Heaviest squid. Caught Antarctic, now in Museum of New Zealand Te Papa Tongarewa.
Humboldt Squid *Dosidicus gigas*	1.5	4	50	Probably grows larger than this. Scientific published source not found.
Giant Octopus *Haliphron atlanticus*	0.69	2.9	61	Incomplete specimen so probably larger. O'Shea (2004)
Pacific Octopus *Enteroctopus dofleini*	n/a	4	70	Largest octopus. Cosgrove (1987)

Maximum statistics of giant cephalopods. Mantle length (ML) is the most reliable and does not include head, arms or tentacles. The data shown here are from scientific published resources as shown, except where indicated.

USES, THREATS, STATUS AND MANAGEMENT

Cephalopods are a vital food resource worldwide and are heavily exploited by both commercial and artisanal fisheries. In 2010 the cephalopod catch worldwide was 3.6 million tonnes (see table p.242). As most squid and other cephalopods die after spawning, it follows that fisheries are targeting animals that have not yet reproduced. Some local fisheries, such as that for the Japanese Flying Squid (*Todarodes pacificus*), do try to catch the squid in the brief period between spawning and death. Sadly the magnificent Australian Giant Cuttlefish (*Sepia apama*) is listed as Near Threatened in the IUCN Red List of Threatened Species (IUCN 2014) mainly because some major breeding aggregations are being targeted. Fisheries assessment and management is particularly important in cephalopods but the methodologies are not as well developed as for finfish. With declining finfish catches cephalopod fisheries are increasing in importance in areas such as Europe, outside the historically important fisheries in Japan and SE Asia.

With their startling colour displays and fascinating behaviour, cephalopods make popular aquarium displays and are widely kept in public and home aquaria. However, many are not easy to keep or to breed in captivity.

Squid such as these drying in the sun in a market in Thailand are important both for local consumption and export.

CEPHALOPOD SPECIES: CLASS CEPHALOPODA

Almost all the 800 or so cephalopods have no shell or have a reduced internal shell and are grouped together in the subclass Coleoidea, subdivided in turn into Decapodiformes and Octopodiformes. The subclass Nautiloidea contains five species with external shells.

Infraclass DECAPODIFORMES

These are the familiar cuttlefishes, little cuttlefishes and squids, all of which have 10 arms. Two of these are longer and only visible when they are shot out from special pits to capture prey.

Caribbean Reef Squid *Sepioteuthis sepioidea*

ORDER Myopsida
FAMILY Loliginidae

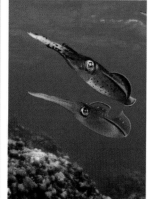

Features During the day, divers are likely to see this small squid hanging around in groups amongst the corals and sea fans of Caribbean reefs. They are shy and soon jet away if approached too closely. At night it hunts small reef fish which it catches with its rather short tentacles. Similar species can be seen on reefs in most tropical seas and the family Loliginidae to which this species belongs, contains eleven genera and many species.

Size Up to about 30cm long.

Flamboyant Cuttlefish *Metasepia pfefferi*

ORDER Sepiida
FAMILY Sepiidae

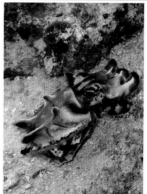

Features This charming little cuttlefish is a favourite amongst scuba divers because of its beautiful bright coloration and habit of 'walking' over sediment waving its arms. These are broad and blade-like and when threatened tend to have red tips. This may warn would-be predators that it contains toxins in its flesh. It is found from Western Australia through to New Guinea, the island of Borneo and the Philippines.

Size Mantle up to about 8cm.

Australian Giant Cuttlefish *Sepia apama*

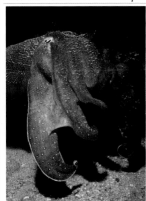

Features The largest of all cuttlefish, this species is endemic to Australia. Unlike most cuttlefish and in spite of their size, they spend most of their time hiding in small caves and crevices. This one was photographed by the author in Shark Bay. It finally gave way to curiosity and emerged to investigate the author's hand with one tentacle. There are over 100 species of *Sepia* worldwide.

Size Up to 50cm body (excluding tentacles).

ORDER Sepiida · FAMILY Sepiidae

Dwarf Bobtail *Sepiola rondeleti*

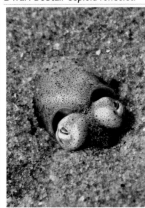

Features Whilst their larger cousins swim and hunt over rocky reefs, *Sepiola* cuttlefish spend most of their time buried in sand, with only their large bulbous eyes showing. They can however move quite fast and will shoot out to catch passing shrimps and small bottom-living fish. This species has a short squat body with a pair of semi-circular fins near the rear end. As with most cephalopods it is an expert at colour change and individual chromatophores can often be seen as dots or larger plates, depending on mood and background.

Size Up to 6cm total length.

FAMILY Sepiolidae

Greater Blue-ringed Octopus *Hapalochlaena lunulata*

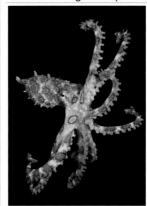

Features There are three and possibly four different species of blue-ringed octopus, which can be difficult to tell apart. However, as they all have an equally deadly bite this is probably immaterial to most people. Whilst two of the species are endemic to Australia, *H. lunulata* can be found throughout shallow, tropical waters in the western Pacific. The blue rings are much brighter when the animal is agitated. Although not aggressive they should be left well alone as their venom tetrodotoxin, can kill within just a few minutes.

Size Up to about 15–20cm.

ORDER Octopoda · FAMILY Octopodidae

Mimic Octopus *Thaumoctopus mimicus*

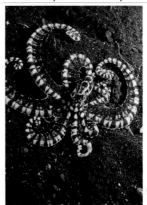

Features This amazing octopus was only scientifically described in 2005 although it was first discovered in 1998. In 2006 another striped species, descriptively called *Wunderpus photogenicus* was also described. The Mimic Octopus hunts over silt and sand in the Indo-West Pacific and therefore has few places to hide. However, it has a remarkable ability to mimic a wide variety of 'dangerous' animals through colour and especially behavioural changes. These include sea snakes and lionfish.

Size Up to 60cm arm span.

FAMILY Octopodidae

Infraclass OCTOPODIFORMES

Octopuses and the confusingly named vampire squid (only one species) all have eight tentacles. They have short sac-like bodies and the tentacles are usually joined together along at least part of their length by a web of skin.

Subclass NAUTILOIDEA

The subclass Nautiloidea encompasses two genera (five species) of cephalopods with an external many-chambered shell.

Common Octopus *Octopus vulgaris*

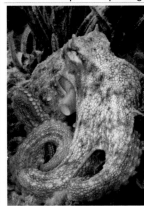

Features As its name suggests this is a common and widespread octopus found throughout the Mediterranean and in warm and tropical parts of the Atlantic Ocean. It theoretically has an even wider world distribution but identifying similar species is always a problem. This typical octopus lives in rocky areas where it mostly hides by day and hunts by night. Given how good it is at camouflage, divers need to look for 'middens' of discarded crab and mollusc shells which give away its hiding places. This is a very important commercial fishery species.

Size Up to 1m total length.

ORDER Octopoda · FAMILY Octopodidae

Emperor Nautilus *Nautilus pompilius*

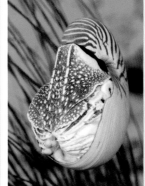

Features *Nautilus* and *Allonautilus* are the only two living genera of cephalopods that have an external shell. Most people will only ever see one either in an aquarium or as dead shells. They take between 5–10 years to reach maturity and only lay a few eggs each year and so are vulnerable to over-exploitation. In the wild they live mostly below about 100m in the Indo-Pacific. Although they appear to have large eyes these do not have lenses and they rely on their chemosensory abilities to find their prey.

Size Shell diameter up to c. 26cm.

ORDER Nautilida · FAMILY Nautilidae

CHITONS

Chitons (Polyplacophora) are readily recognised but often overlooked molluscs that live a life similar to the more familiar limpets. They can be found clinging tenaciously to any hard surface where there is an abundance of encrusting algae and animals on which they graze. The easiest way to find them is to turn over intertidal rocks as they often cling to the underside whilst the tide is out. They are equally as tenacious as limpets but if they are prised loose their multi-plate shell allows them to curl up like a garden pill bug or woodlouse (isopod) and perhaps be rolled away to safety by a wave. When they die, the shell breaks up into its constituent plates and so they are difficult to find in beached material.

DISTRIBUTION

These entirely marine molluscs are found throughout the world, mostly on rocky shores and in shallow coastal waters. A few species have been found on stones dredged from deep ocean trenches.

STRUCTURE

Chitons are also known as coat-of-mail shells because their shell is made up of eight separate, interlocking plates or valves that arch over the body rather like a suit of armour. It is often difficult to tell which end is which because a chiton's head is small and tucked away and does not even have eyes or tentacles, just a rather simple mouth opening. The underside of the animal is basically one large flat, muscular foot which it uses to creep slowly along or to clamp down tightly onto a rock. The visceral mass sits on top of this, protected by the mantle and the shell. The mantle extends out sideways like the skirt on a hovercraft, with a space (mantle groove) between it and the foot into which numerous gills hang down. This encircling part of the mantle is tough, has the edges of the shell plates embedded in it and is often decorated with spines or scales. These, along with the size, shape and colour of the shell plates are used in the identification of different species.

BIOLOGY

Feeding

The reason that most chitons live in shallow water is because the majority eat encrusting algae and diatoms, scraping material off the rocks with a well-developed radula that is sheathed in a long tubular pocket when not in use. The radula is pushed in and out of the mouth and sticky mucus helps to pull the food in. Chitons rarely move very far and they certainly go very slowly so the same ones can often be found in the same place at successive low tides. Some such as *Acanthopleura*, return habitually to the same spot after feeding forays which are usually at night and will even see off other chitons from their home spot. Intertidal species are generally inactive during low tide. Whilst predominantly herbivorous, many chitons also graze on encrusting animals such as sponges and bryozoans. Some species graze the surface of large seaweeds including kelp. A few are more adventurous and at least three genera including *Placiphorella*, *Craspedochiton* and *Loricella* have species that ambush small mobile invertebrates, trapping them under an extended mantle flap at the head end. Chiton radula teeth are exceptional because they are hardened with magnetite, a magnetic iron oxide found in the brains of pigeons and some other animals capable of using the Earth's magnetic field for navigation.

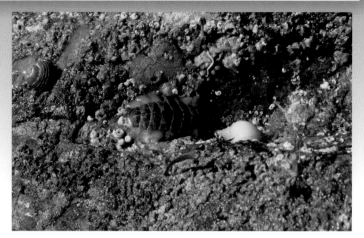

Chitons typically hide away on the underside of rocks as here at Wembury, UK, but even out in the open they are difficult to spot.

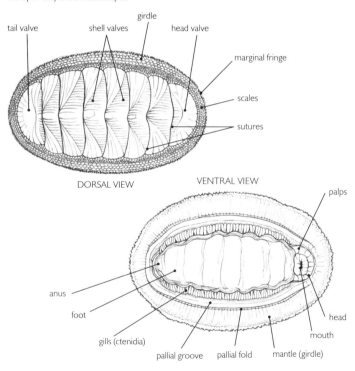

Drawing of a typical chiton from above (top) and when removed from rock and turned over.

Finding your way around and detecting food when you have no eyes or tentacles on your head may seem difficult but chitons are sensitive creatures. They have sensory cells in the mantle cavity to detect chemical cues in the water, protrusible taste organs in the mouth and sensory cells and even primitive eyes scattered all over their shell. The shell eyes are connected by nerves that run down through the shell valves and connect to a simple nervous system. Those with shell eyes react to a predator's (or person's) shadow by clamping down hard.

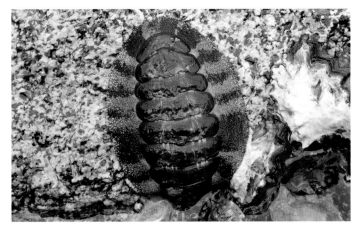

When danger threatens chitons clamp down closely to rocks, but in order to see the detailed structure of the shell plates and girdle with a hand lens they can usually be removed without damage allowing easier identification. With only a photograph as here, identification is difficult.

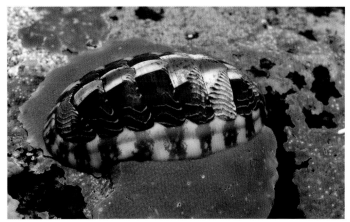

The Blue-lined Chiton (*Tonicella undocaerulea*) found in the cold and temperate waters of the NE Pacific (here Alaska) feeds on encrusting coralline algae and its lovely pink colour provides good camouflage. Unlike many chitons, *Tonicella* species are often brightly coloured.

Life history

Almost all chitons have separate sexes and a single, simple gonad that releases eggs or sperm into the water via two tubes opening one each side into the mantle cavity. Fertilised eggs develop into a non-feeding trochophore larva (p.54) which drifts for a short time before settling down and changing into the adult form. Some chitons retain their eggs which are fertilised in the mantle groove and kept there until they metamorphose. To make fertilisation less of a hit and miss affair, some species such as the Gumboot Chiton (*Cryptochiton stelleri*) aggregate before spawning.

Ecology

The larger chitons can play an important role as grazers within rocky shore communities. The Black Katy (*Katharina tunicata*) feeds on large seaweeds including the kelp *Alaria* and keeps this in check along the rocky coasts of northern California and Alaska, which allows a wider variety of other seaweeds and grazers to thrive. Their way of life is obviously a very successful one as their fossil record goes back at least five hundred million years and the modern versions have remained relatively unchanged. The fossil record though is generally poor. Chitons are considered to be quite similar to the form that scientists think early ancestral molluscs took.

USES, THREATS, STATUS AND MANAGEMENT

Chitons are mostly small and rather tough and are not usually eaten. Only a few species are big enough to make a reasonable meal and even these are said to have an unpleasantly strong fishy taste. The Gumboot Chiton is, or at least was in the past, collected along the Pacific coast of North America by native peoples.

CHITON SPECIES: CLASS POLYPLACOPHORA

With the exception of the largest and a few of the more colourful species, chitons are not easy to identify. At the very least a hand lens is needed to see the details of shell plate shape and the extent and arrangement of spines on the girdle. Two orders are currently recognised: the Lepidopleurida which are considered primitive with only a few pairs of gills, all near the anus, and the Chitonida which have many pairs of gills all along the mantle groove and have the outer edges of the shell plates toothed.

Hairy Chiton *Acanthochitona* sp.

ORDER Chitonida
FAMILY Acanthochitonidae

Features This genus is easily distinguished from other European genera by its broad, spine-covered girdle which has 18 tufts of bristles. Otherwise, like most chitons, it leads a rather dull existence grazing on encrusting and filamentous algae on shallow intertidal and subtidal rocks.

Size 3–6cm long depending on species.

Lepidochitona cinerea

ORDER Lepidopleurida
FAMILY Lepidochitonidae

Features This small chiton is an unremarkable but typical example. It has a relatively wide body and the shell plates are granular and slightly ridged in the middle. The colour is variable but the girdle typically has bands of alternating colour as seen here. This is a common NE Atlantic species found from north of Scandinavia south to the north coast of the Mediterranean.

Size Up to about 3cm long.

MINOR MOLLUSCS

The three big mollusc classes, gastropods, bivalves and cephalopods will be encountered by most people at some time in their lives and chitons, whilst a small class, are at least relatively easy to find. However, there are a further four small classes of molluscs that do not normally impact on our lives and are only recognised by specialists or dedicated naturalists. Of these the tusk shells (Scaphopoda) are the easiest to find and recognise. Monoplacophora do at least look like molluscs but live in the deep ocean. Solenogastres and Caudofoveata are very small and have few of the normal mollusc characteristics. These two latter groups are traditionally treated as subclasses and are put together in one class the Aplacophora. Recent studies including molecular work suggests they should be in separate classes as shown here, but their phylogenetic relationships are an ongoing debate.

TUSK SHELLS

Tusk shells or scaphopods are cleverly adapted to life in soft sediments but are not large, colourful or edible and so are rarely encountered by anyone except observant shell collectors and scientists. Their delicate curved shells are, however intriguing and relatively easily picked out by a careful search along the strandline of sandy shores. Occasionally large numbers are cast up onto the shore from particularly rich offshore grounds. Live animals are mostly brought up in sediments collected in dredges or grabs.

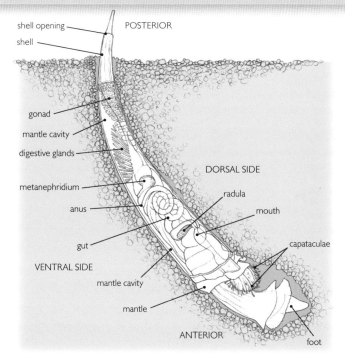

DISTRIBUTION

These molluscs lie partially buried in anything from mud to fine gravel in all the world's oceans. They are rarely found in shore sediments but otherwise range from shallow coastal waters to abyssal depths.

STRUCTURE

Tusk shells, as their name suggests, have a curved, tapering shell resembling a miniature elephant's tusk. Even in the largest species the shell, open at both ends, only reaches a few centimetres long. The animal normally lies obliquely, curved (dorsal) side uppermost in the sediment with the wide end buried and the narrow end projecting above the surface. Both the head and the foot protrude from the wide end. The head is little more than a lobe with a mouth opening but either side of it are two bunches of long thin tentacles called captaculae each tipped with a flattened bulb. The foot is a stout, cylindrical digging organ. The rest of the body is surrounded by a tubular mantle which encloses a large mantle cavity on the ventral side. Water is drawn slowly into the mantle cavity through the narrow projecting tip of the shell.

BIOLOGY

Feeding

The strange delicate, tentacles of tusk shells are the key to their way of life and are both food and information gatherers. The bulbous tip of each tentacle is equipped with sensory cells and is covered with cilia so it can find and collect tiny food organisms between the sand grains. *Dentalium entalis*, a well-studied North Atlantic species feeds mainly on foraminiferans (p.154) whose hard shells are crushed up by the tusk shells' radula. The tentacles contract bringing the food within reach of the mouth or it is moved along the tentacles by cilia. Whilst tusk shells are not known for their exploratory prowess, they can re-position themselves quickly if disturbed. In any case the animal tends to gradually extend and suddenly contract the foot which helps to circulate water in and out of the exposed opening at the tip of the shell.

Life history

Reproduction in tusk shells is a simple affair in which male and female shells release eggs and sperm from a single ovary or testis, into the water for fertilisation. The eggs develop into drifting trochophore and subsequent veliger larvae (p.54) before settling down and metamorphosing into the adult form.

USES, THREATS, STATUS AND MANAGEMENT

The use of tusk shells for making intricate headdresses and other adornments and for commerce has a long history and was once widespread amongst native peoples along the Pacific coast of North America. The shells were of great cultural significance and were widely traded, especially *Antalis pretiosum* (previously *Dentalium pretiosum*). The shells were collected from the shore but also from quite deep water, sometimes using an ingenious device resembling a weighted witch's broom. In 1991 Phil Nuytten, a Canadian scientist, reconstructed this device and tested it, proving that it was an excellent tusk shell collector. Today tusk shells are still harvested for the shell and jewellery trade but these mostly now come from the Indo-Pacific.

MONOPLACOPHORANS

Monoplacophorans are well represented in the fossil record but the first living species (*Neopilina galatheae*) was only collected in 1952, causing much excitement amongst malacologists (those who study molluscs). This is the smallest class of molluscs with only one family currently containing 31 species. They are usually found when scientists dredge up deep, muddy sediments and have the perseverance to sift though it and find these small shells. The shell is conical and shaped like a limpet but with the apex displaced to the anterior (front) end. On the underside is a muscular foot, a simple head at the front end, with no eyes or tentacles, and an anus at the opposite end. On each side of the foot is a series of five or six gills completely unlike the arrangement in limpets and other gastropods. The excretory organs are also serially arranged and there are eight pairs of foot retractor muscles. This simple and almost segmented body arrangement is what biologists think early molluscs might have looked like. Chitons (Polyplacophora) also have rows of gills and new molecular evidence suggests the two groups may be closely related (Giribet *et al.* 2006).

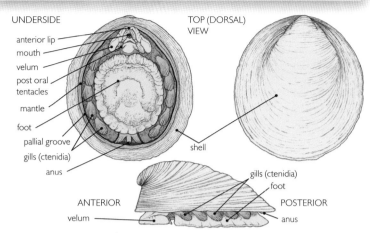

CAUDOFOVEATES

It is very difficult to see why these small, burrowing animals are classified as molluscs and in fact they were not recognised as such until the mid-1940s. They look more like hairy worms and live head-down in vertical burrows in muddy sediment, mostly in deep water. Viewed under the microscope and with some dissection, their mollusc affinities become apparent as they have a radula inside the pharynx behind the mouth, a remnant of foot (the foot-shield) around the mouth and a pair of typically molluscan feathery gills protruding into a water-filled cavity (pallial cavity) at the rear end. They live by eating tiny animals and organic matter selected by the foot shield and broken up by the radula inside the pharynx. They have separate sexes and release their gametes into the water.

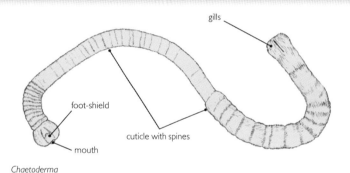

Chaetoderma

SOLENOGASTERS

Solenogasters (Solenogastres) are more varied and numerous than caudofoveates with four orders and around 270 species. They are easier to find in that they are mostly associated with cnidarians, such as hydroids, corals and soft corals on which they feed. Whilst only millimetres to a few centimetres long, some tropical species are colourful enough to have been spotted and photographed *in situ* on corals. Some are worm-shaped whilst others are short and fat. They resemble caudofoveates in having a mouth at one end and anus at the other, opening into a water-filled cavity (cloaca) but it is often difficult to tell which end is which. They have no proper gills though some have gill-like structures in the cloaca. A central groove (pedal groove) runs along the whole ventral (underneath) surface and is roofed by a ridge which is thought to be analogous with the normal molluscan foot. Most species have a radula which helps to place them as molluscs but those without are even harder to identify. They live a slow life moving along a mucous trail propelled by cilia in the pedal groove. Solenogastres are hermaphrodite but very little is known about their life history.

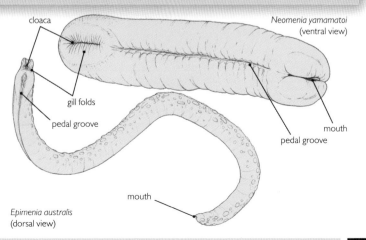

Epimenia australis
(dorsal view)

MINOR MOLLUSCS

BRACHIOPODS

Brachiopods (Brachiopoda) or lamp shells are a small phylum of animals that superficially resemble bivalve molluscs but are not closely related to them. They are placed after the molluscs section in this book to make comparison easier as they are often mistaken for bivalves. However they are actually related to bryozoans (p.284) and phoronids (p.226) and share with them a particular type of feeding apparatus, the lophophore. The shell is just a distraction and so is their name which can easily be confused with branchiopods, a class of mostly freshwater crustaceans.

CLASSIFICATION

Brachiopods were previously grouped into two classes Articulata and Inarticulata depending on whether their shell valves were hinged with articulating teeth (Articulata) or held together only by muscles (Inarticulata). The name 'Articulata' is currently in use for the featherstar subclass of echinoderms (p.288). They are currently divided into three subphyla.

SUBPHYLUM	CLASS	ORDER
Craniiformea	Craniata (Inarticulata)	Craniida
Linguliformea	Lingulata (Inarticulata)	Lingulida
Rhynchonelliformea	Rhynchonellata (Articulata)	Rhynchonellida
		Terebratulida
		Thecideida

DISTRIBUTION

Whilst these exclusively marine animals are found worldwide, they are commonest in temperate and cold waters. The majority of species live on the continental shelf, though there are some intertidal and deepwater species. They are bottom-living animals most of which live attached to the seabed, though a few have adapted to a life buried in muddy sediments.

STRUCTURE

Brachiopods are protected by a two-part, calcareous shell which, in comparison to bivalve mollusc shells, is relatively thin and light. In most species the two parts are different sizes with the smaller valve overlapped by the larger. The majority have a fleshy stalk (pedicle) which emerges near the hinge point of the shell and attaches the animal to rocks or other hard objects. Sediment-living species have a flexible and muscular pedicle which they use to construct their vertical burrow and to stretch up to the surface to feed. Whilst bivalve molluscs are squashed sideways into their shell, which therefore covers their left and right sides, brachiopods can be thought of as squashed 'back to belly' with the shell on their dorsal and ventral surfaces. However this is not something that is in any way obvious from the outside. The shell is actively opened and closed by different sets of muscles.

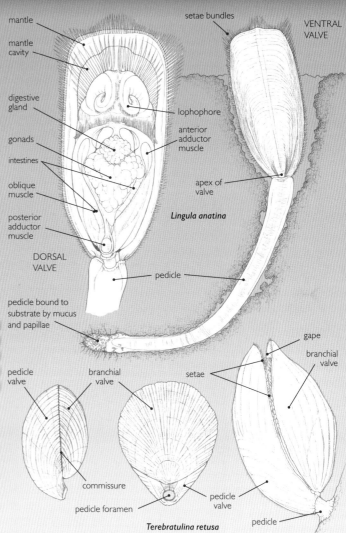

Brachiopods are usually identified from their shells but these are rarely washed ashore because they break easily and because the animals mostly live below about 30m depth.

Most of the space inside the shell is taken up by the feeding apparatus, the lophophore, contained within a brachial cavity open to the surrounding water. The rest of the body is squashed up near the pedicle with the body organs contained within a body cavity. With the shell gaping open, an observant diver (or aquarium keeper) can see the two tentacle-fringed lophophore lobes. The lophophore consists of two coiled arms joined at the base and each with ciliated tentacles along one side. However, the shape and detailed structure of the lophophore varies between species.

BIOLOGY

Feeding
Whether they live on rocks or in sediment, brachiopods are suspension feeders collecting plankton from the water in a similar manner to phoronids and bryozoans. With the shell valves gaping, water is drawn in by beating cilia which cover the lophophore tentacles. Food particles are separated out by the cilia and are directed into a food groove that runs along the length of the lophophore arms and leads to the mouth. The tentacles and their cilia work in such a way that incoming and outgoing water is at least partially kept separate. Some dissolved organic matter (DOM) is also absorbed directly into the animal's body.

Life history
Most species have separate male and female individuals and shed eggs and sperm into the water. Fertilised eggs develop into a short-lived, non-feeding, three-lobed larva which drifts for a while before settling on the seabed and attaching itself by the lower pedicle lobe. The middle mantle lobe develops into the body and secretes the shell whilst the upper apical lobe forms the lophophore. However, lingulids (Linguliformea) develop instead into a drifting and feeding juvenile complete with shell and a coiled up pedicle inside the shell.

Dense bed of *Novocrania anomala* (Craniformea) covering rocks in Loch Duish, Scotland. This species does not have a pedicle but instead lives with the ventral valve cemented to rock. Numerous Black Brittlestars (*Ophiocimina nigra*) are also present.

Ecology
Brachiopods can form dense communities on steep rock faces, along with other filter-feeding animals, especially in food-rich areas created by strong currents. Starfish, sea urchins and carnivorous gastropod molluscs will eat them if they can find them and if they are not put off by distasteful defensive chemicals in their tissues. *Lingula* and *Glottidia* (Linguliformea) can form dense communities with over 1000/m² in intertidal mudflats in the Indo-Pacific and NW Pacific respectively, where they are preyed on by wading birds.

USES, THREATS, STATUS AND MANAGEMENT

Lingula is dug up and eaten in parts of SE Asia where the pedicle is considered a delicacy.

BRACHIOPOD SPECIES: PHYLUM BRACHIOPODA

Of the three subphyla of brachiopods the Linguliformea are considered the most primitive. The shell does not articulate, is held together by muscles and is made from calcium phosphate and organic matter. The pedicle protrudes from between the shell valves. The few species of Craniiformea also fit the above description but have shells made of calcium carbonate. The Rhynchonelliformea is by far the largest subphylum. Species in this group also have a calcium carbonate shell but it articulates with a pair of teeth in the ventral valve that fit into sockets in the dorsal valve. They have an aperture in the ventral valve through which the pedicle emerges and a skeletal support for the lophophore.

Terebratulina retusa
CLASS Rhynchonellata ORDER Terebratulida

Features Brachiopods are rarely easy to find but this species is one of the most common in UK and occurs from Scandinavia to the Mediterranean. In this photograph it is growing attached by its pedicle to steep rock in a sea loch. This species commonly attaches to Horse Mussels (p.229), hydroids and even deep, cold-water corals and ranges in depth from 15m to over 1500m. The shell is pear-shaped with a large foramen (hole) for the pedicle near the hinge.
Size About 3cm long.

Novocrania anomala
CLASS Craniata ORDER Craniida

Features It is difficult to tell that this brachiopod has two parts to its shell because the animal lives with the lower half firmly cemented to rocks and in this respect resembles a small oyster. In life the shell is brown but dead shells are pale or white. This Atlantic species is found from the Arctic to the Canary Islands at depths from 15–1500m usually above 200m in wave-sheltered conditions. Previous names include *Crania anomala* and *Neocrania anomala*.
Size Up to 1.5cm long.

Glottidia albida
CLASS Lingulata ORDER Lingulida

Features Whilst this sediment-living brachiopod lives mostly below low tide level, it can sometimes be found in the sand on a low spring tide along the Californian and Mexican coast. When the animals are dug up it is easy to see their pedicle, two or three times the length of the body. A similar genus *Lingula* lives in tropical shores in the Indo-Pacific. Fossil brachiopods very similar in shape to living *Glottidia* and *Lingula* have been found in rocks dating from 500 million years ago.
Size Shell up to 2cm long.

ARTHROPODS

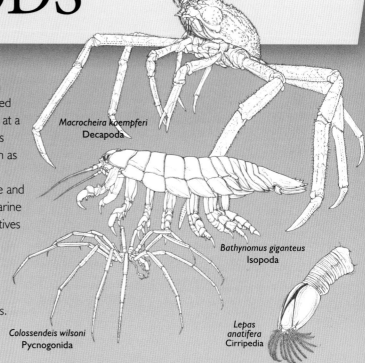

Macrocheira kaempferi
Decapoda

Bathynomus giganteus
Isopoda

Colossendeis wilsoni
Pycnogonida

Lepas anatifera
Cirripedia

Gigantocypris agassizi
Ostracoda

Hutchinsoniella macracantha
Cephalocarida

Speleonectes tanumekes
Remipedia

Of all the animal groups on earth, arthropods (Arthropoda) are the most successful, at least in terms of numbers, the myriad habitats in which they live and their ecological impact. Arthropod means 'jointed (arthro) feet (pod)' and if you substitute 'legs' for 'feet', then looking at a familiar arthropod such as a crab, the reason for the name becomes obvious. This enormous phylum includes many familiar animals such as lobsters and shrimps (crustaceans), spiders (arachnids) and insects. There are no insects in the ocean but crustaceans rule in their place and display an amazing variety of size and form. The only other truly marine arthropods, the horseshoe crabs and sea spiders, are harmless relatives of the land-dwelling spiders and scorpions that instil fear in so many people. However, whilst spiders and scorpions can only live on the fringes of the ocean, some mites, the Halacaridae, which are also arachnids, have made it into the ocean and can be found living amongst and feeding on seaweeds and sessile (fixed) animal growths.

CLASSIFICATION

SUBPHYLUM	SUPERCLASS(SC)/CLASS	SUBCLASS/INFRACLASS (IC)	ORDER/SUPERORDER (SO)
HEXAPODA/INSECTA (insects)			
MYRIAPODA (centipedes & millipedes)			
CHELICERATA	Merostomata (horseshoe crabs)		Xiphosurida
	Pycnogonida (sea spiders)		Pantopoda
	Arachnida (spiders, mites & scorpions etc.)		
CRUSTACEA	Malacostraca	Eumalacostraca	Decapoda (SO Eucarida)
			Euphasiacea (SO Eucarida)
			Amphipoda (SO Peracarida)
			Isopoda (SO Peracarida)
			9 other orders
		Hoplocarida	Stomatopoda (mantis shrimps)
		Phyllocarida	Leptostraca (SO)
	Multicrustacea (SC)	Cirripedia (IC) (barnacles)	9 orders
		Copepoda (copepods)	10 orders
		Tantulocarida (tiny parasites)	Arguloida
		Branchiura (parasitic only)	4 orders
	Oligostraca (SC)	Pentastomida (parasitic 'tongue worms')	
		Mystacocarida (meiofauna)	Mystacocaridida
	Ostracoda (ostracods)	Myodocopa	2 orders
		Podocopa	2 orders
	Remipedia (remipedes in marine caves)		Nectiopoda
	Branchiopoda (mostly freshwater)		
	Cephalocarida (horseshoe shrimps)		Brachypoda

STRUCTURE

It has been said that if the material world were to disappear except for arthropods, then it would still be possible to see the ghostly outlines of cities, forests and oceans. Their huge numbers and diversity of form means it can be difficult to recognise an arthropod as such. However, all arthropods, from butterflies to crabs, share a number of reasonably clear features which define the group. Perhaps the key feature is their jointed appendages the most obvious of which are walking legs or swimming appendages. These limbs are carried in pairs on various body segments. Look at the leg of a crab and you will see that it consists of different sections each of which can only articulate in one plane but adjacent sections articulate in different planes. This gives arthropods considerable versatility of movement.

The other obvious and important feature is the exoskeleton, or cuticle, which protects the body and provides anchorage for muscles. This is secreted by the epidermis, composed of protein and chitin and in marine species is often reinforced with calcium carbonate. Just like our fingernails, the external layer is non-living but is actively maintained and can be repaired. This is not just a suit of armour but an incredibly versatile, multi-layered structure that has contributed significantly to the diversity and success of arthropods. Depending on where it is on the body, it can change from hard plates to flexible membranes to allow easy movements of jointed appendages and bending between segments. It turns inwards as plates and knobs called apodemes to provide extra surface attachment for muscles and it lines the foregut and hindgut. It forms weapons and eating implements in the form of biting jaws, piercing mouthparts and pincers. Extensions of the cuticle help keep larval crustaceans afloat in the ocean by increasing their surface area in the form of spines and projections. Tropical zoea larvae have much longer spines than cold water species to provide support in the less dense warm water in which they live. So the arthropod wonder suit provides protection and support whilst still allowing great mobility.

Internally, arthropods have an open circulatory system where the main body cavity consists of a series of sinuses filled with a blood-like fluid called haemolymph that bathes the organs. A simple heart pumps fluid out into the sinuses via a few arteries and it returns directly to the heart through paired openings, from the sinus within which the heart itself lies.

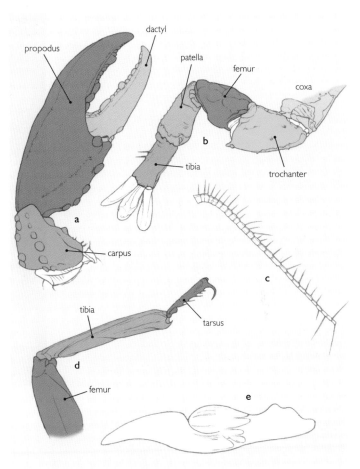

The many joints in arthropod appendages make them versatile tools, that can perform a variety of different functions: (a) cutting claw of lobster; (b) walking leg of horseshoe crab; (c) sensory antenna of copepod; (d) walking leg of insect; (e) mating appendage of male lobster.

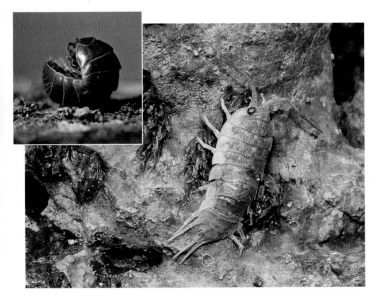

Thin areas of cuticle between body segments allow the well-known pill bug *Armadillidium vulgare* (inset) often found in gardens, to roll into a ball for protection and the sea slater *Ligia*, (right) to creep into crevices.

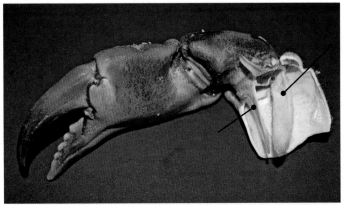

Inwardly projecting cuticle plates (apodemes) provide additional surfaces for muscle attachment but make eating a crab claw a messy business.

Moulting and growth

The disadvantage of wearing what is effectively a suit of armour is that significant growth is only possible by periodic shedding of the exoskeleton. This is a very vulnerable stage in any arthropod's life and is completed as quickly as possible. Most crustaceans, the dominant arthropods in the ocean, moult throughout their lives in contrast to insects which stop moulting once they reach sexual maturity. Moulting frequency in crustaceans varies but usually declines with age as growth slows. Lobsters (*Homarus*) can live for at least 50 years (though fishing pressure means they rarely do) and whilst size is not directly related to age, an old lobster can be recognised from the growths of barnacles and tube worms on its shell. Even barnacles moult within their protective shells.

Control of moulting varies between arthropod groups. In crustaceans, neurohormones that inhibit the production of the moulting hormone ecdysone, are produced continuously from part of the brain situated in the eye stalks. Moulting only occurs when neurohormone production ceases, allowing release of ecdysone, in response to internal stretch receptors and in some cases external stimuli such as light, temperature or even the loss of a limb. The moulted shells of crabs we find on the beach are however, only the outer, hard layer of the cuticle. The soft inner layers are resorbed and recycled, a huge saving in terms of materials and energy. Just before a moult aquatic crustaceans drink large quantities of water which swells their tissues and ruptures the old cuticle allowing the animal to pull itself gradually out of the shell. The new cuticle expands like corrugated cardboard and then hardens around the enlarged animal. The excess water is slowly excreted leaving the animal room to grow.

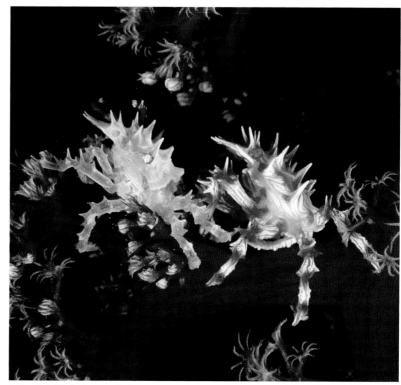

Spider Crab (*Hoplophrys oatesi*) with moulted exoskeleton (left), Coral Sea, Queensland, Australia.

eggs

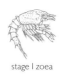
stage I zoea

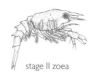
stage II zoea

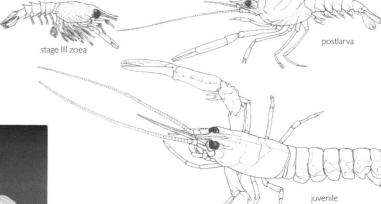
stage III zoea

postlarva

juvenile

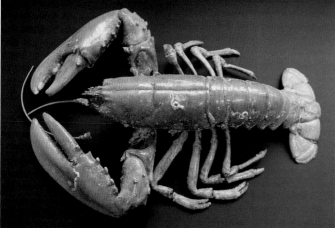

Lobster eggs hatch into already well-developed planktonic larvae which have all their thoracic appendages present. Abdominal appendages appear in subsequent moults. This moulted shell (left) of a European Lobster (*Homarus gammarus*) came from an aquarium animal. With the moult finished, the author collected and dried the shell which was complete with every hair, the covering of the eyes and the inside of the mouth. Old lobsters like this one often have tubeworms and barnacles growing on the shell.

Compound eyes

Try and swat a housefly or mosquito and you will see an excellent demonstration of just how effective arthropod eyes can be. Compound eyes are extremely good at detecting movement as they are made up of thousands of individual eye units called ommatidia. Each ommatidium has its own lens, formed by a transparent thickening of cuticle, is separated from its neighbours by a screen of pigment in special cells and directs the light it collects onto light-sensitive cells. Information from all the ommatidia is passed along nerve fibres to the brain where it is decoded to form a mosaic image. This type of compound eye is only found in arthropods and is very highly developed in some crustaceans such as mantis shrimps (Stomatopoda p.302). The detailed optical structure, including the distribution of pigment cells and number of ommatidia varies to suit the animal within its habitat, but the majority of 'higher' crustacean groups and horseshoe crabs have compound eyes, though sea spiders do not. Horseshoe crab eyes are large and this animal is used extensively in studies on vision and neurophysiology. In general, an animal such as a hermit crab living in the bright sunlight of a tropical lagoon will have a greater ability to alter the distribution of the pigment that isolates one ommatidium from another, than will a crustacean living in the semi-darkness of deeper water. The hermit crab will be able to allow more light into its eyes as night falls. Allowing light to pass from one ommatidium to another results in a less sharp image but allows vision in dim light.

The compound eyes of fast predatory land insects such as dragonflies cover most of the head giving a wide field of view. Mantis shrimps are also fast predators and achieve the same thing with stalked eyes that can be swivelled around independently. Across each eye is a band of extra-sensitive ommatidia. If one eye detects prey, it centres it in this band whilst the other swivels so that its band is at right angles to the first. The prey is then pinpointed as if in the sighting cross hairs of a rifle.

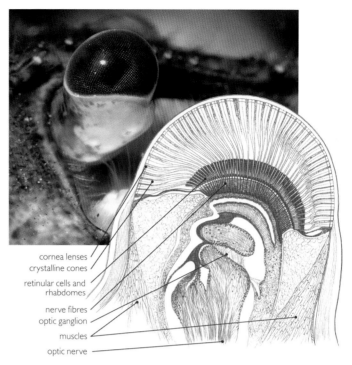

Narrow-clawed Crayfish (*Astacus leptodactylus*) close-up.

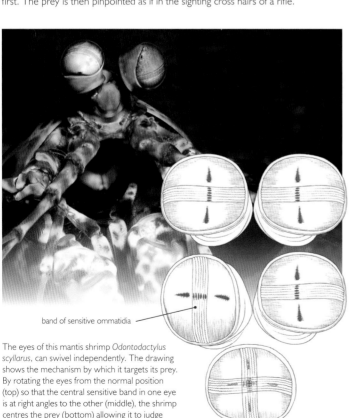

The eyes of this mantis shrimp *Odontodactylus scyllarus*, can swivel independently. The drawing shows the mechanism by which it targets its prey. By rotating the eyes from the normal position (top) so that the central sensitive band in one eye is at right angles to the other (middle), the shrimp centres the prey (bottom) allowing it to judge distance very accurately.

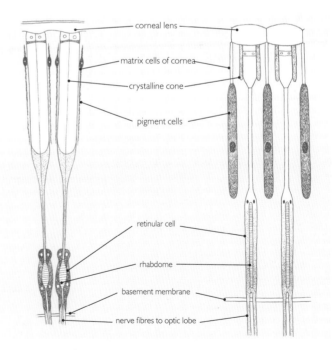

Longitudinal section of generalised ommatidia. Left: superposition type with cells in which the pigment can move up and down the sides of the ommatidium, allowing light to enter adjacent ommatidia to increase sensitivity. Right: apposition type in which the pigment is fixed and the cells act as shutters to prevent light entering adjacent ommatidia.

HORSESHOE CRABS AND SEA SPIDERS

Horseshoe crabs (Merostomata) are evolutionary survivors that have remained almost unchanged for 400 million years. There is no mistaking a fossil horseshoe crab. Few people have the chance to see them today as they have a restricted world range, but anyone in east coast USA walking along a sandy shoreline in late spring might be lucky enough to witness a mass emergence for breeding. Fishermen also bring up these spiny creatures in their trawl nets. Sea spiders (Pycnogonida) on the other hand will only be found by diligent searching amongst sessile animal undergrowths on the shore or amongst material collected by divers. Their small size means that many species probably remain undiscovered. The author, for example, found a new one amongst sponge material collected in Sabah, Borneo (Bamber 2001).

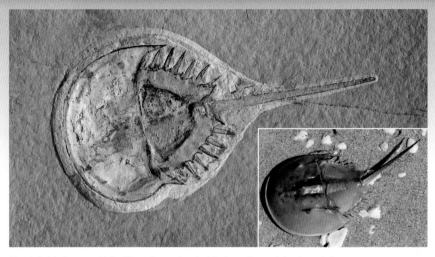

The similarities between this fossil horseshoe crab and a living horseshoe crab (inset) are obvious.

DISTRIBUTION

Whilst sea spiders are found worldwide in all oceans, horseshoe crabs are restricted to shallow sediment areas off the Atlantic coast of North America (one species) and southeast Asia (three species). Sea spiders have a wide depth range from the intertidal to great depths.

STRUCTURE

At first sight it can be difficult to see how tiny sea spiders can be grouped together with lumbering, armoured horseshoe crabs (plus the various arachnids). A close look at their anatomy shows shared features but some studies of the neuroanatomy of sea spiders indicates they may yet prove to be a separate primitive group of arthropods. The body in both groups consists of two parts, the cephalothorax (combined head and thorax) sometimes called the prosoma and the abdomen or opisthosoma. Horseshoe crabs have the two parts hinged and this, along with a strong tail spine allows them to flip right side up if turned over. Five pairs of legs help them to scuttle along the bottom and dig into it with the last pair, whilst flattened appendages on the abdomen are used to swim along upsidedown. Thin page-like book gills on the abdominal appendages absorb oxygen into a system of blood vessels and sinuses.

Like their counterparts on land, sea spiders are all leg. In most species the body is so small that the gut and reproductive systems all extend into the legs, which also absorb oxygen from the water and release waste. Most have eight legs but species with only six and with more than eight have also been found. This is perhaps not surprising given that the larva starts off with three pairs and adds the fourth plus other appendages during subsequent moults. A tubular, segmented prosoma makes up most of the body, preceded by a long proboscis at the head end and a stumpy opisthosoma at the end.

The name of the subphylum to which horseshoe crabs, sea spiders and arachnids belong is Chelicerata named after the single pair of appendages, the chelicerae, found in front of the mouth and which are used to manipulate food. These end in pincers (modified as sharp fangs in spiders). Unlike other arthropods, there are no antennae for the animal to wave around and no chewing mandibles.

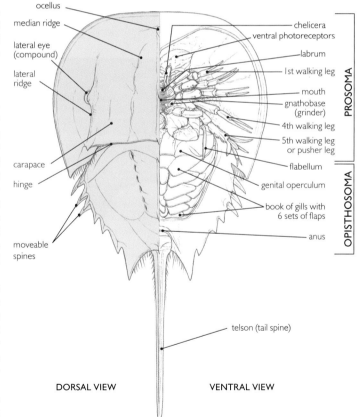

Drawing of a horseshoe crab with the topside shown on the left and the underside on the right. The compound eyes are fixed in the carapace which limits vision. The appendages on the underside are modified for various functions.

BIOLOGY

Feeding

A willingness to take a wide variety of food is one of several reasons that horseshoe crabs have survived almost unchanged to this day. These omnivores eat almost anything but especially worms, algae and molluscs. Their feeding technique is simple; crawl over and into sediment until something edible is encountered. All except the last pair of walking legs have strong pincers that feel for and grab hold of food items. Each leg has mobile spines at its base (gnathobases) that shred up the food. Everything about this animal is spiny. The bases of the last pair are strong enough to crush bivalve shells. Bits of food are pushed into the mouth by the chelicerae. The animal has a strong grinding gizzard to deal with tough food.

In contrast sea spiders are armed with a proboscis that pierces soft-bodied prey and sucks out and strains the contents before the resultant soup is passed into the gut. Most feed on bryozoan and cnidarian polyps but sponges, tunicates and even detritus are on the menu for others.

The Atlantic Horseshoe Crab (*Limulus polyphemus*) spawns in huge numbers along the NW Atlantic coast and in the Gulf of Mexico.

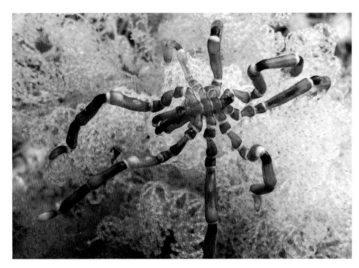

The sea spider *Anoplodactylus evansi* exhibits a kaleidoscope of colours on its 1cm long body. This specimen was photographed at Shellharbour, south of Sydney, Australia on a white bryozoan on which it probably feeds.

Life history

The mass spawning of Atlantic Horseshoe Crab (*Limulus polyphemus*) is legendary along the east coast of USA. Thousands of them crawl up sheltered sandy shores as the tide comes in, and lay their eggs in the damp sand. They spawn in late spring, with peaks on high tides at new and full moon. Relatively clean, well oxygenated sand provides the best chance for hatching success. Each female lays up to 80,000 eggs in shallow depressions depositing them in batches over several high tides. Males scramble to ride piggy-back on the females, clinging on with a specially modified first pair of legs, ready to fertilise the eggs as they are laid. Many are flipped over in the frenzy and, unable to flip back without the water to help them, succumb to heat and scavenging gulls. The eggs hatch into swimming trilobite larvae that develop into bottom-living juveniles within a few days.

Sea spider breeding is a much gentler affair. Males pair off with females and fertilise the eggs as they are shed through pores at the base of each leg. The male then collects up the eggs with his ovigers, a pair of short appendages in front of the legs, and carries them around. The eggs are only deposited onto the undergrowth shortly before they hatch, and some species even carry the young. The protonymphon larva is so called because it resembles an undeveloped, stubby adult with only three pairs of legs.

Ecology

Horseshoe crabs provide seasonal food for migratory shore birds and many invertebrates via their eggs and in spite of their crunchy shells, the adults are eaten by loggerhead turtles. The crabs themselves provide a home for a variety of commensal invertebrates such as *Bdelloura* flatworms which live under the shell and the top of the shell provides a substratum on which barnacles, tubeworms, sponges and other fixed animals grow.

Sea spiders spend most of their time clinging to their prey or crawling slowly over the seabed to new feeding areas. The largest species, with bodies up to 6cm long and legs of 50cm or more, are found in the frigid waters around Antarctica.

USES, THREATS, STATUS AND MANAGEMENT

Whilst not generally eaten by any sensible person, horseshoe crabs are used extensively in the USA as bait for pots designed to attract eels, conch and whelk and are declining in numbers. They are sometimes served up in restaurants in Malaysia and other parts of SE Asia but usually only the roe is eaten. Some states in the USA have implemented fishing bans to help protect Red Knots (*Calidris rufa*) which feed heavily on the eggs when they arrive from their winter breeding grounds. Ongoing (as of 2012) crab tagging programmes provide important ecological information to help with stock management.

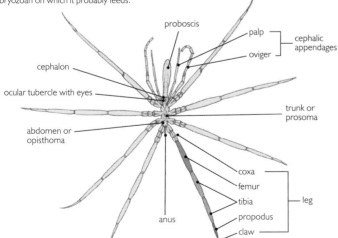

Top view of sea spider *Colossendeis megalonyx*, showing the four pairs of legs plus additional appendages at the head end.

CRUSTACEANS

Crustaceans are often called the 'insects of the sea' which reflects their remarkable diversity and abundance. Crabs and lobsters are familiar to most people, and include large and commercially important species, but there are a myriad of other smaller crustaceans which play vital roles in the ecology of the oceans. These come in an amazing variety of colours, shapes and sizes that easily rival those of insects. The tiny size of some of the smaller planktonic species, such as copepods, belies their importance within food chains that support many of the world's most important commercial fisheries. Huge advances in underwater photography means that these technicoloured animals can now be seen in all their natural glory from red, spiny deepwater Antarctic amphipods to clown-patterned tropical harlequin shrimps (Hymenoceridae). Those that live within diving depths are well-illustrated in Debelius 2001.

Crustaceans are predominantly marine animals, though a number of groups are important in freshwater and a few live on land but most of these need water to breed. The class Branchiopoda, which includes fairy and brine shrimps (Anostraca) and water fleas (Cladocera), is the only crustacean class that lives predominantly in freshwater, with just a few marine representatives. Freshwater crustaceans are generally small and often planktonic, with freshwater crayfish topping the bill in terms of size, but still mostly only a few centimetres long. In contrast the largest marine crustacean, the Japanese Spider Crab (*Macrocheira kaempferi*) has a leg span of nearly 4m.

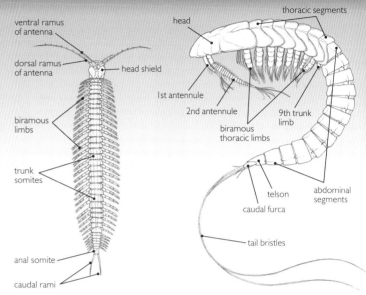

Remipedes (Remipedia) and cephalocarids (Cephalocarida) are the two smallest and most primitive classes of crustaceans with only 27 and 12 described species respectively. Both have unspecialised appendages and probably look much like ancestral crustaceans did. Remipedes, found in marine caves, have one pair on almost every segment. Cephalocarids are only a few millimetres long and lack abdominal appendages. New molecular analyses place them together in the Xenocarida and they are now considered to be the closest relatives to insects (Hexapoda) (Regier et al. 2010).

STRUCTURE

Finding a 'typical' crustacean is difficult because they have diversified so much that the basic crustacean features are often hidden. Crustaceans generally have a head, thorax and abdomen at the end of which is a tail piece (telson). The thorax though, is often partially or completely fused with the head forming a cephalothorax. The head carries two pairs of sensory antennae (which distinguishes crustaceans from all other arthropods) and three pairs of mouthparts. Some groups have additional mouthparts. There are paired appendages on the thorax and often on the abdomen, the number, structure and function of which varies between groups. The appendages are usually biramous, that is they have two branches, though one branch is often effectively absent (e.g. in the walking legs of decapods).

The large size and tough exoskeleton of many crustaceans means they need gills for respiration, though smaller species can simply absorb oxygen all over the body. Gills are usually found externally at the bases of the thoracic and abdominal appendages including legs, swimmerets and maxillipeds and are variously shaped expansions of the body wall. In crabs they lie just under the carapace (shell) and are easily seen when this is removed in preparing a crab for the table. Parasitic species are found in most major crustacean groups and these are highly modified and often difficult to recognise as crustaceans.

Body section	Appendage	Number of pairs	Details
Head	Antennae	2	Sensory. Swimming. Burrowing
Head	Mandibles	1	Feeding: biting and chewing
Head	Maxillae	2	Feeding: manipulating food
Thorax	Maxillipeds	1–3	Feeding: shredding and moving
Thorax	Chelipeds (claws)	Variable	Feeding. Walking. Defence
Thorax	Thoracic limbs	Variable	Walking. Crawling. Swimming. Collecting food
Thorax	Walking legs	Variable	Walking
Abdomen	Swimmerets	Variable	Swimming
Abdomen	Uropods	1	Part of tail fan

Crustacean appendages.

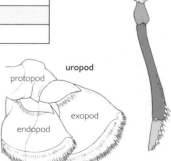

fourth walking leg (see p266 for key to parts)

 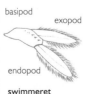

Left: Underside of Edible Crab (*Cancer pagurus*) showing biramous third maxillipeds which cover and hide the other mouthparts. Right: With the exception of the walking legs, the varied appendages of a lobster are clearly biramous.

MALACOSTRACANS

The class Malacostraca is the largest of the six crustacean classes and contains all the animals that most people think of as crustaceans as well as other smaller and less well-known groups. Consequently the huge variation in size, shape and way of life seen in malacostracans makes it difficult to see why they are all relegated to this one group. Why are spiny lobsters (Palinuridae) that grow to half a metre, put in the same class as tiny tanaids only a few millimetres long? The answer lies in a close look at their anatomy, but even then not all the shared features are always apparent. Next time you look at a lobster search for: head with two compound eyes and two pairs of obvious antennae, (the first pair usually having two branches in lobsters); thorax with eight segments though this is only obvious in a few groups as one, two or all (as in the lobster) the segments are usually fused with the head; abdomen with six segments (seven in the superorder Leptostraca which are small primitive shrimp-like animals) plus a telson or tail piece; most segments with a pair of appendages. You will have to turn your lobster over to see the head and thoracic segments which, in its case are hidden by a shield or carapace.

Orders	Common name	Main features
Decapoda	Decapods e.g. crabs	Ten walking legs (including claws)
Euphausiacea	Euphausids e.g. krill	Shrimp-like, flattened side to side, carapace short exposing gills
Amphionidacea		Tiny planktonic, one species *Amphionides reynaudi*
Amphipoda	Amphipods	Flattened side to side, with diversity of appendages
Isopoda	Isopods	Flattened vertically, resemble woodlice
Tanaidacea	Tanaids	Tiny meiobenthos in sand
Cumacea	Cumaceans	Small with large head/thorax, thin abdomen, burrowing
Mysida	Mysid or opposum shrimps	Small, shrimp-like with large brood pouch, often in swarms
Lophogastrida	Lophogastrids	Small shrimp-like, in deep pelagic water
Mictacea and Bothusacea		Small, primitive, crawling, deep sea and caves
Spelaeogriphacea		Small, four species, caves and aquifers
Thermosbaenacea		Tiny in thermal springs
Stomatopoda	Mantis shrimps	Flattened vertically; huge extensible claws
Leptostraca	Leptostracans	Small, bottom-living, with large bivalved carapace

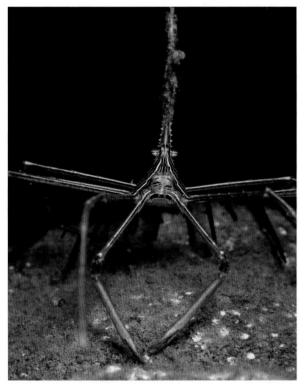

With legs several times the length of its body, it is easy to see why the Yellowline Arrow Crab (*Stenorhynchus seticornis*) belongs to the spider crab family (Majidae). Found along western Atlantic coasts, it is around 6cm long.

Malacostracan orders with main characters.

Crabs, lobsters, prawns and shrimps

A seafood supper would not be complete without at least one decapod. Crabs, lobsters, crayfish, shrimps and prawns are all decapods and there are more species and a greater range of colours, shapes and sizes in this crustacean order than in any other. These familiar animals are well-known to anyone who has anything to do with the sea. To children the world over, crabs and prawns are a fascinating first introduction to marine life, hauled up from jetties on bits of string or goggled at in rock pools. The common names 'shrimp' and 'prawn' tend to be very loosely used and can be confusing. There are no specific features that separate 'prawns' from 'shrimps' and the same species may be called a 'prawn' in the UK and a 'shrimp' in the USA. Some non-decapod crustaceans are also often called shrimps, for example opossum shrimps (Mysidacea), and mantis shrimps (Stomatopoda). Decapod characteristics are described below but in general anything crab-shaped or lobster-shaped is indeed usually a decapod crab or a lobster, whilst with shrimps and prawns more care is needed.

DISTRIBUTION

Decapods are predominantly marine animals though many can tolerate brackish water and a few live permanently in freshwater or on land. Some freshwater habitats are extreme and a number of grapsid crabs (Grapsidae) live in tropical rainforest trees, their young developing in tiny pools of water in epiphytic bromeliad plants. Most land crabs must return to water to lay their eggs and species such as the Red Christmas Island Crab (*Gecarcoidea natalis*), have caught people's imagination with their army-like march back to the sea. Decapods can be found in almost any type of bottom habitat in the ocean, from fringing mangrove swamps to deepsea hydrothermal vents but are especially common on coral reefs and shallow rocky reefs. They are essentially walking and scuttling animals but there are a few species that live a permanently planktonic existence.

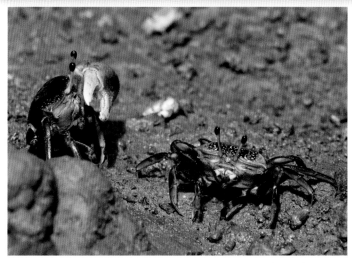

Fiddler crabs use their versatile claws not only for sifting through the mud for food (female right), but also for display (male left) and for defense.

STRUCTURE

A decapod crab and a decapod shrimp look superficially rather different whilst a decapod shrimp and for example a euphausiid shrimp (krill) look superficially similar. However it is relatively easy to tell that the euphausiid shrimp is not a decapod simply by looking to see if it has ten walking legs (it does not). Decapod means ten-footed. Many decapods, and the lobster is the obvious example, have the first pair of legs modified as strong claws or chelipeds. These still count as legs. All decapods have the head and the whole thorax fused together as a cephalothorax, which is covered by

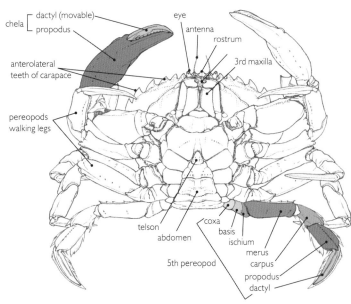

Underside of the Shore Crab (*Carcinus maenas*).

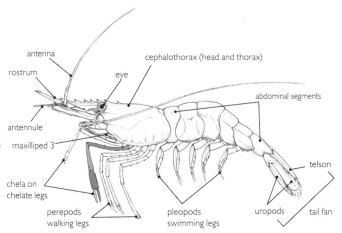

Side view of the Common Prawn (*Palaemon serratus*).

a strong shell or carapace. When you prepare a prawn to eat and break off its head you are actually removing its head and thorax, the latter containing most of the body organs as well as the gills hidden under the carapace between the leg bases. Prawns, shrimps and lobsters have a well-developed abdomen (this is the bit you eat) which has paired swimming appendages on each segment and ends in a tail fan. In crabs the abdomen is small, flat and only visible ventrally, because it lies tucked away beneath the cephalothorax.

Autotomy

Having walking legs could be a disadvantage as a trailing leg can easily be grabbed by a predator, especially if, as crabs do, you stick them out sideways when you walk. Many crabs and lobsters have therefore evolved the ability to shed a limb if this happens and escape with their lives if not their dignity. The limb breaks off at a predetermined point at the limb base where there is an internal membrane with only a small hole through which nerves and blood vessels pass. This hole is quickly plugged. The limb is not just torn off, but actively shed by contraction of special muscles which engage shell protuberances either side of the breakage plane. The lost limb can re-grow but only following moulting and it may be several moults before the new leg reaches full size. The smaller decapods including shrimps and prawns cannot shed limbs in this way but will often survive without one or two legs.

BIOLOGY

Feeding

The majority of decapods are scavengers and feed on dead plant and animal remains. It is easy to tempt crabs, lobsters and prawns into pot traps with a nice piece of rotting fish. Most large decapods also catch and eat live prey, usually immobile or slow-moving animals such as molluscs and worms. Many decapods are omnivorous and will eat almost anything live or dead including plant material. Food is generally picked up, torn apart and manipulated by the chelipeds (claws) and then pushed within reach of the mouthparts. It may be held by the mandibles whilst maxillae and maxillipeds tear it up further. Cancrid crabs such as the familiar North Atlantic edible *Cancer* species, have one claw developed as an effective crushing tool with which they can break open mussels, clams and even sea urchins. The other claw is finer and is used for seizing and tearing up their food.

Mud lobsters (Thalassinidae) and fiddler crabs (Ocypodidae) make use of rotting

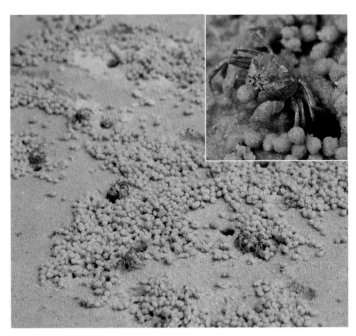

This beach in Thailand is covered with the discarded pellets of sand from which the organic material has been extracted by a tiny sandbubbler crab *Scopimera* sp.

remains at a later stage by eating the organic material found in mud and fine sand. Fiddler crabs are a common sight in tropical estuaries and mangroves where they live up to their name by rapidly and repeatedly scooping up mud with one delicate cheliped and then sifting out organic matter with specialised, hairy mouthparts.

Porcelain crabs (Porcellanidae) hide under stones on shores in the NE Atlantic and have hairy mouthparts with which they filter feed. Their tropical counterparts such as *Neopetrolisthes* have complicated mouthparts and do the same whilst sitting safely amongst the tentacles of large anemones. Huge swarms of pelagic Tuna Crabs (*Pleuroncodes planipes*), which are actually squat lobsters (Galatheidae) filter feed in the warm plankton-rich waters off Baja California and elsewhere. After spending

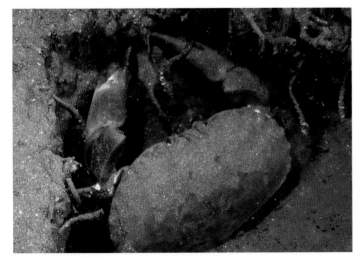

The Edible Crab (*Cancer pagurus*) is heavily fished in northern European waters. Usually found in rocky areas, it will also dig for bivalves in sand and mud.

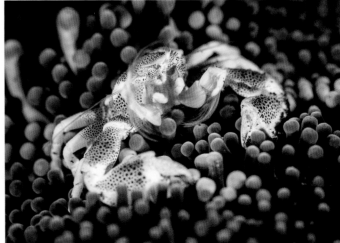

The porcelain crab *Neopetrolisthes maculatus* lives in large sea anemones in the Indo-Pacific. The hairy mouthparts with which it filters out edible particles, are clearly visible in this photograph.

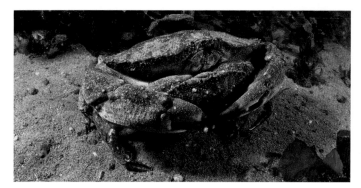

Male crabs pair up with a female and carry her around piggyback style for some time until she moults. He will then turn her over to mate with her and fertilise her eggs. Shown is a pair of Red Rock Crabs (*Cancer productus*).

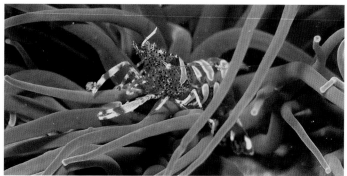

The commensal shrimp *Periclimenes sagittifer* is commonly found associated with Snakelocks Anemones (*Anemonia viridis*) in the Channel Islands, UK. Most other members of this genus are tropical.

their first year of life eating detritus on the seabed they take an upward plunge and become plankton-feeders. By swimming up and then drifting down with hairy legs outstretched, they accumulate plankton on their body which they comb off with their claws (chelipeds). Not surprisingly such swarms draw in tuna (hence their name), sealions, turtles and seabirds which gorge on them.

Life history

Most decapods use modified abdominal appendages to transfer sperm from male to female. In many (but not all) species the female must moult and be soft for the male to mate successfully with her. For this reason some crabs carry their chosen female around for a few days prior to moulting. Boxer or cleaner shrimps (Stenopodidae) search out a mate when they are still juveniles and the pair live and grow together within their chosen crevice. In the majority of decapods the female retains her eggs and carries them safely attached under her abdomen until they hatch and the larvae are released to join the zooplankton. Commercial species are said to be 'berried' when carrying eggs as these look like tiny berries. The first larval stage is usually a zoea or prezoea (p.55). The number and type of other larval stages following the zoeal phase and the length of time spent in the plankton depends on the group (e.g. megalopa in true crabs, phyllosoma in lobsters). Some prawns and shrimps are sequential hermaphrodites where males change into females during their lifetime.

Ecology

As well as exploiting a huge variety of bottom habitats in the ocean, many decapods make their home on other animals. In most cases the host simply provides a safe place to live but the relationship is obligatory for the decapod which cannot live and thrive outside its host (a commensal relationship, p.499).

DECAPOD	HOST
Shrimps *Periclimenes* spp. (Pontoniinae)	Anemones, corals, echinoderms
Imperial shrimp *Periclimenes imperator*	*Hexabranchus* and other large nudibranchs
Coral shrimps (Pontoniinae) e.g. *Pontonides*, *Hamodactylus*	Antipatharians, sea fans, coralliomorpharians
Porcelain crabs (Porcellanidae) e.g. *Neopetrolisthes*	Anemones and soft corals e.g. *Dendronepthya*
Decapod crab *Xenocarcinus* spp. (Epialtinae)	Soft corals, black corals, sea fans
Black coral crabs (Trapeziidae) e.g. *Quadrella*	Soft corals and black corals
Dendronephthya Crab *Hoplophrys oatesi*	Soft coral *Dendronephthya*
Coral hermit crab *Paguritta harmsi*	Corals especially *Porites*

Examples of decapod commensals and their hosts.

Mass migrations of decapods provide some spectacular sights. In autumn spiny lobsters (*Panulirus argus*) living in warm shallow lagoons around the Bahamas, set off on their annual migration. Walking head to tail in long meandering columns they march across the sand to the reef edge many miles distant. Here they disperse into deeper water where they will be safe from storms. Marching in line reduces drag and provides protection from predators such as triggerfish and turtles. Mass aggregations of spider crabs (*Loxorhynchus grandis*) off the coast of California provide protection during moulting and mating.

USES, THREATS, STATUS AND MANAGEMENT

Crustaceans are used as food worldwide, with decapod shrimps and prawns forming the major fisheries. Statistics compiled by the United Nations Food and Agriculture Organisation for 2009 show landings of 5,321,290 metric tons worldwide (FAO 2012). Most species are caught by trawling with consequent problems of bycatch, including turtles. The use of turtle exclusion devices (TEDs) in shrimp trawl nets in the Caribbean is helping to alleviate this. Aquaculture for penaeid prawns, such as the Giant Tiger Prawn (*Penaeus monodon*) poses a significant threat to coastal mangroves in SE Asia as these are cleared to form rearing ponds. Crab and lobster fisheries mostly rely on potting which is less damaging to the environment but many stocks are overfished including the European Lobster (*Homarus gammarus*). Management techniques include size limits, a ban on landing egg-carrying 'berried' females and cultivation of juveniles for release.

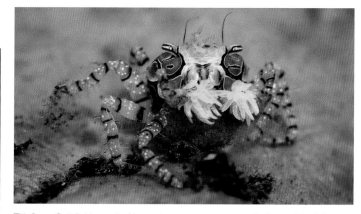

This Boxer Crab (*Lybia tessellata*) is carrying an orange egg mass tucked beneath its abdomen. It has a commensal association with the anemones on its claws (see p.493).

CRABS, LOBSTERS AND SHRIMP SPECIES: ORDER DECAPODA

Numerically the Decapoda is the largest order of crustaceans with many families and nearly 14,000 marine species. It is divided into three suborders of which two are illustrated below. The third one Dendrobranchiata contains two superfamilies of tropical prawns including the commercially important tiger prawns in which the paired primary branches of the gills are themselves branched.

Suborder MACRURA REPTANTIA

These are the lobster-like decapods with a strong carapace, long abdomen and well-developed walking legs. Macrura refers to the large tailfan whilst reptantia refers to crawling. There are about 250 species divided into four infraorders: the marine lobsters and freshwater crayfish (Astacidea) with large claws (chelae) on the first pair of walking legs and small ones on the next two; the spiny and slipper lobsters (Achelata) which have no claws; a group of small but often abundant deepsea species (Polychelida) and two living species in an otherwise fossil group the Glypheidea.

European Lobster *Homarus gammarus*

Features In life this lobster is a beautiful blue colour, a surprise to people who have only seen a red cooked lobster. Most of the colour pigments in the shell are destroyed by the heat of cooking, leaving only red astaxanthin. This important commercial species is found in the NE Atlantic replaced by the larger *H. americanus* in the NW Atlantic.
Size Mostly up to 35cm long, larger in past.

Spiny lobster *Panulirus* sp.

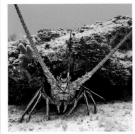

Features Unlike other lobsters, Spiny lobsters do not have large claws on their first pair of walking legs but have a formidable array of protective spines especially on their antennae. Even so, they are mainly nocturnal and hide in crevices during the day. Species of *Panulirus* are widespread on tropical reefs but are heavily fished.
Size Up to about 40cm long.

Ridgeback Slipper Lobster *Scyllarides haani*

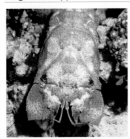

Features Built like flattened tanks, slipper or shovel-nose lobsters have modified second antennae that form a pair of thin shovel-like plates used as armour and to plough through mud and sand. Unlike most other decapods they cannot flip their tails to escape predators. They are found worldwide in tropical and warm temperate areas.
Size Up to about 40cm long.

Suborder PLEOCYEMATA

Seven infraorders contain various types of shrimp (Caridea – shrimps and prawns; Stenopodidea – boxing shrimps; Axiidea – burrowing shrimps; Gebiidea – mud shrimps; Procarididea – procaridid shrimps) plus the true crabs (Brachyura) and hermit crabs (Anomura).

Common Prawn *Palaemon serratus*

Features Also known as Rock Shrimp, this highly edible species is found in shallow rocky areas and rock pools in the NE Atlantic and Mediterranean. A long serrated rostrum projects in front of the head making handling them a potentially painful experience. The front two pairs of legs have small claws with which they delicately search for food. When disturbed they use the tail fan to flip suddenly backwards, out of harms way.
Size Up to 11cm long.

Boxer Shrimp *Stenopus hispidus*

Features Bold red and white markings and white antennae advertise to fish clients that these are cleaner shrimps. Found in all tropical seas, they live in pairs in shallow water rocky crevices. These attractive animals perform a circular courtship dance and are a popular aquarium animal. The other ten species in the genus also have bold markings.
Size Up to 5cm long.

Atlantic Ghost Crab *Ocypode quadrata*

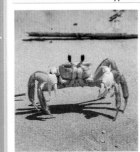

Features Ghost crabs emerge from their tropical and subtropical sandy shore burrows as night falls and scuttle silently along the sea's edge. In some species, burrowed sand is piled up like a castle by the male to attract females. With their eyes up on stalks they have all round vision to spot predators and can run extremely fast.
Size Shell up to about 5cm wide.

Hermit Crab *Dardanus megistos*

Features Hermit crabs have a soft, unprotected abdomen and so live in a discarded mollusc shell which they carry around with them. As it grows a hermit crab must move house by choosing a larger shell. This distinctive Indo-Pacific species is one of the largest.
Size Up to 15cm long.

Euphausid shrimps

Euphausids (Euphausiacea) are small shrimp-like crustaceans that would escape the attention of most people were it not for the fact that Antarctic Krill (*Euphausia superba*) provides the main food source for the largest animal on the planet, the Blue Whale (*Balaenoptera musculus*). However, whilst *E. superba* is the best known species, there are at least 85 others arranged in two families, many only encountered by biologists and fisheries scientists engaged in plankton research. Sometimes, pleasure boats out at sea find themselves in pink water surrounded by a surface swarm of euphausids.

DISTRIBUTION

Euphausids are strictly marine animals that spend their entire lives swimming and feeding in the open ocean far away from land, though some species inhabit coastal waters. They are abundant in the cold waters around Antarctica but are found worldwide, especially in the nutrient-rich waters resulting from upwelling currents such as the Humboldt running up the west coast of South America.

STRUCTURE

It is relatively easy to recognise a euphausiid shrimp and distinguish it from the more familiar decapod shrimps and prawns. For a start it appears half undressed because whilst the head and thorax are covered by a carapace as in all decapods, it reaches only part way down the shrimp's sides. This means that the fluffy gills at the bases of the thoracic limbs are clearly visible. Also clearly visible, especially in live specimens seen in the dark, are light-producing organs or photophores one beneath each eye, several pairs on the thorax and single ones along the abdomen. These are controlled by the nervous system and are important in communication. The eight pairs of long, hairy thoracic legs are used mainly for gathering food (the last two pairs may be reduced or absent) whilst the five pairs of biramous (branched into two parts) abdominal appendages are well-suited to swimming. With their fine thoracic appendages held up beneath their head euphausids look like shrimps with beards.

Stylocheiron maximum is a species of krill with a cosmopolitan distribution, found in the Atlantic, Pacific and Indian Oceans.

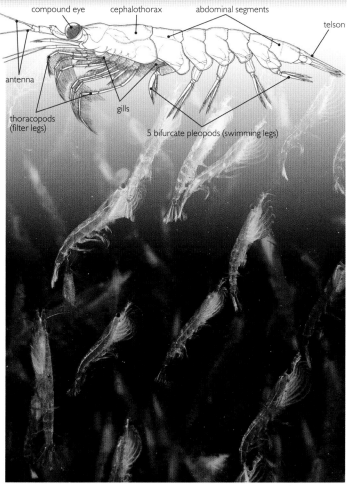

Antarctic Krill (*Euphausia superba*).

BIOLOGY

Feeding

Living out in the open ocean it is not surprising that most euphausiids feed on phytoplankton and zooplankton. The method used to collect their miniscule food varies but most are filter feeders. Constant movements of their appendages draws water past the mouthparts and thoracic legs which are covered in fine hairs (setae) and so form an effective food trap. Food items are manipulated into the mouth and the mandibles can even discard individual diatom shells after extruding the contents. Larger zooplankton such as arrow worms (chaetognaths) and pelagic amphipods are dealt with in a slightly different manner. The thoracic appendages are moved rapidly out sideways and then back in and up to suck in and hold the prey just below the mouthparts where it can be dismembered. Antarctic krill also feed on microalgae that live within holes and passages on the underside of sea ice in winter and spring when phytoplankton in the water column is scarce. Some euphausiids feed on organic matter within bottom-sediments by stirring it up with their abdominal appendages.

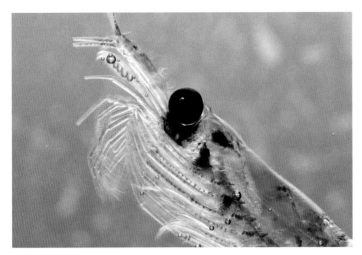

In this close-up photograph of Antarctic Krill (*Euphausia superba*), the fine hairs (setae) on the thoracic limbs are obvious. Plankton are combed out of the water by the hairs as the animal swims along.

ANTARCTIC KRILL

Krill are a keystone species in the Southern Ocean meaning they are essential for the ecology of the region. The krill, of which *Euphausia superba* is the most important species, graze on the phytoplankton and microalgae that thrive in these cold, nutrient-rich waters, to the extent that their huge swarms can be seen from space. Their oil-rich bodies are a high energy food capable of sustaining the enormous bulk of a baleen whale. Recent research carried out by scientists at the British Antarctic Survey using sonar to detect swarms in the Scotia Sea, has shown that we still have a lot to learn about the behaviour of krill (Tarling et al. 2009). They found two types of swarm, the first small, a few tens of metres across and several metres deep and the second 'superswarms' up to a kilometre long and 30m deep. The superswarms were densely packed and consisted mainly of juvenile krill. If this is the general situation throughout the Southern Ocean, then it has obvious implications for krill fishery management.

Life history

Whilst little is known about the detailed mating habits of euphausids the fact that they do so is obvious from their anatomy. In males the shorter of the two branches of the first pair of abdominal swimming legs has a clasping end (known as the petasma) capable of transferring sperm packages to the female. She has an external receptacle for the packages under the thorax (called the thelycum). Depending on the species the eggs are either shed directly into the water and hatch into nauplius larvae or are attached to the female's thoracic legs and hatch at a later stage in development.

Ecology

As they are eaten with relish by a wide variety of nektonic predators including fish, squid, birds, seals and whales, most euphausiids spend their daylight hours away from the surface at depths of several hundred metres. At dusk they migrate up to feed on phytoplankton. However this is probably an over-simplification as some species at some times form feeding and breeding swarms at the surface during daylight hours. Others appear to sink down to safety when they are satiated with food. Many species aggregate into breeding swarms at certain times of the year, late winter in cold climates, but are dispersed at other times. Swarms aggregate using chemical cues and light from their photophores. Surface swarms are at the mercy of strong waves and currents and are occasionally washed onto beaches forming thick blankets (Mauchline 1984).

USES, THREATS, STATUS AND MANAGEMENT

Krill is commercially exploited on a large scale in the Southern Ocean (mainly *E. superba*) and to a lesser extent around Japan. It is used for human consumption but the majority goes for animal feed especially within the aquaculture industry. It is processed at sea as it spoils easily and is only fit for human consumption after peeling as the cuticle contains toxic materials. The krill fishery in the Southern Ocean is managed by the Commission for the Conservation of Antarctic Marine Living Resources. This international body licenses fishing vessels and imposes strict catch limits. Nevertheless there is increasing cause for concern with new markets opening up and new challenges imposed by climate change, fishing technologies and the difficulties of implementation. The retreat of sea ice may affect krill recruitment as the microalgae associated with its lower layers are a vital food source for the krill in winter when phytoplankton is scarce.

The rapid growth of krill fishing in the Antarctic is adding to environmental pressures already faced by these diminutive shrimps. Fish feed based on krill is now widely used in the aquaculture industry and krill oil is becoming popular as a health supplement.

Amphipods

For many people their first introduction to amphipods (Amphipoda) is when they kick through piles of strandline seaweed whilst out walking on the beach. The result is dozens (or even hundreds) of amphipods leaping around like a horde of voracious fleas. However, far from being blood-sucking parasites, these strandline amphipods, often known as beach hoppers, are doing an excellent job of cleaning up the debris. These diminutive, shrimp-like animals are relatively easy to find on almost all seashores and almost anywhere else in the ocean for that matter.

DISTRIBUTION

The majority of amphipods live in the ocean and are found worldwide, but there are also numerous freshwater species and a few that live in damp terrestrial habitats. Most marine species live on the seabed amongst undergrowth or burrow into sediment. Hyperiidean amphipods (Hyperiidea) drift in the plankton sometimes attached to other planktonic animals. Whilst there are a few large and often extraordinary deepwater amphipods (including *Hirondellea gigas* retrieved from below 10,000m in the Mariana Trench), the seashore and shallow-water environments provide a wider variety of habitats for these versatile animals.

STRUCTURE

Amphipods are an extremely diverse group of crustaceans but nevertheless with a little practise, it is relatively easy to recognise one. A typical amphipod has a slightly hunch-back look as it has a curved back and is flattened from side to side. It has clear segments, but in spite of the absence of a carapace, the division into head, thorax and abdomen is not always obvious until you look at the underside. The small head has a pair of compound eyes and two pairs of antennae. During development the head fuses with the first of the eight thoracic segments leaving seven clearly visible. Each of these has a pair of legs (pereopods). The first two pairs have pincers and are called gnathopods. The six abdominal segments have divided (biramous) appendages. This great variety of appendages allows amphipods to feed, crawl, hang on, burrow, swim and jump.

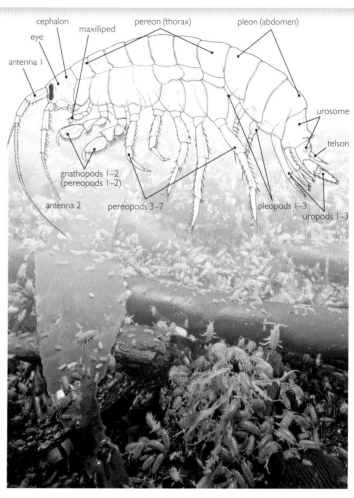

Amphipods feeding on strandline kelp on the Western Cape, South Africa. Sorting out which appendages and segments are which in an amphipod can be difficult but is important for identification. In many species the three rear most thoracic legs are held up and back making it difficult to tell which way up the animal is.

Jassa falcata is a small amphipod that builds itself a protective tube. It is an important fouling species that grows on hard substrata including ships, buoys and harbour structures. Other tubiculous species live on muddy sediments.

BIOLOGY

Feeding

Without amphipods the seabed would disappear under a deluge of dead plant and animal material. These small animals can consume detritus and carrion at a rate of between 60% and 100% of their body weight daily. The first two pairs of walking legs (gnathopods), have pincers with a moveable half and a fixed cutting edge and are used to pick up or tear off pieces of food. Caprellid amphipods hang onto seaweeds, other animals and the seabed using their last pair of thoracic legs, stretch out into the current and wait like miniature praying mantis for zooplankton animals to drift within reach (see figure on p.277). Some amphipods such as *Jassa* (suborder Gammaridea) live in tubes made of debris attached to rocks and are filter-feeders, trapping plankton with their antennae. *Corophium* (suborder Corophiidea) builds tightly packed tubes in sediments.

JUMPING FLEAS

Commonly known as beachhoppers or beach fleas, talitrid amphipods (family Talitridae), such as *Talitrus* and *Orchestia*, live on the seashore and can jump up to 60 times their body length to escape predators (or scuffling feet). They achieve this by straightening out their normally curled abdomen and pushing with their last three abdominal appendages known as uropods which are adapted as short, powerful springs. They might not match the jumping power of true fleas but are still pretty impressive.

Piles of stranded rotting seaweed look unsightly but provide a feast for amphipods and other detritus feeders. The amphipods in turn are eaten by shore birds.

Life history
Amphipods brood their eggs under the thorax in a pouch formed from projections on the bases of their legs. To facilitate mating, males of many species ride piggyback on the females until her eggs are ready for fertilisation. Males of such species are usually larger than the females and hang on tightly even when ignominiously collected in a net or bucket. The eggs hatch in the brood pouch usually within a month or so and when the juveniles are released a few days later, they resemble miniature adults. Time taken to reach sexual maturity varies but is usually after about six moults.

Ecology
Amphipods play a vital role in coastal areas as garbage collectors recycling huge amounts of algal and other detritus. However, some groups have evolved alternative lifestyles. Perhaps the most unusual is that of certain hyperiid amphipods (suborder Hyperiidea) such as *Phronima*. Most hyperiid amphipods are parasites that eat their hosts, often various jellyfish, but *Phronima* attacks floating tunicates called salps (p.309) gradually eating its host and then using the remaining transparent outer casing as a drifting 'house' in which to live and lay eggs. Free-living hyperiids are important predators within the zooplankton. *Themisto gaudichaudii*, a species found in the Southern Ocean around Antarctica, can occur in huge swarms consuming vast numbers of fish larvae and arrow worms and itself sustaining important fish stocks and seabirds.

USES, THREATS, STATUS AND MANAGEMENT

Amphipods are too small to have any direct commercial use but they are appreciated by coastal authorities tasked with clearing tourist beaches of strandline debris. Studies in the USA have shown that *Talorchestia* eats around half of the seaweed washed up on some beaches during one year. Tube-dwelling amphipods can be a problem fouling ships and buoys.

AMPHIPOD SPECIES: ORDER AMPHIPODA

There are currently four accepted suborders of marine amphipods. However, the differences between them are difficult to discern even for specialists and are not described here. The Gammaridea used to contain around 90% of amphipods but has now been split and contains about 50%. 95 families were moved recently to the newly erected suborder Senticaudata (Lowry and Myers 2013) which now contains about 40% of amphipods and includes the caprellid or skeleton shrimps and the whale lice (Cyamidae) as well as most freshwater species and many 'classical' marine genera such as *Gammarus*, *Talitrus* and *Orchestia*. The Hyperiidea are transparent planktonic amphipods with broad bodies and huge eyes taking up much of the head. The fourth suborder Ingolfiellidea are tiny meiofauna (p.90) species.

Eusirus holmi
SUBORDER Gammaridea

Features This pelagic amphipod has been found living near the underside of sea ice and in brine channels within it in the Arctic ocean. However, it is not known how dependent it is on the ice. Its extremely long legs presumably help it to swim and prevent it from sinking.
Size Not recorded.

Ghost Shrimp *Caprella mutica*
SUBORDER Senticaudata

Features Caprellids, also known as skeleton shrimps have long, thin, cylindrical segments resembling beads on a string. They spend most of their time clinging to undergrowth with their thoracic limbs (legs) which have strong claws. The abdomen is very short and essentially legless. This is a northern hemisphere species.
Size Up to about 2.5cm.

Iphemedia obesa
SUBORDER Senticaudata

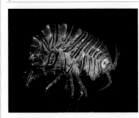

Features This beautiful striped amphipod is a temperate and cold water species found in the shallow sublittoral NE Atlantic and photographed here amongst kelp off the coast of Norway. It varies in background colour from white to yellow but is always banded.
Size Up to about 1.3cm.

Hyperia medusarum
SUBORDER Hyperiidea

Features Living a hitch hiker existence, hyperiid amphipods ride ocean currents within the shelter of their hosts. This species lives inside the bell of hydromedusae, such as the *Sarsia* shown here, where it has an easy supply of food to steal. Very large eyes make use of what little light there is in its drifting home. It is found in the North Atlantic and Arctic Oceans.
Size Up to about 1.5cm.

Isopods

The easiest place to find an isopod (Isopoda) is in damp areas of your garden. These familiar creatures, known variously around the world as woodlice, pillbugs, sowbugs, and slaters, are one of the few crustacean groups that are truly adapted to life on land. However, it is in the ocean that these animals show their greatest diversity. Some marine isopods look just like their counterparts on land whilst others are modified in shape, size and limb design to suit the wide variety of marine habitats in which they live. The larger species with spiny legs and long waving antennae resemble nothing more than underwater cockroaches.

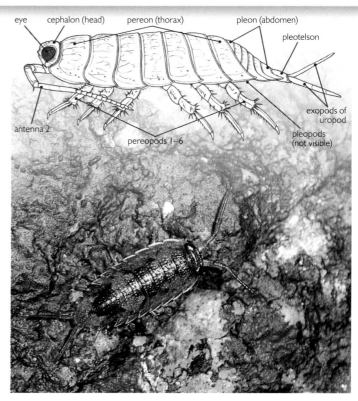

The Sea Slater (*Ligia oceanica*) (photo) is a large isopod that shows clearly the neat segmentation and thoracic walking legs characteristic of this group. The illustration (above) depicts a species of *Idotea* showing the main features of an isopod.

DISTRIBUTION

Isopods live predominantly in the ocean but are also found in freshwater and on land. Marine species are mostly bottom-living and cryptic, that is they hide away and remain as inconspicuous as possible. However, there are a few planktonic species. Isopods are found worldwide from the uppermost parts of the shore down to the deepest depths of the ocean.

STRUCTURE

Typically isopods are flattened from top to bottom and have rather even-sized segments. There is no carapace covering the head and thorax so the segments are clear giving the body the appearance of a piece of articulated armour. The head segment (cephalon) has a long and a short pair of antennae, and compound eyes plus various mouthparts on the underside. The cephalon is actually the head and first thoracic segment fused together. It is followed by the thorax (or peraeon) with seven further segments and then a short abdomen (or pleon) with six narrow segments. In isopods the final segment is called the pleotelson as it consists of the last abdominal segment fused with the tail or telson. However, in many families several or all of the abdominal segments are also fused together. The majority of species scuttle along on seven pairs of thoracic legs and carry five pairs of flattened abdominal appendages which act like gills to absorb oxygen from the water.

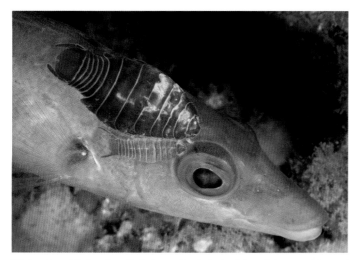

This large isopod (*Anilocra frontalis*) clinging to a female Cuckoo Wrasse (*Labrus mixtus*) is one of many parasitic species that eat scales, skin and blood of fish and can even kill their host.

BIOLOGY

Feeding

Whilst many isopods are harmless vegetarians feeding on detritus and algae, some are decidedly carnivorous. Most isopods are less than half a centimetre long and predatory species eat even smaller animals. However, living in the deep ocean, especially around Antarctica, are some much more impressive isopods that easily reach 35cm long. These monsters are mainly scavengers feeding on dead fish, seal and whale carcasses and so have an important role in recycling marine waste. They are relatively easy to capture with baited traps and perhaps the best known and the largest species so far discovered, is *Bathynomus giganteus* which reaches 45cm long.

Life history

The usual pattern of reproduction is for a male to find a female, hold onto her until she moults and then mate with her. Sperm packets are transferred to the female genital openings (on the fifth abdominal segment) using specialised structures on the male's second abdominal appendage (second pleopod). Females give their offspring a good start in life by retaining their eggs in a brood pouch formed by thin flaps between the bases of their legs. They are eventually released as well-formed juveniles. Parasitic isopods often have miniature males that, on arrival at the host, attach themselves to the underside of the resident female. If no female is present, the first juvenile to arrive develops into a female and the next arrival into the male.

Ecology

Isopods are one of the most diverse of all crustacean groups with different species adapted to a huge variety of adjacent microhabitats. On the shore different species are found at different levels and in different microhabitats under stones, in crevices or in seaweed holdfasts. Some isopods inhabit living homes within sponges and corals. In some deep habitats isopods are the dominant free-living invertebrates and one order the Asellota has diversified to fill many ecological niches and has thirty different families.

Isopods are common ectoparasites of fish and of decapod crustaceans including prawns and crabs. They suck blood from fish gills and tissue and mucus from the skin. These irritating pests are one of the reasons tropical reef fish visit cleaning stations where cleaner fish and shrimps remove and eat them. Another family, the Corallanidae, includes *Argathona macronema*, a species that lives in the nasal passages of serranid fish in the tropics. Here it feeds on slime – effectively fish snot.

Species of *Cymothoa* are perhaps the most gruesome of the parasitic isopods. *C. exigua* is found in snappers and other similar large fish mainly off the coast of California. Instead of extracting blood from the gills of its host, this isopod sucks it from the blood vessels supplying the tongue. Not surprisingly the tongue atrophies but as it does so the isopod grows to take its place. Eventually it can be found facing forwards hanging on to the remaining tongue stub with its rear legs. It then effectively acts as its host's tongue and is thought to feed on food scraps and mucus. To the horror of one shopper and the delight of a nearby museum scientist and the local newspapers, *C. exigua* turned up in the mouth of a red snapper bought in a London fishmonger's in 2005.

USES, THREATS, STATUS AND MANAGEMENT

With one exception isopods do not generally cause many problems. This exception is the tiny gribble *Limnoria*. Ships have sunk and piers have fallen under the onslaught

This wooden pontoon on the south coast of UK has been badly damaged by the boring activities of gribbles (*Limnoria* sp.).

of these wood-munching isopods which burrow into submerged timbers. But in future the tables may be turned as scientists are investigating whether enzymes used by the isopods to digest cellulose could be applied to convert waste wood and straw into liquid biofuel.

Cirolanid isopods (Cirolanidae) are widely distributed and well known pests. Swarms of these carnivorous isopods can descend like locusts and spoil catches of netted and trapped fish. There are also documented instances of cirolanids killing live sharks by boring into vital organs (Bruce 1986). Tropical cirolanids can also spoil a day at the beach as some will bite swimmers and divers. Mammal carcases hung in cirolanid rich waters come out beautifully clean and ready for museum display.

ISOPOD SPECIES: ORDER ISOPODA

There are eleven suborders of isopods and many families reflecting their great biodiversity. Whilst some genera and species (such as the Sea Slater) are easy to recognise, many are not. Allocating an unknown species to suborder and family requires a willingness to understand their detailed morphology and follow available keys. However as the four family examples below show, isopods are at least, usually recognisable as such.

SUBORDER Valvifera

FAMILY Idoteidae

Idotea baltica

Features *Idotea* is a common temperate Atlantic genus with many similar species, found in shallow water amongst seaweeds and undergrowth. Differences in the shape of the pleotelson (final segment) help to distinguish the species. *I. baltica* often has white spots and lines and lives in the NE Atlantic.
Size Up to 3cm long.

FAMILY Chaetiliidae

Saduria entomon

Features This elegant isopod was collected from the Kara Sea in the Arctic Ocean and also occurs in the N Pacific and the Baltic. It prowls over soft sediments, usually in deep water in search of other invertebrates and carrion. Life span is estimated at three years and it is sometimes washed up dead on the shore.
Size Up to 9cm long.

SUBORDER Oniscidea

FAMILY Ligiidae

Dynamene bidentata

Features A search in crevices and seaweeds on a rocky shore in the NE Atlantic will usually show up one or two of these neat little isopods. Males, recognised by two distinct projections on the sixth segment, gather several females around them for mating, and these may turn white after mating.
Size Up to 7mm long.

FAMILY Limnoriidae

Gribble *Limnoria* sp.

Features Whilst there are at least 52 species of *Limnoria* only a few cause significant damage to submerged wood by their tunnelling activities. On pilings, different species prefer different levels depending on their ability to withstand exposure at low tide. Some species bore into seagrasses and kelp holdfasts.
Size Up to 5mm long.

Mantis shrimps

Mohammed Ali is arguably one of the best boxers the world has ever known, but taking size into account, even he cannot match the punching power of a mantis shrimp. Resembling super-animated caterpillars with huge eyes and a large pair of raptorial claws with which to deliver their punch, mantis shrimps (Stomatopoda) are the fastest and most efficient of crustacean predators. Their beautiful colours and fascinating habits make them a favourite amongst scuba-diving photographers. Non-divers can find them by turning boulders on almost any tropical island beach. There are currently 480 described species arranged in 17 families but, apart from the large tropical species, they are not easy to identify.

DISTRIBUTION

Mantis shrimps prefer warm water and so are common in tropical regions and in the warm waters of the Mediterranean, California and similar areas. In the Atlantic, *Rissoides desmaresti* has been found as far north as Cardigan Bay in Wales (UK). They are bottom-living animals, inhabiting holes and crevices in rock and coral or excavating their own burrows in sediment mostly in shallow water and the intertidal.

STRUCTURE

A short and relatively lightweight carapace covering the rear of the head and only part of the thorax gives mantis shrimps a much greater flexibility and speed than their lumbering lobster relatives. The head is adorned with a pair of stalked eyes, antenules and antennae with a large, moveable antennal scale at the base. There are three pairs of walking legs on the exposed thoracic segments, whilst fast swimming is achieved by five pairs of large appendages on the abdominal segments which also carry the gills (the sixth pair forms part of the tail fan). However it is the second pair of thoracic appendages for which the mantis is famous and which have developed into its huge, spiny raptorial claws.

Mantis shrimps have remarkable vision and have the most advanced compound eyes of any arthropod. The eyes are huge in comparison to the animal's size with up to 10,000 ommatidia (the visual elements, see p.261) arranged in a unique pattern. This can be seen as a distinct central band across each eye and results in binocular (sometimes trinocular) vision in each eye and the potential for hexnocular vision if both eyes are directed onto the prey (see Caldwell in Debelius 2001). With such an efficient range finder a mantis shrimp can hardly miss its prey.

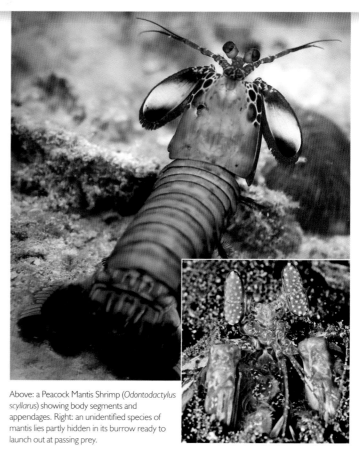

Above: a Peacock Mantis Shrimp (*Odontodactylus scyllarus*) showing body segments and appendages. Right: an unidentified species of mantis lies partly hidden in its burrow ready to launch out at passing prey.

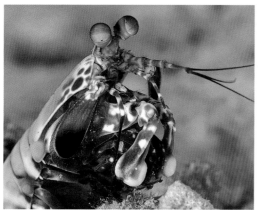

A Peacock Mantis Shrimp (*Odontodactylus scyllarus*) with its claws held back ready to strike with the club-like last joint, which is kept folded like a bent elbow.

BIOLOGY

Feeding

Mantis shrimps are predators that lie in wait for prey and then strike with incredible speed, shooting out their raptorial claws which are normally held folded back under the head. The prey is either speared or clubbed to death. In 'spearers' the last segment of the raptorial claw (the dactyl) ends as a series of sharp spines that impale their soft-bodied prey. Most spearers live in permanent sediment burrows from which they launch out to catch passing fish and shrimp. In contrast 'smashers' live in rock and coral crevices. They add power to their strike by keeping the dactyl folded back against the previous section whilst they strike, effectively doubling its strength. The thickened base of the folded-back dactyl acts like a club head and can break open even the toughest crab and mollusc shells. The speed with which a mantis shrimp strikes is legendary and sometimes exaggerated but has now been measured by specialised high speed photography. Patek *et al.* (2004) recorded strike speeds in *Odontodactylus scyllarus* of up to 23m per second, an average strike taking just under 3 microseconds to complete. The movement is so fast it causes shock waves through the collapse of cavitation bubbles, a second hit to the prey. These collapsing vapour bubbles result in very high temperatures, light and sound and mantis shrimp must moult frequently to repair damage to their raptorial claws. The power surge needed to release the claw on its deadly trajectory is not purely muscular and works in a similar manner to the release of an arrow from a crossbow.

Life history
Most mantis shrimps live and hunt on their own, only coming together to mate, but some burrowing species in the family Lysiosquillidae form monogamous pairs. Males have two penises situated near the base of the last pair of walking legs (pereopods) whilst the female genital slit with two openings is between the first pair of legs. Mantis shrimps are well equipped to protect their eggs. Burrowing species have a ready made home in which to lay them, whilst in wandering species the female carries her eggs around using her maxillipeds, the thoracic appendages she normally employs to manipulate food. This is in contrast to true (decapod) prawns and shrimps which carry their eggs attached to their abdominal appendages. Eggs hatch into planktonic larvae that moult and develop through various stages but never hatch as a nauplius, as most crustaceans do.

Ecology
Whilst most mantis shrimps live individually within their habitat, some burrowing species can form huge beds covering many hectares, with each burrow spaced out to avoid conflict with neighbours. It is these species that are commercially fished.

USES, THREATS, STATUS AND MANAGEMENT
A large 'smashing' mantis shrimp is quite capable of breaking a person's finger and even the glass in a home aquarium tank whilst a 'spearer' can inflict a nasty cut to anyone unwise enough to pick it up. Commercial fisheries exist in the Mediterranean where *Squilla mantis* is abundant enough to be caught in large numbers usually as a bycatch from trawling for bottom fish. They are also eaten in Japan and SE Asia.

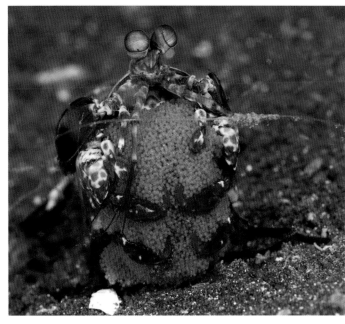

A Peacock Mantis Shrimp carrying her egg mass held in place by the maxillipeds. Whilst carrying the eggs, she cannot feed.

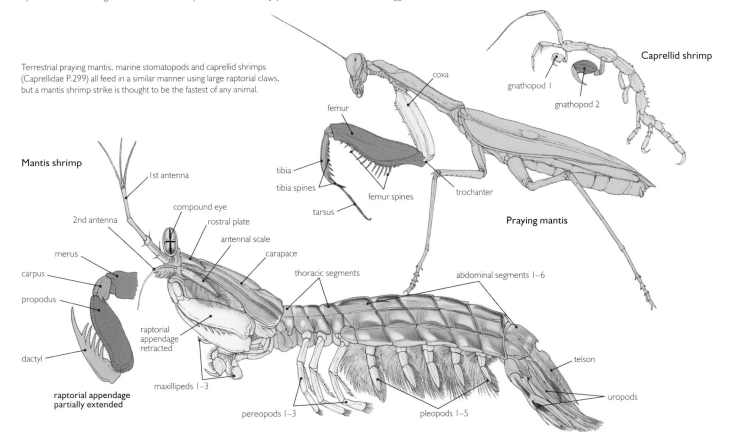

Terrestrial praying mantis, marine stomatopods and caprellid shrimps (Caprellidae P.299) all feed in a similar manner using large raptorial claws, but a mantis shrimp strike is thought to be the fastest of any animal.

OTHER SMALL CRUSTACEANS

Although they look very different, barnacles and copepods were previously grouped together as a class, the Maxillopoda, along with four other subclasses of small, mostly parasitic crustaceans. These latter include fish lice (Branchiura) which, along with parasitic copepods, cause economic mayhem in farmed fish especially salmon. It can be difficult for non-specialists to see the relationships between all these groups, a view shared by many specialists who are now using DNA analysis to help sort out the classification. .

Barnacles

Barnacles (Cirripedia) were long considered to be molluscs, hardly surprising given their hard calcareous outer shell and inability to move. Their crustacean nature is revealed by their jointed legs, something no mollusc has and by their larval stages. To many people barnacles are just a nuisance causing painful scrapes when scrambling over rocky beaches and fouling ships' bottoms. They are however worth a closer look as these tough survivors live an upside down life cemented to rocks by their heads and feeding with their legs, an unusual lifestyle to say the least. The 1,550 or so species are divided into nine orders based largely on the number and form of the shell plates.

DISTRIBUTION

Barnacles are exclusively marine and are found in all oceans attached to hard objects ranging from rocks to pier pilings, floating debris and other animals. They are abundant on rocky shores and in shallow water but can also be found on deep rocky reefs and hydrothermal vents.

STRUCTURE

All you are likely to see of a barnacle is the hard calcareous shell and possibly the feeding appendages. The shell is made up of separate plates, commonly six in sessile barnacles, plus two pairs of moveable plates that can open like double doors at the top. As the plates are separate they can easily be enlarged as the animal grows. The number, shape

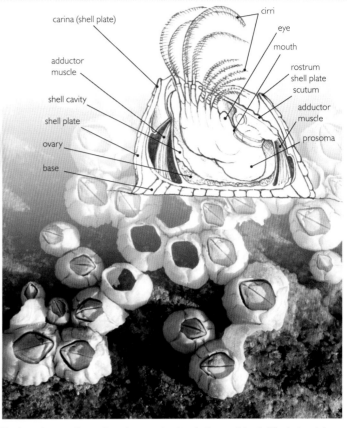

Live barnacles, out of water, have the opercular plates in the top of the shell firmly closed. In dead barnacles the surrounding shell plates may persist or just the calcified basal plate in those that have one.

and size of plates are useful in identification though for some a look at the internal structures (including the penis) is needed. Darwin was the first and certainly the most dedicated of the few that have had the patience to sort out the detailed anatomy of barnacles culminating in his monographs on the subject, published in the early 1850s. The barnacle's body within the shell has a chitinous exoskeleton as in all crustaceans and this must be periodically moulted as the animal grows. This inner shell or mantle encloses the animal and secretes the shell valves.

BIOLOGY

Feeding

Barnacles are filter feeders combing the water for plankton with six pairs of feathery, jointed appendages called cirri which are basically its legs. This can easily be seen by (carefully) leaning over a pontoon or jetty and peering at the submerged structures. Inevitably there will be barnacles busy feeding. Intertidal species slide open the opercular plates to feed only when the tide is in. Submerged barnacles can detect movement and will shut up shop to prevent fish from biting off their cirri. Stalked barnacles as well as a few of the more primitive sessile barnacles feed without beating their cirri, only pulling them back in when they have caught something.

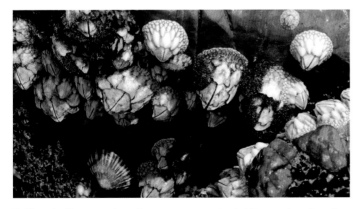

Surf Barnacles (*Catomerus polymerus*) grow on very exposed rock platforms on shores in southern Australia. This species is easily recognised by its small, numerous plates.

Acorn Barnacles (*Semibalanus balanoides*) mating; the long translucent penis can reach out several times the owner's body length.

Cyprid larvae of acorn barnacles settle preferentially in spaces amongst other acorn barnacles. The spaces are often created by winter storms washing off patches of old, tall barnacles.

Life history

Unlike mobile crustaceans, barnacles cannot go in search of a mate. However in most species individuals live in close proximity to each other making exchange of sperm possible with a long penis. This is exactly what barnacles have – one of the longest of any animal in relation to its size. In contrast to the majority of crustaceans, most barnacle species are hermaphrodite, a condition often associated with sessile (non-motile) animal groups. So any individual can mate with any other, swapping roles as necessary. Sperm is deposited through the shell opening into the mantle cavity where it meets eggs released from the ovaries. Most brood their eggs releasing nauplius larvae (p.55). A few moults and several months later the nauplius becomes a non-feeding cyprid larva protected by a two-part carapace. Cyprids are site selectors choosing suitable places by reference to clues such as surface texture and presence of other barnacles. Once attached by their antennae and then firmly cemented down, a cyprid larva metamorphoses into the adult form.

Ecology

Temperate rocky shores exposed to crashing waves are often dominated by sessile acorn barnacles such as *Semibalanus balanoides* in the North Atlantic with up to 100,000 individuals per square metre. In contrast, sheltered shores in the same region will be covered mainly by seaweeds which would be torn off by storm waves.

Drifting logs covered with goose barnacles (*Lepas* spp.) are a common sight throughout the oceans. A long flexible stalk derived from the head supports the body which is protected by blue-white shell plates.

BARNACLE SPECIES	LIVING HABITAT
Cryptolepas rhachianecti	Within pits on skin of Gray Whale (*Eschrichtius robustus*)
Coronula diadema	Skin of whales e.g. Sperm Whale (*Physeter macrocephalus*)
Chelonibia spp.	On shell or skin of turtles, manatees, large molluscs and crustaceans
Octolasmis mulleri	On crab gills
Acasta spp.	Within Sponges
Alepas spp.	On jellyfish umbrellas
Conopea spp.	Branching gorgonians
Pyrogomatidae	Corals

Some examples of barnacles living as obligate commensals.

Where seaweeds and barnacles co-exist barnacles usually prevail at the higher, drier levels as they can close their shell valves to retain moisture. Lower on the shore they are outcompeted for space by faster growing seaweeds. Barnacles in the superfamily Coronuloidea all live as commensals on large, mainly vertebrate hosts.

A few predators are able to penetrate barnacle defences particularly gastropod molluscs. These can bore in through the top using both mechanical and chemical means. On UK rocky shores, the Dog Whelk (*Nucella lapillus*) is a major predator leaving behind a trail of empty shells. These make ideal homes for other tiny gastropods and in larger sublittoral species, even small fish.

Rhizocephalan barnacles are parasitic within decapod crustaceans. Instead of its own egg mass crabs can be found carrying an externa; the egg sac of a parasitic barnacle such as *Sacculina*, which erupts from the crab at the base of its abdomen.

USES, THREATS, STATUS AND MANAGEMENT

Some species of goose barnacles grow in tightly packed colonies on rocky shores and are large enough to eat. *Pollicipes* species thrive along wave-exposed coasts of Portugal and Spain where the fleshy stems are considered a delicacy. In North America they are gathered by licensed collectors along the northern parts of the Pacific coast but it can be dangerous work. Barnacle growths on ships' hulls cause drag and cost ship owners money in terms of increased fuel consumption and removal. Anti-fouling paints such as tributyl tin (TBT), now banned in most countries, leach into the water and can cause significant damage to the environment. TBT was first used on small boats in the 1970s and was responsible for the demise of some oyster beds in the UK.

Copepods

At only a few millimetres long, copepods (Copepoda) are amongst the smallest of crustaceans. However, these diminutive animals occur in huge numbers in the plankton and play a vital role in the ocean food chain. The only way to really see them is with a microscope or a good hand lens. In spring a jam jar of water collected from a pond will be full of tiny flecks swimming around. These are likely to be a mixture of water fleas (Cladocera) and freshwater copepods. Marine copepods are more difficult to find unless you are a plankton biologist with access to special nets. However, a plankton net improvised from a muslin tube or ladies stocking with a jam jar at the end, towed through shallow water, can be surprisingly effective. A rather more unpleasant surprise is to find a parasitic copepod firmly clamped to the gills of the fish you are preparing for dinner. There are more than 11,000 species divided into ten orders.

DISTRIBUTION

Look hard enough in almost any body of clean water either marine or freshwater and you are likely to find copepods. They have even been found in the water-filled centres of epiphytic rainforest plants. However, the majority of the many thousands of species live in ocean plankton or on the seabed amongst undergrowth. One group, the harpacticoid copepods, are abundant as part of the meiofauna (p.90) in sediments.

STRUCTURE

Free-living copepods have a fused head and thorax shaped like a grain of rice and a thinner abdomen that could be mistaken for a tail. The thorax has six segments though these may be unclear depending on how many are fused with the head. The segments have paired legs though the last two pairs are often missing or modified. The abdomen typically has four segments and no appendages (but copepods are good at not being typical). The first pair of bristly antennae, known as antennules can be longer than the body whilst the second pair is short and sometimes branched. The antennae are reasonably easy to see but the two pairs of maxillae and the maxillipeds with which they feed are more difficult to sort out. Harpacticoid copepods must slip in and out between sand grains and so have a streamlined body in which the segments get gradually smaller from head to tail and have short antennae. Parasitic species are mostly highly modified and difficult to recognise as crustaceans. Often the only clue to their nature is a pair of protruding egg sacs.

An unidentified marine planktonic copepod.

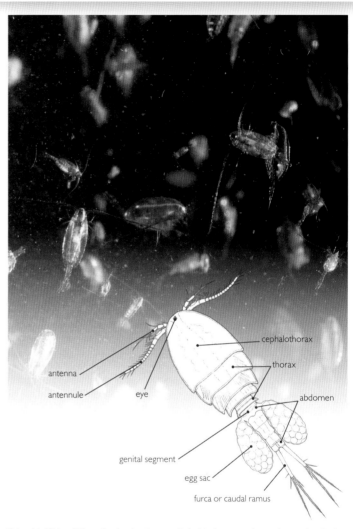

Calanoids (Calanoida) are the dominant group of planktonic copepods seen here swimming in Arctic waters. The drawing is of a cyclopoid copepod.

BIOLOGY

Feeding

Planktonic copepods are essentially herbivores wandering the upper ocean layers and feeding on phytoplankton (plant plankton). At the miniature level, they might almost be likened to the great herds of grazing animals found on African plains. They typically scull along using their biramous (two-part) thoracic limbs sometimes helped by their second pair of antennae. Plankton is extracted from the water using two pairs of maxillae near the mouth. However copepods are nothing if not versatile and filter-feeding species also catch and eat zooplankton (animal plankton) such as fish eggs and tiny larvae. Bottom-living species scrape organic material from seaweeds and rocks using their mandibles. Harpacticoid copepods living within sediment feed on microorganisms found between sand grains. About half of all copepod species are parasitic.

Life history

Tiny as they are copepods have separate sexes with the males searching out females, often attracted to her by pheromones. In many species the first antennae are not only used to find a female but also to grasp hold of her. The last thoracic segment is the genital segment and males transfer sticky packets of sperm to the female genital opening here, using their swimming legs. In most species females carry their fertilised eggs in one or two pear-shaped egg sacs on the underside of this segment. Eggs hatch into nauplius larvae (p.55) which undergo a variable number of moults as they grow over a period of weeks to months before their final moult into the adult form.

Ecology

Take almost any sample of zooplankton and copepods will be the dominant animals in it. Whilst they are busy feeding on phytoplankton many mouths are waiting to feed on them. They are the food of permanent planktonic predators such as arrow worms (chaetognaths, p.176) and sea gooseberries (ctenophores, p.174) but also form an important part of the diet of many small shoaling fish including sandeels and mackerel. They feed in the surface layers mainly at night and sink or swim down to deeper, darker depths in the day to avoid predators such as juvenile herring that hunt by sight and pick off individual animals. Setae (sensitive hairs) on their long first antennae detect minute water movements as a predator approaches and specialist photography has shown they can react fast to avoid predation. Oil droplets derived from their food are often visible in the mostly transparent bodies of copepods and the animals can change their buoyancy by altering the composition of these fats. Copepods even contribute to the fight against global warming by locking up carbon derived from their phytoplankton diet, in their shed skins and faeces that drift down into the depths.

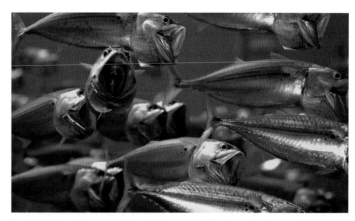

Mackerel rely heavily on copepods as a food source, filtering them from the water with their gill rackers as they swim along with mouths wide open.

Monstrillid copepods (Monstrillidae) are atypical copepods in which the adults exist only to reproduce and do not feed. The larvae are parasitic on polychaete worms and gastropod molluscs.

Parasitic copepods are commonly found attached to fish where they feed on mucus, skin and blood. Above: *Caligus belone* on Garfish (*Belone belone*). Below: freshwater fish louse *Argulus* sp. on trout, which looks similar but is actually a brachiuran, not a copepod.

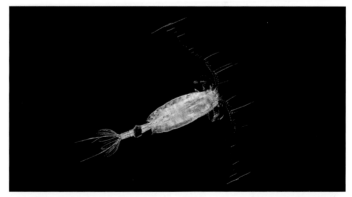

Long, branched antennae help prevent this copepod from sinking as well as sensing vibrations from other copepods and predators.

USES, THREATS, STATUS AND MANAGEMENT

The main importance of copepods to people is as a major player in the ocean food chain. However, heavy infestations of ectoparasitic species such as *Caligus* and *Lepeophtheirus salmonis* have debilitating effects on farmed fish. Chemicals used to control these parasites can cause environmental damage. Copepods also act as an intermediate host to some tapeworms and nematodes that infest humans but this is mostly a problem with freshwater species that may contaminate water supplies.

OSTRACODS

In spite of their external appearance ostracods (Ostracoda) have many similarities to copepods and barnacles and are included with them in the Maxillopoda by some authorities. Others assign them to their own class as here. These miniscule animals resemble tiny animated seeds a few millimetres long and are sometimes called seed shrimps or mussel shrimps. Whilst most people may never see an ostracod they may well have benefited from them because their fossil remains are used to indicate the whereabouts of oil-bearing strata. Ostracods have a long fossil history going back 500 million years and many thousand fossil species have been described. This is far more than the number of living species. Finding ostracods requires a patient search through collected tufts of seaweed (such as *Corallina* from rock pools), seagrass or sessile animal growths or by sieving surface sediments.

DISTRIBUTION

Ostracods live a quiet life scrambling around on and in the seabed in all oceans though a few species live as part of the plankton. Most live in relatively shallow water but they can be found down to at least 2,000m. They are also found in freshwater and a few can survive in the damp soil of humid southern hemisphere forests. Of the two subclasses of ostracods, the Myodocopida are all marine whilst the Podocopida also live in freshwater.

STRUCTURE

It is quite difficult to see why ostracods are crustaceans. Superficially they look much more like tiny clams as they live protected within a bivalve (two-part), hinged carapace resembling a mollusc shell. However, once they protrude their jointed legs and antennae and start clambering around they can be seen for what they are. They also have a nauplius larva typical of crustaceans. Under the carapace the animal looks like a short, stubby shrimp, without clear segments and with between five to seven pairs of appendages. The head has two pairs of antennae used for swimming or digging depending on the lifestyle, a simple eye and sometimes paired compound eyes plus

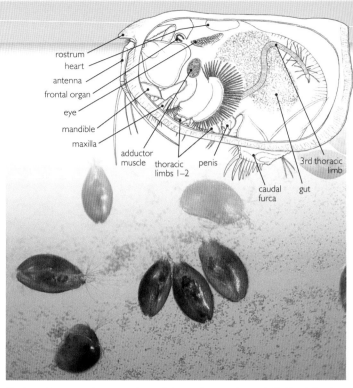

The internal structure of an ostracod can only be seen by removing one half of the shell and using a microscope.

two pairs of feeding appendages. The thorax which merges into the head and is only separated from it by a shallow constriction, has two (usually) or three pairs of legs. The abdomen is tiny or absent. Strong adductor muscles run between the two halves of the carapace to pull it shut. The thickness, texture and colour of the carapace valves are variable, depending on lifestyle and these differences are used in species identification. Under the microscope, ostracod valves are beautifully sculpted with pores, spines and pits (see Athersuch et al. 1989 for detailed ostracod structure).

BIOLOGY

Feeding
One of the reasons for the long fossil history and success of this group of tiny crustaceans is probably because species have evolved to feed in a wide variety of ways. Rather like us they can be predators or grazers, or they can scavenge for dead animals and detritus. Unlike us, some can also gather plankton and there are a few parasitic species (arguably also a human trait). The antennae have sensory bristles and are also used to filter out food particles in some species. In others the fifth appendage is specialised either for filter feeding or grasping food.

Life history
As might be expected from these remarkably adaptable animals, there is considerable variation in reproductive strategies amongst ostracods. Males and females are separate and mature individuals mate, the male delivering his sperm using external appendages. Females mostly lay their eggs on and amongst seaweeds, sessile animals or debris though some species shed them into the water column. The eggs hatch into nauplius larvae but ones which have a bivalve carapace. These moult through various stages until the adult form is reached. Variations on this theme include females

Gigantocypris agassizii is an exceptionally large ostracod up to 2.5cm across. It is one of six recognised species that all live in deep water at around 1,000m depth. These ostracods are similar in size and shape to a marble.

GIANT SPERM

Whilst most ostracods have normal-sized sperm, almost all species in the superfamily Cypridoidea which live predominantly in freshwater, have giant sperm up to seven times their own length. Females have two long tubes to receive these huge sperm whilst the males also have specialised reproductive systems including sperm pumps called Zenker organs. Giant sperm have also been found in other groups including annelid worms, insects and even primates but is generally rare. It is thought to be an adaptation that promotes competition between sperm especially in species where the female mates with more than one male.

that brood their young under the carapace, eggs that hatch into later stages than a nauplius and females that reproduce parthenogenically either entirely without males or with periodic production of males. Parthenogenic species are mostly found in freshwater.

Ecology

Most bottom-living ostracods are associated either with tufted and dense seaweeds and seagrasses or with sediments. Kelp holdfasts provide excellent living quarters. Sediment species either burrow down a few centimetres or crawl around on the surface. Some planktonic species can squirt out luminescent secretions which confuse or startle predators especially fish. Even more surprising are males that produce light in pulses to attract females rather like underwater fireflies. The light sequences are species specific and recognised by the females.

USES, THREATS, STATUS AND MANAGEMENT

Whilst living ostracods are too small to have any practical uses, fossil species are important in oil prospecting as mentioned above.

OSTRACOD SPECIES: CLASS OSTRACODA

Living ostracods are divided into two subclasses Myodocopa and Podocopa, each with two orders. For the non-specialist identification is difficult and dependent on microscopic differences in the carapace, limbs and eyes. Examples from three of the four orders are illustrated. The entirely marine Myodocopa have lightly calcified carapace valves with convex edges, a second antenna with two branches (usually) and many have compound eyes. Podocopa includes marine and freshwater species which have a concave ventral edge to the valves, the second antennae with only one branch (or a reduced second branch) and no compound eyes.

Cythereis (Eucythereis) albomaculata
SUBCLASS Podocopa ORDER Podocopida

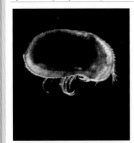

Features At less than 1mm long, this is typical of the multitude of small ostracods found in the North Atlantic living on and in the seabed. Their small size makes identification and classification difficult and this species has changed its name several times. Synonyms include *Heterocythereis albomaculata* and *Cythere albomaculata*. This species can be found by washing seaweeds and algae amongst which it lives.
Size Less than 1mm long.

Sea-firefly *Vargula hilgendorfii*
SUBCLASS Myodocopa ORDER Myodocopida

Features Most ostracods are inconspicuous and relatively hard to find, but the Sea-firefly emits a trail of blue bioluminescent material when disturbed. Previously known as *Cypridina hilgendorfi*, this ostracod is widely used in bioluminescence research and as a teaching aid. Dried animals retain the ability to bioluminesce when rehydrated and crushed. These tiny animals emerge at night from shallow sandy sediment in the Sea of Japan to scavenge.
Size Up to 3mm long.

Chocolate-drop Ostracod *Macrocypridina castanea*
SUBCLASS Myodocopa ORDER Myodocopida

Features This widespread, mesopelagic ostracod derives its popular name from its brown colour and coffee-bean shape. It occurs worldwide in all oceans mostly between about 700–1,000m depth though juveniles are found at only 100m. This species broods its young and females may contain up to 60 embryos, though due to its pigmentation these are not as easy to see as in many translucent species.
Size Up to 9mm long.

Conchoecissa ametra
SUBCLASS Myodocopa ORDER Halocyprida

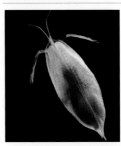

Features With its red colour and characteristic pointed carapace sculptured with rectangular cells, this ostracod is relatively easy to identify, at least for the experts. Carapace pattern and shape are important in ostracod identification. This widespread mesopelagic species is found worldwide in all oceans but not usually beyond the polar fronts.
Size Up to 5mm long.

BRYOZOANS

Finding bryozoans (Bryozoa), also known as sea mats or moss animals, is relatively easy – just look under rocks and boulders on the seashore, peer closely at jetty pilings and pontoons or pick up and examine cast-up seaweed. The problem is in knowing when you have found one. These small colony-forming animals form part of the background material encrusting rocks and other hard objects or growing as turfs mixed in with hydroids with which they are easily confused. Perhaps the easiest way to start is to look for the encrusting, lacy species that grow on the undersides of seashore rocks and on seaweeds. Divers might home in on bryozoans by looking out for colourful sea slugs which often feed on them (and on hydroids).

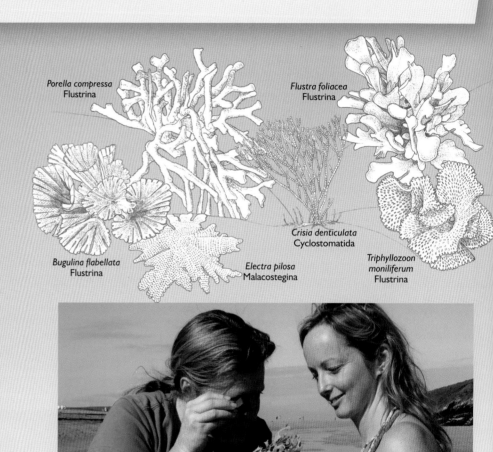

DISTRIBUTION

Bryozoans can be found growing on the seabed or attached to other animals and plants from the seashore to ocean trenches worldwide. They are found on almost any type of hard substratum including pier pilings and ships bottoms and a few specialists live in sediments. Whilst the majority live in the ocean, some are found in brackish and freshwaters.

Bushy clumps of Hornwrack (*Flustra foliacea*) are often cast up on shores in the NE Atlantic where beachcombers often mistake it for seaweed. A quick look with a hand lens will show the arrangement of adjacent tiny box-like zooids so characteristic of bryozoans.

CLASSIFICATION

CLASS	ORDER	SUBORDER
Gymnolaemata	Cheilostomatida (calcified bryozoa)	Flustrina
		Malacostegina
		5 other suborders
	Ctenostomatida (gelatinous bryozoa)	Flustrellidrina
		Alcyonidiina
		5 other suborders
Stenolaemata	Cyclostomatida	Tubuliporina
		5 other suborders
Phylactolaemata (freshwater only)		

Encrusting bryozoans are very common on seaweeds (left), and on the undersides of rocks and stones on the seashore (right) and on shipwrecks.

ZOOID TYPE	FUNCTION
Autozooids	Feeding, reproduction
Heterozooids:	
Avicularia	Protection from predators and settling larvae
Vibricula	Cleaning, sensory(?), locomotion in Cupuladriidae and Lunulitidae
Kenozooids	Attachment, stolons, stalks, space filling
Kleistozooids	Nutrient storage
Gonozooids	Reproduction

Bryozoan zooid types and functions. All bryozoans have autozooids but not all have heterozooids.

STRUCTURE

Bryozoan colonies are immensely variable in shape. Many form encrusting sheets or bushy and twiggy plant-like growths. There are also fleshy species and hard, brittle species which resemble miniature corals.

Most colonies are just a few centimetres across but a few can reach a metre or so wide or high. A colony is composed of genetically identical individuals called zooids, all joined together and produced by asexual budding. Each tiny zooid, around 0.5mm long, is protected by an exoskeleton 'box' (which varies in shape) made of chitin, protein, polysaccharide or hard calcium carbonate. This 'multi-box' structure can often be seen quite easily with a hand lens. The exoskeleton is secreted by and adheres to the underlying body wall of the zooid. Inside the fluid-filled box enclosed by the body wall, each zooid has a feeding apparatus or lophophore, gut, gonads, muscles and a very basic nervous system.

The lophophore is an approximately bell-shaped circle of tentacles covered with cilia and with a mouth in the middle. The mouth leads into a surprisingly complex gut which bends round in a U-shape and opens to the outside via an anus just outside the circle of lophophore tentacles. In addition to these feeding autozooids, many bryozoans have specialised non-feeding heterozooids of various shapes that may help to clean and protect the colony surface.

BIOLOGY

Feeding

Bryozoans can appear rather inert and it is often only by looking at a live colony in water under a microscope that the delicate beauty of their lophophores can be seen. When a colony is actively feeding, each autozooid pushes its lophophore out through an orifice in the exoskeleton box, using hydrostatic mechanisms. With the tentacles extended and cilia beating rhythmically, a current of water is drawn through the lophophore and food particles collected and passed into the mouth. If a predatory sea slug crawls onto the colony the lophophores can be retracted almost instantly by longitudinal muscles. Phoronids (p.226) and brachiopods (p.256) also have a lophophore and feed in a similar way. If necessary, food can be shared throughout the

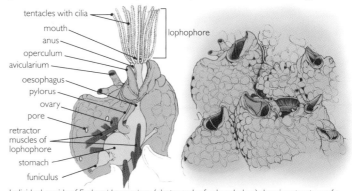

Individual zooids of *Escharoides coccinea* (photograph of colony below) showing structure of a zooid with lophophore extended (left) and several zooids retracted (right).

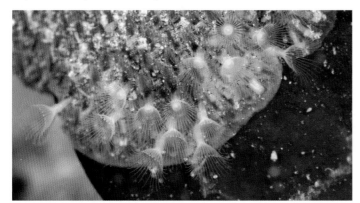

Flustrellidra hispida with extended lophophores.

The sculptured external architecture of individual zooids in *Escharoides coccinea*, a widespread encrusting species from the NE Atlantic, includes protective spines, avicularia and the lids (opercula) that close off the zooid orifice.

colony via a tissue network (funiculus) that runs from one zooid to another through pores in the zooid walls. This is the only source of nutrition for heterozooids. In many species the entire gut, lophophore and muscles periodically degenerate and the resultant material is resorbed, sometimes leaving a residue called a brown body. The zooid soon grows a new set.

Life history

Almost all bryozoan colonies are hermaphrodite but details of their reproduction vary. Eggs and sperm may both develop within one autozooid or in separate ones within the colony. Sperm are released into the water usually through pores at the lophophore tentacle tips. Some species also broadcast their eggs, which are fertilised externally and develop into relatively long-lived, hat-shaped cyphonautes larvae. However, the majority of bryozoans produce a small number of large eggs which are retained and brooded, after fertilisation by sperm drawn in from outside. In Ctenostomatida (gelatinous bryozoans) the embryos develop within the autozooids. In contrast many Cheilostomatida brood their eggs one at a time in special tough, calcified chambers called ovicells. Brooded eggs develop into coronate larvae which settle quickly after release, often near the parent colony. Cyclostomatida brood a single embryo within specialised zooids. Early in its development this embryo divides or fragments to produce many genetically identical embryos.

Ecology

Bryozoans may be small but they often occur in very high densities and form a major part of the animal 'turf' that covers many rock surfaces especially in shallow sublittoral habitats in temperate and cold waters. Such turfs transform a rock or gravel surface into a three-dimensional living space for a myriad of small invertebrates. Epiphytic species growing on seaweeds are able to select particular preferred species on which to settle and will grow and reproduce to fit in with the life cycle of their hosts. For example many red seaweeds are annuals and some kelps lose their fronds in winter along with their epiphytic load. Life span amongst bryozoans varies from a few months to annual, biennial or perennial. Calcareous encrusting or foliose species can live for many years. The coral-like Ross Coral (*Pentapora fascialis*) grows at a rate of about 2cm a year and can live for at least 10 years.

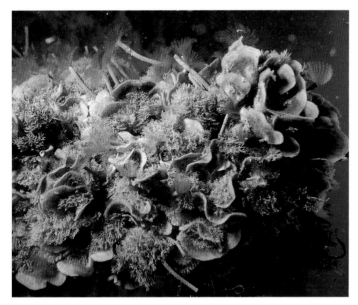

Shipwrecks and pier pilings often support dense bushy growths of bryozoans. Water currents are often stronger at such elevated positions above the seabed and so the bryozoans receive more planktonic food. The brown tubes are fan worms, *Sabella pavonina*.

The NE Atlantic sea slug *Polycera quadrilineata* is a major predator of the sea mat *Membranipora membranacea*. Sea slugs often feed on just a few bryozoan species, especially those with rather thin protective walls.

Bryozoans are sometimes grazed by fish and sea urchins but are mostly eaten by sea slugs (Nudibranchiata) and sea spiders (Pycnogonida) both of which have mouthparts that can break into individual zooids and extract the contents.

USES, THREATS, STATUS AND MANAGEMENT

Bryozoans are excellent at spreading over hard surfaces and are often one of the first organisms to colonise bare areas. Hence they are significant fouling organisms on ships' bottoms, pier pilings, oil rig legs and so on. Although not normally considered invasive, some fast growing species can cause problems when introduced to areas outside their native distribution. In the USA the sea mat *Membraniopora membranacea*, a temperate NE Atlantic species, has affected kelp plants in the Gulf of Maine, significantly changing the habitat for fish and invertebrates (Berman et al. 1992).

Analysis of bryozoan material has uncovered a range of chemicals with the potential for development into clinical drugs. Bryostatins were first isolated from the bryozoan *Bugula neritina* and are now known to come from symbiotic bacteria in its tissues. They show promise as treatments for cancer, Alzheimer's disease and HIV. Extraction from material collected from the wild is impractical on a large scale but work continues on the synthesis of comparable chemicals (analogues).

Although bryozoans do not sting, some gelatinous species can cause allergic reactions in susceptible people. *Alcyonidium diaphanum* is well known for causing a contact dermatitis, known as 'Dogger Bank itch', in North Sea fishermen who inadvertently bring it up in their trawl nets.

UNEXPECTED TRAITS

Bryozoans are supposed to stay firmly fixed to the seabed but there is at least one floating species of *Alcyonidium* found in the Southern Ocean. This forms hollow round balls and may be a juvenile dispersive stage (Peck et al. 1995). A few species form colonies that can move along, albeit slower than a slow slug. Free-living *Cupuladria*, and *Discoporella* are small disc or dome-shaped genera that live on sediment and use specialised zooids with long whip-like structures to move at a rate of a few millimetres per day (O'Dea 2009). *Selenaria* is much faster at 1m per hour. Sand is also the home of *Monobryozoon* a genus in which the individual zooids separate as they are budded off and live independently attached to sand grains.

BRYOZOAN SPECIES: PHYLUM BRYOZOA

Of the two marine classes of bryozoans, the Gymnolaemata is by far the largest and is classically divided into two orders Cheilostomatida (calcified bryozoans) and Ctenostomatida (gelatinous bryozoans). However, recent molecular studies suggest there is no real distinction between these two orders. The class Stenolaemata has one living order the Cyclostomatida.

Class GYMNOLAEMATA: Order CHEILOSTOMATIDA

This order holds the majority of large and familiar bryozoan species. They have zooids with a calcified exoskeleton and so typically feel hard or crisp and have box-shaped zooids with a hinged lid (operculum). This order was traditionally subdivided into the Anasca and the Ascophora but these are now considered to have no phylogenetic basis. There are many families and nearly 5,000 species.

Ross Coral *Pentapora fascialis*

FAMILY Bitectiporidae

Features This hard, calcified bryozoan has a variety of common names and was previously called *Pentapora foliacea*. Large dome-like colonies can be found attached to rock in current-swept areas along the Atlantic coast of Spain northwards to Scotland. A finer form occurs in the western Mediterranean and Adriatic and the name *P. fascialis* was originally applied only to this form. Its wavy-edged plates provide plenty of hiding places for small fish and invertebrates.

Size Usually 10–30cm diameter but up to 2m across and 1m high

Lace coral *Triphyllozoon* sp.

FAMILY Phidoloporidae

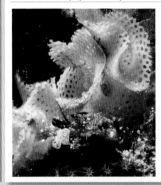

Features Lace corals are aptly named but are not corals but bryozoans from the family Phidoloporidae. The species shown here is found in shaded areas on steep coral reefs in the Indo-Pacific but similar species are found in temperate waters. The small white dots visible around the colony in this photograph are the polyps of tiny hydroids (*Zanclea* spp.) attached to the bryozoan living there as commensals. Their stinging tentacles may help protect the bryozoan colony.

Size Around 5–10cm across.

Monkey Puzzle Bryozoan *Omalosecosa ramulosa*

FAMILY Celleporidae

Features This charming little bryozoan grows as three-dimensional, branched colonies attached to stones or bushy bryozoans and hydroids. It resembles a miniature staghorn coral and its orange or yellow colour, shows up well amongst the rather drab, shallow undergrowth in which it is often found. In spite of its tropical appearance it is a NE Atlantic species occurring from Norway south to the Mediterranean and Mauritania.

Size 3–4cm high.

Canda sp.

FAMILY Candidae

Features Forming a delicate, branched miniature fan, this species is found on coral reefs in the Indo-Pacific where it occurs mainly on steep, shaded rock surfaces. It can be distinguished from other similar genera such as *Bugula* by the small cross-connections joining the branches, clearly seen in this photograph. There are at least 12 species of *Canda* and microscopic examination is needed to tell them apart.

Size 1–5cm across.

Class GYMNOLAEMATA: Order CTENOSTOMATIDA

The zooids of bryozoans in this order have their exoskeleton made from flexible chitin instead of hard calcium carbonate. This makes them feel soft or rubbery and they are usually referred to as gelatinous bryozoans. With a good microscope, a comb-like sheath can be seen surrounding the base of the lophophore when it is extended for feeding. There are 32 families and about 380 species.

Finger Bryozoan *Alcyonidium diaphanum*

FAMILY Alcyonidiidae

Features Worldwide, there are at least 61 species of *Alcyonidium* and many are very difficult to tell apart. Most grow as rather unattractive, brownish fleshy lobes or sheets. *A. diaphanum* grows as rubbery fingers and can cover large areas of hard substratum including shell gravel. This temperate water species is found in NE Atlantic coastal waters and is especially abundant in parts of the North Sea.

Size Usually up to 15cm long but can reach 50cm

Class STENOLAEMATA: Order CYCLOSTOMATIDA

As their name suggests, Cyclostomatida have calcified cylindrical tube-shaped zooids rather than the more familiar box-like shape of Cheilostomatida. There are about 620 species in 44 families.

Tubulipora plumosa

FAMILY Tubuliporidae

Features In this genus, the tube-shaped autozooids characteristic of cyclostomate bryozoans, are pretty obvious, though a close look is often needed because these bryozoans are mostly small. They usually grow as low encrusting discs or mounds though some species develop upright fingers and lobes. This species is common on sheltered rocky shores in the N Atlantic. Others are found throughout the North Atlantic, Arctic and Mediterranean.

Size Colonies up to at least 2cm across.

ECHINODERMS

Slow, prickly and sometimes venomous, echinoderms parade their wonderful colours and fascinating geometrical shapes from the seashore to the deepest depths. These purely marine animals include the familiar sea stars (starfish) and sea urchins that delight small children, as well as brittlestars, basketstars, featherstars, sea lilies and sea cucumbers. 'Star' (and its Greek root *aster*) is a recurring theme in the names of many of these animals and gives a clue to their overall shape. However, these 'stars' hang around on and in the seabed rather than lighting up the marine sky. Their true nature is also reflected in the scientific name of the phylum, Echinodermata, essentially meaning 'spiny-skinned'. This ancient phylum had its zenith in Paleozoic times as can be told from the abundance of fossil forms, revealing many more than the five classes alive today.

Florometra serratissima
Crinoidea

Psammechinus miliaris
Echinoidea

Pisaster brevispinus
Asteroidea

Ophiura ophiura
Ophiuroidea

Holothuria forskali
Holothuroidea

CLASSIFICATION

SUBPHYLUM	CLASS	SUBCLASS (SC) INFRACLASS (IC)	ORDER
ASTEROZOA	Asteroidea (starfish)		Brisingida
			Forcipulatida
			Notomyotida
			Paxillosida
			Spinulosida
			Valvatida
			Velatida
		Concentricycloidea (sea daisies) (IC)	Peripodida
	Ophiuroidea (brittlestars)		Euryalida
			Ophiurida
ECHINOZOA	Echinoidea (sea urchins)	Cidaroidea (SC)	Cidaroida
		Euechinoidea (SC) Acroechinoidea (IC)	Aspidodiatematoida
			Diadematoida
			Micropygoida
			Pedinoida
			Salenioida
		Carinacea (IC)	Arbacioida
			Camarodonta
			Stomatopneustoida
		Irregularia (IC)	Holasteroida
			Spatangoida
			Echinoneoida
			Cassiduloida
			Clypeasteroida
			Echinolampadoida
	Holothuroidea (sea cucumbers)		Apodida
			Aspidochirotida
			Elasipodida
			Molpadida
			Dactylochirotida
CRINOZOA	Crinoidea (featherstars and sea lilies)	Articulata (SC)	Comatulida
			Cyrtocrinida
			Hyocrinida
			Isocrinida

STRUCTURE

Adult echinoderms have neither head nor tail and instead they show radial symmetry with their arms and internal structures arranged like the spokes of a wheel. The basic pattern is of five-rayed or pentamerous symmetry, though some starfish, brittlestars and featherstars have more than five arms. The pattern is clear on a sea urchin test (shell) but is less easy to see in a sea cucumber. Radial symmetry is in contrast to the 'bilateral symmetry' shown by many other invertebrates and all vertebrates. An animal such as a lobster with bilateral symmetry can be cut into two equal (and mirror image) halves in only one plane whilst in a sea urchin (or an orange) the cut can be made in many planes. However, a purist would point out that the presence of a single opening to the water vascular system, the madreporite in starfish, restricts an equal cut to one position. Cnidarians (p.188) and ctenophores (p.174) are also radially symmetrical but echinoderms are not closely related to either of these phyla as was once thought.

So what is unique about echinoderms? First their 'spiny skin', a protective internal skeleton made up of calcareous plates embedded in the body wall. These vary from widely scattered spicules in sea cucumbers to the fused plates that make up the test of sea urchins. The wide variety of spines, knobs and other projections that adorn these 'spiny-skinned' animals are also part of the internal skeleton and are covered in a thin layer of skin. Like the external shells of crustaceans and molluscs, the main constituent of the skeleton is calcium carbonate but in a form called 'calcite' which has added magnesium carbonate. The plates are not solid but consist of a meshwork infused by fluid and tissue rather like the inside of vertebrate bones.

The second unique echinoderm feature is their tube feet or podia, obviously used for walking but also for burrowing, feeding and even respiration. The tube feet are essentially thin-walled extensions of the body wall arranged in double bands (usually five) called ambulacra and connected internally to an ingenious water vascular system. This consists of water-filled canals with a branch (radial canal) to each arm or body segment, extending out from a circular central ring canal that surrounds the mouth region. Each blind-ending tube foot ends internally in a bulb-shaped, muscular sac called an ampulla. Muscles squeeze water from the ampulla into the tube foot to extend it and force it back from the tube foot into the ampulla to contract it. The water vascular system can be topped up with water via a tube (the stone canal) from the ring canal to a sieve-like external opening called the madreporite. This is easily visible in starfish and sea urchins but is hidden internally in sea cucumbers, is tiny in brittlestars and absent in featherstars. Echinoderms are especially sensitive to pollution because water drawn in through the madreporite also feeds into the main body cavity. Break open a sea urchin and you will find it is filled with fluid. However, experimental work now suggests that the madreporite may be much more than just a conduit for sea water and may for example, carry hormones in from the outside to initiate spawning.

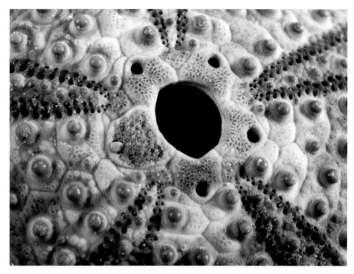

A sea urchin test (shell) without spines shows clearly the pentamerous symmetry typical of echinoderms.

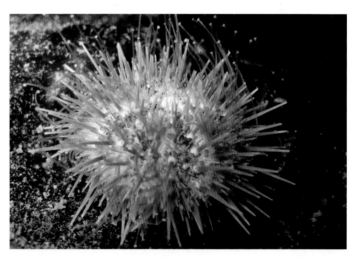

The ends of sea urchin tube feet are shaped like miniature suckers and this along with sticky mucus allows them to climb almost any surface.

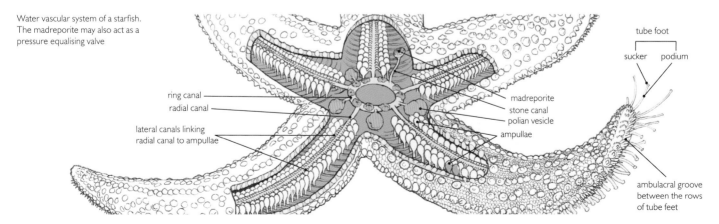

Water vascular system of a starfish. The madreporite may also act as a pressure equalising valve

ECHINODERMS

STARFISH

Starfish, or sea stars (Asteroidea) as they are also commonly called, are one of the most familiar and easily recognised of all marine animals. A few species try to confuse us by having barely visible arms or lots of arms instead of the usual five. In 1986 a tiny disc-like animal, later named *Xyloplax*, was discovered living in rotting timbers at around 1,000m depth. Three species of *Xyloplax* or sea daisies are now known but apart from the scientists who look for them, very few people are ever likely to see them. It took several years to determine that sea daisies were indeed specialised starfish and not a new class of echinoderms. In contrast, it usually only takes a quick search in a deep rock pool or under boulders on rocky shores to find several lurking starfish. Divers will see a greater variety and fishermen sometimes haul up more than they would like clinging onto their pots and traps.

DISTRIBUTION

These adaptable animals are found worldwide mostly on the seashore, in shallow coastal areas and on coral reefs but also down to abyssal depths. Brisingids (order Brisingida) have been found at 5,000–6,000m. The majority of starfish live and hunt over hard substrates but a good number can be found on sand and mud. Some have become specialised predators burrowing through the sediment in search of prey. The Common Starfish (*Asterias rubens*) and a few others can tolerate brackish water and are one of very few echinoderms found in the Baltic sea.

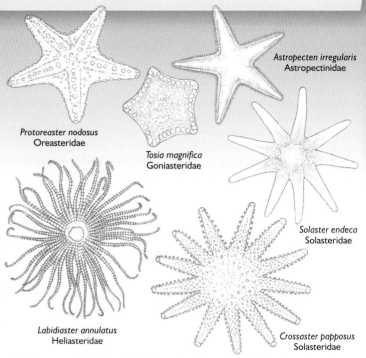

Protoreaster nodosus Oreasteridae
Astropecten irregularis Astropectinidae
Tosia magnifica Goniasteridae
Solaster endeca Solasteridae
Labidiaster annulatus Heliasteridae
Crossaster papposus Solasteridae

Starfish vary greatly in the length of their arms in relation to their body disc size as shown in these examples. Some species have more than the usual five arms.

STRUCTURE

The star-shape of a starfish is formed from five (occasionally more) tapering arms that merge gradually with a central disc. The mouth opens in the centre of the underside and from it radiate V-shapes grooves one along each arm. Two rows of tubefeet emerge from each of these ambulacral grooves. At the tip of each arm the radial canal ends as a terminal tentacle and this, along with some neighbouring tube feet are sensitive to chemicals, the equivalent perhaps of a starfish nose. A close look will also show dark spots here which are clusters of light detectors that cannot form images. It also seems that the whole test surface may be light sensitive (also true in echinoids). The starfish cannot see where it is going but can detect changes in light intensity.

Though the skin on the back of some starfish is smooth, in others it is a fascinating forest of projections that provide protection, respiration, a cleaning service and additional food. The trees in this forest are hard spines and knobs that deter predators. Between these is an 'undergrowth' of moveable spines called pedicellariae ending in pincers capable of crushing smaller would-be invaders such as barnacle larvae. Whilst primarily protective, some species eat what the pedicellariae catch, including small fish. Sea urchins also have pedicellariae, which are described more fully on p.297. Most starfish also include in this undergrowth, tiny thin-walled projections of the body wall called papulae. Starfish are essentially bathed inside (in the body cavity) and out by seawater and the papulae, along with the tubefeet on the underside, allow oxygen and carbon dioxide to diffuse in and out.

Top left: The Spiny Starfish (*Marthasterias glacialis*) has a wonderfully textured skin with a bewildering variety of organelles
Bottom left: The best way to see starfish tubefeet in action is to turn one upsidedown. The starfish will twist its arms and extend its tubefeet as it tries to get a grip. The elasticity of starfish connective tissue allows these contortions but only in those species without too rigid a skeleton

REGENERATION

A lack of speed for escaping predators and a propensity for living on exposed shores may be the reason behind the remarkable regenerative abilities of starfish. Being able to replace an arm crushed by a wave-tossed boulder certainly helps survival. Most starfish can grow a new arm or part of an arm as long as the central disc is not damaged, but a remarkable few can regenerate their whole body from a single detached arm. This is what produces the characteristic 'comet' form of *Linckia*, a tropical starfish. *Linckia* and a few others in the same family (Linckiidae) use this ability as a means of asexual reproduction, by purposefully shedding arms. Echinoderms possess a special type of connective tissue called catch connective tissue whose elasticity and strength can be altered under control of the nervous system. Softening up an arm makes it easier to shed and minimises damage. This same response allows some starfish to change their rigidity and for example, loosen up to allow an upended starfish turn the right way up. Featherstars and brittlestars can regenerate broken arms but sea cucumbers and sea urchins can do little to repair damage.

This *Linckia* starfish has regenerated a disc and four new arms from a single detached arm. More commonly part of the disc as well as an arm is needed for a complete regeneration.

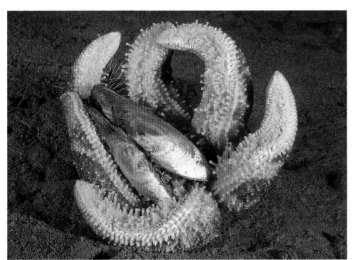

BIOLOGY

Feeding

The ability of a starfish to pull open a firmly closed mussel or clam is legendary and results from the combined pulling action of many tube feet. In fact the opening only needs to be tiny, less than 1mm will do for the starfish to slip part of its out-turned stomach through the gap. Digestive enzymes can then be routed into the prey which soon gives up the unequal struggle. The resulting partially digested soup is swept back into branches of the gut (pyloric caeca) in each arm. Some starfish feed rather like sea anemones, engulfing their prey whole or in lumps and voiding any remains through the mouth. Items on the menu include other echinoderms, molluscs, sponges, anemones, worms, detritus, algae and dead animals. Many starfish also absorb dissolved organic matter directly through the skin.

Life history

The majority of starfish have separate sexes and release eggs and sperm into the water where fertilisation takes place. Most species aggregate in response to external factors such as day length and temperature and once one starfish spawns, others pick up chemical cues. This is more difficult in deepsea environments but even here there are seasonal clues such as an increase in 'marine snow', food debris raining down from above. In *Archaster*, a tropical Indo-Pacific genus, the male drapes himself over the female and the two spawn at the same time, thus ensuring fertilisation. This is called pseudocopulation. Fertilised eggs drift and develop through a series of bilaterally symmetrical larval stages including auricularia, bipinnaria and brachiolaria larvae (p.55). These move and feed amongst the plankton. Some species such as *Leptasterias* retain the developing eggs, keeping them safe in a temporary brood pouch formed by the arms. Brooded embryos are either released as more developed larvae called vitellarias or as fully formed juvenile starfish. Starfish and other echinoderm larvae are relatively easy to rear from eggs in the laboratory. Many larval forms caught in plankton samples have been identified by comparison with laboratory-reared larvae from known species.

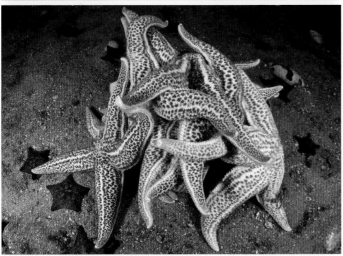

Top left: Polar Starfish (*Leptasterias polaris*) adult, feeding by pulling open a clam on a sandy seabed, Gulf of St. Lawrence, Quebec, Canada.
Bottom left: Standing on tiptoe whilst spawning helps ensure eggs and sperm are released up into the water column from pores near the arm bases. Sea of Japan.

Ecology

Although they may not be on a par with sharks, nevertheless starfish are major marine predators as any mussel or oyster farm manager knows. Occasionally huge numbers of starfish are washed ashore during storms. In the UK such 'wrecks' of Common Starfish (*Asterias rubens*) are well known in areas with extensive mussel beds such as Morecombe Bay, Lancashire. This starfish is the only European species known to gather in huge aggregations in response to an abundant food supply such as a good settlement of mussels.

USES, THREATS, STATUS AND MANAGEMENT

With the exception of some tropical species collected for the aquarium and curio trades, starfish are not generally exploited. Nothing about starfish makes them even remotely appetising as food and their economic importance is usually as pests on commercial shellfish beds. In Europe and eastern USA the Common Starfish (*Asterias rubens*) is a renowned pest of oyster and scallop beds and in mussel farms.

The Crown-of-thorns Starfish (*Acanthaster planci*) is an efficient predator of coral, extracting the soft tissues and leaving behind a trail of white coral skeletons. Plagues of these starfish periodically destroy large areas of coral reef in the Indo-Pacific and the Great Barrier Reef in Australia. Such plagues may be natural but may be exacerbated by over-fishing of its few predators, including the Giant Triton shell (*Charonia tritonis*) and some tough-mouthed fish such as triggerfish. Local outbreaks in areas such as Marine Parks are sometimes controlled by collecting and destroying the animals or by injecting them in situ with a poison (p.511).

Top: Where you find one you will usually find another Ocre Sea Star (*Pisaster ochraceus*). Groups of this brown, orange or purple starfish are common on rocky shores along the Pacific coast of the USA.
Bottom: Starfish with a substantial skeleton dry well and are often sold as curios along with sea shells.

STARFISH SPECIES: CLASS ASTEROIDEA

There are eight starfish orders (p.290) of which five are described below and the differences between them are based largely on skeletal structures. This means that for non-specialists, practice is needed in order to assign an unfamiliar starfish to the correct order. Luckily many starfish can be identified from good field guides simply from their general shape, number of arms and their colour patterns. For sea daisies (Peripodida) see p.290. About 1,840 species of starfish are known.

Order BRISINGIDA

These unusual starfish resemble chunky brittlestars, with a small circular disc and many long, tapering arms. They differ from all other orders in several skeletal details including crossed pedicellariae (see Downey 1986). The two families and 108 or so species all live in deep abyssal water with the exception of a few shallow Antarctic species.

Order FORCIPULATIDA

Starfish in this order of six families and about 270 species have from five to many arms and include some of the most common as well as the world's largest starfish. The skin often appears 'furry' due to bundles of specialised pedicellariae (p.297) each with two valves. The tube feet in most species are arranged in four rows.

Novodinia sp.

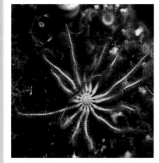

FAMILY Brisingidae

Features With its long feathery arms, *Novodinia* looks more like a featherstar than a starfish. This is not surprising as it and other similar brisingids are examples of deepsea starfish that feed in the manner of featherstars by filter feeding. Prey is scarce here and whilst there are deepsea predatory starfish, filter feeding is a viable alternative. Finding out what these starfish catch is difficult but stomach analyses have shown that benthopelagic copepods are important.
Size Uncertain.

Sunflower Sea Star *Pycnopodia helianthoides*

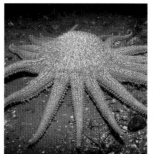

FAMILY Pycnopodiidae

Features This is the largest known starfish and with its multiple arms this makes it a spectacular animal and a deadly predator of other echinoderms including sea urchins. They are also one of the fastest starfish although a metre a minute might still seem slow to us. They are common along the east coast of the USA in coastal areas.
Size Up to at least 1m.

Order PAXILLOSIDA

With the exception of the many species of *Luidia*, these starfish normally have five arms edged by one (*Luidia*) or two rows of skeletal plates, sometimes also by spines. The skin appears relatively smooth with simple, sessile pedicellariae. Tube feet are in two rows. The order has seven families and 365 species.

Nine-armed Starfish *Luidia senegalensis*

FAMILY Luididae

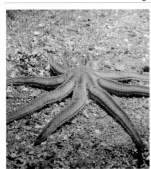

Features Species of *Luidia* could be described as 'odd' starfish as they tend to have an odd number of arms. *Luidia* is found along the east coast of the USA whilst the Seven-armed Starfish *L. ciliaris* occurs in the NE Atlantic and Mediterranean. These predatory starfish hunt over sediment areas and their arms are edged by marginal plates each with several strong spines.

Size Up to 40cm.

Burrowing Starfish *Astropecten irregularis*

FAMILY Astropectinidae

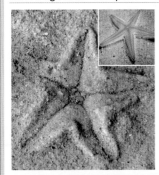

Features Often all that can be seen of this starfish is an outline in the sand where it has buried itself. *A. irregularis* is found in the NE Atlantic but other *Astropecten* species are found worldwide. All are classically star-shaped with five triangular arms each edged with two rows of large, marginal plates and a single row of spines. Their shape, rigidity and toughness make them effective burrowers.

Size Up to 12cm.

Order SPINULOSIDA

The single family in this order has about 134 species in eight genera. These tend to be neat-looking, tough starfish with five rounded arms. Their smooth appearance results from a lack of pedicellariae, spines and obvious plates. However, many have a delicately sculptured surface or a covering of low spines and often very bright colours.

Bloody Henry *Henricia sanguinolenta*

FAMILY Echinasteridae

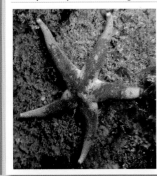

Features The unusual common name of this starfish comes from the tendency for it to be red or splashed with red. It is a tidy starfish with five finger-like arms and a relatively smooth skin. A closer look will show a dense covering of very small spines. *Henricia* species are very difficult to distinguish and this North Atlantic species can be confused with at least four others in the region.

Size Up to 12cm.

Order VALVATIDA

This is the largest order with at least 750 species in 16 families and contains many familiar tropical and temperate starfish. These come in a variety of shapes but most have five relatively short to very short arms and include the plump so-called 'cushion' stars and flat 'leather' stars. The arrangement of skeletal ossicles, especially in the arms, is the basis for classification and for separation from the Spinulosida (see Blake 1981).

Red Tile Starfish *Fromia monilis*

FAMILY Goniasteridae

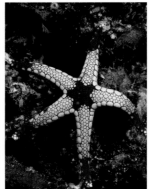

Features Gaily coloured species of *Fromia* are a common sight on coral reefs in the Indo-Pacific region. Starfish in this genus, like most in the order Valvatida, have a stiff body and five arms outlined by rows of prominent skeletal plates. *F. monilis* is a small but common and distinctive species in the western Pacific where it is often seen by divers as it crawls over coral rock feeding on thin films of algae and microorganisms.

Size Up to about 30cm.

Biscuit Sea Star *Tosia australis*

FAMILY Goniasteridae

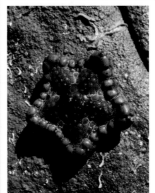

Features Search a rocky seashore in Australia and you might find what looks like a discarded snack. The Biscuit Sea Star is thin and rigid as a result of its cover of interlocking skeletal plates and larger plates along the arm edges. It does not have to be agile as it feeds on fixed animals such as sea squirts, sponges and bryozoans as well as algae. Whilst labelled here as *T. australis*, this could be a recently described, very similar species *Tosia neossia* with benthic crawling larvae rather than free-swimming larvae (Naughton and O'Hara 2009).

Size Up to 5cm.

Cushion Star *Culcita novaeguineae*

FAMILY Oreasteridae

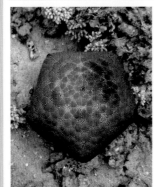

Features The origin of this starfish's common name is obvious from its ultra-short arms and plump body. This is a really chunky starfish as you can tell if you pick one up. It is a widespread, common and variably coloured species on western Pacific coral reefs and is a part-time predator of small corals. Not all cushion stars belong to the order Velatida and body shape is not always a good guide to starfish orders.

Size Up to about 30cm diameter.

BRITTLESTARS

Brittlestars are delicate relatives of starfish with small, rounded bodies and thin arms. They are well-named as their arms are easily broken, making them difficult to pick up, admire and then return intact. Searching under boulders and through seaweed clumps on a rocky shore almost anywhere in the world will usually turn one up but they are best hunted at night when many emerge from cracks and crevices to feed. Except for those that form dense beds, they do not usually catch the eye of divers, but although often inconspicuous, they are everywhere and colourful tropical reef species embrace seafans and soft corals, wrapping their arms around their temporary hosts. Brittlestars are often referred to by their scientifically derived name of ophiuroids (from the class name Ophiuroidea) as they also include basket stars whose arms divide repeatedly, forming intricate patterns.

DISTRIBUTION

Brittlestars are found worldwide in all oceans, living on the seabed from the seashore to the deepest abyssal depths. Of all echinoderm groups they are the most abundant, both numerically and in numbers of species.

STRUCTURE

With few exceptions, brittlestars stick to the pentamerous echinoderm plan and have five arms. These are thin and flexible and sharply demarcated from the rounded disc. It is well worth getting out a magnifying glass and looking closely at the body disc, which is often beautifully patterned. In texture the skin can be soft and smooth or armoured with small scales and spines. The arms are covered on all sides by rows (usually four) of protective skeletal plates lying just beneath the skin and are bordered by spines. The arms are given rigidity and strength by a central axis of articulated cylindrical ossicles. On the underside, the arms do not have an open ambulacral groove with the tube feet as starfish do. Instead, the groove is closed off by the arm plates, sealing in the radial canal of the water vascular system and the tentacle-like tube feet emerge through pores between the plates.

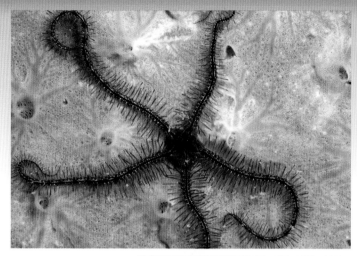

Above: The arms, disc and arm spines are all obvious in this Sponge Brittlestar (*Ophiothrix suensonii*). The arms can only move in the horizontal plane.

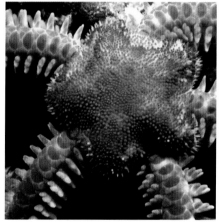

Right: Topside of a brittlestar. The disc in this species is covered in small spines. The dorsal row of skeletal arm plates indicates the internal articulations of the arm ossicles. A single detached arm can look remarkably like a segmented worm.

If you turn a brittlestar upside down and look carefully you will see a central mouth which opens into a blind-ending stomach but also, between the arm bases, five pairs of slit-like openings that each lead into an internal sac called a bursa. Water circulating in and out of these sacs carries oxygenated water deep within the animal from where it can diffuse into the fluid-filled body cavity and so to the tissues and organs. Waste carbon dioxide and excretory products can leave in the same way.

Identifying brittlestars

The detailed arrangement of the various skeletal plates and spines on the disc, arms and around the mouths of brittlestars vary and are important in their identification to family and species level. Therefore whilst larger species can often be identified in the field, most of the smaller species need a magnifying glass or microscope and a certain perseverance.

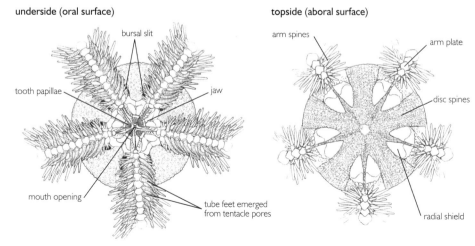

Underside (left) and topside (right) of Common Brittlestar (*Ophiothrix fragilis*).

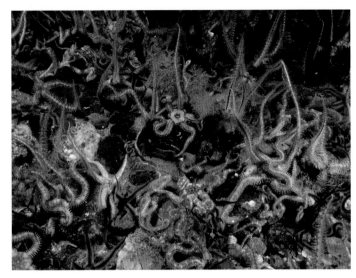

A dense bed of brittlestars *Ophiopholis aculeata* covering rocks in a sea loch in Scotland.

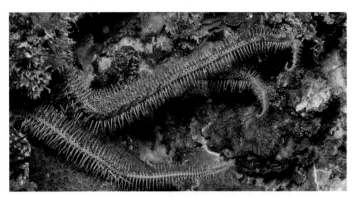

Whilst some well-protected and spiny brittlestars are happy to live out in the open, others prefer to remain hidden, only extending their arms to feed.

BIOLOGY

Feeding

Brittlestars make a living largely by eating particles of organic matter, either collecting suspended material from the water column or sweeping up detritus from rock and sediment surfaces. Suspension feeders raise their arms up and use their tube feet to intercept and catch particles which are passed to the mouth. Some exude sticky mucus to help collect up material, whilst others are able to collect additional food by trapping planktonic animals in a forest of arm spines. Living on and in the seabed, they play an important role in recycling nutrients.

Some of the larger species are true scavengers like their more robust starfish relatives and will home in on a dead fish, or even a whale carcass in the deep sea. Brittlestars can move quite fast by 'rowing' over the bottom using their arms and gaining a grip with their arm spines. The pointed tube feet help burrowing species to push sand grains out of the way. Depending on the species, scavenging may be opportunistic with detritus feeding being the norm. A few are predators, ingesting worms, small molluscs and crustaceans and ejecting non-edible bits back through the mouth. The mouth has five jaws shaped like wedges of cheese with vertical rows of teeth capable of crushing prey.

Life history

The majority of ophiuroids have separate sexes and shed their eggs and sperm via the bursa openings, yet another function of these versatile sacs (see above). The gonads open directly into the bursas. In many species the eggs are released and fertilised in the water and develop into ophiopluteus larvae (p.55) which drift and feed in the plankton. These beautiful larvae resemble miniature space vehicles with long projecting, spine-like arms (resembling an under-carriage and landing feet). The arms are stiffened by skeletal rods and help to keep the larva afloat. Bands of beating cilia along the arms waft food particles towards the mouth. The larvae eventually settle on the seabed and metamorphose into the adult form, reabsorbing much of the larval tissue in the process. Other species retain their eggs and use the bursa sacs as a fertilisation and brood chamber where the eggs develop to the stage where they can crawl away as juvenile brittlestars.

Some six-armed brittlestars in the family Ophiactidae can reproduce asexually by splitting in half and re-growing the three missing arms (Mladenov *et al.* 1983).

Ecology

The sight of an apparently unending mat of writhing brittlestars covering the seabed is slightly unnerving. They can be so densely packed that the seabed is completely hidden. Dense brittlestar beds tend to occur in tide-swept areas such as narrow straits and the entrances to sea lochs for example. Linking arms helps to prevent the whole mass being swept away whilst spare arms are raised into the water current to catch suspended food. However, only a relatively few brittlestar species, living in plankton-rich temperate and cold waters, form such beds. The majority lead more solitary lives tucked away in rocky crevices, or living inside sponges and amongst undergrowth.

In spite of their crunchy nature and lack of much flesh, brittlestars are eaten by many species of fish as well as some starfish, decapod crustaceans and predatory molluscs, and so many only emerge at night. Others live safely buried in sediment, extending their arms to the surface to intercept food particles. Some species such as *Amphipholis squamata* are bioluminescent and use this ability to deter predators at night and in deep water. They may also use it to attract spawning partners (Deheyn 2001).

USES, THREATS, STATUS AND MANAGEMENT

Brittlestars form an important part of the diet of some commercial fish species but are not exploited directly by us. Luckily, unlike starfish and sea urchins, they are too delicate to dry and sell as souvenirs.

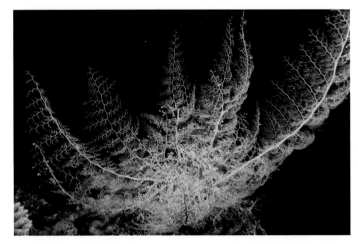

Basketstars such as this *Astroboa* species emerge at night and raise their much divided arms to catch plankton. In this position they look superficially like featherstars (p.302).

BRITTLESTAR SPECIES: CLASS OPHIUROIDEA

The majority of brittlestars are included in one order, the Ophiurida, which is divided into two suborders containing 13 families. Ophiurida have their disc and arms protected by plates (scales), which restrict their arm movements to the near horizontal. The Euryalida is a second much smaller order containing the serpent-stars and basket-stars. These have fewer arm plates and can move their arms vertically and are able to coil them around objects. The disc and arms are covered in thick skin and the arm spines are all directed downwards. Basketstars have branched arms.

ORDER Ophiurida | **FAMILY** Ophiactidae

Ophiopholis aculeata

Features This brittlestar is a common species throughout the northern hemisphere. It exhibits a wide range of colour patterns which not only makes it more difficult for us to identify but may also make it difficult for predatory fish to learn that they are good to eat. The arms are usually banded and the disc is patterned with large, rounded primary plates.
Size Disc up to 2cm, arms to 8cm.

FAMILY Amphiuridae

Amphipholis squamata

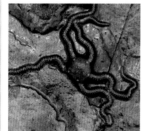

Features This tiny cosmopolitan brittlestar is found in warm and temperate waters down to at least 200m. It is a hermaphrodite that broods and produces live young. Its small size means it can drift and disperse possibly one of the reasons it is so widespread. However molecular work indicates this may be several species that cannot physically be told apart.
Size Disc up to 5mm, arms up to 2cm.

ORDER Euryalida | **FAMILY** Gorgonocephalidae

Basketstar *Gorgonocephalus caputmedusae*

Features With a mesh of dichotomously branched arms, it is easy to see why these extraordinary animals are called 'basket' stars. This species was photographed in the cold waters of a Norwegian fjord but mostly lives below diving depths usually on the seafan *Paramuricea placomus* or amongst the deep coral *Lophelia pertusa* (p.106). Its biology is described by Rosenberg *et al.* 2005.
Size Disc diameter up to about 3cm.

FAMILY Euryalidae

Serpent brittlestar *Astrobrachion* sp.

Features Seafans on reefs and in deepwater are ideal for serpent brittlestars to wrap themselves firmly around a support and this is where they are found most often. To find them, look carefully for brightly coloured bands decorating gorgonians and antipatharians. They are usually identified by collecting them on their support.
Size Disc small; arms up to 15cm.

SEA URCHINS

Of all echinoderms, sea urchins (Echinoidea) best live up to their name of 'spiny-skinned' animals. The long spines of various black sea urchins are a scourge to anyone wanting to swim or snorkel off rocky shores in the Mediterranean and almost all coral reefs worldwide. Waving their spines, moving and jostling, the urchins crowd together seemingly intent on keeping the most interesting cracks and crevices to themselves. In spite of this, sea urchins have always been an important part of people's lives and their history is closely entwined with ours. There is evidence that our prehistoric ancestors ate them as we still do today. Their fossils have been found and treasured since Neolithic times as a result of the five-star pattern imprinted on them. This led to belief in their supernatural powers and their inclusion in burial sites and widespread use as talismans (McNamara 2011). Even today there is great pleasure in finding and keeping such attractive objects which date back to at least 450 million years.

DISTRIBUTION

Sea urchins are essentially seabed animals and are found worldwide in all oceans from the shore to at least 5,000m. Whilst regular urchins are found mainly in rocky areas and on reefs, irregular (heart) urchins and sand dollars burrow through sediments.

A variety of fossil sea urchins collected from East Anglia, England where they were known in the past as Shepherd's Crowns, Fairy Loaves and Thunderstones.

STRUCTURE

There are two major groups of sea urchins, descriptively called regular and irregular. Regular urchins with their globular, radially symmetrical shape are familiar to most people. Irregular urchins live a hidden life buried in sand and mud and whilst retaining a basic radial symmetry have, like sea cucumbers, developed distinct front and rear ends. They too come in two sorts, the heart-shaped heart urchins and the extremely flattened disc-shaped sand dollars.

The shell of a sea urchin, or test as it is more accurately known, is a beautifully geometrical object. The individual plates that make up the skeleton are all joined together, stacked in columns that radiate down from the top (aboral side) to the mouth on the underside (oral side). Five double columns of ambulacral plates perforated by holes for the tube feet, correspond to the arms of a starfish. Between these are five double columns of interambulacral plates with no holes.

Fire urchins and others in their family Echinothuriidae, have flexible tests because their skeletal plates are not joined together. However what they lack in rigid protection, they make up for in their venomous nature as they are armed with needle-sharp spines tipped with poison sacs. In contrast, most other urchins have non-venomous spines.

Pedicellariae

Hedgehogs (Erinaceinae) are well-known for their fleas, a result perhaps of the difficulty of cleaning between a forest of prickly spines. Slow-moving sea urchins solve a similar problem using 'in-house' cleaners, their pedicellariae. These modified spines come in several different sizes, topped with a variously shaped head of three jaws. Activated when needed, tiny ones clean up anything that drops between the spines whilst larger ones catch and kill potential larval settlers. Some urchins have large, toothed pedicellariae that nip the tube feet of predatory starfish.

BIOLOGY

Feeding

Regular urchins have a powerful set of jaws operated by a complex system of skeletal ossicles and muscles called 'Aristotle's lantern'. Turn the animal over and you can see the five-toothed jaws resembling the 'chuck' of a power drill, which allows an urchin to graze algae and tough, fixed animal growths. The teeth can also chop up chunks of dead material, selected by specialised tube feet around the mouth. Undigested remains are voided through the anus which exits at the top of the test, near the madreporite.

Sediment-dwelling irregular urchins have a much simpler mouth. Sand dollars plough through sediment eating it as they go and digesting any organic matter it contains. Heart urchins are more selective and pick up organic matter from the sediment surface using specialised tube feet. With the urchin buried in the sediment, these extra-long tube feet extend up to the surface through a mucus-lined tube which they construct and which ends as a shallow depression. Detritus collects here and is passed down to the mouth which is at one end of the animal with the anus at the other.

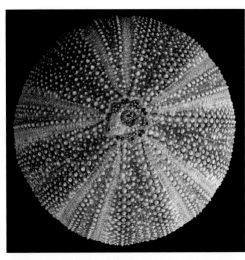

The perfect pentaradiate pattern of regular urchins shows up well in the dried test of this European Edible Sea Urchin (*Echinus esculentus*).

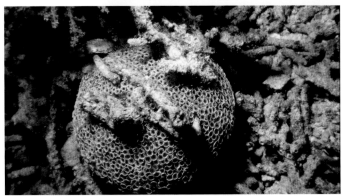

This urchin *Toxopneustes* has decorated itself with stones, held on by the pedicellariae. In shallow water and rock pools this may be the urchin equivalent of putting a sunhat on, providing protection from ultraviolet light. In *Toxopneustes* the pedicellariae have taken over the primary role of defence from the spines. They are equipped with venom sacs and grooved or hollow jaws. Their sting can be very dangerous and they should never be handled without gloves.

Aristotle's lantern, the feeding apparatus of a sea urchin. With around 40 ossicles and numerous muscles, this complex structure was first described by Aristotle.

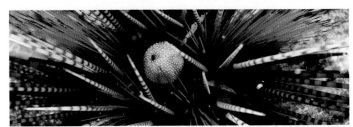

Divers are often puzzled by a conspicuous and colourful sac on the topside of some tropical urchins in the family Diadematidae. This rather beautiful object is a faecal sac where waste is stored until it is ejected away from the body. Some sources suggest it may also serve a respiratory function.

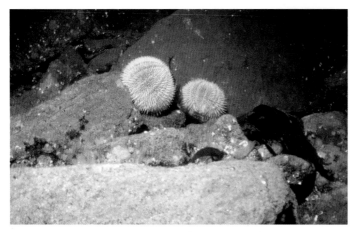

The rocks beneath kelp forests in exposed areas off the west coast of Scotland are often grazed bare by sea urchins. The pink colour is a hard encrusting seaweed impervious to grazing.

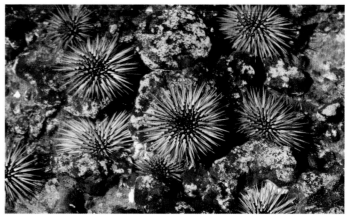

With the tide down, these sea urchins are crowded into a rock pool. Some species can make their own pools and protective holes by gradually scraping away at the rock surface.

Life history

Reproduction is a fairly straightforward affair in most sea urchins. The sexes are separate and eggs and sperm are released into the water from five gonads through small openings called gonopores at the top of the test (see photograph at top of p.297). In irregular urchins there are only one or two gonads reflecting their secondary bilateral symmetry. The resulting elegant pluteus larvae (see p.55) feed and disperse in the plankton. Urchins in the genus *Abatus*, heart urchins endemic to the Southern Ocean, retains their eggs and broods them externally amongst the spines, giving them a better chance of survival in this harsh environment. Urchins can be induced to spawn very easily and have been widely used as subjects in developmental biology. Through such research it is now known that some sea urchin larvae can reproduce asexually by budding off new individuals. Some starfish, brittlestars and sea urchins can do the same (Eaves and Palmer 2003).

Ecology

Grazing sea urchins can have as significant an effect on seaweed growth as rabbits do on grass. Their numbers are usually kept in check by predators but where the natural balance is disturbed very high urchin densities can result. The classic example of this is found in the giant kelp forests off California, USA. Here the Purple Sea Urchin (*Strongylocentrotus purpuratus*) is common and is a favourite prey of sea otters. In the past these attractive animals were heavily exploited for their soft fur and extensive areas of kelp forests subsequently badly damaged or destroyed by sea urchins.

USES, THREATS, STATUS AND MANAGEMENT

Sea urchins are commercially exploited as food and for the souvenir trade worldwide. There is actually very little to eat inside a sea urchin and it is just the gonads that are used. The raw egg masses or roe are a delicacy in Japan and are a popular and expensive item in sushi bars worldwide. The largest sea urchin fishery is in Chile, which along with the USA, exports most its harvest to Japan which is by far the world's largest market for urchin roe. In contrast urchins form part of the normal subsistence diet of some islanders in Malaysia and the Philippines.

Exploited populations of wild sea urchin have declined dramatically worldwide over the past twenty years or so. As the animals are collected individually by hand with no by-catch and no nets, the problem is almost entirely one of over-collection. Apart from implementation of strict fishery controls, the obvious answer to filling this insatiable market is aquaculture. Whilst still in its infancy, this is proving fairly successful using a variety of techniques. A fully land-based system, developed by the University of Cork in Ireland is now in operation on a commercial scale.

Dried and cleaned sea urchin tests are widely sold as curios and incorporated into tourist trinkets. The market for the native Edible Sea Urchin in the UK is small and local but tropical species are more widely exploited.

Sea urchins cut open and prepared ready to eat, for sale in Catania market in Sicily, Italy.

SEA URCHIN SPECIES: CLASS ECHINOIDEA

There are two subclasses within the Echinoidea. The Cidaroidea contains only one order the Cidaroida in which the species have obvious and disproportionately large primary spines. The other subclass the Euechinoidea is divided into three infraclasses (p.288). Acroechinoidea (order Diadematoida shown below) and Carinacea (order Camarodonta) are regular urchins whilst the third infraclass Irregularia contains the irregular heart urchins and sand dollars (Spatangoida and Clypeasteroida). See Smith and Kroh, 2011 for an excellent hierarchical listing of echinoids.

Subclass CIDAROIDEA; Order CIDAROIDA

These urchins have massive, blunt primary spines each on a simple interambulacral plate (see p.297) and surrounded at the base by much smaller secondary spines. The interambulacral areas are much wider than the ambulacral ones but this is most obvious in dead tests. 157 species are known.

Red Slate Pencil Sea Urchin *Heterocentrotus mamillatus*
FAMILY Echinometridae

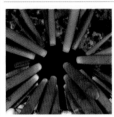

Features Urchins in this order have two types of spines, large primary ones surrounded at the base by numerous small spines. The large spines are tough and survive long after the animal has died. Urchins of this type are commonly found in tropical parts of the Pacific and Indian Oceans but *Eucidaris tribuloides* occurs on both sides of the Atlantic in warm temperate and tropical areas.
Size Spines to 12cm long and 1cm thick.

Subclass EUECHINOIDEA; Order DIADEMATOIDA

This order has a single family of about 33 species in nine genera, best known for their long, needle-sharp, hollow venomous spines borne on a subspherical test. A prominent and colourful anal cone or faecal sac can often be seen amongst the spines (see photo on p.297). They are a common hazard to divers on coral reefs.

Long-spined Sea Urchin *Diadema setosum*
FAMILY Diadematidae

Features Needle-sharp black spines make this common Indo-Pacific urchin a hazard. The spines are mildly venomous thanks to a chemical produced in the skin and they often break off in wounds. A similar species, *D. antillarum* is found in the Caribbean. During the day they hide or flock together out in the open especially in damaged reef areas where algae thrive. They are eaten by tough-mouthed triggerfish.
Size Test about 8cm diameter.

Order CAMARODONTA

Many of the 190 or so species within this order will be familiar to divers and beachcombers. They have a regular ovoid shape and medium to short, strong spines, which are not venomous. However, some (mostly tropical) species have large glandular pedicellariae which are venomous. Features of the test (shell) unite urchins in this order and are difficult to see and include keeled teeth on the mouth apparatus.

Giant Red Sea Urchin *Strongylocentrotus franciscanus*
FAMILY Strongylocentrotidae

Features Found along the Pacific coast of the USA, from the shore to at least 90m, this large urchin forms the basis of an important fishery. The colour is variable within the red range, including pink and orange with some almost black specimens. One of the largest urchins, excluding some deepsea forms, it plays an important role as a grazer in the ecology of rocky shores and reefs within its range.
Size Reaches at least 18cm test diameter.

Rock-boring Urchin *Echinometra mathaei*
FAMILY Echinometridae

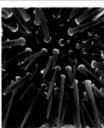

Features Limestone rock formed by corals is relatively soft and easily excavated by this urchin which hides in the round holes it creates with its spines and jaws, emerging at night to feed. It can be recognised from the white rings around the spine bases, even if even only a small bit of it can be seen. It is widespread in the Indo-Pacific.
Size Test diameter up to 8cm.

Order SPATANGOIDA

These 270 or so sediment-burrowing urchins are bilaterally symmetrical with the mouth (which lacks a lantern jaw apparatus) on the underside at the front end and a posterior anus. They are slightly flattened top to bottom and covered in a dense mat of short spines. The test is indented at the front end hence they are commonly known as heart urchins. In dead tests a petal design (ambulacral areas) can be seen on the top.

Heart Urchin *Echinocardium cordatum*
FAMILY Loveniidae

Features In the UK this burrowing urchin is often poetically called a sea potato because its dried shell often found cast up on sandy seashores, is somewhat potato-shaped. The live animal has a dense covering of backward-pointing spines. Those on the undersurface are spatula-shaped to help digging. This animal spends most of its time buried around 15cm below the surface. This specimen has a small commensal bivalve mollusc attached at the rear end.
Size Up to 10cm long.

Order CLYPEASTEROIDA

These extremely flattened, sediment-burrowing urchins are commonly known as sand dollars or sea biscuits. Some are completely circular whilst others have a more obvious front and back but all have the anus at the rear end and move with the front end leading. The mouth is in the centre of the underside. There are about 140 species.

Sand Dollar *Echinodiscus bisperforatus*
FAMILY Astriclypeidae

Features With such a thin body it hardly seems possible that a sand dollar could be alive at all and apart from a downy covering of short spines, the live animal looks little different from its dead test shown here. It is always exciting to find a sand dollar test when walking along a tropical sandy beach. Water passing through the slots or lunules in this species may help to press the animal down and prevent it being swept away.
Size Up to about 11cm.

SEA CUCUMBERS

Lying around on the seabed like fat sausages, sea cucumbers or holothurians (Holothuroidea) might be considered as the 'ugly ducklings' of the echinoderm world. That would, however, be a little unfair as whilst they do not have the charisma of starfish, there are many very colourful and attractive species. At first sight it is difficult to see why these animals are echinoderms at all and they are often mistaken for sea slugs or even large worms. However, whilst they may appear bilateral with a front end and rear end, once stood upright their radial pattern becomes more evident.

DISTRIBUTION

With very few exceptions sea cucumbers live on the seabed and are found worldwide from shallow coastal waters to the depths of the ocean. A few highly modified species live a pelagic drifting existence and are the only echinoderms to do so (apart from larval forms).

STRUCTURE

Sea cucumbers have a cylindrical sausage-shaped body with a set of feeding tentacles and a mouth at one end and an anus at the other. Whilst their skin texture varies hugely, they never have the spines, knobs and prickles seen in other echinoderms. Their pentamerous symmetry is revealed in five rows of tube feet, usually three along the lower surface for locomotion and two on the upper surface which help in respiration.

Most sea cucumbers feel quite soft and flabby when picked up because they do not have much of an internal skeleton. Dissolve the flesh away and all you would be left with is a pile of microscopic calcareous spicules in all sorts of bizarre shapes. These are embedded in the body wall and are important in identifying closely similar species, though obviously not in the field. Surrounding the gut just behind the mouth is ring of ten calcareous plates, imaginatively called the calcareous ring. This too is an important identification feature but from the animal's point of view it supports the mouth and provides attachment for muscles.

Some sea cucumbers are as large and fat as an outsize loaf of bread and their tube feet cannot absorb sufficient oxygen. So in addition, sea cucumbers can 'breathe' through their anus. Water is sucked into the expanded end of the gut called the cloaca. From here it enters two thin-walled, much-branched tubes called respiratory trees which reach far up into the body cavity. Oxygen can diffuse in and carbon dioxide out by this route.

BIOLOGY

Feeding

One of the most useful ecological roles performed by sea cucumbers is as underwater 'vacuum cleaners'. Making their slow way over the seabed, they collect and process organic debris. Enlarged and modified tube feet at the head end act as feeding tentacles that reach out and pick or shovel up food. The food passes through a stomach and long looped intestine before any remains are voided through the anus via the cloaca. In some reef species, this convenient space is used as a home by thin eel-like pearlfish (p.499) which slip in and out through the anus. There are also many sedentary sea cucumbers which live hidden in rocky crevices or buried in sediment. These species have long much-branched tentacles that expand out to fish for plankton and debris. When feeding they make a fascinating if slow entertainment ensnaring a morsel, then stuffing each tentacle into the mouth to be wiped clean.

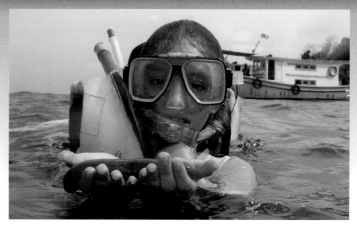

Collected from a coral reef for a closer look, this *Holothuria* sea cucumber has retracted its feeding tentacles making it difficult to tell which end is which. It was returned unharmed but many are not so lucky.

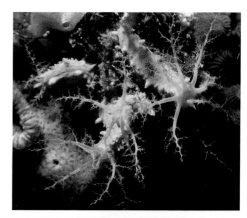

Suspension-feeding sea cucumbers have large, much-branched tentacles that form a net to trap food particles. Coral reef species such as *Colochirus* sp. are often brightly coloured, possibly to deter predators.

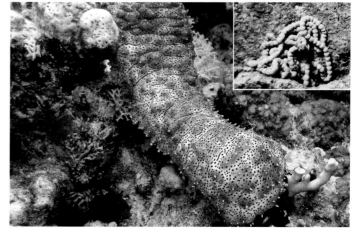

Bohadschia graeffei is a deposit feeder scooping up sediment with its shovel-like tentacles. You can often tell there is a sea cucumber in the vicinity by the necklaces of bead-like waste material left in their wake (inset).

NEW FOR OLD

Like other echinoderms sea cucumbers have considerable powers of regeneration but usually of the internal organs. When picked up by a predator (or a diver) some species will void almost their entire insides including gut, gonad and respiratory trees. Having (hopefully) deterred, distracted or fed the would-be predator the sea cucumber simply re-grows its insides within a few weeks. Some species have an even better trick and spew out sticky white tubules from the anus which can temporarily tie up a marauding crab intent on a meal. Called Cuverian tubules, these are a specialised part of the respiratory trees.

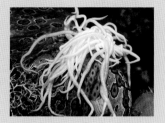

Ecology

In shallow waters most species in sediment areas are immobile, living partially buried and catching suspended food particles with feathery tentacles. In contrast abyssal sea cucumbers tiptoe across the soft surface on peg-like tube feet or are so flattened they can undulate along by rippling their muscles. In this way they move from area to area cleaning up organic debris as they go. Because food is scarce most big animals are widely scattered on deep abyssal sediment plains, but sea cucumbers sometimes occur here in 'herds' as they are expert at utilising the rain of organic material that collects on the seabed.

USES, THREATS, STATUS AND MANAGEMENT

Whilst they may appear unattractive, sea cucumbers are widely prized as food items, especially in the Far East. Not all species are edible and some have greater value than others. Species of *Holothuria* are widely collected especially in the Indo-Pacific. In many developing countries these *beche-de-mer* or *trepang* fisheries, can be amongst the most important and profitable. Over-collection and poor management in areas such as the Galapagos Islands (for *Isostichopus fuscus*) has led to concerns not only for the exploited species but also over the ecological changes resulting from absence of sea cucumbers. A review by the FAO following various international workshops (Toral-Granda *et al.* 2008) highlights the critical status of sea cucumber fisheries worldwide.

Life history

As in most echinoderms sea cucumbers have separate sexes. It is easy to tell when a sea cucumber is spawning because each individual rears up before releasing its eggs or sperm from a single gonad, with an opening near the base of the tentacles. This helps to ensure the sexual products are carried to nearby individuals. An accumulation of spawning individuals can be quite a sight.

Fertilised eggs develop into an auricularia larva (p.55) similar to that of starfish but then metamorphose into another planktonic barrel-shaped form called a doliolaria. This eventually settles on the seabed and becomes a juvenile sea cucumber. A few species omit the planktonic stages by brooding their eggs.

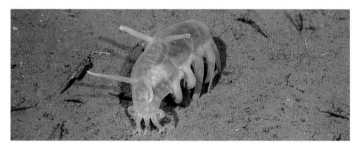

The Sea Pig (*Scotoplanes globosa*) looks very unlike most normal sea cucumbers. The long modified tube feet help it to 'walk' over the soft muddy bottom in the deepsea.

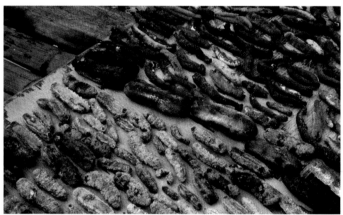

These sea cucumbers were collected and dried by subsistence-living 'Bajau Laut' (sea gypsies) in the Semporna Islands in Sabah, Malaysia.

SEA CUCUMBER SPECIES: CLASS HOLOTHUROIDEA

Of the five orders (see p.288) of sea cucumbers, the Dendrochirotida is the largest and these all have richly branched bushy tentacles and are relatively inactive (see *Colochirus* species p.300). The order Aspidochirotida includes *Holothuria* and *Bohadschia*, (p.300) which have the dorsal side covered in papillae and warts derived from tube feet. Apodida (see right) and Molpadiida have no tube feet. Elaspodida are soft-bodied and bizarre deepwater species such as *Scotoplanes* (see above).

The shape and number of calcareous spicules found in the skin of holothurians are used to help in their identification.

ORDER Apodida

Synaptula sp.

Features Like most synaptulids (family Synaptidae), *Synaptula* has a highly elastic, worm-like body, feather-shaped tentacles and no tube feet. Various *Synaptula* species such as *S. media* live on large sponges on coral reefs where they help to keep the sponge free from detritus, sweeping the surface with their tentacles. They rarely fall off as at the microscopic level their skin is like the hooked side of Velcro. They feel 'sticky' to the touch as a result of spicules extending through the skin. **Size** Variable in length.

FEATHERSTARS

Featherstars and their deepwater relatives the sea lilies, are often known by their more scientific name of crinoids from Crinoidea, the name of their class. Crinoidea itself is derived from a Greek root meaning lily-like. Whilst featherstars are commonly encountered by divers and cursed by them for their annoying habit of leaving bits of their arms stuck to wetsuits, stalked sea lilies are deepwater animals usually only seen from submersibles. However, whilst living sea lilies are a small group, a relatively quick rummage in suitable rock strata will soon turn up fossil sea lilies as this group thrived in the Paleozoic era from the Ordovician period onwards.

The detailed structure of these elegant late Triassic sea lilies has only been revealed by patient preparation of this specimen. However small segments of stalk, and even individual ossicles can easily be picked up by amateur fossil hunters.

DISTRIBUTION

Crinoids are found worldwide in all oceans. Featherstars are at their most numerous and colourful in shallow tropical waters whilst sea lilies are restricted to deep water, mostly beyond 200m.

STRUCTURE

In an echinoderm contest to see who has the most arms, featherstars would win hands (or arms) down with some species reaching the 200 mark. However their structure still follows the basic echinoderm pentamerous plan. Five arms arise from a small central body but divide near their bases. The arms are edged with rows of alternating side branches called pinnules, which gives them their feathery appearance. Both the arms and the pinnules are supported by a series of stacked skeletal ossicles. The soft body is protected inside a cup of skeletal plates capped by a tough 'centrodorsal ossicle' like a well-fitting saucer. Featherstars spend most of their time quietly sitting on the seabed (sometimes in the same spot for months) clinging on by means of a ring of claw-tipped cirri that hang down from the body. Sea lilies have a very similar structure except they are attached by a long stalk.

BIOLOGY

Feeding

Starfish, brittlestars and sea urchins have their mouths on the underside which suits their predatory and grazing styles of life. In contrast crinoids feed on plankton caught by the arms and the only sensible place to have the mouth is facing upwards into the water column. They have essentially turned over so that the dorsal or aboral side is underneath. With its arms held up and pinnules spread out, a featherstar forms an effective fishing net. Small retractable tube feet line a central groove along each

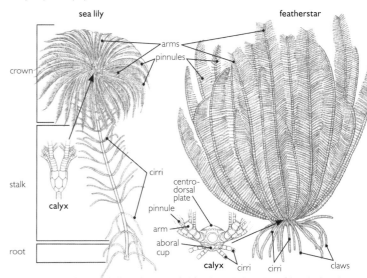

External features of a sea lily (left) and featherstar (right) with detailed drawings of the calyx in each.

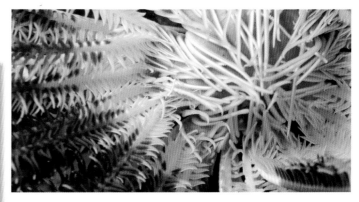

Long oral pinnules surround the featherstar body disc and often obscure the mouth and the cone-shaped anus which also opens on this side of the body.

HOW MANY ARMS?

The majority of tropical featherstars living in warm, shallow seas have a large number of arms whilst those living in cooler temperate and polar waters and the deepsea environment commonly have only ten. Juveniles start with ten arms (five branched once). Each of these can be purposefully broken off (autotomy) at the base with the stump regenerating two in place of one. After each arm has doubled up the process can be repeated. Counting the arms in a fully developed adult should, in theory, result in a multiple of ten. Doing the same in young specimens may result in a variable but even number above ten. Of course broken arms (which can be regenerated) can lead to uneven numbers.

pinnule, arranged in groups of three, each of a different size. Each group works together to select edible particles and push, bounce and shove these into the food groove. The pinnule grooves join a main ambulacral groove along each arm down which the food is passed, helped along by cilia and mucus.

Life history

Almost all crinoids have separate sexes though at least one hermaphrodite species has been identified (Obuchi et al. 2008). Eggs and sperm are released through pores from many gonads within the pinnules on each arm. Some species retain and brood the eggs amongst the pinnules whilst others wave their arms to disperse them into the water column. Fertilised eggs develop into teardrop-shaped, planktonic doliolaria larvae (p.55). As these do not feed they settle within a few days, attach to the seabed and metamorphose into a stalked pentacrinoid stage resembling a tiny sea lily. These can live and feed for months before breaking away from the stalk to become mobile featherstars.

Ecology

Whilst featherstars need rocks or other hard objects to cling to, sea lilies have been able to colonise deepsea sediments. Spotlighted by the probing lights of a submersible, a field of sea lilies apparently sprouting from the mud is a beautiful sight. The long flexible stem and side-shoot cirri anchor the animal firmly and hold it up in the water column where it can feed effectively. If attacked featherstars can crawl away or release their grip and swim off by raising and lowering alternate sets of arms. Fixed-in-place sea lilies are vulnerable to being toppled and eaten by predatory sea urchins and starfish, but it is now known that at least some species can break their stalk and pull themselves to safety using their arms. They then reattach using some of the cirri that are scattered down the stalk. Recent polar research has revealed unusually dense communities of sea lilies covering isolated rock knolls on Admiralty seamount

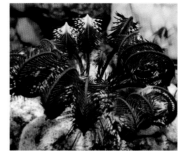

Resting featherstar with arms inrolled (left); featherstar from Sabah, Borneo with arms in an unusual position that may indicate spawning (right).

at the northern tip of Antarctica (Bowden et al. 2011). At this site there are few predators due to a lack of food.

A forest of crinoid arms makes a good home and many tropical reef featherstars are inhabited by commensal shrimps (*Periclimenes* spp.), the squat lobster *Allogalathea elegans*, tiny clingfish (*Discotrema* sp.) and Ghost Pipefish (*Solenostomus* spp.). Featherstars themselves often cling to seafans and other large sessile (fixed) animals where they are well placed to filter-feed.

USES, THREATS, STATUS AND MANAGEMENT

Whilst fossil crinoids are traded commercially, living species rarely are except for use in marine reef aquaria. Here their colour and shape add considerable interest but they are exceptionally difficult to maintain due to their fussy filter-feeding habits.

FEATHERSTAR SPECIES: CLASS CRINOIDEA

Whilst there are four orders of living crinoids and around 600 species, all except a few dozen belong to the Comatulida, generally known as featherstars. These are notoriously difficult to identify and their taxonomy continues to be explored. Stalked crinoids or sea lilies are classified into three further orders plus a few are placed with the featherstars based on their skeletal anatomy.

Passion Flower Featherstar *Ptilometra australis*
FAMILY Ptilometridae

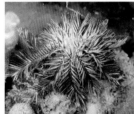

Features This stout species, endemic to southern Australia, has long, stiff pinnules that make it look rather like a flower when viewed from above. However, this is not the reason for their common name which instead stems from their habit of embracing fishermens' nets resulting in them being hauled unceremoniously to the surface.
Size Up to 12cm across outstretched arms.

Common Featherstar *Antedon bifida*
FAMILY Antedonidae

Features This ten-armed featherstar is the most common of three species found around Great Britain. The other two species are *A. petasus* and *Leptometra celtica*. Its wider distribution extends south to west Africa and Azores. In strong current areas, it can carpet areas of shallow rocky seabed turning them red.
Size Arms about 5cm long.

Oxycomanthus bennetti
FAMILY Comasteridae

Features With arms outstretched this featherstar is feeding. When resting it holds its arms folded inwards for protection, a behaviour common to most species. Featherstars feed most actively in strong currents and so are seen at their best when the tide is running. This is a common Indo-Pacific species often found perching on elevated rocks and coral heads.
Size About 15cm across outstretched arms.

Liparometra regalis
FAMILY Mariametridae

Features Coral reefs are home to a great many species of featherstars which look very similar. The banded colour pattern of the species shown here is common to many others and colour is rarely a good identification guide. However, a close look will show that in this species the white bands are an inverted V-shape. In spite of this, an absolute identification is rarely possible from photographs and this one has not been verified as this nocturnal species.
Size Uncertain.

HEMICHORDATES

Hemichordates are a small phylum of mostly worm-like creatures that were previously classified as invertebrate chordates along with tunicates and lancelets. They were thought to have a notochord (see p.307), one of the defining characteristics of true chordates but whilst they do share some characteristics with chordates, a notochord is not one of them. Most people will never knowingly see a hemichordate and probably do not want to, as most of them are soft, slimy and sometimes smelly. However, their mix of physical characteristics makes them of great interest to biologists who dig them out of their intertidal burrows. Divers straying out onto soft mud adjacent to reef bases or wrecks may come across large volcano-like mounds of sediment which indicate a buried hemichordate. There are 130 species of living hemichordates.

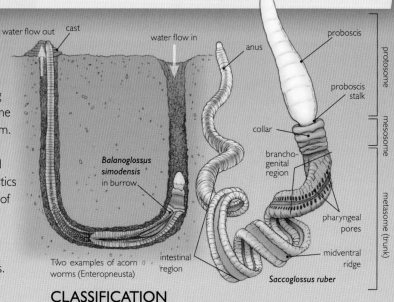

Two examples of acorn worms (Enteropneusta)

DISTRIBUTION

Acorn worms (Enteropneusta), which form the majority of hemichordates, live buried in sediment or hidden amongst seaweed on the shore and in shallow coastal waters in all oceans. Pterobranchs are a much smaller group of hemichordates that live in tubes attached to the seabed or on sessile animals such as bryozoans.

CLASSIFICATION

PHYLUM	CLASS	ORDER
HEMICHORDATA	Enteropneusta (acorn worms)	unassigned
	Graptolithoidea (=Pterobranchia)	Cephalodiscoidea
		Rhabdopleuroidea

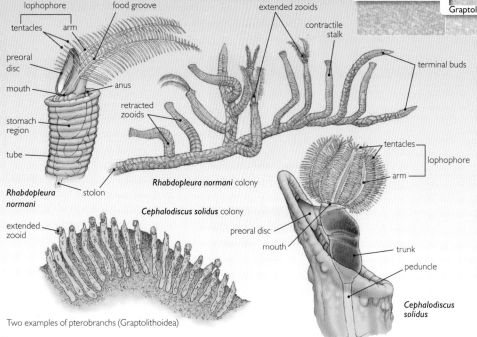

Two examples of pterobranchs (Graptolithoidea)

STRUCTURE

Acorn worms are so-called because the front end looks something like an acorn sitting in its cup. The 'acorn' is a conical, rounded or elongate proboscis used for burrowing whilst the 'cup' is a thick collar used to grip the sides of the animal's burrow. The rest of the animal follows behind as a long trunk. So how do these slimy animals even remotely resemble chordates? The answer lies in their detailed anatomy. Lying on the underside of the collar, the mouth leads into a pharynx. The wall of the pharynx is perforated by a series of U-shaped pharangeal slits, sometimes called gill slits. Water flows in through the mouth and out through the slits into small pouches which open to the outside. Chordates are the only other group to have pharyngeal slits, though in many vertebrate chordates these may only be evident in embryonic stages.

Graptolites are beautiful fossil hemichordates closely related to living pterobranchs. Some authorities still separate them into their own class Grapthlithoidea with living pterobranchs in the class Pterobranchia, whilst others put them together (as here) in the Graptolithoidea.

Yoda purpurata, first described in 2012, is a colourful species of deepsea acorn worm that was found in sediment in the N Atlantic at around 2,700m depth.

Whilst acorn worms commonly reach 20cm long and can grow to 2m, pterobranchs (p.304 bottom left) are only millimetres long. These miniscule hemichordates live in permanent horny tubes secreted by the animal and attached to the substratum. Most species are colonial living in interconnected tubes and often bodily joined by their stalks. They have the same three body regions as acorn worms but modified to suit their attached, filter-feeding way of life. The proboscis is shaped into a shield or disc-shaped pad, used to pull the animal up and down its tube. Two to several arms, fringed by tentacles, extend out from the collar like a punk hair-do. The top part of the trunk is short and sac-like but the bottom of the sac extends out as the stalk. The gut turns back on itself to exit near the mouth. Most species do not have pharangeal slits though some have a single pair.

BIOLOGY

Feeding
Like the more familiar lugworms (p.216) many acorn worms live in U-shaped burrows and feed by eating the sediment in which they live. After digesting any organic matter the rest is voided from the other end of the burrow as a coiled pile or cast of discarded sediment. Other species reach around the top of their burrows and collect organic debris and small creatures which get stuck in sticky mucus on the proboscis. The whole mess is pushed back towards the mouth by beating cilia, akin perhaps to small boys picking their noses and eating the result. In contrast pterobranchs are dainty feeders though they too use cilia for feeding. Beating cilia on the tentacle-fringed arms pull water in, trap food particles and direct them along a groove on each arm which leads to the mouth.

Life history
Most hemichordates have separate sexes and eggs and sperm are discharged through pores and fertilised in the water. Acorn worm eggs develop into a nut-shaped, rotating tornaria larva which swims and feeds using bands of cilia. The shape, feeding method and metamorphosis of a tornaria larva are very similar to starfish and sea cucumber larvae and this is one of the main reasons that hemichordates and echinoderms are considered to be related 'sister' phyla. Some acorn worm species with large eggs develop directly into juveniles. Perhaps surprisingly pterobranch larvae look rather different from enteropneust larvae and resemble small ciliated planulas (p.54). However, pterobranch larvae subsequently develop through a small worm-like stage before attaching and developing into colonies through asexual budding. Some colonies have both male and female individuals.

Ecology
Large hemichordates can make the surface of sublittoral soft mud resemble a lunar landscape of cast mounds and depressions. This is especially noticeable in deep, sheltered tropical lagoons and bays. In this respect they can be important local recycling agents aerating the sediment and preventing a build up of detritus. Faecal mounds are also common on sheltered, muddy tropical shores such as at Changi in Singapore. Some cone shells are known to prey on acorn worms.

USES, THREATS, STATUS AND MANAGEMENT

Unsurprisingly, hemichordates are not exploited as food by people. *Saccoglossus kowaleskii*, which has no free swimming larval stage, is widely used in developmental and evolutionary studies. Recent research has shown a surprising similarity in the underlying molecular blueprint for brain development in vertebrates and this hemichordate (Pani et al. 2012). Hemichordates do not develop a discrete brain and instead have nerve cells all over the proboscis and collar (a so-called 'skin brain').

Whilst not verified, these mounds, formed from very soft sediment in a lagoon in Sabah, Malaysia are thought to be formed by the feeding activities of a tropical hemichordate.

CHORDATES

The familiar vertebrates (Vertebrata), fishes, amphibians, reptiles, birds and mammals make up the majority of the phylum Chordata. With the exception of amphibians, of which there are no truly marine species, the marine representatives of these (vertebrate) groups are all covered in major subsequent sections of the book. However, lancelets and tunicates (sea squirts) are also chordates and these, the non-vertebrate chordates, are described in this chordate section. Although they can be extremely colourful and even ornate, it is difficult to see how a spineless, bag-like sea squirt attached to the seabed can be in the same phylum as a Blue Whale (*Balaenoptera musculus*) or a fast and efficient predator such as a Cheetah (*Acinonyx jubatus*) or, for that matter, humans. To sort this out, it is necessary to look at embryonic or larval stages which reveal chordate characters that are subsequently lost in the majority of adult non-vertebrate chordates.

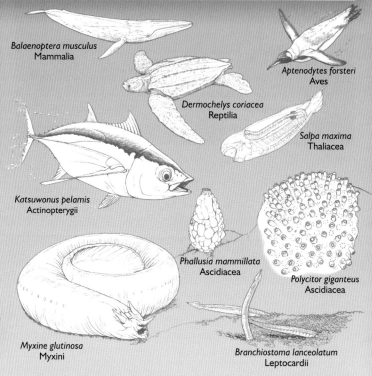

Balaenoptera musculus Mammalia
Aptenodytes forsteri Aves
Dermochelys coriacea Reptilia
Salpa maxima Thaliacea
Katsuwonus pelamis Actinopterygii
Phallusia mammillata Ascidiacea
Polycitor giganteus Ascidiacea
Myxine glutinosa Myxini
Branchiostoma lanceolatum Leptocardii

CLASSIFICATION

Chordates, especially vertebrates, have been well-studied and their relationships to one another are, with a few exceptions fairly clear, thanks in part to an extensive fossil record. However, ordering them into the various taxonomic rankings such as

SUBPHYLUM	SUPERCLASS / CLADE	CLASS	ORDER
Tunicata (Urochordata)		Ascidiacea (sea squirts)	Aplousobranchia
			Phlebobranchia
			Stolidobranchia
		Appendicularia	Copelata
		Sorberacea	Aspiraculata
		Thaliacea	Doliolida
			Pyrosomatida
			Salpida
Cephalochordata (lancelets)		Leptocardii	
Vertebrata (Craniata)	Agnatha (jawless fish p.320)	Myxini (hagfish)	Myxiniformes
		Petromyzonti (lampreys)	Petromyzontiformes
	Gnathostomata (jawed vertebrates) — Pisces	Elasmobranchii (sharks and rays)	12 orders p.326
		Holocephali (chimaeras)	Chimaeriformes
		Actinopteri (Actinopterygii) (ray-finned fishes)	46 orders p.358
		Coelacanthi (coelacanths)	Coelacanthiformes
	Tetrapoda	Amphibia (freshwater)	
		Reptilia (marine reptiles)	3 marine orders p.402
		Mammalia (marine mammals)	3 marine orders p.416
		Aves (marine birds)	10 marine orders p.458

subphylum and class throws up numerous problems if the scientific rules for such things are carefully followed. Therefore inevitably, there are variations in the classifications produced by different authorities. A major and to some extent ongoing contention, is the relationship of hagfish and lampreys which are traditionally placed together as 'agnathans' (jawless fish) as shown here. Some authorities do not consider hagfish to be true vertebrates and place them as non-vertebrate chordates, but with new methods of analysis including DNA, the pendulum now seems to have swung back the other way. Hagfish are therefore described with the lampreys in the next section on Marine Fishes and their relationships are discussed further on p.320.

STRUCTURE

All chordates possess a flexible, rod-like cartilaginous notochord that runs the length of the body beneath a dorsal, tubular nerve cord. However, in most chordates this structure is only present at an early embryonic stage and gradually disappears as the embryo develops. In vertebrates, it is replaced by an internal skeleton made of cartilage or bone including the articulating vertebrae that make up the vertebral column. In tunicates the notochord is clearly present in the free-swimming tadpole-shaped larvae. However, when the larva undergoes metamorphosis into the adult form, all trace of it is lost. Cephalochordates or lancelets retain the notochord into adulthood, as do jawless (agnathan) fish (hagfish and lampreys). The other main characteristic shared by all chordates at the embryonic or larval stage is a pharynx with gill slits that open to the exterior. The pharynx is the region of the digestive tract between the mouth or oral cavity and the oesophagus. In adult tunicates and cephalochordates it becomes an expanded food-straining device. In the various groups of fish, the pharynx develops into gills and in adult reptiles, mammals and birds it is not recognisable at all but its tissues contribute to the development of various head structures such as the inner ear.

Characteristic	Cephalochordata	Tunicata	Vertebrata
Notochord	Larva and adult	Larva only	Developmental stages only (except jawless fishes); remnants in some adult fishes
Dorsal tubular nerve cord	Larva and adult	Larva only	Developmental stages and adults
Pharangeal slits	Larva and adult	Larva and adult	Developmental stages only
Endostyle; ciliated groove on ventral side of pharynx	Larva and adult; secretes iodine compound	Larva and adult; secretes iodine compound	Neither, but thyroid gland analogous
Muscular tail region posterior to anus	Larva and adult	Larva only	Developmental stages and adults

Diagnostic chordate characteristics.

NON-VERTEBRATE CHORDATES

Tunicates (Tunicata) and lancelets (Cephalochordata) might well be described as our spineless relatives but are more usually referred to as non-vertebrate chordates or invertebrate chordates. These two subphyla are entirely marine, nowhere near as numerous and diverse as vertebrate chordates and make up only a few percent of the many thousands of chordates alive today. Tunicates may be bag-like, passive filter-feeders with no brain and a behavioural repertoire similar to a sponge, but they add colour and interest for a rocky shore visitor and are brightly coloured, mostly immobile subjects for underwater photographers. Finding a tiny lancelet which looks half fish and half worm, is an altogether more challenging experience that involves sampling and sieving the particular sublittoral, coarse sands and gravels in which they live.

TUNICATES

By far the majority of tunicates are sea squirts (Ascidiacea) most of which live attached to the seabed and which are a numerous and diverse group. Living and floating in the plankton are salps, doliolids and pyrosomes (Thaliacea) which resemble floating sea squirts. Larvaceans (Appendicularia) are also planktonic but very small and shaped like the tadpole larva common to most tunicates. Finally there is a small class of mostly deepwater, predatory tunicates, the Sorberacea which also live an attached existence.

DISTRIBUTION

Tunicates are found in all oceans, the majority in relatively shallow water. Sea squirts live attached to the seabed or any hard object including other animals and in cool shady areas on rocky seashores. Thaliaceans and appendicularians float or swim mainly in the surface layers of the ocean. There are no freshwater or terrestrial species.

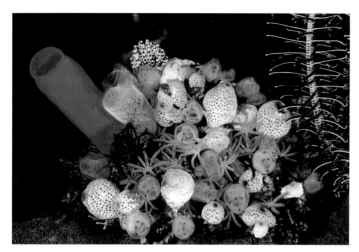

Coral reef sea squirts are often found in colourful, mixed species groups probably because space for settlement is limited by the coral cover.

The Star Ascidian (*Botryllus schlosseri*) is common on seashore rocks in the North Atlantic and Mediterranean. The centre of each 'star' is a shared exhalent opening, whilst each 'ray' is an individual with its inhalant opening at the outer tip.

STRUCTURE

The majority of tunicates whether immobile sea squirts or planktonic species, are shaped like a miniature barrel with two openings or siphons through which water is circulated for feeding and respiration. The body is enclosed, protected and supported within the tunic, a relatively soft but often tough outer covering from which the name 'tunicate' is derived. The tunic is structurally quite complex and as well as proteins and carbohydrates is composed partly of cellulose, a major component of plant cell walls but one rarely used by animals. In most species an inhalant or oral siphon at the front (anterior) end, leads into a sieve-like pharynx or branchial sac which lies within a water-filled cavity called the atrium. Water exits from the atrium via the atrial or exhalent siphon, carrying with it waste discharged from the anus. There is a small tubular heart and a system of blood vessels and blood sinuses.

Colonial sea squirts can be much more difficult to recognise, as many form thin sheets, lumps or blobs easily mistaken for encrusting sponges. Most colonies consist of small but discrete individuals that are embedded within a shared tunic but still operate independently. However, as well as a shared tunic, some species also share exhalent openings around which groups of individuals are clustered. Each individual draws in its own water supply but discharges water into the shared chamber which has a single exit.

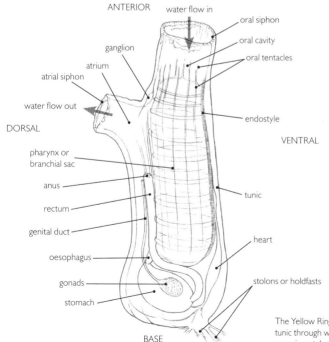

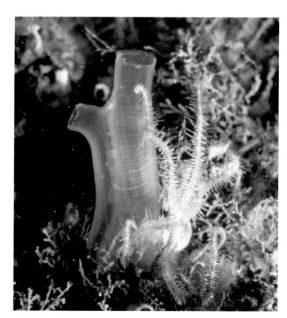

The Yellow Ringed Sea Squirt (*Ciona intestinalis*) (photograph right and diagrammatic section left) has a translucent tunic through which the sieve-like branchial sac can be seen. This widespread species is widely used as an experimental subject in developmental biology and genomics.

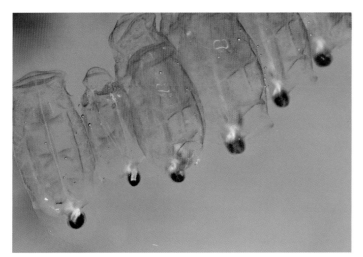

Salps occur singly or in chains and are almost transparent. The dark blob in each individual of this species (probably *Thetys vagina*) is the gut.

Salps, doliolids and pyrosomes are free-floating planktonic species which form the class Thaliacea and are found worldwide, though most commonly in warm, tropical waters. These are difficult to see and photograph as most are transparent and easily damaged when caught up in plankton nets. However they can occur in very large numbers and surfacing scuba divers occasionally report swimming through aggregations that are so dense they darken the water. Salps and doliolids look much like their bottom-living relatives but have their inhalant and exhalent openings one at each end of the body. By squirting water out forcibly with the help of muscle bands that completely (doliolids) or partially (salps) encircle the body, they can swim along like miniature jet-propelled barrels.

Pyrosomes take this to extremes and live in giant, hollow tubular colonies that can grow to at least 10m long and a metre across, though most are smaller. Huge numbers of tiny individuals only about 2mm long, are embedded in the sheet-like shared tunic. The whole enormous colony moves ponderously along through the combined efforts of all of them. Each one is arranged with its anterior inhalant siphon sucking water in from the outside of the colony and its posterior exhalent siphon squirting it out into the central chamber of the colony. This has a single exit at one end where the water flows out. A diver encountering one of these colonies and tempted to touch it, will set off a wave of bright bioluminescence which travels the length of the colony signalling each individual to stop pumping water so that the colony eventually grinds to a halt.

The smallest of all tunicates are minute planktonic appendicularians also called larvaceans, only a few millimetres long and only likely to be seen by plankton biologists. Most tunicates have a tadpole-shaped larva but drastically change shape as they mature into adults. In contrast appendicularians retain the tadpole shape and even as adults have a notochord which extends the length of both body and tail. Like other tunicates they have a pharynx through which water is drawn in, but this is not surrounded by a water-filled atrium and has only two pharangeal slits (rather than a 'basket') which open directly to the outside. However, these tiny animals have a clever trick for improving both their safety and their feeding efficiency. They secrete a separate 'house' around themselves within (or sometimes below) which they live and through which they direct a current of water by wriggling their tail. Food particles collect and concentrate within the house so that when the animal pulls water into its pharynx, it contains much more food than the outside water. The 'house' frequently clogs up and is regularly shed and a new one is secreted.

BIOLOGY

Feeding

Life for tunicates is one long meal. Their whole existence is concentrated on sieving the seawater around them to strain out food particles. A solitary sea squirt only a few centimetres high can filter several litres of seawater per hour. Water is drawn into the pharynx through the inhalant siphon and exits through the pharangeal slits into the atrium and then to the outside via the exhalent siphon. The water current is produced by the beating of thousands of cilia which line the pharangeal slits. Plankton and other food particles are trapped by sheets of mucus lining the pharynx. The mucus lets water through and out but retains food particles. It is produced as a continuous stream from a ciliated groove termed the endostyle, situated at the base of the pharynx. The mucus is moved along by the cilia, twisted into strands and passed into the gut. Every so often sea squirts live up to their name by contracting and shooting out jets of water from both siphons. This clears out debris and provides endless entertainment to small children on the seashore, who soon learn that prodding sea squirts elicits the same response. Planktonic species mostly feed in a similar manner. However, one class of tunicates, the Sorberacea, have adapted to a lack of planktonic food in the deepwater environment in which they live, by becoming predators, albeit small and rather passive ones. Instead of filtering water, the inhalant siphon is greatly enlarged and modified with lobes to grasp and trap passing animals such as small crustaceans.

Life history

The majority of sea squirts (Ascidiacea) are hermaphrodites and release both eggs and sperm into the atrial cavity and out through the exhalent siphon. When an egg is fertilised it then develops into a characteristic tadpole larva supported by a notochord which runs the length of the tail. The notochord provides rigidity and muscle attachment so that the larva can swim by undulations of its tail. The larva does not feed and concentrates all its energy on finding a suitable place to settle and metamorphose into the adult form. To this end, unlike the adult, it is well equipped with sensory structures including a simple eye, statocyst (balance organ), chemical and touch receptors. Colonial ascidians usually retain their eggs in the shared atrial cavities where fertilisation takes place and the embryo develops to an advanced stage before being released.

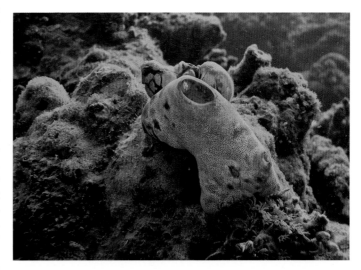

Didemnum molle is a colonial ascidian with a number of large, shared exhalent openings. These are usually coloured green as a result of the symbiotic cyanobacterium *Prochloron didemni*. Some of the photosynthetic products from the cyanobacterium are presumably utilised by the ascidian.

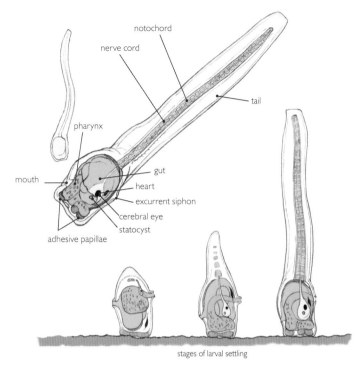

Tadpole larva of a typical ascidian (sea squirt). In some species the larva has a fleeting existence swimming for only a few hours (or even minutes) before settling. Others may swim for a few days before they find a suitable site.

Some solitary salps bud asexually to form chains of small individuals which break away from the parent and later break up as they mature into sexual hermaphroditic individuals.

Planktonic tunicates often have a more complex life cycle. Colonial pyrosomes have no larval stage. Fertilised eggs develop in the central colony cavity and are released as individuals which bud asexually to produce a new colony. Salps retain their eggs which are fertilised internally and develop into individuals that bud asexually when released, forming temporary chains. Like sea squirts, doliolids have a tadpole larva but this metamorphoses into a so called 'nurse' individual with a fleshy 'tail' that trails behind it. The nurse buds off individuals on its tail that are of three different types: feeders that supply nutrients to the nurse and to the second type, the carriers. The latter eventually break away each carrying a third type, a reproductive bud. When mature this breaks from its carrier and the cycle is complete.

Ecology

Whilst solitary sea squirts are often found in ones and twos, some species form dense aggregations possibly as a result of a relatively short larval life (hours to days) and particular hydrodynamic conditions. The Yellow Ringed Sea Squirt (*Ciona intestinalis*) can cover large areas of rock in sheltered sea lochs and inlets and many surfaces in harbours. Their combined filtering capabilities can reduce the plankton available for other filter-feeders but can also improve water clarity by removing particulate matter, converting it to faecal pellets that drop out of the water column. Sea squirts also accumulate some pollutants.

Although tiny, appendicularians can occur in immense numbers with many thousands per m^3. As they constantly manufacture and discard their 'houses' (see above) these rain down to the seabed forming a large part of the particulate matter known as 'marine snow' (p.111). This open water debris supports bacteria and other microorganisms and the whole lot, along with faecal pellets eventually sinks to the seabed to provide food for deepsea invertebrate animals.

A small number of ascidians live as part of the meiofauna (p.90) in the spaces between sand grains.

USES, THREATS, STATUS AND MANAGEMENT

Tunicates are not widely utilised as food but a few large solitary sea squirts are cultured or collected wild for food. For example, the Sea Pineapple (*Halocynthia roretzi*) is eaten raw in Japan and Korea and *Pyura chilensis* in eaten in Chile. In 2010 16,636 tonnes were produced worldwide through aquaculture and 2,128 tonnes were collected wild (FAO 2013). Like sponges, bryozoans and corals, tunicates have the potential to provide chemicals that may be of use as pharmaceuticals. Tunicates are widely used in developmental studies.

Some colonial ascidians have proved to be invasive when accidentally introduced outside their natural range. *Didemnum vexillum* has spread over the last few decades from the NW Pacific where it is assumed to have originated, to New Zealand, Canada, North America, Europe and probably elsewhere. In particular it smothers aquaculture units, shellfish beds and marina structures.

TUNICATE SPECIES: SUBPHYLUM TUNICATA

Of the four classes of tunicates the Ascidiacea (sea squirts) is by far the largest. The differences between the three orders in this class cannot be seen externally and principally concern the structure and complexity of the branchial sac (pharynx) with the Aplousobranchia the simplest and the Stolidobranchia the most complex. The location of the gonads is also important. Differences between the three orders within the planktonic class Thaliacea have been described above, as have the remaining two classes (see Structure p.308).

Class ASCIDIACEA

Lightbulb Tunicate *Clavelina lepadiformis*

ORDER Aplousobranchia — FAMILY Clavelinidae

Features The white markings on this transparent sea squirt supposedly resemble the filament of an incandescent light bulb, hence its name. This is a colonial species where the individuals are joined at the base by a network of stolons, hence it is usually found growing in small clusters. The stolons extend out horizontally and bud off new individuals asexually. This is a common species in the NE Atlantic and Mediterranean.
Size Up to 3cm high.

Atriolum robustum

ORDER Aplousobranchia — FAMILY Didemnidae

Features These little urn-shaped sea squirt colonies look superficially similar to the much larger and more untidy colonies of *Didemnum molle* (see photo p.309) and like that species, it contains the symbiotic cyanobacterium *Prochloron*. The smaller holes scattered over the colony are the individual inhalant siphons of the colony members which share a single large exhalent siphon at the top of the colony. This species is widespread in the Indo-Pacific, mostly on coral reefs.
Size Up to 3cm high.

Clavelina sp.

ORDER Aplousobranchia — FAMILY Clavelinidae

Features *Clavelina* is a widespread genus of sea squirts that has many tropical as well as temperate (see *C. lepadiformis*) representatives. They are all small and colourful and many, including this striking species photographed in the Philippines, are translucent or transparent. Each individual grows from a thick stalk, clearly visible in this photograph and is joined to its neighbours by stolons, forming a loose colony. With its clearly visible branchial basket and dark marks by the two siphons, it is very similar to *C. moluccensis* and is either a variant or a separate species.
Size About 1cm high.

Rhopalaea sp.

ORDER Phlebobranchia — FAMILY Diazonidae

Features This genus of delicate, transparent or blue sea squirts is found throughout the Indo-Pacific where various species are common on coral reefs. The species are difficult to identify from photographs alone. The oral siphons are usually ringed with a thin blue or yellow line and the exhalent siphon lies near to the inhalant one. The inset photograph shows a similar pale blue species. Colours range through various blues to purple and many are translucent.
Size Up to about 5cm high.

Didemnid *Didemnum* sp.

FAMILY Didemnidae

Features Encrusting didemnid (Didemnidae) ascidians are common in all oceans and are very difficult to identify. For a start many look very similar to encrusting sponges because their shared exhalent openings resemble sponge oscula. However, their inhalant siphons are small and neat and often arranged in specific patterns around each exhalent opening. Encrusting sponges often have distinct channels radiating away from the oscula. The inset photograph shows an encrusting sponge found in the same area as the didemnid ascidian.
Size Variable in patch size and thickness.

Perophora namei

ORDER Phlebobranchia — FAMILY Perophoridae

Features Each individual in this delicate species grows from a short stalk attached to a shared central stem. The whole colony thus resembles a delicate flower stalk and will only be seen by scuba divers who make the effort to look closely. This sea squirt tends to grow on steep and vertical coral reefs and rock faces below about 20m depth and is a tropical species found in the central Indo-Pacific area. The photograph was taken in the Semporna Islands off east coast of Sabah, Malaysia (Borneo).
Size Colony up to about 10cm long.

Polycarpa aurata

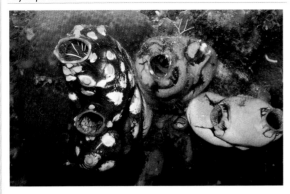

ORDER Stolidobranchia
FAMILY Styelidae

Features Shallow coral and rocky reefs in the Indo-Pacific are home for this large and robust sea squirt which is a common, widespread and obvious species. The colour varies but is always a mixture of white, purple and yellow mottling. Probably through chemical means, this species manages to prevent other organisms from settling and growing on it and the tunic is clean. In this photograph white velar tentacles can be seen inside the inhalant siphon. These prevent large particles from being drawn in.
Size Up to about 15cm high.

Sea Tulip *Pyura spinifera*

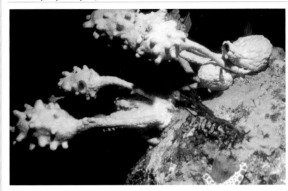

ORDER Stolidobranchia
FAMILY Pyuridae

Features This is a remarkable solitary sea squirt that is found on rocky reefs in the cooler water around the southern half of Australia. The club-like body is perched on top of a long, flexible stalk that bends and sways in rough seas. Experiments have shown that these animals settle preferentially next to an unstalked sea squirt *Cnemidocarpa pedata* (also seen here) and so end up in clumps even though they are not colonial (Davis 1996). Their distinctive yellow or purple colour results from a covering of the encrusting sponge *Halisarca* sp.
Size Up to 60cm high.

LANCELETS

Those of us that learnt our basic school biology more years ago than we care to remember, would have known these little animals as 'Amphioxus', now renamed as *Branchiostoma* and still the best-known genus. Lancelet refers to their flattened shape pointed at both ends whilst the subphylum name Cephalochordata refers to the notochord which extends right up to the tip of the head end. These small animals, only a few centimetres in length, have always interested biologists because they show clearly all the diagnostic chordate features (table on p.307) in a very simple form in both the larva and the adult. Whilst they are now known not to be the direct ancestors of vertebrates, they do indicate what primitive chordates may have been like.

DISTRIBUTION

Lancelets live partially or completely buried in coarse sand and shell gravel and have a global distribution in tropical and temperate parts of the ocean. They are found in relatively shallow water and avoid fine and muddy sediments which clog their feeding apparatus. There are no freshwater species.

CLASSIFICATION

All 30 or so lancelet species are contained in a single class (Leptocardii) and family (Branchiostomidae). The majority also belong to a single genus *Branchiostoma* which contains 23 species. *Branchiostoma* has two series of gonads one down each side of the body. The genus *Asymmetron*, as its name implies, has only a single series (along the right side) and has two species. There are currently five accepted species of *Epigonichthys* (WoRMS 2014).

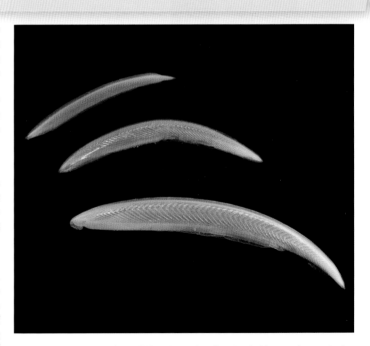

Branchiostoma californiense is one of 23 similar species of lancelets in this genus. It occurs in the eastern Pacific.

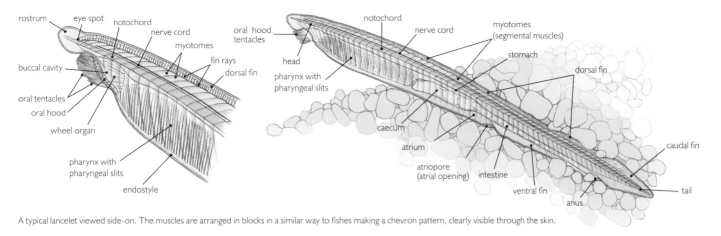

A typical lancelet viewed side-on. The muscles are arranged in blocks in a similar way to fishes making a chevron pattern, clearly visible through the skin.

STRUCTURE

In general shape lancelets resemble an elongate and almost transparent leaf, but one that wriggles like a headless fish. The notochord runs the entire length of the body and allows muscle blocks on either side to contract and alternately bend the body from side to side. The muscles appear as a row of V-shaped blocks (myotomes) along the sides of the body. The fish-like appearance is enhanced by a narrow fin running from the head, back around the tail and forward on the ventral side to the exhalent opening of the pharynx. The large pharynx extends half way along the body and is a more rigid structure than that of tunicates. It empties through numerous gill slits into a long atrial chamber which connects to the outside by a small atrial opening on the ventral side. The gut exits directly to the outside via the anus which opens near the tail.

Lancelets can truly be described as 'brainless' and 'heartless'. In place of a brain there is just a slight swelling of the hollow, dorsal nerve cord that runs almost the whole length of the body adjacent to the notochord. Nerves branch off from it and supply each block of muscles so that movement can be coordinated. The segmental arrangement of muscles and nerves is similar to that found in vertebrates. Without a heart to pump blood, the larger blood vessels are muscular and pulsate to push the colourless blood around the body.

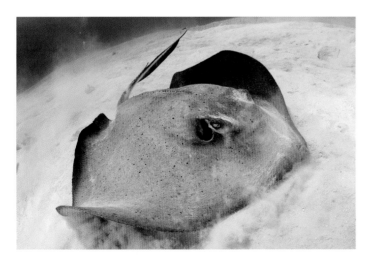

Southern Stingrays (*Dasyatis americana*) relish Florida Lancelets (*Branchiostoma floridae*), digging them out from the sediment (Stokes and Holland 1992).

BIOLOGY

Feeding

Lancelets feed in a very similar manner to tunicates and use their large pharynx to strain the water for food particles. In fine sand the animal usually lies with its head end protruding from the sediment at an angle to prevent clogging, but in coarse sand or gravel they can feed whilst buried. Overhanging the mouth at the front end is a hood fringed by tentacles which keeps out unwanted sand particles. Within the hood is a so-called 'wheel organ' ciliated loops of tissue covered in mucus which concentrate food particles that are then carried back into the mouth and pharynx by the incoming water stream. The water current is created by cilia on the pharangeal bars. Once in the pharynx the food particles are trapped on sheets of mucus secreted by the endostyle and strands of mucus and food pass into the oesophagus and midgut. As in tunicates, the pharynx can contract and force a blast of water out of either the mouth or the exhalent atrial opening to clear out clogged material.

Life history

Lancelets have separate sexes and release eggs and sperm into the water for fertilisation. In mature specimens, a row of rounded gonads can often be seen along one or both sides of the body below the muscle blocks and alongside the atrium. When the gametes are ripe they are discharged into the atrium and are released through the exhalent opening. Fertilised eggs develop into larvae that are similar in shape to the adults but which spend most of their time in the plankton. In some species at least, the larvae spend the day safely on, in or near the seabed and as night falls, rise up towards the surface to feed on plankton. *Branchiostoma lanceolatum*, one of the best studied species, breeds when 2–3 years old and lives for 5–6 years. The development of *Branchiostoma* from egg to adult has been well studied in the past and is summarised in Nielsen (2012).

Ecology

Many different species of fish will eat lancelets given the chance. Their habit of remaining buried whilst they feed gives them some protection and they rarely emerge except at night. Like sandeels, they will swim up out of the sand if disturbed, swim jerkily away and plunge back in head first which confuses at least some of their predators.

USES, THREATS, STATUS AND MANAGEMENT

In most parts of the world lancelets attract no attention and are left to their quiet way of life. However, in some places where the sediment and water conditions are optimal, they occur in very large numbers and in southern China and other parts of SE Asia they are fished for food.

MARINE FISHES

Fishes are as familiar to us as dogs, or cats or horses. We eat them, keep them as pets, wonder at them in public aquaria, catch them for sport and very occasionally get attacked by them. They are the most diverse and numerous of all vertebrate chordates and are found almost anywhere that there is water, whether salty or fresh. In general any vertebrate that swims by undulations of its body, (which is more than often streamlined), breathes with gills and has fins and scales (usually) tends to be called a fish. However, fish do not form a single natural group and are not all closely related to one another. First, there are two groups of eel-like jawless (agnathan) fish, the hagfishes and lampreys, unfamiliar to most people. Then there are the elasmobranchs, which comprise the sharks and their flattened relatives, the rays. Next are the chimaeras, mostly hidden away in deepwater and so-called because of their unusual mix of characteristics. By far the largest group is the ray-finned fishes, often called bony fishes, which includes familiar species such as cod, sardines, flatfishes and the goldfish in your pond. Lastly there are the coelacanths which together with the freshwater lungfishes are often known as lobe-finned fishes. Fish classification to class level is shown on p.306 at the beginning of the chapter on Chordates. Details of lower level classification for each of the six classes are given at the start of the appropriate following sections.

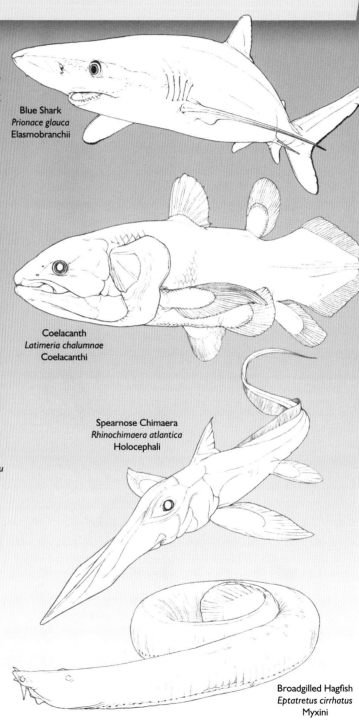

Blue Shark
Prionace glauca
Elasmobranchii

Coelacanth
Latimeria chalumnae
Coelacanthi

Spearnose Chimaera
Rhinochimaera atlantica
Holocephali

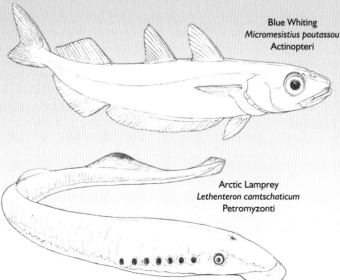

Blue Whiting
Micromesistius poutassou
Actinopteri

Arctic Lamprey
Lethenteron camtschaticum
Petromyzonti

Broadgilled Hagfish
Eptatretus cirrhatus
Myxini

STRUCTURE

Most fishes are vertebrates in the true sense of the word and have a supporting vertebral column made of bone or cartilage. During their development they start off with a notochord (p.307) but this is more or less reduced as vertebrae form around it. However it is still visibly present in jawless fishes (especially hagfishes), coelacanths and the primitive ray-finned sturgeons. All fishes have gills for gas exchange, a heart with two chambers, a similar circulatory system of blood vessels and a similar set of viscera. However none of this can be seen from the outside and as fish come in all shapes and sizes, it can even be difficult to decide if some of the more bizarre ones are fish of any sort. Eels can look like worms, stonefishes like rocks and seahorses like imaginative toys. Most have fins and scales but again not all fishes do. Major shared characters are described below and details of each class in the following pages.

The gills of a freshwater Rainbow Trout (*Oncorhynchus mykiss*).

This Tawny Nurse Shark (*Nebrius ferrugineus*) resting in a cave in Oman must actively pump water over its gills.

Gills and respiration

The problem of obtaining oxygen from water, an environment where it is in relatively low supply (p.24) has been solved in fishes by gills, structures that are designed to have a very large surface area. Everyone knows that fish breathe using gills and that they will die if left out of water for any length of time. This is because the fine structure of gills, normally supported by the water, collapses in air. Gills are an adaptation to living in water just as lungs are to living in air and for most fishes they are the only means of obtaining oxygen. A few species living or feeding in low oxygen environments can supplement their oxygen supply by absorbing it directly through the skin or can get additional supplies from air. Most fishes have five pairs of gills and their gill structure is basically similar though details of the structure and respiratory mechanisms vary especially in jawless fishes (p.321 and p.323). Each gill consists of a skeletal gill arch of cartilage or bone which is the support for a set of gill filaments.

The gill filaments (primary lamellae) are arranged like the folds of a curtain and have secondary lamellae rather like the leaflets of a compound leaf, resulting in a huge surface area. Gas exchange between the water and the blood capillaries of the gills is enhanced by having the blood flow in the secondary lamellae running in the opposite direction to the water flow, a counter exchange system familiar in many other biological settings and domestic settings (such as heat exchangers). Gill filaments in highly active fishes tend to be much longer than those in sedentary fishes.

There is a myth that all sharks must keep swimming in order to get enough water passing over their gills to provide them with the oxygen they need. Seeing a Tawny Nurse Shark (photo above) or a group of Whitetip Reef Sharks (*Triaenodon obesus*) happily relaxing together on the seabed obviously belies this belief. However there are fast swimming open ocean sharks and ray-finned fishes such as tuna for which this is true. This is called ram ventilation where the fish swims along with its mouth open which allows large volumes of water to pass in passively and over the gills providing plenty of oxygen for these very active fish.

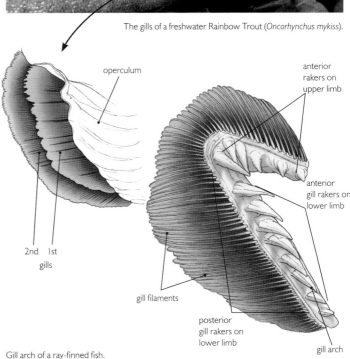

Gill arch of a ray-finned fish.

The bulging gill chambers of this mudskipper (*Boleophthalmus* sp.) hold a mouthful of water sloshing around in trapped air which oxygenates the water. These small Indo-Pacific fishes spend most of their time on mudflats, out of water and can even climb up mangrove trees.

Most fishes must pump water into the mouth, over the gills and back out through the gill openings. They do this by increasing and decreasing the space inside the mouth (buccal) chamber which is in front of the gills and the opercular chamber which is behind the gills. The two chambers can be operated independently and a unidirectional flow is achieved by timing, such that the buccal chamber is always at a higher pressure than the opercular chamber. Water is sucked into the mouth rather in the way that a submerged, squeezed out empty shampoo bottle will suck in water (an excellent and parsimonious way of using up the last dregs). The two methods are not mutually exclusive and many large fishes use ram ventilation when they are actively swimming and pump water when they are quiescent.

The Bluntnose Sixgill Shark (*Hexanchus griseus*) is one of only a very few fishes to have more than five pairs of gills.

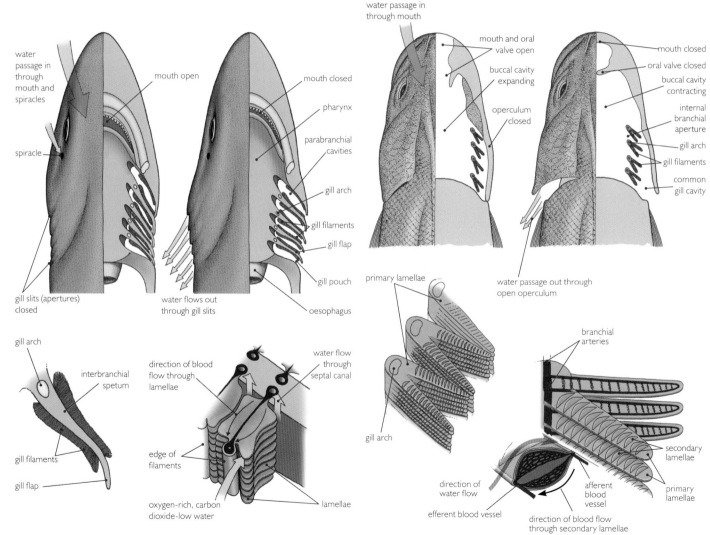

The two pump phases of breathing and the structure of the gills in a typical shark (left) and a typical ray-finned fish (right). External view is on the left and internal view on the right of each of the four drawings (top). The enlargement (bottom far left and right) is a lateral cutaway view of a gill with further enlargement (left and far right) of the gill filaments. Blood flow in the lamellae is in the opposite direction to the water flow.

MARINE FISHES

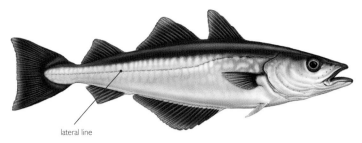

Although subcutaneous, the lateral line shows up because each scale along the line is perforated by a pore to allow water to enter the system, as shown in this Pollack (*Pollachius pollachius*).

Lateral line

Next time you buy a whole fish or catch one, look at it carefully and in many cases you will see a distinct line running along each flank. This is the lateral line, a sensory system that detects water movements such as the vibrations made by another swimming fish. It allows the fish to detect prey, be aware of water currents, to avoid bumping into underwater obstacles and to swim as part of a school. Vibrations transmit much better through water than through air and there is no equivalent to the lateral line system in vertebrates other than fish (and some permanently aquatic and larval amphibians in freshwater). A lateral line system is found in all classes of fish except hagfishes but is much better developed in some groups and species than in others.

The system is based on sensory 'hair cells' similar to those found in the inner ear of most vertebrates including fishes. In the lateral line system the hair cells are arranged in clusters called neuromasts which lie within a fluid-filled channel just beneath the scales. It is this channel that is visible along a fish's flanks, demarcated by tiny pores that connect the system to the outside. Each neuromast is covered by a gelatinous cap (cupula) into which cilia (slender hair-like protruberanes) project from the tops of the hair cells. Waterborne vibrations deflect the cupula thus bending the cilia and sending nerve impulses to the brain. Many fishes have individual superficial neuromasts scattered on the skin especially on the head.

Fishes do not have external ears and sound pressure waves are transmitted to the inner ear through the body tissues. The lateral line system and inner ear have a very similar structural design and origin and are often considered together as two connected parts of an acoustico-lateralis system.

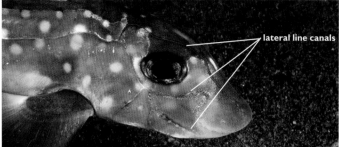

Branches of the lateral line system extend onto the head and these cephalic lateral line canals are well-developed in the White-spotted Rattail (*Hydrolagus colliei*) and other chimaeras.

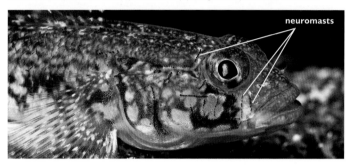

The Slender Goby (*Gobius geniporus*) has no lateral line along the flanks but many short lines of neuromasts (sensory papillae) on the head. The way these are arranged is characteristic for each goby species and is helpful in their identification. This goby is endemic to the Mediterranean.

SYNCHRONISED SWIMMING

Schooling is well-developed in open water fishes and provides safety in numbers. Co-ordination of the group is achieved using both vision and the lateral line system and in this way a standard nearest neighbour distance can be maintained. The fish on the outside of the school react to a predator (or diver) by changing direction and speed. This is detected and followed by their neighbours and the whole school moves almost in unison.

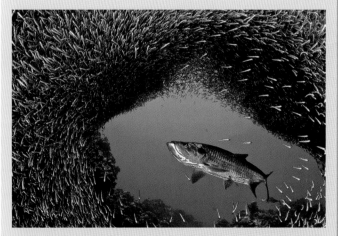

Always just out of reach, a huge school of silversides parts to avoid the predator in their midst, in this case a large Tarpon (*Megalops atlanticus*).

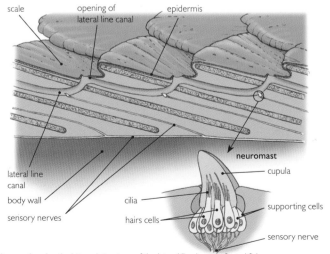

Diagram showing the internal structure of the lateral line in a ray-finned fish.

Young salmon and sea-going trout (parr) lose their characteristic barred markings as they grow into smolts and move down river into estuaries where they spend some time acclimatising to the change in salinity before moving out to sea. These photographs are of Rainbow Trout (*Oncorhynchus mykiss*) in which only certain subspecies, referred to as 'steelheads' migrate from freshwater to the ocean.

Osmotic regulation

Whilst there are a few fishes that can move between saltwater and freshwater, most marine fishes will die if put into freshwater and vice versa. Like other vertebrates fishes must maintain an optimal balance of salts and water in their blood and cells. The problem is that whilst most fish skin is relatively impermeable, the thin soft tissues of the gills, mouth and nasal linings, which are continuously flushed with water, are highly permeable to both salts and water. Marine fishes live in water which has a higher concentration of salts than do their bodies. They therefore tend to dehydrate as water passes out of their bodies through osmosis and they must drink seawater with its attendant salt load. Whilst the kidneys play a role in maintaining salt and water balance, something more is needed and the different groups of fishes have various adaptations to cope with this problem. In ray-finned fishes, the gut and gills both have roles to play. The gills are equipped with specialised chloride cells which remove salts through complex cellular processes.

OSMOSIS

In any situation where two solutions of different strengths are separated by a semi-permeable membrane, then the smaller solvent molecules will tend to diffuse across the membrane from the less concentrated to the more concentrated solution. In marine fishes the solutions are seawater and fish body fluids, the semi-permeable membrane is fish cell walls and the solvent is water.

As salmon smolts move downstream from rivers towards the sea, their chloride cells increase greatly in number. Cartilaginous fishes have specialised kidneys that retain urea, a nitrogenous excretory product which increases the osmolarity of their blood and tissues. This is why skate wings and shark meat need careful handling, storage and preparation otherwise they end up smelling and tasting of ammonia, a breakdown product of urea. Like many invertebrates, jawless hagfish are naturally almost isosmotic (the same strength) with seawater. Cartilaginous fishes, chimaeras and coelacanths also have a rectal gland which removes salt from the blood and secretes it as a concentrated salt solution into the hind gut near the rectum.

Temperature regulation

It used to be thought that all fish were 'cold-blooded' or 'ectothermic' which means that their body temperature fluctuates with and is the same as the ambient seawater around them (see also reptiles p.402). Indeed this is the case for the vast majority of fish because water has a high heat capacity (p.26) and heat generated by muscular activity is rapidly conducted away – as anyone who goes swimming in the sea will certainly know. This is a particular problem for fast-swimming, wide-ranging predatory fish living in cold water because vertebrate muscles operate far less efficiently at low temperatures. Remarkably it is now known that certain lamnid sharks (Lamnidae) such as the White Shark (*Carcharodon carcharias*) and the Salmon Shark (*Lamna ditropis*) can maintain their core swimming muscles and organs, including the brain and eyes, well above ambient temperature. They are, at least partially, 'warm-blooded' or endothermic just as mammals and birds are. As only certain parts of the body are warmed and the temperature cannot usually be regulated this is called regional endothermy. The same applies to a number of fast-swimming ray-finned fishes particularly the larger species of tuna (Scombridae), swordfish and marlin. The mechanism, based on specialised networks of blood vessels called **retia mirabila**, (a single one is a **rete mirabile**) has evolved independently in both sharks and ray-finned fishes.

With eyes and brain kept warm, the Sailfish (*Istiophorus platypterus*) can react extremely fast to its moving prey and can slash its bill into a bait ball at very high speed.

Class and species	Tissues and organs warmed	Body temperature (°C) References	Distribution
ELASMOBRANCHII			
Lamnidae			
White Shark (*Carcharodon carcharias*)	Slow (red) swimming muscle, viscera, brain/eyes	14°C (core)	Cosmopolitan
Salmon Shark *Lamna ditropis*)	Slow (red) swimming muscle, viscera, brain/eyes	20°C (core)	Cold waters of North Pacific
Shortfin Mako (*Isurus oxyrinchus*)	Slow (red) swimming muscle, vicera, brain/eyes	Dickson & Graham 2004	Worldwide temperate and tropical
Longfin Mako (*Isurus paucus*)	Slow (red) swimming muscle (?), viscera, brain/eyes		Probably worldwide
Porbeagle Shark (*Lamna nasus*)	Slow (red) swimming muscle, viscera, brain/eyes	8–10°C (core)	Cool waters of N Atlantic and s hemisphere
Alopiidae			
Thresher Shark (*Alopias vulpinus*)	Slow (red) swimming muscle, other?	Bernal & Sepulveda 2005	Worldwide tropical to temperate
Bigeye Thresher (*Alopias superciliosus*)	Brain and eyes (probably), other?	Weng & Block 2004	Worldwide tropical to temperate
ACTINOPTERYGII			
Scombridae			
Atlantic Bluefin Tuna (*Thunnus thynnus*)	Slow (red) swimming muscle, brain/eyes	Up to at least 21°C (core)	North Atlantic and Mediterranean
Albacore (*Thunnus alalunga*)	Slow (red) swimming muscle, brain/eyes	Ca. 10°C (core)	Worldwide tropical to temperate
Skipjack Tuna (*Katsuwonus pelamis*)	Slow (red) swimming muscle, brain/eyes	12°C (core)	Worldwide 40° N to 40° S
Butterfly Kingfish (*Gasterochisma melampus*)	Brain and eyes		Southern Ocean
Xiphidae			
Swordfish (*Xiphias gladius*)	Brain and eyes	Up to 15°C	Worldwide 60° N to 50° S (in parts)
Istiophoridae			
Blue Marlin (*Makaira nigricans*)	Brain and eyes		Circumtropical to 45° N and 45° S in summer
Sailfish (*Istiophorus platypterus*)	Brain and eyes		Worldwide tropical to temperate
Lampridae			
Opah (*Lampris guttatus*)	Brain and eyes (probably)	2–6°C Runcie et al. 2009	Worldwide tropical to warm temperate

The main species of fish known to exhibit regional endothermy. Several other tuna and billfishes also have the ability to elevate the temperature of some organs. See Dickson and Graham (2004) for list and references.

In the gills, arterial blood is oxygenated but also cooled by its close proximity to the surrounding water. With most fish this means that the core muscles and viscera supplied with this cool blood remain cool because heat generated by the muscles is carried away in the venous blood travelling back towards the heart and gills. Retia mirabilia prevent this loss by using a countercurrent system in which the incoming vessels carrying cool blood are closely applied to the outgoing vessels carrying warmed blood. The incoming blood is warmed by the outgoing and heat loss is prevented. A heat transfer efficiency of over 95% has been measured in the Albacore (*Thunnus alalunga*). The same principle is widely used in industry and even in domestic condensing boilers.

Endothermy is restricted to pelagic open water fishes that swim constantly and which are often wide-ranging. Many pelagic fishes have large amounts of red or slow muscle which is used for steady sustained swimming and in endothermic fishes is found mostly deep within the body near or around the vertebral column. It is this muscle that is kept warm. White muscle is used when the fish needs a burst of speed. Red and white muscle can easily be seen when eating a grilled mackerel. The darker brown flesh is red muscle and the white flesh is white muscle.

In Swordfish, Sailfish, marlin species and the Butterfly Kingfish, heat to keep the brain and eyes warm is produced by a special muscle-derived mass of tissue behind the eyeball and is retained by retia mirabilia in the blood system supplying this area. Tuna and lamnid sharks do not have this specialised brain/eye heater and heat is supplied from elsewhere

By maintaining an elevated body core temperature. the White Shark (*Carcharodon carcharias*) can maintain its hunting efficiency in relatively cold water.

JAWLESS FISHES

If you are ever lucky enough to encounter a hagfish or a lamprey, which most people will not be, you are unlikely to be bitten because these unusual fishes have no jaws. They can however, latch onto you with their sucker-like mouths in the hope of a blood meal, as a few swimmers in the Great Lakes of North America have found out. Here Sea Lampreys (*Petromyzon marinus*) have taken up permanent residence after being accidentally introduced. Today lampreys and hagfishes are the only groups of living jawless fishes (commonly called agnathans) and there are only around 100 species of them. However, the fossil record shows that agnathans were abundant and diverse around 400 million years ago.

CLASSIFICATION

The relationship of the jawless hagfish and lampreys to each other and to jawed vertebrates (commonly called gnathostomes) has been much discussed and researched and the discussion continues to this day. Initially both groups of jawless fish were classified together as 'cyclostomes' (meaning rounded mouth), a group thought to have diverged from a primitive vertebrate ancestor along a separate pathway from the jawed vertebrates, making them 'sister' groups. Then in the latter part of the 20th century, further analysis of their morphology and some early molecular work led to the lampreys being allied with the jawed vertebrates leaving hagfishes as non-vertebrate chordates. Recent detailed molecular work using micro-RNAs (miRNA) has shown that hagfish and lampreys share four unique miRNA families, which is considered to be very strong evidence for their being once more grouped together (Heimberg et al. 2010). An excellent summary behind the historical and current thinking is provided by Janvier (2010).

STRUCTURE

Jawless fish do not have biting jaws, a feature of every other known vertebrate. Instead they have a sucker-like mouth well-suited to their scavenging and parasitic ways of life. Neither do they have true articulating vertebrae forming a vertebral column. Instead the long eel-like body is supported by a simple notochord (p.307) and whilst lampreys may have a few cartilage vertebral supports around it, hagfish have none at all. The whole skeleton including the notochord and cranium (skull) is made of cartilage. Hagfish and lampreys have other structural similarities but also have numerous differences (see table below).

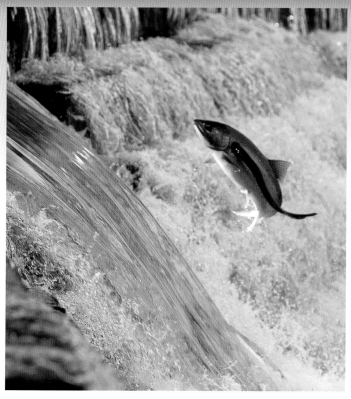

A rare photograph of a lamprey attached to a leaping salmon on its way upriver to spawn.

CLASS (PHYLUM CHORDATA)	ORDER	FAMILY
Myxini (hagfishes)	Myxiniformes	Myxinidae
Petromyzonti (lampreys)	Petromyzontiformes	Petromyzontidae
		Geotridae
		Mordaciidae

Feature	Lampreys	Hagfishes
External gill openings	7 pairs	1–16 pairs
Mouth	Terminal	Subterminal
Eyes	Functional	Vestigial
Pineal organ (light sensitive)	Yes	No (but skin light sensitive)
Nostrils	Single on top of head connecting to a blind pouch under the brain	Single at front of head connected to gills via pharynx
Fins	1 to 2 dorsal near tail	1 continuous
Heart(s)	1	4
Blood	Hypo-osmotic to seawater (less salty)	Isosmotic with seawater (the same as seawater)
Semicircular canals	2	1
Brain	Cerebellum	No cerebellum

Although adult lampreys and hagfishes look superficially similar and share important morphological traits they nevertheless exhibit many differences in detailed anatomy, the most obvious of which are shown here.

HAGFISHES

As their name suggests, hagfishes are not the most pleasant or attractive of animals. They are also variously called slime eels, slime hags and even snot eels, a reference to their amazing ability to produce copious quantities of thick slime if handled or attacked. Some public aquariums keep hagfish and on occasion will handle the fish to demonstrate this ability to the public, but otherwise it is fishermen, scientists and wildlife camera crews who are the most likely to encounter them. A fisherman's crab pot filled with their writhing bodies is not generally a welcome sight, but luckily their depth range rarely overlaps with the crustaceans these baited traps are designed to attract.

DISTRIBUTION

Hagfish species are found in the ocean in temperate and cold waters at latitudes above about 30° in both hemispheres. Most live in deep water down to at least 5,000m but in cold waters they can live in water as shallow as 30m as long as the temperature is below about 22°C.

STRUCTURE

Seen through the lens of a remote camera or the porthole of a submersible, a mass of wriggling sliding hagfish feeding on a carcass, resembles nothing so much as a party for giant worms. Hagfish have four short, fleshy tentacles at the head end, but the slit-like mouth is hidden away on the underside and the eyes are vestigial and lie beneath the skin. *Myxine* and similar genera have a single gill opening just behind the head, while *Eptatretus* and allies have from five to sixteen. A single continuous fin runs along the belly, round the tail and a short way forwards along the back. In a dead specimen it is easy to see a row of 70–200 small dots running along each side near the belly. These are the slime glands which are nearly impossible to see if you pick up a live specimen as it and your hands will soon be covered in thick mucus. Inside the mouth and not usually visible are four tooth plates on the tongue.

Water is taken in through a single nostril at the end of the snout and pumped through the pharynx, into the gill pouches and finally out through the external gill opening(s). However, gills are not the only way in which hagfish obtain oxygen. They can also absorb it through the skin into beds of blood capillaries, which is useful when they are burrowing through a carcass and cannot circulate water through the gills. They can also survive for a long time on very little oxygen as they have a slow metabolic rate.

Interestingly hagfish have not one but four simple hearts which beat at different rates. The circulatory system is partially open with several blood sinuses and three of the hearts are primarily concerned with moving venous blood out of these sinuses.

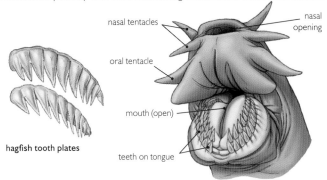

hagfish tooth plates

Hagfish may not be able to remove their dental plates to clean them but they can protract and unfold them to expose their teeth and grasp food.

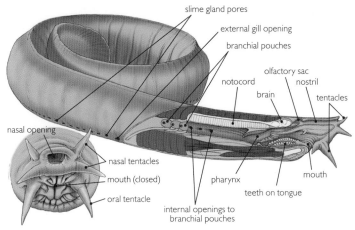

External and internal (head end only) features of a hagfish. Inset (left) shows head-on view.

HAGFISH SLIME

It is hard to imagine anything slimier than a hagfish. A single animal placed in a large bucket of water will turn it to slime in just a few minutes. Two different types of cells within the slime glands separately release coiled-up threads (protein) and mucin vesicles (carbohydrate). On contact with water, the mucin vesicles rupture, swell and expand whilst the threads uncoil. The threads are what make hagfish slime different from normal mucus. They are remarkably long, very strong and give the slime strength and cohesion. The mucin binds the threads together, holds seawater between them and is important in ensuring the slime can be released almost instantaneously. The detailed morphology and mechanics of this remarkable substance are described in Fudge *et al.* 2005. The function of the slime appears to be primarily defensive. Sharks and other fish have been filmed underwater trying to eat hagfish, which they then immediately reject as their mouth and gills fill with slime. The hagfish itself escapes suffocation by literally tying its tail into a knot, which it then slides up its body pushing the slime over and off its head and backing away.

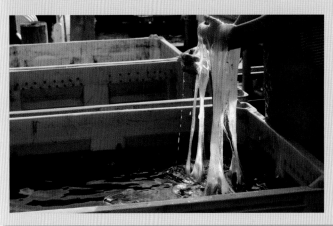

BIOLOGY

Feeding

At night hagfish emerge from their mud burrows and go in search of a meal. They eat a wide variety of bottom-living invertebrates which they find mainly by smell. However they are also consummate scavengers and like nothing better than a dead fish or better still a putrefying mass of blubber and flesh from a dead whale. Using remote cameras, scientists and film makers have captured fascinating footage of hundreds of hagfish homing in on dead whales dropped out at sea for this purpose. By everting their tooth plates, closing and then retracting them, hagfish can rasp off pieces of flesh. With no restrictive vertebral column a hagfish can literally twist its body into a knot and then pass the knot along its body until it is forced against the carcass, thus giving the animal extra leverage to tear off lumps of food. Hagfish have been observed to burrow their way right into a carcass and eat it from the inside out. This charming habit is sometimes extended to trapped or netted live fish which are invaded via the mouth or anus.

Life history

Considering their deepsea habitat and secretive life style, it is not surprising that information on hagfish reproduction is limited. Each animal has a single gonad which contains both male and female tissue in immature specimens. However it appears that individuals then develop either into males or females which release eggs or sperm into the water. There is a possibility that some species may actually be able to function either as hermaphrodites or as separate males and females depending on circumstances (Powell et al. 2005). Eggs are laid on the seabed where they stick to it and each other and are presumably fertilised externally by the male. Each is sausage-shaped with a horny protective shell and they are laid in batches of up to about 30. There is no larval stage and the young hagfish hatch directly from the eggs. In 2007 a Japanese Hagfish (Eptatretus burgeri) was successfully bred in captivity and this technique is now allowing embryonic development to be studied.

Ecology

Hagfish can occur in very high numbers in the soft muddy sediments that typify deep sea habitats in both the Atlantic and Pacific oceans. Like earthworms on land, their burrowing activities allow oxygen into the sediment and their scavenging habits help to recycle nutrients. This is a role that is difficult to study and the potential ecological consequences of overfishing hagfish are difficult to predict.

USES, THREATS, STATUS AND MANAGEMENT

With their propensity for secreting huge quantities of viscous slime, hagfishes are not widely eaten and the main market is for their skin. For the latter use there are substantial fisheries for hagfishes along the eastern Pacific and western Atlantic coasts of North America and off Japan and Korea. They are caught using baited traps and their tough skin is processed into 'eelskin' leather used to make wallets, handbags and similar items. Several fisheries have collapsed in the past and current fisheries indicate a lack of sustainability, but more data is needed to assess accurately the effects of the fisheries on specific species such as the Pacific Hagfish (Eptatretus stoutii). Hagfish also affect fisheries for other species because they attack and damage fish caught on long lines and in nets. Currently hagfish slime is being researched as a potential source of synthetic fabrics. The slime is packed with fine protein fibres of considerable potential strength. The ultimate aim would be to produce these proteins via genetically modified bacteria.

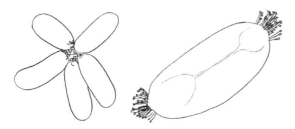

Hagfish eggs are rarely seen in the wild.

HAGFISH SPECIES: CLASS MYXINI

There are 78 hagfish in the single order (Myxiniformes) and family (Myxinidae). Two subfamilies: Myxininae have one pair of branchial openings whilst Eptatretinae have 5–16.

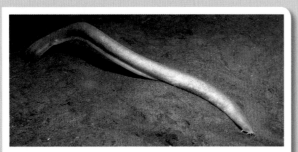

FAMILY Myxinidae SUBFAMILY Myxininae

Hagfish Myxine glutinosa

Features The pinkish colour of this hagfish increases its resemblance to a giant fat earthworm. It has only a single pair of external gill openings behind the head and out of which water exits after passing through 5–7 internal gill pouches. In Scandinavian sea lochs it has been photographed within scuba diving depth but extends down to around 1,500m. This species is widespread in the N Atlantic from Scandinavia and Greenland south to the western Mediterranean and the NE of the USA.
Size Up to 80cm long.

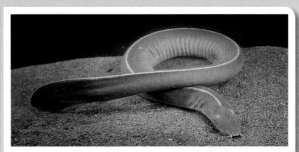

FAMILY Myxinidae SUBFAMILY Eptatretinae

Japanese Hagfish Eptatretus burgeri

Features Like many other hagfish, this one is a dirty brownish pink colour but is also has a white line along its back. It has 6 pairs of round gill openings (other species within this subfamily have up to 16). In comparison to most other hagfish, this species lives in relatively shallow water from around 10m to around 250m. It lives in the NW Pacific mainly around Japan and Taiwan where it is heavily fished and is now listed as Near Threatened in the IUCN Red List of endangered species.
Size Up to 60cm long.

LAMPREYS

With their parasitic lifestyle and slippery, eel-shaped body, lampreys are unlikely to win any prizes in the fish popularity stakes. However, these primitive fishes which can move effortlessly between fresh and salt water, have in the past provided epicurean delights for European royalty. British sovereigns were once presented annually with baskets of lampreys by the township of Gloucester. Nowadays, lampreys are probably most familiar to fishermen and have surprised (and perhaps revolted) many recreational anglers who find them dangling from the prized fish they have just landed. More benign, non-parasitic species are sometimes fished out of small streams by children (and their parents) looking for minnows and sticklebacks.

DISTRIBUTION

Lampreys are cold water fishes that live in coastal and freshwaters at latitudes mostly above 30°. Coastal species are all anadromous, that is they return to freshwater to breed. The largest family (Petromyzontidae) are restricted to the northern hemisphere mostly in North America and Europe, whilst two small families (Geotridae and Mordaciidae) live in the southern hemisphere in Australia, New Zealand and South America.

STRUCTURE

A lamprey looks at first sight very much like an eel, but a closer look will soon show up the differences. Pick one up and if it does not immediately escape it will probably attach itself to your hand with its circular, sucker-like mouth. This will allow you a good view of a row of seven, separate circular gill openings along each side just behind the eyes. The best way to see the mouth is to persuade one to latch onto a sheet of glass or the sides of an aquarium. The actual mouth is at the centre of an

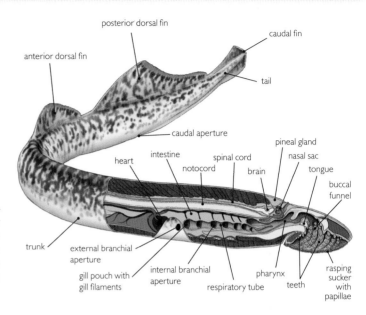

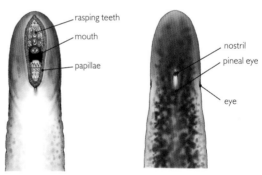

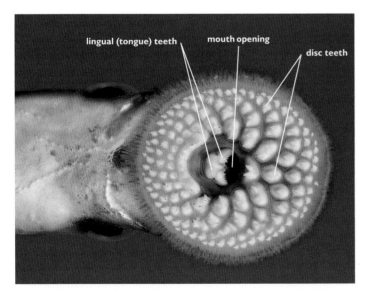

Top: external and internal features of a lamprey. Bottom left: underside of lamprey head and mouth disc relaxed and unattached. Bottom right: top side of lamprey head.

oral disc studded with concentric rows of small conical teeth. Inside the mouth is a tongue equipped with larger lingual teeth which do most of the rasping when the animal is feeding. The teeth are made from keratin, the same material found in human hair and fingernails. All lampreys have either one or two dorsal fins on the back near the tail but the familiar paired pectoral and pelvic fins found in almost all other fishes are absent.

Most fish take water in through their mouths and pass it over and out through their gills for respiration. An adult lamprey firmly attached to another fish by its mouth sucker cannot do this. Instead it draws water in through its external gill openings as well as passing it out again by the same route. When unattached it can breathe normally by taking water in through its mouth. The pharynx leading from the mouth in an adult lamprey divides so that the dorsal part connects to the oesophagus and a ventral branch connects to the gills in their gill pouches. This part has a valve and can be closed off when the animal is feeding so that food fluids are not lost through the gill openings.

The mouth (oral) disc of a Sea Lamprey (*Petromyzon marinus*) showing arrangement of teeth in consecutive circular rows.

BIOLOGY

Feeding

Lampreys are best known for their vampire-like habit of rasping flesh and blood from large living fish such as salmon, mackerel, sharks and very occasionally from whales and dolphins. Some species prefer blood whilst in others the teeth are adapted to take flesh as well. Once a lamprey has clamped onto a fish with its sucker mouth there is very little the victim can do about it, except wait until the lamprey has had its fill and drops off. Marine (anadromous) species all feed parasitically as do some freshwater species (though none in the southern hemisphere). However many freshwater lamprey species are non-parasitic and simply eat small invertebrates. There is evidence that parasitic species can also eat invertebrates or other material as necessary. The Caspian Sea Lamprey (*Caspiomyzon wagneri*) feeds on algae and other vegetation and scavenges dead fish but has also been found attached to and may feed from living fish.

All lampreys go through a larval stage known as an ammocoete (see Life history below) and these feed in an entirely different way to adult lampreys. Here we are straying into the Freshwater World because lampreys all breed in freshwater. Ammocoete larvae live partially buried in the mud of rivers, streams and lakes and feed by trapping plankton and detritus in mucus produced within the pharynx behind the mouth. Adults of some non-parasitic (freshwater) species such as the Brook Lamprey (*Lampetra planeri*) do not feed at all after metamorphosis and their adult life span is only about six months.

Life history

After one to several years living and feeding in coastal waters, marine (anadromous) lampreys reach sexual maturity and swim up rivers to breed (freshwater species are of course, already part way there). Once they reach a suitable site with clean, flowing water and a gravel or pebble bottom, they get busy excavating a nest. Their remarkable sucker mouth means they can easily pick up stones and individually deposit them in a mound just downstream of the nest. Hanging onto a rock and wriggling helps dislodge finer material. In small non-parasitic species spawning is usually a group affair but the larger parasitic species such as the Sea Lamprey (*Petromyzon marinus*) usually spawn in pairs and the male will defend his nest. Eggs or sperm are first released into the body cavity from a single gonad and are then shed through pores in the abdomen. In spawning pairs the male wraps himself around the female and squeezes to help with egg release. After spawning, both males and females die. The eggs hatch after around two weeks and quickly develop into worm-shaped, toothless, blind ammocoete larvae.

These drift downstream until they reach suitable areas of soft silt and sand, burrow in and start filter-feeding. This is how they spend the next unexciting four to eight years or so, the time depending on the species. During this time they may get washed out by flood water but will then resettle further downstream. The larvae finally metamorphose and anadromous species swim downstream and out into coastal waters. Unlike salmon, lampreys do not return to the river where they were born but instead are chemically attracted to rivers which already support healthy populations of ammocoete larvae. This makes it more difficult to attract them back to restored rivers.

Ecology

In coastal water lampreys will attack a wide range of other fish including herring, mackerel and salmon and can kill or weaken a significant proportion of their victims. However they do not usually cause any significant decline in the population of their prey. In 1929 the opening of the Welland Canal allowed Sea Lampreys into the Great Lakes system of North America. Here they thrived and had a devastating effect on trout and other lake fish species. Control measures are still necessary even today. Lampreys (and hagfish) are themselves eaten by dolphins, seals and sea lions.

USES, THREATS, STATUS AND MANAGEMENT

Lampreys are not popular with fishermen because they damage and frequently kill fish particularly those trapped and kept in nets and fish farms. Lampreys are still relished and eaten in parts of Europe especially France and Spain but most come from river fisheries not the sea. In Great Britain their popularity as food has declined since historic times but frozen lamprey is sold for bait. Numbers and hence fisheries have also declined significantly due to river pollution and barriers that prevent upriver migration. No sea-going species are yet listed as globally endangered but some species have declined sufficiently to require legislative protection.

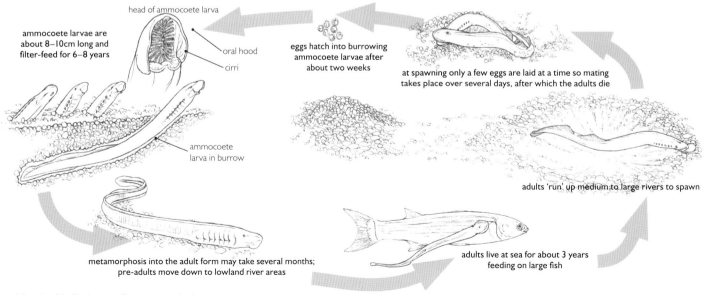

Life cycle of the Sea Lamprey (*Petromyzon marinus*).

LAMPREY SPECIES: CLASS CEPHALASPIDOMORPHI

There is a single order (Petromyzontiformes) with three families of lampreys (p.320). The number of species is small (around 30) and the number of sea-going species is smaller still. If the location in the world, the habitat, colour and size are not sufficient for identification then the detailed arrangement and number of teeth on the oral disc and tongue (on which the taxonomy is largely based), must be examined.

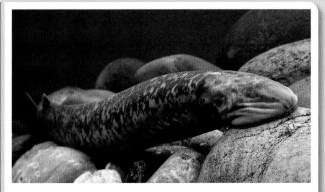

Sea Lamprey *Petromyzon marinus*

Features Sea lampreys have a wide distribution in temperate coastal waters of the North Atlantic, including Iceland, Canada, USA, Europe and the western Mediterranean. It is the only species in the NE Atlantic. This is one of the larger lampreys and mature adults have a distinct dark brown mottling on the back. Adults spend about three years at sea before they mature and move into rivers to spawn, whilst the ammocoete larvae live for six to eight years before undergoing metamorphosis. Males release a pheromone to attract females to their excavated nest and will defend their site against other males.

Size Up to 1m long.

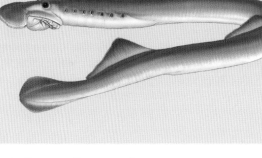

Pouched Lamprey *Geotria australis*

Features This southern lamprey has a wide distribution in temperate and cold waters of the southern hemisphere. It was thought to be the only species in the family but individuals in populations from Argentina and South Georgia show morphological differences from other populations and may represent another species. It is not known how long the adults spend at sea feeding parasitically on other fish but the ammocoete larvae live in rivers for around four years. Males have a large pouch that hangs down behind the oral disc.

Size Up to about 60cm long.

FAMILY Petromyzontidae

FAMILY Geotriidae

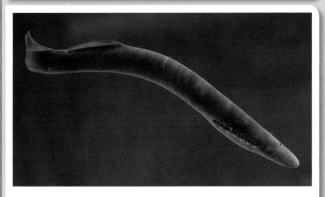

River Lamprey *Lampetra fluviatilis*

Features In spite of its name, this lamprey lives along coasts and especially in estuaries in the NE Atlantic and NW Mediterranean. Adults spend one to two years at sea before moving into rivers to spawn but there are some land-locked populations in lakes such as Loch Lomond in Scotland. Adults are greenish-brown on the back and silvery-white below. The ammocoete larvae spend up to four and a half years in their birth river before they migrate down to the coast. River Lampreys, which are also known as Lamperns are still eaten with relish in France and Spain but in Britain are mostly used as bait for pike fishing.

Size Up to 50cm long, but usually under 35cm.

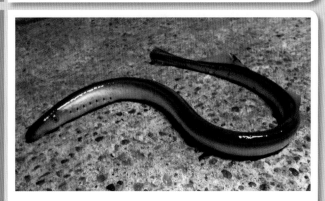

Chilean Lamprey *Mordacia lapicida*

Features This is one of two anadromous lampreys in this family, the other being the Australian Lamprey *M. mordax*. A third species, the Australian Brook Lamprey *M. praecox*, is restricted to freshwater. Mordaciid lampreys are known as southern topeyed lampreys. They are restricted to the southern hemisphere, and this species is found in southern Chile and the others around southeastern Australia and Tasmania. Recently metamorphosed juveniles move from river to sea in the (austral) winter June to August.

Size Up to about 54cm long.

FAMILY Mordaciidae

CARTILAGINOUS FISHES

It is an undisputed fact that 'fish and chips' is a favourite dish in Great Britain. Whilst Atlantic Cod (*Gadus morhua*) still reigns supreme in this respect, a fish sold as 'huss', or 'rock salmon' was once just as popular. This is in fact shark, either the Smallspotted Catshark (*Scyliorhinus canicula*) or Nursehound (*Scyliorhinus stellaris*) both better known inaccurately as 'dogfish'. Eating this had two advantages: it was cheaper and it had no hard, sharp bones. Instead, sharks and their flattened relatives the rays and skates, have a skeleton made almost entirely of flexible cartilage. Many other aspects of their anatomy, physiology and reproduction also differ markedly from the so-called 'bony fishes' including cod, which are more accurately classed as 'ray-finned fishes' (p.358). Whilst sharks (and occasionally rays) often feature in the popular press, chimaeras are a much less well known but fascinating group of generally deepwater cartilaginous fishes.

CLASSIFICATION

Sharks and rays together make up a class of vertebrate chordates the elasmobranchs (Elasmobranchii) whilst chimaeras make up another, the holocephalans (Holocephali). Sharks, rays and chimaeras are also alternatively classified together in the class Chondrichthyes, with the chimaeras as one subclass (Holocephali) and the sharks and rays as another (Elasmobranchii) (e.g. Nelson 2006).

STRUCTURE

Skeleton

Cartilaginous fishes have a relatively simple skeleton, compared to that of ray-finned fishes, composed almost entirely of cartilage, a tough but flexible material and one familiar to us in our noses and outer ears. In most species, various strategic parts of the skeleton are strengthened with calcium deposits. Not surprisingly the skull and vertebrae are commonly calcified but other areas such as the pectoral and pelvic fin girdles may also be strengthened. The amount of calcification is related to lifestyle and active pelagic species generally have a more calcified skeleton than slow-moving deepwater species. In contrast to ray-finned fishes, cartilaginous fishes have large, thick relatively rigid fins. These are stiffened by internal cartilage struts (radials) at the base and a network of fine rods called ceratotrichia which allow greater flexibility at the periphery. The ceratotrichia are made from a supple protein material elastin, similar to the keratin in our fingernails.

In contrast to all other vertebrates with jaws (gnathostomes), sharks and rays have

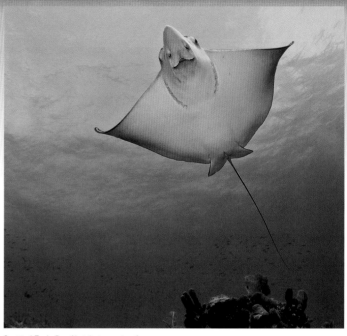

Spotted Eagle Ray (*Aetobatus narinari*).

CLASS (PHYLUM CHORDATA)	INFRACLASS	SUPERORDER	ORDER
Elasmobranchii	Batoidea (rays)		Myliobatiformes (stingrays)
			Pristiformes (sawfishes)
			Rajiformes (skates and rays)
			Torpediniformes (electric rays)
	Selachii (sharks)	Squalomorphi	Hexabrachiformes (cow and frilled sharks)
			Pristiophoriformes (sawsharks)
			Squaliformes (dogfish sharks)
			Squatiniformes (angelsharks)
		Galeomorphi	Carcharhiniformes (ground sharks)
			Heterodontiformes (bullhead or horn sharks)
			Lamniformes (mackerel sharks)
			Orectolobiformes (carpetsharks)
Holocephali			Chimaeriformes (chimaeras)

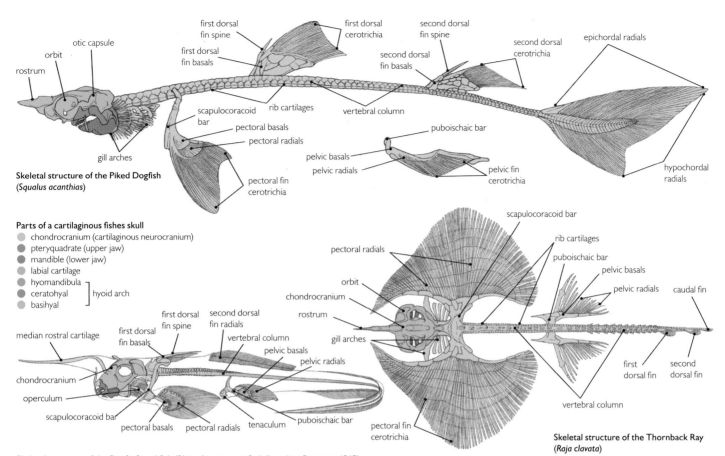

Skeletal structure of the Piked Dogfish (*Squalus acanthias*)

Parts of a cartilaginous fishes skull
- chondrocranium (cartilaginous neurocranium)
- pteryquadrate (upper jaw)
- mandible (lower jaw)
- labial cartilage
- hyomandibula ⎫
- ceratohyal ⎬ hyoid arch
- basihyal ⎭

Skeletal structure of the Pacific Spookfish (*Rhinochimaera pacifica*) (based on Patterson 1965)

Skeletal structure of the Thornback Ray (*Raja clavata*)

jaws which are only loosely attached to the skull by ligaments. The ability of many large predatory sharks including the White Shark (*Carcharodon carcharias*), to thrust the upper jaw forward allows them to bite chunks out of large animals (see photographs of Lemon Shark p.335).

Chimaeras have the upper jaw fused to the underside of the skull, a situation known as 'holocephaly' from which the name of the class is derived (Holocephali).

Skin, scales and teeth

Sharks and rays have exceptionally tough, rough skin, a fact that was recognised by craftsmen in ancient Greece and Persia. They used the dried skin as sandpaper in carpentry and to cover sword and dagger hilts which gave an excellent grip. Even today you can buy fabric made of sharkskin leather (though sharkskin is also used as a brand name). The roughness is due to thousands of tiny placoid scales (also known as dermal denticles) embedded in the skin. These resemble miniature teeth each anchored in the dermis by connective tissue attached to a basal plate and with the top sticking out and pointing backwards. Stroke a shark (dead or alive) from head to tail and it will feel smooth, but from tail to head, very rough. Each scale has a central

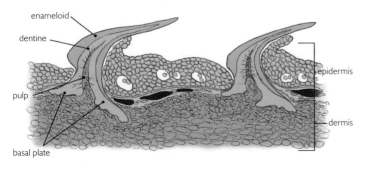

Cross section of shark placoid scales (dermal denticles) embedded in the skin.

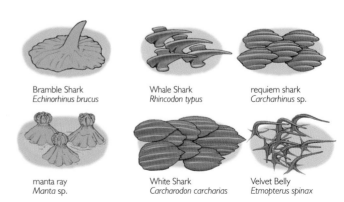

Examples of placoid scales in various elasmobranchs. Once fully formed, placoid scales stop growing but new scales can be slotted in as the animal grows or as scales are damaged and lost.

CARTILAGINOUS FISHES

 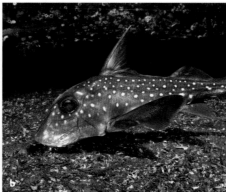

The sharp spine preceding each dorsal fin in bullhead sharks (Heterodontiformes) (a) and the first dorsal fin in chimaeras (b) and the thorns on a ray's back (c) are all modified placoid scales, as is the serrated tail spine in stingrays (Myliobatiformes).

core of dentine, well supplied with blood vessels and an outer covering of a hard, enamel-like (enameloid) material.

The shape of the scales varies between species according to their lifestyle and habitat and can even vary between areas of the body in one species. Placoid scales provide much more than just a protective cover and are one of the reasons for the success of sharks as fast-swimming predators. In pelagic species the placoid scales typically have a flattened expanded top, held away from the skin on a pedestal and decorated with sharp ridges that run parallel to the swimming axis of the fish. It may seem counter-intuitive but this design reduces swimming resistance. The mechanics are quite complex but the size and shape of the placoid scales reduces microturbulence along the shark's body as it swims along. Like the teeth, damaged scales are discarded and quickly replaced.

In contrast to sharks and rays, the skin in chimaeras is smooth and mostly lacks scales. Newly hatched chimaeras have placoid scales on the head and parts of the upper body which may help them to break out of the eggcase, but these are later lost.

Thanks to films such as 'Jaws' the teeth of sharks are legendary. Not only are they extremely hard but they are regularly discarded and replaced as are those of most cartilaginous fishes. A single shark may get through as many as 30,000 teeth in its lifetime. One result of this is that fossilised shark's teeth are relatively common and in some areas can be found simply by searching along a shingle beach. Whilst placoid scales are often described as miniature teeth, the teeth are actually derived from placoid scales and have a pulp-filled central cavity, covered with dentine, with extremely hard enamel over the crown. Like our teeth they have a root but this is not anchored in the jaw cartilage and is instead firmly fixed in the dermis by connective tissue. This means teeth are easily lost when a shark takes a bite, but this is not the problem it would be to us. Sharks have a conveyor belt of teeth which are continuously formed in the tissue that covers the jaws and gradually move forward as the tissue to which they are attached grows. The conveyor belt does not stop and teeth are replaced individually, even if they have not been broken, as frequently as every one to two weeks.

Open the mouth of a ray and you will not be faced with the formidable array of teeth displayed by most sharks. If the ray is alive, you might however get a crushed finger. Ray teeth are arranged in low, flat

Species	Teeth		Function and main prey
Tiger Shark (*Galeocerdo cuvier*)	Triangular, serrated, angled		Cutting, slicing, holding; large fish, turtles, mammals
Shortfin Mako (*Isurus oxyrinchus*)	Dagger-like		Grasping; fish and squid
Nurse Shark (*Ginglymostoma cirratum*)	Stout, plate-like		Grasping, crushing; bottom-living crabs, shellfish, rays
Horn Shark (*Heterodontus francisci*)	Tri-cusped (front), flat-topped (rear)		Grasping (front), crushing (rear); benthic invertebrates, sea urchins.
Thornback Ray (*Raja clavata*)	Molar-like (sharp in males)		Crushing; crustaceans and bottom-living fish
Eagle Ray (*Myliobatis aquila*)	Flat dental plates of fused teeth		Crushing; worms, molluscs, crustaceans
Rabbitfish (*Chimaera monstrosa*)	Plate-like cutting teeth		Cutting, crushing; benthic invertebrates

Tooth shape varies in cartilaginous fish according to where they live and what they eat and can be used to infer the diet of fossil species

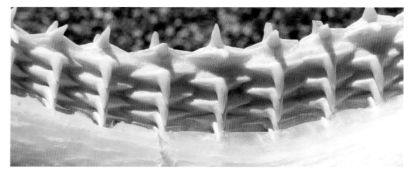

Rows of non-functional teeth can be seen lying inclined behind the front row(s) of functional teeth in this dried shark's jaw. In living sharks the teeth gradually straighten up as they move forward.

Whilst the underside of this guitarfish (*Rhinobatos* sp.) may look like a face with rouged lips, the 'lips' are in fact the outer edges of the pavement-like teeth.

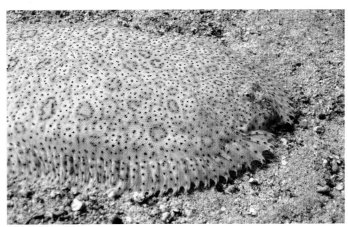

The Moses Sole (*Pardachirus marmoratus*) should be easy prey for a shark with its keen sense of smell and electrical sense, but the sole can secrete a natural shark repellent if attacked, as can the sea cucumber *Actinopyga agassizi*, which will put the shark off its meal.

pavement-like rows designed to deal with the hard-shelled invertebrates on which many of them feed. There are differences between species but nowhere near the variation in shape seen in sharks. Chimaeras have two pairs of plate-like cutting teeth in the upper jaw and one in the lower jaw which is why they are sometimes (inaccurately) called rabbitfishes. Like the teeth in their namesake, these grow continuously rather than being repeatedly replaced as they are in sharks.

Senses

Like other vertebrates, sharks, rays and chimaeras use their eyes, ears and sense of smell and taste to gather information as they go about their daily business. In addition to these well-known major senses, cartilaginous fishes have a unique receptor system that allows them to detect the weak electrical fields produced by all living things. This in effect allows them to 'see in the dark' and find hidden prey. In common with ray-finned fishes, most also have a lateral line system which can detect minute water movements (p.317), though this plays a lesser role than it does in ray-finned fishes.

Olfaction and taste The sense of smell (and taste) is particularly well developed in cartilaginous fishes and the ability of some sharks to detect minute quantities of blood in the water and home into the source, is legendary. Experiments have shown that some sharks can detect blood at concentrations of one part per million and some may be considerably more sensitive than this. It is however, something that is not easy to test. In contrast it might be assumed that Tiger Sharks (*Galeocerdo cuvier*) have a pretty poor sense of taste as objects found in their stomachs include boots, bottles, tin cans and many other artefacts (but why they actually do this is not really known).

The nostrils in sharks and rays are situated on the underside of the head between the mouth and the snout. They are used purely for detecting substances in the water, whether food or odours given off by a potential mate and unlike air-breathing vertebrates such as ourselves, they play no part in breathing. In most species the nostrils have no connection to the mouth but in some such as the Smallspotted Catshark (*Scyliorhinus canicula*) they are joined by a naso-oral groove. This allows water from the mouth to be pumped through the nostrils even when the shark is lying motionless on the seabed.

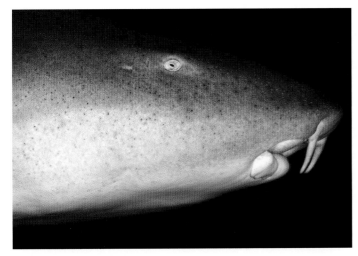

The Nurse Shark (*Ginglymostoma cirratum*) detects buried molluscs and shrimps using its barbels which are supplied with taste buds.

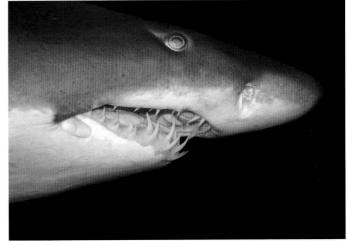

The Sandtiger Shark (*Carcharias taurus*) has large nostrils through which water flows in and out either side of a dividing flap as it swims along hunting for fish mainly at night.

CARTILAGINOUS FISHES

a b c d

Eye shapes of sharks: (a) Swellshark (*Cephaloscyllium ventriosum*) oval with horizontal pupil (b) Galapagos Shark (*Carcharhinus galapagensis*), round eye with nictating membrane; (c) Gulper Shark (*Centrophorus granulosum*) large pupil for deep, dark water; (d) Shortfin Mako (*Isurus oxyrinchus*) black pupil.

Vision Whilst the sense of smell is vitally important to sharks, most cartilaginous fishes also have excellent eyesight. The eyes in most species are well developed and are especially large in those that live in relatively deep, dark water such as the little Velvet Belly (*Etmopterus spinax*) and most chimaeras. Some numbfishes (Narcinidae) which are small electric rays that live on the seabed, have minute non-functional eyes and rely instead on their well developed electro-receptors. The structure of the eye is similar to other vertebrates with a lens, retina, iris and cornea. Sharks living in shallow, clear waters can adapt the size of the pupil to reduce the incoming light but this facility is not needed in many bottom-living cartilaginous fishes. Nocturnal and deepwater species have the opposite problem and must maximise the light available. To do this they have a layer of cells behind the retina called the **tapetum lucidum** which reflects back any light that has passed through the retina. This is why a scuba diver shining his torch through the gloom at night may see two bright 'cats' eyes peering back at him. Such bright light might damage the eyes but the reflective plates of the **tapetum lucidum** cells can be covered by dark melanin granules when needed.

The vexed question of whether cartilaginous fishes can see in colour has still not been fully answered. Photoreceptors in the retina of vertebrates come in two types, rods and cones. Rods register light intensities and vertebrates living in low light habitats and nocturnal species have mostly rods. Cones come in different varieties each sensitive to a different range of light wavelengths (i.e. colours). Experimental work has shown that cones are present in the retinas of some species and not in others. Hart et al. (2011) found cones in seven of seventeen sharks examined but these were all of one type, sensitive to long wavelengths (blue/green end of the spectrum) suggesting sharks are colour blind. Using behavioural experiments, Van-Eyk et al. (2011) demonstrated that Giant Shovelnose Rays (*Glaucostegus typus*), which have some cone cells, can distinguish blue from grey.

Whilst sharks and rays cannot blink, they do have eyelids but these do not completely cover the eyeball. Active predators such as requiem sharks (which include the White Shark) have a moveable 'third eyelid', called a nictating membrane that spreads upwards over the eye to protect it especially during feeding. So these sharks effectively close their eyes before they bite.

Large eyes help the Whitespotted Chimaera (*Hydrolagus colliei*) to make the best use of the dim light available where it lives, up to 1,000m down.

Hearing Although they have no external ears, cartilaginous fishes have a similar inner ear system to other vertebrates and can hear underwater sounds. Sharks especially are very sensitive to sounds, particularly low frequencies. However the lateral line system also works by detecting underwater vibrations and the two senses are interlinked. Sharks will often respond to man-made sound sources of frequencies below 1,000Hz and will come to investigate them, possibly interpreting them as dying fish. Unlike ray-finned fishes, cartilaginous fishes are not known to communicate

With its eyes projecting well above its head, this Bluespotted Ribbontail Ray (*Taeniura lymma*) can bury itself in the sand and still see what is going on around it. Here it has its pupillary opening closed.

The pretty scalloped structure visible in the eye of this Undulate Ray (*Raja undulata*) is part of the iris. As the iris contracts in bright light, this 'operculum' reduces the large papillary opening to a series of smaller ones.

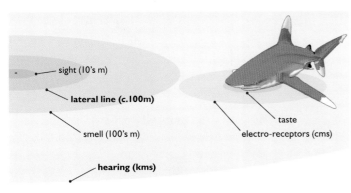

Hunting sharks use their acoustico-lateralis system to identify a potential prey source in the distance, smell then allows the shark to home in on it until sight, electro-reception and taste can take over.

using sounds though there is a small amount of emerging research that suggests jaw snapping may be used in this way. Within the fishes' three-dimensional aquatic environment, the inner ear is particularly important in spatial orientation.

Electro-sensory system If you look closely at a shark's snout (try in an aquarium) you will find it peppered with tiny black spots. What you are seeing are hundreds or thousands of external openings (pores) leading to detectors called ampullae of Lorenzini. These structures can sense the extremely weak bioelectric fields produced by animals, whose bodies act like weak batteries in seawater and so emit an electric field. Lorenzini was an anatomist who discovered these structures in 1678 but it was not until the 1960s that their true function started to become apparent. It is now known that all the major groups of cartilaginous fishes have these electro-receptors and thus a 'sixth sense'.

Each external pore leads into a jelly-filled canal which conducts electricity to a bulb-shaped ampulla lined with sensory cells and lying just beneath the skin. The sensory cells respond to changes in electrical charge within the jelly and this information is transmitted to the brain via connected nerves.

This sophisticated electrical sense means that hammerhead sharks can detect rays hidden well beneath the sand surface, sawfishes can successfully hunt in turbid estuarine water and hunting sharks rarely miss their target fish. Hammerheads have a greater concentration of ampullae than any other sharks. An open water hunter such as a Blue Shark (*Prionace glauca*) uses all its senses to find its prey. Smell and hearing may first alert the shark to a distant potential meal, perhaps wounded fish where other sharks are feeding. Once within sight, vision and taste become important. Then as it closes in for the kill, opens its mouth and closes its eyes it can still 'see' its prey using its electrical sense (see drawing above).

In rays and skates, ampullae of Lorenzini are distributed over the pectoral fins as well as the head and are often clustered with ampullae tubes radiating out from the cluster. Even the plankton-feeding Whale Shark (*Rhincodon typus*) has ampullae of Lorenzini and the electrical sense in cartilaginous fishes is obviously used for functions other than just for prey detection. Although difficult to prove definitively, it seems clear that cartilaginous fishes can orient themselves within the Earth's magnetic field and use this information to travel across whole ocean basins. Moving through a magnetic field induces minute voltage changes and the electrosensory system is sensitive enough to detect this. Of course electricity produced by another fish such as an electric ray (p.354) can easily be detected. More subtle electrical signals are produced by some other rays (Rajidae) which have weak electrical organs in the tail and use this as a means of communication. We often talk about the 'electricity' between newly met human couples and perhaps this is literal between some rays. Sharks will often bite metal objects in the sea, probably because corroding metal creates an electric field around it.

Buoyancy

Open water travellers such as the Blue Shark (*Prionace glauca*) swim almost continuously and might be compared with swifts that remain airborne for almost their whole lives. A Blue Shark will sink if it does stop as will most cartilaginous fishes. Unlike ray-finned fishes they do not have a gas-filled swim bladder (p.360) to help keep them afloat. However what they do have is a large, oil-filled liver. As is patently obvious from oil spills at sea, oil floats on water and it is also non-compressible and so provides buoyancy at any depth. In the plankton-straining Basking Shark (*Cetorhinus*

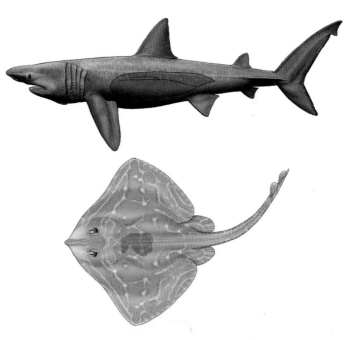

The liver of a Basking Shark (*Cetorhinus maximus*) (top) runs the entire length of its body cavity and can make up 25% of its weight. Whilst now protected in parts of its range, it is still exploited for its squalene-rich liver oil as well as for its large fins. A skate, like the Small-eyed Ray (*Raja microocellata*) (bottom), does not need to be neutrally buoyant as it spends much of its life lying on the seabed. A skate therefore has a proportionally smaller liver than a shark living and hunting in open water.

Ampullae of Lorenzini are concentrated on the snout of this Tiger Shark (*Galeocerdo cuvier*) and are used to locate the precise orientation of its prey once it is about one metre away.

Eggcase of: (a) Smallspotted Catshark (*Scyliorhinus canicula*); (b) Thornback Ray (*Raja clavata*); (c) Chimaera (Chimaeriformes).

maximus) the liver may be as much as a quarter of the total body weight. This allows them to feed near the surface without expending undue energy in swimming. Goblin Sharks (*Mitsukurina owstoni*) also have a large liver which helps with their lifestyle as deepwater ambush predators, as do bentho-pelagic sharks and chimaeras that hover just above the seabed.

Sandtiger Sharks (*Carcharias taurus*) live in relatively shallow water mostly between about 15–25m deep. They can therefore easily reach the surface where they will swallow air and pass it into the stomach. This allows them to attain neutral buoyancy and hover almost stationery in the water, something few other cartilaginous fishes can do.

REPRODUCTION

One of the most surprising aspects of cartilaginous fish is that the majority of them (around 60%) give birth to live young and all of them mate and have internal fertilization. The overall strategy is to put a lot of energy into producing a relatively few young at an advanced stage of development, so that they have a good chance of survival. Mammals employ a similar strategy but extend this with parental care after birth, a trait limited in cartilaginous fishes to not eating their young. This strategy is in direct contrast to most ray-finned fishes which lay huge numbers of small eggs which hatch at an early stage (p.368).

Mating is achieved using paired appendages called claspers or myxopterygia. These are derived during development from the posterior bases of the pelvic fins. The shape and size varies between classes, families and even species. In chimaeras they range from a simple rod to ones with two or three lobes tipped with bristles. Whilst the detailed structure varies, all of them are grooved along the dorsal (back) side to allow for the flow of semen. Mating behaviour also varies but has only been observed in a relatively few species.

Those cartilaginous fishes that lay eggs (oviparity) tend to be relatively small species up to about 1m in length. This includes all chimaeras, some rays and a variety of sharks (see table opposite). The eggs are laid singly each protected by a horny eggcase in which the young fish develops, nourished by a substantial egg sac. Incubation times vary between (and sometimes within) species but are relatively long with 9-12 months not uncommon. Newly hatched juveniles are totally independent, their only protection being the sheltered, relatively predator-free sites chosen for egg-laying by some species. Empty eggcases, washed up on the shore and commonly known as 'mermaid's purses', are a fascinating find for curious beachcombers. Counting and identifying these provides useful data on populations of sharks and rays. The 'Great Eggcase Hunt' in the UK encourages the public to send in their finds and has now been running since 2003 (www.sharktrust.org).

In the more advanced live-bearing cartilaginous fishes there is a true placental connection between the foetus and the mother (placental viviparity) though of a different origin to that seen in mammals. However, the majority of live bearers simply retain their thin-walled eggs within which the young develop, nourished by their yolk sacs. The egg membrane breaks down and the eggs 'hatch' within the mother (aplacental yolksac viviparity, previously called ovoviviparity) either just before the young are born or much sooner in which case the embryos must gain their further nutrition from another source. The most dramatic is uterine cannibalism found in some mackerel sharks (Lamniformes). In species such as the Bigeye Thresher (*Alopias superciliosus*), the developing young, freed from their eggcases, feed on unfertilised eggs (oophagy) produced for this purpose, until they are born. The Sandtiger Shark (*Carcharias taurus*) takes this one stage further. The first and largest foetus will eat any other smaller foetuses as well as unfertilised eggs, leaving only one pup in each of the two uteruses. Rays such as the Eagle Ray (*Myliobatis bovina*) feed their developing embryos on a protein and fat-rich uterine 'milk'. This is secreted into the uterus by threads of glandular tissue called trophonemata, which grow out from the uterine wall. The embryo either ingests the 'milk' or absorbs it through specialised structures.

It is quite easy to tell the sex of a shark, ray or chimaera because the male has a pair of symmetrical claspers on the inner edges of the pectoral fins used to transfer sperm to the female.

Order	Egg-laying (oviparity)	Live birth aplacental yolksac viviparity	Live birth placental
Chimaeriformes (chimaeras)	All	None	None
Hexanchiformes (cow/frilled sharks)	None	All	None
Squaliformes (dogfish sharks)	None	All	None
Pristophoriformes (sawsharks)	None	All	None
Squatiniformes (angelsharks)	None	All	None
Heterodontiformes (bullhead/horn sharks)	All	None	None
Orectolobiformes (carpetsharks)	Hemiscyllidae and Parascyllidae	Nurse sharks, Whale Shark, Zebra Shark	None
Lamniformes (mackerel sharks)	None	All	None
Carcharhiniformes (ground sharks)	Most catsharks (Scyliorhinidae);	Tiger Shark (*Galeocerdo cuvier*)* Most species of all other families	Hammerhead sharks (Sphyrnidae); some houndsharks (Triakidae); requiem sharks (Carcharhinidae) except Tiger Shark
Myliobatiformes (stingrays, devilrays)	None	All	None
Pristiformes (sawfishes)	None	All	None
Rajiformes (skates)	Skates (Rajidae); softnose skates (Arhynchobatidae), smooth skates (Anacanthobatidae)	Guitarfish (Rhinobatidae)	None
Torpediniformes (electric rays)	None	All	None

Reproductive strategies in cartilaginous fishes.

Only sharks have any truly viviparous species with a placental connection and all these are carcharhinids (Carcharhiniformes) (table above). Once the embryo has used up all its yolk, the empty yolk sac attaches to the uterine wall to form a yolk-sac placenta. Nutrients and oxygen pass from the mother to the foetus through an umbilical cord derived from the yolk sac stalk, and waste products pass the other way.

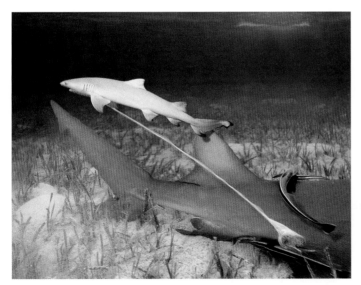

Lemon Shark (*Negaprion brevirostris*) can be observed giving birth to live young in the sheltered shallow waters of Bimini Lagoon, Bahamas.

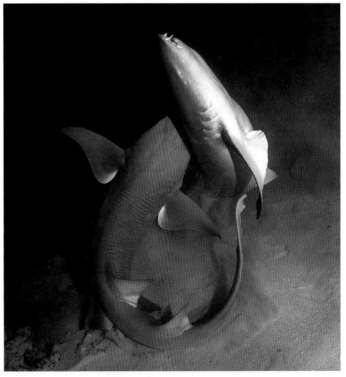

A pair of Nurse Shark (*Nebrius ferrugineus*) preparing to mate in the Maldives. Courtship and mating has only been observed in a few cartilaginous fishes.

CARTILAGINOUS FISHES

SHARKS

Sharks are the most widespread and efficient of all ocean predators, as exemplified by iconic species such as the White Shark (*Carcharodon carcharias*) or Great White Shark as it is often called. After their teeth, sharks are perhaps best known for their amazing ability to detect minute quantities of blood and to home in relentlessly on their prey. They are widely feared as one of the few animals that can and very occasionally do, attack and kill people. It is probably this more than anything else which captures the public interest, which is considerable. New 'popular' books about sharks come out regularly every year. However the vast majority of sharks are actually quite small, measuring less than a metre long and go about their business without attracting reporters or film crews. Whilst different species roam the oceans now compared to when this group first emerged some 455 million years ago, the basic design remains constant and a time traveller to that period would easily recognise any shark he or she met.

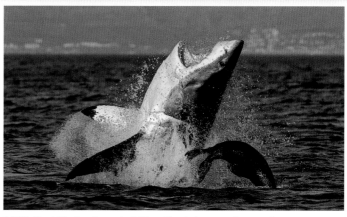

A White Shark (*Carcharodon carcharias*) breaching during an attack on a seal.

DISTRIBUTION

The vast majority of sharks live in the ocean and are found from the poles to the equator, but some inshore species frequent estuaries and mangroves and a few swim up rivers. The Bull Shark (*Carcharhinus leucas*) is famous for this and will swim many hundreds of kilometres upstream. Indo-Pacific river sharks (*Glyphis* spp.) spend most or all of their lives in freshwater and are endemic to specific river systems. The majority of sharks live and hunt in coastal waters and on the shelves and slopes of continents down to around 2000m. Sharks are effectively absent from abyssal waters below about 3000m (Priede et al. 2006) probably because they have high metabolic requirements and little food is available to them there. The deepest reliable record for a shark is the Portuguese Dogfish (*Centroscymnus coelolepis*) at 3700m. Whilst sharks are predominantly open water fish, many species have taken up residence on the seabed.

STRUCTURE

Body form and general features

The classic body form for a shark is a streamlined torpedo shape designed for hydrodynamic efficiency. In fast-swimming species such as the Porbeagle (*Lamna nasus*) the body is oval in cross section, has its widest girth about a third of the way along the body from the head end and tapers gradually towards the tail. This superb design is modified in slow-moving, deepwater species and especially in bottom-living species such as angelsharks (*Squatina* spp.), some of which are grossly flattened and resemble rays. Most sharks have a fairly rigid body, with the notable exception of the Frilled Shark (*Chlamydoselachus anguineus*). This deepwater species has a long flexible body and tail and looks more like a giant eel than anything else.

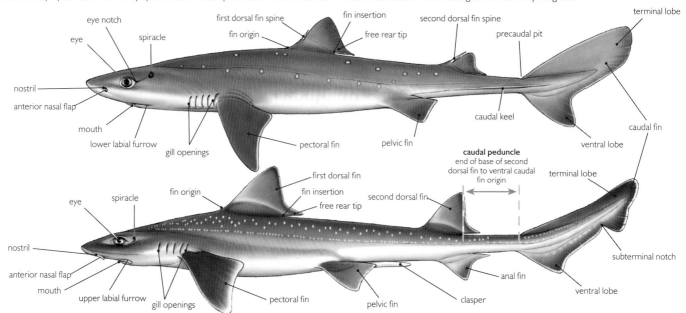

External features of a shark. All sharks have paired pectoral and pelvic fins, the latter set much further back than in ray-finned fishes, one or two dorsal fins and either one or no anal fin.

The awe-inspiring, tooth-filled mouth of sharks lies ventrally beneath the head, except in the giant plankton-eating Whale Shark (*Rhincodon typus*) and Megamouth Shark (*Megachasma pelagios*). Shark gills open through individual gill slits on the side of the head just in front of the pectoral fins. This is in sharp contrast to ray-finned fishes where the openings are protected by a bony cover, the operculum (p.359). Most sharks have five pairs of gill slits whilst a few large, deepwater species have six or seven pairs. Water normally passes in through the mouth, over the gills and out though the gill slits. In some species water enters instead through a pair of holes or spiracles behind the eyes. Spiracles are best developed in flattened, bottom-living species such as wobbegongs, but come into their own in rays (p.348).

Fins and swimming

The sight of a large triangular fin slicing through the water towards you is undoubtedly unnerving but the sight of two such fins one behind the other is even more so. However this serves to illustrate two particular features about shark fins. They are generally fairly rigid and the tail (caudal) fin is asymmetrical (heterocercal) hence its theatrical appearance when seen following behind the dorsal fin. The last part of the spinal column in a shark curves upwards, supporting a large upper tail lobe whilst the lower lobe remains smaller and unsupported. Variations on the theme reflect the lifestyle of different sharks. Fast and powerful lamnid sharks (Lamnidae) have the lobes almost equal whilst slow-swimming cow sharks (Hexanchidae) have a long upper tail lobe. So too do bottom-living catsharks (Scyliorhinidae) and many of these also scramble along the seabed on their strong pectoral fins.

The sinuous swimming movement of sharks is powered by the tail and produced by alternate contractions of the long muscles on each side of the body resulting in undulations travelling along the body from head to tail. Stiff paired pectoral and pelvic fins give lift and counteract the downward movement produced by the thrusting tail. Adjustment to the angle of all the fins helps to control and maintain position – and provides a braking system.

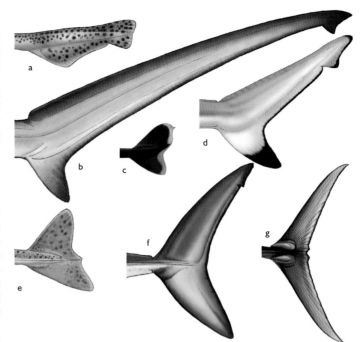

The varied tail shapes in sharks reflects their lifestyle. (a) Scyliorhinidae, bottom-dwelling sluggish swimmers; (b) Alopiidae, powerful swimmers with specialised upper caudal fin; (c) Dalatiidae, moderately active swimmers; (d) Carcharhinidae, fast swimmers; (e) Squatinidae, bottom-dwelling, poor swimmers; (f) Lamnidae, very fast swimmers; (g) Scombridae (ray-finned fish), for comparison, very fast swimmers.

BIOLOGY

Feeding

All sharks are carnivores, which is not surprising, but different species utilise a wide selection of prey which they capture using a variety of strategies. Most are active predators and/or scavengers but the Whale Shark, Basking Shark and Megamouth Shark filter out plankton, shrimp and small fish using long gill rakers. Cookiecutter sharks (p.341) are ecto-parasites cutting out chunks of flesh from larger fish. The shape and arrangement of shark teeth give a good indication of what each species eats and their way of life (p.328). As juvenile sharks grow and develop, their teeth gradually change shape as they are replaced, reflecting the differing diets of juveniles and adults.

Sharks living permanently on the seabed feed mostly on bottom-living fish and invertebrates. For them, having the mouth on the underside of their head is not much of a problem. For pelagic predatory sharks it would make it difficult to grab and bite their prey if it were not for the unique arrangement of sharks jaws. The upper jaw is not fused to the cranium as it is in other vertebrate groups (including humans) but instead articulates with it (p.327). This means a predatory shark can open its mouth very wide, can bend its snout up and back and can thrust both jaws forwards. When a shark attacks, its victim is faced with a wide open, tooth-filled mouth which is now effectively at the end of its head in a perfect position to bite.

Tiger Sharks (*Galeocerdo cuvier*) and others that feed on large prey, often move their jaws rapidly from side to side after grasping their victim, which effectively allows the serrated teeth to act like a saw. This is one of the reasons that they can tackle fully grown sea turtles and rip through the tough shell. The triangular teeth of the White Shark (*Carcharodon carcharias*) are relatively widely spaced but when it tears into large prey the top teeth interlock with the bottom ones and so slice easily through flesh and bone. Measured against other minerals on a hardness scale, shark teeth

Lemon Shark (*Negaprion brevirostris*) (a) searching for food, (b) ready to bite with snout lifted and upper jaw thrust forward exposing the teeth. The lower jaw has also been pushed forward and will contact and hold the prey. Finally the upper jaw will be lowered to bite into the prey.

come out alongside steel and the bite of a large shark can exert a huge force. Theoretical calculations indicate that a large Bull Shark (*Carcharhinus leucas*) can exert a force of nearly 6,000 N (Newton) with its back teeth (Habeggar et al. 2012). An average human bite (molars) is around 700N.

Large predatory sharks mostly hunt alone but there is increasing evidence that some species work cooperatively to herd and corral their prey. This is usually seen in species that normally socialise and live in groups. Obviously observing this is difficult and what little information there is comes either from individual anecdotes or from underwater filming. Bronze Whaler sharks (*Carcharhinus brachyurus*) follow the winter sardine runs off South Africa and have been filmed herding schools of fish towards the surface before diving through them until the few survivors scatter. There are reports of Sandtiger Sharks (*Carcharias taurus*) herding fish into shallow water and trapping them along the surf line. Thresher sharks herd small fish and may work cooperatively to concentrate them more effectively. They use their hugely long tails to stun their prey either directly or by creating intense pressure waves by 'cracking' their tails like a whip. Occasionally sharks go into a 'feeding frenzy' when large numbers have been attracted to a stimulus such as a net full of bloody, thrashing fish (or a shipping disaster at sea). Under these conditions they will be far from cooperative, biting at anything and everything.

Whilst many sharks are quite specific in their diet, for some the choice of prey can be dictated by availability. So for example, White Sharks in California feed mainly on seals and sea lions whilst in the Mediterranean they take tuna, dolphins and porpoises. Great Hammerheads (*Sphyrna mokarran*) take a variety of animals but in some locations their unlikely prey is buried stingrays. They are adept at pinning these down with one end of the hammer-shaped head and are not put off even by a peppering of stingray spines in their snout.

Whatever they eat, sharks are particularly good at digesting their food efficiently. This is because the surface area of their relatively short intestine is greatly increased by the spiral valve, a complex fold of the internal intestinal wall. However this also means that indigestible items such as old boots or mollusc shells have to be regurgitated as they cannot pass through to the anus.

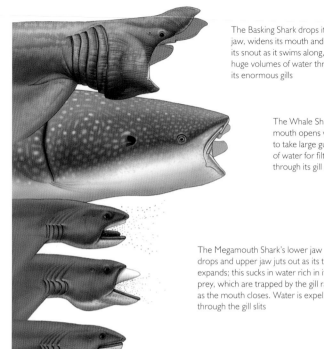

The Basking Shark drops its lower jaw, widens its mouth and raises its snout as it swims along, sieving huge volumes of water through its enormous gills

The Whale Shark's mouth opens wide to take large gulps of water for filtering through its gill rakers

The Megamouth Shark's lower jaw drops and upper jaw juts out as its throat expands; this sucks in water rich in its tiny prey, which are trapped by the gill rakers as the mouth closes. Water is expelled out through the gill slits

Mouth positions of a feeding Basking Shark (*Cetorhinus maximus*) (top), Whale Shark (*Rhincodon typus*) (centre) and Megamouth Shark (*Megachasma pelagios*) (bottom). Profiles of Basking and Whale Sharks with closed mouths appear in the background.

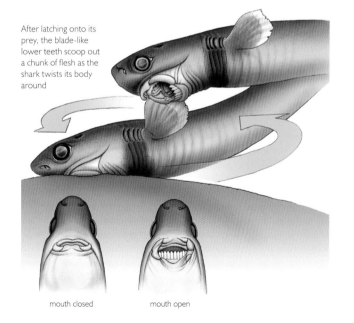

After latching onto its prey, the blade-like lower teeth scoop out a chunk of flesh as the shark twists its body around

mouth closed mouth open

Feeding method of the parasitic Cookiecutter Shark (*Isistius brasiliensis*). After biting into its prey, the shark rotates round so that its lower blade-like teeth scoop out a circular plug of flesh.

Life history

When it comes to reproductive strategies sharks are nothing if not inventive and employ a range of techniques from egg laying to placental live birth as described on p.332 and in the table on p.333. However mating and internal fertilisation is practised by all sharks. Many, especially the larger species, live solitary lives and those that do live together, do so mainly as single sex groups or with both sexes together but segregated by size. This segregation is characteristic of sharks and may be a means of minimising aggression.

Exactly when and where sharks do come together to mate depends on the species. Some can mate during all or much of the year whilst in others mating is seasonal. Whatever the situation, the male must get close enough to the female to insert one or both of his claspers (p.332) into the female's cloaca and deposit his sperm, usually in the form of packets called spermatophores. The claspers normally lie flat and face backwards but can be erected and swivelled forwards by special muscles. Catsharks are small and agile enough for the male to get a good grip by wrapping himself around the female. Larger sharks need to lie side by side with their bellies facing and mating is often quite a violent affair because the male needs to grip and hold the female and often does so by biting behind her head or onto her pectoral fins.

Fertilisation is not always immediate. In Basking Sharks (*Cetorhinus maximus*) the spermatophores do not automatically break open and the female can store a supply in her oviducts until needed. Blue Sharks (*Prionae glauca*) are known to store spermatophores in the nidimental (shell) gland after mating and become pregnant during migration to their pupping grounds (p.338). Gestation in live-bearing species varies from a few weeks to around two years and can also vary regionally within a single

Species	Female maturity	Number of young or eggs per year	Gestation	Maximum longevity
Frilled Shark (*Chlamydoselachus anguineus*)	At 130–135cm long	2–12 pups	probably 1–2 years	Unknown
Broadnose Sevengill Shark (*Notorynchus cepedianus*)	At least 220cm; when 11–21 years old	67–104 pups probably in alternate years	Probably 12 months	30–50 years
Piked Dogfish (*Squalus acanthias*)	At 66–120cm; when 10–20 years old	1–32 pups	12–24 months	70–>100 years
Longnose Sawshark (*Pristiophorus cirratus*)	At 107–113cm long	6–19 pups in alternate years		Unknown
Angelshark (*Squatina squatina*)	At 126–167cm long	7–25 pups	8–10 months	Unknown
Smallspotted Catshark (*Scyliorhinus canicula*)	At >44cm; when 3–5 years old	12–24 eggs year round in twos	5–11 months	9–10 years
Port Jackson Shark (*Heterodontus portusjacksoni*)	At 80–95cm long	10–16 eggs at a time; several layings	12 months	Unknown
Blue Shark (*Prionace glauca*)	At about 220cm; when 5–6 years old.	4–135 pups (15–30 normal) per year or alternate years	9–12 months	15–20 years (Atlantic study)
White Shark (*Carcharodon carcharias*)	At 450–500cm; when 9–23 years old (estimated)	2–13 pups probably at 2–3 year intervals	ca. 12 months	30 years plus (estimated)

Some examples of reproductive capacity in sharks. Details for many species are sketchy or unknown.

species. For example, the Piked Dogfish (*Squalus acanthias*) gives birth between 12 to 24 months after mating. Egg capsules from oviparous species usually hatch within a year. Age of maturity also varies greatly with males often maturing earlier than females. The young are born or hatch at an advanced stage and are able to swim off and fend for themselves immediately.

Nursery grounds are often in shallow water bays and inlets where hungry adults do not normally roam and which are only visited by pregnant females. The shallow mangrove areas and lagoons around North and South Bimini Islands in the Bahamas are well known as nursery areas for Lemon Sharks. Other shark nurseries include Shark Bay in Western Australia (Tiger Shark), Kaneohe Bay in the island of Oahu, Hawaii (Scalloped Hammerhead) and large bays such as Delaware and Chesapeake on the Atlantic coast of USA.

This juvenile Lemon Shark (*Negaprion brevirostris*) will remain in the safety of shallow water and feed around the fringes of the mangrove forest to avoid predation by larger sharks.

'VIRGIN' BIRTHS

When your favourite house plant suddenly becomes infested with large numbers of aphids it is because these small insects can reproduce by parthenogenesis a process by which eggs develop without fertilisation. The resulting offspring are all female. Some other insects, nematodes and small crustaceans can also reproduce in this way but it is rare in vertebrate animals. However there are several documented instances of captive sharks giving birth or laying fertile eggs without ever being in contact with a male (substantiated by DNA testing). Whether this occurs in the wild is not known but if so, it may be a way of surviving when times are bad and shark numbers are low. If this is the case, then we might expect shark parthenogenesis to increase as shark populations decrease with exploitation.

Ecology

Sharks are usually cited as top predators in the ocean and whilst this is undoubtedly true for many of the larger species such as the White Shark (*Carcharodon carcharias*) and Oceanic Whitetip Shark (*Carcharhinus longimanus*), others form important links further down in the ocean food web. Small sharks prey on a wide variety of invertebrates and fishes and are themselves just as much prey for larger sharks, rays and toothed whales as are ray-finned fishes. In competition with Killer Whales (*Orcinus orca*) adult White Sharks, normally top predators, can themselves become prey. The importance of sharks as ocean predators, large and small, means that their over-exploitation in fisheries can have far reaching and often unpredictable consequences. It is also difficult to ascertain exactly what these consequences are. However there is now evidence to show that eliminating or greatly reducing apex predatory sharks can cause considerable degradation within entire ecosystems. Myers *et al.* (2007) have linked a significant increase in numbers of Cownose Rays (*Rhinoptera bonasus*) (and other rays and small sharks) along the southeast seaboard of the USA with the decline in populations of the 'great' sharks that used to prey on them. In turn the Cownose Rays have significantly contributed to the collapse of North Carolina's Bay Scallop (*Argopecten irradians*) fishery because they feed heavily on these surface-living molluscs. The rays also root in the sediment for other molluscs, which has a deleterious effect on seagrass beds, an important nursery habitat for scallop spat.

Migration Oceanic sharks are true ocean wanderers and some make migrations on a par to those of seabirds and whales. In contrast, bottom-living sharks tend to have rather small home ranges and many coastal and reef sharks remain within quite well-defined areas for the whole of their lives. Sharks migrate to take advantage of seasonal food sources, warmer temperatures and to mate and give birth in areas where conditions are favourable for the survival of their young. The complex story of the Blue Shark (*Prionace glauca*) has been pieced together from tagging over many years but is still incomplete. What is known is that North Atlantic Blue Sharks mate off the coast of New England, NE USA, in spring and early summer. Whilst most males remain behind, the females make an epic eastward migration riding the North Atlantic gyre currents to reach Spain, Portugal and the eastern part of the Mediterranean. Here they give birth in sheltered coastal areas. Tagging has shown that at least some females make the return journey although their route is still unknown.

Whale Sharks (*Rhincodon typus*) travel long distances and congregate at feeding hotspots such as Ningaloo Reef off NW Australia. The attraction here is the mass spawning of corals in March and April, which also brings in fish and their predators

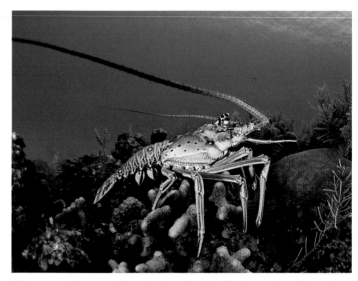

Whilst over-collection can quickly reduce local spiny lobster (*Panulirus* spp.) populations, a loss of reef sharks can do the same. Without sharks octopus numbers multiply and octopuses in turn eat spiny lobsters.

plus tourists keen to watch the whole spectacle. Unusually for sharks, hammerheads sometimes travel in huge schools and gather around rich feeding areas such as seamounts. These gatherings may also play a role in mating.

On the few occasions when scientists have managed to attach satellite tags (p.15) to White Sharks they have been able to show that these fish can make long, solitary journeys. One female was tracked on a round journey of 20,000km from South Africa to Western Australia and back, all within nine months. This may simply have been an extended feeding foray but the reason for such a long journey is not known. White Sharks have a habit of 'spy hopping' where they stick their head above water and look around perhaps in search of seabirds or turtles. It also has the useful effect of allowing a satellite tag to transmit its data. Exactly how sharks navigate is not known but it is thought they can use their electro-sensory system to detect distortions in the Earth's magnetic field (p.331).

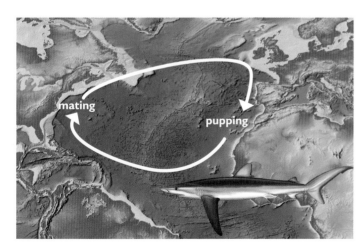

Seasonal migration route of female Blue Sharks. Those that make the round trip might take between 14 to 24 months to complete the circuit, depending on their route, and so cannot breed every year.

Schools of Scalloped Hammerheads (*Sphyrna lewini*) frequent the Galapagos Islands where cold, nutrient-rich upwelling currents sustain plankton which attracts fish and their larger predators.

USES, THREATS, STATUS AND MANAGEMENT

Even with their incredible power and grace, sharks are no match for the world's fishing fleets. Sharks are an important food commodity but their populations are inherently susceptible to overfishing due to their low reproductive rates. Sharks have been utilised for food for thousands of years and traditional uses also include their liver oil, originally used in lamps and their skin which can be made into tough leather. Traditional uses continue today amongst native peoples such as the Inuit, but it is the high levels of commercial exploitation that threaten shark populations. In 2010, the reported world capture of sharks, rays and chimaeras was 738,934 tonnes (FAO 2013) but this is thought to be a considerable underestimate in the case of sharks. The Blue Shark and the Piked Dogfish are two of the most heavily exploited species. Trade in shark fins is the most lucrative commercial outlet, but the practise is also wasteful and can be cruel as in some fisheries the sharks are finned live and tossed back into the sea to die. Most shark fin fisheries are unregulated and this trade represents a serious threat to shark populations. Aside from banning shark finning entirely, restricting the number of fins that can be landed without carcasses can be an effective management tool. European Union fishing boats are now required to land all sharks with their fins attached. Public awareness campaigns are also starting to have an impact even in China.

The practice of feeding sharks for the benefit of divers is controversial but is certainly a tourist draw.

Whilst no longer the exclusive emperor's delicacy that it once was, shark fins are still widely sold to make sharks fin soup which is still an expensive status symbol widely served at weddings and other occasions and in restaurants in China (especially Hong Kong) and SE Asia.

Some countries including the Maldives, the Bahamas, Honduras and Palau have recently banned shark fishing entirely within their territorial waters. Tourism, especially dive tourism, is a major industry in these small countries and live sharks are worth more to them than dead sharks.

Another important commercial use of shark products is in the health supplements and alternative therapies industries. Shark cartilage gained a reputation as an alternative cancer treatment partly because it was once believed that sharks cannot get cancer (they can though seem to be highly resistant to it). Whilst cartilage, including that from sharks, can prevent the growth of blood vessels and thus potentially prevent tumours from growing (as these need a good blood supply), there is still no scientific or medical evidence that shark cartilage can help cure cancer or arthritis in people.

Recreational fishing, especially competitive fishing for sharks can seriously impact local populations of certain sharks as it naturally targets the largest individuals. However many recreational fisherman now participate in tag and release programmes which help gather data on shark populations. 'Catch and release' shark tournaments are also gaining popularity.

Whilst shark attacks are rare in comparison to the number of people entering the ocean each year, they do elicit a large media response. Sharks are after all one of the few remaining large predators capable of attacking and eating people. Shark attacks are investigated by and recorded in the International Shark Attack File, administered by the Florida Museum of Natural History. In 2012 they recorded 80 unprovoked shark attacks worldwide of which seven were fatal. Shark attacks have increased steadily since records began but so too have the number of people using the sea especially for recreation. Attacks on submerged scuba divers are rare, perhaps because they neither look nor smell like a shark's normal prey and also because divers can watch and react to the sharks. Any diver who sees a shark arch its back, lower its pectoral fins and lift and swing its head from side to side as it approaches should recognise that this is a threat display and move away.

Twenty-six sharks are listed as Endangered or Critically Endangered in the IUCN Red List of Threatened Species (IUCN 2014). Seven sharks are listed on Appendix II in CITES which controls international trade: the White Shark, Basking Shark, Whale Shark, Porbeagle and Great Hammerhead.

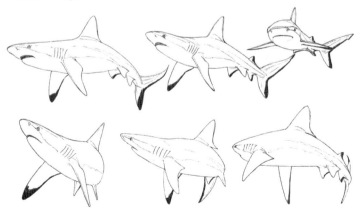

The Grey Reef Shark (*Carcharhinus amblyrhynchos*) presents a clear threat signal if molested. The pectoral fins are lowered, snout raised, back arched and tail held to the side. This is the time for divers to leave.

SHARK SPECIES: INFRACLASS SELACHII

Sharks are divided into eight orders of which by far the largest is the Carchariniformes, the ground sharks.

Frilled and cow sharks HEXANCHIFORMES

Divers are only likely to encounter two of these sharks, the Broadnose Sevengill Shark and the Bluntnose Sixgill Shark. The others live a relatively slow life in deep water. Here the temperature and other conditions are fairly constant and so most of these sharks have a worldwide, if patchy distribution. Hexanchid sharks are unusual in having either six or seven pairs of gill slits instead of the usual five plus a pair of very small spiracles. They have a single dorsal fin near the long, pointed tail.

FAMILY Chlamydoselachidae

Frilled Shark *Chlamydoselachus anguineus*

Features Anyone peering out of the porthole in a submersible and seeing a Frilled Shark, could be forgiven for mistaking it for a giant snake or an eel. Unlike almost all sharks its mouth is at the end of its head rather than underneath. It is armed with well-spaced, pointed teeth, each with three cusps. Living in deep, dark water it may use its ultra-white teeth to attract prey, as hypothesised from captured specimens that remained alive long enough to swim around with their mouths open. This rare shark has a worldwide, but patchy distribution.

Size Up to 2m long.

FAMILY Hexanchidae

Broadnose Sevengill Shark *Notorynchus cepedianus*

Features A wide head and short, thick snout give this shark its common name and distinguish it from the Sharpnose Sevengill, the only other shark with seven pairs of gills. The Broadnose lives in tropical to temperate waters worldwide except the North Atlantic. This powerful, coastal shark puts up a good fight for shore anglers, is occasionally seen by divers and is fished commercially on a small scale for its skin, liver oil and flesh. With its large comb-like teeth it attacks seals and fish and will also take carrion.

Size Up to 3m long.

Bramble sharks ECHINORHINIFORMES

There are only two species in this newly erected order. Previously the family was included in the Squaliformes (below). As their name suggests they are covered with sharp thorn-like denticles. There is no anal fin.

FAMILY Echinorhinidae

Bramble Shark *Echinorhinus brucus*

Features The Bramble Shark is one of two species in this family of prickly sharks, both of which lurk on or near the seabed in deepwater. This shark is covered in large, thorny dermal denticles hence its name. It has a pointed flat head and snout and its dorsal fins are close together near the tail. Although it has a wide distribution in continental shelf areas of the North Atlantic and parts of the Indo-West Pacific, it seems to be quite rare. It occasionally strays into shallow water and has surprised a few anglers.

Size Up to 3m long.

Dogfish sharks SQUALIFORMES

There are seven seemingly rather disparate families in this large order. All of the 130 or so species have two dorsal fins but lack an anal fin. Most have a spine in front of both dorsal fins which is a useful identification feature but Kitefin Sharks (which may have one on first dorsal fin) and some sleeper sharks have lost these. Many of them are deepwater sharks whose biology is poorly known and a few (such as the Pacific Sleeper Shark *Somniosus pacificus*) live near the poles and are the only sharks to do so. In the British Isles catsharks (Carcharhiniformes: Scyliorhinidae) are often confusingly referred to as dogfish.

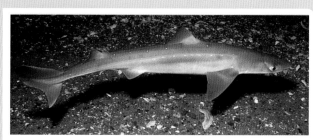

FAMILY Squalidae

Piked Dogfish *Squalus acanthias*

Features This slim shark was once probably the most numerous of all sharks but has been heavily fished globally leading the IUCN to classify it as Vulnerable in their Red List. The problem is that these sharks grow very slowly and do not reproduce until they are 10–25 years old. Even then they take up to two years to produce their young. This makes it surprising that they used to be so common but given the chance, they do live a very long time, possibly up to 100 years. They also aggregate into huge, often single sex groups making them an easy target.

Size Up to 2m long.

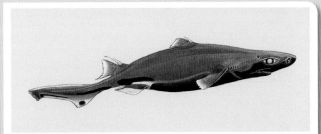

FAMILY Etmopteridae (Lanternsharks)

Velvet Belly *Etmopterus spinax*

Features Lanternsharks are small, secretive sharks that patrol deep, dark waters creating pinpoints of bioluminescent light with photophores (light organs) on their bellies. The Velvet Belly gets its name from its abruptly black underside and is fairly typical of the 50 or so known lanternsharks. It has large eyes to take advantage of what little light there is. This one lives in the NE Atlantic from Iceland to South Africa, between about 70–2500m deep.

Size Up to 60cm long.

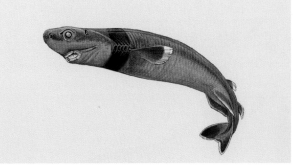

FAMILY Dalatiidae (Kitefin Sharks)

Cookiecutter Shark *Isistius brasiliensis*

Features Large fish, dolphins and whales all have good reason to hope they do not meet a Cookiecutter. This diminutive cigar-shaped shark is a parasite that bites round chunks out of its unsuspecting prey. No tropical waters are safe as it ranges widely in the open ocean. It has thick, flexible lips and can suck onto its victim before twisting round and cutting away a plug of flesh with its large triangular lower teeth. It feeds at night, its lower surface glowing with green bioluminescent light that may attract its prey.

Size Up to 56cm.

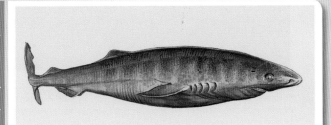

FAMILY Somniosidae (Sleeper Sharks)

Greenland Shark *Somniosus microcephalus*

Features This monstrous, coldwater shark is surprisingly easy to catch on a simple line dropped through an ice hole and is caught this way by Inuit people in Greenland. Living in cold water makes these sharks particularly sluggish unlike the similarly sized White Shark. Strangely the meat is toxic when it is fresh and must be washed and well cooked, dried or fermented before it is eaten, though sled-dogs seem to cope with its toxic effects. It is restricted to cold N Atlantic and Arctic waters though can stray further south.

Size Up to at least 6m possibly 7m long.

Sawsharks PRISTOPHORIFORMES

Whilst their body is a relatively normal cylindrical shape, sawsharks have a flattened head with a long, saw-like snout or rostrum. This is similar to sawfishes (Pristiformes) which are rays, but has rows of teeth underneath as well as along the 'saw' edges. A pair of stringy sensory barbels hangs down from the 'saw', and these are used to detect prey. The 'saw' blade is also very sensitive to vibrations and electrical fields emitted by the fish and buried invertebrates which these fish eat. The Sixgill Sawshark (*Pliotrema warreni*) is the odd one out of the eight known species as it has six gill slits instead of the usual five.

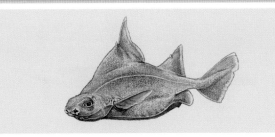

FAMILY Oxynotidae (Roughsharks)

Prickly Dogfish *Oxynotus bruniensis*

Features Roughsharks, of which there are five known species, live in deep water and are occasionally caught accidentally by fishing boats targeting other species. They are therefore not very well known but are easy to identify by their two large sail-like dorsal fins, each with a partially concealed spine and by their prickly skin. The Prickly Dogfish is commonly caught around New Zealand and occasionally southern Australia.

Size Up to 90cm long.

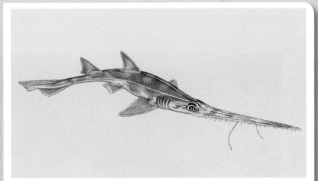

FAMILY Pristiophoridae

Longnose Sawshark *Pristiophorus cirratus*

Features Whilst sawsharks all look rather similar, they differ in the proportions of body and 'saw' and in the position of the barbels along the 'saw'. The Longnose Sawshark has a stout body and a long, narrow rostrum and the barbels are nearer to the saw tip than they are to the nostrils. This sawshark is only found in southern Australia. Three other sawshark species are also restricted to Australian waters.

Size Up to about 1.4m.

Angelsharks SQUATINIFORMES

Angelsharks live on the seabed and as an adaptation to this way of life, they have a bizarre, flattened ray-like body. The head is rounded with the gill slits on the sides and the mouth almost at the end (both are underneath in rays). A pair of large spiracles behind the eyes, allow clean water to be sucked in. The paired pectoral and pelvic fins are very broad and there are two small dorsal fins and no anal fin. At least twenty-three species are known.

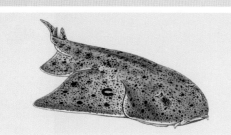

FAMILY Squatinidae

Pacific Angelshark *Squatina californica*

Features As it can be found in shallow water close inshore, this beautiful angelshark attracts diving tourists along the Californian coast. A lucky diver may see one rear up like a cobra and lunge at a passing fish. However, fishing pressure caused a collapse in population numbers in the 1990s and in spite of a gill net ban, it is still not nearly as common as it used to be. Females do not mature until they are at least 10 years old so it takes a long time to replenish lost numbers. This species extends from Alaska to Chile.

Size Up to 1.5m long.

Bullhead sharks HETERODONTIFORMES

There are many more fossil sharks than living ones in this order of ancient sharks. Currently there are ten living species in one family and although they vary in colour, they are easy to recognise as they are all very similar in size and shape. They are mostly active at night when they can be seen crawling slowly along using their large pectoral fins or swimming in short bursts. They have a sloping head profile, enhanced by ridges over the eyes and two large dorsal fins each preceded by a sharp spine.

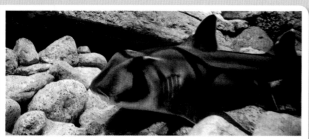

FAMILY Heterodontidae

Port Jackson Shark *Heterodontus portusjacksoni*

Features Found only around southern Australia, this handsome shark wears a harness of distinctive, black markings. Whilst it can be seen by divers and even snorkelers, it is the spiral eggcases that are most commonly seen, found washed up on the beach. Females are believed to screw these into crevices or amongst rocks pointed end first, using their mouth but this is as yet surmised. Bullhead sharks have pointed front teeth to grasp prey and large crushing teeth at the back to deal with urchins, crabs and molluscs.

Size 1.6m.

Mackerel sharks LAMNIFORMES

Whilst there are only 15 species in the seven families of this order, most of them are well-known to divers, fishermen and cinema-goers as these are large sharks and include the White Shark or Great White as it is more often known. Most are fast predators but the Megamouth Shark and Basking Shark are innocuous filter-feeders. All have two, well-separated dorsal fins the first well forward on the body, and the tail fin has a long upper lobe. They produce live young (aplacental viviparity) and most are partially 'warm-blooded' (p.318) and can therefore be very active even in cold water.

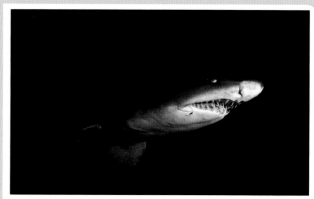

FAMILY Odontaspididae

Sandtiger Shark *Carcharias taurus*

Features In spite of a mouthful of protruding, spiky teeth this shark is docile in captivity and is often displayed in public aquaria. It is also a favourite of underwater photographers. It has a light brown body with scattered darker spots and often appears rather 'pot-bellied'. Sandtigers are famous for 'interuterine cannabalism'; only one pup from each uterus survives. It has a circumtropical distribution, (though may be absent from the east Pacific) and is found from the shoreline to about 200m depth.

Size Up to at least 3.2m long.

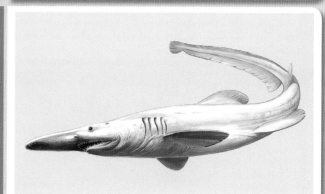

FAMILY Mitsukurinidae

Goblin Shark *Mitsukurina owstoni*

Features Very few people will ever see this extraordinary, deepwater shark. Not only does it have a long, paddle-shaped snout it is also appears partially pink and rather flabby. It is though, an effective hunter and can shoot its jaws forward to catch its prey. Whilst its eyes are tiny, its snout is well-equipped with electrical sense organs to find prey in the dark. It has been caught as bycatch in various disparate locations in the Atlantic, Pacific and Indian oceans and a juvenile has been filmed underwater by divers.

Size Possibly up to 6m, commonly 2m long.

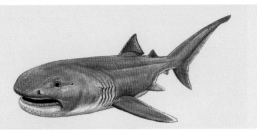

Megamouth Shark *Megachasma pelagios*
FAMILY Megachasmidae

Features It is always exciting when a new species is discovered and described but the accidental capture of a brand new giant shark in 1976 was truly surprising. To date only around 50 have been caught. This huge filter feeder (like the Whale Shark) actively sucks in plankton-filled water and is especially fond of shrimp. Information from a single electronically tagged specimen, released after accidental capture (and filmed), suggests the shark moves towards the surface at night to feed. The white (luminescent?) inside of the mouth may attract prey.

Size At least 5.5m long.

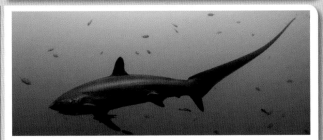

Thresher Shark *Alopias vulpinus*
FAMILY Alopiidae (Thresher Sharks)

Features This is the most commonly seen of the three species of thresher shark. Famed for its extraordinarily long upper tail lobe, there is now film evidence that this is indeed used to kill and stun fish by swipes of its tail. Several fish may work together on a large shoal of fish. Threshers have been photographed making spectacular leaps out of the water but for what reason is still unknown. This species is found almost worldwide excepting Arctic and Antarctic waters and can be seen both close inshore and out in mid-ocean.

Size Frequently 4.5m, possibly up to 6–7m long including tail.

Basking Shark *Cetorhinus maximus*
FAMILY Cetorhinidae

Features The gentle Basking Shark, the second largest fish in the world, is found worldwide in cold to temperate waters. When feeding, it cruises slowly along with its gigantic mouth wide open, relying on its forward motion to bring plankton-filled water into its mouth. Its large gill slits almost encircle its head and allow through up to 1.5 million litres of water per hour. A huge oil-filled liver help keep it afloat to take advantage of surface plankton blooms. This has been its downfall and in spite of protection in several countries, it is still listed as Vulnerable in the IUCN Red List.

Size Up to 10m long (at least).

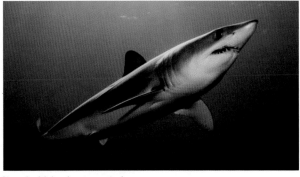

Shortfin Mako *Isurus oxyrinchus*
FAMILY Lamnidae (Mackerel Sharks)

Features If there were an underwater Olympics then the Mako would be its top athlete as this is possibly the fastest of all sharks. Assessing a shark's speed is hard but it can certainly swim at 50kph and make even faster bursts when chasing prey. It can also make spectacular leaps, to the occasional consternation of big game fishermen. Like many fast swimming species its second dorsal fin and anal fin are tiny. This is one of the top predators in the ocean and is distributed worldwide in temperate and tropical waters.

Size Up to 4m long.

Carpetsharks ORECTOLOBIFORMES

There are seven families in this order of which examples from five are illustrated below. The remaining two families are the collared carpetsharks Parascylliidae and the blind sharks Brachaeluridae. So why should the giant Whale Shark be included in this group of about 44 mostly small bottom-living sharks? A close look (that would be nice) will show that it shares the same characteristics including nostril barbels though these are rudimentary in the Whale Shark. Each nostril is connected to the mouth by a nasoral groove. Carpetsharks have two dorsal fins and an anal fin.

Tasselled Wobbegong *Eucrossorhinus dasypogon*
FAMILY Orectolobidae

Features When lying quietly on the seabed, it is almost impossible to see a wobbegong. With a flattened outline, broken up by skin tassels around the head and a complex colour pattern, they blend beautifully with their background. This helps them to ambush passing fish with a fast lunge forward and a snap of their huge mouth. This species is found on coral reefs around the northern part of Australia and New Guinea and possibly Malaysia. All seven known wobbegongs are found in the west Pacific from Australia to Japan.

Size Up to about 1.8m.

FAMILY Hemiscylliidae

Epaulette Carpetshark *Hemiscyllium ocellatum*

Features Because it is pretty and does well in aquariums, this is perhaps the most familiar of the dozen or so small sharks that make up this family. These are small, slender sharks with long tails that live close inshore in the Indo-West Pacific, the Epaulette Carpetshark mainly in coral areas of New Guinea and Australia. The shoulder (epaulette) spots may help to deter predators who think they are large eyes. They seem quite unconcerned by people who find them in pools and shallows.

Size Up to 1.7m long.

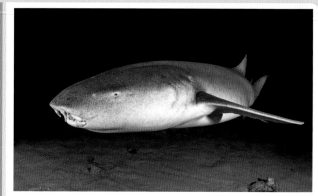

FAMILY Ginglymostomatidae

Nurse Shark *Ginglymostoma cirratum*

Features This large, docile shark is a favourite amongst divers in the Caribbean as it is easy to approach and photograph. It can be found in shallow warm and tropical water on both sides of the Atlantic and from Mexico to Peru in the East Pacific. During the day they lie around in groups though may be more active in areas where divers feed them. At night they swim and scrabble about using their long snout barbels to find buried prey and rooting it out. A similar species the Tawny Nurse Shark (*Nebrius ferrugineus*) (p.315) is found throughout the Indo-West Pacific.

Size Up to at least 3m, sometimes 4m long.

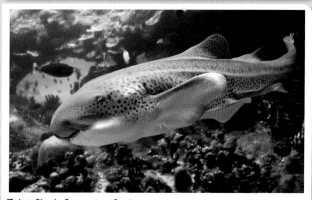

FAMILY Stegostomatidae

Zebra Shark *Stegostoma fasciatum*

Features Divers regularly meet this docile shark as it is widespread throughout the Indo-West Pacific on coral reefs, in reef lagoons and on nearby sediment. Its long, ridged body and dark spots make it easy to recognise. Young Zebra Sharks tend to be banded hence the name. It has a tail nearly as long as its body and large pectoral fins and when not hunting for invertebrates and small fish it lies around on the seabed. This laid back lifestyle makes it a favourite for public aquariums where its large eggcases can also be seen.

Size Easily up to 2.5m possibly up to 3.5m long.

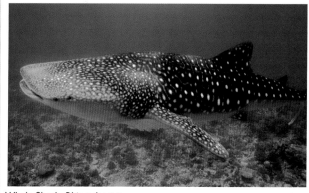

FAMILY Rhincodontidae

Whale Shark *Rhincodon typus*

Features There is absolutely no mistaking a Whale Shark; even a new baby one is half a metre long. These gentle giants are a great tourist attraction in tropical and warm temperate locations worldwide (though they are not found in the Mediterranean). Each shark has its own unique pattern of white spots and photo-identification, along with satellite tagging, has highlighted the huge migrations many of them make to attend seasonal food events such as annual coral spawning. Such plankton feasts are sucked in, filtered by the gill rakers and the remaining water pumped out through the gill slits.

Size Easily 12m long with some reasonably reliable reports of up to 20m.

Ground sharks CARCHARHINIFORMES

Almost every diver and sea fisherman will have seen at least one ground shark in their lives. Not only is this the largest of the eight shark orders but it also includes the largest shark family, the catsharks (Scyliorhinidae) with contains at least 160 species of mostly small and harmless sharks. When a new species of shark is discovered it can almost invariably be placed in this family. This order also includes another large family, the requiem sharks (Carcharhinidae) most of which reach a good size and are familiar to underwater photographers in tropical waters. Ground sharks vary hugely in general body shape and lifestyle but all have two dorsal fins and an anal fin, a long mouth that reaches back to at least level with the eyes which themselves are protected by a nictating membrane (p.330). Representatives of all eight families are included below.

Swellshark *Cephaloscyllium ventriosum*

Features Swellsharks have a neat trick that helps them escape their predators. If one is alarmed it will quickly squeeze into a tight crevice and then swallow water until its belly swells up. This makes it extremely hard to pull out especially as a predator would also get a mouthful of the large, sharp denticles that cover the skin. This swellshark lives in the coastal waters of the east Pacific from California to Mexico and central Chile. It is often seen by divers in kelp forests and is easy to keep in captivity where it will lay eggcases.

Size Up to 1m long.

FAMILY Proscylliidae (Finback catsharks)

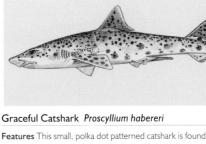

Graceful Catshark *Proscyllium habereri*

Features This small, polka dot patterned catshark is found in coastal areas of the western Pacific from Java south to Japan and Indonesia. Like other members of this family, its biology and behaviour is not well known. Unlike the other five sharks in this family, which are all viviparous, this species lays egg capsules, one or two at a time.

Size Up to 65cm long.

FAMILY Scyliorhinidae (Catsharks)

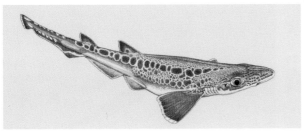

Blackmouth Catshark *Galeus melastomus*

Features Whilst it occasionally appears on fishmongers' slabs, this small, pretty catshark has little commercial value. It lives mainly at depths between about 200m to 500m depths and so is not one that is seen by scuba divers – which is a pity because it is beautifully patterned with dark splotches on the sides and saddle markings over the back. It also has white edged fins and of course a blackish inside to its mouth, something usually noticed by sea anglers who occasionally catch them. This is a NE Atlantic species which is found from Scandinavia south to Senegal and in the Mediterranean.

Size Up to 1m long.

FAMILY Pseudotriakidae

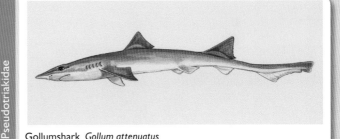

Gollumshark *Gollum attenuatus*

Features This slightly mysterious shark belongs to a small family of relatively deepwater sharks whose biology is poorly known. It is only found around New Zealand where it is mostly left alone but is sometimes taken as bycatch. As many Tolkien fans will realise, it is named after a character in the fantasy book 'Lord of the Rings', which was also later coincidentally filmed in New Zealand. It has a wide head, a long bell-shaped (when viewed from beneath) snout and elongated eyes.

Size Up to 1.7m long.

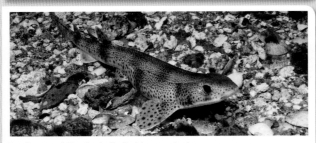

Smallspotted Catshark *Scyliorhinus canicula*

Features A 'dogfish' as this small, common shark is often called, is a familiar sight to divers, fishermen and zoology students (who often dissect them). Divers usually see them lying around on the seabed as they are only really active at night. They can even be picked up but can curl right round and bite. A lucky night diver might see one as a pair of glowing green cat-like eyes, after which the group is called. Beach combers frequently find their tough eggcases with curly tendrils at each corner. This NE Atlantic coastal species occurs from Scandinavia to the Mediterranean and North Africa.

Size Up to 1m long.

FAMILY Leptochariidae

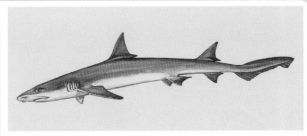

Barbeled Houndshark *Leptocharias smithii*

Features The Barbeled Houndshark is the sole representative of its family and only occurs along the west coast of Africa and possibly in the Mediterranean. Despite that it is often caught and used as edible bycatch. This slender shark has a pair of small barbels on the nostrils and small teeth which it uses to catch and eat bottom-living crustaceans and fish. Males have disproportionately large front teeth and females a unique, spherical placenta (Ebert *et al.* 2013).

Size Less than 1m long.

FAMILY Triakidae (Houndsharks)

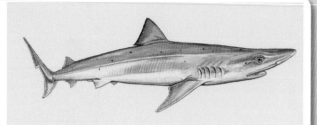

Tope *Galeorhinus galeus*

Features A clue to its popularity in shark fisheries is given by an alternative name Soupfin Shark. The Tope is fished worldwide in temperate waters on a large scale as well as by anglers and is exploited for its fins, liver oil and meat. This has led to some populations now being critically endangered and its IUCN Red listing overall as Vulnerable. This is a wide ranging shark that regularly makes migrations of several thousand miles in pursuit of prey and to and from nursery areas. Given the chance individuals can live for at least 40 years possibly even 60 years.

Size Up to 2m long but varies regionally.

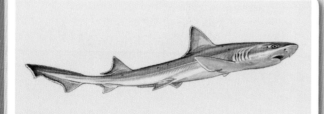

Smoothhound *Mustelus mustelus*

Features The beautiful, burnished skin of this shark give it and its close relative the Starry Smoothhound (*M. asterias*) their common name. Seen in an aquarium in the right light, both species almost glow. This is a slim, elegant shark with two nearly equal-sized dorsal fins that lives in the NE Atlantic from the British Isles to the Mediterranean and South Africa. It has strong, molar-like teeth which reflect its preferred diet of crabs and other crustaceans. Although it is a common species, it is heavily fished and is listed as Vulnerable in the IUCN Red List.

Size Commonly up to 1m; possibly reaches 2m.

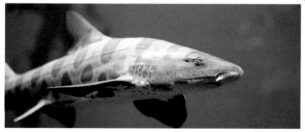

Leopard Shark *Triakis semifasciata*

Features The bold markings of this shark probably act as disruptive camouflage much as the spots of its leopard namesake do. Scuba divers and sport fishermen will encounter Leopard Sharks along the Pacific coast of N America where it is one of the commonest sharks, from Washington to Mexico. It can be found from close inshore in as little as 1m of water, to at least 90m depth offshore. Divers may see small numbers resting on sandy seabeds but it also travels in large schools.

Size Up to about 2m long.

FAMILY Carcharhinidae (Requiem sharks)

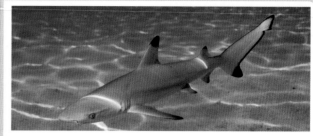

Blacktail Reef Shark *Carcharhinus amblyrhynchos*

Features Sharks in this large family are not all that easy to tell apart especially underwater but a knowledge of their distribution and markings will help. They all have a small second dorsal fin set near the tail, a large curved mouth and (mostly) round eyes. The Blacktail Reef Shark has a broad black margin to the dorsal fin but is confusingly also known as the Grey Reef Shark. It is commonly seen by divers on coral reefs in the Indo-Pacific often in groups and whilst not aggressive, it is inquisitive.

Size Easily 1.5m, possibly up to 2.5m long.

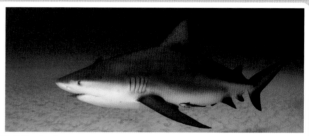

Bull Shark *Carcharhinus leucas*

Features River fishermen mostly have nothing to fear from sharks as few enter freshwater, but the Bull Shark is the exception and will swim hundreds of kilometres upstream. What's more it also hangs around in estuaries and in very shallow water along coasts, just the places where artisanal fishermen wade along and others swim. As it is found worldwide in tropical and subtropical waters, it is a threat to many people. However, it is popular with diving tourists who (hopefully) keep a respectful distance. Listed as Near Threatened in the IUCN Red List.

Size Up to 3.4m long.

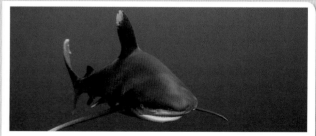

Oceanic Whitetip Shark *Carcharhinus longimanus*

Features This is the shark most feared by shipwreck survivors as they see its huge, rounded dorsal fin slicing towards them. The Oceanic Whitetip patrols the surface waters far out to sea feeding on fish, squid and even seabirds and turtles. It will investigate almost anything including divers and is potentially dangerous. However its very long pectoral fins and first dorsal fin are highly valued in the shark fin trade and numbers have declined severely since the 2nd world war when its reputation was made.

Size Up to at least 2m, possibly 3.9m long.

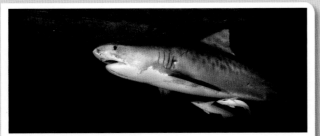

Tiger Shark *Galeocerdo cuvier*

Features Tiger Shark – even the name suggests 'dangerous' and although it is so called because of its striped pattern (especially in young sharks) it is one of the most dangerous sharks to humans. However, sensible behaviour means that many divers have watched this awesome predator in safety. It is found in tropical and warm temperate waters worldwide (not Mediterranean) and prefers coastal waters. It will eat almost anything including fish, mammals, turtles and a wide variety of rubbish. Even the young eat each other whilst still in the uterus.

Size Up to 5m, possibly 7m long.

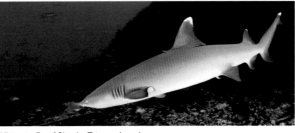

Whitetip Reef Shark *Triaenodon obesus*

Features This small shark can be seen hunting at night over most coral reefs in the Indo-Pacific, sometimes in small packs. During the day it rests up under ledges, in caves and in sandy channels, its indolence belying its night time agility, when it twists and turns through the coral in pursuit of small fish. It is easily recognised from the bright white tips to its first dorsal fin and upper lobe of the tail. Although often very common it is heavily fished on many reefs and is listed as Near Threatened in the IUCN Red List.

Size Up to about 2m long.

FAMILY Carcharhinidae (Requiem sharks)

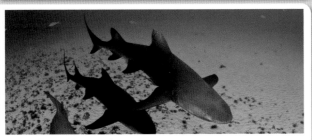

Lemon Shark *Negaprion brevirostris*

Features An encounter with a Lemon Shark can be a fascinating experience. Most divers see them in the sheltered bays and lagoons where they give birth (they are viviparous), and at this time they are generally unaggressive and have even be handled underwater. However this is a large shark and as such, is potentially dangerous. Females giving birth have a suppressed appetite and leave the nursery areas soon after, whilst the juveniles remain behind. This shark, popular with tourists, is found in the tropical west Atlantic, east Pacific (Mexico to Ecuador) and off western Africa.

Size Up to 3.4m long.

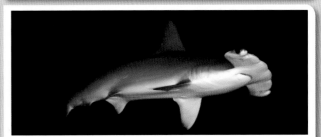

Scalloped Hammerhead *Sphyrna lewini*

Features The extraordinary flattened T-shaped head of all eight hammerhead sharks is a familiar sight on TV documentaries. However, in spite of its worldwide, warm water distribution, the Scalloped Hammerhead is now an endangered species. With its eyes located at the ends of the 'hammer' the shark has a wide field of view which is increased by swinging its head from side to side. The head also gives the shark added lift as it surges after its prey. The 'scalloped' appearance of its head comes from a deep central notch, flanked by two lesser notches each side.

Size Up to 4.3m long, usually smaller.

FAMILY Sphyrnidae (Hammerhead sharks)

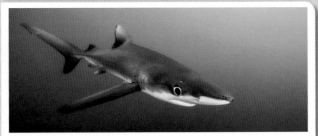

Blue Shark *Prionace glauca*

Features The Blue Shark is an oceanic species that is found worldwide in temperate and tropical waters. Slim and graceful, with a large, appealing eye ringed with white, it is a top model for photographers. Tagging has shown that this ocean wanderer regularly crosses both the North and South Atlantic in search of food and to reach traditional nursery grounds. It is one of the most heavily fished sharks in the world and in spite of also being one of the most common, its numbers have declined drastically and it is listed as Near Threatened in the IUCN Red List.

Size Up to 4m long.

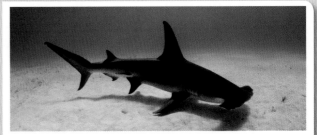

Great Hammerhead *Sphyrna mokarran*

Features This, the largest of all the hammerheads is sadly now also one of the least numerous, in spite of its worldwide distribution. It has a wide, almost straight head with a notch in the centre and a very high, curved first dorsal fin. This often solitary nomadic shark roams continental shelf seas and is sometimes seen by divers off coral reefs and islands. It has a varied fish diet but a reputation for preferring stingrays. Its large size makes this a dangerous shark and there are some reported attacks on people.

Size Up to at least 5.5m long.

RAYS

Whilst sharks are lords of the open ocean, rays have conquered the seabed. These elegant fish are beautifully adapted for lying around on sand and mud, hiding from predators (and nosy scuba divers) under a layer of silt. Many aquariums have large open-topped tanks where visitors can see them from all angles and where they may become tame enough to be hand-fed by their keepers. Many people are rightly wary of stingrays, but in the Cayman Islands (Caribbean) their beauty and grace can be appreciated close up by swimmers and snorkellers in areas where they are regularly fed. Manta rays and a few others buck the trend and spend their whole lives out in the open ocean. For a scuba diver, the sight of a manta darkening the water as it passes overhead, is a never to be forgotten experience.

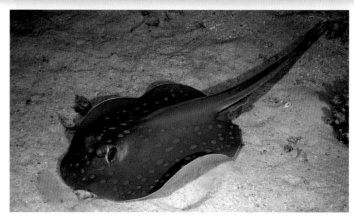

A flattened body makes rays ideal candidates for a bottom-living lifestyle.

DISTRIBUTION

Like sharks, almost all rays live in the ocean but in contrast to them, most live on the seabed rather than in open water. A number of species live in or visit estuaries whilst a few are permanent river and lake residents. Of the latter, the Giant Freshwater Whipray (*Himantura chaophraya*) is perhaps the most dramatic. This enormous and now sadly rare ray has been caught several hundred kilometres upstream in large tropical rivers such as the Kinabatangan in Sabah, Malaysia. Again like sharks, rays live mostly above 3,000m depth and are most common in coastal and continental shelf areas. The deepest reliable record is of Bigelow's Ray (*Rajella bigelowi*) at 4,156m but this species main distribution is much shallower. Rays are found worldwide.

STRUCTURE

Body form and general features

Rays are build on a very similar body plan to sharks except flattened from back to belly (dorsal to ventral). Their classic disc shape results from wide pectoral fins that are joined to the head and form the 'wings' used for swimming. The tail is long, often whip-like with no tail fin and is used more as a rudder for steering and for balance than for swimming. Some groups such as electric rays have a short, stout tail with a tail fin and use their tail for swimming. Mouth, nostrils and gill slits are on the underside and to prevent their gills getting clogged with sediment, bottom-living rays draw water in through a large spiracle behind each eye instead of through the mouth. This is not necessary in pelagic species such as manta rays. After passing over the gills, water exits through five external gill slits (six in the Sixgill Stingray *Hexatrygon bickelli*).

A ray's pectoral fins or 'wings', are the most obvious part of its anatomy and vary in shape with lifestyle. Eagle rays (Myliobatidae) spend a large part of their time swimming and have large, pointed triangular wings which provide plenty of lift. Skates (Rajidae) spend most of their time lying on the seabed and have much smaller wings. However in electric rays (Torpediniformes) the pectoral fins are modified, not for swimming, but for attack and defence. The electric organs are formed from modified gill (branchial) muscles at the bases of the pectoral fins. They consist of stacks of striated muscle fibre cells, each cell supplied by nerves on the same side, the stacks separated by connective tissue giving a honeycomb effect. This arrangement acts like batteries in a series and allows the fish to discharge enough electricity to stun its prey and to give any unwary scuba diver or researcher a nasty shock. Electric rays can produce a discharge of up to 220 volts. For a fish, bumping into a swimming torpedo ray (Torpedinidae) at night is likely to end in a fatal embrace as the ray wraps its pectoral fins around it. The Pacific Electric Ray (*Torpedo californica*) exhibits a surprising variety of hunting techniques based on its electrical abilities (Lowe *et al*. 1994).

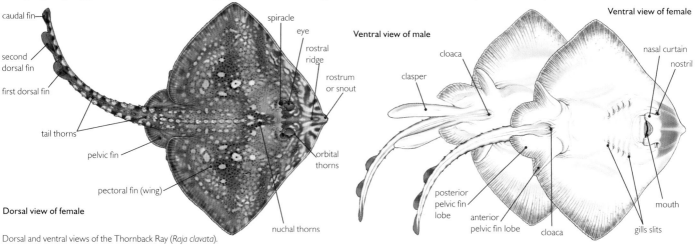

Dorsal and ventral views of the Thornback Ray (*Raja clavata*).

MARINE FISHES

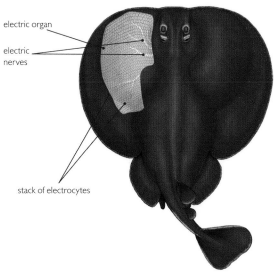

- electric organ
- electric nerves
- stack of electrocytes

The paired electric organs of an electric ray are well-supplied with nerves and can respond to the struggles of its prey by increasing or lowering the rate and duration of electrical discharge. As the pectoral fins are engaged in electrical production, these rays have a well-developed tail fin for swimming.

These strange structures funnel planktonic crustaceans and tiny fish into the mouth as the fish swims slowly along with its cavernous mouth wide open. The food is trapped by gill rakers, finger-like projections on the gill arches, before the water passes out through the gill slits. Mantas are the largest of all rays with a wingspan up to at least 6m and yet, like the Whale Shark (*Rhincodon typus*) they feed on the smallest of animals. In the Maldives, mantas have been filmed swimming in a graceful ballet as they follow one another taking advantage of plankton-rich water channelled into atoll lagoons on the flood tide. Manta-watching is now a popular pursuit amongst scuba divers, but these fish were once considered dangerous thanks to their devil-like cephalic horns. The Pelagic Stingray (*Pteroplatytrygon violacea*) has also adapted to life in open water but feeds on fish, squid and even jellyfish, trapping them with its pectoral fins and grasping hold with pointed teeth.

Sawfishes are also specialised feeders and use their formidable 'saws' to slash their way through fish shoals killing and stunning their prey. The saw is also a useful digging tool for shellfish and other invertebrates.

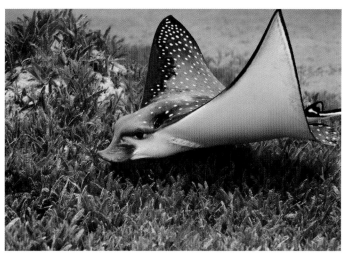

Eagle rays (*Myliobatis* sp.) use their 'snout' to dig in the sediment for bivalve molluscs and other invertebrates.

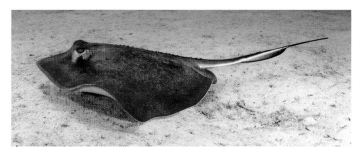

With their eyes positioned high up on the top of the head, rays have an excellent view around them when swimming but cannot see objects directly below them. Unlike many sharks the eye is not protected by a nictating membrane but has a lappet shield which protects it from sunlight.

BIOLOGY

Feeding

The majority of rays can swim well and many are capable of taking fish in mid-water as well as searching the seabed for invertebrates and bottom-living fish. Strategies differ but many bottom-living species such as skates are ambush predators. Lying motionless and partially buried and periodically exploding out from hiding to snap up passing prey, is both effective and reduces the chance of a ray becoming a larger predator's dinner. At night the risk is reduced as visual predators will be inactive and many rays hunt out in the open at this time using their electrical sense to detect prey. Eagle rays and cownose rays (Myliobatidae) spend much of their time swimming in graceful schools but feed almost exclusively on bottom-living invertebrates. These are dug from the sediment using their prominent snout or are washed from the sediment using water currents created by beating their 'wings'.

In contrast, manta rays (*Manta* spp.) and devil rays (*Mobula* spp.) are truly pelagic and feed in a very different manner by filtering plankton from the water. These rays have the mouth at the front of the head rather than under it, flanked on either side by two long lobes called cephalic horns, which are a subdivision of the pectoral fins.

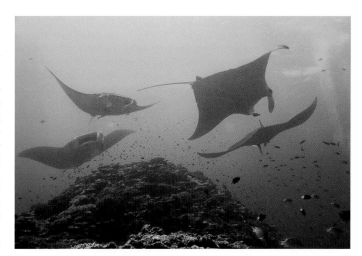

Mantas often swim slowly around in circles to concentrate shrimp and krill and other plankton and then swim fast through the middle with their mouth open and cephalic horns spread out flat in front of them.

Life history

During mating males transfer sperm into the female's cloaca (urinogenital opening) using a pair of claspers on the inner edges of the pelvic fins. Few rays have been observed mating but belly to belly is common. In the Bat Eagle Ray (*Myliobatis californicus*), both sexes swim the right way up with the male close beneath a receptive female. He then twists one of his claspers up and into the female's cloaca. This requires some skilful synchronised swimming, aided by thorns beside his eyes which help him stick (literally) close to her belly. In some species females will mate with more than one male in rapid succession.

Most rays (Batoidea) give birth to live young (p.333) but skates are oviparous and lay eggs in protective cases. Manta ray young seem to have a turbulent start to life as on occasion these rays leap clear of the water (breaching) and have been seen to give birth as they do so. Whether this is normal or not is unclear. Sawfish mothers have an obvious problem giving birth to live young but this is solved as the saws of the pups are flexible and sheathed to prevent damage. Gestation time is variable but generally only two to four months in live bearers but up to a year in egg-laying skates.

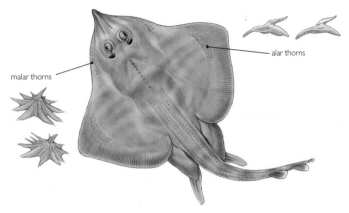

Mature males of many skates have extra thorns next to the eyes (malar thorns) and patches in the middle of the pectoral fins (alar thorns) which help them to grip the females during mating. Shagreen Ray (*Leucoraja fullonica*).

Ecology

As large bottom-living predators, rays play an important part in the ecology of sediment communities. Their feeding activities stir up the seabed and provide access to buried invertebrates for other species. Eagle rays and cownose rays (Myliobatidae) use their snout and 'wings' to expose buried bivalves and are invariably followed by a trail of smaller fish. Rays themselves form an important part of the diet of larger fish including sharks. Hammerhead sharks have perfected the technique of detecting and digging out buried stingrays.

Rays are not generally thought of as social creatures but there are indications that at least some rays exhibit complex behaviours especially during breeding. Fisheries data has indicated that like sharks, some rays segregate into single sex groups outside the breeding season and that some make inshore migrations to egg-laying or pupping grounds. Boats sometimes meet a wall of Cownose Rays (*Rhinoptera bonasus*) as they migrate in their thousands across the Gulf of Mexico, moving south from Florida in late autumn to the Yucatan Peninsula and back in late spring. However it is only by the dedication and patience of scuba diving scientists plus the input of documentary film makers in recent years that a wealth of behavioural detail is starting to emerge for some of the more iconic species. As well as discovering that there are two species of manta ray (see below) Andrea Marshall has documented and filmed their complex courtship 'dances' where males follow and mimic a selected female's every move (Marshall et al. 2009, Couturier et al. 2012).

Sawfishes have declined mainly as a result of habitat loss and the collection of their 'saws' which are still sold as curios in some parts of the world.

USES, THREATS, STATUS AND MANAGEMENT

Rays make good eating and have a long history of exploitation both artisanal and commercial. Unfortunately with their slow reproductive rate, they are just as vulnerable to over-fishing as sharks and many stocks are currently over-exploited. In 2010, the world capture of sharks, rays and chimaeras was 738,934 tonnes (FAO 2012). There are no summary statistics for rays alone but the FAO capture statistics show that all types of rays are exploited worldwide, including skates, manta rays, electric rays, stingrays and sawfishes. Many countries still record catches as 'rays', 'skates' or 'stingrays' etc. rather than as individual species which makes assessment and management of stocks more difficult. Of the 570 rays (listed as Rajiformes) in the IUCN Red List (IUCN 2014), 265 remain Data Deficient, 41 are Endangered or Critically Endangered and only 135 are Least Concern. The Blue Skate (*Dipturus batis*) which is the largest ray in European waters is Critically Endangered and its range has dramatically reduced. However, it is still landed from targeted fisheries and as bycatch. All seven sawfishes (Pristiophoriformes) are listed as Critically Endangered.

The two species of manta ray, the largest of all rays, are both listed as Vulnerable as their populations continue to decrease. Their flesh has always been considered to be of poor quality and they have not been heavily exploited commercially in the past. Their current decline is partly due to targeted fisheries satisfying the growing demand for their gill rakers, used in so-called 'traditional' Chinese medicine. Actually there is no historical record of their use for medicine in China and there is no scientific evidence to back up the medicinal claims made for them. Manta rays were listed in Appendix II of CITES in 2013 and in 2011 in the Convention on Migratory Species of Wild Animals which protects them in international waters. Manta rays are a tourist attraction in some areas and this is helping to protect local populations. Rays are also frequently kept in public aquariums and many are also bred there.

Seen head on the cavernous interior and gill rakers of the mouth of a manta ray are clearly visible. The cephalic horns are curled round here but may be held out forwards when the animal is not feeding.

RAY SPECIES: INFRACLASS BATOIDEA

Four orders of rays are currently recognised but interrelationships within the rays (Batoidea) remain uncertain and there are differences between classifications presented by various authorities. The classification here follows Eschmeyer (2014).

Order Myliobatiformes

This order comprises the stingrays which have a thin whip-like tail with no dorsal or tail fins but armed with a venomous spine, (absent in manta rays and devilrays). The seven marine families (Eschmeyer 2014) are illustrated here. An eighth family (Potamotrygonidae) is restricted to freshwater.

FAMILY Dasyatidae

Ribbontail Stingray Taeniura lymma

Features This ray is strikingly patterned with vivid blue spots and is often called the Blue-spotted Stingray. It has a broad skin fold along the underside of the tail hence 'ribbontail'. It is one of the rays seen most commonly by scuba divers on Indo-Pacific coral reefs. A venomous spine is located near the tip of the tail and some specimens have two. It is classed as Near Threatened in the IUCN Red Data List and is impacted by dynamite fishing in some areas.
Size Up to 70 cm long including tail.

FAMILY Urolophidae

Haller's Round Ray Urolophus halleri

Features Rays in this family are commonly known as stingarees and have leaf-shaped tail fin where dasyatids have none. This species lives near the shore and can be a danger to swimmers wading through the shallows. Females move inshore in summer to join the males which patrol along coastal shallows in search of a mate. This species is found along west coast North America from California to Panama. Thirty or so other stingarees are found in the Atlantic, Pacific and Indian oceans.
Size Up to about 60cm including tail.

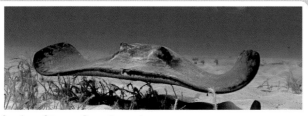

Southern Stingray Dasyatis americana

Features This large stingray is popular with tourists as it readily becomes accustomed to snorkelers and scuba divers. However they are armed with a large venomous spine and will sting if trodden on or aggravated. These rays hunt for buried bivalves and worms in sheltered sandy bays and estuaries and are relatively common along West Atlantic coasts from New Jersey to the Gulf of Mexico and southern Brazil. An obvious fin fold hangs down from the central portion of the tail.
Size Wingspan up to 2m.

FAMILY Myliobatidae

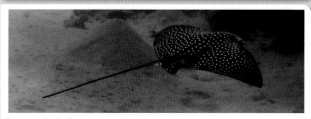

Spotted Eagle Ray Aetobatus narinari

Features The sight of a large school of Eagle Rays swimming in blue water is something few scuba divers are likely to forget. Large aggregations form outside the breeding season but they can also be encountered individually, grubbing up the seabed with their beak-like snout as they search for bivalves. Mostly coastal, they can nevertheless cross whole oceans. They frequent coral reefs and bays in warm and tropical waters. They are classed as 'Near Threatened' in the IUCN Red Data List.
Size Wingspan up to 3m.

FAMILY Gymnuridae

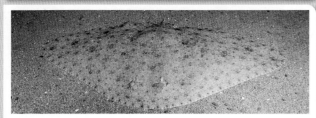

Butterfly Ray Gymnura natalensis

Features With its large wide wings, this ray resembles a Vulcan bomber aeroplane. It has a short, thin tail ringed with black and white and a small stinging spine (some butterfly rays do not have one). The young are born with their large pectoral 'wings' wrapped round under the belly and unfold rather like the wings of a newly emerged butterfly. This ray lives around southern Africa, but 13 other rays in this genus are found in the Atlantic, Pacific and Indian oceans.
Size Wingspan up to about 75cm.

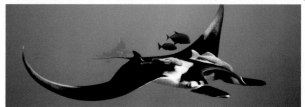

Manta rays Manta birostris and M. alfredi

Features Manta rays are the largest and most spectacular of all rays and swimming with one is like being accompanied by a flying saucer. Individuals can be recognised from their unique patterns (www.mantamatcher.org). On coral reefs they circle around high points where currents bring plankton to them. It is now known that there are two species. The smaller coastal one, familiar to scuba divers, has been renamed Manta alfredi (Marshall et al. 2009) whilst the larger new species retains M. birostris.
Size Wingspan to at least 6m.

Order Rajiformes

Rajiformes is the largest order and mainly comprises the classic bottom-living skates (Rajidae) which have a long, thin prickly tail and lay eggs in a horny capsule. In the UK some skates are confusingly called rays especially those with short snouts such as the Cuckoo Ray (*Leucoraja naevus*). The guitarfishes (Rhinobatidae) has four subfamilies (Eschmeyer 2014) given family status by some.

FAMILY Hexatrydonidae

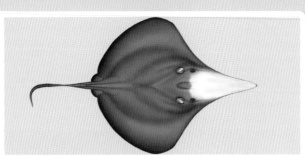

Sixgill Stingray *Hexatrygon bickelli*

Features Currently placed as a single species in its own family, this ray has six gills and gill arches and consequently six gill openings. It is soft-bodied with a long, fleshy snout and relatively short tail with one spine. This Indo-Pacific ray lives in deep water and is occasionally trawled up from around 350m to 1,100m.

Size Up to about 1.4m long including tail.

FAMILY Plesiobatidae

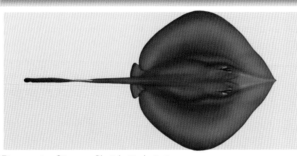

Deep-water Stingray *Plesiobatis daviesi*

Features This giant stingray is currently placed as the only species in its family. It lives in deepwater and is caught occasionally by longlines set near the seabed between about 300m to 700m. It has a round disc and a relatively short tail armed with a long sting that can inflict a painful wound.

Size Up to about 2.7m long including tail.

FAMILY Urotrygonidae

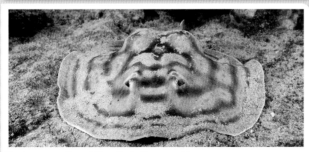

Spot-on-spot Round Ray *Urobatis concentricus*

Features This distinctively patterned ray is one of 17 or so species belonging to two genera in this family, known as American round stingrays. They are similar to round rays or stingarees (Urolophidae) with which they were once included. This species is common in bays and estuaries on west coast USA in the Gulf of California south to Mexico.

Size Up to about 48cm including tail.

FAMILY Rajidae

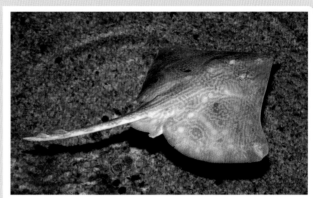

Common Skate *Dipturus batis*

Features The Common or Blue Skate is a classic example of how not to manage a fishery and whilst historically it was one of the most abundant rays in the NE Atlantic, it has now been extirpated from many parts of its former range. This is the largest skate found in European waters, now almost restricted to northwest Scotland, the Celtic Sea, northern North Sea and occasionally the western Mediterranean. It is listed as critically endangered and commercial fishing for it is restricted. This skate lays it large eggcases, which are up to 18cm long (excluding the horns) in summer and can produce up to 40 in a season. Adults can in theory live to 100 years but rarely achieve this.

Size Up to 2.85m long including tail.

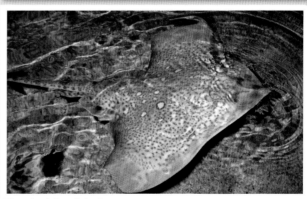

Thornback Ray *Raja clavata*

Features Visit almost any public aquarium in the British Isles and you are likely to find a display with thornback rays. They adapt well to captivity and they exhibit an attractive range of colour patterns from almost plain brown to grey with extensive pale yellow marbling. Whatever the colour, the tail has pale and dark bands and a row of large spines down its centre. Other large thorn-like spines (bucklers) on the disc give it its common name. Found throughout the NE Atlantic, and at least as far south as Namibia, this ray is the one most commonly sold in European fish markets.

Size Up to 1.4m length including tail.

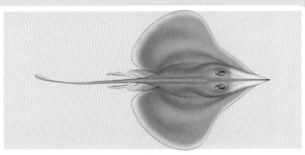

American Legskate *Anacanthobatis americanus*
FAMILY Anacanthobatidae

Features Legskates are so called because their small pelvic fins have two lobes the outermost of which resembles a thin peg-like leg. The snout is long and pointed and is used to probe into sand and mud for food. These skates live in deep water in the southern Caribbean and along the northern parts of South America. Very little else is known about this species as is the case with other legskates and in general many deepwater rays.

Size Up to about 40cm long including tail.

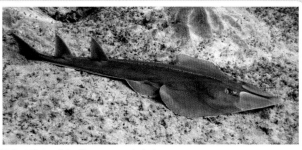

Halavi Guitarfish *Glaucostegus halavi*
FAMILY Rhinobatidae

Features This classic guitarfish has a wedge-shaped snout, flattened head and thick tail. Lucky divers might see one on sandy areas as it prefers shallow water. This species is found from the Red Sea to the Gulf of Oman but there are many other similar guitarfish especially *Rhinobatos* spp. These are all in the subfamily Rhinobatinae along with the majority of guitarfish. Some authorities consider the four subfamilies of Rhinobatidae (all shown on this page) to each have family status.

Size Up to about 1.2m long.

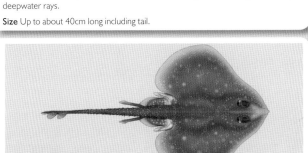

Peacock Skate *Pavoraja nitida*
FAMILY Arhynchobatidae

Features The Peacock Skate is one of a large number of so-called softnose skates as opposed to hardnose skates (Rajidae). They have a flexible snout that is not supported by cartilage or has only a small or thin one. Without handling the fish it would be hard to tell the difference. This family is sometimes classed as a subfamily of the Rajidae. The Peacock Skate is a small species endemic to southern Australian and patterned with clusters of light coloured spots.

Size Up to about 37cm long including tail.

Bowmouth Guitarfish *Rhina ancylostoma*
FAMILY Rhinobatidae

Features This single ray is the only species in the subfamily Rhininae which is sometimes given family status as Rhinidae. Its flattened shape but large shark-like fins has earned it the name of shark-ray and make it a prime target for the shark fin fishery. Raised ridges armed with large thorns run above the eyes and along the back giving it a reptilian appearance and it makes a good but rare subject for underwater photographers. Found throughout the Indo-Pacific.

Size Up to about 3m long.

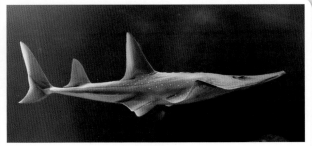

Giant Guitarfish *Rhynchobatus djiddensis*
FAMILY Rhinobatidae

Features Rhinobatid rays have a body shape intermediate between that of a shark and a ray but like all rays, the gill slits are on the underside. The Giant Guitarfish is found inshore along coasts and in estuaries mainly in the Red Sea and western Indian Ocean. Their two large shark-like dorsal fins and tail fin make them open to exploitation for the Asian shark fin market and this ray is listed as Vulnerable. Unlike skates, they do not lay eggcases but have live young. It is in the subfamily Rhynchobatinae.

Size Up to at least 3m long including tail.

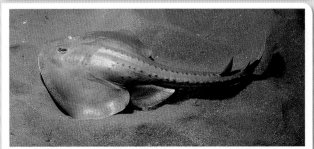

Thornback Guitarfish *Platyrhinoidis triseriata*
FAMILY Rhinobatidae

Features Thornbacks have a disc-shaped body but a heavy, thick tail with two large dorsal fins and three rows of sharp spines running along the back. Following Eschmeyer (2014) they are placed here in the family Rhinobatidae (subfamily Platyrhininae) but their classification remains uncertain and they are sometimes included with the stingrays in the order Myliobatiformes. They are found along the west coast of USA from California to Mexico and are sometimes seen by divers.

Size Up to about 90cm long.

Order Torpediniformes

Torpediniformes or electric rays are armed with powerful electric organs. They are relatively easy to recognise from their rounded outline, soft skin, small eyes and well-developed dorsal and tail fins. The four families (Eschmeyer 2014) are illustrated here.

FAMILY Torpedinidae

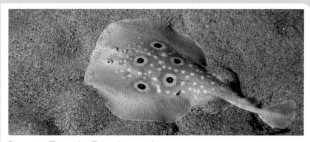

Common Torpedo *Torpedo torpedo*

Features Fishermen are not best pleased when they catch a torpedo ray as they can produce a shock of around 200 volts and they are usually discarded. This species is found in the eastern Atlantic from southern Biscay to Angola and in the Mediterranean. It has a rounded body, short thick tail ending in a large fin and distinctive spots. It hunts mainly at night for fish and invertebrates and as it lives close inshore it is often seen by divers.

Size Up to 60cm long.

FAMILY Narcinidae

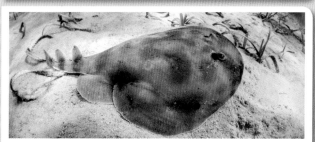

Brazilian Electric Ray *Narcine brasiliensis*

Features Electric rays in this family are known as numbfishes a name that perhaps reflects their ability to inflict a relatively weak electric shock of up to about 37 volts. It is fairly common in tropical waters of the western Atlantic including Florida and Brazil. It swims into shallow water and is sometimes disturbed by people wading along the shoreline.

Size Up to about 45cm including tail.

FAMILY Narkinidae

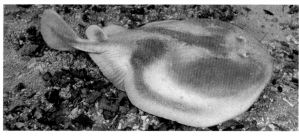

Cape Numbfish *Narke capensis*

Features An electric ray with a limited distribution around southern Africa. Members of this family are sometimes known as sleeper rays because they stay still partly buried in sand for long periods at a time. This ray has an oval disc but is almost straight-edged across the front end. Numbfish can discharge a shock of about 80 volts.

Size Up to about 40cm long including tail.

FAMILY Hypnidae

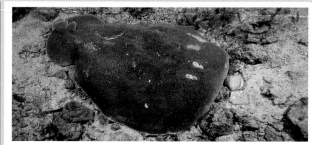

Coffin Ray *Hypnos monopterygius*

Features This unusual electric ray is the only one in its family and is endemic to Australian waters. The body and pectoral fins together make a large pear-shaped disc with large pelvic fins at the rear plus a tiny stubby tail. They occasionally get stranded on the shore or in the shallows where they are a danger to anyone stepping on them as they give a severe shock. Their rather macabre name stems from their swollen dead bodies, said to resemble a coffin.

Size Up to 60cm long.

Order Pristiformes

The Pristiformes or sawfishes have a long, flat blade-like snout edged on both sides with even-sized teeth. Their body shape is elongated and they resemble a flattened shark (detailed anatomical features class them as rays) with two dorsal fins and a well-developed tail fin.

FAMILY Pristidae

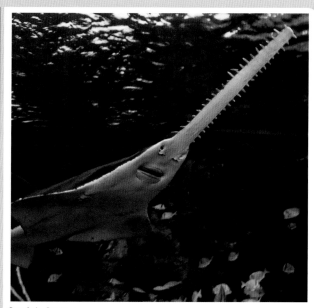

Sawfish *Pristis* sp.

Features All seven species of sawfish are included in one family (Pristidae). The Smalltooth Sawfish (*P. pectinata*) is widely distributed and lives in coastal waters and estuaries in tropical and subtropical waters of the Atlantic and Indo-West Pacific. So a diver might in theory find one in the Caribbean, Red Sea and possibly even the Mediterranean but sadly this species and all sawfish are now critically endangered. The 'saw' (rostrum) is used to stir up sediments to find invertebrates as well as to slash through shoals of fish.

Size Up to 7.6m length including rostrum.

CHIMAERAS

In mythology a chimaera (or chimera) was a monstrous animal that was part lion, part goat and had a snake for a tail. Marine chimaeras, whilst not quite so unbelievable, still have a mix of characters and behaviour that sets them apart from both sharks and rays. They are made even more mysterious because they hide mainly in deep water out of reach and sight of most people. Only in a few places in the world such as Norwegian sea lochs, do they come within scuba diving depths and to most fishermen they are nothing but a nuisance and are quickly discarded although there are commercial and recreational fisheries for some species.

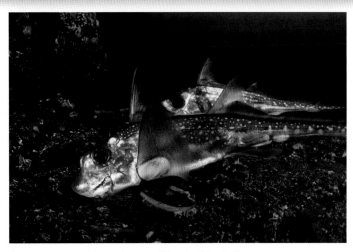

DISTRIBUTION

Chimaeras are exclusively marine fishes and so are only found in the ocean (and the occasional public marine aquarium). They have a worldwide distribution from the Arctic and subantarctic to the tropics in relatively deep water from around 200m to 3,000m depth. Here they lurk near the bottom and hunt for sediment and rubble-living invertebrates and fish.

Chimaeras are only rarely seen in water within scuba diving depths.

STRUCTURE

Body form and general feature

Chimaeras have a large, bulbous head and a tapering body ending with a small, leaf-shaped or shark-like asymmetrical tail fin, which is often extended as a thin filament. Of the two dorsal fins, the first is short and erectile and is preceded by a sharp, venomous spine which can cause havoc in fishermen's nets. The small tail is not of much use for swimming and instead chimaeras flap along using their large pectoral fins in a similar way to rays, but without the same grace. The mouth is on the under-side of the head and is connected to a pair of large nostrils by deep grooves. These channel water down to the mouth and from there it reaches the four pairs of gills (not five as in most other fishes). The gills are protected and hidden behind a soft gill cover superficially similar to the operculum of ray-finned fishes. Large eyes are necessary to make best use of what little light there is in their deepwater habitat, adding to their rather ghoulish appearance, which is further enhanced by the well-developed mucous canals and sensory pores of the lateral line system on the head (p.316). Most chimaeras are rather uniform in colour, varying from very dark to very pale the latter earning them the name of ghost sharks, though there are also black ghostsharks.

BIOLOGY

Feeding

Chimaeras live their lives in the slow lane and are not particularly efficient swimmers. Chasing and catching fast-moving prey is therefore not an option and most chimaeras feed on benthic invertebrates, such as molluscs and crustaceans which are efficiently crushed by their tough, plate-like teeth. Worms, shrimps and jellyfish also feature on the menu as well as small bottom-living fish and cephalopods, but presumably only the more dozy ones. However, the exact diet of many species is not known. Plownose chimaeras or elephant fishes (Callorhynchidae) probe through muddy sediments using their extraordinary long, recurved snout to sense and dig up their prey. Longnose chimaeras or spookfishes sense prey ahead of them in the darkness using their long pointed snout which is covered in electrical receptors (ampullae of Lorenzini (p.331).

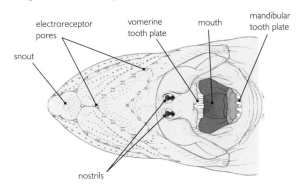

Chimaeras have three pairs of tooth plates, two in the upper jaw and a larger pair in the lower jaw. The front upper plates (vomerine and mandibular) are blade-like whilst the rear ones (palatine) are flattened crushing implements.

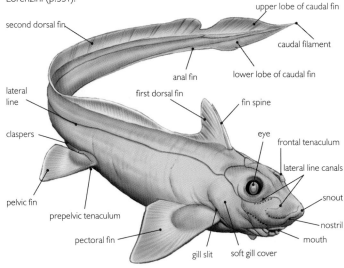

External features of a Small-eyed Rabbitfish (*Hydrolagus affinis*).

Life history

Like sharks and rays, male chimaeras are equipped with a pair of cylindrical claspers on the inner edges of the pelvic fins, which are used to transfer sperm to the female. In most species the claspers are forked, at least at the tips, into two or three and are covered in hook-like dermal denticles. As if this wasn't enough, the males also have an extra pair of denticle-covered claspers one in front of each pelvic fin (pre-pelvic tenaculae) and many species have an additional door knocker-shaped clasper on the head (frontal tenaculum). All this helps the male to grasp the female during copulation ensuring his success. The shape and ornamentation of the claspers differ between genera and species and so are useful in identification.

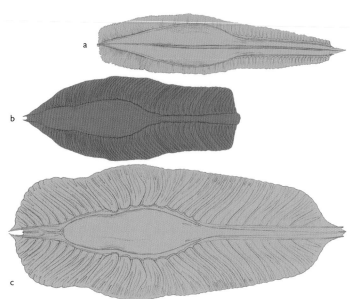

Chimaera egg capsules vary in shape between the three families. (a) Chimaeridae: spindle-shaped, dorsal keel, small or no side panels, ca. 17cm X 2.5 cm; (b) Rhinochimaeridae: bottle or pear-shaped with ribbed side panels, ca. 15cm X 6 cm; (c) Callorhinchidae: ovoid, with wide, ribbed side panels, ca. 27cm X 13cm.

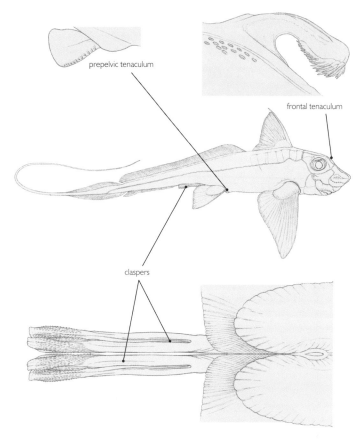

Position and details of tenaculae and claspers in male shortnose chimaeras (Chimaeridae).

After mating, females lay their egg capsules on the seabed two at a time, one from each of their two uteri. Unlike ray eggcases, they are rarely found washed up on the shore because of the deepwater habitat of most of these fishes. The eggs hatch between 6–12 months later. For many species this is about all that is known and details of their spawning behaviour remain sketchy, hardly surprising given the difficulties of studying them in their deepwater habitat. Some species such as the Rabbitfish (*Chimaera monstrosa*) are known to have a defined reproductive season and to migrate inshore and congregate in spawning groups in spring and summer. Sometimes fishermen report catches consisting of only one sex of a particular chimaera species, which suggests that these species normally live in single sex groups outside the breeding season.

Ecology

Unlike many sharks, chimaeras do not roam the oceans in search of prey. Instead they live near but not on the seabed, a lifestyle known as pelagobenthic. There are no known oceanic species and most species live around the margins of continents and oceanic islands including seamounts. Their feeding activities must have a significant effect on populations of bottom-living invertebrates especially in areas where they are common or when they gather into large breeding aggregations. For example, the White-spotted Ratfish (*Hydrolagus colliei*) can be abundant in some areas such as Puget Sound, Washington, USA. The large venomous spine at the front of the first dorsal fin provides them with considerable protection and their only predators appear to be large sharks and other larger chimaeras. A sting from a chimaera spine is very painful as the tissue surrounding it contains a toxin, but is not generally dangerous. Fishermen are just as wary of the strong, crushing teeth as they are of the spine.

USES, THREATS, STATUS AND MANAGEMENT

Chimaeras attain sexual maturity late (at least 10 years old), are slow-growing, live for a long time (25–30 years) and have only a few young each year. This way of life makes them very vulnerable to uncontrolled or poorly managed fisheries. Deepwater trawl fisheries for ray-finned fishes have expanded rapidly since the 1990s as shallower stocks have become depleted and this has resulted in an increased bycatch of chimaeras in areas such as the North Atlantic. Hauled up from the depths with their soft bodies battered by nets, chimaeras rarely survive if discarded. There are targeted fisheries for some of the larger species including the Elephant Fish (*Callorhinchus milii*) in New Zealand and Australia, where it is sold as whitefish fillets and as 'fish and chips'. This fishery is managed and the target populations appear to be stable. There is currently increased interest in extraction of oil from chimaeras for cosmetic and therapeutic uses which may encourage new fisheries. The main concern is that so little is known about the life history or current status of many chimaeras, that such fisheries will be difficult to manage effectively. There are currently three species listed as Near Threatened in the IUCN Red List of Threatened Species.

CHIMAERA SPECIES: CLASS HOLOCEPHALI

There is only one living order of chimaeras, the Chimaeriformes which contains three families. The shortnose chimaeras or ratfishes (Chimaeridae) is by far the largest family with 39 of the 50 or so known species. They are characterised by a short, rounded fleshy snout. Longnose chimaeras (Rhinochimaeridae) have a long pointed fleshy snout whilst the three species of plownose chimaeras have the end of the snout hooked to one side.

ORDER Chimaeriformes
FAMILY Chimaeridae (Shortnose Chimaeras)

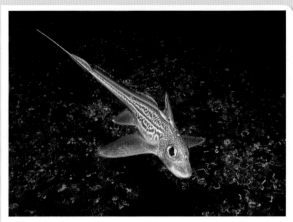

Rabbitfish *Chimaera monstrosa*

Features This is one of the best known chimaeras. It has been photographed at night at depths as shallow as 15m in Norwegian fjords when its green eyes appear to glow. Like all members of this family, it has a short, rounded snout and a leaf-shaped (diphycercal) tail fin, followed by a long, thin trailing filament. The first dorsal fin is short and triangular with a stout spine, whilst the second is long and low and stops just short of the tail fin. The Rabbitfish is widespread in the NE Atlantic from the southern Arctic to Morocco and the Mediterranean. There is one other genus (*Hydrolagus*) in this family.

Size Up to 1.5m long.

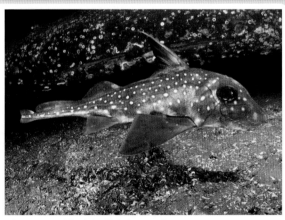

White-spotted Ratfish *Hydrolagus colliei*

Features As this chimaera lives in nearshore waters it is occasionally seen by scuba divers though it ranges down to at least 900m depth. An easier place to see it is in public aquaria where it seems to survive well. It occurs on the west coast of North America from Alaska to Mexico and is another well-studied species. From the available data (which is limited) it appears to lay two eggs every 10-14 days for several months which take up to 12 months to hatch. It is currently not commercially exploited but is affected by inshore trawling for other species.

Size 60cm, possibly up to 90cm long.

ORDER Chimaeriformes
FAMILY Callorhinchidae

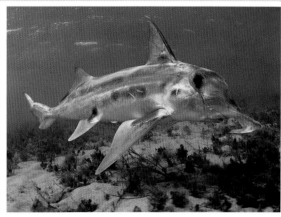

Elephant Fish *Callorhinchus milii*

Features Of all the chimaeras, this is surely one of the most bizarre with its long, flexible snout, shaped like a plough blade and possibly used as such to dig up buried invertebrates. Both dorsal fins are short and are widely separated whilst the tail is heterocercal (like a shark's) and does not have a tail filament. This species is restricted to the temperate waters around southern Australia and all round New Zealand. It moves inshore to breed seasonally and once the juveniles hatch, they stay in shallow water for around three years before moving offshore. So those seen by scuba divers are likely to be young ones.

Size Up to 1.2m long.

FAMILY Rhinochaemeridae

Smallspine Spookfish *Harriotta haeckeli*

Features Chimaeras in this family are also known as longnose chimaeras because they have an elongated and pointed snout. The first dorsal fin is triangular and in this species is short hence its common name. The second is long-based but much shorter than that in shortnose chimaeras. The tail is leaf-shaped (diphycercal) with only a short filament though other species in this family may have a longer one. It has been found in the N Atlantic, Indian Ocean and off Tasmania and New Zealand. There are two other genera in this family, *Neoharriotta* and *Rhinochimaera*.

Size Up to 1.7m (including tail filament).

RAY-FINNED FISHES

The diversity, colour, lifestyle and sheer numbers of ray-finned fishes (Actinopteri or Actinopterygii) exceed that of any other vertebrate group. In size they range from tiny gobies less than 1cm long to the gigantic Ocean Sunfish (*Mola mola*) weighing in at over two tonnes. They include your pet goldfish as well as most of the commercial fish species that are so vital to our diet and well-being. Almost every conceivable watery habitat has its complement of these fishes whose species number over 31,000. They are often referred to as bony fishes or Osteichthyes as they have a hard, calcified skeleton unlike the cartilaginous sharks, rays and chimaeras. However, ray-finned is a more accurate term that reflects the structure of their fins, which is fundamentally different from that of cartilaginous fishes (p.326) and lobe-finned fishes (p.400). The latter are also usually included as 'bony fishes' but again have a very different fin structure.

The spiny and soft rays in the fins of this tropical grouper (Serranidae) are obvious.

CLASSIFICATION

Ray-finned fishes (Actinopteri or Actinopterygii) are a huge group and their classification is complex. The number of orders within this class of fishes remains a topic for research and will continue to change when scientists split or combine closely related orders as a result of their work. Forty-six orders are currently (2014) listed in Fishbase (www.fishbase.org), and WoRMS (www.marinespecies.org), 45 in Eschmeyer's Catalog of Fishes (Eschmeyer 2014) whilst Nelson (2006) lists 44. A summary of the generally accepted changes since Nelson 2006, is shown in the table on p.374. Teleost fishes (Teleostei) are better engineered for a watery environment and evolved later than the other subclasses and euteleosts (Euteleostei) are the most modern ray-finned fishes. They are also by far the largest group. See also Laan et al. (2014).

DISTRIBUTION

Ray-finned fishes occupy habitats throughout the ocean from the seashore to the abyssal zone including deepsea trenches and from the warmest to the coldest regions. In freshwater they are equally well-distributed and survive even in isolated, hot desert pools. Approximately 56% of ray-finned fish species live in the ocean (Nelson 2006).

CLASS (PHYLUM CHORDATA)	SUBCLASS (DIVISION)	SUBDIVISION	SUPERORDER (ORDERS)
Actinopteri (Actinopterygii)	Cladistii (freshwater only)		(Polypteriformes)
	Chondrostei		(Acipenseriformes: sturgeons)
	Neopterygii		(2) freshwater
	Neopterygii (Teleostei)	Osteoglossomorpha	(1) freshwater
		Elopomorpha	no superorder (5 orders)
		Ostarioclupeomorpha	Clupeomorpha (1)
			Ostariophysi (5)
		Euteleostei	Protacanthopterygii (3)
			Stenopterygii (1)
			Ateleopodomorpha (1)
			Cyclosquamata (1)
			Scopelomorpha (1)
			Lampriomorpha (1)
			Polymixiomorpha (1)
			Paracanthopterygii (5)
			Acanthopterygii (16)

Examples of the highly varied body shapes found amongst ray-finned fishes. (a) fusiform: Skipjack Tuna (*Katsuwonus pelamis*); (b) elongate: Conger Eel (*Conger conger*); (c) flattened top to bottom: Angler (*Lophius piscatorius*); (d) compressed side to side: European Plaice (*Pleuronectes platessa*); (e) truncate box-like: Boxfish (*Ostracion cubicus*); (f) unique: Long-snouted Seahorse (*Hippocampus guttulatus*).

STRUCTURE

Body form and general features

The body form and shape of ray-finned fishes is extremely varied and whilst many look like what most people might consider as a 'typical' fish, others deviate considerably from the norm. Some have such bizarre shapes that it is difficult to recognise them as fish at all. Those that live and swim actively in the water column generally conform more closely to our view of a 'normal' fish, tapering at both ends and oval in cross-section with the widest point about a third of the way along the body. This fusiform or torpedo-shape is highly refined in tuna, some of the fastest and most efficient swimmers of all ray-finned fishes. The same body shape is seen in fast-swimming sharks. Pick up a pipefish or a boxfish and it will feel as stiff as a plank. Try that with an eel and it will slip lithely out of your hand in seconds. Catch a pufferfish and it will rapidly turn itself into a spiny football sucking in water or air to inflate itself. The variations in shape, size, flexibility and colour are fabulous and almost endless.

With a few exceptions, ray-finned fishes have the mouth at the front end of the head, rather than underneath it as in cartilaginous fishes. There are five gill openings hidden and protected by a bony flap, the operculum. Water for respiration is taken in through the mouth, passes over the gills and exits via the raised opercula. Interestingly in some temperate water fishes such as the Ballan Wrasse (*Labrus bergylta*), the operculum shows annual rings of growth and can be used to age the fish (Dipper et al. 1977).

Skeleton and fins

The hard, bony skeleton of ray-finned fishes is complex and contains many more bones in both the skull and skeleton than we and other mammals have. In some primitive fishes such as the sturgeon, only the skull (cranium) and some of the fin supports are made of bone whilst the vertebral column and other bones consist of pliable cartilage. However, by far the majority of ray-finned fishes, have the whole skeleton ossified. The skull surrounds and protects the brain and sense organs and from it are suspended the jaws and gill arches. The vertebral column or backbone seems to bristle with spines as it supports the ribs ventrally and neural spines dorsally, which give it the typical 'fishbone' pattern. The fins, after which the group is named, are built up from a radiating fan of narrow rods called rays, made either from cartilage

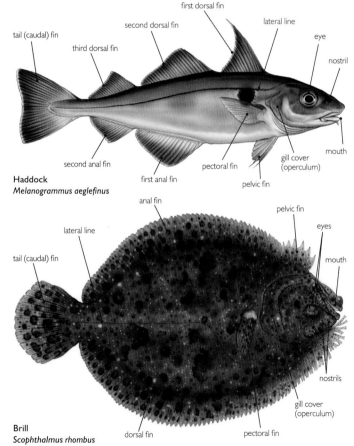

Haddock
Melanogrammus aeglefinus

Brill
Scophthalmus rhombus

Ray-finned fishes have paired pectoral and pelvic fins, one to three dorsal fins, one or two anal fins and a (usually) symmetrical tail fin. One or more of these fins or pairs of fins may be modified, reduced or even absent in some species.

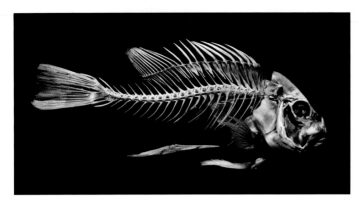

The skeleton of an unidentified ray-finned fish.

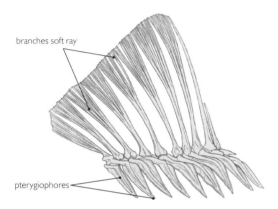

The soft rays or lepidotrichia in the fin of a ray-finned fish often branch dichotomously towards the margin. Each ray has a hard basal segment that articulates with other supporting fin elements.

or bone. The bases of these articulate with the endoskeleton and are themselves segmented, making the fins flexible and mobile as well as lightweight. Eat a fish such as a mackerel and it is the numerous supporting bones at the bases of the dorsal and anal fins that are so troublesome to remove. As well as soft flexible rays, many ray-finned fishes also have sharp spines in their fins. A European Seabass (*Dicentrarchus labrax*) has a spiny first dorsal fin and a soft second dorsal fin, a pattern seen in many other species. Wrasses (Labridae) have a single long dorsal fin with a spiny part preceding the soft rays. In such 'mixed' fins, the spines always precede the rays.

Swimming and buoyancy

Ray-finned fishes and cartilaginous fishes have the same basic set of fins, but in ray-finned fishes they have developed into highly versatile appendages used for a great number of other purposes apart from swimming. This is possible because these fish have a swim bladder, the internal equivalent of a scuba diver's buoyancy compensation device (BCD). The swim bladder allows fish to maintain neutral buoyancy and stay at their preferred depth with minimal use of fins. So fins can take on secondary roles without the fish plummeting into the depths if it stops swimming.

The swim bladder is a balloon-like structure filled with gas, situated in the body cavity. As it is gas-filled, its volume will be affected by pressure (p.23) when the fish ascends or descends. So, just like a scuba diver with his BCD, the fish must be able to feed gas in and out of the swim bladder. In most fish this must be done via diffusion into and out of the blood, a much slower process than feeding air in and out of a BCD. This is why fish brought to the surface from depth, often have their gut protruding from the mouth, pushed there by the swim bladder as its contained gas expands with the pressure decrease on ascent. The swim bladder wall is (obviously) impermeable to gases but has special areas for resorption (the oval) and absorption (gas gland) both well supplied with blood vessels. Resorbed gas is eventually released via the gills. The control mechanisms and mechanics are complex especially the chemistry behind gas production and bladder inflation. The gas usually consists of oxygen and carbon dioxide. A few species have a direct connection between the swim bladder and the top of the gut (oesophagus) and can release gas via this route. Some species can take air in at the surface but this is difficult and mostly pointless as the air compresses on the way back down.

Function	Example	Fins involved	Fin shape
Defence	Lesser Weeverfish (*Echiichthys vipera*)	First dorsal fin, venomous spines	
Defence	Flying gurnards Dactylopteridae	Pectoral fin display scares predators	
Escape	Flying fish Exocoetidae	Pectoral and pelvic fins act as 'wings'	
Attack	Lionfish (*Pterois* spp.)	Pectoral fins used to 'corral' prey fish	
Feeding	Anglerfishes Lophiiformes	Dorsal fin spine modified as fishing lure	
Feeding	Gurnards Triglidae	First 3 pectoral fin rays have taste buds	
Feeding	Tripodfish (*Bathypterois grallator*)	Pelvic fins and tail act as props	
Courtship	Mandarinfish (*Synchiropus splendidus*)	First dorsal fin larger in males	
Novel locomotion	Frogfish (*Antennarius* spp.)	Stubby pectoral and pelvic fins for crawling	
Camouflage	Leaf-fish (*Taenianotus* spp.)	Enlarged dorsal fin resembles seaweed	
Attachment	Lumpsucker (*Cyclopterus lumpus*)	Pelvic fins modified as a strong sucker	

Examples of ray-finned fishes fin uses.

European Eel (*Anguilla anguilla*) have tough, smooth skin that allows them to slither effortlessly over intertidal rocks or between freshwater pools and streams. They do have scales but these are microscopic and embedded.

Diagrammatic cross-section of fish skin.

Skin and scales

Fish scales can be a messy problem when preparing fish to eat but for the fish themselves they provide an essential and beautifully engineered protection. They are a first line of defence against predation as well as abrasion, infection and the nips and skirmishes that go with everyday life. A covering of scales also helps with streamlining as it does in sharks (p.328). A few specialists manage without scales but may compensate by having extremely tough or very slimy skin. In teleost fishes (Teleostei) and therefore in most ray-finned fishes, cycloid and ctenoid scales (see below) form a continuous, overlapping layer arranged like slate tiles on a house roof. Each scale, made of thin bone, is firmly embedded in the lower layer of the skin (dermis) and the 'free' edge is also covered by a thin layer of epidermis (outer skin). Catch and handle a herring and your hands will soon be covered in silvery scales but try that with a cod and the scales remain firmly in place, reflecting differing strengths of attachment. Scales that are easily lost are termed deciduous and may leave a predator with a mouthful of scales and nothing else. Damaged and lost scales can be replaced.

Scale shape and type varies in ray-finned fishes and is a fundamental feature that is reflected in their classification and for that matter, the classification of all fishes (see table opposite). Look closely at a sturgeon (perhaps in an aquarium) and you will see that instead of a neat covering of scales it has five rows of large, lumpy plates whilst the rest of the body is naked. These modified ganoid scales are found in primitive ray-finned fishes in the subclass Chondrostei, which also includes freshwater orders not shown in the classification on p.358. Teleost (Teleostei) fishes have the more familiar cycloid and ctenoid scales, together known as leptoid scales. These consist of two layers, a thin bony surface layer overlying a fibrous layer made mostly of collagen. Cycloid scales have smooth margins whilst ctenoid scales have spiny or crenulated rear edges and come in several variants.

While most teleost fishes have either cycloid or ctenoid scales some have a mixture of both. Some flatfishes (Pleuronectiformes) have ctenoid scales on the upper (eyed) side and cycloid scales on the under (blind) side. Ctenoid scales are found in most of the advanced ray-finned fishes (Euteleostei) but even families within one order may differ.

Group (clade)	Scale	Example
Chondrichthyes (sharks and rays)	**Placoid** Tooth-like with basal plate & projecting spine, outer hard vitrodentine, cone of dentine with pulp cavity (see p.327)	
Sarcopterygii (coelacanth)	**Cosmoid** Similar to placoid; outer dentine-like cosmine, basal dense bony isopedine with spongy bone supplied with blood vessels in between	
Acanthopterygii: Chondrostei (sturgeon)	**Ganoid** Rhomboid shape, articulating peg & socket joints, three bony layers ganoine (outermost), dentine & isopedine (no dentine in sturgeons)	
Acanthopterygii: Teleostei: soft-rayed fishes e.g. Clupeiformes, Gadiformes	**Cycloid** Round or oval with smooth posterior margin, overlapping. Outer, bony organic layer with calcium salts, deeper fibrous collagen layer	
Acanthopterygii: Teleostei: spiny-rayed fishes	**Ctenoid** Angular, with spiny posterior margin (ctenii), structure as for cycloid	

Scale types in fishes.

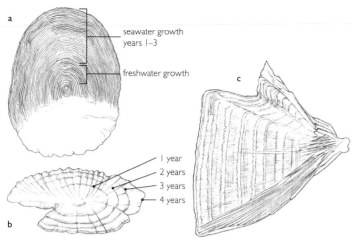

Scales, otoliths (ear bones) and opercula can all be used to determine how old a fish is, the method depending on the species. (a) Scale from a *Oncorhynchus nerka*; (b) sectioned otolith from *Clupea harengus*; (c) operculum from a wrasse.

Although it has large scales, Ballan Wrasse (*Labrus bergylta*) can be aged more accurately from the opercular bone. This large male is probably around 25–30 years old.

BOXED IN

The thin scales sported by most ray-finned fishes allow them great flexibility but only provide limited protection against predators. Boxfishes (Ostraciidae) takes things to the other extreme sacrificing flexibility for the ultimate in suits of armour. Their scales form a box of fused bony plates beneath the outer skin layers, enclosing and protecting all the vital organs. Pipefish and seahorses are similarly encased in bony rings. Spiny pufferfish such as the Porcupinefish (*Diodon hystrix*) have scales modified as three-pronged spines that normally lie flat but provide an effective defence when the fish inflates itself, taking in water and stretching out its elastic skin.

Unable to flex its box-like body the Longhorn Cowfish (*Lactoria cornuta*) swims using its pectoral fins in a stiff ungainly manner whilst the tail becomes a steering a rudder.

Scales can be used to determine the age of many fish especially temperate water species, and age determination is important in fisheries management. The scale grows from its outer edge when new material is added in the form of tiny plates or sclerites. The sclerites laid down in winter are small and form a dense and therefore darker band whilst those in summer are larger. So the number of winters that the fish has gone through can be counted. The method is less reliable in older fish and in those that regularly shed scales.

Fish are slippery customers thanks to numerous mucus glands in the epidermal skin layers. A slippery fish is more difficult to get hold of but some fish produce distasteful or even toxic mucus to deter predators. Soapfishes (Serranidae) as their name suggests, are likely to be quickly spat out except by the most undiscerning predators, whilst skin toxins released by colourful *Gobiodon* reef gobies can disable and even kill other fish (Schubert et al. 2003) even before they have taken a bite. The toxic properties of pufferfish skin and internal organs is well known and whilst people can (and do) eat the non-toxic muscle tissue, it can be a dangerous and sometimes lethal meal. Various groups of ray-finned fishes have venom glands in the skin, associated with sharp fin spines which are normally used to deter predators. Stepping on a weeverfish (Trachinidae) can be a very painful process whilst an encounter with a stonefish (Synanceiidae) can be fatal. Specialised skin cells called chromatophores (p.247) are largely responsible for the myriad colour patterns found in ray-finned fishes whilst photophores (p.66) produce bioluminescent light in deepsea species.

Scale patterns and counts can be very useful in identifying fish and in distinguishing similar species. The scales of the lateral line are often slightly raised and are perforated by a pore making them easily visible and allowing them to be counted. Scale patches on the head and nape of gobies helps in species identification in this notoriously difficult group.

Senses

In common with cartilaginous fishes and other vertebrates, ray-finned fishes use the five senses of vision, hearing, smell, taste and touch to gather information from their surroundings. They also make full use of the lateral line, a system for detecting water vibrations found in all major groups of fishes and described on p.317. Many ray-finned fishes produce sounds and use them as a means of communication and hearing is especially important in these species. Surprisingly there are also a few ray-finned fishes with an electrical sense.

Smell and taste Whilst it is sharks that are usually attributed with the most acute sense of smell, it is also very important in ray-finned fishes, especially those that hunt at night, or in dark and low visibility waters. Water is an excellent solvent and dissolved chemical substances are what fish actually detect so this skill is known as chemoreception. Chemicals may emanate from food sources, dead or alive, from would-be mates releasing pheromones or even from potential prey exuding off-putting substances. Perhaps the most dramatic use for an acute sense of smell is in long distance migration. When mature and ready to breed, salmon (Salmonidae) find their way back from the ocean to the very rivers and streams where they were born and which they left as young fishes. Like tracker dogs they follow chemical clues remembered from their outward journey. The exact nature of this homing ability is still not known but it is obvious that some sort of olfactory memory or imprinting is involved.

Tiny dwarf male anglerfishes use an acute sense of smell to find the much larger females, following a trail of pheromone in the darkness of the deep ocean. Once found, Soft Leafvent Angler (*Haplophryne mollis*) males attach to the female, tap into her blood supply and remain as parasitic partners.

The paired nostrils in ray-finned fishes are usually situated on the topside of the head on the snout. A common arrangement is a simple pit covered by a flap or flaps of tissue which direct water in one end and out the other. Some species have a more enclosed nasal capsule. The pit or capsule is lined by a convoluted sensory epithelium rich in chemoreceptor cells over which water flows moved along by cilia. The nostrils are isolated from the pharynx and play no part in the respiratory flow.

A Dash-and-dot Goatfish (*Parupeneus barberinus*) makes use of a sandy patch on a coral reef as a dining area, flicking its two mobile chin barbels in an elegant search for dinner. The Red-breasted Wrasse (*Cheilinus fasciatus*) above it is hoping to share the meal.

Taste is used by fish to confirm that something is edible. Whilst we need to put something into our mouth to tell what it tastes like, fish can also use their lips, barbels and even parts of their fins and body, all of which may have chemosensory taste receptor cells. Like us, these cells may be organised into taste buds but numerous scattered, single chemosensory cells are not unusual and are sometimes found over the whole body. Barbels are especially common in bottom-living fishes that search for buried invertebrates. Gurnards (Triglidae) probe the sediment with the first three thickened and separate rays of their pectoral fins which act both as 'feet' and as 'feelers' tasting for prey.

Vision As might be expected in such a large and diverse group, the eyes of ray-finned fishes vary widely in terms of size and functionality. Vision is vitally important to open water predators such as tuna. Indeed some of the larger species of tuna can keep their eyes at a warmer temperature than their surroundings (p.318) so that they perform at their best. At the other extreme many deepsea fishes have very small eyes but ones that are excellent at picking up nearby pinpoints of bioluminescent light. As well as size, the position of the eyes may reflect the way of life of particular fishes. Bottom-living gobies and blennies have bulbous eyes near the top of the head so they can see all round as they sit propped up on their paired fins on the seabed and can probably move their eyes independently of each other as seahorses and pipefish can. Butterflyfishes have lateral eyes out of sight of each other and cannot

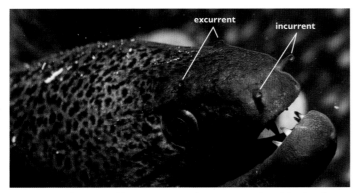

Eels such as this Giant Moray (*Gymnothorax javanicus*), have an especially well-developed sense of smell and each nasal capsule has two separate openings. Water enters through a tubular incurrent nare (nostril opening) and leaves via a separate excurrent opening. Thus eels appear to have two pairs of nostrils.

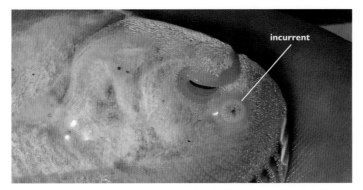

The Sand Sole (*Pegusa lascaris*) and other flatfish have one of their pair of nasal capsules on the underside (blind side) and one on the topside (eyed side). The front incurrent nare on the underside is expanded into a rosette-like organ which helps to distinguish it from other similar soles.

The unimaginatively named Bloch's Bigeye (*Priacanthus blochii*) seen here and the Common Bigeye (*P. hamrur*) use their large eyes to hunt small shrimps and larval fishes at night on the deeper parts of coral reefs. During the day they hide in caves and under overhangs.

Many flatfish have eyes that stick up above the body and out of the sediment when they are buried; Peacock Flounder (*Bothus mancus*).

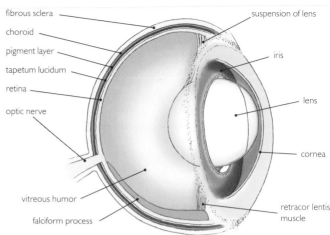

Vertical section through the eye of a teleost fish.

do this. The shape and size of the eyes may be very different in a larval and an adult fish which usually have different ways of life. Larval Black Dragonfish (*Idiacanthus atlanticus*) have extraordinary eyes out on stalks almost as long as themselves but adults have normal eyes.

A visit to a healthy, well-lit coral reef will make it pretty obvious that fish in this habitat can see in colour. The myriad hues and patterns of the fish would be pointless if they could not. Fishes living in other shallow-water environments also have good colour vision. However, as depth increases, colours at the red end of the spectrum (long wavelengths) are preferentially absorbed (p.18) and many fishes have eyes that are most sensitive to the green and blue end of the spectrum. It is also clear that reef fishes, like many insects on land, can see parts of the spectrum that we cannot. Many shallow water coral reef fishes are sensitive to UV light and the patterns and colours that we see on reef fish may not be the same as another fish would see. Some fishes, including anchovies (Engraulidae) and salmonids (Salmonidae) can detect polarized light.

The structure of the eye is similar to that of cartilaginous fishes with the significant difference that in ray-finned fishes the diameter of the pupil is fixed and the fish cannot control the amount of light entering the eyes. This begs the question of whether repeated underwater flash photography at popular dive sites might affect resident fish. The tough, outer covering of the eye is reinforced by bony plates (sclerotic bones) in open water hunting fish such as sailfish, swordfish and tuna.

Many deepwater fishes, both ray-finned and cartilaginous, produce their own bioluminescent light from special light organs called photophores. These can be quite complex structures with pigment cups to shield the light source and even lenses to direct and concentrate it. Patterns of photophores on the belly and flanks can be used by individual fish to recognise their own species and to tell male from female. The same pattern but different flash rates can provide similar information. Diving at night on a steep, ocean-facing coral reef can be an eerie experience if Flashlight Fish (*Photoblepharon palpebratus*) are around. Rising up from the depths at night, these small, gregarious fish have a light organ beneath each eye which they can blink on and off, using a flap of skin and they use this to communicate their whereabouts to each other. Naval ships use a similar principle for signalling, using a light that stays on and shutters that are opened and closed, based on the Aldis lamp developed in the late 1800s. Disruptive patterns of photophores can blur body outlines and so provide camouflage.

Hearing and sound production Sound travels well in water and hearing is an important sense for most fishes. The marine world is a noisy place and it is ray-finned fishes that are responsible for quite a lot of that noise, along with 'finger'-snapping shrimps, shell-butting molluscs and habitat-derived background noise. A scuba diver in a fish-rich environment will hear clicks, grunts, whistles and other sounds in between breathing out his own noisy bubbles. The common names of grunts (Haemulidae), croakers and drums (Sciaenidae) reflect the noise-making abilities of these fish families. In contrast, cartilaginous fishes can hear well, but they themselves produce few sounds. Fish make noises for a variety of reasons. Gurnards (Triglidae) grunt to each other as they work across the seabed, feeling for food and so can keep together as a group. Male toadfish 'sing' to attract mates and the Oyster Toadfish (*Opsanus tau*) is famous along parts of east coast USA for its load calls, heard along the shore between April and October. Other fishes make warning sounds whilst schooling fish use sound as one way of maintaining spacing between individuals.

Fish produce sounds in several ways of which perhaps the most common is to vibrate the walls of the swim bladder (p.360), using it as a resonating chamber. The vibrations are set up using special muscles. Codfish (Gadidae), toadfishes (Batrachoididae) and gurnards (Triglidae) all use this method. The Three-spined Toadfish (*Batrachomeus trispinosus*) is the only fish so far known to produce non-linear sounds. It has a split swim bladder with the two halves working independently and so can

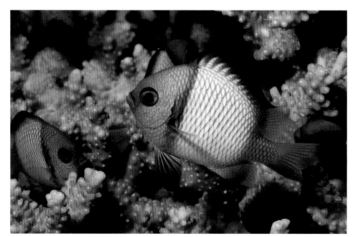

Two-bar Damselfish (*Dascyllus reticulatus*) live around branching coral heads and dive in when danger threatens. UV-reflective markings flashed up by raising the dorsal fin warn their neighbours, but cannot be seen by their non-UV sensitive predators (Losey 2003).

The colourful Splendid Toadfish (*Sanopus splendidus*) lives in shallow reef areas on Cozumel Island, east coast Mexico. Squat and wide-mouthed, toadfishes both look and can sound like their namesake.

produce different sounds simultaneously (Rice and Bass 2009, Rice et al. 2011). More bizarrely some catfishes can rub bones in the pectoral girdle together and a variety of fishes grind together their pharangeal teeth, a sleeper's nightmare. Cartilaginous fishes lack a swim bladder and this may be one reason that they do not appear to produce sounds. Sharks have always been viewed as the archetypal 'silent killers' but observations on one particular group of Blacktip Sharks has resulted in a theory (only so far) that they may use the sound of their jaws snapping shut as a form of group communication.

Fish have no external ears and as in other vertebrates, it is the inner ear that does the actual hearing. This works on a similar principle to our own ears in that sound vibrations trigger sensory hair cells which send messages to the brain via an auditory nerve. Sound waves pass through a fish's body as though it were water, because most of the tissues have almost the same density as water. However in each inner ear there are three fluid-filled sacs (utriculus, sacculus and lagena) each containing a small, rounded, bony ear stone or otolith which vibrates at a different rate because of its density. Hair cells within the sac pick up this difference. Some fishes with sensitive hearing use the swim bladder to enhance their hearing abilities. Sound sets the swim bladder vibrating and these vibrations can be transmitted to the inner ear if the swim bladder is close to it as in cod or has a forwards extension as in some herrings (Clupeidae). However the fish with the best hearing are freshwater species found in four related orders (otophysans). These have a more sophisticated transmission route from swim bladder to inner ear, via a set of tiny interconnected bones called the Weberian ossicles. The only marine otophysans are catfishes in the family Plotosidae.

Fish can both hear and feel the approach of a predator because both the inner ear and the lateral line system respond to water-born vibrations and operate through sensitive hair cells. The two systems are therefore often grouped together as the acustico-lateralis system.

Electro-sensory and magnetic Whilst it is in cartilaginous fishes and especially sharks that we see the ultimate electro-sensory system (p.331), a relatively small number of ray-finned fishes also possess an electrical sense and can detect the extremely weak bioelectric fields produced by other animals. The main use for electro-receptors is to find prey and as most cartilaginous fishes are predatory then it follows that evolving such a system would be a great advantage to them. Seawater conducts electricity well making such a system easy to use. Most of the few ray-finned fishes that have this sense live in freshwater, often in murky conditions where vision is of little use for hunting. The most sensitive are paddlefishes, strange relatives of sturgeon with a platypus-like snout covered in sensory ampullae similar to those found in cartilaginous fishes. Sturgeons also have an electrical sense and live in coastal and brackish waters as well as fresh. Sensory ampullae have also been found in jawless lampreys.

Some fishes have electric organs and can generate their own electricity for attack and defence, but in the ocean it is mainly cartilaginous fishes such as electric rays (Torpedinidae) that do this. However, Stargazers (Uranoscopidae) can also produce strong currents. Electric freshwater fishes include electric eels (Electrophoridae) and electric catfishes (Malapteruridae). Some freshwater fishes can also produce an electric field that can be used for electrolocation. They have special 'tuberous receptors' that can detect when their electrical field is deformed by other animals moving into it or when they come close to objects. This useful ability is unknown in marine fishes.

Lying half buried with just the large, tooth-filled mouth and upturned eyes showing, stargazers make excellent ambush predators. Species in the genus *Astroscopus* may also have electric organs which are derived from eye muscles.

Diagrammatic representation of the inner ear of a typical ray-finned fish.

BIOLOGY

Feeding

Ray-finned fishes exhibit a very wide range of feeding strategies both in the way they find and catch their food and in what they eat. Predators such as barracuda are well known for their ferociously efficient teeth and stealthy hunting skills. Others spend a much quieter life as herbivores grazing on algae, seaweed and seagrass. There are also scavengers, omnivores with a wide diet and specialists reliant on one or a few food sources. However with the possible exception of a few top predators, all fish face the daily dilemma of managing to eat without being eaten themselves. Survival pressures have resulted in some fascinating structural and behavioural adaptations that combine predator avoidance and prey capture, of which camouflage (p.496) is a prime example. A well camouflaged fish can see its prey whilst predators remain oblivious to its presence.

Strictly herbivorous fishes are restricted to relatively shallow, coastal waters where there is enough light for plants to grow. They are therefore far fewer in number than carnivorous species which can utilise the whole ocean realm. Coral reefs support a wide variety of herbivores and it is the resident rabbitfishes, surgeonfishes and blennies, along with grazing invertebrates such as sea urchins, that prevents reefs from overgrowth and smothering by algae. Unintentional experiments where reefs have been overfished are testament to their importance in this respect.

Plant material is difficult to digest and herbivorous fishes tend to have a long gut and feed continuously during daylight hours. Surgeonfishes have no stomach but instead have a specialised hind gut with a selection of microbes that aid digestion. Whilst common in many herbivorous land vertebrates, this is very unusual in fishes. Herbivores and fishes that feed on tough animal material such as molluscs, often have pharangeal (throat) teeth that help to manipulate, tear and grind up their food. Mullets (Mugilidae) have a gizzard, a specialised muscular part of the stomach to help them grind up their muddy diet of detritus and algae.

Ray-finned fishes that are grazers are not all herbivores. In the marine environment many animals live as colonies permanently fixed to the seabed (see p.44) and are therefore prone to being grazed. Even corals with their protective skeleton are not immune. Parrotfishes have a tough beak derived from modified incisor teeth and some use this to crunch their way into corals, though many just scrape overlying algae from coral rock.

A proboscis monkey and a surgeonfish have more in common than might be supposed. Both feed on plant material (leaves and algae respectively) and have gut microbes that help them digest this tough material.

Plankton is an excellent source of food for fishes and whilst no ray-finned fishes can match the plankton-filtering capabilities of the cartilaginous whale sharks and manta rays, there are some that do pretty well for their size. Fish living out in open water must of necessity either be predators of planktivores. Atlantic Horse Mackerel (*Trachurus trachurus*) and other carangid fishes (Carangidae) swim along with their mouths open and strain plankton from the water (see photograph on p.281) using their gill rakers. Planktivorous fishes, have longer, thinner and more numerous gill rakers than predatory fishes. In the latter their main function is to protect the delicate respiratory part of the gills from mechanical damage. They are essentially omnivores since they do not select their food and so take in both plant and animal matter, but the structure of their gill rakers determines what is retained and what is small enough to pass through with the water flow. Plankton pickers do as their name suggests and pick out individual plankton animals (plant plankton is too small), usually by sight. On a coral reef there may at times be a 'wall of mouths' sufficient to remove most of the animal plankton in the vicinity. The giant sized Sunfish (*Mola mola*) feeds mainly on large planktonic jellyfish.

Some damselfishes (Pomacentridae) 'garden' the filamentous algae on which they feed, by defending an area of rock or coral. The fish will actively remove other grazers such as marine snails and may even nip off coral polyps to clear suitable ground.

Schools of graceful fusiliers (Caesionidae) patrol the waters over coral reefs and tropical seagrass beds searching for aggregations of zooplankton on which they feed.

MARINE FISHES

Most open water fishes are predators and it is here that the fastest and most active predators are found. Everything about a Sailfish (*Istiophorus platypterus*) is designed for speed and manoeuvrability, from its powerful crescent-shaped tail to the slot into which it can retract its dorsal fin. These fish are one of the few ray-finned fishes that have been observed to hunt cooperatively. Several fish will 'herd' shoals of sardines or other 'baitfish', using the huge dorsal fin to scare their prey into a dense mass from which they can take it in turns to feed. In the vast blackness of the deep ocean, speed and acute vision are of little use and predators here must use stealth and cunning. Anglerfishes entice their prey within reach using a modified fin ray as a mobile, bioluminescent lure. Others have huge mouths in relation to their size, fang-like teeth and expandable stomachs to allow them to swallow anything they find.

Atlantic Herring (*Clupea harengus*)
Planktivore
Soft mouth, small teeth

The John Dory (*Zeus faber*) is obvious when seen from the side, but is so thin that prey are oblivious to it during a head on approach. It can also protrude its jaws forward, a feature used to advantage by many other 'stealth hunters' and taken to extremes by the Sling-jaw Wrasse (*Epibulus insidiator*).

Queen Parrotfish (*Scarus vetula*)
Herbivore
scrapes algae from rocks and dead coral with beak-like fused teeth

Sheepshead (*Archosargus probatocephalus*)
Carnivore
tough, blunt molars crush molluscs, crabs and barnacles

Great Barracuda (*Sphyraena barracuda*)
Predator – Piscivorous
sharp canine teeth seize and hold slippery prey

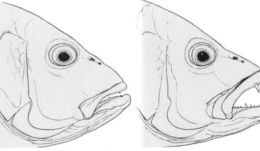

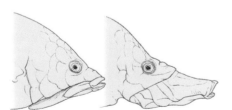 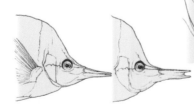

Sling-jaw Wrasse (*Epibulus insidiator*)
Small fish and crustaceans
suction

Yellow Longnose Butterflyfish (*Forcipiger flavissimus*)
Carnivore
tweezer-like mouth extracts small crustaceans from coral crevices and snips pieces from anemones etc.

Northern Red Snapper (*Lutjanus campechanus*)
Carnivore
short, needle-like teeth grasp and bite small fish and crustaceans

Head profiles of some ray-finned fishes showing different mouth shapes and teeth types, each suited to a particular feeding method.

RAY-FINNED FISHES

Life history

Most ray-finned fishes lay large numbers of small eggs which are broadcast into the water and fertilised externally. A large adult cod can spawn around 10 million eggs in a single season, something to think about next time you eat 'cod roe', which is essentially the fishes ovary. Very few ray-finned fishes show parental care and large numbers of eggs are needed to compensate for the huge losses that are incurred. Fish eggs are a wonderful source of nutrition for myriads of filter-feeding invertebrates and plankton-feeding fish so we are not the only ones to appreciate caviar. This is in complete contrast to the few, large, internally nurtured eggs and young produced by cartilaginous fishes (sharks, rays and chimaeras). Within this overall reproductive strategy, ray-finned fishes have developed a wide variety of techniques to ensure their breeding success, including when, where and with whom they spawn.

The first problem is to get mature individuals together. With external fertilisation, timing is crucial as both eggs and sperm must be released simultaneously or immediately after each other. So males and females must find each other and meet up at the right time. In cold waters breeding is usually seasonal and the window of opportunity often short. Open water pelagic schooling fishes frequently migrate *en masse* to specific and traditional breeding grounds. Atlantic Herring (*Clupea harengus*) spawn in spring and summer over large areas of continental shelf gravel banks on both sides of the Atlantic. The eggs sink and stick to the gravel which provides some security until the larvae hatch out. They then drift into sheltered, inshore nursery areas where they are less likely to be eaten. However, Cod (*Gadus morhua*) eggs float in the plankton where they hatch into larvae and the young fish only start to live near the seabed when they are around six months old. Losses at this stage are huge but in spite of this, the shear numbers of eggs ensured that cod were once perhaps the most abundant of all fishes in the North Atlantic, until the scourge of over-fishing finally defeated even their fecundity (Kurlansky 1999). Whilst pelagic fishes spawn together in the greatest numbers, groupers, snappers and many other reef-associated fishes also gather in spawning aggregations in particular weeks or even days of the year.

Butterflyfishes including this Red Sea species *Chaetodon larvatus*, are often seen in pairs and some species are known to remain together and spawn with their partner for several years.

Sex is not always so casual an affair and many species spawn in pairs or small groups. The best time and place to see this is underwater on a coral reef on a warm, still evening. A sudden vertical run of a few or even dozens of wrasse, parrotfish or surgeonfishes is followed by a clouding near the surface as eggs and sperm are released.

Small fishes living on or near the seabed often deposit their eggs in rocky crevices, under stones, in shells or in specially constructed nests of sediment or algae. This gives them the opportunity to protect the eggs and whilst the majority do nothing more than choose a safe site and perhaps glue their eggs to rocks, some also guard them until they hatch. Almost always it is the male that chooses or builds the nest site and looks after the eggs. Diminutive anemonefish (*Amphiprion* spp.) are so protective they will attack a peering diver's face mask when guarding their eggs which are fixed to rocks at the base of their anemone home. Nesting Titan Triggerfish (*Balistoides viridescens*) have been known to attack and draw blood when unwitting divers swim over their coral rubble seabed nests. Whilst many of these fishes spawn in pairs, in others a single male may entice several females to spawn sequentially in his nest.

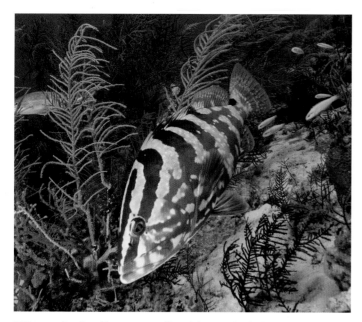

Whilst normally solitary, Nassau groupers (*Epinephelus striatus*) gather in large spawning aggregations. This makes them vulnerable to unscrupulous or unknowing fishermen.

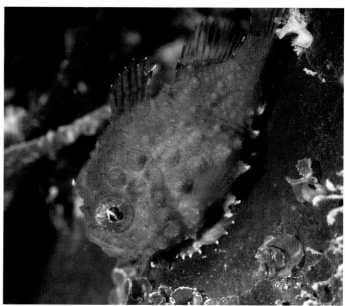

Living along the surf-tossed coasts on both sides of the North Atlantic, male Lumpsuckers (*Cyclopterus lumpus*) use their strong pelvic sucker to cling onto rocks whilst guarding their eggs. Females simply deposit the eggs and swim off.

	Hermaphrodite species (marine)	Example species
Protogynous (female to male)		
Wrasses (Labridae)	Most	Ballan Wrasse *Labrus bergylta*. NE Atlantic
Parrotfishes (Scaridae)	Most	Bicolor Parrotfish *Cetoscarus bicolour*. Indo-Pacific
Angelfishes (Pomacanthidae)	All	Royal Angelfish *Pygoplites diacanthus*. Indo-Pacific (p.394)
Groupers (Serranidae:Epinephelinae)	Some	Nassau Grouper *Epinephelus striatus*. Tropical western Atlantic
Fairy basslets (Serranidae:Anthiinae)	Most	*Anthias* spp., *Pseudanthias* spp. Indo-west Pacific
Porgies (Sparidae)	Many	Common Pandora *Pagellus erythrinus*. Eastern Atlantic
Emperors (Lethrinidae)	Some	Spangled Emporer *Lethrinus nebulosus*. Indo-West Pacific
Gobies	Some	Greenbanded Goby *Elacatinus multifasciatus*. Western Atlantic
Protandrous (male to female)		
Anemonefishes (Pomacentridae:Amphiprioninae)	All	*Amphiprion* spp. Indo-Pacific (p.393)
Moray eels (Muraenidae)	Few	Ribbon Eel *Rhinomuraena quaesita*. Indo-Pacific (p.376)
Porgies (Sparidae)	Many	Gilthead Bream *Sparus aurata* Eastern Atlantic
Simultaneous (functions as male or female)		
Hamlets (Serranidae:Serraninae)	All	*Hypoplectus* spp. Caribbean
Groupers (Serranidae:Serraninae)	All *Serranus* spp.	Comber *Serranus cabrilla* Eastern Atlantic
Porgies (Sparidae)	Few	Blackspot Seabream *Pagellus bogaraveo* Eastern Atlantic

Ray-finned fish groups in which at least some species are hermaphrodites.

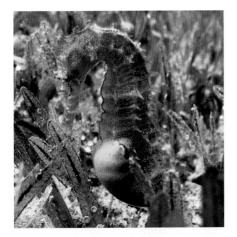

The belly pouch of this 'pregnant' male seahorse is swollen with eggs deposited there by the female.

The ultimate in fish parenting is demonstrated by seahorses and their straight pipefish relatives. After a complex courtship often lasting several days the female lays her eggs in a special pouch on the male's belly. Here they stay in complete safety (unless the parent is eaten) until they hatch and even then they may return to the pouch when danger threatens during their first few days. Male and female remain faithful for at least one breeding season.

A variant on this parental theme is demonstrated by jawfishes (Opistognathidae) and cardinalfishes (Apogonidae). Both these groups are mouth brooders and the male picks up the eggs after the female has laid them and keeps them safely in his mouth. He will not feed until the eggs hatch and the young have left to fend for themselves.

In most fishes sex is determined early on in life and individuals remain as either male or female. However, unusually for vertebrates, some ray-finned fishes have developed an alternative hermaphroditic strategy. In this system an individual can function both as a male and as a female, sometimes simultaneously but usually at different times of its life. In a few families this is the rule rather than the exception. The family Sparidae (porgies) exhibit the greatest variation in reproductive strategies with species that are gonochoritic (separate sexes), protogynous (female first changing to male) and protandrous (male first changing to female) (Buxton and Garratt 1990). Most wrasses (Labridae) are protogynous. Wrasse males and females often have very different colour patterns especially in tropical species. As they change sex their colours also change through a series of intermediate patterns, which makes them notoriously difficult to identify. Anemonefish (Pomacentridae) live in more or less permanent pairs with one large female and a smaller male living in one anemone. Sharing their home is a number of even smaller immature individuals. If the female dies, then the male changes sex into a functioning female whilst the largest immature develops into a male and

A Cuckoo Wrasse (*Labrus mixtus*) normally begins life as a red female. Later, aged between about 7–13 years, some females change sex and become blue secondary males. Mature males court females and spawn individually with them. However, a few eggs hatch as males but with the female coloration and these primary males take part in group spawning with females.

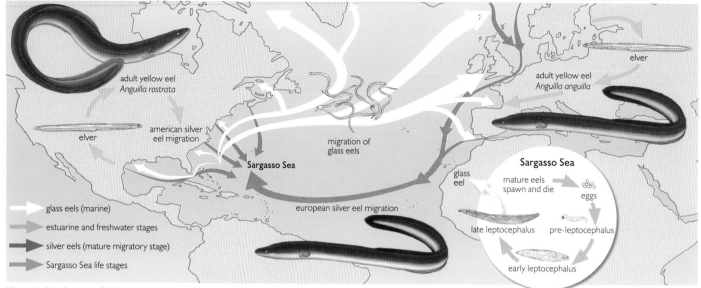

Life cycle of the European Eel (*Anguilla anguilla*) and American Eel (*A. rostrata*).

pairs up with the new her. The advantage of this system is that it is not necessary for the fish to leave the safety of their anemone home to find a mate.

Changing from female to male is much more common than the reverse and has the obvious advantage that it maximises the number of eggs and young that can be produced. Many protogynous fishes hold harems with just a single male spawning with many females. If the lead male is lost then the next largest female can change sex and take his place.

The majority (about 75%) of ray-finned fishes, whether they live on or near the seabed or spend their lives out in the open ocean, lay eggs that are buoyant and float near the surface in the plankton. The larval stages that develop from the eggs are also planktonic for a variable length of time. Many of them have adaptations that help them to find and catch food using the minimum of energy. This sometimes results in bizarrely shaped larvae that look nothing like the adult. The flattened leaf shape of eel (*Anguilla*) leptocephalus larvae help them to float on their long journey back from spawning grounds in the Sargasso Sea to the coasts of North America and Europe. There are different opinions on how long the journey takes but for the European Eel (*A. anguilla*) it may be as long as two to three years.

In contrast to fish where the larvae have special adaptations to their environment, flatfish start life as a normal upright fish-shaped larvae and it as they metamorphose from larva to juvenile and settle out of the plankton that they become flattened and so well-suited to life on the seabed. During their extraordinary metamorphosis, the larval fish starts to sink down towards the seabed and gradually becomes more and more flattened from side to side. Eventually it takes up life on the seabed lying either on its right or its left side according to species. The underneath eye migrates round onto the upper side and the now blind underside loses any pigmentation it may have had. The mouth also twists round.

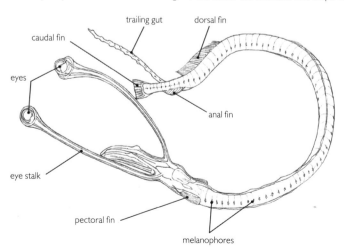

The larvae of some mesopelagic (midwater) fishes such as *Idiacanthus* dragonfishes, have their eyes literally out on stalks. This greatly increases their field of view allowing them both to avoid predators and find prey in the dimly lit depths at which they live.

Juvenile Harlequin Sweetlips (*Plectorhinchus chaetodonoides*) are a completely different colour to the adult (inset) and move with undulating wriggles that imitate swaying algae and soft corals.

	Major groups/species	Common features (but not in all species)
PELAGIC		
Coastal	Mackerels, herrings, anchovies	Small, streamlined, silvery
Open ocean	Billfishes, tunas, sauries, snake mackerels, sunfish, oceanic puffer	Streamlined, silvery
Associated with floating objects	Unicorn Leatherjacket (*Aluterus monoceros*), tripletails (*Lobotes*), Rainbow Chubb (*Sectator ocyurus*)	Few
Mesopelagic	Oarfish, lanternfishes, hatchetfishes, lancetfishes	Swimbladder usual; may make daily vertical migrations
Bathypelagic and abyssopelagic	Deepsea anglerfishes, dragonfishes, bristlemouths (especially *Cyclothone*)	No or defunct swimbladder; no vertical migration, flabby with reduced body mass, bioluminescence
BENTHOPELAGIC	Cods, Orange Roughy (*Hoplostethus atlanticus*), Patagonian Toothfish (*Dissostichus eleginoides*), rattails, cusk eels, reef fishes	Swimbladder; flabby or robust
BENTHIC		
Surface	Flatfishes, gobies, blennies, clingfishes, sculpins, tripodfish	No swimbladder
Burrowing	Red Bandfish (*Cepola Macrophthalma*), gardeneels, gobies, weeverfishes, stargazers	No swimbladder

Ecological groupings of ray-finned fishes.

Ecology

The ocean is a three-dimensional environment and ray-finned fishes have exploited almost every conceivable ecological niche within it. They therefore fulfil a huge number of roles within the whole ocean ecosystem as predators, scavengers, herbivores and planktivores and of course as prey for seabirds, mammals, reptiles, sharks and within their own ranks. Incalculable numbers of tiny fish larvae and small pelagic fishes form a vital link between plankton and these larger animals. In an ecological sense, ray-finned fishes can be divided into several large groups according to where they live within the ocean: pelagic (swimming in open water), benthic (living on or in the seabed) and benthopelagic (swimming near the bottom). Many species change their lifestyle as they develop and mature, moving from a pelagic larval existence to a benthic or benthopelagic one.

The largest volume of living space belongs to pelagic fishes. However, the majority of pelagic ray-finned fishes are coastal, living over continental shelves where there is far more food. It is no coincidence that most of the world's major fisheries are concentrated in these regions and coastal states protect their living with an exclusive economic zone out to 200nm. In comparison relatively few species of ray-finned fishes are truly oceanic, living their whole lives well away from land. Those

Pilotfish (*Naucrates ductor*) live and travel with large oceanic fish including sharks. Their juveniles often use drifting logs and other flotsam or large jellyfish for shelter.

Red Bandfish (*Cepola macrophthalma*) live in vertical burrows in soft mud down to about 400m depth in the NE Atlantic. They feed by picking plankton from the water usually retaining contact with their burrow using the tip of their tail. Their burrows are shared by several different crab species which construct side tunnels.

that have taken up this lifestyle are, however, very successful and some occur in huge numbers. Look at any supermarket shelf anywhere in the world and there will probably be tins of Skipjack Tuna (*Katsuwonas pelamis*). Given the chance it is a prolific breeder and has a very wide distribution right round the world in tropical and warm temperate waters. These oceanic species live out their lives in the top 200m or so of water – the epipelagic zone (p.34) where there is enough light to support an abundance of phytoplankton. This provides 'grazing' for huge shoals of silvery filter-feeding fishes such as anchovies and supports the zooplankton on which others feed.

Many pelagic fishes undertake long migrations moving between areas suited to feeding, breeding and juvenile survival. Some of the largest species move across or make circuits of whole ocean basins (oceanodromous fish). Many highly prized fish fall into this category which has obvious implications for stock management (see below). Tagging of Atlantic Bluefin Tuna (*Thuunus thynnus*) has shown that whilst western and eastern (including Mediterranean) populations mix on feeding grounds, they appear to return to separate breeding areas.

Mesopelagic (midwater fish) live a slower life below the epipelagic zone, but many still have a connection with the surface because they make vertical feeding migrations upwards at night. If you want to find a 'sea serpent' then dusk might be the time to do it. This is when Oarfish (*Regalecus glesne*) are most likely to come up from the depths to feed on shrimp and squid. A few lucky 'blue water' divers have seen them hanging vertically in the water, holding their long thin pelvic fins out sideways like a swimmer treading water.

Benthic fishes and benthopelagic fishes are together often called demersal fishes and encompass a huge array of species from tiny gobies to halibut which weigh in at over three hundred kilograms. Demersal fishes can be found from the seashore right down to the muddy abyssal plains and trenches and there are even a few species endemic to hydrothermal vents (e.g. *Thermarces*). However due to a much reduced food supply and lack of rocky substrata only a relatively few specialised species live at great depths. In shallow waters species such as Sand Tilefishes (Malacanthidae) excavate deep burrows and throw up large sand and rubble piles and burrowing fish can modify the seabed quite dramatically.

USES, THREATS, STATUS AND MANAGEMENT

Some people will not eat fish but millions of others around the world rely on them as their major source of protein. Marine ray-finned fishes make up a large proportion of the world's fisheries with pelagic fishes topping the bill. Herrings, sardines and anchovies (Clupeiformes) are by far the most important group in terms of tonnage. The benthopelagic cods, hakes and haddocks (Gadiformes) are also vitally important. Not surprisingly the major threat to ray-finned fish populations is overfishing. With huge advances in technology over the past 50 years or so, we have just got too good at fishing. Of the nearly 600 fish stocks monitored by the FAO, 29.9% are currently overfished and another 57.4% are fully exploited (FAO 2011). In 2005 17% were overfished so the problem continues to escalate.

It is not just taking too many fish that is the problem but also collateral damage to the environment and to non-target species. Whilst pelagic fish can be caught with little damage to the environment, taking demersal species often results in considerable disturbance. Dragging large, heavy nets across the seabed is very destructive. The largest trawl nets can be 60m across and it has been clearly demonstrated that repeated trawling reduces biodiversity in an area. By displacing and killing invertebrates living in and on the seabed, trawling also destroys the very food resources of the target fish themselves.

Whilst pelagic trawling may be less damaging, it does share one problem in common with demersal trawling. Both types of fishing can result in landing unwanted fish and other animals as well as the target species. Bycatch, as it is known, is mostly thrown back overboard and much of it does not survive. Dolphins are a common

Even a small bottom trawl can bring up large amounts of bycatch. This young shark was lucky because it was returned to the sea.

bycatch in tuna fisheries especially in the tropical Pacific where they commonly swim with yellowfin tuna. Sharks, dorado, sunfish and billfish are also common in tuna fishery bycatch.

Whilst the majority of trawling takes place over continental shelves there are increasing moves to target deepsea fish as shallow stocks dwindle. Such fisheries often have their own unique problems because target species like the Atlantic Orange Roughy (*Hoplostethus atlanticus*) have a very different biology to their shallow water counterparts. Orange Roughy have characteristics more like those of sharks than ray-finned fishes in that they grow slowly, mature late, are extremely long-lived and have low fecundity. This makes them especially vulnerable to over-exploitation.

Markets for high value, specialist products can pose particular threats to target species. Just as shark finning for shark fin soup heavily impacts shark numbers so the caviar industry has contributed to a huge decline in sturgeon numbers. In this case it is not just the legitimate fisheries that are impacting the stocks, but also illegal fishing,

Seabirds are one of the few animals to benefit from discarded bycatch. Underwater scavengers such as crabs may also do well – if they themselves are not caught.

A wide variety of reef fish can be found for sale in markets such as this one in Borneo, Malaysia. Some will have been caught illegally by fish blasting.

Products from MSC certified fisheries can be promoted using the MSC ecolabel.

deterioration in water quality and access to the rivers where the fish return from the sea to breed. The same problems face other anadromous fishes such as salmons and shads.

Fishery management is a complex and difficult subject and whole books are devoted to it. Most countries regulate fishing using a variety of techniques ranging from net design and mesh size restrictions, to landing controls, time at sea and fleet restrictions. Fisheries scientists have many methods available to them to determine the state of stocks. However the implementation of fishery controls is fraught with practical and political difficulties and is not always effective. Pelagic fishes that migrate over long distances and move in and out of the jurisdictions of various states and the high seas are particularly difficult to manage. Article 64 of the United Nations Convention on the Law of the Sea lists tuna (most large species), marlin, sailfish, swordfish, pomphret and sauries as Highly Migratory Species (also included are some oceanic sharks). These are subject to various international management agreements by parties to the convention.

However, even with controls and laws in place, implementation can be difficult and costly. Just as illegal logging takes its toll on rainforest trees and damages the wider environment, so illegal fishing practises affect both fish stocks and their habitats. Fish blasting and cyanide fishing are common in some parts of SE Asia and whilst the fish remain edible, their coral reef habitat is badly damaged by these practises. Perhaps less obvious is the damage caused to the inner ear systems of nearby fish. Air guns used during petroleum exploration may have similar effects though the effects on dolphins are better known.

Illegal and unregulated fishing, commonly called pirate fishing also occurs at a much larger scale out at sea. This not only adversely affects fish stocks but also impacts local communities that rely on fishing. Schemes that provide a chain of custody through to the big supermarkets can help combat this trade. In recent years consumer pressure in developed countries has been having an increasing effect on concentrating the minds of fishermen and politicians alike on the sustainability of fisheries. An example is the Marine Stewardship Council (MSC), a global organisation which aims to promote sustainable fishery practises. MSC certified fisheries must demonstrate that they are effectively managed to maintain sustainable fish stocks and minimise environmental impacts. This is analgous to the long running Forest Stewardship Council (FSC) and allows consumers to track products from boat to plate.

Sixty-five marine ray-finned fishes are listed as Critically Endangered or Endangered in the IUCN Red List (IUCN 2014). The majority of these are species with specialist lifestyles such as the anadromous sturgeons or those that live in restricted habitats. A significant number are coral reef species including groupers and the Humphead Wrasse (*Cheilinus undulatus*). However, both the Atlantic Bluefin Tuna (*Thunnus thynnus*) and the Southern Bluefin Tuna (*T. maccoyii*) are listed. These are widespread, highly migratory pelagic species but their extremely high and increasing value means that scientific recommendations to reduce fishing pressure are often ignored.

The Humphead Wrasse (*C. undulatus*) grows slowly, lives for many years and has a complex life cycle. It also fetches very high prices in many SE Asian markets, especially Hong Kong. It is now only found in any numbers on coral reefs where it is protected by law, such as in the Maldives.

RAY-FINNED FISH SPECIES: CLASS ACTINOPTERI (ACTINOPTERYGII)

The vast array of ray-finned fishes is currently classified into 45 or 46 orders (see p.358) most, but not all of which, have marine representatives. By far the largest and most diverse order is the Perciformes with 165 families and which contains many marine commercial species, coral reef species and other familiar fishes. Details of all orders and families can be found in the online version of Eschmeyer's Catalog of Fishes (Eschmeyer 2014), at www.fishbase.org, in the detailed systematic treatment of all major fish groups in Nelson (2006) and in the comprehensive biology of fishes presented by Helfman et al. (2009). Twenty-seven of the major orders are described below with examples.

Clade	Nelson (2006)	Catalog of Fishes and Fishbase (2014)
Osteoglossomorpha	2 orders	1 order: Hiodontiformes merged with Osteoglossiformes
Elopomorpha	4 orders	5 orders: Notocanthiformes separated out from Albuliformes
Procanthopterygii	4 orders	3 orders: Argentiniformes merged with Osmeriformes
Acanthopterygii	13 orders	16 orders: Cetomimiformes separated out from Stephanoberyciformes; Syngnathiformes from Gasterosteiformes and Gobiesociformes from Perciformes

Differences in orders between Nelson (2006) and Catalog of Fishes (2014).

SUBCLASS CHONDROSTEI

Order ACIPENSERIFORMES: sturgeons

Few people will ever see a live sturgeon whose numbers are now greatly depleted, their downfall hastened by the popularity of caviar. Some species can still be caught on rod and line in rivers during their spawning runs but the best chance of seeing one for most people is in a public aquarium. Surprisingly these primitive fishes have a skeleton made largely of cartilage though based on the bony skeleton of their direct ancestors. They have a superficially shark-like appearance with an underslung mouth, heterocercal (unequal) tail and pelvic fins set far back on the body. Five rows of thick, bony scutes (p.361) give them a prehistoric appearance. Sturgeons are only found in the northern hemisphere.

FAMILY Acipenseridae

European Sturgeon *Acipenser sturio*

Features European Sturgeon used to be a common sight running up all the major rivers of Europe to their spawning sites. Today this species is critically endangered, they are rarely caught in coastal waters and breeding is restricted to the Garonne River in France. There are sixteen other similar species of *Acipenser* in the northern hemisphere many of which are difficult to tell apart and most of which are endangered. However, many are not anadromous and are restricted to freshwater. The photograph is of a farmed fish.

Size Up to 3.5m.

FAMILY Acipenseridae

Beluga Sturgeon *Huso huso*

Features Whilst this is undisputedly the largest of the sturgeons, Belugas now rarely reach their full size potential. Heavily exploited for the caviar industry, they are critically endangered and it is very likely that the few remaining natural wild populations will disappear in the relatively near future. Wild stocks are no longer found in the Adriatic and Asov seas and limited riverine spawning grounds remain for those in the Black Sea basin and Caspian basin. A triangular snout, underslung mouth and unequal tail give Beluga an almost shark-like appearance.

Size Up to 5m long.

SUBCLASS NEOPTERYGII: SUBDIVISION ELOPOMORPHA

Order ELOPIFORMES: tenpounders

Fishes in this small order, which has two families and eight species in it, are slender silvery fish which look superficially like large herring, with one dorsal fin, pelvic fins set well back on the abdomen and a forked tail. Tenpounders have a ribbon-like leptocephalus larva (p.370) totally unlike the adult, an attribute shared by eels (Anguilliformes) and the other three orders grouped together in the subdivision Elopomorpha.

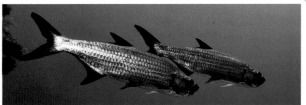

Atlantic Tarpon *Megalops atlanticus*
FAMILY Megalopidae

Features Given its size and the great airborne leaps it makes when hooked, it is not surprising that this giant, silvery fish is prized by game fishermen but populations are declining. Preferring warm waters, tarpon are found along coasts on both sides of the Atlantic. These elegant fish have obvious cycloid scales (p.361), large enough to have an ornamental use. The mouth faces upwards and the fins have dark edges. Tarpon can survive in stagnant lagoons by gulping air into their swim bladder which is connected to the oesophagus (p.360). These long-lived fish do well in large public aquaria and can live for over 50 years.

Size Up to 2.5m long.

Order ABULIFORMES: bonefishes

This is a small order with only one family and 13 described species. Halosaurs (Halosauridae) and spiny eels (Notacanthidae) have also been included here but recently have their own order (Notacanthiformes). Like tenpounders (Elopiformes) they are silvery herring-shaped fish with a single dorsal fin and have a similar elongated leptocephalus larva. The differences lie in the morphology of various bones in the head.

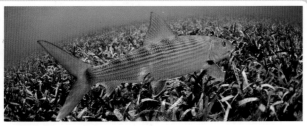

Bonefish *Albula vulpes*
FAMILY Albulidae

Features The 11 or so species of bonefishes in this genus are all similar and difficult to tell apart. *A. vulpes* was once thought to have a widespread distribution in the eastern Pacific and western Atlantic but genetic research has shown that it is restricted to the Caribbean, Florida and the Bahamas. Here it lives mainly in warm, shallow habitats such as mangroves and seagrass beds and loss of these has led to a decline in numbers. It and other bonefishes are also excellent gamefishes though hardly edible due to their small bones.

Size Up to 1m long.

Order SACCOPHARYNGIFORMES: deepsea eels

Living in the dark depths of the bathypelagic zone (p.34) deepsea eels or sackpharynx fishes have some bizarre adaptations. They have no ribs or operculum (gill cover), highly extensible stomachs, large mouths and loose jaws, all of which allow them to eat anything they come across, even if it is bigger than them. They hang in mid-water and hardly swim so have a minute tailfin or none at all, no pelvic fins and no scales. Like true eels they have a leptocephalus larva.

Pelican Gulper Eel *Eurypharynx pelecanoides*
FAMILY Eurypharyngidae

Features Of all the weird fishes in the ocean, this must rank near the top of the list. The shape of its huge mouth is reminiscent of a pelican's bag-like beak. This strange fish is known mostly from mangled specimens caught in nets but has also been filmed engulfing small fish and crustaceans into its black-lined and hence invisible mouth. The mouth is so large that a small fish would not even know it was inside, before it was gulped down. This bathypelagic gulper has a circumglobal distribution in deep to very deep water.

Size Up to 1m.

Swallower *Saccopharynx lavenbergi*
FAMILY Saccopharyngidae

Features There are ten described species in this genus, which like *Eupharynx* are also known as gulper eels. They too have large mouths with many small teeth, tiny eyes and a very unfish-like tail shaped like a long whip. This feature is very well-developed in *Saccopharynx* hence their other name of whiptail gulpers. The tail is tipped with a bioluminescent organ but exactly how this is used is unknown. These fish live in deepwater between about 2,000–3,000m and so are very difficult to observe alive. *S. lavenbergi* is found in the eastern half of the Central Pacific.

Size Up to 1.5m long most of which is tail.

RAY-FINNED FISHES

Order ANGUILLIFORMES: eels

True eels have a long, snake-like body and feel exceptionally smooth or slimy because they either have no scales or tiny cycloid ones embedded in the skin. They have no pelvic fins and in some species no pectoral fins either. The dorsal, anal and tail fins are joined as one long, continuous fin. All this allows them to squeeze through small openings and most live a secretive life in rocky crevices or sandy burrows. They have a leaf-like leptocephalus larva. There are 16 families and about 900 species

FAMILY Anguillidae

European Eel *Anguilla anguilla*

Features Whilst this photograph was taken in coastal waters by a diver, European Eels are more usually encountered in freshwater or slithering overland on a damp evening (see photograph p.361). Maturing adults migrate downriver to the sea becoming silver eels with a dark back and pale belly. They then make an epic journey across the Atlantic to the Sargasso Sea where they are thought to spawn in deepwater before dying. The larvae drift back to Europe on the Gulf Stream taking a year or more and swim up rivers as tiny transparent elvers (see p.370).
Size Up to 1.3m long.

FAMILY Ophichthidae

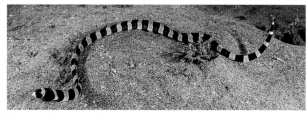

Harlequin Snake Eel *Myrichthys colubrinus*

Features With its uncanny resemblance to a venomous Sea Krait (p.414), the Snake Eel can deter predators and divers alike. A close look will show a dorsal fin running along the back, something no snake has. The tail is pointed and has a hard tip which is used to help the eel bury itself backwards into sand. Tubular downward directed nostrils allow it to smell its prey as it hunts over Indo-Pacific reefs and seagrass beds mainly at night. There are at least 250 species in this large, diverse family.
Size Up to about 1m long.

FAMILY Muraenidae

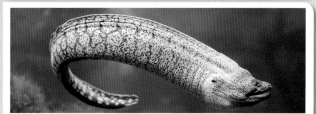

Giant Moray Eel *Gymnothorax javanicus*

Features Moray eels are a common sight on tropical reefs peering out from rocky crevices or holes in ship wrecks. Their habit of rhythmically opening and closing their mouth, exposing fang-like teeth can be unnerving for divers but they are simply breathing in clean water. At night morays emerge to hunt using a keen sense of smell to locate fish hidden amongst coral and striking in a snake-like manner. This species is one of many in the genus, but one of the commonest large ones, and is widespread in the Indo-Pacific area.
Size Up to 3m long.

FAMILY Congridae

Garden Eel *Gorgasia sillneri*

Features A great deal of patience is needed to watch garden eels which are extremely wary and react to divers by disappearing completely into their sandy burrows. Eventually they re-emerge and an apparently bare expanse of sand becomes populated with their gracefully swaying bodies. Large colonies can number hundreds of individuals, especially on slopes of sand exposed to currents which carry the plankton on which they feed with upturned mouths. This is a Red Sea species but similar eels are found throughout the tropics and the family also includes conger eels.
Size Up to 84cm long.

Ribbon Eel *Rhinomuraena quaesita*

Features In terms of colour and elegance the ribbon eel is a winner amongst moray eels and is a favourite with photographers. Males are a bright blue with yellow jaws and dorsal fin, the colours developing as the almost black juveniles mature. Adult males eventually change colour again and at the same time change sex to become all yellow females. These eels are found throughout the Indo-Pacific region on shallow reefs but are secretive and a patient wait is needed before they will partially emerge from hiding.
Size Up to 1.3m.

FAMILY Nemichthyidae

Snipe eel *Nemichthys* sp.

Features The deep mesopelagic and bathypelagic regions of the ocean are home to long, thin, lightweight snipe eels which swim and drift slowly through the inky depths. This family of eels is characterised by extremely long, out-turned jaws, resembling a wading bird's beak and which cannot be completely closed. Males in this small family of nine species undergo a bodily transformation when ready to breed, losing their teeth and long jaws whilst their nostrils enlarge, presumably to help in the search for a mate. Both sexes probably die after spawning.
Size Up to 1.4m long.

SUBDIVISION OSTARIOCLUPEOMORPHA: SUPERORDER CLUPEOMORPHA

Order CLUPEIFORMES: herrings

This large order contains some of the world's most important commercial fishes including anchovies and sardines as well as herrings. The majority live in large shoals in open water and are a vital link in the open ocean food web. Most are plankton-feeders straining out their food using long gill rakers. They themselves are eaten by larger predatory fishes, cetaceans and numerous seabirds. These are all silvery fish with a forked tail, a single short dorsal fin, a keel-shaped belly and scales that detach easily (deciduous). There are seven families and about 400 species. The two most important marine families are Clupeidae (herrings, sardines, sprats, pilchards, shads) and Engraulidae (anchovies). Unlike the other families, wolf herrings (Chirocentridae) are voracious predators with a large mouth and dagger-like teeth.

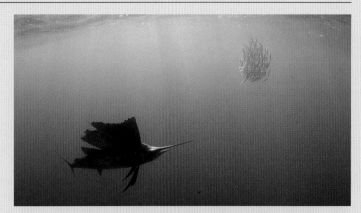

Cupeiform fishes are eaten by many predatory fish, cetaceans and seals and form huge shoals as a means of defense.

FAMILY Clupeidae

Atlantic Herring *Clupea harengus*

Features Atlantic Herring swim and feed in huge shoals and have long been targeted as a highly commercial species. Overfishing has led to the collapse of various stocks such as in the North Sea. Today some stocks are well-managed and sustainable whilst others are not. Herring spawn on the seabed with thousands of individuals producing a thick mat of sticky eggs in specific inshore spawning areas. Damage to these areas may contribute to the decline in some stocks. Herring feed largely on copepods and themselves are an important food for many larger fish, birds and mammals.

Size Up to 45cm long.

FAMILY Clupeidae

South American Pilchard *Sardinops sagax*

Features With rows of dark spots along the flanks, and radiating bony ridges on the operculum, this species stands out from the crowd of other similar clupeids. All other described species of *Sardinops* are now all thought to be subspecies of this one. Together they range throughout the subtropics in the Pacific and Indian oceans including Australia, Chile, California and Japan. Large shoals range along coastal areas and off California they migrate northward in summer and south again in winter. They are commercially fished in many countries.

Size Usually up to 20cm, sometimes to 40cm long.

FAMILY Clupeidae

Madeiran Sardinella *Sardinella maderensis*

Features One of 20 or so species in this genus, the Madeiran Sardinella is found from the Mediterranean south to Angola in warm coastal waters. With its silvery body and forked tail, it is a typical clupeid and is difficult to distinguish from the many other species in this large family, especially when seen underwater. It has large eyes, indicating that like the Atlantic Herring it feeds mainly by sight picking zooplankton and fish larvae from the water. It is heavily fished off Senegal and Morocco and both catch size and fish size are declining.

Size Up to 37cm usually smaller.

FAMILY Engraulidae

Anchovy species Engraulidae

Features The 17 genera and about 144 species of anchovy occur in huge numbers in the Atlantic, Indian and Pacific Oceans. They are a vital resource for people, predatory fish and marine mammals. A protruding snout and short lower jaw separate them from other clupeiform fishes. Peruvian Anchoveta (*Engraulis ringens*) are the most numerous but numbers can crash in 'El Nino' years when plankton-laden currents change, bringing great hardship to fishermen and wildlife that depend on them. With wide open mouths they filter plankton from the water with their gill rakers.

Size Varies between species. Up to about 20cm long.

SUPERORDER OSTARIOPHYSI

Order GONORYNCHIFORMES: milkfishes

Most of the fishes in this small order live in freshwater but the Milkfish (Chanidae) and beaked sandfishes (Gonorynchidae) of which there are five species, live in the ocean. As they mostly feed on plankton and small invertebrates, they have small mouths. They have a single dorsal and anal fin and the paired pelvic fins are set far back near the anal fin. There are about 37 species in four families.

Order SILURIFORMES: catfishes

Catfishes are a diverse and numerous order of mostly freshwater fishes. They live and feed by grubbing around on the bottom, searching for algae, invertebrates and small fishes. This is why they are so well equipped with mouth barbels which help them find their food and it is their whiskery appearance that gives them their name. They have a long body, and most species have a spine at the front of the dorsal fin. Many also have a small, adipose (fleshy) fin on the back near the tail. Marine catfishes are restricted to two families (out of 40), Plotosidae and Ariidae with about 135 species between them (out of about 3,000).

FAMILY Chanidae

Milkfish *Chanos chanos*

Features The Milkfish is a mainstay of fish farming in SE Asia and is widely eaten throughout the region. It is easy and cheap to rear as it feeds mainly on filamentous algae, cyanobacteria and plankton and can tolerate fluctuating salinities and high water temperatures. Maturing leptocephalus larvae move inshore into estuaries and mangroves where they may be safe from predators but are collected for growing on in ponds. Larvae are also reared from broodstock fish in hatcheries. Shoals of adult fish are most often seen in the vicinity of coral reefs.

Size Up to 1.8m long.

FAMILY Plotosidae

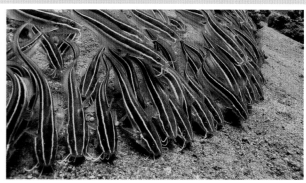

Striped Catfish *Plotosus lineatus*

Features Divers often see the juveniles of this catfish appearing like floating orbs as they bunch close together in tight protective shoals. Additional protection comes from a venomous spine in front of the first dorsal fin, a catfish characteristic well-appreciated by fishermen and great care is needed in handling any catfish. These young fish are common on coral reefs in the Indo-Pacific and are the only catfish found in this habitat. Adults are usually seen singly or in small groups foraging in sediment areas for invertebrates.

Size Up to about 30cm long.

FAMILY Gonorynchidae

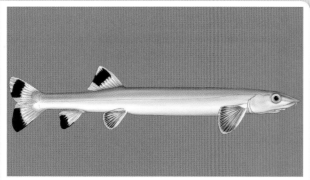

Beaked Sandfish *Gonorynchus greyi*

Features This fish has the surprising habit of diving head first into the sand if threatened and so are not that easy to photograph, especially as it is active mainly at night. A pointed snout and elongate shape makes this easier and such behaviour is an effective protection from predators. Small groups of adults can be seen swimming just above the bottom in shallow sandy bays and estuaries nuzzling in the sand for small invertebrates. This species is found in temperate waters around most of Australia and New Zealand.

Size Up to 50cm long.

FAMILY Ariidae

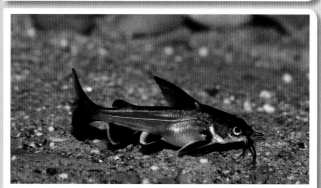

Tete Sea Catfish *Ariopsis seemanni*

Features Catfish are renowned for their long whisker-like barbels, hence their name. Most catfish live in freshwater but sea catfishes (Ariidae) have fully marine species as well as species that enter estuaries and rivers and some restricted to freshwater. The Tete Sea Catfish is common in brackish estuaries along the Pacific coast of Central and South America. It also lives some way upstream in corresponding rivers. The dorsal fin is tall and armed with a strong spine, and is followed by a small adipose (fleshy) fin. It uses its three pairs of barbels to detect hidden invertebrates.

Size Up to 35cm long.

SUBDIVISION EUTELEOSTEI: SUPERORDER PROTACANTHOPTERYGII

Order OSMERIFORMES: smelts

In addition to the true smelts (Osmeridae) and argentines (Argentinidae), this order contains many deepsea species such as barreleyes (Opisthproctidae) and slickheads (Alepocephalidae). Most smelts resemble slim salmon and like them have two dorsal fins, the second of which is a small adipose (fleshy) fin near the (usually) forked tail. The paired pelvic fins are set far back near the middle of the belly. Many of the coastal species are anadromous and move back from the sea into rivers to spawn. There are 14 families and around 320 species.

Order SALMONIFORMES: salmon and trout

Recreational anglers the world over will be very familiar with salmon and trout as will many other people through the farmed species sold widely in supermarkets. There is only one family Salmonidae but it contains over 200 recognised species within which is a bewildering array of subspecies and races. Salmonids are powerful, torpedo-shaped fishes with large eyes adapted for hunting by sight and large mouths. Marine species are all anadromous and return to freshwater rivers to spawn. They have a small adipose (fleshy) fin on the back near the tail as well as a normal centrally-placed dorsal fin. The paired pelvic fins are set far back on the belly. Their natural distribution is restricted to the northern hemisphere but Brown Trout and Rainbow Trout have been introduced into freshwaters virtually worldwide.

FAMILY Osmeridae

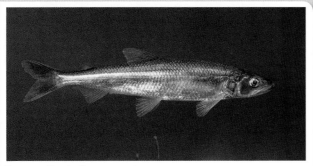

European Smelt *Osmerus eperlanus*

Features European Smelt have the silvery look of a herring and the shape and small adipose dorsal fin found in salmon and trout. Like the latter they are anadromous, swimming up rivers to spawn and are mostly found close inshore and are common in estuaries such as the Wash on the east coast of England. They occur in the NE Atlantic from the White Sea southward to France. Their name derives from the distinctive smell of freshly caught fish, described by fishermen as similar to cucumber, though perhaps a rather fishy one.

Size Up to 45cm long.

FAMILY Salmonidae

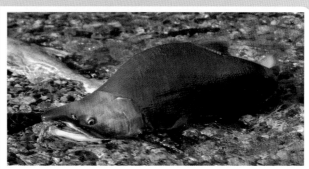

Sockeye Salmon *Oncorhynchus nerka*

Features Sockeye Salmon are iconic North Pacific fish well known and loved by fly fishermen who, along with brown bears, stalk it on its upriver breeding migrations (though the main sport fishery is for the land-locked form called Kokanee). After one to three years, the Sockeye returns from its life of ocean foraging, to spawn in the river where it was born. The males take on a dramatic red colour with a green head and compete for females. After spawning almost all the fish die, littering the river with their bodies. There are important commercial fisheries for this species.

Size Up to 60cm long.

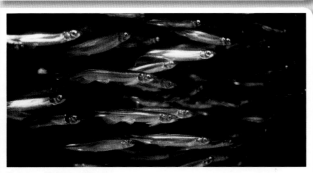

Capelin *Mallotus villosus*

Features Capelin may be small but they are one of the most abundant and ecologically important fish in the Arctic, perhaps equivalent to the sardine shoals of warmer waters. In the Barents Sea and right round the Arctic, they provide a vital link in the food web consuming planktonic crustaceans and themselves being eaten by seabirds, Beluga Whale, seals and predatory fish. Large shoals migrate close inshore to spawn where they can form quite a spectacle massed along the shoreline. They are extensively fished for their roe, for canning and for fishmeal.

Size Up to 20cm long.

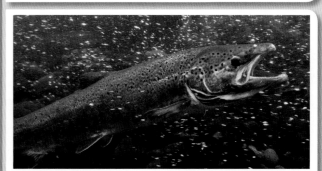

Sea Trout *Salmo trutta*

Features Sea Trout are the ocean-going, anadromous form of the purely freshwater Brown Trout played by fly fishermen in rivers and streams. Mature fish are silvery and easily mistaken for Atlantic Salmon (*Salmo salar*). After one or two years spent foraging at sea they return to spawn in their natal rivers. However unlike Sockeye Salmon (above), they do not die after spawning and many make return visits, exceptionally up to ten. Sea Trout are a NE Atlantic species found from Iceland, Scandinavia and Russia, south to Spain.

Size Up to 1.4m.

SUPERORDER STENOPTERYGII

Order STOMIIFORMES: dragonfishes

Living in the dark depths of the ocean, dragonfishes are the stuff nightmares are made of. Luckily these fearsome predators are mostly quite small rarely reaching more than 40cm in length. Most have a long body, with a large mouth, fang-like teeth and often a long chin barbel. Mostly black or dark brown in colour they would be invisible were in not for bioluminescent light shows produced by their photophores. These species have specific patterns arranged to allow recognition, to help them hunt and to hide by breaking up their outline. There are four families and 413 species.

SUPERORDER CYCLOSQUAMATA

Order AULOPIFORMES: lizardfishes

Lizardfishes are sometimes called grinners because they typically have a large, slightly upturned mouth with many small teeth. They also have large scales and benthic species are the size and shape of a small lizard. The pelvic fins are on the abdomen and are used by many species to prop themselves up. This gives them a good view all round as their eyes are near the top of the head. They have one dorsal fin plus a small adipose (fleshy) fin on the back. This is a large and diverse order with deepsea as well as shallow water representatives and benthic (bottom-living) species as well as pelagic mid-water ones. 17 families, 258 species.

FAMILY Stomiidae

FAMILY Synodontidae

Graceful Lizardfish *Saurida gracilis*

Features Divers will see this lizardfish perched on prominent rocks on coral reefs throughout the Indo-Pacific region. This photograph was taken off east coast Sabah, Borneo. It will often remain quite still until it finally darts a short distance away and takes up station again. It feeds on reef fishes in this way, its stillness encouraging its prey to come within reach and its large mouth allowing it to swallow quite large fish.
Size Up to about 30cm long.

Sloane's Viperfish *Chauliodus sloani*

Features Viperfish excel in the business of catching elusive prey in deep, dark water. The exact position of its deadly head is difficult for small fish and crustaceans to ascertain when faced with long rows of bright photophores that shift like a train passing in the night. Fang-like teeth impale the prey making escape impossible. This worldwide species is found down to several thousand metres.
Size Up to 35cm long.

FAMILY Sternoptychidae

Greater Silver Hatchetfish *Argyropelecus gigas*

Features Hatchetfish look very different from the other families in this order. The body is shaped like the head of an axe with the tail as the handle. However their light-producing photophores have the same morphology. Hatchetfish use their silvery colour and bioluminescence as camouflage. They are also incredibly thin and almost invisible when seen head on. Found worldwide to 1000m.
Size Up to about 12cm.

FAMILY Ipnopidae

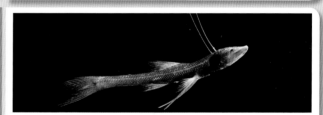

Tripodfish *Bathypterois grallator*

Features Like its coral reef relatives, the tripodfish props itself up on its pelvic fins to catch passing fish. However this deepsea species also has a greatly elongated lower lobe to its tail which acts as an additional prop to keep it above the soft mud of the abyssal plain where it lives. Its elongated pectoral fins are held above its head and it is thought these help detect fish that stray within reach in the inky darkness.
Size Up to about 40cm long.

FAMILY Gonostomatidae

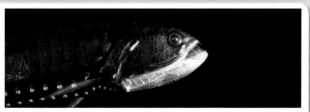

Atlantic Fangjaw *Gonostoma atlanticum*

Features This small mesopelagic fish is so named because it has a large mouth lined by many needle-like teeth. It is found worldwide in warm areas. Bristlemouths are hugely abundant and *Cyclothone* (which may be synonomous with *Gonostoma*) is estimated to have more individuals alive at any one time than any other vertebrate genera. At night it rises to within 50m of the surface where it feeds mainly on planktonic crustaceans.
Size Up to about 7cm long.

FAMILY Alepisauridae

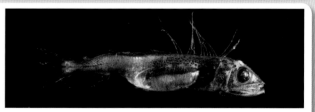

Short-snouted Lancetfish *Alepisaurus brevirostris*

Features The two species in this family both live in deepwater. This species has a circumglobal distribution and lives between about 600–1,600m deep. Whilst it is a slow mover, it can accelerate fast to ambush shrimp and fish. Most sightings are of bycatch from tuna long lining. For its size it has a huge sail-like dorsal fin but this is always damaged in net-caught specimens as shown here. It is a soft and flabby fish.
Size Up to about 1m long.

SUPERORDER SCOPELOMORPHA

Order MYCTOPHIFORMES: lanternfishes

The vast inky mid-depths throughout the entire ocean are lit up by lanternfishes which are found from the Arctic Ocean through the tropics to the Southern (Antarctic) Ocean. These small fishes have numerous photophores on the head and body, arranged in rows and small groups and must be good at pattern recognition to decipher the moving pinpricks of bioluminescent light that represent each fish. Lanternfishes are an important prey species for many larger predatory fish and cetaceans and remain in deep water down to around 1,200m during the day, rising up to as shallow as 10m at night. Here they feed on planktonic animals. Almost all of the 254 recognised species belong to one family (Myctophidae) with just six in a second family the blackchins (Neoscopelidae).

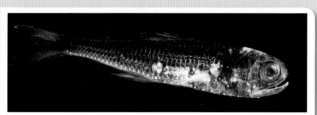

Spotted Lanternfish *Myctophum punctatum*
FAMILY Myctophidae

Features Lanternfishes are rather like the herring family in that there are lots of very similar species that are impossible for the non-specialist to tell apart. Even distinguishing the genera is difficult. However, this is a reflection of just how successful these fish are and they are undoubtedly the most abundant fish in the deep ocean both in terms of species and numbers. The Spotted Lanternfish is widespread in the N Atlantic down to about 750m. At night it migrates near to the surface to feed on small crustaceans and fish larvae.
Size Up to 11cm long.

SUPERORDER POLYMIXIOMORPHA

Order POLYMIXIFORMES: beardfishes

This single family and genus of fishes has only ten species, named for a distinctive pair of long barbels that dangle down behind the chin. As befits mesopelagic fishes living between about 180m to 650m depth, they have large eyes to make best use of the available light. Fish in this order have a unique arrangement of ligaments in the face. Some authorities place beardfishes with squirrelfishes (Beryciformes p.387) and like them they have spiny fins.

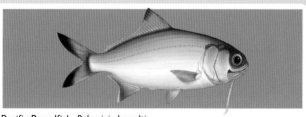

Pacific Beardfish *Polymixia berndti*
FAMILY Polymixiidae

Features Beardfishes currently have no commercial interest and tend to live in muddy and sandy areas and depths not frequented by divers and so are generally only seen as bycatch. However the solid-bodied greyish-silver Pacific Beardfish is sometimes caught by sports fishermen using deep lures. It ranges from about 20m right down to 600m depth and is found throughout the Indo-Pacific region.
Size Up to about 48cm long.

SUPERORDER LAMPRIOMORPHA

Order LAMPRIFORMES: opahs

All the fish in this small order, which has only seven families and 24 species, are large, colourful and elusive ocean wanderers. Velifers (Veliferidae) and Opahs (Lampridae) are deep-bodied fishes with a single tall dorsal fin whilst fishes in the remaining five families are long and ribbon-like with a correspondingly long dorsal fin, strange asymmetrical tails and a weak skeleton. Oarfishes (Regalecidae) are the longest of all ray-finned fishes and probably responsible for many of the famous sea-serpent stories. Although seemingly very different, all share a number of detailed morphological features including a protrusible upper jaw.

Opah *Lampris guttatus*
FAMILY Lampridae

Features Opah are as brightly coloured as any coral reef fish which is unusual for an oceanic species living in mid-water down to about 400m. Few people ever see them and even fewer see them alive as they are mostly known from stranded specimens and the occasional trawl. However the reds and blues that seem so colourful to us, provide camouflage in deep water. Very little is known about the natural history of this unusual fish except that it feeds on open water squid, pelagic crustaceans and fish and swims by flapping its pectoral fins.
Size Up to 2m long.

Oarfish *Regalecus glesne*
FAMILY Regalecidae

Features For a less than obvious reason, this fish is also known as King-of-the-herring, though it does indeed have a red 'crown' on its head, consisting of the elongate, first few rays of the dorsal fin. The pectoral fins each consist of a very long, single ray which ends in an expanded 'blade', hence Oarfish. These immense fish drift with ocean currents catching whatever other fish and squid they can, mostly between about 20–200m deep. They are occasionally scooped up by pelagic trawlers or washed ashore and are filmed even more rarely.
Size Up to 11m long.

SUPERORDER PARACANTHOPTERYGII

Order GADIFORMES: cods

Many familiar commercial fish species are included in this large order and without them the world's marine fish catch would be sadly depleted. True codfish (Gadidae) are familiar to most people especially in the Atlantic where this family attains its greatest diversity and the Atlantic Cod (*Gadus morhua*) is undoubtedly the most important and best known species. Gadiform fishes have their pelvic fins on the underside of the head or just behind it, but always in front of the pectoral fins and have between one and three dorsal fins. They are predominantly benthopelagic fishes, living near the seabed, often in large shoals which can be tracked and caught using large trawl nets. One family, rocklings (Lotidae) can be found on the shore in rock pools as can the young of some others. There are ten families and about 615 species.

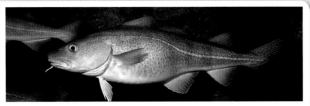

FAMILY Gadidae
Atlantic Cod *Gadus morhua*

Features The Atlantic Cod is perhaps the best known of all northern hemisphere fish, though in Great Britain many people only know in wrapped in batter. This highly edible species used to occur in huge shoals and reached weights of up to 90kg but modern fishing techniques have drastically reduced both its abundance and average size. Most of the time the fish remain within easy reach of the seabed where they feed on almost anything but they also shoal in midwater.
Size Up to 2m long; now mostly smaller.

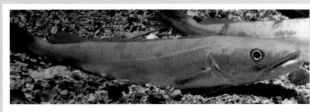

FAMILY Merlucciidae
European Hake *Merluccius merluccius*

Features Hake are a valuable commercial codfish caught in moderately deep water mostly below about 70m in the NE Atlantic. Underwater photographs of them are therefore a rarity but they seem to live within diving depths in some sealochs and fjords. They are significant predators of small fish which they catch in mid-water mainly at night and rest on the seabed during the day. Stocks have been heavily overexploited in some sea areas and are subject to EU minimum landing size restrictions.
Size Up to about 1.5m.

Shore Rockling *Gaidropsarus mediterraneus*

Features A glimpse of a long sinuous body slipping away in a rockpool or in shallow water in the NE Atlantic, is often all that can be seen of this fish. However it is worth a closer look and in a captive fish the mesmeric rippling movements of the short hair-like rays that make up the first dorsal fin are visible. This creates a current of water which brings the scent of food to the three chemo-sensitive barbels on the upper lip and chin. Other species may have four or five such barbels.
Size Up to 50cm long, usually smaller.

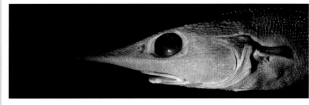

FAMILY Macrouridae
Grenadier *Coelorinchus* sp.

Features Grenadiers are often called ratfish because they have a thick head tapering to a thin rat-like tail. These fish inhabit the vast spaces of the deep ocean down to at least 6,000m. The genus illustrated has at least 123 species and in the family there are around 400 species, testimony to their success as deepwater fish. Grenadiers are mostly known from trawled specimens (as here) but have been filmed by submersibles at hydrothermal vent sites. They will eat almost anything.
Size Up to about 1m long.

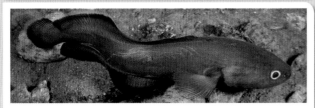

FAMILY Hexatrydonidae
Tadpole Fish *Raniceps raninus*

Features This secretive fish is usually only seen by divers at night but once spotted the same fish can often be found again because they maintain a home territory. They eat a wide range of invertebrates and small fish and are sometimes caught by anglers using baited lines. During the day the fish tend to stay hidden in crevices and amongst seaweed. The mouth appears disproportionately large mouth and has startlingly white edges to the lips and a single chin barbel.
Size Up to 30cm long.

FAMILY Lotidae
Ling *Molva molva*

Features Ling are a familiar fish to many divers, commercial fishermen and anglers but these groups might disagree on what the fish look like. Divers see young fish which lurk under rocky ledges inshore and have an attractive pale marbling over greeny-brown plus white-edged fins. Those caught offshore in deeper water, commonly between 100–300m, lack the highlights and are much larger. Ling span the North Atlantic from Canada, Greenland and Iceland to the Barents Sea and south to Morocco.
Size Up to 2m long.

Order OPHIDIIFORMES: cusk-eels

Although there are five families and a large number of species, cusk eels are not fish that most people will come across. These eel-shaped fishes lurk on the seabed, some on the seashore but often in deep water and are not generally eaten or fished for sport. However some species of pearlfishes (Carapidae) have the interesting habit of making their home with or even inside other animals including bivalve molluscs and tunicates. Inside a sea cucumber seems to be an especially desirable place to live. *Abyssobrotula galatheae* (Ophidiidae) has the record for the deepest reliable record of any fish – one was hauled up from 8,370m in the Puerto Rico trench. Viviparous brotulas (Bythitidae) are amongst the few ray-finned fishes to mate and give birth to live young. There are five families and 518 recognised species.

FAMILY Carapidae

Pearlfish *Carapus acus*

Features Fish can be found in almost every conceivable habitat within the ocean but the Pearlfish has certainly chosen one of the most unlikely. This Mediterranean fish hunts for invertebrates but spends much of its time in the rectum of large sea cucumbers. It wriggles its long, highly flexible body in tail first, an easy task with no scales or pectoral fins. Divers might see one slip half way in to the main hosts *Holothuria tubulosa* and *Stichopus regalis*, and then keep a careful watch.
Size Up to 21cm long.

Grey mullets

There is still much debate amongst fish taxonomists over the relationship of grey mullets (Mugilidae) to other fish families. Some consider that they are sufficiently different to be in their own order MUGILIFORMES, whilst other researchers place them in the PERCIFORMES. They are currently listed as Perciformes in the online Catalog of Fishes (Eschmeyer 2016) but are placed in the Mugiliformes in Fishbase (2016). Nelson (2006) discusses both possibilities but retains them in the Mugiliformes. Grey mullets have two widely separated dorsal fins, the first with four spines and the second with soft rays. The pectoral fins are set high up whilst the pelvics are below the belly. A small mouth, tiny or no teeth and a very long intestine reflect their diet of filamentous algae, diatoms and detritus. There are about 20 genera and 80 species.

Thicklip Grey Mullet *Chelon labrosus*

Features Grey Mullet are often seen milling around the surface of sheltered bays, harbours and marinas in the eastern Atlantic and Mediterranean, opening and closing their mouths as they search for floating edible debris. On the seabed they shovel in mouthfuls of mud sorting out edible material such as worms and algal detritus using their long gill rakers and modified pharynx. Puffs of rejected material come out through the gills. This species does well in public aquariums and is fished commercially and by recreational fishermen.
Size Up to about 75cm long.

Order BATRACHOIDIFORMES: toadfishes

Toadfishes all belong in one family and mostly live on the seabed in shallow coastal waters of the Atlantic, Pacific and Indian oceans. As their name suggests these fishes have a broad, squat head with a wide mouth and eyes on the top. They have two dorsal fins, the first short and the second long. Like their namesakes that can secrete poisonous slime, they should not be picked up without considerable care, but in this case it is because they have sharp, sometimes venomous, spines in the first dorsal fin, on the operculum and in the pelvic fins and will also bite if handled. Most are rather drab and stay well hidden but are easy to find when they put into use their well-known ability to produce loud sounds (see p.364).

FAMILY Batrachoididae

Oyster Toadfish *Opsanus tau*

Features Often the only part of this fish to be seen is a large toad-like head sticking out of a rocky crevice. They are frequently seen by divers along rocky coastlines and in shipwrecks but can be heard in the breeding season simply by standing on the shore or on a pier, jetty or even a houseboat. Male Oyster Toadfish make loud grunting calls in the summer to attract females into holes they excavate under rocks. These tough fish will survive in polluted and litter-strewn water and adapt well to captivity.
Size Up to about 45cm.

Plainfin Midshipman *Porichthys notatus*

Features Midshipmen, of which there are 14 species in the genus, are toadfishes with two sharp dorsal spines and as these are solid, not hollow, they cannot inject venom. This is just as well as they often come up in commercial shrimp trawls. This species and most others in this genus live on mud and sand in shallow water and yet have numerous bioluminescent photophores, something usually only found in deepwater fishes. This species is found in the eastern Pacific from Alaska to Baja California.
Size Up to 29cm long.

Order LOPHIIFORMES: anglerfishes

Of all marine fish orders, this one contains some of the most bizarre species. Anglerfishes have cavernous mouths and use modified first dorsal fin rays and sometimes chin barbels as fishing lures. Divers and fishermen will encounter shallow water species with flattened bodies living on the seabed and some of these are commercially valuable. There are also many round-bodied, deepwater pelagic anglerfishes which live slow lives drifting in the darkness, enticing their prey within reach using bioluminescent lures. There are 18 families and about 350 species.

Angler *Lophius piscatorius*
FAMILY Lophiidae

Features The angler is an expert in camouflage and has surprised many divers who do not see it until it explodes out from the seabed and swims hurriedly away. Its large, flattened head, fringed with lobes of skin that break up its outline, is followed by a stout tapered body and tail. Seen head on it appears to be all mouth and it has needle-sharp teeth to impale any fish foolish enough to be taken in by its flickering lure. This species is found in the eastern North Atlantic as far south as the Mediterranean and Mauritania in depths from around 20m to as much as 1,000m. It is caught and sold as 'monkfish' or 'goosefish'.
Size Up to 2m long.

Red-lipped Batfish *Ogcocephalus darwini*
FAMILY Ogcocephalidae

Features In shape and colour, batfish are about as far removed from the normal conception of a fish as you can get. These knobbly, squat anglerfish scramble over the seabed using their pectoral and pelvic fins as props. Unlike most anglerfishes they have only a very short fishing lure on the head and exactly how they find their food is unknown. However there is structural evidence that the lure may secrete an attractive substance. Why this species has such red lips is also a mystery. It occurs in the Galapagos Islands and along the west coast of S America.
Size Up to about 20cm.

Warty Frogfish *Antennarius maculatus*
FAMILY Antennariidae

Features It is difficult to imagine anything less like a 'normal' fish or more charming than a frogfish. For a start they have arm-like pectoral fins which they use to clamber around over the seabed. Then there is their colour, which is highly variable in this and many other species. Frogfish can swim but rely on their camouflage both to protect them from larger predators and to remain hidden from their prey. The Warty Frogfish, like most in its family, lives in warm tropical waters, in its case in the Indo-West Pacific, but will only be spotted by very observant divers.
Size Up to 15cm long.

Linophryne (probably) *arborifera*
FAMILY Linophyrinidae

Features The specific name of this anglerfish reflects its hugely developed, branching bioluminescent fishing lure and chin barbel, both of which are used to attract prey. Bioluminescence in the fishing lure is produced by bacteria contained in the basal bulb whilst light from the chin barbel is produced directly by many tiny photophores. Observations of just how such deepsea fish feed are naturally scarce and information on what they eat is derived from stomach contents of trawled fish. This species is not often caught but has been recorded from various locations in both the Atlantic and Pacific oceans.
Size Female up to about 8cm long, male tiny and parasitic.

Sargassumfish *Histrio histrio*

Features The Sargassumfish lives a floating existence on rafts of *Sargassum* seaweed along with a myriad of other animals (see p.61). Diving or snorkelling amongst a mass of seaweed is not to everyone's taste, but this is the best way to observe this exceedingly well-camouflaged fish. In colour and skin texture it closely resembles the weed amongst which it scrambles, using its stumpy leg-like fins. This allows it to lure in unsuspecting small fish and shrimps. The fish will also associate with floating debris and are sometimes washed ashore during storms.
Size Up to 20cm long.

Atlantic Footballfish *Himantolophus* (probably) *groenlandicus*
FAMILY Himantolophidae

Features This is one of the most widespread of deepsea anglerfishes and is found worldwide in temperate and tropical areas but there are also 21 other species in this genus. The female is large and rotund with a short, blunt snout covered in wart-like papillae and a stout, luminous, fishing lure topped with a fringe. The small males are free-swimming unlike the parasitic males found in many other families of deepsea anglerfishes. They have large olfactory organs to help in the search for a mate.
Size Female up to 60cm long, male to 4cm.

SUPERORDER ACANTHOPTERYGII

Order GOBIESOCIFORMES: clingfishes

These small fishes, mostly less than 10cm long, all belong to one family and live on the seabed in shallow water. Some use sea urchins and other echinoderms as their home and are only found in association with their chosen host. Clingfishes have their pelvic fins modified to form a sucker disc which they use to hold onto rocks, seaweeds or other objects. They have one soft, dorsal fin and generally no scales. Their exact taxonomic relationships remain uncertain and some authorities include them in the Perciformes. There are about 160 species.

Order ATHERINIFORMES: silversides

Almost all the numerous species in this order are small, silvery fish found in warm temperate and tropical waters. Swirling shoals can be seen in lakes and other freshwaters as well as the sea, since only around a third of the 335 species live in the ocean. Lucky boat users may see them pour up in a silvery arc, frightened out of the water by engine noise. Silversides usually have two dorsal fins and one anal fin. There are nine families.

Shore Clingfish *Lepadogaster purpurea*

Features This clingfish lives in the underworld of the seashore and can be found by turning boulders over (and back again) on rocky shores of the NE Atlantic. Another hiding place is amongst kelp holdfasts in shallow water. Females attach their eggs to the undersides of their stone or boulder home and one of the pair guards them until they hatch and drift away as planktonic larvae. The flattened duck-billed shape of the head and low profile helps the fish to slip in and out of crevices and resist wave wash.
Size Up to 6.5cm long.

California Grunion *Leuresthes tenuis*

FAMILY Antherinopsidae

Features Grunion provide an annual spectacle and a feast for seabirds as thousands of them spawn on sandy beaches on night-time high spring tide along the Californian coast. The spawning runs occur a few days after the new or full moon during spring and summer. Each female partially buries herself in the wave-washed sand to lay her eggs whilst a male wraps himself around her to fertilise them. They then wriggle back on the receding waves but the eggs remain until washed out on the next spring tide when they hatch immediately.
Size Up to 19cm long.

Two-spotted Clingfish *Diplecogaster bimaculata*

FAMILY Gobiesocidae

Features Small clingfishes such as this one can be very difficult to identify especially as there are 46 genera in the clingfish family found worldwide. This NE Atlantic and Mediterranean species has a small, pointed head and a short dorsal fin set near the tail. Males have a characteristic purple spot behind each pectoral fin but females without them as here, are very similar to several other species. With an enviable ability to hang onto rocks and stones in strong currents and waves, this and most other clingfish species live on shores and in shallow water.
Size Up to 6cm long.

Sand Smelt *Atherina presbyter*

FAMILY Atherinidae

Features These small pelagic fish shoal along coasts and in estuaries in the NE Atlantic where they are an important food source for plunge diving seabirds such as terns, especially during the nesting season. Seen underwater they have a brilliant iridescent stripe running along their flanks but otherwise the silvery shoals could be mistaken for sandeels. Sometimes their eggs can be seen in shore pools and shallows each attached to seaweed by a sticky filament. Though not directly exploited they are a constituent of 'whitebait'.
Size Up to 20 cm long.

Crinoid Clingfish *Discotrema crinophilum*

Features This small, striped clingfish makes its home amongst the arms of featherstars especially *Oxycomanthus bennetti* (p.303) where it lives as a harmless commensal. It leads a slow life searching for food scraps in and around its host. Whilst it always has a central pale stripe flanked by two others on a dark background, the intensity of its colours depends on the colour of its home featherstar. It is found in the tropical western Pacific on sheltered coral reefs down to about 20m depth.
Size Up to about 5cm long.

Surf Sardine *Notocheirus hubbsi*

FAMILY Notocheiridae

Features Surf Sardines are not sardines at all and the alternative name of Surf Silverside is perhaps more appropriate. This species is the only one in its genus and family though five closely related species (*Iso*) are variously placed with it or in their own family (Isonidae). It has a slightly top heavy look with the deepest part of its body just behind the head. The Surf Sardine occurs in surface water along the Pacific coasts of Chile and Argentina where it feeds mainly on copepods.
Size Up to about 6cm long.

Order BELONIFORMES: needlefishes

Most of the aptly named needlefishes have long, rod-shaped bodies and jaws that are extended and form a beak. However this order also includes the slightly stouter but very graceful flying fishes. Using their powerful tail, flying fish can propel themselves up out of the water and then glide on large outspread pectoral and pelvic fins. This is an excellent escape mechanism from predators. Needlefishes on the other hand are so long and thin that they often escape detection. There are six families and about 250 species. Nearly half of these live in freshwater.

FAMILY Exocoetidae

Flyingfishes Exocoetidae

Features Flyingfishes have evolved the stunning ability to launch themselves out of the water and glide for long distances on outstretched pectoral and pelvic fins. Their streamlined torpedo-shape and deeply forked, powerful tail make this a very effective predator escape tactic. All of them have their pectoral fins developed as 'wings' but in two genera (*Exocoetus* and *Parexocoetus*) the pelvic fins are large enough to aid flight and these are often dubbed 'four-winged' species.
Size Up to about 30cm long.

FAMILY Belonidae

Red Sea Needlefish *Tylosurus choram*

Features It can be slightly unnerving seeing a needlefish out of the corner of your eye during a dive. They tend to hang motionless just beneath the surface like a disembodied silver sword. With such a stealthy approach, they are able to pick off smaller fish with their long, beak-like jaws lined with sharp teeth. Although this is a Red Sea fish, divers might nowadays see it in the eastern Mediterranean which it has reached through the Suez Canal. Similar species are found in the warm waters of other oceans.
Size Up to 1.2m long.

FAMILY Hemiraphidae

Ballyhoo Halfbeak *Hemiramphus brasiliensis*

Features Halfbeaks, of which there are 11 species in tropical and warm temperate water worldwide, look and behave very much like needlefishes. They hang around just subsurface near rocky or coral reefs singly or in small groups but also form sizeable shoals. As their name suggests, the top jaw is a fraction of the length of the lower jaw, an arrangement reminiscent of seabirds called skimmers (p.475). The species illustrated here occurs in warm waters of the western Atlantic.
Size Up to 50cm long.

FAMILY Scomberesocidae

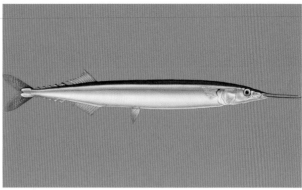

Atlantic Saury *Scomberesox saurus*

Features The Atlantic Saury ranges right across the North Atlantic and large shoals can be found far out to sea feeding in surface waters on zooplankton and fish eggs and larvae, mainly at night. This species is an important food for larger fishes and the shoals are attacked by billfishes, tuna, codfishes and also dolphins. When chased the fish often leap well clear of the water to try and confuse pursuing predators. It is highly migratory and moves to the south of its range at the onset of winter and northward in spring.
Size Up to 50cm long, usually smaller.

Order STEPHANOBERYCIFORMES: pricklefishes

There are currently four families and about 66 species included in this order whilst three families of so-called whalefishes previously included are now placed in the order Cetomimiformes. Information on most species comes from specimens trawled up from the deepsea and so little is known of their lifestyle. These are chunky, rounded fishes with large mouths. The name of the order derives from the spiny scales that cover some species.

FAMILY Stephanoberycidae

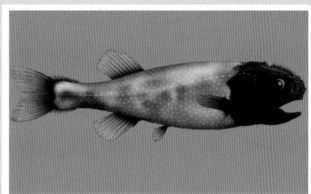

Pricklefish *Acanthochaenus luetkenii*

Features This small prickly fish covered in spines, inhabits deep bathyal regions in subtropical and temperate areas of the Pacific, Atlantic and Indian Oceans. Like so many little known deepwater fishes, its depth limits and biology have been worked out from relatively few specimens and much remains to be learnt. It probably lives in midwater and ranges from about 1,500m down to 6,400m. However, crab remains found in the stomach contents of some individuals suggest these were taken from the seabed.
Size Up to about 14cm long.

Order BERYCIFORMES: squirrelfishes

Anyone diving in the dim recesses of shipwrecks in tropical waters or on a coral reef at dusk will be familiar with the beautifully striped squirrelfishes and soldierfishes. However there are also some deepsea species in this order including the commercially important Orange Roughy. Fishes in this marine order have deep bodies covered in large scales. They have a single dorsal fin usually with a spiny front section and a forked tail. Most live in dim or dark water and so have large eyes and are coloured red, orange or black. There are seven families and 163 species.

Pinecone Soldierfish *Myripristis murdjan*

FAMILY Holocentridae

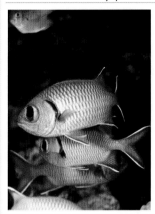

Features This soldierfish is just one of 28 species in the genus *Myripristis* but is typical of those found in the Indo-Pacific region. They are all very similar, distinguished by subtle differences in head shape, colour and markings. This species has an obvious white leading edge to most of its fins. It is commonly seen by divers lurking in the recesses of wrecks or near shelter on reef flats during the daytime, usually in small groups. At night it uses its large eyes to pick out planktonic crustaceans.
Size Usually up to 20cm long, sometimes more.

Pineapplefish *Cleidopus gloriamaris*

FAMILY Monocentridae

Features Australian animals have a tendency to be either venomous or outrageous. The endemic Pineapplefish certainly fits the latter with its eye-catching colour pattern and large plate-like scales each with a stout spine. It also has a pair of light organs on the lower jaw which house bioluminescent bacteria. Normally hidden by the upper jaw, the lights are 'turned on' when the fish opens its mouth. It inhabits steep rocky reefs down to around 300m but can be seen by divers lurking in dark recesses. It is one of only four species in its family.
Size Up to 22cm long.

Longspine Squirrelfish *Holocentrus rufus*

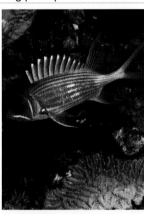

Features Squirrelfishes are similar in size and colour to soldierfishes but most species have dark stripes along the body and all have a strong spine on the edge of the gill cover (preopercle spine). Longspine Squirrelfish are found in the western Atlantic including the Gulf of Mexico and Caribbean. However most species in this family live in the warm waters of the Pacific and Indian oceans. At night this nocturnal species moves away from its daytime rocky lairs and out over shallow reefs and seagrass beds to search the seabed for crustaceans and gastropods.
Size Up to about 30cm long.

Eyelightfish *Photoblepharon palpebratum*

FAMILY Anomalopidae

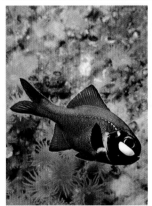

Features Most fish with bioluminescent light organs live too deep for divers to see but the Eyelightfish is an exception. Hiding in caves during the day, the fish rise up at night to within 10m or so of the surface and signal each other with large light organs, one under each eye. Divers see them in the Indo-West Pacific on ocean-facing steep rocky or coral slopes as blinking lights, switched on and off by a moveable black membrane. This strategy can startle and confuse predators as well as showing up prey.
Size Up to 12cm long.

Orange Roughy *Hoplostethus atlanticus*

FAMILY Trachichthyidae

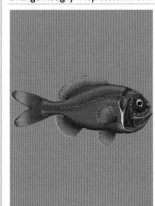

Features The Orange Roughy was once a fish that almost no-one ever saw as it lives in steep rough areas between about 1,000–2,000m down. However in recent years advances in technology have allowed a fishery to develop for this species, targeting aggregations that occur sporadically and that can be detected with sonar. It grows and reproduces extremely slowly and it has been heavily overfished in some areas. Age determinations suggest it may live for around 150 years. Trawling for it also damages cold water corals and sponges.
Size Up to about 75cm long.

Common Fangtooth *Anoplogaster cornuta*

FAMILY Anoplogastridae

Features The fangtooth is well-named as it has a mouthful of very long, rapier-like teeth. Prey is short in the bathypelagic depths where this fish lives but with these teeth it has a good chance of keeping anything it might bite into, even fish larger than itself. Like many deeepsea fish it has very small scales, no fin spines and lightweight bones all of which reduce its weight. It is found worldwide in the ocean depths, mostly between 500–2,000m. Juveniles live much nearer the surface and look totally unlike the adult, with long head spines.
Size Up to 18cm long.

Order ZEIFORMES: dories

Now you see them, now you don't. This is a trick many dories can play because most have thin but deep bodies. So whilst obvious seen from the side, they virtually disappear when seen head on. Most have greatly distensible jaws and 5–10 spines in the front part of the dorsal fin. There are six families with 33 species.

Order GASTEROSTEIFORMES: sticklebacks

Sticklebacks are perhaps most familiar as small fish caught by children in streams and lakes in the northern hemisphere and most of the 29 species live in freshwater. However there are a few marine species plus a number of closely related tropical Indo-West Pacific sea moths. Fish in this order have a long, thin body, usually stiffened by bony scutes along the flanks and with sharp, separated spines along the back preceding a normal, soft dorsal fin. There are five families.

John Dory *Zeus faber*

FAMILY Zeidae

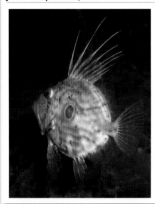

Features Shaped like an oval dinner plate, with a tall spiny first dorsal fin and a thumbprint mark on each side, the John Dory could hardly be mistaken for any other fish. It is best known for its ability to hang almost motionless in the water as it stalks its prey head on. When it has edged near enough it shoots out its highly protrusible jaws with great accuracy and engulfs its victim. The action is so fast it can only be truly appreciated by slow motion photography. It is found worldwide at depths ranging from about 5m down to 400m.
Size Up to 90cm long.

Three-spined Stickleback *Gasterosteus aculeatus*

FAMILY Gasterosteidae

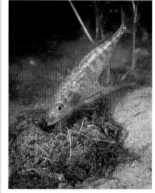

Features This little fish along with others in this family is amongst the most intensively studied of any. It is easy to obtain and keep in captivity allowing its nest building and elaborate courtship dance to be scrutinised closely. A wide variability in colour and other features has prompted genetic and evolutionary work. It is widespread in shallow coastal waters as well as in freshwater streams and even ditches. When raised up, the three spines on its back help protect it from predatory fish and birds.
Size Up to 11cm long.

Thorny Tinselfish *Grammicolepis brachiusculus*

FAMILY Grammicolepididae

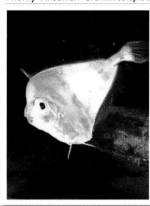

Features Like its larger relatives, this little dory has a thin body, upward-sloping mouth and a large well-armoured head. It and the other two species in this family, are also called tinselfishes because of their intense, silvery colour. The dorsal fin has six to seven spines followed by a long, soft-rayed portion. It lives in the Atlantic Ocean between about 300m and 1,000m depth, mostly within reach of the seabed. This species serves to illustrate the less well known deepwater members of this small order.
Size Up to about 60cm long.

Sea Stickleback *Spinachia spinachia*

Features The elongated shape, stiff posture and spiny back make this a typical stickleback. As it has 15 spines on its back, it is also (naturally) called the Fifteen-spined Stickleback though the range is 14–17. The best way to find these fish is to search amongst dense stands of seaweed in rocky areas or amongst seagrass in the NE Atlantic. Sometimes divers find neat nests of seaweed strands glued together by the male with kidney secretions. The female lays her eggs in the nest but it is the male that guards them until they hatch.
Size Up to 20cm long.

Boarfish *Capros aper*

FAMILY Caproidae

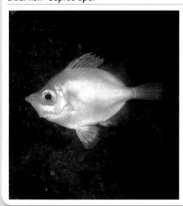

Features The Boarfish and the other genus (*Antigonia*) of 17 species in the Caproidae family used to be placed within the Zeiformes but work in the last ten years strongly suggests that they belong in the Perciformes and this is where most classifications now place them. The Boarfish does superficially resemble a small dory but there are clear (to specialists) differences in their skeletal morphology. Divers sometimes see small shoals of this NE Atlantic fish but it mostly lives in rocky areas below 100m depth.
Size Up to 30cm long.

Sea moth *Pegasus* sp.

FAMILY Pegasidae

Features Like sticklebacks, sea moths have a rigid body protected by bony plates. They have a very odd shape for a fish and divers coming across them on the seabed often wonder what on earth they are. Their pectoral fins are large and lie horizontally and the mouth is hidden beneath a flattened rostrum (snout extension). Unlike sticklebacks they have no spines on the back, but there is are remnants of their bony bases present. The five known species are difficult to tell apart.
Size Largest species up to about 14cm long.

Order SYNGNATHIFORMES: seahorses and pipefishes

The slow, stately progress of a seahorse through the water is dictated by the stiffness of its body which is encased by a series of bony rings. This means it must swim by fluttering movements of its dorsal fin. Elongate pipefish have a little more flexibility plus a tail fin to help them along. A small mouth at the end of a long tubular snout restricts their diet to tiny planktonic animals such as copepods (p.306). However their most famous feature is the male's brood pouch where the female lays her eggs and leaves them to be reared by the male. There are five families and about 312 species.

Short-snouted Seahorse *Hippocampus hippocampus*

Features Whilst most seahorses live in tropical waters this is a NE Atlantic species, one of only two that breed as far north as the Channel Islands, UK. Here it is a favourite with divers, as are all seahorses. Relying on camouflage to protect them, they usually remain quite still clinging onto seaweed and seagrass with a prehensile tail. The tube-like mouth is used daintily like a drinking straw to suck in planktonic copepods. Males court the females with an elegant dance until she finally lays her eggs in his brood pouch.
Size Up to 16cm tall.

FAMILY Syngnathidae

Trumpetfish *Aulostomus maculatus*

Features Trumpetfish are mostly encountered on coral reefs and flats often standing on their heads amongst sea whips and other gorgonians of which there are plenty on Caribbean reefs. With their long, straight bodies this is an effective way of hiding. They are clever predators well-known in some areas for their habit of shadowing moray eels and then catching small fish flushed from their hiding places. They also use large herbivorous fish as cover to sneak up on unsuspecting small fish, flaring the mouth wide open.
Size Up to 1m long.

FAMILY Aulostomidae

Leafy Seadragon *Phycodurus eques*

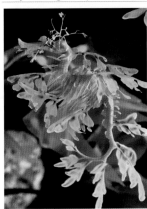

Features The Leafy Seadragon is another of Australia's quirky endemic fishes and resembles a piece of seaweed with eyes. The luxuriant fin extensions and tassels that adorn it and its irregular twisted body, provide excellent camouflage amongst the seaweed-covered rocks and seagrass beds where it lives. It uses its extremely long tubular snout to suck in small shrimps from some distance away. Even its movements are designed to mimic swaying seaweeds. The male carries the eggs stuck to the underside of his tail.
Size Up to 35cm long.

FAMILY Syngnathidae

Razorfish *Aeoliscus strigatus*

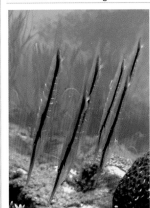

Features Being encased in transparent bony plates and flattened from side to side should make it difficult to swim in synchronised groups, but Razorfish manage it in a vertical position with their long, tubular snouts pointing down. Small groups moving over a reef certainly look nothing like normal fish fit for a predator. They can swim horizontally if necessary but rarely do so. A vertical posture allows them to hide amongst tall gorgonians and branched corals and even between the spines of black *Diadema* sea urchins.
Size Up to 15cm long.

FAMILY Centriscidae

Snake Pipefish *Entelurus aequoreus*

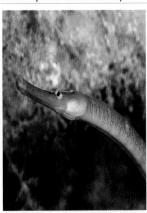

Features Pipefish are found worldwide in shallow coastal waters and whilst some are drab, many exhibit a variety of colourful patterns. The Snake Pipefish is encircled by elegant pale blue bands and is surprisingly well camouflaged in the seaweeds amongst which it lives. It has a particularly smooth body for a pipefish and moves with an effortless snake-like grace that belies the stiff segmented bony armour beneath its skin. Recent unusual population explosions along European coasts have not been fully explained.
Size Up to 60cm long.

Harlequin Ghost Pipefish *Solenostomus paradoxus*

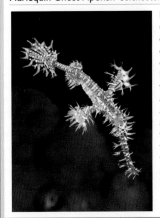

Features Ghost pipefish drift unobtrusively through the undergrowth on tropical Indo-West Pacific reefs confident in their camouflage. To our eyes the Harlequin or Ornate Ghost Pipefish appears brightly coloured, but the broken pattern, skin tassels and apparently disembodied tail and fins are an excellent disguise in its usual haunt amongst featherstars and seafans. In the five species in this genus and family, it is the female that cares for the eggs, carrying them in a pelvic fin pouch, not the males as in true pipefishes and seahorses.
Size Up to 12cm long.

FAMILY Solenostomidae

RAY-FINNED FISHES

Order SCORPAENIFORMES: mail-cheeked fishes

This large and diverse order includes the highly venomous stonefishes, scorpionfishes, sea robins or gurnards, flatheads, sculpins, lumpsuckers and sea snails amongst others. There are 36 families and over 1,600 species and their classification remains a subject for research and interpretation. What they share in common is a bony ridge across the cheek (suborbital stay). Most have a large head and are armoured with various bony plates and spines. In spite of their sometimes unappealing appearance some of the larger species make good eating.

Stonefish *Synanceia verrucosa*

FAMILY Scorpaenidae

Features The Stonefish has the dubious honour of being the world's most venomous fish, with a sting that can kill. However, it is also one of the world's best camouflage experts and can match its background to perfection. This of course, is what makes it so dangerous to divers and swimmers who put out a hand to steady themselves or inadvertently tread on one. There are four other species in the genus, all found in the Indo-Pacific and all venomous and five other monotypic (with only one species) genera of stonefishes.
Size Up to 40cm long.

Beaufort's Crocodilefish *Cymbacephalus beauforti*

FAMILY Platycephalidae

Features Like their namesake, crocodilefish lie quietly resting on the seabed but explode out of hiding to catch their prey. This family are also known as flatheads but crocodilefish certainly suits this species. A diver can often get within touching (not recommended) distance before the fish swims off with a burst of speed, settling back down a short distance away. Flatheads are widespread Indo-Pacific fish and this species is relatively common in the western Pacific including Malaysia, Philippines and northern Australia, on sand and rubble areas of coral reefs.
Size Up to 50cm long.

Spotted Lionfish *Pterois antennata*

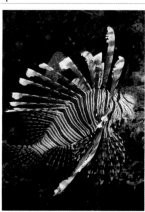

Features Like stonefishes, lionfishes have venomous fin spines, but unlike the former they advertise this fact with their gaudy red, black and white stripes. The best time to see Spotted Lionfish or any of the other nine species in this genus is at dusk when most come out to hunt. Lionfishes are Indo-Pacific fish, but in recent years, *P. volitans* and *P. miles* have invaded West Atlantic and Caribbean coral reefs as a result of home aquarium releases. These voracious predators are having a significant impact on native fish populations.
Size Up to 20cm long.

Hooknose *Agonus cataphractus*

FAMILY Agonidae

Features The Hooknose is a NE Atlantic representative of the poachers, a family of fish that occur mostly in the North Pacific. It is an excellent example of the heavy body armouring of bony plates, common in the Scorpaeniformes. Its descriptive common name results from a pair of strong, hook-like spines on the snout. A wealth of short barbels under the head help the fish to find invertebrates amongst the sand, stones, shell-gravel or maerl, where it is commonly seen by divers. Its diet includes young shellfish and it can be a nuisance on commercial beds.
Size Up to about 20cm long.

Longspined Bullhead *Taurulus bubalis*

FAMILY Cottidae

Features The Long-spined Bullhead is just one of nearly 200 marine species in the family Cottidae, generally known as sculpins with the widest diversity occurring along the North Pacific coastline. This will be a familiar resident to anyone who has searched rock pools in the NE Atlantic, but tidepool species in North America are very similar. Seen head on as here, its long protective spines, hard, knobbly body and large eyes give it a reptilian appearance. However a well-developed ability to change colour and blend in, makes it hard to spot.
Size Up to 25cm long.

Lumpsucker *Cyclopterus lumpus*

FAMILY Cyclopteridae

Features The lumps and bumps that cover an adult Lumpsucker are the ends of rows of protective bony plates under the skin. This protection is particularly important for males which guard the eggs assiduously after one or several females have laid them on rocks. Females however, may lose their eggs (and lives) to the caviar industry. A strong sucker derived from the pelvic fins allows the fish to cling onto wave-battered rocks near low tide, a favoured egg-laying site which deters predators. Marble-sized young appear in rock pools on both sides of the northern North Atlantic in spring.
Size Up to 60cm long.

Order PLEURONECTIFORMES: flatfishes

Flatfishes undergo a unique metamorphosis from a normal upright juvenile living in the plankton, to a flattened adult with both eyes on the same side of the head, lying on the seabed (see p.xxx) eyed side uppermost. This order contains some of the world's most important commercial fishes with species found worldwide, mostly in the relatively shallow waters covering continental shelves (p.36). There are 11 families and about 780 species. This and the following order normally follow Perciformes but are placed here for convenience.

FAMILY Pleuronectidae

European Plaice *Pleuronectes platessa*

Features Plaice can be found on fishmongers' slabs from Greenland, Iceland and Norway to Morocco and the Mediterranean and is one of the most important North Atlantic commercial fishes. Dotted with bright orange spots, this right-eyes flatfish is also commonly seen by divers and juveniles can be netted in sandy pools and along shorelines. However, many stocks have been overfished necessitating fishing controls such as minimum landing size. Left alone, they can live for at least 30 years, emerging from a covering of sand to hunt as darkness falls.
Size Now mostly to 50cm long but potentially 1m.

FAMILY Bothidae

Peacock Flounder *Bothus lunatus*

Features Divers in the Caribbean often come across the aptly named, brilliantly coloured Peacock Flounder. Most flatfish are rather drab and many have the ability to change their colour to suit their background but this species appears to stand out. However, it too can change its colouring though the spots remain faintly visible. Flounders in this family (Bothidae) are all left-eyed in contrast to righteye flounders (Pleuronectidae) such as the Plaice (see above). It lives in sand and rubble areas especially near mangroves, seagrass beds and reefs from Florida and the Bahamas to Brazil.
Size Up to 46cm long.

FAMILY Scophthalmidae

Turbot *Scophthalmus maximus*

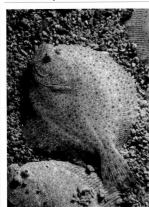

Features Turbot is in the same family as Topknot (below) and so is also left-eyed, but is a giant in comparison and lives on sediment not rock. It makes very good eating and is aptly shaped like a round dinner plate. It is commercially fished in the N Atlantic and the Mediterranean and fetches high prices. It does well in captivity and is found in many commercial aquaria and is also farmed, with Spain the main producer. Females move inshore to breed and juveniles can be sometimes be caught in push nets along sandy shores.
Size Up to 1m long.

Topknot *Zeugopterus punctatus*

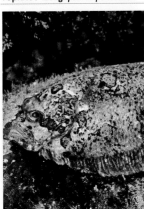

Features Whilst most flatfish live and hunt on sediment, Topknot have adapted to life on rocks. Finding them can be difficult as they can cling tightly to vertical surfaces using the suction of their wide, flat body and fins. They do well in public aquariums but even there they are not easily spotted. This species, found in the NE Atlantic from the Bay of Biscay to Norway, has recently (2000) been recorded from Newfoundland, Canada. Topknots, of which there are several other species, are left-eyed flatfish in the same family as the widely exploited Turbot (*Scophthalmus maxima*) but their smaller size and rocky habitat saves them from exploitation.
Size Up to 25cm.

FAMILY Soleidae

Moses Sole *Pardachirus marmoratus*

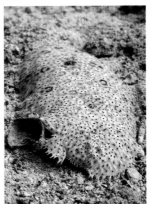

Features Soles give the impression of being slightly woebegone due to their small, down curved mouth shaped like a new moon. They have a stubble of short skin tassels under the head that is particularly well-developed in the Moses Sole. The approximately 160 species in the family (Soleidae) are oval-shaped and many, such as the Dover Sole (*Solea solea*) make good eating and are commercially important. However the Indian Ocean Moses or Speckled Sole produces a bitter defensive chemical from its fin bases which has been demonstrated to deter predators including sharks.
Size Up to 26cm long.

Carpet Sole *Liachirus melanospilos*

Features The blotched and spotted leopard-like pattern of this sole acts as disruptive camouflage, breaking up its outline and making it hard for predators to pinpoint their target. This Indo-West Pacific species lives in sandy shallow areas, estuaries and straits such as Lembeh Strait, Indonesia which is famous for the many small but weird and wonderful animals found there. Out in the open with no rocks or coral to hide behind, camouflage is a major means of defence for this and other bottom-living fish
Size Up to 15cm long.

Order TETRAODONTIFORMES: pufferfishes and relatives

Whilst differing hugely in size and shape, fishes in this order all have the same sort of teeth, either just a few large ones or fused tooth plates. They grind these or pharangeal teeth together to make sounds though some vibrate their swim bladder. Most have scales modified as spines or protective plates. Included here are the puffers, well-known both for their poisonous flesh and their ability to inflate themselves by swallowing water. Triggerfishes and boxfishes are also in this order. There are 10 families and around 430 species.

Blackspotted Puffer *Arothron nigropunctatus*

FAMILY Tetradontidae

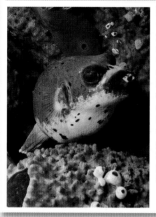

Features Confident in their ability to deter predators with their tough prickly skin and poisonous flesh, puffers, especially the larger ones, are relatively unafraid of divers and can often be approached quite closely. If it is attacked by a predator, the Blackspotted Puffer can, like other puffers, inflate itself with water thus increasing its size and making itself a much less desirable target. Most of the time it can be found grazing peacefully on Indo-Pacific coral slopes rich in invertebrates such as sponges, corals, molluscs, sea squirts all of which it eats.
Size Up to 35cm.

Scrawled Filefish *Aluterus scriptus*

FAMILY Monacanthidae

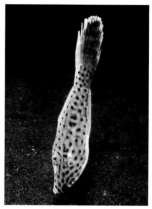

Features Divers in the Caribbean, Indian or Pacific Oceans are all equally likely to see this fish which is found on tropical reefs all round the world. Filefish are also known as leatherjackets reflecting their tough skin and are closely related to triggerfish. They too have a sharp first dorsal spine which they can erect but cannot lock in place. The Scrawled Filefish can be easily recognised by its squiggly blue pattern and large, fan-like tail. Its pointed snout and strong teeth allow it to pick off seafan polps, nibble algae and tear off sea squirts.
Size Up to just over 1m long.

Spot-fin Porcupinefish *Diodon histrix*

FAMILY Diodontidae

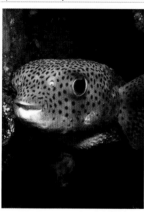

Features Porcupinefishes are similar in shape and habit to puffers but have a dense covering of sharp, prickly spines. This species has a circumtropical distribution and so can be found in the Atlantic, Pacific and Indian Oceans. Like puffers, porcupinefish drink water to inflate their bodies when threatened and the resulting prickly ball is impossible for most predators to tackle. Sadly this ability has led to their sale as inflated, dried curios. The best time to see them is at dusk when they come out to feed. Juveniles are pelagic which explains the wide distribution of this species.
Size Up to 90cm long.

Boxfish *Ostracion cubicus*

FAMILY Plesiobatidae

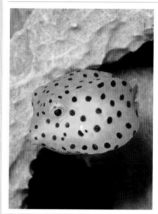

Features As it is encased in a bony box, this ungainly fish must swim using only its fins and steering with its tail. The photograph is of a juvenile and adults are a more muted dull yellow with the spots less prominent. The young hide in crevices, here amongst sponges but often between the branches of *Acropora* coral. They can be seen on Indo-Pacific coral reefs picking delicately at algae but also eat a wide range of small invertebrate animals.
Size Up to 45cm long.

Clown Triggerfish *Balistoides conspicillum*

FAMILY Balistidae

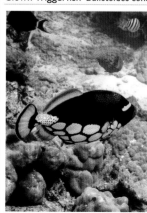

Features Of all the fish in the ocean, this must rank the top for gaudy colours. In the fish-crowded Indo-Pacific reef waters that it inhabits, its colours help in recognition but perhaps surprisingly, may also help to disguise it when some distance from a predator. All triggerfish also have the ability to wedge themselves safely in crevices by erecting and locking their so-called 'trigger', actually the leading spine in their first dorsal fin. Apart from colour, they can be recognised by the way they swim with a waggling motion of the second dorsal and anal fins.
Size Up to 50cm long.

Ocean Sunfish *Mola mola*

FAMILY Molidae

Features This is the world's heaviest bony fish and yet it feeds largely on jellyfish and other gelatinous plankton. However it will also make a meal of other small fish and various invertebrate. They often swim near the surface using their tall dorsal and anal fins and can be spotted from ferries and other ships especially on calm, sunny days. Divers may see them near reefs where they possibly come to be cleaned by cleaner fish. Although not often seen it is widespread in all temperate and warm oceans.
Size Up to 4m long.

Order PERCIFORMES: perches and relatives

The majority of fishes that any one person will see in their lifetime will belong to this order. This is the largest and by far the most diverse order of ray-finned fishes with approximately 10,760 species. Perciform fishes are far more numerous than any other vertebrates in the ocean and there are also well over 2,000 freshwater species especially in the tropics. To give a feel for the immense variety of these fishes, which inhabit almost every conceivable niche in the ocean (and freshwaters) typical species found in various habitats are shown in the following pages. There are 165 families but just eight of these contain around 55% of the species (Nelson 2006). These are gobies (Gobiidae), wrasses (Labridae), blennies (Blenniidae), cardinalfishes (Apogonidae), damsfishes (Pomacentridae), drums or croakers (Sciaenidae), sea basses (Serranidae) and the purely freshwater cichlids (Cichlidae). Perciform fishes have spines in the first dorsal, anal and pelvic fins.

Indo-Pacific coral reef PERCIFORM fishes

Staghorn Damselfish *Amblyglyphidodon curacao*

FAMILY Pomacentridae

Features Dive or snorkel over a healthy coral reef and you will be almost certain to see a wide variety of damselfishes, wherever you are in the world. Many of these small oval fish are territorial and will stay to defend their patch even from bubble-blowing divers. The Staghorn Damsel is common throughout the tropical western Pacific and is often seen feeding in groups over staghorn coral, picking plankton from the water or nibbling on filamentous algae. Like other damsels, the males guard the eggs which are stuck onto rocks.
Size Up to 11cm long.

Blacktip Grouper *Epinephelus fasciatus*

FAMILY Serranidae

Features During the day this small grouper can be seen resting on corals or rocks and in dimly lit areas can often be approached quite closely. This one was photographed in the typical habitat of a seaward-facing reef, off Mabul Island, Sabah, Malaysia. It is a common species with a wide Indo-Pacific range from the Red Sea and South Africa to Australia and Japan. Groupers are important reef predators but are now uncommon in many areas as even small species such as this one are fished widely in both commercial and artisanal fisheries.
Size Up to 40cm long, usually smaller.

Clown Anemonefish *Amphiprion ocellaris*

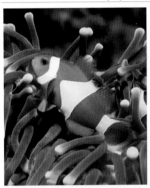

Features Thanks to children's books, films and the aquarium industry anemonefish, and this species in particular, are known and recognised worldwide. The colour pattern of the Orange Anemonefish (*A. percula*) is very similar and the two are easily confused and both are often simply called the Clownfish. It lives on Indo-West Pacific reefs sheltering within the tentacles of three large, stinging anemones *Heteractis magnifica*, *Stichodactyla gigantea* and *S. mertensii*. It is increasingly being bred successfully in captivity which takes the pressure off wild populations.
Size Up to 11cm long.

Fairy Basslet *Pseudanthias sp.*

Features Great clouds of basslets or anthiases, are a common sight along the edges of coral reefs and at reef drop offs. Here these small relatives of groupers pick plankton from the water where currents sweep along. There are many similar species in two main genera *Pseudanthias* and *Anthias* and all are decked out in bright orange and red colours. They are hermaphrodites that mature first as females and then later as males. Breeding males are the more colourful and in any aggregation one or a few can be picked out from the many females.
Size Up to about 12cm long.

Ornate Butterflyfish *Chaetodon ornatissimus*

FAMILY Chaetodontidae

Features Butterflyfishes are quintessential coral reef fish and a coral reef without them is in general an unhealthy reef. Compressed from side to side and with a small neat mouth, each species has a very specific colour pattern by which they can be recognised and very specific feeding habits. The Ornate Butterflyfish can be seen swimming in pairs over Indo-Pacific reefs picking off coral polyps but does little damage unlike some coral-eating starfish and molluscs. Each pair has its own home range but juveniles live on their own.
Size Up to 20cm long.

Ochre-striped Cardinalfish *Ostorhinchus compressus*

FAMILY Apogonidae

Features Cardinalfishes are mostly nocturnal and are best seen on a night dive or snorkel. This species, previously called *Apogon compressus*, spends the day hiding in small groups amongst coral branches on shallow, sheltered reefs in the Indo-West Pacific, hanging there almost motionless. Large mounds of branching and broken *Porites cylindrica* in sheltered lagoons make an ideal habitat. This photograph was taken in just such a place in the Semporna Islands, Sabah, Malaysia. Its striped pattern, found in many cardinalfishes, provides camouflage in dim light.
Size Up to 12cm long.

Indo-Pacific coral reef PERCIFORM fishes

Bigeye Snapper *Lutjanus lutjanus*

FAMILY Lutjanidae

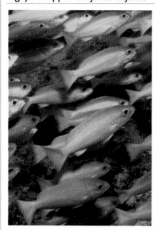

Features Snappers are most often seen swimming in schools of a few to several hundred individuals. They are relatively streamlined fish with a single, long dorsal fin and the thin or curved pectoral fins and forked tail typical of many open-water hunting fish. Bigeye Snapper hunt along clear, ocean reef faces searching for the smaller fish and crustaceans on which they feed. When not hunting they can often be found milling quietly around reef faces or wrecks as shown here, often mixed in with other similar-sized snapper species. Along with other Indo-West Pacific snappers, it is a highly commercial species.
Size Up to 30 cm long.

Royal Angelfish *Pygoplites diacanthus*

FAMILY Pomacentridae

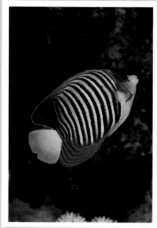

Features Angelfishes are sometimes mistaken for butterflyfishes as they are similar in shape though usually larger. A close look at the edge of the gill cover will show up a prominent spine. In the colourful Royal or Regal Anglefish it shows as a contrasting blue on a yellow background but is not always so clear in other species. This species lives a mostly solitary life picking at sponges and tunicates on Indo-Pacific reefs. Along with other angelfishes it plays an important role in grazing sessile reef animals.
Size Up to 25cm long.

Green Humphead Parrotfish *Bolbometodon muricatum*

FAMILY Scaridae

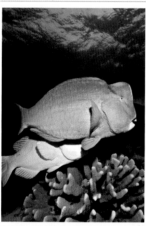

Features Of all the 100 or so different species of parrotfishes, the Bumphead is certainly the most impressive, if not in colour then for its sheer size. Divers who are careful not to touch and break coral might well feel aggrieved watching a school of these heavy-headed fish bite into the coral with their massive beak-like teeth. They will scrape off algae as well as living coral and the indigestible remains are later void as a shower of sand. Large individuals sometimes head butt the coral to break it up.
Size Up to 1.3m long.

Yellowtail Coris *Coris gaimard*

FAMILY Labridae

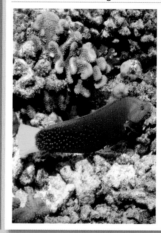

Features Wrasses are amongst the most numerous, colourful and diverse of perciform fishes and are especially common on tropical reefs. Species diversity is lower in temperate areas. The Yellowtail Coris is a Pacific reef species that can be seen searching for molluscs, crustaceans and sea urchins which it dispatches with its strong teeth. Like other wrasse (and parrotfish) it swims with a rowing motion using its pectoral fins. Juveniles are bright orange with white saddles outlined in black, but change colour as they mature into females. Some may then change sex and become brighter males.
Size Up to 40cm long.

Powder-blue Surgeonfish *Acanthurus leucosternon*

FAMILY Acanthuridae

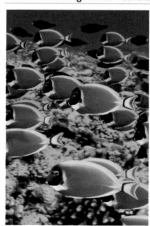

Features With its sleek blue body and yellow and white fins, this is a favourite for marine aquarists. However, anyone who handles this or any other surgeonfish should take care as they are armed with a flick-knife-style spine at the base of the caudal fin. In this species it is picked out in yellow and clearly visible. A slash from the tail provides effective protection for this usually peaceful Indian Ocean, algae-eating vegetarian. However, the spine is also used aggressively in territorial disputes.
Size Usually up to 20cm but can reach 50cm long.

Masked Rabbitfish *Siganus puellus*

FAMILY Siganidae

Features Rabbitfishes live up to their name and are important grazers of algae on coral reefs. Their activities and those of other grazers such as sea urchins, keep seaweed growth under control and prevent the coral from being smothered. Like other rabbitfishes, the Masked Rabbitfish has a small mouth and close-set teeth eminently suitable for picking off algae but adults also eat sponges and tunicates. It has venomous fin spines which deter predators and careless handling by fishermen can result in a very painful sting. This is an Indo-Pacific species as are most rabbitfishes.
Size Up to 38cm long.

NE Atlantic seashore PERCIFORM fishes

European Seabass *Dicentrarchus labrax*

FAMILY Moronidae

Features The Seabass is well-known to sports fishermen throughout the NE Atlantic and is a valuable recreational fish. It is also a popular restaurant fish and is netted commercially, though is being increasingly successfully farmed. It thrives in public aquaria and as it is extremely shy in the wild, this is a good way to see it. As it manoeuvres, the fish erects and lowers its spiny first dorsal fin and then flashes away with a thrust of its powerful tail. Young fish can be caught in the surf zone of sandy beaches and sometimes in estuarine pools.
Size Up to 1.3m long.

Lesser Weever *Echiichthys vipera*

FAMILY Trachinidae

Features This is one of a very few venomous fishes in the NE Atlantic and causes misery to holidaymakers unlucky enough to tread on one when paddling in the shallows along sandy shores. The sting is painful but not usually dangerous. They can also cause problems to inshore fishermen (and marine biologists) when they come up in trawl nets. However, the sting is purely defensive allowing them to hunt in safety at night and stay hidden just beneath the sand surface in the day. The latter is, of course, when they cause us problems.
Size Up to 15cm long.

Corkwing Wrasse *Symphodus melops*

FAMILY Labridae

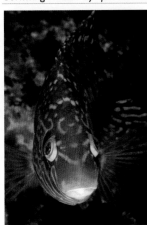

Features Like its tropical relations, the Corkwing wrasse is colourful both in terms of patterns and its reproductive strategy. Unlike some other wrasses in the area, such as the Cuckoo Wrasse (*Labrus mixtus*) which change sex part way through their lives (p.369), the Corkwing remains either male or female, distinguished by different colour patterns (male shown). Territorial males build a nest and entice in egg-laden females. However, some smaller males mimic the female coloration and sneak in with the aim of fertilising the eggs. This wrasse is common in intertidal rock pools.
Size Up to 15cm long.

Shanny *Lipophrys pholis*

FAMILY Blenniidae

Features The Shanny is the quintessential seashore fish, able to survive out of water in damp places for several hours, by absorbing oxygen through its scaleless skin. Whilst most common in pools on rocky shores, they can also be found in the sandy pools that form around groynes and breakwaters as long as these have seaweed on them to provide cover. The best way to find them is to look under shore rocks in summer. In winter most move off the shore to avoid the worst of the cold. They are easily caught in baited 'bottle traps' placed in rock pools as they are happy to scavenge.
Size Up to 30cm but usually to 15cm long.

Rock Gunnel *Pholis gunnellus*

FAMILY Pholidae

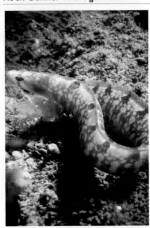

Features In the UK this little fish is commonly called the Butterfish which aptly reflects its slippery eel-like nature. Whilst this makes it difficult to catch one in a rock pool where they are commonly found, it allows the fish to slip from pool to pool even when the tide is out. Larger individuals are more commonly found lurking in sublittoral undergrowth down to about 20m depth. Males are sometimes seen by hardy divers in January or February, coiled protectively round a clump of eggs laid on rock by the females.
Size Up to 25cm long.

Tompot Blenny *Parablennius gattorugine*

FAMILY Gobiidae

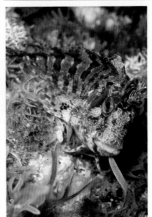

Features Whilst divers are most likely to see a Tompot, young fish are sometimes found in rock pools near low water mark. Like other true blennies found in this area, it sports a pair of feathery head tentacles (the Shanny is an exception) and has a single long dorsal fin. These alert fish characteristically sit propped up on their pectoral and pelvic fins allowing them a good view all round, using their high set eyes. Males assiduously guard eggs laid in protective crevices by their females. A similar species the Red or Portuguese Blenny (*Parablennius ruber*) occurs in the area.
Size Up to 30cm, commonly to 20cm long.

NE Atlantic seashore PERCIFORM fishes

Rock Goby *Gobius paganellus*

Features Gobies are notoriously difficult to identify but the Rock Goby is the one most likely to be found on rocky shores in this region, hidden beneath stones and in rock pools. It is similar in size and shape to the Shanny (p.395) but has two separate dorsal fins, typical of all blennies. The best place to search for them is on sheltered, seaweed covered shores below around mid-tide level. Unlike the tough Shanny, they are rarely found above this level. Breeding males (at least) have an orange band along the dorsal fins.
Size Up to 12cm long.

FAMILY Gobiidae

Black-faced Blenny *Tripterygion delaisi*

Features In spite of its name and blenny-like shape, this is not a true blenny and belongs to a separate but related family called triplefin blennies. These have three dorsal fins. When breeding, males develop an intense black colour over the head, which contrasts markedly with an orange body. A male will assiduously court a female and performs an elaborate dance to entice her to lay eggs in his patch. Whilst normally sublittoral they are sometimes found in deep, shaded rock pools.
Size Up to 9cm long.

FAMILY Tripterygiidae

Dragonet *Callionymus lyra*

Features With their triangular-shaped heads and flattened profile, dragonets are adapted to live on the seabed and are usually found on sand or gravel. They are most likely to be seen by divers or trawled up, but can sometimes be found trapped in pools on extensive intertidal sand flats. Male dragonets have a spectacularly tall first dorsal fin which they use in courtship and territorial display, along with heightened coloration. Females are rather drab and are very similar between the various species.
Size Up to 30cm long.

FAMILY Callionymidae

Lesser Sandeel *Ammodytes tobianus*

Features Sandeels swim in large shoals offshore and are a vital food resource for many seabirds. However, young fish can be caught in beach seine or push nets on spring low tides and are occasionally stranded in sandy shore pools. Further south in the Baltic, it is fished commercially. The several different N Atlantic species in two genera (*Hyperoplus* and *Ammodytes*) are difficult to tell apart and divers will certainly see only silvery shoals or bursts of sand as the fish dive head first into the seabed for cover.
Size Up to 20cm long.

FAMILY Ammodytidae

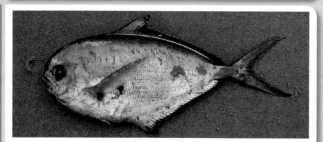

Atlantic Pomphret *Brama brama*

Features This species has been included here with shore fishes because whilst it does not live on the shore and is a mid-water fish with a depth range from the surface to 1,000m, it is frequently washed ashore dead on beaches, especially those bordering the North Sea. So this is how many people will be familiar with it. Pomphret are highly migratory and extend northwards in the N Atlantic in warm summers but it appears that some leave it too late to return and are slowed and sometimes killed by the cold.
Size Up to 1m long.

FAMILY Bramidae

Viviparous Blenny *Zoarces viviparus*

Features This eel-like blenny lives mostly in sediment areas but in the northern parts of its NE Atlantic range it is quite common on seashores hiding under sediment-embedded rocks and in pools. Unusually amongst ray-finned fishes, it has live young. Eggs hatch inside the female and are sustained by yolk but recent histological evidence indicates the young uniquely 'suckle' on ovarian follicles (Skov *et al.* 2010). They are born after four to five months.
Size Up to 30cm long.

FAMILY Zoarcidae

Open ocean PERCIFORM fishes

FAMILY Coryphaenidae

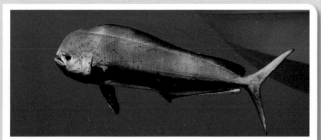

Dolphinfish *Coryphaena hippurus*

Features Most fish that live out in the open ocean come in various shades of blue and grey that merge well with their watery background. Dolphinfish are rather more brightly coloured with golden yellow flanks, a metallic blue and green back and a peppering of blue spots. These ocean cruisers can travel long distances on migration and are found worldwide in tropical and subtropical waters. They have been exploited and admired since Greek and Roman times.
Size Up to 2m long but usually 1m or less.

FAMILY Scombridae

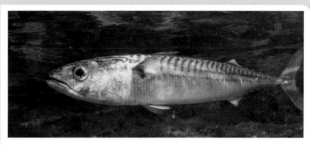

Atlantic Mackerel *Scomber scombrus*

Features Mackerel live in huge schools feeding on plankton and other small fish such as sandeels, in surface waters from close inshore to far out to sea. By moving and hunting together, they are better able to avoid their many predators which include larger fish, seals and dolphins. However, this behaviour makes it easier for commercial fishermen to catch them and some stocks have been overexploited. In winter they move offshore and into deeper water but spawn inshore in spring.
Size Up to 60cm long.

FAMILY Carangidae

Bluefin Trevally *Caranx melampygus*

Features With their compressed shape, Bluefin Trevally are built for speed as they hunt for fish around reefs in coastal and oceanic Indo-Pacific waters. A narrow tail base reinforced with a centre line of bony scutes, forked tail fin and scimitar-shaped pectoral fins provide for both speed and manoeuvrability. Fish in this large family of about 150 species, are also known as jacks, pompanos and carangids. This trevally is commercially exploited but can build up toxins and cause ciguatera poisoning.
Size Up to 1.2m long.

FAMILY Scombridae

Atlantic Bluefin Tuna *Thunnus thynnus*

Features Bluefin Tuna are one of the fastest and most efficient predators in the open ocean as well as one of the most valuable commercial fish. They have the classic, streamlined torpedo shape of fast swimming fish with a large, powerful tail. This species has been hunted in the Mediterranean for thousands of years but stocks are now endangered through overfishing. Although highly migratory, western and eastern stocks remain largely separate.
Size Up to 4.6m but now usually to 2m.

FAMILY Sphyraenidae

Great Barracuda *Sphyraena barracuda*

Features A mouthful of long, sharp teeth and its predatory nature give the Great Barracuda a dangerous reputation. It has been known to attack divers, lunging towards the glint of a watch or camera which it probably mistakes for the silvery flash of its usual small fish prey. However, such attacks are rare for this solitary hunter. Like the freshwater pike that it resembles, it can hang almost motionless in the water, waiting to strike. It ranges throughout the tropical Indo-Pacific and Atlantic.
Size Up to 2m long.

FAMILY Xiphiidae

Atlantic White Marlin *Kajikia albida*

Features White Marlin is a billfish, a group of spectacular fish named after the slender rapier-like upper jaw used to slash into shoals of small 'baitfish' such as sardines. Everything about this fish is designed for speed and long distance cruising and it is no surprise that for sport fishermen billfish are one of the ultimate challenges. White Marlin range throughout the tropical and warm Atlantic and Mediterranean whilst Striped Marlin (*Kajikia audax*), do the same in the Pacific.
Size Up to 3m long and 82kg in weight.

Polar PERCIFORM fishes

The Southern Ocean surrounding Antarctica is relatively isolated from the rest of the ocean by thermal and current barriers and supports a large number of endemic fish species. Notothenioids (suborder Notothenioidei) are especially common and live on or near the seabed. The Arctic has much greater water exchange with the seas that connect with it and many fewer endemics. Many Antarctic and a few Arctic fishes have antifreeze compounds in their blood.

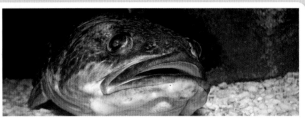

Marbled Rockcod *Notothenia rosii*

Features Like many other Antarctic fishes in this family, Marbled Rockcod have a biological antifreeze in their blood and other fluids. This species lives in inshore waters of the Southern Ocean around the Antarctic Peninsula and islands including the Scotia Arc, Macquarie and Kerguela. It is found mainly in shallow water down to about 20m. Slow growth and longevity are common traits in marine organisms living in very cold water and this species lives for at least 16 years, possibly longer.
Size Up to 25cm long.

FAMILY Nototheniidae

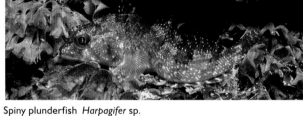

Spiny plunderfish *Harpagifer* sp.

Features Eleven species of spiny plunderfish are known and all are in the same genus. At least five of them are found in the cold waters of the Southern Ocean. This one was photographed in shallow water off the Antarctic Peninsular. Most prey on amphipods which they find amongst seaweed and under stones. In turn, an array of protective head spines make life difficult for predators that want to eat them. *H. antarcticus* and *H. georgianus* are common on Antarctic and sub-Antarctic island shores.
Size Up to about 10cm long.

FAMILY Harpagiferidae

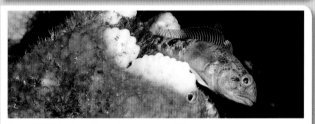

Emerald Notothen *Trematomus bernacchii*

Features Rock crevices, sponges, seaweeds and debris on the seabed all provide a hiding place for this fish. Juveniles especially prefer to remain hidden. It emerges to feed on a wide variety of invertebrates such as polychaete worms, molluscs and small crustaceans. In depth it ranges from the shoreline down to at least 700m and is found along most of the coastline of Antarctica. With biological antifreeze in its blood, it copes well with water as cold as -2°C.
Size Up to 35cm long.

Atlantic Wolffish *Anarhichas lupus*

Features Although these fish are regularly seen by divers in northern parts of the UK and in Norwegian fjords, they extend far northwards to the icy waters around Spitzbergen, as well as Canada and northern USA. Seen head on, their large bulbous head and protruding, fang-like teeth can be intimidating but they are normally unaggressive and most live well beyond diving limits down to at least 600m. However, they can quickly dispatch hard-shelled invertebrates with their strong teeth.
Size Up to 1.5m long.

FAMILY Anarhichadidae

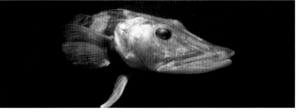

Blackfin Icefish *Chaenocephalus aceratus*

Features The Blackfin Icefish lives and hunts for fish and krill on and near the seabed in the Scotia Sea and around the northern Antarctic Peninsula and is an important species there. The flattened and elongated shape of its head is reflected in the other name of Crocodile Icefish. Most fish in this family, have no red corpuscles in their blood. This allows it to flow more easily in the cold. The fish can also absorb oxygen, of which there is plenty in the cold water, through its scaleless skin.
Size Up to about 75cm long.

FAMILY Channichthyidae

Yarrell's Blenny *Chirolophis ascani*

Features Although not a truly polar species as its distribution does not quite reach the Arctic Circle, this little fish extends as far north as northern Norway, the Murmansk coast and Canada. With continued global warming, it may well push further north whilst retreating from its southern limit around the British Isles. Divers often mistake it for a true blenny (Blennidae) as it has a similar shape and head tentacles. The family name (Stichaeidae) reflects the long spiny dorsal fin of most species.
Size Up to 25cm long.

FAMILY Stichaeidae

Juvenile PERCIFORM fishes

The juveniles of some perciform fishes look entirely different from the adult (as do some in other fish orders). Some examples are shown here (see also p.370). Reasons for this adaptation include the differing habitats of adults and juveniles and avoidance of adult on juvenile aggression. Sometimes the same species has been given two different scientific names as a result. Main photos are juveniles, insets are adults.

Dusky Batfish *Platax pinnatus*

FAMILY Ephippidae

Features Batfishes or spadefishes are highly compressed from side to side and shaped much like a dinner plate with tall fins. Adults of this species can be seen on steep reef drop-offs usually on their own. Juveniles in contrast shelter amongst mangroves and in coral reef lagoons. They are almost black with extremely tall fins and are edged right round with a bright orange line. Their colour and shape mimic toxic polyclad flatworms (such as *Pseudobiceros hancockanus*), even more so as they often swim on their sides.
Size Adult up to 45cm long.

High-hat *Pareques acuminatus*

FAMILY Sciaenidae

Features The imaginative name of this Atlantic reef fish comes from its very tall first dorsal fin. Adults and juveniles inhabit coral reefs and sheltered bays from N Carolina, USA south to Brazil. Whilst the striped black and white colour pattern is similar in both adults and juveniles, the latter have greatly elongated dorsal and pelvic fins. This probably acts as camouflage as the youngest fish certainly look more like mobile twigs than fish. The young adult shown here will further reduce the fin length as it grows.
Size Adult up to 23cm long.

Emperor Angelfish *Pomacanthus imperator*

FAMILY Pomacanthidae

Features The colour patterns of marine angelfishes are only outshone by the patterns of their juveniles. These are usually completely different from the adult and in the genus *Poamacanthus* juveniles are usually dark blue with white markings. Emperor juveniles have vertical white lines followed by concentric circles. Adult males are very territorial and by having a completely different colour pattern, juveniles are thought to avoid being chased in territorial disputes.
Size Adult up to 40cm long.

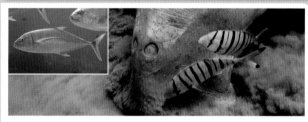

Golden Trevally *Gnathanodon speciosus*

FAMILY Carangidae

Features Whilst adult Golden Trevally are themselves large and fast predators, the small juveniles are vulnerable in open water. So once they reach about 5cm long, they find protection by accompanying larger animals such as slow moving sharks, manta rays, dugongs and even divers. Swimming alongside their host's head like a small swarm of flies they are well protected from potential predators. Very young ones sometimes shelter amongst the tentacles of anemones.
Size Adult up to 1.1m long.

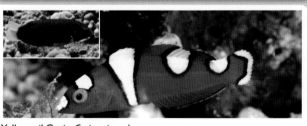

Yellowtail Coris *Coris gaimard*

FAMILY Labridae

Features Wrasses are well known for their propensity for having different colour patterns at different stages of their lives and the Yellowtail Coris is no exception. More details of life history are given for this species in the entry on p.394. Juveniles are a totally different colour to any of the adult male, female or intermediate phases. Interestingly the juvenile colour is very similar to juvenile African Coris (*Coris africana*) though the adults are different and their distributions do not overlap.
Size Adult up to 38cm long.

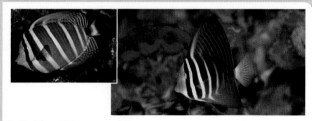

Sailfin Tang *Zebrasoma velifer*

FAMILY Stichaeidae

Features With its exceptionally tall sail-like dorsal fin, especially so in juveniles, this surgeonfish makes a striking splash of colour on Pacific Ocean reefs. Juveniles are barred with alternate black and yellow vertical stripes whilst adults have a more complex pattern of stripes. Juveniles are usually solitary and shelter within lagoons and inner reefs but move out to populate a wider area of seaward reefs as they mature. The similar Indian Sail-fin Surgeonfish occurs throughout the Indian Ocean.
Size Up to 40cm long.

LOBE-FINNED FISHES

Every discipline has its favourite stories and for ichthyologists (fish biologists) it must be the discovery of the coelacanth. Fossil coelacanths are relatively common with the most recent species dating from around 65 million years ago. So when a living coelacanth was discovered in 1938, it was not unnaturally dubbed a 'living fossil'. Actually it was dead and was found by a young museum curator, Marjorie Courtney-Latimer, called down to the docks in East London, South Africa to look at a strange fish hauled up by a fishing boat. Recognising that it was completely different from any fish she had ever seen, she made great efforts to preserve the rapidly rotting corpse (only the skin survived) and contacted the great JLB Smith, the top fish expert of the time. He recognised it for what it was and eventually named the fish *Latimeria chalumnae* after her. Since then a second coelacanth species has been found and described, and these enigmatic animals have even been filmed in their natural environment.

The lobed fins of this fossil coelacanth species are clearly visible and the fish looks much like its living counterparts.

CLASSIFICATION

The two species of coelacanth are placed in a single order Coelacanthiformes in their own class of chordates the Coelacanthi. They were previously grouped together with the freshwater lungfishes in the class Sarcopterygii, but lungfishes are now considered as a separate chordate class the Dipneusti. However, there is still much debate and ongoing research into these relationships.

Coelacanths were once thought to be the route whereby tetrapods, the land-living vertebrates, developed the limbs necessary for life out of water and that they might be the 'missing link' between fish and amphibians. It is now accepted by most scientists that lungfishes are more closely related to land vertebrates than are coelacanths and that earlier primitive fishes might provide the main line of descent.

DISTRIBUTION

Coelacanths (*Latimeria chalumnae*) live in deep rocky environments in the western Indian Ocean. The only known 'large' population is from the Comoros Islands, Madagascar, but specimens have been caught in South Africa, Mozambique, Tanzania and Kenya. The Indonesian or Sulawesi Coelacanth (*L. menadoensis*) has so far only been recorded from north of Sulawesi in the Celebes Sea. Lungfishes are found in freshwater in Australia (one species) and Africa (four species).

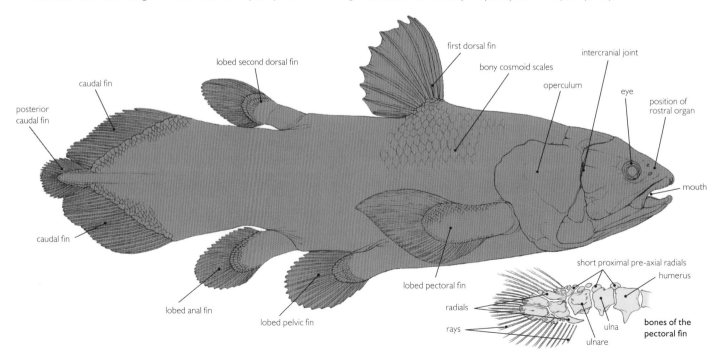

With its heavy body, large cosmoid bony scales (p.361) and muscular fin bases, it would be hard to confuse a coelacanth with any other living fish. Unlike all other fishes, coelacanths have a three-lobed tail with a small, rounded central lobe between the larger upper and lower lobes.

MARINE FISHES

STRUCTURE

Lobe-finned fishes are so-called because of their unique fin structure. The fin membrane is supported on a fleshy, muscular lobe which is especially prominent in the paired pectoral and pelvic fins giving rise to the affectionate name of 'Old Four Legs'. However, limited film footage of coelacanth behaviour suggests they rarely or never use these fins to rest on the seabed. Like ray-finned fishes, the skeleton of lobe-finned fishes contains hard bone but also cartilage and the detailed arrangement is different. In coelacanths the vertebral column is incomplete and the notochord remains as a distinct, tough flexible tube.

The skull has an articulation that allows the head to bend upwards so that the jaws can open wider and there are two large gular plates between the two halves of the lower jaw. A few primitive ray-finned fishes such as the Bowfin also have a gular plate but only one. Unlike the solid spines found in ray-finned fishes, fin rays (and vertebral spines) in coelacanths are hollow, rather like the central shaft of a bird's feather but much stronger.

Coelacanths have a tough covering of large, overlapping, bony cosmoid scales. Each scale has a basal layer of dense lamellar bone (isopedine) overlain by spongy bone with a good blood supply. The exposed surface is made of a hard dentine-like substance. Fossil coelacanths had much thicker cosmoid scales with several very hard outer layers.

BIOLOGY

Feeding

Stomach contents have shown that coelacanths feed on a wide variety of relatively small deepsea fishes, squid and cuttlefishes suggesting they are opportunistic feeders eating whatever swims near enough to be sucked into their large mouth. Film footage taken from small submersibles on expeditions, mainly led by Dr Hans Fricke, has documented aspects of coelacanth behaviour (Fricke et al. 1987 and 1991). Off the Comoros Islands at least, coelacanths are nocturnal, hiding out in groups in caves during the day and hunting by night. Drifting with the current a few metres above the bottom, they use their paired fins to skull along, operating the left pectoral and right pelvic fins together, followed by the right pectoral and left pelvic. This is the same pattern used by four-legged land animals (tetrapods). Darkness is not a problem as coelacanths have a gel-filled rostral organ on the snout, which is thought to be electro-sensory and probably serves not only to detect prey but also to find their way back to favourite daytime resting places.

Life history

Coelacanths give birth to live young, a fact amongst others, that is only known from dissecting captured females. The young hatch and develop in the oviducts from very large eggs up to 9cm in diameter and rely on an attached yolk sac for their nutrition. So far a maximum of 26 foetuses have been found in one female and the gestation period has been estimated at as much as three years, amongst the longest of known vertebrates. Females need at least 15 years to mature and whilst maximum age may be as much as 50 years, it might only be 20. Given the immense difficulty of observing these fish underwater, nothing is known of their courtship and mating. A juvenile Indonesian Coelacanth was filmed by a Japanese ROV in 2007 at around 160m depth off Sulawesi.

Ecology

Coelacanths can reach a size of at least 2m long and a population of such large predators must have a significant local effect on prey fish within their home range. However, they are relatively slow-moving, perhaps because their gills are small for their size and their blood not that efficient at carrying oxygen. They have been observed to hang head-down in the water which may be part of their hunting strategy.

USES, THREATS, STATUS AND MANAGEMENT

Probably never very common to begin with, as evidenced by the 14 years of searching between the discovery of the first fish and the next one, coelacanths are now decidedly rare. *L. chalumnae* is listed as Critically Endangered and *L. menadoensis* as Vulnerable in the IUCN Red Data List (IUCN 2014). International trade in coelacanths is strictly controlled by their listing in Appendix I of CITES. The vast majority of the fewer than 200 fish so far caught (or at least examined by scientists) come from the Comoros Islands and are limited to steep rocky areas formed from lava flows, and thus have a restricted habitat and range. Coelacanths make poor eating but once they became famous and therefore valuable, they were targeted, because of the interest of the scientific and museum communities. Although the Comoros targeted fishery is no longer allowed, they are still caught incidentally on hook and line by fishermen searching for Oilfish (*Ruvettus pretiosus*) and their low reproductive rate and poor survival after capture makes them especially vulnerable. One innovative idea provided by the coelacanth rescue mission (www.dinofish.com) provides Comoran fishermen with a special kit that helps them to return incidentally caught fish to their deepwater habitat without the fish using up precious energy having to swim back down through warm oxygen-poor surface waters.

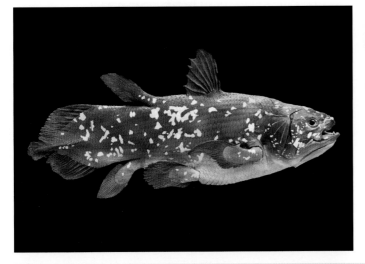

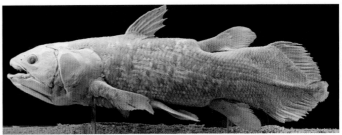

In the early decades following the discovery of the coelacanth, museums were naturally keen to obtain specimens for display. A new threat is the wish by some aquariums to display live specimens. Left: reconstruction. Above: preserved specimen of *L. chalumnae* in the Natural History Museum, Vienna, Austria. This fish was caught in 1974 in the Comoros Islands and weighed 60kg.

MARINE REPTILES

Reptiles are a diverse and successful group of air-breathing vertebrates with at least 8,000 species found worldwide. The majority live on land in the tropics and subtropics with only around 100 species found in the ocean and even fewer that are wholly marine. Marine species retain the defining reptile characteristics of tough scaly skin, amniotic eggs and behavioural thermoregulation (see below). However they also have anatomical and physiological adaptations to an aquatic existence.

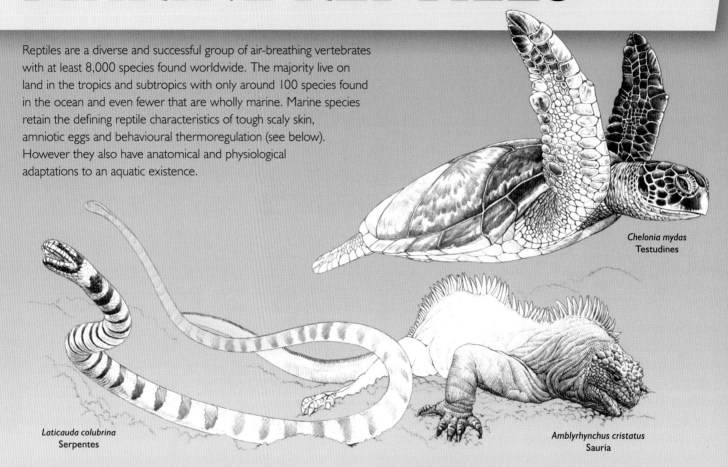

Chelonia mydas
Testudines

Laticauda colubrina
Serpentes

Amblyrhynchus cristatus
Sauria

CLASSIFICATION

In simple Linnaean classification reptiles, mammals, amphibians and birds are placed in separate classes within the subphylum Vertebrata. However, it is well known from fossil evidence that reptiles have a close evolutionary relationship with birds and that modern birds evolved from small theropod dinosaurs. Current DNA evidence from extant (living) species also suggests that birds and crocodiles are most closely related. The exact relationship of turtles to other reptiles remains contentious (Laurin and Gauthia 2012).

CLASS	ORDER	SUBORDER
REPTILIA	Testudines (turtles)	
	Squamata (lizards and snakes)	Sauria
		Serpentes
	Crocodilia (crocodiles and alligators)	
	Sphenodontida (tuatara, terrestrial only)	

ANATOMICAL AND PHYSIOLOGICAL ADAPTATIONS

Temperature regulation

The majority of reptiles cannot maintain their body temperature more than a few degrees above that of their surroundings and regulate their temperature by behavioural mechanisms such as basking. They, along with fish, are often called 'cold-blooded' or technically 'ectothermic'. Water, especially moving water, conducts heat much more efficiently than air and so marine reptiles find it even harder than terrestrial reptiles to keep warm enough to remain active. The cold waters surrounding the Galapagos Islands pose a particular problem for Marine Iguanas (*Amblyrhnchus cristatus*) which must spend considerable periods basking on the rocks to warm up after feeding forays into the sea. The dark colour of their skin helps absorb warmth from the sun. This reliance on external warmth is the main reason that the majority of marine reptiles are found in warm tropical waters. The exception to this is the Leatherback Turtle (*Dermochelys coriacea*). This ocean wanderer can remain active in water only a few degrees above freezing. The Leatherback uses

physiological as well as behavioural mechanisms to adjust its body temperature up or down. Its large size and an extra layer of blubber helps to retain core heat and a counter-current heat exchange system in the capillaries at the base of the flippers allows it to store heat generated by muscular activity. In captivity Leatherback Turtles have been shown capable of maintaining a body temperature of 25.5°C in 7.5°C water – a differential of 18°C (Friar et al. 1972).

Salt and water balance

Living in saltwater, marine reptiles must face the problem of salt and water balance. As they have body fluids that are less salty than seawater (hyposmotic) they would be expected to lose water by osmosis (see p.318). Reptiles have relatively impermeable skin which to a large degree prevents both salt getting in and water getting out. Tests on marine snakes have shown that their skin is much less permeable than that of freshwater snakes. In spite of this, living and feeding in the sea means that marine reptiles take in excess salt in their food, a problem that their land-based counterparts do not usually face. This excess cannot be dealt with by the kidneys which in reptiles cannot produce urine more salty (hyperosmotic) than their blood. The solution comes in the form of salt glands, an adaptation also found in seabirds (p.461). These glands extract salt from the bloodstream via active transport and a sodium-potassium pump and secrete a concentrated salt solution.

In the Saltwater Crocodile (*Crocodylus porosus*) the salt glands are derived from salivary glands and are found thickly scattered over the tongue (lingual glands). It seems that all crocodiles (Crocodilidae) have these glands, even those that rarely or never enter brackish water or the sea. However, in these species the glands are probably not efficient enough to allow them to survive indefinitely in salt water. In contrast, freshwater alligators (Alligatoridae) do not have salt glands. Sea snakes also employ modified salivary glands, this time situated in the floor of the mouth under and emptying into the tongue sheath. Every time the snake flicks its tongue out, concentrated brine goes with it.

Marine turtles secrete excess salt through their eyes via modified lacrymal (tear) glands and 'cry' copious gooey tears. This is most clearly seen in females as they haul themselves up and down the shore during egg laying, giving the impression that their efforts are truly exhausting. Leatherback Turtles have especially large salt glands as their diet of jellyfish imposes a high salt load on them. The strange sight of Marine Iguanas sneezing regularly whilst basking on intertidal rocks is explained by the fact that they have nasal salt glands situated between the eyes and the nostrils and opening into the nose. At each sneeze they spray themselves and often end up with a crusty white head.

Salt glands may be effective at removing salt taken in with food but this does not mean that all marine reptiles can drink seawater as was once assumed. It now seems that at least in the case of sea snakes there is still a need to drink fresh water. Evidence for this comes from recent experiments on captive sea kraits which would only drink fresh or slightly brackish water and became dehydrated when kept in seawater (Lilywhite et al. 2008). Sea kraits tend to remain inshore, can move on land and so can drink from coastal springs, streams and rivers. Ocean wanderers such as the Yellow-bellied Sea Snake (*Pelamis platura*) may be able to get sufficient freshwater when it rains and the lighter freshwater floats briefly on the sea surface. This happens especially in calm waters such as reef lagoons where sea snakes are often common. Measurements of the salt concentration in marine turtle tears shows that they are able to extract enough salt to allow them to drink seawater. If needed, crocodiles and Marine Iguana have access to freshwater.

Reptilian salt glands vary in their detailed structure and complexity (see Peaker and Linzell 2009) but are in the main similar to those found in true seabirds (p.461). Secretory tubules are packed into lobules each with a central canal. Canals unite to form main ducts that open to the exterior as described above.

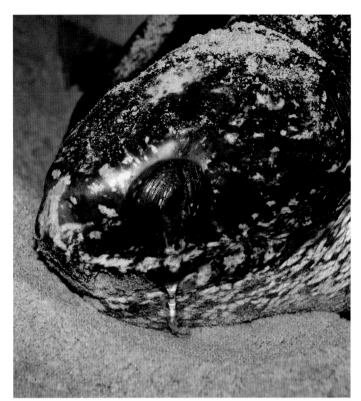

A Leatherback Turtle (*Dermochelys coriacea*) can cry away its excess salt load through lacrymal salt glands.

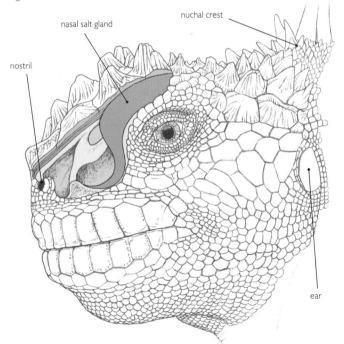

The nasal salt gland of the Marine Iguana (*Amblyrhynchus cristatus*) lies above the orbit and extends under the nasal passage (cut-away drawing after R.D. Chambers, from Dunson, 1969, nasal gland in blue).

Diving

Problems faced by diving reptiles are similar to those faced by diving birds and mammals which also breathe air, namely a sufficient supply of oxygen and avoiding 'the Bends' (p.419). Reptiles have a natural advantage in that they have a low metabolic rate compared to warm-blooded animals such as whales and so require less oxygen.

Like diving mammals, marine reptiles can slow their heartbeat and direct blood flow away from non-essential areas such as limbs in order to conserve oxygen whilst underwater. Diving mammals store extra oxygen in their blood or tissues and whilst this technique is used by at least some sea snakes and the deep-diving Leatherback Turtle, all sea turtles use the lungs as their main oxygen store. Most reptiles have simple lungs, but in sea turtles they are complex and divided and can store sufficient oxygen for normal dive durations. Turtle haemoglobin is particularly efficient at carrying and releasing oxygen. If necessary they can also survive for some time without oxygen by using anaerobic respiration, a process that releases energy from food without oxygen.

Most marine reptiles only dive to a few tens of metres and do so in search of food but satellite-tagging has shown that Leatherback Turtles on migration occasionally (but regularly) dive to at least 1,000m. Other marine turtles do not perform such deep dives which, whilst originally attributed to predator avoidance, are now thought to be exploratory dives to locate jellyfish (Houghton et al. 2008) to refuel on long migrations. Leatherbacks have been shown to remain in areas where they have located such prey and feed on it at night when it comes near the surface through diurnal movements.

With their relatively thin skin, sea snakes can absorb some oxygen from the water. Pelamis platurus gets up to a third of its oxygen in this way when submerged. It can also eliminate both carbon dioxide and nitrogen through this route; the loss of nitrogen effectively prevents it from suffering from the bends. It achieves this by forcing blood to bypass the lungs sending it to capillaries under the skin instead (Priede 1990). In most other marine aquatic reptiles the skin is too tough to be used in this way but in chelonians (tortoises and turtles) the rectum, oviducts and bladder all empty into a communal cloacal chamber with a single exit (vent or anus). Work on Australian freshwater turtles has shown that the cloacal chamber is lined with papillae which have a rich blood supply acting rather like gills to absorb oxygen from water. During a long stay underwater, the cloaca can be flooded with water but there is little evidence for this type of respiration in marine turtles.

The flattened tail of sea snakes such as this Olive Sea Snake (*Aipysurus laevis*) acts as a paddle and helps it to dive and hunt efficiently.

Species	Normal dive duration (minutes)	Maximum dive duration (minutes)	Maximum recorded dive depth (metres)
Crocodiles (in general)	4–6 usual and up to 15	120 (but only recorded by forced submergence)	
Leatherback Turtle	10–20	86 on active dive to 1186m (Milagros et al. 2008)	1,250 (Houghton et al. 2008)
Green Turtle	10–40	>60	>45 (Wyneken et al. 2013)
Loggerhead Turtle	4–6	410 inactive (Hochscheid 2005)	233 (Wyneken et al. 2013)
Olive Ridley Turtle	24–48	115	200 (Wyneken et al. 2013)
Sea snakes (in general)	30–60	120	100
Pelamis platurus	7–15	213	50 (Rubinoff et al. 1986)
Marine Iguana	10	About 30 but do not rest underwater	10–15

Examples of dive duration and depth of marine reptiles taken from various references. Wyneken et al. (2013) provide referenced data for all turtle species.

CROCODILES

Crocodiles and their close relatives the alligators are essentially freshwater animals, and as such are adapted to an aquatic existence. It is therefore perhaps surprising that as adults, only two species are equally at home in the sea and in freshwater. The Saltwater Crocodile (*Crocodylus porosus*) can survive long sea journeys and has been found up to 600 miles (1,000km) away from the nearest coast – much to the consternation of those in small boats. The American Crocodile (*Crocodylus acutus*) can swim a fair distance but tends to stay near the coast.

DISTRIBUTION

The Saltwater Crocodile is an Indo-Pacific species that extends from southern India to northern Australia and New Guinea north to the Philippines. However, whilst there are thriving populations in Australia and Borneo, it has been driven to extinction in many other areas. The American Crocodile is found in the Caribbean and along both the Pacific and Atlantic costs of Central America and the north of South America.

STRUCTURAL ADAPTATIONS

Webbed feet and a sideways flattened tail make crocodiles efficient swimmers and hunters underwater. When a crocodile dives to hide or hunt it closes its nostrils and protects its eardrums with moveable scales. It also closes off its throat with a fleshy muscular flap, the palatal valve at the back of the lower palate/tongue. This prevents water entering either its lungs or oesophagus and allows it both to catch fish underwater and to take land animals (and on occasion humans) drag them into the water and drown them. A crocodile can hold its breath for much longer than its prey. However, it must then surface and hold its head above water before swallowing its prey or must take it onto land. The classical view of a crocodile is of one cruising slowly along with just its eyes and nostrils above water. In this position its mouth will be full of water as it cannot make a watertight seal as we can with our lips and so the palatal valve will be closed. It can however still breathe as long as the external nostrils are kept open because the internal openings are right at the back of the upper palate behind the palatal valve.

BIOLOGY AND ECOLOGY

Feeding

Crocodiles are top predators and with a mouthful of interlocking teeth up to 13cm long can take prey much larger than themselves. In the ocean, young crocodiles feed on fish and invertebrates whilst large adults also tackle sea turtles and seabirds.

MAN-EATERS

Saltwater Crocodiles are known man-eaters and are responsible for several fatalities each year, mostly people fishing or bathing along river banks. Crocodiles definitely consider humans as potential food. In the ocean, people and crocodiles rarely meet and crocodile attacks on divers are very rare. In 2009 a diver taking photographs in the Bluewater mangroves off the coast of Nampale Island in the Indonesian province of West Papua was attacked and dragged down to the seabed in an attempt to drown and then eat him. Whilst cut and battered, his SCUBA gear allowed him to breathe and he eventually escaped by gouging the crocodile's eyes. In 2010 a tourist was killed by a crocodile whilst snorkelling in the sea off the Andaman Islands in India.

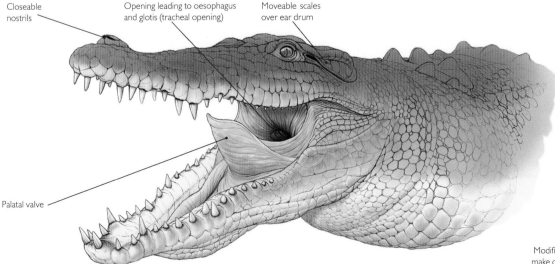

Modifications of the mouth, nostrils and ears make crocodiles superb underwater hunters.

Life history

Female Saltwater Crocodiles mature between about 12–14 years old and males between 16–17 years. Like all crocodiles, the two sea-going species lay their eggs on land in a mound constructed from vegetation and mud, usually along the banks of a tidal river or estuary. In Florida (USA) nests of the American Crocodile are common in sandy areas above high tide level in Florida Bay. The female deposits 40–90 eggs in the nest and then, unlike turtles, lizards and all other reptiles, she does not abandon the nest but either remains nearby to protect it or returns when the eggs are ready to hatch after about three months. With her acute hearing she can hear the hatchlings calling, and she excavates the nest to release them. It seems incredible that the Saltwater Crocodile, the largest living reptile and a fearsome predator, then gently picks up her young in her mouth and carries them down to the safety of the water. Nest temperature influences sex and higher temperatures result in more males (the opposite of sea turtles). The American Crocodile has a similar life history.

USES, THREATS, STATUS AND MANAGEMENT

In spite of the great size and strength of the Saltwater Crocodile, it has been hunted to near extinction in many areas. It is a slow-growing species that may live to 65 and possibly 100 years old, but matures late and cannot sustain intense exploitation. It is hunted for its meat, eggs and especially for its skin and as a trophy. In Australia the population was reduced down to 5% of its size, mainly during the early days of Colonial rule. Today this species is legally protected throughout much of its range as is the American Crocodile. International trade is carefully controlled under its listing on Appendices I and II of the Convention on International Trade in Endangered Species (CITES). Education and tourism has also changed public attitudes and in Australia numbers have recovered dramatically. However, careful management of both species is still needed. Illegal hunting and habitat loss are continuing threats.

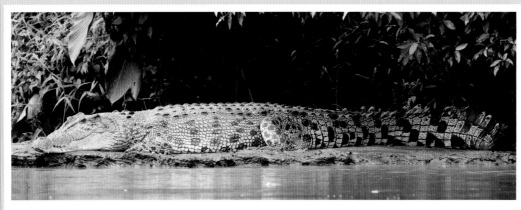

Saltwater Crocodile *Crocodylus porosus*

Features The huge 'saltie' is perhaps best known in Australia but has a wide Indo-Pacific range (p.405). Its heavy head with a pair of bony ridges diverging out from the snout to each eye, together with its massive jaws, make it one of the world's most formidable predators. It is a blackish to dark grey colour with bands and stripes on the flanks that fade with age.

Size Average 4m; maximum recorded 6.2m and 1,000kg; unconfirmed 10m.

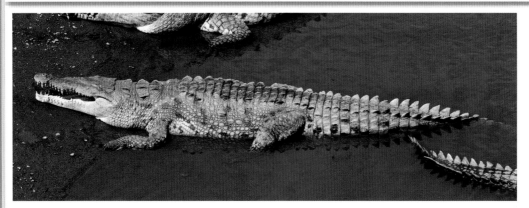
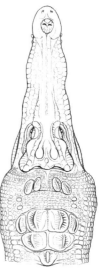

American Crocodile *Crocodylus acutus*

Features In freshwater, males of this species are known to use very low sounds (infrasound) to produce vibrations along the back that make the water above it 'dance' with droplets. This fascinating display helps warn off rival males. Adults are a dark, patchy grey whilst juveniles are greenish with dark bands that fade as they grow.

Size Average 3.5m; maximum 6m.

SEA TURTLES

Only seven species of turtles are adapted to a truly marine existence, their single connection with land being the females' laborious journey onto sandy shores to lay their eggs. In recent times such a sight has become a magnet for tourists and sea turtles have become a source of fascination and delight to naturalists, divers and holidaymakers alike. But these creatures also have a long history of exploitation and in spite of a fossil record dating back to the late Triassic around 230 million years ago, the seven living species are all now endangered.

A number of other turtles and terrapins live part or all their lives in brackish estuaries, mangroves and coastal swamps, whilst some other primarily freshwater species use the sea as a route to feeding and nesting sites.

DISTRIBUTION

Sea turtles are mostly restricted to warm temperate and tropical waters with temperatures of at least 20°C. Thanks to an ability to regulate its body temperature (p.402), the Leatherback Turtle (*Dermochelys coriacea*) can also range into cold temperate waters and is found as far north as the Arctic Circle and some distance south of New Zealand.

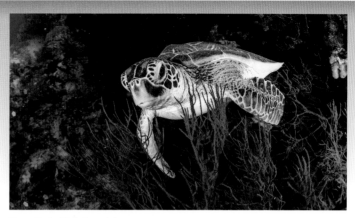

Green Turtle (*Chelonia mydas*).

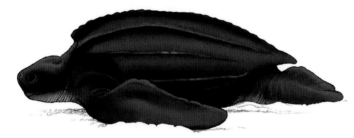

The low, streamlined carapace of marine turtles is an adaptation to their aquatic lifestyle. However, there is no room to withdraw their head and flippers into the shell.

Land tortoises have a much heavier and higher carapace than their marine relatives. Withdrawing the head and legs under the protection of the shell is an effective defence strategy.

STRUCTURAL ADAPTATIONS

In contrast to their rather ponderous and often dome-shaped land relatives the tortoises, marine turtles have flattened streamlined shells and long flippers for swimming. This is especially obvious in the Leatherback Turtle whose flippers can be nearly as long as its body. This makes them extremely cumbersome on land and a turtle captured and turned onto its back cannot usually right itself.

BIOLOGY AND ECOLOGY

Feeding

Turtles use their strong beak-like jaws to tear or snatch their food from the seabed. Most are specialist feeders and this is reflected in the various beak shapes. Adult Green Turtles (*Chelonia mydas*) are exclusively vegetarian and graze on seagrasses and marine algae. Hawksbill Turtles (*Eretmochelys imbricata*) feed almost exclusively on sponges, though the author has seen them feeding on large-polyped corals such as *Plerogyra*, and Loggerhead Turtles (*Caretta caretta*) can cope with tough crustaceans and molluscs. Kemp's Ridley (*Lepidochelys kempii*) and Olive Ridley Turtles (*Lepidochelys olivacea*) are opportunistic and will eat crustaceans and sea urchins, with Kemp's Ridley also taking molluscs and even fish. Flatback Turtles (*Natator depressus*) are thought to eat mainly soft-bodied animals including sea cucumbers, soft corals and jellyfish. Leatherback Turtles eat jellyfish and other gelatinous and soft-bodied animals, and the throat is lined with backward-pointing spines to help the passage of their slippery prey down into the stomach. This is why litter such as plastic bags are a problem as once a Leatherback has mistaken a bag for a jellyfish and started eating it, it cannot regurgitate it.

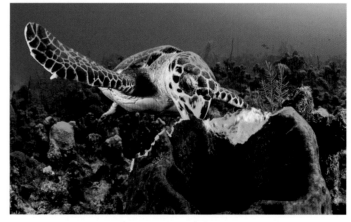

The sharp beak of a Hawksbill Turtle is ideal for tearing sponges. The remnants of the sponge will often regrow.

Life history

Turtles become sexually mature between about 6 and 35 years old (see table below) and are then ready to mate. This is not easy in open water and to help things along the male's claw on the leading edge of the front flippers enlarges and the tail grows much longer. A female ready to mate may have to put up with the attention of several males until the strongest gains a firm grip on her back using his claws and wrapping his tail underneath her. Sometimes small females drown after several hours of piggy-back from the male and they often have neck wounds where the male has clung on with his strong beak.

When they are ready to lay their eggs females come ashore, mostly at night and usually on the same beach or at least in close proximity to where they themselves hatched. This is an amazing feat considering the time elapsed and distances covered (see Migration p.58). It can also lead to problems and confusion when such beaches have meanwhile been developed for tourism. After dragging herself above the high tide line, the female laboriously digs a wide hole up to a metre deep in the sand with a smaller egg chamber at the bottom using her front flippers, before laying up to 100 white eggs. After covering them up and scattering sand to disguise the site as best she can, she makes her way back to the sea. Most turtles lay individually but whilst Olive Ridleys also do this, in some areas they have mass synchronised nesting involving up to 150,000 females and called an 'arribida'. The size of the much rarer Kemp's Ridley Turtle 'arribida' is now much reduced.

If the nest has not been raided by predators such as monitor lizards, the eggs hatch after about two months, the exact time depending on temperature and species, and the young push their way out of the nest. The hatchlings wait near the surface until nightfall which they detect as a drop in temperature and then scuttle down the shore attracted by the light on the natural horizon and so out to sea. If the bright lights of tourist resorts swamp out the horizon the hatchlings may head inland and may not survive. Once they reach the sea they swim out using wave direction as a guide for about 24 hours. Beyond that little is known about the early years of their lives. Flat-back Turtle young remain in coastal waters.

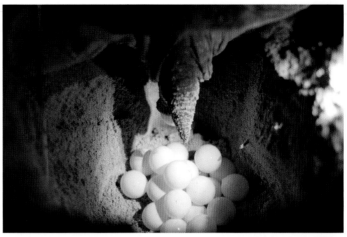

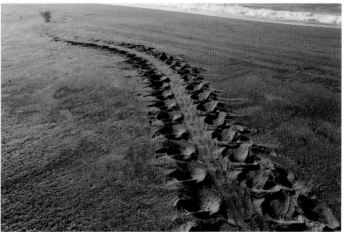

Eggs of a Green Turtle (top) and track of a Loggerhead Turtle (bottom). The eggs have a soft shell and are laid at night when it is cool and there are fewer predators about.

Species	Distribution. Significant nesting areas	Number of eggs and nesting frequency	Max age female maturity (years)	IUCN status
Green Turtle	Tropical and warm temperate worldwide. Malaysia, Indonesia, Australia, Costa Rica	100–150 Up to 9 clutches every 2-5 years	26–40	Endangered
Hawksbill Turtle	Tropical and warm temperate worldwide. Australia, Seychelles, Caribbean, Mexico	100–140 Up to 5 clutches every few years	20–40	Critically Endangered
Loggerhead Turtle	Tropical and warm temperate worldwide. Mediterranean, S.Africa, Australia, Oman, SE USA	Ca. 100 3–5 clutches ca. every other year	35	Endangered
Kemp's Ridley Turtle	Caribbean, Gulf of Mexico, SE USA. Nests only near Rancho Nuevo in Mexico and rarely Texas	Ca. 90 2–3 clutches every year or two	11–16	Critically Endangered
Olive Ridley Turtle	Tropical worldwide. Mexico, Costa Rica, India – mostly E coast at Gahirmatha.	110–120 2–3 clutches every few years	unknown, 11–16?	Endangered
Flatback Turtle	N and NE Australia, New Guinea, Arafura Sea. Australia	50–60 2–3 clutches 15 days apart	unknown	Data Deficient prev. Vulnerable
Leatherback Turtle	Tropical to temperate worldwide. French Guiana, Surinam, Ghana, Mexico, Indonesia, S Africa	About 100 4–10 clutches every few years	6–10 (?)	Critically Endangered

Distribution, nesting and status of marine turtles.

TURTLES AND TEMPERATURE

Temperature has a remarkable effect on the lives of sea turtles and many other reptiles. The sex ratio of the young hatchlings in a nest is determined by temperature, known as TSD – Temperature-dependent Sex Determination. This in turn is determined by the depth and position of the nest. Higher temperatures result in more females and the critical time for sex determination seems to be during the middle third of the incubation period. A nest temperature of 28–30° Celsius during this time results in an approximately equal sex ratio. At temperatures above 33° or below 23° Celsius most eggs fail to hatch. The exact pivotal temperature, as it is known, varies between species and even between populations of the same species. A summary of reported pivotal temperatures is given in Lutz and Musick 2002.

This is very important in turtle nest management practised for conservation reasons in some areas such as the Turtle Islands, situated off the north coast of Sabah, Borneo. Here rangers collect the eggs each night from new nests and transfer them to the safety of fenced areas. Simply by positioning such hatcheries in the shade or not could greatly influence nest temperature and hence affect the sex ratio or hatching success.

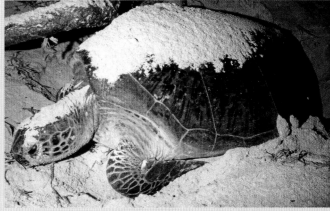

A Green Turtle (*Chelonia mydas*) digging her nest on Heron Island, Great Barrier Reef Australia.

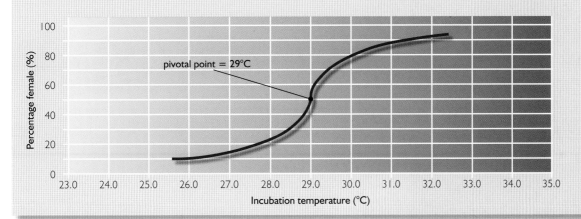

A generalised graph showing the relationship between incubation temperature and hatchling sex of marine turtles.

USES, THREATS, STATUS AND MANAGEMENT

Turtle eggs are still widely collected and eaten, and adults are taken for their flesh (turtle soup) and their shells which are made into souvenirs. An equal if not larger threat comes from their incidental catch in fishing gear such as shrimp trawl nets and baited tuna long-lines (especially Loggerheads in the Mediterranean). Destruction and invasion of traditional nesting beaches from unregulated development including tourism is a worldwide threat, as is marine litter especially for Leatherback Turtles. As a result all seven species are threatened (see Table p.408).

International trade in all sea turtles and their products is banned under their listing on Appendix I of the Convention on International Trade in Endangered Species (CITES). Important nesting beaches for Olive and Kemp's Ridley Turtles are protected and turtle excluding devices (TEDs) on shrimp trawl nets have helped reduce loss of these species in USA but are not widely employed or enforced worldwide. Artificial rearing in protected beach hatcheries and subsequent release help prevent predator loss and disturbance from tourists.

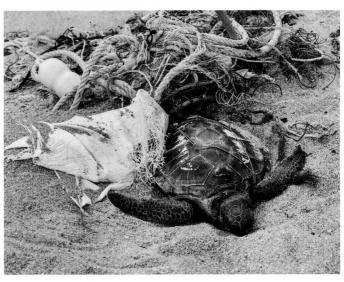

Sea turtles caught in fishing trawl nets or in discarded and lost nets quickly use up their oxygen supply and drown as they struggle to get free.

SEA TURTLE SPECIES: ORDER TESTUDINES

The number of living turtles is around 290. The seven extant species of sea turtles are all contained in the suborder Cryptodira, six in the family Cheloniidae and one in the family Dermochelyidae. Two other turtles also in the suborder Cryptodira are restricted to coastal salt and brackish habitats such as estuaries, saltmarshes and saline lagoons. These are the African Soft-shelled Turtle *Trionyx triunguis* (Family Trionychidae) and the Diamondback Terrapin *Malaclemys terrapin* (Family Emydidae), found on the Atlantic coast of North America from Cape Cod to Texas and the Florida Keys.

FAMILY Cheloniidae

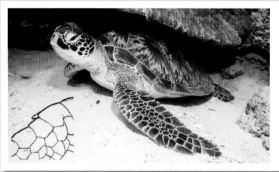

Green Turtle *Chelonia mydas*

Features Green Turtles are not actually green but a variable dark olive-grey to brownish with dark speckles or blotches, and young are chestnut with a 'tortoiseshell' pattern similar to Hawksbill. In profile the head is rounded and steep with the upper beak only slightly overlapping the lower beak. This shape is ideally suited to grazing the sea grasses on which it largely feeds. The nostrils are on the beak, there are two prefrontal scales between the eyes and a claw on each flipper. A subspecies, the Black Turtle *C. mydas agassizi* with a darker and higher carapace, inhabits the eastern Pacific and is classified by some as a separate species.
Size Second largest species, to 1.5m long and 230kg.

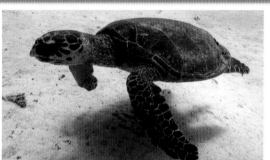

Hawksbill Turtle *Eretmochelys imbricata*

Features Mostly a rich marble of chestnut-brown and amber to yellow ('tortoiseshell'). The central scutes along the back overlap one into the next (diagnostic if visible, see diagram p.411). The head profile slopes with a long bird-like upper beak hooked over lower one. This sharp, strong design allows Hawksbills to tear into tough sponges and soft corals, a decidedly rough diet. Nostrils on a separate scale above the beak and four prefrontal scales help distinguish it from the Green Turtle. Two claws on each flipper.
Size Small, to about 1m long and 60kg.

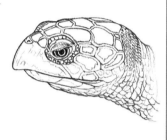

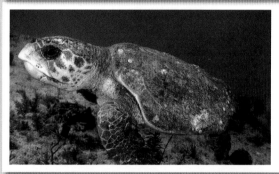

Loggerhead Turtle *Caretta caretta*

Features An over-sized, solid head and thick neck with a steep profile and the upper beak just overlapping lower make this reddish-brown turtle easy to recognise. The nostrils are on the beak and there are four or more prefrontal scales. The front flippers are short at only about a third of body length (diagnostic) and there are two claws on each flipper. The massive head and jaws allows them to tackle a variety of hard-shelled clams, gastropod molluscs and sea urchins. They seem to be especially vulnerable to incidental by-catch in nets.
Size Large, to 1.2m and 160kg.

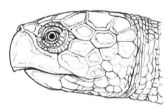

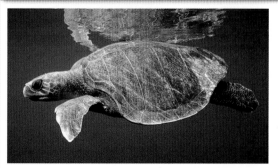

Olive Ridley Turtle *Lepidochelys olivacea*

Features This small turtle is the most abundant of the seven sea turtle species but as with all the species, accurate population statistics are difficult to obtain. Even so it is considered Vulnerable in the IUCN Red List of Threatened Species. Olive grey with 6–9 tall narrow costal plates on each side is diagnostic. The front carapace is conspicuously indented behind the head and over the base of flippers (often described as heart-shaped). The nostrils are on a separate scale, and there are four prefrontal scales and two claws on each flipper.
Size Small, to 1m and 35–50kg.

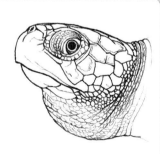

MARINE REPTILES

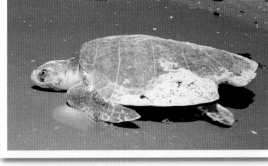

Kemp's Ridley Turtle *Lepidochelys kempii*

Features Kemp's Ridley is greyish and similar to the Olive Ridley but with only five costal plates. It is the rarest of all marine turtles and its restricted nesting range (p.408) make it especially vulnerable. Unusually the females come ashore to nest during daylight. Although numbers are hugely reduced, the sight of them arriving simultaneously to lay, is impressive. They feed largely on swimming crabs, other crustaceans and small molluscs.
Size Small, to 1m and 35–50kg

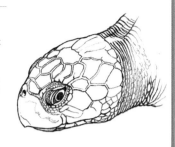

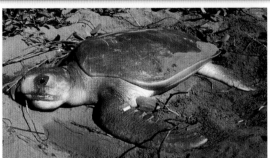

Flatback Turtle *Natator depressus*

Features The Flatback is the least known of the marine turtles with a limited range off Australia and New Guinea. It is similar in shape and profile to the Green Turtle but the carapace is flattened to a low dome with a clearly upturned edge especially at the rear. In older animals this is flexible, and unlike other species, they shed their hard scutes. The nostrils are on the beak, there are two prefrontal scales and one claw on each flipper (juveniles may have two). Its diet includes sea cucumbers, soft corals and squid (presumably dead or moribund as they are not swift predators).
Size Medium, to 0.9m and 75kg.

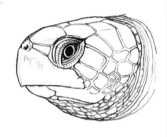

FAMILY Cheloniidae

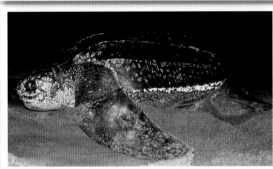

Leatherback Turtle *Dermochelys coriacea*

Features The Leatherback is by far the largest and most wide ranging of sea turtles. Specimens stranded on shores in northern Europe often make the headlines. The leathery carapace has seven distinct longitudinal ridges and the upper jaw has a distinctive tooth-like projection on either side. There are no scales on the head and no claws on the exceptionally long flippers. Large accumulations of the jellyfish on which they feed, are a magnet for them.
Size Large, to 2m and 500kg (largest documented was nearly 3m and 916kg).

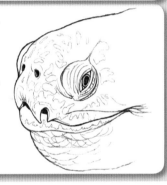

FAMILY Dermochelidae

TURTLE IDENTIFICATION

Underwater In areas with diving tourism and good turtle protection such as Sipadan Island in Malaysia, close encounters underwater are common. The shape of the beak (look and photograph from the side) and pattern and colour of scutes on the back (look and photograph from above) should be enough for positive identification of Green and Hawksbill which commonly occur on the same reefs in the Indo-Pacific.
From a boat Most turtles will dive down away from noisy boat engines, making identification difficult.
On land Note or photograph the following:
head from above to show size and number of prefrontal scales
head from side to show beak shape and position of nostrils
shell from above to show number and arrangement of scutes
underside to show inframarginal pores in Kemp's Ridley

Most likely encounters
Indo-Pacific and Great Barrier Reef: Green and Hawksbill
Caribbean and Gulf of Mexico: Green, Kemp's Ridley
Northern Europe: Leatherback
Mediterranean: Loggerhead

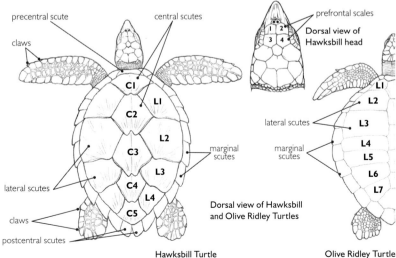

Dorsal view of Hawksbill and Olive Ridley Turtles

Hawksbill Turtle

Olive Ridley Turtle

SEA TURTLES

SEA SNAKES

True sea snakes (Hydrophiinae) have morphological and physiological adaptations that allow them to live their entire lives at sea where they feed, rest and reproduce. On land they are helpless and if stranded they die because they lack the broad belly scales (gastrosteges) that allow most terrestrial snakes to grip the substratum and move over the ground. Sea kraits (Laticaudinae) are also adapted to a marine existence but retain gastrosteges and the ability to move on land. A number of other, primarily freshwater and mostly non-venomous snakes can also be found in estuaries and shallow coastal waters but lack many of the adaptations of true sea snakes and sea kraits. These are excluded from the term 'sea snake' as used below.

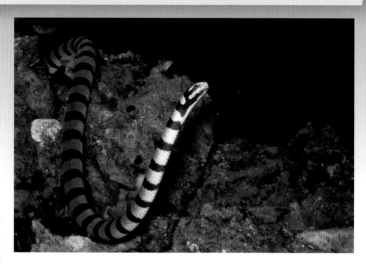

DISTRIBUTION

Sea snakes are found in coastal tropical waters from the Arabian Gulf eastwards through the Indo-Pacific south to northern Australia and islands of the north-west Pacific, and north to Japan. One species, the Yellow-bellied Sea Snake (*Pelamis platura*) is pelagic with a wider range extending additionally down the east coast of South Africa and across the Pacific Ocean to the west coast of Central America and adjacent waters of southern USA and northern South America. There are no sea snakes in the Red Sea or the Atlantic Ocean.

STRUCTURAL ADAPTATIONS

Sea snakes show a number of morphological adaptations to their marine environment. The most obvious is a flattened paddle-shaped tail (see photograph p.404) which greatly increases their speed and agility when swimming. Most snakes can swim and many spend time swimming and hunting in freshwater, but do not show this adaptation which allows sea snakes to swim long distances in open water.

BIOLOGY AND ECOLOGY

Feeding

Although sea snakes can swim they cannot do so fast enough to pursue very active prey. Consequently most of them feed on bottom-living, sedentary fish that live in sediment burrows or rock and coral crevices. A hunting snake will swim slowly over the seabed poking its head into likely holes, using its tongue to taste and smell. Once bitten and subdued, fish are swallowed head first, almost always underwater. Different species specialise in different prey such as eels, gobies and catfish. A few species including the Beaked Sea Snake (*Enhydrina schistosa*) have a rather more

DEADLY VENOM

Many sea snakes such as sea kraits *Laticauda* spp. are docile and will ignore divers or swim away from them. Some are curious and will investigate divers whilst a few such as *Hydrophis spiralis* are aggressive and easily provoked. However, all sea snakes should be treated with the utmost caution because they rank amongst the most venomous of all snakes. When fully primed the Beaked Sea Snake (*Enhydrina schistosa*), an aggressive species, can produce an amount of venom about 50 times higher than the estimated fatal dose for humans. Sea snakes use their venom primarily to subdue their prey and the extreme toxicity may be the result of an evolutionary 'arms race' with prey such as eels developing immunity, requiring yet stronger venom.

Sea snakes have relatively short, hollow, fixed fangs, one on either side at the front of the mouth located on the maxillary bones. A pair of elongated venom glands lying beneath the skin of the upper jaw provides the fangs with venom via a duct. The venom builds up in a central cavity in the gland and the snake has muscular control over how much venom it injects.

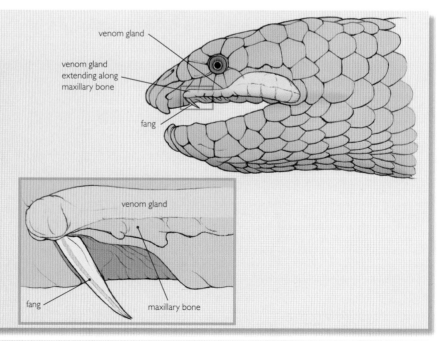

MARINE SNAKES SPECIES: ORDER SQUAMATA

All snakes are included in the suborder Serpentes with an estimated 2,700 species and 21 families worldwide (www.reptile-database.org). The other suborder in the Squamata is Autarchoglossa which includes skinks and the Komodo Dragon. There are about 68 species of sea snakes traditionally included in the family Elapidae (which also includes the cobras) and shown below. The majority of these are true sea snakes, in the subfamily Hydrophiinae (Family Hydrophiidae in earlier references). The remaining six species are sea kraits in the subfamily Laticaudinae. All species in these two subfamilies are fully marine. Wells (2007) divides the Hydrophiidae into five families. Identification of sea snakes to species is difficult, especially in the genus *Hydrophis* where it may be necessary to count scale rows around the body and head shields etc.

Estuarine snakes belong to two subfamilies of primarily freshwater species, the Homalopsinae and Natricinae within the family Colubridae.

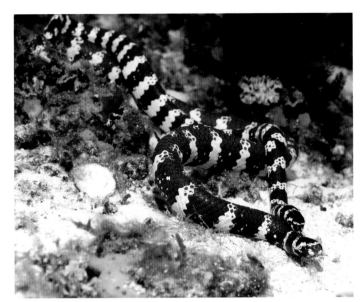

A pair of Ijima's Turtlehead Sea Snakes (*Emydocephalus ijimae*) preparing to mate underwater.

Family and genus	Number of species	Distribution
ELAPIDAE HYDROPHIINAE	Marine	
Acalyptophis peronii*	1	Central Indo-Pacific
Aipysurus	8	Central Indo-Pacific
Astrotia stokesii*	1	Arabian Sea to Central Indo-Pacific
Chitulia	2	Central Indo-Pacific; S Pacific
Disteira	4	N Indian Ocean; Central Indo-Pacific
Emydocephalus	2	Australasia
Enhydrina	2	Arabian Gulf to N Australia
Ephalophis greyi*	1	Central Indo-Pacific
Hydrelaps darwiniensis*	1	Central Indo-Pacific
Hydrophis	28	Indian and Pacific Oceans
Kerilia jerdonii*	1	India to Central Indo-Pacific
Kolpophis annandalei*	1	Central Indo-Pacific
Lapemis	2	Arabian Gulf to Central Indo-Pacific
Microcephalophis	2	Arabian Gulf to Western Indo-Pacific
Parahydrophis mertoni*	1	Central Indo-Pacific
Parapistocalamus hedigeri*	1	Solomon Islands
Pelamis platurus*	1	Indian & Pacific Oceans
Polyodontognathus caerulescens*	1	N Indian Ocean to Central Indo-Pacific
Praescutata viperina*	1	N Indian Ocean to Central Indo-Pacific
Thalassophis anomalis*	1	Central Indo-Pacific
ELAPIDAE LATICAUDINAE	Marine	
Laticauda	6	Indo-Pacific
COLUBRIDAE	Estuarine	
Bitia hydroides*	1	SE Asia
Cantoria	2	SE Asia
Cerberus	1	Central Indo-Pacific
Enhydris	2	China
Fordonia leucobalia*	1	Central Indo-Pacific
Gerada prevostiana*	1	SE Asia
Myron richardsoni*	1	West South Pacific
Nerodia	4	North America
ACROCHORDIDAE	Estuarine	
Acrochordus	1	India to Australia

haphazard method of feeding, simply swimming along near the seabed until they are close enough (within a few centimetres) to smell or touch a fish and strike it. These tend to be generalist feeders taking a wide variety of species though some crevice feeders are also generalists. The Yellow-bellied Sea Snake catches its prey at the surface by floating and drifting often in large aggregations. Small surface-living fish are attracted to what seems like debris to them and are ambushed by a sideways swipe as they approach. Even in this species it seems that vision plays little part in hunting.

Life history

True sea snakes (Hydrophiinae) are viviparous and give birth to live young underwater. The baby snakes quickly surface and take their first breath with no help from the mother who swims away. In contrast the sea kraits (Laticaudinae) are oviparous and come ashore to mate and lay their eggs. Small islands are favourite sites and may support hundreds of snakes which also come ashore to rest and drink freshwater. Some spend long periods out of the water. Between two and twenty eggs are laid on land above high tide under litter or in crevices, the number varying both between and within species, and hatch about two months later. *Pseudolaticauda semifasciata* has been filmed laying eggs in rocky crevices inside a flooded sea cave on Nuie in the South Pacific (BBC Life). Here large air pockets provide dry land where the eggs and young are safe from predators. Females *L. colubrina* are ready to breed at about 18 months old and males by about two years.

USES, THREATS, STATUS AND MANAGEMENT

In Asia, sea snakes are exploited for their skins for the leather industry, and in some areas are also eaten or fed to livestock. They are collected by hand underwater, often by free diving as well as on land. Sea snakes are also taken as bycatch in commercial prawn trawls in northern Australia. The Rennell Island Sea Krait *Laticauda crockeri* is listed as 'Vulnerable' in the IUCN Red List of Threatened Species.

Marine and estuarine snake genera in WoRMS (2015). There are additional genera and species in the Elapidae and Colubridae that are not marine.. *=monotypic genus.

SUBFAMILY Hydrophiinae

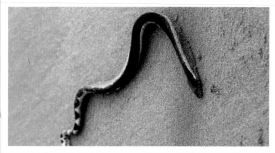

Yellow-bellied Sea Snake Pelamis platura

Features With the widest distribution of any snake (p.412) and entirely pelagic habit, individuals of this sea snake are inevitably sometimes washed ashore. Here they are helpless and usually die. Whilst tail markings are variable, most have a black back and the yellow belly after which the species is named. Exactly where these snakes wander and whether their movements are influenced by seasonal rainfall is still unknown (Ingley 2010).
Size 1.5m.

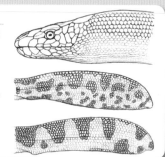

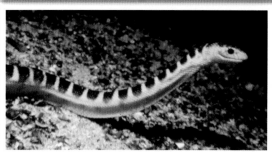

Arabian Gulf Sea Snake Hydrophis lapemoides

Features There are many different species of *Hydrophis* and they are difficult to tell apart, often necessitating careful scale counts. This one was photographed in the Arabian Gulf and is most likely this species which is usually yellow with incomplete black rings. However, *H. cyanocinctus* is very similar. Whilst some species are distinctive, identifying sea snakes from photographs alone is not easy, especially the numerous species in this genus.
Size Up to about 1m long.

SUBFAMILY Laticaudinae

Yellow-lipped Sea Krait Laticauda colubrina

Features This is the most widespread of the six species of sea krait in this genus and can be recognised by its distinctive yellow head markings. It occurs throughout the Indo-Pacific and is frequently seen by divers on coral reefs. Here the snakes wind in and out of crevices hunting for small fish. In some areas large numbers hunt together by following trevallies and other predatory reef fish. These scare smaller fish into hidey holes where the snakes can trap them.
Size Average 1.4m; max 3m.

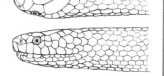

FAMILY Colubridae

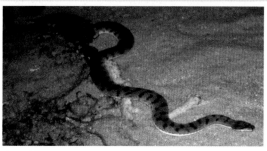

Dog-faced Water Snake Cerberus rynchops

Features Not all snakes found in the ocean are true sea snakes. The Dog-faced Water Snake is commonly found in freshwater streams and mangroves but is tolerant of saltwater and often hunts over tidal shallows at night, as seen here off Tioman Island, Malaysia. Unlike true sea snakes it is only mildly venomous and is easily caught and handled (but this is NOT advised). It gives birth to live young on land.
Size Average 75–90cm; max 1.2m.

SNAKE IMPOSTERS

Hunting for small fish over coral reefs in Malaysia, this Banded Snake Eel (*Myrichthys colubrinus*) is a fish that looks exactly like the Sea Krait (*Laticauda colubrina*). This gives it a distinct advantage as, although it is entirely harmless, it will be avoided by predators, a phenomenon known as Batesian mimicry. A careful look will show the dorsal and pectoral fins, a pointed tail and no scales.

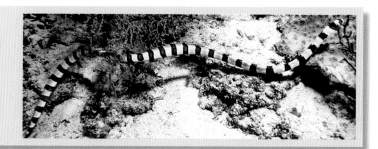

MARINE IGUANA

The Marine Iguana (*Amblyrhynchus cristatus*) is the only lizard that, as an adult, feeds entirely from the sea and so spends a considerable part of its time submerged. Although there is only one species there are differences in size and coloration between individuals on different islands equating to subspecies or races.

DISTRIBUTION

Endemic to the Galapagos Islands, these large lizards live in groups on the rocky seashores where they are a considerable tourist attraction.

STRUCTURAL ADAPTATIONS

Just below the tide line of the barren rocks and lava fields where Marine Iguanas spend much of their time are lush beds of seaweeds. Seaweed forms the stable diet of these large vegetarians, but getting it is difficult and consequently they show several structural adaptations designed to make this method of feeding possible. Long, sharp claws enable them to cling to the rocks whilst being pounded by surf or washed by strong currents deeper down. A short snout allows them to get up close and scrape off the seaweed with strong three-cusped teeth. Swimming and diving is helped by a long, sideways flattened tail and their habit of holding their limbs tucked tightly in to minimise drag.

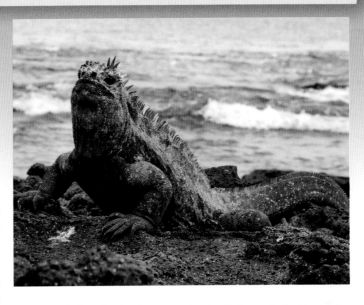

BIOLOGY AND ECOLOGY

In the breeding season around November and December, males defend small territories and engage in highly ritualised head-wrestling. Sparring partners will lock heads using tall pyramid-shaped scales which cover the top of the head and bouts may last several hours. The winner mates with any female that enters his territory. When they are ready to lay their eggs, usually about five weeks after mating, females move inland to sandy areas where they dig a metre-deep tunnel and lay up to six eggs. After filling in and smoothing over the entrance to hide it from predators, the females remain for a few days but eventually return to the sea to feed, leaving the eggs to hatch three to four months later. When the young emerge they make a dash for cover and gradually make their way down to the sea's edge.

USES, THREATS, STATUS AND MANAGEMENT

Eggs and young are especially vulnerable to introduced predators including cats, dogs and rats. Adult populations can be seriously affected by changes in sea temperature following an 'El Nino' event (p.17). This can affect the growth of their normal seaweed food or encourage overgrowth by other non-edible species. Oil spills contaminate feeding and nesting grounds. Conservation efforts within the Galapagos Marine Reserve are being made to eradicate non-native pests, and control tourists.

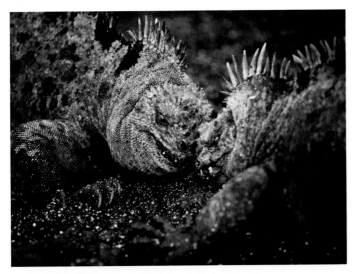

Two male Marine Iguanas in red breeding colours, battling over females.

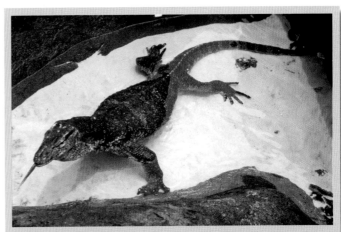

The Water Monitor (*Varanus salvator*) frequently enters the sea to catch crabs, fish and other prey and to swim between islands in coastal areas of the Indo-Pacific. This is a common sight at Tulai Island (near Tioman), east Malaysia.

MARINE MAMMALS

Marine mammals are very much at ease in their watery world whilst we, as terrestrial mammals, are not. Entering their world, we can watch their fascinating behaviour from the sidelines, but often we too become the subjects of intense curiosity. Swimming gracefully around us they watch while we struggle to hold our breath or maintain our buoyancy. Secure in their size and agility, many exhibit little fear. However, those that venture out of the water and on to land are far less confident and often take fright at the slightest alarm, hurrying back to the security of the water. The majority of mammals are terrestrial and out of 5,146 known species only 125 are truly marine. Whales and dolphins (cetaceans) are the most highly adapted and soon die if stranded out of water, whilst pinnipeds such as seals and Walrus (*Odobenus rosmarus*) only come ashore to moult, mate and give birth. Otters spend time both in and out of the water, mostly in rivers and lakes and only a few species live primarily in the ocean. The Polar Bear (*Ursus maritimus*) may seem perfectly at home on land, but is so reliant on the ocean for a living that it is usually, as here, included as a marine mammal.

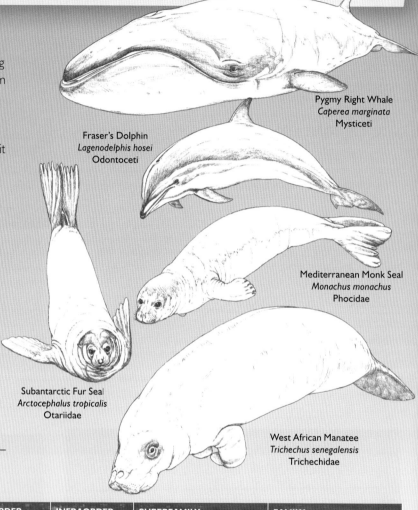

Pygmy Right Whale
Caperea marginata
Mysticeti

Fraser's Dolphin
Lagenodelphis hosei
Odontoceti

Mediterranean Monk Seal
Monachus monachus
Phocidae

Subantarctic Fur Seal
Arctocephalus tropicalis
Otariidae

West African Manatee
Trichechus senegalensis
Trichechidae

CLASSIFICATION
Marine mammals form a class in the phylum Chordata (p.306).

CLASS	SUBCLASS	ORDER	SUBORDER	INFRAORDER	SUPERFAMILY	FAMILY
MAMMALIA	Theria	Cetartiodactyla	Cetancodonta	Cetacea	Mysticeti (baleen whales)	4 families
					Odontoceti (toothed whales)	10 families
		Sirenia				Dugongidae (Dugong)
						Trichechidae (manatees)
		Carnivora	Caniformia	Pinnipedia		Odobenidae (Walrus)
						Otariidae (sea lions)
						Phocidae (seals)
						Mustelidae (otters)
						Ursidae (Polar Bear)

ANATOMICAL AND PHYSIOLOGICAL ADAPTATIONS

Marine mammals evolved from land-dwelling ancestors and have developed secondary adaptations to life in water. In contrast to the wide variety of shapes and sizes seen in land mammals, marine species are all relatively large and have sleek and streamlined bodies for efficient swimming. Most propulsive power comes from specially adapted hind limbs or in cetaceans (where the hind limbs have been lost completely) from a broadened and horizontally aligned tail. The number of body projections has been reduced, with mammary glands and sex organs all internalised and external ears reduced to small flaps or simply to small holes. However, hearing remains acute and is often far better than in terrestrial mammals.

Most marine mammals are of necessity carnivorous as sufficient vegetation (seaweeds and seagrasses) to support large herbivores is restricted to shallow water. However, many have become filter-feeders (a feeding method not found in any terrestrial mammal) and so can take advantage of the abundant plankton resource of the ocean. This method is best known in the large baleen whales, but it is also practised by three species of pinnipeds: the Crabeater Seal (*Lobodon carcinophagus*), juvenile Leopard Seal (*Hydrurga leptonyx*) and Antarctic Fur Seal (*Arctocephalus gazella*), all of whom feed primarily on krill.

Temperature regulation

Like all mammals, marine mammals are endothermic ('warm-blooded') and must maintain a stable core temperature. This is especially challenging in cold and moving water which is a very effective heat sink and marine mammals have had to evolve a suite of anatomical, physiological and behavioural methods to reduce heat loss. Pinnipeds, sea otters and Polar Bears spend considerable periods out of the water and for them the traditional mammalian layer of fur, thickened and modified with a water-repellent undercoat, provides a good means of insulation. However, fur alone is not enough and of course cetaceans and sirenians are virtually hairless. So many marine mammals, particularly cetaceans, have a sub-cutaneous layer of blubber.

Made up of vascularised adipose (fatty) tissue, blubber is an amazing insulating and storage material. It can constitute up to 50% of a marine mammal's body mass at certain times in its life, and may range in thickness from 5cm in dolphins and smaller whales right up to 50cm in the Bowhead Whale. In some species the amount of blubber varies between seasons. Many of the great whales build up their blubber fat reserves when feeding in cold polar waters and then live off it when they migrate to warmer, but food-poor, calving and mating areas. Interestingly, it is not the overall thickness of blubber that determines its insulating properties so much as the lipid to water ratio within the blubber. The higher the proportion of fat present, the greater the heat retention. Other mechanisms also help to conserve heat and size is one of them. Whilst the smallest known mammal is the size of a large bumble-bee, the smallest marine mammal is about 1m long. A larger size and the generalised cylindrical body shape with small appendages, reduces the surface area to volume ratio of the body, thus reducing heat loss. Various counter-current systems of blood flow allow heat from the arteries to be passed to adjacent veins before the blood reaches the extremities. Lowering the rate of respiration and increasing the metabolic rate are further means of reducing heat loss. In warm climates, over-heating may be a problem and seals or sea lions can sometimes be seen swimming at the surface waving their wet front flippers in the air to benefit from convection cooling. On shore, flicking sand over the body can provide a sunscreen and blood vessels in the skin can be expanded to help radiate heat away.

Salt and water balance

Living in salt water means that sea mammals need an efficient means of regulating the salt and water balance within their bodies. The osmotic concentration of seawater is nearly four times greater than that of mammalian body fluids, which results in a tendency for water to try to move out of the body tissues and for electrolytes (salts) to move in through osmosis (see p.218). Marine mammals have developed various strategies to overcome this, to conserve water and to remove excess salt taken in with their food. Like marine reptiles, their skin is largely impermeable thus preventing osmotic water loss. Sweat glands are either reduced or absent, the digestive system is designed to extract maximum liquid from their food and the kidneys are extremely efficient at retaining water. This still leaves the problem of obtaining sufficient freshwater in the first place and getting rid of excess salt. Our kidneys cannot concentrate excess salt into urine to a sufficient extent to allow us to live without a source of freshwater or to drink seawater. Neither can the kidneys of marine birds and marine reptiles, but these two groups solve the problem with special salt glands (p.404 and p.462). In contrast, marine mammal kidneys can produce highly concentrated urine. Most research in this field has looked at seal and sea lion species (it is not known how cetaceans may differ). Typically, this has shown their urine to contain up to two and a half times more salt than seawater does and seven or eight times more salt than their blood. With this ability and efficient conservation of dietery water (water makes up about 70% of a fish, 80% of a squid and over 90% of aquatic plants) (Geraci and

A female Northern Elephant Seal (*Mirounga angustirostris*) covering itself with cooling sand on a hot Californian beach, USA.

In warm summer weather, Cape Fur Seals (*Arctocephalus pusillus pusillus*) can overheat, but by holding their large wet flippers up, they lose heat by convection.

This Sperm Whale (*Physeter macrocephalus*) off Kaikoura, New Zealand was on the surface for less than 10 minutes before diving again and remaining submerged for about an hour.

Lounsbury 2008) they do not need to drink freshwater. In addition, the metabolic breakdown of dietary fat or blubber produces water. Whether they ever purposely drink seawater is unknown. Seals have occasionally been seen to eat snow and coastal manatees are known to drink freshwater when available (such as from garden hoses left running into waterways in Florida). Sea Otters (*Enhydra lutris*) almost never come ashore and have no access to fresh water. Their kidneys are nearly twice the size of river otters, to help them cope with excess salt.

Diving adaptations

While we humans tend to think in terms of 'returning to the surface' after a dive, marine mammals that are wholly aquatic (i.e. the cetaceans and sirenians) do things the other way round. Thus, the time they spend visiting the surface is kept to a minimum and they will 'return to being under water'. Their breathing cycle has been adapted so that the air intake portion (when at the surface) has been reduced and the breath-holding portion has been significantly extended. Diving ability varies from species to species and depends to a large extent on diet. Sirenians feed on seagrasses found in shallow water and will spend little more than 10 minutes between breaths. Some toothed whales, on the other hand, regularly dive to over 1,000m for periods of 30 minutes or more, where they have to contend with extraordinary pressures and the potential accumulation of nitrogen.

When diving, oxygen is conserved and nitrogen uptake into the blood and tissues limited, by means of the so-called 'mammalian diving reflex'. This set of physiological changes is most developed in marine mammals but also elicited to a limited extent by other mammals including humans when they enter the water. Circulation to the muscles, skin and viscera is reduced dramatically (peripheral vasoconstriction), allowing oxygen to be channelled to organs that need it most, such as the heart and brain. At the same time the heart rate is reduced, sometimes dramatically (brachycardia).

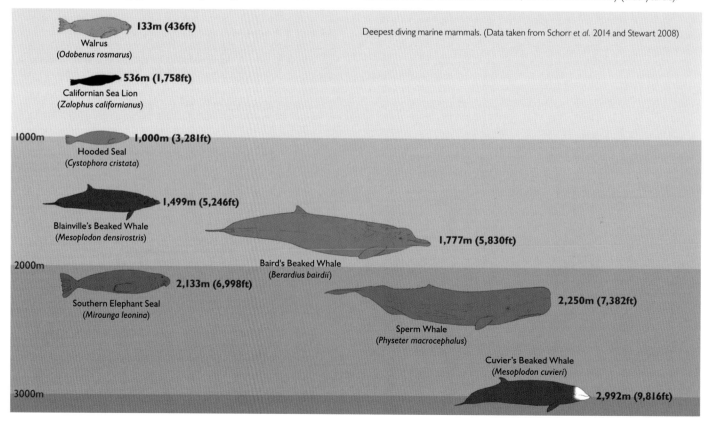

Deepest diving marine mammals. (Data taken from Schorr et al. 2014 and Stewart 2008)

Satellite tagging of Crabeater Seals (*Lobodon carcinophaga*) indicates most of their dives are shallow. Therefore they rarely use up their stored oxygen supply, recovery period between dives is short and they may dive as many as 150 times a day. Longer recovery periods are needed after extended deep dives as time on the surface is then required to metabolise lactate built up in the muscles by anaerobic metabolism.

Other specific adaptations of diving mammals include the ability to store oxygen in the muscles using a specially-adapted protein called myoglobin. This has recently been found to have 'non-stick' properties (Mirceta et al. 2013), which allows huge amounts of oxygen to be packed into the muscles without them clogging up. The lungs are collapsible so that air can be pushed into the windpipe and nasal sacs where excess nitrogen will not be absorbed into the tissues. In this way, they avoid the danger of decompression sickness, commonly known as 'the bends'. Finally, but as a last resort, if it is a particularly long dive a shift can be made to anaerobic metabolism, although this is physiologically exhausting.

	ml O_2 per kg body weight	% stored in lungs	% stored in blood	% stored in muscles
Pinnipeds	40–60	10	60	30
Cetaceans	35	22	30	48
Humans	20	25	60	15

Oxygen storage in diving mammals. Oxygen is stored in the lungs, blood (haemoglobin) and muscles (myoglobin). Diving mammals have a greater total storage capacity per kilogram of body weight than non-diving species such as humans. Both cetaceans and pinnipeds store the least amount in their lungs (and may even exhale before diving). In general, cetaceans store the most in the muscles and pinnipeds most in the blood. Modified from Kooyman, 1989.

THE BENDS

Decompression sickness (DCS), often called 'the bends', is a potentially fatal and damaging condition that can result from breathing compressed air. The air in a scuba divers' tank (cylinder) is compressed to a high pressure but is delivered to him by his diving regulator at ambient pressure (i.e. at the same pressure as the water surrounding him). Air is approximately 78% nitrogen which is normally breathed straight out again when a person exhales. However, breathing compressed air results in nitrogen being forced into the bloodstream and as water pressure increases with depth (p.23) so the deeper he dives the greater proportional increase in the levels of dissolved nitrogen in the bloodstream. The longer and deeper the dive, the more nitrogen will accumulate. A rapid ascent from depth with an associated sudden decrease in pressure can allow bubbles to form in a diver's blood, in much the same way as bubbles are released when the top is taken off a bottle of carbonated drink. The resultant 'bends' can maim and kill. Divers avoid this by controlling the time, depth and ascent speed of their dive using decompression tables or more usually today, wrist-worn diving computers.

Diving mammals such as whales are also exposed to the risk of decompression sickness because the air held in their lungs will be compressed by the increasing water pressure as they descend. Nitrogen will therefore be forced into the blood stream during the relatively long periods they spend underwater. Many then ascend relatively fast to the surface from great depths. Under normal circumstances, various adaptations (see above) prevent them from getting the bends. A swimmer or snorkeller will generally take a large breath before diving down, but diving mammals do not generally do this. Less air in the lungs means less nitrogen can forced into the bloodstream.

There is some post mortem evidence (of gas bubble lesions) from stranded cetaceans that indicates they can suffer damage from DCS. However such evidence is difficult to obtain as the animals need to be examined very soon after death. Research indicates that the DCS most probably results from uncharacteristically rapid ascents from depth when the animals have been frightened, possibly as a result of incidences such as naval or commercial sonar noise. Interestingly, the first definitive diagnosis of DCS in marine turtles from specimens caught as by-catch has recently been demonstrated by García-Párraga et al. (2014).

WHALES AND DOLPHINS

Whales, dolphins and porpoises are collectively known as cetaceans (Order Cetacea), from the Greek word *ketos* meaning 'a large sea creature'. To us they are elusive creatures which spend a major portion of their lives under water or in remote areas far out to sea. We are only really aware of them when they surface to breathe or become stranded on the shore. For this reason they can be extremely difficult to study and our understanding of their behaviour, distribution and biology is improving all the time. Even the number of cetacean species in existence is uncertain: new ones are still being discovered and there are constant discussions about whether or not others should be split into two or more different species. In 1995 for example, 79 cetacean species were generally recognised, whereas today that number has grown to 90. As recently as 2010, the first ever live sighting was made of what was regarded as the world's rarest whale: the 5m long Spade-toothed Beaked Whale (*Mesoplodon traversii*). Two individuals, a mother and her male calf, were found stranded on a beach in New Zealand. Previously, the species had only been known from three partial skulls collected from New Zealand and Chile, over a 140 year period. Initially they were thought to be the far more common Gray's Beaked Whale, but their true identity came to light following DNA analysis (Thomson *et al.* 2012). In fact this technique has led to the reappraisal of the status of several other species, some of which have subsequently been split into two or more species.

Cetaceans are descendants of land-living mammals and they retain many clues to their terrestrial origins, the most obvious of which is that they must breathe air. In addition the bones of their flippers look like huge, jointed hands and the vertical up and down movement of their backbones when swimming is more like that of a running mammal than it is of the side to side horizontal movement of a fish. Exactly how land animals evolved into present day cetaceans has remained a mystery for a long time, owing to gaps in the fossil record. However, recent fossil discoveries in northern Pakistan have helped fill many of these gaps. Perhaps the most remarkable discovery (in 1993) was that of *Ambulocetus* or the 'walking whale', a 3m long mammalian 'crocodile'. This transitional fossil, present in the early Eocene (48 to 40 million years ago), was clearly amphibious, as its back legs were better adapted for swimming than for walking on land, and it probably swam by undulating its back vertically, as otters, seals and whales do. Another 'missing link' fossil found in 2000, also in Pakistan, showed that the closest modern day terrestrial relatives to whales are deer and hippopotamuses.

Popularly, cetaceans tend to be divided into three groups: whales, dolphins and porpoises. However, whilst there are some clear differences between these (most obviously their size), the terms are not based on hard and fast rules and, for some at least, the terms can be used interchangeably. Thus the Killer Whale or Orca (*Orcinus orca*) is actually the largest member of the dolphin family (Delphinidae) and the term 'porpoise' is sometimes used, particularly in North America, to mean any small dolphin. True dolphins are distinguished from porpoises by their head shape (dolphins have beaks while porpoises do not), their fins (dolphins have a curved dorsal fin whereas those of porpoises are more triangular) and their overall body shape (dolphins are leaner and porpoises more portly). It is generally accepted there are currently 32 dolphin species (excluding six freshwater species) and six species of porpoise.

Humpback Whales (*Meganoptera novaeangliae*) often make spectacular leaps known as breaching. Such acrobatic behaviour is more usually associated with smaller cetaceans notably dolphins.

CLASSIFICATION

Taxonomically, the order Cetacea is spit into two superfamilies: the Mysticeti (baleen whales) and the Odontoceti (toothed whales) (p.416). The baleen whales include most of the larger whales such as the rorquals, right whales and the Gray Whale (*Eschrichtius robustus*). Their cavernous mouths allow them to catch vast quantities of krill (shrimp-like crustaceans) or small fish at one time. The toothed whales include the sperm whales, the beaked whales, the Narwhal (*Monodon monoceros*) and the Beluga (*Delphinapterus leucas*), and all the dolphins and porpoises. They feed mostly on fish, squid, and in a few cases other marine mammals, and normally capture one animal at a time.

Characteristic	Mysticeti	Odontoceti
Size	Larger (except Pygmy Right Whale)	Smaller (except Sperm Whale and beaked whales)
Dentition	Baleen plates	Teeth
Feeding	Slow filter feeders	Fast predators
Skull	Skull symmetrical; no oil-filled melon present	Skull asymmetrical; melon present
Echolocation	Do not echolocate	Echolocate
Blowhole	Two (located anterior to eyes)	One (located posterior to eyes)
Number of species (approx.)	14	76

Main differences between the superfamilies Mysticeti and Odontoceti.

DISTRIBUTION

Cetaceans inhabit all of the world's oceans, from the ice-cold polar seas to the warm tropics and from coastal areas dominated by human activities to the vast emptiness of the open oceans. A few species are also found in freshwater rivers and lakes (in South America, North America and Asia) and estuaries. Some species such as the Killer Whale, have a cosmopolitan distribution, being found in all of the world's oceans. Indeed, the Killer Whale is second only to humans as the most widely distributed mammal in the world. Others are limited to just one hemisphere (for instance, the Antarctic Minke Whale) or to just one ocean (such as the Atlantic White-sided Dolphin). A few species may have highly restricted ranges, such as the Vaquita (*Phocoena sinus*), a rare porpoise only found in the northern part of the Gulf of California, Mexico.

Knowledge of the distribution of cetaceans has increased rapidly in the past 20–30 years due to advances in tracking technology using satellite tags (typically fired into an individual's dorsal fin or back) and GPS (p.15). Previous to this, all distribution patterns were determined from surface observations from ships, in particular whaling vessels.

STRUCTURE

Body form and general features

At first glance, whales and dolphins resemble large fish, particularly sharks. Both have a similar streamlined body shape and possess dorsal fins, flippers (pectoral fins in fish) and huge tails. In fact, in centuries past, whales and other cetaceans were known as 'spouting fish'. However there is an obvious difference in the orientation of the tail: a cetacean's tail is horizontal and moves up and down, whilst a fish's tail is vertical and moves from side to side. Like many open water fish, cetaceans are adapted for a fast-moving existence and they have lost almost all of their mammalian body hair to

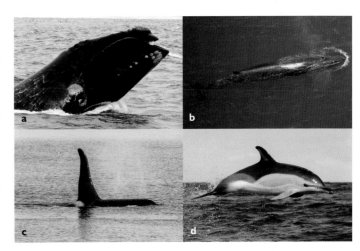

improve hydrodynamic efficiency. Variations on the basic body design range from the beautiful to the bizarre. The distorted head shape of the right whales, the portly body of the Bowhead Whale (*Balaena mysticetus*) (a), the sleek, streamlined shape of a Bryde's Whale (*Balaenoptera brydei*) (b), the dominance of the dorsal fin of a Killer Whale (c), the single, lance-like tooth of the Narwhal, the bulbous head-shape of the bottlenose whales (*Hyperoodon* spp.) and the beautiful coloration of the Common Dolphin (*Delphinus delphis*) (d) are all associated with specific functions such as feeding, though sometimes their use is difficult to fathom. The sexes tend to be of a similar size but some species show noticeable sexual dimorphism. For example female Blue Whales (*Balaenoptera musculus*) are larger than males and male Bottlenose Dolphins (*Tursiops truncatus*) are larger than females.

WHALE MIGRATIONS

Some whales, particularly baleen whales, undertake famously long annual migrations. Some migrate from high to low latitudes, some move between onshore and offshore areas and some do both. The whales which undertake these migrations tend to spend their summers, usually lasting 3–4 months, in cool polar regions where their favoured food is plentiful. In the Antarctic, several of the baleen whales such as Humpbacks and Southern Right Whales (*Eubalaena australis*) rely on the abundance of Antarctic Krill (*Euphausia superba*) (p.271) as their staple diet. In Arctic waters, a similar diet of small planktonic crustaceans is taken. The whales are able to put on weight quickly and build-up energy supplies by adding to their layer of fat-rich blubber. However the water in these regions is just too cold for newborn calves with minimal insulation, hence the need to migrate to warmer but food-poor climes.

Calving areas are often thousands of miles away and it may take several weeks to get there. Gray Whales are thought to make the longest migrations of all, a round trip of almost 20,000km along the west coast of North America. Typically older and pregnant whales will migrate first, with sexually immature whales bringing up the rear. For Humpback Whales, some juveniles may not migrate at all, preferring to over-winter in polar waters and exploit what prey they can find. For those that do make the journey and for all the time they are at the calving area, virtually nothing is eaten, a situation which may last up to four months. During this time they survive on their blubber reserves. Mating may well follow swiftly after giving birth, before the long trek back to the feeding grounds is undertaken, with young calves this time accompanying the adults (see also p.58).

Whilst Belugas do not migrate the huge distances of Humpback and Gray Whales, in autumn they move away from bays and estuaries to spend the winter in polynyas within the Arctic ice pack.

BALEEN

Baleen is a strong, yet flexible material made out of keratin, a protein that is the same material that makes up our hair and fingernails. It is used by baleen whales (Mysticeti) to filter out their prey from the water column. The baleen grows continuously as a series of plates from the upper jaw, along each side of the mouth cavity. Each slat-like plate looks like a right-angled triangle with a slightly curved base, but only the curved hypotenuse facing the inside of the mouth has the filtering bristles. Depending on the species there are between 140 and 430 plates on each side of the mouth, spaced 1–2cm apart. The fringe on the plates overlaps and creates a mesh-like strainer inside the whale's mouth. The colour of baleen varies with species: a Blue Whale has black baleen plates with dark grey bristles, whereas a Minke Whale has creamy-white plates with pure white bristles.

Dense concentrations of prey organisms, be they small schooling fish (targeted by Humpbacks), krill (by Blue Whales) or copepods (by Bowhead Whales), can be scooped up in an open mouthful. By closing the mouth and bringing the tongue up against the upper palate, water is forced out of the mouth sideways through the baleen, and the remaining prey forms a bolus which is then swallowed.

Baleen was highly prized in the whaling industry, particularly during the nineteenth century. Confusingly referred to as 'whalebone', its stiff yet bendy nature made it ideal for a wide variety of products where flexibility and strength were required, such as watch-springs, collar stiffeners, corset stays, umbrella ribs, and even as springs in the first typewriters. The advent of plastics and other alternatives in the early twentieth century saw the rapid demise in the use of whalebone products.

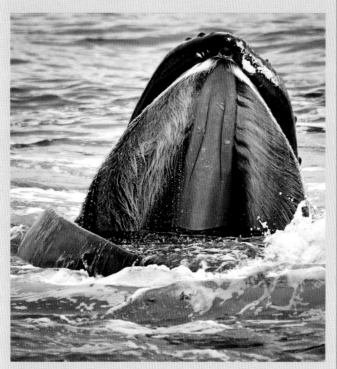

The baleen lining the upper jaw of this Humpback Whale (*Megaptera novaeangliae*) is clearly visible as it forces water from its mouth preparatory to swallowing its food.

Colour in cetaceans tends to be muted with white, grey and black predominant plus yellow and occasionally pink. However, many are spotted, mottled, streaked, or boldly patterned. Both colour and patterning may vary between animals of the same species and may change with age. Patterning on the flippers and tail flukes of certain species such as Humpback Whales varies and can be used to identify individual animals from photographs. Most species show some degree of countershading, tending to be lighter ventrally than dorsally.

Whilst most mammals have nostrils at the end of the snout, in cetaceans these are on the top of the head, an adaptation that makes breathing at the surface easier. In all species except the Sperm Whale (whose single nostril is on the left of the snout due to the presence of the huge spermaceti organ), the nostrils are located medially. In toothed cetaceans (Odontoceti) a single opening is shared by two breathing passages, whereas in the baleen whales (Mysticeti) there are two separate openings. Below the lungs, the obliquely aligned diaphragm has highly developed muscles responsible for the mighty exhalations followed by incredibly rapid inhalations. For humpback whales, it has been estimated that 3,000 times the contents of the human lung is expelled within two to three seconds. Blows (or spouts), the explosive exhalation of breath which appears like a jet of steam, are most apparent in the whales and can be used to identify species as their shape and height are often characteristic of particular species.

In whales especially, the tail can be surprisingly large, appearing to be out of proportion with the rest of the body, but as the main organ of propulsion, it needs to be big. It is mostly made of connective tissue, with the tendons of muscles splayed out within the flukes. The tail is not just used for propulsion but together with the flippers assists with turning, spinning, twisting and even slapping the water surface as a means of communication. Not all cetaceans have a dorsal fin and those that do cannot move it. This often quite small appendage helps maintain stability, much like the centreboard of a sailing yacht.

Water flow over cetacean bodies is virtually laminar, that is with little turbulence or drag. The bow wave generated at the front of the animal by its forward movement through the water is effortlessly parted and flows over the body, with vortices only forming beyond the tail. A number of anatomical features make this possible, the skin being particularly important. The outer layer, barely a millimetre thick, is pliable and only loosely attached. For Bottlenose Dolphins, the sloughing rate of this layer is nine times faster than in humans, ensuring a perpetually smooth body surface which helps to reduce drag. Beneath this layer is the tougher dermis which has a number of ridges running parallel to the long axis of the animal, with oily fluid trapped between them. The dermis contains blood vessels, nerves, and connective tissue. Minute reflex adjustments of this layer help to prevent eddies from forming, enabling the animal to move through the water more efficiently. Below the dermis is the blubber layer, comprising connective tissue and fat cells, which aids in buoyancy, locomotion, thermoregulation and fat storage.

Skeleton

The underlying skeleton of cetaceans is perfectly adapted to their aquatic lifestyle. They have evolved short, stiff necks, essential for swimming efficiently at high speed. They possess the same number of cervical vertebrae (seven) as other mammals, but the bones are unusually short and they may be partly fused in some species. Together with the lumbar (waist) and caudal (tail) vertebrae, they form an uninterrupted arched backbone from the head to the tail. The vertebrae are designed primarily to serve as anchorages for the powerful propulsion muscles and not so much to support the weight of organs (which are nearly weightless in water). But whilst sturdiness is essential, the bones must also be light, though strangely Blainville's Beaked Whale (*Mesoplodon densirostris*) has been found to have the densest bones in the animal kingdom, a fact reflected in its specific name. Lightness is achieved through a hard shell encasing a spongy, web-like inner structure which has a very high content of oil. In fact, in the days of whaling, a third of all the oil extracted from harpooned whales came

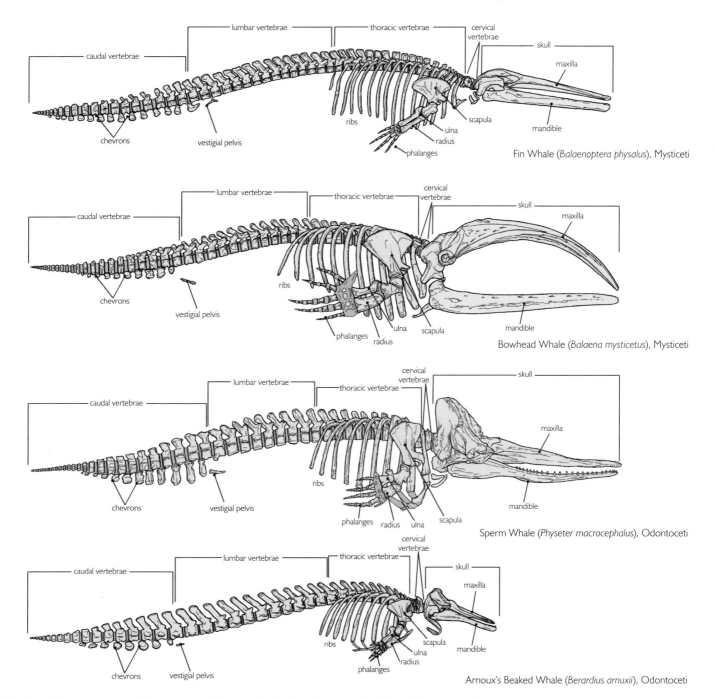

Whilst whale skeletons have a fundamentally similar design, differences in their feeding techniques result in significant differences in skull shape.

from their bones. The fore limbs have become flippers, used to provide stability and manoeuvrability, with 'arm' bones (the humerus, radius and ulna) that are stubby and thick and usually four digits, the second and third of which are disproportionately long. The hind limbs of course have disappeared completely, though some of the baleen whales do still have rudiments of a vestigial femur and tibia embedded within muscle and no longer attached to the rest of the skeleton.

Cetacean behaviour and intelligence

The anatomy and physiology of cetaceans is relatively well known through the study of dead animals washed ashore or killed by whalers, but far less is known about their behaviour in the wild. However, whilst they are difficult to study underwater, cetaceans exhibit a range of behaviours which can be relatively easily observed at the surface. While some of these are clearly meant for the purposes of communication,

WHALES AND DOLPHINS

others seem to be purely playful. Play can be defined as 'actions performed for no other apparent purpose than to provide enjoyment'. However, it is also recognised that play in young animals helps them to learn motor and social skills needed for survival. Recognised cetacean behaviours include:

(a) **Breaching** – a head-first launch up into the air and subsequent fall back into the water with a dramatic splash.

(b) **Flipper-slapping** – when the animal rolls over at the surface and slaps its flippers down with a loud noisy splash. Humpbacks also wave both flippers in the air before slapping them onto the water simultaneously.

(c) **Tail-slapping** (also known as lob-tailing) – with most of the animal beneath the surface, the flukes of the tail are slapped against the water.

(d) **Spyhopping** – when the head is poked above the surface of the water, apparently to simply 'have a look around'.

(e) **Bow-riding and surfing** – particularly practised by various species of dolphins and porpoises. This seems to be a favourite pastime for some, utilising the energy of the wave to push them along.

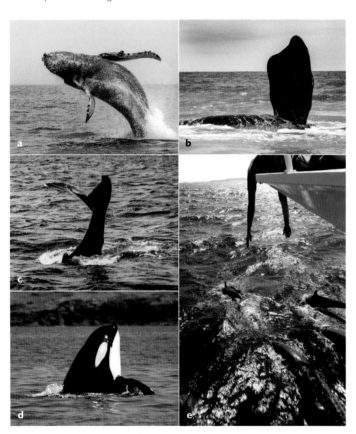

Perhaps the most intriguing quality of certain cetacean species to us humans is their complex social behaviour and their high intelligence. It is considered that a more intelligent animal will respond to an environmental stimulus faster or more accurately than a less intelligent one. Whilst overall brain size might be thought to indicate intelligence, this is not a straightforward linear relationship. Sperm Whales have the largest known brains of any animal (7.7kg in males) but they are probably not the most intelligent. Bottlenose Dolphins, which are well known for their problem-solving skills, have a brain mass of 1.5–1.7kg and humans that of 1.3–1.4kg. Instead, intelligence is now assessed using an 'encephalisation quotient' (EQ). This is defined as the ratio between actual brain mass and predicted brain mass for an animal of a given size. Using this measure, humans have an EQ of 7.4–7.8, Bottlenose Dolphins of 4.14 and Killer Whales of 2.57–3.3. The recent discovery of spindle cells (neurons that lack extensive branching) in the brains of Humpback Whales, Fin Whales, Sperm Whales, Killer Whales, Bottlenose Dolphins, Risso's Dolphin and Beluga Whales may also be relevant. These cells, which are also present in humans, great apes and elephants, appear to play an important role in the development of intelligent behaviour.

Senses

Water is a medium in which sight and smell are not as efficient as sound. Sound travels roughly four times faster in water than in the atmosphere at sea level. Cetaceans have used this to their advantage, developing sound as a means of acquiring information about their environment and also a highly sophisticated means of communication.

Hearing/Sound The majority of cetaceans have excellent hearing and rely on underwater sound for communication, prey location, predator avoidance and probably for navigation. The range of hearing in dolphins has been measured as being from 100Hz to an amazing 150,000Hz (for humans, the range is from 30–16,000Hz). In order to remain streamlined, no external ear is present and in whales, all that can be seen is a miniscule opening behind the eye. However, sound is likely to be detected by other parts of the body, particularly through the lower jaw or mandible. The middle ear is specially modified to enhance hearing and the earbones are fused and are not directly connected with the rest of the skull. They are surrounded by foamy mucus which is thought to act as insulation, helping to filter out all but essential sounds and allowing for greater directional hearing.

WHALE SONG

Baleen whales have a highly sophisticated means of communication known as whale song which marks them apart from the toothed whales. Humpback Whales have an especially complex song, but the ability is developed to a lesser extent in Bowhead, Blue, Fin and minke whales. Songs consist of a series of repeated sequences, sung at varying frequencies that can travel underwater for hundreds of kilometres. The song of the Humpback Whale is composed of a sequence of highly varied sounds ranging from high-pitched squeaks to midrange trumpeting and screeches to lower frequency ratchets and roars and combinations of all of these. Each song typically lasts between 10 to 15 minutes, although the range is from 5 to 40 minutes. All the whales in a given area sing virtually the same song at any point in time, though it will gradually change over time. Whales from other areas will sing quite different songs.

The exact purpose of the songs remains a mystery although as male Humpbacks often sing them during the mating season, it is thought they may indicate a male's 'fitness' to a female. However, other suggestions are that they indicate competitive behaviour between males seeking the same mate, or that they serve as a means to define territories, as a spacing mechanism between males, to synchronise oestrus, as a migratory beacon, or as sonar by males to find females. The sound of such haunting songs could well have given rise to the stories of sailors being enticed onto the rocks by sirens. It was not until the 1960s that underwater recordings of the songs could positively be confirmed as emanating from Humpback Whales.

Cetaceans are well known for their ability to produce a range of sophisticated sounds both above and below water. Terrestrial mammals have vocal chords and must exhale in order to make a sound, but this is not the case with cetaceans. Most sounds are made underwater, but dolphins can vocalise at the surface by releasing air though their blowhole, altering its size and shape to produce different sounds. Captive dolphins often develop a wider repertoire than would normally be used in the wild.

Underwater sounds, including those used for echolocation, are produced with the blowhole closed and are generated by air sacs located in the head below the blowhole. Exactly how the sounds are produced remains unclear but involves air returning from the lungs to fill the sacs. Anatomical studies suggest air could be forced out of the sacs and make a noise as it passes by a nasal plug at the entrance. Or flaps of fatty tissue beneath the blowhole may vibrate as air is forced by them, rather like 'blowing a raspberry' with your lips. Sounds produced by cetaceans include groans, moans, chirps, squeaks, whistles and clicks with 'phrases' sometimes being repeated. Of the toothed cetaceans, the most vocal has to be the Beluga, which has a great repertoire earning it the nickname of 'the canary of the sea'.

Echolocation Perhaps the most impressive and intriguing capability of whales, dolphins and porpoises is the ability of most of them to build up a 'picture' of their surroundings with the help of sound. This is called 'echolocation' and is a form of sonar, similar to that used by bats to find their way around in the dark. This ability is fully developed in toothed cetaceans (Odontoceti) but not in baleen whales (Mysticeti). Rapid pulses of sound are generated, typically loud, sharp clicks and these bounce back from nearby objects and alert the animal that something is in the water. The frequency and loudness of the returning sound signals allow the size, shape, surface characteristics, distance and movement of an object to be discerned. With this ability, cetaceans can search for, chase and catch fast-swimming prey in total darkness. Some species may even be able to stun prey with a fast succession of sound pulses. The clicks a Sperm Whale produces are the loudest sound produced by any animal (at 230 decibels).

The melon organ in toothed cetaceans is believed to assist with focussing emitted sound, acting as a form of acoustic lens. This unique structure varies in size between species, is made up of adipose tissue (containing triglycerides and wax esters) and is situated in the head between the blowhole and the tip of the snout. The Beluga has a particularly versatile and sophisticated echolocation system. It can change the shape of the melon at will, which other cetaceans do not appear to be able to do. This allows it to modify the sound passing through it. The huge spermaceti organ in the head of Sperm Whales may well serve a similar purpose to the melon, being filled with a liquid wax that is an excellent sound conductor. The detailed structure of this organ provides some evidence that it may also play a role in buoyancy control (Clarke 1978).

Touch Cetaceans have a reasonably well-developed sense of touch, which serves important social purposes. Most touching tends to take place during play or parental care, but may also be used for competition, aggression and defensive purposes. Whilst courting and mating will involve two individuals rubbing against each other, this practice also takes place at other times, apparently just for the sheer pleasure of it. Some individuals will brush against inanimate objects such as the hulls of wooden ships, and intimate behaviour of this kind with humans is well known. Although toothed cetaceans are practically hairless after infancy, baleen whales retain some hairs around the mouth and snout and these vibrissae are thought to be important as organs of touch.

Taste and smell The senses of taste and smell are very poor or even completely lacking in cetaceans. This is not surprising since smell is not used in prey detection and as they do not chew their food they have little opportunity to taste it. However, anatomical studies have revealed there are taste buds present at the base of the tongue. Bottlenose Dolphins have been found to spit out putrid fish fed to them in captivity, so the ability to distinguish good food from bad remains.

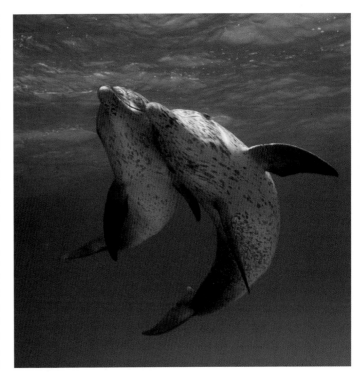

Atlantic Spotted Dolphins (*Stenella frontalis*) in the Bahamas showing apparently affectionate behaviour.

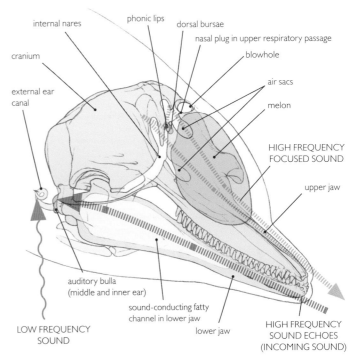

Probable sound pathways in a typical toothed cetacean. Sounds are produced by passing air through air sacs in the head. High frequency sounds for echolocation are focused through the melon.

Vision Visual ability in cetaceans varies but all show complex structural adaptations of their eyes and retinas to allow them to see both underwater and in air (Mass and Supin 2007). The position of the eyes on the sides of the head means that with the exception of dolphins with pointed beaks, most have little if any binocular vision. Cetacean eyes are adapted to make full use of low light levels and to this end have a highly developed tapetum lucidum (reflective layer), and large pupil opening. However they must also cope with greatly increased light intensity as they surface. The pupil opening can be closed down to a U-shaped slit and finally to two narrow holes by a protuberance (the operculum) on the upper part of the iris. Light refraction and focusing is performed almost entirely by the lens and to achieve this, the lens is almost spherical. The cornea has almost the same refractive index as water and so cannot contribute as it does in land mammals. Cetaceans do not see colour in the same way as we do and their retinas have a preponderance of rod cells and few of the cone cells associated with colour vision. However, behavioural experiments with dolphins, suggests they can discern some wavelengths that we would term 'colour'.

Many whales seem to have rather poor eyesight. However, the perception of light by the brain is important for baleen whales in particular. Changes in day length (known as the circadian rhythm), together with changes in air temperature, play a crucial role in triggering the urge to migrate as regulated by the pituitary gland. The vision of dolphins, by contrast, would appear to be very good particularly out of the water, as witnessed by their ability to catch fish in the air, perform precisely aimed jumps to reach targets above the water and even to recognise their trainers. However, even underwater their vision appears to be important and supplements echolocation when locating prey.

CETACEAN STRANDINGS

It is estimated that as many as 2,000 cetacean strandings occur each year, typically on gently shelving shores. Sometimes just a single individual is involved but on other occasions it can be as many as several hundred. The largest stranding of False Killer Whales (*Pseudorca crassidens*) on record is of 835 animals. In June 2009, a pod of 26 Common Dolphins stranded in Falmouth Bay, UK. Exactly why these tragic events should happen remains a mystery, but it is likely that each event involves several contributing factors. Most strandings are of echolocating toothed whales rather than baleen whales. Of these it is the species that inhabit deep waters and exhibit strong social bonds that are usually involved. The ten species which become stranded most frequently are the Sperm Whale, some pilot and killer whales, some beaked whales and some oceanic dolphins.

Many strandings can be attributed to natural and environmental factors such as weakness due to old age or an infectious disease, hunting too close to the shore or navigation errors. There are intriguing cases where cetaceans in distress purposely come ashore and will re-strand even after being rescued. This may represent an effort by animals unable to keep afloat to keep breathing, whatever the ultimate cost. Distress signals from one stranded individual can even lead to an entire pod being stranded alongside it. It has been proposed that in recent years shipping noise and underwater sonar have increased the frequency and severity of stranding events. A report from 2013 in *Nature* stated that the Canary Islands used to be a hotspot for mass stranding, but there have been no such events since 2004 when the Spanish government imposed a ban on the use of military sonar in these waters (Fernández *et al.* 2013).

Many countries have specific procedures and organisations that should be contacted if stranded animals (alive or dead) are found on the shore. Measurements and samples collected from such animals can provide useful scientific data.

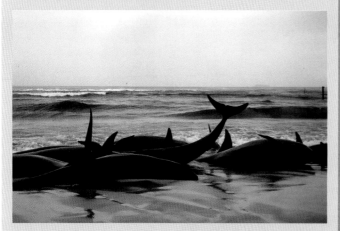

Cetacean strandings occur on beaches all round the world. Most of this large pod of False Killer Whales in Flinders Bay, Australia, were successfully refloated in a massive rescue attempt.

BIOLOGY

The ability of cetaceans to dive to great depths and to do so using a single lungful of air shows just how well they are adapted to the aquatic environment in comparison with us. The deepest a human has reached on a single lungful of air currently stands at (a very impressive) 214m. The deepest cetacean dive that has been recorded was by a Cuvier's Beaked Whale (*Ziphius cavirostris*) to 2,992m. A number of anatomical and physiological adaptations allows them to do this.

For the actual process of breathing, the muscles surrounding the blowholes are relaxed when the blowhole is closed and automatically contract to open the blowholes when the animal surfaces. Exhaled air is blown out extremely rapidly and fresh air is taken in within 2–3 seconds. This happens by means of a very powerful diaphragm, reinforced trachea and bronchi and a collapsible rib cage. At rest, a human's breathing will normally renew 10–20% of the content of the lungs, rising to 55% post-exertion. In whales, the turn-over rate is 80–90%. Interestingly, relative to body weight, the lung capacity of the large whales is not that great. However, they have a much more extensive network of capillaries associated with them which means gaseous exchange is very efficient. Cetaceans have also been found to use about 12% of the oxygen that they inhale, compared to 4% used by terrestrial mammals, and they show a higher tolerance to elevated carbon dioxide levels in their bloodstream. They also have at least twice as many erythrocytes and myoglobin molecules in their blood, for efficient capture and transport of oxygen. Their muscles too have a very high myoglobin content, allowing large amounts of oxygen to be stored within them.

As with all mammals, cetaceans need to sleep periodically. However, unlike terrestrial mammals in which breathing is automatic, they are conscious breathers which means they decide when to take a breath. For this reason they cannot afford to switch off completely or they might asphyxiate. Brain monitoring of captive toothed cetaceans has shown that only one hemisphere of the brain sleeps at a time and they keep one eye open, apparently so they can still swim and breathe consciously during their period of rest. Larger whales have been observed in a 'sleep-like state' resting horizontally or with just their heads out of the water, gently moving their tail and flippers to keep their position in the water. A study in 2008 observed Sperm Whales in the wild drifting passively and apparently sleeping fully, in a vertical posture just under the surface during the day for periods lasting ten to fifteen minutes (Miller *et al.* 2008). Whether such whales also exhibit half sleep is not yet known and it will be very difficult to find out.

Feeding

Most of what is known about cetacean diets comes from autopsies on stranded or (mainly in the past) harpooned individuals. In general dolphins and porpoises, all of which are toothed cetaceans, eat a wide variety of fish and squid. Large toothed cetaceans, particularly Killer Whales, can also tackle bigger prey and will eat other cetaceans, seals and even seabirds resting on the surface. In contrast baleen whales, some of the largest creatures on the planet, feed on zooplankton, some of the smallest. This may seem bizarre but it is their very size that allows them to utilise such tiny organisms in a biologically efficient way. With their huge mouths they can make maximum use of seasonally abundant prey and build up large fat reserves. Their whole lifestyle, of long migrations and calving periods spent without feeding, followed by intense bouts of feeding, is based on this premise. Smaller animals would be unable to consume a sufficient quantity of zooplankton to allow them to behave in this way.

Not surprisingly, considerably more is known about the near-surface feeding behaviour of the baleen whales than of the behaviour of deep-hunting species such as Sperm Whales. With their remarkable diving ability, Sperm Whales have become deepsea hunters specialising in Giant Squid which comprise about 80% of their diet. The remaining 20% is comprised of octopus, fish, shrimp, crab and even small bottom-living sharks. However, they don't always get it all their own way as evidenced by disk-shaped scars and wounds on their bodies, likely to have been made by giant squid fighting back. It has been estimated that Sperm Whales are responsible for consuming 100 million tonnes of squid a year, a staggering figure.

Baleen whales exhibit three main feeding techniques. 'Skimmers' swim very slowly with the mouth open, filtering constantly until enough food has accumulated on the baleen to be scraped off and swallowed. This group includes the three species of right whales and the Bowhead and Sei Whales (*Balaenoptera borealis*). 'Gulpers', which include Blue, Fin (*Balaenoptea physalus*), Bryde's, minke and Humpback whales swim a little faster and take in individual mouthfuls of plankton-containing water. The water is then forcefully expelled through the baleen. The third group are bottom feeders, or 'grubbers', exemplified by the Gray Whale. This species feeds by rolling on its side and scooping up benthic crustaceans (primarily amphipods and isopods) from sediments in shallow areas (see p.103). Large amounts of sand and mud are also ingested and must be filtered out.

Whilst most cetaceans feed individually, there are some remarkable instances of co-operative hunting. Dolphins will sometimes encircle shoals of fish in open water and then take it in turns to dart in and catch a fish. Dolphins and even baleen whales

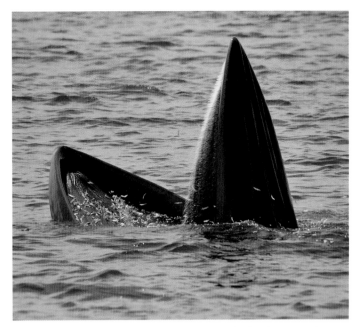

This Bryde's Whale (*Balaenoptera brydei*) strained out a mouthful of small crustaceans from a single gulp of water.

have been filmed striking into 'bait balls' of small sardines along with oceanic sharks such as the Bronze Whaler. Some pods of Humpback Whales have developed a 'bubble-net' technique to hunt small shoaling fish. This astonishing feeding behaviour involves one or more individuals swimming below the shoal (typically capelin, anchovy, cod, herring or mackerel) and releasing a plume of bubbles from their blowholes. As the bubbles move towards the surface, they create a 'wall' which forces the fish into an ever-tighter shoal close to the surface. They are then scooped up from below by vast gaping mouths. An average-sized Humpback Whale will eat 2,000–2,500kg of plankton, krill and small schooling fish each day during the feeding season (which lasts about 120 days) in cold waters. When hunting particularly large prey, Killer Whales may hunt in small packs. Pods of three to four Killer Whales have been seen to target Gray Whale calves swimming alongside their mothers, some-

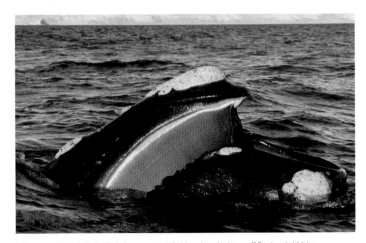

A Southern Right Whale (*Eubalaena australis*) skimming plankton off Peninsula Valdes, Argentina.

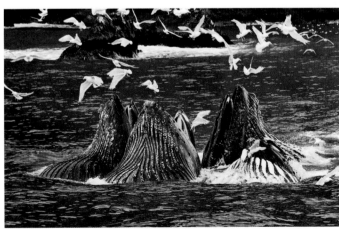

Only certain pods of Humpback Whales (*Megaptera novaeangliae*) such as this one in Alaska, have developed the complex cooperative feeding method known as bubble-net feeding.

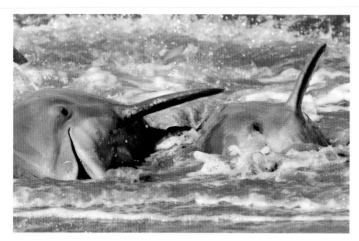

Bottlenose dolphins sometimes 'strand feed', partially beaching themselves to collect fish that they have herded and trapped against a sand or mud shore.

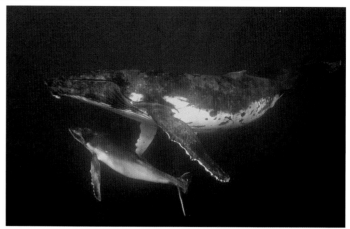

Humpback (*Megaptera novaeangliae*) females are attentive mothers and escort their young on the long journey from calving to feeding grounds.

thing a single individual could never achieve. Hunting in pods of a few individuals to 30 or more, Killer Whales will often pick on calves or injured or sick adult whales, first chasing an individual until exhaustion sets in and then baiting it like a pack of hyenas. The dead animal is not usually completely eaten and the tongue in particular seems to be the main prize.

All cetaceans swallow their food without chewing it. A typical cetacean stomach consists of four compartments arranged in succession. The first has a muscular lining with no digestive glands and is thought to be responsible for grinding the food in a similar way to a bird's gizzard. Thereafter, the various chambers are all involved with the chemical breakdown of the food, assisted by digestive enzymes. At the other end of the digestive tract, faecal waste is expelled as a dark, smelly semi-liquid, avidly collected by whale researchers for DNA analysis. Interestingly, Sperm Whales and other whale species have recently been highlighted as being important in the recycling of nutrients from the depths of the ocean (where they extract their prey) to the surface waters (where they defecate), a process which has been called the 'whale pump'. Inputs of iron and nitrogen which are essentially fertilisers, can then be utilised by phytoplankton in these surface waters.

Life history

Full life histories have only been elucidated for a relatively few cetacean species, not surprising given that they mate and give birth at sea. Most species exhibit polygamy meaning they have no fixed partnerships. A male may mate with several females and a female may mate with several males during their reproductive lifetime. Baleen whales do not reach sexual maturity until they are at least ten years old and whilst toothed cetaceans physically mature earlier, they may have to wait several years before they are socially mature enough to breed. Courtship behaviour can be complex and sometimes quite violent. Male Northern Right Whales (*Eubalaena glacialis*) may congregate around a single female and jostle for position in a frenzy of activity. The female may mate with several males in succession, or even with two at the same time. In a similar way, male Humpback Whales may gather into 'competitive groups' and fight for females.

The gestation period in most cetacean species is surprisingly short, lasting for just 10 to 14 months. When comparing a human pregnancy of nine months, a rhinoceros of 18 months and an elephant of 22 months, large whales might be expected to take much longer. The relatively short period, for baleen whales at least, is dictated by ecological imperatives and their cyclical migrations. As the toothed cetaceans are not restricted in this way, their gestation periods can be and often are longer, for example 17 months for Killer Whales and 15–18 months for Sperm Whales. Narwhal (14 months) and Beluga whales (14–15 months) also have gestation periods that exceed the 'standard' 11–12 months.

Most cetaceans will have an interval of at least two years between births. Typically a single calf is born, with twins being very rare. Almost all terrestrial mammals deliver their young head first. Cetaceans, however, have had to adapt the birth process for underwater, so calves are born tail first to help prevent drowning. Once the umbilical cord is broken (at a built-in weak spot when pulled taut), the calf is assisted by its mother (or possibly by an attendant female) to the surface for its first breath. The newborn calf is usually one-quarter to a third the length of its mother. The subsequent nursing and care of the calf is very much the mother's responsibility and males are not usually involved.

Baleen whales will have weaned their calves by their first summer when they are less than a year old, while toothed whales may take up to three years. An autopsy on one 13-year-old Sperm Whale even found milk in its stomach. Nursing calves grow very rapidly, thanks to the extremely high proportion of fat and proteins contained in whale milk. This thick, creamy milk is actually squirted into the calf's mouth once the

Young bottlenose dolphins learn hunting skills from their mothers. This juvenile is staying in close attendance as it mother hunts over sand flats in the Bahamas.

Both species of common dolphins (*Delphinus* spp.) will gather in schools that number in the hundreds or sometimes even thousands.

calf has latched on to the concealed nipple. A Blue Whale calf is estimated to drink 190 litres of milk and put on 90kg of weight every day while being nursed.

Cetacean lifespans are difficult to determine due to the difficulties involved with tracking and studying individuals. Estimates suggest that most species live at least two decades and some live for much longer. The Bowhead Whale is amongst the longest lived. In 2007, a 15m long specimen was caught off Alaska with the head of an explosive harpoon embedded in its neck blubber. The arrow-shaped object was found to have been manufactured around 1890, suggesting the animal may have survived a similar hunt more than a century earlier.

Ecology

The complex social organisation of cetaceans has long intrigued us and is something that we are only just beginning to understand. Many species spend their lives with other individuals in groups, whether in small family pods (as for most baleen whales), larger single-sex 'schools' preferred by Sperm Whales, or 'superpods' of thousands of individuals as exhibited by Short-beaked Common Dolphins (*Delphinus delphis*). This last species is also known to swim alongside other toothed cetaceans such as pilot whales. Some cetaceans such as Gray Whales spend most of their time in small pods but form much larger seasonal groupings on cold-water feeding grounds or in the tropical lagoons where they bear their young. Exactly how the members of pods and groups interact and communicate is poorly understood. Whilst we may know something of the physical process we have little idea of what particular sounds, movements or touches actually signify, whether in close proximity or from several hundreds of miles away. Even the daily activity patterns of cetaceans are poorly known. Most activity is documented in the daytime, of course, when observations are easiest to make. But what happens during the hours of darkness? Spinner Dolphins are known to feed at night and doubtless other species do the same.

There are occasions when cetaceans and man show mutual co-operation. One group of dolphins in Laguna, Brazil has learnt to herd mullet towards lines of cast-net fishermen and have been doing so for generations. In Myanmar fishermen call the dolphins by tapping on the sides of their boats or by slapping the water surface. One or two lead dolphins will then swim in smaller and smaller semi-circles herding the fish towards the shore. During cooperative fishing, the dolphins often dive deeply with their flukes aloft just after the net is cast and create turbulence under the surface around the outside of the net. The dolphins seem to benefit from the fishing by preying on fish that are confused by the sinking net.

Whilst the smaller dolphins and porpoises feature in the diet of many large sharks, the large whales have few natural predators. However, the Killer Whale is an important top predator in the ocean and preys particularly on other cetaceans, be they dolphins, porpoises or even the mighty right whales, sperm whales or rorquals. Also known as 'wolves of the sea', the Killer Whale is a remarkably intelligent 'superdolphin' that lives up to its name. Killer Whales are also known to attack seals, sea lions and even Walruses.

Almost all mammals will act as hosts to one or more parasites during their lives and cetaceans are no exception. External parasites are most obvious on certain species of whale, in particular right whales, Gray Whales and Humpbacks. The attached fauna may include acorn and pseudostalked barnacles (on the head and flippers), copepods (small crustaceans which burrow through the skin and feed on the blood), whale lice (isopod crustaceans which are present in amongst the barnacles) and lampreys (which attach to tender areas of the skin such as the mouth and the genital zones. Whilst heavy infestations may adversely affect the overall functioning of the individual in some way, for most it must just be an irritation which has to be tolerated.

Whales may also be accompanied on their travels by commensals, such as remoras ('whale suckers') or pilot fish, animals which derive a benefit (scraps of food) from the whale but, unlike parasites, do it no harm. On occasion, whales may benefit from being cleaned and certain species of seabirds are known to land on the backs of some whale species when at the surface and peck at attached parasites.

Whilst there is still a lot to learn, it is important to note here the tremendous and rapid advances which have been made recently in our understanding of cetacean behaviour and ecology (and subsequently their management) through the use of scientific advances such as remote tracking devices and DNA profiling.

Humpback Whales (*Megaptera novaeangliae*) seem particularly prone to infestation by barnacles with especially heavy growths on the head and flippers.

Common name	Scientific name	Estimated population size	IUCN Red List status
Vaquita	*Phocoena sinus*	<100? [177–1073 estimated in 1997]	Critically Endangered
North Atlantic Right Whale	*Eubalaena glacialis*	300–350	Endangered
North Pacific Right Whale	*Eubalaena japonica*	~ 500	Endangered
Blue Whale	*Balaenoptera musculus*	10,000–25,000	Endangered
Sei Whale	*Balaenoptera borealis*	insufficient data; possibly ~ 20,000	Endangered
Fin Whale	*Balaenoptera physalus*	insufficient data; probably <100,000	Endangered
Hector's Dolphin	*Cephalorhynchus hectori*	~ 7,000	Endangered

Cetaceans listed as endangered on the IUCN Red List of Threatened Species. See individual IUCN assessments for dates of population estimates. Many cetacean species are listed by IUCN as 'Data Deficient'.

USES, THREATS, STATUS AND MANAGEMENT

Historically, cetaceans have been hunted for centuries for their meat, oil and 'whale-bone' or baleen. For indigenous peoples of the Arctic the traditional practice of subsistence hunting is deeply ingrained in their cultures. Commercial hunting of whales and of baleen whales in particular, was initiated by Europeans in the 12th century, expanded rapidly during the 17th century and became all-consuming in the 18th–20th centuries, with large profits to be made and a self-generated demand for whale products. While eating whalemeat was an 'acquired taste' (a 16th century

WHALE FALL

Whilst we are aware of the occasional dead cetacean being found washed-up on beaches, over 99% of them die and decay at sea, out of our sight. Smaller individuals will be preyed upon by scavengers in the upper layers of the open ocean, leading to a relatively rapid recycling of their tissues. However, whilst large whale carcasses may float for a while and be partially scavenged, some eventually end up on the deep ocean floor.

The decomposing carcass of a whale on the ocean floor is known as 'whale fall' and has recently been recognised as constituting an ecosystem in its own right, albeit very localised and extremely specialised (see also p.111). The appearance of such an entity produces a massive pulse of organic material to a realm that is typically nutrient and energy impoverished. For example, it has been estimated that a 40-tonne Gray Whale provides more than 2,000 times the background carbon flux that would typically rain down on the area underlying the carcass in an entire year (Roman et al. 2014). A wide variety of organisms are attracted to the carcass including bristleworms, giant isopods, various other crustaceans, limpets, mussels, sea cucumbers, hagfish, and sleeper sharks. Polychaetes of the genus *Osedax* (gruesomely known as 'zombie worms'), together with chemosynthetic bacteria, are able to break down bone tissue. The whole decomposition process is thought to take about 100 years.

Skeleton of a 35ton, 13m Gray Whale (*Eschrichtius robustus*) after 18 months on the sea floor of the Santa Cruz Basin (around 1,700m deep) Animals visible include swimming, eel-like hagfish, and thousands of amphipods and newly settled, juvenile clams.

French surgeon describing it as 'having no value, but the tongue is soft and delicious'), it was their oil which made the profits. This was obtained by heating the blubber in large vats and storing the resulting oil (which would subsequently not spoil) in sealed wooden barrels.

Whale oil was used as a cheap fuel in oil lamps (though it gave off a strong odour) and to make industrial soap and margarine. Baleen whales were generally the main source of whale oil. The Bowhead Whale and right whales were considered the ideal whaling targets as they are slow, docile, and float when killed. With the commercial development of substitutes such as kerosene and vegetable oils, the use of whale oils declined considerably in the 20th century. Oil from the spermaceti organ of Sperm Whales ('sperm oil') was of a higher quality and fetched a higher price than standard whale oil. It was made into candles which burned brighter than oil lamps and were also smokeless. The only other whale product of any value was ambergris, a valuable but unattractive grey, waxy substance found within the intestines of Sperm Whales (and which occasionally washes ashore), used as a fixative in the perfume industry.

The north-east coast of the New World proved a popular hunting ground but even by 1700, the number of right whales off the coast of New England was reportedly declining. The first documented Sperm Whale kill was in 1712 and, once its potential for oil was realised, it became the main target of the American whaling industry for the next 150 years.

Whaling voyages became longer and longer (up to five years) as the number of whales in the North Atlantic declined. The height of the (American) whaling industry was from 1820 to 1850 when around 10,000 whales were killed each year. With the advent of steam-power, bow-mounted explosive harpoons and factory ships, 50,000 whales were being killed annually by the late 1930s. Any whale was fair game, though clearly some were more valuable than others. It was clear this was an unsustainable harvest, but it wasn't until the advent of the International Whaling Commission in 1946 that catch quotas for specific species were introduced.

The main species still hunted commercially today are the Common Minke Whale (Norway, Greenland, Iceland), Fin Whale (Greenland, Iceland), and Long-finned Pilot Whales (Faroe Islands). In 2012, South Korea stated it would be starting 'scientific' whaling. Japan had been practising this for a number of years but in March 2014, the International Court of Justice ruled that Japan's taking of whales was not for scientific research, and their hunting of whales in the Antarctic is now banned. Whale oil is little used today and modern commercial whaling is done primarily for meat with blubber being rendered down mostly to cheap industrial products such as animal feed or, in Iceland, as a fuel supplement for whaling ships.

A rusting hulk beached at Grytviken on South Georgia, NW of the Antarctic Peninsula. Abandoned ships and buildings and whale skeletons are testament to this island's long whaling history.

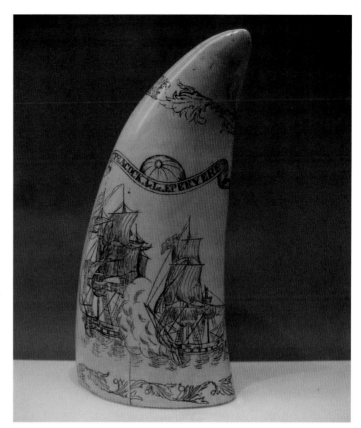

Sperm Whale teeth were often carved and decorated by whalers, as were baleen, Walrus tusks and bones. These decorated trophies are collectively called scrimshaw.

The growing interest in whale-watching over the past 60 years has given the term 'whale hunting' a new meaning and offered an alternative and sustainable source of income from whales. It originally started as land-based viewings of Gray Whales along the Californian coast but soon became water-based, spread to other sites within the US and internationally, and included other species, especially dolphins. By 2008, whale watching was being undertaken in 119 countries, generating a direct revenue of £540 million plus an indirect revenue (through associated tourism) of £1,300 million, and employing 13,000 workers. When moves were afoot in the early 1980s to create a worldwide ban on commercial whaling, conservationists adopted the slogan 'A whale is worth more alive and watched than it is dead'. However, the rapid growth in the number of whale-watching trips and the size of vessels used may affect whale behaviour, migratory patterns and breeding cycles. There is now strong evidence that in some circumstances, whale-watching can significantly affect the biology and ecology of whales and dolphins. Some countries have strict codes of conduct to address this issue.

Dolphins have a natural appeal to humans and are inevitably kept in captivity. The first dolphinarium opened in 1938 and their popularity increased rapidly until the 1960s. However, increasing animal welfare concerns and adverse public opinion has led to stricter regulations and the trend is now downwards. In the UK in the early 1970s there were 36 dolphinariums and travelling shows, but by 1993 they had all closed. However, they are still widespread in other parts of Europe, Japan and North America. Whilst the Bottlenose Dolphin is the commonest species in captivity (easy to train, long-lived and a friendly appearance), other species such as Killer Whales, Common Dolphins, Spotted Dolphins and False Killer Whales are also used.

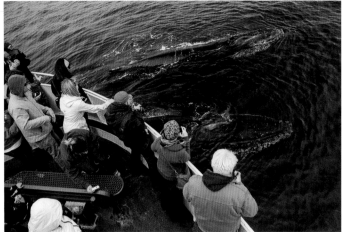

Whale-watching trips are now big business in many parts of the world. Such experiences can be fun, educational and help boost conservation. However, operators need to maintain rigid standards and follow guidelines to minimise negative impacts.

Concern about the ethics of commercial dolphin and Killer Whale shows such as this one have led to a decline in attendance and some countries have banned such shows entirely.

Thousands of dolphins are caught in 'drive hunts' each year. This method of hunting involves herding the dolphins into shallow bays using a number of small boats. It is practised in a number of places around the world, particularly the Faroe Islands, Solomon Islands, Peru and Japan. In Japan, it is estimated that 25,000 dolphins and porpoises are killed each year in this way. Targeted species are primarily Striped Dolphins, Bottlenose Dolphins, Risso's Dolphins and Short-Finned Pilot Whales. This is considered to be a traditional fishery. However, the meat and blubber of the dolphins caught has been found to have higher than average levels of mercury, cadmium, the pesticide DDT and organic contaminants like PCBs.

Dolphins have also become non-targeted victims of commercial fisheries, particularly those that use large nets in areas of open sea, such as the fishery for yellowfin tuna in the eastern tropical Pacific Ocean. The fishermen use the surface-swimming dolphins (primarily Spinner Dolphin and Pantropical Spotted Dolphin) to indicate where the deeper-swimming tuna are likely to be. The tuna are caught with seine nets (laid out in a circle around the target species) but many dolphins are also trapped. Since the practice was introduced in the late 1950s, it has been estimated that as many as 6 million dolphins may have died in this way. Public outcry initiated the introduction of 'dolphin-friendly' labelling on tuna products, indicating trapped dolphins are either released from nets or fishing methods are used that do not impact on dolphins. The number of dolphin deaths has decreased considerably but the problem remains.

The by-catch of other cetacean species in fishing gear has been a major problem in coastal waters too. In recent years, trials have been undertaken to scare cetaceans away from drift nets by attaching acoustic 'pingers' to the nets, with mixed success. In some instances, dolphins have become used to the sounds over time and simply disregard them. Other threats include collisions with ships and it has been estimated that 90% of all Northern Right Whales killed by human activities are from ship collisions. Cetacean carcasses frequently have pieces of litter within their stomachs and their blubber often contains elevated levels of PCBs. Noise pollution may be a particular problem for echo-locating dolphins and other toothed whales. Some stranding events have occurred at the same time and in the same vicinity as loud sounds used in seismic testing and naval exercises.

While several species of whale have made remarkable comebacks in terms of their numbers after the introduction of the whaling moratorium, others are still at dangerously low levels. Currently, six marine cetaceans are listed as Endangered on the IUCN Red List of Threatened Species and one, the Vaquita, as Critically Endangered (see p.430). It is likely this species' confined distribution is one of the main factors contributing to its status and there are probably fewer than 100 individuals alive today (Johnson 2014).

Arguably, the most significant event in the management of cetaceans was the signing of the International Convention for the Regulation of Whaling in 1946 by the representatives of 15 countries. Not only was this important for the conservation of whale stocks, it was a major step forward in the international regulation of natural resources, as it was one of the first to place conservation at the forefront. The International Whaling Commission (IWC) was also established in 1946. The IWC is an intergovernmental body set up to conserve whale stocks and thus make possible 'the orderly development of the whaling industry'. Whilst this was a laudable aim, its history has been dogged by balancing conservation with the interests of the whaling industry. IWC membership is open to any sovereign state – as of July 2013 there were 88 members – who are able to agree or disagree with its adopted policies.

In 1982 the IWC proposed a moratorium on commercial whaling, which came into being in 1986 and is still in force. However, there are exceptions (for 'scientific' purposes) which are discussed further on p.504, but also currently two whale sanctuaries, one in the Indian Ocean and the other in the Southern Ocean have been established (p.504).

WHALE AND DOLPHIN SPECIES: INFRAORDER CETACEA

The mammalian infraorder Cetacea contains about 90 species (the exact number varies as sub-species are constantly being re-classified as species). They are all marine with the exception of six species of freshwater dolphins. The infraorder contains two superfamilies: the Mysticeti (baleen whales – 14 species) and the Odontoceti (toothed whales which includes the dolphins and porpoises – 76 species). Cetaceans range in size from the diminutive Commerson's Dolphin (*Cephalorhynchus commersoni*), smaller than a human, to the giant Blue Whale, at 33m in length and 190 tonnes in weight, the largest animal ever known to have lived.

The lineage of the two superfamilies of modern whales can be traced back to a common ancestor that existed in the Oligocene (34–23 million years ago). Only a few fossils of early cetaceans have been discovered from this time, though one, *Aetiocetus*, had skull and jaw features typical of baleen whales, yet it also bore a full set of teeth.

SUPERFAMILY MYSTICETI: BALEEN WHALES

Baleen whales are characterised by having brush-like baleen plates for filtering food from water rather than teeth, as is the case with the toothed whales (superfamily Odontoceti). The baleen consists of a large number of keratin plates attached to the upper jaw which are used to filter plankton or small fish from the water. (Baleen was confusingly given the name of 'whalebone' when it was used in the manufacture of various artefacts such as corset stays.) Baleen whales have two blowholes which often results in a V-shaped blow when they surface. These are closed when the whale submerges. There are 14 species in four families.

Rorquals BALEOPTERIDAE

The name 'rorqual' comes from the Norwegian meaning 'furrow whale'. All members of the family have a series of longitudinal folds of skin running from below the mouth along the underside of the body. These allow the mouth to expand immensely when feeding.

Common Minke Whale *Balaenoptera acutorostrata*

Features It is thought the name 'Minke' derives from the name of a Norwegian whaler who mistook a Minke Whale for a Blue Whale. It is the smallest and most abundant of the rorquals. The Antarctic Minke Whale is now thought to be a separate species, *B. bonaerensis*. This is one of the most commonly sighted whales on whale-watching trips in the NE and the NW Atlantic. Most of the length of the back, including the dorsal fin and blowholes, appears at once when the whale surfaces to breathe.
Size Up to 9.8m for males and 10.7m for females; maximum weight of 9.8 tonnes.

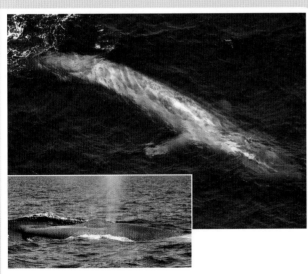

Blue Whale *Balaenoptera musculus*

Features This magnificent creature is the largest living animal on the planet and the heaviest that has ever existed (the largest dinosaur is estimated to have weighed 90 tonnes). There are known to be three (possibly four) subspecies, distributed throughout each of the large oceans. The common name of 'Blue' derives from Norwegian usage of the term from 1874 onwards. This giant whale was hunted close to extinction by the whaling industry and its numbers have still to recover fully. Its blow is a single spout up to 9m high.
Size Up to 33m in length and 190 tonnes in weight.

Humpback Whale *Megaptera novaeangliae*

Features The Humpback has a distinctive body shape, with unusually long pectoral fins and a knobbly head. The generic name *Megaptera*, from the Greek *mega* 'giant' and *ptera* 'wing', refers to these large front fins, while the common name derives from the curving of their backs when diving. It is arguably the most acrobatic of the large whales, with its displays of breaching and slapping the water. Genetic research in 2014 has indicated there are likely to be three subspecies belonging to the North Atlantic, North Pacific and Southern Oceans. Individuals may be identified by the unique patterns on their tail flukes and flippers.
Size Up to 16m long and 36 tonnes in weight.

Right whales BALAENIDAE and NEOBALAENIDAE

There are four species within the Balaenidae, three belonging to the genus *Eubalaena* (the true right whales) and the Bowhead Whale of the genus *Balaena*. The Pygmy Right Whale (*Caperea marginata*) is the only representative of the Neobalaenidae.

Gray Whale ESCHRICHTIIDAE

There is only one living member of this family though a further three genera are known from the fossil record.

Bowhead Whale *Balaena mysticetus*

Features This 'stocky' species of whale has no dorsal fin. Its main claims to fame are that it has the largest mouth of any animal (with the longest baleen plates at 3m long) and also the thickest blubber layer, at 43–50cm. It spends its entire life in the fertile waters of the Arctic and sub-Arctic, not migrating to feed or reproduce in waters of lower latitude like many other whales. As a result of recent DNA studies, it is now classified into its own genus of *Balaena*, distinguishing it from the other *Eubalaena* right whales with which it was once grouped.
Size Up to 20m long and 100 tonnes in weight.

FAMILY Balaenidae

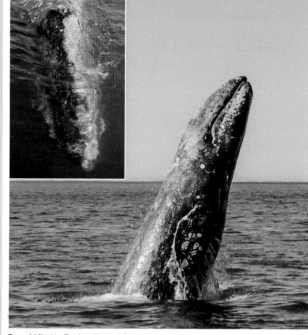

Gray Whale *Eschrichtius robustus*

Features This species is named after the characteristic grey-white patterns on its dorsal surface (actually scars left by parasites which drop off in its cold feeding grounds) and these patterns are used to help identify individuals. Gray Whales have no dorsal fin, though there are 6 to 12 'knuckles' (the dorsal ridge) on the midline of its rear quarter, leading to the flukes. They feed largely on benthic crustaceans (primarily amphipods), obtained by scooping up quantities of sediment from the seabed. Most do this with the right side of their face downwards. They will also feed in midwater. The Gray Whale's distribution is split between an eastern North Pacific (North American) population and a critically endangered western North Pacific (Asian) population.
Size Up to 15m long and 36 tonnes in weight.

FAMILY Eschrichtiidae

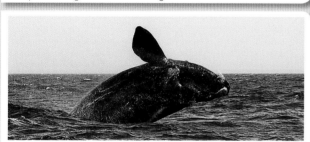

Southern Right Whale *Eubalaena australis*

Features There are three species of right whale, the other two (*E. glacialis*, *E. japonica*) of which are confined to the northern hemisphere. Right whales can be distinguished from all other whales by the white callosities on their heads, their unique patterns assisting in identifying individuals. The Southern species appears to enjoy 'performing' at the surface. Not only does it breach, in a manner similar to Humpbacks, but off Argentina and S Africa in particular, it has been observed 'sailing', using its elevated flukes to catch the wind whilst remaining in the same posture for a considerable length of time.
Size Up to 16m long and 70 tonnes in weight. .

SUPERFAMILY ODONTOCETI: TOOTHED WHALES

Toothed whales and dolphins are characterised by the presence of proper teeth in contrast to the baleen whales. The number of teeth each species possesses varies considerably: Narwhals have just a single long tusk, while some dolphin species may have over 100 teeth. They are also characterised by having a single blowhole on the top of the head. Toothed whales possess a fatty organ called a melon within their head which is used like a lens to focus sound waves for echolocation. Pulses of short clicks are generated for this purpose. These sounds are produced from the blowhole system and not from vocal cords which are absent. Intriguingly, it has been found that toothed whales have lost the ability to smell. There are 76 species in 10 families (four of the families are freshwater species).

Ocean dolphins DELPHINIDAE

The Delphinidae range in size from the diminutive Haviside's Dolphin (*Cephalorhynchus heavisidii*) at 1.2m in length and 40kg in weight (found off the coast of Namibia), to the impressive Orca (*Orcinus orca*) at 9m long and 10 tonnes in weight. With 32 species, in 17 genera, this is by far the largest family of cetaceans, as well as being the most diverse. Their bodies are sleek and streamlined, with the majority possessing a curved dorsal fin. Some species have striking colour patterns over their bodies, while others are more or less uniform. Delphinids are found in the shallow waters of all oceans as well as in some river systems. They are fast, acrobatic swimmers and appear to be highly intelligent, adapting quickly and flexibly to novel situations. Typically, males are slightly larger than females.

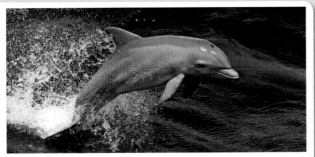

Common Bottlenose Dolphin *Tursiops truncatus*

Features Common Bottlenose Dolphins are found in temperate and tropical oceans worldwide. Their necks are more flexible than those of other dolphins, due to five of their seven neck vertebrae not being fused together. Common Bottlenose Dolphins are a distinctly social species that often travel in groups of up to 15 individuals, or occasionally up to several hundred. An individual's distinctive 'whistle' is used to communicate information on its identity, location, and condition to other dolphins.
Size Up to 4m long and 650kg in weight.

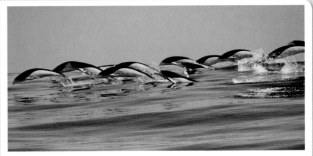

Southern Right Whale Dolphin *Lissodelphis peronii*

Features Named 'Right Whale Dolphin' due to its lack of a dorsal fin (a feature it shares with the right whales), this species is found only in the cool temperate to sub-Antarctic waters of the southern hemisphere. They have been seen in groups of up to 1,000, though 50 is more typical. They are very graceful and often move by leaping out of the water continuously. They have also been observed belly-flopping, side-slapping and lob-tailing (p.423).
Size Up to 3m long and 100kg in weight. Females slightly larger than males.

FAMILY Delphinidae

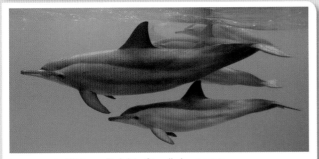

Long-snouted Spinner Dolphin *Stenella longirostris*

Features Famous for their acrobatic displays, in which they spin along their longitudinal axis as they leap into the air, Spinner Dolphins are found in nearly all seas between latitudes 40°N and 40°S. They have a long, slender beak, an erect dorsal fin and a three-toned colour pattern. Most Spinner Dolphins feed at night on small midwater fish, squids and shrimps. This and the Pantropical Spotted Dolphin are the two most frequently by-caught dolphins.
Size Up to 2.5m long and 80kg in weight.

FAMILY Delphinidae

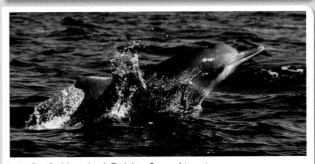

Indo-Pacific Humpback Dolphin *Sousa chinensis*

Features Currently considered as a single, widespread and highly variable species, there are at least three (and possibly four) subspecies centred around SE Asia, northern Australia and the western Indian Ocean. They are rarely encountered more than a few kilometres from the shore. This has led to them being particularly susceptible to human activities such as net fishing, boating and sewage discharge.
Size Up to 3.5m long and 280kg in weight.

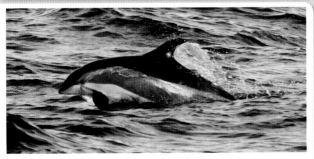

Atlantic White-sided Dolphin *Lagenorhynchus acutus*

Features Atlantic White-sided Dolphins are found in cold temperate to subpolar waters of the N Atlantic (including UK waters). Populations appear to be in a healthy state, with current population estimates exceeding 200,000. These dolphins often associate and feed alongside Fin and Humpback Whales, and are known to form mixed groups with pilot whales, Bottlenose, White-beaked and other dolphins. They feed mostly on small schooling fish (such as herring and mackerel), shrimp and squid.
Size Up to 2.8m long and 230kg in weight.

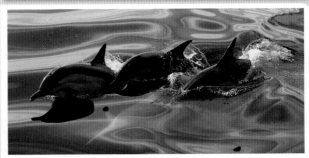

Short-beaked Common Dolphin *Delphinus delphis*

Features It is only recently (since the mid-1990s), that *D. delphis* was split into two species: there is now a separate Long-beaked Common Dolphin *D. capensis*. It is found throughout the warm temperate and tropical waters of the Atlantic, Pacific and SE Indian Ocean. Highly social, it may occur in 'superpods' of hundreds or even thousands of individuals. A fast swimmer (up to 60km/h) noted for its bow-riding, breaching and other acrobatics. It has a maximum lifespan of about 35 years in the wild.
Size Up to 2.4m long and 140kg in weight.

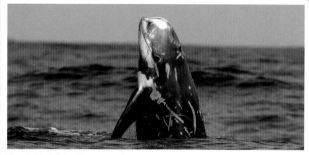

Risso's Dolphin *Grampus griseus*

Features Named after the French naturalist Antoine Risso (1777–1845), older Risso's Dolphins are characterised by the large number of scars they have on their backs. These are believed to result from social interactions. There are no teeth in their upper jaw but 2–7 pairs of peg-like teeth are present in the lower jaw. They are found worldwide in temperate and tropical waters. Under the name 'grampus', it was one of the royal fish which were traditionally the property of the English Crown.
Size Up to 4.3m long and 500kg in weight, making it the largest 'dolphin' species.

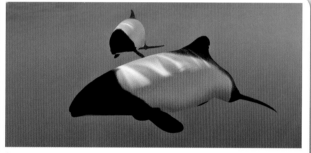

Commerson's Dolphin *Cephalorhynchus commersonii*

Features There are two subspecies of Commerson's Dolphin; one found in the coastal waters of southern S. America (including the Falkland Islands), the other centred on the Kerguelen Islands in the southern Indian Ocean. Their distinct markings and small size makes them easy to identify. They like to spin and twist whilst swimming and appear to favour areas with strong currents (up to 4 m/s).
Size Up to 1.5m long and 65kg in weight – one of the smallest cetacean species.

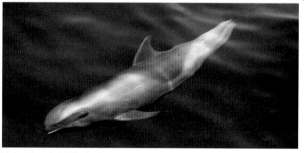

Melon-headed Whale *Peponocephala electra*

Features As it is similar in size and shape to Pygmy Killer Whales, to which it is closely related, these two species can be difficult to tell apart in the field. The head of the Melon-headed Whale is not as rounded, however, and its flippers are longer and pointed. It is widespread throughout the world's tropical and subtropical oceans though, as it prefers deep water (where it feeds on squid), it is not often seen by humans. It swims fast and may group into superpods of 100–1,000 individuals.
Size Up to 3m long and 200kg in weight.

FAMILY Delphinidae

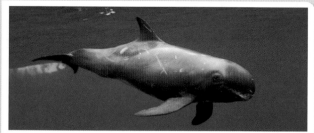

Pygmy Killer Whale *Feresa attenuata*

Features In spite of its common name and similarity of features, the Pygmy Killer Whale is not closely related to its namesake, the Killer Whale. However, they have been observed attacking, killing, and eating other cetacean species such as the Common Dolphin. The species is widely distributed throughout tropical and subtropical waters, yet it is rarely seen, with most sightings being made off Hawaii and Japan.
Size Up to 2.6m long and 170kg in weight.

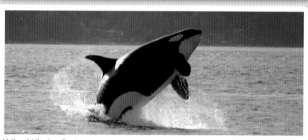

Killer Whale *Orcinus orca*

Features Regarded as being apex predators (i.e. they lack natural predators), Killer Whales or Orcas are found throughout the world's oceans, from the cold Arctic and Antarctic to the tropics. They are known to be highly intelligent with a complex social structure. Individuals within pods (which may number up to 50) are usually related to each other. Females may live to be 90 years old and males up to 60 years.
Size Up to 9.7m long and about 9 tonnes in weight.

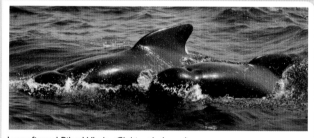

Long-finned Pilot Whale *Globicephala melas*

Features Long-finned Pilot Whales are found in cold temperate and subpolar waters and Short-finned (*G. macrorhynchus*) in warm temperate and tropical waters. Primarily squid eaters, Long-finned Pilot Whales will also take small and medium-sized fish, such as mackerel. They have been recorded diving to a depth of 1,800m. The only current fishery for them is undertaken in the Faroe Islands and Greenland.
Size Up to 8.5m long and 3.8 tonnes in weight.

FAMILY Delphinidae

Beluga and Narwhal MONODONTIDAE

This family includes two unusual cetacean species, both found in the coastal regions and pack ice around the Arctic Sea and the far north of the Atlantic and Pacific Oceans. Both are medium-sized whales lacking a true dorsal fin, instead having a narrow ridge running along the back, which is much more pronounced in the Narwhal. They are highly vocal animals, communicating with a wide range of sounds.

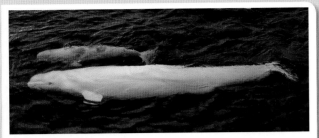

Beluga *Delphinapterus leucas*

Features The name Beluga comes from a Russian word meaning 'white'; it is also known as the white whale. Fifty percent of their body weight is fat, noticeably higher than other non-Arctic whales, whose bodies are only 20% fat. Belugas aggregate in herds consisting of hundreds to thousands of individuals. They clearly have complex social interactions and frequently swim around, over and under each other.
Size Up to 5m long and 1.6 tonnes in weight.

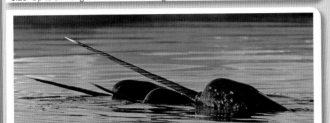

Narwhal *Monodon monoceros*

Features The name Narwhal is thought to derive from an old Norse word 'nár' meaning corpse. The single tusk, actually the left canine tooth, may grow as long as 3m in males. Single shorter tusks are also grown by 15% of females. The tusk may be important in mating rituals or even for breaking sea ice. It could well have a sensory role, as it has been found to have up to 10 million nerve endings inside.
Size Up to 5m long (excluding tusk) and 1.6 tonnes in weight.

Sperm whales PHYSETERIDAE and KOGIIDAE

The modern Sperm Whale (*Physeter macrocephalus*) is the only living species of Physeteridae, though the fossil record shows that 25 million years ago the parent family included as many as 20 genera. The two species of Kogiidae, the Pygmy (*Kogia breviceps*) and the Dwarf (*Kogia sima*) Sperm Whales, are closely related to the Physeteridae.

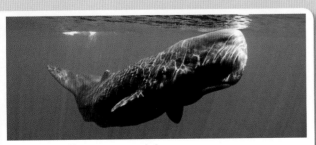

Sperm Whale *Physeter macrocephalus*

Features With the largest brain of any animal on earth (although proportional to weight, not exceptional) and a gigantic nose which encloses the oil-soaked spongy tissue of the spermaceti organ complex, Sperm Whales are highly adapted to a life spent exploiting the world's deep ocean waters in search of large squid. They are intensely social animals, with females spending their entire lives living with female relatives.
Size Females to 12.5m long and 24 tonnes in weight; males to 16m and 45 tonnes.

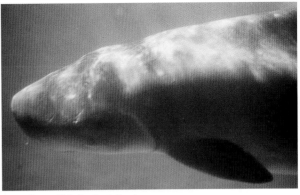

Pygmy Sperm Whale *Kogia breviceps*

Features Pygmy Sperm Whales are found throughout the tropical, subtropical and temperate waters of the Atlantic, Pacific and Indian Oceans. Rarely sighted at sea, most of what is known about them comes from the examination of stranded specimens. Like the Sperm Whale, they have a spermaceti organ in their forehead as well as a melon, used to focus and modulate sounds. When seen at sea, they are usually on their own, in pairs or in small groups of up to six. Whilst almost impossible to tell apart from the Dwarf Sperm Whale (*Kogia sima*), the latter is slightly smaller with a larger dorsal fin.
Size Up to 3.5m long and 400kg in weight.

Porpoises PHOCOENIDAE

Whilst being closely related to dolphins, porpoises are distinguished from them by their lack of a beak and flattened, spade-shaped teeth (as distinct from the conical-shaped teeth of dolphins). Porpoises also tend to be smaller and stouter than dolphins. Due to their small size, porpoises lose body heat to the water more rapidly than other cetaceans. To compensate for this, they have a thick layer of insulating blubber and they tend to eat frequently rather than relying on fat reserves.

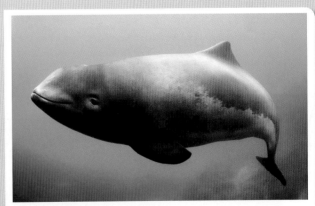

Harbour Porpoise *Phocoena phocoena*

Features Harbour Porpoises are found in coastal regions of the North Atlantic, Arctic, and North Pacific Oceans, as well as in the Mediterranean and Black Seas. They are typically present in bays and estuaries and sometimes venture considerable distances up rivers. They feed mostly on small pelagic schooling fish though have also been known to take squid and crustaceans in some localities. Bite marks present on a number of dead porpoises off NE Scotland were found to be due to Bottlenose Dolphins (*Tursiops truncatus*). It is suggested these attacks may be linked to competition for a decreasing food supply.
Size Up to 2m long and 65kg in weight.

Finless Porpoise *Neophocaena phocaenoides*

Features The Finless Porpoise inhabits the coastal waters of Asia, from the Persian Gulf to Japan. Although it lacks a dorsal fin, it does have a midline dorsal ridge covered by thick skin, whose function may be sensory. Though probably active swimmers, they barely break the surface so are often overlooked. They are either solitary or seen in small mother-offspring groups of up to four individuals.
Size Up to 2.2m long and 72kg in weight.

FAMILY Phocoenidae

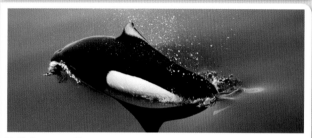

Dall's Porpoise *Phocoenoides dalli*

Features Dall's Porpoise is only found in the cool waters of the North Pacific. It is a deepwater species, though they are also commonly observed in sounds and inland passages where these meet the open sea. Three distinct colour types, all variations on the black/white theme, may correspond to the three possible subspecies. They are the fastest of all the porpoises, reaching speeds of up to 55km/h.
Size Up to 2.2m long and 220kg in weight.

Beaked whales ZIPHIIDAE

The family Ziphiidae includes 19 species belonging to six genera, making it the second largest family of cetaceans after the Delphinidae. They are medium-sized whales (up to around 13m in length) with distinctive narrow beaks. Unlike other cetaceans, the trailing edge of the fluke does not have a notch. They are a diverse group, but their ecological and social habits are not well known.

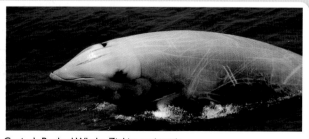

Cuvier's Beaked Whale *Ziphius cavirostris*

Features This is the most widely distributed and common of the beaked whales, found in all major oceans from the tropics to cool temperate latitudes. Its worldwide population is likely to be well over 100,000. The species has recently been confirmed as the deepest diving mammal, reaching 2,992m (p.418). They feed mainly on squid and deep-water fish. The average lifespan is believed to be about 35 years.
Size Up to 7m long and 2.5 tonnes in weight.

FAMILY Ziphiidae

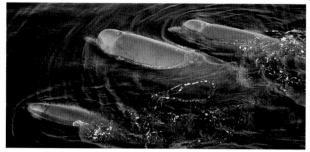

Northern Bottlenose Whale *Hyperoodon ampullatus*

Features The Northern Bottlenose Whale is found in the sub-Arctic waters of the N Atlantic. Individuals are known to be curious of ships (unlike most beaked whales), but this was one of the factors making them an easy target for whalers. On 20 January 2006, a Northern Bottlenose Whale was spotted in central London in the River Thames. Despite a major rescue attempt, it died the following day and its skeleton is now in the Natural History Museum in London.
Size Up to 9.8m long and 7.5 tonnes in weight.

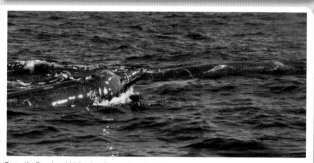

Baird's Beaked Whale *Berardius bairdii*

Features This is one of the largest of the beaked whales, with a particularly long prominent beak. It is found in the deep oceanic waters of the N Pacific Ocean, the Sea of Japan and the Sea of Okhotsk, and these three geographical areas delimit the range of three subspecies. From June to August, *B. bairdii* can be found in warm waters near Japan and California, but in the autumn, the whales migrate north towards the Bering Sea and spend their winters in cold water near the Aleutian Islands.
Size Up to 13m long and 14 tonnes in weight.

FAMILY Ziphiidae

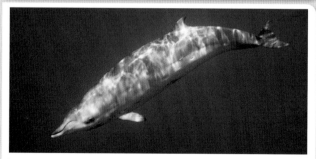

Blainville's Beaked Whale *Mesoplodon densirostris*

Features This cosmopolitan species occurs in every ocean with the exception of the Arctic and the Southern, favouring tropical and warm waters (10°–32°C). They appear to prefer deep waters (700–1,000m) that are topographically diverse. Males have large teeth that project out from the lower jaw and rise above the upper jaw. Single-stalked barnacles often bind to these exposed teeth in small clusters. The species was first described in 1817 from a small piece of jaw (see also p.422).
Size Up to 4.6m long and 1 tonne in weight.

DUGONG AND MANATEES

Dugong and manatees (together known as sirenians) are not closely related to other marine mammals. These ponderous and beguiling animals are descended from terrestrial mammals that browsed grassy swamps during the Eocene epoch, some 58 million to 37 million years ago and their closest modern relative is the elephant. They are also famously thought to have given rise to the myth of mermaids in folklore and their names bear witness to this. Dugong is derived from a Malay word meaning 'lady of the sea', while 'manati' comes from the language of the pre-Columbus people of the Caribbean meaning 'breast'. They are also both known as sea cows, because they graze on underwater meadows of seagrass.

There is just one species of living dugong (*Dugong dugon*) and three species of manatee all in the genus *Trichechus*: the West Indian Manatee (*T. manatus*), the West African Manatee (*T. senegalensis*) and the Amazonian Manatee (*T. inunguis*). Whilst the Dugong is strictly marine, the Amazonian Manatee lives only in freshwater in the Amazon basin. The other two manatees move between coastal waters, estuaries and freshwater river systems, and are easiest to observe in the latter. In the Florida Everglades the West Indian Manatee is a major tourist attraction and their placid nature makes them popular with swimmers and snorkellers. Finding and diving with Dugong is more difficult but the Red Sea and Arabian Gulf are good places to try.

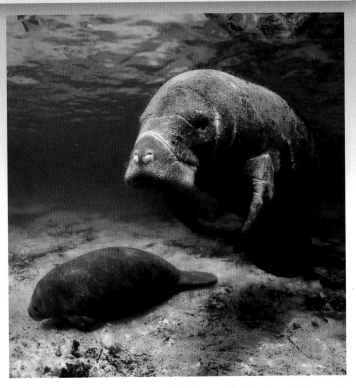

In winter, West Indian Manatees concentrate in Florida, especially where the water is warmed by output from industrial plants and natural springs.

DISTRIBUTION

Dugong are found in shallow, coastal tropical and subtropical waters of the western Pacific and Indian Oceans, including the Red Sea and the Arabian Gulf. Large concentrations of Dugongs occur in the Great Barrier Reef Marine Park (p.510) and the Torres Strait, Australia and at the southern end of the Arabian Gulf. Its range spans at least 48 countries and an estimated 140,000km of coastline. In contrast manatees are only found in Atlantic coastal waters and associated marshy areas and river systems. The West Indian Manatee ranges from Florida to NE South America and is divided into two distinct subspecies, based on geographical groupings. Tagged Florida Manatees (*T. manatus latirostris*) have been recorded as far north as Cape Cod, at Long Island (New York City) and at Rhode Island (IUCN 2014). The Antillean subspecies (*T. manatus manatus*) occurs in the Greater Antilles and south to Brazil. The West African Manatee is found along the west coast of Africa from the Senegal River south to the Kwanza River in Angola. They live as far upriver on the Niger River as Gao, Mali, some 1,300km from the coast.

STRUCTURE

Body form and general features

At first sight Dugong and manatees appear to be very similar in appearance. Each, over time, has lost their hind limbs and evolved a more streamlined shape which creates less drag in the water. Even so, the word 'portly' most accurately describes their barrel-like bodies. Paddle-like fore limbs (flippers) are used for manoeuvring (turning and slowing down), for 'walking' along the bottom and to help in manipulating food. A broad tail provides propulsion and is moved up and down in long strokes as the animal swims along. It can also be twisted to help in turning.

Whilst bearing a superficial resemblance to each other, there are a number of differences by which Dugong and manatees can be told apart (see table below), the most obvious of which is their tail shape. The Dugong has a particularly large snout and a fluked, whale-like tail, while manatees have a shorter snout and a tail which is rounded and plate-like.

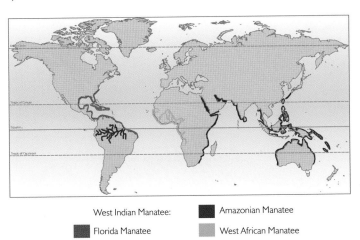

West Indian Manatee:
- Florida Manatee
- Antillean Manatee
- Amazonian Manatee
- West African Manatee
- Dugong

The geographical distributions of the Dugong and the three species of manatee do not overlap.

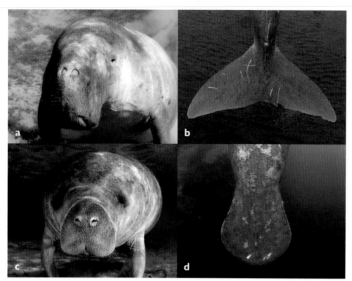

Dugong	Manatees
Tail with flukes like a whale	Tail rounded like a beaver
Solid upper lip	Divided upper lip
Relatively smooth but often scarred skin	Pleated, rough skin often with attached barnacles and algae
Body hairs short and rigid	Body hairs long and flexible
Easily visible ear opening	Small, indistinct ear opening
Pointed ends to forelimbs without nails	Rounded ends to forelimbs with nails (except Amazonian Manatee)
Long, tusk-like incisor teeth (not visible when mouth shut)	No incisor teeth

Head and tail of Dugong (a and b) and manatee (c and d).

Key external differences between Dugong and manatees.

Both Dugong and manatees grow to be a similar size, with adults reaching 3.6m long and weighing up to 590kg, though typically the average length is about 3m and the average weight about 450kg. Females tend to be larger than males. An adult Dugong is typically brown to dark grey in colour, although the colour can change due to the growth of algae on the skin. An adult manatee is generally grey in colour, sometimes with brown speckles on its back where algae are present.

All sirenians have sparse, short body hair, which may allow for tactile interpretation of their environment, but the muzzle and chin are extremely bristly. The bristles have a sensory function and help to find food and to deal with slippery plant strands. The large flexible, prehensile upper lip is used to wrap round and grasp aquatic plants and strip seagrass leaves or snuffle rhizomes from within the sediment. As well as a tongue they have a horny mouth pad at the front of both upper and lower jaw. Manatees have unusual dentition for a herbivore, with only a few (four to seven) molar teeth on the back end of each jaw. However, these teeth are continuously replaced throughout life with new ones growing at the rear as older teeth fall out from farther forward in the mouth, a process called horizontal succession. In this way they can get through around 80 teeth during their lifetime. Dugongs also have a reduced set of teeth but these do not continuously grow back. However, adult Dugongs do grow short canine tusks, most visible in males but also apparent in some large females in later life.

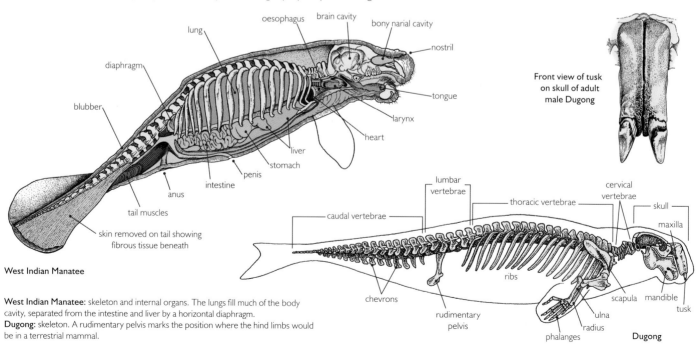

West Indian Manatee

West Indian Manatee: skeleton and internal organs. The lungs fill much of the body cavity, separated from the intestine and liver by a horizontal diaphragm.
Dugong: skeleton. A rudimentary pelvis marks the position where the hind limbs would be in a terrestrial mammal.

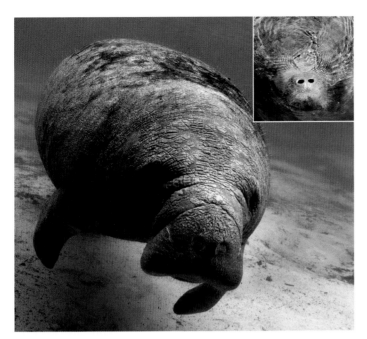

Manatees (seen here) and Dugong close their large nostrils with special valves before they submerge. The position of the nostrils close to the top of the snout allows them to breathe when at the surface (inset), whilst leaving the rest of the body submerged.

The backbone of sirenians has between 57 and 60 vertebrae, with the cervical vertebrae of manatees numbering just six (almost all other mammals have seven). Interestingly, their ribs and other long bones are unusually solid and contain little or no marrow. These heavy bones, which are among the densest in the animal kingdom, may act as a ballast to help keep them suspended slightly below the water's surface. Buoyancy is further regulated in the surface-feeding manatees, by elongated lungs which extend almost all the way along the animal's back.

Senses

With very small eyes, both Dugong and manatees rely much more on hearing and touch than they do on vision. However, manatee (but not Dugong) eyes do have a reflective layer called the tapetum lucidum behind the retina. This increases the eye's sensitivity by reflecting light back through the retina and helps the animal to see in murky river and estuarine water. At night a manatee's eyes can be picked out by torchlight as two shining pinkish orbs just as a cat's eyes can. Sirenian ears lack external flaps or pinna but in Dugong at least, can be seen as small depressions just behind the eyes. They hear well at high frequencies but their limited ability to hear low frequency noises such as those made by an approaching motor boat, may be one reason that manatee and boat collisions are so common. From their anatomy and behaviour, both Dugong and manatees must have a sense of smell but this is not particularly well developed and their nostrils are kept closed underwater. Taste on the other hand is more important. All sirenians have a strong tactile sense and feel their surroundings with the long sensitive bristles which surround the mouth.

Sirenians communicate with each other using a range of chirps and squeaks and higher frequency whistles and squeals, the latter used especially when they are alarmed. Whilst the specific meanings of these sounds have not been precisely determined, it is obvious that they use different sounds in different situations. A mother chirping quietly to her calf makes a very different screaming alarm call if a predator approaches. Adults communicate to maintain contact and during sexual and play behaviours.

BIOLOGY

Feeding

Both Dugong and manatees spend a large proportion of their time feeding and it is estimated that Dugong can eat up to 45kg of seagrass a day. They will also snuffle up small crustaceans and molluscs and occasionally macroalgae if seagrass is in short supply. As they feed they leave a muddy trail in their wake, sometimes uprooting whole plants from the surrounding sediment. Typically, Dugong will visit seagrass beds on a rising tide and feed until the ebb tide. They can remain underwater for a maximum of about ten minutes before they need to return to the surface for another breath. Manatees do rather better and can manage 20 minutes when inactive. Manatees have a far wider diet than Dugong, eating a range of freshwater and marine vegetation (including seagrass) and they have even been known to eat fish from nets. Like Dugong, a manatee can eat between 10–15% of its body weight in a day, a task that takes up to seven hours to fulfil.

The Dugong's down-turned snout is well suited to its mode of bottom-feeding. Manatees, on the other hand, frequently feed on surface vegetation such as Water Hyacinth (*Eichhornia crassipes*) which is another reason they are so prone to being hit by boats. Internally, sirenians possess a simple stomach and a long large intestine with a rich microflora that helps digest tough plant matter. In general, their intestines have a typical length of about 40m, which is unusually long for animals of their size. Both Dugong and manatees produce enormous amounts of gas, rather as cattle and other ruminants do.

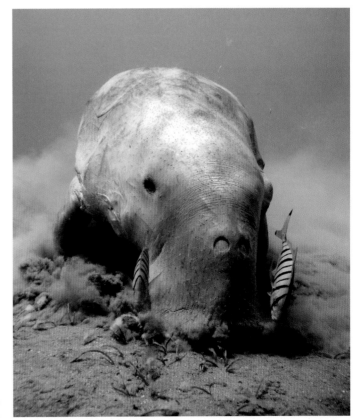

Juvenile Golden Trevally (*Gnathanodon speciosus*) often follow feeding Dugongs looking for invertebrates stirred up from the seabed.

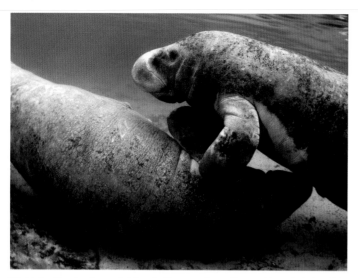

West Indian Manatees frequently interact with one another, rolling, touching and gripping. This behaviour is aptly called 'cavorting' and touch is probably an important means of communication.

Life history

Apart from comparative size (females tend to be larger than males), it can be hard to tell the sexes apart in both Dugong and manatees as males do not have external genitalia. The main difference between the sexes is the location of the genital aperture, which is near the middle of the belly in males and near the anus in females. However, it would be difficult (and intrusive) for a diver to get close enough to spot the difference.

Dugong and manatees are polygamous and a receptive female attracts a crowd of male suitors. Observations of natural behaviour in the wild are relatively scarce and the available information is based mainly on West Indian Manatees. In this species, many males will attempt to mate with the same female, on occasion inflicting wounds on the other males or even on the female. It is thought that by mating with several males, the female increases her chances of conception. Dugongs employ a similar strategy but males in some areas, specifically Shark Bay in Australia, use a different tactic whereby dominant males will defend a territory from other males (a practice known as 'lekking'), whilst trying to impress on-heat females.

Only a single calf is born at a time (though manatees sometimes have twins) after a gestation of 12–14 months and whilst manatees typically breed once every two years, in Dugong the interval is three to seven years. Limited observations suggest that calving takes place in very shallow water where they are relatively safe from large predators. Newborn Dugong and manatee calves weigh in at up to 35kg and just over 1m long. They can swim as soon as they are born, although they may need a little help from the mother to get to the surface to breathe. Sirenians mature late and Dugong females do not have their first calf until they are 12–17 years old (although there is some evidence for births in individuals as young as six years old).

STELLER'S SEA COW

Steller's Sea Cow (*Hydrodamalis gigas*) was first described by the German explorer and naturalist Georg Steller in 1741. He encountered this, the largest of all sirenians, whilst marooned on the uninhabited Commander Islands in the Bering Sea, during an expedition in Arctic waters. Here it grazed peacefully on kelp and other seaweed and unlike its living relatives it could clearly tolerate cold water. Sadly, within 27 years of his discovery, this slow-moving and easily captured sirenian was finally hunted to extinction. These island animals were probably the last of a much wider North Pacific population, once extensively hunted by indigenous people.

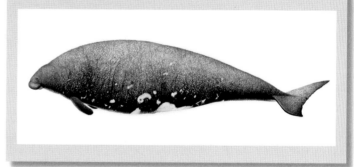

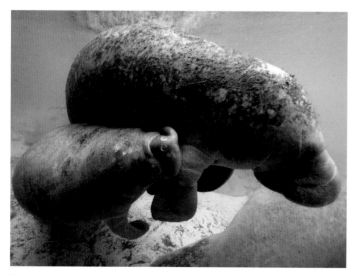

Manatee (seen here) and Dugong calves suckle from two teats one just behind each paddle until they are weaned at about 18 months (Dugong). However, they begin to eat plant material long before this at a very young age. Dugong calves may stay with the mother for several more years.

Ecology

Dugongs live in coastal waters, with major concentrations occurring in wide, shallow protected bays, mangrove channels and in amongst small islands, all areas where sizeable seagrass beds are found. They are semi-nomadic, often travelling long distances in search of food (or warmer waters during winter periods), but staying within a certain range their entire life. Tracking studies have shown they are able to return to specific places after long travels.

For Dugongs, offshore waters may provide a thermal refuge from cooler coastal areas during winter. Manatees are known to travel some distance up rivers at this time, again probably linked with escaping from colder coastal waters (the trigger appears to be 20°C). Along the coast of Florida, some groups of manatees are known to overwinter in close proximity to the warm water outflows of power plants, instead of migrating south as they once did. Some conservationists are concerned these manatees have become too reliant on these artificially warmed areas.

Dugongs can dive to a maximum depth of around 40m (possibly in search of

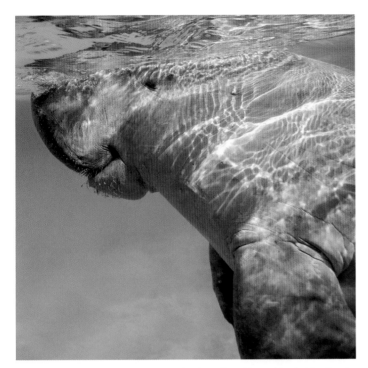

With high set nostrils, Dugong can take a breath at the surface without raising their head much above the water surface.

certain tasty species of seagrass which are only found in deeper waters) although they spend most of their lives no deeper than 10m. Manatees show similar depth preferences. Both animals are shy and they do not readily approach humans. Consequently, relatively little is known about their day to day behaviours. They are social animals, but usually only form small groups of up to about six due to the inability of seagrass beds to support large populations. However, gatherings of several hundred Dugongs sometimes happen, but they last only for a short time and may be linked with searching for new areas of seagrass.

Manatees can spend up to half of any 24 hour period sleeping, especially those living in the relative safety of rivers. They do this whilst submerged but need to surface every 20 minutes to take a fresh breath of air. The sleeping habits of Dugongs are not well known but they are vulnerable to attack from large sharks, estuarine crocodiles and Killer Whales, and probably remain more active. Both Dugong and manatees can put on a burst of speed estimated at up to 30km/h if threatened but their average swimming speed is only 5–10km/h.

USES, THREATS, STATUS AND MANAGEMENT

Dugong and manatees have been traditionally hunted for food by indigenous people for many centuries with evidence for exploitation from 4,000 years ago in the Arabian Gulf. Legal and illegal indigenous harvest remains an unquantified but potentially substantial threat. Besides providing meat for local consumption, the extraction of Dugong oil even maintained a small-scale commercial industry at several locations along the Queensland coast in the 1850s. Put to a more recent, but unusual use in Guyana, South America, are four manatees kept within a storage canal of a mains water treatment works in order to keep it free of weeds.

Apart from subsistence hunting significant, albeit inadvertent, mortality results from other human activities including gill netting, beach protection nets, human settlement (including boat strikes) and agricultural pollution (directly by affecting seagrass habitat and indirectly by stimulating the occurrence of toxic algal blooms). Natural causes of death amongst Dugong and manatees include adverse sea water temperatures (too hot or too cold), storms, hurricanes and disease. In Queensland, 30% of Dugong deaths since 1996 are thought to be a result of disease. Collisions with boat craft are estimated to be the cause of 25% of the deaths of Florida Manatees (IUCN 2014). However, one of the greatest threats to the latter is the potential loss of ageing power plants that act as warm-water winter refuges and to which this population has become accustomed.

It is extremely difficult to obtain accurate data on population numbers for both Dugong and manatees, but especially Dugong. Aerial surveys pick up those breaking the surface, but it is much harder to see beneath, particularly if the water is at all murky (as is often the case in areas of shallow sediment). A number of tagging studies have been carried out on both Dugong and manatees, which is helping to understand their behaviour and long-range movements. Photographs of the scars on the bodies and tails of Florida Manatees, often the result of boat collisions, have been used to identify individuals. In spite of this the total population of Dugong remains unknown as many important areas remain unsurveyed. Past, intensive hunting has certainly caused large declines or extinction in around a third of its range. Overall, it is classified as Vulnerable in the IUCN Red List of Threatened Species but until further studies are carried out, there can be no certainty over its status.

The three species of manatee are also listed as Vulnerable to extinction. However, both subspecies of the West Indian Manatee (the Florida Manatee *T. manatus latirostris* and the Antillean Manatee *T. manatus manatus*) are listed as Endangered, as their numbers are predicted to decline by 20% over the coming 40 years (IUCN 2014).

To date, there has been little effective management intervention to reduce anthropogenic impacts on Dugong, although protective legislation now exists over much of its range with Australia leading in this respect. Marine Protected Areas such as the Great Barrier Reef Marine Park in Australia, play an important conservation role as they protect the seagrass beds on which Dugong depend.

In recent years, Florida Manatees have become the centre of a large ecotourism industry at certain winter aggregation sites. Perhaps surprisingly, manatees have been found to increase their use of these sites when more boats and swimmers are present.

SEALS AND WALRUS

With their propensity to spend time on land as well as out at sea and their widespread presence in zoos, aquaria and parks, seals and sea lions will be familiar to many people around the world. As a group they are called pinnipeds (Pinnipedia), which encompasses fur seals and sea lions together known as eared seals (Otariidae), plus the earless or true seals (Phocidae) and the Walrus (*Odobenus rosmarus*) (Odobenidae). There are 33 living species of pinnipeds, which is about a quarter of all marine mammals and a further 50 species are known from the fossil record. Whilst there are roughly the same number of species of true seals (18) and eared seals (14), the former vastly outnumber the latter by about nine to one in terms of individuals.

The word pinnipedia translates from Latin as 'feather foot', referring to their often large wing-like flippers. All species are amphibious and must come ashore to mate (although some do so in the water) and particularly to give birth. Resting on land also allows them to escape the attentions of their aquatic predators such as sharks and Orcas, though in some places the latter have been filmed taking individuals in dramatic runs right to the edge of the sea.

DISTRIBUTION

Pinnipeds are almost exclusively marine, but the Baikal Seal (*Pusa sibirica*) and Caspian Seal (*Pusa caspica*) live in the freshwater Lake Baikal and Caspian Sea respectively, and two subspecies of the Ringed Seal (*Pusa hispida*) also live exclusively in freshwater. Pinnipeds have a wide distribution in both hemispheres but most are found in polar and temperate waters. However, a few fur seals and sea lions and two species of true seals are found in tropical and subtropical areas such as the Galapagos Islands. All but two species of fur seal (the Northern *Callorhinus ursinus* and the Guadalupe *Arctocephalus townsendi*) are found in the southern hemisphere, whilst sea lions and true seals are common to both hemispheres. Much more is known about the terrestrial location of pinniped breeding colonies than about where they forage when at sea. Most species have specific locations which have been used as haul-out sites and

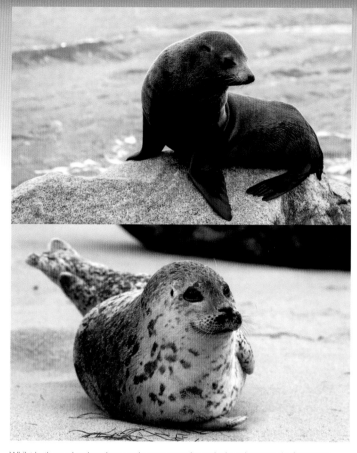

Whilst both eared seals and true seals are extremely acrobatic underwater, the former are much more at home on land than the latter. Australian Fur Seal (*Arctocephalus forsteri*) top; Harbour Seal (*Phoca vitulina*) bottom.

BACK ON DRY LAND

Haul-out sites on land or ice are used by all pinniped species for resting, mating, avoiding predators and socialising. A distinction is usually made between a 'haul-out site' and a 'rookery', the latter being used for breeding aggregations of individuals, where males may fight competitors and establish harems and pregnant females give birth. A species may have hundreds of haul-out sites within its range, but only a handful of rookeries. A recent study of Harbour Seals (*Phoca vitulina*) at Svalbard, off northern Norway, showed that the average period spent at haul-out sites varied for adults from about five hours a day in September to just over one hour a day in February (Hamilton *et al.* 2014).

Harbour Seals, often adopt a characteristic 'bow' stance when hauled out, perhaps to warm up more quickly. They sometimes share haul-out sites with Grey Seals (*Halichoerus grypus*).

rookeries for countless generations. However, they may range far and wide from these areas when foraging. Recent studies of individual pinnipeds such as Californian Sea Lion (*Zalophus californianus*) utilising satellite tags, is helping to provide a much better understanding of the movements and ecology of certain pinniped species.

STRUCTURAL ADAPTATIONS

Body form and general features

All pinnipeds, even the massive Walrus, share a streamlined torpedo body shape, with a broad middle that tapers at both ends. This minimises drag and together with the absence of a clavicle (collar bone), allows them to move with great flexibility and amazing balletic gracefulness when underwater. This contrasts noticeably with their movement on land which can appear rather ungainly. Sea lions, fur seals and Walrus are able to rotate their pelvis so that their hind limbs are under the body facing forward, and so are capable of walking 'on all fours' and moving with considerable speed when out of the water, with a characteristic lolloping gait. When underwater,

Family Phocidae	Family Otariidae
No external ear flaps	External ear flaps (pinnae)
Hind flippers unable to turn forwards	Hind flippers can turn forwards
Main propulsion underwater comes from their hind flippers	Main propulsion underwater comes from their fore flippers
Flippers completely furred	Flippers have naked 'soles'
When out of water tend to be quiet; able to make soft grunting noises	When out of water can be noisy: roaring, barking, honking and trumpeting.

The main physical differences between true seals (Phocidae) and sea lions and fur seals (Otariidae)

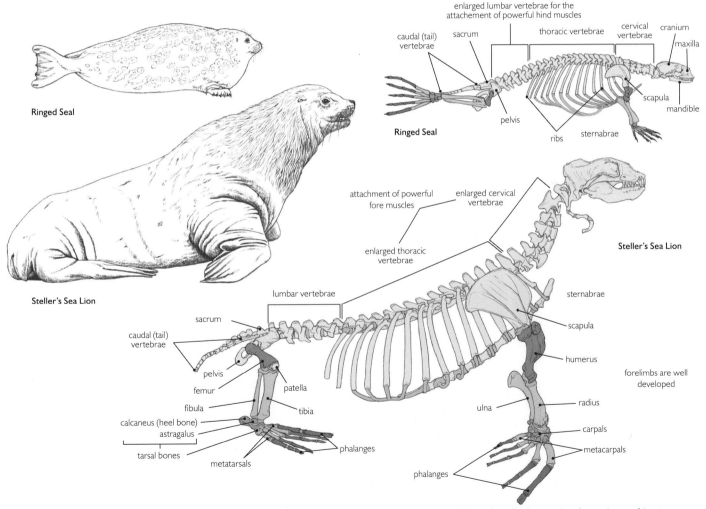

Pinniped skeletons. The Ringed Seal (*Pusa hispida*) is the smallest pinniped (up to about 1.6m long and 100kg). Like all true seals it has enlarged lumbar vertebrae for attachment of the strong muscles used in propulsion. Steller's Sea Lion (*Eumetopias jubatus*) is one of the largest (up to about 3.3m long and 1,100kg) topped only by elephant seals and Walrus. Eared seals have enlarged neck and thoracic vertebrae as they swim mainly with the foreflippers.

SEALS AND WALRUS

sea lions and fur seals swim using their large, fore flippers. True seals are much more cumbersome on land and have to perform a series of belly-flopping undulations in order to move around. They swim in a different way too, using their rear flippers and lower body in a side-to-side motion to propel themselves through the water. Walruses also swim with their rear flippers, using alternate strokes and sinuous body movements but are not particularly agile.

Generally speaking, Antarctic seals tend to be larger than Arctic seals, perhaps due to greater insulation or possibly a more plentiful supply of food. For many species there is dimorphism between the sexes, with males typically being larger than females, in some instances by as much as five times. All nine species of fur seal show such dimorphism, though it often less apparent in the sea lions and true seals.

All pinnipeds have a dense covering of fur which is at its most luxuriant in the fur seals and least apparent in the true seals. With their small size, pups need an especially thick coat. Fur insulates the body by trapping air and is particularly effective when the animal is out of water. However, pinnipeds lack erector pili muscles in the skin and so the fur remains flat, which helps maintain their streamlined shape. It is kept waterproof by secretions from sebaceous glands associated with each hair follicle. Pinnipeds have to moult their covering of fur annually and most species do so some time after their breeding season has ended, usually during the warmer summer months.

In addition to fur, pinnipeds also possess a layer of blubber under their skin, comprised of fat-filled cells which are incompressible. This property of blubber is most important to seals when diving, as its ability to insulate remains unaffected by

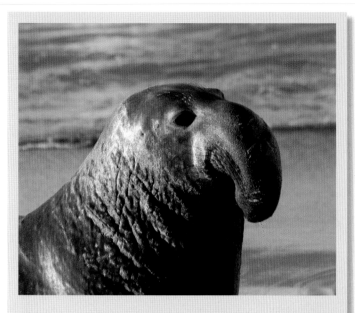

PINNIPED ODDITIES

A few pinniped species have evolved bizarre-looking appendages. Elephant Seals (*Mirounga* spp.) (above) have noses developed into a proboscis resembling an elephant's trunk. The proboscis is riddled with cavities which, as air is exhaled from the lungs, help to retain water moisture. The proboscis also assists in producing impressively loud roaring noises which are made during the mating season. Male Hooded Seals (*Cystophora cristata*) (below) not only possess a strange looking bladder on their heads, but also have the ability to inflate one of their nostrils to form a large balloon-like sac. The reason for doing this is simply to impress – the larger the balloon, the greater their chance of fending off rivals and winning the attention of a female. The Walrus also has the ability to inflate an air sac, though this one is hidden under its throat. It acts like a flotation bubble, allowing the Walrus to bob vertically in the water and sleep.

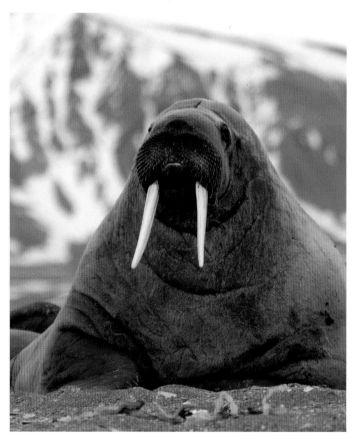

Walrus tusks serve a variety of purposes but are especially well-developed in males and used in battles over females.

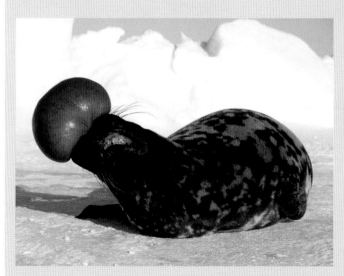

depth. Blubber provides buoyancy, helps to streamline the body and can also act as a food reserve. Seal blubber contains omega-3 fatty acids and high levels of vitamins D and E in particular. Unfortunately it also accumulates pollutants such as PCBs which do no harm until they enter the bloodstream when the animal starts to use up its fat reserves. In most pinnipeds the blubber layer is just a few centimetres thick but in the Walrus it can be up to 15cm.

Another specialised adaptation of pinnipeds is their large oxygen-carrying circulatory system. The blood volume relative to body weight is between one and a half to two times larger than in other mammals. Within the blood, they also have a higher concentration of haemoglobin, allowing them to store large amounts of oxygen, an adaptation which is of great benefit for their diving.

In general, pinnipeds have the sort of teeth you would expect in carnivores. However, like elephants, Walruses have extremely long canine teeth and both males and females grow them. They can reach 90cm in length and weigh over 5kg. It was once thought they had evolved to dig out prey from the seabed, but whilst they may help with this, abrasion patterns on them indicate they are dragged through the sediment while the upper edge of the snout is used for digging. The widely accepted view is that they are used primarily to form and maintain holes in the ice and aid the walrus in climbing out of water onto ice. Males use their longer, thicker tusks for display and fighting, the strongest male with the largest tusks dominating social groups. In the past whalers prized them (along with whale teeth) for 'scrimshaw', intricate pictures and letters engraved into the surface and then pigmented (p.431).

Senses

All mammals that spend part of their lives in water and part in air, need senses that will operate within these two different media. This is particularly the case for hearing and vision. Experiments have shown that both eared seals (with their external ear flaps) and true seals (who lack them) are able to hear well both underwater and in air. The current trend of constructing offshore wind turbines has led to a number of research projects investigating how sounds and underwater vibrations produced by these turbines are affecting the behaviour of seals. Pinnipeds can see almost as well in air as they can under water. To do this, they have evolved an extremely rounded 'fish-eye' lens, which provides a sharp image underwater but a slightly blurry one in air. The corneas of polar species are specially adapted to contend with the intense glare of ultraviolet rays reflected off ice (which can cause snow-blindness in humans). Pinnipeds have limited colour vision and their underwater world is seen in blue or green. The eyes are protected by both a nictating membrane, which acts like a inner eyelid to wipe away sand and debris and by a constant supply of tears from their lacrimal glands.

All pinnipeds have sensitive hairs (vibrissae) on their snouts, able to detect both touch and vibrations. The bristles, up to 30cm long in some species, are highly sensitive and are used when foraging for prey. They are particularly well developed on the Walrus, the bristles providing the adults with their characteristic whiskered appearance.

BIOLOGY

Feeding

Pinnipeds are regarded as being opportunistic predators, eating whatever fish and cephalopods are available, although each species will typically have a small number of preferred prey species (see Bowen et al. 2008). Some have a more specialised diet, such as krill for Crabeater Seals (*Lobodon carcinophaga*) and crustaceans for Harp Seals (*Pagophilus groenlandicus*). Gender and age also have a bearing. For example, Bearded Seals (*Erignathus barbatus*) tend to eat more benthic prey items (such as crabs and clams) as they get older and in species where there is a clear difference in size between the genders, the diet of each will in part be determined by their different energy requirements. The behaviour of the prey species can also be important. This has been demonstrated by a study of the feeding behaviour of Harbour Seals off Sable Island, Canada, using small video cameras attached to the heads of the seals. Prey behaviour was shown to affect both the capture technique adopted by the seals and their success rate (Bowen et al. 2002). As the abundance and distribution of prey species will change with the seasons, so the foraging behaviour of pinnipeds will alter too. Thus, when prey availability is reduced, it has been shown that Antarctic Fur Seals will increase their time at sea, Northern Fur Seals will increase their diving effort, and Californian Sea Lions will use both tactics in order to

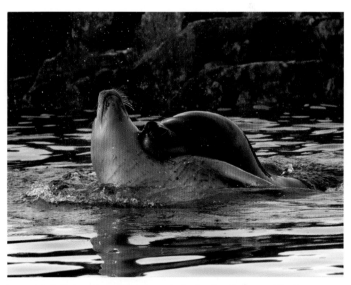

The New Zealand Fur Seal (*Arctocephalus forsteri*) has relatively long pinnae (external ears) and vibrissae (facial whiskers). They forage mainly at night so touch and hearing are important.

Leopard Seals (*Hydrurga leptonyx*) have a massive head and a wide gape enabling them to tackle large prey. This individual has managed to bite into the neck of a Crabeater Seal (*Lobodon carcinophaga*).

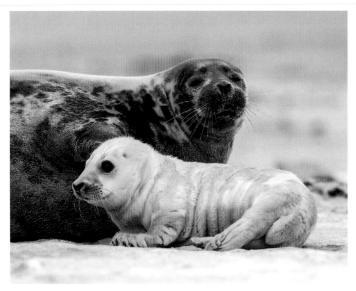

Grey Seal (*Halichoerus grypus*) pups are born with white fur as are those of several other species. This is moulted after about three weeks when they take on the adult coloration and learn to swim. In Common Seals this 'lanugo' coat is moulted before birth to allow them to swim almost immediately.

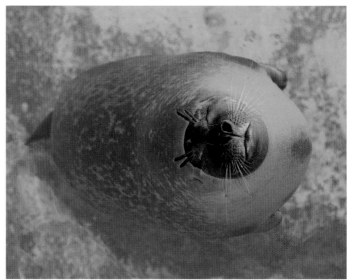

Some seals, such as Harbour and Grey, sleep whilst 'bottling', where most of the animal's body is submerged and just its snout shows above the water.

sustain their intake. A few species of pinniped prey upon other pinniped species, with the Leopard Seal top of the list, regularly eating Weddell Seals (*Leptonychotes weddellii*). Walruses will scavenge seal carcasses when food is scarce whilst Steller's Sea Lions (*Eumetopias jubatus*) will very occasionally attack and eat small seals.

Life history

The majority of pinnipeds are polygynous, meaning that males will establish territories (through fighting or shows of aggression) within which they protect a harem and breed with a number of females (the average number varies with species). This is particularly true for all sea lions and fur seals. The males will not eat for the duration of the breeding season, relying on their blubber to provide their energy requirements. True seals, in which males and females are much the same size, show more variable breeding behaviour. Some breed as solitary pairs, while others breed in large aggregations of hundreds of individuals.

Female pinnipeds give birth during the summer or autumn when environmental conditions out of water are at their best. Typically a single pup is born, although twins are not unknown. Usually this takes place on an open beach or on ice, though some ice-breeding species, such as the Ringed Seal use small lairs under the snow to protect their offspring from marauding Polar Bears. True seals suckle their young for 4 (Hooded Seal) to 50 days, whereas eared seals do so from 3 to 36 months. To compensate for their short lactation periods, true seals have milk with a fat content higher than any other species of marine mammal (45–60% fat). Hooded Seals are able to double their weight in the four days they are suckled. Once their young have been weaned, true seal mothers head off on long migrations to feeding grounds for intensive foraging to recoup their depleted energy reserves. By contrast, eared seal feeding grounds are generally closer to shore and females go on regular short foraging trips to maintain lactation.

Mating typically takes place soon after giving birth, often within 1–2 weeks. Implantation of the embryo is delayed (for 2–5 months), which allows the timing of the subsequent birth and mating to be synchronized to just one haul-out period.

Female pinnipeds typically reach sexual maturity at 3–6 years old. Males, however, do not actively mate until they are 8–9 years old when they become large enough to challenge other males successfully and to defend harems in the polygynous mating system. There is uncertainty about the average life span of pinnipeds. For most pinniped species in the wild, an individual that survives the first few years would be expected to live 13–23 years. In captivity however, pinnipeds have been known to live for 30 years or more. Walruses are probably the longest lived of all pinnipeds, with some individuals reaching 40 (their age being determined by counting the number of growth rings in their cheek teeth).

Ecology

Many pinnipeds are top predators and as such, play an important role in marine ecosystems, just as sharks do (see p.338). Diving behaviour varies, determined by the amount of oxygen which can be stored prior to a dive, the rate of its consumption and the tolerance of the animal's body and musculature to anoxic conditions, the depth at which favoured prey are likely to be found and the presence of both competitors and predators. Generally speaking, otariids tend to opt for a succession of short and shallow dives lasting about 2–12 minutes, whilst phocids tend to dive deeper and for longer periods from about 10 minutes (sometimes less) to more than an hour (see examples in table on p.418). In fact, some phocid species could be said to live at depth, periodically coming to the surface to breathe. With many pinniped species spending weeks at a time at sea, they have developed the ability to sleep whilst in the water. This certainly happens with fur seals which sleep at the surface. Other species are even able to sleep underwater, though they have to wake up frequently and return to the surface to breathe.

Many of the ice-breeding phocid species, such as the Harp Seal and the Hooded Seal, are known to undergo considerable migrations between their breeding and foraging areas. This behaviour is best documented in the Northern Elephant Seal (*Mirounga angustirostris*). Both males and females undertake some of the longest migrations of any mammal species. In any one year, they will make two migrations of between 18,000 and 21,000km between breeding sites in California and foraging areas in the North Pacific. Certain otariids, such as the Northern Fur Seal (*Callorhinus ursinus*) and the Antarctic Fur Seal (*Arctocephalus gazella*), are also known to migrate considerable distances between wintering and summer breeding grounds.

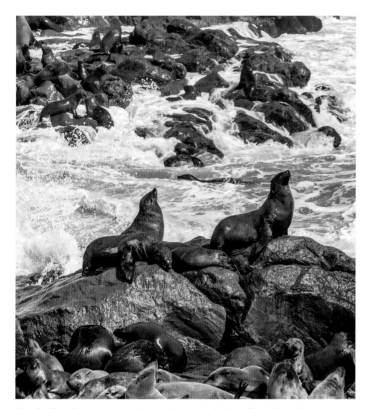

Cape Fur Seals (*Arctocephalus pusillus pusillus*) along the Skeleton Coast of Namibia spend much of the middle of the day resting in the nearshore surf, to avoid the intense heat. Namibian seals suffer an annual slaughter for their skins.

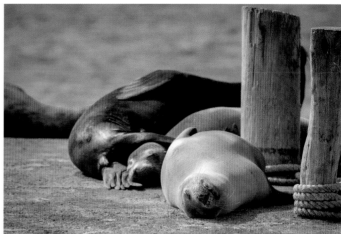

Galapagos Sea Lions (*Zalophus wollebaeki*) are unafraid and commonly seen by visitors to the Galapagos Islands. However, their restricted range and declining population size threaten their survival. Although often classified as a subspecies of California Sea Lion, recent genetic data supports their status as a separate species.

USES, THREATS, STATUS AND MANAGEMENT

Archaeological evidence suggests seals have traditionally been hunted by the indigenous peoples of the Arctic for at least 4,000 years. Seal hunting has been an integral part of their culture with products being used to make tools, thread, cords, games, fuel, clothing, boats, and tents. The first documented commercial hunting of seals by Europeans was in 1515, though it began in earnest during the 18th century in both the northern and southern polar seas. Prime target species were Harp Seals, Hooded Seals, Elephant Seals, Walruses and all species of fur seal. They were prized for their pelts (skins), their oil (blubber) and to a lesser extent, their meat. Walruses were also hunted for their tusks. The sealing industry was big business but so many individuals were taken that several species came close to extinction. With total or partial bans on the hunting of seals being introduced in several countries during the latter part of the 20th century, many of these populations have made remarkable recoveries, especially the Northern Elephant Seal, the Antarctic Fur Seal and the Northern Fur Seal. Other species are recovering more slowly. Whilst certain species are now fully protected, such as the Southern Elephant Seal, Ross Seal and the Antarctic Fur Seal, others, such as the Harp Seal, are still hunted albeit within a quota system.

Pinnipeds also face a number of other threats including entanglement in fishing nets, a reduction in abundance of their fish prey species due to human fishing pressure, coastal developments, marine pollution (particularly of organic chemicals) and diseases such as phocine distemper. In 1988 and 2002, over 23,000 European Harbour Seals became infected and died from the phocine distemper virus. It is still not clear what caused the original outbreak, but it is thought that Grey Seals may have acted as a carrier of the virus and spread it to other isolated seal colonies (Härkönen et al. 2006).

Estimating population numbers of pinnipeds is difficult because a large and generally unknown proportion of the population is always at sea. Population size is usually determined from annual counts of pups in rookeries. If assumptions are then made about the population dynamics of the species, this number can also be used to estimate total population size. Mediterranean Monk Seal (*Monachus monachus*) and Hawaiian Monk Seal (*Neomonarchus schauinslandi*) (see p.505) are listed as Critically Endangered on the IUCN Red List of Threatened Species whilst Galapagos Fur Seal (*Arctocephalus galapagoensis*), Australian Sea Lion (*Neophoca cinerea*) and Galapagos Sea Lion (*Zalophus wollebaeki*) are listed as Endangered.

Seal skins for sale in Norway.

SEALS AND WALRUS SPECIES: INFRAORDER PINNIPEDIA

Pinnipeds were once considered to be a separate order from the Carnivora in which they are now generally included (see p.416). The three families are all closely related and it is easy to recognise a pinniped as such. Berta and Churchill (2012) review the relationships between the different families and species. Both front and hind limbs are modified to form paddle or fin-like structures generally referred to as flippers. When pinnipeds are swimming the rear flippers can be mistaken for a tail. All pinnipeds have a tail but this is tiny and rarely visible, lost in folds of blubber and obscured by the flippers. There are currently 33 species and some of these have several subspecies. Genetic studies may yet reveal some of these to be true species.

Walrus ODOBENIDAE

The unmistakable Walrus is the only living representative of its family. No other pinniped has its wrinkled, almost hairless skin, coarse moustache and canine teeth modified into tusks. Like true seals it has no external ears but it resembles otariids in its ability to rotate its hind legs forward for walking on land.

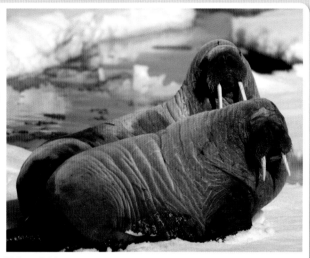

Walrus *Odobenus rosmarus*

Features Adult Walruses are easily recognised by their prominent tusks, whiskers, and general bulk. Tusks are present in both males and females and may grow up to 1m and weigh 5.4kg. Besides being used by males for fighting, they are also used for making holes in ice and assisting in climbing out of the water. The Walrus body shape shares features with both sea lions and seals: it can turn its rear flippers forward and move on all fours (similar to sea lions), yet its swimming technique relies less on flippers and more on sinuous whole body movements (like that of true seals).
Size Ranges from 2.2–3.6m, with females being two thirds the size of males.

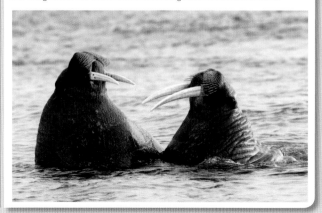

FAMILY Odobenidae

Eared seals OTARIIDAE

Eared seals comprise the sea lions and fur seals, all of which have external ear flaps called pinnae. They can walk on land using both front and hind flippers and use their long foreflippers, which are fully enclosed by skin, for swimming. Fur seals have two layers of fur whilst sea lions have one. There are seven genera and at least 14 species.

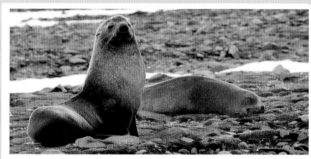

Antarctic Fur Seal *Arctocephalus gazella*

Features Around 95% of the world population of the Antarctic Fur Seal breeds on the island of South Georgia and, as its name suggests, this species is only found in the waters of the Southern Ocean. It was nearly driven to extinction by hunters during the 18th and 19th centuries. However, as a result of protective measures, the population size is now over 5 million and increasing. Adult males are dark brown in colour, females and juveniles tend to be grey with lighter undersides. As colour patterns are highly variable, some scientists believe there to have been hybridisation, on occasion, with Subantarctic Fur Seals (*Arctocephalus tropicalis*).
Size Males up to 2m long (females to 1.4m).

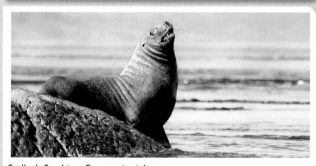

Steller's Sea Lion *Eumetopias jubatus*

Features Also known as the Northern Sea Lion, this species is the largest of the eared seals (Otariidae). Adults range in appearance from pale yellow to tawny. Two subspecies are distinguished, one in the NW Pacific (Western) and one in the NE Pacific (Loughlin's). The Western subspecies suffered major declines during the 1980s/90s, while the Loughlin's subspecies has been steadily increasing. Together, there are presently about 143,000 individuals. The decline in the Western's numbers has been put down to fewer prey fish (Herring, Capelin, Pollack), increased predation by Orcas, and the effects of disease, contaminants and shooting by fishermen.
Size Males up to 3.25m long (females to 2.9m).

FAMILY Otariidae

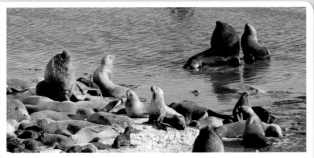

South American Sea Lion *Otaria flavescens*

Features Males of this species have an archetypal lion-like appearance, with a large head and a well-developed mane. Both sexes are orangey-brown in colour with upturned snouts. They are found along the coasts and islands of S America, from Peru to Chile in the Pacific and then north to southern Brazil in the Atlantic. Their diet consists of fish, cephalopods and occasionally penguins. One colony on the Chilean coast, is even used by vampire bats as a source of fresh blood.
Size Males up to 2.7m long (females to 2m).

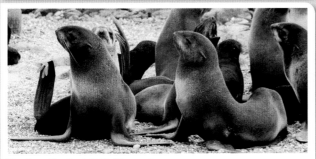

Northern Fur Seal *Callorhinus ursinus*

Features This species can be distinguished from other pinnipeds by exceptionally long hind flippers and a lack of hair on the distal half of the front flippers. The range overlaps almost exactly with that of Steller's Sea Lions and cohabitation occurs at some rookeries. They have been a staple food of native north-east Asian and Alaskan Inuit peoples for thousands of years. Despite a ban on commercial hunting for their pelts, their numbers are declining and they are listed as Vulnerable by IUCN.
Size Males up to 2.1m long (females to 1.5m).

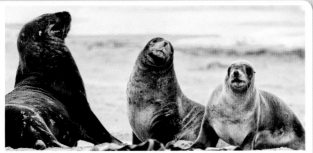

Hooker's or New Zealand Sea Lion *Phocarctos hookeri*

Features This may be the world's rarest sea lion with a population of around 10,000, listed as Vulnerable by IUCN. Their range once extended to include the whole of New Zealand, but they are now restricted to the southeast of South Island and some sub-Antarctic islands. Pups are born with a thick coat of dark brown fur that becomes grey with cream markings as they get older. Males are blackish-brown with a well-developed mane. Outbreaks of bacterial disease have led to significant pup mortality in recent years.
Size Males up to 2.7m long (females to 2m).

FAMILY Otariidae

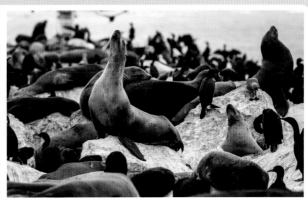

California Sea Lion *Zalophus californianus*

Features Male California Sea Lions are typically light or dark brown to black, whilst females are a tawny brown. Their range extends along the west coast of North America, from south-east Alaska to central Mexico. As a result of their intelligence and training ability, this is the species of sea lion you are likely to come across in marine mammal parks, performing tricks with balls or climbing ladders. They are also used by the US Navy for detecting mines and enemy divers. In San Francisco, they have become a well-known tourist attraction at their haul-out site on Pier 39.
Size Males up to 2.4m long (females to 1.8m).

True seals PHOCIDAE

The true or earless seals do not have external ear flaps. On land they pull themselves along using their front flippers and trail their hind flippers. The latter are used for swimming and are swept from side to side with the digits spread apart, acting rather like a fish tail. The front flippers have short webs which leave the digit tips and claws exposed. There are 13 genera, 18 living species and one recently extinct species.

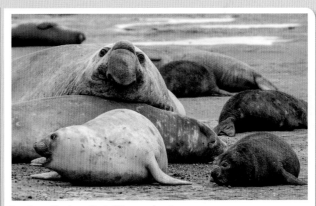

Southern Elephant Seal *Mirounga leonina*

Features The Southern Elephant Seal is named for the trunk-like proboscis of the adult males, as well as for their enormous size – they are the largest of all the pinniped species, with males weighing as much 4,000kg. The proboscis is used to make extraordinarily loud roaring noises, especially during the mating season. In order to defend his harem of females, a male Southern Elephant Seal may have to survive up to three months on land without feeding, living off his blubber store. These seals are the deepest diving air-breathing non-cetaceans with a maximum recorded depth of 2,133m.
Size Males up to 5.8m long (females to 3m).

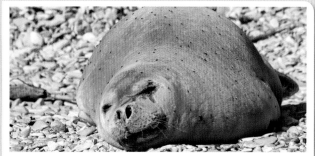

Mediterranean Monk Seal *Monachus monachus*

Features The coat of a Mediterranean Monk Seal is generally smooth dark brown (said to resemble the robe of a Franciscan friar – hence the name). They are believed to live up to 45 years old, though the average life span is more likely to be 20 to 25 years old. They feed during the day in shallow water on a wide variety of fish, lobsters, squid and octopuses. This rare seal is Critically Endangered and despite international conservation efforts over the past 25 years, their population remains at just 600.
Size Both males and females grow to 2.4m long.

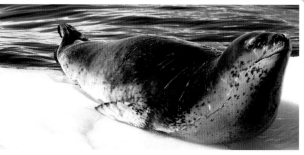

Leopard Seal *Hydrurga leptonyx*

Features The Leopard Seal lives in the cold waters surrounding Antarctica and is second only to the Orca among top predators there. It has a grey coat which is peppered with black spots – hence its common name. Leopard Seals tend to be solitary, both at sea and on the ice. Their diet is highly varied and changes seasonally. They will consume krill, fish, squid, penguins, other seabirds, and juvenile seals including Crabeater, Southern Elephant and Fur Seals. Killer Whales are their only known predators.
Size Females up to 3.6m long (males to 3.3m).

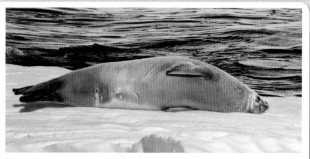

Crabeater Seal *Lobodon carcinophaga*

Features Crabeater Seals are relatively slender and pale-coloured, with older individuals appearing almost white. They are by far the most abundant seal species with an estimated population of at least 7 million. Even so, up to 80% of their pups are killed by Leopard Seals each year. They occur in the seasonally shifting pack ice surrounding the Antarctic continent and feed almost exclusively on Antarctic Krill. Tell-tale reddish stains from their faeces are frequently seen on the ice.
Size Grow to 2.6m long, with females being slightly larger and heavier than males.

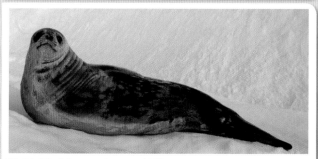

Weddell Seal *Leptonychotes weddellii*

Features Weddell Seals have the distinction of having the most southerly distribution of any mammal. They live in fast (perpetual) ice areas and must prevent their access holes from freezing over by biting and grinding the ice away with their teeth. This can lead to an accelerated tooth wear and a decrease in an individual's life expectancy. Weddell Seals can dive to over 600m depth with dives lasting at least 82 minutes, especially when the animals are searching for new breathing holes.
Size Females up to 3.3m long (males to 2.9m).

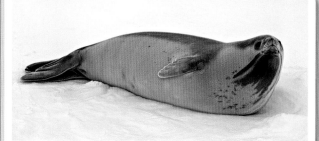

Ross Seal *Ommatophoca rossi*

Features The Ross Seal (named after the British explorer James Clark Ross in 1841) is the smallest, least common and least known of the Antarctic seals. Its population is estimated tentatively to be in the region of 130,000 individuals. The coat is brown on top and silvery-white underneath with dark throat streaks. They have particularly large eyes and are able to produce complex, trilling and siren-like vocalisations. These noises are made both above and below water.
Size Females up to 2.5m long (males to 2.1m).

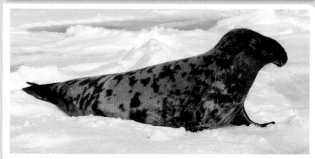

Hooded Seal *Cystophora cristata*

Features Hooded Seals are found in the waters of the central and western North Atlantic. Adult males bear a peculiar bladder on their heads, which is inflated to show aggression (p.446). The species has the shortest lactation period for any mammal, with most pups being weaned in just four days. Except when breeding and moulting, Hooded Seals are solitary, spending extensive periods at sea without hauling out. They can dive to over 1,000m for almost an hour.
Size Males up to 2.5m long (females to 2.2m).

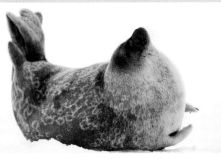

Ringed Seal *Pusa hispida*

Features There are five recognised subspecies of Ringed Seal and together they are distributed all around the Arctic and sub-Arctic. The common name derives from the dark spots on their coats which are surrounded by light grey rings. This, the smallest and the commonest seal species in the Arctic, survives the extreme cold of winter by having a very thick blubber layer and by building lairs (small caves) in the snow on top of sea ice. Their main predators are Polar Bears and humans.
Size Grow to 1.3m long, with males being slightly larger than females.

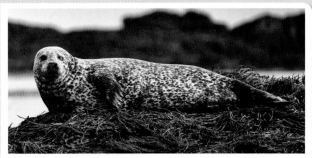

Common or Harbour Seal *Phoca vitulina*

Features This is one of the most widespread of all pinnipeds, and one of only two species native to the British Isles. It is found throughout coastal waters of the northern hemisphere, from temperate to polar regions. Adults may be brown, tan or grey in colour, and both sexes have distinctive V-shaped nostrils and rounded heads. They are gregarious and will frequent favoured haul-out sites on a daily basis, usually over low-tide periods. On land they are very shy and will stampede into the water if approached.
Size Males up to 1.9m long (females to 1.7m).

FAMILY Phocidae

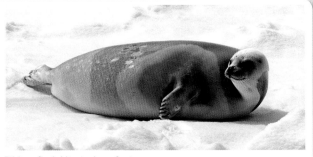

Ribbon Seal *Histriophoca fasciata*

Features The Ribbon Seal is a small seal with a very distinctive appearance. Adults older than four years old have white bands around the neck, the tail and one around each flipper, against a background of dark brown or black fur. The patterning, which is most apparent in males, is thought to help break up their outline. The species is found in the Arctic and sub-Arctic regions of the North Pacific. They spend winter and spring hauled out onto pack ice, but remain in open water for the remainder of the year.
Size Both males and females grow to 1.6m long.

FAMILY Phocidae

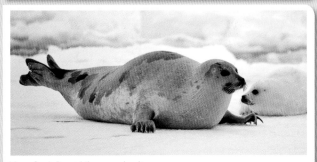

Harp Seal *Pagophilus groenlandicus*

Features Harp Seals have a silvery-grey coat with a harp-like black marking on their backs. Their pups have a thick white coat and it is for this that they are hunted by several nations. The species is widespread in the N Atlantic and adjacent Arctic Ocean. It is the most abundant seal in the northern hemisphere, with a population of about 8 million. Outside of the moulting and breeding season, Harp Seals migrate huge distances to their summer feeding grounds, with one tagged individual travelling 4,640km.
Size Both males and females grow to about 2m long.

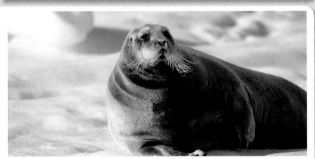

Bearded Seal *Erignathus barbatus*

Features The common name for this seal derives from the mass of thick, sensory bristles on its muzzle. Adults are greyish-brown in colour, darker on the back, and may have spots on the back or sides. They have a patchy distribution throughout much of the Arctic and sub-Arctic and are the largest species of seal in the northern hemisphere. Bearded Seals feed on or near the seabed usually at depths of less than 100m, using their bristles to search for molluscs, shrimps and bottom-dwelling fish.
Size Grow to 2.7m long, with females being slightly larger than males.

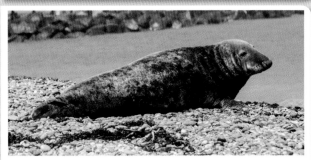

Grey Seal *Halichoerus grypus*

Features Grey Seals have a characteristic straight nose profile with the nostrils set well apart. They occur on both the western and eastern coasts of the N Atlantic, with a separate population in the Baltic Sea. Their diet includes a variety of fish species and they are sometimes blamed for decreasing fish stocks. The Grey Seal population in the UK is one of the most intensively monitored large mammal populations in the world.
Size Males up to 3.3m long (females to 2m).

MARINE OTTERS

Most people associate otters with freshwater but there are two species which are largely or wholly dependent on the sea. The Sea Otter (*Enhydra lutris*), best known as a charming inhabitant of Californian kelp forests, is wholly marine in all that it does. It eats, sleeps, mates and even gives birth at sea and rarely comes ashore except during violent storms. The South American Marine Otter (*Lutra felina*) by comparison spends more time ashore than in the water and sometimes ventures into estuaries and rivers in search of prey. Other freshwater otter species also visit seashores opportunistically to hunt in the rich shallows. Otters are related to weasels, skunks and badgers (Mustelidae) and share their carnivorous habits and inquisitive nature.

DISTRIBUTION

The Sea Otter lives in the coastal waters of the northern and eastern North Pacific. Recently, as a result of DNA analysis, three distinct subspecies have been distinguished (Cronin *et al.* 1996): the Common Sea Otter (*Enhydra lutris lutris*), the Northern Sea Otter (*Enhydra lutris kenyoni*) and the Southern Sea Otter (*Enhydra lutris nereis*). The Common Sea Otter is found along the coast of eastern Russia, from the Kuril Islands north to the Kamchatka Peninsula; the Northern Sea Otter is found from Alaska south to northern Oregon and the Southern Sea Otter, (or Californian Sea Otter), lives along the coast of central California, USA. The South American Marine Otter occurs in disjunct populations along the coasts of Peru and Chile, typically inhabiting rocky coastlines exposed to heavy seas and strong wind.

STRUCTURAL ADAPTATIONS

Body form and general features

All otters are adapted to swim and hunt in water but the Sea Otter particularly so as it spends its whole life in the ocean. Long, broadly flattened and fully webbed hind feet provide excellent propulsion and the whole the rear end of the body, including tail and feet, are moved up and down, in a similar way to cetaceans. When under water, the short forelimbs are kept pressed closely against the chest to help with streamlining. At the surface, they typically float on their back and move by sculling feet and tail from side to side.

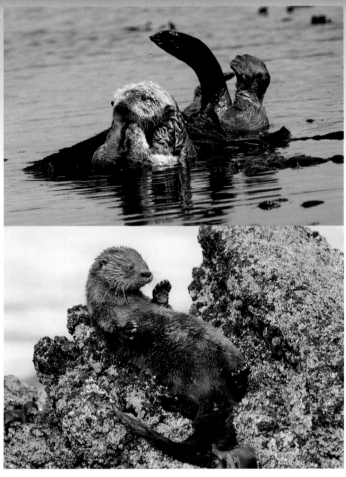

The Sea Otter (top) has fully webbed, flipper-like hind feet, folded ears, a short tail and grows up to 1.5m long and 40kg in weight. The Marine Otter (below) has smaller, partly-webbed hind feet, a long tail and reaches only 1.3m and 6kg.

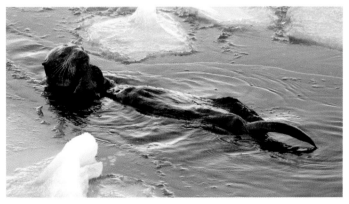

With its thick, waterproof fur, the Northern Sea Otter (*Enhydra lutris kenyoni*) thrives in the icy cold but rich fishing grounds of coastal Alaska.

The front paws have retractable claws and tough pads on the palms to give grip and provide protection from prickly prey. Under each foreleg, there is a loose pouch of skin in which they carry both prey items and flat rocks up to the surface, the latter famously used to break open shellfish and urchins. A large lung capacity about 2.5 times greater than that of similar-sized land mammals, allows them to make deep dives and both nostrils and ears can be closed.

With no insulating blubber layer, these otters have low body weights relative to their size (certainly in comparison to seals) and the tiny South American Marine Otter could not survive long periods in the cold ocean. The Sea Otter, however, gains insulation and buoyancy from its remarkable fur, the densest of any mammal with up to 150,000 strands of hair/cm². The fur consists of long, waterproof guard hairs overlying a short dense underfur which remains dry. Hairs are shed and replaced gradually rather than during a distinct moulting season, so the fur remains thick year-round. The Sea Otter has the ability to reach and groom the fur on any part of its body, taking advantage of its loose skin and an unusually supple skeleton. Frequent grooming traps pockets of air within their fur which keeps them warm and buoyant on the surface.

Senses

Both Sea Otters and Marine Otters have a bushy mass of whiskers (vibrissae) around their snouts. These are sensitive to touch and to underwater vibrations. A Sea Otter has good eyesight both above and below the water, although not as good as that of seals. In air, it has been found that their sense of smell is more important than sight when it comes to detecting danger. It has average hearing.

BIOLOGY

Feeding

Sea Otters forage over rocky seabed, through kelp forests and over soft sediment areas. Recent studies using implanted time-depth recorders indicated average deepest foraging depths of 54m for female and 82m for males (Bodkin et al. 2004), though most foraging dives are in shallow water and last for between one and three minutes. They eat hard shelled invertebrates such as clams, abalone and sea urchins, and will use a stone under water to dislodge them. Once back on the surface, they lie on their back and if it is too tough to crush with their teeth, will pound the shell against a flat stone balanced on their chest. This behaviour is unique to the Sea Otter. They have even been observed hitting shells against the hull of yachts in marinas, where no suitable rocks were available. Sea Otters are voracious feeders and must eat approximately 25% of their body weight in food every day.

The diet of the South American Marine Otter is a little more varied. Whilst being composed mostly of invertebrates, including crabs, shrimps, bivalves and gastropods, they will also eat small fish, small mammals and even birds.

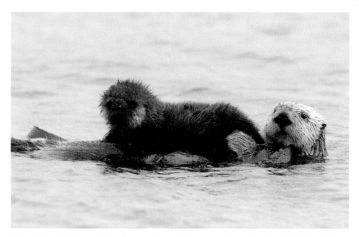

A Sea Otter (Enhydra lutris) mother carries her baby around balanced on her belly but will leave it wrapped in kelp fronds (which have flotation bladders) whilst she hunts for food.

Life history

Male Sea Otters reach sexual maturity around the age of six, but may not mate successfully for another two or three years. Most female Sea Otters are sexually mature by five years old. Mating can occur at any time during the year, with a gestation of 6–8 months. One or occasionally two pups are born at sea. Pups can swim well by five weeks old and are fully independent after eight months. When a mother goes off to hunt, she wraps her youngster in a kelp frond and leaves it bobbing on the surface like a cork. Males can live for 10–15 years and females up to 20 years.

South American Marine Otters give birth on land, typically in a small den hidden away at the top of the shore in January to March. Gestation is about nine weeks and two to four pups are usual. Both parents look after the pups for ten months or so, sharing food provision duties. When not in breeding pairs, most marine otters are solitary.

Ecology

Sea Otters generally occupy a home range of a few kilometres and remain there year-round. They often raft together in single-sex groups on the surface, typically with 10 to 100 animals. Sleeping individuals will tether themselves with a kelp frond so they do not drift away and individuals split off to forage under water, typically three times during any 24 hour period. Suckling females seem more inclined to feed at night.

The Sea Otter is regarded as being a 'keystone' species, critical in maintaining the balance of the near-shore kelp ecosystems (see box on p.100). Predators include Killer Whales, sharks and on occasion, birds of prey that take juveniles. Little is known about the habits and behaviour of the South American Marine Otter.

USES, THREATS, STATUS AND MANAGEMENT

The pelts of Sea Otters have long been prized for their dense, insulating fur and they had been hunted nearly to extinction by the early 1900s. Although populations recovered when hunting stopped and although protected by law, numbers are still declining. Deaths of many adult Southern Sea Otters in their prime have been attributed to disease, possibly resulting from coastal development and pollution. Spillage from the oil tanker Exxon Valdez in Prince William Sound, Alaska in 1989 killed an estimated 3,000 Sea Otters. As the Sea Otter's diet includes prey species that are also valued by humans as food, there have been conflicts between Sea Otters and fisheries interests. Both the Sea Otter and the South American Marine Otter are listed as Endangered on the IUCN Red List of Threatened Species (IUCN 2104).

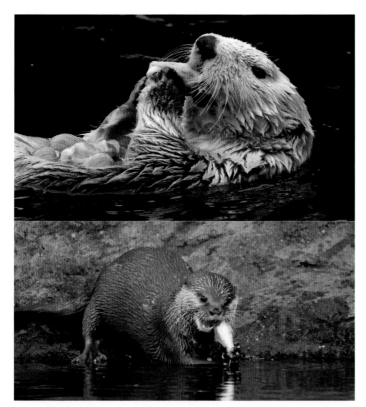

Sea Otters (top) typically feed in the water lying on their backs whilst freshwater otters such as the Oriental Small-clawed Otter (Aonyx cinerea) (below) eat their catch on land. The latter catches fish and crustaceans in coastal mangroves and estuaries as well as inland freshwater rivers.

POLAR BEAR

Polar Bears (*Ursus maritimus*) epitomise the icy wastes of the Arctic, lone hunters on the immense pack ice on which they are totally dependent. With the ice retreating year on year through global warming, the plight of this iconic animal has brought it to the attention of people across the world. However, Polar Bears have always played an important part in the material, spiritual, and cultural life of Arctic indigenous peoples. This, the largest member of the bear family (Ursidae) is an excellent swimmer and is regarded as being a marine mammal because of the large amount of time it spends at sea. However, unlike seals, cetaceans and sirenians (but like South American Marine Otters), it has limbs which allow it to move at speed on land and over ice and snow as well as swim well in the water.

DISTRIBUTION

Polar Bears are found throughout the circumpolar Arctic on ice-covered waters, from Alaska and northern Canada to Norway, the Russian Federation and Greenland. Their range is limited by the southern extent of sea ice, vital as seal hunting grounds. The furthest south that Polar Bears occur all year round is currently James Bay in Canada, which is about the same latitude as London. They rarely enter the zone of the central polar basin as there is thick ice all year round and there is little to eat.

STRUCTURAL ADAPTATIONS

Body form and general features

The body of a Polar Bear is well adapted to the very cold climate in which it lives. Their relatively large body size, increased by a 10cm layer of insulating blubber under the skin, helps reduce heat loss. Adult male Polar Bears (boars) typically weigh between 350 and 700kg and measure 2.4 to 3m in total length. Females (sows) are about half the size, weighing up to 300kg and 2m in length. The entire skin (apart from the nose and foot pads) is covered by a thick white fur made up of long guard

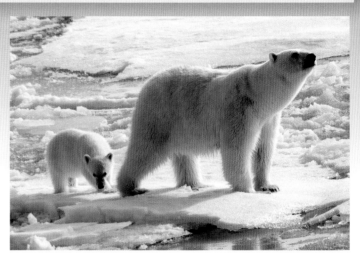

Even from a young age Polar Bears are completely at home on the Arctic ice pack.

hairs and a dense, soft underfur. The fur is moulted gradually and replaced during the summer months from May to August.

The feet of a Polar Bear, which can be up to 30cm across, have soles incorporating small projections and indents which act like suction cups, helping the bear to walk on ice without slipping. Each foot has five digits with non-retractile claws, which can dig into the snow like ice-picks to stop slipping as well. Normal pace is about 6km/h, though they can reach an impressive 40km/h when running.

Senses

Whilst Polar Bears' hearing is thought to be about as acute as that of a human and they have good long-distance vision, it is their sense of smell on which they chiefly rely for hunting and finding a mate. They are able to sniff out seals nearly 1.6km away and buried under 1m of snow. When communicating with each other, especially between mother and cubs, they use a wide range of vocalisations, including bellows, roars, growls, chuffs and purrs.

BIOLOGY

Feeding

Polar Bears mainly hunt Ringed Seals (*Pusa hispida*), Bearded Seals (*Erignathus barbatus*) and Harp Seals (*Phoca groenlandica*), but will also feed opportunistically on Hooded Seals, Walrus, Belugas and Narwhals. They hunt and catch seals primarily when they surface through breathing holes and when the seals are pupping. Catching these fast-swimming animals in open water is far more difficult. A bear will crouch near to a hole and wait patiently for several hours until a seal bobs up. Once it does, the bear may stun it with a blow from its huge paws, or simply reach in and drag it out onto the ice. The high fat blubber is eaten preferentially which carries with it the risk of accumulating harmful pollutants, such as polychlorinated biphenyls (PCBs). However, recent research (Bytingsvik *et al.* 2012) has shown that this risk has reduced substantially following a global ban on PCB production in 2004.

Polar Bears that have continuous access to sea ice are able to hunt throughout the year. However, in those areas where the sea ice melts completely each summer, the bears are forced to spend several months on land fasting on stored fat reserves and scavenging for anything remotely edible until the winter freeze-up returns.

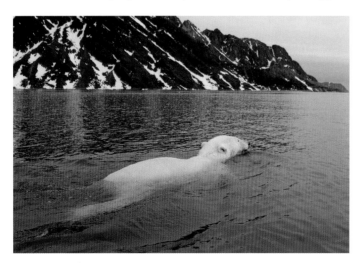

Polar Bears are excellent swimmers and use a doggy-paddle stroke of their partially webbed front paws to propel themselves along at speeds of up to 10kph.

Around human habitation, hunger and curiosity are increasingly leading to conflicts as bears raid garbage bins much like land-based Brown Bears. Starving Polar Bears can pose a real danger to people.

Life history

In general, Polar Bears lead solitary lives as adults. However, they tend to congregate between March and May on the sea ice in the best seal hunting areas. At this time males seek out receptive females, following their scent avidly for many miles. Rival males will spar with each other, rearing up on their hind legs to display their size and strength. There is intense competition because females feed and look after their cubs for about two and a half years and so will only mate every three years or so. Mating takes place not just on one occasion but several times during the course of a week, as the mating ritual induces ovulation in the female. Implantation of the fertilised embryo is then delayed until the autumn and in the intervening months the mother-to-be will eat prodigious amounts of food, often more than doubling her body weight. She will then seek out a suitable den (typically dug out of snow) for the birth, which takes place two to three months later between late November and mid-January. Female Polar Bears begin to breed at about five years old, while males are sexually active from about eight years old. Life expectancy is about 25 years for both sexes; death may occur as a result of being too old to catch food, or through injuries suffered in sparring bouts.

Ecology

Polar Bears are excellent long-distance swimmers and individuals have been seen in open Arctic waters as far as 300km (200 miles) from land. To find out just how far they can swim, a study (from 2004–2009) tracked 52 sows fitted with GPS collars in the southern Beaufort Sea off Alaska (Pagano et al. 2012). The longest swim was 687km and the average 154km. The time taken ranged from one to ten days. One of the study's conclusions was that such long-distance swimming is a behavioural response to declining summer sea-ice conditions.

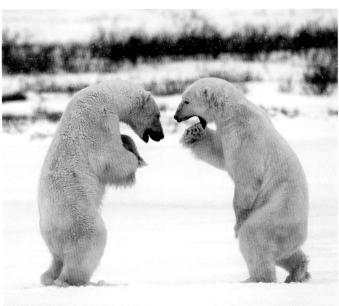

Like other bears, Polar Bears can stand upright and will do so when trying to intimidate a rival for food or a mate.

USES, THREATS, STATUS AND MANAGEMENT

The Polar Bear has long been and continues to be a valued quarry species for Arctic peoples, both for their meat and hides which are made into clothes and boots as well as small scale handicraft items. Hunting is now highly regulated though conservation varies between the five nations that include Polar Bear territory. All are signatories to the International Agreement on the Conservation of Polar Bears. Other threats include pollution, poaching, and disturbances from potential oil and gas activities.

However, the real threat to Polar Bears and one that has become much more apparent in recent years is the loss of sea ice during the Arctic summer as a result of climate change. Kerr (2012) predicts that much of the Arctic may have no summer ice within it by 2030. It is possible that if climatic trends continue, Polar Bears may disappear from most of their range within 100 years. The total population, which continues to decline, is estimated to be between 20,000 and 25,000 and the species is listed as Vulnerable on the IUCN Red List (IUCN 2014) and is in Appendix II of CITES.

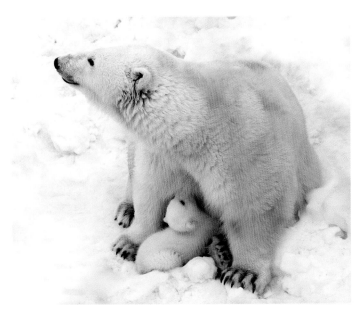

After giving birth, a female will remain in the relative warmth and safety of her den throughout the winter, relying on fat reserves for survival until she and her pups finally emerge.

MARINE BIRDS

With about 10,000 species in the world, grouped into some 200 families, birds are second only to ray-finned fishes in terms of species diversity among vertebrate animals. However, they show much less morphological diversity than the other vertebrate groups. The power of flight, common to all but a handful of bird species, limits the variety of workable physical forms for the avian body. On the other hand, the ability to fly provides birds with great freedom to travel and this has enabled them to colonise virtually every land mass and environment type in the world. Several different families of birds are regarded as 'true seabirds', highly adapted to exploit the rich feeding opportunities available at sea. True seabirds typically only come ashore for any length of time during the breeding season and for the rest of the year many are entirely pelagic. Within some of the true seabird families, a few species have become adapted to life away from the sea. Several species of cormorants (Phalacrocoracidae) and terns (Sternidae) and a few gulls (Laridae) are birds of inland wetlands.

Additionally, there are many other birds from within predominantly land and freshwater-based taxonomic families that have become adapted to a marine lifestyle and have a significant degree of dependency on sea or coastal habitats. The most notable are some ducks and geese (Anatidae) and waders or shorebirds (Scolopacidae and allies). Ducks of the subfamily Merginae, especially the eiders (*Somateria*) and scoters (*Melanitta*) are almost as highly adapted to marine life as are true seabirds. True seabirds, marine wildfowl, waders and other strongly coastal species are collectively referred to as 'marine birds' and each of these four groups is discussed in more detail in separate subsections below.

CLASSIFICATION

Birds form a class in the phylum Chordata (p.306). See table opposite.

ANATOMICAL AND PHYSIOLOGICAL ADAPTATIONS

The avian body plan is very similar across all bird species and even the most outlandish birds are instantly recognisable as birds. Birds are tetrapod vertebrates (p.306) in which the forelimbs have become wings, used for flying (in almost all species) and additionally for underwater propulsion in the case of some swimming birds. The hind limbs are legs, which are usually unfeathered and are used variously for walking, swimming, clinging and climbing. To facilitate flight the body and in particular the skeleton is very lightweight for its size, with some bones pneumatised (mostly hollow inside, with supporting cross-pieces). Birds that are deep divers tend

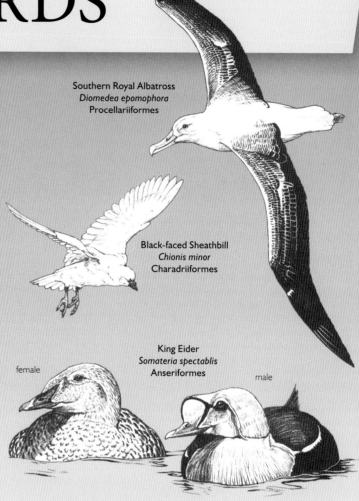

Southern Royal Albatross
Diomedea epomophora
Procellariiformes

Black-faced Sheathbill
Chionis minor
Charadriiformes

King Eider
Somateria spectablis
Anseriformes

female male

to have less pneumatised bone than other birds because the air held within such bone increases buoyancy and makes diving more difficult.

Unlike most tetrapods, birds lack teeth. The bones of the jaw have a lightweight keratin coating, forming a bill, the shape of which varies according to diet and mode of feeding. Most marine birds have a fairly long, straight and narrow bill for grabbing fish or cephalopods or probing for buried invertebrates. In some cases there is a small hook at the tip which helps the bird to hang on to large and vigorous prey. The inside edges of bills of mergansers have small serrations for extra grip and some species also have barbed tongues for the same reason. Puffins additionally have spines on the upper palate on which they can retain fish whilst they catch others. Some auks have seasonal augmentations to their bills, such as the colourful plates that adult puffins develop prior to breeding and these are likely to have a role in courtship. More remarkable still are the bills of skimmers, in which the lower mandible is much longer than the upper. During the skimmer's low hunting flight it holds the bill open and head dipped, and trails the lower mandible in the water, snapping the bill shut when it feels the touch of a fish. Shearwaters, albatrosses and petrels are noted for their tubular nostrils, a trait that is probably related to their exceptionally highly developed sense of smell.

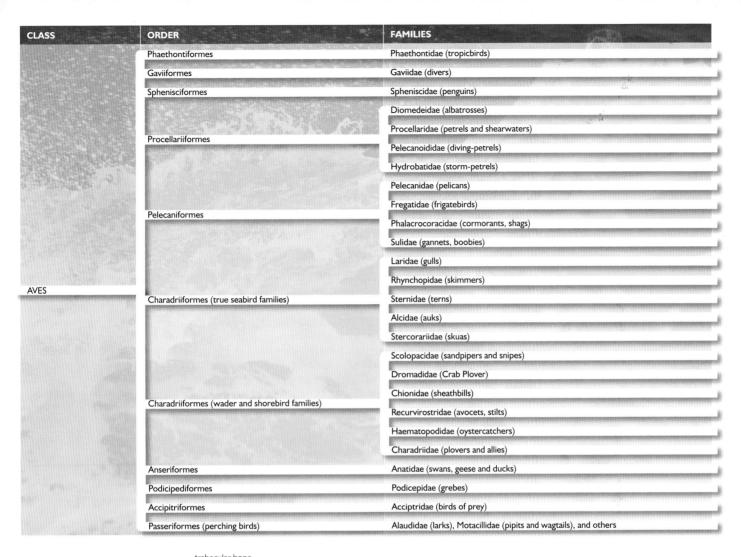

CLASS	ORDER	FAMILIES
AVES	Phaethontiformes	Phaethontidae (tropicbirds)
	Gaviiformes	Gaviidae (divers)
	Sphenisciformes	Spheniscidae (penguins)
	Procellariiformes	Diomedeidae (albatrosses)
		Procellaridae (petrels and shearwaters)
		Pelecanoididae (diving-petrels)
		Hydrobatidae (storm-petrels)
	Pelecaniformes	Pelecanidae (pelicans)
		Fregatidae (frigatebirds)
		Phalacrocoracidae (cormorants, shags)
		Sulidae (gannets, boobies)
	Charadriiformes (true seabird families)	Laridae (gulls)
		Rhynchopidae (skimmers)
		Sternidae (terns)
		Alcidae (auks)
		Stercorariidae (skuas)
	Charadriiformes (wader and shorebird families)	Scolopacidae (sandpipers and snipes)
		Dromadidae (Crab Plover)
		Chionidae (sheathbills)
		Recurvirostridae (avocets, stilts)
		Haematopodidae (oystercatchers)
		Charadriidae (plovers and allies)
	Anseriformes	Anatidae (swans, geese and ducks)
	Podicipediformes	Podicepidae (grebes)
	Accipitriformes	Acciptridae (birds of prey)
	Passeriformes (perching birds)	Alaudidae (larks), Motacillidae (pipits and wagtails), and others

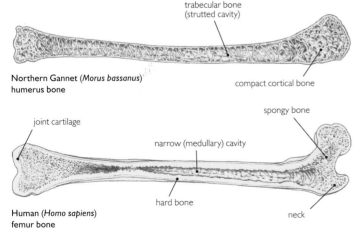

A comparison of the structure of the humerus bone in the wing of a seabird (above) and of a human (below).

Most birds swallow their prey whole. Their digestive systems carry out the kind of processing that would be done by teeth in mammals. The gizzard, a highly muscular section of the stomach, breaks down hard food items such as the shells of molluscs eaten by scoters and some other seaducks. In some species, such as cormorants, gulls, terns and waders, the gizzard also forms compacted pellets of indigestible material such as bones, which are then ejected via the mouth.

Feathers are today unique to birds, although they first evolved in theropod dinosaurs, ancestral precursors to modern birds. Feather structure varies according to function, with small and soft down feathers close to the skin to trap air, overlaid with longer and firmer contour feathers which provide insulation and (of particular importance to diving birds) waterproofing (see 'Temperature regulation' below). The long primary and secondary wing feathers have an aerofoil shape, thickened along the leading edge to generate lift for flight and the wing as a whole is similarly shaped. The tail has elongated feathers and is mainly concerned with steering and braking.

Marine birds' wing shapes tend to be either very long and narrow, allowing for prolonged, fast and energy-efficient gliding flight (as in albatrosses and shearwaters), or short and powerful, adapted for swimming strongly underwater (as in auks and penguins). Wings that are good at 'underwater flight' are less efficient in the air and

MARINE BIRDS

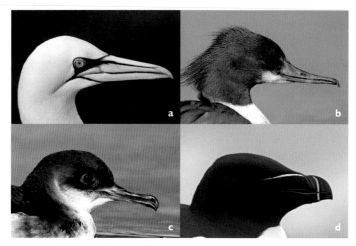

Some seabird bill forms. a) Northern Gannet: plunge-diver that swallows prey underwater, strong streamlined bill. b) Goosander: pursuit diver bringing prey to surface, serrated hook-tipped bill for grip. c) Manx Shearwater: surface-picker, delicate bill. d) Razorbill: pursuit diver that carries prey to nest, vertically deep shape gives a powerful, secure grip.

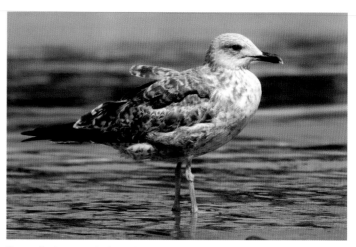

Young gulls of many species have a drab speckled brown coloration which persists for some time after fledging.

auks, for example, must flap hard and constantly to stay airborne, using up much more energy than similar-sized but longer-winged birds. Some smaller petrels have proportionately broad and rounded wings, a shape that allows these surface-pickers to manoeuvre with great agility at low speeds. Most marine birds have rather short and sturdy tails, though greatly elongated outer or central tail feathers ('streamers') are seen in several families, including terns, skuas, tropicbirds and frigatebirds.

The plumage as a whole also provides a 'canvas' for colour, whether for display or camouflage. A very common pattern in marine birds is a black or dark back and white underside, making the bird harder for predators to see against the surface of the sea from above, and less likely to be noticed by prey in the sea such as fish. Several species from different families, including prions and some juvenile gulls and terns, show a distinctive dark-on-light zigzagging pattern across the back and wings, which may replicate the appearance of wave crests when seen from above. Bright feather colours are uncommon in marine birds, though the males of some seaducks show bright tones and bold patterns, which are exhibited to their best advantage in courtship displays directed at females. Juveniles sometimes have a more uniform and drab plumage than adults, which serves as protective camouflage, especially for the pre-fledging period.

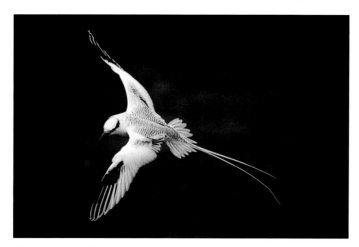

Tail streamers in tropicbirds are thought to have a role in mate attraction.

Most marine birds have short, strong legs, often with webbing between the toes to facilitate swimming (on the surface and sometimes underwater). This is most developed in the cormorants and allied species that swim underwater using their feet rather than wings. Their toes are long with broad spreads of webbing connecting all four, an arrangement called 'totipalmate'. In many other species, including gulls and ducks, the hind toe is very small and there is webbing only between the three forward-facing toes a foot type known as 'palmate'. The grebes have fleshy lobes on each toe rather than webbing and less aquatic groups such as terns and waders have reduced or no webbing.

Temperature regulation

Like mammals, birds are endothermic (warm-blooded) animals, using their own internal physiological functions to regulate their body temperature. This means they are not reliant on the sun to warm them up as reptiles are, and can continue their metabolic processes more or less uninterrupted. Birds of all kinds have various adaptations to overcome the challenges of maintaining their body temperature. Marine birds as a group show the full range of these, as they include species capable of enduring prolonged sub-zero temperatures and others that breed in hot climates. For those species that make prolonged deep dives in cold water, the need to retain heat is of prime importance and goes hand in hand with effective waterproofing.

The feathers are the first line of defence against low temperature. As mentioned above, the layer of feathers closest to the skin are the down feathers, which are very small with no strong central shaft and have soft fluffy branches (barbs) to trap air. The longer contour feathers are arranged in overlying groups or tracts, shaped and angled to provide complete body coverage. Each contour feather has a firm shaft, with some loose, down-like barbs at its base that contribute to the down layer. Further up the shaft, the barbs become firmer and more orderly, and 'zip' into each other via tiny interlocking barbules. The matrix of barbules is resistant to both air and water and when the contour feathers are flattened they create a smooth 'shell' that holds in the air trapped in the down layer. Birds preen frequently to 're-zip' barbules that have pulled apart and rearrange feather tracts that have become disarrayed.

Waterproofing is improved considerably by the application of preen oil, a secretion produced by the uropygial or preen gland located on the upperside of the tail base. This gland is well-developed in nearly all swimming birds. The bird accesses the oil and applies it to its feathers using the bill. As well as providing direct waterproofing, the oil helps the feathers to remain flexible and resistant to breakage. The

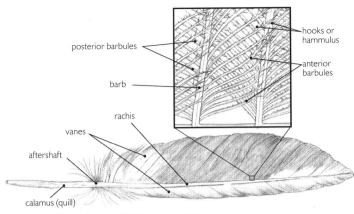

Secondary feather of Herring Gull (*Larus argentatus*).

Tropical-nesting seabirds such as the Blue-footed Booby (*Sula nebouxii*) may need to shade their chicks from direct sunshine.

cormorants are unusual in that they have reduced preen glands and use less oil on their plumage. This means that they have incomplete waterproofing and after they have spent time swimming and diving, they can often be seen perched with their wings outspread to speed up drying of the feathers. The incomplete waterproofing has the advantage of reducing their natural buoyancy, allowing for easier dives (see 'Diving adaptations' below).

Marine mammals possess generous stores of subcutaneous fat to help insulate their bodies from cold water. The majority of swimming marine birds also have a significant fat layer though in their case the amount of body fat that can be stored must be offset against maintaining a low enough body weight for flight. The obvious exception to this is of course the penguins and these birds possess the thickest fat layers, enabling them to dive deeper and for longer than any other birds.

With no feathers, bird legs could lose significant amounts of heat and people have long puzzled over the mystery of how penguins and other birds can stand on bare ice without their feet freezing solid. The answer lies primarily in a counter-current heat exchange system where small arteries carrying warmer blood on its way out from the heart flow very close to a network of similarly small veins carrying blood on the return journey, allowing heat exchange. The blood vessels can also constrict to help prevent heat loss. The temperature of the foot may still fall very low but this system maintains a stable temperature above freezing point. Penguins also minimise the amount of bare skin in contact with ice and sub-zero air by having very short legs and pouches of skin on top of the feet. Longer-legged birds such as gulls and sandpipers often rest on one foot at a time, keeping the other foot and leg folded up within the warm belly plumage.

Overheating can also be an issue in birds adapted to cold. Birds lack sweat glands, but have other methods of losing heat when necessary. The useful counter-current system of heat exchange can work in reverse and allow considerable heat loss through the feet, which can be held exposed on a hot day. Birds may also pant, rest with wings spread and in some species such as pelicans and gannets, flutter the loose gular skin around the throat. Overheating can be a particularly serious risk for young chicks. Gulls and terns nesting in very open situations keep their chicks cool on hot days by shading them with their bodies.

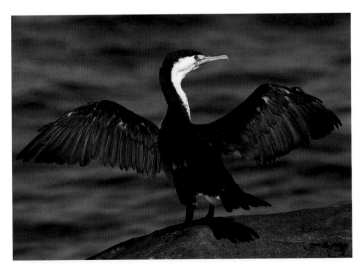

Pied Shag (*Phalacrocorax varius*) drying its wings in the sun on the Coromandel peninsula, New Zealand.

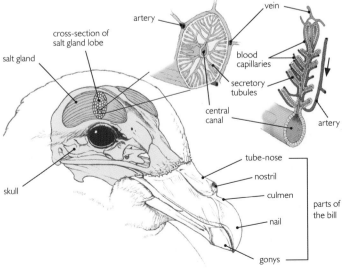

The head of a Northern Fulmar (*Fulmarus glacialis*) showing the position and detailed structure (right) of the salt glands.

MARINE BIRDS

Salt and water balance

Drinking seawater would be fatal to terrestrial birds and even small amounts of salt can be harmful. Marine birds naturally ingest seawater with their food but many can also drink it and do not have to rely on a source of freshwater. This is a key adaptation, enabling them to fully exploit the marine environment and for true seabirds to live an entirely pelagic existence. Like mammals and other vertebrates, birds can filter excess salt from their blood via their kidneys and expel it with their urine (which in birds is a paste added to the faeces and is the white component of the droppings). However, bird kidneys are not capable of dealing with this much salt and as in marine reptiles (p.403) the solution lies in special salt glands, structures found in all true seabirds and also some coastal birds. There are two salt glands located just above or just in front of each eye, the exact location varying between different groups. Their structure is relatively simple each consisting of many cylindrical lobes bundled together in parallel. Each lobe contains thousands of branching tubules radiating from a central duct. Excess salt is extracted from the blood as it flows through a system of tiny capillaries within the gland. The resultant strong salt solution is carried along ducts towards the bill and expelled through the nostrils. The bird's bill may look wet because of this, and when it shakes its head it may release a fine spray of droplets.

Diving adaptations

Many marine birds hunt prey underwater, sometimes at considerable depths. To reach the right depth they can either surface-dive, or plunge-dive from flight. Some species employ both methods, though nearly all are specialists in one style or the other. The plunge-divers tend to be those that are strong flyers but less powerful swimmers and so use gravity rather than their own propulsion to reach deeper water. The difficulties birds face through diving are the same as those that marine mammals and marine reptiles must overcome, namely the fight against their own buoyancy (which can be considerable in birds as much air is trapped in the plumage), the need to meet their bodies' demand for oxygen, avoiding decompression sickness and withstanding the increased pressure of water at depth. Plunge-divers must additionally cope with the impact of striking water at high speed.

Once a diving bird has reached a certain depth, it achieves neutral buoyancy whereby the density of its body is matched by that of the water around it. At this point, the bird can swim most efficiently as it is not being pulled towards the surface nor is it fighting against sinking deeper. Diving birds therefore try to descend quickly and directly to this point. Plunge-divers such as gannets achieve this by entering the water headfirst and at high speed, with the wings pulled back in a streamlined posture that 'punches' deep into the water. Surface-divers may give themselves an extra push at the start of their dive by jumping almost clear of the water before tilting themselves into a headfirst posture. Rather than 'taking a deep breath' before diving these birds may actually exhale which also helps decrease buoyancy. However, they have a high blood volume relative to their body size and have an increased oxygen carrying capacity in both blood and tissues. Like diving mammals and reptiles, diving birds can slow their heartbeat and restrict blood flow to all but essential organs, a reflex which forms part of the 'diving response' described further in the marine mammals section (p.418).

As water pressure increases, so the air spaces within the bird's body shrink down (see Water Pressure p.23). At its maximum recorded dive depth of 265 metres, the air spaces in an Emperor Penguin's (*Aptenodytes forsteri*) lungs reduce to 1/26th of their size at the surface. Deep-diving marine birds like auks, penguins and seaducks have strongly built rib cages to prevent damage as the lung volume decreases. Birds spend only a little time underwater and the risk of getting 'the bends' or decompression sickness (p.419) is therefore minimal.

To maximise useful foraging time underwater, the ascent from a dive is also rapid, something that human scuba divers try hard to avoid. Once above the point of negative buoyancy, the air spaces in the bird's body (including trapped air in the plumage) rapidly re-expand and its increasing buoyancy allows it to bob up to the surface. Emperor Penguins (*Aptenodytes forsteri*) make extremely rapid ascents in order to leap onto the ice and avoid predatory leopard seals. Film observations suggest that they purposely load their plumage with air before diving and that the trail of bubbles they leave behind them as they ascend again, acts as a lubricant increasing their speed (Davenport *et al.* 2011).

Plunge-diving birds such as gannets and pelicans have various adaptations to protect them from the force of hitting the water surface at speed. Their nostrils open on the inside rather than the outside of the bill, so water is not forced up them. Like most birds they have a transparent nictitating membrane or 'third eyelid' which protects each eye. The front of the skull has thickened bone to help absorb impact and there are small air sacs under the skin on the head and neck, which cushion these parts like a layer of bubble-wrap.

MIGRATION

Unlike marine mammals which give birth out at sea, even the most pelagic of marine birds must come ashore to breed. For many that is the extent of their migration and they remain in the same latitudes all year round feeding at sea and breeding seasonally at coastal or inland sites or wander in a more unpredictable, nomadic manner.

Penguins use their stubby wings to 'fly' through the water and their upward impetus to leap out of the water and onto ice floes.

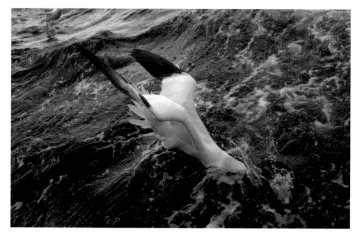

Gannets can hit the water at over 100kph and can do so repeatedly over their lifetime without any harm, thanks to modifications of the head and neck.

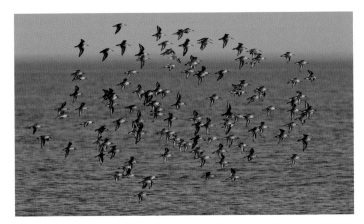

Although waders like these Dunlins cannot rest on the water, many are able to undertake long non-stop flights across open sea.

However, some species breed in polar and temperate zones when conditions are hospitable, but spend their non-breeding months thousands of miles away in order to avoid harsh winter conditions and to exploit richer feeding grounds.

While terrestrial bird migration tends to be concentrated along certain well-established routes or flyways (often those that allow the birds to avoid lengthy sea crossings), truly pelagic birds are subject to fewer restrictions. Their routes are often associated with oceanic currents such as the Benguela and Humboldt currents. Upwelling (p.52) produced by such currents creates good feeding grounds for true seabirds as abundant plankton and fish are available close to the surface. Coastal but non-swimming species tend to follow coastlines. The East Asian–Australasian flyway down the eastern coast of Asia is an important route for waders.

Research into bird migration is entering a new and exciting era. Studying this aspect of bird behaviour has long been very difficult, with ringing recoveries the main source of data. Every year, thousands of birds are trapped and fitted with uniquely numbered leg-rings by organisations such as the British Trust for Ornithology. A few of these will subsequently be observed (if the ring is of a type where its number can be read 'in the field'), or caught again, or recovered dead and the time and distance between the recording points tells us something about migration and longevity. However, it is now possible to fit satellite tracking technology (p.15) into devices small enough to be carried by birds without ill-effect, and tracking studies are yielding incredibly detailed pictures of the precise details of bird migration. Recent fascinating finds have included an 11,680km non-stop oceanic flight by a Bar-tailed Godwit (*Limosa lapponica*) migrating from Alaska to New Zealand and the discovery that Sooty Shearwaters (*Puffinus griseus*) average 500 kilometres a day on their epic, figure-of-eight journey from the far south to the far north of the Pacific Ocean and back again.

Exactly how migrating birds navigate remains uncertain but probably involves a combination of different cues. An ability to sense and orient by the earth's magnetic field has been demonstrated in some birds; homing pigeons have been found to have magnetite crystals in their bills and to lose their navigational skills if small magnets are fixed to their bills. Birds may also use star arrangements as visual navigation aids. For terrestrial birds, the use of landmarks is likely to be important, especially when close to 'home', but these are obviously no use to pelagic birds. However, water temperature and salinity may play a part and for species with a well-developed olfactory sense such as petrels, smell could also assist with navigation. Migration in marine animals is described further on p.58.

INCREDIBLE JOURNEYS

The Arctic Tern (*Sterna paradisaea*) has long been known to undertake an epic annual migration. The most northerly breeding populations of this bird can be found well inside the Arctic Circle and some migrate as far south as Antarctica for the winter, meaning that they spend a large part of their lives in 24-hour daylight. The direct distance from their breeding grounds to wintering grounds and back again is about 38,000km. The exact details of the route were not known until recently, when researchers fitted satellite-tracking tags to the legs of several Arctic Terns on breeding grounds in Greenland and collected positional data for their outward and return migrations. The data revealed that in both directions the birds' route was not direct but markedly zigzag as they took advantage of prevailing winds. Nor did all birds from the same colony follow the same route, with some southbound birds travelling off West Africa, others off eastern South America. In total the round-trips made by the birds covered an average of 70,900km. As Arctic Terns can live for well over 20 years, an individual tern could easily clock up more than 3 million km in its lifetime.

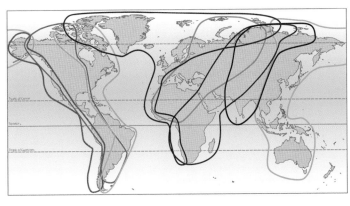

— East Asia/Australian flyway
— Pacific Americas flyway
— East Atlantic flyway
— East Africa West Asia flyway
— Mississippi Americas flyway
— Atlantic Americas flyway
— Black Sea/Mediterranean flyway
— Central Asia flyway

Migratory landbirds across all continents mainly stick to particular flyways that allow them to hug coastlines but avoid long sea crossings.

Arctic Terns are the true pole-to-pole travellers of the animal world.

MARINE BIRDS

SEABIRDS

The birds we consider to be 'true seabirds' are those that make their living from the sea all year round and can live away from land for weeks or months at a time. Taxonomically they span a diverse range of orders, but all show adaptations to a marine lifestyle. The easiest time to see (and hear) them is when they come ashore to breed, often in large, noisy colonies. Outside the breeding season, most are only spotted from ships and boats, resting in rafts on the ocean surface or wheeling above as they search for food.

DISTRIBUTION

Seabird species are found worldwide, breeding on every continent and ranging across all seas and oceans. Islands in temperate and sub-polar regions hold the highest concentrations and diversity of species. There are several species of breeding seabirds within the Arctic Circle and on the Antarctic landmass. Some individual species have very extensive global distributions, for example Wilson's Storm-petrel (*Oceanites oceanicus*) breeds on the Antarctic coastline and associated islands but wanders as far north as Canada and northern Europe in the austral winter. Many gulls and some terns nest inland and forage locally during the breeding season, but return to the sea in winter. Other species breed inland but commute long distances to the sea to find food throughout the breeding season. The Snow Petrel (*Pagodroma nivea*) breeds in Antarctica, further south than any other bird, sometimes more than 450km from the coast. The Marbled Murrelet (*Brachyramphus marmoratus*), a pursuit-diving auk without obvious adaptations to long-distance flight, breeds as much as 80km inland, nesting in forests in North America and commuting to the coast daily to forage in bays and the open sea. Emperor Penguins walk 60km or further between their breeding grounds and the sea.

With its huge wingspan a Black-browed Albatross (*Thalassarche melanophris*) glides over the ocean with only an occasional wingbeat to keep up momentum.

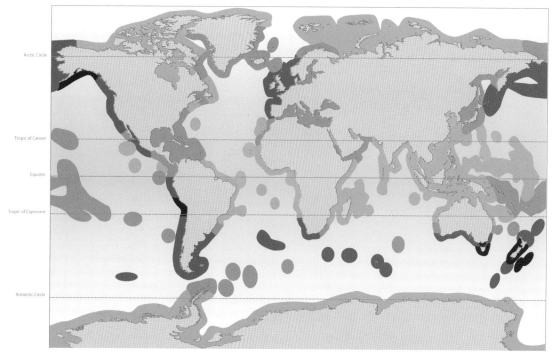

Seabird biodiversity. Numbers of seabird species differ between marine areas. Diversity is generally higher in temperate regions. Based on Hoekstra et al. (2010).

STRUCTURE

Seabirds are generally sturdy, streamlined birds with strong, short necks and short tails, and have long bodies with short legs set quite near the tail. There is typically webbing between the front three toes (all four toes in sulids, cormorants and pelicans). Most seabirds have a proportionately quite long and strong bill, either dagger-shaped or vertically compressed and often with a hooked tip. Wing shape varies from short, pointed and sturdy for wing-propelled divers like auks and penguins, to very long, parallel-edged and narrow for efficient long-distance fliers like albatrosses, while smaller petrels and small gulls that specialise in surface-picking have long and broad wings for efficient and agile flapping flight.

Most seabird species have well-developed uropygial (oil) glands and also have salt glands that allow them to drink seawater and expel excess salt (p.462). There are numerous specific structural adaptations within particular seabird groups, such as air-pockets to cushion the heads and necks of the plunge-diving gannets and boobies, heavy bones and generous subcutaneous fat on the bodies of auks and penguins that dive deeply in cold water, tubular nostrils to enhance olfaction in shearwaters and petrels, and water-permeable plumage in cormorants to reduce the energy costs of overcoming their own buoyancy when diving.

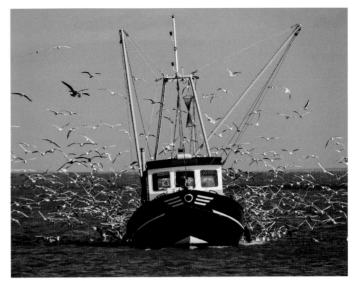

Discarded fish scraps can be a valuable food source to seabirds of many different species.

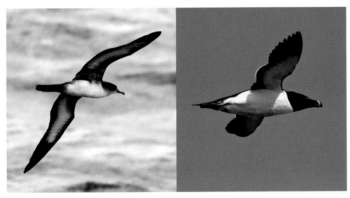

The very different wing shapes of shearwaters (left) and auks (right) are adaptations to their feeding styles, the former a surface feeder and the latter a wing-propelled deep diver. However, in many other respects, including plumage pattern and breeding strategy, the two are rather similar.

BIOLOGY

Feeding

Broadly speaking, there are two feeding styles employed by seabirds that take live prey at sea. Some seabirds dive deeply from the surface to pursue active prey or to forage over the seabed. These surface-divers include penguins, diving-petrels, cormorants, divers and auks. They submerge for a minute or more and chase prey underwater. Others capture prey at or just under the surface by picking or plunge diving, without submerging for very long, if at all. These surface-feeders scan the sea as they fly and make shallow 'splash-dives', or pick prey from the surface, relying on the element of surprise.

Surface-divers are strong on and in the water at the expense of efficient flight, having heavy, well-insulated bodies, small wings, high wing loading and a laboured flight, or are flightless as in the case of penguins and some cormorants. Surface-feeders and plunge-divers are typically strong long-distance fliers with a light build and long, narrow wings, adapted to exploit air currents produced at wave height to allow for very energy-efficient flight. However, most in this group are relatively weak swimmers and divers. There is some cross-over between the two strategies, with sulids (Sulidae) making deep plunge-dives from flight and then briefly pursuing prey underwater.

The groups classed as true seabirds mostly feed on living prey which they capture on and in the water. Of particular importance are fish, cephalopods, pelagic crustaceans and zooplankton. Nearly all seabirds will scavenge from time to time, with gulls, skuas and petrels relying particularly heavily on carrion, especially during the non-breeding season. A large sea mammal carcass, whether floating or washed up, will attract a wide range of scavenging seabird species. Petrels and albatrosses can locate carrion by scent from many kilometres away. Many seabirds follow fishing boats and scavenge scraps that are thrown overboard. Gulls and skuas may hunt small mammals over land or fresh water and some gulls and terns catch winged insects especially flying ants, as these swarm in great abundance when they emerge and this attracts gatherings of diverse bird species. A few seabirds are specialist kleptoparasites, obtaining much of their food by stealing it from other birds.

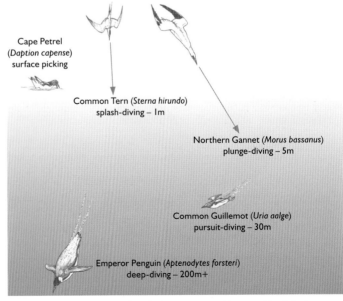

Between them, the various seabird species forage at a very wide range of depths in the sea.

Co-operative hunting is known in several seabird species. Auks will dive in a line and work together to drive a shoal of fish into a defensive ball, allowing them to take fish from the edges. Some seabirds also take advantage of the similar feeding behaviour employed by toothed whales and dolphins and wide-ranging seabirds may follow such cetaceans and use them as guides towards feeding opportunities.

Kleptoparasitism is of particular importance to the skuas and frigatebirds, which obtain a significant proportion of their food this way, relentlessly pursuing and grabbing at other less agile seabirds until the latter either drop or disgorge their catch. Many other seabirds will opportunistically steal prey from others if the chance arises, including from neighbours of the same species in their breeding colonies. Skuas and gulls will also readily prey on other birds, small mammals, worms and any other living prey that they find and can subdue; they also take other birds' eggs and chicks. Gulls in urban areas often make themselves unpopular by scavenging from bins and rubbish dumps and even snatching food directly from unsuspecting tourists' hands.

Life history

Seabirds are nearly all much longer-lived than similar-sized terrestrial birds and most species form enduring pair bonds, which are renewed through courtship displays at the start of each breeding season after spending the winter months apart. They typically nest in large colonies, show strong year-on-year loyalty to the breeding site and choose sites such as vertical cliffs and rocky islets free of predatory land mammals. Many smaller species nest in burrows rather than in the open and may also visit their colonies only at night, both of which are tactics to avoid predation by other birds. Most seabirds produce just one brood a year and broods are small with just a single chick in many species of auks, penguins and tubenoses. It is very common for breeding birds to skip one or more years over their lifetime and only to breed when in peak condition. In the weeks prior to egg-laying, the male will often bring food for the female, which is part of pair-bonding and courtship but also very important for helping her to gain fat and bodily resources prior to forming her egg or eggs. Often the female goes on an extended feeding trip in the last few days before laying. In many colonies, the timing of egg-laying is highly synchronised.

One trait that the majority of true seabirds share is very low breeding productivity. Many species take several years to reach breeding maturity, and once they do they produce just one small brood (often a single youngster) per breeding season. This low breeding productivity is related to a very high adult survival rate. In many species, in excess of 90% of adults will survive each year. True seabirds are well-known for their tremendously long lifespans. The oldest wild bird recorded is a ringed female Laysan Albatross (*Phoebastria immutabilis*) known as 'Wisdom' which, at the time of writing (2014), is aged 62 and has recently become a mother for the 35th time. Even the smallest species have a longer life span than similarly sized landbirds and much longer than similarly sized land mammals. The European Storm-petrel (*Hydrobates pelagicus*), which weighs in at just 27g, often reaches its thirties, while its larger relative the Northern Fulmar (*Fulmarus glacialis*) can live to its fifties. This potential longevity means that it makes sense for these birds to invest heavily in a small number of offspring, giving each the best possible start in life (the so-called 'k-selectionist' reproductive strategy), rather than to produce more young but spread resources more thinly among them (r-selectionism). The drawback to k-selectionism occurs when some crisis severely reduces numbers of adults as the low reproductive rate means it can take many generations for the population to bounce back.

Activity at seabird colonies is intense. Among most species, the birds make no attempt to conceal themselves or their nests, relying instead on sheer weight of numbers to guard against predation. The arrival of a potential predator often triggers a strong and co-ordinated response, many birds rising up simultaneously and beginning to chase and mob the intruder. This can be highly effective, but a determined nest-robber will often break through the defences. Nests nearest the centre of the colony are invariably safer than those at the periphery and the coveted central spots are occupied by older, more experienced and more successful breeding pairs.

Few seabirds build elaborate nests and many build none at all, laying eggs directly onto the bare rock of a cliff ledge, a scrape on the ground or even, in the case of the White Tern (*Gygis alba*), very carefully onto a tree branch. Those that do build nests usually make simple structures, such as the heaps of vegetation used by gulls, or the piles of stones preferred by some penguin species. Nests offer a means to contain

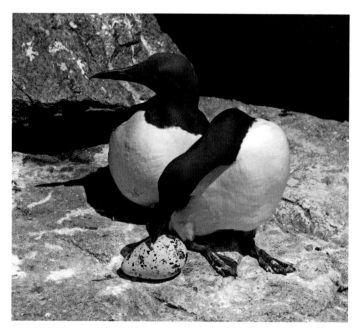

The pyriform shape of the Common Guillemot's (*Uria aalge*) egg helps to reduce the chances of it falling from the cliff-ledge if accidentally knocked, as it will spin rather than roll.

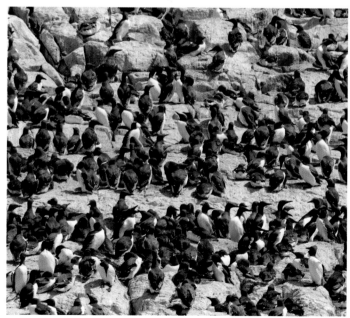

Because Guillemots feed at sea, they do not need to defend a large territory around their nests and can benefit from the increased vigilance and defensive response of colonial living.

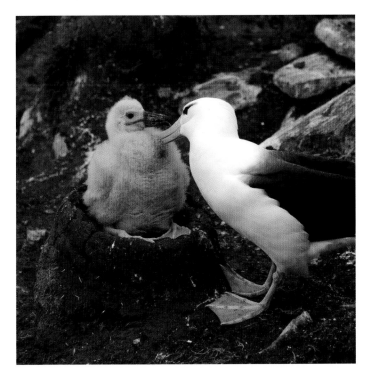

Black-browed Albatrosses tend their single chick assiduously for around four months until it fledges.

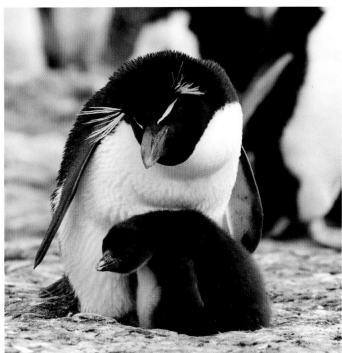

The chick survival rate is high in most seabird species, including the Southern Rockhopper Penguin (*Eudyptes chrysocome*), thanks to high parental investment in a small number of offspring.

the eggs and keep them close together and may also help to hold heat when the eggs are unattended. Burrow-nesting species may use holes dug by other animals or dig their own, or they may instead use natural rock crevices.

Both members of the pair participate equally in incubation and caring for the chick or chicks and their 'shifts' can be very long, sometimes several days while the off-duty bird is away foraging. Most seabird chicks are semi-precocial, hatching with a coating of down and open eyes, but limited mobility. They usually need to be brooded (or in hot climates, shaded) by a parent for at least the first few days of their lives. Some species such as puffins carry food to their chicks in their bills but others swallow it and then regurgitate it for the chicks to eat. Chicks in open colonies may become quite mobile soon after hatching, but parents and their chicks can recognise and locate each other by call. In some species, such as most tubenoses, chicks exceed adult body-weight by a considerable margin prior to leaving the nest. By contrast, some auk chicks leave the nest when barely half the adults' size and quite unable to fly or feed themselves. In these cases a parent will accompany them at sea until they are able to hunt their own prey. Parental care may extend for weeks after fledging (in terns and some auks for example), while other species abandon the chick pre-fledging and it lives off its fat stores for some time before leaving the nest site and beginning its independent life.

After breeding, adults and chicks both leave the breeding grounds and may disperse many kilometres away. Some species wander or migrate huge distances and live at sea for many months. They also moult after breeding, which may mean a temporary inability to fly in those species that spend most of their time swimming rather than on the wing. Young seabirds rarely attempt to breed before they are at least three years old and often spend their first full summer away from their colonies, but in subsequent years return and observe proceedings from the sidelines. Finding a mate and a spot within the colony in which to nest is a significant challenge for young seabirds and it is common for them to fail in their first few seasons.

Ecology

Most seabirds occupy high trophic levels within their ecosystems and many experience no significant predation once they reach adulthood. Some species are hunted habitually or opportunistically by larger predatory birds (including other seabirds) and by land and marine mammals such as seals, toothed whales, Polar Bears and Arctic Foxes. Large sharks such as Tiger Sharks can also pose a threat. Many species suffer high rates of predation of their chicks and eggs. When non-native predatory mammals, especially rats and cats, are introduced to islands occupied by seabird colonies, the consequences can be disastrous and several species have become extinct (such as the Guadelupe Storm-petrel *Oceanodroma macrodactyla*) or brought close to extinction (such as the New Zealand Storm-petrel *Fregetta maorianus*) as a result of this.

Seabirds are not usually thought to have a significant impact on their prey species. Many seabird species have suffered steep declines as a result of reduced prey availability due to overfishing and fish redistribution in response to climate change. Where fish stocks are depleted, some seabirds can cause problems by turning their attention to other prey and, for example, Great Skuas (*Stercorarius skua*) in Scotland kill large numbers of other seabirds in years of poor fish supply. Some species may compete significantly with other seabirds for nest sites and burrow-nesting species may also have to contend with competition from mammals such as rabbits.

USES, THREATS, STATUS AND MANAGEMENT

It is a widespread custom among coastal communities to harvest seabird eggs, chicks and sometimes adult birds for consumption, such as the controversial 'guga' harvest of Northern Gannet (*Morus bassanus*) chicks on Sula Sgeir, Scotland. The birds' habit of colonial nesting in open situations makes them very convenient for this and they can form an important part of the diet for some communities. Such harvesting is a

FISH-FETCHER

While they are not exactly ideal pet material, seabirds of some species have been used as working animals. In China and Japan, fishermen traditionally use trained cormorants of various species to catch fish. The tame, hand-reared birds are controlled via a leash around their necks, which is tight enough to prevent them from swallowing fish larger than a certain size. The practice is also known from Europe, China and Peru, but is becoming scarce in all areas.

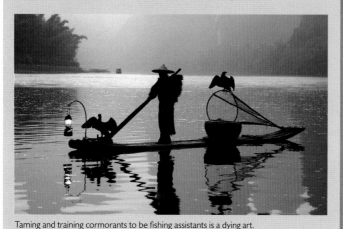

Taming and training cormorants to be fishing assistants is a dying art.

practice which can be done sustainably if managed with care, but can be very damaging if uncontrolled. The extinct Great Auk (*Pinguinus impennis*) was killed in huge numbers for its flesh, feathers and oil, and ironically, when it had become extremely rare it was finally wiped out by collectors seeking specimens for museums. Today penguins are prized as living exhibits, in zoos and marine parks, but most are captive-bred although in some cases are wild-caught.

Seabirds are popular with birdwatching tourists and boat trips to encounter a variety of species are commonplace in countries such as Great Britain, USA and New Zealand. However, seabirds can also cause issues considered serious enough to warrant culling or other forms of control. Gulls nesting in towns can cause a nuisance and some inland fisheries claim to suffer serious losses from cormorant predation. Gulls are also sometimes controlled for conservation purposes, where their predation of eggs and chicks threatens vulnerable breeding populations of other bird species.

Many species of seabirds are listed on the IUCN Red List of Threatened Species as being in danger of extinction. For example, of 131 recognised species of tubenoses, 13 are classed as Critically Endangered. A wide range of threats face seabirds, some affecting them on land at their breeding grounds and others at sea. Some governments have instigated measures to prevent accidental introductions of non-native species and on some islands mammal eradication programmes have allowed seabirds to re-colonise or recover their numbers. Another difficult problem to manage is that of seabirds becoming fishery bycatch. Deep-diving seabirds are liable to become entangled in gillnets, while surface pickers take bait from long lines, become hooked and subsequently drown. The latter in particular has received much publicity as a key cause of decline among nearly all albatross species. Research into new ways to bait and set long lines is showing some promise in preventing this. Albatrosses are naturally very long-lived, with experience contributing greatly to breeding success and produce only one chick per pair each year (or every other year in some cases). Therefore losses of adult birds are very significant and a population's recovery rate from decline is very slow.

Surface-diving seabirds are particularly vulnerable to spills of oil and other pollutants, and major spills can cause huge mortality among auks and cormorants. In some countries, volunteers spend much time rescuing and rehabilitating victims of oil spills. This is a complex and costly process with varying degrees of success, but ringing studies show that at least some oiled birds go on to live normal life spans and breed successfully after rehabilitation and release. Projects to map areas most used by seabirds at sea can help with decisions on tanker routes, offshore wind farms and whether to use dispersants on slicks. Seabirds are also at risk of ingesting or becoming tangled in floating plastic waste and because of their position high up the food chain can accumulate large amounts of toxins in their bodies. This may affect breeding success even if it does not kill them. Climate change is the most difficult threat to quantify at present, but with many seabirds breeding and foraging in polar areas there are likely to be significant changes underway. Loss of breeding habitat due to development is another cause of concern, particularly with beach-nesting species such as terns.

Because seabirds can be observed and monitored very easily on land when they are breeding, they are important indicators for researchers studying the health of marine ecosystems. Changes in seabird distribution and population can reveal large-scale issues affecting all kinds of marine life.

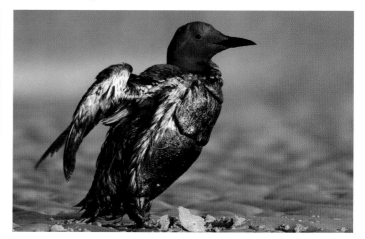

Of the world's 21 albatross species, 19 are considered to be in danger of extinction and long-line fishing is a major cause. This Shy Albatross (*Dimedia cauta*) is feeding on bycatch from a longline trawler off Cape Town, South Africa.

Oiled seabirds, in this case a Common Guillemot (*Uria aalge*), often die from poisoning after trying to preen the oil from their feathers.

SEABIRD SPECIES

Six taxonomic orders of birds are described here. All of them are adapted to live at sea for at least part of the year.

Order GAVIIFORMES

The divers (genus *Gavia*) are five very similar species of fairly large birds which live in the northern hemisphere. They are sleek and streamlined diving birds with lobed feet and dagger-like bills and they prey mainly on fish. They nest at inland lakes and in winter use bays and estuary mouths as well as inland water bodies. Monogamous and long-lived, they have strongly patterned breeding plumage (the same in both sexes) but moult to a paler and drabber plumage in winter.

Great Northern Diver *Gavia immer*

FAMILY Gaviidae

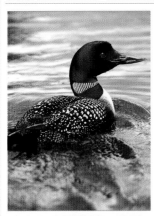

Features This large, robust diver is handsomely patterned in black and white during the breeding season, but moults to a drab grey plumage in winter. It breeds on undisturbed lakes inland, where the loud and haunting calls exchanged by pairs during courtship are among the most evocative sounds of the North American wilderness. It also breeds in Greenland and Iceland and moves south and east to sheltered bays or coastal lakes in winter. It can be numerous along parts of the British coastline. A deep-diving species, it preys on fish and crabs, which it brings to the surface to consume.
Size 81cm (wingspan 136cm).

Order SPHENISCIFORMES

These flightless, highly colonial seabirds are native to the southern hemisphere and include some species that breed on the Antarctic continent. Penguins are small to large birds with an upright stance, very rear-set legs and modified wings which function as powerful flippers underwater. The group includes the deepest-diving and longest-diving of all seabirds. Without need for flight, penguins' bodies are more fully adapted to aquatic life than any other seabirds. There is a single family (Speniscidae) with 16–18 species (depending on taxomony).

King Penguin *Aptenodytes patagonicus*

FAMILY Spheniscidae

Features For sheer size, elegance and perseverance the King Penguin is only topped by the Emperor Penguin (*A. forsteri*). The King breeds on sub-Antarctic islands such as South Georgia and Macquerie Island, usually on ice-free beaches. In contrast the Emperor breeds in the icy wastes of the Antarctic pack ice. Both species incubate their single egg on top of the feet, kept warm by the thick, soft feathers on the belly. Male and female Kings take shifts of up to three weeks duration to incubate the egg and chick. At about six weeks old the fluffy, brown young join a crèche.
Size 95cm tall.

Fairy Penguin *Eudyptula minor*

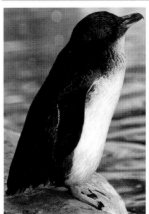

Features A diminutive size, easy accessibility and habit of wandering into urban areas abutting nesting shorelines, make this penguin a favourite with naturalists and tourists alike. Fairy or Little Penguins breed in holes, burrows or even under buildings along the southern coastline of Australia and in New Zealand. Many colonies in close proximity to habitation have been severely impacted by dogs, feral cats and development but others are well protected and managed as tourist attractions. At Phillip Island in Victoria, Australia the nightly 'parade' of penguins returning from the sea at dusk is a fascinating sight.
Size 40cm tall.

Gentoo Penguin *Pygoscelis papua*

FAMILY Spheniscidae

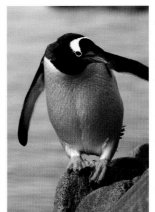

Features Gentoo Penguins breed on sub-Antarctic islands and the Antarctic Peninsula but range further north at other times, reaching New Zealand and Australia. Individual pairs return each year to the same breeding colony and often to the same nest, which they build or patch up with vegetation, stones and twigs. Pair bonds, formed at first mating when they are about two years old, may last for many years. Out at sea they are expert divers and can reach at least 150m depth in their search for fish, krill and squid. On land they have a characteristic waddle, brushing their tail from side to side.
Size 80cm tall.

Jackass Penguin *Spheniscus demersus*

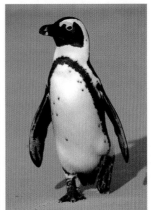

Features Unlike the majority of penguins, the Jackass, named for its donkey-like call, has to contend with very high temperatures instead of freezing conditions. Africa's only breeding penguin, it occurs along the coast from Namibia to South Africa. Here the birds waddle inland, often up and over steep slippery shoreline rocks and must sit out the hot day to protect their eggs and young. Pushing through intervening seal colonies provides another challenge. In very hot years, many nests are abandoned. Populations are declining and this species is listed as Endangered by the IUCN.
Size 70cm tall.

Order PHAETHONTIFORMES

A small order containing a single genus, the tropicbirds are graceful medium-sized seabirds, mainly white, with long slim wings and greatly elongated central tail feathers. All three species live in tropical regions although they wander widely outside the breeding season and often reach temperate waters. They are solitary when not breeding but breed in colonies, mainly on islands and feed on fish which they catch by making shallow plunge-dives into the sea.

Red-tailed Tropicbird *Phaethon rubricauda*

FAMILY Phaethontidae

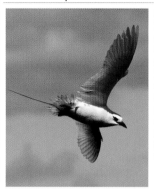

Features With its elegant, ribbon-like tail-streamers and crisply marked plumage, this is a striking bird. It is the largest and probably the most familiar of the tropicbirds, but with about 7,500 individuals worldwide it is also the least numerous. It breeds in small colonies on widely dispersed islands in tropical seas but is otherwise pelagic, roaming long distances. Its wide breeding range makes conservation difficult but reduces the risks from one-off catastrophic events.
Size 48cm (wingspan 100cm).

Order PROCELLARIIFORMES

Also known as 'tubenoses', these are long-winged seabirds with a distinctive bill morphology, including more or less obvious tubular nostrils which give them an enhanced sense of smell, allowing them to find floating carrion from many kilometres away. They are widespread across all oceans and are among the great seafarers, regularly spending months or even years wandering at sea without any need to visit land. Most pick their prey from the sea surface.

Family Procellariidae (shearwaters and petrels)

Most of the 90 or so species in this large and diverse family are relatively small tubenoses, with black, dark brown, grey or white plumage. Graceful and tireless in flight, they are awkward on land and some breed in burrows. Many also visit their colonies only at night, which helps protect them from predatory birds. However, the family also includes the giant petrels which are among the largest tubenoses and are themselves predators of other birds.

Snow Petrel *Pagodroma nivea*

FAMILY Procellariidae

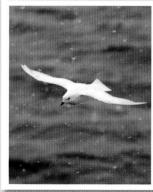

Features True to its name, the Snow Petrel is an all-white bird that lives in the icy wastes on and round the Antarctic continent and adjacent islands. Out at sea it flies low over the water dipping down to snatch krill, small fish and squid but it can also make shallow dives. Like most petrels it will also eat carrion. These normally solitary birds gather inland at breeding colonies seeking shelter under rocks and overhangs on rocky slopes and cliffs. It vies for the record of most southerly breeding bird with the South Polar Skua (*Catharacta maccormicki*).
Size 40cm (wingspan 95cm).

Great Shearwater *Puffinus gravis*

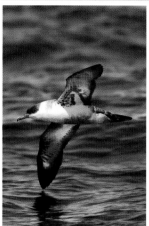

Features This species is the largest in its genus, though some scientists place it in the genus *Ardenna* and its affinities remain unclear. Each year these shearwaters fly from their remote S Atlantic breeding grounds, mainly in the Tristan da Cunha group of islands, to the N Atlantic via S America and Canada. Like many others in this family, Great Shearwaters are attracted to offal and discards and will follow trawlers and even ferries and ocean liners from which they can be spotted in comfort.
Size 50cm long (wingspan 1.8m).

Manx Shearwater *Puffinus puffinus*

FAMILY Procellariidae

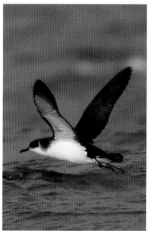

Features This fairly small shearwater breeds primarily on islands around Britain and Ireland, but has recently spread to North America. It is a burrow-nester, each pair rearing a single plump chick which they visit by night only. The chick weighs some 50% more than its parents when they abandon it to its own devices – it then goes without food for several days before making its maiden flight – an extremely dangerous time, with skuas and gulls killing many fledglings. Manx Shearwaters can live for more than 50 years, their chances of a long life much increased if they make it through their first year.
Size 34cm (wingspan 82cm).

Southern Giant Petrel *Macronectes giganteus*

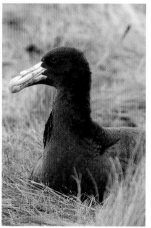

Features The Southern Giant Petrel is large enough to be mistaken for an albatross especially as it also lives and breeds in the Southern Ocean and adjacent areas. However, like all petrels it has a distinctive beak topped by sensitive tubular nostrils which leads it unerringly to mammal carcasses on land and offal discarded from fishing boats at sea. Whilst these petrels are happy to bully and eat other birds' eggs and young, they readily abandon their own nests if there is too much human (or other) disturbance. The very similar Northern Giant Petrel (*M. halli*) has an overlapping range but does not breed as far south.
Size 87cm (wingspan 2m).

Northern Fulmar *Fulmarus glacialis*

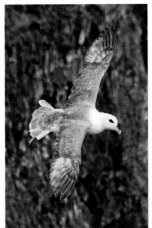

Features This is a fairly large and robust tubenose, resembling a gull at first glance with its white body and grey wings. Some individuals are entirely smoky-grey ('blue' Fulmars); this colour morph is more numerous in the north of the range, which extends around the north Atlantic and north Pacific. Northern Fulmars nest in colonies on sea cliffs, and occasionally coastal buildings, and are famed for defending their nests by spitting the noxious, oily contents of their stomachs at any animal that ventures too close. They feed mainly by picking prey or carrion from the sea surface and will follow boats.
Size 46cm (wingspan 107cm).

Antarctic Prion *Pachyptila vittata*

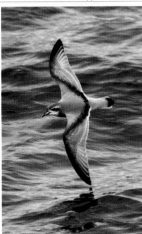

Features The previously accepted scientific name for this bird was *Pachyptila desolata*, referring presumably to its icy habitat in the southern Pacific and Southern Ocean. This highly sociable bird can be seen flying and searching for food in flocks numbering thousands. Prions feed by 'running' along the surface using their outstretched wings for stability and scooping up krill, copepods and small squid but can also dive a few metres down. Breeding colonies, on South Georgia and sub-Antarctic Islands, are also large and crowded. However, with an excellent sense of smell, they can relocate their burrow by the scent of their mate.
Size 26cm long (wingspan 20cm).

Wedge-tailed Shearwater *Puffinus pacificus*

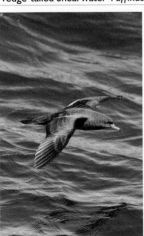

Features Shearwaters are renowned (and named) for their ability to fly low over the water, with wingtips almost touching the surface. This species, also known as *Ardenna pacifica*, is no exception. However, when breeding they shuffle clumsily along the ground, and on protected islands such as Heron Island on the Great Barrier Reef of Australia, tourists find they have to walk around them as they sit outside their burrows. They are also known as mutton birds as they are easy to catch and were used as food by sailors who were presumably not deterred by their wailing calls.
Size 45cm long (wingspan 1m).

Cory's Shearwater *Calonectris diomedea*

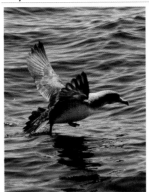

Features This robust shearwater has a very wide world range. However, between March and November it concentrates in the Mediterranean for breeding. Within each colony, egg laying is roughly synchronised and having many birds sitting at one time helps in dealing with predators. They migrate to South Africa for the winter. DNA analysis now suggests that Scopoli's Shearwater, which breeds mainly on East Atlantic islands and was previously considered a subspecies (*C. diomeda borealis*), is a species in its own right *Calonectris borealis* (Sangster *et al.* 2012).
Size 50cm long (wingspan 130cm).

Great-winged Petrel *Pterodroma macroptera*

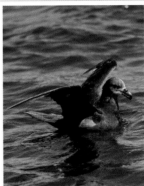

Features Species of *Pterodroma* are also known as gadfly petrels and are agile fliers with short, thick bills used to dip into the water for food either on the wing or from the surface. There are at least 35 species. The Great-winged Petrel feeds mostly on squid, often at night when it can detect their bioluminescence. Its long wings allow it to soar effortlessly out over the open ocean in the southern hemisphere. It has a wide distribution and breeding colonies are found between about 30–50°S on many islands.
Size 42cm long (wingspan 95cm).

Family Diomedeidae (albatrosses)

These are the largest tubenoses, with longer wingspans than any other birds. Most have mainly white plumage but a few are entirely dusky grey. They are exceptionally long-lived and prior to breeding may spend five years or more wandering at sea, mainly in the North Pacific and Southern Ocean. Nearly all of the 21 or so species are threatened with extinction, with accidental drowning on long-line fishing hooks a major cause of mortality.

Wandering Albatross *Diomedea exulans*

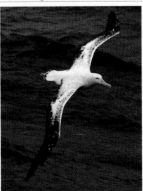

Features More than any other bird, this itinerant epitomises the wide open spaces of the ocean. With its immense wingspan, the largest of any living bird, Wandering Albatross can travel long distances in a short time, allowing breeding birds to forage several thousand kilometres from their nest sites on South Georgia and similar remote islands. Their habit of following boats and eating refuse means chicks can die when fed plastic waste. A greater threat is accidental catch by the long-line tuna fleet and it is Vulnerable on the IUCN Red List of Threatened Species.
Size 1.3m (wingspan 3.5m).

Black-browed Albatross *Thalassarche melanophris*

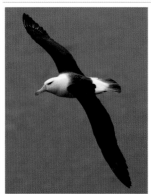

Features Named for the black eyebrow-like streak over each eye, this is the most widespread and common albatross with a circumpolar distribution ranging from subtropical to Antarctic waters. Nevertheless its population may still be declining and it is listed as Near Vulnerable in the IUCN Red List of Threatened Species. The Falkland Islands are a breeding area and any impact here could tip the population into decline. However, there are colonies on many other islands in their southern breeding range.
Size 95cm (wingspan 2.4m).

FAMILY Diomedeidae

Waved Albatross *Phoebastria irrorata*

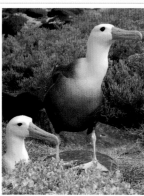

Features With an extremely restricted breeding range essentially on one island in the Galapagos and a declining population, this albatross is listed as Critically Endangered on the IUCN Red List of Threatened Species. Nesting birds forage mainly off the Peruvian coast where upwelling yields rich fish populations. Like other albatrosses they mate for life and males return first to the breeding grounds. When the female arrives the pair performs an elaborate bonding display, with head-waving and bill-clacking. They breed annually and can live for 50 years.
Size 90cm (wingspan 2.4m).

Family Pelecanoididae (diving-petrels)

Unlike other tubenoses, the diving-petrels feed primarily by diving rather than surface-picking and resemble auks rather than other petrels with their chunky outline, heavy bills and relatively short wings, which are their means of propulsion underwater. There are four species all found in the southern hemisphere and two of these species (South Georgia and Common) are among the most abundant of all seabirds. They are colonial breeders, nesting in burrows on islands and only coming ashore at night.

Common Diving-petrel *Pelecanoides urinatrix*

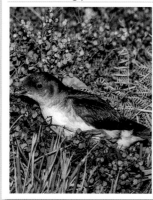

Features With a stubby body, short black bill and blue feet these small birds appear ungainly compared to other petrels. However, their way of life is obviously successful as they are extremely abundant. With wings whirring, they fly close to the sea surface mostly in inshore waters. When feeding they pursue krill and other pelagic crustaceans underwater, much in the manner of auks. For their size they dive deep, easily reaching 10m and sometimes as much as 60m depth. They excavate and breed in burrows on sub-Antarctic islands, New Zealand and SE Australia.
Size 20cm long (wingspan 38cm).

FAMILY Pelecanoididae

Family Hydrobatidae (storm-petrels)

These charming birds are the smallest of all seabirds. Despite their delicate proportions they can live into their thirties and roam huge distances at sea. Most are blackish, often with a white rump patch, belly or wingbar and have rather shorter and broader wings than other tubenoses, which helps them hold position as they 'walk' on the sea surface, picking up floating food items. They occur in all oceans and breed mainly on islands, visiting their nesting burrows only at night.

Wilson's Storm-petrel *Oceanites oceanicus*

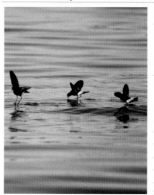

Features With a population estimated at well over 12 million individuals, this dainty little petrel is one of the most abundant marine bird species in the world. It breeds on islands across the entire sub-Antarctic, and in winter these birds move northwards, pursuing a pelagic lifestyle. It is best observed from boats, especially if 'chum' is on offer, and will fly close, using a curious bounding flight action and touching the surface with its dangling, yellow-webbed feet. It nests in burrows or crevices, and incubates its large single egg for seven weeks, three times as long as a similar-sized landbird.
Size 17cm (wingspan 40cm).

Leach's Storm-petrel *Oceanodroma leucorhoa*

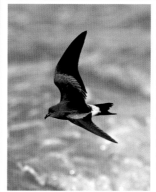

Features In contrast to the Black-bellied Storm-petrel (below) this species breeds in the northern hemisphere and migrates south to the tropics in winter as many other northern seabirds do. At this time it has a very extensive global range reaching as far south as South Africa. It is a difficult bird to study and count as it spends almost all its time at sea. It tends to breed on remote, undisturbed coastlines and islands, in burrows to which it only returns at night in order to avoid predation and so as not to draw attention to its nest site.
Size 20cm long (wingspan 48cm).

FAMILY Hydrobatidae

Black-bellied Storm-petrel *Fregetta tropica*

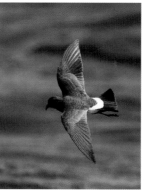

Features This small, neat bird might be found almost anywhere in the southern hemisphere. It has a circumpolar, sub-Antarctic breeding distribution but migrates north to warmer climes at other times, reaching the equator. It spends most of its life at sea, only coming ashore to breed in colonies, mostly on remote islands where the female lays a single egg in a burrow or a rocky crevice. It often follows ships and sailing boats, flying alongside with legs trailing. It feeds mainly on fish and crustaceans, and 'patters' on the surface.
Size 20cm long (wingspan 45cm).

Order PELECANIFORMES

This order contains several quite different seabird families and its taxonomy is currently under review, with a rearrangement of the group looking probable as DNA research reveals more about their relationships. One trait that unites them is their totipalmate feet, that is webbing connecting all four toes. Most have slit nostrils and breathe through their mouths and all feed on fish although one family does not catch its own but steals it from other seabirds.

Family Pelecanidae (pelicans)

There are eight species of pelicans. These are large, stocky, usually white seabirds. Their most distinctive trait is the very long, heavy and hook-tipped bill, with an extensive gular pouch below the lower mandible. Pelicans are primarily fish-eaters and catch their prey by either plunge-diving or scooping them up while swimming on the surface. Pelicans are found patchily in tropical and temperate areas and nest colonially in trees or on the ground.

Brown Pelican *Pelecanus occidentalis*

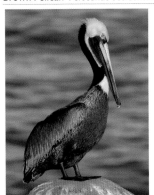

Features Brown Pelicans are a familiar sight along coastlines of southern and western USA, standing on pontoons and shores or swimming on the sea. It and the closely related Peruvian Pelican (*Pelecanus thagus*) are the only pelicans to plunge dive for fish. Their untidy grass and stick nests can be found from California to Chile and South Carolina and Florida to Venezuela. Noisy colonies gather in mangrove forests and on predator-free islands where the nests are often scraped soil on the ground. Peruvian Pelican numbers can plummet in strong El Niño years (p.17).
Size 1.4m (wingspan 2.5m).

Family Sulidae (gannets and boobies)

Noted for their spectacular plunge-dives from well above the sea surface, these large powerful seabirds are long-winged with dagger-like bills and several anatomical adaptations around their heads and necks to protect them from the impact of their dives. There are 10 species, most of them native to the tropics, although the three gannet species also occur in temperate seas. They are colonial and monogamous, with highly ritualised courtship and pair-bonding displays.

Northern Gannet *Morus bassanus*

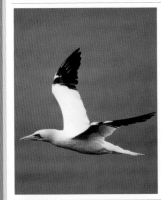

Features A stack or island hosting a gannetry looks snow-capped in summer, so densely packed are the Northern Gannets on their seaweed nests. This graceful seabird breeds in the north Atlantic, favouring small islands free of predators. Its 100kph plunge-dive can take it more than 10m underwater, where it can briefly pursue fish before using wings and feet to propel it back to the surface. Gannet chicks bear white down; this gradually disappears to reveal brown juvenile plumage. The adult plumage appears through annual moults over several years.
Size 90cm (wingspan 172cm).

Blue-footed Booby *Sula leucogaster*

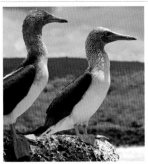

Features As well as being efficient paddles for underwater swimming, the bright blue feet of this species are used by the males as an irresistible lure to females. During courtship the male presents his feet in a shuffling dance, throws his head up and presents nesting material. Females assess males by the brightness of their feet and choose accordingly. Young healthy males have the brightest feet, reflecting their ability to catch fish which contain blue carotenoid pigments (Velando et al. 2006).
Size 90cm long (wingspan 1.5m).

Family Fregatidae (frigatebirds)

The frigatebirds comprise a single genus of five species and are large, highly aerial seabirds with long forked tails and long hook-tipped bills. They have dark plumage and the males possess a remarkable large red gular pouch which they inflate like a balloon during courtship. Frigatebirds are highly kleptoparasitic, obtaining up to 40% of their food by stealing it from other birds. They also catch prey from the sea surface, but never settle on the water.

Great Frigatebird *Fregata minor*

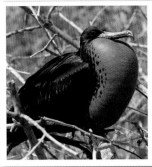

Features Seen in flight this frigatebird is a magnificent sight and has an aerial dexterity that matches that of many raptors. Its wings are long and angular with a large area in comparison to its body mass and it can stay aloft for several days, using thermals to gain height and save energy. Sustained flight is important as its plumage is not waterproof and it catches surface fish and squid without swimming or diving. Chicks are often fed for up to 18 months after fledging.
Size 1m (wingspan 2.3m).

Family Phalacrocoracidae (cormorants and shags)

Most of the species in this large family are marine birds. A few are also flightless. Cormorants and shags (the two names do not relate to any meaningful taxonomic distinction) catch fish by surface-diving and are noted for having water-permeable plumage. This allows them to reach neutral buoyancy at shallow depths, but they must air-dry their plumage after each dive. Most are black, with or without white underparts. They are heavy-set with long bills, necks and tails.

Great Cormorant *Phalacrocorax carbo*

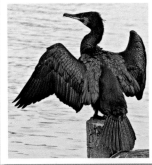

Features This is a large, mostly dark cormorant with an extensive global distribution, occurring (as several different subspecies) on Atlantic, African, southern Asian and Australasian coasts. It also breeds well inland in some areas. Its adaptable ways are key to its success – it will nest on cliffs, low-lying gravel islands and even in waterside trees alongside egrets and herons. It has a mixed history in terms of associations with humans. In Norway it is a gamebird.
Size 85cm (wingspan 135cm).

FAMILY Phalacrocoracidae

European Shag *Phalacrocorax aristotelis*

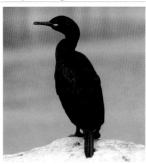

Features Slimmer than the Great Cormorant that it often occurs alongside, the glossy green-black European Shag sports a head crest in the breeding season. It breeds on rocky coasts across northwest and southern Europe to northwest Africa. It can dive to depths exceeding 40m, using its large feet to propel it to the seabed where it looks for prey, although it also takes fish at middle depths. Although its dives are deep they are also brief, rarely exceeding 45 seconds.
Size 73cm (wingspan 100cm).

Order Charadriiformes

A very large and varied order, this group includes the waders or shorebirds (p.478), as well as the families of true seabirds included here. Across the group, there is great diversity in almost every respect, including feeding behaviour, diet, mating system and parental care. There are charadriiform birds in all parts of the world, with a few species even found in desert and forest, but the vast majority are marine or coastal for at least part of the year.

Family Alcidae (auks)

A distinctive and large family, the auks are often viewed as the northern hemisphere's equivalent of penguins, although the only flightless species in modern times was the now-extinct Great Auk. Squat, small-winged and heavy-bodied, they feed by surface-diving and are wing-propelled underwater, pursuing fish at considerable depths. Some have remarkable colourful head and bill ornamentation; otherwise they are black and white. They breed in colonies and winter on the open sea.

FAMILY Alcidae

Common Guillemot *Uria aalge*

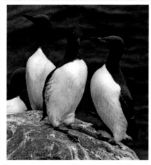

Features Cliff-face seabird colonies in the north Atlantic are often dominated by tightly packed rows of Common Guillemots. This is a relatively large auk with smart chocolate-and-white plumage, becoming whiter-faced in winter. It can use the narrowest ledges to nest, thanks to adaptations such as its pear-shaped egg, which will spin rather than roll if nudged. Chicks leap to the relative safety of the sea when barely half-grown and swim under the care of their fathers.
Size 42cm (wingspan 67cm).

Razorbill *Alca torda*

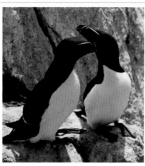

Features In British seabird colonies, a pair or two of Razorbills will often be spotted nesting discreetly alongside clusters of Common Guillemots, looking blacker and heavier-billed than their more abundant relatives. As the closest living relative to the extinct Great Auk, its habits give some insights into how that species might have lived, but unlike Great Auks, Razorbills can fly (albeit with much effort). They regularly dive to 30m and sometimes 100m.
Size 40cm (wingspan 65cm).

Little Auk *Alle alle*

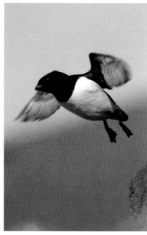

Features The Little Auk is a tiny seabird only the size of a Blackbird, but still manages to overwinter in the wilds of the Arctic and northern North Atlantic Oceans, seldom coming anywhere near land unless blown there by onshore gales. It breeds in immense colonies on island coasts and cliffs in the high Arctic, including Greenland, where some birds are caught by Inuit to make a fermented winter food called kiviak. The catch is stuffed into a seal skin, sealed to keep air out and left for many months. However this tradition has little impact on this abundant and widespread auk.
Size 19cm (wingspan 48cm).

Japanese Murrelet *Synthliboramphus wumizusume*

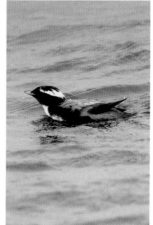

Features To see this grey-backed and crested bird, you would have to visit Japan where it is endemic and thrives in the warm waters brought by the Kuroshia Current. However, its restricted range and a population in decline through loss of breeding habitat and bycatch in driftnet fisheries means that it is listed as Vulnerable on the IUCN Red List of Threatened Species. Rats, unintentionally introduced by anglers and fishermen to the remote rocky islets and reefs where it nests, plus scavengers such as crows attracted by discarded fish, add to the pressure. However, it is a protected species in Japan.
Size 26cm.

FAMILY Alcidae

Parakeet Auklet *Aethia psittacula*

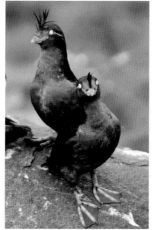

Features With its bright red bill, white eye stripe, upright stance and comical tuft of head feathers, it is easy to see how this auk gained its name. It has a very wide distribution in the North Pacific and might be spotted in Japan, Canada, USA and parts of Russia. It breeds on islands and along the mainland coast of Alaska and Siberia, travelling far out to sea to dive for planktonic crustaceans and small fish. Seabirds that feed on plankton, such as this species, are especially prone to ingesting plastic pellets that look just like their normal tiny prey.
Size 25cm.

Atlantic Puffin *Fratercula arctica*

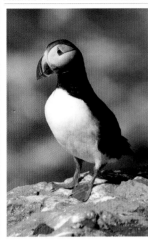

Features With its clownish face, upright stance and oversized, technicolour bill, the Atlantic Puffin is one of the most easily recognised and much-loved seabirds in the northern hemisphere. It breeds across much of the North Atlantic, nesting in cliff-top burrows which it either digs itself, or commandeers from Rabbits. The single chick is well-fed, primarily on sandeels which are brought by the dozen, neatly packed crosswise in the adult's bill. The chick fends for itself from the day it fledges. Both juveniles and winter-plumaged adults are less distinctive than breeding birds, which moult their colourful bill-plates and acquire grey cheeks after the breeding season.
Size 29cm (wingspan 55cm).

FAMILY Alcidae

Family Rynchopidae (skimmers)

There are just three species of skimmers, all found in the tropics. They resemble large, dark terns, but have a peculiar and unique bill morphology, the lower mandible projecting some way beyond the upper. When feeding, they fly with the head bowed, the bill open and the lower mandible trailing in the water, ready to snap the bill shut on prey. They nest on sand-banks and shingle islands, in rivers as well as on coasts and feed in calm water.

Black Skimmer *Rynchops niger*

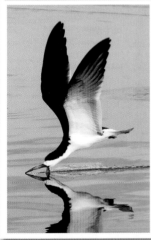

Features On land the large red and black bill of this bird looks oversized and faintly ridiculous. However, seen in action skimming fish and crustaceans from just beneath the water's surface, it is apparent what an effective tool it is. With a wide gape, the upper mandible is kept clear of the water and it is the sensitive lower half that feels the prey. With this method of feeding skimmers do not need to swim or dive and so are rarely seen in the water. Various subspecies of Black Skimmer can be seen feeding in calm, coastal waters almost anywhere around the whole of USA and South America.
Size 46cm (wingspan 127cm).

FAMILY Rynchopidae

Family Sternidae (terns)

Terns are sometimes known as 'sea swallows', reflecting their light, graceful flight and fork-tailed outline. They are long-winged and short-legged and feed by surface picking or splash-diving. Most species are very pale with dark caps and long, brightly coloured bills, and have elongated outer tail feathers. They breed in colonies, usually on flat beaches or lagoon islands and respond aggressively to passing gulls and other potential predators. The marsh terns breed inland but most others are coastal nesters.

Sandwich Tern *Sterna sandvicensis*

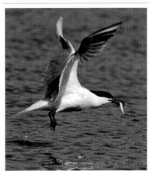

Features In the UK, this is the first tern species to return from its African wintering quarters. It quickly re-establishes its breeding colonies on beaches and coastal lagoon islands, often alongside Black-headed Gulls (the terns benefitting from the gulls' robust defensive reaction to any would-be predators). Sandwich Terns also breed elsewhere in NW Europe. This large tern has a grating screech of a call.
Size 40cm (wingspan 92cm)

Arctic Tern *Sterna paradisaea*

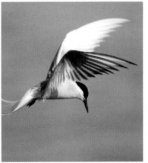

Features Celebrated for its pole-to-pole migration, the Arctic Tern puts in more air-miles per year than virtually any other bird, and the most northerly breeders see 24-hour daylight in both summer and winter. It is also famed for its fierce response to intruders near its nest – visitors to Arctic Tern colonies on the Farne Islands in England need head protection to save their scalps from laceration. This tern is a favourite target of kleptoparasitic Arctic Skuas.
Size 35cm (wingspan 72cm).

Whiskered Tern *Chlidonias hybrida*

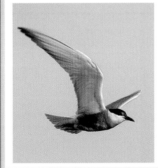

Features Far from being a true oceanic seabird this is one of four species known as marsh terns, that typically breed and feed on inland and coastal marshes and lakes. However, the Whiskered Tern is also a familiar sight plunge-diving in the shallow water of estuaries and coastal lagoons. Those breeding in southern Europe migrate south to tropical Africa, India and SE Asia in winter. Non-migratory birds also breed in warm areas of the southern hemisphere.
Size 27cm long (wingspan 78cm).

Caspian Tern *Hydroprogne caspia*

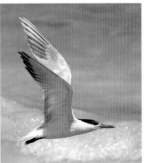

Features Although still elegant and acrobatic in flight, the world's largest tern is ungainly on land and its waddling gait, size and heavy, blood-red bill tipped with black, make it fairly easy to identify. It has a wide, almost cosmopolitan distribution and breeds in coastal N America, Europe (especially the Baltic and Black Seas), Asia and Australasia. Northern birds migrate south to warmer tropical areas in winter. Parents continue to provide food long after fledging.
Size 56cm (wing span 140cm).

FAMILY Sternidae

Sooty Tern Onychoprion fuscatus

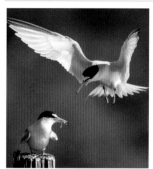

Features In recent years tern classification has been revised and this species was previously known as *Sterna fuscatus*. A handsome black and white bird of the tropics, it can be seen out at sea for most of the year and along coasts and oceanic islands during the breeding season. A truly aerial bird, it does not dive but picks prey from the surface in flight. They rarely rest on the water and only rest on land at night during the breeding season.
Size 40cm long (wingspan 90cm).

Little Tern Sternula albifrons

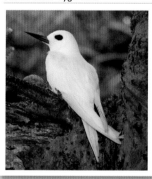

Features This tern has an extremely large range and breeding pairs can be found on coasts throughout Europe and Asia and in Australasia. It can also be found round Africa and the Middle East especially outside the summer breeding season. It fishes in coastal lagoons, saltmarsh pools and estuaries, preferring to hunt for small fish in very shallow water. As with other terns, courtship involves the male presenting his mate with a fish. Their nests are prone to disturbance.
Size 28cm (wingspan 55cm).

White Tern Gygis alba

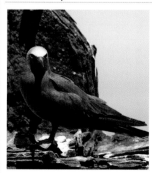

Features With its pure white plumage and black bill and eyes, the White Tern or White Noddy is an elegant and striking bird. It can be encountered at any time of the year on vegetated coral islands almost anywhere in the tropics. It makes no nest but lays its single egg balanced in the crook of tree branches or on palm fronds. The young chicks have strong claws and are adept at hanging onto their branch home. Females usually lay again if the egg is smashed.
Size 30cm (wingspan 80cm).

Brown Noddy Anous stolidus

Features The Brown or Common Noddy is an elegant, streamlined tern with glossy brown plumage and a distinctive white to pale grey forehead. However, on some of the tropical islands it behaves in a very un-tern-like manner, sitting (and nesting) in trees and totally ignoring, or even landing on passing tourists. Noddies are so-called because they bow gracefully to each other during courtship.
Size 45cm (wingspan 86cm).

FAMILY Sternidae

Family Laridae (gulls)

This large family has a global distribution but more representatives north of the equator than south. Gulls are intelligent and adaptable and are generalist feeders, taking much carrion and other scavenged food as well as a range of live prey. They are relatively long-winged and long-billed, and swim easily though they do not dive. Some species live inland for much of their lives. They nest colonially and often exploit urban habitats.

Herring Gull Larus argentatus

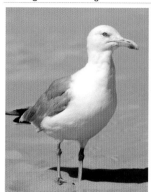

Features This is the most familiar coast-nesting gull across most of northwest Europe. Its North American subspecies is often regarded as a distinct species, and it is part of a confusing array of similar species across the northern hemisphere, known as the 'large white-headed gull complex'. It nests on cliffs and increasingly town rooftops, where it may be unpopular as it is noisy, messy and sometimes very bold, snatching food from tourists' hands at seaside resorts. However, this intelligent and adaptable bird is declining rapidly in some areas.
Size 60cm (wingspan 140cm).

Great Black-backed Gull Larus marinus

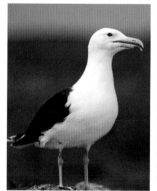

Features The largest of all gulls, this imposing species is a significant predator of other birds and small mammals, as well as being a fish-catcher and shoreline scavenger. Its scientific name relates to its preference for coastal habitats year-round; unlike other gulls it is rare inland in the winter. Great Black-backed Gulls are found across the northern Atlantic and usually nest on remote rocky shores, occasionally on buildings. When not breeding they often frequent harbours, where they compete with (and usually defeat) other gulls for scraps.
Size 72cm (wingspan 160cm).

Swallow-tailed Gull Creagrus furcatus

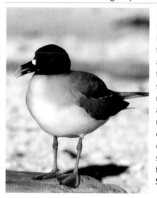

Features Gulls are often considered not true seabirds because so many occur inland, exploiting our wasteful lifestyles for food. However, this gull is truly pelagic and can be found hundreds of kilometres from the nearest land, searching for shoals of squid and small fish. Unlike most seabirds, it feeds almost exclusively at night when such prey tends to come nearer to the surface and is easier to catch. Almost all breeding colonies are on the Galapagos Islands but outside the season it extends from Ecuador at least as far south as southern Peru.
Size 60cm (wingspan 1.3m).

FAMILY Laridae

Black-headed Gull *Choicocephalus ridibundus*

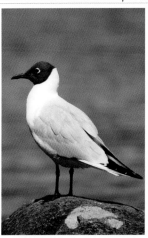

Features A smallish gull that occurs across the Palearctic, the Black-headed Gull is misleadingly named because its 'hood' (present only in the breeding season) is chocolate-coloured rather than black. It is highly gregarious at all times, nesting in busy and extremely noisy ground-level colonies, often on islands in marshland. It spends its winters foraging on farmland, estuaries, rubbish tips and alongside ducks and geese in urban parkland. It readily flocks with other gulls, and often shares its breeding colonies with terns. A few Black-headed Gulls now breed in eastern North America, where they rub shoulders with their near-identical transatlantic cousin, Bonaparte's Gull.
Size 37cm (wingspan 93cm).

FAMILY Laridae

Little Gull *Hydrocoloeus minutus*

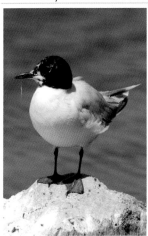

Features In contrast to many gulls this, the smallest species, is dainty with a fine, pointed black bill and dark to bright red legs. In summer it has a completely black head but in winter only smudges of colour remain. It is a versatile feeder, catching prey by 'dipping' in flight, by picking from the surface when swimming and occasionally by plunge-diving like a tern. In summer it feeds mainly on insects, but in winter when these are harder to come by it switches to small fish, marine invertebrates and carrion.
Size 30cm long (wingspan 80cm).

Dolphin Gull *Leucophaeus scoresbii*

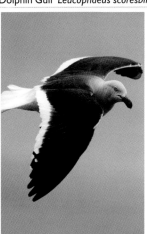

Features Living around the coasts of Argentina, Chile and the Falkland Islands, the Dolphin Gull must survive extremely harsh winter weather. With its unusual grey head and underparts and stocky body it could be mistaken for an out-of-place pigeon except for the typically broad, bright red, gull bill. It may have got its name from its unsavoury habit of eating the faeces, placentae and carcasses of cetaceans. Like other large gulls it will take eggs and chicks and is highly adaptable, having learnt that tourists and walkers will scare away defending parents. It will also hang around carrion sources such as slaughter houses and farmyards.
Size 46cm (wingspan 1m).

Kittiwake *Rissa tridactyla*

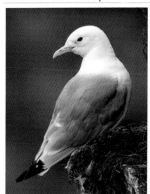

Features Along with Common Guillemot, this bird is one of the most numerous (and certainly the noisiest) species at north Atlantic seabird cliffs, and it is also found in the North Pacific. A highly pelagic gull, the Kittiwake is dainty and long-winged and looks noticeably short-legged and strong-clawed compared to most gulls, an adaptation to a life where clinging to a cliff is more important than walking. When not breeding it roams the oceans and seldom strays inland. Juveniles are black, grey and white unlike the brown of most gulls.
Size 39cm (wingspan 98cm).

FAMILY Laridae

Family Stercorariidae

This small family holds about seven species (taxonomy is still unresolved) of medium-sized, gull-like seabirds. Those species found in the southern hemisphere are large with mottled dark brown plumage, while the northern birds (with one exception) are smaller with more uniform dark-and-light plumage and elongated central tail feathers. Skuas are highly predatory and also kleptoparasitic, harrying other seabirds into dropping the fish they have caught. They breed in loose colonies inland and winter at sea.

Great Skua *Stercorarius skua*

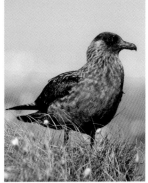

Features The Great Skua's Shetland nickname of 'Bonxie' nicely captures its robust appearance and belligerent character. The only one of the 'large brown' skuas found in the northern hemisphere, it is restricted to Iceland and northern northwest Europe and breeds on moors or upland grassland. It nests in loose colonies and fiercely attacks intruders (including humans) near its nest. Like other skuas, it will chase seabirds returning to their nests, forcing them to drop or disgorge their catch, but also preys on smaller seabirds.
Size 54cm (wingspan 133cm).

Arctic Skua *Stercorarius parasiticus*

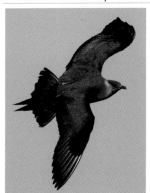

Features One of the small northern skuas, this bird has a falcon-like look in flight with its long, pointed wings and fast, agile flight. Adults are pale morphs with whitish undersides or uniformly dusky dark morphs – depending on terrain, one morph may be better camouflaged when sitting on its nest than the other. Arctic Skuas derive up to 100% of their diet from food stolen from other seabirds, especially terns, but they themselves sometimes fall victim to the larger Great Skua, and in Scotland their numbers are declining at a worrying rate.
Size 44cm (wingspan 117cm).

FAMILY Stercorariidae

WADERS

Waders or shorebirds comprise several families of birds within the order Charadriiformes. The same order also holds the skuas, gulls, terns, skimmers and auks, but the waders are distinct from these more marine species (covered in the previous section) in that they are associated with shorelines rather than the sea itself. There are more than 200 species of waders worldwide, most of which are closely associated with coastal habitats for at least part of the year, although many species breed inland. These are the birds that can be seen walking, running and probing at the water's edge or roosting in great flocks that take to the air the instant they are disturbed. Some familiar species seen in winter on the coast can be spotted and frequently heard inland in summer. The familiar lilting call of curlews in the uplands of Great Britain is a classic example.

The daily cycle of wader life on the shoreline is governed by the state of the tide, with many species going to roost at high tide and feeding by day and night at low tide. Most waders are strongly territorial when breeding but gregarious at other times, with their own species and others using the same habitat. Many are long-distance migrants and have traditional 'stop-off' sites on their migratory routes where huge numbers gather to refuel.

A flock of Ruffs (*Philomachus pugnax*) busy probing intertidal mud for worms and other invertebrates. Feeding together provides protection with many eyes to look out for predators.

DISTRIBUTION

Wader species are found worldwide, breeding on every continent both inland and on the coast, although they are relatively scarce in tropical regions and heavily forested areas. The highest diversity of breeding species is in northern temperate areas, with many of these species crossing to the southern hemisphere in winter. The sheathbills, which are rather atypical members of the group, are the only waders to breed in Antarctica and are also the only bird family endemic to the Antarctic region. Although waders are not able to rest and feed on the open sea (with the notable exception of the phalaropes), some species will make long sea crossings on migration and so may be observed thousands of kilometres from land.

STRUCTURE

In build, waders are small to medium-sized birds with tapered, well-balanced bodies and short tails. They have proportionately long legs and long fine bills (shorter in the case of the plovers and lapwings). The three forward-facing toes are long while the hind toe is small or even absent, an arrangement which allows the birds to run quickly on flat ground. In species that forage mainly on rocks, such as the Purple Sandpiper (*Calidris maritima*), the claws are strong and curved and some species have partial webbing between the bases of the toes. The phalaropes, most aquatic of the group, have this arrangement plus fleshy lobes along the rest of the toe length, reaching to the claw.

Most waders have more or less straight bills but in some the bill is markedly downcurved and in avocets it is upswept. A few species have very unusual bill morphology, for example the Spoon-billed Sandpiper (*Eurynorhynchus pygmeus*) with its spatulate bill and the Wrybill (*Anarhynchus frontalis*) whose bill bends sideways to the right. Some waders possess salt glands (p.462) that empty salt water via the bill. These glands may change in size through individual birds' lifetimes in response to the salinity of the water locally; the same is true of their kidney development.

Wader plumage patterns are quite variable. The sandpipers are typically mainly brown with paler undersides while plovers tend to show a bolder pattern

OUTLIERS

The waders that deviate most from the general wader 'look' are the sheathbills (Chionidae) and the pratincoles (Glareolidae). The former are stocky and squat, short-billed and thick-legged birds, resembling chickens or heavily built pigeons. They move with a ponderous, head-bobbing gait, are reluctant to fly and feed mainly on carrion and other debris. The latter could hardly be more different, being elegant and highly aerial birds, reminiscent of terns. They have small bills, long forked tails and a graceful flight, and feed mainly on the wing, catching flies and other winged insects. Pratincoles are related to coursers, which are also rather atypical, being inhabitants of deserts and other arid areas.

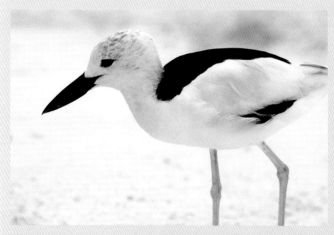

Although it doesn't look so very different to some other wader groups, the Crab Plover's (*Dromus ardeola*) very heavy bill reveals its true place within the Charadriiformes. Its name is a misnomer as it is more closely related to gulls and terns than it is to the plovers and other true waders.

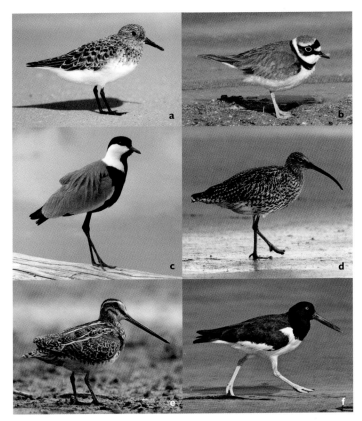

Wader bills relate to their preferred diet and feeding strategy. Sanderlings (a) chase small active prey, while Little Ringed Plovers (b) and Spur-winged Lapwings (c) are more patient watchers and searchers. Curlews (d) and Snipe (e) probe soft ground and feel burrowing prey with their sensitive bill tips. The Oystercatcher (f) has a long but powerful bill that can probe for mud-dwelling invertebrates but also batter mussels and limpets from their moorings.

incorporating areas of black and white. Most species show a contrasting pattern on the spread wing, which may function as a signal to others of the species and as disruptive camouflage when trying to evade an aerial predator. Many sandpipers develop a brighter plumage in the breeding season and it is quite common for females to be more highly coloured as well as physically larger than males. Most waders are fast, strong fliers, with long wings that have broad bases and pointed tips. The lapwings differ, having broad and round-tipped wings and a more leisurely flight action.

SECRET SCENT

Like most birds, waders possess uropygial glands which secrete preen oil, used for waterproofing and to repel parasites. There is evidence that the molecular composition of this oil changes just before the breeding season, to contain a high proportion of diester waxes. These are less volatile than the monoester waxes that predominate at other times and the change appears to make incubating birds less readily detectable by smell. Tests using trained dogs confirmed this in 20 species of Arctic sandpipers. Presumably by rendering themselves less smelly, the waders reduce the chances of their nests being discovered by mammalian predators such as Arctic Foxes and mustelids.

Unlike true seabirds, waders do not have especially highly insulating plumage and appear to cope with the challenge of keeping warm in exposed and sometimes watery habitats by maintaining a higher than average (relative to other, similar-sized birds) metabolic rate. Many waders will readily feed on night-time low tides and accordingly have relatively large eyes and this is most marked in the stone-curlews. Some also have larger than average olfactory bulbs, indicating that they may use their sense of smell to find prey. The wader digestive system is adapted to deal with hard prey parts. Most species have a relatively large and strong gizzard and regularly eject pellets formed from indigestible prey remains.

Broadly speaking, shorebird feeding methods are visual or tactile (see below) and there are corresponding differences in brain anatomy between species that use primarily one method or the other. In the case of long-billed, probing species that locate prey by touch, such as snipes, curlews and godwits, the distal part of the upper mandible can be flexed strongly upwards or downwards. This ability (rhynchokinesis) is not present in most other bird groups. The bill tip in such birds is also very sensitive, allowing the bird to locate prey by touch.

BIOLOGY

Feeding

Watch a mixed group of waders foraging on a flat sandy beach or mudflat and you will notice a range of feeding methods. Sanderlings (*Calidris alba*) run at the water's edge, dashing after tiny morsels carried ashore by the waves, while plovers have a distinctive stop-and-start action, with long pauses to scan around for prey. Turnstones methodically lift pieces of seaweed and other shoreline debris to find sandhoppers and other small arthropods hiding underneath. Curlews insert their long bills deeply into the soft ground to find burrowing worms and crabs and oystercatchers look for mussels which they pull loose from rocks before breaking into or levering open the shells. On saltmarshes just inland from the beach, other feeding methods can be seen. Avocets wade belly-deep and sweep their upturned bills from side to side through the water, tern-like pratincoles gracefully catch insects in flight and the long-legged *Tringa* sandpipers chase after tiny fish in the shallows.

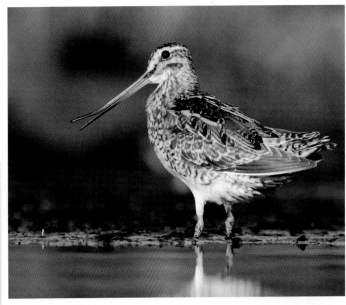

A flexible and sensitive bill-tip allows long-billed waders such as Snipe to find prey within mud or soil using touch alone.

Almost without exception waders feed on live prey, although shoreline foragers may also eat carrion if they find it. A flock of Ruddy Turnstones (*Arenaria interpres*) was famously flushed from a washed-up human corpse in Wales in 1966. This same species will also scavenge dropped food from seaside town promenades in some areas. Some waders take a small amount of plant material. Northern Lapwings (*Vanellus vanellus*), for example, include a varying proportion of seeds along with the worms and insect larvae that form the bulk of their diet.

Life history

The waders run the full gamut of mating systems between them, with many being functionally monogamous (albeit with variable rates of extra-pair copulations) but several others demonstrate polyandry (more than one male partner) which may be serial or simultaneous and less commonly, polygyny (more than one female partner). There is also variability in how the eggs and chicks are cared for, with both parents helping out or sole care by either mother or father. However, it is much more common for the male to be the sole carer than the female and even in species where both parents care for the young, such as the Common Redshank (*Tringa totanus*), often the female departs before the chicks are fully independent, leaving the male to care for the brood alone.

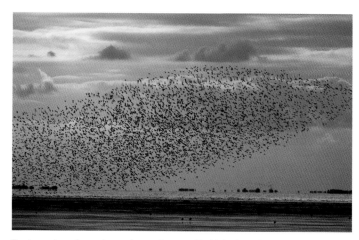

Feeding and roosting waders are frequently targeted by birds of prey. They counter these attacks by tight formation flying, all the birds turning and twisting in unison to form a confusing blur of shapes that will hopefully disorientate the predator.

THREE WAYS TO BE MALE

Most male Ruffs (*Philomachus pugnax*) are very obviously distinct from females (a), with their larger size and lavish crown and neck plumes that range in colour from black, through various shades of brown and chestnut to pure white. Dark-ruffed males (b) typically hold a display territory within a lekking area which they defend from others, but tolerate the presence of a white-ruffed 'satellite' male (c). The satellite helps attract females, although usually only gets to mate if the territory-holding male is distracted by another male at the critical time. Some male Ruffs lack the ornamentation and are close to females in size. These males, known as 'faeders' do not attract aggression from ruffed males and indeed are often mounted by them, but their non-threatening appearance affords them the chance to get close to the real females as well. To compensate for this risky strategy they produce much more sperm than other males, boosting the chances that any mating will be successful. Faeders are on average a little larger than females, but cannot reliably be distinguished from them in the field except by behaviour.

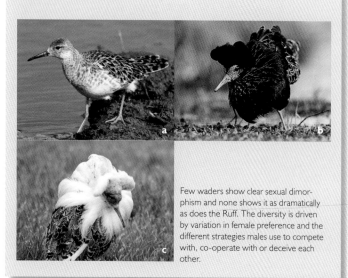

Few waders show clear sexual dimorphism and none shows it as dramatically as does the Ruff. The diversity is driven by variation in female preference and the different strategies males use to compete with, co-operate with or deceive each other.

Monogamous species include oystercatchers and lapwings, while all three species of phalaropes are polyandrous, with females displaying to court males and taking no part in parental care once eggs are laid (as might be predicated by the fact that female phalaropes are larger and more colourful than males). In the Ruff (*Philomachus pugnax*), males are markedly larger than females and develop ornamental head plumes in the breeding season. They display communally (lekking) to attract females and win mating opportunities.

Some waders are territorial, using song and both terrestrial and aerial displays to advertise their patch and keep same-sex rivals away. However, at the onset of nesting they become much more discreet. Waders typically nest on the ground, in well-concealed locations and use camouflage (of themselves, their eggs and their chicks) as protection against predators. If disturbed from their nests they may use distraction displays, feigning injury to lure a predator well away from the nest. Some species, such as avocets, have more visible nests and are colonial. They rely instead on a very robust defensive response to drive away predators, while in lapwings often one parent guards the nest area while the other is incubating.

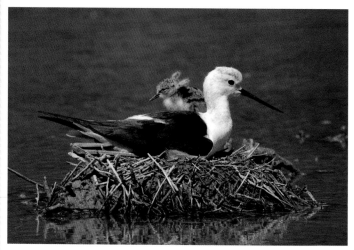

Black-winged Stilts (*Himantopus himantopus*) nest colonially on shallow coastal saltmarshes, and will attack fiercely any potential predator that wanders near the nest.

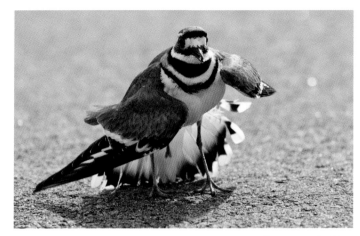

By feigning a broken wing and moving away from its nest, this Killdeer (*Charadrius vociferus*) is attempting to draw away a potential predator (in this case probably the photographer).

Wader nests are usually quite rudimentary, frequently just bare scrapes or flattened plant matter, with some overhanging vegetation for cover. Many shoreline plovers nest on open shingle, their eggs beautifully patterned to resemble stones. Clutch sizes are typically small, of three or four eggs, but may be increased by 'egg-dumping', when a female lays an egg in another female's nest. Egg-dumping is often in response to predation of an incomplete clutch. Laying the remaining egg or eggs in an established nest is probably a better bet than hastily finding a new nest site. However, many dumped eggs will not hatch as the existing eggs in the nest are likely to be at a more advanced stage of incubation.

When the chicks hatch, they are usually mobile and able to feed themselves within a few hours. In a few species the adults bring food for the chicks. This has the advantage of allowing them to nest on small islands where food supplies are low but the danger of predation is also much reduced. Newly hatched wader chicks depend on their parents for protection and for the first few days of their lives at least, for warmth. Instinctively they stop and remain totally still when danger threatens, although when older they will run for shelter. Once they have developed their first set of feathers,

both the juveniles and the adults tend to move away from the breeding grounds. Many species will migrate very long distances at the end of the breeding season (see p.463), either before or after the annual moult and most are highly social throughout the non-breeding season.

Migrating waders in autumn arrive at their staging posts in a series of waves, with the failed breeders first, followed in many cases by adult females and then juveniles and adult males. Autumn stop-offs may last many weeks. In many countries several wader species occur only as 'passage migrants' and are most frequent in autumn. The return migration in spring is usually considerably quicker, with fewer and briefer stops to refuel. Young waders will normally attempt to breed at one year old and many species are long-lived; the Eurasian Curlew (*Numenius arquata*), for example, can survive into its thirties.

Ecology

Waders are an important component of intertidal ecology, especially outside the breeding season when many inland-nesting species move to coastal areas. They take a very broad cross-section of prey types from shoreline habitats and at favoured sites they are extremely abundant. Experiments have found that they can remove up to 50% of a preferred prey type from a set area over the course of a month. In Arctic tundra habitats in spring and summer, waders form a major part of the avifauna and are key prey species for predators such as Arctic Foxes, Gyr Falcons (*Falco rusticolus*) and Snowy Owls (*Bubo scandiacus*). The availability of small rodents such as lemmings has a wide-ranging impact on all tundra-breeding vertebrates. In years when lemming numbers are low, the tundra predators will take a much higher proportion of wader chicks.

USES, THREATS, STATUS AND MANAGEMENT

A variety of wader species are legal quarry in various countries. For example, in the UK it is legal to shoot Common Snipe (*Gallinago gallinago*), Eurasian Woodcock (*Scolopax rusticola*) and Eurasian Golden Plover (*Pluvialis apricaria*) in autumn and early winter. Legislation in many countries protects migrating waders from destruction, although illegal hunting is rife in some places. Wader eggs have also traditionally been harvested for food, but not to any significant extent because waders generally have dispersed and well-concealed nests.

Habitat loss is the biggest danger to wader species today. Inland, many of the preferred open habitat types are at risk from activities such as forest expansion, drainage, cultivation and associated use of pesticides (that reduce prey for the birds), and building development. As so many species nest in polar and subpolar regions, the impact of climate change may also be considerable. Migrating waders make use of many sites such as estuaries en route to their breeding and winter destinations and loss and degradation of habitat at such sites can have devastating impacts on the populations.

Several species of waders are classed as Critically Endangered on the IUCN Red List of Threatened Species including the Spoon-billed Sandpiper, St Helena Plover (*Charadrius sanctaehelenae*), Jerdon's Courser (*Rhinoptilus bitorquatus*), Black Stilt (*Himantopus novaezelandiae*) and Sociable Lapwing (*Vanellus gregarius*). The Eskimo Curlew (*Numenius borealis*) and Slender-billed Curlew (*N. tenuirostris*) are Critically Endangered (Possibly Extinct). At the other end of the scale, the Eurasian Woodcock has a world population of up to 26 million individuals and other species with populations in the millions include Northern Lapwing (*Vanellus vanellus*), Dunlin (*Calidris alpina*), Red-necked Phalarope (*Phalaropus lobatus*), Wood Sandpiper (*Tringa glareola*) and Oriental Pratincole (*Glareola maldivarum*).

The habitats used by most wader species are among the most vulnerable of all types, with the constant demand for more land to farm and build upon leading to a constant stream of demands for wetland drainage and coastal development. Many of the planned projects go ahead with little or no resistance and as a result the majority

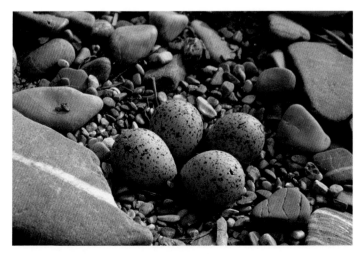

The cryptic colour of these Little Ringed Plover (*Charadrius dubius*) eggs make them almost impossible to spot amongst shoreline shingle.

A GAUNTLET OF DANGERS

The Spoon-billed Sandpiper (*Eurynorhynchus pygmeus*), unique and endearing with its dainty spatulate bill, is classed as Critically Endangered by the IUCN, with a world population of fewer than 2,500 individuals. In many respects it is a typical wader, breeding on wet tundra inland and making use of various coastal wetlands on migration and through the winter. Its decline is the result of multiple factors. One key refuelling site in South Korea has been partially drained to reclaim the land for agriculture and industry. Some other sites have suffered pollution and on its wintering grounds in Bangladesh and Burma it is regularly trapped by hunters. On the breeding grounds in north-east Russia, some nests close to settlements have been destroyed by dogs and collecting of adults and eggs for supposedly scientific purposes has reduced populations further. Climate change models predict that suitable habitat for the species could be reduced by more than 50% over the course of the 21st century. Captive breeding programmes are underway and proving successful and some of the resultant young have been released into the wild. However, effective conservation will require co-ordinated efforts across up to ten countries, to protect the many areas that are used by the species on its travels.

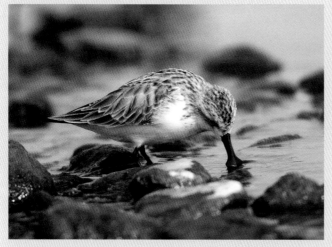

Spoon-billed Sandpipers use their unusual bill to filter out small animals and need clean, unpolluted water for feeding.

Rich mudflats teem with invertebrate life, which in turn supports huge numbers of migrating waders. Pressure from a range of human interests has led to the damage or loss of many internationally important wader staging posts.

Internationally protected areas such as this Ramsar site at Walvis Bay Lagoon, Namibia, provide undisturbed feeding and breeding grounds for waders.

of the world's wader species are declining. Of those that are stable or increasing, many are endangered species which have responded to last-ditch conservation efforts, but to restore their numbers to a safe level will require considerably more work. Not every development battle can be won, but it is key that the most important sites be identified and protected in perpetuity.

Many wetlands considered to be of international importance for wildlife are designated as Ramsar sites, under the Ramsar Convention. This is an international agreement signed in Ramsar, Iran, in 1971, which provides for the conservation and good use of wetlands (see p.502). Ramsar sites are protected from development and disturbance. In the European Union, most Ramsar sites are also designated Special Protection Areas (SPAs), a designation under the European Union Directive on the Conservation of Wild Birds which covers marine as well as terrestrial sites. EU member states are obliged to protect SPAs and the resident and migratory birds they support.

WADER SPECIES

Although there are more than 200 species of waders or shorebirds in the world, as a group they are rather conservative in appearance.

Order CHARADRIIFORMES

Waders form a significant part of the order Charadriiformes, the rest being true seabirds (see p.464). They are distinct from the marine charadriid families though in that most are proportionately long-legged, lack webbing on the feet and do not habitually swim.

Family Scolopacidae (sandpipers and allies)

Sandpipers are found worldwide but breeding species reach their peak density and diversity in the Arctic. Many migrate long distances to their wintering grounds, with refuelling stops en route. They range from very small to medium-large, are mainly brown-plumaged and have proportionately long legs with long toes apart from the hind toe. They are also long-billed and feed by picking at a substrate or probing soft ground. Most species can be found on shorelines outside of the breeding season.

Eurasian Curlew *Numenius arquata*

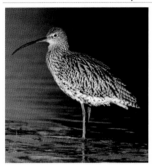

Features With its large size and down-curved, very long (especially in mature females) bill, the Curlew cuts a distinctive figure among flocks of waders feeding on a muddy shore. The sensitive bill-tip allows it to detect movements of its prey as it probes the soft ground. It breeds across middle latitudes in Europe and Asia and many move a few hundred miles south to flat coastlines in winter. It breeds on open heaths and moors and here in spring the remarkable bubbling song can be heard.
Size 55cm (wingspan 96cm).

Black-tailed Godwit *Limosa limosa*

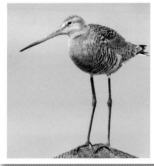

Features A slim, leggy large wader with a long bill, the Black-tailed Godwit is a striking bird, particularly when in its brick-red and piebald breeding plumage. It breeds patchily in Iceland and northwest Europe across Asia to the far east of Russia, nesting on open, grassy wetlands where muddy shores offer good feeding grounds for the young chicks. This is a vulnerable habitat, increasingly being drained for agriculture and the species has declined and is classed as Near Threatened.
Size 42cm (wingspan 76cm).

Common Snipe *Galinago galinago*

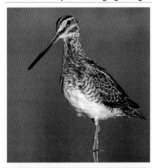

Features This small wader is perfectly camouflaged as it feeds among reeds on the edge of a marshy wetland. Its bill is extremely long relative to its body size (up to 7cm), flexible and exceptionally sensitive, as befits its probing technique when foraging. Snipe can be found inland and near the coast (though rarely on actual shorelines) across northern Europe and Asia. Territorial males make a remarkable 'drumming' sound by vibrating the outer feathers of their fanned tails.
Size 26cm (wingspan 45cm).

Red-necked Phalarope *Phalaropus lobatus*

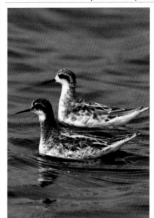

Features A tiny, dainty wader, this is the smallest of the world's three phalarope species and is very numerous, breeding across the Holarctic and wintering at sea, mainly in the tropics. The group are noted for being the most aquatic waders, with partly webbed feet allowing them to swim easily. They have a characteristic spinning motion when feeding, which stirs the water and brings aquatic invertebrates to the surface. The female Red-necked Phalarope is larger and more colourful than the male, and displays and competes with other females to attract a mate, which she then abandons to fulfil parental obligations as soon as she has laid her clutch.
Size 18cm (wingspan 32cm).

Greenshank *Tringa nebularia*

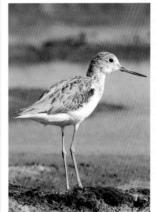

Features The Greenshank is an elegant wader with distinctive, long green legs. It is easiest to see in autumn and winter, which it typically spends in estuaries and sheltered coastal bays. However, it will also frequent a variety of freshwater wetlands including lake margins, ponds, flooded fields and even sewage works. Summer breeding is in the north from Scotland and Scandinavia across to Russia and Siberia in damp forests, blanket bogs, moors and marshes. Winter migration takes it south to Europe, Africa, the Middle East and even Australia.
Size 35cm (wingspan 70cm).

Ruddy Turnstone *Arenaria interpres*

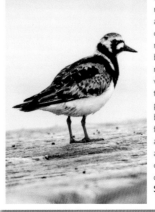

Features This sturdy little bird is one of relatively few waders that prefer rocky and stony shores to muddy or sandy ones. It is also one of the most highly migratory and widespread waders, breeding on coastal tundra across northern Eurasia and North America, but wintering on coasts almost everywhere in the world. Breeding plumage is strikingly pied and ginger, but in winter they are browner. They are social birds, each flock showing a distinct 'pecking order', and are versatile feeders, searching rocks and pebbles for prey but also scavenging carrion and even chasing tourists for dropped chips in seaside towns.
Size 23cm (wingspan 54cm).

Family Recurvirostidae (avocets and stilts)

The ten or so species in this group are exceptionally elegant birds with proportionately very long legs and long, fine bills. Most have black and white plumage. Avocets have strongly upturned bills, which they sweep side to side through the water's surface to catch prey. Stilts are preposterously long-legged but with shorter, straight bills. Unusually for waders they are colonial breeders, nesting on coastal wetlands, and occur on all continents except Antarctica.

Pied Avocet *Recurvirostrata avosetta*

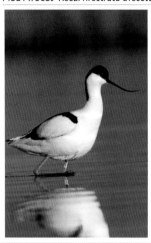

Features The distinctive emblem of the Royal Society for the Protection of Birds, the Pied Avocet is a major conservation success story in the UK, re-colonising after more than 100 years of absence. It now thrives at many coastal wetlands, establishing large, noisy breeding colonies on shallow lagoons. Its range extends across temperate Eurasia and in winter most move south to Africa or south-east Asia. Like other avocets, this species feeds by sweeping its upturned bill side-to-side in water and often wades deeply or swims. Nesting birds are exceptionally vigilant and anything vaguely predatory that ventures too close will be attacked with vigour.
Size 43cm (wingspan 78cm).

Family Haematopodidae (oystercatchers)

There are a dozen or so species of oystercatchers, which are largish and very distinctive coastal waders. Some are black and white, others solid black, but all possess long, sturdy red bills and long and stout pink legs. They forage for worms and other soft prey on beaches and for molluscs on rocky shorelines, using their powerful bills to break open or force open bivalve shells. Some breed inland but many can be seen by the sea year-round.

American Oystercatcher *Haematopus palliatus*

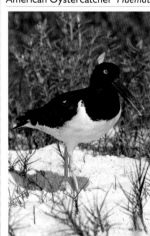

Features The first indication that American Oystercatchers are around is their distinctive, liquid call, heard along the shoreline where they live year-round. This large wader is found discontinuously down both east and west coastlines of North and South America. It can be seen on rocky and sandy beaches but forages mainly along sediment shores probing for buried bivalve molluscs. In winter large flocks congregate to feed and roost but in spring and summer they disperse to pair up at suitable breeding sites nesting just above high water. A pair will defend its scrape nest noisily and doggedly.
Size 45cm (wingspan 90cm).

Family Charadriidae (plovers and lapwings)

This family of waders are shorter-billed than the sandpipers and more colourful and strongly patterned. All hunt by sight and have large eyes. They are birds of open country, both on the coast and inland and occur worldwide. Some species have distinct summer and winter plumages and a few exhibit reverse sexual dimorphism with females more colourful than males, which indicates a polyandrous mating system (p.480).

Northern Lapwing *Vanellus vanellus*

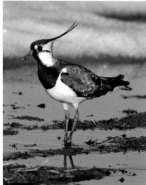

Features The bizarre whooping 'toy-trumpet' call of a male Northern Lapwing as it loops and dips on wide wings over its territory is, sadly, becoming rarer in the UK and some other parts of the species' extensive range across Eurasia. Drainage of wet pasture and conversion to arable use is the main cause of its decline. A striking bird, with beautiful violet and green gloss to the back and wings and a long, fine, fluttering crest, the Northern Lapwing is very social in winter, gathering in flocks on farmland, often with European Golden Plovers.
Size 30cm (wingspan 77cm).

Ringed Plover *Charadrius hiaticula*

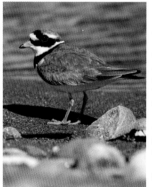

Features This small, compact plover looks boldly patterned when seen against a plain sandy shore, with strong black markings on face and chest. However, the pattern becomes a beautiful example of disruptive camouflage when the bird is on shingle, its preferred nesting habitat. The eggs and young chicks are similarly well-matched to their surroundings. If a predator does locate a nest, the incubating adult will attempt to lure it away with a 'broken-wing' distraction display. Ringed Plovers breed in northern Eurasia and north-eastern North America.
Size 18cm (wingspan 38cm).

Eurasian Golden Plover *Pluvialis apricaria*

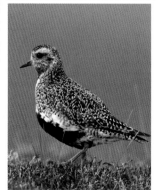

Features In its golden summer plumage this is surely one of the most attractive of wading birds. Its spangled colours provide excellent camouflage in the short vegetation of the upland moors and tundra where it nests. Outside the breeding season, it can be found in a much wider variety of habitats including farmland fields. Many also take advantage of rich coastal feeding grounds in estuaries, bays and saltmarshes, especially in hard winters. With its relatively short bill it can only access surface and shallow-burrowing worms and other invertebrates.
Size 30cm (wingspan 70cm).

MARINE WILDFOWL

Ducks, geese and swans are familiar water birds that belong to the family Anatidae but are more commonly known as wildfowl. All of this large group of around 145 species are aquatic, but only a few can be considered truly marine with others as regular coastal visitors. These medium to large, heavy-bodied birds with webbed feet and flattened bills, are distinctive and easy to recognise especially as many have been domesticated. Most are highly gregarious, especially in winter and large flocks of geese are a spectacular sight as they fly in and away from estuarine roosting areas. Estuaries, sheltered bays and sea lochs are also good places to see floating rafts of seaducks. True seaducks include eiders, scoters, goldeneyes and mergansers and all belong to the subfamily Merginae along with a few freshwater species.

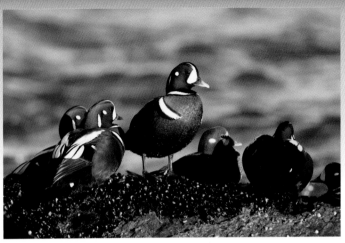

Harlequin Ducks (*Histrionicus histrionicus*) feed and overwinter on rocky shorelines in North America.

DISTRIBUTION

All of the dozen or so true seaduck species in the world are found in the northern hemisphere, primarily in the far north. Their distribution ranges across Europe, Asia and North America. Some breed inland but winter at sea, usually on sheltered inshore waters. There is very little exchange between populations separated by long stretches of open sea. For example, the Black Scoter (*Melanitta americana*) and Common Scoter (*M. nigra*), while descended from a recent common ancestor, are distinct enough to be regarded as separate species. A few other northern hemisphere wildfowl species, such as Brent Goose (*Branta bernicla*), have a strongly coastal distribution in the winter. In the southern hemisphere, the four species of steamer ducks (*Tachyeres* spp.) are exclusively coastal throughout the year.

STRUCTURE

Wildfowl are all clearly adapted for swimming, with large feet set near the rear of the body, full webbing between the front three toes and a high level of plumage waterproofing. They have proportionately small wings with high wing-loading, meaning a powerful, fast but rather laboured and energy-costly flight. The Common Eider (*Somateria mollissima*) is one of the fastest birds in the world in level flight. Seaducks are heavy for their size, with heavier bones than similar-sized but non-diving birds. Swans and geese are larger and longer-necked than ducks, the sexes look alike and pairs work together to raise their young. Most ducks, on the other hand, are sexually dimorphic and form short-lived pair bonds, the females then incubating eggs and rearing their young alone. Most species of wildfowl feed either on or in the water much of the time and among the ducks are species which dive deeply to find food. Seaducks are mainly rather large with a heavy build, short neck and pointed tail. As diving ducks, they sit lower in the water than do the dabbling ducks and dive from the surface to feed. Underwater, they swim with strong strokes of their webbed feet, in contrast to some diving seabirds such as auks, which use their wings. A wingstroke or two may be used in the early, descent phase of a dive, but for most of the time underwater the wings remain folded.

Most wildfowl have bills of the typical 'duck-bill' form, of medium-length, deep at the base, broad and somewhat flattened, strong but sensitive. The exceptions are the fish-eating mergansers, which have a longer, narrower bill without such a deep base. Merganser bills have a pronounced hook at the tip, an adaptation seen in some other unrelated fish-catchers like cormorants, and have serrations lining the inner edge of each mandible, like the teeth of a saw (see box on p.486). This structure gives the mergansers the alternative name of 'sawbills'.

Like other deep-diving, cold-climate birds, seaducks require very effective insulation and waterproofing to remain warm enough whilst feeding in cold water. The uropygial gland is well developed in all wildfowl but is proportionately larger in seaducks. Application of oil from this gland to the plumage improves waterproofing and general feather condition. The plumage is dense and sleek, with a thick soft down layer below the contour feathers to trap air for warmth. The resultant increase in buoyancy means they must dive strongly down to the point where they are neutrally buoyant and can feed with less energy expenditure. Seaducks possess well-developed salt glands to filter excess salt from the blood, allowing them to drink sea water whilst other wildfowl have smaller salt glands, but this organ can adapt and become larger if the bird spends a lot of time on salty or brackish water.

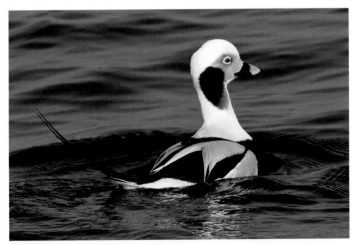

While males of many freshwater dabbling ducks have colourful plumage which they display in courtship, male seaducks such as the Long-tailed Duck (*Clangula hyemalis*) tend to have black, white and grey plumage for camouflage and compensate in courtship by having particularly vigorous, posturing display behaviour.

DUCKS' TEETH

The small pointed structures that line the inner edges of a merganser's bill (below) and which look so disconcertingly like tiny teeth, are present in all wildfowl (Anatidae), though they show considerable variation in structure. They are called lamellae and in the other seaducks they are less obvious and look more like combs than rows of teeth. Lamellae help seaducks to grip onto slippery prey, while in freshwater dabbling ducks they are used to filter tiny food items from water and in geese they give good grip for cropping grass and other vegetation.

In general seaducks are less colourful than their freshwater cousins, with black, white and brown predominating. However, all species are sexually dimorphic with males being more strongly patterned and colourful. The courtship displays they perform to attract females are geared towards exhibiting coloured or contrastingly marked parts of the plumage to their best advantage. The females, which have sole responsibility for incubation and chick care, have camouflaged plumage to protect them from predators at this vulnerable time. All seaducks undergo an annual moult after the breeding season and cannot fly until their new flight feathers grow. So at this time the drakes may assume a drabber eclipse plumage, but their best protection is to stay offshore at this time.

BIOLOGY

Feeding

Seaducks feed underwater, diving to 40 metres or more to reach the seabed. Because they are primarily bottom-feeders, they need to time their feeding sessions with the tides, such that suitable seabed with concentrations of their mollusc prey is within comfortable reach for them. The dive is initiated with a small jump and the bird uses strong kicks and also beats of the half-folded wings to overcome its own buoyancy. Seaducks frequently forage in flocks, taking cues from each other for when and where to dive, so once one bird begins to feed the whole flock moves quickly from being at rest to actively feeding.

Most seaducks use their bills to search for food amongst loose lying seabed material, or to pull prey from rocks. Mussels and other molluscs are the most commonly taken prey, with the widespread Blue Mussel (*Mytilus edulis*) being a key prey item for several seaduck species. They also take urchins, crabs, worms and other creatures found on the sea-bed. When a scoter or eider pulls a mussel free from its moorings, it returns quickly to the surface and there swallows the prey. Unlike many other carnivorous birds, seaducks do not regurgitate pellets of indigestible prey remains, but process their prey in its entirety. Their gizzards are powerfully muscular to crush up the shells of crabs and molluscs and also contain a quantity of grit, which the birds swallow to aid digestion. The grit helps to grind up swallowed prey via the muscular contractions of the gizzard.

Some seaducks, notably mergansers, feed on active prey, primarily fish, and are pursuit divers. Red-breasted Merganser (*Mergus serrator*), the only merganser species which is truly a seaduck, rarely dives below 5 metres. Like other fish-eaters, they may work in pairs or groups, diving along a line and driving fish towards shallow water where they may be more easily caught.

Those seaducks which nest inland, such as the scoters, need to use rather different feeding tactics. Scoters nest inland in boggy uplands and forage on small, shallow lakes. Deep dives are not needed here, so they may dabble or up-end rather than dive. Their ducklings often catch insects on or near the water's surface. When the young birds are fully grown both they and their parents move to the sea where they feed by deep diving.

Some wildfowl, such as Pink-footed Geese, habitually roost on the sea in sheltered bays, as this offers safety from land-based mammalian predators. They may also feed on marine vegetation. Brent Geese, for example, overwinter on undisturbed coastlines where they feed on *Zostera* and other marine plants.

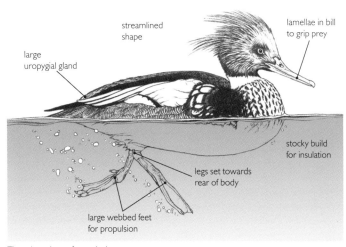

The adaptations of a seaduck

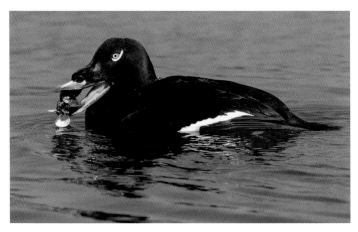

Eating crustaceans or molluscs in their entirety means swallowing a lot of useless exoskeleton which has to be broken down and excreted. This means that seaducks, like the White-winged Scoter (*Melanitta deglandi*), must maintain a high feeding rate.

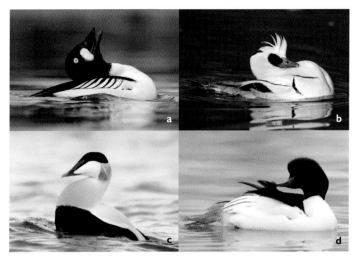

Courtship displays in seaducks give males the opportunity to show off their vigour and body condition. There is no need for a demonstration of provisioning skills as they will play no part in chick care. (a) Common Goldeneye (*Bucephala clangula*); (b) Smew (*Mergellus albellus*); (c) Common Eider (*Somateria mollissima*); (d) Goosander (*Mergus merganser*).

Life history

Seaducks usually begin the process of finding a mate during the winter, when they are living in large flocks on the sea. Drakes display communally to females, a ritual which involves adopting unusual postures and performing repeated movements such as neck-stretching and bowing, often accompanied by noisy vocalisations. Each female selects a partner and then benefits from the male's guarding behaviour, which keeps other males away and enables her to feed uninterrupted. This improves her chances of reaching peak breeding condition by spring.

The pairs move to breeding habitats in mid-spring, most commonly on the coast but sometimes in wet areas inland (e.g. scoters). The nesting habitat varies from the rocky areas used by eiders to the burrows in sand dunes or dense vegetation favoured by Shelduck. The male remains with the female until she has begun to lay her eggs but will normally depart soon afterwards. Females may nest alone or in loose association with other females. The nest is a sheltered hollow, close to water, which the female will line with the down she sheds from her breast as her brood patch (an area of bare skin, allowing for efficient heat transfer to the eggs) develops. Clutches are of four to ten eggs, depending on the species and the incubation period is about a month. The chicks hatch with open eyes and a coat of down and within hours are strong enough to follow their mother, who leads them to water. They are able to feed themselves, usually on small swimming organisms or flying insects near the surface and the female does her best to guard them from predators, though predation rates in the first two weeks especially can be very high. The ducklings are usually safe from mammalian predators on the water, but gulls and skuas account for many in the early days.

Sometimes, where several females are nesting in close proximity their broods will combine, with the ducklings living together in large crèches. In such circumstances, some of the females will migrate early, while a few remain to oversee the crèche. When the young birds can fly, they and the remaining females leave the breeding grounds and head for the sea to complete their moult and will live in groups there through the winter. Most winter close to their breeding grounds, though young birds are likely to disperse further than adults. Seaducks can be long-lived, with Common Eiders regularly reaching their thirties.

Ecology

Seaducks make use of very specific areas at specific times where their preferred prey is available to them and they can be significant predators of mussel beds. Their ducklings can be important prey for various predatory bird species, including seabirds such as large gulls. At some estuaries, huge numbers of wildfowl may gather in winter, for example Pink-footed Geese using the Wash in eastern England may number more than 40,000.

USES, THREATS, STATUS AND MANAGEMENT

Wildfowl, including seaducks, are hunted seasonally for sport and food in many countries. Seaducks are also shot in some coastal areas where they can cause damage to commercial mussel beds and mussel farms. Similarly, large numbers of geese overwintering in coastal areas can cause problems for arable farmers. Like seabirds, seaducks are particularly vulnerable to surface pollution especially oil spills at sea and to disturbance from offshore developments such as wind farms. In many countries environmental impact assessments for such projects are now required to take account of seaduck feeding and roosting areas.

For seaducks the IUCN Red List of Threatened Species lists the Velvet Scoter (*Melanitta fusca*) as Endangered, Steller's Eider (*Polysticta stelleri*) and Long-tailed Duck as Vulnerable and Black Scoter (*Melanitta americana*) as Near Threatened.

Producing many young helps offset the high predation rate in the ducklings' first weeks of life. Only one or two of these Common Shelduck (*Tadorna tadorna*) ducklings is likely to survive to adulthood.

Eiderdown has long been sustainably harvested for use in bedding. When taken from nests after the ducklings have hatched, this activity causes no harm to the birds.

MARINE WILDFOWL **487**

MARINE WILDFOWL SPECIES

A single order and family encompass the wildfowl, the majority of which are freshwater ducks, geese and swans. Some species are coastal and the seaducks in the suborder Merginae are truly marine.

Order ANSERIFORMES

This large order is mostly made up of wildfowl, the swans, geese and ducks, but also includes the screamers, which resemble game birds and the Magpie Goose (*Anseranas semipalmata*), an aberrant and primitive relative of the true wildfowl. The Anseriformes are a primitive group of birds, with distinctive bill and mouth morphology including a modified tongue shape and rows of comb-like lamellae lining the inner cutting edges of the bill.

Family Anatidae (swans, geese and ducks)

These birds are characterised by a heavy, chunky build, large webbed feet and a deep-based, flattened bill and spend much of their time swimming on open water (inland fresh water in most cases). Swans are very large with long, graceful necks, the group including some of the world's heaviest flying birds. Geese are mostly smaller and shorter-necked, while ducks are smaller still with even shorter necks. A few species of ducks are entirely marine and are known as seaducks.

Whooper Swan *Cygnus cygnus*

Features This is a highly migratory white swan that occurs across Eurasia. It is named for its loud bugling call, which announces from some distance the approach of a flock on the wing. Whooper Swans travel in family groups, the young birds of the year staying with their parents for several months, and these groups team up to form flocks a thousand strong or more. They can be found both inland and on the coast in winter, often feeding in arable fields, but use sheltered water, including bays and estuaries, to roost in safety from foxes and other mammalian predators.
Size 150cm (wingspan 220cm).

Brent Goose *Branta bernicla*

Features Brent Geese live almost exclusively along coastlines and are particularly common in large estuaries. In their European wintering grounds they graze especially on eel-grass (*Zostera* spp.) growing on intertidal mud and sand flats, plus saltmarsh plants and fine seaweeds. In the UK this species is increasingly found grazing on coastal farmland. Brent Geese breed in coastal Arctic tundra and meadows including Canada and Norway and are strong fliers that migrate south in autumn to Europe, Asia and USA. There are several subspecies, including the Pale-bellied and (as here) the Dark-bellied, with differing migration patterns.
Size 66cm (wingspan 1.2m).

Canada Goose *Branta canadensis*

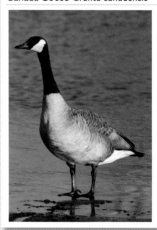

Features This is one of the most familiar of all geese as it is perfectly ready to make a home in urban lakes and reservoirs and grazes happily in parkland and farmland. It also occurs in large flocks in estuaries and along coasts. Native to N America, it breeds in the tundra of Canada, Alaska and northern USA and migrates to southern USA for the winter. However, it has been widely introduced and is now the most widespread and common goose in the UK and many parts of western Europe. Its habit of enjoying arable crops can bring it into conflict with farmers.
Size 110 cm (wingspan 1.8m).

Common Eider *Somateria mollissima*

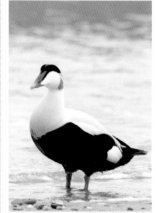

Features This hefty seaduck is well-known as the source of eiderdown, the extremely soft and highly insulating down feathers that the female sheds when breeding and uses to line her nest. This down can be harvested harmlessly once the ducklings have left the nest. Eiders breed around the northern coasts of Europe, Asia and North America; flocks of non-breeding birds may wander further south. They feed mainly on mussels and other molluscs which they pull loose from the seabed and bring to the surface to eat, shell and all. In late winter the males display to females, with loud, fruity 'ahh-oooh' calls.
Size 60cm (wingspan 95cm).

Common Shelduck *Tadorna tadorna*

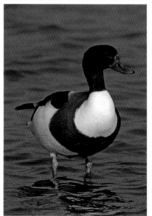

Features A look across any estuary in Britain, especially in winter, is likely to reveal some Common Shelducks, resplendent in their pied and chestnut plumage. A large, goose-like duck, it occurs across temperate Eurasia (and further south in winter) although only in western Europe is it strongly associated with coasts all year round. Virtually all UK birds and many more from western Europe, some 100,000 birds altogether, assemble on the Wadden Sea in Germany after breeding, where they undergo their annual moult. A few adults stay at breeding areas, overseeing large crèches of partly grown ducklings.
Size 65cm (wingspan 121cm).

Surf Scoter *Melanitta perspicillata*

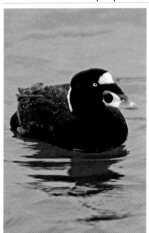

Features This hardy seaduck is native to North America though vagrants can be found further afield in western Europe. It spends the winter at sea in coastal bays and estuaries and feeds by diving for molluscs, crustaceans and worms. Its strong, heavy bill enables it to tear mussels from rocks and subdue crabs. Its common name comes from its habit of diving for food along the surf-line. Its summer breeding grounds extend from Alaska to Labrador, in boreal forests and tundra on freshwater lakes and pools. However, young non-breeders may remain for the summer in coastal areas.
Size 80cm (wingspan 1.6m).

Snow Goose *Chen caerulescens*

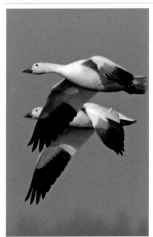

Features Whilst some Snow Geese live up to their name and are pure white with black primary feather wing tips, there is also a blue-grey colour morph in which only the head and neck are white. It is found throughout N America, breeding in northern tundra and migrating to warm southern areas in winter and further afield to Japan and China. In winter, large flocks can be found in coastal saltmarshes but they also utilise agricultural land and will graze on grass, rice and wheat fields. Great 'V'-shaped formations can be seen flying overhead during spring and autumn migrations. Some authorities place this goose in the genus *Anser*.
Size 80cm (wingspan 1.6m).

Magpie Goose *Anseranas semipalmata*

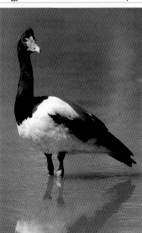

Features This unusual goose is the only species in the subfamily Anseranatinae (sometimes elevated to full-family status) and is found in coastal northern and eastern Australia and New Guinea. Whilst it is primarily a coastal freshwater wetland species, it can also be found in coastal lagoons and estuaries, often in large noisy flocks. Unlike almost all other wildfowl, the flight feathers moult gradually instead of all at once and so it can always fly. This is a useful adaptation in areas where food can be scarce. With its long legs and long, partially webbed toes, it is more agile than most geese and will even perch in trees, though it nests on the ground.
Size 89cm (wingspan 1.5m).

FAMILY Anatidae

Red-breasted Merganser *Mergus serrator*

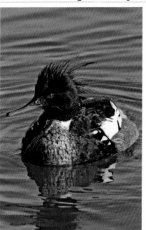

Features With their thin, saw-edged bill (p.486) mergansers are expert fish-catchers and can be seen fishing on the sea and in estuaries in winter. They are fast swimmers, sitting very low in the water and diving down in search of their prey. Unlike many ducks, they walk well on land and can also be found pacing along on the seashore, but to avoid predation they often fly out to sea as darkness falls, only returning to land at dawn. They breed in N America and northern Europe and Asia on tundra near freshwater. Like most ducks male and female have different coloration but both have a double crest on the head.
Size 60cm (wingspan 78cm).

Harlequin Duck *Histrionicus histrionicus*

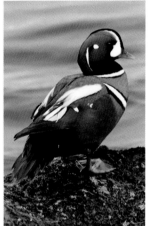

Features In contrast to many ducks, Harlequins like moving water. They nest along the edges of fast streams and rivers and spend the winter on exposed rocky coastlines, much of the time at sea. These small ducks do not make long distance migrations, just far enough to change habitats between seasons. Breeding ranges from northern parts of N America to Iceland, Greenland and NE Asia. This is an agile duck that is at home walking over slippery intertidal rocks or landing on half-submerged river boulders. It feeds from the surface in shallow water or by diving in deeper water, taking crustaceans, molluscs, insects and worms.
Size 55cm (wingspan 65cm).

Goldeneye *Bucephala clangula*

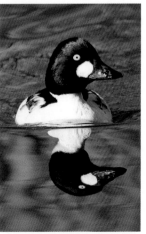

Features Apart from the bright golden eye colour after which it is named, this duck is perhaps best known for the leap of faith made by the ducklings soon after they hatch. Goldeneyes nest in tree holes from which the young jump down before being led to water by the female. In winter, flocks can be seen on inland freshwater bodies and in coastal lagoons and estuaries, or further out at sea in sheltered areas such as the Baltic and northern Mediterranean. They breed throughout the northern parts of N America and northern Europe and Russia. In flight their very rapid wingbeats create a whistling noise and they are sometimes known as 'whistlers'.
Size 50cm (wingspan 83cm).

FAMILY Anatidae

MARINE WILDFOWL

OTHER MARINE BIRDS

Many other bird species are regular or more casual users of coastal habitats. Some species of grebes can often be found offshore in the winter months, although they also use inland fresh water. Others with a strong tie to the coast include certain raptors such as eagles of the genus *Haliaeetus*, some of which regularly hunt over the sea and take fish as well as seabirds. Falcons of various species nest on sea cliffs, as does the widespread Rock Dove (*Columba livia*), ancestor of domestic pigeons. A few passerines are highly coastal, for example the Eurasian Rock Pipit (*Anthus petrosus*) and certain corvids. Some herons feed on shorelines and in shallow seas at times, as do some of the wildfowl species more closely associated with freshwaters.

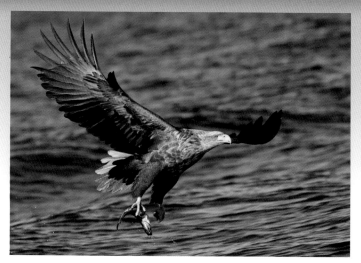

The White-tailed Eagle (*Haliaeetus albicilla*) is a Eurasian bird with a predominantly coastal distribution. It hunts a range of prey types and is adept at catching marine fish such as this Coley (*Pollachius virens*).

DISTRIBUTION

Most coastlines will have regular avian visitors besides seabirds, waders and wildfowl. In many parts of south-east Asia, gulls are scarce and their niche as tideline scavengers is occupied by House Crows (*Corvus splendens*). Eurasian Rock Pipits nest on rocky shorelines in western Europe, while Eleonora's Falcons (*Falco eleonorae*) breed on Mediterranean islands. Bald Eagles (*Haliaeetus leucocephalus*) and Great Blue Herons (*Ardea herodias*) hunt along shorelines in North America. In northern areas birds that breed in uplands may spend the winter months on nearby coastlines, foraging along shorelines. In the UK, for example, those include Snow Bunting (*Plectrophenax nivalis*) and Meadow Pipit (*Anthus pratensis*), while upland raptors like Hen Harrier (*Circus cyaneus*) and Merlin (*Falco columbarius*) may follow their prey to the coast.

STRUCTURE

This is a diverse group of species with no particular traits that distinguish them from birds that do not occur in coastal habitats. Most feed on live prey, but some such as buntings and finches are herbivorous.

BIOLOGY

Feeding

With no particular adaptations to a marine existence, most of these birds feed mainly at and above the intertidal zone. Corvids scavenge washed-up carrion, while herons will hunt for small fish and invertebrates in very shallow, clear seawater and also in rock pools. Some raptors specialise in preying on cliff-nesting seabirds, catching them as they commute between the sea and the cliff. Various small passerines, primarily finches, larks, buntings and pipits, work along shorelines for tiny invertebrates such as sandhoppers, as well as plant seeds which may originate from the local floral community or be washed up from more far-flung places. On the sea itself, grebes use bays and estuaries where they dive for fish prey.

Life history

Many coastal birds are winter visitors, only visiting the shore when cold weather renders their upland breeding grounds seriously challenging places in which to try to survive. Of those that breed along the coast and can be seen there all year round, most make use of similar nest sites to the true seabirds, such as ledges and crevices on cliff faces, or gaps between boulders on island beaches. A typical cliff-face seabird colony on the western Atlantic coast may well include a few breeding pairs of Rock Doves, Jackdaws (*Corvus monedula*), Common Kestrels (*Falco tinnunculus*) and Peregrine Falcons (*Falco peregrinus*), with Eurasian Rock Pipits using beaches or areas of cliff-fall. The details of their life-histories vary, as they are representatives of a wide range of avian families.

Ecology

The number and variety of birds that visit a coastline to feed gives a good indication of how rich that habitat is in invertebrate life of all kinds. There can also be variation depending on weather conditions. If inland waters freeze over in a harsh winter, wildfowl, kingfishers and other freshwater birds may be forced to move to estuaries and sheltered bays.

USES, THREATS, STATUS AND MANAGEMENT

Although not strictly seabirds, these species can be valuable indicators of the health of a coastline. The birds mentioned in this section are all common and widespread species.

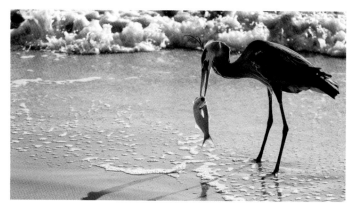

Great Blue Herons (*Ardea herodias*) hunt shrimp, crabs and small fish along coastlines in North America. This species is a rare vagrant in Europe.

OTHER MARINE BIRD SPECIES

Many non-marine birds from different orders and families visit coastlines and shores, especially in cold winter weather. A selection of the most common are shown here.

Order PODICIPEDIFORMES (grebes)

Grebes are rather like divers in many respects but are not closely related to them. They breed inland, are monogamous and are famed for very elaborate mutual courtship dances. Some species remain inland all year round, but a few spend winter offshore, especially in their first year. They are graceful birds with long necks and lobed feet and colourful plumes on the head in spring and summer. They dive from the surface to catch fish.

Great Crested Grebe *Podiceps cristatus*

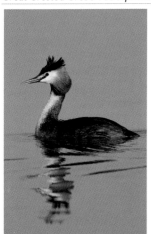

Features Whilst essentially a freshwater bird that breeds inland on lakes, ponds and slow rivers, this magnificent grebe can also be found in estuaries and sheltered coastal waters during the winter. Freezing conditions will see more birds moving to the coast. At this time they are only interested in finding enough fish to eat and their beautiful head crest and colourful ruff are not apparent until spring when they perform their famous and elegant mating 'dance'. In the nineteenth century the species suffered a huge decline, hunted for its feathers.
Size 51cm (wingspan 88cm).

FAMILY Podicipedidae

Black-necked Grebe *Podiceps nigricollis*

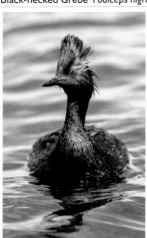

Features Like all grebes, the Black-necked or Eared Grebe is mostly found in freshwater systems and builds its nests in shallow wetlands such as lakes and marshes. However, it is a migratory species and many move to the coast in winter to escape intense cold and frozen fishing grounds. Many populations also migrate to warmer climes. This is the most abundant of all the grebes and aggregations of several hundred thousand occur in N America and Asia. It has a patchy worldwide distribution but is not found in Australasia and Antarctica.
Size 35cm (wingspan 55cm).

Order ACCIPITRIFORMES (birds of prey)

This order contains all the diurnal birds of prey except the falcons. All are predators and some take large vertebrate prey. They are strong fliers and possess powerful hooked bills for tearing prey and formidable curved talons for gripping. Most species live inland, but a few species have a strongly coastal distribution. Several of the sea eagles (*Haliaeetus*) in particular often hunt over the sea and catch marine fish, as well as seabirds.

Bald Eagle *Haliaeetus leucocephalus*

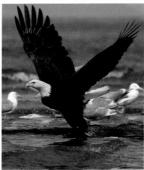

Features The Bald Eagle is not bald at all but its white head contrasting with dark blackish-brown body might give the illusion that it is. This is a large raptor found throughout most of North America with a concentration in Alaska. Bald Eagles are mainly fish-eaters and range along the coast and inland on large lakes and rivers. Quite large fish, up to about 2kg, can be caught, but the bird can open its talons and release the prey if its weight or struggles are too much. It will also scavenge carrion.
Size 94cm long (wingspan 2.3m).

Brahminy Kite *Haliastur indus*

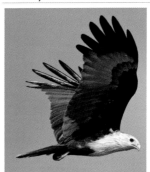

Features In the tropics this raptor is often seen circling above tree-clad coastal islands, or soaring low over mangrove forests and along estuaries and beaches searching for fish and crustaceans. With its rich chestnut brown body and contrasting white head, neck and belly it is a striking bird, but one with decidedly un-majestic feeding habits. It will scavenge anything from carrion to garbage. It ranges along tropical and subtropical coasts and inland wetlands from India through the Indo-Pacific to northern Australia.
Size 50cm (wingspan 1.4m).

FAMILY Accipitridae

Order PASSERIFORMES (perching birds)

The largest order of bird species by a huge margin, Passeriformes contains a wide array of species, a few of which are predominantly coastal in their distribution. Passerines are mainly terrestrial birds and are adapted to perch on branches and other objects rather than live on the ground, hence their alternative name of 'perching birds'. Most passerines eat insects and other invertebrates, but in temperate areas may switch to plant matter in the winter, if they do not migrate. Coastal passerines include certain crows, finches, buntings, pipits and larks.

Eurasian Rock Pipit *Anthus petrosus*

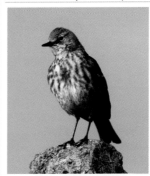

Features This dusky-brown bird, native to coasts of western Europe, lives and breeds on rugged, rocky coastlines and finds a large proportion of its food on the tideline, eating small invertebrates like sandhoppers but also picking at carrion. As well as occurring in remote areas, it breeds in some seaside towns, harbours and villages, and where it regularly encounters people it will become as approachable as a town sparrow. It will forage on roads, picking up insects squashed by cars.
Size 18cm (wingspan 26cm).

FAMILY Motacillidae

INTERRELATIONSHIPS

The ultimate goal of all organisms is to survive for long enough to reproduce and so continue the species. During their lifespan, all the marine animals, plants and other organisms described in this book will interact with many individuals of their own and other species as predator, prey, food source, mate, a place to live and so on. For animals the necessity to eat without being eaten has led to the development of many ingenious ways to camouflage, hide and protect themselves. The food web examples shown on p.46–48 show just how many predators one species may have, something we might find hard to comprehend from our almost predator-free pedestal.

As well as such everyday interactions, some organisms have permanent and much closer links to each other, associations known as symbiosis and which involve varying degrees of interdependence. These associations are not mere curiosities but underpin some of the most important ecosystems in the ocean. Without the association between stony corals and certain species of dinoflagellate and cyanobacteria known collectively as zooxanthellae (p.206), there would be no Great Barrier Reef of Australia, or any other coral reefs for that matter.

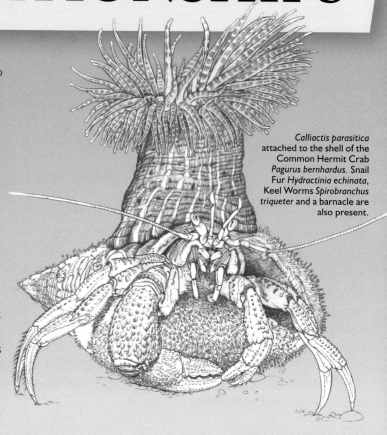

Calliactis parasitica attached to the shell of the Common Hermit Crab *Pagurus bernhardus*. Snail Fur *Hydractinia echinata*, Keel Worms *Spirobranchus triqueter* and a barnacle are also present.

DEFENCE, ATTACK AND CAMOUFLAGE

Physical defence

Physical protection is an obvious and common method that marine animals, plants and seaweeds use to deter predators and grazers. For seaweeds and sessile animals it is the only possible method as they cannot invoke behavioural responses, hide or change colour. They can, however, contain poisonous, bad-tasting or inedible substances such as the stone-like calcium carbonate within seaweeds of the tropical genus *Halimeda* and the temperate *Corallina*. Crustaceans and molluscs have the inbuilt protection of a hard shell which in some of the larger species can be almost impenetrable. Sea turtles too are well protected as adults, even though they cannot withdraw their head and flippers into the shell as land-based tortoises do.

Sessile animals such as some bryozoans and barnacles can respond to predators by increasing their physical defences. The Sea Mat (*Membranipora membranacea*) will grow extra and longer spines if repeatedly attacked by predatory sea slugs. The intertidal acorn barnacle *Chthamalus anisopoma* has an atypical form in which the shell is bent over so that the opening lies perpendicular to the base. This has been shown experimentally in a northern California population to be a growth response to the presence of one of its major predators the gastropod *Acanthina angelica* (Lively 1986). The snail finds it more difficult to perch on and eat the bent over variety. This is known as an inducible defence. On land many plants exhibit such defences in response to grazing animals.

Shields

Some species use external objects as a shield against predators. Boxer crabs (*Lybia* spp.) carry small anemones in their specially modified claws, which they hold up to defend themselves. The anemones can be one of several species and this is thought

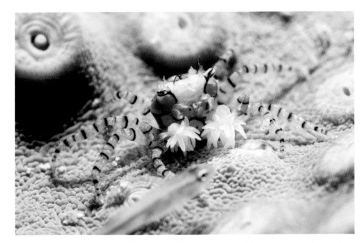

The Boxer Crab (*Lybia tessellata*) is also called the Pom Pom Crab from the resemblance of its pincer-held anemones to the pom poms carried by cheer leaders.

Venom and poison

Venomous animals hold a particular interest for anyone venturing into the sea. Stepping on a weeverfish or a stingray buried in the sand can be a painful end to a relaxing day out. A sting from a box jellyfish or a cone shell can be much more serious and sometimes fatal. However, from the animals' point of view they are simply defending themselves. Weevers and stingrays, along with stonefish are slow-moving bottom-living fishes and their habit of sitting still and ambushing prey necessitates some means of protection. However, for box jellyfish and cone shells, venom is a double asset since it can also be used to subdue and kill their prey. Cone shells are well known for their ability to stalk and kill fish that are at least as long as themselves (p.232), something they could never do without venom. Similarly box jellyfish are active hunters that target their prey (p.197) and need to subdue it quickly before their relatively delicate tentacles are torn.

to be a mutually beneficial arrangement (see p.498). The small anemone *Triactis producta* is often carried and this species has a sting powerful enough to cause blisters in humans. With its specially modified claws full of anemone, a boxer crab cannot use them to feed and must instead collect food particles using its maxillipeds (mouth parts). These crabs are popular aquarium pets and observations of captive animals suggest the crab may also use its anemones to collect food which it then eats off the anemone's tentacles. If this is the case then the question remains as to why it is not stung itself. Both the crab and the anemones can live without each other.

Some parrotfish (Scaridae) produce their own shield of mucus in which they wrap themselves at night whilst wedged into a coral crevice. The mucus is secreted from glands within the gill chamber (opercular cavity) and comes out of the mouth forming a gelatinous mass as it comes into contact with the water. The mucus is thought to deter predators such as moray eels that hunt by feel or smell. Conclusive experimental evidence to confirm this is still lacking.

Venomous and poisonous animals are found in a wide range of taxonomic groups with a correspondingly wide range of venoms with different chemical compositions and modes of operation. Several different bioactive compounds are often involved in one species. Tetrodotoxin, named after the famously poisonous pufferfish family Tetraodontidae, is certainly top of the list in terms of potency, at least as far as people are concerned. This neurotoxin can cause paralysis and death in humans and all other mammals. Since mammals are not the target prey of the animals that use it, this may seem surprising. However, in the 'evolutionary arms race' between predator and the normal prey, the latter builds up resistance hence the need for increasingly potent venom. With their sophisticated nervous system, mammals happen to be especially susceptible to this toxin. In evolutionary terms it may also seem surprising that animals in widely different taxonomic groups use this particular venom. As well as pufferfish and their relatives, it is found in blue-ringed octopuses in which it was originally called maculotoxin until the two chemicals were found to be the same. It also occurs in a few amphibians and some shellfish (derived from their plankton diet). There is now substantial evidence that in at least some cases, tetrodotoxin is produced not by the animals themselves, but by bacterial symbionts. *Vibrio alginolyticus* and other similar bacteria are known to produce tetrodotoxin and are found living within the tissues of many species that employ this toxin (Chau *et al.* 2011).

The mucus cocoon around this sleeping parrotfish may help to prevent attack by biting gnathiid isopods (Gnathiidae) (Grutter *et al.* 2010).

The Porcupinefish (*Diodon histrix*) can inflate itself with water and erect a formidable spiny defence, but is also poisonous to eat (see also p.420 for photograph of deflated fish).

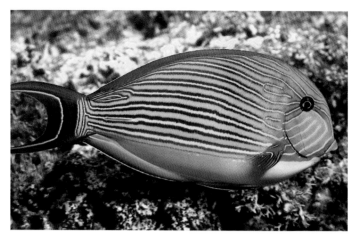

Surgeonfishes such as this Striped Surgeonfish (*Acanthurus lineatus*) can slash an unwary photographer with sharp 'flick-knife' spines near the tail base. Many other fish including rabbitfishes (Siganidae), ratfishes (Chimaeridae), some sharks and toadfishes (Batrachoididae) have sharp protective fin spines that may or may not be venomous but are certainly protective.

Venomous fishes deliver their poison via strong and sharp fin spines, a method not available to the more primitive fish groups such as herrings (Clupeiformes), that lack any fin spines. The venom in fishes is used as a means of defence rather than for attacking prey. Stonefishes (*Synanceia* spp.), scorpionfishes (Scorpaenidae), stingrays (Myliobatiformes), weeverfishes (Trachinidae) and catfishes (Plotosidae and Ariidae) all fall into this category. Pufferfishes have non-venomous spines but an exceedingly strong poison in the skin and various internal organs. In contrast, sea snakes and octopuses use their venom primarily to subdue and kill their prey by biting, and cone shells (Conidae) similarly sting with a harpoon-like radula tooth. However their toxic nature also provides protection for these animals.

Venomous, toxic or distasteful species often have bright, contrasting colour patterns that are easy for predators to see. Such warning signals are known as aposematic coloration. Once a predator has tried (and survived) an encounter with such prey, it will soon learn to avoid it and other species with similar markings. Lionfish (*Pterois* spp.) are patterned with red and white stripes to advertise the fact that they are armed with long venomous fin spines. Stripes and blotches in red, yellow, black and white are the most common aposematic colours and can also be seen in terrestrial animals such as stinging wasps and hornets. Stonefish (*Synanceia* spp.) which belong to the same family as lionfish (Scorpaenidae) are even more venomous but have the opposite coloration in that they are extremely well camouflaged. The difference lies in their mode of feeding. Lionfish are active hunters that roam the reef in search of prey whilst stonefish are ambush predators that lie in wait and need to remain hidden. However, many coral reef fish are brightly coloured but highly edible and harmless, and interpreting the function of colour and pattern is difficult. Fish also have the ability to see light wavelengths outside our range and may see patterns that we cannot.

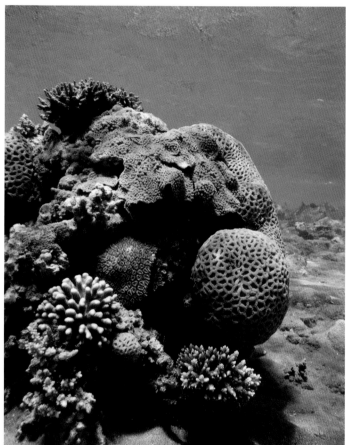

Even sessile animals such as corals which are fixed in one place, can chemically and physically attack other abutting corals, soft corals or sponges.

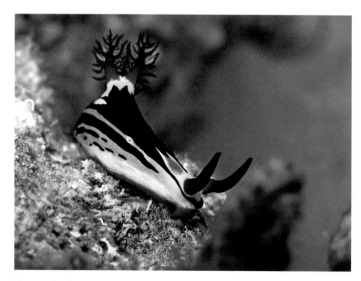

Many sea slugs (Nudibranchiata) such as *Nembrotha megalocera* contain distasteful chemicals derived from their diet of sponges and (in this case) colonial tunicates, and their bright colours may warn predators of this.

Sponges, corals and a number of other sessile invertebrates also interact with one another by using toxic chemicals. Where different species of corals abut onto one another as they grow, one will often win the race for space. Time lapse photography has clearly shown that the polyps of each competitor repeatedly sting the other once they grow within reach. Sponges exude chemicals to the same effect and some encrusting species can also overgrow and kill corals in spite of the latter's defences. Sea slugs utilise both the chemicals from sponge prey and stinging cells from cnidarian prey for their own defences. Many have brilliant aposematic colours that reflect this.

Escape mechanisms

Appropriate behavioural responses to a predator attack can be an effective means of escape. The Great Scallop (*Pecten maximus*) normally lies quietly on the seabed half buried in sand and is not the most exciting of animals to watch. Scallops would seem to be an easy target for predatory starfish but react to such an approach by jetting away backwards with a surprising turn of speed (p.245). Such specific escape responses are vital to slow-moving or sedentary animals and vary from the sudden withdrawal of tube worms and tube anemones into their protective burrows, to anemones releasing their hold on the seabed and swimming up out of reach of marauding starfish. Most fishes and fast-moving invertebrates such as crabs have good eyesight and swim or scuttle rapidly away when they see a predator. However, some show advanced behaviours such as 'playing dead'. Shysharks (*Haploblepharus* spp.) curl up with their tail hiding their eyes when captured which seems like the fish equivalent of sticking your head in the sand. However, a predator would then be faced with an apparently eyeless, circular lump that no longer looks like an appetising fish. The Leopard Catshark (*Poroderma pantherinum*) has been photographed underwater doing the same thing (www.thomaspeschak.com). In this case the shark was seen to curl up in midwater and sink to the seabed. This species and the shysharks all live along the coast of South Africa where large predatory sharks are common.

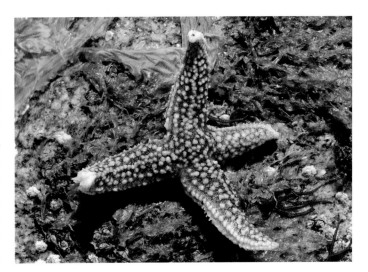

This Common Starfish (*Asterias rubens*) has probably lost two arms but only one has re-grown. Starfish sometimes also grow extra arms following autotomy.

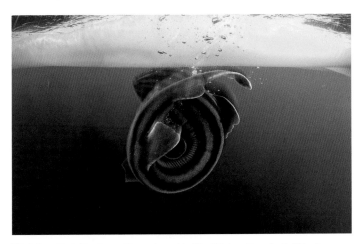

This Pyjama Shark (*Poroderma africanum*), caught off the Western Cape, South Africa, has curled itself into a defensive circle when put back into the water.

Autotomy

Autotomy involves the sacrifice of part of the body, usually a limb or tail to a predator and is an effective defensive strategy, albeit at a high energy cost as the body part must be re-grown. The mechanism is described for crabs on p.267 and involves a breakage along a pre-determined line with mechanical and physiological arrangements in place to minimise bleeding and tissue damage. It is initiated under nervous control. The lost part serves both to give the prey a chance to escape and to distract the predator, which may be content just to eat that bit. In the marine environment autotomy is practised by many of the larger decapod crustaceans including crabs and lobsters and by echinoderms, principally starfish and brittlestars (see p.291). Fleming et al. (2007) summarise available information on autotomy in 200 invertebrate species (marine, terrestrial and freshwater). Many sessile invertebrate animals such as sponges and colonial species of bryozoans, hydroids and tunicates have no need or means to autotomise body parts but simply re-grow and regenerate if they are grazed, in much the same way as plants do.

Snares

Some marine animals including anemones and sea cucumbers use parts of their body to disable and deter would-be predators. The Cloak Anemone (*Adamsia carciniopados*) which lives attached to the shells of hermit crabs, discharges long threads called acontia if its crab host is attacked. These are laden with stinging nematocysts and break off and adhere to a predator, rather like the tentacles of jellyfish do. Acontia are most commonly discharged through the mouths of anemones and have one end attached to the mesenteries (p.205) that hang down within the anemone's body. In some anemones they are discharged through small pores or soft spots on the column called cinclides instead of or as well as the mouth. The Plumose Anemone (*Metridium senile*) has a tall column and acontia emitted through it are an effective deterrent to large predatory sea slugs such as *Aeolidia papillosa*. Young anemones usually succumb and are eaten.

Sea cucumbers in the tropical genera *Holothuria*, *Bohadschia* and *Pearsonothuria* throw out superficially similar white threads called Cuvierian tubules, this time from the anus. These lengthen as they hit the water and are sufficiently sticky to tie up a crab's claws for long enough to allow the sea cucumber to crawl away (see p.301). This could be considered a type of autotomy since the tubules, which form the base of the respiratory tree in the body cavity, are forced through a preformed tear into the cloaca, from which they are expelled through the anus. They are then later regenerated.

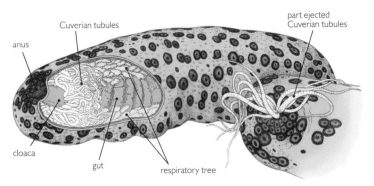

Longitudinal section of the rear half of a sea cucumber showing Cuvierian tubules.

Camouflage

Blending in with the background is an obvious way to avoid predation or alternatively, to hide from prey until it comes within easy reach. This strategy is known as crypsis and animals that live a hidden or camouflaged life have a cryptic lifestyle. Camouflage can be either permanent or variable. Permanently camouflaged animals match the background where they normally live. The camouflage can be simply a dark or drab coloration, or be designed to match a specific habitat through colour, texture and behaviour. Closely matching camouflage is common in animals that live on other animals, such as the many species of spindle and allied cowries (Ovulidae) that inhabit sea fans. Permanently camouflaged animals that are swept, rolled or moved by an experimenter onto a different background cannot change their colour and are likely to suffer a high predation rate if they cannot move back quickly.

Decorator crabs employ a completely different strategy by 'dressing' themselves with pieces of seaweed, hydroids, anemones, soft corals and sponges. Spider crabs (Majidae) are well adapted to do this as they have long legs and many spines to which they can attach their chosen disguise. Any sessile organism that will grow from fragments will do, but some crabs appear to specialise in one or two types. Sponge crabs (Dromiidae) cut a piece of sponge big enough to cover their carapace, trim it to fit and hold it in place with their modified last pair of walking legs. The sponge grows and is kept trimmed by the crab. Some species use colonial tunicates instead of sponge.

Terrestrial chameleons are well-known for their amazing repertoire of colour changes that allows them to match whatever background they are currently on. A similar ability is shown by many fishes, shrimps, prawns and cephalopods, with octopuses and cuttlefish being the ultimate quick-change artists. Colour changes are effected by specialised cells containing different pigments called chromatophores (see p.247). In cephalopods the changes are under nervous control and are almost instantaneous such that an octopus can settle on a rock and virtually disappear in front of your eyes. Cuttlefishes have been observed to mesmerise their prey with a neon display of changing colours, before striking. In most fishes the change is a much slower one and is under hormonal control. Flatfish and scorpionfish are two fish groups well-known for their colour change abilities. Unlike cephalopods which are fast hunters and move rapidly between different habitats, these fish often remain for long periods in one place and can afford a slower colour change.

Camouflage strategies are a very effective way of avoiding predation but are only useful against visual predators. Hammerhead sharks use their sophisticated electric sense (p.331) to detect stingrays completely hidden beneath the sand and dolphins have been observed to nose out buried sand perch and other fish using their sonar.

With a dense covering of sponges, algae, colonial tunicates and other organisms, this sponge crab is difficult to identify but is probably *Camposcia retusa*. Like most disguised crabs, they move slowly and are very difficult to spot.

The Pygmy Seahorse (*Hippocampus bargibanti*) is not only coloured exactly like the sea fans it lives on, but also sports tubercles that resemble the polyps of its host. With such a specific disguise it is only ever found associated with *Muricella* sea fans.

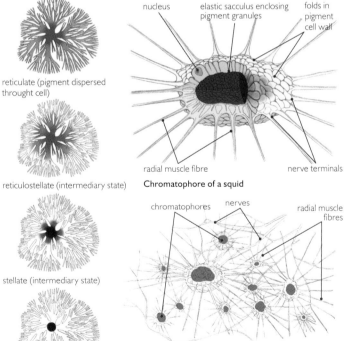

Left: Chromatophore of a fish (top pigment fully dispersed, middle intermediate stages, bottom fully concentrated). Right: Chromatophores of a squid (top detail of single cell; bottom, various stages of expansion and contraction).

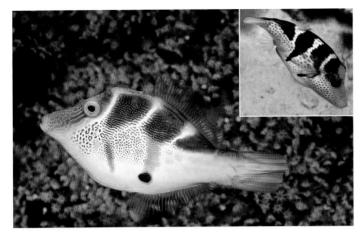

The Mimic Filefish (*Paraluteres prionurus*) is sometimes called the False Puffer because although it is perfectly edible, it looks like the poisonous Valentin's Sharpnose Puffer (*Canthigaster valentini*) (inset).

Swimming near the seabed in groups, Razorfish (*Aeoliscus strigatus*) resemble stalks of soft coral or seaweeds and are hardly recognisable as fish.

Mimicry

Most cases of mimicry in ocean animals involve a harmless species pretending to be a harmful one in order to trick predators into leaving them well alone. This is known as Batesian mimicry and on land is common amongst insects. The harmless species will only benefit from this arrangement if it lives in the same place as the poisonous or venomous species and shares the same predators. It is usually the case that the population of mimics is much smaller than that of the animal being mimicked. If mimics are too numerous then predators would soon discover by trial and error that most of a particular type of prey are actually edible.

Most examples of Batesian mimicry are between species within the same major taxonomic grouping such as between two ray-finned fishes. However, there are a few examples that involve very different species. The Snake Eel (*Myrichthys colubrinus*) (p.404) resembles a highly venomous sea snake, the Yellow-lipped Sea Krait (*Laticauda colubrina*) (p.414). Eels of course are anyway similar in shape to snakes.

The Sabre-toothed Mimic Blenny (*Aspidonotus taeniatus*) operates the opposite system in order to sneak a meal. In size and appearance it closely resembles the Blue-streak Cleaner Wrasse (*Labroides dimidiatus*) which picks parasites and dead skin from larger fish. The cleaner wrasse performs an essential function and is very rarely attacked by its clients, even when it swims into their mouths and gill cavities. The mimic takes advantage of this to make a close approach, copying the signature 'dance' of the cleaner, before darting in and taking a bite of skin and flesh.

In the cut and thrust world of the coral reef, mimicry is also used widely by fish to deceive or scare predators. A visual predator will naturally lunge towards the head end of an animal where its eyes are. Many butterflyfishes (Chaetodontidae) have a false eye spot near the tail end complemented by dark pigmentation in the true eye area. Tricked into thinking that the tail is the head, a predator may well miss its target as the fish darts away.

Behaviour

Camouflage is made even more effective if the camouflaged animal behaves in a manner appropriate to its disguise. This is most evident in highly mobile animals such as fishes and cephalopods. A common ploy amongst fish living in seagrass beds, is to swim slowly along in a manner which blends in with the movement of the plants as they sway with waves and currents. The Leafy Seadragon (*Phycodurus eques*) (p.417) always swims in this manner whilst the Seagrass Filefish (*Acreichthyes tomentosus*) does so when frightened, allowing its rigid body to drift like dead vegetation. Razorfish (*Aeoliscus strigatus*) have long bodies, flattened into a razor shape and swim vertically in a very un-fishlike manner, pointed snout down. This not only provides good camouflage but puts them in an excellent position to find and suck up minute crustaceans with their tubular snouts.

The bold circular, eye-like markings on the sides of the Epaulette Shark (*Hemiscyllium ocellatum*) may trick a predator into thinking it is facing a much larger animal and deter it from attacking.

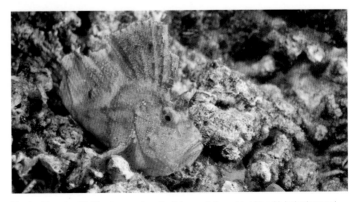

The Leaf Scorpionfish (*Taenianotus triacanthus*) does not always blend in with its background. However, it sways gently from side to side imitating a piece of seaweed or soft coral.

SYMBIOSIS

Symbiosis is a word derived from ancient Greek that means 'living together' and is used to describe persistent relationships between two or more different species. Its use has sometimes been restricted to associations where both partners gain mutual benefit (mutualism), but today it is more usually used as an umbrella word for relationships with varying degrees of interdependence including commensalism (see below) and parasitism. Some relationships are difficult to slot into any particular category because, whilst it is may be obvious how one partner benefits, it can be difficult to establish whether the other one does so. Symbiotic partnerships can be obligatory for one or both partners, or facultative where the partners can live perfectly well without one another.

Mutually beneficial relationships

In the marine world there are many obvious and well known examples of mutualism, the classic symbiotic relationship where both partners benefit. In many cases the relationship is more or less obligatory and neither partner will thrive without the other. One of the best known examples is the relationship between tropical anemonefishes (*Amphiprion* spp. and *Premnas* spp.) which belong to the damselfish family (Pomacentridae) and ten large sea anemone species from five genera (*Heteractis, Entacmaea, Cryptodendrum, Macrodactyla, Stichodactyla*). This mutualism is typical in that one partner, in this case the fish, usually gains protection against predators. The gain for the other partner is more variable but often involves increased feeding opportunities. The 'house keeping' activities of anemonefish may help the anemone but in this case observations suggest that the anemone host may also gain protection against butterflyfish (Chaetodontidae) some of which nip off anemone tentacles for food. This will be obvious to any diver who has been warned off by a feisty anemonefish protecting its eggs laid near the base of its anemone home.

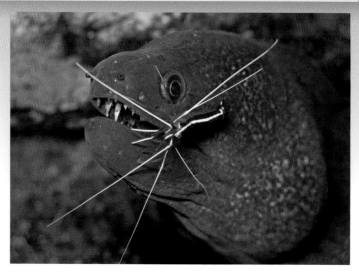

The White-banded Cleaner Shrimp (*Lysmata amboinensis*) is one of a number of shrimps in the families Hippolytidae and Stenopodidae that act as cleaners. It signals its intention by waving its conspicuous white antennae in a particular way.

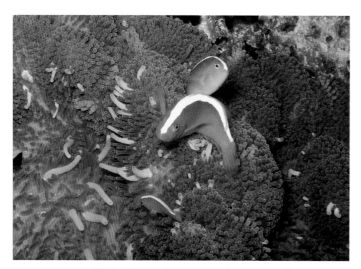

The Orange Anemonefish (*Amphiprion sandaracinos*) uses only two anemone hosts (*Heteractis crispa* and *Stichodactyla mertensii*). Some species are less fussy and use any of ten species.

A much looser facultative mutualism is shown by cleaner wrasse (*Labroides* spp.) in the crowded world of a coral reef. Crustacean ectoparasites are a problem for reef fish, but one that is alleviated by the wrasse. These small fish maintain cleaning stations at prominent coral heads or other obvious sites, where large fish and turtles will queue up for their attention. Different species vary in their dependence on cleaning and for a few species the relationship is obligate (e.g. Hawaiian Cleaner Wrasse (*Labroides phthirophagus*). As well as parasites, they take mucus and dead skin from their hosts. Cleaning behaviour is also seen in some temperate water wrasse such as the Goldsinny (*Ctenolabrus rupestris*) but is a far more casual business. Nevertheless, these fish are used in organic salmon fish farms to help keep crustacean parasites under control.

Crabs commonly form mutualistic partnerships with cnidarians including anemones and hydroids. The cnidarian partner provides protection for its crab host with its stinging cells whilst the cnidarian is carried around and can benefit from the crab's messy eating habits. Examples include boxer crabs that carry anemones in their claws (see Shields above) and hermit crabs with anemones attached to their carapace. For the Cloak Anemone (*Adamsia palliata*) and the Anemone Hermit Crab (*Pagurus prideaux*) the relationship is obligatory and neither is found without the other. In contrast the inappropriately named Parasitic Anemone (*Calliactis parasitica*) can live on rocks as well as the shells of several different hermit crabs.

Whilst mutualism confers obvious benefits, it also has certain drawbacks. Stable populations of both species are needed for the partnership to work. On reefs damaged by storms or blast fishing, where there are not enough anemones to go round, young clownfish are found out in the open and are easily predated. The partners must also be able to find one another in the first place and this is achieved in a variety of ways. The hydroid *Hydractinia* can be found attached to rocks and wrecks but usually grows on the shells of hermit crabs. The planktonic planula larvae must therefore be attracted to settle on the crab shells. Leitz and Wagner (1993) showed experimentally that a bacterium associated with hermit crab shells induced the larvae to metamorphose. Mobile animals such as crabs can pick up anemones, though some anemones are known to move slowly towards their host.

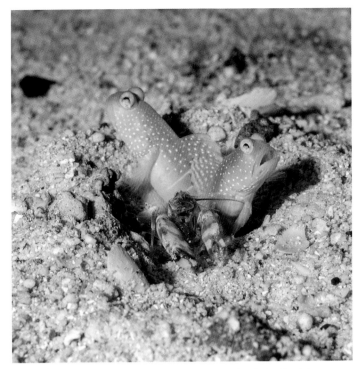

Alpheid shrimps (*Alpheus* spp.) share burrows with various species of goby. The shrimp maintains the burrow whilst the goby acts as lookout, maintaining contact through the shrimp's long antennae.

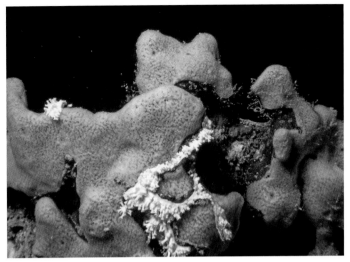

This sponge in the Semporna Islands off Sabah in Borneo is a three-in-one symbiosis. A central yellow sponge (*Rhabdastrella* sp.) is overlain by the visible greyish sponge (*Gellius* sp.) with a third sponge (*Terpios* sp.) making up the basal crust.

The cup corals *Heterocyathus* and *Heteropsammia* are unusual in that they live freely on sediment. Once the planktonic larval planula has settled and metamorphosed into a polyp, it can no longer move around, as with almost all stony corals (Scleractinia). However, the larvae of these tiny, solitary corals settle on tiny (dead) gastropod shells already inhabited by a sipunculid worm, commonly *Aspidosiphon corallicola*. The coral grows and spreads over the entire shell leaving just a small hole in its base through which the worm can reach out to drag itself and its new home along and feed. If the coral becomes buried in sediment or upturned then the worm will right it and in this way the coral can successfully live on soft sediments. Whether the sipunculid worm benefits from the increased security of its home is debatable and it is difficult to confirm this as either mutualism or commensalism. Sipunculan associated coral species are described in Hoeksema and Borel-Best (1991).

Permanent obligatory relationships

Mutualistic relationships can be so close that not only can the partners not survive without each other but the two together create a completely different type of organism. Lichens are the classic example of this in which a fungus and a single-celled alga or cyanobacterium grow together, each partnership producing a different lichen species. As described on p.169, lichens are identified as species by their fungal component, each of which is unique. The relatively small number of symbiotic microorganisms living within them, are shared by numerous different lichens.

Reef-building (hermatypic) stony corals cannot live permanently without their contained zooxanthellae (p.206) but the latter confers nothing to the shape and form of the coral, apart from colour. The zooxanthellae can be temporarily expelled at times of stress and later regained provided the coral has not starved meanwhile, a phenomenon known as coral bleaching (p.27).

Commensal relationships

Commensal relationships are one-sided with the benefactor either tolerating its guest or unaware of its presence. The benefit for the commensal is usually a safe place to live and sometimes an enhanced food supply. Some commensals are obligate and are always found with their host or one of several hosts, whilst others can also live freely.

Living homes

The Pearlfish (*Carapus acus*) has one of the most unusual homes of any fish as it uses the cloaca of large sea cucumbers such as *Stichopus regalis*, as a refuge from danger. The fish emerges at night to hunt for small invertebrates but with its elongated, scaleless body and no protruding pelvic fins to get in the way, it can quickly dive back in at any time. The first larval stage (vexillifer) is pelagic but settles on the seabed and transforms into a worm-like tenuis larva capable of finding and entering a sea cucumber. The sea cucumber may play host to more than one fish but is not harmed. There seems little evidence to back up claims that the fish may eat some of the internal organs of the sea cucumber but at least some sea cucumbers use evisceration

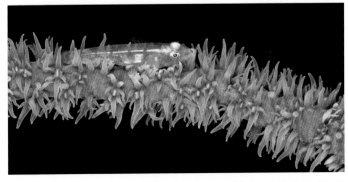

The Sea Whip Goby (*Bryaninops yongei*) clings to the branches of black corals (Antipatharia) with its sucker-like pelvic fins.

Commensal shrimps can be found living on the upper surface of tropical starfish but more usually on the hidden lower surface where they are safe from predators.

and subsequent regeneration as a means of defence. Other pearlfishes (Carapidae) live inside tunicates and bivalve molluscs, for example *Onoxodon parvibrachium* with the giant oyster *Pycnodonta hyotis*.

Living inside a host is termed iniquiline behaviour but many more commensals live on the outside of their host. Echinoderms, sea fans and other anthozoans in particular, play host to a wide range of small crustaceans, molluscs and fish. Some examples of decapod commensals and their hosts are given on p.268 and species inhabiting octocorals on p.202. A great many such associations are found on coral reefs and a patient and observant underwater photographer searching along the branches of sea fans and black corals (Antipatharia), will be rewarded with tiny gobies, shrimps, squat lobsters and spindle cowries. These commensal animals are usually well camouflaged and some species have only been discovered incidentally when their host has been collected. Soft corals such as *Sarcophyton* also appear to host larger animals such as the white Egg Cowrie (*Ovula ovum*), but in this case the cowrie is simply intent on eating the soft coral. This relationship is more like that between a caterpillar and its host plants.

Sharing a home is another typical commensal behaviour. Any animal that makes a substantial burrow or tube and that is not strong enough to evict tenants makes a good host. The echiuroid worm *Urechis caupo* (p.224) has more than its fair share of resident commensals in its U-shaped burrow, earning it the name of 'innkeeper worm' or 'fat innkeeper'. The Arrow Goby (*Clevelandia ios*) is a facultative commensal with it, whilst the scale worm *Hesperonoe adventor* and the pea crab *Scleroplax granulata* are obligate commensals but live with a variety of hosts. Using burrows allows these commensals to live in mudflats where they could not otherwise survive.

On land, the ability of some insects to induce their host plant to form a protective gall around them is well known. In the marine world a similar commensal relationship is seen between colonial sea fans and barnacles. Strange lumps along the branches of the sea fan *Leptogorgia* house the sea whip barnacle *Conopea galeata*, which is an obligate commensal. The sea fan grows around the settled barnacle which has a wide boat-shaped base but the barnacle aperture remains uncovered. More usual barnacle commensals are those that live on large vertebrates including whales and turtles, using them as a mobile platform from which to feed on plankton. Whale barnacles (Coronulidae) can have a specific host or sometimes several hosts.

HITCHHIKERS

In recent years, underwater photographers that venture out into 'blue water', plus photographs taken from submersibles and ROVs, have highlighted the way in which some planktonic crustaceans use jellyfish and other large gelatinous animals such as the By-the-wind Sailor (*Velella velella*) as transport. Juvenile shrimps, megalopa larvae of crabs and phyllosoma larvae of slipper lobsters have all been seen and filmed riding in this way. As adults these animals are benthic and live on the seabed. Exactly what these hitchhikers gain from this association remains uncertain but is likely to be food and possibly protection. Remoras are small fish with suckers on their heads that are well-known for attaching themselves temporarily to large fish, sharks, turtles and even scuba divers for a free ride. They feed on their host's scraps as well as live food and the crustaceans may be doing the same thing. Some shrimps are known to inhabit jellyfish on a permanent basis.

Parasitic relationships

Parasites are as prevalent in the marine world as they are in terrestrial and freshwater environments. As in commensal relationships the advantage is one-sided but parasites cause damage, disease and sometimes premature death to their hosts. The gain for the parasite is an easy supply of nutrients and a safe home, but the downside is that they can cause their own demise by pushing the host population towards local or complete extinction. Ectoparasites that live temporarily or permanently attached to the outside of their host can be very obvious and easily seen. Leeches, isopods and lampreys on fish are good examples (see photographs on pp.217, 274 and 325 respectively) and can be spotted by divers and fishermen alike. Others are much less obvious such as the highly modified copepods found attached to the gills of many fish and the gruesome isopod *Cymothoa* that eats and replaces the tongues of fish (p.275). Anyone preparing a whole fish to eat has a chance to see these parasites and any endoparasites living in the gut and body cavity, though many would probably prefer not to look.

Endoparasites live within their host's body in a variety of tissues and body cavities. Whilst some such as tapeworms (Cestoda) are easily recognisable, others are so highly modified that it is difficult to determine which phylum they belong to. However, some species such as the rhizocepalan barnacles that infest crabs, have normal planktonic larvae from which their origin can be deduced. It is difficult to envisage anything less like a normal barnacle than one of these parasites. *Sacculina* is

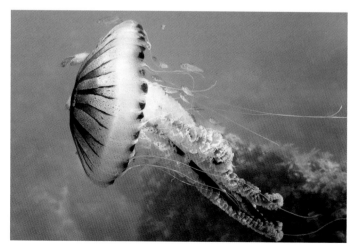

Fish of several species are known to associate with jellyfish as juveniles, living amongst the tentacles. The protection they gain presumably outweighs the danger of being stung and eaten.

piercing their prey, but kill and consume the animal, which *Thyca*, as a successful parasite, does not.

Various types of parasitic flatworms including tapeworms are common endoparasites in marine vertebrates. Spiny-headed worms (Acanthocephala) and tapeworms attach themselves firmly to the inside wall of their hosts' intestine and absorb nutrients through their specialised tegument (skin). Flukes have complicated life cycles with two to three intermediate hosts and a vertebrate final host. They can infect humans who eat raw fish but this occurs mostly through freshwater species.

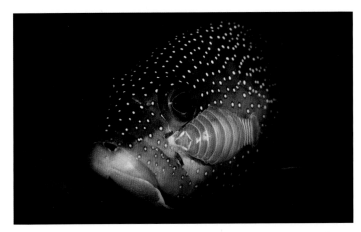

A naturally flattened body and many legs with sharp claws help parasitic isopods to cling firmly to their host. They often occur on the head where they will try to creep underneath the operculum to suck blood from the gills and soft tissues within.

a widespread genus with over 100 species and its only visible part is its egg-laden sacs (externa) that erupt through the cuticle under the abdomen where the crab's own eggs would normally be carried. The parasite alters the hormone regime of the host so that the host's gonads do not grow and instead food resources are directed to the parasite's growth and reproduction. The parasite's eggs are fertilised by a male cypris which delivers sperm-producing tissue into the externa.

The most successful marine ectoparasites, at least in terms of numbers and biodiversity, are crustaceans and most of these are small maxillopods (see table below). This is not surprising considering the remarkable diversity and abundance of crustaceans in the ocean. Molluscs are also a large and diverse phylum within the ocean but there are relatively few ectoparasitic species. A typical example is the parasitic cap shell *Thyca crystallina*, a small limpet-like gastropod which attaches to starfish, mainly the tropical *Linckia laevigata*. Females remain permanently attached in one place and suck body fluids (haemolymph) from their host. Males are dwarf and live under the female's shell. Many predatory gastropods such as dog whelks (*Nucella* spp.) feed by

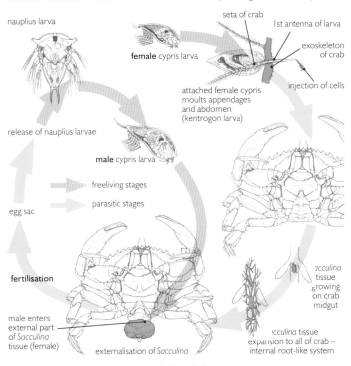

Life cycle of a parasitic rhizocephalan barnacle (*Sacculina*).

Phylum	Class	Usual host of adults
Platyhelminthes (flatworms)	Monogenea (parasitic flatworms)	Ectoparasites on skin and gills of fish
Platyhelminthes (flatworms)	Trematoda (flukes)	Endoparasites in digestive tract and organs of molluscs and vertebrates
Platyhelminthes (flatworms)	Cestoda (tapeworms)	Endoparasites in intestinal tract of vertebrates
Acanthocephala (spiny-headed worms)	All three classes are parasitic	Endoparasites in intestinal tract of vertebrates
Annelida (segmented worms)	Hirudinea (leeches). Majority parasitic	Ectoparasites on skin of vertebrates
Nematoda (nematodes)	Minority of parasitic species in the three classes	Endoparasites in plants, invertebrates, vertebrates
Cephalorhyncha	Nematomorpha (horsehair worms)	Larvae endoparasitic in crabs
Nemertea (ribbon worms)	Enopla. A few parasitic	Crab egg masses
Arthropoda	Malacostraca: Isopoda. Many parasitic	Ectoparasites on fish and decapod crustaceans
Arthropoda	Maxillopoda: Copepoda	Ectoparasites on fish
Arthropoda	Maxillopoda: Branchiura (fish lice, all parasitic)	Ectoparasites on fish
Arthropoda	Maxillopoda: Pentastomia (tongue worms, all parasitic)	Endoparasites in lungs of reptiles, birds, mammals
Arthropoda	Maxillopoda: Cirripedia (rhizocephalan barnacles)	Endoparasites in decapod crustaceans mainly crabs
Arthropoda	Maxillopoda: Tantulocarida	Ectoparasites on small crustaceans e.g. copepods
Mollusca	Gastropoda. A few parasitic species	
Chordata	Cephalaspidomorphi (lampreys)	Ectoparasites on fish

Parasitic marine animals.

MARINE PROTECTED AREAS

Throughout the world there are Protected Areas managed primarily to conserve nature, biodiversity and natural resources. Such areas come under a myriad of different names and vary from small nature reserves only known and loved by local people, to huge internationally famous national parks such as the Serengeti in Africa. Marine Protected Areas (MPAs) are similarly diverse but have a much more recent history, though Pacific nations have had 'tabu' areas for centuries and some of these now form the basis for more modern western-style MPA systems. The Poor Knights Islands Marine Reserve in New Zealand established in 1981, was one of the earliest statutory marine reserves in the world and commercial fishing was banned from the start. Currently all marine life is protected within the reserve which is a 'no take' area (p.506). Nature reserves, whether on land or at sea, are a great attraction to anyone interested in the natural world and the Poor Knights have become a world famous scuba diving and tourist destination. MPAs showcase the best of the marine world and it is for this reason that they are included here as the final chapter of this book.

There are many different aspects to marine conservation and MPAs are only one way of protecting the marine environment. However, they are a critical tool for protecting coral reefs and other marine communities such as seagrass beds and kelp forests that have a long-term fixed, structural component. MPAs will not protect coral reefs against global threats such as ocean warming and increased ocean acidification (p.25), but healthy, protected reefs have been shown to be more resilient than reefs already damaged by inappropriate fishing methods and stressed by local pollution.

Some sanctuaries encompass large areas of ocean but only protect specific groups of species. For example, the Indian Ocean Whale Sanctuary covers the whole of the Indian Ocean south to 55°S and is one of two designated by the International Whaling Commission. The second is in the Southern Ocean around Antarctica and is described below. In recent years shark sanctuaries have been declared within the EEZs (Exclusive Economic Zones) of Palau, Maldives, Honduras, The Bahamas, and Tolelau. Within these areas all commercial fishing for sharks is banned. This is in response to the continued decline in the numbers of many shark species and the importance of sharks to the tourist industry in theses nations.

The World Database on Protected Areas (WDPA) provides a comprehensive list of protected sites found throughout the world and includes MPAs. This joint project between UNEP (United Nations Environment Programme) and WCMC (World Conservation Monitoring Centre) has a public interface on Protected Planet (www.protectedplanet.net).

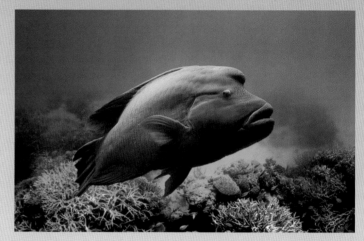

As well as declaring the waters within its EEZ a shark sanctuary, the Maldivian government also protects certain specific fish species that are important for tourism, including the Humphead Wrasse (*Cheilinus fasciatus*) which cannot be exported.

INTERNATIONAL CONVENTIONS

Various international agreements exist which help and encourage nations to recognise and establish protected areas of particular international importance. Countries that sign up to these agreements are asked to put forward candidate sites for recognition. The actual nature conservation designation of a site is the responsibility of individual nations. One of the best known of these conventions is the UNESCO World Heritage Convention. An area included as a World Heritage Site is recognised as being of 'outstanding universal value'. The list (www.whc.unesco.org/en/list) includes a wide variety of sites that fall within different national designations, from buildings and towns to entire islands, natural areas and archaeological sites. Perhaps the best known marine example is the Great Barrier Reef Park, Australia.

The Ramsar Convention on Wetlands produces a list of internationally important wetland sites known as Ramsar sites (www.ramsar.org). As well as inland sites, these include coastal sites such as estuaries with important saltmarsh systems and wildfowl populations. In the UK the Severn Estuary and the North Norfolk Coast are examples of Ramsar sites that are important for breeding and overwintering birds with the former also important for anadromous fishes.

The Barcelona Convention for the Protection of the Mediterranean Sea Against Pollution, although concerned mainly with pollution abatement, includes the Specially Protected Areas and Biological Diversity protocol. ASEAN (Association of Southeast Asian Nations) member states have declared outstanding national parks and reserves as ASEAN Heritage Parks. There is a single MPA within this network, Tarutao National Marine Park, an area of islands in the Andaman Sea.

World Heritage Site	Country	Marine interest
Great Barrier Reef	Australia	Coral reefs and associated habitats
Frazer Island	Australia	Sand dunes, mangrove
Lord Howe Island Group	Australia	Coral reefs, seabirds
Ningaloo Reef	Australia	Coral reefs, Whale Sharks
Shark Bay	Australia	Stromatolites
New Zealand Sub-Antarctic Islands	New Zealand	Seabirds and penguins
Rock Islands Southern Lagoon	Palau	Coral reefs, lagoons
Phoenix Islands Protected Area	Kiribati	Oceanic coral archipelago, sea mounts.
Lagoons of New Caledonia: Reef Diversity and Associated Ecosystems	France (special collectivity)	Coral reefs and associated ecosystems
Papahānaumokuākea	USA (Hawaii)	Oceanic and deepwater habitats, coral reefs
Cocos Island National Park	Costa Rica	Large pelagic species
Coiba National Park and its Special Zone of Marine Protection	Panama	Pelagic fish, marine mammals, turtles, other marine life
Galápagos Islands	Ecuador	Outstanding and varied marine life, Marine Iguana
Islands and Protected Areas of the Gulf of California	Mexico	Very high diversity of marine habitats and wildlife
Dorset and East Devon Coast	UK	Coastal geomorphology and marine fossils
St Kilda	UK	Rich seabed communities, seabird cliffs
Wadden Sea	Germany and Netherlands	Transitional habitats: seagrass, saltmarsh, estuaries etc.

Worldwide examples of Marine Protected Areas with World Heritage Site status.

The Convention on Biological Diversity was adopted in May 1992 and is concerned with maintaining sustainable development and biological diversity of all life on Earth. A vital aspect of the convention is to encourage parties to establish, develop and maintain protected areas and that includes a programme of work on marine and coastal areas.

MARITIME ZONES

Individual states (countries) have varying degrees of jurisdiction over the marine waters that abut their coastlines, depending on the distance offshore. This will obviously affect the location of MPAs and types of restrictions that can be imposed. The maritime zones recognised by international law and defined by the United Nations Convention on the Law of the Sea are: internal waters, territorial sea, contiguous zone, exclusive economic zone (EEZ), the continental shelf and the high seas. The baseline for the measurement of the territorial sea, EEZ and continental shelf is generally the mean low water mark. Measurement is in nautical miles (nm).

Territorial Sea out to 12nm (less in some circumstances) over which a state has full sovereignty. Foreign ships have the right of innocent passage;

Contiguous Zone from territorial sea outer limit to 24nm. This allows a state to exercise controls to prevent infringement of its customs, fiscal, immigration and sanitation laws and regulations within its territory and territorial sea;

Exclusive Economic Zone (EEZ) extending out to 200nm (and thus including its territorial sea and contiguous zone). Within its EEZ a state has jurisdiction over most activities including exploitation, exploration, management and conservation of natural resources, on, beneath and in the waters above the seabed. It is therefore within this zone that states can unilaterally declare MPAs.

In general a 200nm EEZ will encompass the whole of the natural continental shelf (p.36) and the limit was agreed with this in mind. However, where the continental shelf extends beyond the 200nm limit, a state can claim an extended continental shelf where it has jurisdiction over the seabed (non-living resources) and sedentary organisms but not of the waters above it. In other words a state would not have jurisdiction over most fishing activities in its extended continental shelf area. A coastal state with a continental shelf that does not extend out to 200nm will have an EEZ that includes deep seabed and water beyond the continental shelf.

The High Seas comprise all maritime areas outside the EEZ, territorial sea or internal waters of a state and also archipelagic waters. States such as the Philippines comprising an archipelago of islands have a defined baseline around the perimeter within which they have full sovereignty. The seabed and everything on and beneath it that lies outside national jurisdictions is called The Area and no state can claim or have sovereign rights over any part of it.

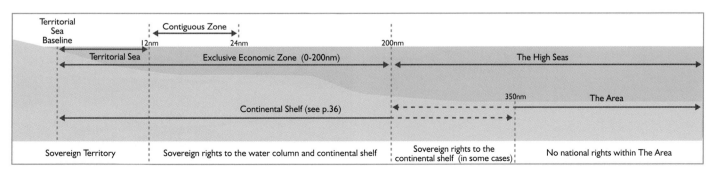

International Maritime Zones. Note that the Territorial Sea, Exclusive Economic Zone (EEZ) and continental shelf are each measured from the same baseline and are not added on one after the other. The physical Continental Shelf mostly coincides with the 200nm EEZ but may extend further so jurisdiction may be extended to a maximum of 350nm in some circumstances.

OCEAN SANCTUARIES

Whales and other migratory animals such as fish and turtles, move freely between high seas and waters controlled by national jurisdiction. MPAs can be effective in protecting breeding and feeding grounds if these lie within national jurisdictions but conservation of wide-ranging species is difficult. However for the great whales protection can be provided on the high seas through the International Whaling Commission (IWC) which controls where and how many whales can be exploited. The Southern Ocean Whale sanctuary is described below along with a whale sanctuary within the national jurisdiction of Hawaii. Marine areas beyond national jurisdiction comprise almost two thirds of the global ocean. Biodiversity in the high seas is threatened by fishing, seabed exploitation and climate change. The United Nations (UN) has recently agreed that initial steps should be taken towards setting up international governance to allow the possibility of setting up high seas MPAs.

SOUTHERN OCEAN WHALE SANCTUARY

The IWC implemented a whale sanctuary in the Southern Ocean around Antarctica in 1994. The area is precisely defined and encompasses about 50 million square kilometres of ocean where commercial whaling is banned. Setting up such sanctuaries is within its remit of providing proper conservation of whale stocks but it can only do so with a three-quarters majority vote of member states. Japan controversially has continued to catch a quota of Antarctic Minke and Fin Whales within the sanctuary under a provision that allows whaling for the purposes of scientific research. However, in March 2014 the International Court of Justice declared Japan's scientific whaling programme in Antarctica illegal in a case brought to court by Australia, and Japan has complied with the ruling.

The worldwide zero catch limit for commercial whaling imposed by the IWC in 1986 remains in force but should it ever be relaxed in the future then existing whale sanctuaries will become even more important. Of course the IWC could (by majority vote) allow controlled commercial whaling within these sanctuaries and conservation organisations such as WWF are calling for more robust protection. New whale sanctuaries in the South Atlantic and South Pacific have been proposed but the proposals have so far failed to reach the three-quarters majority vote required.

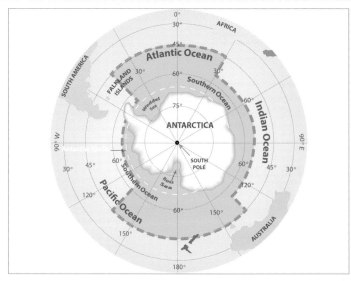

Southern Ocean Whale Sanctuary.

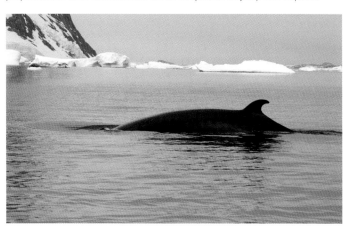

The Antarctic Minke Whale (*Balaenoptera bonaerensis*) is a separate species from the Minke Whale (*B. acutorostrata*) and it is mainly Antarctic Minke Whales that until the 2014 ban, were targeted by Japan for scientific whaling in Antarctica.

The icy wastes of the Southern Ocean surround the Antarctic continent and its islands (seen in the background).

HAWAII

The Hawaiian Islands Humpback Whale National Marine Sanctuary was designated in 1992 by the US Congress specifically to protect Humpback Whales (*Megaptera novaeangliae*) and their habitat. Hawaii is an important breeding area for these whales which arrive each winter to give birth in the warm tropical waters around the islands and to nurse their young before their long journey back to higher latitude feeding grounds. Equally the whales are vitally important to the Hawaiian economy through whale-watching tourism which provides income and employment. The tourists themselves, along with local residents, play a vital part in collecting data through an annual Sanctuary Ocean Count which involves surface sightings. Most tourists have cameras and Humpback Whales have unique patterns on their tail flukes that are clearly visible as the whale dives. This can provide additional useful data on population structure.

Involvement of local people and visitors alike in research programmes is one of the keys to the success of this sanctuary. Research and monitoring is carried out at many levels and, like most MPAs, is a vital tool in achieving its conservation aims. Hawaii is a popular tourist destination and the sanctuary also provides an ideal focus for education and awareness programmes. Specific issues include ways of avoiding boat collisions, rules governing whale-watching and protection of resources including the seabed.

PAPAHĀNAUMOKUĀKEA

In addition to Hawaii itself and the other seven nearby principal islands, a series of other atolls, rocky outcrops and tiny islands extends northwest for at least 1200 nautical miles. This remote and largely uninhabited place, known as the Northwestern Hawaiian Islands (NWHI) encompasses a huge area of around 362,000 sq km of extremely remote and largely undisturbed coral reefs. In 2006 the entire area was declared a National Monument by US presidential proclamation and in sympathy with its cultural importance was later given the Hawaiian name of Papahānaumokuākea. Activities such as oil exploration are completely banned within this huge area whilst others such as native Hawaiian practices are regulated by permit. In 2010 it was also declared a World Heritage Site (p.502) for both its natural and its heritage features. The remote location and restrictions on access mean that, like the Chagos Archipelago (p.508) it is never likely to be a diving and tourist destination.

The Hawaii whale sanctuary is an unusual MPA in that it comprises five separate areas, each known to support particularly high densities of whales.

HAWAIIAN MONK SEAL

The Northwestern Hawaiian Islands chain is home to one of the most endangered of all marine mammals, the Hawaiian Monk Seal (*Monachus schauinslandi*). Listed as Critically Endangered on the IUCN Red List, they have suffered in the past from direct exploitation, disturbance and degradation of their habitat from fishing, guano collecting and military activities. This is the only species of true seal (p.444) to breed and remain in, tropical waters year-round.

These seals appear to be disturbed by human presence so should benefit from the increased protection provided by the National Monument and World Heritage status of the area. It will be interesting to see how successfully injured and sick seals can be rehabilitated in the new Monk Seal hospital Ke Kai Ola healthcare facility that opened in 2014.

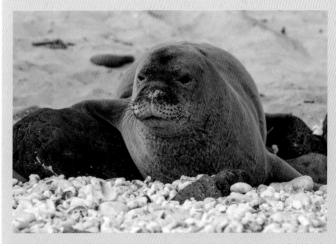

The Hawaiian Monk Seal is one of many marine species endemic to the Hawaiian Island chain. The remoteness of the area has resulted in a high level of endemism in both terrestrial and marine species.

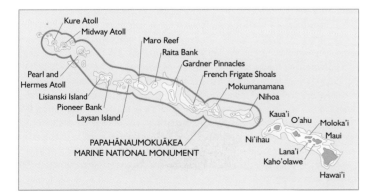

Northwestern Hawaiian Islands.

OCEAN SANCTUARIES

MARINE RESERVES

Marine nature reserves, like their counterparts on land, generally confer a high level of protection on the marine life within them. A useful management tool is the concept of zoning where different levels of protection are afforded to different areas within the reserve. Two examples at opposite ends of the size spectrum are described below.

Zoning is also applied in other types of MPA such as marine parks. No Take Zones are MPAs where marine life is fully protected and nothing can be taken by any means. Such zones may be stand-alone e.g. in Lamlash Bay, Arran, UK, or lie within other MPAs including Marine Reserves and Marine Parks (p.510).

LUNDY ISLAND

The tiny island of Lundy, only about 5km long and just over 1km wide, rises from the sea with dramatic suddenness, sporting cliffs up to 90m high. A stronghold for breeding Atlantic Puffins (*Fratercula arctica*) and Manx Shearwaters (*Puffinus puffinus*), home to the endemic Lundy Cabbage (*Coincya wrightii*) and with a remarkably diverse flora of seaweeds adorning its shores, it has attracted naturalists ever since there were any. The richness of the marine life in the waters around it was first recognised by pioneering scuba divers in the 1960s and it was they and a handful of dedicated professional biologists who set Lundy on the road to becoming the first statutory Marine Nature Reserve in the UK. Over 40 years of marine research and monitoring add to the importance of this small area.

LOCATION AND DESIGNATION

Lundy Island lies off the N Devon coast in the SW of Great Britain. It falls within the mouth of the Bristol Channel and is about 18km from the nearest point on the mainland. This makes it relatively remote and it remains largely unspoilt. The waters around Lundy have now been designated a Marine Conservation Zone (MCZ), a new type of MPA within the UK and one of 27 as of 2015, with a series of others currently (2016) being considered. It became a MCZ in 2010, but before this it was a statutory Marine Nature Reserve designated in 1986. The two other MNRs in the UK are Skomer Island and Strangford Lough. Of these three Lundy alone has a statutory No Take Zone where it is illegal to remove marine life and consequently there is no fishing, angling or collecting allowed in a 3.2km² zone off the island's east coast.

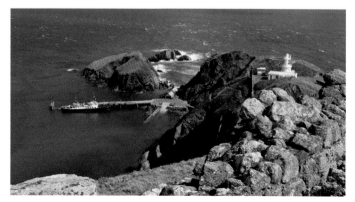

In summer a daily ferry brings visitors to Lundy to explore the rock pools and snorkel trail, for scuba diving and to walk and watch birds.

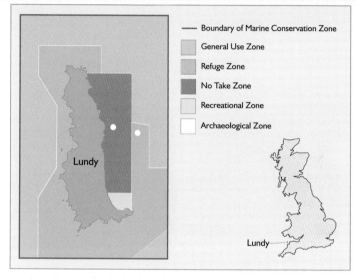

Location and zoning within the Lundy Island Marine Nature Reserve.

MARINE LIFE

Lying along a north-south axis, Lundy Island is exposed to strong tidal flows in and out of the Bristol Channel. It is also at the confluence where warm southern currents flowing north, meet cooler water. This, along with clear water and a varied geology results in a wide variety of shore types and underwater habitats and a range of species including many normally only found much further south. Plankton brought in on the strong currents supports rich populations of filter-feeding sessile animals particularly hydroids, bryozoans and sponges. Dramatic cliff faces and overhangs provide a colourful spectacle covered with Jewel Anemones (*Corinactis viridis*) and all five species of solitary cup corals that occur in the British Isles, the only known site to date where they are all found together. Those divers with more than a passing interest in marine life and who venture out onto the rich sediment plains along the east coast, might be rewarded with the sight of an eel-like Red Bandfish (*Cepola macrophthalma*) (p.371) picking plankton from the water above its burrow. These fish are normally found in much deeper water and Lundy is one of only a few sites where they live within scuba diving depths. Close inshore a rich and varied kelp forest (p.99) is home to a variety of fish including all five species of British wrasse (Labridae), Leopard-spotted Goby (*Thorogobius ephippiatus*), Pollack (*Pollachius pollachius*) and on sandy patches, Anglerfish (*Lophius piscatorius*) (p.384).

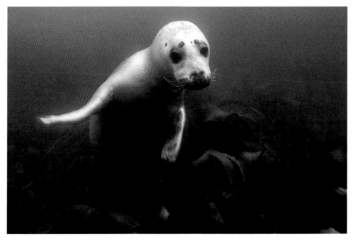

Lundy Island is an important breeding site for Grey Seals (*Halichoerus grypus*). Because they are used to divers, individual seals readily interact with them, playfully nipping fins and cameras but they should always be treated with respect as they have powerful jaws.

CONSERVATION

Protection of marine species and habitats within the Lundy Marine Conservation Zone is based on a zoning scheme where different activities are allowed within various zones (see map opposite). This proven technique allows non-damaging and sustainable fishing and recreation to continue alongside more strictly protected areas. For example recreational angling and potting (for crabs and lobsters) are allowed around most of the island excepting the NTZ. The island's small size and limited access make enforcement relatively straightforward, something that is not true of many large MPAs, especially in undeveloped countries.

When rats were eliminated from the island in a programme initiated in 2003, numbers of Manx Shearwaters rose rapidly in the following ten years. Rats eat eggs and young of ground nesting birds and are a particular problem when introduced to islands, usually through visiting ships. Invasive marine species such as Wireweed (*Sargassum muticum*) are much more difficult to control and the latest seaweed invader is Devil's Tongue (*Grateloupia turuturu*), native to Japan and Korea and first recorded in Lundy in 2008 (Hiscock and Irving 2012).

LUNDY ISLAND SPECIES

Sunset Coral *Leptopsammia pruvoti*

Features This bright yellow or orange cup coral is found on steep, shaded bedrock and boulders, especially under overhangs and in gullies on the east side of the island. The first record in Great Britain was from Lundy in 1969 and its population there has been closely monitored ever since. Here it is at the limits of its northern range from its main distribution in the Mediterranean Sea and Portugal. Numbers of this slow-growing and long-lived species are currently declining around Lundy.

Size Up to about 3cm across.

Sea slug *Greilada elegans*

Features With its bright orange body and blue spots, this sea slug is unmistakable and is one of the most colourful of all sea slugs found in the British Isles. Here it is only found in southern parts and its main distribution is in the Mediterranean. In the 1970s it was common around Lundy but the last reported sighting was in 1986 and it also appears to have retreated from the rest of SW Britain. The reasons are unknown but species at the limits of their distribution tend to be more sensitive to changes in temperature and water quality.

Size Up to about 5cm long.

Pink Sea Fan *Eunicella verrucosa*

Features Much of the known biology of the Pink Sea Fan, especially growth rates and diseases, comes from long term observations of populations around Lundy. By monitoring and measuring individual fans, it was found that growth rates were extremely slow, in the order of 1cm per year. The Sea Fan Anemone (*Amphianthus dohrnii*) has been recorded only once on Lundy sea fans, perhaps just as well, as it appears to damage its host (Wood, 2013). This sea fan is a protected species in England and Wales.

Size Up to 50cm high.

Crawfish *Palinurus elephas*

Features This large spiny lobster (Palinuridae) was heavily fished around Lundy in the 1970s and 1980s and numbers fell. Although their lifespan is unknown, they grow slowly and do not breed until they are at least 3 years old so are susceptible to overfishing. By monitoring the size and numbers of this species within and outside the No Take Zone, it should be possible to see whether the implementation of this zone is of positive value to fishermen as has been documented in other parts of the world.

Size Up to 60 cm long.

CHAGOS ISLANDS

The 55 small islands that make up the Chagos Archipelago form the British Indian Ocean Territory (BIOT) and come under the political jurisdiction of the UK. The islands are dotted throughout an immense area of clear, clean tropical water with over 60,000 sq km of coral reef and associated habitats (Chagos Trust 2014). The islands themselves make up only about 16 sq kms and today are totally uninhabited although there is a military presence on Diego Garcia. The history of habitation on the islands of the archipelago, which has been British territory since 1814, is complex and has at times been controversial. With only small scale economic and subsistence activities, all now in the past, the whole marine area has remained almost pristine and the coral reefs are amongst the least damaged and healthiest in the world. The question of whether the Chagos islanders will ever be able (or now willing) to return, and how they might make a harmonious living within the reserve, remains. Regrettably but understandably, the only people likely to see the underwater beauty of these remote reefs first hand are diving marine scientists on official expeditions. There is no commercial or recreational diving and any private boats require special permission to visit from the BIOT government. With the exception of some areas around Diego Garcia the reefs have remained almost completely undisturbed for at least 30 years (Sheppard 2013) and with the current MPA designation, should remain so for the future.

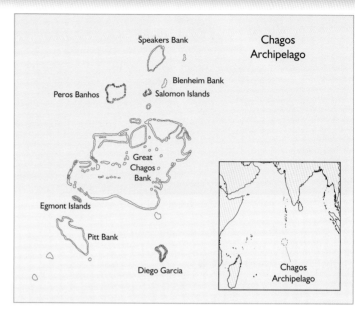

The Chagos Archipelago comprises five main atolls with islands, including the Great Chagos Bank, which is the largest atoll in the world at 150km long and 100km wide.

LOCATION AND DESIGNATION

The Chagos Archipelago lies in the middle of the Indian Ocean, 1500km south of the southern tip of India. It is at the southern end of the Chagos–Laccadive Ridge, and the Maldives and the Laccadive Islands lie in line with it to the north. The atolls within the archipelago are separated from each other by deep water extending over 1km down in some places. The entire territorial sea and EEZ out to the 200 mile limit (p.503) was designated as the Chagos Marine Reserve on 1st April 2010 by the British Government. This encompasses an area of approximately 640,000 sq km, all of which is a fully protected No Take Area. This makes it the largest fully protected marine reserve in the world.

Salomons atoll island and lagoon, within the Chagos Archipelago.

MARINE LIFE

For a coral biologist, the Chagos Archipelago is a paradise with some of the most extensive and healthy stands of coral found anywhere in the world. Coral cover is high though naturally varied according to location and aspect. Dense coral extends into relatively deep water on outer reef slopes where the water is exceptionally clear and the reefs tend to slope steeply down. Reefs facing into lagoons support species more tolerant of sand and silt. Large knolls rising up within lagoons provide additional living space for corals. Around 220 species of hard corals have been recorded which is only a slightly lower number than is found within the whole 'coral triangle' (p.96) in SE Asia and there are relatively few heavily impacted reefs. With ideal growing conditions, fast-growing thickets of staghorn coral (*Acropora* spp.) form a fringe around many of the small islands and sand keys. In slightly deeper water, some of the corals grow to a massive size and great age, and mounds of *Porites* coral grow to at least 2m tall and several metres across. Such slow-growing corals can be hundreds of years old and are rare in areas impacted by fishing and pollution.

On steeper and deeper slopes, particularly on seaward facing reefs, large sea fans and a wide variety of soft corals colour the reefs. *Tubastrea micrantha*, an azooxanthellate hard coral (p.206) also thrives here. In these ideal conditions it grows (slowly) to at least 2m tall, which is very large for a coral to grow without the additional food provided by zooxanthellae. A wide variety of other invertebrates inhabit the reefs.

Populations of fish around the reefs and islands in Chagos are healthy and diverse and nearly 800 different species have been recorded. Large groupers and Humphead Wrasse (*Cheilinus undulatus*) are frequently seen by divers and counts indicate healthy populations. This is far from the case in the Tun Sakaran Marine Park (p.512) where fish diversity is high but large and valuable species have been heavily impacted by fishing. Diving scientists see sharks on most dives in Chagos, but shark numbers are known to have declined due to continued illegal shark fishing and by-catch from previous tuna fisheries and continuing illegal commercial (including tuna) fisheries.

CONSERVATION

The Chagos reefs have remained relatively untouched by human activities and as such, provide scientists with a baseline against which to compare other reefs. The reefs provide a living museum showcasing what a healthy coral reef system should be like. Healthy reefs appear to show a greater resilience to the damaging effects of hurricanes and to the effects of climate change, especially ocean warming and ocean acidification (p.25). The Chagos MPA provides a unique opportunity to study this and other aspects such as the effects of ocean warming on the spread of coral diseases. Severe warming associated with the 1998 El Niño event (p.17) caused massive coral mortality throughout the Indian Ocean and the Chagos reefs were no exception, with up to 90% of coral killed on some ocean-facing reefs. However, perhaps excepting coral experts, a visitor today would not notice any effects. Coral recovery has been good and a recent 2014 survey has confirmed that the percentage coral cover is largely back to pre-event levels. The same cannot be said for similarly affected coral in the Tun Sakaran Marine Park (p.512) where reef monitoring has revealed only patchy recovery on bleached reefs. With a history of blast-fishing and misuse, coral recovery is likely to take much longer even when full protection is implemented.

Populations of pelagic fish such as Skipjack (*Katsuwonus pelamis*) and Yellowfin Tuna (*Thunnus albacares*) for which there was a legal fishery prior to the declaration of the MPA in Chagos, are likely to recover well with fishing pressure now removed. However, illegal commercial fishing for both tuna and sharks remains a problem with boats coming into the area from Sri Lanka. Within the immense area of the Chagos marine reserve, such illegal fishing is hard to eradicate.

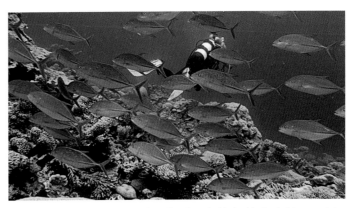

A school of jacks swims over a wide variety of corals on the Isle Anglaise knoll, Salomons atoll.

CHAGOS MARINE RESERVE SPECIES

Ctenella chagius

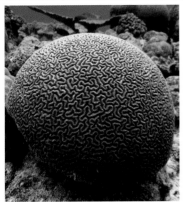

Features This brain coral is considered endemic to the Chagos Archipelago where it is locally common on reef slopes, but it has also been recorded from Mauritius and Réunion which are also within the BIOT. Although it looks similar to some other brain corals, it is the only species in this genus. It is listed as Endangered in the IUCN Red List because of its restricted distribution and vulnerability to coral bleaching. It is also listed on Appendix II of CITES.

Size Unrecorded.

Sooty Tern *Onychoprion fuscatus*

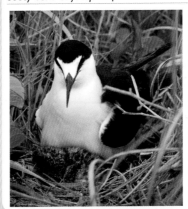

Features This large, elegant tern has a wide equatorial distribution but ground nesting birds such as the Sooty Tern do particularly well in Chagos where there is no disturbance from people or dogs. There is a large colony on South Brother, a coral island that forms part of the Great Chagos Bank atoll. The island has been identified as an Important Bird Area, defined as a place with global importance for nesting birds. Sooty Terns are highly pelagic only coming ashore to breed or during violent storms. Large flocks can be seen at sea picking fish from the surface waters.

Size 40cm.

Coconut Crab *Birgus latro*

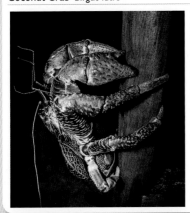

Features This giant arthropod has a global distribution in tropical areas but is rare in most areas due to over exploitation for food and for the curio trade. However, in the Chagos this crab thrives undisturbed. It is essentially a land animal but like all crustaceans, must lay its eggs in water. The larvae drift in the plankton and healthy populations, such as that in Chagos, produce plenty of larvae that disperse widely and can replenish depleted stock in other areas. Its large claws are strong enough to husk coconuts and eventually break in to the flesh.

Size Over 1m leg span.

Silky Shark *Carcharhinus falciformes*

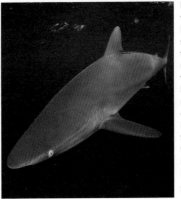

Features Sharks are in decline worldwide and the Silky is no exception. However, in the Chagos, populations should have a chance to recover since tuna fishing is now banned in the reserve. Prior to this, many Silky Sharks were caught as bycatch by tuna boats both on longlines and in purse seine nets. Loose aggregations of Silky Sharks commonly follow tuna shoals. However, it is one of the most important sharks to the fin trade and illegal fishing continues to impact Chagos populations. Globally it is listed as Near Threatened by the IUCN Red List of Threatened Species.

Size Up to 3.3m long.

MARINE PARKS

Although there is no universal definition of a Marine Park, such areas are usually those in which people live and where the needs of marine conservation and resource exploitation must be carefully balanced. Two very different marine parks are illustrated here; the Great Barrier Reef Marine Park of Australia, long-established and from a developed part of the world, and the Tun Sakaran Marine Park in Sabah, Borneo. Much of the immense island of Borneo remains undeveloped but still suffers from severe human impact.

GREAT BARRIER REEF MARINE PARK

From its initial discovery in 1770 when Captain James Cook accidentally ran his ship aground there, the Great Barrier Reef of Australia has gained international fame as the most extensive living reef system in the world. It is frequently described as being visible from space (along with the Great Wall of China) and is a prime destination for scuba divers from all over the world. However, the myriad coral reefs that justifiably make this area famous are only one of a wide variety of associated marine habitats including seagrass beds, mangrove forests, sand-lined lagoons, estuaries and deep channels. It also encompasses over 900 islands varying in nature from small coral cays made of bare sand to larger vegetated cays and rocky continental islands, the highest of which rises to over 1,000m above sea level.

LOCATION AND DESIGNATION

The Great Barrier Reef Marine Park stretches for 2,300km along the eastern coast of Australia from the tip of Queensland in the north to just short of Bundaberg in the south and so spanning around 14 degrees of latitude. It covers an immense area of 344,400km² extending from the low water mark on the mainland out to between 60km to 250km. It was designated in 1975 through the Great Barrier Reef Marine Park Act, a piece of primary legislation, and was inscribed as a World Heritage Site in 1981. It is administered by the Great Barrier Reef Marine Park Authority and considerable information is available on their website (www.gbrmpa.gov.au).

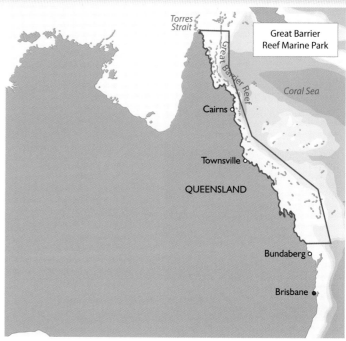

The Great Barrier Reef Marine Park encompasses many developed and undeveloped areas along the Queensland coast as well as remote offshore islands and reefs.

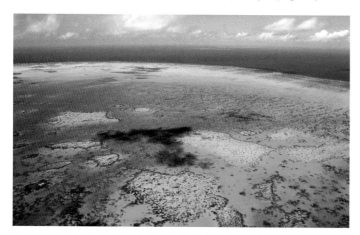

Numerous atolls dot the Great Barrier Reef. Shallow water within atoll lagoons contrasts with the deep oceanic water that bathes their outer reefs.

MARINE LIFE

The huge diversity of interconnected habitats along with the sheer size of the park means that the diversity of species (marine and terrestrial) is one of the highest found in any World Heritage site. Considered as a single marine ecosystem, it is one of the richest and most complex in the world and in terms of biodiversity it is certainly on a par with the Amazonian rainforest.

Whilst often talked about as a single entity, the GBR is made up of nearly 3,000 separate coral reefs subject to their own particular physical conditions of wave exposure, water clarity, temperature and so on, and therefore supporting different assemblages of species. In its entirety the GBR supports around 350 species of hard coral (Scleractinia), at least 1,500 fish species and several thousand species of molluscs. The only one of the seven species of marine turtles that is not present is the Kemp's Ridley Turtle (*Lepidochelys kempii*). Raine Island supports the largest Green Turtle (*Chelonia mydas*) breeding area in the world. Around 30 cetaceans are

known to breed within the park. Humpback Whales (*Megaptera novaengliae*) migrate north from cold Southern Ocean waters and can be seen in the park from May to September.

There is a long history of marine research and monitoring within the park meaning that the wildlife is well-documented, at least for the more easily accessible areas and for the better known taxa such as birds, fish and corals. Heron Island Research Station, established in 1951 and situated about 80km from Gladstone, is the oldest and largest research and teaching facility on the GBR. The island also accommodates visitors and although only one of numerous wildlife-rich places to visit, it caters well for diving marine naturalists.

CONSERVATION

The park is managed primarily through a complex zoning scheme that allows for different uses in different areas, with seven zone categories ranging from preservation zones which are fully protected no-take areas, to general use zones where most (normal) activities are allowed. A single zoning map of such an immense area would be of limited use and consequently there are 14 detailed regional zoning maps which are freely available to the general public in digital or paper format. The zoning plan was updated in 2004 and the area of no-take increased from 4.5% to 33.4% (Chin *et al.* 2008). Whilst the GBR has good and effective management in place, global problems such as ocean acidification, climate change and declining water quality in inshore areas, are much more difficult to tackle and are already having serious consequences.

Crown-of-thorns Starfish (*Acanthaster planci*) pose a significant threat to coral within the GBRMR, along with cyclones, coral bleaching and disease. Enrichment of coastal waters by agricultural run-off and sewage inputs can greatly increase larval starfish survival rates, because the resultant algal blooms provide extra food and more larvae survive to adulthood. Long-term measures to improve water quality may eventually solve the problem but meanwhile the starfish are often culled. The development of a new chemical mixture that indirectly kills the starfish within 24–48 hours following a single injection (Rivera Posada *et al.* 2011) has greatly increased the success of such culls.

Political pressures for economic development unsurprisingly also affect the GBRMP. A recent (2014) decision to approve the dumping of dredged material from a major coal port expansion project within the park boundaries has caused widespread concern and this, amongst other management problems, now threatens its continued UNESCO World Heritage Status. Sediment plumes can spread from dumping grounds onto sensitive coral reefs and seagrass beds unless such sites are extremely carefully chosen.

GREAT BARRIER REEF MARINE PARK SPECIES

Giant Triton *Charonia tritonis*

Features The Giant Triton shell, also known as the Trumpet Triton, is a protected species within the GBRMP but a proposal by Australia to add this mollusc to CITES (see Appendix 1) was unsuccessful in 1994. One of the largest of all gastropod molluscs, it is best-known for its ability to attack and eat Crown-of-thorns Starfish (p.293). Extensive collection for its meat and ornamental shell before the establishment of the marine park is thought to have greatly reduced its numbers.

Size Up to 40cm long.

Dugong *Dugong dugon*

Features The GBRMP is home to a significant proportion of the world population of Dugongs, which is one of the reasons that the area attained World Heritage status. Within the park they are a protected species but in the more populated areas numbers are killed or wounded by boats, or become entangled in fishing nets and drown, and they are also affected by coastal developments that impinge on their seagrass habitat. These iconic sirenians are described in detail on p.439.

Size Up to 3m long.

Potato Cod *Epinephelus tukula*

Features This giant grouper (Serranidae) has become a major attraction for divers at Cod Hole, the name given to one of the best known dive sites on the GBR, situated about 240km north of Cairns. Here the fish have been fed by divers for many years (itself a contentious activity) and are consequently unafraid. Highly territorial and sometimes aggressive, this fish is potentially dangerous due to its huge size. It is widespread in the Indo-Pacific but is uncommon.

Size Up to 2m long and >100kg in weight.

Red-footed Booby *Sula sula*

Features The Red-footed Booby is one of around 30 seabird species that breed within the GBRMP. This widespread tropical species thrives on islands with trees and shrubs where it can perch. Important bird breeding islands such as the Brook Islands in NE Queensland, are closed during the summer breeding season. As well as benefiting Red-footed Booby and other ground-nesting birds such as terns, closure of the Brook Islands protects coastal Pied Imperial Pigeons (*Ducula bicolor*).

Size Up to about 75cm tall.

TUN SAKARAN MARINE PARK

The majority of divers who pass through the coastal town of Semporna in the SE corner of Sabah, in Malaysian Borneo, are on their way to Sipadan Island, a world-renowned diving site. However, in recent years the many other diving sites in the area have been gaining in popularity and the Semporna Islands, just visible from the town, lie much closer and within easy reach of a morning's dive. Local divers already know and appreciate the wide range of habitats and wealth of marine life found in the area. However, like other parts of SE Asia, inappropriate fishing methods and pressure from nearby centres of population have had serious impacts on the coral reefs in the area. The richness of the area was first highlighted by a diving survey in 1980 (Malayan Nature Society 1987) and confirmed by further surveys carried out as part of the Semporna Islands Project initiated in 1998 by Dr Elizabeth Wood of UK Marine Conservation Society in collaboration with Sabah Parks. A survey organised by WWF Malaysia in 2008 placed the reefs in the Semporna area as amongst the richest in the renowned 'Coral Triangle' of high marine biodiversity (Kassem et al. 2012). Collaborative work there continues and its designation as a marine park provides an opportunity to monitor the recovery (hopefully) of a rich but highly impacted area of coral reef (Wood and Dipper 2008).

LOCATION AND DESIGNATION

The Tun Sakaran Marine Park encompasses eight islands and their surrounding reefs and lies about 20km north-east of Semporna at the western end of the Sulu Archipelago. It was gazetted as a Marine Park in 2004 and covers 340 sq km of sea and 10 sq km of land, making it the largest of Sabah's marine parks. The larger islands are inhabited and are used by local communities and by people from the mainland and other islands. Those who live within the park rely on the natural resources especially through fishing but also through seaweed farming and limited cultivation. Ensuring that these resources are used sustainably is therefore vital both for conservation and for the local inhabitants.

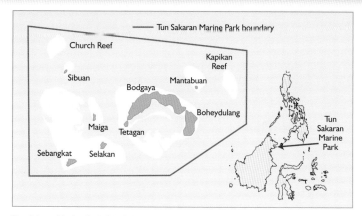

Tun Sakaran Marine Park, Sabah, Malaysia.

MARINE LIFE

Three volcanic islands (Bodgaya, Boheydulang and Tetagan) form a semi-circle that marks the rim of an ancient volcanic crater, now inundated by the sea (Wood 1987), with the highest rising to about 300m above sea level. Submerged reefs mark the remainder of the rim. Within this circle there is now a central sheltered lagoon.

The other five outlying islands are low-lying and based on coral rubble. The varied nature of the islands and reefs results in a corresponding variety of underwater habitats. These include extensive shallow fringing coral reefs, submerged coral banks, steep drop-offs, seagrass beds, fringing mangroves and deep channels between the reefs and islands. Within the lagoon are unusual deep, sheltered coral reefs and extensive muddy sand plains. Species diversity is high with more than 350 species of hard coral, 550 reef fishes, 60 soft corals and 100 sponges identified so far. The number of hard corals is remarkably similar to that recorded for the Great Barrier Reef (see above). However, the biomass of reef fish is low and there are few large clams or crustaceans due to problems with overfishing and blast fishing. Below about 10m depth the reefs remain mostly undamaged and support a wide variety of sea fans, soft corals and anemones (Anthozoa) as well as an exceptional variety of sponges.

Many new and undescribed species of sponges (Porifera) and soft corals (Anthozoa) are found within the marine park (pers. obs.) and a complete inventory of marine life within the park remains to be collated and published.

A helicopter ride provides a view that shows clearly the circular arrangement of the main islands and reefs, the outline indicating the rim of an ancient volcano.

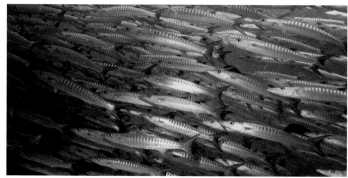

Barracuda (*Sphyraea* sp.) are a common sight in protected Sipadan Island and numbers should increase in the Semporna Islands as protection improves.

CONSERVATION

Implementation of the management plan and a zoning scheme within the marine park is progressing but still faces many problems not least of which is a lack of resources and manpower. Illegal fishing activities, particularly fish blasting, still persist with boats coming in from well outside the area. A balance needs to be struck between the resource needs of the local people and protection of the reefs through the zoning scheme. An alternative livelihood programme within the park is helping to reduce fishing pressure. Alternative livelihoods are being encouraged in order to reduce pressure on marine resources. Seaweed farming is the most widespread and successful activity in the park and progress is also being made with the cultivation and rearing of giant clams and abalone. A giant clam hatchery is successfully producing young clams that can be grown on and eventually used to re-seed the reefs where giant clams (*Tridacna* spp.) are rare, due to heavy exploitation. Seaweed farming using suspended ropes is already well established within the park and has minimal environmental impact. Ultimately, well-controlled ecotourism and 'home stays' are likely to bring benefit to both the park and the people living within it. Throughout the history of the development of this park, education programmes and outreach programmes have played and continue to play a key part.

The Bajau Laut (sea gypsies) maintain a traditional nomadic way of life within and outside the Tun Sakaran Marine Park. They have little concept of maps which makes explanations of zoning schemes difficult.

TUN SAKARAN MARINE PARK (SEMPORNA ISLANDS) SPECIES

Giant Cup Sponge *Petrosia* sp.

Features This remarkable sponge, shaped like a huge goblet, is as hard as rock and grows only on deep, gently sloping reefs below about 40m depth. It has been recorded at only two locations within the marine park but photographs exist of what may be the same species from Indonesia (e.g. in Colin and Arneson 1995). This is likely to be an as yet undescribed species of *Petrosia*. Much work remains to be done on the sponge fauna of Sabah and the marine park provides an excellent opportunity for such research.

Size Up to at least 1m in diameter.

Slender Grouper *Anyperodon leucogrammicus*

Features Groupers are highly prized edible fish and even this small species is taken for food. Large groupers are currently rare within the park but with adequate protection, they and other large fish such as the Humphead Wrasse (*Cheilinus undulatus*) could return. The Slender Grouper prefers coral-rich areas where it feeds on other smaller fishes. Juveniles mimic wrasse (*Halichoeres* spp.) that do not feed on fishes and so can get near to their prey.

Size Up to about 60cm long.

Scaly Giant Clam *Tridacna squamosa*

Features Six of the seven species of giant clam (Tridacnidae) that are found within SE Asia still occur in the park. The largest species (*T. gigas*) appears to be locally extinct within the park. The Scaly Giant Clam is perhaps the most colourful of all the species with a mantle in various hues of green, blue, brown, yellow and orange. This and other giant clams are most common on reefs within the lagoon where fishing has been informally controlled for many years. With protection they could also flourish again outside the lagoon.

Size Up to 40cm long.

Copper-banded Butterflyfish *Chelmon rostratus*

Features This widely distributed Indo-West Pacific species uses its long snout to pick out small invertebrates from amongst the coral and rock of the reef. Butterflyfishes are indicators of a healthy reef system and large numbers and a high biodiversity are both good signs. Although this is one of the commonest species within the park, few are found on blast-damaged reefs. Found singly or in monogamous pairs, it can live for 10 years but is one of many small reef fishes that are illegally caught in nets.

Size Up to 20cm long.

APPENDICES

APPENDIX I Organisations and recording schemes

Many different organisations worldwide run marine recording schemes designed to allow naturalists, divers, snorkellers and fishermen (as well as marine biologists) to record their findings and to contribute data that can be used for marine conservation and management. There are far more 'amateur' marine biologists and naturalists out there than there are professionals and taking part in such 'citizen science' schemes can enhance experience and enjoyment of hobbies such as diving, fishing and shore rambles. A small selection of such organisations and schemes are described in this appendix but there are many others, both local and international.

An increasing number of global and local recording schemes are now available to the general public as 'citizen science' projects. Anyone interested can record their wildlife sightings and so contribute to national and international datasets that provide vital information on the distribution and abundance of various groups of animals and plants. Some of these specifically target marine species whilst others are more general but may include or have individual marine projects. The data collected is normally made available to other data contributors on the recording website and to the broader science and conservation communities via portals such as the GBIF (Global Biodiversity Facility).

With the rise in use of smart mobile phones, many online recording initiatives have developed apps (applications) that can be downloaded and used to help in identification. For example, in the UK the *Sealife Tracker* app is designed to collect data on 25 marine invasive and climate change indicator species around the UK coastline. The app provides photographs of all the target species and records are delivered directly to a central database and made available through *iRecord* (www.brc.ac.uk/iRecord). As well as wildlife recording projects in the field, some citizen science projects allow contributors to help in a wide variety of computer-based initiatives. These can be accessed at Zooniverse (www.zooniverse.org) or via the Citizen Science Alliance (www.citizensciencealliance.org) and include marine projects on the ocean floor, plankton and kelp forests.

Certain organisations referred to in the text are also described in more detail below. For the UK a useful list of marine recording websites is available at www.marinesightingsnetwork.org

Organisations with recording schemes

REEF CHECK FOUNDATION
www.reefcheck.org

Reef Check is an international non-profit organisation with its headquarters in California, USA. Its core work is to survey coral reefs worldwide using trained volunteer divers with the aim of preserving and sustaining coral reef ecosystems. The survey technique follows a simple but well-established scientific protocol that can either be repeated year on year at the same site to follow changes or used to provide a 'snapshot' of the reefs in a wider area. For example, the technique has been used to monitor reef recovery following coral bleaching events and to establish the effectiveness of MPAs (Marine Protected Areas). By collecting data using the same methodology, comparisons can be made both temporally and geographically. Much of the data collected is published as scientific papers or reports such as Chavanich et al. (2012).

Sabah Parks rangers lay a transect line for a Reef Check survey in the Semporna Islands, Sabah, Malaysia.

MARINE CONSERVATION SOCIETY (UK)
www.mcsuk.org

The Marine Conservation Society is a UK-based charity dedicated to protecting seas, shores and wildlife. It promotes the need for marine wildlife protection, sustainable fishing and clean seas and beaches through campaigns, education, scientific research, surveys and expeditions. Whilst the focus is on UK marine conservation and campaigns, it has a number of international initiatives particularly in Malaysia and the Maldives. It runs a number of recording projects and public participation events. Wildlife sighting projects that accept records online include basking sharks, jellyfish, marine turtles and alien species. National beach cleaning events (Beachwatch) are run annually with volunteers not only collecting litter but making detailed records of the amount and type of litter found.

Seasearch – www.seasearch.org.uk

This MCS UK-based initiative provides marine life identification and survey training and expeditions for volunteer sports divers. It aims eventually to map out the habitats and species found within diving range around Britain and Ireland. After progressive training divers can take part in an annual programme of Seasearch dives or can record individually at their normal dive sites. In recent years the data collected has been invaluable in the UK government initiative to set up Marine Conservation Zones (p.506).

SHARK TRUST

www.sharktrust.co.uk

The Shark Trust is a UK registered charity with a worldwide interest in promoting the conservation and proper management of sharks, rays, skates and chimaeras. It works through education, support of scientific projects and campaigns such as highlighting the need for science-based catch limits for exploited species. It runs a number of recording projects for the general public, divers and recreational fishermen.

Shark sightings database (www.sharktrust.org/en/about_sightings): allows individuals and organisations worldwide to submit their sightings to generate data for researchers and conservationists. Records of sharks or any other elasmobranchs can be submitted and viewed online. The trust collaborates with Ecocean (see below) for photographic records of Whale Sharks.

Great Eggcase Hunt (www.sharktrust.org/en/great_eggcase_hunt): aims to collect data on egg-laying species by collection and identification of empty eggcases washed up on the shore or found (or photographed if alive) underwater by snorkellers and divers. Instructions on how to prepare, identify and record the egg cases is given on the website. Whilst primarily focused on the UK, records from anywhere in the world are accepted.

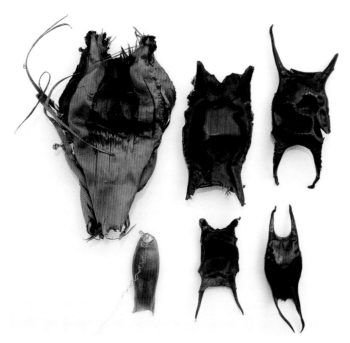

Shark and ray eggcases are easy to collect from seashores and provide an indication of species and numbers living near the coast.

PROJECT AWARE

www.projectaware.org

The Project AWARE Foundation was initiated by PADI (Professional Association of Diving Instructors) more than 20 years ago and is now a separate, registered non-profit organisation. It supports divers around the world who want to help mitigate environmental issues in the ocean, and currently focuses in particular on marine litter and shark conservation. Dive Against Debris (www.projectaware.org/project/dive-against-debris) is a global underwater survey documenting (and removing) marine litter that can be done on an individual or organised group basis.

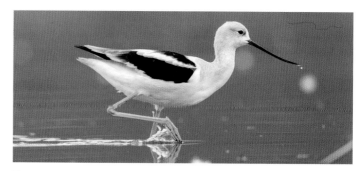

The American Avocet (*Recurvirostra americana*) is just one of many shorebirds included in the global shorebird count on World Shorebirds Day in September 2014.

BIRDS

eBIRD

www.ebird.org

This initiative was launched in 2002 by the Audubon Society and the Cornell Lab of Ornithology. Whilst currently used mainly in North America it is an international initiative that can be used by recreational and professional birdwatchers anywhere in the world. It is also used for specific initiatives such as the newly launched *World Shorebirds Day* which had its first global shorebird count on 6th September 2014. This is designed to provide a snapshot of the overall health of shorebird populations worldwide and to highlight the need for regular shorebird monitoring. Estimates suggest that about half the world's shorebird populations are in decline.

BRITISH TRUST FOR ORNITHOLOGY

www.bto.org

The UK has a long history of bird recording and monitoring especially through the BTO. Surveys include a Wetland Bird Survey (WeBS) that covers non-breeding water birds including coastal birds, and BirdTrack, an initiative similar to eBird covering Britain and Ireland.

WHALE SHARKS

THE ECOCEAN WHALE SHARK IDENTIFICATION LIBRARY

www.whaleshark.org and www.whaleshark.org.au

This is a Whale Shark monitoring programme and database to which anyone can contribute photographic records online. Whale Sharks have a unique pattern of light spots along the forward flanks and these, along with acquired injuries and scars on the first dorsal fin, allow individual animals to be identified from photographs. Whale Sharks are also a great draw for snorkellers, divers and boat users many of whom have cameras. The data provides information on migration and feeding patterns (such as the annual gathering at Ningaloo Reef in Australia (p.338) that is vital for the conservation of this iconic species, listed as Vulnerable on the IUCN Red List of Threatened Species.

FISH

Recreational and sports fishers are ideally placed to record the species they catch and in many countries there are local or national schemes in place to do this for marine fish species. An example of a national project is the Angler Recording Project run by the Shark Trust (see above) for sharks and rays. On a worldwide basis the Billfish Foundation (www.billfish.org) runs a tag and release programme, the largest private billfish tagging database in the world.

Other organisations and conservation groups

There are many marine organisations and conservation groups worldwide. A small selection of useful websites are described below.

CITES (Convention on International Trade in Endangered Species of Wild Fauna and Flora)
www.cites.org

CITES is an international agreement between governments designed to regulate wildlife trade for conservation purposes, to ensure that it does not threaten their survival. To date it provides varying degrees of protection to more than 35,000 species of animals and plants including many marine species, whether traded alive, dead or made into various products. Currently (2014) there are 180 states party to the convention. The species covered by the convention are listed in one or other of three appendices, each of which varies in the degree of protection it affords. Appendix I provides the most protection and includes species threatened with extinction. Almost all international trade in specimens of these species is prohibited. Appendix II species are not necessarily threatened with extinction, but are those in which trade must be controlled in order to avoid utilisation incompatible with their survival. Appendix III species are protected in at least one country and that country has asked other CITES parties for help in controlling the trade. So, for example, all seven marine turtle species are listed on Appendix I and tourists who unwittingly bring back curios made from 'tortoiseshell' (usually marine turtle shell), to their home country are breaking the law. The Whale Shark is on Appendix II (listed as Vulnerable on the IUCN Red List – see below) whilst the Walrus is on Appendix III.

IUCN (International Union for Conservation of Nature)
www.iucn.org

The IUCN is the largest professional global conservation network with its headquarters in Gland, Switzerland. It carries out an extremely wide range of influential conservation activities but from the point of view of anyone reading this book, one of the most useful is the IUCN Red List of Threatened Species (www.iucnredlist.org). This is an invaluable source of information on the taxonomic, conservation status and distribution of animal, plant and fungi species. The current number of species that have been assessed is 73,686 including many marine species, especially mammals, birds and reef-building corals. Each species is globally evaluated by experts using specified IUCN red list categories and criteria with the principal aim of assessing the relative risk of extinction. For extant species the categories are: Critically Endangered (CR), Endangered (EN), Vulnerable (VU), Near Threatened (NT), Least Concern (LC), Data Deficient (DD) and Not Evaluated (NE).

FAO (Food and Agriculture Organisation of the United Nations)
www.fao.org

The FAO is an intergovernmental organisation with 194 member nations plus the European Union. It has its headquarters in Rome, Italy and a presence in over 130 countries. The main interest for readers of this book lies in the fishery statistics that it compiles and publishes (www.fao.org/fishery/statistics). These are compiled, analysed and disseminated by the FAO fisheries and aquaculture department, and the data collections are readily available online. Of these the FAO Yearbooks of Fishery and Aquaculture Statistics are one of the most useful, with the most recent being for the year 2012 (FAO 2014). For example, from this it can be seen that the world total capture production in 2012 was 91,336,230 metric tonnes. Of that 1,114,382mt was Atlantic Cod (*Gadus morhua*) and of the latter the UK caught 970mt.

Save Our Seas Foundation (SOSF)
www.saveourseas.com

Supports research, conservation and education projects worldwide, focusing on threatened wildlife and their habitats.

THE CONVENTION ON MIGRATORY SPECIES (CMS) also known as the Bonn Convention
www.cms.int

Aims to conserve terrestrial, aquatic and avian migratory species throughout their range.

TRAFFIC: The wildlife trade monitoring network
www.traffic.org

Leading non-governmental organisation working globally to ensure that trade in wild plants and animals is not a threat to nature conservation.

OCEAN BIOGEOGRAPHIC INFORMATION SYSTEM (IOBIS)
www.iobis.org

This website allows users to search a variety of marine species datasets from all the world's oceans.

THE AUSTRALIAN MARINE CONSERVATION SOCIETY
www.marineconservation.org.au

A national charity dedicated exclusively to protecting ocean wildlife and their habitats.

OCEAN CONSERVANCY
www.oceanconservancy.org

Based in Washington, USA, this charity runs marine initiatives such as a yearly international coastal cleanup, and various educational initiatives.

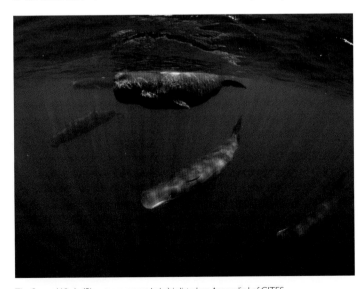

The Sperm Whale (*Physeter macrocephalus*) is listed on Appendix I of CITES.

APPENDIX II Metric and imperial measurements and SI units

Most countries have officially adopted the metric (decimal) system of measurement. Some imperial measurements are still generally used in the UK (e.g. miles). Although widely used in the USA, the metric system has not been officially adopted there. Their official system, United States customary units, uses units which were derived from British imperial units and are mostly identical to these (e.g. inch, foot and yard). However, some do differ (e.g. one US gallon is 0.83 imperial gallons).

SI Units (Système Internationale d'Unités) is an international system of units adopted by scientific circles and used in most scientific journals. The basic SI units are: length (metre), mass (gram), time (second), electric current (ampere), thermodynamic temperature (kelvin), luminous intensity (candela) and amount of substance (mole). Others are derived from these.

UNITS OF LENGTH, DEPTH AND AREA

The SI unit and the metric unit for length is the metre (m).

1 nanometre (nm)	= 10^{-9} metres
1 micron (micrometre) (μm)	= 10^{-6} metres
1 millimetre (mm)	= 0.001 metre
1 centimetre	= 0.01 metre
1 kilometre	= 1,000 metres

Imperial units and metric equivalents:

1 inch (in)	= 2.54 centimetres
1 foot (ft)	= 30.48 centimetres
1 yard (yd) (3 feet)	= 0.91 metres
1 statute mile	= 1.61 kilometres
1 nautical mile	= 1.85 kilometres (1.15 miles)
(1 knot (one nautical mile per hour)	= 5.14 metres per second)
1 fathom (6 feet)	= 1.83 metres
1 hectare (ha)	= 10,000 square metres
1 acre (0.40ha)	= 4046.86 square metres

UNITS OF MASS

The SI unit of mass is the gram (g).

1 microgram (μg)	= 10^{-6} grams	= 0.001 milligrams
1 milligram (mg)	= 10^{-3} grams	= 0.001 gram
1 kilogram	= 1,000 grams	
1 metric ton (mt) (or tonne)	= 10^6 grams (1,000 kg)	

Imperial units and metric equivalents:

1 ounce (oz)	= 28.35 grams
1 pound (lb) (16 ounces)	= 453.59 grams
1 stone (14 lbs)	= 6,350.29 grams (6.35 kilograms)
1 long ton (UK) (t) (2,240lb)	= 1,016.05 kilograms
1 short ton (USA) (2,000lb)	= 907.19 kilograms

UNITS OF VOLUME

The metric unit of volume is the litre.

1 millilitre (ml)	= 0.001 litre (1 cubic centimetre (cc))
1 cubic metre	= 1,000 litres

Imperial units and metric equivalents:

1 fluid ounce (fl oz)	= 28.41 millilitres
1 pint (pt) (20 fl oz)	= 568.26 millilitres
1 gallon (8 pints)	= 4.55 litres

United States units and metric equivalents:

1 US fluid ounce	= 1.04 imperial fluid ounce (29.57 ml)
1 US pint (16 US fluid ounces)	= 0.83 imperial pint (473 ml)
1 US gallon	= 0.83 imperial gallon (3.78 litres)

UNITS OF FORCE AND PRESSURE

The newton (N) is the SI derived unit of force. It is the force needed to accelerate one kilogram of mass at the rate of one metre per second squared. The SI unit for pressure is the pascal (Pa) which is defined as one newton per square metre. Pressures are normally measured in kilopascals (KPa). Ten KPa is one N per square centimetre. Pressure in the ocean (and in scuba diving cylinders) is usually measured in atmospheres (atm), bars or pounds per square inch (psi).

1 kilopascal (KPa)	= 10 hectopascals (hPa)	= 1,000 Pascals (Pa)
1 atmosphere (atm)	= 1013.25 hPa	= 101,325 Pa
1 bar	= 100 KPa	
1 atmosphere	= 1.01325 bar	
1 psi (pound per square inch)	= 6.89 KPa	
1 N/sq cm	= 1.45 psi	
1 N/sq cm	= 10 KPa	

UNITS OF CONCENTRATION

Salinity of the ocean is generally measured as:
Parts per thousand (ppt) = grams per kilogram (g kg^{-1}) (but see also p.20)

UNITS OF TEMPERATURE

The SI unit of thermodynamic temperature is the degree kelvin. Absolute zero is the lowest possible temperature.

	Kelvin (K)	Celcius or Centigrade (°C)	Fahrenheit (°F)
Absolute zero	0.0	-273.2	-459.7
Freezing point of water	273.2	0.0	32.0
Boiling point of water	373.2	100.00	212.0

Useful conversions:

°F = (1.8 × °C) + 32
°C = (°F − 32) / 1.8
°K = °C + 273.2

APPENDIX III Prefixes and suffixes

The purpose of this appendix is to show the Latin or Greek derivations of some of the more common prefixes and suffixes likely to be encountered in the vocabulary of the marine environment. The prefix may vary slightly depending on whether or not it precedes a vowel or a consonant. Becoming familiar with these terms can give an insight into the appearance and way of life of marine organisms. For example, the group name for comb jellies is ctenophore (Ctenophora p.174). The prefix cteno- means 'comb' and the suffix -phore means 'carrier of'. This describes the comb-like bands of cilia with which the animal propels itself along.

a- not, without (G)
ab-, abs- off, away, from (L)
abysso- deep (G)
acanth- thorn (G)
acro- top (G)
actin- a ray (G)
aero- air, atmosphere (G)
ad- toward, at, near (L)
al-, alula wing (L)
albi- white (L)
alga- seaweed (L)
alti- high, tall (L)
ampho- both, double (G)
anomal- irregular, uneven (G)
antho- flower (G)
apic- tip (L)
ap-, apo- away from (G)
apsid- arch, loop (G)
aqua- water (L)
arachno- spider (G)
arch- beginning, first in time (G)
arena- sand (L)
arthro- joint (G)
asthen- weak, feeble (G)
astro- star (G)
auto- self (G)
avi- bird (L)
balano- acorn (G)
bas- base, bottom (G)
batho- deep (G)
bentho- deep sea (G)
bio- living (G)
blasto- bad (G)
botryo- grape-like (G)
brachio- arm (G)
brachy- short (G)
branchi- gill-like (G)
broncho- windpipe (G)
bryo- moss (G)
bucc- cheek (L)
bysso- a fine thread (G)
calci- limestone (L)
calic- cup (L)
calori- heat (L)
capill- hair (L)
capit- head (L)

carno- flesh (L)
cartilagi- gristle (L)
cat- down, downward (G)
caud- tail (L)
cen-, ceno- recent (G)
cephalo- head (G)
cer-, cera- horn (G)
chaeto- bristle (G)
chir-, cheir- hand (G)
chiton- tunic (G)
chlor- green (G)
choano- funnel, collar (G)
chondri- cartilage (G)
chord- guts, string (G)
chorio- skin, membrane (G)
chrom- colour (G)
cilio- small hair (L)
cirri- hair (L)
clino- slope (G)
cloac- sewer (L)
cocco- berry (G)
coelo- hollow (G)
cope- oar (G)
cornu- horn (L)
cortic-, cortex- bark, rind (L)
costa- rib (L)
cran- skull (G)
crusta- shell (L)
cteno- comb (G)
cut-, cutis- the skin (L)
cyano- dark blue (G)
cyn- dog (G)
cypri- Venus-like (L)
-cyst bladder, bag (G)
-cyte cell (G)
dactyl- finger (G)
de- down, away from (L)
deca- ten (L)
delphi- dolphin
dent- tooth (L)
derm- skin (G)
di- two, double (G)
di-, dia- through, across (G)
dino- fearful (G)
diplo- double, two (G)
dolio- barrel (G)

duct- leading (L)
dur- hard (L)
e-, ex- out, without (L)
echino- spiny (G)
eco- house, abode (G)
ecto- outside, outer (G)
edrio- seat (G)
eid- form, appearance (G)
endo- inner, within (G)
entero- gut (G)
epi- upon, above (G)
erythr- red (G)
eu- good, well (G)
eury- broad (G)
exo- out, without
fec- excrement (L)
fecund- fruitful (L)
fer- carrier of (L)
fil- thread (L)
flacci- limp (L)
flagell- whip (L)
flora- flower (L)
fluvi- river (L)
gastro- belly (G)
geno- birth, race (G)
geo- Earth (G)
giga- very large (G)

globo- ball, globe (L)
glom-, glomer- ball of yarn (L)
gloss- tongue (G)
gnatho- jaw (G)
gracil- slender (L)
gul- throat (L)
gymno- naked, bare (G)
gyr- round, circle (G)
haem- blood (G)
halo- salt (G)
haplo- single (G)
helio- sun (G)
helminth- worm (G)
hemi- half (G)
hepat- liver (G)
herbi- plant (L)
herpeto- creeping (G)
hetero- different (G)
hexa- six (G)
hist- web, tissue (G)
holo- whole (G)
homo-, homeo- alike (G)
hydro- water (G)
hygro- wet (G)
hyper- over, above, excess ((G)
hypo- under, beneath (G)
ichthyo- fish (G)

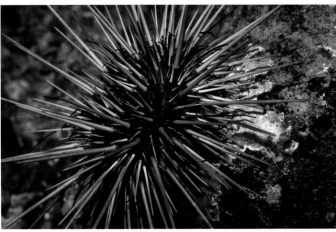

Sea urchins are typical **echinoderms** (Echinodermata). **Echino**- means 'spiny' and -**derm** means 'skin'. Sea urchins certainly live up to this name.

-idae members of the animal family of (L)
infra- below, beneath (L)
insula- island (L)
inter- between (L)
intr- inside (L)
iso- equal (G)
-ite indicating a mineral or rock (G)
juven- young (L)
juxta- near to (L)
kera- horn (G)
kilo- one thousand (G)
kin- movement (G)
lacto- milk (L)
lamino- layer (L)
latero- side (L)
lati- broad, wide (L)
lecith- yolk (G)
lingu- tongue (L)
lipo- fat (G)
litho- stone (G)
lopho- tuft (G)
lorica- armour (L)
luci- light (L)
luna- moon (L)
lut- yellow (L)
luci- light (L)
macro- large (G)
magn- great, large (L)
mamilla- teat (L)
mari- sea (L)
mastigo- whip (G)
masto- breast, nipple (G)
maxillo- jaw (L)
medi- middle (L)
medull- marrow, pith (L)
medus- jellyfish (G)
mega- great, large (G)
meio- less (G)
melan- black (G)
mero- part (G)
meso- middle (G)
meta- after (G)
-meter measure (G)
-metry science of measuring (G)
micro- small (G)
milli- thousandth (L)
moll- soft (L)
mono- one, single (G)
-morph form (G)
myo- muscle (G)
myst- moustached (G)
nano- (10^{-9}) dwarf (G)
necto- swimming (G)
nemato- thread-like (G)
neo- new (G)

neph- cloud (G)
-nomy the science of (G)
noto- the back (G)
nutri- nourishing (L)
o-, oo- egg (G)
ob- opposite (L)
octo- eight (L/G)
oculo- eye (L)
odonto- teeth (G)
oiko- house, dwelling (G)
oligo- few, scant (G)
-ology science of (G)
omni- all (L)
ophi- serpent (G)
opisth- behind (G)
-opsis appearance (G)
opto- eye, vision (G)
ornitho- bird (G)
ortho- straight (G)
-osis indicating a process (G)
oste- bone (G)
oto- hear (G)
ovo- egg (L)
palaeo-, paleo- ancient (G)
pan- all (G)
para- beside, near (G)
pari- equal (L)
pecti- comb (L)
pedi- foot (L)
penta- five (G)
phag- eating (G)
phil- loving, friend (G)
pholado- lurking in a hole (G)
-phore carrier of (G)
photo- light (G)
phyl- tribe, race (G)
phyto- plant (G)
pisci- fish (L)
plano- flat, level (L)
platy- broad (G)
plankto- wandering (G)
pleisto- most (G)
pleuro- side (G)
plio- more (G)
pluri- several (L)
pneuma- air, breath (G)
pod- foot (G)
poikilo- variegated (G)
poly- many (G)
poro- channel (L)
post- behind, after (L)
-pous foot (G)
pre- before (L)
primo- first (L)
procto- anus (G)
proto- first (G)

pseudo- false (G)
ptero- wing (G)
pulmo- lung (L)
pycno- dense (G)
quadra- four (L)
quasi- almost (L)
ram- branch (L)
rept- crawl (L)
retro- backward (L)
rhin- nose (G)
rhizo- root (G)
rhodo- rose-coloured (G)
rhynch- beak, snout (G)
sali- salt (L)
sarc- flesh (G)
saur- lizard (G)
schizo- split, division (G)
scler- hard (G)
scyphi- cup (G)
semi- half (L)
septi- partition (L)
sessil- sedentary (L)
siphono- tube (G)
somato- the body (G)
sphen- wedge (G)
spiro- spiral, coil (G)
splanchn- viscera (G)
spondyl- vertebra (G)
squam- scale (L)
stego- roof (G)
sten- narrow, straight (G)
stoma- mouth (G)
strati- layer (L)
styl- style (G)
sub- below (L)
supra- above ((L)
syn-, sym- together (G)
taxo- arrangement (G)
tecto- covering (G)
tele- from afar (G)
terra- earth (L)
terti- third (L)
tetr- four (G)
thalasso- sea (G)
thec- case (G)
theri- wild animal (G)
therm- heat (G)
-tom cutting (G)
trem- hole (G)
tri- three (G)
trich- hair (G)
trocho- wheel (G)
trop- turn, change (G)
tropho- nourishment (G)
tunic- cloak, covering (L)
turbi- disturbed (L)

ultim- farthest, last (L)
vas- vessel (L)
vel- veil (L)
ventro- underside (L)
-vorous feeding on (L)
xantho- yellow (G)
xipho- sword (G)
zoo- animal (G)
zyg- pair (G)

REFERENCES

Alderslade, P. 2001. Six new genera and six new species of soft coral, and some proposed familial and subfamilial vhanges within the Alcyonacea (Coelenterata: Octocorallia). *Bulletin of the Biological Society of Washington* 10: 15–65.

Athersuch, J., Horne, D.J. and Whittaker, J.E. 1989. Marine and brackish water ostracods. *Synopses of the British Fauna No. 43.* Linnean Society London and Estuarine and Brackish Water Sciences Association.

Ballantine, W.J. 1961. A biologically-defined exposure scale for the comparative description of rocky shores. *Field Studies* 1(3): 1–19.

Ballesteros, E., Cebrian, E., Garcia-Rubies, A., Alcoverro, T., Romero, J. and Font, X. 2005. Pseudovivipary, a new form of asexual reproduction in the seagrass *Posidonia oceanica*. *Botanica marina* 48: 175–177.

Bamber, R.N. 2001. A new species of *Rhopalorhychus* (Arthropoda: Pycnogonida) from the Semporna Islands, Sabah. *Species Diversity* 6: 179–183.

Bayer, F.M. 1981. Key to the genera of Octocorallia exclusive of Pennatulacea (Coelenterata: Anthozoa), with diagnoses of new taxa. *Proceedings of the Biological Society of Washington* 94: 901–947.

Bernal, D. and Sepulveda, C.A. 2005. Evidence for temperature elevation in the aerobic swimming musculature of the common thresher shark, *Alopias vulpinus*. *Copeia* 2005(1): 146–151.

Berta, A. and Churchill, M. 2012. Pinniped taxonomy: Review of currently recognized species and subspecies, and evidence used for their description. *Mammal Review* 42 (3): 207–34.

Blake, D.B. 1981. A reassessment of the sea-star orders Valvatida and Sinulosida. *Journal of Natural History* 15: 375–394.

Bodkin, J.L., Esslinger, G.G. and Monson, D.H. 2004. Foraging depths of sea otters and implications to coastal marine communities. *Marine Mammal Science* 20(2): 305–321.

Boetius, A. et al. (18 authors) (2013). Export of algal biomass from the melting Arctic sea ice. *Science* 339: 1430–1432.

Bortone, S.A., Brandini, F.P., Fabi, G. and Otake, S. 2011. *Artificial reefs in fisheries management*. CRC Press, 350pp.

Bouchet, P. and Rocroi, J-P. 2005. Classification and nomenclature of gastropod families. *Malacologia* 47(1–2): 1–397.

Bowden, D.A.; Schiaparelli, S.; Clark, M.R. and Rickard, G.J. 2011. A lost world? Archaic crinoid-dominated assemblages on an Antarctic seamount. *Deep Sea Research Part II: Topical Studies in Oceanography* 68(1–2): 119–127.

Bowen, W.D., Beck, C.A. and Austin, D.A. 2008. Pinniped Ecology. In: *Encyclopedia of Marine Mammals*, 2nd Edition, eds William F. Perrin, Bernd Versig, J.G.M. Thewissen. Academic Press (Elsevier), pp852–861.

Bowen, W.D., Tully, D., Boness, D.J., Bulheier, B.M. and Marshall, G.J. 2002. Prey-dependent foraging tactics and prey profitability in a marine mammal. *Marine Ecology Progress Series*. 244: 235–245.

Boyle, P. 2009. *Life in the Mid Atlantic. An exploration of marine life and environment in the middle of the North Atlantic Ocean from the sea surface to the sea bed.* Bergen Museum Press. 240pp.

Brierley, A. et al. (12 authors) 2002. Antarctic krill under sea ice: elevated abundance of krill in a narrow band just south of ice edge. *Science* 295: 1890–1892.

Bruce, N.L. 1986. Cirolanidae (Crustacea : Isopoda) of Australia. *Records of the Australian Museum Supplement* 6.

Butler, P. 2007. The Tree of the Sea: the shell of the bivalve mollusc *Arctica islandica* as a natural archive of the marine environment. *Porcupine Marine Natural History Newsletter* 22: 39–47.

Buxton, C.D. and Garratt, P.A. 1990. Alternative reproductive styles in seabreams (Pisces:Sparidae). *Environmental Biology of Fishes* 28: 113–124.

Bytingsvik, J., Lie, E., Aars, J., Derocher, A.E., Wiig, Ø. and Jenssen, B.M. 2012. PCBs and OH-PCBs in polar bear mother–cub pairs: A comparative study based on plasma levels in 1998 and 2008. *Science of the Total Environment*, 117: 417–418.

Cannicci, S., Burrows, D., Fratini, S., Smith III, T.J., Offenberg, J. and Dahdouh-Guebas, F. 2008. Faunal impact on vegetation structure and ecosystem function in mangrove forests: A review. *Aquatic Botany* 89: 186–200.

Cantero (2004). How rich is the deep-sea Antarctic benthic hydroid fauna? *Polar Biology* 27, 764–774. Online Springer-Verlag 27 August 2004.

Cavalier-Smith, T. 2004. Only six kingdoms of life. *Proc. R. Soc. Lond.* B 271: 1251–1262.

Cavalier-Smith, T. 2010. Kingdoms Protozoa and Chromista and the eozoan root of the eukaryotic tree. *Biology Letters* 6(3): 342–345.

Chagos Trust (2014). www.chagos-trust.org

Chau, R., Kalaitzis, J.A. and Neilan, B.A. (2011). On the origin and biosynthesis of tetrodotoxin. *Aquatic Toxicology* 104 (1–2), 61–72.

Chin, A., Sweatman, H., Forbes, S., Perks, H., Wlaker, R., Jones, G., Williamson, D., Evans, R., Hartley, F., Armstrong, S., Malcolm, H. and Edgar, G. (2008). Status of the Coral Reefs in Australia and Papua New Guinea. In: Wilkinson, C. (Ed.) *Status of Coral Reefs of the World: 2008*. Global Coral Reef Monitoring Network and Reef and Rainforest Research Centre, Townsville, Australia, 296p.

Clarke, M.R. 1978. Structure and proportions of the spermaceti organ in the sperm whale. *Journal of the Marine Biological Association UK* 58:, 1–17.

Cronin, M. A., Bodkin, J. L., Ballachey, B. E., Estes, J. A. and Patton, J. C. 1996. Mitochondrial-DNA variation among subspecies and populations of Sea otters. *Journal of Mammalogy*, 77: 546–557.

CITES See Appendix I.

Clague, D., Lundsten, L., Hein, J., Paduan, J. and Davis, A. 2010. Spotlight 6: Davidson Seamount. *Oceanography* 23(1): 126–127.

Colin, P.L. and Arneson, C. 1995. *Tropical Pacific Invertebrates. A Field Guide to the Marine Invertebrates Occurring on Tropical Pacific Coral Reefs, Seagrass beds and Mangroves*. Coral Reef Press, USA. 296pp.

Comeau, S., Gorsky, G., Jeffree, R., Teyssié, J.L. and Gattuso, J.-P. 2009. Impact of ocean acidification on a key Arctic pelagic mollusc (*Limacina helicina*). *Biogeosciences* 6: 1877–1882.

Cosgrove, J.A. 1987. Aspects of the natural history of *Octopus dofleini* the Giant Octopus. MSc. Thesis. Dept. Biology, University of Victoria (Canada) 101pp.

Couturier, L.I.E., Marshall, A.D., Jaine, F.R.A., Kashiwagi, T., Pierce, S.J., Townsend, K.A., Weeks, S.J., Bennett, M.B. and Richardson, A.J. 2012. Biology, ecology and conservation of the Mobulidae. *Journal of Fish Biology* 80(5): 1075–1119.

Cronin, M. A., Bodkin, J.L., Ballachey, B.E., Estes, J.A. and Patton, J.C. 1996. Mitochondrial-DNA variation among subspecies and populations of Sea otters. *Journal of Mammalogy*, 77: 546–557.

Cuypers, E.; Yanagihara, A.; Karlsson, E. and Tytgat, J. 2006. Jellyfish and other cnidarian envenomations cause pain by affecting TRPV1 channels. *FEBS Letters* 580: 5728–5732.

Daly, M. and Gusmao, L. 2007. The first sea anemone from a whale fall. *Journal of Natural History* 41: 1–11.

Davenport, J., Hughes, R.N., Shorten, M. and Larsen, P.S. 2011. Drag reduction by air release promotes fast ascent in jumping emperor penguins – a novel hypothesis. *Marine Ecology Progress Series* 430: 171–182.

Davis, A. R. 1996. Association among ascidians: facilitation of recruitment in *Pyura spinifera*. *Marine Biology* 126(1): 35–41.

Dawson, M.N. 2005. Five new subspecies of *Mastigias* (Scyphozoa: Rhizostomae: Mastigiidae) from marine lakes, Palau, Micronesia. *J. Mar. Biol. Ass. U.K.* 85: 679–694.

De'Ath, G., Lough, J.M. and Sabricius, K.E. 2009. Declining coral calcification on the Great Barrier Reef. *Science* 323: 116–119.

Debelius, H. (2001). *Crustacea Guide of the World*. Ikan, Germany.

De Goeij, J.M., van Oevelen, D., Vermeij, M.J.A., de Goeij, A.F.P.M. and Admiraal, W. 2013. Surviving in a marine desert: the sponge loop retains resources within coral reefs. *Science* 342(6154): 108–110.

Dehyn, D.D. 2001. Bioluminescence in the Brittle Star *Amphipholis squamata* (Echinodermata): An Overview of 10 Years of Research. In: *Proceedings of the 11th Symposium on Bioluminescence and Chemoluminescence*. Eds. Case et al. World Scientific Publishing Ltd.

Diaz, R. and Rosenberg, R. 2008. Spreading Dead Zones and Consequences for Marine Ecosystems. *Science* 321(5891): 926–929.

Dickson, K.A. and Graham, J.B. 2004. Evolution and consequences of endothermy in fishes. Physiological and Biochemical Zoology 77(6): 98–1018.

Dipper, F. 1991. Colonisation and natural changes in a newly established 'artificial reef' in Gulf waters. In: *Estuaries and Coasts: Spatial and Temporal Intercomparisons*. ECSA19 Symposium. Eds Elliott, M. and Ducrotoy, J-P.

Dipper, F. and Chua, T-H. 1997. *Biological impacts of oil pollution: Fisheries*. IPIECA.

Downey, M.E. 1986. Revision of the Atlantic Brisingida (Echinodermata: Asteroidea), with Description of a New Genus and Family. *Smithsonian Contributions to Zoology*, No.435. Smithsonian Institution Press.

Dunson, W.A. 1969. Electrolyte excretion by the salt gland of the Galapagos marine iguana. *American Journal of Physiology* 216: 995–1002.

Eakins, B.W. and Sharman, G.F. 2010. Volumes of the World's oceans from ETOPO1, NOAA National Geophysical Data Center, Boulder, USA. http://www.ngdc.noaa.gov/mgg/global/etopo1_ocean_volumes.html

Eaves, A.A. and Palmer, A.R. 2003. Widespread cloning in echinoderm larvae. *Nature* 425: 146.

Ebbinghaus, S., Meister, K., Born, B., DeVries, A.L., Gruebele, M. and Havenith, M. 2010. Antifreeze glycoprotein activity correlates with long-range protein–water dynamics. *Journal of the American Chemical Society* 132(35), 12210–12211.

Debelius, H. 2001. *Crustacea Guide of the World*. Ikan, Germany, 321pp.

Ebert, D.A., Fowler, S. and Compagno, L. 2013. *Sharks of the World*. Wild Nature Press. 528pp.

Epibiont Research Cooperative (ERC) 2007. A Synopsis of the Literature on the Turtle Barnacles (Cirripedia: Balanomorpha: Coronuloidea) 1758–2007. *Epibiont Research Cooperative Special Publication* Number 1, 62 pp.

Eschmeyer, W. N. (ed). 2014. Catalog of Fishes. California Academy of Sciences (http://research.calacademy.org/research/ichthyology/catalog/fishcatmain.asp). Electronic version.

Fabricius, K. and Alderslade, P. (2001). *Soft Corals and Sea Fans. A comprehensive guide to the tropical shallow-water genera of the Central-West pacific, the Indian Ocean and the Red Sea*. Australian Institute of Marine Science and the Museum and Art Gallery of the Northern Territory, 264pp.

FAO, 2011. FAO Review of the state of world marine fishery resources. *FAO Fisheries and Aquaculture Technical Paper* 569. Rome, FAO, 2011, 334pp.

FAO, 2012. FAO Yearbook. Fishery and Aquaculture Statistics. 2010. Rome FAO. (www.fao.org/fishery/publications/yearbooks)

FAO, 2013. FAO. Yearbook. Fishery and Aquaculture Statistics. 2011. Rome FAO. (www.fao.org/fishery/publications/yearbooks).

FAO, 2014. FAO. Yearbook. Fishery and Aquaculture Statistics. 2012. Rome FAO. (www.fao.org/fishery/publications/yearbooks).

Fernández, A., Arbelo, M. and Martín, V. 2013. Whales: no mass strandings since sonar ban. *Nature* 497, 317 (16 May 2013).

Fleming, P.A., Muller, D. and Bateman, P.W. (2007). Leave it all behind: a taxonomic perspective of autotomy in invertebrates. *Biological Review* 82(3), 481–510.

Fontaneto, D., De Smet, W.H. and Ricci, C. 2006. Rotifers in saltwater environments, re-evaluation of an inconspicuous taxon. *J. Mar. Biol. Ass. UK* 86: 623–656.

Fortes, M.D. 1990. *Seagrasses: A resource unknown in the ASEAN region*. ICLARM Educational Series 5, International Centre for Living Aquatic Resources Management. Manila, the Philippines.

Fourqurean, J.W., Duarte, C.M., Kennedy, H., Marbà, N., Holmer, M., Mateo, M.A., Apostolaki, E.T., Kendrick, G.A., Krause-Jensen, D., McGlathery, K.J. and Serrano, O. 2012. Seagrass ecosystems as a globally significant carbon stock. *Nature Geoscience* 5: 505–509.

Friar, W., Ackman, R.G. and Mrosovsky, N. 1972. Body temperature of *Dermochelys coriacea*: warm turtle for cold water. *Science* 177:791–793.

Fricke, H.W., Reinicke, O., Hofer, H., and Nachtigall, W. 1987.Locomotion of the coelacanth *Latimeria chalumnae* in its natural environment. *Nature* 329: 331–333.

Fricke, H.W., Schauer, J., Hissmann, K., Kasang, L. and Plante, R. 1991. Coelacanth *Latimeria chalumnae* aggregates in caves: first observations on their resting habitat and social behaviour. *Environmental Biology of Fishes* 30: 281–285.

Fudge, D.S., Levy, N., Chiu, S. and Gosline, J.M. 2005. Composition, morphology and mechanics of hagfish slime. *Journal of Experimental Biology* 208: 4613–4625.

García-Párraga, D., Crespo-Picazo, J.L., Bernaldo de Quirós, Y., Cervera, V., Martí-Bonmati, L., Díaz-Delgado, J., Arbelo, M., Moore, M.J., Jepson, P.D. and Fernández, A. 2014. Decompression sickness ('the bends') in sea turtles. *Diseases of Aquatic Organisms* 111: 191–205.

Garm, A., Oskarsson, M. and Nilsson, D-E 2011. Box jellyfish use terrestrial visual cues for navigation. *Current Biology* 21(9): 798–803.

Gazave, E., Lapébie, P., Ereskovsky, A., Vacelet, J., Renard, E., Cárdenas, P. and Borchiellini, C. 2012. No longer Demospongiae: Homoscleromorpha formal nomination as a fourth class of Porifera. *Hydrobiologia* 687: 3–10.

Gazave, E., Lapébie, P., Renard, E., Vacelet, J., Rocher, C., Ereskovsky, A.V., Lavrov, D.V. and Borchiellini, C. 2010. Molecular phylogeny restores the supra-generic subdivision of homoscleromorph sponges (Porifera, Homoscleromorpha). *PLoS One*. Published December 14 2010. doi:10.1371/journal.pone.0014290

George, J.D. and George, J.J. 1979. *Marine Life. An Illustrated Encyclopedia of Invertebrates in the Sea*. Lionel Leventhal Ltd. 288pp.

Geraci, J.R. and Lounsbury, V.J. 2008. *Health*. In: *Encyclopedia of Marine Mammals*, 2nd edition 2008, edited by William F. Perrin, Bernd Versig and J.G.M. Thewissen. Academic Press (Elsevier), 546–553.

German, C.R., Parson, L.M. and Mills, R.A. 1996. Mid-Ocean Ridges and Hydrothermal Activity. In: *Oceanography. An Illustrated Guide*. Eds C.P. Summerhayes and S.A. Thorpe. Manson Publishing. 352pp.

Gershwin, L.-a. 2013. *Stung! On Jellyfish and the Future of the Ocean*. The University of Chicago Press, 456pp.

Gershwin, L.-a and Dawes, P. (2008). Preliminary observations on the response of *Chironex fleckeri* (Cnidaria: Cubozoa: Chirodropida) to different colours of light. *Biological Bulletin (Woods Hole)* 215: 57.

Giribet, G., Okusu, A., Lindgren, A.R., Huff, S.W., Schrödl, M. and Nishiguchi, M.K. 2006. Evidence for a clade composed of molluscs with serially repeated structures: monoplacophorans are related to chitons. *Proceedings of the National Academy of Sciences of the United States of America* 103 (20): 7723–7728.

Gower, J. and King, S. 2008. Satellite images show the movement of floating *Sargassum* in the Gulf of Mexico and Atlantic Ocean. Available from *Nature Precedings* http://precedings.nature.com/documents/1894/version/1/files/npre20081894-1.pdf

Gray, L.J., Shubin, K., Cummins, H., McCollum, D., Bruns, T. and Comiskey, E. 2010. Sacrificial leaf hypothesis of mangroves. *ISME/GLOMIS Electronic Journal* 8(4): 7–8.

Green, E.P. and Short, F.T. (eds) 2003. *World Atlas of Seagrasses*. UNEP World Conservation Monitoring Centre. University of California Press. 298pp.

Grutter, A.S., Rumney, J.G., Sinclair-Taylor, T.,Waldie, P. and Franklin, C.E. (2010). Fish mucous cocoons: the 'mosquito nets' of the sea. Biology Letters. Published online 17 Nov. 2010.

Guiry, M.D. and Guiry, G.M. 2014. *AlgaeBase*. World-wide electronic publication, National University of Ireland, Galway. http://www.algaebase.org.

Habegger, M.L., Motta, P.J., Huber, D.R. and Dean, M.N. 2012. Feeding, biomechanics and theoretical calculation of bite force in bull sharks (*Carcharhinus leucas*) during ontogeny. *Zoology* 116(6): 354–364.

Hadas, E.,Shpigel, M. and Ilan, M. 2005. Sea ranching of the marine sponge *Negombata magnifica* (Demospongiae, Latrunculiidae) as a first step for latrunculin B mass production. *Aquaculture* 244: 159–169.

Haddock, S.H.D., Moline, M.A. and Case, J.F. 2010. Bioluminescence in the Sea. *Annual Review of Marine Science* 2: 443–493.

Hamilton, C.D., Lydersen, C., Ims, R.A. and Kovacs, K.M. 2014. Haul-out behaviour of the world's northernmost population of Harbour Seals *Phoca vitulina* throughout the year. *PLoS ONE* 9(1): e86055. doi:10.1371/journal.pone.0086055.

Hamner, W.M., Hamner, P.P. and Strand, S.W. 1994. Sun-compass navigation by *Aurelia*

aurita (Scyphozoa): population retention and reproduction in Saanich Inlet, British Columbia. *Marine Biology* 119(3): 347–356.

Hanlon, R.T. and Messenger, J.B. 1996. *Cephalopod Behaviour*. Cambridge University Press. Cambridge, UK.

Härkönen, T., Dietz, R., Reijnders, P., Teilmann, J., Harding, K., Hall, A., Brasseur, S., Siebert, U., Goodman, S.J., Jepson, P.D., Dau Rasmussen, T. and Thompson, P. 2006. The 1988 and 2002 phocine distemper virus epidemics in European harbour seals. *Diseases of Aquatic Organisms*. 68(2):115–30.

Hart, N.S., Theiss, S.M., Harahush, B.K. and Collin, S.P. 2011. Microspectrophotometric evidence for cone monochromacy in sharks. *Naturwissenschaften* 98(3): 193–201.

Hayward, P.J. and Ryland, J.S. 1995. *Handbook of the Marine Fauna of North-West Europe*. Oxford University Press, Oxford, UK. 800pp.

Heimberg, A.M., Cowper-Sallari, R., Sémon, M., Donoghue, P.C.J. and Peterson, K.J. 2010. MicroRNAs reveal the interrelationships of hagfish, lampreys, and gnathostomes and the nature of the ancestral vertebrate. *Proceedings of the National Academy of Science of the USA* 107(45): 19379–19383.

Helfman, G.S., Collette, B.B., Facey, D.E. and Bowen, B.W. 2009. *The Diversity of Fishes. Biology, Evolution and Ecology* 2nd ed. Wiley-Blackwell. 720pp.

Hibbett, D.S. *et al*. (66 authors) 2007. A higher-level classification of the Fungi. *Mycological Research* 111(6): 509–547.

Hiscock, K. and Irving, R.A. (2012). *Protecting Lundy's marine life: 40 years of science and conservation*. Lundy Field Society. 108pp.

Hochscheid, S., Bentivegna, F., and Hays, G.C. 2005. First records of dive durations for a hibernating sea turtle. *Biology Letters* 1(1): 82–86.

Hoeksema, B.W. and Borel-Best, M. (1991). New observations on scleractinian corals from Indonesia 2. Sipunculan associated species belonging to the genera *Heterocyathus* and *Heteropsammia*. Zoologische Medelingen 65, 221–245.

Hoekstra JM, Molnar JL, Jennings M, Revenga C, Spalding MD, Boucher TM, Robertson JC, Heibel TJ, Ellison K (2010) *The Atlas of Global Conservation: Changes, Challenges, and Opportunities to Make a Difference*. University of California Press.

Hogg, M.M., Tendal, O.S., Conway, K.W., Pomponi, S.A., van Soest, R.W.M., Gutt, J., Krautter, M. and Roberts, J.M. 2010. Deep-sea Sponge Grounds: Reservoirs of Biodiversity. UNEP-WCMC Biodiversity Series No. 32. UNEP-WCMC, Cambridge, UK.

Holstein, T.W. and Tardent, P. 1984. An ultra high-speed analysis of exocytosis: nematocyst discharge. *Science* 223(4638): 830–833.

Houghton, J.D.R., Doyle, T.K., Davenport, J., Wilson, R.P. and Hays, G.C. 2008. The role of infrequent and extraordinary deep dives in the leatherback turtle (*Dermocheles coriacea*). *Journal of Experimental Biology* 211: 2566–2575.

Ingley, S. 2010. New perspectives on the ecology and natural history of the Yellow-bellied Sea Snake (*Pelamis platurus*) in Costa Rica: Does precipitation influence distribution? *IRCF Reptiles and Amphibians* 17(2): 69–72.

IUCN (2014). *The IUCN Red List of Threatened Species*. International Union for Conservation of Nature: www.iucnredlist.org. See also Appendix I.

Janvier, P. 2010. MicroRNAs revive old views about jawless vertebrate divergence and evolution. *Proceedings of the National Academy of Sciences of the United States of America* 107 (45): 19137–19138.

Jeng, M.S., Huang, H.D., Huiao, Y.C. and Benayahu, Y. 2011. Sclerite calcification and reef-building in the flshy octocoral genus *Sinularia* (Octocorallia: Alcyonacea). *Coral Reefs* 30: 925–933.

Johnson, C. 2014. "Report: Vaquita population declines to less than 100". *Vaquita: Last Chance for the Desert Porpoise*. http://vaquita.tv/blog/2014/08/03/report-vaquita-population-declines-to-less-than-100. 03 August 2014.

Kassem, K., Hoeksema, B. and Affendi, Y.A. (eds) 2012. *Semporna Marine Ecological Expedition*. WWF-Malaysia, NCB Naturalis, Universiti Malaysia Sabah. Kota Kinabalu, Malaysia.

Kelly, R. 2012. *Indo Pacific Coral Finder*. BYO Guides, Townsville, Australia.

Kerr, R. A. 2012. Ice-Free Arctic Sea May be Years, Not Decades, Away. *Science* 337: 1591.

Kirby, R.R. 2010. *Ocean Drifters. A secret world beneath the waves*. Studio Cactus Books, UK. 192pp.

Kooyman, G.L. 1989. Oxygen stores. In: Diverse divers: Physiology and Behaviour. *Zoophysiology* 23, 53–65. Springer-Verlag, Germany.

Krembs, C., Eicken, H. and Deming, J.W. 2011. Exopolymer alteration of physical properties of sea ice and implications for ice habitability and biogeochemistry in a warmer Arctic. Proceedings of the National Academy of Sciences of the USA 8(9): 3653–3658.

Kurlansky, M. 1999. *Cod. A biography of the fish that changed the world*. Vintage. 294pp.

Laan, R. van der; Eschermeyer, W.N. and Fricke, R. 2014. Family group names of recent fishes. *Zootaxa* 3882 (2): 001–230.

Lalli M.L. and Parsons, T.R. 1993. *Biological Oceanography: an Introduction*. Pergamon Press. 301pp.

Lampitt, R.S. 1996. Snow falls in the open ocean. In: *Oceanography. An illustrated guide*. Eds C.P. Summerhayes and S.A. Thorpe. Manson Publishing.

Laurin, M. and Gauthier, J.A. 2012. Amniota. Mammals, reptiles (turtles, lizards, *Sphenodon*, crocodiles, birds) and their extinct relatives. Version 30 January 2012. http://tolweb.org/Amniota/14990/2012.01.30in The Tree of Life Web Project, http://tolweb.org/

Leitz, T. and Wagner, T. (1993) The marine bacterium *Alteromonas espejiana* induces metamorphosis of the hydroid *Hydractinia echinata*. *Marine Biology* 115, 173–178.

Lilywhite, H.B., Babonis, L.S., SheehyIII, C.M. and Ming-Chung, T. 2008. Sea snakes (*Laticauda* spp.) require fresh drinking water: implications for the distribution and persistence of populations. *Physiological and Biochemical Zoology* 81(6): 785–796.

Lisotte, M.P. 2001. The contribution of sea ice to Antarctic marine primary production. *American Zoologist* 41: 57–73.

Littler, M.M., Littler, D.S., Blair, S.M. and Norris, J.N. 1985. Deepest known plant life discovered on an uncharted seamount. *Science* 227: 57–59.

Lively, C.M. (1986). Predator-induced shell dimorphism in the acorn barnacle *Chthamalus anisopoma*. *Evolution* 40(2), 232–242.

Losey, G.S. 2003. Crypsis and communication functions of UV-visible colouration in two coral reef damselfish, *Dascyllus aruanus* and *D. reticulatus*. *Animal Behaviour* 66: 229–307.

Lowe, C.G., Bray, R.N. and Nelson, D.R. 1994. Feeding and associated electrical behaviour of the Pacific electric ray *Torpedo californica* in the field. *Marine Biology* 120(1): 161–169.

Lowry, J.K. and Myers, A.A. 2013. A phylogeny and classification of the Senticaudata subord. nov. (Crustacea: Amphipoda). *Zootaxa* 3610(1): 1–80.

Luther, G.W. III; Rozan, T.F., Taillefert, M., Nuzzio, D.B., Meo, C.D., Shank, T.M., Lutz, R.A. and Cary, S.C. 2001. Chemical speciation drives hydrothermal vent ecology. *Nature* 410: 813–816.

Lutz, R.A., Desbruyères, D., Shank, T.M. and Vrijenhoek, R.C. 1998. A deep-sea hydrothermal vent community dominated by Stauromedusae. *Deep-Sea Research II* 45: 329–334.

Lutz, P.L., Musick, J.A. and Wyneken, J. 2002. *The biology of sea turtles Vol. III*. CRC Marine Biology Series. 472pp.

Maciá, S., Robinson, M.P., Craze, P., Dalton, R. and Thomas, J.D. 2004. New observations on airborne jet propulsion (flight) in squid, with a review of previous reports. *Journal Molluscan Studies* 70: 297–299.

Malayan Nature Society 1987. The coral reefs of the Bodgaya Islands (Sabah: Malaysia) and Pulau Sipadan. *The Malayan Nature Journal* 40(3&4): 167–324.

Marshall, A.D., Compagno, L.J.V. and Bennett, M.B. 2009. Redescrition of the genus Manta with resurrection of *Manta alfredi* (Krefft, 1868) (Chondricchthyes; Myliobatoidei; Mobulidae). *Zootaxa* 2301: 1–28.

Martin, D. and Britayev,T.A. 1998. Symbiotic Polychaetes: Review of known species. *Oceanography and Marine Biology Annual Review* 36: 217–340.

Mass, A.M. and Supin, A.YA. 2007. Adaptive features of aquatic mammals eye. The Anatomical Record 290: 701–715.

Mauchline, J. 1984. Euphausiid, Stomatopod and Leptostracan Crustaceans. *Synopses of the British Fauna (New Series)* No. 30. Published for The Linnean Society of London and the Estuarine and Brackish-Water Sciences Association by E.J. Brill/W. Backhuys.

Mauseth, J.D. 2009. Botany: An introduction to plant biology 4th edn. Jones and Bartlett Publishers, Canada.

McClintock, J.B. and Baker, B.J. (2001). *Marine chemical ecology*. CRC Press. Florida, USA.

McNamara, K. J. 2011. *The Star-Crossed Stone. The Secret Life, Myths and History of a Fascinating Fossil*. University of Chicago Press.

Miliagros, L-M., Rocha, C.F.D., Domingo, A., Wallace, B.P. and Miller, P. 2008. Prolonged, deep dives by the leatherback turtle *Dermocheles coriacea*: pushing their aerobic dive limits. *JMBA2 – Biodiversity records*. Published on-line.

Miller, P.J.O., Aoki, K., Rendell, L.E. and Amano, M. 2008. Stereotypical resting behaviour of the sperm whale. *Current Biology* 18: 21–23.

Mitchell, R., Dipper, F.A., Earll, R. and Rowe, S. 1980. A preliminary study of Loch Obisary: a brackish Hebridean loch. *Progress in Underwater Science* vol.5.

Mirceta, S., Signore, A.V., Burns, J.M., Cossins, A.R., Campbell, K.L. & Berenbrink, M. 2013. Evolution of Mammalian Diving Capacity Traced by Myoglobin Net Surface Charge. *Science* 14 June 2013: Vol. 340 no. 6138.

Mladenov, P.V., Emson, R.H., Colpit, L.V. and Wilkie, I.C. 1983. Asexual reproduction in the West Indian brittle star *Ophiocomella ophiactoides* (H.L. Clark) (Echinodermata: Ophiuroidea). *Journal Experimental Marine Biology and Ecology*, 72(1): 1–23.

Mora, C., Tittensor, D.P., Adl, S., Simpson, A.G.B. and Worm, B. 2011. How Many Species Are There on Earth and in the Ocean? *PLoS Biology* 9(8): e1001127. doi:10.1371/journal.pbio.1001127

Morton, B. 1981. Prey capture in the carnivorous septibranch *Poromya granulata* (Bivalvia :Anomalodesmata:Poromyacea). *Sarsia* 66: 241–256.

Moy, A.D., Howard, W.R., Bray, S.G. and Trull, T.W. 2009. The reduced calcification in modern Southern Ocean planktonic foraminifera. *Nature Geoscience* 2: 276–280.

Munn, C. 2011. *Marine microbiology: ecology and applications*. 2nd ed. Garland Science, New York, USA.

Myers, R.A., Baum, J.K., Shepherd, T.D., Powers, S.P. and Peterson, C.H. 2007. Cascading effects of the loss of apex predatory sharks from a coastal ocean. *Science* 315: 1846–1850.

Naughton, K.M. and O'Hara 2009. A new brooding species of the biscuit star *Tosia* (Echinodermata: Asteroidea: Goniasteridae). *Invertebrate Systematics* 23(4), 348–366.

Nelson, J.S. 2006. *Fishes of the World*. 4th ed. John Wiley and Sons Inc.

Obst, M. and Funch, P. 2003. Dwarf male of *Symbion pandora* (Cycliophora). *Journal Morphology* 255: 261–278.

Obuchi, M., Kogo, I. and Fujita Y. 2008. A new brooding feather star of the genus *Dorometra* (Echinodermata: Crinoidea: Comatulida: Antedonidae) from the Ryukyu Islands, southwestern Japan. *Zootaxa* 2008: 61–68 (2009).

O'Dea, A. 2009. Relation of form to life habit in free-living cupuladriid bryozoans. *Aquatic Biology* 7: 1–18.

Orr, J.C., et al. (27 authors) 2005. Anthropogenic ocean acidification over the twenty-first century and its impact on calcifying organisms. *Nature* 437: 681–686.

O'Shea, S. 2004. The giant octopus *Haliphron atlanticus* (Mollusca: Octopoda) in New Zealand waters. *New Zealand Journal Zoology* 31: 7–13.

Pagano, A.M., Durner, G.M., Amstrup, S.C., Simac, K.S. and York, G.S. 2012. Long-distance swimming by polar bears (*Ursus maritimus*) of the southern Beaufort Sea during years of extensive open water. *Canadian Journal of Zoology*, 90(5): 663–676.

Patek, S.N., Korff, W.L. and Caldwell, R.L. 2004. Deadly strike mechanism of a mantis shrimp. *Nature* 428: 819 (brief communications).

Peaker, M. and Linzell, J.L. 2009. *Salt glands in Birds and Reptiles*. Cambridge University Press, Cambridge, UK.

Peck, L.S., Hayward, P.J. and Spencer-Jones, M.E. 1995. A pelagic bryozoan from Antarctica. *Marine Biology* 123: 757–762.

Philippe, H., Brinkmann, H., Copley, R.R., Moroz, L.L., Nakano, H. Poustka, A.J., Wallberg, A., Peterson, K.J. and Telford, M.J. 2011. Acoelomorph flatworms are deuterostomes related to *Xenoturbella*. *Nature* 470: 255–258.

Piraino, S., De Vito, D., Schmich, J., Bouillon, J. and Boero, F. 2004. Reverse development in Cnidaria. *Canadian Journal Zoology* 82: 1748–1754.

Pitcher, T.J. 2010. Eight major target species in world seamount fisheries. In: *Mountains in the Sea, Oceanography* 23(1): 130–131.

Powell, M.I., Kavanaugh, S. and Sower, S.A. 2005. Current knowledge of Hagfish reproduction: Implications for Fisheries Management. *Integrative and Comparative Biology* 45(1): 158–165.

Priede, M. 1990. The Sea snakes are coming. *New Scientist* 1742, 10th November 1990.

Priede, I.G., Froese, R., Bailey, D.M., Bergstad, O.A., Collins, M.A., Dyb, J.A., Henriques, C., Jones, E.G. and King, N. 2006. The absence of sharks from abyssal regions of the world's oceans. *Proc. Roy. Soc. B* 273: 1435–1441.

Regier, J.C., Shultz, J.W., Zwick, A., Hussey, A., Ball, B., Wetzer, R., Martin, J.W. and Cunningham, C.W. 2010. Arthropod relationships revealed by phylogenomic analysis of nuclear protein-coding sequences. *Nature* 463: 1079–1083.

Rice, A.N. and Bass, A.H. 2009. Novel vocal repertoire and paired swimbladders in the three-spined toadfish *Batrachomoeus trispinosus*: insights on the diversity of the Batrachoididae. *Journal Experimental Biology* 212: 1377–1391.

Rice, A.N., Land, B.R. and Bass, A.H. 2011. Nonlinear acoustic complexity in a fish 'two-voice' system. *Proc. Roy. Soc. B*. Published online doi:10.1098/rspb.2011.0656

Riemann-Zürneck, K. 1998. How sessile are sea anemones? A review of free-living forms in the Actiniaria, Cnidaria:Anthozoa. *Marine Ecology* 19(4): 247–261.

Rivera Posada, J.A., Pratchett, M., and Owens, L. (2011). Injection of *Acanthaster planci* with thiosulfate-citrate-bile-sucrose agar (TCBS). II. Histopathological changes. *Diseases of Aquatic Organisms*, 97 (2). pp. 95–102.

Rogers, A.D., Tyler, P.A., Connelly, D.P., Copley, J.T. James, R. 2012. The discovery of new deep-sea hydrothermal vent communities in the Southern Ocean and implications for biogeography. *PLoS Biology* 10(1): e1001234. doi:10.1371/journal.pbio.1001234.

Roman, J., Estes, J.A., Morissette, L., Smith, C., Costa, D., McCarthy, J., Nation, J.B., Nicol, S., Pershing, A. & Smetacek, V. 2014. Whales as marine ecosystem engineers. *Frontiers in Ecology and the Environment*, 12: 377–385.

Rosa, R. and Seibel, B. 2010. Slow pace of life of the Antarctic colossal squid. *Journal Marine Biological Association* 90: 1375–1378.

Royal Society 2005. *Ocean acidification due to increasing atmospheric carbon dioxide*. Policy Document 12/05 June 2005.

Rubinoff, I., Graham, J.B. and Kotta, J. 1986. Diving of the sea snake *Pelamis platurus* in the Gulf of Panama I. Dive depth and duration. *Marine Biology* 91: 181–191.

Runcie, R.M., Dewar, H., Hawn, D.R., Frank, L.R. and Dickson, K.A. 2009. Evidence for cranial endothermy in the opah (*Lampris guttatus*). *Journal of Experimental Biology* 212: 461–470.

Sangster, G., Collinson, J.M., Crochet, P.A., Knox, A.G., Parkin, D.T. and Votier, S.C. 2012. Taxonomic recommendations for British birds: eighth report. *Ibis*: 874–883.

Schöne, B.R., Fiebig, J., Pfeiffer, M., Gleb, R., Hickson, J., Johnson, A.L.A., Dreyer, W. and Oschmann, W. 2005. Climate records from a bivalved Methuselah (*Arctica islandica*, Mollusca; Iceland). *Palaeogeography, Palaeoclimatology, Palaeoecology* 228: 130–148.

Schorr, G.S., Falcone, E.A., Moretti, D.J. & Andrews, R.D. 2014. First Long-Term Behavioural Records from Cuvier's Beaked Whales (*Ziphius cavirostris*) Reveal Record-Breaking Dives. *PLoS ONE* 9(3): e92633. doi:10.1371/journal.pone.0092633.

Schubert, M., Munday, P.L., Caley, M.J., Jones, G.P. and Llewellyn, L.E. 2003. The toxicity of skin secretions from coral-dwelling gobies and their potential role as a predator deterrent. *Environmental Biology of Fishes* 67: 359–367.

Sheppard, C. (Ed.) (2013). *Coral Reefs of the United Kingdom Overseas Territories*. Coral Reefs of the World Vol. 4. Springer 323pp.

Short, F.T. and Wyllie-Echeverria, S. 2000. Global seagrass declines and effects of climate change. In: Sheppard, C. (ed.). *Seas at the millennium: An Environmental evaluation*, Vol. 3, 10–11. Elsevier Science.

Siedler, G, J. Church and J. Gould (eds) 2001. *Ocean Circulation and Climate – Observing and Modelling the Global Ocean*. Academic Press, International

Geophysics Series No 77, 715pp.

Sjøtun, S. and Fredriksen, S. 1995. Growth allocation in *Laminaria hyperborea* (Laminariales, Phaeophyceae) in relation to age and wave exposure. *Marine Ecology Progress Series* 126: 213–222.

Skov, P.V., Steffensen, J.F., Sørensen, T.F. and Quortrup, K. 2010. Embryonic suckling and material specialisations in the live-bearing teleost *Zoarces viviparous*. *Journal of Experimental Marine Biology and Ecology* 395(1–2): 120–127.

Smith, A. B. and Kroh, A. (eds) 2011. *The Echinoid Directory*. World Wide Web electronic publication. http://www.nhm.ac.uk/research-curation/projects/echinoid-directory [accessed June 2012]

Spalding, M., Kainuma, M. and Collins, L. 2010. *World Atlas of Mangroves*. Earthscan. 319pp.

Spalding, M., Ravilious, C. and Green, E.P. 2001. *World Atlas of Coral Reefs*. UNEP-WCMC, University of California Press.

Stewart, B.S. 2008. Diving Behaviour. In: Encyclopedia of Marine Mammals, 2nd Edition, eds William F. Perrin, Bernd Versig, J.G.M. Thewissen. Academic Press (Elsevier), p. 321–327.

Stocks, K. 2004. Seamount invertebrates: Composition and vulnerability to fishing. In: Morato, T. and Pauly, D. (eds) *Seamounts: Biodiversity and Fisheries. Fisheries Research Reports* 12(5), 78pp.

Stokes, M.D. and Holland, N.D. 1992. Southern stingray (*Dasyatis americana*) feeding on lancelets (*Branchiostoma floridae*). Journal of Fish Biology 41: 1043–1044.

Stow, D. 2004. *Encyclopedia of the Oceans*. Oxford University Press. Oxford, UK.

Struck, T.H., Paul, C., Hill, N., Hartmann, S., Hösel, C., Kube, M., Lieb, B., Meyer, A., Tiedemann, R., Purschke, G. and Bleidorn, C. 2011. Phylogenomic analyses unravel annelid evolution. *Nature* 471: 95–98.

Sumoski, S.E. and Orth R.J. 2012. Biotic dispersal in eelgrass *Zostera marina*. *Marine Ecology Progress Series* 471: 1–10.

Tarling, G.A., Klevjer, T., Fielding, S., Watkins, J.L., Atkinson, A., Murphy, E.J., Korb, R., Whitehouse, M. and Leaper, R. 2009. Variability and predictability of Antarctic krill swarms structure. *Deep Sea Research Part I* 56: 1994–2012.

Thiel, M. and Junoy, J. (2006). Mating behaviour of nemerteans: present knowledge and future directions. *Journal Natural History* 40(15–16): 1021–1034.

Thompson, K., Baker, C.S., van Helden, A., Patel, S., Millar, C. & Constantine, R. 2012. The world's rarest whale. *Current Biology* 22 (21): R905–R906.

Thurber, A.R., Jones, W.J. and Schnabel, K. 2011. Dancing for food in the deepsea: bacterial farming by a new species of yeti crab. *PLoS ONE* 6(11): DOI: 10.1371/journal.pone.0026243

Toral-Granda, M.V., Lovatelli, A., Vasconcellos, M. (eds) 2008. Sea cucumbers. A global review of fisheries and trade. *FAO Fisheries and Aquaculture Technical Paper*. No. 516. Rome, FAO 317pp.

Vacelet, J. and Duport, E. 2004. Prey capture and digestion in the carnivorous sponge *Asbestopluma hypogea* (Porifera:Demospongiae). *Zoomorphology* 123: 179–190.

Van-Eyk, S.M., Siebeck, U.E., Champ, C.M., Marshall, J. and Hart, N.S. 2011. Behavioural evidence for colour vision in an elasmobranch. *Journal of Experimental Biology* 214: 4186–4192.

Velando, A., Beaumonte-Barrientos, R. and Torres, R. 2006. Pigment-based skin colour in the blue-footed booby: an honest signal of current condition used by females to adjust reproductive investment. *Oecologia* 149(3): 535–542.

Veron, J.E.N. 2000. *Corals of the World Vols. 1–3*. Australian Institute of Marine Science, Townsville, Australia.

Wells, R.W. 2007. Some taxonomic and nomenclatural considerations on the class Reptilia in Australia. The sea snakes of Australia. An introduction to the members of the families Hydrophiidae and Laticaudidae in Australia, with a new familial and generic arrangement. *Australian Biodiversity Record* 8: 1–124.

Weng, K. and Block, B. 2004. Diel vertical migration of the bigeye thresher shark (*Alopias superciliosus*), a species possessing orbital retia mirabilia. *Fishery Bulletin* 102: 221–229.

Whittaker, R.H. 1969. New concepts of kingdoms or organisms. Evolutionary relations are better represented by new classifications than by the traditional two kingdoms. *Science* 163(3863): 150–160.

Wilkinson, C. 2008. *Status of coral reefs of the world: 2008*. Global Coral Reef Monitoring Network and Reef and Rainforest Research Centre, Townsville, Australia, 296p.

Williams, G.C. and Alderslade, P. 2011. Three new species of pennatulacean octocorals with the ability to attach to rocky substrata (Cnidaria: Anthozoa: Pennatulacea). *Zootaxa* 3001: 33–48.

Wilson, W.H. 1991. Sexual reproductive modes in polychaetes: classification and diversity. *Bulletin of Marine Science* 48(2): 500–516.

WOCE, 2003. WOCE observations 1990–1998: a summary of the WOCE global data resource. *WOCE International Project Office, WOCE Report* No. 179/02., Southampton, UK.

Woese, C.R. and Fox, G.E. 1977. Phylogenetic structure of the prokaryotic domain: the primary kingdoms. *Proceedings of the National Academy of Science USA* 74(11): 5088–5090.

Wood, C.R. (1987). The coral reefs of the Bodgaya Islands (Sabah: Malaysia) and Pulau Sipadan. 2. Physical features of the islands and coral reefs. *Malayan Nature Journal* 40: 169–188.

Wood, E. and Dipper, F. 2008. What is the future for extensive areas of reef impacted by fish blasting and coral bleaching and now dominated by soft corals? A case study from Malaysia. *Proceedings of the 11th International Coral Reef Symposium*, Ft. Lauderdale, Florida, 7–11 July 2008 Session number 12.24.

Wooldridge, S.A. 2010. Is the coral-algae symbiosis really 'mutually beneficial for the partners'? *BioEssays* 32(7): 615–625.

WoRMS Editorial Board (2016). World Register of Marine Species. Available from http://www.marinespecies.org.

Wyneken, J., Lohmann, K.J. and Musick, J.A. (eds) 2013. *The Biology of Sea Turtles* Volume III. CRC Press, 275pp.

Yancey, P.H. 2005. Organic osmolytes as compatible metabolic and countracting cytoprotectants in high osmolarity and other stresses. *Journal Experimental Biology* 208: 2819–2830.

FURTHER READING

Brewer, R., Kloser, J., Steven, A. and Condie, S. 2013. Biology and ecology of Irukandji jellyfish (Cnidaria: Cubozoa). *Advances in Marine Biology* 66: 1–85.

Brodie, J., Maggs, C.A. and John, D.M. (eds) 2007. *The green seaweeds of Britain and Ireland*. British Phycological Society, 242pp.

Fautin, D.G. 2006. *Hexacorallians of the World. Sea anemones, Corals and their allies*. Online catalogue http://hercules.kgs.ku.edu/hexacoral/anemone2/index.cfm

Gupta, B.K.Sen (ed.) 2002. *Modern Foraminifera*. Klumer Academic Publishers, 384pp.

Herring, P. 2002.The Biology of the Deep Ocean. Oxford University Press, 314pp.

Hooper, J.N.A. and van Soest, R.W.M. 2002. *Systema Porifera: A Guide to the Classification of Sponges*. 2 vols. Kluwer Academic/Plenum Publishers, New York.

Gareth-Jones, E.B. and Pang, K-L. (eds) 2012. *Marine Fungi and Fungal-like Organisms*. Marine and Freshwater Botany Series. Walter de Gruyter and Co. 532pp.

Larkum, A.W.D., Orth, R.J. and Duarte, C. (eds) (2006). *Seagrasses: Biology, Ecology and Conservation*. Springer, 676pp.

Jereb, P., Roper, C.F.E. (eds) 2005. An annotated and illustrated catalogue of cephalopod species known to date. Volume 1: Chambered Nautiluses and Sepioids (Nautilidae, Sepiidae, Sepiolidae, Sepiadariidae, Idiosepiidae and Spirulidae). *FAO Species Catalogue for Fishery Purposes* 4(1). FAO, Rome. 262pp.

Little, C. 2000. *The Biology of Soft Shores and Estuaries*. Oxford University Press. Oxford, UK. 252pp.

Littler, D.S. and Littler, M.M. 2003. *South Pacific Reef Plants. A divers' guide to the plant life of South Pacific coral reefs*. Offshore Graphics Inc., 332pp.

Marsh, H., Penrose, H., Eros, C. and Huges, J. 2002. Dugong – status reports and action plans for countries and territories. IUCN.

Munn, C. 2011. *Marine microbiology: ecology and applications*. 2nd ed. Garland Science, New York, USA.

Naylor, P. 2011. *Great British Marine Animals 3rd edition*. Sound Diving Publications, UK.

Nielsen, C. 2012. *Animal Evolution. Interrelationships of the Living Phyla. 3rd ed*. Oxford University Press, Oxford, UK, 402pp.

Segers, H. 2007. Annotated checklist of the rotifers (Phylum Rotifera), with notes on nomenclature, taxonomy and distribution. *Zootaxa* 1564, 3–104.

Southward, E.C. and Campbell, A.C. 2006. *Echinoderms*. Synopses of the British Fauna (New Series) No. 56. Field Studies Council, Shrewsbury, UK.

Thomas, D. 2002. Seaweeds. The Natural History Museum, London. 96pp.

Weinberg, S. 1999. *A fish caught in time. The search for the Coelacanth*. Fourth Estate, London 239pp.

Wood, C. (2013). *Sea Anemones and Corals of Britain and Ireland*. Wild Nature Press, Plymouth, UK. 160pp

Acknowledgements

Frances Dipper would like to thank all her colleagues and friends who have helped so generously with this book through their encouragement, expertise and excellent photography. Particular thanks are due to the following individuals who kindly read and commented on various sections of the book:

Phil Alderslade (CSIRO, Australia) Anthozoans
Geoff Boxshall (Natural History Museum, London, UK) Arthropods
John Buckley Marine environment
Francis Bunker (Marineseen, UK) Marine plants and chromists
Andrew Campbell (Queen Mary University of London, UK) Echinoderms
Lisa-Anne Gershwin (Australian Marine Stinger Advisory Services) Jellyfish
Claire Goodwin (National Museums Northern Ireland) Sponges
David Kipling (Cardiff University, UK) Tunicates
Andrew Mackie (National Museum Wales, UK) Annelid worms
Graham Oliver (National Museum Wales, UK) Molluscs
Joanne Porter (Heriot-Watt University, UK) Bryozoans, hydroids
Sue Wells (IUCN World Commission on Protected Areas – Marine) Marine Protected Areas
Elizabeth Wood (Marine Conservation Society) Corals, Tun Sakaran MPA

The section on Marine Birds (pp.458–491) was written by Marianne Taylor
The section on Marine Mammals (pp.416–457) was written by Robert Irving (Sea-Scope)

The book would not have been possible without the generous giving of photographs by the following friends and colleagues: Phil Alderslade (sclerite drawing), Claudia Arango, Lin Baldock, Peter Barfield, Sarah Bowen, Helen Brunt, Dan Bolt, Alison Buckley, Francis Bunker, Karen Chen, Fiona Crouch, Sue Daly, David Fenwick, Louise Firth, Claire Goodwin, Keith Hiscock, Robert Irving, Russel Kelley (corallite drawing), David Kipling, Paul de Ley, Paula Lightfoot, Penny Martin, Andrew Mackie, Dan Minchin, Paul Naylor, Peter Nicholson, Bernard Picton, Sally Sharrock, Anne Sheppard, Rob Spray, Jeremy Stafford-Deitch, Erling Svensen, Marianne Taylor, Dawn Watson, Séamus Whyte, Elizabeth Wood, Chris Wood and Melissa Yoder. Thanks are also given to Nigel Redman for proofreading the entire text.

Frances Dipper would also like to thank Marc Dando and Julie Dando for initiating this book and for their invaluable guidance and expertise in putting it all together and making the whole thing happen.

Finally, she would like to thank her husband John Buckley for endless encouragement, numerous cups of tea and resigned patience.

Image credits

Wild Nature Press and the author would like to thank the following for the use of their photographs and illustrations.

Key: t=top; m = middle; b = bottom; l = left; r = right. On species pages R = row
SS = Shutterstock; FLPA = Frank Lane Photography Agency; NPL = Nature Picture Library.
Illustrations by Marc Dando, except those on pages 206 and 442.

1 SS; **9** SS; **10** SS; **11** SS; **12** tr Séamus Whyte, mr Frances Dipper, bl Elizabeth Wood; **13** bl SS, br Frances Dipper; **14** tr Frances Dipper, ml Joint Irish Bathymetric Survey (JIBS), br Frances Dipper; **15** SS; **18** Frances Dipper; **19** tr SS, mr & br Frances Dipper; **20** bl SS, br Frances Dipper; **21** t NASA Scientific Visualization Studio, b SS; **22** SS; **23** SS; **24** SS; **25** SS; **26** Frances Dipper; **28** SS; **31** tl, tr & mr SS, bl Mark Humpage; **33** tl Fiona Crouch, tr Alison Buckley, bl & br Frances Dipper; **34** SS; **39** SS; **41** tr Francis Bunker, br Sally Sharrock; **42** SS; **43** Frances Dipper; **44** tr & br SS, bl Dawn Watson; **45** R1 l & r SS, R1 m Keith Hiscock, R2 l & r SS, R2 m Keith Hiscock, R3 l & r SS, R3 m Dawn Watson; **47** SS; **49** SS; **50** bl & r SS; **52** t SS, b SeaWiFS Project, NASA/Goddard Space Flight Center and ORBIMAGE; **52** SS; **53** R1 both D P Wilson/FLPA, R2 l OAR/National Undersea Research Program (NURP), R2 r Uwe Kils (CC BY-SA 3.0), R3 l SS, R3 r Russ Hopcroft, Institute of Marine Science, University of Alaska Fairbanks (UAF) and NOAA, R4 l Uwe Kils (CC BY-SA 3.0), R4 r Hiroya Minakuchi/FLPA; **56** both NOAA Okeanos Explorer Program; **57** both SS; **58** both SS; **59** t Penny Martin, m Visuals Unlimited/NPL, b David Shale/NPL; **60** t David Fenwick, b Photo Researchers/FLPA; **61** t both David Fenwick, b SS; **62** both SS; **63** t Visuals Unlimited/NPL, bl Photo Researchers/FLPA, br David Shale/NPL; **65** Solvin Zanki/NPL; **66** t Photo Researchers/FLPA, b SS; **67** David Shale/NPL; **68** bl SS, br Frances Dipper; **69** all SS; **70** R1 both Frances Dipper, R2 l SS, R2 r Frances Dipper, R3 l Frances Dipper, R3 r SS; **71** SS; **72** t Frances Dipper, R1 l SS, R1 r Frances Dipper, R2 l SS, R2 r Frances Dipper; **73** R1 both Frances Dipper, R2 l SS, R2 r Frances Dipper, R3 l SS, R3 r both Frances Dipper; **74** t SS, b Francis Bunker; **75** all SS; **76** all SS; **77** Frances Dipper; **78** both SS; **79** tl main Frances Dipper, all others SS; **80** all SS; **81** all SS; **82** Julie Dando; **83** tl all Frances Dipper, bl & br SS; **84** tl & tr Frances Dipper, bl & br SS; **85** t Frances Dipper, bl Frances Dipper, bm SS, br Frances Dipper; **86** t Frances Dipper, b SS; **87** all tl, tr & bl Frances Dipper, br David Fenwick; **88** all Frances Dipper; **89** t Frances Dipper, bl & br SS; **90** SS; **91** t & br Frances Dipper, bl SS; **92** t SS, b Rob Spray; **93** tl SS, tr Frances Dipper; **94** SS; **95** all SS; **96** tl Elizabeth Wood, tr Frances Dipper; **97** tl & bl Frances Dipper, br SS; **98** Elizabeth Wood; **99** SS; **100** tl Chris Wood, tml SS, tmr Frances Bunker, tr & b SS; **101** SS; **102** both SS; **103** t Flip Nicklin/FLPA, b Lin Baldock; **104** tl Bernard Picton, tr SS, bl Keith Hiscock; **105** bl Lin Baldock, br SS; **106** bl Erling Svensen, br SS; **107** tl & tr & inset Frances Dipper, bl Paulo Goode, br SS; **108** bl SS, br Flip Nicklin/FLPA; **109** David Shale/NPL; **111** SS; **112** both Photo Researchers/FLPA; **113** David Shale/NPL; **114** Norbert Wu/FLPA; **115** SS; **117** all SS; **119** all SS; **120** SS; **121** all SS; **123** SS; **124** all SS; **125** SS; **127** tl David Fenwick, tr SS; **130** Frances Dipper; **131** t SS, bl & br Frances Dipper; **132** both Frances Dipper; **133** t Frances Dipper, b SS; **134** all Frances Dipper; **135** t & bl Frances Dipper, br Chris Wood; **136** SS; **137** t Francis Bunker, bl SS, bl inset & br Frances Dipper; **138** both SS; **139** R1 l & r, R2 r Francis Bunker, R2 l Frances Dipper; **140** R1 l, R2 l Frances Dipper, R1 r, R3 l & r Francis Bunker; **141** SS; **142** both Frances Dipper; **143** R1 l, R2 l, R3 l & r Frances Dipper, R1 r & R4 r SS, R2 r & R 4 l Francis Bunker; **144** t SS, b Frances Dipper; **146** all Frances Dipper; **147** tl SS, tr Frances Dipper; **148** R1 l & r, R 3 r SS, R2 l, R3 l & R4 r Frances Dipper, R 2 r & R 4 l Francis Bunker; **149** t SS, b D P Wilson/FLPA; **151** Imagebroker/Martin Jung/FLPA; **152** SS; **153** tl D P Wilson/FLPA, tr SS; **154** t David Fenwick, b D P Wilson/FLPA; **155** tl NASA, mr Alison R. Taylor, University of North Carolina Wilmington Microscopy Facility (CC BY 2.5), br SS; **156** bl & r Peter Barfield; **157** both SS; **159** t SS, b & inset Frances Dipper; **160** tl & bl Steve Trewhella, br Robert Irving; **161** R1 l & R3 r Frances Dipper, R1 r & all R2 SS, R3 l Elizabeth Wood; **162** both SS; **163** tl & br SS, bl Frances Dipper; **164** both SS; **165** all SS; **166** R1 l main, R1 r inset, R2 l inset, R2 r main and inset SS, Rl l main Peripitus (CC BY-SA 4.0), R 1 r main & R 2 l main Frances Dipper; **167** all SS, except R2 r main Frances Dipper; **168** David Fenwick; **169** t Frances Dipper, b SS **170** all Frances Dipper; **171** R1 l & r, R2 l main, R3 l & r Frances Dipper, R2 l inset & r David Fenwick; **173** SS; **174** bl SS, br Frances Dipper; **176** SS; **178** Frances Dipper; **179** SS; **180** SS; **183** all Claire Goodwin/National Museums Northern Ireland; **184** l keith Hiscock, r Sarah Bowen; **185** tl Fred Bavendam/FLPA, mr SS, br Birgitte Wilms/FLPA; **186** t SS, bl & r Frances Dipper; **187** R1 r Helen Brunt, R2 l SS, R2 r NOAA, R3 l Keith Hiscock, R4 l SS, R4 r Frances Dipper; **190** t Paul Naylor, b Sally Sharrock; **191** t & b main Sally Sharrock, b inset SS; **192** t both SS, b Erling Svensen; **194** R1 l Keith Hiscock, R1 r & R 3 l Frances Dipper, R2 l Elizabeth Wood, R2 r Penny Martin, R3 r Norbert Wu/FLPA; **195** t Frances Dipper, b Richard Lord; **196** both SS; **197** Chris Wood; **198** t David Fenwick, b SS; **199** R1 l, R 2 l & R3 l SS, R1 r Erling Svensen, R2 r Kelvin Aitkin/FLPA, R3 r David Fenwick; **200** t, ml & mr Chris Wood, b SS; **201** t both Frances Dipper, b both SS; **202** tr & bl inset Frances Dipper, br main SS; **203** tl & r, bl SS, br Elizabeth Wood; **204** R 1 l Chris Wood, R1 r, R2 l, m, r & R3 r SS, R3 l Elizabeth Wood; **205** t SS, b Elizabeth Wood; **206** tl Frances Dipper, mr both SS, bl Russell Kelly; **207** tr both & br Chris Wood, bl Frances Dipper; **208** t both Frances Dipper, bl & br main SS, br inset Elizabeth Wood; **209** R1 l & R3 r SS, R1 r & R2 l Chris Wood, R2 r and R3 l both Frances Dipper; **212** both SS; **213** tl main & br main SS, tl inset & br inset Frances Dipper, bl David Fenwick; **214** tl & ml Louise Firth, br A.S.Y. Mackie (National Museum Wales); **215** R1 l A.S.Y. Mackie (National Museum Wales), R2 l & r, R3 r David Fenwick, R3 l Lucy Kay; **216** all David Fenwick; **217** t Erling Svensen, b Paul Naylor; **218** R1 & R 2 SS, R3 Eduard Solà (CC BY-SA 3.0), R4 Karen Chen; **219** tr SS, bl Erling Svensen, br Keith Hiscock; **220** all SS; **221** tr Norbert Wu/FLPA, mr David Fenwick, bl Keith Hiscock, br Erling Svensen; **222** Melissa Yoder and Paul de Ley; **223** David Shale/NPL; **224** l SS, r Frances Dipper; **226** both Keith Hiscock; **227** SS; **229** tr & br Frances Dipper, ml SS; **230** Frances Dipper; **231** tl, tr & bl SS, br Frances Dipper; **232** tr Chris Newbert/FLPA, ml Frances Dipper, br keith Hiscock; **233** tl, tml, tr Frances Dipper, tmr, bl &br SS; **235** R1 l Sue Daly, R1 r main & R2 l SS, R2 l inset and R3 both Frances Dipper; **236** all Frances Dipper, except R1 r SS; **237** R1 l Frances Dipper, R1 r, R2 r, R3 l both & R3 r SS, R2 l Sue Daly; **238** Frances Dipper; **239** tl SS, tr & br Frances Dipper; **240** SS; **241** tl & br SS, tr & bl Frances Dipper; **242** tl & br SS, mr Frances Dipper; **243** both Frances Dipper; **244** R1 l & R3 r SS, R1 r, R2 l & R3 l Frances Dipper, R2 r David Fenwick; **245** R1 r, R2 l & r & R4 l SS, R 3 l Sue Daly, R4 r David Fenwick; **247** all SS; **248** all SS; **249** tr, ml & br SS, mm Frances Dipper; **250** tr & bl SS, br Frances Dipper; **251** R1 l Frances Dipper, rest SS; **252** Frances Dipper; **253** tl SS, tr Norbert Wu/FLPA, bl & br Paula Lightfoot; **257** tr, ml & mr Keith Hiscock, br Visuals Unlimited/NPL; **259** bl main & br Frances

Dipper, bl inset SS; **260** t Fred Bavendam/FLPA, b Frances Dipper; **261** both SS; **262** both SS; **263** tr Mark Newman/FLPA, bl C. P. Arango; **264** SS; **265** SS; **266** SS; **267** tr both & br SS, bl Keith Hiscock; **268** tl & br SS, tr Dawn Watson; **269** Rl r Paul Taylor, R4 r Helen Brunt, rest SS; **270** tr Flip Nicklin/FLPA, bl Norbert Wu/FLPA; **271** tl SS, mr Richard Herrman/FLPA, bl Flip Nicklin/FLPA; **272** tr Piotr Naskrecki/FLPA, bl Keith Hiscock; **273** tl Julie Dando, ml Russ Hopcroft/NOAA, mr & bl Erling Svensen, br Norbert Wu/FLPA; **274** t Keith Hiscock, b Sue Daly; **275** tr & br Keith Hiscock, ml & mr David Fenwick, bl SS; **276** all SS; **277** SS; **278** t SS, b Frances Dipper; **279** tl Rob Spray, tr Frances Dipper, bl SS; **280** tr Flip Nicklin/FLPA, bl SS; **281** tr & bl SS, ml David Fenwick, mr D P Wilson/FLPA, br Ingo Arndt/FLPA; **282** tr B Borrell Casals/FLPA, bl Photo Researchers/FLPA; **283** R1 l D P Wilson/FLPA, R1 r Nature Production/NPL, R2 l & r Solvin Zankl/NPL; **284** Frances Dipper, **285** tl both Frances Dipper, bl David Fenwick, br Keith Hiscock; **286** t Chris Wood, b Dawn Watson; **287** R1 l & R3 r Sally Sharrock, R1 r & R2 l Frances Dipper, R2 r Chris Wood, R3 r David Fenwick; **289** both SS; **290** both SS; **291** tr & bl SS, ml Photo Researchers/FLPA; **292** tr, mr & br SS, bl NOAA Photo Library: Lophelia II 2010 (CC BY 2.0); **293** R2 l both Frances Dipper, rest SS; **294** both SS; **295** tl Keith Hiscock, tr & br SS; **296** tl Keith Hiscock, tr Erling Svensen, ml David Fenwick, mr & br Frances Dipper; **297** tr, mr & br Frances Dipper, bl SS; **298** tl Frances Dipper, tr, bl & br SS; **299** R1 l & r, R2 l, R3 l SS, R2 r & R3 r Frances Dipper; **300** tr, mr, br inset Frances Dipper, br main SS; **301** tl SS, ml NOAA/MBARI (CC BY-SA 3.0), mr Frances Dipper, br Elizabeth Wood; **302** both SS; **303** tl & br SS, tr, mr & bl Frances Dipper, ml Richard Ling (CC BY-SA 2.0); **305** tl Richard Becker/FLPA, tr David Shale/NPL, bl Elizabeth Wood; **308** tl SS, tr David Fenwick, br Frances Dipper; **309** t SS, b Frances Dipper; **310** t SS, b Dan Minchin; **311** R1 l Rob Spray, R1 r, R2 l & R2 r main David Kipling, R3 l both & R3 r Frances Dipper, R2 r inset SS; **312** tl & tr Frances Dipper, br Norbert Wu/FLPA; **313** SS; **315** tr & br SS, ml Frances Dipper; **316** SS; **317** all SS; **318** all SS; **319** SS; **320** Anne de Haas/iStock; **321** dirtsailor2003 (CC BY-ND 2.0); **322** bl Florian Graner/NPL, br Nature Production/NPL; **323** Jelger Herder/FLPA; **324** R1 l Wil Meinderts/FLPA, R1 r Marc Dando, R2 l Tiit Hunt (CC BY-SA 3.0), R2 r memobig2 (CC BY-SA 3.0); **326** SS; **328** tl, m & r SS, b Frances Dipper; **329** all SS; **330** all SS; **331** SS; **332** tl Sue Daly, tm Paul Kay, tr Franco Banfi/NPL, b Guy Stevens; **333** bl Doug Perrine/NPL, br SS; **334** SS; **335** both SS; **337** both SS; **338** both SS; **339** both SS; **340** R1 l & r Marc Dando, R2 l SS, R2 r Doug Costa, NOAA/SBNMS; **341** all Marc Dando; **342** R1 l & R2 r Marc Dando, R1 r & R2 l SS; **343** R1 l Marc Dando, R1 r Mark Conlin, SWFSC Large Pelagics Program, R 2 l & R 3 r SS, R 3 l Jeremy Stafford-Deitsch; **344** all SS; **345** R1 l SS, R1 r, R2 l & r, R3 r Marc Dando, R3 l Sue Daly; **346** R1 l & R2 l Marc Dando, rest SS; **347** all SS; **348** SS; **349** all SS; **350** tr Frances Dipper, br SS; **351** R1 r Laszlo Ilyes (CC BY 2.0), rest SS; **352** R1 l & R2 l Marc Dando, R2 r Paul Kay, R3 l Reinhard Dirscher/FLPA, R3 r Frances Dipper; **353** R1 l & R2 l Marc Dando, R1 r, R2 r & R3 l SS, R3 r Jeff Rotman/NPL; **354** R1 l, R2 l & R3 r SS, R1 r Fred Bavendam/FLPA, R3 l Peter Southwood (CC BY-SA 3.0); **355** SS; **356** R1 l Erling Svensen, R1 r Doug Perrine/NPL, R2 l SS, R2 r David Shale/NPL; **358** SS; **360** SS; **361** SS; **362** both SS; **363** tr Elizabeth Wood, ml SS, bl & br Frances Dipper; **364** tl SS, bl Elizabeth Wood; **365** both SS; **366** tr r Elizabeth Wood, rest SS; **367** SS; **368** tr Elizabeth Wood, bl & br SS; **369** ml SS, bl, bm & br Sue Daly; **370** br main SS, br inset Elizabeth Wood; **371** bl SS, br Robert irving; **372** both SS; **373** tl Elizabeth Wood, tr Frances Dipper, br SS; **374** R1 l SS, br Flip Nicklin/FLPA; **375** R1 l & R2 l SS, R1 r David Shale/NPL, R2 r Norbert Wu/FLPA; **376** R1 l Rob Spray, R1 r Elizabeth Wood, R2 l & r & R3 l SS, R3 r David Shale/NPL; **377** R1 r ShaneGross/Thinkstock Photos, R2 l Marc Dando, R2 r Jupiterimages/Thinkstock Photos, R3 l & r SS; **378** R1 l Nancy Nehring/iStock, R1 r SS, R2 l Marc Dando, R2 r Linda Lewis/FLPA; **379** R1 l Jelger Herder/FLPA, R1 r SS, R2 l S Jonasson/FLPA, R2 r Gunter Gruner/FLPA; **380** R1 l, R2 l, R3 l & r David Shale/NPL, R1 r Frances Dipper, R2 r Norbert Wu/FLPA; **381** R1 l David Shale, R1 r, R2 l & r Marc Dando; **382** R1 l Paul Kay, R1 r Drow male (CC BY-SA 4.0), R2 l D P Wilson/FLPA, R2 r Doc White/NPL, R3 l Erling Svensen, R3 r Sue Daly; **383** R1 l Etrusko25 (CC BY-SA 3.0), R1 m Jurgen Freund/NPL, R1 r Frances Dipper, R2 l Sue Daly, R2 r Visuals Unlimited/NPL; **384** R1 l Paul Kay, R1 r Fred Bavendam/FLPA, R2 l Frances Dipper, R2 r & R3 r David Shale, R3 l SS; **385** R1 l & R2 r Frances Dipper, R1 r, R2 l & R3 l SS, R2 r Marc Dando; **386** R1 l, R2 l & R3 l SS, R1 r & R3 r Marc Dando; **387** R1 l & r & R2 l SS, R2 r Norbert Wu/FLPA, R3 l Marc Dando, R3 r David Shale/NPL; **388** R1 l Dawn Watson, R1 r Fabio Liverani/NPL, R2 l NOAA, R2 r Alex Mustard/2020 Vision/NPL, R3 l Keith Hiscock, R3 r SS; **389** R1 l Sue Daly, rest SS; **390** R1 l & r & R3 r SS, R2 l & R3 l Frances Dipper, R2 r Paul Kay; **391** R3 r Paul Kay, rest SS; **392** all SS; **393** R1 l, R2 l, R3 l & l Elizabeth Wood, R1 r Frances Dipper, R2 r SS; **394** R1 l Frances Dipper, R3 r Elizabeth Wood, rest SS; **395** R1 l, R3 l & r SS, R1 r & R2 r Frances Dipper, R2 l Sue Daly; **396** R1 l Frances Dipper, R1 r SS, R2 l Paul Kay, R2 r David Shale/NPL, R3 l Peter Nicholson, R3 r Jussi Murtosaari/NPL; **397** R1 l, R2 r, R3 l & r SS, R1 r Dan Bolt, R2 l Elizabeth Wood; **398** R1 l Visuals Unlimited/NPL, R1 r & R2 l Norbert Wu/FLPA, R2 r SS, R3 l Doug Allan/NPL, R3 r Paul Kay; **399** R1 l inset Elizabeth Wood, rest SS; **400** SS; **401** bl SS, br Alberto Fernandez Fernandez (CC BY-SA 3.0); **403** Kim Taylor/NPL; **404** Fred Bavendam/FLPA; **405** SS; **406** both SS; **407** both SS; **408** both SS; **409** t Frances Dipper, b SS; **410** R1 l Elizabeth Wood, R2 & R3 SS, R4 Tui De Roy/FLPA; **411** R1 l Doug Perrine/NPL, R2 Commonwealth of Australia (GBRMPA), R3 SS; **412** SS; **413** SS; **414** R1 & R3 SS, R2 & R4 Frances Dipper, R5 Elizabeth Wood; **415** t & bl SS, br Frances Dipper; **417** both SS; **418** Frances Dipper; **419** both SS; **420** SS; **421** t all SS, b Doug Allan/NPL; **422** SS; **424** all SS; **425** Doug Perrine/NPL; **426** Bahnfrend (CC BY-SA 3.0); **427** all SS; **428** all SS; **429** SS; **430** t SS, b NOAA; **431** both SS; **432** both SS; **433** R1 r Jurgen Freund/NPL, rest SS; **434** R1 l Martha Holmes/NPL, rest SS; **435** R1 r Todd Pusser/NPL, rest SS; **436** R1 l, R2 r & R3 r SS, R1 r & R3 l Mammal Fund Earthviews/FLPA, R2 l Doug Perrine/NPL; **457** R1 l Doug Allan/NPL, R1 r FLPA/FLPA, R2 l Eric Baccega/NPL, R2 l SS, R3 r Peter Verhoog/FLPA; **438** R1 l Mammal Fund Earthviews/FLPA, R1 r Flip Nicklin/FLPA, R2 l & R3 l Todd Pusser/NPL, R2 r Peggy Stap/NPL, R3 r Chris Newbert/FLPA; **439** SS; **440** tl, bl & br SS, tr Doug Perrine/NPL; **441** all SS; **442** tl & bl SS, mr Martin Camm/FLPA; **443** both SS; **444** all SS; **446** tr & bl SS, br Doug Allan/NPL; **447** both SS; **448** both SS; **449** all SS; **450** all SS; **451** all SS; **452** R1 l & r, R2 l & r SS, R3 l Sue Flood/NPL, R3 r Egmont Strigl/FLPA; **453** R1 l Roy Mangersnes/NPL, R1 r, R2 r, R3 l & r SS, R2 l Aflo/NPL; **454** tr & bl SS, mr Kevin Schafer/NPL; **455** all SS; **456** t SS, b Steven Kazlowski/NPL; **457** all SS; **460** all SS; **461** both SS; **462** both SS; **463** both SS; **464** both SS; **465** all SS; **466** bl Roger Powell/NPL, br SS; **467** both SS; **468** all SS; **469** all SS; **470** R2 r Marianne Taylor, rest SS; **471** all SS; **472** R1 l & r, R2 l & R3 r SS, R2 l Steve Young/FLPA, R3 l Brent Stephenson/NPL; **473** all SS; **474** all SS; **475** all SS; **476** all SS; **477** all SS; **478** both SS; **479** all SS; **480** all SS; **481** both SS; **482** all SS; **483** all SS; **484** all SS; **485** both SS; **486** both SS; **487** all SS; **488** all SS; **489** R3 l Jurgen & Christine Sohns/FLPA, rest SS; **490** both SS; **491** all SS; **493** all SS; **494** all SS; **495** t SS, m Cheryl-Samantha Owen/NPL; **496** both SS; **497** tl main Georgette Douwma/NPL, rest SS; **498** t SS, b Elizabeth Wood; **499** tl & br SS, tr Frances Dipper; **500** both SS; **501** SS; **502** SS; **504** both SS; **505** both SS; **506** both SS; **507** t SS, rest Keith Hiscock; **508** Anne Sheppard; **509** R1 r & R2l Anne Sheppard, R2r, R3 l & r SS; **510** SS; **511** all SS; **512** both Elizabeth Wood; **513** R1 r, R2 l & R3 l Frances Dipper, R2 l & R3 r Elizabeth Wood; **514** SS; **515** Frances Dipper; **516** lm Frances Dipper, tr SS; **517** SS; **519** SS.

All cover images **SS**.

INDEX

Page numbers in **bold** refer to main entries, and in *italics* to either a photograph or illustration. Other entries are in plain.

A

Abalone 234, **235**
Abuliformes **375**
Abyssal plains 36, **110**
 community *110*
Abyssobenthic zone **34**
Abyssopelagic zone **34**
Acanthaster planci 232, 292
Acanthochaenus luetkenii **386**
Acanthochitona **253**
Acanthopterygii **385**
Acanthuridae **124**
Acanthurus leucosternon **394**
Acanthurus lineatus 494
Acanthurus monroviae 124
Acanthurus sohal 124
Accipitriformes **491**
Acetabularia **143**
Acidity **24**
Acipenseriformes **374**
Acipenser sturio **374**
Acoelomorpha **227**
Acorn worms **304**
Acropora 96, **208**
Actinia equina 33, 190
Actiniaria **188**
Actinonema **222**
Actinopteri 314, 358, **374**
Actinopterygii 306, 358, **374**
Aegiceras corniculatum 167
Aeolidida **231**
Aeoliscus strigatus **389**, 497
Aequorea **194**
Aethia psittacula **474**
Aetobatus narinari 326, *351*
Aglantha digitale *192*
Aglaophenia cupressina 194
Agnathans **320**
Agonus cataphractus **390**
Aipysurus laevis 404
Alaria esculenta 146
Albatross, Black-browed *464, 467*, **472**
 Shy 468
 Southern Royal 458
 Wandering 471
 Waved 472
Albatrosses **471**
Albula vulpes **375**
Alca torda **474**
Alcidae **474**

Alcyonidium diaphanum **287**
Alcyonium digitatum **204**
Alcyonium glomeratum 200
Alepisaurus brevirostris **380**
Algae, Golden-brown
 structure 151
Alismatales **160**
Alle alle **474**
Alopias vulpinus **343**
Alpheus **499**
Aluterus scriptus **392**
Alveopora 205
Alvin 13
Amastigomonas debruynei *172*
Amblyglyphidodon curacao **393**
Amblyrhynchus cristatus *402, 403*, **415**
Ammodytes tobianus **396**
Ammonites 119
Amoeba proteus *173*
Amphibians **306**
Amphilectus fucorum *183*
Amphinomidae 211
Amphioxus 312
Amphipholis squamata **296**
Amphipoda 272, **273**
Amphipods **272**
 beachhoppers 273
 biology 272
 distribution 272
 ecology 273
 feeding 272
 life history 273
 species 273
 structure 272
 uses, threats, status and management 273
Amphiprion ocellaris **393**
Amphiprion sandaracinos **498**
Amplexidiscus fenestrafer **209**
Anacanthobatis americanus **353**
Anarhichas lupus **398**
Anatidae 485, **488**
Anchovies **377**
Anemone, Beadlet *33*, **190**
 Elephant Ear **209**
 Jewel 207
 Magnificent Sea **208**
 Plumose *93*
 Sea Loch *106*
 Snakelocks *268*
 tube *208*, **209**
 Yellow Cluster **209**
Anemonefish, Clown **393**
 Orange **498**
Anemones **205**
 biology 206
 distribution 205

 ecology 207
 feeding 206
 life history 207
 species 208
 structure 205
 uses, threats, status and management 208
Anemonia viridis *188*, 207, *268*
Angelfish, Emperor **399**
 Royal **394**
Angelshark, Pacific **342**
Angelsharks **342**
Angler 359, **384**
Anglerfishes **384**
Anguilla anguilla 361, *370*, **376**
Anguilla rostrata 370
Anguilliformes **376**
Angulus tenuis **244**
Anilocra frontalis **274**
Annelid worms **210**
Annelida **210**
Annella mollis **204**
Anomalocera patersoni **53**
Anoplodactylus evansi 263
Anoplogaster cornuta **387**
Anoplostoma 222
Anous stolidus **476**
Anseranas semipalmata **489**
Anseriformes 458, **488**
Antedon bifida **303**
Antennarius maculatus **384**
Anthozoa 203, **208**
Anthus petrosus **491**
Antillogorgia **204**
Antipathes **209**
Anurida maritima 60
Anyperodon leucogrammicus **513**
Aonyx cinerea **455**
Aphrodita aculeata **215**
Aplysia punctata **237**
Aplysina archeri **187**
Aplysina lacunosa *182*
Appendicularians **310**
Aptenodytes forsteri **306**
Aptenodytes patagonicus **469**
Apusozoa *172*
Archaea **126**
 biology 126
 classification 126
 distribution 126
 ecology 126
 roles played by *126*
 structure 126
Archaeopteryx lithographica *123*
Archosargus probatocephalus *367*
Arctica islandica 240
Arctocephalus forsteri *444*, 447

Arctocephalus gazella **450**
Arctocephalus pusillus pusillus *417*, 449
Arctocephalus tropicalis 416
Ardea herodias 490
Arenaria interpres 84, **483**
Arenicola 213
Arenicola marina **216**
Arestorides argus **236**
Argonauta **249**
Argulus **281**
Argyropelecus gigas **380**
Ariopsis seemanni **378**
Aristotle's lantern **297**
Armeria maritima **70**
Arothron nigropunctatus **392**
Arrow worms 53, *174*, **176**
 biology 176
 classification 176
 distribution 176
 feeding 176
 life history 176
 structure 176
Artemis, Rayed **244**
Arthropoda **258**
Arthropods **258**
 appendages 259
 classification 258
 compound eyes 261
 moulting and growth 260
 structure 259
Ascidiacea 306, 307, **311**
Ascomycota *168*, **171**
Ascophyllum nodosum 33, 131, *146*
Asparagopsis armata 138
Astacus leptodactylus 261
Asterias rubens *495*
Asteroidea 288, 290, **292**
Astrobrachion **296**
Astropecten 89
Astropecten irregularis 290, **293**
Astropectinidae 290
Astroscopus *365*
Atherina presbyter **385**
Atheriniformes **385**
Atlantic Fangjaw **380**
Atlantic Footballfish **384**
Atolla manubrium *63*
Atriolum robustum **311**
Auklet, Parakeet **474**
Auk, Little **474**
Auks **474**
Aulopiformes **380**
Aulostomus maculatus **389**
Aurelia aurita 53, *125, 195, 196, 197*
Autotomy 267, **495**
Aves 306
Avicennia marina *166*

Avocet, Pied **484**
Avocets **484**

B

Bacillariophyceae *128*
Bacteria **126**
 biology *126*
 classification *126*
 distribution *126*
 ecology *126*
 roles played by *126*
 structure *126*
Balaena mysticetus **434**
Balaenidae **434**
Balaenoptera acutorostrata **433**
Balaenoptera bonaerensis *504*
Balaenoptera brydei **427**
Balaenoptera edeni *52*
Balaenoptera musculus *306*, **433**
Balanoglossus simodensi *304*
Baleopteridae **433**
Balistoides conspicillum **392**
Bandfish, Red *371*
Bangiophyceae **140**
Barentsia *179*
Barentsia discreta *174*
Barnacle, acorn *279*
 goose *84*, *279*
 Surf *278*
Barnacles *52*, **278**
 biology *278*
 commensals *279*
 distribution *278*
 ecology *279*
 feeding *278*
 life history *279*
 structure *278*
 uses, threats, status and management *279*
Barracuda *512*
 Great *367*, **397**
Basketstar *296*
Basslet, Fairy **393**
Batfish, Dusky **399**
 Red-lipped **384**
Bathybenthic zone *34*
Bathymodiolus *112*
Bathynomus giganteus *258*
Bathypelagic zone *34*, **65**
 adaptations *65*
Bathypterois grallator *380*
Batoidea **351**
Batrachoidiformes **383**
Beachhoppers *273*
Beardfish, Pacific **381**
Beardfishes **381**
Bear, Polar **456**, *457*
 biology *456*
 body form and general features *456*
 distribution *456*
 ecology *457*
 feeding *456*

life history *457*
senses *456*
structural adaptations *456*
uses, threats, status and management *457*
Beaufort wind scale **520**
Belemnites *119*
Beloniformes **386**
Beluga **436**, *437*
Benthic environments **68**
Berardius bairdii **438**
Beroe *175*
Beryciformes **387**
Bicosta spinifera *172*
Biddulphia *149*
Bigeye, Bloch's *363*
Bindweed, Sea *73*
Biological hotspots *117*
Biological sampling **14**
Bioluminescence **66**
 functions of *67*
 light production *66*
Birds *306*
Birds, marine **458**
 anatomical adaptations *458*
 bill forms *460*
 bone *459*
 classification *458*
 diving adaptations *462*
 feather *461*
 feathers *460*
 flyways *463*
 incredible journeys *463*
 migration *462*
 physiological adaptations *458*
 salt and water balance *462*
 salt glands *461*
 temperature regulation *460*
Birds of prey **491**
Birds, other marine **490**
 biology *490*
 distribution *490*
 ecology *490*
 feeding *490*
 life history *490*
 species *491*
 structure *490*
 uses, threats, status and management *490*
Birds, perching **491**
Birgus latro **509**
Bivalves **238**
 biology *239*
 distribution *238*
 ecology *241*
 feeding *239*
 life history *241*
 pearls *242*
 plant-laden *240*
 shell identification *243*
 species *244*
 structure *238*

uses, threats, status and management *242*
Bivalvia *228*
Black Sea *25*
Black Shields *171*
Blenny, Black-faced **396**
Blenny, Tompot **395**
Blenny, Viviparous **396**
Blenny, Yarrell's **398**
Bloody Henry **293**
Blue Buttons **194**
Boarfish **388**
Bobtail, Dwarf *251*
Bohadschia graeffei *300*
Bolbometodon muricatum **394**
Boleophthalmus *315*
Bolinopsis infundibulum *53*
Bonefish **375**
Bonellia viridis *224*
Boobies **473**
Booby, Blue-footed *461*, **473**
 Red-footed **511**
Bothus lunatus **391**
Bothus mancus *364*
Botryllus schlosseri *308*
Boulder shores *87*
Boxfish *359*, **392**
Boxfishes *362*
Brachionus plicatilis *174*
Brachiopoda *256*, **257**
Brachiopods **256**
 biology *257*
 classification *256*
 distribution *256*
 ecology *257*
 feeding *257*
 life history *257*
 species *257*
 structure *256*
 uses, threats, status and management *257*
Brachiuran *281*
Brama brama **396**
Branchiostoma californiense *312*
Branchiostoma floridae *313*
Branchiostoma lanceolatum *306*
Branta bernicla **488**
Branta canadensis **488**
Branta leucopsis *74*
Brill *359*
Brisingida *292*
Brittlestar, Common **294**
 serpent **296**
 Sponge **294**
Brittlestars **294**
 biology *295*
 distribution *294*
 ecology *295*
 identifying *294*
 life history *295*
 species *296*
 structure *294*

uses, threats, status and management *295*
Brown-lined Paper Bubble **237**
Brown seaweeds **144**
Bruguiera gymnorhiza *164*, **166**
Bryaninops yongei *105*, *499*
Bryopsis plumosa *143*
Bryozoa *284*, **287**
Bryozoan, Finger **287**
 Monkey Puzzle **287**
Bryozoans **284**
 biology *285*
 classification *284*
 distribution *284*
 ecology *286*
 encrusting *285*
 feeding *285*
 life history *286*
 species *287*
 structure *285*
 unexpected traits *286*
 uses, threats, status and management *286*
 zooid types and functions *285*
Buccinidae *230*
Buccinum undatum *233*, **235**
Bucephala clangula **489**
Bugloss, Vipers *73*
Bugulina flabellata *284*
Bullhead, Longspined **390**
Buoyancy *248*
Burrowing depth *240*
Butterflyfish, Copper-banded **513**
 Ornate **393**
 Yellow Longnose *367*
Butterflyfishes *368*
Bythaelurus giddingsi *125*
By-the-wind Sailor *61*

C

Caenogastropoda **235**
Caesionidae *366*
Calanoida *280*
Calanoids *280*
Calcarea **186**
Caligus belone *281*
Calliactis parasitica *492*
Callionymus lyra **396**
Callorhinchus milii *357*
Calonectris diomedea **471**
Calpurnus verrucosus *202*
Calystegia soldanella *73*
Camarodonta *299*
Camouflage **496**
 behaviour *497*
 mimicry *497*
Camposcia retusa *496*
Cancer pagurus *264*, *267*
Cancer productus *268*
Canda **287**
Canthigaster valentini *497*
Capelin **379**

Caperea marginata 416
Caprella mutica 273
Capros aper 388
Caranx melampygus 397
Carapus acus 383
Carcharhiniformes 344
Carcharhinus amblyrhynchos 339, **346**
Carcharhinus falciformes **509**
Carcharhinus galapagensis 330
Carcharhinus leucas **346**
Carcharhinus longimanus **346**
Carcharias taurus 329, **342**
Carcharodon carcharias 319, 334
Carcinus maenas 266
Cardinalfish, Ochre-striped 393
Caretta caretta 15, 64, **410**
Carpediemonas 172
Carpetshark, Epaulette 344
Carpetsharks 343
Carpobrotus edulis 70
Cartilaginous fishes 326
Caryophyllia smithii 209
Cassiopea 149
Cassiopea andromeda **199**
Catfish, Striped 378
 Tete Sea 378
Catfishes 378
Catomerus polymerus 278
Catshark, Blackmouth **345**
 Graceful **345**
 Jaguar 125
 Smallspotted 332, **345**
Caudofoveates 255
Caulerpa racemosa **143**
Census of Marine Life 12
Centrophorus granulosum 330
Cephalaspidomorphi **325**
Cephalocarida 258, 264
Cephalocarids 264
Cephalochordata 312
Cephalodiscus solidus 304
Cephalopoda 228, **250**
Cephalopods 59, 246
 biology 248
 buoyancy 248
 distribution 246
 ecology 249
 feeding 248
 hard parts of 248
 life history 249
 mass escape 247
 maximum statistics of giant cephalopods 250
 species 250
 structure 246
 uses, threats, status and management 250
Cephalorhyncha **225**
 biology 225
 classification 225
 distribution 225
 structure 225

Cephalorhynchus commersonii **436**
Cephaloscyllium ventriosum 330, **345**
Cepola macrophthalma 371
Cerastoderma edule 240
Ceratium fusus 152
Ceratium longipes 152
Ceratium tripos 152
Cerberus rynchops 414
Ceriantharia 208
Cerianthus **209**
Cestum veneris 174
Cetacea 420
Cetaceans 420
Cetorhinus maximus 331, **343**
Chaenocephalus aceratus **398**
Chaetoderma 255
Chaetodon larvatus 368
Chaetodon ornatissimus **393**
Chaetognatha 176
Chagos Archipelago 508
Chalinula nematifera 185
Chanos chanos 378
Charadriidae **484**
Charadriiformes 458, 474, 478, **483**
Charadrius dubius 481
Charadrius hiaticula **484**
Charadrius vociferus 481
Charonia tritonis 228, **511**
Chauliodus sloani 65, 67, **380**
Cheilinus fasciatus 363, **502**
Cheilinus undulatus 373
Cheilostomatida **287**
Chelmon rostratus **513**
Chelon labrosus **383**
Chelonia mydas 402, 407, 409, **410**
Chemosynthesis 112
Chen caerulescens **489**
Chimaera monstrosa **357**
Chimaera, Spearnose 314
 Whitespotted 330
Chimaeras 314, 326, 328, 332, **355**
 biology 355
 body form 355
 claspers 356
 distribution 355
 ecology 356
 egg capsules 356
 external features 355
 feeding 355
 general feature 355
 life history 356
 species 357
 structure 355
 tooth plates 355
 uses, threats, status and management 356
Chimaeriformes 332, 357
Chionidae 478
Chionis minor 458
Chirolophis ascani **398**
Chironephthya **204**
Chironex fleckeri **199**

Chiton, Blue-lined 253
 Hairy 253
Chitons **252**
 biology 252
 distribution 252
 ecology 253
 feeding 252
 life history 253
 species 253
 structure 252
 uses, threats, status and management 253
Chlamydoselachus anguineus 340
Chlamys opercularis 239, 241
Chlidonias hybrida **475**
Chlorodesmis fastigiata **143**
Chlorophyta **142**
Choanozoa 172
Chondrichthyes 326
Chondrostei 374
Chordata 306
Chordates **306**
 classification 306
 diagnostic characteristics 307
 non-vertebrate 307
 structure 307
Chroicocephalus ridibundus **477**
Chromatophores 496
Chromista 149, 151, 152, 154, 155
Chromists **128**
 classification of 128
Chromodoris 233
Chromodoris willani 218
Chrysaora hysoscella 188, **199**
Chthamalus montagui 42
Chthamalus stellatus 42
Cidaroida **299**
Cidaroidea **299**
Ciona intestinalis 308
Circalittoral community 41
Cirripedia 258, 278
Cladistics **123**
 museum collections 123
Cladonia uncialis 171
Cladophora 141
Cladophora rupestris **143**
Clam, Crocus 244
 fire 241
 Giant 240, 243
 Scaly Giant **513**
Clangula hyemalis **485**
Classification **120**
 of the Red-knobbed Starfish 120
 systems 120
Claudea elegans 134
Clavelina **311**
Clavelina lepadiformis **311**
Clavularia **200**
Cleidopus gloriamaris **387**
Cliff flowers 70
Clingfish, Crinoid 385
 Shore 385

 Two-spotted **385**
Clingfishes **385**
Clinocardium nuttallii **244**
Cliona celata **187**
Clione limacina **237**
Clupea harengus 367, **377**
Clupeiformes **377**
Clupeomorpha **377**
Clypeasteroida **299**
Cnidaria 188
Cnidarians **188**
 classification 188
 cnidocytes 189
 distribution 188
 medusa 189
 nematocyst 189
 polyp 189
 stinging cells 189
 structure 189
 venom 190
Coastal habitats 68
Coastal squeeze 79
Cockle, Basket **244**
 Common 240
Cod, Atlantic **382**
 Potato **511**
Codium fragile **142**
Cods 382
Coelacanthi 314, 400
Coelacanths 400
Coelenterates 188
Coelorinchus **382**
Collembola 60
Colochirus 300
Colossendeis megalonyx **263**
Colossendeis wilsoni 258
Colpomenia peregrina **148**
Comb jellies 53, **174**
 benthic creeping 175
 biology 175
 classification 174
 distribution 174
 feeding 175
 life history 175
 structure 175
 use, threats, status and management 175
Commensals 429
 barnacles 279
 decapod 268
 shrimp 268
Compound eyes 276
Conchoecissa ametra **283**
Cone, California 231
 Textile **236**
Conger conger 359
Continental shelf 36
Conus californicus 231
Conus textile **236**
Copepoda **280**
Copepods 53, **280**
 atypical 281

INDEX 531

biology 280
Calanoida 280
Calanoids 280
distribution 280
ecology 281
feeding 280
life history 281
parasitic 281
structure 280
uses, threats, status and management 281
Corallimorpharia 207, 208
Corallimorpharians 208
Corallina officinalis **139**
Corallium rubrum 203
Coral, black **209**
 Blue **203**
 brain **209**
 bubble 227
 Devonshire Cup **209**
 fire 192
 lace **287**
 mushroom 208
 Organ Pipe **204**
 reefs **94**
 Acropora 96
 biodiversity 96
 life and diversity 96
 Lophelia 106
 major predators 98
 reef zones 95
 status of 98
 The Coral Triangle 96
 world distribution of 94
 Ross **287**
 soft **200**
 biology 201
 commensals 202
 distribution 200
 ecology 202
 feeding 201
 life history 202
 skeleton 201
 species 203
 structure 200
 uses, threats, status and management 203
 spawning 44
 staghorn **208**
 stony **205**
 biology 206
 coral skeletons 206
 distribution 205
 ecology 207
 feeding 206
 identification 208
 life history 207
 polyps 206
 species 208
 structure 205
 uses, threats, status and management 208

zooxanthellae 206
 Sunset **507**
 triangle 117
Coriolis effect 28
Coris gaimard **394**, **399**
Coris, Yellowtail **394**, **399**
Cormorant, Great **473**
Cormorants **473**
Corollospora maritima 168
Corollospora pulchella 168
Corophium volutator 74
Corynactis viridis 207
Coryphaena hippurus **397**
Coryphella browni 190
Cowfish, Longhorn **362**
Cowrie *202, 234*
 Egg 202
 Eyed **236**
 Tiger 229
Crab, American Horseshoe 79
 Angular 105
 Atlantic Ghost **269**
 Atlantic Horseshoe **263**
 Boxer 268, 493
 Broad-clawed Porcelain *87*
 Coconut **509**
 Edible 264, **267**
 fiddler 266
 ghost *91*
 Hermit **269**, 492
 horseshoe **262**
 biology 263
 distribution 262
 ecology 263
 feeding 263
 life history 263
 structure 262
 uses, threats, status and management 263
 Pom Pom *493*
 porcelain **267**
 Red Rock 268
 Red Tuna **59**
 sandbubbler 267
 Shore *266*
 Spider *260*
 stone *109*
 Yellowline Arrow *265*
 yeti *113*
Crabs **266**
 autotomy 267
 biology 267
 distribution 266
 ecology 268
 feeding 267
 life history 268
 species 269
 structure 266
 uses, threats, status and management 268
Crambe maritima **70**
Crassostrea gigas **245**

Cratena peregrina **237**
Crawfish **507**
Crayfish, Narrow-clawed *261*
Creagrus furcatus **476**
Crepidula fornicata 232
Crinoidea 288, 302, **303**
Crinoids 119, 302
Crisia denticulata 284
Crithmum maritimum **70**
Crocodile, American **406**
 Saltwater **406**
Crocodilefish, Beaufort's **390**
Crocodiles **405**
 biology and ecology 405
 distribution 405
 feeding 405
 life history 406
 man-eaters 405
 structural adaptations 405
 uses, threats, status and management 406
Crocodylus acutus **406**
Crocodylus porosus **406**
Crossaster papposus 290
Crustaceans 59, **264**
 structure 264
Ctenella chagius **509**
Ctenophora 188
Ctenostomatida 287
Cubozoa 195, **199**
Culcita novaeguineae 293
Curlew, Eurasian **483**
Cushion Star 293
Cusk-eels **383**
Cuttlefish 246, *247, 249*
 Australian Giant **251**
 Common **246**
 Flamboyant **250**
Cyanea capillata 59
Cyanobacterium *126*, *127*
Cycliophora 181
Cycliophoran 174
Cycliophorans 181
Cyclopterus lumpus 368, **390**
Cyclosquamata 380
Cyclostomatida 284, **287**
Cygnus cygnus **488**
Cymbacephalus beauforti **390**
Cymodocea **158**
Cynthia cardui 79
Cyphoma gibbosum **236**
Cypraea tigris 229
Cystoclonium purpureum 134
Cystophora cristata 446, **452**
Cythereis (Eucythereis) albomaculata **283**

D

Dabberlocks *146*
Daffodil, Sea **73**
Damselfish, Staghorn **393**
 Two-bar *364*

Damselfishes **366**
Dardanus megistos **269**
Dark zone 34, **65**
 adaptations 65
Dascyllus reticulatus **364**
Dasyatis americana 313, **351**
Dead Man's Fingers **204**
Dead Sea **20**
Dead zones **25**
Decapoda 258, **269**
Decapodiformes **250**
Decapods 266
Deep seabed 109
 abyssobenthic seabed 109
Deepsea Challenger 13
Defence and attack **492**
 autotomy 495
 cuverian tubules 495
 escape mechanisms 495
 mucus cocoon, parrotfish 493
 physical defence 492
 poisonous animals 493
 shields 492
 snares 495
 tetrodotoxin 493
 venomous animals 493
 venomous fishes 494
Delesseria sanguinea 130
Delphinapterus leucas **437**
Delphinidae **434**
Delphinus 429
Delphinus delphis **435**
Demospongiae 187
Dendrophyllia 206
Dentalium elephantinum 228
Depth measurement 14
Depth zones 35
Dermochelys coriacea 306, 403, **411**
Diadema setosum **299**
Diadematidae 297
Diadematoida **299**
Diatoms 149, **151**
 asexual reproduction 150
 biology 150
 structure 150
Dicentrarchus labrax **395**
Dictyoceratida 182
Dictyota 134
Didemnid 311
Didemnum 311
Didemnum molle 309
Didemnum vexillum 310
Didymosphaeria lignomaris 168
Diel Vertical Migration 64
Dimedia cauta 468
Dimethyl sulphide 155
Dinoflagellata **152**
Dinoflagellates **152**
 biology 153
 structure 152
Dinophysis acuminata 152
Diodon histrix **392**, 493

Diomedea epomophora 458
Diomedea exulans 471
Diomedeidae 471
Diplecogaster bimaculata 385
Diploria 209
Dipturus batis 124, 352
Dipturus cf. *flossada* 124
Dipturus cf. *intermedia* 124
Discotrema crinophilum 385
Dissolved gases 24
Diver, Great Northern 469
Divers 469
Diving 13
Diving-petrel, Common 472
Diving-petrels 472
Dogfish, Piked 327, 340
　Prickly 341
Dolphin, Atlantic Spotted 425
　Atlantic White-sided 435
　Bottlenose 428
　Commerson's 436
　common 429
　Common Bottlenose 75, 428, 435
　Fraser's 416
　Indo-Pacific Humpback 435
　Long-snouted Spinner 435
　ocean 434
　Risso's 436
　Short-beaked Common 435
　Southern Right Whale 435
Dolphinfish 397
Dolphins 420
　behaviour and intelligence 423
　biology 426
　body form and general features 421
　bow-riding 424
　breathing 426
　classification 420
　distribution 421
　echolocation 425
　ecology 429
　feeding 427
　hearing 424
　life history 428
　melon organ 425
　senses 424
　skeleton 422
　sleep 426
　sound 424
　sound pathways 425
　species 433
　strand feeding 428
　strandings 426
　structure 421
　surfing 424
　taste and smell 425
　touch 425
　uses, threats, status and management 430
　vision 426
Doridacea 231
Dories 388

Dory, John 367, 388
Dosinia exoleta 244
Drachiella spectabilis 135
Dragonet 396
Dragonfishes 370, 380
Drimia maritima 70
Dromus ardeola 478
Duck, Harlequin 485, 489
　Long-tailed 485
Ducks 485, 488
Dugesia subtentaculata 218
Dugong 159, 439, 441, 511
　biology 441
　body form and general features 439
　distribution 439
　ecology 442
　external differences between Dugong and manatees 440
　feeding 441
　life history 442
　nostrils 443
　senses 441
　skeleton 440
　structure 439
　uses, threats, status and management 443
Dugong dugon 159, 511
Dulse 139
　Pepper 135
Dumbo octopus 59
Dunlin 463
Durvillaea potatorum 87
Dynamene bidentata 275

E

Eagle, Bald 491
　White-tailed 490
Echiichthys vipera 395
Echiniscoides sigismundi 174, 177
Echinocardium cordatum 299
Echinodermata 288
Echinoderms 288
　classification 288
　sea urchin test (shell) 289
　structure 289
　water vascular system 289
Echinodiscus bisperforatus 299
Echinoidea 288, 296, 299
Echinometra mathaei 299
Echinorhiniformes 340
Echinorhinus brucus 340
Echinus esculentus 297
Echium vulgare 73
Echiura 224
Ecosystems 40
Eel, American 370
　Conger 359
　European 361, 370, 376
　Garden 376
　Giant Moray 376
　Harlequin Snake 376
　moray 102

　snipe 376
　Pelican Gulper 375
　Ribbon 376
Eelgrass 161
Eels 376
　deepsea 375
　life cycle 370
Eider, Common 488
　King 458
Ekman spiral 28
Elasmobranchii 314, 326
Elasmobranchs 314, 326
Electra pilosa 284
El Niño 17
Elopiformes 375
Elopomorpha 375
Elysia crispata 44
Emiliania huxleyi 155
Emydocephalus ijimae 413
Engraulidae 377
Enhalus 159
Enhalus acoroides 161
Enhydra lutris 100, 454, 455
Enhydra lutris kenyoni 454
Entada gigas 84
Enteropneusta 304
Entoprocta 179
Environments 40
Epibenthic animal beds and reefs 104
Epibulus insidiator 367
Epimenia australis 255
Epinephelus fasciatus 393
Epinephelus striatus 368
Epinephelus tukula 511
Epipelagic zone 34, 62
　adaptations 62
Eptatretus burgeri 322
Eptatretus cirrhatus 314
Eretmochelys imbricata 410
Erignathus barbatus 453
Errantia 214
Eryngium maritimum 73
Escharoides coccinea 285
Eschrichtiidae 434
Eschrichtius robustus 103, 434
Estuaries 74
　estuarine fish 75
　human impact 75
　physical conditions 74
　salinity tolerances 74
Etmopterus spinax 341
Eubalaena australis 427, 434
Eucheuma 137
Eucrossorhinus dasypogon 343
Eudocimus ruber 80
Eudyptes chrysocome 467
Eudyptula minor 469
Euechinoidea 299
Euglena 173
Eulalia clavigera 215
Eulopiscium fishelsoni 126

Eumetopias jubatus 445, 450
Eunice aphroditois 212
Eunicella verrucosa 200, 507
Eunicida 214
Euphausiacea 270
Euphausia superba 108, 270, 271
Euphausid shrimps 270
　biology 270
　distribution 270
　ecology 271
　feeding 270
　life history 271
　structure 270
　uses, threats, status and management 271
Eupolymnia nebulosa 215
Eurotiomycetes 171
Eurynorhynchus pygmeus 482
Eurypharynx pelecanoides 375
Eusirus holmi 273
Euspira catena 232
Euteleostei 379
Exocoetidae 386
Eyelightfish 387

F

Fangtooth, Common 387
Featherstar, Common 303
　Passion Flower 303
Featherstars 302
　autotomy 302
　biology 302
　distribution 302
　ecology 303
　feeding 302
　life history 303
　species 303
　structure 302
　uses, threats, status and management 303
Feresa attenuata 436
Fig, Hottentot 70
File shells 241
Filefish, Mimic 497
　Scrawled 392
Fireworms 211
Fish, Elephant 357
　Tadpole 382
Fishes 306, 314
　bony 314
　buoyancy 331, 360
　cartilaginous 326
　　acoustico-lateralis system 331
　　Ampullae of Lorenzini 331
　　aplacental yolksac viviparity 332
　　buoyancy 331
　　claspers 332
　　classification 326
　　eggcases 332
　　electro-sensory system 331
　　eye shapes of sharks 330
　　hearing 330

mating 332
olfaction 329
oviparity 332
placental viviparity 332
placoid scales 327
reproduction 332
reproductive strategies 333
scales 327
senses 329
skeletal structure of 327
skeleton 326
skin 327
structure 326
taste 329
teeth 327, 328
tooth shape 328
vision 330
gills and respiration 315
jawless 320
 classification 320
 structure 320
lateral line 317
lobe-finned 400
 biology 401
 classification 400
 distribution 400
 ecology 401
 feeding 401
 life history 401
 structure 401
 uses, threats, status and management 401
mail-cheeked 390
osmotic regulation 318
perciform
 Indo-pacific coral reef 393
 juvenile 399
 NE atlantic seashore 395
 open ocean 397
 Polar 398
ray-finned 314, **358**
 age determination 362
 body form 359
 body shapes 359
 biology 366
 buoyancy 360
 classification 358
 distribution 358
 ecological groupings 371
 ecology 371
 electro-sensory 365
 eye 364
 feeding 366
 fins 359
 fin uses 360
 general features 359
 hearing 365
 hermaphrodites 369
 inner ear 365
 life history 368
 magnetic 365
 mouth shapes 367

scales 361
senses 362
skeleton 359, 360
skin 361
smell 363
sound production 364
species 374
structure 359
swimming 360
taste 363
teeth types 367
uses, threats, status and management 372
vision 363
respiration 316
scale types 361
schooling 317
structure 315
temperature regulation 318
 regional endothermy 318
Fjords 106
Flamingo Tongue 236
Flatfishes 391
Flatworm, acoel 227
 Candy Striped 219
 Persian Carpet 219, **220**
 Tiger 220
Flatworms 218
 biology 219
 classification 218
 distribution 218
 ecology 219
 feeding 219
 life history 219
 movement 219
 species 219
 structure 219
 uses, threats, status and management 219
Floating communities 61
Floridiophyceae 139
Florometra serratissima 288
Flounder, Peacock 364, **391**
Flustra foliacea 284
Flustrellidra hispida 285
Flustrina 284
Flying squid 247
Flyingfishes 386
Food chains 46
 continental shelves 47
 open ocean 47
 upwelling regions 47
Food webs 46
 seagrass beds 102
 Southern Ocean 48
Foraminifera 128
Foraminiferans 128, **154**
 biology 154
 structure 154
Forcipiger flavissimus 367
Forcipulatida 292
Fragilaria 149

Fratercula arctica 47, **475**
Fregata minor 473
Fregatidae 473
Fregetta tropica 472
Frigatebird, Great 473
Frigatebirds 473
Frogfish, Sargassum 61
 Warty 381
Fromia monilis 293
Fucaceae 144
Fucus, life cycle of 145
Fucus ceranoides 74
Fucus vesiculosus 85, 131, 144, **148**
Fucus vesiculosus var. *linearis* 85
Fulmar, Northern 471
Fulmarus glacialis 471
Fungi in the marine environment 168
Furbellows 131
Fusiliers 366

G

Gadiformes 382
Gadus morhua 382
Gaidropsarus mediterraneus 382
Galeocerdo cuvier 347
Galeorhinus galeus 346
Galeus melastomus 345
Galinago galinago 483
Gannet, Northern 473
Gannets 462, **473**
Gaper, Fat 243
 Sand 240
Gasterosteiformes 388
Gasterosteus aculeatus 388
Gastropoda 228, **235**
Gastropods 230
 biology 231
 distribution 230
 ecology 233
 eggs 233
 feeding 231
 life history 232
 shell identification 234
 species 235
 structure 230
 uses, threats, status and management 233
Gastrotrichs 174, **178**
 biology 178
 classification 178
 distribution 178
 feeding 178
 life history 178
 structure 178
Gavia immer 469
Gaviiformes 469
Geese 485, **488**
Geoduck 244
Geotria australis 325
Gephyrocapsa oceanica 128
Giardia lamblia 172
Gigantocypris agassizii 258, 282

Ginglymostoma cirratum 329, **344**
Girdle-wearers 225
Glarolidae 478
Glassworts 79
Glaucium flavum 70, 130
Glaucostegus halavi 353
Glaucus atlanticus 60
Global thermohaline conveyor belt 29
Globicephala melas 436
Glottidia albida 257
Gnathanodon speciosus 399, 441
Goatfish, Dash-and-dot 363
gobies 105
Gobiesociformes 385
Gobius geniporus 317
Gobius paganellus 88, **396**
Goblet worms 179
 biology 179
 classification 179
 distribution 179
 feeding 179
 life history 179
 structure 179
Goby, Fries's 105
 Rock 88, **396**
 Sea Whip 499
 Slender 317
Godwit, Black-tailed 483
Goldeneye 489
Golfingia 223
Gollum attenuatus 345
Gollumshark 345
Goniasteridae 290
Goniplax rhomboides 105
Gonorynchiformes 378
Gonorynchus greyi 378
Gonyaulax 128
Goose, Barnacle 74
 Brent 488
 Canada 488
 Magpie 489
 Snow 489
Gorgasia sillneri 376
Gorgonocephalus caputmedusae 296
Grammicolepis brachiusculus 388
Grampus griseus 436
Grantessa 186
Graptolites 305
Graptolithoidea 304
Grass, Neptune 161
Grebe, Black-necked 491
 Great Crested 491
Grebes 491
Green seaweeds 141
Green Sponge Fingers 142
Greenshank 483
Greilada elegans 507
Grenadier 382
Gribble 275
Grimpoteuthis 59
Grouper 358, 368
 Blacktip 393

Slender 513
Grunion, California 31, **385**
Gryphaea 119
Guillemot, Common 466, 468, **474**
Guitarfish 329
 Bowmouth 353
 Giant 353
 Halavi 353
 Thornback 353
Gull, Black-headed **477**
 Dolphin **477**
 Great Black-backed **476**
 Herring **476**
 Little **477**
 Swallow-tailed **476**
Gulls **476**
Gunnel, Rock 395
Guyot 38
Gygis alba **476**
Gymnodinium sanguineum 152
Gymnolaemata **287**
Gymnothorax 102
Gymnothorax javanicus 363, **376**
Gymnura natalensis 351

H

Haddock 359
Haematopodidae **484**
Haematopus palliatus 242, **484**
Hagfish 322
 Broadgilled 314, **322**
 Japanese **322**
Hagfishes 314, 320, **321**
 biology 322
 distribution 321
 ecology 322
 eggs 322
 life history 322
 slime 321
 species 322
 structure 321
 uses, threats, status and management 322
Hake 217
 European **382**
Halfbeak, Ballyhoo 386
Haliaeetus albicilla 490
Haliaeetus leucocephalus **491**
Haliastur indus **491**
Halichoerus grypus 91, 444, 448, **453**
Halichondria panicea 184
Haliclystus octoradiatus 198
Halimeda 132, **143**
Haliotis 235
Halodule uninervis 160
Halophila engelmanni 158
Halophila ovalis 158, **161**
Halophila spinulosa 158
Halophila stipulacea **161**
Halosphaera minor 156
Hammerhead, Great 347
 Scalloped 338, **347**

Hapalochlaena lunulata 251
Haplotaxida 210
Haptophyta 128, **155**
Harmothoe extenuata 215
Harpagifer 398
Harriotta haeckeli 357
Hatchetfish, Greater Silver 380
Hawaii 38, **505**
Heart Urchin **299**
Heliasteridae 290
Heliopora coerulea **203**
Hemichordata **304**
Hemichordates **304**
 biology 305
 classification 304
 distribution 304
 ecology 305
 feeding 305
 life history 305
 structure 304
 uses, threats, status and management 305
Hemiramphus brasiliensis 386
Hemiscyllium ocellatum 344, 497
Henricia sanguinolenta 293
Heron, Great Blue 490
Herring, Atlantic 367, **377**
Herrings **377**
Heteractis magnifica 208
Heterobranchia 237
Heterocentrotus mamillatus **299**
Heterodonta 244
Heterodontiformes 328, **342**
Heterodontus portusjacksoni **342**
Hexabranchus sanguineus 237
Hexacorallia 205, **208**
Hexacorals 205
Hexactinellida **187**
Hexanchiformes **340**
Hexanchus griseus 316
Hexatrygon bickelli 352
High-hat 399
Himanthalia elongata 135, 146
Himantolophus groenlandicus 384
Himantopus himantopus 480
Hippocampus bargibanti 496
Hippocampus guttulatus 359
Hippocampus hippocampus **389**
Hirudinea 217
Histioteuthis 67
Histrio histrio 61, **384**
Histrionicus histrionicus 485, **489**
Histriophoca fasciata **453**
Holocentrus rufus 387
Holocephalans 326
Holocephali 314, 326, **357**
Holothuria 300
Holothuria forskali 288
Holothurians 300
Holothuroidea 288, 300, **301**
Homarus gammarus 260, **269**

Homoscleromorpha 182, **187**
Hooknose **390**
Hoplophrys oatesi 260
Hoplostethus atlanticus 387
Hormosira banksii 148
Hornwrack 284
Horseshoe crabs **262**
 biology 263
 distribution 262
 ecology 263
 feeding 263
 life history 263
 structure 262
 uses, threats, status and management 263
Houndshark, Barbeled 345
Huso huso **374**
Hutchinsoniella macracantha 258
Hydatina physis 237
Hydrobatidae **472**
Hydrocoloeus minutus **477**
Hydrodamalis gigas **442**
Hydroid, Oaten Pipe **194**
 Stinging **194**
Hydroids **191**
 biology 193
 distribution 191
 ecology 193
 feeding 193
 life cycles 193
 life history 193
 regeneration 193
 species 194
 structure 191
 uses, threats, status and management 193
Hydrolagus affinis 355
Hydrolagus colliei 317, 330, 357
Hydromedusae **192**
Hydrophiinae 412
Hydrophis lapemoides **414**
Hydroprogne caspia **475**
Hydrothermal vents 112
 vent fields 112
 'white smokers' 112
Hydrozoa 191, **194**
Hydrurga leptonyx 447, **452**
Hymedesmia peachi 183
Hyperia medusarum 273
Hyperoodon ampullatus **438**
Hypnos monopterygius 354
Hypselodoris iacula 237

I

Ibis, Scarlet 80
Ice communities **108**
 pancake ice 108
Icefish, Blackfin **398**
Idiacanthus 370
Idotea baltica **275**
Iguana, Marine 403, **415**
 biology 415

 distribution 415
 ecology 415
 structural adaptations 415
 uses, threats, status and management 415
Infaunal communities **105**
International Conventions **502**
 Barcelona Convention for the Protection of the Mediterranean Sea Against Pollution 502
 Marine Protected Areas with World Heritage Site status 503
 Ramsar Convention on Wetlands 502
 UNESCO World Heritage Convention 502
Interrelationships **492**
Intertidal 82
 zone 34
Iphemedia obesa **273**
Ipmoea pes-caprae **157**
Isistius brasiliensis 336, **341**
Isoparactis fabiani 205
Isopoda 258, 274, **275**
Isopods **274**
 biology 274
 distribution 274
 ecology 275
 feeding 274
 life history 274
 species 275
 structure 274
 uses, threats, status and management 275
Istiophorus platypterus 318
Isurus oxyrinchus 57, 330, **343**

J

Japweed 148
Jassa falcata 272
Jawless fishes **320**
Jellyfish, Australian Box **199**
 Barrel **199**
 box 196
 polyps 198
 Common 125
 Compass **199**
 Crown 199
 Moon 53, 196, 197
 Spotted 50
 Upsidedown 149, **199**
Jellyfishes 53, 59, **195**
 biology 197
 distribution 195
 feeding 197
 life cycle 197
 life history 197
 rhopalium 196
 scyphistomae 197
 sensory systems 196
 species 199
 stalked 198, **199**
 structure 195

the eyes have it 196
uses, threats, status and management 198
Jialong 13
Johnson Sea-Link 1/2 13
Jumping fleas 273

K

Kajikia albida **397**
Kale, Sea 70
Kandelia candel **167**
Katsuwonus pelamis 306, 359
Kelp, Bull 87
 forests **99**
 keystone species **100**
 native distribution of 99
 Fur *191*
 Giant *99*, **148**
Killdeer *481*
Kinorhyncha **225**
Kite, Brahminy **491**
Kittiwake **477**
Kiwa 113
Kogia breviceps **437**
Kogiidae **437**
Kraits, sea 412
 Yellow-lipped Sea **414**
Krill, Antarctic *108, 270,* **271**
 Northern 53

L

Labidiaster annulatus 290
Labrus bergylta 138, 362
Labrus mixtus 274, 369
Lace coral **194**
Lactoria cornuta 362
Lagenodelphis hosei 416
Lagenorhynchus acutus **435**
Lagis koreni **216**
Laminaria, life cycle of *145*
Laminaria digitata **148**
Laminaria hyperborea 41, 131
Lamniformes **342**
Lampetra fluviatilis **325**
Lamprey *320*
 Arctic *314*
 Chilean **325**
 Pouched **325**
 River **325**
 Sea *323*, **325**
Lampreys *314,* **323**
 ammocoete larva *324*
 biology 324
 distribution 323
 ecology 324
 feeding 324
 life cycle 324
 life history 324
 respiration 323
 species 325
 structure 323

uses, threats, status and management 324
Lampriformes **381**
Lampriomorpha **381**
Lampris guttatus **381**
Lancelet, Florida *313*
Lancelets *306, 312, 313*
 biology 313
 classification 312
 distribution 312
 ecology 313
 feeding 313
 life history 313
 structure 313
 uses, threats, status and management 313
Lancetfish, Short-snouted **380**
Lanternfish, Spotted **381**
Lanternfishes **381**
Lapwing, Northern **484**
Lapwings **484**
Laridae **476**
Larus argentatus **476**
Larus marinus **476**
Larvae **54**
 tadpole *310*
Laticauda colubrina 402, **414**
Laticaudinae 412
Latimeria 400
Latimeria chalumnae *314,* 400
Latimeria menadoensis 400
Latrunculia magnifica **187**
Laver **140**
Lecanoromycetes **171**
Leech *210*
Leeches **217**
 biology 217
 distribution 217
 ecology 217
 structure 217
Legskate, American **353**
Lepadogaster purpurea **385**
Lepas 279
Lepas anatifera 258
Lepidochelys kempii **411**
Lepidochelys olivacea **410**
Lepidochitona cinerea **253**
Lepidonotus melanogrammus *210*
Leptasterias polaris **291**
Leptocardii *306*
Leptocharias smithii **345**
Leptonychotes weddellii **452**
Leptopsammia pruvoti **507**
Lesuerigobius friesii *105*
Lethenteron camtschaticum *314*
Leucetta chagosensis **186**
Leucophaeus scoresbii **477**
Leucoraja fullonica **350**
Leucosolenia **183**
Leuresthes tenuis 31, **385**
Liachirus melanospilos **391**
Lichen, Black Tar **171**

Lichens **169**
 biology 170
 distribution 169
 ecology 170
 species 171
 structure 169
 uses, threats, status and management 170
Lichina pygmaea **171**
Lichinomycetes **171**
Light **18**
 camouflage 18
 wavelengths 18
Ligia 259
Ligia oceanica **274**
Limacina helicina **53**
Limidae **241**
Limnoria **275**
Limonium 79
Limosa limosa **483**
Limpet, Blue-rayed *231*
 Common **235**
 Slipper *232*
Limulus polyphemus 79, *263*
Linckia 291
Lineus longissimus **221**
Ling **382**
Lingula anatina **256**
Linnaeus, Carl **120**
Linophryne arborifera **384**
Lionfish *19*
 Spotted **390**
Liparometra regalis **303**
Lipophrys pholis **395**
Lissodelphis peronii **435**
Littoral zone *34, 41*
Littorina littorea **236**
Lizardfish, Graceful **380**
Lizardfishes **380**
Lobe-finned fishes **400**
Lobodon carcinophaga *419, 447,* **452**
Lobster, European *260,* **269**
 Ridgeback Slipper **269**
 spiny **269**, *338*
Lobsters **266**
 autotomy 267
 biology 267
 distribution 266
 ecology 268
 feeding 267
 life history 268
 species 269
 structure 266
 uses, threats, status and management 268
Loch Obisary **20**
Loligo vulgaris **246**
Lopha cristagalli **245**
Lophelia 106
Lophiiformes **384**
Lophius piscatorius 359, **384**
Lophophore **285**

Loricifera **225**
Lough Hyne **107**
Loxosoma *179*
Lucernariopsis campanulata **199**
Luciferase 67
Luciferin 67
Lugworm, Blow **216**
Lugworms *213*
Luidia senegalensis **293**
Lumpsucker *368,* **390**
Lutjanus campechanus **367**
Lutjanus lutjanus **394**
Lutra felina **454**
Lybia tessellata 268, **493**
Lysmata amboinensis **498**

M

Mackerel, Atlantic **397**
Macoma balthica **240**
Macroalgae **130**
Macrocheira kaempferi **258**
Macrocypridina castanea **283**
Macrocystis pyrifera 99, **148**
Macronectes giganteus **470**
Macrura Reptantia **269**
Marine Iguana *403,* **415**
Maerl *137,* **139**
 beds **103**
Mako, Shortfin *57, 330,* **343**
Malacostegina **284**
Malacostraca 258, **265**
Malacostracans **265**
Mallotus villosus **379**
Mammalia *306*
Mammals 306
Mammals, marine **416**
 anatomical adaptations 417
 classification 416
 deepest diving *418*
 diving adaptations 418
 the bends 419
 physiological adaptations 417
 salt and water balance 417
 satellite tagging *419*
 temperature regulation 417
Manatee, West African *416*
 West Indian *439,* 442
Manatees **439**
 biology 441
 body form and general features 439
 distribution 439
 ecology 442
 external differences between Dugong and manatees *440*
 feeding 441
 life history 442
 nostrils *441*
 senses 441
 skeleton 440
 structure 439
 uses, threats, status and management 443

Mangrove 77
 Cannonball 166
 Red 164
 River 167
 White 166
Mangrove Apple 163, 167
Mangroves 162
 aerial roots 80, 163, 164
 biology 164
 distribution 162
 ecology 164
 forests 80
 life history 164
 physiology 162
 prop roots 80, 81, 164, 165
 seedlings 165
 species 166
 structure 162
 uses, threats, status and management 165
Manta alfredi 351
Manta birostris 351
Mantis shrimps 276, *277*
 biology 276
 distribution 276
 ecology 277
 feeding 276
 life history 277
 structure 276
 uses, threats, status and management 277
Mar-Eco expedition 109
Mariana trench 36
Marine environment 16
 benthic division 34
 ocean statistics 16
 main divisions 34
 pelagic division 34
Marine flowering plants 157
 structure 157
Marine fossils 118
 Burgess Shale Formation 118
 common marine fossils 118
 fossil hotspot 118
 Messel Pit 118
Marine fungi 168
 classification 168
 in the marine environment 168
 structure 168
Marine microalgae 149
 distribution 149
Marine organisms, ways of life 43
Marine parks 510
 Great Barrier Reef Marine Park 510
 conservation 511
 designation 510
 location 510
 marine life 510
 species 511
 Tun Sakaran Marine Park 512
 Bajau Laut (sea gypsies) 513
 conservation 513

 designation 512
 location 512
 marine life 512
 species 513
Marine phyla 122
Marine plants
 classification of 128
 classification of marine chromists 128
Marine Protected Areas (MPAs) 502
 World Database on Protected Areas (WDPA) 502
Marine reserves 506
 Chagos Islands 508
 conservation 509
 designation 508
 location 508
 marine life 508
 species 509
 Lundy Island 506
 conservation 507
 designation 506
 location 506
 marine life 506
 species 507
 zoning 506
Marine snow 111
Maritime zones 503
 contiguous zone 503
 exclusive economic zone (EEZ) 503
 high seas 503
 territorial sea 503
Marlin, Atlantic White 397
Marphysa belli 212
Marphysa sanguinea 212, **214**
Marram grass 72
Marthasterias glacialis 290
Mastigias 76
Maxillopoda 278
Megachasma pelagios 343
Megalops atlanticus 317, **375**
Meganyctiphanes norvegica 53
Megaptera novaeangliae 58, 422, 427, 428, 430, **433**
Meiofauna 90
Melanitta deglandi 486
Melanitta perspicillata **489**
Melanogrammus aeglefinus 359
Melibe leonina 233
Merganser, Red-breasted **489**
Mergus serrator **489**
Merluccius merluccius 217, **382**
Mermaid's Wine Glass 143
Merostomata 262
Mertensia maritima 69
Mesopelagic zone 34, 63
 adaptations 63
Mesoplodon densirostris **438**
Metamonada 172
Metasepia pfefferi 250
Metridium senile 93
Microalgae 149

distribution 149
Microanimals 174
Micromesistius poutassou 314
Micro-plants 156
 biology 156
 structure 156
Mid-ocean ridges 36
Migration 58, **338**, 462
 Diel Vertical Migration 64
 flyways 463
 incredible journeys 463
 route of female Blue Shark 338
 whale 421
Milkfish 378
Millepora 192
MIR 1 & 2 *13*
Mirounga 446
Mirounga angustirostris 417
Mirounga leonina **451**
Mitsukurina owstoni 342
Modiolus modiolus 104, 229, 241
Mola mola 57, **392**
Molluscs 228
 classification 228
 minor 254
 radula 229
 shell 229
 structure 229
 world capture production and aquaculture production for 242
Molva molva 382
Monachus monachus 416, **452**
Monachus schauinslandi 505
Monitor, Water 415
Monodon monocero **437**
Monodontidae 436
Monoplacophorans 255
Montipora 205
Moray, Giant 363
Mordacia lapicida 325
Morning Glory, Beach 157
Morus bassanus **473**
Moss animals 284
Mud shores 90
Mudskippers 165, 315
Mullet, grey 383
 Thicklip Grey 383
Murrelet, Japanese **474**
Mussel, Common 238
 Green-lipped 245
 Horse 104, 229, 241
Mussels, vent 112
Mustelus mustelus 346
Mya 239
Mya arenaria 240
Myctophiformes 381
Myctophum punctatum 381
Myliobatiformes 351
Myliobatis 349
Myrichthys colubrinus 376
Myriogramme bonnemaisoni 134
Myripristis murdjan 387

Mysticeti 416, **433**
Mytilus edulis 238
Myxine glutinosa 306, **322**
Myxini 306, 314, **322**
Myzozoa 128, **152**

N

Narcine brasiliensis 354
Narke capensis 354
Narwhal 436, 437
Natator depressus 411
Naticidae 232
Naucrates ductor 57, 371
Nauplius lava 52
Nautile *13*
Nautiloidea 251
Nautilus, Emperor 246, **251**
 Paper 249
Nautilus 248
Nautilus pompilius 246, **251**
Nebrius ferrugineus 315, 333
Negaprion brevirostris 333, 335, 337, **347**
Negombata magnifica 187
Nekton 57
 invertebrates 59
Nematoda 222
Nematodes 222
 biology 222
 classification 222
 distribution 222
 feeding 222
 life history 222
 movement 222
 structure 222
 uses, threats, status and management 222
Nematomorpha 225
Nembrotha megalocera 494
Nemertea 220, **221**
Nemertesia ramosa 191
Nemichthys 376
Neobalaenidae **434**
Neolithodes 109
Neomenia yamamatoi 255
Neopetrolisthes maculatus 267
Neophocaena phocaenoides **438**
Neopterygii 375
Neptune's Necklace 148
Nereocystis luetkeana 128
Nereus *13*
Neries pelagica 211
Nerita 235
Nerite 235
Neritimorpha 235
Neuston 60
Ningaloo Reef 117
Nipponnemertes pulcher **221**
Noctiluca scintillans 152, 153
Noddy, Brown **476**

Non-vertebrate chordates 306
Nori 140
Notocheirus hubbsi 385
Notorynchus cepedianus 340
Nototeredo norvagica 244
Notothen, Emerald 398
Notothenia rossii 398
Novocrania anomala 257
Novodinia 292
Nucella lapillus 233
Nucula nitidosa 245
Nudibranch, aeolid 237
　dorid 237
　Hooded 233
Numbfish, Cape 354
Numenius arquata 483
Nypa fruticans 167

O

Oarfish 381
Oarweed 148
Obelia geniculata 191
Ocean acidification 25
Ocean currents 28
　subsurface currents 29
　surface currents 28
Ocean life 116
　how many species are there in the Ocean? 116
　distribution of 117
Ocean research 12
Ocean sanctuaries 504
　Hawaii 505
　　Hawaiian Islands Humpback Whale National Marine Sanctuary 505
　　Hawaiian Monk Seal 505
　　Monachus schauinslandi 505
　　Northwestern Hawaiian Islands (NWHI) 505
　　Papahānaumokuākea 505
　International Whaling Commission (IWC) 504
　Southern Ocean Whale Sanctuary 504
Ocean topography 36
Ocean trenches 36
Oceanapia sagittaria 187
Oceanic global primary production 51
Oceanites oceanicus 472
Oceanodroma leucorhoa 472
Oceans and seas of the world 16
Ochrophyta 128, 147, 149, 151
Octocorallia 203
Octocorals 200
Octopodiformes 251
Octopus 246, 248, 249
　Common 246, 251
　Greater Blue-ringed 251
　Mimic 251
Octopus vulgaris 246, 251
Ocypode 91
Ocypode quadrata 269

Odobenidae 444, **450**
Odobenus rosmarus 444, 450
Odontaster validus 221
Odontoceti 416, **434**
Odontodactylus scyllarus 261, 276
Ogcocephalus darwini 384
Olavius algarvensis 210
Oligochaeta 216
Oligochaetes 210, **216**
　biology 216
　distribution 216
　structure 216
Omalosecosa ramulosa 287
Ommatophoca rossi 452
Oncorhynchus mykiss 315, 318
Oncorhynchus nerka 379
Onychoprion fuscatus 476, **509**
Opah 381
Open water 49
Ophidiiformes 383
Ophiopholis aculeata 295, **296**
Ophiothrix fragilis 294
Ophiothrix suensonii 294
Ophiura ophiura 288
Ophiuroidea 288, 294, **296**
Opsanus tau 383
Orcinus orca 436
Oreasteridae 290
Orectolobiformes 343
Organisations **515**
Osmeriformes 379
Osmerus eperlanus 379
Osmosis 318
Osmundea pinnatifida 135
Ostarioclupeomorpha 377
Ostariophysi 378
Ostorhinchus compressus 393
Ostraciidae 362
Ostracion cubicus 359, **392**
Ostracod, Chocolate-drop 283
Ostracoda 258, 282, **283**
Ostracods **282**
　biology 282
　distribution 282
　ecology 283
　feeding 282
　giant sperm 283
　life history 282
　species 283
　structure 282
　uses, threats, status and management 283
Otaria flavescens 451
Otariidae 416, **444**, **450**
Otter, Northern Sea 454
　Oriental Small-clawed 455
　Sea 100, 454, 455
　South American Marine 454
Otters, marine **454**
　biology 455
　body form and general features 454
　distribution 454

ecology 455
feeding 455
life history 455
senses 455
structural adaptations 454
uses, threats, status and management 455
Oxycomanthus bennetti **303**
Oxygen storage in diving mammals 419
Oxynotus bruniensis 341
Oyster, Black-lipped Pearl 242
　Cock's-comb 245
　Japanese 245
　Thief 148
　Thorny 245
Oysters **242**
Oystercatcher, American 242, **484**
Oystercatchers **484**
Oysterplant 69

P

Pachyptila vittata **471**
Padina 134
Padina pavonina 148
Paelopatides grisea 110
Pagodroma nivea **470**
Pagophilus groenlandicus 453
Pagurus bernhardus 492
Painted Lady 79
Palaemon serratus 266, **269**
Palinurus elephas 507
Palmaria palmata 139
Palm, Nipa 167
Pancratium maritimum 73
Panopea generosa 244
Panulirus 269, 338
Parablennius gattorugine 395
Paracanthopterygii 382
Paracis 201
Paraluteres prionurus 497
Parasagitta elegans 53
Parasagitta setosa 176
Parasites **500**
Paratetilla bacca 182
Parazoanthus axinellae **209**
Parborlasia corrugatus 221
Pardachirus marmoratus 329, **391**
Pareques acuminatus 399
Parrotfish, Green Humphead 394
　Queen 367
Parupeneus barberinus 363
Passeriformes **491**
Past ocean life **118**
　Burgess shale formation 118
　common marine fossils 118
　fossil hotspot 118
　Messel pit 118
Patella pellucida 231
Patella vulgata 235
Patellogastropoda 235
Pavoraja nitida 353
Paxillosida 293

Peacock's Tail 148
Peanut worms **223**
　biology 223
　classification 223
　distribution 223
　feeding 223
　life history 223
　structure 223
　uses, threats, status and management 223
Pearlfish 383
Pearls, a string of 242
Pecten maximus 241, 245
Pegasus 388
Pegusa lascaris 363
Pelagia noctiluca 195
Pelagic environments 49
Pelamis platura 414
Pelecanidae **473**
Pelecaniformes **473**
Pelecanoides urinatrix 472
Pelecanoididae 472
Pelecanus occidentalis **473**
Pelican, Brown **473**
Pelicans **473**
Pelvetia caniculata 144
Penguin, Fairy **469**
　Gentoo 469
　Jackass 469
　King 469
　Southern Rockhopper 467
Penguins 462, **469**
Pennatulacea 105
Pennatula phosphorea 200
Pentapora fascialis 287
Peponocephala electra 436
Perches 393
Perciformes **393**
Percolomonas 172
Percolozoa 172
Periclimenes sagittifer 268
Peridinium depressum 152
Periphylla periphylla 199
Periwinkle, Edible 236
Perna canalicula 245
Perophora namei 311
Petrel, Great-winged **471**
　Snow 470
　Southern Giant 470
Petrels **470**
Petromyzon marinus 323, **325**
Petromyzonti 314
Petrosia 513
Peyssonnelia 140
Phaeophyceae **147**
Phaethon rubricauda **470**
Phaethontiformes **470**
Phalacrocoracidae **473**
Phalacrocorax aristotelis **474**
Phalacrocorax carbo **473**
Phalacrocorax varius 461
Phalarope, Red-necked 483

Phalaropus lobatus **483**
Phallusia mammillata 306
Philodina roseola 180
Philomachus pugnax 478, 480
Phocarctos hookeri 451
Phoca vitulina 91, 444, **453**
Phocidae 416, 444, **451**
Phocoena phocoena **437**
Phocoenidae **437**
Phocoenoides dalli **438**
Phoebastria irrorata **472**
Pholadidae 43
Pholas dactylus 85
Pholis gunnellus **395**
Phoronida 226
Phoronids **226**
 biology 226
 classification 226
 distribution 226
 ecology 226
 feeding 226
 life history 226
 structure 226
Phoronis hippocrepia 226
Photobacterium leiognathi 126
Photoblepharon palpebratum **387**
Photophores 67
Photosynthesis 112
Phycodrys rubens 134
Phycodurus eques **389**
Phyllodocida 210, **215**
Phyllodocidae 213
Phyllorhiza punctata 50
Phyllospongia papyracea 182
Phymatolithon calcareum **139**
Physalia physalis 188, 192
Physeteridae **437**
Physeter macrocephalus 418, **437**
Physophora hydrostatica **194**
Piddocks 43, 85
Pigface **70**
Pilchard, South American **377**
Pilotfish 57, 371
Pinctada margaritifera 242
Pineapplefish **387**
Pinnipedia 444, **450**
Pinnipeds **444**
Pipefish, Harlequin Ghost **389**
 Snake **389**
Pipefishes **389**
Pipit, Eurasian Rock **491**
Pisaster brevispinus 288
Pisaster ochraceus **292**
Placozoa 181
Placozoan 174
Placozoans **181**
Plaice, European 359, **391**
Plainfin Midshipman **383**
Plakortis lita **187**
Plankton 49
 auricularia 55
 bipinnaria 55

climate change 56
continuous plankton recorder 56
cyphonautes larva 56
cypris larva 55
doliolaria 55
echinopluteus 55
holoplankton 53
megalopa larva 55
merozooplankton 54
nauplius larvae 55
ophiopluteus 55
parenchymula larva 54
phytoplankton 49, **51**
 bloom 51
 planula larva 54
 sizing and collecting **50**
 tadpole larva 56
 trochophore larvae 54
 veliger larvae 54
 zoea larva 55
 zooplankton 49, **52**
Plantae **156**
Plant-like animals **44**
Platax pinnatus **399**
Plate tectonics 37
Platyhelminthes 218
Platyrhinoidis triseriata **353**
Plectorhinchus chaetodonoides **370**
Pleocyemata **269**
Plerogyra 227
Plesiobatis daviesi **352**
Pleurobrachia 175
Pleuroncodes planipes **59**
Pleuronectes platessa 359, **391**
Pleuronectiformes **391**
Pleuston 60
Plocamium lyngbyanum **139**
Plotosus lineatus **378**
Plover, Crab **478**
 Eurasian Golden **484**
 Little Ringed **481**
 Ringed **484**
Plovers **484**
Pluvialis apricaria **484**
Podiceps cristatus **491**
Podiceps nigricollis **491**
Podicipediformes **491**
Polar Bear **456**, 457
Pollachius pollachius 317
Pollack 317
Pollicipes polymerus 45
Polycarpa aurata **312**
Polycera quadrilineata 286
Polychaeta 211, **214**
Polychaete 210
Polychaetes **211**
 biology 212
 distribution 211
 ecology 213
 feeding 212
 life history 212
 species 214

structure 211
uses, threats, status and management 214
Polychaete worms 53
Polycitor giganteus 306
Polycladida **219**
Polykrikos schwarzi 152
Polymixia berndti **381**
Polymixiformes **381**
Polymixiomorpha **381**
Polyplacophora 228, 252, **253**
Polysiphonia 137
Pomacanthus imperator **399**
Pomacentridae **366**
Pomphret, Atlantic **396**
Pontobdella muricata **217**
Poppy, Yellow Horned **70**, 130
Porcellana platycheles 87
Porcellanidae 87
Porcupinefish **493**
 Spot-fin **392**
Porella compressa **284**
Porichthys notatus **383**
Porifera 182, **186**
Poroderma africanum **495**
Porphyra **140**
 life cycle 136
Porpita porpita **194**
Porpoise, Dall's **438**
 Finless **438**
 Harbour **437**
Porpoises **437**
Portuguese Man-of-War **192**
Posidonia oceanica **161**
Pratincoles 478
Prawn, Common 266, **269**
Prawns **266**
 autotomy 267
 biology 267
 distribution 266
 ecology 268
 feeding 267
 life history 268
 species 269
 structure 266
 uses, threats, status and management 268
Praying mantis 277
Prefixes **518**
Priacanthus blochii **363**
Pricklefish **386**
Prionace glauca 314, **347**
Prion, Antarctic **471**
Pristiformes **354**
Pristiophorus cirratus **341**
Pristis **354**
Pristophoriformes **341**
Procellariidae **470**
Procellariiformes 458, **470**
Proscyllium haberi **345**
Prostheceraeus vittatus **219**

Protacanthopterygii **379**
Protanthea simplex **106**
Protobranchia **245**
Protoreaster nodosus **290**
Protozoa **172**
 biology 173
 classification 172
 distribution 172
 ecology 173
 structure 173
Prymnesiophytes **155**
 biology 155
 structure 155
Psammechinus miliaris **288**
Pseudanthias **393**
Pseudobiceros **220**
Pseudobiceros bedfordi 219, **220**
Pseudobiceros ferrugineus **220**
Pseudoceros cf. *dimidiatus* **220**
Pseudopterogorgia **204**
Pseudorca crassidens **426**
Pseudosagitta maxima **174**
Psychropotes 109
Pteriomorphia **245**
Pterobranchs 304
Pterodroma macroptera **471**
Pterois antennata **390**
Pterois volitans 19
Ptilometra australis **303**
Ptilosarcus gurneyi **203**
Puffer, Blackspotted **392**
 False **497**
 Valentin's Sharpnose **497**
Pufferfishes **392**
Puffin, Atlantic 47, **475**
Puffinus gravis **47**
Puffinus pacificus **471**
Puffinus puffinus **470**
Pusa hispida 445, **453**
Pycnogonida 258, **262**
Pycnopodia helianthoides **292**
Pygoplites diacanthus **394**
Pygoscelis papua **469**
Pyura spinifera **312**

Q

Quahog, Ocean 240

R

Rabbitfish **357**
 Masked **394**
 Small-eyed **355**
Radiolaria **154**
Radiolarians **154**
Radula **229**
Ragworm, Slender 211
Raja clavata 217, 327, 332, 348, **352**
Raja microocellata **331**
Raja undulata **330**
Rajiformes **352**
Ramalina 170
Ramalina siliquosa **171**

Raniceps raninus **382**
Ratfish, White-spotted 357
Ray, Bluespotted Ribbontail *330*
 Brazilian Electric **354**
 Butterfly **351**
 Coffin **354**
 eagle *349*
 electric *349*
 Haller's Round **351**
 manta *176, 349, 350,* **351**
 Shagreen *350*
 Small-eyed *331*
 Spot-on-spot Round *352*
 Spotted Eagle *326,* **351**
 Thornback *217, 327, 332, 348,* **352**
 Undulate *330*
Rays **348**
 biology 349
 body form 348
 distribution 348
 ecology 350
 feeding 349
 general features 348
 gill rakers *350*
 life history 350
 species 351
 structure 348
 uses, threats, status and management 350
Ray-finned fishes **358**
Razorbill 474
Razorfish **389**, *497*
Recording schemes **515**
Recurvirostidae 484
Recurvirostrata avosetta **484**
Red seaweeds 135
Red tides 153
Regalecus glesne 381
Regeneration 291
Remipedes *264*
Remipedia *258,* 264
Remote sensing 15
Reptiles 306
Reptiles, marine **402**
 Anatomical adaptations 402
 classification 402
 dive duration and depth 404
 Diving 404
 Physiological Adaptations 402
 Salt and water balance 403
 Salt glands 403
 Temperature regulation 402
Reptilia 306
Rhabdopleura normani 304
Rhina ancylostoma 353
Rhincodon typus 57, *117,* **344**
Rhinobatos 329
Rhinochimaera atlantica 314
Rhinochimaera pacifica 327
Rhinomuraena quaesita 376
Rhizophora 166
Rhizophora mangle 128, *164*

Rhizostoma pulmo 199
Rhodophyta 139
Rhopalaea 311
Rhopalium 196
Rhynchobatus djiddensis 353
Rhynchobdellida 210
Ribbon worms **220**
 biology *221*
 classification 220
 distribution 220
 ecology 221
 feeding 221
 life history 221
 movement 221
 structure 220
 uses, threats, status and management 221
Rissa tridactyla **477**
Rivularia bullata *127*
Rock pools **88**
Rockcod, Marbled 398
Rockling, Shore **382**
Rocky reefs **92**
Rocky shore **85**
 zonation of fucoid seaweeds 87
 zones 86
Rorquals **433**
Rotifer *174*
Rotifera 180
Rotifers **180**
 biology 180
 classification 180
 distribution 180
 feeding 180
 life history 180
 structure 180
Roughy, Orange 387
Ruff *478,* 480
Rynchopidae **475**
Rynchops niger **475**

S

Sabella pavonina *211,* 286
Sabella penicillus 44
Sabellaria alveolata 214
Sabellida 210, **215**
Sabellidae 212
Saccoglossus ruber 304
Saccopharyngiformes 375
Saccopharynx lavenbergi 375
Saccorhiza polyschides 131
Saduria entomon **275**
Sailfish *318*
Sailor's Eyeball *142*
Salicornia 79
Saline lagoons **76**
Salinity **20**
 ocean 20
Salmo trutta **379**
Salmon 318, **379**
 parr *318*
 Sockeye 379

Salmoniformes 379
Salpa maxima 306
Salpa thompsoni **53**
Salps 310
Salsola kali **73**
Salt glands **403**, *461*
Saltmarsh **77**
 adaptations of halophytic saltmarsh plants 78
 migration 79
 zonation 78
Saltwort, Prickly **73**
Samphire, Rock **70**
Samphires 79
Sampling **14**
Sand Dollar **299**
Sand dunes **71**
 development *71*
 dune heath 72
 embryo dunes 72
 grey dune 72
 plants 72
 types of 72
 yellow dune 72
Sandeel, Lesser **396**
Sandfish, Beaked 378
Sandpiper, Spoon-billed *482*
Sandpipers **483**
Sand shores **90**
Sanopus splendidus *365*
Sarcophyton **204**
Sardine, Surf **385**
Sardinella, Madeiran 377
Sardinella maderensis 377
Sardinops sagax 377
Sargasso Sea 61, *146*
Sargassum 146
Sargassum muticum *148*
Sargassumfish 384
Satellites **15**
 tagging *15*
Sauria 402
Saurida gracilis 380
Saury, Atlantic 386
Sawfish *350,* 354
Sawshark, Longnose 341
Sawsharks **341**
Scallop, Great *241,* **245**
 Queen *239, 241*
Scaphopoda 228
Scaphopods **254**
Scarus vetula 367
Scleronephthya 201
Scolecida **216**
Scolopacidae 483
Scomberesox saurus 386
Scomber scombrus 397
Scopelomorpha 381
Scophthalmus maximus **391**
Scophthalmus rhombus *359*
Scopimera 267
Scorpaeniformes **390**

Scorpionfish, Leaf *497*
Scoter, Surf **489**
 White-winged *486*
Scotoplanes globosa *301*
Scrobicularia plana 239, 240
Scyliorhinus canicula *332,* **345**
Scyllarides haani **269**
Scyphozoa 195, **199**
Sea Angel **237**
Sea Bean *84*
Sea cliffs **68**
Sea cucumbers *109, 110,* **300**
 biology 300
 cuverian tubules *301*
 distribution 300
 ecology 301
 feeding 300
 life history 301
 species 301
 structure 300
 uses, threats, status and management 301
Sea daisies 290
Sea Fan, Giant **204**
 Pink **507**
Sea fans **200**
 biology 201
 commensals 202
 distribution 200
 ecology 202
 feeding 201
 life history 202
 skeleton 201
 species 203
 structure 200
 uses, threats, status and management 203
Sea hare **237**
Sea Holly **73**
Sea ice 108
Sea Ivory *171*
Sea Lettuce **143**
Sea lilies 302
Sea Lion, California **451**
 Galapagos *449*
 Hooker's **451**
 New Zealand **451**
 South America **451**
 Steller's **445,** 450
Sea Oats *73*
Sea mats **284**
Sea moth **388**
Sea Mouse **215**
Sea Pen, Orange **203**
Sea Pig *301*
Sea plume **204**
Sea shore *82*
Sea Slater *259,* **274**
Sea Slug **507**
 aeolid *231*
 dorid *231*
 Ruffled Lettuce 44

Sea snakes 412
Sea spiders 262
 biology 263
 distribution 262
 ecology 263
 feeding 263
 life history 263
 structure 262
 uses, threats, status and management 263
Sea Squirt, Yellow Ringed 308
Sea squirts 306, 307
Sea Star, Biscuit 293
 Ocre 292
 Sunflower 292
Sea stars 290
Sea temperature 26
Sea Tulip 312
Sea Urchin, Giant Red 299
 Long-spined 299
 Red Slate Pencil 299
Sea urchins 296
 Aristotle's lantern 297
 biology 297
 distribution 296
 ecology 298
 feeding 297
 fossil 296
 life history 298
 pedicellariae 297
 species 299
 structure 297
 tests 298
 uses, threats, status and management 298
Sea-firefly 283
Sea-lavender 79
Seabass, European 395
Seabed 68
 measurement 14
Seabirds 464
 biodiversity 464
 biology 465
 co-operative hunting 466
 distribution 464
 ecology 467
 feeding 465
 fish-fetcher 468
 kleptoparasitism 466
 life history 466
 salt glands 465
 species 469
 structure 465
 uses, threats, status and management 467
 wing shapes 465
Seadragon, Leafy 389
Seaducks 485
 adaptations of 486
 courtship displays in 487
Seagrapes 143
Seagrass beds 101

food web 102
world distribution of 101
Seagrass, Tropical 161
Seagrasses 157
 biology 159
 distribution 158
 ecology 159
 life history 159
 species 160
 structure 158
 uses, threats, status and management 160
Seahorse 369
 Long-snouted 359
 Pygmy 496
 Short-snouted 389
Seahorses 389
Seal
Seal, Antarctic Fur 450
 Australian Fur 444
 Bearded 453
 Cape Fur 449, 417
 Common 453
 Crabeater 419, 447, 452
 eared 450
 earless 444
 elephant 446
 Grey 91, 444, 448, 453
 Harbour 91, 444, 453
 Harp 453
 Hawaiian Monk 505
 Hooded 446, 452
 Leopard 447, 452
 Mediterranean Monk 416, 452
 New Zealand Fur 447
 Northern Elephant 417
 Northern Fur 451
 Ribbon 453
 Ringed 445, 453
 Ross 452
 Southern Elephant 451
 Subantarctic Fur 416
 true 444, 451
 Weddell 452
Seals 444
 back on dry land 444
 biology 447
 body form and general features 445
 bottling 448
 distribution 444
 ecology 448
 feeding 447
 haul-out sites 444
 life history 448
 main physical differences between true seals (Phocidae) and sea lions and fur seals (Otariidae) 445
 oddities 446
 senses 447
 species 450
 structural adaptations 445

uses, threats, status and management 449
Sealochs 106
Seamounts 38, 114
Seapens 105
Seasonal hotspots 117
Seawater, density 22
 viscosity 22
Seaweeds 130
 brown 144
 biology 145
 ecology 146
 life history 145
 species 147
 structure 144
 uses, threats, status and management 147
 calcareous 132
 depth and zonation 133
 distribution 130
 green 141
 biology 141
 ecology 142
 life history 141
 species 142
 structure 141
 uses, threats, status and management 142
 pigments 133
 pressing and identifying 134
 red 135
 biology 136
 ecology 137
 life history 136
 species 139
 structure 135
 uses, threats, status and management 138
 reproduction 132
 structure 130
Secchi disc 18
Sedentaria 215
Sediment shores 89
 ecological aspects 91
Seison nebaliae 180
Selachii 340
Semaeostomeae 188
Semibalanus balanoides 42, 279
Sepia apama 228, 251
Sepia offciinalis 246
Sepiola 247
Sepiola rondeleti 251
Sepioteuthis sepioidea 250
Serpula vermicularis 104
Serpentes 402
Serranidae 358
Sessile marine phyla 45
Shag, European 474
 Pied 461
Shags 473
Shallow sublittoral sediments 103
Shanny 395

Shark, Basking 331, 343
 Blacktail Reef 346
 Blue 314, 347
 Bluntnose Sixgill 316
 Bramble 340
 Broadnose Sevengill 340
 Bull 346
 bullhead 328, 342
 Cookiecutter 336, 341
 cow 340
 Dogfish 340
 Epaulette 497
 Frilled 340
 Galapagos 330
 Goblin 342
 Greenland 341
 Grey Reef 339
 ground 344
 Gulper 330
 Lemon 333, 335, 337, 347
 Leopard 346
 mackerel 342
 Megamouth 343
 Nurse 329, 333, 344
 Oceanic Whitetip 346
 Port Jackson 342
 Pyjama 495
 Sandtiger 329, 342
 Silky 509
 Tawny Nurse 315
 Thresher 343
 Tiger 347
 Whale 57, 117, 344
 White 319, 334
 Whitetip Reef 347
 Zebra 344
Sharks 334
 biology 335
 body form 334
 distribution 334
 ecology 338
 external features 334
 feeding 335, 339
 feeding method of the parasitic Cookiecutter Shark 336
 fins 335
 general features 334
 life history 336
 migration 338
 mouth positions of a feeding 336
 reproductive capacity in 337
 species 340
 swimming 335
 tail shapes 335
 uses, threats, status and management 339
 'virgin' births 337
Shearwater, Cory's 471
 Great 470
 Manx 470
 Wedge-tailed 471
Shearwaters 470

Sheathbill, Black-faced *458*
Sheathbills *478*
Sheepshead *367*
Shelduck, Common **487**, **488**
Shell, cone *231*
 necklace *232, 233*
 Peppery Furrow *239, 240*
 Shining Nut **245**
 Tellin **244**
 Tower Screw **236**
 Triton *232*
Shingle flowers *70*
Shinkai 6500 *13*
Shipworm, Norway **244**
Shipwrecks *92*
Shrimp, alpheid *499*
 Boxer **269**
 caprellid *277*
 euphausid *53*
 Ghost **273**
 mantis *261*, **276**
 biology *276*
 distribution *276*
 ecology *277*
 feeding *276*
 life history *277*
 structure *276*
 uses, threats, status and management *277*
 Peacock Mantis *276, 277*
 White-banded Cleaner *498*
Shrimps **266**
 autotomy *267*
 biology *267*
 distribution *266*
 ecology *268*
 feeding *267*
 life history *268*
 species *269*
 structure *266*
 uses, threats, status and management *268*
Siganus puellus **394**
Siluriformes **378**
Silversides **385**
Siphonophorae *188*, **192**
Siphonophores *192*
Sipuncula *223*
Sirenians **439**
Skate, Blue *124*
 Common *124*, **352**
 Flapper *124*
 Peacock **353**
Skimmer, Black **475**
Skimmers **475**
Skua, Arctic **477**
 Great **477**
Smelt, European **379**
 Sand **385**
Smelts **379**
Smoothhound **346**
Snail, worm *236*

Snake, Arabian Gulf Sea **414**
 Dog-faced Water **414**
 Ijima's Turtlehead Sea *413*
 Olive Sea **404**
 Yellow-bellied Sea **414**
Snakes, sea **412**
 biology and ecology *412*
 distribution *412*
 feeding *412*
 imposters *414*
 life history *413*
 marine and estuarine snake genera *413*
 species *413*
 structural Adaptations *412*
 uses, threats, status and management *413*
 venom *412*
Snapper, Bigeye **394**
 Northern Red *367*
Snipe, Common **483**
Soft corals **200**
Solaster endeca **290**
Solasteridae **290**
Soldierfish, Pinecone **387**
Sole, Carpet **391**
 Moses *329*, **391**
 Sand *363*
Solenogasters **255**
Solenogastres **255**
Solenostomus paradoxus **389**
Solieria chordalis *140*
Somateria mollissima **488**
Somateria spectabilis *458*
Somniosus microcephalus **341**
Sonar *14*
Sonneratia caseolaris *163*, **167**
Sousa chinensis **435**
Spanish Dancer **237**
Spartina *78*
Spatangoida **299**
Species **124**
 classification and arrangement of in this book *125*
 names *124*
 naming new *125*
Specific heat capacity (SHC) **26**
Speleonectes tanumekes *258*
Sphenisciformes **469**
Spheniscus demersus **469**
Sphyraea *512*
Sphyraena barracuda *367*, **397**
Sphyrna lewini *338*, **347**
Sphyrna mokarran **347**
Spinachia spinachia **388**
Spinulosida **293**
Spiny plunderfish **398**
Spirobranchus *213*
Spirobranchus triqueter *210*
Spirophorida *182*
Spirorbis spirorbis **215**
Spondylus *178*

Spondylus versicolor **245**
Sponge, Boring **187**
 Breadcrumb *184*
 Chicken Liver **187**
 Giant Barrel *185*
 Giant Cup **513**
 Lemon **186**
 Pink Puffball **187**
 Shredded Carrot *183*
 Stove-pipe **187**
 Toxic Rope **187**
 Yellow Picasso **187**
Sponges **182**
 biology *184*
 calcareous *186*
 carnivorous *184*
 choanocytes *184*
 classification *182*
 collar cells *184*
 demosponges *187*
 distribution *182*
 ecology *185*
 feeding *184*
 glass *187*
 identification *182*
 life history *185*
 new from old *184*
 species *186*
 spicule skeleton *183*
 structure *183*
 uses, threats, status and management *186*
Spookfish, Pacific *327*
 Smallspine *357*
Spoon worms **224**
 biology *224*
 classification *224*
 distribution *224*
 feeding *224*
 life history *224*
 structure *224*
 uses, threats, status and management *224*
Springtails *60*
Squaliformes **340**
Squalus acanthias *327*, **340**
Squamata **413**
Squatina californica **342**
Squatiniformes **342**
Squid **246**, *247*
 bobtail *247*
 Caribbean Reef **250**
 European *246*
 Firefly *66*
 Sea *70*
Squirrelfish, Longspine **387**
Squirrelfishes **387**
Star Ascidian *308*
Starfish, Burrowing **293**
 Common **495**
 Crown-of-thorns *232*, *292*
 Nine-armed **293**

Polar *291*
Red Tile **293**
Spiny *290*
Starfishes **290**
 biology *291*
 distribution *290*
 ecology *292*
 life history *291*
 regeneration *291*
 species *292*
 structure *290*
 uses, threats, status and management *292*
Stargazers *365*
Staurocalyptus **187**
Staurozoa **195**, **199**
Stegostoma fasciatum **344**
Steller's Sea Cow **442**
Stenella frontalis **425**
Stenella longirostris **435**
Stenolaemata **287**
Stenoplax conspicua **228**
Stenopterygii **380**
Stenopus hispidus **269**
Stenorhynchus seticornis **265**
Stephanoberyciformes **386**
Stercorariidae **477**
Stercorarius parasiticus **477**
Stercorarius skua **477**
Stereomastis *63*
Sterna paradisaea **463**, **475**
Sterna sandvicensis **475**
Sternidae **475**
Sternula albifrons **476**
Stickleback, Sea **388**
 Three-spined **388**
Sticklebacks **388**
Stilt, Black-winged *480*
Stilts **484**
Stingray, Deep-water **352**
 Ribbontail **351**
 Sixgill **352**
 Southern *313*, **351**
Stingrays **351**
Stomatopoda **276**
Stomiiformes **380**
Stonefish **390**
Storm-petrel, Black-bellied **472**
 Leach's **472**
 Wilson's **472**
Storm-petrels **472**
Strandline *83*
Stromatolite *127*
Strongylocentrotus franciscanus **299**
Structure **334**
Sturgeon, Beluga **374**
 European **374**
Sturgeons **374**
Stylaster **194**
Stylocheiron maximum *270*
Stylochoplana maculata **219**
Sublittoral *92*

zone 34, 41
Submersibles 13
Suffixes 518
Sula leucogaster 473
Sula nebouxii 461
Sula sula 511
Sulidae 473
Sunfish 57
 Ocean 392
Sunlit zone 34, **62**
 adaptations 62
Surface living 60
Surgeonfish, Monrovian 124
 Powder-blue 394
 Sohal 124
 Striped 494
Surgeonfishes 124
Swallower 375
Swan, Whooper 488
Swans 485, **488**
Sweetlips, Harlequin 370
Swellshark 330, **345**
Swordfish 57
Symbion pandora 174, 181
Symbiosis 169, **498**
 commensal relationships **499**
 commensal shrimps 500
 hitchhikers **500**
 jellyfish 500
 juvenile fish and jellyfish 62
 life cycle of a parasitic rhizocephalan
 barnacle 501
 living homes **499**
 mutually beneficial relationships **498**
 parasitic isopods 501
 parasitic marine animals 501
 parasitic relationships **500**
 permanent obligatory relationships
 499
 plant-laden bivalves 240
Symphodus melops 395
Symsagittifera roscoffensis 156
Synanceia verrucosa 390
Synaptula 301
Syngnathiformes 389
Synthliboramphus wumizusume 474

T

Tadorna tadorna 487, **488**
Taenianotus triacanthus 497
Taeniura lymma 330, **351**
Tang, Sailfin 124, **399**
Tardigrada 177
Tarpon 317
 Atlantic 375
Taurulus bubalis 390
Tellin, Baltic 240
 Shell 244
Tenpounders 375
Tephromela 170
Tephromela atra 171
Terebellida 215

Terebratulina retusa 256, **257**
Tern, Arctic 463, **475**
 Caspian 475
 Little 476
 terns 475
 Sandwich 475
 Sooty 476, **509**
 Whiskered 475
 White 476
Testudines 402, **410**
Tetraodontiformes 392
Tetraselmis 156
Tetraselmis cordiformis 156
Thalassarche melanophris 464, **472**
Thalassia hemiprichii 161
Thalassia testudinum 128
Thalassiosira 149
Thalassiothrix 149
Thaliacea 306
Thaumastoderma ramuliferum 174
Thaumoctopus mimicus 251
The bends 419
Thermoclines 27
Thermotoga naphthophila 126
Thrift 79
Thunnus thynnus 23, **397**
Thylacodes 236
Thysanozoon 218
Tidal electricity generator 107
Tidal rapids 107
 SeaGen 107
Tides 30
 lunar cycle 30
Tinselfish, Thorny 388
Toadfish, Oyster 383
 Splendid 365
Toadfishes 383
Tomopteris 53
Tonicella undocaerulea 253
Tope 346
Topknot 391
Topographical features of the ocean 37
Topshell 234
Torpediniformes 354
Torpedo, Common 354
Torpedo torpedo 354
Tosia australis 293
Tosia magnifica 290
Toxopneustes 297
Tracheaophyta 128
Trachymedusae 192
Trematomus bernacchii 398
Tresus capax 243
Trevally, Bluefin 397
 Golden 399, **441**
Triaenodon obesus 347
Triakis semifasciata 346
Trichechidae 416
Trichechus senegalensis 416
Trichoplax adhaerens 174, 181
Tridacna crocea 244
Tridacna gigas 228, **240**

Tridacna squamosa 513
Triggerfish, Clown 392
Trilobites 119
Tringa nebularia 483
Triphyllozoon 287
Triphyllozoon moniliferum 284
Tripodfish 380
Tripterygion delaisi 396
Triton, Giant 511
Tropicbird, Red-tailed 470
Tropicbirds 460, **470**
Trout 379
 Rainbow 315, **318**
 Sea 379
Trumpetfish 389
Tubastrea 206
Tubipora musica 204
Tubulanus annulatus 221
Tubularia indivisa 45, **194**
Tubulipora plumosa 287
Tuna, Atlantic Bluefin 397
 Bluefin 23
 Skipjack 359
Tunicata 311
Tunicate, Lightbulb 311
Tunicates 53,306, **307**
 appendicularians 309
 biology 309
 distribution 307
 doliolids 309
 ecology 310
 larvaceans 309
 life history 309
 pyrosomes 309
 salps 309
 species 311
 structure 308
 tadpole larva 310
 uses, threats, status and management
 310
Turbinaria 148
Turbot 391
Turnstone, Ruddy 84, **483**
Turritella terebra 236
Turritopsis nutricula 193
Tursiops truncatus 75, **435**
Turtle, Flatback 411
 Green 407, 409, **410**
 Hawksbill 407, 410, *411*
 Kemp's Ridley 411
 Leatherback 64, 403, **411**
 Loggerhead 15, **410**
 Olive Ridley 410, *411*
Turtles, sea 407
 biology and ecology 407
 distribution 407
 distribution, nesting and status 408
 eggs 408
 feeding 407
 identification 411
 life history 408
 species 410

structural adaptations 407
temperature 409
temperature-dependent sex
 determination 409
track 408
uses, threats, status and management
 409
Tusk shells 254
 biology 254
 distribution 254
 feeding 254
 life history 254
 structure 254
 uses, threats, status and management
 254
Twilight zone 34, **63**
 adaptations 63
Tydemania expeditionis 143
Tylosurus choram 386

U

Ulva, life cycle 141
Ulva stitipata 143
Ulvophyceae 142
Undaria pinnatifica 147
Uniola paniculata 73
Upwelling 52, 117
Urchin, Edible Sea 297, *298*
 Rock-boring 299
Uria aalge 466, 468, **474**
Urobatis concentricus 352
Uroglena 151
Urolophus halleri 351
Ursus maritimus 456

V

Valvatida 293
Vanellus vanellus 484
Varanus salvator 415
Vargula hilgendorfii 283
Velella velella 61
Velvet Belly 341
Venom and poison 493
Ventricaria ventricosa 142
Verongida 182
Verrucaria maura 171
Vertebrata 306
Vertebrates 306
Vetigastropoda 235
Viperfish 65, 67
 Sloane's 380

W

Waders 478
 a gauntlet of dangers 482
 bills 479
 biology 479
 distribution 478
 ecology 481
 feeding 479
 life history 480
 outliers 478

species 483
structure 478
three ways to be male 480
uropygial glands 479
uses, threats, status and management 481
Wakame 147
Walrus 446, **450**
 biology 447
 body form and general features 445
 distribution 444
 ecology 448
 feeding 447
 life history 448
 oddities 446
 senses 447
 species 450
 structural adaptations 445
 uses, threats, status and management 449
Waminoa 227
Watasenia scintillans 66
Water bears *174*, 177
 biology 177
 classification 177
 distribution 177
 feeding 177
 life history 177
 living dead 177
 structure 177
Water pressure **23**
Waves **32**
 period *32*
 velocity *32*
 wavelength *32*
Ways of life **43**
Weed, Cactus 143
 Common Green Branched 143
 Coral **139**
 Harpoon *138*
 Mossy Feather 143
 Paddle **161**
 Rainbow *135*
 Red Comb **139**
 siphon *137*
 Solier's Red String **140**
 pink paint **140**
 Thong *135*, *146*
 Trumpet **148**
 Turtle **143**
Weever, Lesser 395
Whale, Antarctic Minke *504*
 Baird's Beaked **438**
 beaked 438
 Blainville's Beaked **438**
 Blue **433**
 Bowhead **434**
 Bryde's *52*, 427
 Common Minke **433**
 Cuvier's Beaked **438**
 False Killer *426*
 Gray *103*, *430*, **434**

 Humpback *58*, 422, 427, 428, 430, **433**
 Killer **436**
 Long-finned Pilot **436**
 Melon-headed **436**
 Northern Bottlenose **438**
 Pygmy Killer **436**
 Pygmy Right *416*
 Pygmy Sperm **437**
 Southern Right *427*, **434**
 Sperm *418*, 437
 right 434
 toothed 434
Whales **420**
 baleen 422, 433
 biology 426
 body form and general features 421
 breaching *424*
 breathing 426
 cetacean behaviour and intelligence 423
 classification 420
 commensals 429
 differences between the superfamilies Mysticeti and Odontoceti 420
 distribution 421
 echolocation 425
 ecology 429
 fall *111*, 430
 feeding 427
 flipper-slapping *424*
 hearing 424
 life history 428
 melon organ 425
 migrations 421
 scrimshaw *431*
 senses 424
 skeleton 422, *423*
 sleep 426
 song 424
 sound 424
 sound pathways *425*
 species 433
 spyhopping *424*
 strandings 426
 structure 421
 tail-slapping *424*
 taste and smell *425*
 touch 425
 uses, threats, status and management 430
 vision 426
 watching trips *432*
Whelk, Common **235**
 Dog *233*, 234
White-spotted Rattail *317*
Whiting, Blue *314*
Wildfowl, marine 485
 adaptations of *486*
 biology 486
 courtship displays in seaducks *487*

 distribution 485
 ecology 487
 feeding 486
 life history 487
 species 488
 structure 485
 teeth 486
 uses, threats, status and management 487
Wireweed **148**
Wobbegong, Tasselled **343**
Wolffish, Atlantic **398**
World Register of Marine Species (WoRMS) 116
Worm, Bobbit *212*
 bootlace *220*, **221**
 Christmas Tree *213*
 Football Jersey **221**
 goblet *174*
 Green Paddle **215**
 hair 225
 Honeycomb *214*
 horseshoe *226*
 leeches **217**
 oligochaetes *210*, **216**
 paddle *213*
 Peacock *211*
 peanut **223**
 penis 225
 polychaete 53
 ribbon **220**
 sabellid tube *212*
 Scale *210*, **215**
 spiny-crown 225
 Spiral **215**
 spoon **224**
 Strawberry **215**
 Trumpet **216**
 classification 210
 structure 210
Worms, annelid **210**
Wrack, Bladder *85*, *131*, **148**
 Channelled *144*
 Horned *74*
 Knotted *131*, *146*
Wrasse, Ballan *138*, 362
 Corkwing **395**
 Cuckoo *274*, 369
 Humphead **373**, *502*
 Red-breasted **363**
 Sling-jaw *367*
Wrecks **92**
 succession of species *93*

X

Xanthoria 170
Xanthoria parietina *168*, **171**
Xenacoelomorpha **227**
 biology 227
 classification 227
 distribution 227
 ecology 227

 feeding 227
 life history 227
 structure 227
 uses, threats, status and management 227
Xenia **202**
Xenophthalmichthys danae *63*
Xenoturbella **227**
Xerophytes **69**
Xestospongia testudinaria *185*
Xiphias gladius *57*
Xylocarpus granatum **166**
Xyloplax 290

Y

Yoda purpurata *305*

Z

Zalophus californianus **451**
Zebrasoma velifer *124*, **399**
Zeiformes **388**
Zeugopterus punctatus **391**
Zeus faber *367*, **388**
Ziphiidae **438**
Ziphius cavirostris **438**
Zoantharia **208**
Zoanthids **208**
Zoarces viviparus **396**
Zonation *19*, **41**
 reef zones *95*
 rocky shore zones *86*
 seaweed *133*
Zooxanthellae **206**, *207*
Zostera marina *161*